The Grove Dictionary of Art

From Monet to Cézanne

Late 19th-century French Artists

Edited by Jane Turner

GROVEart

The Grove Art Series
From Monet to Cézanne
Late 19th-century French Artists
Edited by Jane Turner

© Macmillan Reference Limited, 2000

Published in the United Kingdom by
MACMILLAN REFERENCE LIMITED, 2000
25 Eccleston Place, London, SW1W 9NF, UK
Basingstoke and Oxford
ISBN: 0-333-92043-0
Associated companies throughout the world
http://www.macmillan-reference.co.uk

British Library Cataloguing in Publication Data
From Monet to Cézanne: late 19th-century French artists. -
 (Grove art)
 1. Artists—France—Biography
 2. Art, Modern—19th century—France
 3. Art, French
 I. Turner, Jane, 1956-
709.4'4'09034
ISBN 0-333-92043-0

Typeset in the United Kingdom by Florence Production Ltd, Stoodleigh, Devon
Printed and bound in the United Kingdom by TJ International Ltd, Padstow, Cornwall

Contents

Preface

In these days of information glut, *The Dictionary of Art* has been a godsend, instantly relegating all its predecessors to oblivion. Within its stately thirty-four volumes (one for the index), the territory covered seems boundless. Just to choose the most amusingly subtitled of the series, *Leather to Macho* (vol. 19), we can learn in the first article not only about the way animal skins are preserved, but about the use of leather through the ages, from medieval ecclesiastical garments to Charles Eames's furniture. And if we then move to the last entry, which turns out to be a certain Victorio Macho, we discover that in the early 20th century, he graced Spanish cities with public sculpture, including a monument to the novelist Benito Pérez Galdós (1918) that many of us have passed by in Madrid's Parque del Retiro. And should we wish to learn more about Macho, there is the latest biblio-graphical news, bringing us up to date with a monograph of 1987.

Skimming the same volume, we may stumble upon everything from the art of the LEGA people in Zaïre and the use of artificial LIGHTING in architecture to somewhat more predictable dictionary entries such as LICHTENSTEIN, ROY; LONDON: WESTMINSTER ABBEY; LITHOGRAPHY; or LOS ANGELES: MUSEUMS. If browsing through one volume of *The Dictionary of Art* can open so many vistas, the effect of the whole reference work is like casting one's net into the waters and bringing back an unmanageable infinity of fish. Wouldn't it be more useful at times to single out in one place some of the myriad species swimming through the pages of *The Dictionary*? And then there is the question of cost and dimensions. In its original, complete form, the inevitably stiff price and the sheer size of all thirty-four volumes meant that it has fallen mostly to reference libraries to provide us with this awesome and indispensable tool of knowledge.

Wisely, it has now been decided to make this overwhelming databank more specialized, more portable, and more financially accessible. To do this, the myriad sands have been sifted in order to compile more modest and more immediately useful single volumes that will be restricted, say, to Dutch painting of the 17th century or to a survey of major styles and movements in Western art from the Renaissance to the end of the 19th century. So, as much as we may enjoy the countless delights of leafing through the thirty-four volumes in some library, we can now walk off with only one volume that suits our immediate purpose, an unparalleled handbook for a wide range of readers, especially for students and scholars who, rather than wandering through the astronomical abundance of art's A to Z, want to have between only two covers the latest words about a particular artist or 'ism'.

The great art historian Erwin Panofsky once said 'There is no substitute for information'. This new format of *The Dictionary of Art* will help many generations meet his sensible demands.

<div align="right">

ROBERT ROSENBLUM
Henry Ittleson jr Professor of Modern European Art
Institute of Fine Arts
New York University

</div>

List of Contributors

Abdy, Jane
Alemany-Dessaint, Véronique
Baas, Jacquelynn
Bajou, Valérie M. C.
Bantens, Robert J.
Bascou, Marc
Beard, Dorathea K.
Becker, David P.
Benge, Glenn F.
Berhaut, Marie
Bidon, Colette E.
Boime, Albert
Boucher, Marie-Christine
Bouillon, Jean-Paul
Bourrut Lacouture, Annette
Boyer Ferrillo, Lynn
Brisac, Catherine
Burollet, Thérèse
Caffort, Michel
Cain Hungerford, Constance
Cardinal, Roger
Carter Southard, Edna
Cate, Phillip Dennis
Chazal, Gilles
Condon, Patricia
Corbin, Donna
Curtis, Penelope
Daguerre De Hureaux, A.
Davenport, Nancy
Davy-Notter, Annick
Delage, Anne-Marie
Distel, Anne
Durand-Revillon, Janine
Durey, Philippe
Estève, J.
Farwell, Beatrice
Faxon, Alicia Craig
Fields, Barbara S.
Flagg, Peter J.
Fouace, Jean
Frey, Julia Bloch
Garb, Tamar
Georgel, Pierre
Georges Goeneutte, Norbert
Goetz, Thalie
Greenspan, Taube G.

Grunewald, Marie-Antoinette
Hargrove, June
Hauptman, William
Herding, Klaus
Hild-Ziem, Eric
Hobbs, Richard
Howard, Michael
Hunisak, John M.
Hurel, Roselyne
Isaacson, Joel
Johnston, William R.
Jones, Mark
Kaplan, Julius
Kharibian, Leah
Lampert, Catherine
Lannoy, Isabelle De
Lavallée, Michèle
Leighton, John
Lemaistre, Isabelle
Leoussi, Athena S. E.
Lloyd, Christopher
Lymbery, Etrenne
Margerie, Laure De
Marin, Régis
McPherson, Heather
Melot, Michel
Millard, Charles
Miquel, Pierre
Misfeldt, Willard E.
Mitchell, Peter
Monnier, Geneviève
Morel, Dominique
Munro, Jane
Normand-Romain, Antoinette Le
Ojalvo, David
Pauchet-Warlop, Laurence
Peake, Lorraine
Pingeot, Anne
Preston, Harley
Ramade, Patrick
Rapetti, Rodolphe
Rocher-Jauneau, Madeleine
Rosenthal, Donald A.
Scottez-De Wambrechies, Annie
Sheon, Aaron
Smith, Paul

Stevenson, Lesley
Stocker, Mark
Thiebaut, Philippe
Thompson, James P. W.
Thompson, James
Thomson, Belinda
Thomson, Richard
Trapp, Frank
Tscherny, Nadia

Vogt, Christiane
Ward, Martha
Ward-Jackson, Philip
Weisberg, Gabriel P.
Whiteley, Jon
Whiteley, Linda
Wilcox, Timothy
Wissman, Fronia E.
Wright, Beth S.

General Abbreviations

The abbreviations employed throughout this book do not vary, except for capitalization, regardless of the context in which they are used, including the bibliographical citations and for locations of works of art. For the reader's convenience, separate full lists of abbreviations for locations, periodical titles and standard reference books and series are included as Appendices.

AD	Anno Domini	*d*	died	inc.	incomplete		
addn	addition	ded.	dedication,	incl.	includes,		
a.m.	ante meridiem		dedicated to		including,		
	[before noon]	dep.	deposited at		inclusive		
Anon.	Anonymous(ly)	destr.	destroyed	Incorp.	Incorporation		
app.	appendix	diam.	diameter	inscr.	inscribed,		
Assoc.	Association	diss.	dissertation		Inscription		
attrib.	attribution,	Doc.	Document(s)	intro.	introduced by,		
	attributed to				introduction		
		ed.	editor, edited (by)	inv.	inventory		
B.	Bartsch [catalogue	edn	edition	irreg.	irregular(ly)		
	of Old Master	eds	editors				
	prints]	e.g.	*exempli gratia* [for	jr	junior		
b	born		example]				
bapt	baptized	esp.	especially	kg	kilogram(s)		
BC	Before Christ	est.	established	km	kilometre(s)		
bk, bks	book(s)	etc	*et cetera* [and so on]				
BL	British Library	exh.	exhibition	l.	length		
BM	British Museum			lb, lbs	pound(s) weight		
bur	buried	f, ff	following page,	Ltd	Limited		
			following pages				
c.	circa [about]	facs.	facsimile	m	metre(s)		
can	canonized	fasc.	fascicle	m.	married		
cat.	catalogue	*fd*	feastday (of a saint)	M.	Monsieur		
cf.	confer [compare]	fig.	figure (illustration)	MA	Master of Arts		
Chap., Chaps		figs	figures	MFA	Master of Fine Arts		
	Chapter(s)	*fl*	*floruit* [he/she	mg	milligram(s)		
Co.	Company;		flourished]	Mgr	Monsignor		
	County	fol., fols	folio(s)	misc.	miscellaneous		
Cod.	Codex, Codices	ft	foot, feet	Mlle	Mademoiselle		
Col., Cols	Colour;			mm	millimetre(s)		
	Collection(s);	g	gram(s)	Mme	Madame		
	Column(s)	gen.	general	Movt	Movement		
Coll.	College	Govt	Government	MS., MSS	manuscript(s)		
collab.	in collaboration	Gt	Great	Mt	Mount		
	with, collaborated,	Gtr	Greater				
	collaborative			N.	North(ern);		
Comp.	Comparative;	h.	height		National		
	compiled by,	Hon.	Honorary,	n.	note		
	compiler		Honourable	n.d.	no date		
cont.	continued			NE	Northeast(ern)		
Contrib.	Contributions,	ibid.	*ibidem* [in the	nn.	notes		
	Contributor(s)		same place]	no., nos	number(s)		
Corp.	Corporation,	i.e.	*id est* [that is]	n.p.	no place (of		
	Corpus	illus.	illustrated,		publication)		
Corr.	Correspondence		illustration	nr	near		
Cttee	Committee	in., ins	inch(es)	n. s.	new series		
		Inc.	Incorporated	NW	Northwest(ern)		

Occas.	Occasional	**red.**	reduction,		Santissimi
op.	opus		reduced for	**St**	Saint, Sankt,
opp.	opposite; opera	*reg*	*regit* [ruled]		Sint, Szent
	[pl. of opus]	**remod.**	remodelled	**Ste**	Sainte
oz.	ounce(s)	**repr.**	reprint(ed);	**suppl., suppls**	supplement(s),
			reproduced,		supplementary
p	pence		reproduction	**SW**	Southwest(ern)
p., pp.	page(s)	**rest.**	restored,		
p.a.	per annum		restoration	**trans.**	translation,
Pap.	Paper(s)	**rev.**	revision, revised		translated by;
para.	paragraph		(by/for)		transactions
pl.	plate; plural	**Rev.**	Reverend;	**transcr.**	transcribed
pls	plates		Review		by/for
p.m.	post meridiem				
	[after noon]	**S**	San, Santa,	**unpubd**	unpublished
Port.	Portfolio		Santo, Sant',		
Posth.	Posthumous(ly)		São [Saint]	*v*	*verso*
prev.	previous(ly)	**S.**	South(ern)	**var.**	various
priv.	private	**SE**	Southeast(ern)	**viz.**	*videlicet*
pseud.	pseudonym	**sect.**	section		[namely]
pt	part	**ser.**	series	**vol., vols**	volume(s)
pubd	published	**sing.**	singular	**vs.**	versus
pubn(s)	publication(s)	**sq.**	square		
		SS	Saints, Santi,	**W.**	West(ern)
R	reprint		Santissima,	**w.**	width
r	*recto*		Santissimo,		

Note on the Use of the Book

This note is intended as a short guide to the basic editorial conventions adopted in this book.

Abbreviations in general use in the book are listed on pp. x–xi; those used in bibliographies and for locations of works of art or exhibition venues are listed in the Appendices.

Author's signatures appear at the end of the articles. Where an article was compiled by the editors or in the few cases where an author has wished to remain anonymous, this is indicated by a square box (□) instead of a signature.

Bibliographies are arranged chronologically (within a section, where divided) by order of year of first publication and, within years, alphabetically by authors' names. Abbreviations have been used for some standard reference books; these are cited in full in Appendix C. Abbreviations of periodical titles are in Appendix B. Abbreviated references to alphabetically arranged dictionaries and encyclopedias appear at the beginning of the bibliography (or section).

Biographies in this dictionary start with the subject's name and, where known, the places and dates of birth and death and a statement of nationality and occupation. In the citation of a name in a heading, the use of parentheses indicates parts of the name that are not commonly used, while square brackets enclose variant names or spellings.

Members of the same family with identical names are usually distinguished by the use of parenthesized small roman numerals after their names. Synonymous family members commonly differentiated in art-historical literature by large roman numerals appear as such in this dictionary in two cases: where a family entry does not contain the full sequence (e.g. Karel van Mander I and Karel van Mander III); and where there are two or more identical families whose surnames are distinguished by parenthesized small roman numerals (e.g. Velde, van de (i) and Velde, van de (ii)).

Cross-references are distinguished by the use of small capital letters, with a large capital to indicate the initial letter of the entry to which the reader is directed; for example, 'He commissioned LEONARDO DA VINCI...' means that the entry is alphabetized under 'L'. Given the comprehensiveness of this book, cross-references are used sparingly between articles to guide readers only to further useful discussions.

Aizelin, Eugène-Antoine

(*b* Paris, 8 July 1821; *d* Paris, 4 March 1902). French sculptor. A pupil of Etienne-Jules Ramey and Augustin-Alexandre Dumont at the Ecole des Beaux-Arts, Paris, he made several unsuccessful attempts to win the Prix de Rome. He nevertheless pursued a successful career and produced sculpture as markedly classical in style as that of his contemporaries who had studied at the Académie de France in Rome. He received numerous commissions from the State and from the City of Paris for the decoration of public buildings, working on the three great Parisian building projects of the Second Empire (1851–70), the new Louvre, the Opéra and the Hôtel de Ville, as well as on theatres, churches and other institutions. Apart from decorative sculpture, his output consists of classicizing statues on mythological, biblical and allegorical subjects, which were exhibited at the Salon and were sometimes reproduced in bronze editions. Among these works are *Psyche* (marble, 1863; Quimper, Mus. B.-A.), *Judith* (bronze, 1890; Le Mans, Mus. Tessé) and *Hagar and Ishmael* (marble, 1889; Belleville-sur-Bar, Sanatorium). He also exhibited genre sculpture, widely circulated in bronze editions (many cast by Ferdinand Barbedienne, 1810–92), including *Marguerite in Church*, *Mignon* and *The Youth of Raphael*. A collection of his works was given to the Musée Départemental de l'Oise, Beauvais, in 1975.

Bibliography
Lami

LAURE DE MARGERIE

Aligny, Théodore Caruelle d'

(*b* Chaume, Nevers, 24 Jan 1798; *d* Lyon, 24 Feb 1871). French painter. His father was the artist Jean-Baptiste Caruelle (*d* 1801). About 1859 he added to his name that of his stepfather, Claude Meure-Aligny. He spent his early life in Paris, leaving the Ecole Polytechnique in 1808 to frequent the studios of Jean-Baptiste Regnault and the landscape artist Louis-Etienne Watelet (1780–1866). He exhibited at the Salon for the first time in 1822 with *Daphnis and Chloe* (untraced),

which went unremarked. He finished his apprenticeship with the customary journey to Italy, staying in Rome from 1822 to 1827. During 1826 and 1827 he became friendly with Corot, whom he acknowledged as his master, although Aligny preceded Corot in his repeated studies of the Roman countryside and even appears to have led the way for the group of landscape artists who stayed there at the same time as himself, such as Edouard Bertin and Prosper Barbot. The sketches from this period (Rennes, Mus. B.-A. & Archéol., and Rome, Gab. Stampe) already bear witness to his conception of landscape as an organization of form and mass. He established himself in Paris in 1827 and that year exhibited at the Salon with *Saul Consulting the Witch of Endor*, which went unnoticed. From 1828 he spent much time in the Forest of Fontainebleau, one of the first of several generations of landscape artists who frequented the place.

In 1831, Aligny exhibited six landscapes and a historical landscape, *Massacre of the Druids under the Emperor Claudius* (Nîmes, Mus. B.-A.), which won him a second-class medal. He made trips to Normandy (1831) and Switzerland (1832). From 1833 he exhibited regularly at the Salon. The same year, he presented three landscapes that surprised his contemporaries with their naturalism. In 1834–5 he made a second journey to Italy, where he made large numbers of studies and sketches, especially in the environs of Rome and Naples. He returned to Fontainebleau, once more keeping company with Corot, Diaz and Rousseau. At the Salon of 1837 his *Prometheus on the Caucasus* (Paris, Louvre) was bought by the state and won him a first-class medal; his studio became much visited, and numerous landscape artists studied there, including Eugène Desjobert (1817–63), Charles Lecointe (1824–86), Jean-Joseph Bellel (1816–98), Théophile Chauvel, François-Louis Français and Auguste Ravier. Aligny spent the summer of 1838 in the Auvergne, where he executed an important series of drawings. He exhibited regularly at the Salon and drew attention in 1842 with his *Hercules Fighting the Hydra* (Carcassone, Mus. B.-A.), for which he was awarded the Légion d'honneur. The same

year, he was given a state commission to paint a *Baptism* (*in situ*) for the church of St-Paul-Saint-Louis in Paris. Two years later, Corot was to paint the same subject in the chapel of St Nicolas du Chardonnet in Paris. Aligny's next commission followed in 1850 with two decorative paintings for the church of St-Etienne-du-Mont in Paris: *Baptism* and *St John Preaching in the Desert* (both *in situ*).

With all the advantages of an official career, Aligny was commissioned to draw the sites of ancient Greece. The year after his return in 1844 he published a series of engravings entitled *Views of the Most Famous Sites of Ancient Greece*; these were admired by Baudelaire who paid homage to his 'serious and idealistic talent' (Salon, 1846). His Salon exhibits bore witness to his travels, for example the *Infant Bacchus Reared by the Nymphs on the Island of Naxos* (Salon of 1848; Bordeaux, Mus. B.-A.) and *Solitude of a Monk at Prayer in a Landscape* (Salon of 1850; Rennes, Mus. B.-A. & Archéol.). These large compositions were accompanied by more modest landscapes, all attesting to a profound knowledge of nature founded on the constant practice of sketching from life. In 1861 he reached the height of his career as Director of the Ecole des Beaux-Arts in Lyon, a position he occupied until his death, but he continued to produce studies from nature, in Haute-Saône and around Lyon and Grenoble, and to take part in the Salon until 1869. Two sales of his studio were held in Paris (Hôtel Drouot) in 1874 and 1878.

Aligny belonged to a generation of landscape artists for whom landscape painting was first and foremost a study of nature. His large paintings seem marked by a concern for strict and rigorous composition, dominated by the search for arabesques and the harmonies of large masses: rocks, foliage and depressions. This aesthetic, which became less rigid after 1860, was nevertheless considered cold when Realism triumphed. His art continued to be founded on careful study of, and meditation on, nature as his numerous drawings and sketches in oil demonstrate. His contemporaries saw him as the true leader of landscape reform.

Bibliography

M. M. Aubrun: *Théodore Caruelle d'Aligny et ses compagnons* (exh. cat., Orléans, Mus. B.-A.; Dunkirk, Mus. B.-A.; Rennes, Mus. B.-A. & Archéol.; 1979)

P. Ramade: 'Théodore Caruelle d'Aligny: Dessins du premier séjour italien (1822–7)', *Rev. Louvre*, ii (1986), pp. 121–30

M. M. Aubrun: *Théodore Caruelle d'Aligny, 1798–1871: Catalogue raisonné de l'oeuvre peint, dessiné, gravé* (Paris, 1988)

PATRICK RAMADE

Amaury-Duval [Pineu-Duval], Eugène-Emmanuel

(*b* Montrouge, Paris, 4 April 1806; *d* Paris, 29 April 1885). French painter and writer. A student of Ingres, he first exhibited at the Salon in 1830 with a portrait of a child. He continued exhibiting portraits until 1868. Such entries as *M. Geoffroy as Don Juan* (1852; untraced), *Rachel, or Tragedy* (1855; Paris, Mus. Comédie-Fr.) and *Emma Fleury* (1861; untraced) from the Comédie-Française indicate an extended pattern of commissions from that institution. His travels in Greece and Italy encouraged the Néo-Grec style that his work exemplifies. Such words as refinement, delicacy, restraint, elegance and charm pepper critiques of both his painting and his sedate, respectable life as an artist, cultural figure and writer in Paris. In contrast to Ingres's success with mature sitters, Amaury-Duval's portraits of young women are his most compelling. In them, clear outlines and cool colours evoke innocence and purity. Though the portraits of both artists were influenced by classical norms, Amaury-Duval's have control and civility in contrast to the mystery and sensuousness of Ingres's.

Amaury-Duval's extant drawings, often of carefully contoured, barely modelled nudes, again link him to Ingres, although the expressions of his figures are often more dreamy than those of his master's. The drawings of nudes were incorporated into such paintings as the *Birth of Venus* (1863; Lille, Mus. B.-A.), using a pose from Ingres's *Venus Anadyomene* (Chantilly, Mus. Condé), and in the fresco decorations for two rooms (one a Pompeian

Revival dining-room) of the château at Linières in the Vendée in 1865 (destr. 1912).

Though a religious sceptic, Amaury-Duval was active, along with many of Ingres's other students, in the programme of church decoration pressed on the Second Empire by the conservative Catholic Church. His commissioned works include frescoes for the chapel of the Virgin (1844–66) in St Germain-l'Auxerrois, Paris, the chapel of St Philomena (1844) in St Merri, Paris, apse and wall decorations for the church (1849–57) at Saint-Germain-en-Laye, cartoons for two stained-glass windows in Ste Clotilde in Paris (all *in situ*) and a number of large canvases, such as the *Annunciation* (1860; Mâcon, Mus. Mun. Ursulines). The artist's reliance on Perugino and more particularly on Fra Angelico's frescoes for the convent of S Marco in Florence has been noted (Foucart, 1987). Amaury-Duval visited the Nazarenes and admired their Casino Massimo frescoes in Rome in 1836 but, unlike their sophisticated mix of 15th-century Renaissance styles, his religious art is consciously archaic. Angels stand in serried rows as in a 14th-century *Maestà*, air is still and transparent, light casts no shadows (backgrounds are often painted in gold leaf), defined outlines freeze profiles, gestures are repeated as in a chorus, and drapery falls in columnar flutes over Gothic tubular bodies. Visual effects are architecturally severe, although the subjects are more likely to be naive and simple than those of other students of Ingres. Amaury-Duval's writings, such as *Souvenirs de l'atelier d'Ingres* (1878), centre on his connections to the Ingres circle.

Writings

Journal de Voyage (MS.; 1836); ed. B. Foucart (Paris, in preparation)

Souvenirs de l'atelier d'Ingres (Paris, 1878; preface and notes by D. Ternois (Paris, 1986))

Souvenirs de jeunesse, 1829–30 (Paris, 1885)

Bibliography

Bénézit; Thieme–Becker

E. J. Délécluze: *Les Beaux-arts dans les deux mondes en 1855* (Paris, 1856), pp. 247–9

L. Legrange: 'Salon de 1864', *Gaz. B.-A.*, xxv (1864), p. 510

H. Delaborde: 'Des oeuvres et de la manière de M. Amaury-Duval', *Gaz. B.-A.*, xviii (1865), pp. 419–28

P. Mantz: 'Salon de 1867', *Gaz. B.-A.*, xxii (1867), pp. 517–18

Amaury-Duval, 1806–85 (exh. cat. by V. Noël-Bouton, Montrouge, Hôtel de Ville, 1974)

The Second Empire: Art in France under Napoleon III (exh. cat., ed. G. H. Marcus and J. M. Iandola; Philadelphia, PA, Mus. A.; Detroit, MI, Inst. A.; Paris, Grand Pal.; 1978–9), pp. 249, 362

B. Foucart: *Le Renouveau de la peinture religieuse en France, 1800–1860* (Paris, 1987), pp. 212–14

NANCY DAVENPORT

Angrand, Charles

(*b* Criquetot-sur-Ouville, Normandy, 19 April 1854; *d* Rouen, 1 April 1926). French painter. He was trained at the Académie de Peinture et de Dessin in Rouen, where he won prizes. Although he failed to gain entry to the Ecole des Beaux-Arts in Paris, Angrand began to win a controversial local reputation for canvases in a loosely Impressionist manner. In 1882 he secured a post as a school-teacher at the Collège Chaptal in Paris. With this security he was able to make contacts in progressive artistic circles, and in 1884 he became a founder-member of the Salon des Indépendants. His paintings of this period depict rural interiors and kitchen gardens, combining the broken brushwork of Monet and Camille Pissarro with the tonal structure of Bastien-Lepage (e.g. *In the Garden*, 1884; priv. col., see 1979 exh. cat., p. 27).

By the mid-1880s Angrand had met Seurat through Signac and the literary salon of the writer Robert Caze. From 1887 Angrand began to paint in Seurat's Neo-Impressionist manner and adopted his tenebrist drawing style. Paintings such as *The Seine at Dawn* (1889; Geneva, Petit Pal.) typify Angrand's ability to distil poetry from the most banal suburban scene. In the early 1890s he concentrated on conté crayon drawings, producing rural scenes and mother-and-child subjects of dark Symbolist intensity, and on submitting illustrations to anarchist publications such as *Les Temps Nouveaux*. In 1896 Angrand retreated to Normandy, though throughout his life he remained loyal to the Salon des Indépendants.

Returning to painting about 1906, Angrand took up the mosaic touch and sumptuous colours of Signac and Henri Edmond Cross in landscapes that verge on the non-representational (e.g. *Farmyard in Normandy*, c. 1907; Paris, Pierre Angrand priv. col.). Angrand always stressed that his art was concerned with 'an intellectual vision of harmony', and he single-mindedly pursued his disciplined humanitarian purpose.

Bibliography

P. Angrand: 'Charles Angrand', *The Neo-Impressionists*, ed. J. Sutter (London, 1970), pp. 77–88

B. Welsh-Ovcharov: *The Early Work of Charles Angrand and his Contact with Vincent van Gogh* (The Hague, 1971)

Charles Angrand (exh. cat. by P. Angrand, Dieppe, Château-Mus., 1976)

Post-Impressionism: Cross-currents in European Painting (exh. cat., London, RA, 1979–80), pp. 27–8

F. Lespinasse: *Charles Angrand, 1854–1926* (Rouen, 1982)

F. Lespinasse, ed.: *Charles Angrand: Correspondances* (Rouen, 1988)

RICHARD THOMSON

Antigna, (Jean-Pierre-)Alexandre

(*b* Orléans, 7 March 1817; *d* Paris, 26 Feb 1878). French painter. He was taught at the school of drawing in Orléans by a local painter, François Salmon (1781–1855). On 9 October 1837 he entered the Ecole des Beaux-Arts in Paris, first in the atelier of Sebastien Norblin de la Gourdaine (1796–1884). A year later he became a pupil of Paul Delaroche, from whom he acquired his understanding of dramatic composition.

Antigna exhibited at the Salon for the first time in 1841 with a religious canvas, the *Birth of Christ* (untraced), and showed there every year for the rest of his life. Until 1845 his exhibits were primarily religious scenes and portraits. Influenced by the effects of industrialization and the sufferings of the urban working class, which he witnessed at first hand while living in the poor quarter of the Ile St Louis in Paris, he turned towards contemporary social subjects dominated by poverty and hardship. The 1848 Revolution confirmed him in his allegiance to Realist painting,

and he continued to paint in this style until c. 1860. During this period he produced his most important and personal works, which frequently dramatized natural or manmade disasters with bold lighting, dramatic poses and rich colour, almost exclusively on a large scale: for example *Lightning* (1848; Paris, Mus. d'Orsay), *The Fire*, his most famous painting (1850; Orléans, Mus. B.-A.), the *Forced Halt* (1855; Toulouse, Mus. Augustins) and *Visit of His Majesty the Emperor to the Slate Quarry Workers of Angers during the Floods of 1856* (1856–7; Angers, Mus. B.-A.). In 1849 he painted *After the Bath*, a large canvas bought by the state and sent the same year to the Orléans museum. The sensuality of the nudes and the topical quality of the scene provoked a local scandal.

Around 1860 Antigna moved from tragic Realism to a gentler Naturalism, and social subjects were replaced by anecdotal scenes, although he never lost his sense of compassion for the poor. He travelled in search of local colour and the picturesque: from 1857 onwards he made several journeys to Spain; in 1858 he stayed in Gargilesse and the Creuse. He visited Brittany many times over several years. Landscape, including the sea, appeared with increasing frequency in his works, which often had a moralizing or satirical flavour: the *Village Cock* (c. 1858; Bagnères-de-Bigorre, Mus. A), *Young Breton Sleeping* (c. 1858–9; Orléans, Mus. B.-A.), *Young Girls Reading a Lament* (1860; Nantes, Mus. B.-A.), *Summer Evening* (1862; Dinan, Hôtel de Ville) and *High Tide* (1874; Dunkirk, Mus. B.-A.).

At the same time Antigna also produced a number of canvases of mystical and sentimental inspiration and of a Symbolist tendency: for example *A Mother's Last Kiss* (c. 1865; Lille, Mus. B.-A.). Children appear in most of his works, and he painted them with sympathy, whether happy or sad. Antigna received numerous distinctions and honours, including the Chevalier of the Légion d'honneur in 1861. In the same year he married Hélène-Marie Pettit (1837–1918), who herself became a painter. Their son, André-Marc Antigna (1869–1941), was also a painter and miniaturist.

Bibliography

Alexandre Antigna (exh. cat. by D. Ojalvo, Orléans, Mus.
 B.-A., 1978)
*The Realist Tradition: French Painting and Drawing,
 1830–1900* (exh. cat. by G. P. Weisberg, Cleveland, OH,
 Mus. A., 1980), pp. 265–6

DAVID OJALVO

Appian, Adolphe(-Jacques-Barthélémy)

(*b* Lyon, 28 Aug 1818; *d* Lyon, 29 April 1898).
French painter and printmaker. He was a student
of François Grobon (1815–1901) and Augustin
Thierriat (1789–1870) at the Ecole des Beaux-Arts,
Lyon. Appian made a speciality of charcoal studies
from nature in which colours were transposed
into tonal values. From 1852 he worked from
nature at Crémieu, together with Corot, Charles-
François Daubigny, Auguste Ravier, Louis-Hector
Allemand (1809–86) and Louis Carrand. He had by
this time achieved financial independence and
devoted himself completely to painting.

Appian depicted an enormous range of sub-
jects, visiting the Pyrenees, the Auvergne, the
Bugey and Italy: he often favoured views of still
waters and the Mediterranean such as *The Beach*
(1870; Lyon, Mus. B.-A.). His scenes are frequently
dotted with little figures in the style of his friend
Corot. The style of this prolific and meticulous
production remained rather static until 1877,
when Appian abandoned his earlier sombre
palette and became a virtuoso colourist, produc-
ing work with a glistening enamel-like quality. In
1885 he painted in the environs of Fontainebleau.
His work as a whole is regional in outlook, with
its frequent concentration on the landscape of the
Lyon area, and can be found in the collections of
the Musées des Beaux-Arts at Dijon and Lyon. His
studio in the Villa des Fusains came to symbolize
19th-century landscape painting in the region.
Appian was also a notable printmaker; from 1863
he belonged to the Société des Aquafortistes, pro-
ducing etchings for Alfred Cadart and working
in drypoint. He also produced work for the
Gazette des beaux-arts, the *Revue du Lyonnais*, *Le
Fusain* and *Paris Salon*. His son Jean-Louis Appian
(1862–96) was also a painter and printmaker.

Bibliography

A. Curtis and P. Prouté: *Adolphe Appian, son oeuvre gravé
 et lithographié* (Paris, 1968)

COLETTE E. BIDON

Aubé, Jean-Paul

(*b* Longwy, Meurthe et Moselle, 3 July 1837; *d*
Capbreton, Landes, 23 Aug 1916). French sculptor.
In 1851 he entered the Ecole Gratuite de Dessin,
Paris, also studying with Antoine-Laurent Dantan,
and in 1854 moved to the Ecole des Beaux-Arts. A
grant from his native *département* enabled him to
travel to Italy in 1866–7, though he was evidently
little influenced by antique or Renaissance works
of art. Apart from his bronze monument to *Dante
Alighieri* (1879–80; Paris, Square Monge), his work
is in a neo-Rococo style, as exemplified in his ter-
racotta bust of his daughter *Marcelle Aubé* (1910;
Paris, Mus. d'Orsay). Besides many portrait busts
he also executed public monuments to notable
Frenchmen, several of which were destroyed on the
orders of the Vichy government in 1941. The most
important, and most controversial, was that to
Léon Gambetta (bronze, 1884–8), built in collabo-
ration with the architect Louis-Charles Boileau
in the courtyard of the Louvre in Paris; it was
damaged during World War II and dismantled from
1954 onwards (model, Paris, Mus. d'Orsay). Aubé
also supplied decorative sculpture for public build-
ings as well as private mansions in Paris such as
the Hôtel de la Païva on the Champs-Elysées and
the Palais Rose (destr. 1969), which belonged to
Comte Boni de Castellane.

Aubé had a consistent interest in the decorative
arts. Between 1876 and 1882 he supplied models
for the Haviland atelier in Paris, and then for that
of the ceramicist Ernest Chaplet, as well as for the
national Sèvres porcelain manufactory. One of his
table centrepieces (silver and rock crystal; Paris,
Mus. d'Orsay) was exhibited at the Exposition
Universelle (Paris, 1910). He was one of the first
members of the Société Nationale des Beaux-Arts.
In 1883 he was appointed professor of sculpture
and later director of the Ecole Municipale Bernard
Palissy, a school intended to promote the applica-
tion of the fine arts to industry.

Bibliography

La Sculpture française au XIXe siècle (exh. cat., ed. A.
 Pingeot; Paris, Grand Pal., 1986)

LAURE DE MARGERIE

Avisseau, Charles-Jean

(b Tours, 25 Dec 1796; d Tours, 6 Feb 1861). French
potter. He was the son of a stone-cutter and at a
young age was apprenticed in a faience factory at
Saint Pierre-des-Corps. In 1825 he entered the
ceramic factory of Baron de Bezeval at Beaumont-
les-Autels where he saw a dish made by the
Renaissance potter Bernard Palissy, which was to
inspire his work. In 1843 Avisseau established an
independent factory on the Rue Saint-Maurice in
Tours, where individual ceramics inspired by and
in the style of Palissy's 'rustic' wares were pro-
duced (e.g. lead-glazed dish, 1857; Bagnères-de-
Bigorre, Mus. A.). Although critics complained that
his works merely imitated the Renaissance master,
he never directly copied Palissy's pieces. During
the 1840s and 1850s he received a number of major
commissions, including a large dish for Frederick
William IV, King of Prussia, by the Princesse de
Talleyrand and a perfume burner for the Turkish
Ambassador Prince Kallimaki. Avisseau exhibited
his ceramics in Paris at the 1849 Exposition de
l'Industrie, where he was listed as a 'fabricant de
poterie genre Palissy', and again at the Exposition
Universelle of 1855, where he received a second-
class medal for the technical distinction of his
work.

Bibliography

E. Giraudet: Les Artistes tourangeaux (Tours, 1885)

R. Maury: 'Faïences en relief: Les figulines rustiques', abc
 décor, lxvi (1970), pp. 56-82

H.-J. Heuser: Französische Keramik zwischen 1850 und
 1910 (Munich, 1974)

DONNA CORBIN

Bail

French family of painters. Jean-Antoine Bail (b
Chasseley, Rhône, 8 April 1830; d Nesle-la-Vallée,
20 Oct 1919) was largely self-taught, but he
received some training at the Ecole des Beaux-Arts
in Lyon before showing the intimate, monochro-
matic Artist's Studio (Saint-Etienne, Mus. A. &
Indust.) at the Salon there in 1854. He subse-
quently showed works at the Paris Salon, begin-
ning in 1861 with The Cherries (untraced), and he
exhibited at the Salon of the Société des Artistes
Français, Paris, until 1898. He was recognized
by contemporary critics as the artist who best
exemplified the realist tradition in provincial
themes. He used models who posed in his studio
on the Ile St Louis for his paintings of cooks and
maids, and many of his interior scenes, with
their intimate figural groupings and close atten-
tion to detail, display an awareness of Chardin and
Dutch 17th-century painting. Sensitive portraits
such as the Member of the Brass Band (1880;
Cognac, Mus. Cognac) demonstrate his ability to
suggest the character of his sitters. His older
son Franck Bail (1858–1924) painted still-lifes,
interiors and portraits, exhibiting at the Paris
Salon and receiving honourable mention at the
Exposition Universelle of 1889. Joseph Bail (b
Limonest, Rhône, 22 Jan 1862; d Paris, 26 Nov
1921), a younger son of Jean-Antoine Bail, was
also an artist. In a series of compositions—often
purchased by middle-class collectors—he perpe-
tuated his father's involvement with Chardin
through studies of cooks playing cards, smoking,
preparing a meal or cleaning utensils. Such paint-
ings as The Housewife (exh. Salon 1897; Paris, Pal.
Luxembourg) also demonstrates his familiarity
with the works of Théodule Ribot, and Bail's
works achieved a comparable popularity with
the public and critics. His career continued to
flourish during the Third Republic and culmi-
nated in the award of a gold medal at the
Exposition Universelle of 1900. His absorption
of past styles and his dedication to Realism also
won him a medal of honour at the Salon of
1902. This award demonstrated the Salon's com-
mitment to Realism at a time when the tradition
was being challenged by a reinvigorated mod-
ernist movement that viewed the earlier style
as conservative and outmoded. The largest
collection of his work is at the Musée Lombart,
Doullens.

Bibliography

J. Valmy-Baysse: 'Joseph Bail', *Peintres d'aujourd'hui* (Paris, 1910), pp. 361–400

The Realist Tradition: French Painting and Drawing, 1830–1900 (exh. cat., ed. G. P. Weisberg; Cleveland, OH, Mus. A.; New York, Brooklyn Mus.; St Louis, MO, A. Mus.; Glasgow, A.G. & Mus.; 1980), pp. 266–7

G. P. Weisberg: 'Painters from Lyon: The Bails and the Continuation of a Popular Realist Tradition', *A. Mag.*, lv (1981), pp. 155–9

GABRIEL P. WEISBERG

Baron, Henri (Charles Antoine)

(*b* Besançon, 23 June 1816; *d* nr Geneva, 13 Sept 1885). French painter and illustrator. He was a pupil of Jean Gigoux in Paris *c.* 1835 and travelled through Italy with him and François-Louis Français. He made his début at the Salons of 1837 and 1838 with *Under the Willows* (1837; Tours, Mus. B.-A.) and *Macbeth and the Witches* in collaboration with Français and showing the paintings under Français' name. Baron emerged as a reputable painter of genre and idyllic scenes, painting fanciful scenes, often set in Renaissance Venice. His rather precious style and romantic, dashing subject-matter won him lasting success with a clientele much enamoured of facile compositions. Such works included *Sculpture Studio* (1840), *Fêtes galantes* (1845) and the *Mother of the Family* (1847; Marseille, Mus. B.-A.). Baron paid homage to several famous painters in such anecdotal works as *An Evening with Giorgione* (1844) and *Andrea del Sarto Painting* (1847). Among other works were the spirited *Wedding of Gamache* (1849; Besançon, Mus. B.-A. & Archéol.) and *Cabaret Scene* (1859; Paris, Louvre), purchased by Napoleon III. Baron also illustrated books, including François de Salignac de la Mothe-Fénelon's *Aventures de Télémaque* (Paris, 1846), and he collaborated on Honoré de Balzac's *La Peau de chagrin* (Paris, 1838) and an edition of Boccaccio's *Decameron* (Paris, 1842). With Français and Célestin Nanteuil (1813–73) he also produced the three-volume *Les Artistes anciens et modernes* (1848–62), a collection of lithographs after works by contemporary artists.

Prints

with F.-L. Français and C. Nanteuil: *Les Artistes anciens et modernes*, 3 vols (Paris, 1848–62)

Bibliography

A. Estignard: *H. Baron: Sa vie, ses oeuvres* (Besançon, 1896)

P. Brune: *Dictionnaire des artistes et ouvriers d'art de la Franche-Comté* (Paris, 1912)

RÉGIS MARIN

Barre, Jean-Auguste

(*b* Paris, 25 Sept 1811; *d* Paris, 5 Feb 1896). French sculptor and medallist. After training with his father the medallist Jean-Jacques Barré (1793–1855) and with Jean-Pierre Cortot, he entered the Ecole des Beaux-Arts in Paris in 1826. He was one of the few 19th-century French sculptors who pursued a successful official career without having competed for the Prix de Rome. He was principally a portrait sculptor and exhibited at the Salon from 1831 to 1886, initially showing medals and medallions such as the series of the *Orléans Family* (Paris, Mus. A. Déc.). With Jean-Etienne Chaponnière he was one of the first French sculptors to produce miniature portraits of eminent contemporaries in plaster, biscuit or bronze editions for broad popular circulation, showing figures ranging from *Queen Victoria* to the dancer *Marie Taglioni* (both 1837; e.g. in bronze, Paris, Mus. A. Déc.).

As his reputation grew Barre also received commissions for life-size busts and statues of royalty, including the recumbent tomb effigy of King Louis-Philippe's mother *Louise-Marie-Adelaide, Duchesse of Orléans* (marble, 1847; Dreux, Chapelle Royale) and no less than 26 varied busts of *Napoleon III* (e.g. marble, 1857; Paris, Ecole B.-A.). He also executed historical portraits for the Musée Historique at Versailles, including a bust of *Louis de la Trémoille* (plaster, 1839; *in situ*), as well as a certain number of ideal statues (e.g. *Ulysses Recognized by his Hound*, marble, exh. Salon 1834; Compiègne, Château) and religious works (e.g. *St Luke*, stone, 1844; Paris, St Vincent de Paul). In addition he received commissions for allegorical statues in stone for the rebuilding of the Louvre

(*c*. 1853–*c*. 1868). His talents as a sympathetic portrait sculptor, uncritical but highly skilled, assured him an important position in official sculpture of the 19th century.

Bibliography

La Sculpture française au XIXe siècle (exh. cat., ed. A. Pingeot; Paris, Grand Pal., 1986), nos 144, 146–8, 150–52

<div style="text-align: right">ISABELLE LEMAISTRE</div>

Barrias
French family of artists.

(1) Félix(-Joseph) Barrias
(*b* Paris, 13 Sept 1822; *d* Paris, 25 Jan 1907). Painter and illustrator. He was a pupil of his father, a miniaturist and painter on porcelain. He began his training in the studio of Léon Cogniet at the Ecole des Beaux-Arts, Paris, on 7 April 1838. From 1840 he exhibited in the Salon many portraits that were dismissed by the critics as insignificant. This failure induced him to turn to the elevated genres of history and religious painting, which were more likely to bring him critical recognition. In 1844 he won the Prix de Rome with *Cincinnatus Receiving the Ambassadors of the Senate* (Paris, Ecole N. Sup. B.-A.). Profoundly academic in handling, this work adheres closely to the rules of Neo-classicism. The clearly legible frieze composition exhibits a severity and a certain stylistic rigidity that characterized almost all his subsequent output. His career developed within the sphere of academic art, of which he was a notable representative. He also enjoyed the rewards of an official career: third-class medal in 1847 for *Sappho*, first-class medal in 1851 for the *Exiles of Tiberius* (1850; Paris, Mus. d'Orsay; on loan to the Hôtel de Ville, Bourges), another medal in 1855 for the *Jubilee of 1300 in Rome* (Laval, Mus. Vieux-Château) and a gold medal in the Exposition Universelle of 1889.

In tandem with his career as a history painter, Barrias also devoted himself to large-scale mural decorations, both religious and secular. In 1851 he decorated the chapel of St Louis in the church of St Eustache in Paris. In the following years he produced numerous religious works: scenes from the life of the Virgin (1863) in the church of Notre-Dame at Clignancourt; five tympana in the main nave and the great tympanum at the end of the sanctuary (started 1864) in the church of the Trinity, Paris, where he also decorated the chapel of Ste Geneviève (1873). He was responsible for important state decorations for the museum in Amiens (*France Crowning the Glories of Picardy*, 1865; Amiens, Mus. Picardie); for the Opéra in Paris (salon Ouest du Foyer, 1874; *in situ*); for the Pavilion of the Argentine Republic in the Exposition Universelle in 1889; and for the Hôtel de Ville in Paris (north portico of the Ceremonial Hall, commissioned 1889, completed 1892).

Barrias also executed such private commissions as the ceiling (1855) of the reading-room of the former Hôtel du Louvre, which he reworked at the time of the conversion of the building into a shop in 1876 (now in Paris, Mus. d'Orsay); a hemicycle (1856) in the Institut Eugénie; and a great ceiling (1866) for the residence of Prince Nariskine in St Petersburg.

A champion of academicism, Barrias left a considerable oeuvre, in which the qualities that gained him the Prix de Rome—a predictable palette and flawless technique—are employed in works that were inspired by mythology (e.g. *The Sirens*, 1893; Périgueux, Mus. Périgord) and ancient and contemporary history (e.g. the *French Army Disembarking at Old Port, September 14 1854*, 1859; Versailles, Château), as well as the Orientalist tradition. He also illustrated works of Classical literature (Horace, Virgil) as well as the great French dramatists (Racine, Corneille, Molière) and the popular novels of Alexandre Dumas and Frédéric Soulié.

Bibliography

Thieme–Becker

<div style="text-align: right">A. DAGUERRE DE HUREAUX</div>

(2) Louis-Ernest Barrias
(*b* Paris, 13 April 1841; *d* Paris, 4 Feb 1905). Sculptor, brother of (1) Félix Barrias. He began his artistic training as a painter under Léon Cogniet

but moved on to study sculpture under P.-J. Cavelier. He enrolled at the Ecole des Beaux-Arts, Paris, in 1858, where he was a pupil of François Jouffroy, and he won the Prix de Rome in 1864. In the meantime he had been involved in the sculptural decoration of the Paris Opéra and had executed a marble statue of *Virgil* (1865; *in situ*) on the staircase of the Hôtel de la Païva in the Champs Elysées.

During his Roman sojourn Barrias produced the *Spinner of Megara* (marble, exh. Salon 1870; Paris, Mus. d'Orsay), a pretty, sensuous, modern Greek genre piece, and the group the *Oath of Spartacus* (marble, exh. Salon 1872; Paris, Jard. Tuileries), in which a theme of heroic defiance in extremity is concentrated in the idealized yet naturalistic anatomies of the protagonists. When shown at the Salon the *Spartacus* was felt to express the mood of France in the wake of the 1870 defeat in the Franco-Prussian War. Having volunteered for military service during the war and the siege of Paris (his Prix de Rome exempted him from call-up), Barrias was chosen to execute two major war memorials in bronze: the *Saint-Quentin* memorial (inaugurated in 1881, melted down by the Germans in 1917; plaster model of the principal group, Lille, Mus. B.-A.), and the *Defence of Paris in 1870* for the Rond Point de la Défense, Courbevoie, Hauts-de-Seine (exh. Salon 1881; *in situ*). The crowning group in each case incorporated an allegorical female representation of the town in question supporting a wounded soldier.

Barrias's war memorials imbued allegory with an air of the familiar, and he was to extend this accessibility to the areas of both biblical and historical subjects, where his success may be gauged by the commercial circulation enjoyed by two of his works in particular: the group the *First Funeral* (marble, exh. Salon 1883; Paris, Hôp. Ste Anne) and the bronze figure of the *Young Mozart* (exh. Salon 1887; marble replica, Copenhagen, Ny Carlsberg Glyp.). In the first, Adam accompanied by Eve carries towards the spectator the limp body of the dead Abel, while in the second Mozart is seen in a childishly knock-kneed posture tuning his violin. In such works Barrias concealed his

academic training behind the facility of an accomplished illustrator to produce a form of sculpture equally suited for public exhibition and domestic decoration. This illustrative quality also emerges in such public monuments as the tomb of the war hero *Anatole de la Forge* (bronze, 1893; Paris, Père-Lachaise Cemetery) and the marble statue of *Joan of Arc Taken Prisoner* (exh. Salon 1892; Plâteau des Aigles, nr Rouen).

In the sphere of allegory Barrias favoured well-built female figures, which he occasionally reworked, as in the case of *Nature Unveiling herself before Science*, first conceived in marble for the Bordeaux Medical Faculty (exh. Salon 1893) but later reinterpreted in a mixture of coloured marbles and onyx (1899; Paris, Mus. d'Orsay). This partiality for female allegory reached a culmination in the bronze and stone monument to *Victor Hugo*, inaugurated in 1902 in the Place Victor Hugo, Paris (mostly destr. 1942; one relief survives in Calais, Mus. B.-A.).

Bibliography

Lami

G. Lafenestre: 'Ernest Barrias', *Rev. A. Anc. & Mod.*, xxiii (1908), pp. 321–40

The Romantics to Rodin (exh. cat., ed. P. Fusco and H. W. Janson; Los Angeles, CA, Co. Mus. A., 1980)

PHILIP WARD-JACKSON

Bartholdi, Frédéric-Auguste

(*b* Colmar, Alsace, 2 April 1834; *d* Paris, 4 Oct 1904). French sculptor. After the death of his father, he grew up in Paris, but the family retained property in Colmar. He studied painting with Ary Scheffer, who encouraged him to develop his talents as a sculptor. To this end Bartholdi studied with Jean-François Soitoux (1816–91) and Antoine Etex. His first major work was the neo-Baroque monument to *Gen. Jean Rapp* (h. 3.5 m, 1855; Colmar, Place Rapp), an over life-size bronze statue whose flamboyant contrapposto stance reflects the influence of François Rude's monument to *Marshal Ney* (1853; Paris, Carrefour de l'Observatoire) and foreshadows Bartholdi's taste for the colossal. In 1856 Bartholdi visited Egypt with Jean-Léon Gérôme

and was inspired to emulate the magnificence of the sculpture he saw. However, his project for a gigantic female figure as a lighthouse for the mouth of the Suez Canal, intended for its opening in 1869, was rejected by the Khedive.

At the outbreak of the Franco-Prussian War in 1870 Bartholdi enlisted in the Garde Nationale. The German annexation of Alsace was a bitter blow and remained a constant theme in his work until his death. Among his many statues and monuments expressing his patriotic devotion were the *Curse of Alsace* (1872; Colmar, Mus. Bartholdi), the monument to the *Garde Nationale* (1872; Colmar Cemetery), *Switzerland Comforting the Anguish of Strasbourg* (1895; Basle, Centralbahnplatz) and the *Three Sieges of Belfort* (1903; Belfort, Place de la République). The most remarkable was the colossal *Lion of Belfort* (c. 12.5×c. 23 m, 1871–80), constructed from blocks of sandstone and set into the cliff below the fort dominating the town. Inspired by Bertel Thorvaldsen's *Lion of Lucerne* (1819–21; Lucerne, Denkmalstrasse), Bartholdi's *Lion* defies his fate, resisting subjugation like the citizens of Belfort.

While working on the *Lion of Belfort*, Bartholdi also embarked on the colossal statue of *Liberty Enlightening the World*, an adaptation of his earlier lighthouse design. This scheme was to be a gift from the French people to the USA to commemorate French aid during the American War of Independence. It had first been proposed in 1865 by a group of Republican intellectuals, but it was not until after the collapse of the regime of Napoleon III in 1870 and the re-establishment of Republican government in France that work began in earnest. In 1871 Bartholdi visited New York to gain the approval of the US government and chose Bedloes Island in New York Harbor as the site for what was to become perhaps the most famous statue in the world. With the help of the statesman Edouard de Laboulaye, funds were raised by public subscription in 1875 and the statue of *Liberty* was dedicated in 1886.

Few of Bartholdi's contemporaries understood so well the demands of colossal scale. He used the dramatic harbour location of the statue to set off its strong, simple silhouette, and he modelled the figure to be seen from the changing perspective that a ship's passenger would encounter arriving in the harbour. To create a pacific image, he gave the classically draped *Liberty* the tablets of law, the torch of progress, the rays of enlightenment and, at her feet, the broken chains of tyranny. There are two smaller versions in Paris, on the Pont de Grenelle and in the Jardin du Luxembourg. Bartholdi explained his ideas and the technical procedure of constructing *Liberty*, acknowledged as a remarkable engineering achievement, in his book *The Statue of Liberty Enlightening the World*. The statue, 46 m high, was made in the Paris workshop of Gaget, Gauthier & Cie from beaten copper sheets riveted together and suspended by steel and iron struts from an inner pylon. This structure, designed by Eugène-Emmanuel Viollet-le-Duc and, following his death in 1879, continued by Gustave Eiffel, permitted the statue to be assembled in France and then dismantled and reconstructed after its Atlantic crossing; its Neo-classical pedestal was designed by Richard Morris Hunt.

While the bold classical contours and simplified modelling of the *Lion of Belfort* and the statue of *Liberty* reflect their huge scale and solemn purpose, other works such as *Gen. Rapp* and the flamboyant fountain group *The Sâone and its Tributaries* (lead, 1898; Lyon, Place des Terreaux) display great vigour in design and liveliness of surface detail. Among Bartholdi's other works are many portraits of his contemporaries and a number of historical monuments in bronze, including the *Marquis de Lafayette* (1876; New York, Union Square), *Diderot* (1884; Langres, Place Diderot) and *Washington and Lafayette* (1895; Paris, Place des Etats-Unis). The *Aeronauts and Pigeon Trainers of the Siege of Paris* (destr.) for Neuilly was completed posthumously in 1906.

Bartholdi aspired to create 'monuments of great moral value' (1885), but his true genius was as an entrepreneur exploiting his organizational flair and enthusiasm for technology. His work was well received by his contemporaries, but only the statue of *Liberty* brought him the international recognition he sought. After his death his work was largely forgotten—except in Alsace—until the centenary of *Liberty*.

Writings

The Statue of Liberty Enlightening the World (New York, 1885)

Bibliography

J. Betz: *Bartholdi* (Paris, 1954)

A. Gschaedler: *True Light on the Statue of Liberty and its Creator* (Narbeth, PA, 1966)

M. Trachtenberg: *The Statue of Liberty* (New York, 1976)

M. Warner: *Monuments and Maidens* (London, 1985)

J. Schmitt: *Bartholdi: A Certain Idea of Liberty* (Strasbourg, 1986)

Liberty: The French-American Statue in Art and History (exh. cat., ed. J. Hargrove and P. Provoyeur; New York, Pub. Lib., 1986)

<div align="right">JUNE HARGROVE</div>

Bartholomé, Albert

(*b* Thivernal, Seine-et-Oise, 29 Aug 1848; *d* Paris, 1928). French sculptor and painter. He first studied law; when the Franco-Prussian war broke out in 1870 he enlisted as a volunteer in Gen. Charles Bourbaki's army. After the battle of Sedan he fled to Switzerland. As a prisoner on parole, he attended Barthélemy Menn's studio at the Ecole des Beaux-Arts in Geneva and decided to devote himself to painting. He worked alone, in a naturalistic manner heavily influenced by that of Jules Bastien-Lepage, with its insistence on working in the open air rather than in the studio. Bartholomé exhibited for eight years at the Salon des Artistes Français (e.g. *Recreation*, 1885; Paris, priv. col.), receiving encouragement from Joris-Karl Huysmans. His first wife's death in 1887 plunged him into depression; his best friend, Edgar Degas, advised him to sculpt a tombstone for her (1888; Bouillant cemetery, Crépy-en-Valois, Oise).

Soon after, Bartholomé embarked on the chief work of his career: from 1889 to 1899 he worked on the stone *Monument to the Dead* in Père Lachaise cemetery, Paris, which, together with Rodin's *Gates of Hell*, is one of the greatest expressions of Symbolist sculpture. This large stone sculpture in high relief, with its harmonious rhythms, its lyrical interlinking of figures and its sober modelling expresses in sculpture an ideal of

refined restraint close to that of Pierre Puvis de Chavannes. Among Bartholomé's minor works of this period is the expressive mask of the Japanese official *Tadamasa Hayashi* (Paris, Mus. d'Orsay). Later he returned to sculpture in the round (*Adam and Eve*, 1902–5; St Petersburg, Hermitage) and executed some handsome female nudes (e.g. *La Cuscute*, 1904; Reims, Mus. St Denis). From 1907 to 1912 he worked on the stone cenotaph of *Jean-Jacques Rousseau* in the Panthéon, Paris. This is a simple, serious work, punctuated by the classicizing repetition of five female figures.

From 1918 onwards, Bartholomé devoted himself to executing monuments to the dead of World War I. The Cognac (Charente) monument, with its two noble female figures embracing one another, reveals a technique almost Impressionist in its blurred contours, while the Le Creusot (Saône-et-Loire) monument shows more contemporary influences in the socialist themes of its bas-reliefs. Bartholomé took part in the establishment of the Société Nationale des Beaux-Arts; he was for many years the Society's vice-president and later its president.

Bibliography

L. Bénédite: 'Albert Bartholomé', *A. & Déc.*, vi (1899), pp. 161–74

M. Demaison: 'Bartholomé et le Monument aux Morts', *Rev. A. Anc. & Mod.*, vi (1899), pp. 265–80

P. Clemen: 'Albert Bartholomé', *Kst Alle: Mal., Plast., Graph., Archit.*, xviii (1902), pp. 35–55

T. Burollet: 'A propos du Monument aux Morts d'Albert Bartholomé: Une Nouvelle Acquisition du musée de Brest', *Rev. Louvre*, 2 (1974), pp. 109–16

La Sculpture française au XIXe siècle (exh. cat., ed. A. Pingeot; Paris, Grand. Pal., 1986), pp. 224, 226–30; figs 243–5

<div align="right">THÉRÈSE BUROLLET</div>

Barye, Antoine-Louis

(*b* Paris, 24 Sept 1796; *d* Paris, 25 June 1875). French sculptor, painter and printmaker. Barye was a realist who dared to present romantically humanized animals as the protagonists of his sculpture. Although he was a successful monumental sculptor, he also created a considerable

body of small-scale works and often made multiple casts of his small bronze designs, marketing them for a middle-class public through a partnership, Barye & Cie. His interest in animal subjects is also reflected in his many watercolours. He thus challenged several fundamental values of the Parisian art world: the entrenched notion of a hierarchy of subject-matter in art, wherein animals ranked very low; the view that small-scale sculpture was intrinsically inferior to life-size or monumental work; and the idea that only a unique example of a sculptor's design could embody the highest level of his vision and craft. As a result of his Romantic notion of sculpture, he won few monumental commissions and endured near poverty for many years.

1. Training and early work, to c. 1830

The son of a goldsmith from Lyon, Barye learnt his father's craft at an early age and retained some of its values as a mature artist. At the age of 13 he worked for the military engraver Fourier. Soon after he worked in the prestigious workshop of Martin-Guillaume Biennais, goldsmith to Napoleon. In 1816 he studied with the Neoclassical sculptor François-Joseph Bosio; Barye also studied painting briefly with the Romantic history painter Antoine-Jean Gros.

As a student at the Ecole des Beaux-Arts, Paris (1818–23), Barye repeatedly failed to win the Prix de Rome. Nonetheless his experiences there deepened his commitment to the classical tradition and acquainted him with a very broad spectrum of artistic sources. He also read works on art theory and archaeology by E.-M. Falconet, Quatremère de Quincy and Emeric-David and studied the engravings of John Flaxman. He studied animal anatomy diligently, reading scholarly essays by the naturalists François Marie Daudin and Georges Cuvier. He made drawings after zoological displays in the Musée d'Anatomie Comparée and after dissections performed at the Jardin des Plantes. He also made a close study of ancient sculptures of animals.

Barye's earliest works, dated c. 1819 to c. 1830, were executed in three divergent styles: painterly, naturalist and hieratic. These are epitomized

respectively by his delicately modelled medallion relief *Milo of Crotona Devoured by a Lion* (1819; Baltimore, MD, Walters A.G.), which echoes Pierre Puget's marble group of the same title (1671–82; Paris, Louvre), the humorous *trompe l'oeil* piece *Turtle on a Base* and the *Stork on a Turtle* (both Baltimore, MD, Walters A.G.), based on an ancient prototype engraved by Lorenzo Roccheggiani (*fl* 1804–17).

2. Mature work, c. 1830 and after

(i) **Large-scale sculpture.** Barye's style had become more unified by c. 1830, and his images of predators grew larger, more humanized and more dramatic, as in the *Tiger Devouring a Gavial Crocodile of the Ganges* (bronze, exh. Salon 1831; Paris, Louvre). This exotic, exquisitely detailed and satanic work is an image of evil in the sense of Victor Hugo's notion of the grotesque. Astonishingly, it was characterized by the classical critic and follower of David, Etienne-Jean Delécluze, as 'the strongest and most significant work of the entire Salon'. This unforgettable image, of a sphinx-like tiger slowly biting into the genitalia of a writhing and serpentine gavial, launched Barye's artistic career.

Larger but more restrained, *Lion Crushing a Serpent* (1832; Paris, Louvre) was shown in the Salon of 1833, in its plaster version, and was cast in bronze for Louis-Philippe in time for the Salon of 1836. In recognition of its excellence Barye was named Chevalier of the Légion d'honneur on 1 May 1833. An allegory on two levels, *Lion Crushing a Serpent* was intended to flatter the King: the lion connotes not only courage, strength and fortitude but also kingship itself as triumphant over the serpent of evil; as a commemoration of the July Revolution of 1830, which had placed Louis-Philippe on the throne, it also represents the lion of Leo, the constellation that 'ruled the heavens' on 27, 28 and 29 July 1830. Indeed, the appellation *Lion of the Zodiac* occurs in the official documents for Barye's slightly later bronze relief (1835–40s) on the July Column in the Place de la Bastille, Paris. *Lion of the Zodiac* recalled an ancient marble relief in Rome, engraved by Pietro Bartoli. Remains of the fallen heroes of 1830

were taken to the July Column cenotaph on 18 April 1840.

Another monumental work of Barye's maturity is *St Clotilde* (marble, 1840–43), executed for the church of the Madeleine in Paris. This figure is based on the Roman marble of Julia, daughter of Augustus (Paris, Louvre), and is also reflected in a contemporary portrait by Ingres (e.g. *Comtesse d'Haussonville*, 1845; New York, Frick). Barye also executed the *Seated Lion* (bronze, 1847; Paris, Louvre), a companion piece to *Lion Crushing a Serpent* in a less detailed style, and eight colossal eagle reliefs (1849) for piers of the Jena Bridge over the Seine, which echo an ancient oil-lamp relief engraved by Bartoli. In 1848 Barye was named director of plaster casting and curator of the gallery of plaster casts at the Musée du Louvre. He also taught drawing for natural history in the Ecole Agronomique at Versailles in 1850. The same year he submitted two monumental sculptures to the Salon; he had not exhibited there since 1837, when the jury had rejected his ensemble of nine small sculptures made for the young Ferdinand-Philippe, Duc d'Orléans (*see* §3 below). *Jaguar Devouring a Hare* (Baltimore, MD, Walters A.G.) is a Romantic animal combat reminiscent of his innovations of *c.* 1830, while *Theseus Combating the Centaur Bienor* (Washington, DC, Corcoran Gal. A.) is an academic piece whose figures recall Giambologna's *Hercules and Nessus* (1594; Florence, Loggia Lanzi). By pairing these two works at the Salon, Barye aimed to reaffirm his conviction that an image of a predator with its prey, encapsulating his own Romantic vision of nature, was worthy to stand beside an academically sanctioned mythological combat.

Around 1851 Barye produced a series of 97 decorative masks in stone for the cornice of the Pont Neuf in Paris; the expressive range and formal variety of facial representations that encompasses the Buddha, Christ and Hercules may be regarded as a virtuoso feat. For the vast new Louvre of Napoleon III, Barye created a stone ensemble of four groups representing *Strength*, *Order*, *War* and *Peace* (1854–6), which were installed on the façades of the Denon and Richelieu pavilions. He also produced a stone relief, *Napoleon I Crowned by History and the Fine Arts* (1857), for the façade pediment of the Sully Pavilion. Focal points in the Cour du Carrousel (also known as the Place Napoléon III) of the new Louvre, these works were a pinnacle of Barye's official career, though they were executed in an academic style. *Napoleon I Crowned by History and the Fine Arts* is a splendid example of imperial propaganda intended to enhance the reign of Napoleon III by recalling the legend and aura of Napoleon I.

In 1854 Barye was appointed Master of Zoological Drawing in the Musée d'Histoire Naturelle, Paris (where Rodin was among his pupils in 1863), a position he retained until his death. Later monumental works include a classical bronze relief for the Riding Academy façade of the new Louvre, *Napoleon III as an Equestrian Roman Emperor* (1861; destr. 1870–71), a tribute to the Emperor's great love of horsemanship. Between 1860 and 1865 Barye executed *Napoleon I as an Equestrian Roman Emperor*, a free-standing bronze, for the Bonaparte family monument in Ajaccio, Corsica. Around 1869 he carved four feline predators standing over their prey for the Palais de Longchamp at Marseille, not with the nervous intensity of the 1830s but with a hieratic formality and lordly grandeur of mood, qualities appropriate to this late statement of his favourite theme.

(ii) Small bronze works. Barye often made multiple casts of his designs, marketing them for the homes of middle-class Parisians through Barye & Cie, the partnership he formed in 1845 with the entrepreneur Emile Martin (see doc. in Pivar, 1974). Small bronzes were his greatest love, as the 230 or so designs offered in his last sale catalogue (1865) amply attest. After 1830 his style became more subtle, embracing a wide range of moods, compositional types and themes, albeit within the larger framework of a decoratively detailed realism. He produced many animal portraits from the mid-1830s to the mid-1840s, such as the exotic *Turkish Horse* and the poignant *Listening Stag* of 1838 (both Baltimore, MD, Walters A.G.). Predators with prey abound. Hunting scenes may include man, as in *Arab Horseman Killing a Lion*, or animals only,

as in the *Wounded Boar* (both Baltimore, MD, Walters A.G.), which depicts a fallen boar with a spear jutting from its side. Scenes from history include an equestrian group in plaster, *Charles VI, Surprised in the Forest of Mans* (exh. Salon 1833; Paris, Louvre), showing the assassination attempt that triggered the King's lunacy. Among the literary subjects is *Roger Abducting Angelica on the Hippogriff* (Baltimore, MD, Walters A.G.), from Ariosto's *Orlando Furioso* (1532), a scene made famous by Ingres's *Roger Rescuing Angelica* (1819; Paris, Louvre). Barye depicted equestrian figures from several periods of history: *Charles VII* (Baltimore, MD, Walters A.G.), *General Bonaparte* (Calais, Mus. B.-A.) and *Ferdinand Philippe, Duc d'Orléans* (Baltimore, MD, Walters A.G.). In mood his works encompass the agony of *Wolf Caught in a Trap* (New York, Brooklyn Mus.), the exuberant vigour of *African Elephant Running*, the playful dreaminess of *Bear in its Trough*, the excitement of *Bear Overthrown by Three Dogs* and the powerfully restrained tension of *Panther Seizing a Stag* (all Baltimore, MD, Walters A.G.).

Barye's designs range from the delicately atmospheric, painterly effects of *Lion Devouring a Doe* (1837) to the architectural clarity of *Python Killing a Gnu* (c. 1834–5; both Baltimore, MD, Walters A.G.). The latter was one of nine small bronzes (four animal combats and five hunting scenes) executed for Ferdinand-Philippe, Duc d'Orléans, between 1834 and 1838. They were intended as an elaborate decoration for a banqueting table. The Salon jury rejected the models for the ensemble in 1837, and Barye did not again submit works to the Salon until 1850. The Baroque manner of the hunting scenes (all Baltimore, MD, Walters A.G.), for instance the *Tiger Hunt* (1836), contrasts strongly with the classical severity of the tiny reliefs *Walking Leopard* and *Walking Panther* (both 1837) and of the free-standing *Striding Lion* and *Striding Tiger* (all Baltimore, MD, Walters A.G.). A similar restraint is apparent in the *Candelabrum Goddesses*, the classical *Juno* and *Minerva* and the mannerist *Nereid* (all Baltimore, MD, Walters A.G.). An understated tone and a descriptive realism are evident in the late *Caucasian Warrior* (Baltimore, MD, Walters A.G.)

and *Horseman in Louis XV Costume* (Paris, Louvre), both of which were included in Barye's last sale catalogue (1865).

(iii) **Paintings and prints.** Barye's extensive oeuvre as a painter of landscapes and of animal subjects linked with his sculpture awaits further study, though Zieseniss produced an introductory catalogue raisonné of 216 animal watercolours in 1956. Noting that an exact chronology for the wholly undated painted oeuvre cannot be established, he nonetheless distinguished an early and late style, contrasting the emphatic detail, exaggerated drama, confused movement and theatrical chiaroscuro effects of the former (e.g. *Two Tigers Fighting*; Cambridge, MA, Fogg) with the majestic ease, glowing colour and unity and balance of the latter (e.g. *Two Rhinos Resting*; Baltimore, MD Inst., Decker Gal.; see Zieseniss, nos B52, K2).

Barye's tiny watercolours of animals are technically intricate and often combine several media: a single work may show the use of both transparent watercolour and bodycolour as well as pastel chalk, black ink, lead-white highlights, scratched-in lines for whiskers or fur and varnishes of various colours and densities. He developed the surfaces of his watercolours almost as he would patinate a bronze. Most of the subjects of his paintings are the same as those of his small bronze images. These include *Tiger Looking for Prey* (Paris, Louvre; see col. pl. I), *Tiger Hunt* (priv. col., z E9, E10; cf. Benge, 1984, fig. 127), *Turkish Horse* (priv. col., z I2, I3; cf. Benge, 1984, fig. 82), *Elk Attacked by a Lynx* (priv. col., z D19; cf. Benge, 1984, fig. 134), *Bear Attacking a Bull* (priv. col., z H3; cf. Benge, 1984, fig. 120), *Lion of the Zodiac* (priv. col., z A29, A30, A32, A33; cf. Benge, 1984, figs 25, 64) and *Seated Lion* (priv. col., z A22; cf. Benge, 1984, fig. 27). A few creatures, however, appear only in watercolours, for example the *Bison* (priv. col., z J3, J4), the *Rhinoceros* (priv. col., z K1, K2) and *Vultures* (priv. col., z G1–G5). The *Dead Elephant* (priv. col., z E1–E3; cf. Benge, 1984, fig. 179) surely reflects dissection drawings made in the Musée d'Anatomie Comparée. The very precise paintings of serpents (priv. col., z F1–F6) must also have been derived from specimen study;

by contrast, Barye's *Two Tigers* (priv. col., z B51) approaches the moodiness and emotional fullness of Delacroix. Cast shadows and a concern with natural light are rare in Barye's paintings. Some of his landscapes have a central area of bright light (z D1, D3, D5, D15, D35, H1, I1), an obvious device seen in Barbizon landscapes by Diaz and Rousseau; others range from the depiction of an elaborate tracery of tree limbs above the antlered head of a stag (z D28) to the larger and subtler systems of craggy rock-fields whose swirling arabesques echo the outlines of a creature (z B18, D18, D20).

In Zieseniss's view, Barye regarded his paintings in oil as merely preparatory; he neither exhibited nor offered any for sale, although more than 90 were listed for the posthumous sale of his studio effects, held at the Ecole des Beaux-Arts, Paris, in 1875. Eleven lithographs and one etching of his animal subjects are illustrated in Delteil.

Bibliography

Lami
A. Alexandre: *Antoine-Louis Barye* (Paris, 1889)
C. DeKay: *Barye: Life and Works* (New York, 1889)
R. Ballu: *L'Oeuvre de Barye* (Paris, 1890)
L. Delteil: *Barye: Le Peintre graveur illustré*, vi (Paris, 1910)
C. Saunier: *Barye* (Paris, 1925)
G. H. Hamilton: 'The Origin of Barye's *Tiger Hunt*', *A. Bull.*, xviii (1936), pp. 248–51
A. Dezarrois: 'Le Monument de Napoléon Ier à Grenoble par Barye: Un Projet mystérieusement abandonné', *Rev. A.*, lxxi (1937), pp. 258–66
G. Hubert: 'Barye et la critique de son temps', *Rev. A.*, vi (1956), pp. 223–30
C. O. Zieseniss: *Les Aquarelles de Barye: Etude critique et catalogue raisonné* (Paris, 1956) [z]
Barye: Sculptures, peintures, aquarelles des collections publiques françaises (exh. cat., Paris, Louvre, 1956–7) [major exhibition, excellent documentation]
J. de Caso: 'Origin of Barye's *Ape Riding a Gnu*: Barye and Thomas Landseer', *Walters A.G. Bull.*, xxvii–xxviii (1964–5), pp. 66–73
G. F. Benge: *The Sculptures of Antoine-Louis Barye in the American Collections, with a Catalogue Raisonné*, 2 vols (diss., Iowa City, U. IA, 1969)
J. Peignot: 'Barye et les bêtes', *Conn. A.*, 243 (1972), pp. 116–21
S. Pivar: *The Barye Bronzes: A Catalogue Raisonné* (London, 1974) [incl. doc. forming and liquidating Barye & Cie, 1845–57, and Barye's last sale cat., 1865]
G. F. Benge: 'Antoine-Louis Barye (1796–1875)', *Metamorphoses in Nineteenth-century Sculpture* (exh. cat., ed. J. L. Wasserman; Cambridge, MA, Fogg, 1975), pp. 77–107
—: 'A Barye Bronze and Three Related Terra Cottas', *Bull. Detroit Inst. A.*, lvi/4 (1978), pp. 231–42
—: 'Barye, Flaxman and Phidias', *La scultura nel XIX secolo. Acts of the 24th International Congress of Art History: Bologna, 1979*, vi, pp. 99–105
—: 'Antoine-Louis Barye', *The Romantics to Rodin: French Nineteenth-century Sculpture from North American Collections* (exh. cat., ed. P. Fusco and H. W. Janson; Los Angeles, CA, Co. Mus. A., 1980), pp. 124–41
—: 'Barye's Apotheosis Pediment for the New Louvre: *Napoleon I Crowned by History and the Fine Arts*', *Art the Ape of Nature: Studies in Honor of H. W. Janson* (New York, 1981), pp. 607–30
D. Viéville: 'Antoine-Louis Barye', 'Napoléon Ier en redingote, 1866', *De Carpeaux à Matisse: La Sculpture française de 1850 à 1914 dans les musées et les collections publiques du nord de la France* (exh. cat., Calais, Mus. B.-A.; Lille, Mus. B.-A.; Paris, Mus. Rodin; 1982–3), pp. 93–7
G. F. Benge: *Antoine-Louis Barye, Sculptor of Romantic Realism* (University Park, PA, 1984) [crit. disc., documentation, good illus.]

GLENN F. BENGE

Bastien-Lepage, Jules

(*b* Damvillers, Meuse, 1 Nov 1848; *d* Paris, 10 Dec 1884). French painter. Bastien-Lepage grew up on a farm. Although his earliest efforts in drawing were encouraged, his parents violently objected when he decided to become a professional artist. To mollify them he worked for a time as a postal clerk in Paris while studying at the Ecole des Beaux-Arts. In 1868 he left the civil service and was accepted into Alexandre Cabanel's atelier. During this apprenticeship, Bastien-Lepage won two prizes in drawing, and in 1870 he made his début at the Salon with a *Portrait of a Young Man* (untraced). In the Franco-Prussian War (1870–71) he joined a regiment of sharpshooters and was severely wounded in the chest. When he recovered he attempted unsuccessfully to find work as an illustrator. A pastiche of Watteau was accepted at the Salon in 1873, and two further canvases in 1874—an allegory, *Song of Spring* (Verdun, Mus.

Princerie), and *Portrait of my Grandfather* (Nice, Mus. B.-A.), the critical success of which launched his career.

The Communicant (1875; Tournai, Mus. B.-A.) reveals, in its intricate detail, Bastien-Lepage's study of 16th-century northern masters: in examining the work, critics commented on its 'Holbein-like' gravity and spirituality. For his Prix de Rome entry of 1875, the *Annunciation to the Shepherds* (Melbourne, N.G. Victoria), he borrowed elements from Ingres and the 17th-century Spanish painter Jusepe de Ribera; although Bastien-Lepage did not win the competition with this work, it was much admired for its skill and erudition. He submitted the *Hay Gatherers* (1878; Paris, Mus. d'Orsay; see fig. 1) to the 1878 Salon; contemporary critics were appalled by the supposedly simian features of the peasant girl in this work. The following year he sent a pendant picture, *October Season: The Potato Harvest* (Melbourne, N.G. Victoria).

Bastien-Lepage's next major work was *Joan of Arc Listening to the Voices* (1879; exh. Salon 1880; New York, Met.). In homage to Joan's intense heroism and patriotism he visited her birthplace

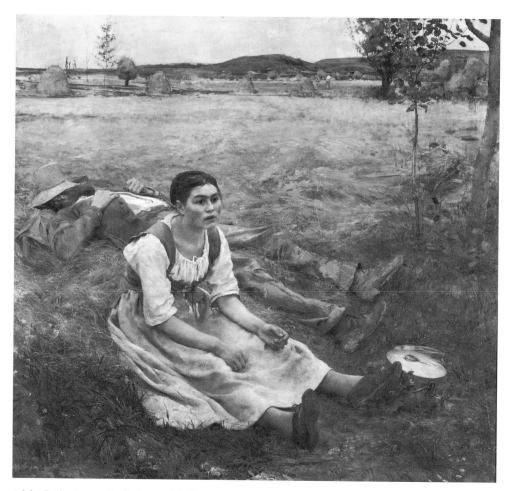

1. Jules Bastien-Lepage: *Hay Gatherers*, 1878 (Paris, Musée d'Orsay)

to gather details and returned to his own village to find suitable models for the figure. In the finished painting Bastien-Lepage depicts the saint leaving her chores to follow the celestial voices. The apparitions he painted behind her aroused considerable controversy when the painting was first shown, as this was an unconventional rendering of the theme. The picture provoked a mixed response among art critics because of the tension between the naturalistic rendition of the setting and the supernatural elements of the subject. Bastien-Lepage retreated to London, where a small retrospective of his work was arranged at the Grosvenor Gallery.

By 1880 Bastien-Lepage was suffering from stomach cancer. In his last years he remained faithful to peasant themes, inspired by the memories of his childhood. For example The Beggar (1881; Copenhagen, Ny Carlsberg Glyp.) and Le Père Jacques (1882; Milwaukee, WI, A. Mus.) effectively contrasted aged peasants to children. In Le Père Jacques Bastien-Lepage used the theme of the woodcutter to show that all forest inhabitants, including children, had a place in nature. The unfinished Burial of a Young Girl (1884; oil sketch, see Aubrun, 1985, p. 195) was meant to extend the rustic naturalism of the Hay Gatherers. Paintings such as Pas mêche (1881; Edinburgh, N.G.) spread a type of Salon naturalism that influenced painters internationally. British artists, especially George Clausen and Henry Herbert La Thangue, Australians such as Tom Roberts and Americans such as Julian Alden Weir were deeply affected by his compositions and complex and varied painting technique.

In his handling of a rich, thick paint texture he owed much to an awareness of earlier Realist painters such as Courbet; he was also influenced by Whistler and possibly John Singer Sargent. Bastien-Lepage's ability to keep certain areas of his canvas free from reworking also reflected an awareness of Impressionistic broken brushstroke painting and an immediacy of touch. However, other sections of a work reflected a painstaking exactitude, suggestive of a classical training and an interest in photographic detail. This technique, as well as the subject-matter of his paintings,

made him seem compellingly modern when his work was shown at Salons in Paris and exhibitions in London. This modernity is also evident in numerous portraits of theatrical friends, including Marie Samary (priv. col.), Coquelin (U. Notre Dame, IN, Snite Mus. A.) and his emblematic image of Sarah Bernhardt (priv. col.). These portraits were often inspired by photographic techniques. A large retrospective exhibition of his paintings and drawings in Paris in 1885 displayed his contribution to the naturalistic style through elevation of peasant and rustic themes as subjects for large-scale painting, completed in a detailed and intricately painted manner.

Bibliography

J. A. Weir: 'Jules Bastien-Lepage', Modern French Masters, ed. J. C. Van Dyke (New York, 1896/R 1976)
W. Feldman: The Life and Work of Jules Bastien-Lepage (1848–1884) (diss., New York U., 1973)
K. McConkey: 'The Bouguereau of the Naturalists: Bastien-Lepage and British Art', A. Hist., i (1978), pp. 371–82
The Realist Tradition: French Painting and Drawing, 1830–1900 (exh. cat., ed. G. P. Weisberg; Cleveland, OH, Mus. A., 1980)
K. McConkey: 'Listening to the Voices: A Study of Some Aspects of Jules Bastien-Lepage's Joan of Arc Listening to the Voices', A. Mag., lvi (Jan 1982), pp. 154–60
G. P. Weisberg: 'Jules Breton, Jules Bastien-Lepage and Camille Pissarro in the Context of Nineteenth-century Peasant Painting and the Salon', A. Mag., lvi (Feb 1982), pp. 115–19
W. Feldman: 'Jules Bastien-Lepage: A New Perspective', A. Bull. Victoria, xxiv (1983), pp. 2–10
K. McConkey: 'A la moderne: A Study of Jules Bastien-Lepage's Au Printemps', A. Mag., lvii (Jan 1983), pp. 107–9
Jules Bastien-Lepage (exh. cat., preface, P. Pagnotta; Verdun, Mus. Princerie, 1984)
M. Aubrun: Jules Bastien-Lepage (Paris, 1985) [cat. rais.]
G. P. Weisberg: Beyond Impressionism: The Natural Impulse (New York, 1992)

GABRIEL P. WEISBERG

Baudry, (Jacques-Aimé-)Paul

(b La Roche-sur-Yon, 7 Nov 1828; d 17 Jan 1886). French painter. Like many artistic children from the provinces in 19th-century France, he went to

Paris with a grant from his municipality to pay his tuition fees. He entered the studio of Michel-Martin Drolling in 1844 and enrolled at the Ecole des Beaux-Arts in 1845. In five successive attempts at the Prix de Rome, he rose up through the ranks of the finalists, winning the first prize (which he shared with Bouguereau) in 1850 with *Zenobia Found by Shepherds on the Banks of the Araxes* (Paris, Ecole N. Sup. B.-A.). Critics had already noticed that he was more attracted by Venetian painting than was customary among candidates for the prize. This was reaffirmed by the works he sent from Rome to Paris, especially his *Fortune and the Child* (1853–4; Paris, Mus. d'Orsay), which was clearly indebted to Titian's *Sacred and Profane Love* (Rome, Gal. Borghese).

Baudry's first appearance at the Salon, in 1857, was a triumph, despite reservations in the Académie about his handling of the brush. Of his five exhibits *Torture of the Vestal Virgins* (1856; Lille, Mus. B.-A.), *St John the Baptist* (1857; Amiens, Mus. Picardie) and his portrait of *Charles Beulé* (1857; Angers, Mus. B.-A.) were bought by the State. He was awarded a first-class medal and the influential art critic, Edmond About, whom he had met in Pompeii in 1853, wrote the first of several enthusiastic reviews in praise of Baudry's work. By the late 1850s his reputation as a portrait painter had been established. The State continued to buy his work and award him the various grades of the Légion d'honneur. Baudry began doing decorative work in 1857 with the commission for an overdoor for the Hôtel Guillemin, Paris, followed by paintings in 1858 for the Hôtel Païva (now the Travellers' Club), the Hôtel Fould (now in Chantilly, Mus. Condé) and work for the Comtesse de Nadaillac. His work was increasingly affected by the taste for the art of the 18th century in the Second Empire. The *Pearl and the Wave* (1862; Madrid, Prado), bought at the Salon of 1863 by the Empress Eugénie, a particular devotee of the genre, is composed like a Rococo overdoor. In 1863 Baudry's former colleague at the Ecole de Rome, Charles Garnier, commissioned him to decorate the foyer of the Paris Opéra. Garnier had in mind a plain ceiling with figures in the vault, but Baudry persuaded his patron to let him cover the ceiling with a more ambitious scheme. He spent a year preparing himself for the task by studying Michelangelo in the Sistine Chapel, Correggio in the Galleria Borghese and Raphael in London. Work on the scheme, comprising three oval ceilings with side panels and over-life-size figures of muses and poets, lasted from 1866 until 1874.

No doubt because he was heavily committed to decorating interiors, Baudry had less time for Salon pictures. He exhibited portraits and occasional mythological compositions, inspired by his decorative work. *Charlotte Corday* (1860; Nantes, Mus. B.-A.), exhibited in 1861, is a curious exception, conceived as a sort of factual riposte to David's celebrated picture, and inspired partly by Jules Michelet's account of the assassination of Marat and surely also by the play on the theme written by his friend, François Ponsard. Baudry never repeated this experiment in historical realism. His later work has a flutter and lightness of form that works best when, like the pale ceiling, *Abduction of Psyche* (completed in 1885 for Henri-Eugène-Philippe-Louis Orléans, Duc d'Aumale's château at Chantilly), it is seen in an architectural setting. The same stylistic development is evident in his easel paintings. The rich Venetian colour and solid modelling of his *Repentant Magdalene* (1858; exh. Salon 1859; Nantes, Mus. B.-A.) gave way, in later works such as *Amor and Psyche* (1884; Noirmoutier-en-l'Ile, Mus. Château), to a lighter, more colourful touch that anticipates the work of Paul Albert Besnard. His portraits, especially those of his friends *Edmond About* (1871; Paris, priv. col., see 1986 exh. cat., p. 104) and *Charles Garnier* (1868; Versailles, Château), are lively, elegant and inventive. Critics sometimes accused him of eclecticism, but, while his borrowings are obvious, his styles of painting and drawing are unmistakably his own.

Writings

E. Grimaud, ed.: *Lettres de Paul Baudry* (Nantes, 1886)

Bibliography

H. Beraldi: *Les Graveurs du XIXe siècle* (Paris, 1885–92), i, pp. 105–6

J.-A. Breton: *Notice sur M. Paul Baudry* (Paris, 1886)

C. Ephrussi: *Paul Baudry: Sa vie et son oeuvre* (Paris, 1887)

K. Cox: 'Paul Baudry', *Modern French Masters*, ed. J. C. van Dyke (Paris, 1896/R 1976), pp. 15–28

G. Sprigath: 'Paul Baudry: *Charlotte Corday* im Pariser Salon von 1861', *Städel-Jb.*, v (1975), pp. 200–26

J. Foucart and L.-A. Prat: *Les Peintures de l'Opéra de Paris, de Baudry à Chagall* (Paris, 1980)

Baudry, 1828–1886 (exh. cat. by V. Goarin, La Roche-sur-Yon, Mus. A. & Archéol., 1986)

C. Robinson: 'The Artist as "Rénovateur": Paul Baudry and the Paris Opéra', *A. J.* [New York], xlvi (1987), pp. 285–90

JON WHITELEY

Bazille, (Jean-)Frédéric

(*b* Montpellier, 6 Dec 1841; *d* Beaune-la-Rolande, 28 Nov 1870). French painter. The son of a senator, he was born into the wealthy Protestant middle class in Montpellier. He soon came into contact with the contemporary and still controversial painting of Eugène Delacroix and Gustave Courbet through the Montpellier collector, Alfred Bruyas. In response to his family's wishes he began to study medicine in 1860. He moved to Paris in 1862 and devoted his time increasingly to painting. In November 1862 he entered the studio of Charles Gleyre where he produced academic life drawings (examples in Montpellier, Mus. Fabre) and made friends with the future Impressionists, Claude Monet, Auguste Renoir and Alfred Sisley. When the studio closed in 1863, he did not look for another teacher but followed his friends to Chailly, near the forest of Fontainebleau, where he made studies from nature (e.g. *Study of Trees*; priv. col.). From 1863 he took an active part in Parisian musical life, attending the Pasdeloup and Conservatoire concerts. He developed a passion for opera (Berlioz and Wagner in particular) and German music (Beethoven and Schumann). He attended the salon of his cousins, the Lejosne family, where Henri Fantin-Latour, Charles Baudelaire, Edmond Maître, Renoir and Edouard Manet were frequent guests, and at the end of 1863 he met Courbet.

Bazille's earliest paintings are either lost or destroyed. A canvas painted at Saint-Sauveur in 1863 (priv. col.) reveals his affinity with the Provençal school, especially Paul Guigou, in the definition of masses and simplification of forms and colours. The same intensity is found in a *Reclining Nude* (1864; Montpellier, Mus. Fabre), the composition of which is taken from a painting by Guido Cagnacci, while the pose is modelled on one of Gleyre's bacchantes. In the course of his travels with Monet in Normandy during the summer of 1864, he visited Honfleur, an important site for *plein-air* painting before Impressionism, in the company of Eugène Boudin and Johan Barthold Jongkind. However, his *Small Farmyard* (priv. col.) shows the influence of the Barbizon school in its drab colours and austere subject. The same tonal simplicity occurs in the *Studio in the Rue de Furstemberg* (Montpellier, Mus. Fabre). In 1865 he returned to Chailly with Monet and posed for his *Déjeuner sur l'herbe* (Paris, Mus. d'Orsay). After this he painted *Landscape at Chailly* (1865; Chicago, IL, A. Inst.), which closely followed the stylistic direction then being taken by Sisley and Monet, and the *Improvised Sickbed* (1865; Paris, Mus. d'Orsay; see fig. 2), showing Monet resting after a leg injury. The realist emphasis, the austere and subtle colouring and the apparent disorder of these works are at odds with his more ordered landscapes of the Midi, such as the *Pink Dress* (1865; Paris, Mus. d'Orsay), which he produced soon afterwards.

The friendship that linked Bazille and the future Impressionists and their common artistic researches took concrete form in his series of views of the Paris studios in which he recorded the gatherings of his friends and combined their works with his own: for example *Rue de Furstemberg* and *Studio in the Rue de la Condamine* (1870; Paris, Mus. d'Orsay); in the series of still-lifes with a heron by Bazille and Sisley (1867; Montpellier, Mus. Fabre); and in the portrait of Bazille by Renoir (1867; Paris, Mus. d'Orsay). His tastes and friendships are further emphasized in a series of portraits including *Edmond Maître* (1869; Washington, DC, N.G.A.).

Apart from landscapes of the Languedoc countryside such as the *Walls of Aigues-Mortes* (1867;

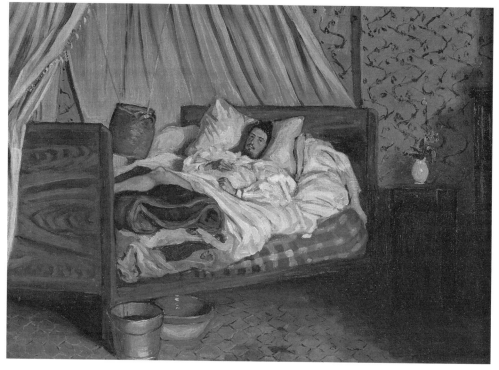

2. Frédéric Bazille: *Improvised Sickbed*, 1865 (Paris, Musée d'Orsay)

Montpellier, Mus. Fabre), Bazille concentrated almost exclusively on painting the figure. After *Young Girl at the Piano* (refused by the 1866 Salon; destr.), he generally preferred to depict family scenes involving several figures, which he sketched at Méric during the summer and completed in Paris. Bazille's handling of multi-figure compositions, which he had learnt from Courbet, Manet and Monet, was essentially traditional. The *Terrace at Méric* (refused by the 1867 Salon; Geneva, Petit Pal.) and the *Family Reunion* (exh. Salon 1868; Paris, Mus. d'Orsay; see col. pl. II) show his progressive integration of the figure into the landscape as well as his attempts to arrange the still rather stiff figures with greater coherence and naturalism. The constant search for balanced composition led him to simplify forms and give priority to light colours. The *View of a Village* (1868; Montpellier, Mus. Fabre) exploits the light of the Midi to separate planes in a homogeneous

and spontaneous pictorial structure, which recurs with a more monumental aspect in the latent energy of the *Fisherman with Net* (Zurich, Rau Found.) and *Summer Scene, Bathers* (1869; Cambridge, MA, Fogg). While the rural scenes combine academic attitudes and traditional technique with the dazzling limpidity of the landscapes of the Provençal school, in his urban paintings Bazille depicted contemporary activities in an austere palette and carefully structured brushwork (*Little Italian Street Singer* and *The Cardsharp*, both 1869; priv. cols).

After painting the still-life *Flowers* (1868; Grenoble, Mus. Peint. & Sculpt.), Bazille combined luxuriant composition with a sensuous model in *The Toilet* and the *Negress with Peonies* (both 1870; Montpellier, Mus. Fabre). These pictures recalled Manet's *Olympia* (1863; Paris, Mus. d'Orsay) as well as Fantin-Latour and Courbet, transformed by a bright, even light that intensified rather than

dissolved forms. Bazille had first experimented with the studio exoticism found in these works in the shimmering costume of *Moorish Woman* (1869; Pasadena, CA, Norton Simon Mus.). His last painting, *Ruth and Boaz* (1870; priv. col.), was taken from a passage in Victor Hugo's *La Légende des siècles*. Bazille included a familiar landscape in the background but departed from naturalism by introducing monumental figures of restrained energy, which were close in spirit to Puvis de Chavannes and Paul Cézanne. At the outbreak of the Franco–Prussian War he enlisted in a Zouave regiment on 10 August 1870 and was killed at Beaune-la-Rolande, near Orléans, the following November.

Because of his early death, Bazille will always be judged in the light of his friendships with the future Impressionists. He bought Monet's *Woman in a Garden* (c. 1866–7; Paris, Mus. d'Orsay) in 1868 and provided important financial support for both Monet and Renoir. Yet while he is justly considered to be a precursor of Impressionism by virtue of his *plein-air* work and the dynamism of the forms and bright colours he employed, his classical understanding of space in terms of graduated planes and the sensuality of his subject-matter also link him with the earlier painters he admired, most notably the Venetian Old Masters, Delacroix and Courbet.

Bibliography

G. Poulain: *Bazille et ses amis* (Paris, 1932, rev. Paris, 1991)
F. Daulte: *Frédéric Bazille et son temps* (Lausanne, 1952), rev. as *Frédéric Bazille et les débuts de l'impressionnisme* (Paris, 1991) [cat. rais.]
Frédéric Bazille and Early Impressionism (exh. cat. by P. Marandel, Chicago, Il, A. Inst., 1978)
Frédéric Bazille et ses amis impressionnistes (exh. cat., Montpellier, Mus. Fabre, and New York, Brooklyn Mus., 1992–3)
V. Bajou: *Frédéric Bazille* (Aix-en-Provence, 1993)
VALÉRIE M. C. BAJOU

Béjot, Eugène

(*b* Paris, 31 Aug 1867; *d* Paris, 28 Feb 1931). French etcher. He studied at the Académie Julian in Paris and learnt to etch in 1891. His technical skill and quality of line were already apparent in 1892 in his first commissioned series, *La Seine à Paris* (Paris, 1892), which established his reputation. *La Samaritaine* (e.g. Paris, Bib. N., Cab. Est.) was widely acclaimed at the Peintres–Graveurs exhibition in Paris in 1893. His work included many etchings of the Seine and the quays and buildings of Paris, in which his sensitive use of light evokes the city's atmosphere, and his name became inextricably linked with Paris, although it was not the only place in which he worked. In 1897 he was elected to the Royal Society of Painters and Etchers in London.

Bibliography

J. Laran: *L'Oeuvre gravé d'Eugène Béjot* (Paris, 1937)
ETIENNE LYMBERY

Bellangé, (Joseph-Louis-)Hippolyte

(*b* Paris, 17 Jan 1800; *d* Paris, 10 April 1866). French painter and printmaker. He was enrolled briefly at the Lycée Bonaparte, Paris, and at 16 he entered the studio of Antoine-Jean Gros, where Nicolas-Toussaint Charlet, R. P. Bonington and Paul Delaroche were also pupils. Influenced by Charlet in particular, in 1817 Bellangé worked as a commercial illustrator, employing the still new process of lithography, notably for the publisher Godefroy Engelmann. Bellangé's independent works can only be traced, however, from 1822 onwards. Between 1823 and 1835 he published 15 albums of lithographs devoted to the patriotic military subjects that had long attracted popular favour, and he turned increasingly to representing them in oil. The narrative appeal of his depictions of the veterans of the Napoleonic campaigns—the Old Guard or *grognards*—soon won him official and commercial approval: he was awarded a second-class medal at the Salon of 1824. Ten years later he was made a Chevalier of the Légion d'honneur for the *Return of Napoleon from Elba* (1834; Amiens, Mus. Picardie), a composition widely lithographed by Bellangé himself. Further successes soon followed with *Battle of Fleurus* (exh. 1835) and *Battle of Wagram* (exh. 1837; both Versailles, Château). Bellangé also produced humorous genre scenes,

such as *Mistress of the Household* (exh. Salon 1838; untraced), in which a soldier is being dragged home from his wayward pleasures by his wife.

In 1837 Bellangé left Paris to head the Museé des Beaux-Arts in Rouen, where he remained for 16 years before returning to Paris in 1853. His much admired *Eve of the Battle of Moscow* (untraced) was painted at Rouen; Napoleon is depicted being shown Baron François Gérard's portrait of the King of Rome, which he orders to be removed because it is too soon for his son to see a battlefield. Bellangé's theatrical sense is also apparent in such works as the *Field of the Battle of Wagram* (1857; untraced), in which Napoleon tends a fallen carabinier. For these qualities, as well as for his capacity to render scenes of massive encounters, as in the *Taking of Malakoff* (1858; untraced) by Marshal MacMahon's forces, Bellangé earned the admiration of contemporaries, who compared him with Auguste Raffet and Charlet as a master of his chosen genre. At the end of his life he took up lithography again to create a series of scenes from the Crimean War.

Bellangé's paintings are rather dryly detailed, while his drawings are apt to be freer and hence more attractive to the modern viewer. They were often sketched in crayon broadly toned with watercolour and pen-and-ink, but other media were also used, sometimes with elaborate hatching. His reputation faded after his death, but he remains an informative witness to the enthusiasms of an age when the military role in society was the subject of popular satisfaction and approval.

Bibliography

Catalogue de l'exposition des oeuvres d'Hippolyte
 Bellangé à l'Ecole Impériale des Beaux-Arts (exh. cat.
 by F. Way, Paris, Ecole N. Sup. B.-A., 1867)
J. Adeline: *Hippolyte Bellangé et son oeuvre* (Paris, 1880)
H. Beraldi: *Les Graveurs du XIXe siècle*, ii (Paris, 1885),
 pp. 5–24

FRANK TRAPP

Belly, Léon(-Adolphe-Auguste)

(*b* Saint-Omer, Pas-de-Calais, 10 March 1827; *d* Paris, 24 March 1877). French painter. He studied briefly with the history painter François-Edouard Picot, then trained with the landscape specialist Constant Troyon. Early in his career Belly showed a dual interest in Orientalist exoticism and naturalistic views of the French landscape. He was influenced by the Near Eastern scenes of Alexandre Decamps and Prosper Marilhat but in 1849 visited Barbizon, where he admired the works of Théodore Rousseau, Millet and Corot.

In 1850–51 Belly accompanied the travellers L. F. Caignart de Saulcy and Edouard Delessert to Greece, Lebanon, Palestine, Syria, Egypt and the Black Sea. His first showing at the Salon, in 1853, consisted of Orientalist landscapes from Beirut, Cairo, Nablus and the Dead Sea, which were well received. His views of the Forest of Fontainebleau, a Norman fishing scene and a portrait of the Italian political refugee Daniele Manin (all untraced) were equally successful in the Salon of 1855. During his second Near Eastern trip (1855–6) Belly travelled up the Nile with the painter Edouard Imer (1820–81) and expressed an interest in painting the desert scene that became *Pilgrims going to Mecca* (exh. Salon 1861; Paris, Mus. d'Orsay), which gained him a first-class medal and is generally regarded as his masterpiece. In this work Belly applied the forms of French mid-19th-century naturalism to an exotic subject, demonstrating a control of perspective, pose and lighting equal to that of any academic painter of the time. His techniques in preparing for this large exhibition piece were as complex and time-consuming as those used in traditional history painting: figural and landscape drawings, compositional studies and oil sketches. Belly's third and final voyage to Egypt (1857) had been devoted to making preparatory studies for the painting, which accurately depicts the varied cross-section of Muslim society that took part in the pilgrimage. His obsessive concern to reproduce accurately details of ethnic type, costume, light and atmosphere was shared by contemporary Orientalists, Jean-Léon Gérôme in particular.

After 1861 Belly and his mother maintained a weekly salon in their Paris home on the Quai d'Orsay which was attended by many prominent Barbizon and Orientalist artists, including

Rousseau and Eugène Fromentin. They also carried on an extensive correspondence with Puvis de Chavannes. After 1867 Belly, in poor health, spent an increasing amount of time at his country estate at Montboulan in the Sologne. In his landscapes of provincial France, such as the *Ford at Montboulan* (exh. Salon 1877; Paris, Mus. d'Orsay), Belly continued to work in a sober, naturalistic style derived from the Barbizon painters. His Orientalist pieces were more intense in lighting and colour and more vivid in brushwork, recalling the origins of this genre in the Romantic period. In his attempt to unite two disparate types of subject-matter, one inspired by the Barbizon painters and the other Orientalist, Belly consistently adhered to the mid-19th-century ideal of faithfully representing the beauty of everyday life, whether in France or exotic countries, which achieved its ultimate expression in the works of Courbet and Manet. In 1878 a memorial exhibition of Belly's works was held at the Ecole des Beaux-Arts in Paris.

Bibliography

J. K. Huysmans: 'Art contemporain: Belly', *Les Chefs-d'oeuvre d'art au Luxembourg* (Paris, 1881)

C. de Mandach: 'Artistes contemporains, Léon Belly (1827–1877)', *Gaz. B.-A.*, n. s. 4, ix (1913), pp. 73–84, 143–57 [incl. some of Belly's travel corr.]

P. Wintrebert: *Catalogue de l'oeuvre de Léon Belly* (diss., U. Lille, 1974)

Autour d'un tableau de Léon Belly (exh. cat. by P.-G. Chabert, Saint-Omer, Mus. Hôtel Sandelin, 1974)

Léon Belly, 1827–1877 (exh. cat., Saint-Omer, Mus. Hôtel Sandelin, 1977)

Orientalism: The Near East in French Painting, 1800–1880 (exh. cat., U. Rochester, NY, Mem. A.G., 1982), pp. 73–5

The Orientalists: Delacroix to Matisse (exh. cat., ed. M. A. Stevens; London, RA; Washington, DC, N.G.A.; 1984), pp. 115–16

DONALD A. ROSENTHAL

Benouville

French family of painters.

(1) Jean-Achille Benouville

(*b* Paris, 15 July 1815; *d* Paris, 8 Feb 1891). He was a pupil of François-Edouard Picot until he entered the Ecole des Beaux-Arts in Paris in 1837. From 1834 he exhibited at the Salon many landscapes of the surroundings of Paris, Compiègne and Besançon that were sometimes similar to the works of his friend Corot. These landscapes were painted directly from nature and show his considerable sensitivity to variations in light. In 1845 he won the Prix de Rome for historical landscape with *Ulysses and Nausicaa* (Paris, Ecole N. Sup. B.-A.), which was a great success with the critics. He remained faithful for the rest of his career to the French tradition of historical landscape inspired by Claude Lorrain with works such as the *Colosseum Seen from the Palatine* (1870; Paris, Louvre).

A. DAGUERRE DE HUREAUX

(2) (François-)Léon Benouville

(*b* Paris, 30 March 1821; *d* Paris, 16 Feb 1859). Brother of (1) Jean-Achille Benouville. He was a student of Picot at the same time as his brother and entered the Ecole des Beaux-Arts at the age of 16. He exhibited regularly at the Salon from 1838 and won the Prix de Rome in 1845 (the same year as his brother) with his *Christ before the Tribunal* (Paris, Ecole N. Sup. B.-A.), the almost violent intensity of expression and realism of which is rare in paintings of this period. In Rome he became interested in Early Christian art, from which he acquired a sense of the monumental without being distracted from his search for realism, as exemplified in *Martyrs Led away to their Ordeal* (1855; Paris, Louvre).

Benouville gained fame at the Salon of 1853 with *St Francis of Assisi Taken Dying to S Maria degli Angeli, Blesses the Town of Assisi* (Paris, Louvre); in this he combined a daring composition of figures seen from behind with realistic vigour in the almost primitive solidity of the Franciscans and with delicate colour harmonies in the atmospheric subtlety of the landscape. Gautier justly praised it as 'Zurbaran tempered by Le Sueur' (*Le Moniteur*, 11 Oct 1855). Benouville's later works, however, are less remarkable. They include the decorations (1849–56) for the church at Saint-Germain-en-Laye, again based on the life of St Francis and painted with Eugène-Emmanuel

Amaury-Duval; the decorations for the throne room of the Hôtel de Ville, Paris (destr. 1871); and such large canvases as *St Claire Receiving the Body of St Francis of Assisi* (exh. Salon 1859; Chantilly, Mus. Condé).

Bibliography

M. M. Aubrun: *Léon Benouville (1821–1859): Catalogue raisonné de l'oeuvre* (Paris, 1981) [incl. corr. with J.-A. Benouville]
B. Foucart: *Le Renouveau de la peinture religieuse en France (1800–1860)* (Paris, 1987)

GILLES CHAZAL

Béraud, Jean

(*b* St Petersburg, 31 Dec 1849; *d* Paris, ? 1935). French painter. His father was a sculptor and after his death in 1853 the family left St Petersburg to return to Paris. In 1871, after the Franco-Prussian War, Béraud enrolled in painting classes in the studio of Léon Bonnat. He began his career as a portrait painter, following the example of Bonnat, but by the end of the 1870s and through to the 1890s, he favoured depictions of the daily life of the Parisian boulevards (e.g. *La Pâtisserie Gloppe*, 1889; Paris, Carnavalet). Urbane and sophisticated, he cultivated the company of the Franco-Russian aristocracy in Paris, several of whom were his patrons. He achieved success and honours quickly, exhibiting regularly at the annual Salons from 1873 to 1889. He also painted lovers' rendezvous and such genre scenes as *Return from the Funeral* (exh. Salon 1876; untraced), all of which are rendered in minute detail in a naturalist vein, often with humour and occasionally mockery. By the 1890s he was painting religious themes in contemporary settings, creating an atmosphere reminiscent of the work of 17th-century artists from northern Europe. Paintings of this sort, such as *Mary Magdalene in the House of the Pharisees* (1891; Paris, Mus. d'Orsay), were considered quite scandalous when exhibited. He was an active founding member of the Société Nationale des Beaux-Arts, Paris, showing there from 1890 to 1929. In 1936, a year after his death, the Société Nationale des Beaux-Arts and the Musée Carnavalet, Paris, held memorial exhibitions of his work.

Bibliography

Thieme–Becker
M. Laclotte and J.-P. Cuzin, eds: *Petit Larousse de la peinture*, 2 vols (Paris, 1979)
Un Témoin de la Belle Epoque: Jean Béraud, 1849–1935 (exh. cat. by G. Blazy, Paris, Carnavalet, 1979)
The Realist Tradition: French Painting and Drawing, 1830–1900 (exh. cat. by G. Weisberg, Cleveland, OH, Mus. A.; New York, Brooklyn Mus.; St Louis, MO, A. Mus.; Glasgow, A.G. & Mus.; 1980–82), p. 269
S. Brossais: (MA thesis, U. Paris IV, 1982)

ANNIE SCOTTEZ-DE WAMBRECHIES

Bertall [(Charles-)Albert, Vicomte d'Arnoux, Comte de Limoges-Saint-Saens]

(*b* Paris, 18 Dec 1820; *d* Paris, Feb 1882). French printmaker. On the suggestion of Honoré de Balzac, he used an approximate anagram of his first name Albert—Bertall—as his artistic pseudonym. He studied painting under Michel-Martin Drolling but soon began working as an illustrator and caricaturist, a move probably influenced by Balzac. His first published work was the humorous *Les Omnibus, pérégrinations burlesques à travers tous chemins* (Paris, 1843) for which he produced both text and woodcuts. Two years later he provided illustrations for Balzac's *Petites misères de la vie conjugale* (Paris, 1845) and from 1842 to 1855 he collaborated on illustrating the *Oeuvres complètes de Balzac* (Paris, 1842–55, 20 vols).

For the series *Romans populaires illustrés*, published by Barba, Bertall is said to have produced some 3600 plates for works by James Fenimore Cooper, Paul de Kock and others, including those for Alphonse Karr's *Guêpes à la bourse* (Paris, 1847). He also contributed to many journals, such as *Le Journal pour rire*, *Le Journal amusant*, *L'Illustration* and *Le Magasin pittoresque*. Among several works designed for children, he contributed to the *Bibliothèque des enfants*, published by Hetzel, from 1848 onwards. From

1855 he collaborated with the photographer Hippolyte Bayard in a business producing *cartes-de-visite*, which lasted till the mid-1860s. From 1869 to 1870 he edited the review *Le Soir* and in April 1871, during the Commune, he founded the satirical journal *Le Grelot*, which attacked the Communards. His reactionary views were further expressed in the illustrated *Types de la Commune* (Paris, 1871). He both wrote and illustrated a number of books, such as *Comédie de notre temps* (Paris, 3 vols, 1874–80). He received the Croix de la Légion d'honneur in 1875. Bertall was one of the most prolific graphic artists of the second half of the 19th century.

Bibliography

DBF

H. Beraldi: *Les Graveurs du XIXe siècle* (Paris, 1885–92), ii, pp. 45–9

Inventaire du fonds français après 1800, Paris, Bib. N., Cab. Est. cat., ii (Paris, 1937), pp. 266–73

Berthon, Paul

(*b* Villefranche, Rhône, 1872; *d* Paris, 1909). French designer and lithographer. He began his training in Villefranche, where he studied painting, and in 1893 he moved to Paris, entering the Ecole Normale d'Enseignement du Dessin. There he became a pupil and disciple of Eugène-Samuel Grasset, the Professor of Decorative Arts, and was also influenced by Luc Olivier Merson. Berthon's main output consisted of posters and decorative panels. However, he also produced bookbindings and furniture designs, both of which he exhibited at the Salon in 1895; designs for ceramics for Villeroy & Boch in the late 1890s; and a few designs for the covers of such magazines as *L'Image* (July 1897) and *Poster* (May 1899). His work is in an Art Nouveau style, and he adopted that movement's plant and figural motifs, especially the motif of the *femme fatale*, and also its long sinuous lines. These features can be seen in such works as the poster *Leçons de violon* (1898). Berthon distinguished himself in the production of large,

coloured posters in the relatively new medium of chromolithography, some of which were printed under the direction of Jules Chéret by Chaix & Company.

Bibliography

Bénézit

V. Arwas: *Berthon and Grasset* (London, 1978)

M. Osterwalder: *Dictionnaire des illustrateurs, 1800–1914* (Paris, 1983)

S. Jervis: *Penguin Dictionary of Design and Designers* (London, 1984)

ATHENA S. E. LEOUSSI

Bertrand, James [Jean-Baptiste]

(*b* Lyon, 25 March 1823; *d* Orsay, Seine-et-Oise, 26 Sept 1887). French painter and lithographer. He was a student of Etienne Rey (1789–1867) and then of Jean-Claude Bonnefond (1796–1860) at the Ecole des Beaux-Arts in Lyon (1840–43). On the advice of Alphonse Périn (1798–1874), he then moved to Paris, where he entered the Ecole des Beaux-Arts in 1844 and first exhibited at the Salon in 1857. He worked for 11 years with Périn and his teacher and friend Victor Orsel on decorations for the chapel of the Eucharist in the Church of Notre Dame de Lorette in Paris and in 1854 executed a series of reproductions of work by Orsel. From 1857 to 1862 he stayed in Italy, where he probably met the Nazarenes who had not yet left Rome (Friedrich Overbeck, Gebhard Flatz and Franz Riepenhausen). Back in Paris, he became friendly with such sculptors of the Second Empire as Jean-Baptiste Carpeaux, Alexandre Falguière and Auguste Clésinger. From 1866, under the influence of his sculptor friends, Bertrand devoted himself to representing allegories and genre scenes in which he abandoned his early Nazarene style. These were pleasant compositions showing the great heroines of history and the novel, as in the *Death of Sappho* (1867), the *Death of Virginie* (1869), the *Death of Manon Lescaut* (1870) and the *Death of Ophelia* (1872). These works, widely known through engravings, assured him a certain popularity.

Bibliography

DBF

Les Peintres de l'âme (exh. cat. by E. Hardouin Fugier,
 Lyon, Mus. B.-A., 1981), pp. 97–9

 A. DAGUERRE DE HUREAUX

Besnard, (Paul-)Albert

(*b* Paris, 2 June 1849; *d* Paris, 4 Dec 1936). French
painter, printmaker and designer. He was born to
an artistic family and was precociously talented.
In 1866 he entered the Ecole des Beaux-Arts, where
he studied under Jean François Brémond (1807–68)
and Alexandre Cabanel. His Salon début in 1868
and his subsequent entries were well received, and
in 1874 he won the Prix de Rome with the *Death
of Timophanes, Tyrant of Corinth* (Paris, Ecole N.
Sup. B.-A.). Remaining in Italy for five years,
Besnard worked in an academic style influenced
by Pietro da Cortona and Michelangelo.

Besnard spent three years in London (1879–81),
which were crucial to the development of his
mature painterly style. In a climate favourable for
the development of individuality, and far removed
from academic circles in Paris, Besnard experi-
mented with vibrant colour and spontaneous
brushwork. With the opportunity in London to
study Turner and British 18th-century portraits,
Besnard recognized that 'their colourists are more
painters than ours, they draw with colour'. His
successful assimilation of this painterly tradition
brought him many portrait commissions from
aristocratic patrons such as *Garnet Joseph, 1st
Viscount Wolseley* (1880; London, N.P.G.). His por-
traits are distinguished by a mastery of drawing
and a gift of observation; character and spirit are
expressed through physiognomy.

On his return to Paris, Besnard's reputation as
a portrait painter flourished. His expressive style
of bravura brushwork and atmospheric colour is
best exemplified in what the artist called an 'envi-
ronmental portrait' of *Mme Roger Jourdain* (1885;
Paris, Mus. d'Orsay). In his mature work Besnard
placed little emphasis on acute psychological
observation, since he was primarily concerned
with conveying an ideal of feminine beauty. For
each portrait he created a unique ambience for
the figure in his effort to place the sitter in his or
her natural setting. With vibrant colour contrasts
and theatrical illumination Besnard created a
mood, thus surpassing the Impressionist goal of
recording the external appearance of objects. This
aspect of his work was praised by Symbolist critics.
The artist's preoccupation with luminosity and
heightened colour marks all aspects of his oeuvre:
in figural studies such as *Nude Woman Warming
herself* (1886; Paris, Mobilier N.), in diverse land-
scapes and in exotic subjects drawn from his
travels to Spain, Algeria and India, for example
Arab Women, Arab Horse Market (1895; untraced)
and *Spanish Dancer* (untraced).

Besnard was constantly employed on state com-
missions for mural decorations in Paris. He intro-
duced scientific subject-matter in a decorative
scheme for the Ecole de Pharmacie (1884–7) and
the chemistry amphitheatre at the Sorbonne
(?1888). For the former he painted the *Laboratory,
Illness and Convalescence* and a series of panels
on geology, animals and vegetation in the prehis-
toric era. For his ceiling decorations in the
Salon des Sciences (1890) in the Hôtel de Ville in
Paris, Besnard developed a scheme of scientific
cosmogony that gave form to invisible forces of
electricity, biology and chemistry. Other impor-
tant decorative commissions were for the Salles
des Mariages of the 1er arrondissement (1887), the
cupola of the Petit Palais (1907), the ceiling of
the Comédie-Française (1903–11) and the Grand
Salon of the Pavillon des Arts Décoratifs at the
Exposition Universelle (1900). Their style combines
graceful line, harmonious proportion and striking
juxtapositions of colour.

Besnard also made pastels and etchings
(notably a suite of 26 on the theme of death
for Baron Vitta in 1900) and created designs for
stained glass. He was a regular contributor to
the major Paris Salons and the recipient of
many honours. Although he was resented by the
Impressionists for what they considered a super-
ficial application of their luminous effects,
he won the respect of a broad range of artists
and critics for his audacious use of colour and
reflected light, in combination with permanent
values of imaginative and lyrical expression.

Bibliography

R. Marx: *The Painter Albert Besnard* (Paris, 1893)

D. Delteil: *Le Peintre-graveur illustré*, xxx (Paris, 1906–26; New York, 1969; appendix and glossary, New York, 1970)

A.-C. Coppier: *Les Eaux-fortes de Besnard* (Paris, 1920)

C. Mauclair: *Albert Besnard* (Paris, 1924)

G. Lecomte: *Albert Besnard* (Paris, 1925)

J. E. Blanche: *Les Arts plastiques* (Paris, 1931), pp. 174–7

Post-Impressionism: Cross Currents in European Painting (exh. cat., London, RA, 1979–80), pp. 44–6

Le Triomphe des mairies: Grands décors républicains à Paris, 1870–1874 (exh. cat., Paris, Petit Pal., 1986–7), pp. 120–23, 142–5, 175–9, 314–16

TAUBE G. GREENSPAN

Besson, Faustin

(*b* Dôle, Jura, 15 March 1821; *d* Paris, 1 March 1882). French painter. The son of the painter and sculptor Jean-Séraphin-Désiré Besson (1795–1864), he was a pupil of A. Brune (1802–80), Alexandre-Gabriel Decamps and Jean Gigoux. He made his début in the Salon of 1842 with two portraits that were poorly received. On the advice of his friend Gigoux he then concentrated on painting mural genre subjects in the style of Jean-François Millet. He also produced many amorous scenes inspired by 18th-century French painting (especially Nicolas Lancret). He was responsible for some fine pastiches in the Rococo revival style much in favour during the 1850s. In 1850 he received a commission for two religious paintings, *Angels at the Tomb of the Magdalene* (Paris, St Eustache) and the *Flight into Egypt* (Besançon, Mus. B.-A.). He also painted some decorative works for the private residences of Napoleon III, for the foyer of the Comédie-Française and for private houses in Paris (e.g. *Apotheosis of Woman*; Paris, Hôtel de la Païva), and in Brussels and Cologne. His total output was considerable.

Bibliography

A. Marquiset: *Célébrités franc-comtoises: Peintres: Faustin Besson* (Besançon, 1859)

A. DAGUERRE DE HUREAUX

Blanc, (Paul) Joseph

(*b* Paris, 25 Jan 1846; *d* Paris, 5 July 1904). French painter. He was a pupil of Emile Bin (1825–97) and Alexandre Cabanel at the Ecole des Beaux-Arts in Paris and in 1867 won the Prix de Rome with the *Murder of Laius by Oedipus* (1867; Paris, Ecole N. Sup. B.-A.), which opened up an official career to him. He painted religious and mythological subjects (e.g. *Perseus on Pegasus*, 1869; Nîmes, Mus. B.-A.) and also worked on numerous decorative projects in both Paris and the provinces. Between 1873 and 1883 he worked on the huge mural compositions the *Vow of Clovis at the Battle of Tolbiac* and the *Baptism of Clovis* for the Panthéon in Paris, executed in an academic style. He produced a series of 14 panels depicting the *Passion of Christ* for the church of St Peter at Douai. He executed four grisailles for the cupola of the church of Saint-Paul-Saint-Louis in Paris, which were commissioned in 1873 and finished in 1875 and depicted *St Louis*, *Charlemagne*, *Robert the Pious* and *Clovis*. He painted four panels for the corridor of the foyer of the Opéra Comique in Paris, showing *Music*, *Comedy*, *Song* and *Dance*. In 1882 he was commissioned to decorate the staircase leading to the 'Comité des Maréchaux' room in the Ministère de la Guerre [now Ministère de la Défense], Paris, with three panels depicting *The Departure*, *The Charge* and *Salve Patria*. His tapestry cartoons for the Gobelins included one for the *Arms of the Town of Paris* (1892) for the Tribunal de Commerce in Paris; he contributed a large decorative frieze for the Palais des Beaux-Arts at the Exposition Universelle in Paris in 1900. He also participated in the enormous enterprise of decorating the new Hôtel de Ville in Paris, producing five compositions influenced by Luc Olivier Merson. Destined for the north landing of the Escalier des fêtes, they represent the *Republican Months*, *Dawn*, *Day*, *Evening* and *Night* and were finished in 1903.

Bibliography

Bénézit; *DBF*; Thieme–Becker

A. DAGUERRE DE HUREAUX

Blanchard, Auguste (Thomas Marie), III

(b Paris, 18 May 1819; d Paris, 23 May 1898). French engraver. He first studied with his father, Auguste Jean-Baptiste Marie Blanchard II (1792–1849), and then in 1836 enrolled at the Ecole des Beaux-Arts, Paris. In 1838 he took part in the competition for the Prix de Rome and won second prize, which enabled him to study in Italy. In 1840 he made his début in the Salon in Paris with an engraving of *Spartacus* after the painting by Domenichino. His first major plate was a portrait of the architect *Jean Nicolas Huyot* (1842) after the painting by Michel-Martin Drolling, in which he displayed complete mastery of the medium. Its success brought him the patronage of two major publishers, Adolphe Goupil in Paris and Ernest Gambart in London. In his later engravings he adopted the fashionable contemporary calligraphic style, although he also produced some luminous plates in the new technique of *taille douce* (Fr.: 'smooth-cut'). He also specialized in reproducing the work of Ernest Meissonier (e.g. the *Chess Players*, 1873) and Lawrence Alma-Tadema (e.g. the *Parting Kiss*, 1884).

Bibliography

Bellier de La Chavignerie–Auvray; Bénézit; Thieme–Becker
J. Laran and J. Adhémar: *Inventaire du fonds français après 1800*, Paris, Bib. N., Dépt Est. cat., 3 vols (Paris, 1930–42)

ATHENA S. E. LEOUSSI

nature or from his own drawings, his etchings (frequently combined with drypoint, burin or roulette) are meticulous, delicate and highly wrought, although superficially they often seem uneventful and repetitive. They usually appeared in series, concentrated particularly between 1838 and 1868. Although his subjects owe a little to Claude, they are principally a skilful and well-integrated compendium of Rococo motifs; picturesque Boucher-like water-mills and farm buildings inhabited by elegant peasants underline the 18th-century mood. Despite their occasional Romantic overtones of transience, the formal topography of his landscapes and tree portraits belongs essentially to Barbizon naturalism. He also produced many closely focused botanical studies gracefully composed with an acute realization of species. The strongest influence on him (perhaps initiated by the example of Jean-Jacques de Boissieu) was that of Dutch 17th-century art, in particular Antoni Waterlo and contemporary etchers, as well as Meindert Hobbema and Jacob van Ruisdael, both of whom Bléry copied. The finest collection of his work is in the Bibliothèque Nationale, Paris.

Bibliography

C. Le Blanc: *Manuel de l'amateur d'estampes*, i (Paris, 1854/R Amsterdam, 1970), pp. 359–71 [incorporates Bléry's own cat. rais. of his prints]
H. Béraldi: *Les Graveurs du XIXe siècle*, ii (Paris, 1885), pp. 94–131

HARLEY PRESTON

Bléry, Eugène(-Stanislas-Alexandre)

(b Fontainebleau, 3 March 1805; d Paris, 10 June 1887). French printmaker and draughtsman. At the age of 20 he became a mathematics tutor to Charles Montalivet in Berry and during his three years in the post began the first of his long series of tours of France commemorated in a set of 12 lithographs of 1830, which marked his decision to concentrate on landscape art. The etchings of Jean-Jacques de Boissieu, which he encountered in Lyon, appear to have confirmed him in this vocation by 1836, when he exhibited with increasing popular success under the initial patronage of the Montalivet family. Worked either directly from

Boilvin, Emile

(b Metz, 7 May 1845; d Paris, 31 July 1899). French painter and engraver. He was a pupil of Isidore-Alexandre-Augustin Pils and of Edmond Hédouin. He entered the Ecole des Beaux-Arts in Paris on 5 April 1864 and began his career as a painter of genre scenes (e.g. *Francesca da Rimini*, 1866), which he exhibited at the Salon. In 1868 he first experimented with etching, the medium for which he became famous, and from 1871 he abandoned painting entirely in favour of this. He reproduced the work of such major contemporary artists as Courbet and Ernest Meissonier and of

such Old Masters as Frans Hals and Rubens. He also illustrated such books as Gustave Flaubert's *Madame Bovary* (Paris, 1874) and an edition of Rabelais's works, *Les Cinq Livres de F. Rabelais* (Paris, 1876–7).

Bibliography

Bellier de La Chavignerie–Auvray; Bénézit; DBF; Thieme–Becker

Valabrègue: 'Le graveur E. Boilvin', *L'Oeuvre d'art* (November 1899)

ATHENA S. E. LEOUSSI

Bonheur, (Marie-) Rosa [Rosalie]

(*b* Bordeaux, 16 March 1822; *d* Thomery, nr Fontainebleau, 25 May 1899). French painter and sculptor. She received her training from her father, Raymond Bonheur (*d* 1849), an artist and ardent Saint-Simonian who encouraged her artistic career and independence. Precocious and talented, she began making copies in the Louvre at the age of 14 and first exhibited at the Salon in 1841. Her sympathetic portrayal of animals was influenced by prevailing trends in natural history (e.g. Etienne Geoffroy Saint-Hilaire) and her deep affinity for animals, especially horses. Bonheur's art, as part of the Realist current that emerged in the 1840s, was grounded in direct observation of nature and meticulous draughtsmanship. She kept a small menagerie, frequented slaughterhouses and dissected animals to gain anatomical knowledge. Although painting was her primary medium, she also sculpted, or modelled, studies of animals, several of which were exhibited at the Salons, including a bronze *Study for a Bull* (1843; ex-artist's col., see Roger-Milès, p. 35) and *Sheep* (bronze; San Francisco, CA, de Young Mem. Mus.). In 1845 she attracted favourable notice at the Salon from Théophile Thoré. In 1848 she received a lucrative commission from the State for *Ploughing in the Nivernais* (1849; Paris, Mus. d'Orsay), which, when exhibited the next year, brought her further critical and popular acclaim. Typical of the Realist interest in rural society manifested in the contemporary works of Gustave Courbet and Jean-François Millet, *Ploughing* was inspired by George Sand's rustic novel *La Mare au diable* (1846). She exhibited regularly at the Salon until 1855. Her paintings sold well and were especially popular in Great Britain and the USA.

Bonheur's masterpiece, the *Horse Fair* (1853; New York, Met.), which is based on numerous drawings done at the horse market near La Salpetrière, was inspired by the Parthenon marbles (London, BM) and the works of Théodore Gericault. This immense canvas (2.45×4.07 m) combines her Realist preoccupation with anatomical accuracy and a Romantic sensitivity to colour and dramatic movement rarely found in her work. After its triumphant showing at the Paris Salon, the painting went on tour in Great Britain and the USA and was widely disseminated as a print. In 1887 Cornelius Vanderbilt purchased the *Horse Fair* for £53,000 and donated it to the newly founded Metropolitan Museum of Art, New York.

After 1860 Bonheur withdrew from the Paris art world and settled in the Château de By on the outskirts of the Forest of Fontainebleau with her companion, Nathalie Micas. Independent and financially secure, she painted steadily and entertained such celebrities as the Empress Eugénie and Buffalo Bill, whose portrait she painted in 1889 (Cody, WY, Buffalo Bill Hist. Cent.). In favour at court, Bonheur received the Légion d'honneur from the Empress Eugénie in 1865, the first woman artist to be so honoured. Although she enjoyed widespread renown during her lifetime, she was not universally admired by contemporary critics. Her spectacular success in Great Britain, her eccentric lifestyle and her militant feminism no doubt contributed to her mixed critical reception at home. Bonheur, who wore her hair short, smoked and worked in masculine attire, was a nonconformist who transcended gender categories and painted, according to various critics, like a man. After her English tour in 1856 she adopted a more detailed realistic manner, influenced perhaps by Edwin Landseer, though her style evolved little during her long career. She never abandoned her strict technical procedures and was unaffected by contemporary artistic trends. Her reputation declined after her death but has been revived in the 20th century by feminist art historians.

Bonheur was devastated by the death of Micas, her lifelong companion, in 1889. Her final years were brightened by Anna Klumpke (1856–1942), a young American portrait painter who was her biographer and her sole heir when Bonheur died in May 1899. In 1901 the town of Fontainebleau erected a monument in honour of Bonheur that was melted down during the German occupation of World War II. Her studio at the Château de By in Thomery has been restored and is open to the public.

Writings

'Fragments of my Autobiography', *Mag. A.*, xxvi (1902), pp. 531–6

Bibliography

L. Roger-Milès: *Rosa Bonheur: Sa vie, son oeuvre* (Paris, 1900)

A. E. Klumpke: *Rosa Bonheur: Sa vie, son oeuvre* (Paris, 1908)

T. Stanton, ed.: *Reminiscences of Rosa Bonheur* (New York, 1910/R 1976)

Women Artists: 1550–1950 (exh. cat. by A. Sutherland Harris and L. Nochlin, Los Angeles, CA, Co. Mus. A., 1976)

D. Ashton and D. Browne Hare: *Rosa Bonheur: A Life and a Legend* (New York, 1981)

A. Boime: 'The Case of Rosa Bonheur: Why Should a Woman Want to be more like a Man?', *A. Hist.*, iv (1981), pp. 384–409

C. Styles-McLeod: 'Historic Houses: Rosa Bonheur at Thomery', *Arch. Digest*, 43 (1986), pp. 144–50, 164

B. Tarbell: 'Rosa Bonheur's Menagerie', *Art and Antiques*, 15 (1993), pp. 58–64

HEATHER MCPHERSON

Bonhommé, (Ignace-)François

(*b* Paris, 15 March 1809; *d* Paris, 1 Oct 1881). French painter, draughtsman and printmaker. His father painted scenes on carriages, and he provided his son with a rudimentary artistic training in an artisan's milieu of simple machinery and fellow workers. In 1828 Bonhommé entered the Ecole des Beaux-Arts in Paris under the aegis of Guillaume Lethière, whom he always listed first among his masters. Bonhommé drew from the model with Horace Vernet and studied further with Vernet's son-in-law, Paul Delaroche. Bonhommé's first Salon exhibit, in 1833, was a painting of a Newfoundland dog (untraced). In 1835 he showed a sequence of portraits in pastel and watercolour, owned by the writer Alexandre Dumas, who later published an article on Bonhommé in *L'Indépendance belge*. In 1835 Bonhommé also made two prints detailing the installation of the Luxor obelisk in the Place de la Concorde, Paris, on 25 October of that year, one made at noon and the other at 3 o'clock, an early manifestation of his facility for rapid and accurate description of machinery and topography. During the next year Delaroche chose Bonhommé to undertake a task he had himself declined, to paint the factories of Forchambault. Bonhommé claimed his first sight of molten metal being cast determined the course of his career. His Salon début as an industrial artist came in 1838, when he showed *Sheet Metal Manufacture in the Forges of Abbainville* (untraced). Two years later he exhibited another view of the Abbainville works, as well as a dramatic cross-section of the Forchambault factory, irregularly shaped to conform with the building. From then on Bonhommé executed almost exclusively industrial scenes, although he did occasionally exercise his talent as a portraitist, as in his portrait of M. Aubertot, the head of an iron manufactory (1847; Paris, Mus. d'Orsay). The 1848 Revolution excited Bonhommé as much as had that of 1830. He was commissioned by the Republican government to provide etched portraits of its major figures, as well as two important lithographs of key events, *Session of 15 May 1848, at the Constitutional Assembly* and *Barricade on the Saint-Martin Canal, 23 June 1848*, turbulent works reflecting his admiration for Delacroix.

In 1851, with the help of his neighbour Champfleury, Bonhommé won a state commission to produce pictures for the Ecole des Mines. During 1854–5 he worked for the same patrons on a more ambitious project, which included framed horizontal scenes on a large scale of metallurgical processes and crowds of workers. For the Exposition Universelle of 1855 Bonhommé

assembled four of his past Salon works and received a third-class medal, his only such award. Later that year he executed a spectacular watercolour, *Fireworks set off at Versailles in Honour of Queen Victoria, 25 August 1855* (Paris, Carnavalet), which possesses the architectural sweep and cosmic chiaroscuro of John Martin's work. Bonhommé sent mining and factory scenes to the Salon intermittently until 1873, varying his perspective from that of the factory floor (e.g. *Workshop with Mechanical Sieves at the Factory of La Vieille Montagne, c. 1859*; Paris, Mus. N. Tech.) to an aerial viewpoint that recalls some of his teacher Vernet's battle scenes (e.g. *Coalpits and Clay Quarries at Montchanin*; Montchanin, Mairie; see fig. 3). Bonhommé spoke of his intention to compile a project entitled *Soldiers of Industry*, in which he could celebrate the 'peaceful conquests' of his favourite 'army'. His knowledge of profes-

sional dress was thorough and complete, and his impressive pen and ink drawings of individual workers can be equally exact in their description of occupational poses and gestures. In many of Bonhommé's works expressive power was subordinate to technical accuracy, but the best, like his nightmarish scene of a blindfolded white horse being lowered for work down a mine shaft (Jarville, Mus. Hist. Fer), have the descriptive poetry of Zola's *Germinal*. Bonhommé's mills are dark and satanic, but the artist, who signed his work 'François Bonhommé, called the Blacksmith', felt enthusiasm for industry and its magnates, as well as empathy for the workers.

Never prosperous, Bonhommé was saved from absolute indigence when Charles Lauth appointed him Professor of Drawing at the Sèvres Manufactory, through the intercession of supporters such as Jules Simon. Bonhommé was given

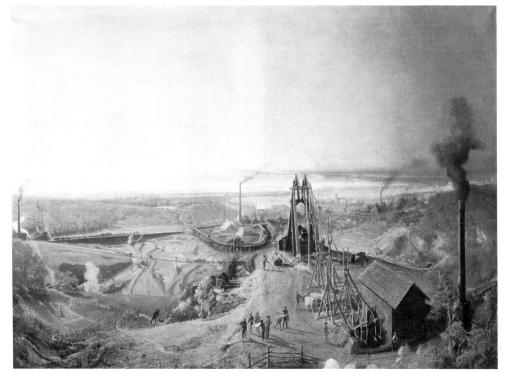

3. François Bonhommé: *Coalpits and Clay Quarries at Montchanin* (Montchanin, Mairie)

a studio and associated with friends also employed there, such as Bracquemond and Champfleury, director of the Sèvres Museum. However, his salary was low and his admirably consistent career ended sadly when he lost his mind and had to be committed to the Sainte-Anne Asylum, where he died shortly afterwards.

Bibliography

H. Béraldi: *Les Graveurs du XIXe siècle*, ii (Paris, 1885), pp. 155–6

J. F. Schnerb: 'François Bonhommé', *Gaz. B.-A.*, n.s. 4, ix (1911), pp. 11–25, 132–42

Exposition François Bonhommé, dit le Forgeron (exh. cat. by B. Gille, Nancy, Mus. Fer, 1976)

L. Nochlin: *Gustave Courbet: A Study of Style and Society* (New York, 1977), pp. 111–14

P. Le Nouëne: '"Les Soldats de l'industrie" de François Bonhommé: L'Idéologie d'un projet', Les Réalismes et l'histoire de l'art, *Hist. & Crit. A.*, 4/5 (1977–8), pp. 35–61

G. Weisberg: 'François Bonhommé and Early Realist Images of Industrialization, 1830–1870', *A. Mag.*, 54 (April 1980), pp. 132–4

The Realist Tradition: French Painting and Drawing, 1830–1900 (exh. cat. by G. Weisberg, Cleveland, OH, Mus. A., 1981), pp. 71–9, 270–71

JAMES P. W. THOMPSON

Bonnassieux, Jean-Marie-Bienaimé

(*b* Panissières, Loire, 19 Sept 1810; *d* Paris, 3 June 1892). French sculptor. He trained in Lyon with manufacturers of church furnishings, then in Paris at the Ecole des Beaux-Arts with Augustin Dumont. In 1836 he won the Prix de Rome and completed his education at the Académie de France in Rome under the directorship of Ingres. Though he exhibited only a few works at the Salon, including the classicizing *Cupid's Wings Clipped* (marble, 1842; Paris, Louvre), he received numerous commissions for decorative sculpture for the major public building projects of the second half of the 19th century, including the Louvre (1855, 1856, 1857, 1868, 1876), the Palais de Justice, Paris (1868), and the Lyon Bourse (1858, 1863). He also executed several public monuments, such as that to *Henry IV* (bronze, 1856; La Flèche, Sarthe, Place Henri IV).

Most of Bonnassieux's commissions, however, were for private patrons—often ecclesiastic—and included portrait busts and tombs such as the austerely classicizing *Duchesse Honoré de Luynes* (marble, 1866; Dampierre, Seine-et-Oise, parish church) and monuments such as that to *Ingres* (marble, 1868; Paris, Père Lachaise Cemetery). He executed the sculptural decoration of the church of La Madeleine in Tarare (Rhône) and contributed to the decoration of many churches in Paris, Lyon and his native Forez region of the upper Loire Valley. The most famous of his series of monumental statues of the Virgin is *Notre-Dame de France* (h. 16 m, cast iron, 1860), erected by public subscription at Le Puy. Sketch models of a number of his works are in the Musée d'Orsay, Paris.

Bibliography

Lami

L. Armagnac: *Bonnassieux statuaire* (Paris, 1897)

A. Le Normand: *La Tradition classique et l'esprit romantique: Les Sculpteurs de l'Académie de France à Rome de 1824 à 1840* (Rome, 1981)

A. Le Normand-Romain: 'Six Esquisses du sculpteur Bonnassieux', *Rev. Louvre*, 5/6 (1982), pp. 366–72

La Sculpture française au XIXème siècle (exh. cat., ed. A. Pingeot; Paris, Grand Pal., 1986), pp. 29, 32–6, 47, 130, 235

ANTOINETTE LE NORMAND-ROMAIN

Bonnat, Léon(-Joseph-Florentin)

(*b* Bayonne, 20 June 1833; *d* Monchy-Saint-Eloi, Oise, 8 Sept 1922). French painter, collector and teacher. He lived in Madrid from 1846 to 1853, where his father owned a bookshop, and there he studied with both José de Madrazo y Agudo and Federico de Madrazo y Küntz. After moving to Paris in 1854, he entered Léon Cogniet's atelier at the Ecole des Beaux-Arts and competed for the Prix de Rome in 1854, 1855 and 1857. He won second prize in 1857 with the *Resurrection of Lazarus* (Bayonne, Mus. Bonnat), a painting characterized by the jury as frank, firm and powerful, terms applied to his art throughout his career (see fig. 4). His early paintings of historical and religious subjects gave way in the late 1860s to the less esteemed field of

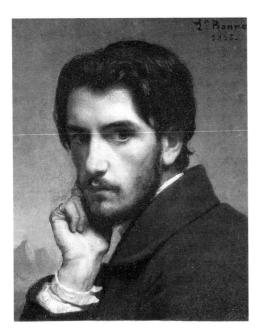

4. Léon Bonnat: *Self-portrait*, 1855 (Paris, Musée d'Orsay)

genre—scenes of Italian life and the Near East—based on sketches made during visits to Italy (1858–60) and the Near East and Greece (1868–70).

Bonnat's final change of career occurred in the mid- to late 1870s, when he became internationally renowned for his portraits, particularly of members of the European and American establishment. His highly realistic technique reflected his frequent use of photographs as models. The portraits, which cost 30,000 francs each, were so desirable that by the 1880s he had to schedule three to four sittings a day to accommodate his long waiting list.

Bonnat's portraits followed a pattern set by the monumental and elegant *Mme Pasca* (1874; Paris, Mus. d'Orsay), his first painting to be universally praised. His actress friend dominates a dark, amorphous space and is brightly lit to create a strong chiaroscuro effect. Bonnat's style was strongly influenced by Ribera and the portraits by Titian, Velázquez and van Dyck that he saw as a youth in the Museo del Prado in Madrid. In addition he owed a debt to Rembrandt, Courbet and Manet,

the last of whom also loved Spanish painting, a fact that may account for Bonnat's support for Manet's Salon entries. Bonnat's portrait of *Adolphe Thiers* (1876; Paris, Mus. d'Orsay), the first President of the Third Republic, established his fame. The portrait is serious and formal, full of the strength and dignity the audience expected of this contemporary hero. Bonnat adapted a pose from Titian's *Charles V* (Madrid, Prado), one of the first paintings to establish the pattern for state portraiture, which has been dominant ever since. His dour, stiff, implacable Thiers, portrayed as a confident national leader, became a model for every establishment figure desiring a portrait. Bonnat's approach in this and the innumerable portraits that followed distinguished him from his rival portrait painters, Carolus-Duran, John Singer Sargent and Jules Lefebvre.

Bonnat's work has a wide expressive range, though almost all his portraits flatter the sitters. Portraits of his close friends are full of energy and life (e.g. *Harpignies*, 1889; Paris, Petit Pal.). However, several portraits are dull and vapid (e.g. *Leland Stanford jr*, 1884; Stanford, CA, U. A.G. & Mus.), a result in part of the speed with which he worked to fulfil his many commissions. Contemporary critics mentioned that Bonnat's portraits of public officials enhanced their dignity, and in most of his portraits the subjects appear younger and more animated than in their contemporary photographs. The stiffness of many of the portrait figures reflects the cold, inexpressive public image that most 19th-century patrons cultivated. By generalizing the setting and minimizing attributes, features that might indicate profession or character, Bonnat diminished the personality of his sitters while emphasizing the idea of the importance of the individual. They form a telling document of a triumphant bourgeoisie, produced in a period when the focus on great individuals was yielding to the idea that broad social and economic forces were the significant factors shaping the world.

Bonnat was an important teacher and ran an active studio for over 30 years. In addition to supervising an independent studio from 1865, he taught the evening course at the Ecole des Beaux-Arts in

Paris from 1883 until he became a *chef d'atelier* at the same institution in 1888, a post he held until he became Director in 1905. His best-known students included Thomas Eakins, Gustave Caillebotte, Raoul Dufy and Henri de Toulouse-Lautrec, although they did not stay with him long and soon rejected his guidance. He influenced artists from Scandinavia to the USA. Bonnat was also a popular Salon juror, as it was felt that he would be a sympathetic judge. He was a liberal teacher who stressed simplicity in art above high academic finish, as well as overall effect rather than detail. He encouraged strong chiaroscuro and heavy modelling as well as careful drawing, the hallmarks of his own work. In the 20th century he altered his technique and produced works that show the marks of the Impressionism and Neo-Impressionism that he had so long opposed (e.g. *George Cain*, 1909; priv. col.).

Bonnat's significance as an art collector dates from c. 1880, when he began collecting the Old Master drawings that form the basis of the Musée Bonnat in Bayonne (founded in 1924) and range from the Renaissance up to the 19th century.

Writings

Notes et dessins de Léon Bonnat (Paris, 1928)

Bibliography

A. Fouquier: *Léon Bonnat: Première partie de sa vie et son oeuvre* (Paris, 1879)

H. Demesse: 'Léon Bonnat', *Gal. Contemp.*, v, pt a (1880)

L. Bénédite: 'Léon Bonnat, 1833–1922', *Gaz. B.-A.*, n. s. 4, vii (1923)

C.-M. Widor: *Notice sur la vie et les travaux de M. Léon Bonnat*, Acad. des B.-A. (Paris, 1923)

R. Cuzacq: *Léon Bonnat* (Mont-de-Marsan, 1940)

H. Jeanpierre: 'Une Correspondance inédite de Léon Bonnat', *Bull. Soc. Sci., Lett. & A. Bayonne*, 65 (1953)

——: 'Bonnat et l'art moderne', *Bull. Soc. Sci., Lett. & A. Bayonne*, 113 (1967), pp. 1–19

Dessins français du XIXe siècle du Musée Bonnat à Bayonne (exh. cat. by V. Ducourau and A. Serullaz, Paris, Louvre, 1979)

The Realist Tradition: French Painting and Drawing, 1830–1900 (exh. cat., ed. G. P. Weisberg; Cleveland, Mus. A.; New York, Brooklyn Mus.; St Louis, A. Mus.; Glasgow, A.G. & Mus.; 1980–81), pp. 164–6, 177–80, 271–3

H. Usselmann: 'Léon Bonnat, d'après les témoignages de ses élèves nordiques', *Ksthist. Tidskr.*, lv (1986), pp. 67–76

JULIUS KAPLAN

Bonvin

French family of painters. (1) François Bonvin and his younger half-brother (2) Léon Bonvin came from humble origins; their father was a constable in the Parisian suburb of Vaugirard. As artists they were largely self-taught.

(1) François (Saint) Bonvin

(*b* Vaugirard, Paris, 22 Nov 1817; *d* Saint-Germain-en-Laye, 19 Dec 1887). François trained first as a printer and later briefly at the Gobelins. From 1828 to 1830 he was a student at the Ecole de Dessin, Paris, and later attended the Académie Suisse. In 1843 Bonvin showed some of his drawings to François Granet, whom he considered his only mentor.

In his earliest known canvas, *Still-life with a Beer Mug* (1839; Paris, priv. col., see Weisberg, 1979, p. 208), painted while working as a clerk for the Paris police, he displayed a predilection for still-lifes that he maintained throughout his career. By the mid-1840s Bonvin devoted more time to his painting, although he did not officially leave the police until February 1850. In 1844 Bonvin met his first patron, Laurent Laperlier (1805–78), an official in the War Office, who bought some drawings that Bonvin showed under the arcades of the Institut de France, Paris. In 1847 he exhibited a portrait in the Salon and continued to show there until ill-health forced him to retire in 1880.

Through his friends, the novelist and art critic Jules Champfleury and the painter and writer Gustave Courbet, Bonvin joined the Realist movement. He had lengthy discussions with Amand Gautier, the writer Max Buchon (1818–69) and later the art critic Jules-Antoine Castagnary at the Brasserie Andler, Paris. These conversations probed the nature of Realism and the principles of truth and exactitude held by the artists in the group. François remained attached to the group until the mid-1860s.

In *La Silhouette* (1849) Champfleury singled out François's small *The Cook* (exh. Salon 1849; Mulhouse, Mus. B.-A.), comparing it with the work of Chardin, an artist whom François greatly admired. (Indeed, Bonvin convinced Laperlier to collect works by Chardin, from which he then borrowed motifs.) *The Cook* was awarded a third-class medal and won Bonvin a much-needed 250 francs. By the early 1850s François's dark-toned canvases were frequently exhibited and were sufficiently successful to win him a state commission to complete *The Girls' School* (exh. Salon 1850–51; Langres, Mus. St-Didier), which was awarded a second-class medal.

During the Second Empire (1852–70) François became well known for his small still-lifes and intimate genre scenes inspired by earlier painting. His *Interior of a Tavern* (1859; Arras, Mus. B.-A.) shows the influence of the Le Nain brothers. *Interior of a Tavern (Cabaret flamand)* (1867; Baltimore, MD, Walters A.G.) is reminiscent of 17th-century Dutch painting, especially the work of Pieter de Hooch. Bonvin's preference was for thin tones of brown, grey and black, enlivened with red or yellow highlights. In 1859, when a number of young painters (including Whistler and Fantin-Latour) were rejected at the Salon, Bonvin held an exhibition of their work at his own atelier.

After his half-brother's death in 1866 François went to the Netherlands, where he studied Dutch painting in order to find inspiration for his images of 'an art for man' as expressed by the critic Théophile Thoré. Bonvin spent a year in London during the Franco-Prussian War (1870–71). When he returned to France he settled in the village of Saint-Germain-en-Laye, where, despite failing health and eyesight, he continued to create intimate Realist charcoal drawings and paintings of humble everyday objects and scenes.

(2) Léon Bonvin

(*b* Vaugirard, Paris, 28 Feb 1834; *d* Meudon, Hauts-de-Seine, 30 Jan 1866). Half-brother of (1) François Bonvin, he first earned his living as an innkeeper but had artistic ambitions from an early age. He first executed small, sombre charcoal and ink sketches of his bleak environment, but by the end of his life he was producing luminous watercolour still-lifes (such as *Still-life: Containers and Vegetables*; 1863; Baltimore, MD, Walters A.G.) and studies of the countryside directly from nature, in a style that looked forward to Impressionism. When his watercolours were rejected by a Parisian art dealer, Léon committed suicide in a fit of despair by hanging himself from a tree in the forest of Meudon. Although encouraged and supported by his half-brother, he was largely ignored during his lifetime; however, a sale of his watercolours after his death brought his destitute family over 8000 francs. The Walters Art Gallery in Baltimore, MD, has the largest collection of his work.

Bibliography

E. Moreau-Nélaton: *Bonvin raconté par lui-même* (Paris, 1927)

G. P. Weisberg: 'François Bonvin and an Interest in Several Painters of the Seventeenth and Eighteenth Centuries', *Gaz. B.-A.*, lxxvi (1970), pp. 359–66

—: 'The Traditional Realism of François Bonvin', *Bull. Cleveland Mus. A.*, lxv (1978), pp. 281–98

—: *Bonvin: La Vie et l'oeuvre* (Paris, 1979)

—: 'Léon Bonvin and the Pre-Impressionist Innocent Eye', *A. Mag.*, liv/10 (1980), pp. 120–24

The Drawings and Watercolours of Léon Bonvin (exh. cat. by G. P. Weisberg, Cleveland, OH, Mus. A., 1980)

G. P. Weisberg: 'Small Works and Simplified Forms in the Art of Léon Bonvin', *A. Mag.*, lxiii/1 (1987), pp. 54-8

GABRIEL P. WEISBERG

Borrel

French family of medallists. Valentin Maurice Borrel (*b* Montataire, Oise, 24 July 1804; *d* Chevilly-Larue, Val-de-Marne, 29 March 1882) learnt his craft in the workshop of Jean-Jacques Barre (1793–1855). His first medal, of the dramatist *Louis-Benôit Picard*, was well received, and he pursued a successful and prolific career recording the main events of Louis-Philippe's reign, the Second Republic and the Second Empire. His son Alfred Borrel (*b* Paris, 18 Aug 1836; *d* 1927) trained under François Jouffroy at the Ecole des Beaux-Arts. Like his father, he exhibited regularly at the Salon, where his portrait medals and his

allegorical figure compositions, notably that for the *Centenary of the Foundation of the School of Living Oriental Languages* (1895; Paris, Bib. N.), were admired. In 1906 he became a Chevalier of the Légion d'honneur.

Bibliography

Bellier de la Chavignerie–Auvray

F. Mazerolle: 'V.-M. Borrel', *Gaz. Numi. Fr.* (1904), pp. 1–38

Catalogue général illustré des éditions de la Monnaie de Paris, iii (Paris, 1978), pp. 53–8

MARK JONES

Bottini, George (Alfred)

(*b* Paris, 1 Feb 1874; *d* Villejuif, nr Paris, 16 Dec 1907). French painter and printmaker. The son of an Italian hairdresser, Bottini always lived in the Montmartre area of Paris except for two years' military service (1895–7). He favoured the English fashions, bars and language (as in the titles of his pictures and the spelling of his first name). Apprenticed with Annibale Gatti (1828–1909) from 1889 to 1891, he studied at Fernand Cormon's studio and first showed at Edouard Kleinmann's gallery in 1894. From 1897 he showed large oil paintings at the Salon of the Société Nationale des Beaux-Arts. He collaborated on woodcuts with Harry van der Zee from 1896 in compositions influenced by Japanese prints, for example *Arrival at the Masked Ball* (1897; Paris, Bib. N., Cab. Est.). His woodcuts, lithographs and etchings sold quickly after publication by Edmond D. Sagot. Bottini illustrated for *Le Rire* in 1897, made several posters and from 1902 to 1904 did illustrations for books by Gustave Coquiot and Jean Lorrain. His short career ended in an asylum where he died from syphilis, which he had contracted at the age of 15.

His typical subject-matter was the female inhabitants of the Montmartre cafés, bars and brothels of the Belle Epoque. He had an elegant compositional style and a rich sense of colour. After a cloisonnist phase (1895–6), he developed a lighter touch and Art Nouveau manner in 1898. Between 1899 and 1904 he employed stronger colour and more strictly geometric forms.

Linearism, strength of movement and clarity characterize his output until 1905. After 1906 his draughtsmanship became weaker and the subjects shifted from café life to odalisques and actresses. He painted with mixtures of gouache and watercolour, plus tea, iodine and coffee, and ironed his pictures to give them a shiny surface. *Woman with a Parrot* (oil, 1905; Paris, Mus. d'Orsay) shows Edouard Manet's influence, but the style and subject-matter of Bottini's work have more in common with Henri de Toulouse-Lautrec. Large collections of his work are in the Musée du Petit Palais, Geneva, and the Bibliothèque Nationale, Paris.

Bibliography

George Bottini: Painter of Montmartre (exh. cat. by E. C. Southard, Oxford, OH, Miami U., A. Mus., 1984)

EDNA CARTER SOUTHARD

Boudin, (Louis-)Eugène

(*b* Honfleur, 12 July 1824; *d* Deauville, 8 Aug 1898). French painter. The son of a mariner, he served as a cabin boy on his father's coastal vessel and thus became familiar with the moods and atmosphere of the sea, which, with the Normandy grazing lands, was his main subject-matter. After a year of schooling in Le Havre in 1835, Boudin worked with a local printer and then with a stationer and framer who displayed paintings by visiting artists; thus he became acquainted with Théodule Ribot, Thomas Couture and Jean-François Millet, as well as Constant Troyon and Eugène Isabey, who were important influences. By 1844 he had set up his own stationery business from which he withdrew in 1846 after spending all his money on buying a conscription substitute. In 1847 he decided to become a professional painter and went to Paris, where he was stimulated by the landscapes, marines and still-lifes of the 17th-century Dutch school and contemporary Barbizon paintings. He copied Old Masters, some of which he did for Baron Isidore-Justin-Séverin Taylor, who subsidized Boudin's travel in northern France and Belgium in 1849. In 1851 Boudin was granted a three-year scholarship by Le Havre Municipal Council to work in Paris, Rouen and Caen, as well

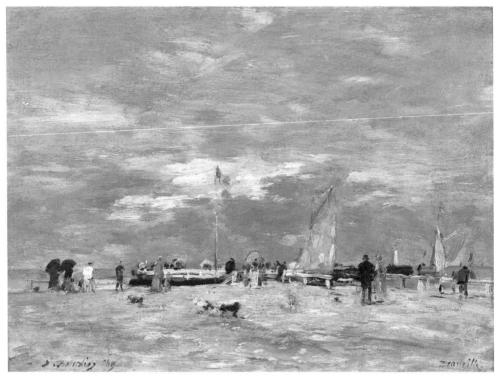

5. Eugène Boudin: *The Jetty of Deauville* (Paris, Musée d'Orsay)

as locally. In 1854 he made wider contacts with the group of artists who frequented the Ferme Saint-Siméon, near Honfleur. His visit in 1855 to Quimper aroused an interest in local costume (e.g. *Breton Festival, c.* 1864; priv. col., see Jean-Aubry, 1968, p. 34); a second, extended Breton tour in 1857 enamoured him of the landscape and yielded an important sequence of monochrome drawings reflecting Barbizon influences. At an exhibition of the Société des Amis des Arts du Havre in 1858, Boudin met Claude Monet to whom he offered substantial encouragement, stressing particularly the primacy of working directly from nature. In 1859 Boudin's *Pardon of Ste-Anne-la-Palud* (1858; Le Havre, Mus. B.-A.) was accepted at the Paris Salon, where it was praised by Charles Baudelaire. In the same year Boudin befriended Gustave Courbet, the style of whose largely studio-painted sea and sky pictures he raised to a new pitch of naturalism.

In 1861 Boudin worked briefly with Troyon in Paris, squaring up larger subjects and occasionally painting the skies. He encountered Camille Corot and Charles-François Daubigny, whose works had already impressed him, the former appropriately designating him 'le roi des cieux'. From 1863 to 1897 he exhibited regularly at the Salon, usually a single work or pair of paintings; he was also represented in the First Impressionist Exhibition of 1874. In 1864 Boudin met Johan Barthold Jongkind, with whose art his has many affinities. In 1881 he signed a contract with the dealer Paul Durand-Ruel, with resulting American sales.

Boudin's life followed a consistent pattern of annual travel to his favoured sites in Normandy and Brittany, as well as Bordeaux, and in the 1890s the French Riviera. He inscribed his works with both location and date. During the Franco-

Prussian War (1870–71) he visited Belgium and the Netherlands, and he extended his later tours to Brussels, Antwerp, Dordrecht, Rotterdam and Scheveningen. From 1892 to 1895 he regularly visited Venice and depicted traditional views with a cool, resonant luminosity, as in *Venice* (1895; Washington, DC, Phillips Col.).

Boudin's reputation was forged on his scenes of harbours, rivers, estuaries and coasts and their shipping, but he also made some inland landscapes and a long series of still-lifes in the tradition of Jean-Siméon Chardin (e.g. *Still-life with Lobster on White Cloth*, *c.* 1862; Atlanta, GA, High Mus. A.); these culminated in the decorative panels of exotic birds, fruit and flowers painted in 1869 for the Château de Bourdainville. His figure subjects range from studies of peasants at their festivities or devotions to marketing scenes and washerwomen; however, his most famous sequence is his depictions of beach scenes (1860–94), prompted by Isabey, showing the bourgeoisie and aristocracy at recreation on the sands of Deauville (see fig. 5) and Trouville (e.g. *The Beach at Trouville*; 1867, Paris, Mus. d'Orsay; see col. pl. III).

Boudin prefigured Impressionism with his acute and subtle awareness of atmospheric luminosity, with particular emphasis on passing effects of wind-blown cloud and sea. His penchant for cool, silvery lighting and blond tonality is often enlivened with brilliant touches of colour in costumes, flags or bunting, while a richer intensity of hue is seen in his warmer, southern seascapes. Despite a generalization of forms, broken contours, an impasto of splintery brushstrokes of broadly suggestive immediacy and an overall instantaneity of vision, he never pushed as far as the Impressionists in the visual analysis and optical blend of colour divisions; nor did he attempt the mix of short or scrolling brushstrokes of his unofficial pupil, Monet. He did not paint the same subjects consecutively under varying atmospheric conditions but often returned at longer intervals to a favourite motif such as the Etretat cliffs or Trouville jetties. Although Boudin's stylistic development is neither extreme nor dramatic, his tendency to greater emptiness and animated effects became exaggerated in his last decade to a wild and broken handling and severe formal austerity.

Throughout his career Boudin made bright, lively and schematic pastels, and he filed for reference a vast oeuvre of watercolours revealing a sparse skeleton of chalk or graphite over which float broad, approximate washes of vibrant yet delicately transparent colour. At the end of his life he made one original lithograph and a brilliantly vital, if technically flawed, marine etching that indicate the ability if not the inclination to become an important printmaker.

Bibliography

G. Cahen: *Eugène Boudin: Sa vie et son oeuvre* (Paris, 1900)

G. Jean-Aubry: *Eugène Boudin d'après des documents inédits: L'Homme et l'oeuvre* (Paris, 1922); rev. with R. Schmit as *La Vie et l'oeuvre d'après les lettres et les documents inédits d'Eugène Boudin* (Neuchâtel, 1968; Eng. trans., Greenwich, CT, 1968)

Boudin aquarelles et pastels (exh. cat., Paris, Louvre, 1968)

R. Schmit: *Eugène Boudin, 1824–1898*, 3 vols (Paris, 1973/R 1984) [cat. rais.]

V. Hamilton: *Boudin at Trouville* (London, 1993)

HARLEY PRESTON

Bouguereau, William(-Adolphe)

(*b* La Rochelle, 30 Nov 1825; *d* La Rochelle, 19 Aug 1905). French painter. From 1838 to 1841 he took drawing lessons from Louis Sage, a pupil of Ingres, while attending the collège at Pons. In 1841 the family moved to Bordeaux where in 1842 his father allowed him to attend the Ecole Municipale de Dessin et de Peinture part-time, under Jean-Paul Alaux. In 1844 he won the first prize for figure painting, which confirmed his desire to become a painter. As there were insufficient family funds to send him straight to Paris he painted portraits of the local gentry from 1845 to 1846 to earn money. In 1846 he enrolled at the Ecole des Beaux-Arts, Paris, in the studio of François-Edouard Picot. This was the beginning of the standard academic training of which he became so ardent a defender later in life. Such early works as *Equality* (1848;

priv. col., see 1984–5 exh. cat., p. 141) reveal the technical proficiency he had attained even while still training. In 1850 he was awarded one of the two Premier Grand Prix de Rome for *Zenobia Discovered by Shepherds on the Bank of the River Araxes* (1850; Paris, Ecole N. Sup. B.-A.). In December 1850 he left for Rome where he remained at the Villa Medici until 1854, working under Victor Schnetz and Jean Alaux (1786–1864). During this period he made an extensive study of Giotto's work at Assisi and Padua and was also impressed by the works of other Renaissance masters and by Classical art. On his return to France he exhibited the *Triumph of the Martyr* (1853; Lunéville, Mus. Lunéville) at the Salon of 1854. It depicted St Cecilia's body being carried to the catacombs, and its high finish, restrained colour and classical poses were to be constant features of his painting thereafter. All his works were executed in several stages involving an initial oil sketch followed by numerous pencil drawings taken from life. Though he generally restricted himself to classical, religious and genre subjects (see fig. 6), he was commissioned by the state to paint *Napoleon III Visiting the Flood Victims of Tarascon in 1856* (1856; Tarascon, Hôtel de Ville; see col. pl. IV), so applying his style to a contemporary historical scene. In 1859 he provided some of the decorations for the chapel of St Louis at Ste Clothilde church, Paris (*in situ*), where he worked under the supervision of Picot. The austere style of the scenes from the life of St Louis reflect Bouguereau's knowledge of early Italian Renaissance art.

Among Bouguereau's Salon entries of the 1860s was *Destitute Family* (1865; Birmingham, Mus. & A.G.), exhibited in 1865, which conformed to a declining though still prevalent fashion for moving contemporary subjects. It depicts a mother surrounded by her children, seated by the Madeleine church in Paris. Though the mournful mother and wretched children were intended to play upon the emotions of the public, the classically inspired architectural backdrop and carefully arranged poses tend to idealize and ennoble the subject so as to avoid offence by too honest a form of realism. In 1867 he executed the ceiling decorations for the chapels of St Pierre-Paul and

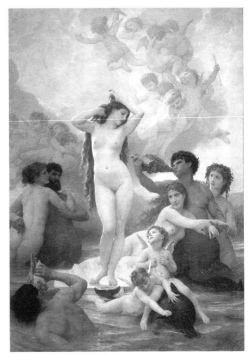

6. William Bouguereau: *Birth of Venus* (Paris, Musée d'Orsay)

St Jean-Baptiste at St Augustin church in Paris (*in situ*), where he was required to follow the rigid instructions of the commissioning body. In 1869 he painted decorations and the ceiling of the Salle des Concerts at the Grand Théâtre de Bordeaux (*in situ*). He remained in the capital during the siege of Paris (1870–71) in the Franco-Prussian War and in 1875 he began teaching at the Académie Julian in Paris. The sober, even melancholy, nature of several works of the 1860s gave way to lighter, playful paintings in the 1870s. Most notable of these is *Nymphs and Satyr* (1873; Williamstown, MA, Clark A. Inst.), which depicts nymphs playing around a satyr in a woodland setting. Employing an elegant, dynamic composition, the work was much praised by critics as well as being favoured by Bouguereau himself. A similar spirit pervades *Donkey Ride* (1878; Jacksonville, FL, Cummer Gal. A.), which was based upon the traditional festival

that accompanies the harvest. Bouguereau was always eager to include children in his works and he here altered the figure playing Bacchus from the traditional young man to a small child. This prevalent use and idealization of children is often responsible for the sentimentality that mars many of his works.

In 1881 Bouguereau was commissioned to provide decorations for the Chapelle de la Vierge of the St Vincent-de-Paul church in Paris (*in situ*). He executed eight large paintings depicting traditional scenes from the life of Christ, the last of which was finished in 1889. In 1884 he completed the huge painting of the *Youth of Bacchus* (1884, 3.31×6.1 m; priv. col., see 1984–5 exh. cat., pp. 24–5) showing the young god amidst a wild, dancing crowd at the coming of summer. As it was highly priced by Bouguereau, the work remained in his studio until his death. Many of the figures in the painting were inspired by those in contemporary and antique sculpture, an influence that was noticeable in other works also. In 1888 he was appointed a professor at the Ecole des Beaux-Arts in Paris. He continued painting and exhibiting until his death and among his later canvases is the characteristic work *Admiration* (1897; San Antonio, TX, Mus. A.), which shows how little his style had changed throughout his life. In addition to his better-known figure works, Bouguereau was also admired for his portraits, one of the most striking being *Aristide Boucicart* (1875; Paris, Bon Marché Col.), a stern three-quarter-length portrait of the founder of the famous Bon Marché store in Paris.

Although his work was widely collected by the English and more especially by the Americans in his lifetime, Bouguereau's reputation in France was more equivocal—indeed quite low—in his later years. While popular with the public and various critics, his work ignored the increasing demand for paintings of modern life which had been made by Charles Baudelaire and was to be fulfilled by the Impressionists. He remained a staunch supporter of the academic training system at a time when it was criticized for stifling originality and nurturing mediocrity. With the advent of modernism he was scorned as one of the most

prominent representatives of everything the new movement opposed: high technical finish, narrative content, sentimentality and a reliance on tradition. This hostility was further heightened by the perceived association of academic painting with the bourgeois values that had resulted in world war. However, recent more objective assessments have reinstated Bouguereau as an important 19th-century painter.

Bibliography

L. Baschet: *Catalogue illustré des oeuvres de W. Bouguereau* (Paris, 1885)

M. Vachon: *W. Bouguereau* (Paris, 1900)

Oeuvres italiennes de Bouguereau (exh. cat., ed. R. Jullian; Lyon, Mus. B.-A., 1948)

William-Adolphe Bouguereau (exh. cat., Paris, Gal. Breteau, 1966)

William-Adolphe Bouguereau (exh. cat. by R. Isaacson, New York, Cult. Cent., 1974–5)

The Other Nineteenth Century: Painting and Sculpture in the Collection of Mr and Mrs Joseph M. Tanenbaum (exh. cat., Ottawa, N.G., 1978), pp. 54–60

R. Lack: *Bouguereau's Legacy to the Student of Painting* (Minneapolis, 1982)

William Bouguereau (exh. cat. by L. d'Argencourt and others, Paris, Petit Pal.; Montreal, Mus. F.A.; Hartford, CT, Wadsworth Atheneum; 1984–5)

☐

Boulanger, Gustave(-Clarence-Rodolphe)

(*b* Paris, 25 April 1824; *d* Paris, Oct 1888). French painter. Born of creole parents, Boulanger became an orphan at 14. His uncle and guardian sent him to the studio of Pierre-Jules Jollivet and then in 1840 to Paul Delaroche, whose prosaic Realism and dry, careful technique influenced Boulanger's style of painting. A first visit to Algeria in 1845 gave him an interest in North African subjects, which was taken up later by his friend Jean-Léon Gérôme. In 1849 he won the Prix de Rome with *Ulysses Recognized by his Nurse* (Paris, Ecole N. Sup. B.-A.), in which he combined academic figure drawing with Pompeian touches inspired by Ingres's *Antiochus and Stratonice* (1840; Chantilly, Mus. Condé). Boulanger's knowledge of the ruins at Pompeii, which he visited while studying at the

Ecole de Rome, gave him ideas for many future pictures, including the *Rehearsal in the House of the Tragic Poet* (1855; St Petersburg, Hermitage), in which the influence of *Stratonice* is still obvious. This was later developed into the *Rehearsal of the 'Flute Player' and the 'Wife of Diomedes'* (1861; Versailles, Château), which recorded the preparations being made for a performance given before the imperial Court in Napoleon's mock-Pompeian Paris house. Boulanger specialized in painting studies of daily life from ancient Greece and Rome, as well as Arab subjects. He also painted a number of decorative schemes, at the theatre of the Casino in Monte Carlo (1879), at the Paris Opéra (1861–74) and other locations, opportunities gained through his friendship with Charles Garnier, his fellow *pensionnaire* at the Ecole de Rome. He entered the Institut de France in 1882 and became an influential teacher, well known for his dislike of the Impressionists and their successors.

Writings

A nos élèves (Paris, n.d. [early 1880s])

Bibliography

M. Lavoix: 'G. Boulanger', *Grands peintres français*, vii (Paris, 1886)

L'Art en France sous le Second Empire (exh. cat., Paris, Grand Pal., 1979), pp. 313–14

J. Foucart and L. A. Prat: *Les Peintures de l'Opéra de Paris, de Baudry à Chagall* (Paris, 1980)

JON WHITELEY

Boutet de Monvel, (Louis-)Maurice

(*b* Orléans, 18 Oct 1851; *d* Nemours, Seine-et-Marne, 16 March 1913). French painter and illustrator. From 1869 he took a course at the De Rudder school of art and in the following year was admitted to the Ecole des Beaux-Arts in Paris, where he worked in the atelier of Alexandre Cabanel. He took part in the Franco-Prussian War (1870–71) and afterwards studied under Jules Lefebvre, Gustave Boulanger and Carolus-Duran. From Carolus-Duran he acquired a liking for portraiture (e.g. *Rachel Boyer as Diana*, 1886; Paris,

Louvre) and for the works of Ribera, which he admired particularly for their dark and resinous tones. From 1873 he exhibited at the Salon and in 1885 he created a stir with his *Apotheosis of a Scoundrel* (or *Apotheosis of Robert Macaire*; Orléans, Mus. B.-A.), a work imbued with a violently anti-republican spirit. As well as painting, he illustrated children's literature, beginning with the successful *La France en zig-zags* (1881). Other collections followed: *Vieilles chansons pour les petits enfants* and *Chansons de France pour les petits français* (both Paris, 1883), two books of songs for which he provided illustrations, and Anatole France's *Nos enfants: Scènes de la ville et des champs* (Paris, 1887). In these works, Boutet de Monvel's delicate and refined draughtsmanship enhanced the authors' delight in the world of children. He managed to retain the individuality of his subjects, using a modern style that was influenced by Japanese aesthetics. His fame spread quickly: numerous exhibitions were organized in Europe as well as in the USA, and many foreign editions of his works were published. His finest work is *La Vie de Jeanne d'Arc* (Paris, 1896), for which he provided both text and illustrations (drawings; Washington, DC, Corcoran Gal. A.).

Bibliography

A. Nourrit: 'Artistes contemporains: Maurice Boutet de Monvel', *Rev. A. Anc. & Mod.*, xxxiv/2 (1913), pp. 133–48

Catalogue of a Collection of Drawings and Sketches by Louis Maurice Boutet de Monvel (exh. cat., Buffalo, Albright A.G., 1920)

D. Autie: 'Livres pour enfants: Maurice Boutet de Monvel et les petits enfants de la IIIe République', *Impact*, 13 (1977), pp. 36–8

F. C. Heller: 'Maurice Boutet de Monvel: Illustrateur de livres d'enfants', *Rev. Bib. N.* (Spring 1988), pp. 14–25

THALIE GOETZ

Bracquemond

French family of artists.

(1) Félix(-Auguste-Joseph) Bracquemond

(*b* Paris, ?28 May 1833; *d* Sèvres, nr Paris, 27 Oct 1914). Printmaker, designer, painter and writer.

From a humble background, he set out on an artistic career after meeting the painter Joseph Guichard, a pupil of Ingres and Delacroix, who was to be his only teacher. He was brought up by a philanthropist friend of Auguste Comte, Dr Horace de Montègre, whose portrait he drew in pastel in 1860 (Paris, Mus. d'Orsay). Comte's positivist philosophy was a considerable influence on Bracquemond's aesthetic ideas. From 1852 he exhibited at the Salon both drawn and painted portraits in the style of Ingres, for example *Mme Paul Meurice* (Compiègne, Château), but he gave up painting after 1869.

Bracquemond is better known as a printmaker and designer. He taught himself etching and began working in the medium as early as 1849, supporting himself with difficulty by means of commercial lithographic work. He was one of the last friends of Charles Meryon and with him was the principal inspiration of the etching revival in France. In 1862 he founded the Société des Aquafortistes, which included a large proportion of the etchers of the period. His masterpiece and best-known etching is *Le Haut d'un battant de porte* ('The top of a door', 1852), a startling combination of the prosaically macabre and decorative *trompe l'oeil*. Bracquemond produced almost 900 plates, divided about equally between original and reproductive prints. He etched portraits (e.g. *Meryon*, 1853; *Edmond de Goncourt*, 1882) and some 80 landscapes, many in the spirit of Corot (e.g. *Willow Trees in Mottiaux*, 1868), but specialized in depicting animals, particularly ducks (e.g. *Teal*, 1853). His reproductive prints convey with astonishing faithfulness the different styles of such painters as Ingres, Delacroix (*Boissy d'Anglas*, 1881), Corot, Millet, Ernest Meissonier (*The Brawl*, 1885) and Gustave Moreau (*King David*, 1884).

Admired by Théophile Gautier and Edmond About at the Exposition Universelle in 1855, Bracquemond rapidly became a central figure in the Parisian artistic and literary avant-garde. Among his numerous friends were Théodore de Banville, Baudelaire, Jules Champfleury, Paul Gavarni and the Goncourt brothers, whom he came to know largely through the publisher Poulet-Malassis, for whom he worked from the end of the 1850s. From the early 1860s he belonged to Manet's circle. He encouraged Manet to etch and took part with him in the Salon des Refusés in 1863 and then in the gatherings at the Café Guerbois. Bracquemond exhibited at the Impressionist exhibitions of 1874, 1879 and 1880.

Bracquemond was one of the first to discover and popularize Japanese prints, having reputedly come upon Hokusai's *Manga* in Auguste Delâtre's printshop. He adopted their asymmetrical compositions and specific naturalistic motifs in his etchings and ceramics, which he began designing in the 1860s. He worked for a while in the studio of Joseph-Théodore Deck (1823–91), where he learnt the technique of enamel painting. In 1866 he was commissioned by Eugène Rousseau (1827–91) to design a large faience service. The 'Rousseau service' incorporates motifs from his animal etchings: for example, *The Duck*, published in *L'Artiste* (1856), was reused on one of the plates (Nevers, Mus. Mun.), as were some motifs from the etching *Teal* (1853; dinner plate, Paris, priv. col.), which shows his continued interest in Japanese aesthetics combined with a more delicate and sophisticated sense of composition and colour. The more abstract style of his 'Flower and ribbon service' of 1879 anticipates the designs of the Art Nouveau movement. From 1873 to 1880 he was head of the Auteuil studio (near Paris) of the Haviland Limoges factory, where he personally designed individual pieces and several important porcelain services including the 'Parisian service' of 1876. While director of the Haviland factory he continued to exhibit his etchings at the Salon. His greatest success as a printmaker was in 1900, when his etchings won first prize at the Exposition Universelle in Paris. He designed furniture, gold and silver jewellery and tableware, bookbindings and tapestry in collaboration chiefly with Rodin and Jules Chéret. His furniture designs for Baron Joseph Vitta's Villa La Sapinière at Evian were shown at the Salon of 1902. At the end of his life he produced designs for decorative art for his friend and devoted admirer, the writer and critic Gustave Geffroy, who was then director of the Gobelins.

Bracquemond published theoretical writings, particularly from 1878 onwards. His very personal theory of the art of relief and the place of colour in design is summarized in *Du dessin et de la couleur* (1885). He was a founder-member of the Société des Artistes Français and later belonged to the Société Nationale des Beaux-Arts. In 1890 he founded the Société des Peintres-Graveurs Français to preserve the art of original engraving against the rapid development of photographic techniques.

Writings

Du dessin et de la couleur (Paris, 1885)

(2) Marie Bracquemond [née Quivoron-Pasquiou]

(*b* Argenton, nr Quimper, 1 Dec 1840; *d* Sèvres, nr Paris, 17 Jan 1916). Painter, draughtsman, printmaker and designer, wife of (1) Félix Bracquemond. After a difficult start in life, she began to study drawing at Etampes, near Paris. She took advice from Ingres but never received any formal teaching. Admitted to the Salon from 1857, she was commissioned by the State to copy pictures in the Louvre. There she met Félix Bracquemond in about 1867 and married him on 5 August 1869. She was involved in her husband's work for the Haviland Limoges factory and produced in particular several dishes and a wide panel of ceramic tiles entitled the *Muses*, shown at the Exposition Universelle in Paris in 1878; the sketch for this was shown at the Impressionist Exhibition of 1879 and was greatly admired by Degas. Originally very much influenced by Ingres and then by Alfred (Emile-Léopold) Stevens, her style of painting changed completely *c.* 1880 as a consequence of her admiration for Renoir and Monet and subsequently because of advice from Gauguin. The few pictures surviving from this period illustrate her conversion to a clearly Impressionist style, comparable to that of Berthe Morisot and Mary Cassatt. Examples include *The Lady in White* (1880; Cambrai, Mus. Mun.), *On the Terrace at Sèvres* (*c.* 1880; Geneva, Petit Pal.) and *Afternoon Tea* (*c.* 1880; Paris, Petit Pal.). After exhibiting at the Salon in 1874 and 1875, she took part in the Impressionist exhibitions of 1879, 1880

and 1886. In spite of the support of friends such as Gustave Geffroy, her husband was against any broadening of her career, and confined to Sèvres she produced only a limited amount of work. The retrospective exhibition of 1919 at the Galerie Bernheim-Jeune, Paris, included 90 paintings (to a large extent small sketches), 34 watercolours and 9 engravings. She also produced ceramics and several drawings for *La Vie moderne* (1879–80).

Félix and Marie's son Pierre Bracquemond (*b* Paris, 26 June 1870; *d* Paris, 29 Jan 1926) was a pupil of his father and as such was involved in works for the Gobelins. He pursued a career as an interior decorator (carpets, tapestries) and painter (nudes, seascapes), chiefly employing the technique of encaustic painting. He left several critical articles and important unpublished manuscripts on the life of his parents and the aesthetic ideas of his father.

Bibliography

H. Beraldi: *Les Graveurs du XIXème siècle*, iii (Paris, 1885/*R* 1980)

Félix et Marie Bracquemond (exh. cat., ed. J.-P. Bouillon; Mortagne-au-Perche, Maison Comtes du Perche, 1972)

Céramique impressionniste (exh. cat., ed. J.-P. Bouillon, J. d'Albis and L. d'Albis; Paris, Bib. Forney, 1974)

Hommage à Félix Bracquemond (exh. cat. by J.-P. Bouillon, Paris, Bib. N., 1974)

J.-P. Bouillon: *Félix Bracquemond: Les Années d'apprentissage, 1849–1859* (diss., U. Paris I, 1979)

The Crisis of Impressionism, 1878–1882 (exh. cat., ed. J. Isaacson; Ann Arbor, U. MI, Mus. A., 1979)

J.-P. Bouillon and E. Kane: 'Marie Bracquemond', *Woman's A. J.*, v/2 (1984), pp. 21–7

T. Garb: *Women Impressionists* (Oxford, 1986)

J.-P. Bouillon: *Félix Bracquemond, le réalisme absolu: Oeuvre gravé, 1849–1859, catalogue raisonné* (Geneva, 1987) [with complete bibliog.]

Le Service 'Rousseau' (exh. cat. by J.-P. Bouillon, C. Shimizu and P. Thiébaut, Paris, Mus. d'Orsay, 1988)

Félix Bracquemond (exh. cat. by C. van Rappard-Boon, Amsterdam, Rijksmus. van Gogh, 1993)

JEAN-PAUL BOUILLON

Brascassat, Jacques-Raymond

(*b* Bordeaux, 30 Aug 1804; *d* Paris, 28 Feb 1867). French painter. He began his artistic career in

Bordeaux at the age of 14 with the landscape painter Théodore Richard (1782–1859) and showed an early interest in drawing animals. By 1825 he was studying under Louis Hersent at the Ecole des Beaux-Arts in Paris and was sent to Italy the following year, despite coming only second in the Prix de Rome with *Hunt of Meleager* (Bordeaux, Mus. B.-A.). In Rome Brascassat met Théodore-Caruelle d'Aligny, with whom he spent most of his first year sketching in the surrounding countryside, producing such masterly works as *View of Marino, Morning* (Orléans, Mus. B.-A.). The history paintings he sent back to Paris, however, met with little success. Returning to Paris in 1830, he rejoined d'Aligny at Barbizon in 1831 and exhibited six landscapes of the area at the Paris Salon.

At the Salon of 1831 Brascassat received a first prize for his landscapes, while a special mention was made of his animal pieces, a genre that he subsequently made his own, abandoning history painting completely. By 1837 when he exhibited *Bulls Fighting* (Nantes, Mus. B.-A.) at the Salon his reputation as an animal painter was firmly established. The massive popularity of his works provoked the scorn of the critics, whose cutting comments on his entries at the Salon of 1845, coupled with the artist's failing health, prompted him to stop exhibiting at the Salon, despite his reception as an Academician the following year. Brascassat continued to produce landscapes from nature, drawing when he was no longer able to paint, and such works as a *Study of Oak and Elm Trees at Magny* (1865; Reims, Mus. St-Denis) show his continuing sensitivity as a landscape painter.

Bibliography

P. Miquel: *Le Paysage français au XIXe siècle, 1824–1874: L'Ecole de la nature*, ii (Maurs-la-Jolie, 1975), pp. 248–67

Barbizon au temps de J.-F. Millet, 1849–1875 (exh. cat., ed. G. Bazin; Barbizon, Salle Fêtes, 1975), pp. 126–9

Théodore Caruelle d'Aligny et ses compagnons (exh. cat., ed. M. M. Aubrun; Rennes, Mus. B.-A. & Archéol., 1975)

LORRAINE PEAKE

Bresdin, Rodolphe

(*b* Le Fresne, 13 Aug 1822; *d* Sèvres, 11 Jan 1885). French printmaker and draughtsman. He grew up in Paris, leaving his working-class family as a teenager to take up a Bohemian lifestyle. Apparently self-taught, he executed his first crudely drawn etchings in 1839. He knew several writers, including Baudelaire and Jules Champfleury, and was himself the model for the latter's first novel, *Chien-Caillou* (1845), a romantic portrait of an eccentric, poverty-stricken artist. The title was Bresdin's nickname, actually a fractured version of Chingachgook, the hero of James Fenimore Cooper's novel *The Last of the Mohicans* (1826).

After 1848 Bresdin lived in isolation for over a year near Tulle, moving on to Bordeaux; by 1852 he was in Toulouse, where he spent nine years. He executed his first lithographs in 1854, including the *Comedy of Death* (see van Gelder, no. 84) and the *Flight into Egypt* (VG 85). In 1860 Bresdin began his lithographic masterpiece, the *Good Samaritan* (e.g. London, BM, VG 100), which was originally entitled *Abd-el-Kader Aiding a Christian*; Bresdin moved back to Paris in 1861 to have it printed and shown in the Salon of that year. This very large lithograph (564×444 mm) was highly praised and was reprinted several times, providing Bresdin with an important source of income. Baudelaire subsequently secured him a commission to illustrate the new journal *Revue Fantaisiste* with 13 etchings.

Leaving Paris again in 1862, Bresdin had settled in Bordeaux by 1864, becoming a member of the Société des Amis des Arts there. Odilon Redon, who became a close friend to Bresdin, was one of his students at this time. Bresdin lived for short periods in Libourne, Paris and Biarritz before returning to Paris by 1869. He had received a commission in 1868 to illustrate a book of fables by Hippolyte Thierry, Comte de Faletans, and took up lithography again after a break of several years to produce the prints. Faletans refused many of Bresdin's early proofs, and publication was delayed until 1871, when Bresdin also finished major etchings of the *Enchanted House* (VG 135) and the *Holy Family* (VG 137–8).

Bresdin and his family left for Canada in 1873, realizing a lifelong dream to emigrate to a less

industrialized country. He taught at an art school in Montreal, but in 1877 he returned disillusioned to France, his fare paid by writer friends including Victor Hugo. He etched a series of complex forest landscapes in 1880 (VG 142–7) and in 1883 executed two visionary scenes, an etching entitled *My Dream* (VG 150) and a lithograph of the *Miraculous Draught of Fishes* (VG 151). His fitful employment and chronic poor health caused him to become increasingly destitute. After working for a time as a street labourer in Paris, he eventually left his family in 1881, moving to Sèvres.

Over 150 prints by Bresdin are known, of which *c.* 130 are etchings. The remainder (excepting two experimental gelatin drypoints, VG 94–5) are lithographs. In several instances he transferred his etched designs to lithographic stones, and some images exist in both media (e.g. VG 86, 135). His drawings comprise both preliminary studies and finished works for presentation or sale. The former, for example *Sketch for a Battle in the*

Mountains (1865; London, BM), are usually worked in India ink on a transparent tracing paper, often traced from other sources and then transferred to other sheets or printing plates. Most of Bresdin's finished drawings, such as *Peasant Interior* (1860; The Hague, Gemeentemus.), are pen and black ink and wash on white cardboard. The majority of his drawings and prints are on a small scale. His mature works are marked by an obsessive profusion of detail and a personal imagery fired by a romantic, pantheistic imagination rather than direct observation of nature. However, some of his characteristic images (landscapes, exotic horsemen, peasant genre scenes and macabre allegories) are derived from 17th-century Dutch art and from contemporary etchings or wood-engravings by artists such as Adolphe Hervier, Alexandre Decamps, Auguste Raffet and Gustave Doré. The prints are skilfully enriched by a welter of elaborate textural effects (see fig. 7), and the central figures, for instance in *Rest on the Flight into*

7. Rodolphe Bresdin: *The Stream*, 1880 (Paris, Bibliothèque Nationale)

Egypt, are often depicted within a dense mass of foliage.

Bresdin never achieved popular or critical success during his lifetime and was known only by a small circle of writers, artists and connoisseurs. He exhibited in the official Salon only six times between 1848 and 1879. His posthumous reputation was largely kept alive by Redon and a few print collectors in Europe and America until the revival of interest in 19th-century French printmaking during the second half of the 20th century. The facts of his life were surrounded by romantic legend until the publication of van Gelder's biography in 1976. The major public collections of Bresdin's works are in the Louvre and the Bibliothèque Nationale, Paris, the Gemeentemuseum, The Hague, the Rijksprentenkabinet, Amsterdam, the Metropolitan Museum of Art, New York, and the Art Institute of Chicago.

Bibliography

H. A. Peters: *Die schwarze Sonne des Traums: Radierungen, Lithographien und Zeichnungen von Rodolphe Bresdin* (Cologne and Frankfurt, 1972)

R. de Montesquiou: *L'Inextricable Graveur* (Paris, 1913; Ger. trans., intro. P. Hahlbrock, Berlin, 1977)

D. van Gelder: *Rodolphe Bresdin*, 2 vols (The Hague, 1976) [VG; the fullest biography and the cat. rais. of the prints]

Rodolphe Bresdin, 1822–1885 (exh. cat., ed. D. van Gelder and J. Sillevis; The Hague, Gemeentemus., 1978)

R. Bacou: 'Rodolphe Bresdin et Odilon Redon', *Rev. Louvre*, xxix (1979), pp. 50–59

J. Baas Slee: 'A Literary Source for Rodolphe Bresdin's *La Comédie de la mort*', *A. Mag.*, liv/6 (1980), pp. 70–75

M. Parke-Taylor: 'A Canadian Allegory by Rodolphe Bresdin: *L'Apothéose de Cartier*', *Rev. A. Can.*, ix (1982), pp. 64–8

D. P. Becker: *The Drawings of Rodolphe Bresdin: Development and Sources with a Provisional Catalogue* (MA thesis, New York U., Inst. F.A., 1983)

——: 'Rodolphe Bresdin's *Le Bon Samaritain*', *Nouv. Est.*, 70–71 (1983), pp. 6–14

DAVID P. BECKER

Breton, Jules

(*b* Courrières, Pas-de-Calais, 1 May 1827; *d* Paris, 5 July 1906). French painter and writer. After the death of his mother he was brought up in the village of Courrières by his father, grandmother and uncle. The last instilled in him respect for tradition and a commitment to the philosophical ideas of the 18th century. Breton's father, as supervisor of the lands of the Duc de Duras, encouraged him to develop a deep knowledge of and affection for his native region and its heritage, which remained central to his art.

Breton received his earliest drawing lessons at the College St Bertin (nr St Omer). In 1842 he met Félix de Vigne (1806–62), and from 1843 he studied with him and Hendrik Van der Haert (1790–1846) at the Academy of Fine Arts in Ghent. Breton's training was academic though he was aware of traditions of genre painting. During the spring of 1846 he worked at the Antwerp Art Academy under Baron Gustaf Wappers but spent most of his time at the museum studying the Flemish masters, including Hans Memling, Jan van Eyck and Rubens.

Breton went to Paris in 1847 to complete his education in the atelier of Michel-Martin Drolling, and he became friendly with the Realist painters François Bonvin and Gustave Brion. His painting (1849; priv. col., see 1980 exh. cat., p. 158) of the studio he shared with Ernest Delalleau (1826–64) illustrates his early Realist style.

During the Revolution of 1848 Breton sided with the liberals. *Misery and Despair* (1848; exh. Salon 1849; destr.) and *The Hunger* (1850; exh. Salon 1850–51; destr.) mirrored his preoccupation with social causes and his own intense struggle to make ends meet. The successful exhibition of *The Hunger* in Brussels and Ghent encouraged Breton to move to Belgium, where Félix de Vigne's daughter, Elodie, became his model and in 1858 his wife.

In 1852 Breton returned to France and made trips to the outskirts of Paris, garnering ideas for new canvases. The *Return of the Reapers* (exh. Salon 1853; priv. col.) is the first in a series of rural peasant scenes that Breton based on an awareness of contemporary themes and of similar subjects painted by Léopold Robert. Breton's interest in peasant imagery continued and in 1854 he settled in Courrières, where he began *The Gleaners* (Dublin, N.G.), a work inspired by seasonal field labour. The third-class medal it received at the

Salon drew Breton to the attention of other artists including Jean-François Millet, and his career developed rapidly during the Second Empire. The *Blessing of the Wheat, Artois* (1857; Compiègne, Château; see fig. 8) was awarded a medal at the Salon of 1857 and due to the fervent support of Count Emilien de Nieuwerkerke his work was bought by the State.

Other major paintings of the 1850s present a serene view of field work; for example, the *Recall of the Gleaners* (1859; Paris, Mus. d'Orsay; see fig. 9) and *Dedication of a Calvary* (Lille, Mus. B.-A.), both shown at the Salon of 1859. In these canvases Breton's realistic themes were modified by an idealized treatment of physiognomy and anatomy that recalls works of the Italian High Renaissance, most notably those by Raphael. In 1861 Breton received the Légion d'honneur for works such as *The Colza* (1860; Washington, DC, Corcoran Gal. A.).

Breton travelled in 1862 and 1863 to the south of France where he did studies for the *Grape Harvest* (exh. Salon 1864; Omaha, NE, Joslyn A. Mus.), which marks the apex of his more classical style. By 1867 Breton's fame was further assured when he exhibited ten paintings at the Exposition Universelle in Paris and was awarded a first-place medal. His interest in provincial life, especially views and religious rites of Brittany (e.g. a *Great Breton Pilgrimage*, 1867; Havana, Mus. N. B. A.),

continued throughout the 1870s and guaranteed his importance during the Third Republic.

In such later paintings as *St John* (1875; Norfolk, VA, Chrysler Mus.) Breton modified his Realist inclinations to create images with a pronounced Symbolist inflection. This shift is most notable in late poetic canvases such as the extremely popular *Song of the Lark* (1884; Chicago, IL, A. Inst.), where a solitary field worker is contrasted against a dimming light to create a highly subjective mood. Such paintings became increasingly sought after by American collectors, such as W. P. Wilstach, in the last years of the 19th century. Popular demand often led Breton to repeat motifs and to produce canvases that are feeble reflections of his more thoughtful works. The wide availability of his work through engravings enhanced his real talent and made him one of the best-known artists of the period.

Breton was also a productive writer. In 1875 he published a volume of poems, *Les Champs et la mer*, with considerable success, followed in 1880 by the long poem *Jeanne*. Such works as *La Vie d'un artiste: Art et nature* (1890), *Un Peintre paysan* (1896) and *Nos peintres du siècle* (1899) added to Breton's esteem in artistic, literary and official circles. He was appointed to the Institut de France in 1886. Breton's brother Emile (1831–1902) and daughter Virginie (1859–1935) were also painters.

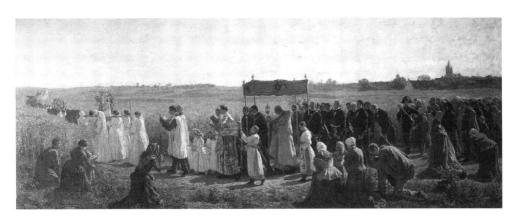

8. Jules Breton: *Blessing of the Wheat, Artois*, 1857 (Compiègne, Château)

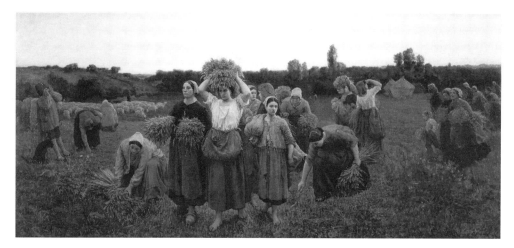

9. Jules Breton: *Recall of the Gleaners*, 1859 (Paris, Musée d'Orsay)

Writings

La Vie d'un artiste: Art et nature (Paris, 1890)
Un Peintre paysan (Paris, 1896)
Nos peintres du siècle (Paris, 1899)
La Peinture (Paris, 1904)

Bibliography

M. Vachon: *Jules Breton* (Paris, 1899)
M. Fiddell Beaufort: '*Fire in a Haystack* by Jules Breton', *Bull. Detroit Inst. A.*, lvii/2 (1979), pp. 55–63
The Realist Tradition: French Painting and Drawing, 1830–1900 (exh. cat., ed. G. P. Weisberg; Cleveland, OH, Mus. A., 1980)
G. P. Weisberg and A. Bourrut Lacouture: 'Jules Breton's *The Grape Harvest at Château-Lagrange*', *A. Mag.*, lv (Jan 1981), pp. 98–103
Jules Breton and the French Rural Tradition (exh. cat., ed. H. Sturges; Omaha, NE, Joslyn A. Mus., 1982)
A. Bourrut Lacouture: '*Les Communiantes* (1884) de Jules Breton et le thème de la procession: Genèse d'une oeuvre d'après des documents inédits', *Bull. Soc. Hist. A. Fr.* (1985), pp. 175–200
A. Bourrut Lacouture and G. P. Weisberg: 'Delphine Bernard au Louvre en 1847 ou la rencontre du sacré et du profane dans l'oeuvre de Jules Breton (1827–1906)', *Gaz. B.-A.*, cviii (1986), pp. 31–7
A. Bourrut Lacouture: 'Jules Breton. *Une Source au bord de la mer*', *Arts de l'Ouest*, ed. D. Delouche, ii (Rennes, 1987), pp. 105–27

ANNETTE BOURRUT LACOUTURE,
GABRIEL P. WEISBERG

Brian, Joseph

(*b* Avignon, 25 Jan 1801; *d* Paris, 1 May 1861). French sculptor. He was introduced to drawing and sculpture in the small private art school opened in Avignon by his father (who ran a barber's shop next door); he also attended the local Ecole de Dessin. In 1815 he won a prize from the Musée Calvet, Avignon, which enabled him to go to Paris *c.* 1827; he became a pupil of François-Joseph Bosio and in 1829 won second place in the Prix de Rome competition with the group the *Death of Hyacinthus* (plaster; Avignon, Mus. Calvet). He spent two years at the Académie de France in Rome, where he was joined by his brother Jean-Louis Brian; thereafter their work is often indistinguishable. They worked on several projects together, mostly in a Neo-classical style, among them the bronze statue of *Jean Althen* (1847; Avignon, Jardin du Rocher des Doms), which is signed *Brian frères*. In their partnership Joseph's role was principally that of entrepreneur.

Bibliography

Lami
A. Le Normand: *La Tradition classique et l'esprit romantique* (Rome, 1981), pp. 243–56

ISABELLE LEMAISTRE

Brion, Gustave

(b Rothau, Vosges, 24 Oct 1824; d Paris, 5 Nov 1877).
French painter and illustrator. His family settled
in Strasbourg in 1831 and placed him in the
studio of the portrait and history painter Gabriel-
Christophe Guérin (1790–1846) in 1840. He then
earned his living mainly by teaching drawing and
copying paintings. In 1847 he successfully sub-
mitted his first work to the Salon: *Farmhouse
Interior at Dambach* (untraced). In the summer of
1850 he moved to Paris, where he took a studio in
a house shared by Realist artists. Brion exhibited
regularly at the Salon: in 1852 *The Towpath*
(untraced) was bought by the de Goncourt broth-
ers; and in 1853 he showed the *Potato Harvest
during the Flooding of the Rhine in 1852* (Nantes,
Mus. B.-A.), in which the influence of Gustave
Courbet and Jean-François Millet can be seen in
the Alsatian peasant figures.

During the 1850s Brion produced landscape,
rustic and historical genre subjects and portraits,
but later in the decade he concentrated on sub-
jects from Alsace, which he regularly visited. Their
success, and Napoleon III's campaign to foster
Alsatian culture, led him to produce such histor-
ical pieces as *Vosges Peasants Fleeing before the
Invasion* (1867; St Louis, MO, Washington U., Gal.
A.), combining the idealized peasant types of Jules
Breton with the techniques of academic history
painting. Local detail became increasingly impor-
tant in his works, earning him the reputation of
leading painter of Alsatian folklore.

In 1862 Brion produced the designs for the first
illustrated version of Victor Hugo's *Les Misérables*
(Paris, 1865), which contain 100 wood-engravings.
Following its enormous commercial success, he
made studies for Hugo's *Notre-Dame de Paris*
(Paris, 1867).

The loss of Alsace Lorraine after the Franco-
Prussian War in 1870 was a crushing personal and
professional blow to Brion. He did not see Alsace
again and led a very secluded life until his pre-
mature death from apoplexy.

Bibliography

H. Haug: 'Un Peintre alsacien sous le second empire:
 Gustave Brion, 1824–1877', *Vie Alsace* (March 1925), p. 45

R. Heitz: *La Peinture en Alsace, 1050–1950*
 (Strasbourg, 1975)
The Realist Tradition (exh. cat., ed. G. Weisberg;
 Cleveland, OH, Mus. A., 1982),
 p. 276

MICHÈLE LAVALLÉE

Brown, John-Lewis

(b Bordeaux, 16 Aug 1829; d Paris, 14 Nov 1890).
French painter and lithographer of Scottish
descent. He spent his childhood in Bordeaux,
where he developed a love of horses. In 1841 the
family moved to Paris, where Brown taught
himself to paint by studying works in museums,
especially the Louvre. He first exhibited at the
Salon in 1848, with a number of equestrian
paintings. In 1852 he received a commission from
the State to make a copy (Tours, Mus. B.-A.) of
Rembrandt's *Christ at Emmaus* (Copenhagen,
Stat. Mus. Kst). In 1859, after a five-year stay in
Bordeaux, he returned to the Salon, again
showing equestrian works. During the Franco-
Prussian War (1870–71) Brown was in the front
line painting battle scenes that often concen-
trate on the tragic aspects of the conflict. For
some years after this he continued to work on
military subjects, as in *Episode from the Life
of Marshal Conflans* (1876; Tours, Mus. B.-A.).
He then returned to equestrian and sporting
subjects, producing such works as the *Fox Hunters*
(1886; New York, Met.). The content of his later
work was influenced by Edgar Degas and the
Impressionists and includes scenes from the
racetrack, as in *Before the Start* (1890; Paris,
Louvre). His style was most strongly influenced
by Ernest Meissonier and the academic artist
Eugène Lami.

The subject-matter of Brown's graphic work
was also dominated by equestrian and military
scenes, as in the lithograph *Dragoon on a
Horse* (1861; Paris, Bib. N.). He often produced
coloured lithographs—a late example is
Cavalryman on a Grey Horse (1884; Paris, Bib. N.)—
and was an important figure in the revival of
interest in this medium during the Second
Empire.

Bibliography

DBF

G. Hediard: *Les Maîtres de la lithographie: John-Lewis Brown* (Paris, 1897)

L. Bénédite: *John-Lewis Brown: Etude biographique et critique suivie du catalogue de l'oeuvre lithographique et gravé de cet artiste exposé au Musée du Luxembourg* (Paris, 1903)

J. Laran: *Inventaire du fonds français après 1800*, Paris, Bib. N., Cab. Est. cat., iii (Paris, 1942), pp. 459–61

He also had work published in *L'Illustration* and *Revue de l'art*. In addition to his original work he made many etchings after paintings by Constable, Turner, Canaletto, Corot and others.

Bibliography

DBF

H. Béraldi: *Les Graveurs du XIXe siècle*, 12 vols (Paris, 1885–92), iv, pp. 22–5

Inventaire du fonds français après 1800 (Paris, Bib. N., 1930–), iii, pp. 478–84

Brunet-Debaines, Alfred-Louis

(*b* Le Havre, 5 Nov 1845; *d* Hyères, *c.* 1935). French printmaker and painter. He was the son of the architect Charles-Louis-Fortuné Brunet-Debaines (1801–62), and he studied architecture at the Ecole des Beaux-Arts in Paris before he studied painting under Isidore-Alexandre-Augustin Pils. He became interested in etching and engraving and took lessons with Maxime Lalanne, Charles Normand, Jules Jacquemart and Léon Gaucherel (1816–86). After encouragement from Johan Barthold Jongkind, he made his début at the Salon in 1866 with a number of etchings and watercolours. Thereafter he regularly sent works in both media to the Salon, his subjects being flowers, landscapes or architecture. A typical example is the etching of *Nôtre Dame at Bourges* (1869; Paris, Bib. N.). In 1869 he produced plates of the château at Saint Germain-en-Laye for the *Gazette des Beaux-Arts* (e.g. *Chapelle St Louis at the Château St Germain*, 1869; Paris, Bib. N.) and in 1871 provided engravings for A. de Bullemont's *Catalogue raisonné des peintures, sculptures et objects d'art qui décoraient l'Hôtel de Ville de Paris avant sa destruction* (Paris, 1871). Many of the subjects for his etchings were taken from Paris, Bourgogne, Hyères and Normandy. Among the latter were several views of Rouen (e.g. *Rue de l'Epicerie à Rouen*, 1878; Paris, Bib. N.). From 1884 to 1897 Brunet-Debaines lived in Britain, and in 1878–9 and 1887–8 his views of London, Oxford and Edinburgh appeared in *Portfolio*. After a trip to Tunis, a number of his watercolours painted there were published in the London *Art Journal* in 1903.

Buhot, Félix(-Hilaire)

(*b* Valognes, Normandy, 9 July 1847; *d* Paris, 26 April 1898). French printmaker, painter, draughtsman and writer. He moved to Paris in 1866 and enrolled at the Ecole des Beaux-Arts, where he studied under Isidore-Alexandre-Augustin Pils. In 1867 he enrolled in a drawing course run by Horace Lecoq de Boisbaudran, and the following year he studied with the marine painter Jules Noël (1815–81). He learnt the techniques of etching from Louis Monziès (*b* 1849) and Adolphe Lalauze (1838–1905) around 1873, producing his first etching later that year. He concentrated on landscapes and urban scenes such as *Cabs, a Winter Morning at the Quai de l'Hôtel-Dieu* (1876; Washington, DC, N.G.A.). Many of these etchings combine a central image with a margin of supplementary illustrations, which the artist described as either anecdotal or 'symphonic', the latter being evocative additions rather than narrative extensions to the main image. They were published in *L'Art*, then directed by Léon Gaucherel, and also in Roger Lesclide's *Paris à l'eau-forte*. Buhot also illustrated books such as Jules Barbey d'Aurevilly's novels *Une Vieille Maîtresse* (Paris, 1879) and *L'Ensorcelée* (Paris, 1897), Alphonse Daudet's *Lettres de mon moulin* (Paris, 1882) and Octave Uzanne's *Les Zigzags d'un curieux* (Paris, 1888).

Buhot first exhibited at the Salon in 1875 and in the late 1870s and early 1880s he concentrated on painting, producing works such as *La Butte des Moulins during the Demolition for the Avenue de*

l'Opéra (1878; Paris, Carnavalet). He had a great love for England, which he first visited in 1876, returning in 1879 and on other occasions. His second visit inspired *Landing in England* (1879; Caen, Mus. B.-A.), an atmospheric etching which the artist considered characteristic of his work: it shows its links with Romanticism through its depiction of the power and grandeur of nature (in this case a storm at a landing pier on the coast). By the early 1880s Buhot's graphic output had begun to decrease, though his reputation was growing. Helped by his acquaintance with the print dealer Frederick Keppel (1845–1912) in New York, he found a large market in the USA. Throughout much of his life Buhot wrote essays; he also contributed to the *Journal des Arts* between 1884 and 1892. In 1890 he succumbed to a profound depression and by 1892 had given up etching altogether, producing only a handful of lithographs.

Bibliography

G. Bourcard: *Félix Buhot: Catalogue descriptif de son oeuvre gravé* (Paris, 1899/*R* New York, 1979)

A. Fontaine: *Félix Buhot: Peintre graveur* (Paris, 1932/*R* Paris, 1982)

Félix Buhot: Peintre graveur (exh. cat. by J. M. Fisher and C. Baxter, Baltimore, MD, Mus. A., 1983)

□

Bussière, Gaston

(*b* Cuisery, Saône-et-Loire, 24 April 1862; *d* Saulieu, Côte d'Or, 29 Oct 1928). French painter, illustrator and printmaker. He was taught by his father, Victor Bussière, a decorative painter in Mâcon. He went to the Ecole des Beaux-Arts in Lyon and then to Paris, where he studied in the atelier of Alexandre Cabanel. During further studies under Puvis de Chavannes, he came into contact with Gustave Moreau. Symbolist paintings followed, drawing on French legend, as in the *Song of Roland* (exh. Salon 1892), and Nordic myth (*Valkyries*, exh. Salon 1894); he exhibited at the Symbolist Salon de la Rose+Croix, 1893–5. In 1905 he rented a studio at Grez-sur-Loing on the edge of the Forest of Fontainebleau. Paintings such as

the *Rhine Maidens* (1906; Mâcon, Mus. Mun. Ursulines) drew on observations of the forest, populating its streams with adolescent water nymphs. Such studies of the female nude—a lifelong speciality of Bussière's—uphold a rigorous draughtsmanship that is yet not devoid of sensuality.

Bussière was also a prolific illustrator, having learnt the art of engraving on the advice of Luc Olivier Merson. He worked for 15 years with the publisher Ferroud, for whom he illustrated Flaubert (*Hérodias*, 1913; *Salammbô*, 1921), Théophile Gautier, Balzac and Anatole France (Abeille, 1927). The Musée Municipal des Ursulines, Mâcon, has a large collection of his work.

Bibliography

E. Bussière: *La Vie et l'oeuvre de Gaston Bussière, peintre, illustrateur, graveur* (Paris, 1932)

COLETTE E. BIDON

Cabanel, Alexandre

(*b* Montpellier, 28 Sept 1823; *d* Paris, 23 Jan 1889). French painter and teacher. His skill in drawing was apparently evident by the age of 11. His father could not afford his training, but in 1839 his département gave him a grant to go to Paris. This enabled him to register at the Ecole des Beaux-Arts the following October as a pupil of François-Edouard Picot. At his first Salon in 1843 he presented *Agony in the Garden* (Valenciennes, Mus. B.-A.) and won second place in the Prix de Rome competition (after Léon Bénouville, also a pupil of Picot) in 1845 with *Christ at the Praetorium* (Paris, Ecole N. Sup. B.-A.). Both Cabanel and Bénouville were able to go to Rome, as there was a vacancy from the previous year. Cabanel's *Death of Moses* (untraced), an academic composition, painted to comply with the regulations of the Ecole de Rome, was exhibited at the Salon of 1852. The pictures he painted for Alfred Bruyas, his chief patron at this time (and, like Cabanel, a native of Montpellier), showed more clearly the direction his art had taken during his stay in Italy. *Albaydé*, *Angel of the Evening*, *Chiarruccia* and *Velleda* (all in Montpellier, Mus. Fabre) were the first of many mysterious or tragic

heroines painted by Cabanel and show his taste for the elegiac types and suave finish of the Florentine Mannerists.

On Cabanel's return to Paris, the architect Jean-Baptiste Cicéron Lesueur (1794–1883) commissioned him to decorate 12 pendentives in the Salon des Caryatides in the Hôtel de Ville (destr. 1871). Several major decorative commissions followed, which included work on the Hôtel Pereire, the Hôtel Say and the Louvre. Much has been destroyed, but the ceiling in the Cabinet des Dessins in the Louvre, *The Triumph of Flora*, which combines the hard contours and careful finish of Ingres's school with a composition and colour that recalls the ceilings of the French Rococo, is probably typical of Cabanel's talent for achieving sumptuous effects.

In 1855 Cabanel exhibited *Christian Martyr* (Carcassonne, Mus. B.-A.), *Glorification of St Louis* (Lunéville, Mus. Lunéville) and *Autumn Evening* (untraced), establishing his academic and official credentials. In 1855 he received the Légion d'honneur and in 1863 he was elected to the Institut and nominated professor (along with Jean-Léon Gérôme and Isidore-Alexandre-Augustin Pils) at the reorganized Ecole des Beaux-Arts in Paris. He won the Grande Médaille d'Honneur at the Salons of 1865, 1867 and 1878. His dark-eyed heroines, thinly painted, usually in muted colours, and immaculately drawn, were popular with collectors on both sides of the Atlantic; likewise his mythological paintings, which were a by-product of his decorative works. *Nymph Abducted by a Faun* (1860, exh. Salon, 1861; Lille, Mus. B.-A.) is a solid, decorative group in the manner of Charles Coypel or François Lemoyne. He exhibited the *Birth of Venus* (1862; Paris, Mus. d'Orsay; see fig. 10) in 1863 to widespread acclaim. It is composed like an overdoor by Boucher, although it has been suggested that it was influenced by Ingres's *Odalisque and her Slave* (1839; Cambridge, MA, Fogg). Both paintings were acquired by Napoleon III. In 1867 he painted a huge *Paradise Lost* (Munich, Maximilianum) for Ludwig II, the King of Bavaria, and in 1868 *Ruth* (untraced) for the Empress Eugénie. The full-length portrait of the Emperor that Cabanel painted for the Tuileries in 1865 was liked by critics less than Hippolyte Flandrin's dreamy portrait exhibited in 1863 (*c*. 1860–61; Versailles, Château), but it was much more

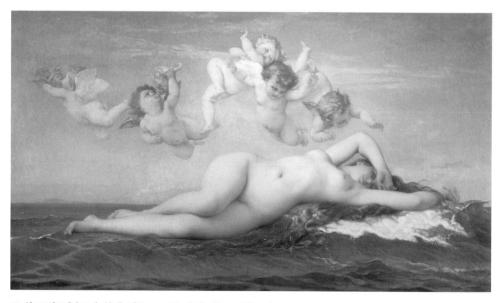

10. Alexandre Cabanel: *Birth of Venus*, 1862 (Paris, Musée d'Orsay)

popular at court. Cabanel's portraits were already in demand, and he rivalled Edouard Dubufe and Franz Xavier Winterhalter as portrait painter to the Napoleonic aristocracy.

Cabanel was also a successful teacher. His pupils (like those of his master, Picot) often won the Prix de Rome; among the best known are Jules Bastien-Lepage, Edouard Debat-Ponsan, Edouard Théophile Blanchard (1844–79), Henri Gervex and Lodewijk Royer. He was elected regularly to the Salon jury, and his pupils could be counted by the hundred at the Salons. Through them, Cabanel did more than any other artist of his generation to form the character of 'belle époque' French painting. Cabanel's pictures were always drawn and painted with a high degree of academic virtuosity, combined with an undercurrent of strong feeling, as in the *Death of Francesca da Rimini and Paolo Malatesta* (1870; Paris, Mus. d'Orsay). This made him popular in his lifetime, but it was the wrong combination for the tastes of later generations. After his death his reputation collapsed.

Bibliography

A. Meynell: 'Our Living Artists: Alexandre Cabanel', *Mag. A.*, ix (1886), pp. 271–6

G. Lafenestre: 'Alexandre Cabanel', *Gaz. B.-A.*, n.s. 3, i (1889), pp. 265–80

J. Nougaret: *Alexandre Cabanel: Sa vie, son oeuvre* (diss., U. Montpellier, 1962)

Alexandre Cabanel (exh. cat., Montpellier, Mus. Fabre, 1975)

JON WHITELEY

Cabat, (Nicolas-)Louis

(*b* Paris, 12 Dec 1812; *d* Paris, 13 March 1893). French painter. From 1825 to 1828 he was apprenticed as a decorator of porcelain at the Gouverneur Factory in Paris. He then studied under Camille Flers, who taught him to paint landscape *en plein air* and compelled him to sharpen his powers of observation of nature at the expense of the rules of classical landscape. In 1830 he visited Normandy and on his return to Paris he associated with two avant-garde painters, Philippe-Auguste Jeanron, founder of the Société Libre de Peinture et de Sculpture, and Jules Dupré. The latter was a committed member of the Barbizon school who sought to portray the truthfulness of nature in his landscapes rather than an arranged composition. In order to deepen their study of nature, Cabat and Dupré painted together in the Forest of Fontainebleau. In 1832 they also visited the region of Berry. The following year, Cabat exhibited for the first time at the Salon in Paris, where until 1891 he showed landscapes inspired by his travels to Normandy, Picardy, Berry, the Ile de France and Italy (e.g. *Farm in Normandy*; Nantes, Mus. B.-A.). His paintings feature trees and ponds and often show the influence of the Dutch school of the 17th century. Around 1840 the honest emotion and sincerity of his early works began to be superseded by a conventional manner that gained him some official honours and cost him the friendship of other members of the Barbizon school. He was a member of the Institut de France in 1867 and was Director of the Académie de France in Rome from 1877 to 1885. His paintings embody a confrontation between two tendencies prominent at that time: realism and classicism.

Bibliography

Bellier de La Chavignerie–Auvray

M.-M. Aubrun: 'La Tradition du paysage historique et le paysage naturaliste dans la première moitié du XIXe siècle français', *Inf. Hist. A.*, xiii (1968), pp. 63–73

The Realist Tradition: French Painting and Drawing, 1830–1900 (exh. cat. by G. Weisberg, Cleveland, OH, Mus. A.; New York, Brooklyn Mus.; St Louis, MO, A. Mus.; Glasgow, A.G. & Mus.; 1980–82), pp. 277–8

Louis Cabat, 1812–1893 (exh. cat., Troyes, Mus. B.-A. & Archéol., 1987)

ANNIE SCOTTEZ-DE WAMBRECHIES

Caillebotte, Gustave

(*b* Paris, 18 Aug 1848; *d* Gennevilliers, nr Paris, 21 Feb 1894). French painter and collector.

1. Life and work

Caillebotte's parents, of Norman descent, were wealthy members of the Parisian upper middle class, and his paintings often evoke his family

background. After studying classics at the Lycée Louis Le Grand, he obtained a law degree in 1870, and during the Franco–Prussian War he was drafted into the Seine Garde Mobile (1870–71). He joined Léon Bonnat's studio in 1872 and passed the entrance examination for the Ecole des Beaux-Arts on 18 March 1873. The records of the Ecole make no mention of his work there, and his attendance seems to have been short-lived. He was very soon attracted by the innovative experiments, against academic teaching, of the young rebels who were to become known as the Impressionists. In 1874 Edgar Degas, whom Caillebotte had met at the house of their mutual friend Giuseppe de Nittis, asked him to take part in the First Impressionist Exhibition at the Nadar Gallery in the Boulevard des Capucines in Paris. However, it was only at the time of their second exhibition in April 1876 that, at Auguste Renoir's invitation, Caillebotte joined the Impressionist group. From then on he was one of the most regular participants in their exhibitions (1877, 1879, 1880, 1882). He organized the show of 1877 and made great efforts to restore the cohesion of the group by persuading Claude Monet to exhibit in 1879. Having inherited a large fortune from his parents, Caillebotte had no need to sell his pictures and could afford to provide crucial financial assistance for his artist friends. He purchased their work, much disparaged at the time, and amassed the famous collection of Impressionist masterpieces that he left to the State (*see* §2 below).

Caillebotte's first important painting, *Planing the Floor* (1875; Paris, Mus. d'Orsay; see col. pl. VI), shows that he was involved in the search for a new Realism that was to a great extent the catalyst of the Impressionist revolution. The subject seems to have been suggested by work being carried out in his Paris home, 77 Rue de Miromesnil. In the choice of subject rather than the manner of its execution, this image of working-class life marked Caillebotte's rejection of academic conventions. The sombre palette and traditional technique with which he described the carefully foreshortened torsos of the kneeling floor-scrapers (recorded in preliminary crayon and charcoal drawings;

see Varnedoe, 1987, p. 56) recall his training in Bonnat's atelier. The composition, however, is more unusual, emphasizing the receding right angles of the floor-planking in a way that he was to repeat in many later works. Apparently turned down by the jury of the Salon in 1875, the painting formed part of Caillebotte's submission to the Impressionist exhibition of 1876.

Until 1881 most of Caillebotte's paintings depicted the contemporary urban life of Paris (e.g. *Housepainters*, 1877; priv. col., see Berhaut, 1978, cat. no. 48) or the everyday domestic existence of his family and friends (e.g. *Luncheon*, 1876; priv. col., see Berhaut, 1978, cat. no. 32). His *plein-air* studies executed during summer visits to his family property at Yerres (Seine-et-Oise) from 1871 to 1878 more often than not have a similarly modern touch, as in the depiction of skips in *Canoes on the Yerres* (1878; Rennes, Mus. B.-A.). These themes were widely represented in Caillebotte's contributions to the Impressionist exhibitions, where he was dealt with by the critics as harshly as his friends; however, this wide press coverage indicates the interest his painting aroused. He was considered one of the painters most responsive to the ideas of French Realist writers. There is a particularly close correspondence between the theories on the representation of contemporary life expressed by Edmond Duranty in *La Nouvelle Peinture* (1876) and such pictures by Caillebotte as *Young Man at his Window* (1876; priv. col., see Berhaut, 1978, cat. no. 26). Emile Zola hailed him as 'a painter of the highest courage' (*Le Sémaphore de Marseille*, 19 April 1877) and Joris-Karl Huysmans, his most enthusiastic commentator, linked his name with that of Degas in contrasting their art with the 'factitious and anecdotal art' of the Realist painters in the official Salons ('Salon des Indépendants (1882)' in *L'Art moderne*, 1883). Caillebotte's two great Parisian street scenes at the Impressionist exhibition of 1877, *Pont de l'Europe* (1876; Geneva, Petit Pal.) and *Paris Street: Rainy Weather* (1877; Chicago, IL, A. Inst.), illustrate his characteristically individual use of plunging recession and firmly Realist choice of contemporary urban subject-matter.

In 1878 Caillebotte moved to 31 Boulevard Haussmann behind the Opéra. In this district, recently transformed by the urban planning of the Second Empire, Caillebotte's vision was renewed. His earlier Realist painting gave way to more sensitive interpretations of the Parisian scene. His chosen subjects dealt with the play of light and shade and are reminiscent of contemporary cityscapes by Monet and Renoir. Caillebotte was less interested in the movement of crowds under the shade of great trees than in the architectural rhythm expressed in the rigorous alignment of tall apartment blocks, seen for example in *Boulevard des Italiens* (c. 1880; priv. col., see Berhaut, 1978, cat. no. 135). On long balconies that emphasize the rising perspective, figures in top hats—sometimes seen from the rear, with their back to the light or framed in windows—convey the note of Parisian modernism always important to Caillebotte (e.g. *Balcony*, 1880; priv. col., see Berhaut, 1978, cat. no. 136). This series of views of Paris was completed in 1880 and includes two works that appear to have been painted from a point overhanging Caillebotte's apartment on the Boulevard Haussmann: *Traffic Island, Boulevard Haussmann* (1880; priv. col., see Berhaut, 1978, cat. no. 141) and *Boulevard Seen from Above* (1880; priv. col., see Berhaut, 1978, cat. no. 143). These were the boldest spatial interpretations of the Impressionist era. Pierre Bonnard and Edouard Vuillard were perhaps inspired by these works during their Nabi period, and they even foreshadow the photographic experiments of the early 20th century.

Disillusioned by disagreements that resulted in the breakup of the Impressionist group, Caillebotte took little part in Parisian artistic life after 1882. He settled in Petit-Gennevilliers near Argenteuil, which had been an important site for Impressionist painting some years earlier. The Parisian landscape no longer featured in his work, except for some snow scenes executed in 1886 and 1888; he was almost alone among the Impressionists in his interest in depicting the effects of snow in an urban setting, most notably in his *Rooftops of Paris* series painted around 1878 (e.g. *Rooftops (Snow)*, 1878; Paris, Mus. d'Orsay; see fig. 11).

An important group of paintings of the Normandy coast, dating from the summers of 1880 to 1884, marked the transition from Caillebotte's Paris period to that of Gennevilliers. The seaside villas of Trouville, Villers and Villerville, situated below the level of the overhanging road, provided him with bird's-eye views reminiscent of his Parisian compositions (e.g. *Cottage, Trouville*, 1882; Chicago, IL, A. Inst.). He used unexpected angles to show to advantage the typical Normandy architecture of that period. He also produced many paintings of the Seine, the Normandy countryside and gardens, and seascapes (e.g. *Seascape: Regatta at Villers*, 1880; priv. col., see Berhaut, 1978, cat. no. 152), which capture changing effects of light and atmosphere with broken Impressionist brushwork and a high-key palette particularly indebted to Monet. However, his representation of fleeting atmospheric changes never led him to sacrifice the permanence of forms and the rhythm of structures. He was also always conscious of the unexpected, sometimes peculiar angles that his chosen subject might offer. His series of regatta pictures testifies to his increasing enthusiasm for yachting (e.g. *Regattas at Argenteuil*, 1893; priv. col., see Berhaut, 1978, cat. no. 447).

Like Monet at Giverny, Caillebotte lavished much care on his garden at Petit-Gennevilliers. In his final years in Paris he had painted still-lifes of cut flowers and fruit (e.g. *Fruit on Display*, 1881; Boston, MA, Mus. F.A.). At Petit-Gennevilliers he often preferred to paint in his garden directly from the subject (e.g. *Dahlias, the Garden at Petit-Gennevilliers*, 1893; priv. col., see Berhaut, 1978, cat. no. 443). Roses and gladioli, dahlias and chrysanthemums, painted in a freer technique, retain on canvas the brilliance of daylight. The exotic plants in his greenhouse provided the theme for a series of decorative panels begun in 1893 and intended for the dining-room at Petit-Gennevilliers (priv. col., see Berhaut, 1978, cat. nos 464–74). In a very original decorative effect, the orchids appear to be entwined in the metal structure of the greenhouse where they hang. Caillebotte died from apoplexy at the age of 45 before he was able to finish the last two panels.

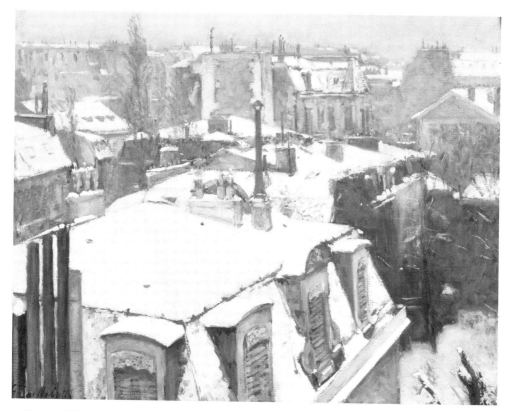

11. Gustave Caillebotte: *Rooftops (Snow)*, 1878 (Paris, Musée d'Orsay)

Most of his paintings remained in the collections of his family and friends, and for many years his bequest provoked more comment than his artistic achievement, which has only been reassessed since the 1970s.

2. The Caillebotte collection and bequest

Caillebotte began to buy his friends' paintings very soon after they were created. During the period of the Impressionist exhibitions he acquired such masterpieces as Renoir's *Moulin de la Galette* (1876), Monet's *Gare St-Lazare* (1877), Edouard Manet's *Balcony* (1869) and Degas's *Dancer on the Stage* (c. 1878; all Paris, Mus. d'Orsay). From an early stage Caillebotte was determined that at his death his collection should be accepted in its entirety by the Musée du Luxembourg in Paris, and later the Louvre, even if a period of 20 years or more should elapse before this was possible. He made his first will on 3 November 1876 and confirmed his intentions on 20 November 1883. As Caillebotte had anticipated, his bequest raised great problems. Laborious negotiations between his executors, his brother Martial and Renoir, and the State representatives, Henry Roujon and Léonce Bénédite, finally ended in compromise in 1896. Of the 67 Impressionist works in the collection, the State accepted 38: two by Paul Cézanne, seven by Degas, eight by Monet, seven by Camille Pissarro, two by Manet, six by Alfred Sisley and six by Renoir. Although the bequest was only partially accepted, it provoked numerous and violent protests from political and artistic circles when it was first shown at the Musée du

Luxembourg in January 1897. It subsequently moved to the Musée d'Orsay, Paris, where it forms the core of the Impressionist collection.

Bibliography

A. Tabarant: 'Le Peintre Caillebotte et sa collection', *Bull. Vie A.*, xv (1921), pp. 405–13

Gustave Caillebotte, 1848–1894 (exh. cat. by D. Sutton, London, Wildenstein's, 1966)

M. Berhaut: *Caillebotte, l'Impressionniste* (Paris and Lausanne, 1968)

K. Varnedoe: 'Caillebotte's *Pont de l'Europe*: A New Slant', *A. Int.*, xviii/4 (1974), pp. 28–9

—: 'Gustave Caillebotte in Context', *A. Mag.*, i/9 (1976), pp. 94–9

Gustave Caillebotte: A Retrospective Exhibition (exh. cat. by K. Varnedoe and T. P. Lee, Houston, Mus. F.A., 1976)

M. Berhaut: 'Gustave Caillebotte et le réalisme impressionniste', *L'Oeil*, 68 (1977), pp. 42–9

—: *Gustave Caillebotte: Sa Vie et son oeuvre* (Paris, 1978, rev. 1994 as *Catalogue raisonné de Gustave Caillebotte*)

—: 'Le Legs Caillebotte, vérités et contre-vérités', *Bull. Soc. Hist. A. Fr.* (1983), pp. 209–39

P. Vaisse: 'Le legs Caillebotte d'après les documents', *Bull. Soc. Hist. A. Fr.* (1983), pp. 201–8

K. Varnedoe: *Gustave Caillebotte* (New Haven, 1987)

MARIE BERHAUT

Cain, Auguste-Nicolas

(*b* Paris, 10 Nov 1821; *d* Paris, 6 Aug 1894). French sculptor and designer. After working in his father's butchery, he entered the studio of Alexandre Guionnet (*fl* 1831–53), an animal sculptor who worked in wood, and then became a pupil of François Rude; he augmented his training by drawing animals in the Jardin des Plantes, Paris. During the 1840s he worked for the goldsmiths François-Auguste Fannière (1818–1900) and his brother François-Joseph-Louis (1822–97) and also made models for the jewellers Frédéric-Jules Rudolphi and the house of Christofle. He exhibited small-scale animal sculptures at the Salon from 1846 onwards, making his début with the wax group *Warblers Defending their Nest against a Dormouse* (untraced). He went into partnership with the sculptor Pierre-Jules Mène (whose daughter he married in 1852), casting many of his own works in bronze at their foundry; he also made casts of his father-in-law's works, continuing to do so after Mène's death. Among the utilitarian objects he made, usually featuring animal motifs, were matchboxes and cigarette cases, ashtrays decorated with frogs or rats, as well as goblets and candlesticks.

Cain began to receive official commissions in the 1850s, making animal sculptures to decorate the Egyptian department in the Louvre, the grounds of the château of Fontainebleau, the palaces of the Tuileries (where he also provided four sculptural groups for the gardens, e.g. *Family of Tigers*, bronze, 1876), the Louvre and the Elysée, as well as the Jeu de Paume at Versailles. He was also involved in the decoration of the Opéra, the Hôtel de Ville and the Palais du Trocadéro (destr.), all in Paris, as well as the grounds of the château of Chantilly and the Hôtel de Ville in Poitiers. Outside France, Cain is represented in public sites in New York, Buenos Aires and in Geneva, where he erected the colossal red marble monument to *Charles II, Duke of Brunswick* (*d* 1873), in the form of a copy of the 14th-century tombs to the della Scala family in Verona.

Bibliography

Lami

LAURE DE MARGERIE

Cals, Adolphe-Félix

(*b* Paris, 17 Oct 1810; *d* Honfleur, 3 Oct 1880). French painter and printmaker. A workman's son, he was apprenticed to the engraver Jean-Louis Anselin (1754–1823) at the age of 12. On his master's death he went to the workshop of Ponce and Bosc, where he learnt to use the burin. He also lithographed works by François Boucher and Devéria. In 1828 he joined the studio of Léon Cogniet. Cals was never attracted by the brand of history painting practised by Cogniet, who failed to recognize his talent and compared him with Jean-Baptiste-Camille Corot. This conventional apprenticeship, therefore, had no influence on his art. At the beginning of the 1830s he drew and painted landscapes, and he made his début in the

Salon in 1835 with a genre painting, *Poor Woman* (untraced), and several portraits. He exhibited regularly in the Salon until 1870.

Cals painted his landscapes in front of the motif, in the outskirts of Paris, at Argenteuil, Versailles and Saint-Cyr, initially with a rather firm and heavy touch. He depicted models he came across in everyday life, favouring tired faces and expressions of melancholy and restrained sorrow. His relative poverty in the 1840s brought him close to the poor, and his earliest, little-known works reveal an interest in peasant life, sometimes anticipating Jean-François Millet. In 1846 he exhibited 11 canvases in the Salon, probably including *Peasant Woman and her Child* (Barnard Castle, Bowes Mus.). Cals treated the deprivation of the figures (echoed by the bareness of the setting) with a sentimentality that he never entirely shook off and which distinguishes him from Gustave Courbet.

In the 1850s Cals specialized in peaceful scenes of family life, painted in a manner similar to contemporary works by Octave Tassaert and Edouard Frère. *Young Girl Knitting* (1850; Reims, Mus. St-Denis) shows the influence of Dutch art in the simplicity of the pose and use of chiaroscuro. Cals was also interested in still-lifes of rustic objects and domestic themes, as in *Woman Plucking a Duck* (1854; Barnard Castle, Bowes Mus.). These intimist scenes, in which he depicted the activities of his daughter Marie or children playing, also indicate the influence of Jean-Siméon Chardin. The technique used in panels such as *Portrait of a Young Woman* (Honfleur, Mus. Boudin) was looser and more sketchlike than in his earlier work. Chiaroscuro tended to mask the sad expressions of his subjects, while his lighter touch blended the colours in a misty harmony. Although he was accepted by the Salon, his pictures were little valued, badly hung and ignored by the critics.

In 1848 Cals met the dealer Père Martin, who sold the works of Corot, Millet and Cals in his Paris shop in the Rue Mogador, later in the Rue Laffitte. In 1858 Père Martin introduced Cals to Count Armand Doria, who became his most important patron and invited him often to his château at Orrouy, until 1868. The second half of Cals's career coincided with a more settled life, which he divided between Paris and Orrouy. These new circumstances explain the commissions he received for portraits and the importance of the works he painted for Doria (sold, 4 May 1899). He continued to work on intimist genre scenes: *The Caress* and *Reading* (1867; priv. col.), *The Nurse and the Child* (1869; priv. col.) and *Woman Mending Nets* (after 1873; Dijon, Mus. B.-A.,). His paintings of the 1860s had a greater freedom and the colour was organized in less brilliant harmonies than the more patiently executed earlier panels. Representation of light became his major concern, particularly in the landscapes produced in the Nièvre (1861), at Saint-Valéry-en-Caux (1864) and at Elbeuf-en-Bray (1869), in which his brushwork became more vaporous and transparent; for example, *Bend in the Marne* (Lyon, Mus. B.-A.).

In 1871 Cals met Adolphe Hervier, Eugène Boudin and Johan Barthold Jongkind at Honfleur, where he settled. He became increasingly interested in landscape and developed a greater spontaneity of expression with which to describe different times of day, using a lighter range of colours. He took part in the Salon des Refusés in 1863 and exhibited with the Impressionists in 1874, 1876, 1877 and 1879. *Woman in an Orchard* (1875; Paris, Mus. d'Orsay) revealed his interest in the new artistic developments in France in the 1870s. Although he was a friend of Claude Monet he remained closer in spirit to the precursors of the Impressionist movement such as Auguste Ravier and the painters of the Barbizon school, Charles-François Daubigny and the group who met at the Saint Siméon farm, where he often stayed.

Bibliography

A. Alexandre: *A.-F. Cals ou le bonheur de peindre* (Paris, 1900)

L'oeuvre de A.-F. Cals (exh. cat., Paris, Gal. Petit, 1901)

V. Jannesson: *Le Peintre A.-F. Cals* (Paris, 1913)

Exposition de peintures de A.-F. Cals (rétrospective) et de sculptures de Paul Paulin (exh. cat., Paris, Gal. Louis-le-Grand, 1914)

Exposition rétrospective de A.-F. Cals (exh. cat., Paris, Gal. Druet, 1930)

Exposition rétrospective de A.-F. Cals (exh. cat., Paris, Gal. Dubourg, 1943)

A. Doria: 'Un Peintre injustement oublié: Adolphe-Félix
 Cals', *A. Basse-Normandie*, 22 (1961)
A.-F. Cals (exh. cat., London, Hazlitt, Gooden & Fox, 1969)
Cals, 1810–1880 (exh. cat. by F. Delestre, Paris, Gal.
 Delestre, 1975)

VALÉRIE M. C. BAJOU

Bibliography

DBF

H. M. Bateman: *Caran d'Ache the Supreme* (London,
 1933)

Inventaire du fonds français après 1800, Paris, Bib. N.,
 Cab. Est. cat., iv (Paris, 1949), pp. 64–83

MICHEL MELOT

Caran d'Ache [Poiré, Emmanuel]

(*b* Moscow, 1859; *d* Paris, 26 Feb 1909). French draughtsman and illustrator. Born into a French family in Moscow, he was the grandson of a squadron leader in Napoleon's Guides who had remained in Russia after being wounded in the Battle of Moscow. He left Russia in 1878 and enlisted in the French army in Paris. After designing uniforms for the army, he worked on the *Chronique parisienne* in 1880 and then on a number of other French as well as American, Italian and Russian magazines. He adopted as his pseudonym the Russian word for pencil ('karandash') and specialized in amusing military scenes, some of which were published in *Nos soldats du siècle* (1890). His 'Lundis' in *Le Figaro*, a series of satirical drawings that appeared each Monday from 1899, were particularly celebrated and many of his satirical plates on the Dreyfus affair appeared there. He also co-founded with Jean-Louis Forain the anti-Dreyfus weekly satirical journal *Psst!*, which ran from 1898 to 1899. In addition Caran d'Ache was a co-founder of the paper the *Tout Paris* and provided illustrations for a number of books, such as Albert Millaud's *La Comédie du jour sous la république athénienne* (Paris, 1886) and Nikolai Dmitrievich Benardaki's *Prince Kozakokoff* (Paris, 1893). He had made a fortune by 1900, becoming one of the celebrities of the 'Belle Epoque'. In his work he created a completely linear style, schematized like shorthand, and developed his stories through a succession of pictures, usually grouped together under one title but without captions. In this sense he can be seen as a precursor of the modern cartoon, breaking up the story into a sequence of extremely simplified images.

Writings

Nos soldats du siècle (Paris, 1890)

Carolus-Duran [Durand, Charles-Emile-Auguste]

(*b* Lille, 4 July 1837; *d* Paris, 1917). French painter. He came from a humble background and by the age of 11 was taking lessons at the Académie in Lille from the sculptor Augustin-Phidias Cadet de Beaupré (*b* 1800) who taught him to sketch. At 15 he began a two-year apprenticeship in the studio of one of David's former pupils, François Souchon (1787–1857), whose name he still referred to several years later when he exhibited at the Salon. In 1853 he moved to Paris. He copied in the Louvre where he must have met Henri Fantin-Latour, then taking life classes at the Académie Suisse (1859–60). He exhibited at the Salon for the first time in 1859. His first period in Paris, from 1853 to 1862 (interspersed with visits to Lille, where he received portrait commissions and an annuity in 1861), shows the influence of Gustave Courbet, whose *After Dinner at Ornans* (1849) he had been able to see in the Musée des Beaux-Arts at Lille. Thanks to Fantin-Latour or Zacharie Astruc, whom he had known in Lille, he soon befriended Courbet, Manet and the Realist artists, painting their portraits with a serious Realism full of concentrated energy: *Fantin-Latour and Oulevay* (1861), *Zacharie Astruc* (*c*. 1860–61; both Paris, Mus. d'Orsay) and *Claude Monet* (1867; Paris, Mus. Marmottan).

The award of the Wicar prize in 1860 made it possible for Carolus-Duran to visit Rome from 1862 to 1866. He stayed at Subiaco, in the Franciscan convent, where he did the *plein-air* painting *Evening Prayer* (1863). On his return to Paris he received a medal at the Salon of 1866 for the *Assassination* (Lille, Mus. B.-A.), a dramatic genre scene inspired by Italian life and the examples of Léopold Robert and Victor Schnetz.

Carolus-Duran's journey to Spain from 1866 to 1868 confirmed his admiration of Spanish painting (his change of name during the first Paris trip had been its outward sign). *The Kiss* (1868; Lille, Mus. B.-A.), painted on his return, bears traces of his study of Spanish painting, with a sombre palette and rich impasto. It is probably a self-portrait with his wife, Pauline-Marie-Charlotte Croizette, who exhibited pastel portraits between 1864 and 1875. He portrayed her again in the *Woman with the Glove* (1869; Paris, Mus. d'Orsay; see fig. 12), in muted colours and with energetic handling. The fallen glove accentuates the spontaneous appearance of the genre scene.

After staying in Brussels during the Commune (1870), Carolus-Duran opened a studio in Paris in 1872, which was visited regularly by Americans, including John Singer Sargent. A fashionable portrait painter, he stayed close to artistic and literary circles and did several portraits of Manet

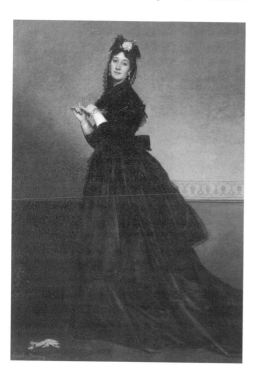

12. Carolus-Duran: *Woman with the Glove*, 1869 (Paris, Musée d'Orsay)

(e.g. 1872, U. Birmingham, Barber Inst.; *c.* 1880, Paris, Mus. d'Orsay) and a portrait of *Emile de Girardin* (1875; Lille, Mus. B.-A.) who had founded *La Presse* in 1836. His portraits of men sometimes recall Degas, as in those of the picture dealer *Etienne Haro* (1873; Paris, Petit Pal.) or of *Gustave Doré* (1875; Strasbourg, Mus. B.-A.). However, it was his portraits of women that made him famous. Besides the spontaneous images of his family, such as the *Laughing Women* (1870; Detroit, MI, Inst. A.), Carolus-Duran specialized in portraits of the aristocratic women who reigned over the Paris salons, such as *Woman with a Dog* (1870; Lille, Mus. B.-A.); his sister-in-law, the actress Sophie Croizette, in *Mlle Croizette on Horseback*, painted in Trouville in 1873 (Tourcoing, Mus. Mun. B.-A.); or *Mme Sainctelette* (1871; Brussels, Mus. A. Mod.). He also painted portraits of children, as, for example, in *Blue Child* (1873; Paris, Brame & Lorenceau Col.).

A one-man show in 1874–5 at the Cercle des Mirlitons confirmed Carolus-Duran's success. Although he was still using clear contrasts of light and shade in the portrait of *Nadezhda Polovtsova* (St Petersburg, Hermitage), painted during a trip to Russia in 1876, settings became sumptuous and the colour vivid. A *plein-air* setting accentuated the naturalism of the portrait of his sister-in-law, revealing an interest in the experiments in landscape painting then being undertaken by the Impressionists. Although the poses became mannered his technique was always dazzling, as in *Anna Alexandrovna Obolenskaya* (1887; St Petersburg, Hermitage). The portrait of *Mme Georges Feydeau* (1897; Tokyo, N. Mus. W. A.) shows the influence of Anthony van Dyck on his sophisticated compositions.

Carolus-Duran won a commission to paint a ceiling in the Palais du Luxembourg, Paris, the *Glorification of Marie de' Medici* (1878; now Paris, Louvre). He painted several religious pictures such as the *Last Hour of Christ* and the *Embalming of Christ* (both St Aygulf, Notre-Dame de l'Assomption). In 1890 he was a founder-member of the Société Nationale des Beaux-Arts, whose president he became in 1900. In 1904 he was elected a member of the Institut and in the same

year he was made Director of the Académie de France in Rome.

Bibliography

A. Alexandre: 'Carolus-Duran', *Rev. A. Anc. & Mod.*, xiii (1903), pp. 185–200; xiv (1903), pp. 289–304

Carolus-Duran (exh. cat., Paris, Gal. Flavian, 1973)

Ingres and Delacroix through Degas and Puvis de Chavannes: The Figure in French Art, 1800–1870 (exh. cat., New York, Shepherd Gal., 1975)

VALÉRIE M. C. BAJOU

Carpeaux, Jean-Baptiste

(*b* Valenciennes, 11 May 1827; *d* Courbevoie, 11 Oct 1875). French sculptor, painter, draughtsman and etcher. He was one of the leading sculptors of the Second Empire (1852–70) in France.

1. Training and early sculpture

He was born into poor circumstances as the son of a lacemaker and bricklayer who wanted him to be a mason. He made friends easily throughout his life, including the painters Bruno Cherier, Eugène Giraud and Jospeh Soumy and the architect Charles Garnier, together with writers, actors and highly placed patrons. In 1838 his family moved to Paris although Carpeaux always retained strong links with his native town. When his family went to the USA, Carpeaux was left in Paris and from 1844 worked ceaselessly for ten years at the Ecole des Beaux-Arts to obtain the Prix de Rome. For the first six years he was a pupil of the sculptor François Rude and then of Francisque-Joseph Duret. To make a living he modelled popular subjects for reproduction in bronze and gave classes at the Petite Ecole, the predecessor of the Ecole des Arts Décoratifs.

A sculptor could not survive without official commissions, and, before those that the Prix de Rome would later bring him, Carpeaux attempted to attract the attention of Emperor Napoleon III and his wife Empress Eugénie with the historic relief the *Reception of Abd-el-Kader at Saint-Cloud* (plaster, 1853; Versailles, Château; marble, 1896, executed by Charles Romain Capellaro, Valenciennes, Mus. B.-A.) and the *Empress Eugénie*

Protecting Orphans and the Arts (plaster, 1854; Valenciennes, Mus. B.-A.), a work of pious propaganda. In 1854 he won the Grand Prix de Rome with his *Hector Imploring the Gods to Save his Son Astanyax* (plaster; Paris, Ecole B.-A.; Valenciennes, Mus. B.-A.). While at the Académie de France in Rome, where he stayed until 1862, he produced such works as the *Fisherboy Listening to a Seashell* (plaster, 1857; Paris, Louvre; Valenciennes, Mus. B.-A.), in homage to Rude's *Neapolitan Fisherboy* (marble, 1833; Paris, Louvre), and the group *Count Ugolino and his Sons* (plaster, 1857–61; bronze, 1860, Paris, Mus. d'Orsay; see fig. 13). This powerful work proceeds from the ideal aspiration of 19th-century sculpture to combine both skill and competition with the works of the past from which might spring vigorous new growth. Carpeaux himself explained this progression in a letter to Chérier, 'a statue imagined by the poet of the *Divine Comedy* and created by the father of *Moses* [i.e. Michelangelo]—that would indeed be a masterpiece of the human spirit'.

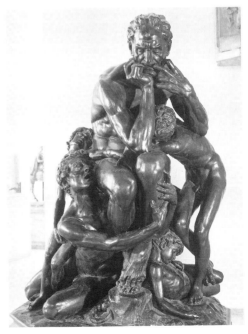

13. Jean-Baptiste Carpeaux: *Count Ugolino and his Sons*, 1860 (Paris, Musée d'Orsay)

2. Architectural sculpture and public monuments

Before his departure for Rome, Carpeaux produced the *Genius of the Navy* (1854) for the attic storey of the Pavillon de Rohan, at the Louvre, Paris. On his return from Rome in 1862, he was entrusted by the architect Hector-Martin Lefuel with producing two stone groups (*in situ*) for the south side of the Pavillon de Flore, which Lufuel had just rebuilt, at the Louvre: *Imperial France Bringing Enlightenment to the World and Protecting Science and Agriculture*, which was close to Michelangelo, and *Flora*, evoking the ballet danced by Louis XIV at the Louvre in 1669 and after which the pavilion was named. The putti in this relief were called 'Rubenesque' by art historians, who recalled, in this connection, Carpeaux's journey to Bruges, Antwerp and Ghent in 1863. This was the first time that Carpeaux introduced the complex, diagonally placed figures and the circular, dance-like compositions that he explored in his later groups. Both groups dominate the façade, projecting beyond the lines of the building in a way that Lefuel never intended, and the work was only accepted after the intervention of the Emperor.

His group *Temperance* (1863–6; destr.; replaced by a modern copy) for Théodore Ballu's church of La Trinité (1861–7), Paris, depicting qualities Carpeaux most lacked, would be equally suited to secular surroundings. If the completion of the Louvre proclaimed the continuity and hence the legitimacy of Napoleon III's regime, the great work of the second decade of the Second Empire, the Paris Opéra, affirmed the triumphant prosperity that flowed from it. The architect of the Opéra, Charles Garnier, Carpeaux's friend from the Petite Ecole, suggested that Carpeaux should sculpt a group depicting the Dance of Bacchus for the main façade of the Opéra 'in the spirit of the Arc de Triomphe' (Carpeaux to his friend Dutouquet, 25 December 1863), and three untitled figures were commissioned from him on 17 August 1865. After attempting another subject, *Drama and Comedy* (two plaster sketches; Paris, Mus. d'Orsay), Carpeaux decided upon the subject of *The Dance* (1866; Paris, Mus. d'Orsay; copy *in situ* in 1964; see col. pl. VII) adding, as Garnier wrote jokingly in

Le Nouvel Opéra de Paris (Paris, 1878), up to one figure a day; the final work comprises seven figures, surrounding a winged genius.

The sculpture was carved in echaillon stone and unveiled 27 July 1869, and immediately provoked a public scandal: 'It is the very personification of art under the Second Empire . . . it is the unleashing of appetites . . . Carpeaux's girls say "To pleasure!" Rude's woman cries "To arms"' (Claretie, pp. 26–8). A bottle of ink was thrown at the work a month after the unveiling. Public opinion demanded its removal, and Garnier was forced to commission a new group from Charles Gumery (1827–71). Although a plaster version (1870; untraced) and the stone version (1873; Angers, Mus. B.-A.), which was finished by Gumery's pupils, were made, the group was never erected because of the Franco-Prussian War of 1870 and because, after Carpeaux's death in 1875, the criticism of Carpeaux's work turned to praise.

In 1861 a competition was launched for a monument to be erected in Paris commemorating the defence of Paris against the Russians in 1814 at the Porte de Clichy. Although Carpeaux's submission did not win, in 1910 his widow presented the Petit Palais with a striking maquette of *Maréchal Moncey* on horseback scaling a bristling array of soldiers and guns. Carpeaux's entry for the international competition of 1864, for the erection of a monument to Peter IV, King of Portugal (*reg* 1826) (also Emperor Peter I of Brazil; *reg* 1822–31), in Lisbon was again unsuccessful (maquette; Valenciennes, Mus. B.-A.).

In 1867 the architect Gabriel-Jean-Antoine Davioud commissioned a monumental fountain for the gardens of the Observatoire, Paris, from Carpeaux, Emmanuel Fremiet, Eugène Legrain (1837–1915) and Louis Villeminot (1826–after 1914). In a letter to E. Chesneau in November 1872 Carpeaux described his intentions: 'I have represented the four cardinal points turning to follow the rotation of the globe. Their attitudes follow their polar arrangement, so that there is one full face, one three-quarters, one profile and one rear.' The model was accepted and shown at the Salon of 1872, the first since the Franco-Prussian War. The casting was carried out by Matifat and the

figures were erected in 1873–4. The figures were not, however, polychromed as had been Carpeaux's wish.

In addition to these monumental works in Paris, Carpeaux contributed to the reconstruction of the Hôtel de Ville in his home town of Valenciennes. The architect Batigny (b 1838) commissioned the city artists of Valenciennes (the 22 winners of the Prix de Rome) to provide the decoration of the façade. In disagreement with his uncle, the academician and sculptor Henri Lemaire, Carpeaux saw his project—an allegorical statue of Valenciennes repulsing an attacking army—reduced to just one figure, Valenciennes (stone, 1868–70; destr. 1940; replaced with a copy), which was severely criticized because of its nudity and 'disturbed' appearance. His other work for Valenciennes was the monument to the 18th-century painter Antoine Watteau. Carpeaux first suggested to the mayor on 16 July 1860 that he should execute a statue of Watteau for the Grand Place in Valenciennes. His project was accepted but not the proposed site, and Carpeaux dropped the idea until 1867 by which time he had decided to execute the figure in marble instead of the bronze originally planned. The plaster model (h. 2.5 m; Valenciennes, Mus. B.-A.) was shown in Paris during the 1870 Salon in front of the Palais de l'Industrie and was moved to Valenciennes in 1875. After Carpeaux's death a fund was opened in 1880 for the completion of the monument, which consisted of the figure of Watteau, finally in bronze, supported on a fountain decorated with children dressed in costumes of the commedia dell'arte, swans—the symbol of Valenciennes—and bas-reliefs inspired by Watteau's paintings. Ernest-Eugène Hiolle completed the monument, which was installed in front of the church of St Géry on 12 October 1884. Carpeaux had therefore lost on two counts: the site and the material.

3. Portraits

In 1862 Carpeaux was presented to Princess Mathilde Bonaparte, Napoleon III's cousin, by his patrons from Rome (the Marquis de Piennes, the Marquise de La Valette, Comte de Nieuwerkerke). He executed two busts of her at Saint-Gratien, her summer residence outside Paris. In the official bust (Paris, Mus. d'Orsay), which she bequeathed to the Louvre in 1904, tiara, ermine and jewels show the imperial pose to advantage. The other (1863), which was more intimate, was intended for friends; a plaster copy (Paris, Mus. d'Orsay) was dedicated to the writer Charles-Augustin Sainte-Beuve. In appreciation the Princess presented Carpeaux at the court of Napoleon III and in 1864 he was appointed drawing-master to Eugène-Louis-Jean-Joseph Bonaparte, Prince Imperial (1856–79). Carpeaux produced a full-length portrait sculpture (marble, 1867; Paris, Mus. d'Orsay) of his 11-year-old pupil in a simple everyday pose. After the fall of the Second Empire (1870), this made it possible for the Sèvres Porcelain Factory to continue to reproduce the figure in biscuit porcelain under the title Boy with a Dog. The Empress Eugénie commissioned a posthumous portrait of Napoleon III (1873; New York, Met.; unfinished marble copy, Compiègne, Château), and Carpeaux completed his court sketches (Compiègne, Château) with those of the Imperial Mortuary Chapel in the church of St Mary, Chislehurst, Kent.

Carpeaux also executed portraits of celebrities who were often seen around the Tuileries, including Ernest André (marble, 1862), deputy for the Gard, his son Edouard André (marble, 1863; both Mus. d'Orsay), banker, deputy and art collector. While in exile in London (1871–3) Carpeaux executed busts of Madame Lefèvre (marble, 1871; Paris, Mus. d'Orsay), Madame de Fontreal (1873) and Madame Turner (1871–2; London, V&A). On his return to France he made those of Alexandre Dumas the Younger (marble, 1873; Paris, Comédie Française) and Madame Dumas (orig. plasters for both; Paris, Mus. d'Orsay).

Among Carpeaux's well-known works, the portraits of the women he loved are calm and sad: 'La Palombella', who died during his stay in Rome and whose 'antique' features are seen in the face of Imperial France (1863, model, Paris, Mus. d'Orsay; limestone, S. façade, Pavillon de Flore, Louvre), and Amélie de Montfort (1869; Paris, Mus. d'Orsay; Valenciennes, Mus. B.-A.), his wife from 1869. Nine years earlier Carpeaux's vitality had absorbed the laughter of the fifteen-year-old Anna Foucart,

whose portrait he carried out in 1860; it is her smile that can be seen in the *Laughing Girl* (1860), *Flora* (1863), the *Mischievous Child* (1865; all Valenciennes, Mus. B.-A.) and the *Kneeling Flora* (marble, 1873; Lisbon, Mus. Gulbenkian). The series of sketches produced from Carpeaux's studio recall 18th-century taste, which was brought back into fashion by the French family of writers and critics the Goncourts. This taste gained a wide appreciation because Carpeaux reproduced in his lifetime terracotta sketches of the *Dance* (Valenciennes, Mus. B.-A.) and put forward as examples the bust of *Asia* or the *Mater Dolorosa* in two versions—one finished, the other 'sketched'.

4. Painting

His painted work, mostly in the form of oil sketches, includes a series of introspective self-portraits (e.g. *Self-portrait in a Red Shirt*, 1862; Valenciennes, Mus. B.-A.), in which his pain and illness caused by cancer are increasingly evident. There are also evocative scenes of balls (e.g. *Masked Ball at the Tuileries*, 1867; Paris, Mus. d'Orsay) and such visionary works as the *Berezowski's Attempt on the Life of Tsar Alexander II* (1867; Paris, Mus. d'Orsay).

A man of intense emotions, Carpeaux found expression through drawing in notebooks, which he took everywhere. His inner turbulence led him to follow the path that links romanticism to expression: 'You tell me that I'm too enthusiastic, *e caro mio*, if I did not have these flights of admiration, which the public take for exaggeration, I would not be capable of expressing myself' (letter to his friend Foucart, 29 June 1861).

Unpublished sources

Paris, Louvre, and Mus. d'Orsay [main archives, incl. notebooks]

Valenciennes, Mus. B.-A. [archives of Valenciennes and drawings]

Bibliography

J. Claretie: *J.-B. Carpeaux, 1827–1875* (Paris, 1875)

L. Delteil: *Le Peintre-graveur illustré*, vi (Paris, 1906–26; Eng. trans., New York, 1969)

L. Clément-Carpeaux: *La Vérité sur l'œuvre et la vie de J. B. Carpeaux 1827–1875*, i (Paris, 1934), ii (Nemours, 1935)

Sur les traces de J. B. Carpeaux (exh. cat., ed. V. Beyer; Paris, Grand Pal., 1976)

A. Hardy and A. Braunwald: *Catalogue des peintures et sculptures de J. B. Carpeaux à Valenciennes* (Valenciennes, 1978)

D. Kocks: *Jean Baptiste Carpeaux: Rezeption und Originalität* (Cologne, 1981)

A. M. Wagner: *Jean-Baptiste Carpeaux: Sculptor of the Second Empire* (New Haven and London, 1986)

L. de Margerie: *Carpeaux: La Fièvre créatrice*, Découvertes Gallimard, no. 68 (1989)

ANNE PINGEOT

Carrier-Belleuse [Carrier], Albert-Ernest

(*b* Anizy-le-Château, Aisne, 12 June 1824; *d* Sèvres, 3 June 1887). French sculptor and designer. He was one of the most prolific and versatile sculptors of the 19th century, producing portrait busts, monuments and ideal works, as well as exploiting to the full the commercial opportunities offered by developing technology for the mass production of small-scale sculpture and decorative wares. His style ranged from the unembellished Realism of his male portraits to the neo-Baroque exuberance of his architectural decoration, and his art is particularly associated with the amiable opulence of the Second Empire. He signed his works A. Carrier until *c.* 1868, thereafter adopting the name Carrier-Belleuse.

Carrier-Belleuse began a three-year apprenticeship with a goldsmith at the age of 13, a training that gave him a lifelong sensitivity to intricate surfaces. In 1840 David d'Angers sponsored his entry to the Ecole des Beaux-Arts, Paris, but his straitened financial circumstances led him to study decorative arts at the Petite Ecole. This left him free to produce small models for such commercial manufacturers of porcelain and bronze as Michel Aaron, Auguste Lemaire, Vittoz and Paillard, who were beginning to flourish in the 1840s. Few examples of his work of this period are identifiable. By 1850 he was in England, employed as a designer at the Minton ceramic factory, though it is not clear if the revolutionary political events of 1848

were the cause of his departure from France. In addition to the many decorative objects and statuettes that he modelled for Minton, such as *Seahorse with Shell* (1855; London, V&A), he supplied models for ceramics and metalwork to other English companies, including such Staffordshire-based firms as Wedgwood and William Brownfield & Sons. In 1855 he returned to France but continued to collaborate with English firms until his death.

From 1857 Carrier-Belleuse regularly exhibited large-scale sculpture at the Salon. His first important success was in 1863 when Napoleon III bought the life-size marble *Bacchante with a Herm of Dionysus* (Paris, Jard. Tuileries). He often repeated the theme of the beguiling female nude, notably in *Sleeping Hebe* (marble, 1869; Paris, Mus. d'Orsay). As in the work of his contemporary Jean-Baptiste Carpeaux, the neo-Baroque opulence of these statues is tempered by a strain of closely observed Realism.

Carrier-Belleuse also produced religious statuary, notably the *Messiah* (marble, 1867; Paris, St Vincent-de-Paul), which earned him the Médaille d'Honneur, and a number of ambitious public monuments, including *General Massena* (bronze, 1867; Nice, Place Massena) and *Alexandre Dumas père* (bronze, 1884; Villers-Cotterêt, Rue Alexandre Dumas). He supplied monuments abroad, and the large number of works by him in Argentina, including the marble monument to *General St Martin* (1879) in Buenos Aires Cathedral, raises the possibility that he might have maintained a workshop there to execute his designs.

Carrier-Belleuse was one of many sculptors to benefit from Baron Haussmann's rebuilding of Paris, begun during the Second Empire (1851–70), although in 1870 he was in Brussels working on the decoration of the Bourse and was therefore spared the privations of the siege of Paris in the following year. He contributed to the embellishment of the Louvre, the Tribune du Commerce, the Théâtre de la Renaissance, the Banque de France and Charles Garnier's Opéra. His magnificent electrotyped *torchères* (1873; *in situ*) for the grand staircase of the Opéra, each with its three over-life-size figures derived from the work of such 16th-century sculptors as Jean Goujon and Germain Pilon, perfectly illustrate Carrier-Belleuse's talent for combining historicist styling with the most recent technical innovations (see col. pl. VIII).

In his many portrait busts, Carrier-Belleuse contributed to the reaction against the static poses and idealizing tendencies of Neo-classicism. He preferred to draw his inspiration from the 18th-century tradition of lively Realism, and in such lifelike male portraits as the bust of *Honoré Daumier* (patinated plaster, *c.* 1865–70; Versailles, Château) he used contemporary dress. Among his few court commissions are two portraits of *Napoleon III* (e.g. patinated plaster, 1864; Paris, Carnavalet); most of his sitters, however, were well-known artists, writers and politicians, often drawn from his circle of friends. A number of his elegant female portraits were reworked as fantasy busts, the features of Marguerite Bellanger, for instance, reappearing in the guises of *Diana* (tinted plaster; Paris, Martin de Nord priv. col.) and *Winter* (plaster; Paris, Mus. A. Déc.). The basic cast would often be varied by changing accessories, costumes or patinas. His portraits of historical figures include a statuette of *Michelangelo* (bronze, 1855; Berlin, Bodemus.) and a miniature portrait bust of the same artist (silvered version, *c.* 1860; New York, Met.) and are distinguished by the high quality of their chasing in examples from the artist's studio. Carrier-Belleuse sold reproduction rights to commercial manufacturers who executed many of these works in metal, terracotta, ceramic and marble without such careful attention to finish.

Carrier-Belleuse produced his own terracotta editions of gallant themes in the Rococo spirit, sometimes reductions of his Salon exhibits. Statuettes and groups were cast in moulds and then reworked while still wet to ensure a fresh, crisp surface. These pieces were sold by the artist, sometimes at auction. A similar diversity of themes and media characterized his applied designs. Supported by his reputation as a serious sculptor, he executed lavish one-off pieces, for instance a silvered bronze chimney-piece (1866) for the mansion of the courtesan and patron Païva, on the Champs-Elysées, Paris. He also continued to

collaborate with commercial manufacturers to exploit the opportunities inherent in mass production, devoting as much care to the design of such a mass-produced object as his zinc clock-case (e.g. 1867; London, V&A) as to a unique de luxe one. In order to sustain his many activities, Carrier-Belleuse maintained a busy studio, in which some of the leading sculptors of the next generation, including Auguste Rodin, Jules Dalou and Alexandre Falguière, learnt to appreciate the value of the applied arts and the benefits of working in series, editions and variations.

In 1876 Carrier-Belleuse was made artistic director of the Sèvres porcelain manufactory to reform what were seen at the time as the aesthetic excesses of the previous decades. He devoted himself to revitalizing Sèvres with dozens of new designs, such as the 'Vase Carrier-Belleuse' (e.g. 1883; Paris, Hôtel du Sénat). In 1884 he published *L'Application de la figure humaine à la decoration et à l'ornementation industrielles*, a collection of 200 designs of anthropomorphic objects, which underlined his belief that since the human figure was traditionally the focus of art, its application to everyday objects would elevate their status. In the same year he was made an officer of the Légion d'honneur for his services to the decorative arts.

Bibliography

A. Segard: *Albert Carrier-Belleuse* (Paris, 1928)

J. Hargrove: *The Life and Work of Albert Carrier-Belleuse* (New York, 1977)

P. Ward-Jackson: 'A.-E. Carrier-Belleuse, J.-J. Feuchère and the Sutherlands', *Burl. Mag.*, cxxvii (1985), pp. 147–53

JUNE HARGROVE

Carrière, Eugène

(*b* Gournay, Seine-et-Oise, 27 Jan 1849; *d* Paris, 27 March 1906). French painter and printmaker. The eighth of nine children of a poor insurance salesman, he was brought up in Strasbourg, where he received his initial training in art at the Ecole Municipale de Dessin as part of his apprenticeship in commercial lithography. In 1868, while briefly employed as a lithographer, he visited Paris and was so inspired by the paintings of Rubens in the Louvre that he resolved to become an artist. His studies under Alexandre Cabanel at the Ecole des Beaux-Arts were interrupted by the Franco-Prussian War (1870–71), during which he was taken prisoner. In 1872–3 he worked in the studio of Jules Chéret. In 1878 he participated in the Salon for the first time, but his work went unnoticed. The following year he ended his studies under Cabanel, married and moved briefly to London where he saw and admired the works of Turner. Success eluded him for a number of years after he returned to Paris and he was forced to find occasional employment, usually with printers, until as late as 1889, to support his growing family. Between 1880 and 1885 his brother Ernest (1858–1908), a ceramicist, arranged part-time work for him at the Sèvres porcelain factory. There he met Auguste Rodin who became and remained an extremely close friend.

Carrière had great admiration for many of the Old Masters, but in his early work he was mainly influenced by his contemporary Jean-Jacques Henner. In the early 1880s Carrière requested Henner's comments on his work. Carrière increasingly used a near monochromatic brown palette with occasional touches of other colours and a painterly technique somewhat like that of Henner, and by the mid-1880s Carrière's work was characterized by a dense brown atmosphere out of which the images emerged. *Sick Child* (1885; Paris, Mus. d'Orsay) is an example of the theme of a mother and her child that Carrière often used and that has come to be regarded as typifying his work.

Carrière described at length the manner in which he worked (*Ecrits et lettres choisies*, ed. J. Delvolvé (Paris, 1907), pp. 321–3). This was similar to the Old-Master method of laying in the preliminary underpainting. His innovative idea was to develop this underpainting by modifications of value and sparse additions of subtle colour, and to present the result as a finished work of art. He said that painting is the logical development of light, and his earth tone palette and the effect of light picking out images from a vaporous environment produced works that illustrated his belief, as a spiritualist, in creation as a continuing process of coalescence out of primal, universal forces.

At the Salon of 1884 one of Carrière's paintings received an honourable mention, and the influential art critic Roger Marx became a champion of his work. Thereafter, Carrière found friends in most of the important artists, critics, writers and collectors of his time.

Carrière occupies an important place in the Symbolist movement, which developed in the visual arts from the mid-1880s. The quality of poetic, dreamlike reverie that pervades his work particularly appealed to Symbolist critics such as Charles Morice and Jean Dolent; the latter described Carrière's art as reality having the magic of dreams. Carrière also frequented the Café Voltaire and was involved in Symbolist theatre, bringing him into the main stream of Symbolism. By employing a monochromatic brown palette, softening the focus and enveloping his figures in a thick, dark atmosphere, as in *Maternity* (c. 1889; Philadelphia, PA, Mus. A.), Carrière achieved a natural sense of space, light and colour. His ethereal images have a quality of pervasive stillness.

Carrière's strong belief in the essential brotherhood of man led him to consider his family as a microcosm of mankind. Though most of his paintings are of family members or family relationships, his interest in the universal rather than the specific usually resulted in figures without much individuality presented in a formless environment. He also produced a number of portraits, however; most notable is that of *Verlaine* (Paris, Mus. d'Orsay).

From the late 1880s Carrière's work in oil and graphic media developed an emphasis on technique. There is evidence of stroking, wiping and scratching in the textural surfaces of his pictures. The limited range of colours and the apparentness of the technique and medium, as in *Self-portrait* (c. 1903; Paris, Grunbaum Col.), further underline his concern to present the spiritual aspect, rather than the physical appearance, of objects.

Carrière received many honours during his career. He was a founder member of the Société Nationale des Beaux-Arts and of the Salon d'Automne (of which he was named honorary president). Carrière also exhibited with the Libre Esthétique in Brussels (in 1894, 1896 and 1899),

the Munich Secession (in 1896, 1899, 1905 and 1906) and the Berlin Secession in 1904. After his death from cancer of the throat, the Société Nationale des Beaux-Arts and the Salon d'Automne in 1906, as well as the Ecole Nationale des Beaux-Arts and the Libre Esthétique in 1907, held major retrospective exhibitions. The Musée d'Orsay in Paris owns a large collection of his work.

Bibliography

C. Morice: *Eugène Carrière—l'homme et sa pensée, l'artiste et son oeuvre: Essai de nomenclature des oeuvres principales* (Paris, 1906)

E. Faure: *Eugène Carrière: Peintre et lithographe* (Paris, 1908)

L. Delteil: *Eugène Carrière* (1913), viii of *Le Peintre-graveur illustré*, 31 vols (Paris, 1906–30/R New York, 1969)

J.-R. Carrière: *De la vie d'Eugène Carrière* (Toulouse, 1966)

R. J. Bantens: *Eugène Carrière: His Work and his Influence* (diss., Penn. State U., 1975; microfilm, Ann Arbor, 1976)

The Other Nineteenth Century (exh. cat., ed. L. d'Argencourt and D. Druick; Ottawa, N.G., 1978), pp. 63–71

R. J. Bantens: *Eugène Carrière: The Symbol of Creation* (New York, 1990)

ROBERT J. BANTENS

Carriès [Cariès], Jean(-Joseph-Marie)

(*b* Lyon, 15 Feb 1855; *d* Paris, 1 July 1894). French sculptor and ceramicist. He was brought up in an orphanage and in 1868 entered the studio of a sculptor of religious images named Vermare. In 1874 he became a probationary pupil of Augustin-Alexandre Dumont at the Ecole des Beaux-Arts in Paris but, having failed the tests for full admission, left to set up on his own. He made his début at the Salon of 1875; his first success, however, came after that of 1881, and above all from a private exhibition organized by the Cercle des Arts Libéraux in 1882. Most of his sculptural work, principally bronze portrait busts cast by the lost-wax method, was carried out between 1881 and 1888. It includes portraits of contemporaries, for example *Jules Breton* and *Léon Gambetta* (plaster casts of both, Paris, Petit Pal.); historical representations, for example of *Frans Hals* and *Diego*

Velázquez (plaster casts of both, Paris, Petit Pal.); and a number of ideal busts—Symbolist reinterpretations of the academic *tête d'expression*—for example *The Desperate* (plaster cast, Paris, Petit Pal.) and *The Nun* (bronze, Lyon, Mus. B.-A.). He also produced studies of various heads of babies (examples in Paris, Petit Pal.). From 1888 Carriès was able to fulfil a long-standing desire to experiment with ceramics. His most ambitious work in this medium, a monumental Symbolist doorway (destr.) commissioned in 1889 by Winaretta Singer (1865–1943), Princesse de Scey-Montbéliard, was intended to adorn the room in which she kept the manuscript of Wagner's opera *Parsifal*. He died before it was completed, but the plaster maquette, together with a collection of works by Carriès donated by his friend Georges Hoentschel (1855–1915), is at the Musée du Petit Palais, Paris. He signed his works *Joseph Carriès* until 1890–91 and *Jean Carriès* thereafter.

Bibliography

A. Alexandre: *Jean Carriès, imagier et potier: Etude d'une oeuvre et d'une vie* (Paris, 1895)

P. Thiébaut: 'A propos d'un groupe céramique de Jean Carriès: *Le Grenouillard*', *Rev. Louvre*, 2 (1982), pp. 121–8

PHILIPPE THIÉBAUT

Cavelier, Pierre-Jules

(*b* Paris, 30 Aug 1814; *d* Paris, 28 Jan 1894). French sculptor. The son of the painter and draughtsman Adrien Cavelier (1785–1867), he began his studies at the Ecole des Beaux-Arts in 1831 as the pupil of David d'Angers and Paul Delaroche. He won the Prix de Rome in 1842 and in the same year received a third-class medal at the Salon for the plaster version of his statue *Penelope* (marble, 1849; Dampierre, Château), whose success is reflected in numerous marble reductions, most notably those by the firm of Barbedienne.

His stay in Rome between 1843 and 1848 consolidated his style: a return to the Classical Antique tempered with a discreet lyrical note. He pursued a successful official career during the Second Empire (1851–70) and was involved in the sculptural decoration of many public buildings, of which the most important was the Palais Longchamp in Marseille, for which he executed several pieces including the colossal principal group, the *Durance* (stone, 1869; *in situ*). He also sculpted many portraits, a few free-standing statues, including *Cornelia, Mother of the Gracchi* (marble, 1855–61; Paris, Mus. d'Orsay), and sometimes provided models for decorative objects.

Bibliography

Lami

M. Pajot-Villerelle and J. Marchand: *Pierre-Jules Cavelier, 1814–1894* (Paris, 1979)

La Sculpture française au XIXe siècle (exh. cat., ed. A. Pingeot; Paris, Grand Pal., 1986), pp. 36–7, 47, 251, 301

LAURE DE MARGERIE

Cazin

French family of artists. The painter and ceramicist (1) Jean Charles Cazin and his wife, (2) Marie Cazin, a sculptor and decorative artist, represent a wide range of artistic involvement characteristic of the late 19th-century movement to unify the arts. Their son Michel Cazin (*b* Paris, 12 April 1869) was active as a medallist, sculptor, ceramicist and printmaker.

(1) (Stanislas Henri-)Jean Charles Cazin

(*b* Samer, 25 May 1841; *d* Lavandou, 17 March 1901). Painter and ceramicist. His earliest paintings reveal close affinities with the realist tradition, while his later compositions (mostly landscapes of northern France) demonstrate an awareness of Impressionism and a commitment to recording the changing effects of light and atmosphere. He was sent to England for health reasons but by 1862 or 1863 was living in Paris and active in avant-garde artistic circles. In 1863 he exhibited *Recollections of the Dunes of Wissant* (untraced), a work based on close observation of the coastline of northern France, at the Salon des Refusés. He enrolled at the Ecole Gratuite de Dessin under Horace Lecoq de Boisbaudran, where he became friends with Alphonse Legros, Théodule Ribot, Henri Fantin-Latour and Léon Lhermitte, all of

whom adopted Boisbaudran's method of developing paintings from memory as a way of heightening perceptions. During this period Cazin also met Marie Guillet, whom he married in 1868.

By the mid-1860s Cazin had developed a varied career. He taught for about three years at the Ecole Spéciale d'Architecture in Paris, then moved to Chailly, near Barbizon, where he completed studies in the style of the Barbizon artists. These were shown at the Salons of 1865 and 1866. Later in the decade he became curator of the Musée des Beaux-Arts and director of the Ecole de Dessin in Tours. In 1868 he reorganized the school in accordance with the memory theories of Boisbaudran. He also valued Tours as a centre of local industry that encouraged the decorative arts. Both Cazin and his wife were stimulated by this new environment and began to make and decorate stoneware ceramics.

In 1871, depressed by the ravages of the Franco-Prussian War, Cazin returned to England and earned a living at the Fulham Potteries, using saltglaze in his stoneware and producing ceramics in the highly fashionable style of Japonisme. Cazin's commitment to ceramic decoration continued after his return to France in 1875, when he settled in Equihen, near Boulogne-sur-Mer. This dedication to the decorative arts was recognized in 1882 when his large sandstone pieces, shown at the Union Centrale des Arts Décoratifs, Paris, were admired as significant examples of the developing renaissance in French pottery.

During the same period, Cazin began to paint again. His studies of the region near Boulogne encouraged him to execute numerous landscapes. *The Boatyard* (exh. Salon 1876; Cleveland, OH, Mus. A.), for instance, demonstrates the affinities between Cazin's muted colours and the monochromatic tones of the region itself. By the early 1880s he had changed direction to produce large figural compositions intended for the Salon; such canvases as the *Voyage of Tobias* (1878; Lille, Mus. B.-A.) and *Judith at Prayer* (1883; Tours, Mus. B.-A.) depict biblical figures in contemporary dress. The tonal, pastel colours are the product of Cazin's lighter palette and show the impact of the murals of Puvis de Chavannes. Cazin's enthusiasm for these scenes abated, however, and he returned to pure landscape painting, inspired by the countryside around the summer cottage rented by his family at Equihen. He executed a series of impressive landscape compositions of the dunes near Boulogne and won awards for some figural compositions at the Salon, most notably for his *Ishmael* (1880; Tours, Mus. B.-A.). He was awarded the Légion d'honneur (for his ceramics and painting) in 1882, a gold medal at the Exposition Universelle of 1889 and a *Grand Prix* at that of 1900.

(2) Marie Cazin [née Guillet]

(*b* Paimboeuf, 1845; *d* Boulogne, 18 March 1924). Sculptor and decorative artist, wife of (1) Jean Charles Cazin. At first she decorated ceramics, winning admiration during the 1870s for her stoneware pieces. She exhibited sculptural pieces annually at the Salon from 1876 until the first decade of the 20th century, some of which reflect her early training in the studio of the animal painter Rosa Bonheur. It was possibly in Bonheur's studio that Marie was introduced to the value of working in bronze, her chosen medium for *The Regret* (1885) and *Science and Charity* (1893; both untraced), works which demonstrate her interest in figural groupings with symbolic overtones. Marie received a certain amount of recognition during her extremely productive career. Her reputation was overshadowed by that of her husband, but in 1893 she shared with him the honour of having one of her works, a bronze head of *David* (untraced), purchased by the Musée du Luxembourg.

Bibliography

L. Bénédite: 'Jean Charles Cazin', *Rev. A. Anc. & Mod.*, x (1901), pp. 1–32, 73–104

—: *Jean Charles Cazin*, Les Artistes de tous les temps, série D: Le XXe Siècle (Paris, n.d.)

The Realist Tradition: French Painting and Drawing, 1830–1900 (exh. cat., ed. G. P. Weisberg; Cleveland, OH, Mus. A.; New York, Brooklyn Mus.; St Louis, MO, A. Mus.; Glasgow, A.G. & Mus.; 1980), pp. 266–7

G. P. Weisberg: 'Jean Charles Cazin: Memory Painting and Observation in *The Boatyard*', *Bull. Cleveland Mus. A.*, lxviii (1981), pp. 2–16

GABRIEL P. WEISBERG

Cézanne, Paul

(*b* Aix-en-Provence, 19 Jan 1839; *d* Aix-en-Provence, 23 Oct 1906). French painter. He was one of the most important painters of the second half of the 19th century. In many of his early works, up to about 1870, he depicted dark, imaginary subjects in a violent, expressive manner. In the 1870s he came under the influence of Impressionism, particularly as practised by Camille Pissarro, and he participated in the First (1874) and Third (1877) Impressionist Exhibitions. Though he considered the study of nature essential to painting, he nevertheless opposed many aspects of the Impressionist aesthetic. He epitomized the reaction against it when he declared: 'I wanted to make of Impressionism something solid and enduring, like the art in museums.' Believing colour and form to be inseparable, he tried to emphasize structure and solidity in his work, features he thought neglected by Impressionism. For this reason he was a central figure in Post-impressionism. He rarely dated his works (and often did not sign them either), which makes it hard to ascertain the chronology of his oeuvre with any precision. Until the end of his life he received little public success and was repeatedly rejected by the Paris Salon. In his last years his work began to influence many younger artists, including both the Fauves and the Cubists, and he is therefore often seen as a precursor of 20th-century art.

I. LIFE AND WORK

1. Oil paintings

(i) **Early period, before 1872.** Cézanne studied from *c.* 1849 to 1852 at the Ecole Saint-Joseph and from 1852 to 1858 at the Collège Bourbon, both in Aix-en-Provence. At the latter, in about 1852, he met Emile Zola, who was to become his closest friend. In 1857 he enrolled at the Ecole Municipale de Dessin in Aix-en-Provence, where he studied under Joseph Gibert (1806–84). In 1859, following his father's wishes, he began to study law at the Université d'Aix. The same year his father bought the estate Le Jas de Bouffan, near Aix, where Cézanne set up a studio and worked frequently throughout his life. He also attended the Ecole Municipale de Dessin again for the academic years 1858-9, 1859-60 and 1860-61. In 1861 he abandoned his law studies and, wishing to become a painter, he moved to Paris in April of that year. There he met up with Zola and worked at the Académie Suisse, where he became acquainted with Camille Pissarro. This first trip was unhappy, however, and, having repeatedly thought of leaving, in September he went back to Aix and enrolled at the local drawing school. He returned to Paris in November 1862, where he again attended the Académie Suisse. While in Paris he copied works by Titian, Giorgione, Veronese, Rubens, Delacroix, Courbet and others at the Louvre but failed the entrance examination for the Ecole des Beaux-Arts. In 1863 he participated in the Salon des Refusés with Manet, Pissarro, Jongkind, Guillaumin and others, and during their first meeting, in 1866, Manet praised his still-lifes. Cézanne submitted works for the Salon every year at this time but was refused on each occasion. Extremely disappointed, he moved continually between Aix and Paris from 1864 to 1870. In 1869 he met a young model, Hortense Fiquet, then 19 years old, who became his mistress, and in 1870, when war was declared with Prussia, he took refuge with her in L'Estaque, near Marseille, where his mother owned a house. He returned to Paris in the autumn of 1871, after the fall of the Commune.

For the early period the problem of establishing the chronology of Cézanne's work is compounded by the fact that some pieces were destroyed by Cézanne himself, or by his father, which makes an exact analysis difficult. Of the remaining paintings, with the exception of portraits and still-lifes, many are expressively executed in dark colours and inspired by violent, dramatic themes. They are full of exuberance and intensity, and the style is impetuous, the rhythm lively and the paint thick. The serene and subdued vision of Cézanne's final period, in which there is a tendency towards abstraction, is little in evidence in these early works. At this time Cézanne was attempting to forge a personal technique, and the works are therefore quite varied in style. The imaginary paintings reflect his studies of the Old Masters and in particular of Delacroix, whom he

greatly admired. There are a few surviving copies of works from this period, the most faithful being after paintings by Delacroix (e.g. *Barque of Dante*, *c.* 1864; Cambridge, MA, priv. col., see 1988-9 exh. cat., p. 79).

One of Cézanne's most remarkable early paintings is *The Abduction* (1867; Cambridge, King's Coll., on loan to Cambridge, Fitzwilliam), which he gave to Zola. Set against a carefully painted, dark-green background, the two large naked figures that dominate the scene create a striking image of force and dynamism. The *Black Scipio* (*c.* 1867; São Paolo, Mus. A. Mod.) depicts a model from the Académie Suisse, whom Cézanne must have painted in his own studio. Painted in long, sinuous brushstrokes, the work belonged to Monet, who called it a 'fragment of raw power'. The violence of many of the early works is particularly evident in *The Murder* (*c.* 1870; Liverpool, Walker A.G.), in which the turbulent technique enhances the impact of the subject. A *Modern Olympia* (or *The Pasha*, *c.* 1869-70; priv. col., see 1988-9 exh. cat., p. 151) was painted as a tribute to Manet's celebrated picture *Olympia* (1863; Paris, Mus. d'Orsay), which had caused a scandal at the Salon of 1865. In his version, Cézanne used strong, striking colours and a composition in which the various planes overlap to create a swirling and unstable movement, full of impetuosity and intensity. In homage to Manet and in reference to Spanish art, he employed a palette of blacks that accentuates the stridency of the coloration. The tribute is somewhat equivocal, however: the title suggests that the work is a modernization of Manet's original. Both Cézanne and Zola believed that art should be marked by the temperament of the artist, and so, in addition to his more expressive style, Cézanne painted himself in the foreground of the picture, gazing at the female figures. Thus, in contrast to the more reticent approach of Manet, Cézanne imposed his personality directly on the work both through style and content. This attitude is again apparent in *Young Girl at the Piano: Overture to Tannhäuser* (*c.* 1869-70; St Petersburg, Hermitage), in which the reference to Richard Wagner's music prompts associations with powerful, abundant emotion and thus implicitly with the artistic personality. Also in this work Cézanne included the circle and arabesque forms that he developed more fully in later paintings.

Cézanne painted several portraits in this early period, mostly of family members and close friends. In contrast to the passion and violence of his imaginative works these have a notable sobriety and detachment. Nevertheless, the colours are often vivid and the paint thickly impastoed with a palette knife. One of his favourite models was his mother's brother, Uncle Dominique, of whom he made several portraits (e.g. *Man with a Cloth Cap (Uncle Dominique)*, *c.* 1866; New York, Met.), and he also painted his father (e.g. *Louis-Auguste Cézanne Reading 'L'Evénement'* (1866; Washington, DC, N.G.A.). One of the most moving portraits is that of his dwarf painter friend *Achille Emperaire* (*c.* 1868-70; Paris, Mus. d'Orsay; see fig. 14), which was refused by the Salon of 1870. Painted life-size and in strongly contrasting colours, it shows the artist seated in an armchair with his fragile legs resting on a low stool. Throughout his life Cézanne also produced self-portraits: an early example (1861-2; priv. col., see 1988-9 exh. cat., p. 73) is imbued with the same passion evident in the other works of this period. Executed in a dark palette highlighted with flecks of red, the artist looks out at the viewer with an intense, penetrating gaze in a self-portrait typical of Romanticism.

Though they constitute the greater part of his subsequent work, Cézanne produced few landscapes in this early period. The most important is *The Cutting* (*c.* 1869-70; Munich, Neue Pin.), which already reveals his dislike for deep, one-point perspective. The undulating landscape elements are repeated in layers in the composition, while the imposing bulk of Mont Sainte-Victoire, which dominates Aix and was later a favourite subject of Cézanne, is painted as clearly and solidly as the features in the foreground. The landscape rises up towards the top corners of the picture, so introducing a strong equilibrium into the work in a format that he repeated in the following few years. He began to study nature in earnest only during his trip to L'Estaque in 1870-71.

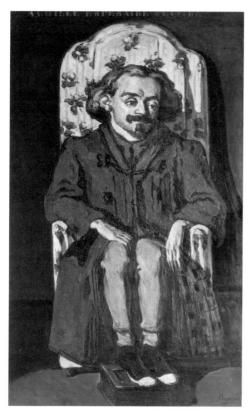

14. Paul Cézanne: *Achille Emperaire*, c. 1868–70 (Paris, Musée d'Orsay)

Of all his early works, it was primarily in his still-lifes that Cézanne adumbrated the themes and concerns that he developed in more detail later. One of the most masterly of these is the *Black Clock* (c. 1870; Stavros Niarchos priv. col., see 1988–9 exh. cat., p. 169). It depicts the top of a mantelpiece partly covered by a tablecloth with starched and rigid creases. On this several objects are arranged: a large shell with a glaring pink opening, a coffee cup with a black rim, a single glass vase, a vivid yellow lemon, a black clock (without hands) that belonged to Zola and a square pottery vessel. By its composition and structure as well as by the equilibrium of colours, it prefigures the works of Cézanne's maturity.

(ii) Impressionist period, 1872–82. In 1872, the year of the birth of their son Paul, Cézanne went to live at Pontoise with Hortense. (He hid the existence of his family from his father, who discovered the situation only in 1878 and reduced Cézanne's financial aid as a result.) There he worked outdoors alongside Pissarro and also met Dr Paul Gachet, a collector and friend of the Impressionists. From late 1872 or early 1873 until 1874, together with his family, he stayed in Gachet's house at Auvers-sur-Oise, again working with Pissarro. In 1873 he met van Gogh, and in 1874 he participated in the First Impressionist Exhibition at the studio of the photographer Nadar in Paris. Of all the artists showing work at the exhibition Cézanne received particular criticism in the press, and some painters, fearing this, had wished to have him excluded from the show. After the Romantic and Baroque style of his early period, from 1872 Cézanne turned to a more Impressionist aesthetic while working with Pissarro at Pontoise and while at Auvers-sur-Oise. This interest in nature and the move away from the turbulent early style are expressed in the calm *Self-portrait* (1872; Paris, Mus. d'Orsay), which includes a landscape in the background. During his time with Pissarro, Cézanne painted the *House of the Hanged Man* (1873; Paris, Mus. d'Orsay), which was exhibited at the First Impressionist Exhibition. The structure and density of the forms are the essential qualities of this painting, in which Cézanne shows himself very close to the works of the older artist. The subject, the composition and the clear colour testify to the proximity of conception and execution between the works of Cézanne and his Impressionist friends. He worked outdoors and made studies of his subjects, marking a distinct difference from the methods used in his early works. Cézanne also exhibited a second version of the *Modern Olympia* (1872–3; Paris, Mus. d'Orsay) at the First Impressionist Exhibition. This was executed in much looser, more fluid brushstrokes than the earlier version and thus reflects his new style, though it also reveals his continued interest in imaginative subjects.

Cézanne was working in Aix at the time of the Second Impressionist Exhibition in 1876 and so

did not take part in it, but for the third, in 1877, he submitted 16 works. While there had been a slight softening in the attitudes of some critics towards the work of other participants, Cézanne was again singled out for ridicule, and his portrait of the collector *Victor Chocquet* (1876–7; priv. col., see Rewald, 1936, Eng. trans. 1986, p. 117) was particularly attacked. He was deeply hurt by this reaction and resolved to take no part in further group shows with his Impressionist friends. Given the repeated failure of his works to be accepted at the Salon, this decision closed off the only form of access to the public available to him at that time. While the Impressionists devoted themselves primarily to *plein-air* painting, during the period of his flirtation with Impressionism Cézanne continued to paint some imaginary subjects and such still-lifes as *Overturned Fruit Basket* (1873–7; Glasgow A.G. & Mus.). In particular he produced a number of flower paintings (e.g. *Green Vase*, 1873–7; Philadelphia, PA, Mus. A.), and this sustained interest in studio painting reflects his cautious approach to the Impressionist aesthetic. This caution is furthermore evidenced by the fact that Cézanne chose to adopt Pissarro's form of Impressionism. This is not as light and spontaneous as, for example, that of Monet: Pissarro built up his works by the careful application of brushstrokes. Nevertheless, his influence on Cézanne lent a greater immediacy to the younger painter's style, as well as encouraging him to work outside.

In the mid-1870s Cézanne produced his first works on the theme of bathers, a subject that interested him increasingly thereafter. He depicted groups, placed in landscape settings, of female bathers (e.g. *Three Women Bathers*, 1875–7) and of male bathers (e.g. *Four Male Bathers*, 1875–6; both Merion Station, PA, Barnes Found.), the latter recalling his boyhood days spent bathing with Zola and their friend Baptistin Baille. Probably on account of his shyness with models and because of the difficulty of using them in parochial Aix, Cézanne constantly reused figures in these works (as he also did in his later works on the theme). Thus the female figure on the far left in *Three Women Bathers* (1879–82;

Paris, Petit Pal.) is the same as that in *Five Women Bathers* (1879–82; Merion Station, PA, Barnes Found.). In 1878 Cézanne went to live with Hortense and their son in L'Estaque, where he worked again in 1879. Also in 1878, Zola bought a house at Médan, on the Seine near Paris, and from 1879 to 1882 Cézanne made annual visits there. In Paris in 1880 he met Gauguin (V. Merlhès, ed.: *Correspondance de Paul Gauguin*, Paris, 1984, pp. 350–51), and from May to October 1881 he worked in Pontoise with Pissarro. In 1882 Cézanne stayed at L'Estaque, where Renoir visited him, and in October 1882 he returned to work in Aix at Le Jas de Bouffan. Between *c.* 1878 and 1882 Cézanne moved away from the style of other Impressionist painters in search of greater structure, as shown in *Bridge at Maincy* (1879; Paris, Mus. d'Orsay), where flat areas of colour in large, geometric brushstrokes cover the surface of the canvas. Water is used for its density rather than the reflective, shimmering surface that so appealed to the Impressionists. *Zola's House at Médan* (*c.* 1880; Glasgow, Burrell Col.) is also executed in careful, parallel brushstrokes, examples of the so-called 'constructive stroke'.

(iii) Period of synthesis, 1883–c. 1895. During this period Cézanne placed the accent more on mass and structure, and his composition consequently became more architectural. This continued move away from Impressionism was motivated by his belief that the painter must interpret as well as record the scene before him. The role of the brain was as important as that of the eye and the two must work in harmony, an attitude implicit in his comment on Monet: 'He is nothing but an eye, yet what an eye!'. From 1883 to 1885 Cézanne executed the core of his work at Aix and at L'Estaque, where he was visited by Renoir and Monet in February 1884. The intense light of L'Estaque sharply outlines forms, and Cézanne spent months painting different views of the landscape there. He simplified and synthesized the scenes in compositions built up of verticals, horizontals and diagonals, as in *Rocks at L'Estaque* (1883–5; São Paulo, Mus. A. Mod.). These works attest to the profound modification that he brought to his conception of

landscape, in which he broke with the traditional conception of successive planes defining depth of field. He emphasized the foreground by using asymmetrically framed views. His brushstrokes became broader and thicker, and sometimes the use of a palette knife can be seen. L'Estaque also inspired most of Cézanne's landscapes representing the sea, such as *Gulf of Marseille Seen from L'Estaque* (1883–5; New York, Met.). No life animates these views, and the sea, which is almost always enclosed by the land and hills, is treated rather like a mirror, an immobile—as if vitrified—surface. Cézanne painted Mont Sainte-Victoire most concentratedly from the mid-1880s up to his death. He produced many variants, including about thirty paintings and many watercolours, in which rhythm, form and colour are indissolubly unified. The most detailed and precise works were those done around 1884–8, such as *Mont Sainte-Victoire* (1885–7; U. London, Courtauld Inst. Gals), while other, more visionary versions followed until his last years. Presenting a clear geometric form, Cézanne studied the mountain for the structure of its various planes, which are cleanly delimited in broad facets of a rigorous equilibrium.

In March 1886 Cézanne fell out with Zola following the publication of the latter's novel *L'Oeuvre* in Paris: Cézanne thought he recognized himself in the principal figure Claude Lantier, a failed artist who commits suicide. Cézanne never saw Zola again. In April 1886 he married Hortense with the consent of his father, who died on 23 October, leaving Cézanne a large inheritance, and from 1886 until his death he divided his time mainly between Paris and Aix. In 1888 he worked for a time in Chantilly and in 1889 exhibited with Les XX in Brussels, writing to its organizer, Octave Maus, that: 'I had made up my mind to work in silence . . . until the time when I would feel able to back up theoretically the fruits of my research' (*Correspondance*, p. 227). At this time Cézanne seems to have emerged from his isolation and solitude. In 1890 he spent five months in Switzerland with his family, his only period abroad, and in 1892 he bought a house at Marlotte near the forest of Fontainebleau. He worked there at various times in the following few years, and

it was probably at Fontainebleau that he painted *Rocks in the Forest* (c. 1894; New York, Met.). In 1894 he visited Monet at Giverny, where he met Auguste Rodin, the journalist and politician Georges Clemenceau and the writer Gustave Geffroy, and in 1895 he painted views of the Bibémus Quarry, near Aix, and of Mont Sainte-Victoire.

Throughout this synthetic period Cézanne painted numerous still-lifes that reflect his constructive concerns at this time (see fig. 15). In *Still-life* (1883–7; Cambridge, MA, Fogg) he used a dark background, as he had in earlier works, and, as in many still-lifes, he also included a tablecloth to provide tonal contrast and to add structure through the creases and folds. Such later works of this period as *Still-life with Basket of Apples* (1890–94; Chicago, IL, A. Inst.) are executed in brighter, more luminous colours. The light blue background tends to flatten the picture space, an aspect further emphasized by the raising of the composition towards the viewer. Hortense was a frequent subject of Cézanne's portrait works. In *Mme Cézanne in a Yellow Chair* (1890; Chicago, IL, A. Inst.) she is depicted as calm and fashionably dressed in a typical image of a bourgeois woman. Among numerous other interior scenes from this period is the *Boy with the Red Vest* (c. 1895; Zurich, Stift. Samml. Bührle; see fig. 16), in which all the volumes are created through the articulation of planes, the various facets being used to underpin the structure. The right arm of the young boy is deliberately elongated and deformed, so enhancing the sense of the sitter's relaxation and emphasizing the compositional lines: the curve of the back, the bent left arm, the diagonals of the curtain and table and the horizontal of the wall panelling.

Cézanne had not entirely given up his interest in imaginary subjects and in the late 1880s he produced a number of paintings of *Harlequin* (version, c. 1888–90; Washington, DC, N.G.A.). He also painted several more images of bathers (e.g. *Five Women Bathers*, 1885–7; Zurich, Kstmus.) in which the figures became more simplified, statuesque and integrated with the landscape. From whatever period, in all his treatments of this

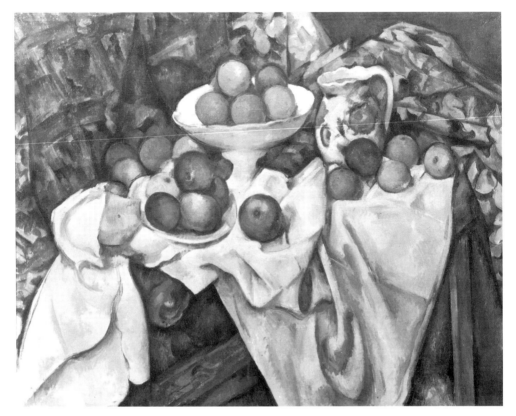

15. Paul Cézanne: *Apples and Oranges* (Paris, Musée d'Orsay)

subject the trees and the sky form the main part of the setting, while the water remains a scarcely visible element. Among the most important works of the period of synthesis is the series of paintings of *Card Players* (see col. pl. V). According to the daughter of one of the models, these were begun in 1890, the year usually accepted as the starting date. The most important versions are those held at the Barnes Foundation in Merion Station, PA, the Metropolitan Museum in New York, the Courtauld Institute Galleries in London and the Musée d'Orsay in Paris. These differ in the framing, in the number of figures and in the colouring, and various theories have been proposed regarding the respective datings. The most probable progression places the brighter, multi-figure works (Merion Station, PA, Barnes Found.,

and New York, Met.) earlier than the dark, two-figure works (U. London, Courtauld Inst. Gals; and Paris, Mus. d'Orsay). The most famous, the Orsay version, is perhaps the last and thus datable in 1894–5 in keeping with the subsequent development of Cézanne's work (T. Reff, 1977–8 exh. cat., p. 17). In this final painting a great tension is generated by the forms and poses of the figures, who face one another against a dark field in an enclosed space, creating a deeply mysterious image.

(iv) Late period, c. 1895–1906. In November 1895 Cézanne had his first one-man show, of about 150 works, at Ambroise Vollard's gallery in Paris. Two years later, in 1897, Vollard bought everything in Cézanne's studio near Corbeil. In 1898 Cézanne

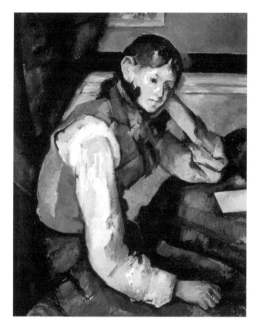

16. Paul Cézanne: *Boy with the Red Vest*, c. 1895 (Zurich, Stiftung Sammlung E. G. Bührle)

Cézanne's lyrical works from this late period are characterized by more violent colours and a greater articulation of volumes into facets. In his landscapes Cézanne emphasized the rough appearance of sites, mixing wild vegetation with rocks in unusual, asymmetric framings. His composition became less serene and his colour more violent. In the foreground he often incorporated red-orange rocks, inspired by those of the Bibémus Quarry and the estate of Château Noir. At these locations he scrupulously studied the overlapping of trees and rocks that sprang from the earth, as shown in *Bibémus Quarry* (c. 1895; Essen, Mus. Flkwang), where the huge blocks of red rock create lines of tumbling diagonals, giving the work a sense of instability. The works of the same scenes from the early 1900s have an even greater turbulence created through the fragmented manner of execution as well as the composition, as in *Château Noir* (1900–04; Washington, DC, N.G.A.). Even in the last years of his life Cézanne pursued his quest after nature untiringly, and in a letter of 29 January 1904 to Louis Aurenche he wrote of 'a long day spent grappling with the difficulties of expressing nature' (*Correspondance*, p. 294).

worked near Aix at the Château Noir, and in 1899 he sold Le Jas de Bouffan and settled into a flat in Aix, while his wife and son remained in Paris. In 1901 he bought land at Les Lauves, on a hill dominating Aix, where he built a studio, which he settled into the following year. Having spent most of the time since his Impressionist period away from the public, in these last years Cézanne exhibited widely, and his reputation grew. In 1899 Paul Durand-Ruel bought many of his works at the Victor Chocquet sale (1–4 July, Galerie Georges Petit, Paris) and in 1890 the same dealer sent 12 pictures to Berlin, where Paul Cassirer organized Cézanne's first one-man show in Germany, though the pictures remained unsold. In 1899, 1901 and 1902 Cézanne exhibited at the Salon des Indépendants; in 1901 and 1904 he showed works with La Libre Esthétique in Brussels; in 1903 seven of his pictures were shown by the Secession in Vienna; and in 1904, 1905 and 1906 he exhibited at the Salon d'Automne, where in 1904 a whole room was devoted to his paintings.

The most extraordinary landscapes of the late period are the series of paintings of *Mont Sainte-Victoire* that Cézanne produced from 1900 until his death. Composed of discrete patches of colour, the image becomes almost illegible beneath the intricate surface pattern of brushstrokes, showing a tendency towards abstraction, as in *Mont Sainte-Victoire Seen From Les Lauves* (1904–6; Basle, Kstmus.). Many contain areas of intense blue, especially in the depiction of the sky (e.g. *Mont Sainte-Victoire*, 1902–6; Philadelphia, PA, Mus. A.). His severe analytical approach, coupled with his treatment of unpopulated natural scenes, distances the works from humanity. One of Cézanne's most famous statements, in a letter to Emile Bernard of 15 April 1904, describes this analytical method (*Correspondance*, p. 296):

Deal with nature as cylinders, spheres and cones, all placed in perspective so that each aspect of an object or a plane goes towards a central point Now, for us men, nature

consists more of depth than of surface, whence the need to introduce into our vibrations of light, represented by reds and yellows, a sufficient amount of shades of blue to make the air felt.

Cézanne did not aim at a traditional representation of nature; he rather sought, above all, to express the idea of the internal construction of that which he had before him, to capture the unchanging element beneath the surface: 'Nature is always the same, but of that aspect which appears to us, nothing lasts. Our art must give to it the frisson of its duration with the elements, the semblance of all these changes'. Though speaking of a different motif, his ability to work at the same subject in so many works is explained in a letter he wrote to his son Paul on 8 September 1906 (*Correspondance*, p. 322):

Here, on the river bank, there are so many motifs, the same subject seen from another angle offers a subject of the most compelling interest and so varied that I believe I could work away for months without changing position, but by just leaning a little to the right and then a little to the left.

In several of the late works of Mont Sainte-Victoire, as well as in many other works of the period, Cézanne left parts of the canvas bare. Some of these paintings, such as *Mont Sainte-Victoire* (1904–6; Zurich, Ksthaus) and *Cabanon de Jourdan* (1906; Milan, Jucker priv. col., see 1977–8 exh. cat., p. 286), are executed with extremely diluted oils. Undoubtedly Cézanne's investigations in the domain of watercolour (*see* §2 below) influenced this oil painting technique, as Fry (1927) and then Venturi (1943) noticed, leading to the explosive liberation in the last works: greater rapidity of execution, lightness and fluidity. Some considered these works unfinished, and Cézanne explained this aspect of his work in a letter to Bernard on 23 October 1905 (*Correspondance*, p. 313): 'The sensations of colour that light gives create abstractions that don't let me cover my

canvas or follow the outlines of objects when the points of contact are tenuous, delicate; thus my image or picture is incomplete'. Here Cézanne broke with the long established tradition of highly finished and perfected paintings, at that time still the only recognized goal. He therefore presaged the later interest in the art of non-finish and in a certain form of Tachism. In *Garden at Les Lauves* (1904–6; Washington, DC, Phillips Col.) these tendencies are particularly evident: several areas of canvas are exposed and the rest covered with large, separate colour marks, leading to a near dissolution of the subject. Another bold innovation of the late works is found in Cézanne's expression of space, which is most apparent in such still-lifes as *Still-life with Onions* (1895–1900; Paris, Louvre). He abandoned classical perspective for good: there were no longer any vanishing lines. Ignoring single-point perspective, he contrived multiple viewpoints inside the picture space. This gave each object several facets, a process later extended by the Cubists. Subjected to multiple distortions, objects lose their spatial depth but are emphasized by wide rings of dark or red-orange colour. Tables covered with draperies or tablecloths, on which objects are set, lose their relief in relation to the other planes of the picture and appear to topple forward.

Cézanne told his dealer, Vollard, that: 'The result of art is the figure'. However, with Victor Chocquet, Vollard was one of the rare collectors to commission his own portrait from the artist. After over one hundred sittings Cézanne apparently abandoned the resulting work, *Ambroise Vollard* (1899; Paris, Petit Pal.), claiming that the only thing he was not dissatisfied with was the shirt front. His slow work rate and need for so many sittings partly explain why most of his late portraits are of anonymous figures, such as *Man with a Pipe Leaning on a Table* (1895–1900; Mannheim, Städt. Ksthalle), *Man with Folded Arms* (1895–1900; New York, Guggenheim) and the various *Card Players*. They also reflect the fact that Cézanne approached his sitters as if they were still-lifes (he wanted Vollard to sit like an apple); his prime concern was not so much their identity as the compositional problems they

presented. In his last years Cézanne also painted several portraits of *Vallier* (version, 1902–6; London, Tate), his gardener at Les Lauves. Probably his last portrait is *Self-portrait with a Beret* (*c.* 1898–1900; Boston, MA, Mus. F.A.), which is composed of large, flat areas of colour and has a complete lack of superfluous detail. He presents himself as serene and magisterial, seated against a plain background.

The culmination of Cézanne's images of bathers was the series of *Large Bathers* (London, N.G.; Merion Station, PA, Barnes Found.; Philadelphia, PA, Mus. A.). These were painted between 1895 and 1906 in overlapping periods, during which the framing, colour and background settings were altered. As with the *Card Players*, the chronology of the series is not clear, though it seems most probable that the version in the Barnes Foundation was started first, then that in the National Gallery in London and finally that in the Museum of Art in Philadelphia. This suggests datings of 1895–1906, 1900–06 and *c.* 1906 respectively (T. Reff, 1977–8 exh. cat., pp. 38–44; M. L. Krumrine, 1989 exh. cat.). Thus, in contrast to the *Card Players* series, where the number of figures was reduced, in these works the number of bathers went from 8 to 11 to 14. The compressed arrangement of figures in the first two versions gives way to the more spacious composition of the last, in which the bathers are ordered in two pyramidal groupings, a geometry echoed by the triangular vault of trees above them. The static composition in this last version creates a serenity that is further enhanced by the predominant use of blue. As in the preceding bather works, Cézanne frequently repeated the poses of the figures in this series and likewise painted them with few individual features. Contemporaneously with these large works he painted a number of smaller images of the same subject, as in *Bathers* (1895–8; Aix-en-Provence, Mus. Granet), in which many of the poses resemble those in the first of the *Large Bathers*.

In his late works Cézanne maintained his fascination for nature and at the same time sought a means to express himself through it, as he remarked to Louis Aurenche on 24 January 1904 (*Correspondance*, p. 294): 'if a strong feeling for

nature—and mine is certainly intense—is the necessary basis for any artistic concept, upon which rest the grandeur and beauty of future work, a knowledge of the means of expressing our emotion is no less essential and can only be gained through long experience'. In these works 'the objective sought is no longer to describe reality but to express a spiritual concept' (J. Rewald, 1978 exh. cat., p. 198). Cézanne's late works reveal him to be at the turning-point of two eras, of two worlds. This is especially true of the *Large Bathers*, which foreshadows Cubism, particularly Picasso's *Demoiselles d'Avignon* (1907; New York, MOMA).

2. Watercolours

Cézanne first started to use watercolour seriously in the mid-1860s, producing such works as *House in Provence* (1865–7; Paris, Louvre). Until the early 1870s he used heavy body colour, and the bold, turbulent style of these watercolours resembled that found in the oils. During his Impressionist period the medium became secondary as it was incompatible with the style used in oils, in which thick layers of carefully applied paint were used. With the advent of his 'constructive stroke' in about 1880 Cézanne realized that watercolour was unable to create the substance and volume he desired and he therefore began to use the medium more independently. From the 1880s the composition of the watercolours was rigorously arranged according to linear rhythms, reflecting Cézanne's wish to contrast the objectivity of his perception with the subjective vision of the Impressionists. In the watercolours of the last period (exhibited by Vollard in 1905) the works not only were independent of the oils but even significantly influenced the latter, and a double evolution took place, both in the system of composition and in the framing of motifs. The central importance of architectonic elements in his late works is shown by the *House on the Water's Edge* (*c.* 1898; Basle, priv. col., see Rewald, 1983, fig. 540), in which a harmonious equilibrium is established between the network of verticals of the trees and the diagonals of the roofs and shoreline.

In Cézanne's early watercolours, such as the *Battle of Love* (1875–6; Walter Feilchenfeldt priv.

col., see Rewald, 1983, fig. 60), the multiple, swirling Baroque pencil strokes are intimately blended with the watercolour. The texture is organized in diagonal, parallel brushstrokes in the direction of the shadows in such works as *Large Tree and Undergrowth* (1878-80; New York, Met.). Cézanne subsequently evolved a more elliptical style, emphasizing certain details in a calligraphic manner, and, finally, he diversified the texture to create a greater richness. He frequently applied the watercolour directly on to the sheet without preliminary pencil strokes, sometimes in broad, amorphous splashes, sometimes in fine, parallel brushstrokes. He used additional watercolour (most often blue) to emphasize subtle and curvilinear, occasionally broken, contours. The pencil lines were often added over the watercolour, sometimes parallel to the contours of the brushstroke, thus forming a double texture that brings effects of movement and reflections into play. These interplays of texture are produced sometimes by networks of pencil lines interspersed with brushstrokes (e.g. *Carafe, Bottle, Grapes and Apples*, 1906; New York, Henry and Rose Pearlman priv. col., see Rewald, 1983, fig. 642) or sometimes by multiple superimpositions, creating a much richer impression of space than could be achieved by linear perspective, as in *Pine and Rocks at Château Noir* (c. 1900; Princeton U., NJ, A. Mus.). Here, the trees and rocks are indicated with blue watercolour. Additional dabs of watercolour were then applied: clear beige and rose tonalities first, and then blues and greens over the top. The lightest colours suggest zones of light, and, in the last stage, shadows were created by a patchwork of triangular forms of pencil lines.

In such watercolours as the *Bridge at Gardanne* (c. 1885-6; New York, MOMA), Cézanne painted the motif so that it occupied the whole surface of the sheet, and the various elements were arranged in tiers of planes. Like the oils with patches of bare canvas, in his late watercolours Cézanne increasingly left areas of the paper blank, giving an impression of fullness, space and luminosity. In such works as *Rocks at Château Noir* (c. 1895-1900; New York, MOMA) the motif is localized on the sheet, occupying only the central area and the

bottom right corner. The motif seems unbalanced and devoid of spatial depth or substance as Cézanne concentrated more on the individual elements than on the illusion of space. In such other works as *Trees near a Road* (c. 1900; New York, A. Pearlman priv. col., see Rewald, 1983, fig. 507), which has substantial areas of uncovered paper, the dabs of watercolour on top of a fine pencil sketch lend the work a light texture, suggesting the circulation of air between the foliage.

In many watercolours Cézanne seems to have been concerned with capturing the effects of reflections and movement in nature. In *Pots of Flowers* (c. 1883-7; Paris, Louvre), reflections appear between the masses of leaves, while the terracotta pots and the background are enlivened by moving shadows in an almost Impressionist style. In a later watercolour of the same subject (1902-6; untraced, see Rewald, 1983, fig. 624) the reflections are enriched by an interplay of transparencies and vibrations resulting from his more elliptical, fragmented vision. These effects were developed until they resembled the reflections on coloured glass, as in such studies of undergrowth as *Trees Forming a Vault* (1904-6; New York, Rose and Henry Pearlman Foundation, priv. col., see Rewald, 1983, fig. 632). In this work the composition created by the verticals of the trees constitutes a sort of weft on which triangular dabs of watercolour and then pencil strokes are superimposed. Cézanne structured some watercolours around reflections of light, as suggested in his letter to Bernard in 1905: 'Draw, but remember: the play of light defines the object, light contains all' (*Correspondance*, p. 311). This sort of structure is evident in *River at the Bridge of the Trois Sautets* (1906; Cincinnati, OH, A. Mus.), and referring to this motif Cézanne wrote to his son Paul on 14 August 1906: 'I began a watercolour like those I did in Fontainebleau; it seems more harmonious to me; the whole thing is to put in as much consonance as possible' (*Correspondance*, p. 320). The studies of skulls set on draperies express another aspect of this pursuit. In the three works of that series (e.g. *Three Skulls*, 1902-6; Chicago, IL, A. Inst.) Cézanne was concerned, among other things, with how the reflections of the vivid hues of the

cloth play on both the surfaces of the skulls and on the background planes, which he enlivened with light, unstable, informal splashes.

The form of Tachism found in both Cézanne's late oils and watercolours reflects his refusal to 'circumscribe outlines with black' (letter to Emile Bernard, 23 Oct 1905, *Correspondance*, p. 313) in the cloisonnist manner. For example, the pots and bottles in *Kitchen Table: Pots and Bottles* (1902–6; Paris, Louvre) are evoked by masses of light, imprecise coloration in cylindrical forms. This work clearly contrasts with such still-lifes of the years 1885–7 as the *Small Green Jug* (Paris, Louvre) in which the form, the weight and the material vividly assert themselves. In several watercolours of the last period the close alliance between form and colour appears to be broken in favour of a new dissolution of forms. To this group of more informal works belongs *Study of Foliage* (1900–04; New York, MOMA), composed of a few patches of watercolour over light pencil lines. The black stripes and scratchings in pencil bear no relation to the form and contours but rather correspond to the direction of the branches and shadows. The mass of leaves is depicted as if it were an unstable fabric, without fixed contours.

Cézanne's late still-lifes, executed in alternating styles, have a great diversity that creates particularly acute problems of dating. Until the years 1890–95 the still-lifes were set in well-defined spaces, generally on tables whose edges were precisely delimited and whose backgrounds were distinctly indicated. After 1895 the support and setting sometimes became less important, while the objects themselves were emphasized using vivid coloration, as in *Apples, Pears and Casserole* (1900–04; Paris, Louvre). Sometimes objects seem to be suspended in space as in *Kitchen Table: Pots and Bottles* (1902–6; Paris, Louvre), where the pots and bottles appear to float above the surface of the table, the contours of which are invisible. The colour was applied in rapid, superimposed brushstrokes disregarding the preliminary sketch. In addition to the numerous still-lifes of this late period, Cézanne continued his prolonged study of the motif of Mont Sainte-Victoire. Like the oils, these have slightly different framings,

and the very multiplicity of the works tends to distance the subject itself. The two specific qualities of watercolour, transparency and lightness, were developed to their highest level in this series, as shown, for example, by the remarkably diaphanous *Mont Sainte-Victoire* (1900–02; Paris, Louvre) executed in a range of pale colours. In the watercolours of the last period the analysis is based on a series of contrasts, oppositions and often contradictions. A total contrast is established between the two simultaneous series of *Mont Sainte-Victoire* and of the gardener *Vallier* (e.g. *Vallier in Profile*, 1906; Chicago, IL, priv. col., see Rewald, 1983, pl. 50). In the former the watercolour is used in very diluted, broad splashes of pale colours, while in the latter the expressively sketched figure is modelled by multiple fine, curvilinear and calligraphic brushstrokes of pure colour. Thus the two series reflect the two poles of Cézanne's work: constructive synthesis and expressionistic intensity.

II. Working methods and technique

Cézanne's technique changed during the different periods of his life, and even within those periods his mode of execution varied according to the subject and the individual work. Nevertheless, though not rigidly fixed, broad changes can be discerned. In his early oils the paint is fairly thick and was laid down with rapidity and violence. Some of the early portraits, in particular, are painted in large slabs of colour in which the marks of the palette knife are evident. This gives them an extremely tactile surface texture, as in the *Man with the Cotton Cap (Uncle Dominique)* (c. 1866). Given the subject-matter of most of the early works—imaginary scenes, portraits and still-lifes—they were painted almost entirely in the studio. Under the influence of Pissarro, Cézanne began to work directly from nature in an Impressionist style. Nevertheless, while his palette brightened, several works of this period, such as *House of the Hanged Man* (c. 1873), still have a heavily encrusted surface, though the paint is applied in a more ordered, careful manner. The same qualities are evident in the portrait of *Victor Chocquet*

(1876–7), but, as Cézanne moved into his period of synthesis, the colour was applied in thin layers and the surface of the paintings became fairly smooth with little impasto. In the late period, layers of paint were often superimposed until a thick impasto of very granular paint was formed. Describing his technique, Cézanne told Maurice Denis that if he did not manage to 'render his sensations at the first try; well, I hold off on the colour, I hold off on it as long as I can. But when I begin, I always try to paint with a full brush like Manet, giving form with the brush' (M. Denis: *Théories, 1890–1910*, Paris, 4/1920, p. 257). However, some late works, such as *Cabanon de Jourdan* (1906), were painted in highly diluted oils. Others were unfinished: part of the canvas is left bare, or part of the sheet of paper is left in reserve. Such works are important as they give evidence of the underdrawing, colours and structure that Cézanne deemed essential. They also testify to his mastery of his media and to his synthetic, simplifying vision. The presence of these untouched, virgin spaces marks an important moment in his work, and one that has deeply influenced such 20th-century artists as Braque. In some paintings the untouched canvas or blank paper remains visible on three of the four sides of the work, and Cézanne seems to have concentrated only on a small area. In other cases, where patches of canvas were left untouched, it appears that Cézanne started with a network of pencil lines before applying any paint.

From the beginning of his career Cézanne produced drawings, the earliest of which (e.g. *Male Nude*, 1862; Aix-en-Provence, Mus. Granet) are in a proficient but academic mould. He continued to make pencil as well as oil sketches in later life, and though sometimes connected with finished paintings much of the work for these was done on the canvases themselves. His analytical approach to his subjects, in which he built up the image slowly, meant that his production of pictures was an extremely arduous task. For his still-lifes he used artificial flowers because of the impossibility of capturing real ones before they wilted, while for his portraits he demanded numerous sittings. He found similar difficulties when dealing with landscapes and pursued a gruelling routine of

work, setting off on foot and often painting from almost inaccessible vantage points. The struggle he felt in realizing his works led him to abandon those he thought unsatisfactory, either temporarily or altogether. In his early period especially he even destroyed paintings. His artistic problems derived more from the activity of painting itself than from the nature of the subject-matter, and this explains his concentration on a limited range of motifs, each of which required prolonged and detailed treatment to achieve resolution.

GENEVIEVE MONNIER

III. CHARACTER AND PERSONALITY

During his childhood in Aix with Zola and Baille, Cézanne displayed many of the character traits for which he became renowned in his maturity. He was temperamental, shy and introspective, this last quality often resulting in bouts of depression. He was also extremely volatile, being especially angered by any opposition to his own opinions. Throughout his life he was unwilling to engage in arguments and he consequently distrusted any theorizing about art, rigidly adhering to his own views. His abrasiveness and shyness made it hard for him to forge friendships or keep those he had. In particular, he was suspicious of his artistic peers, many of whom he disliked. He felt more at ease with those younger artists, such as Emile Bernard and Charles Camoin, who befriended him in his old age and looked on him as their 'master'. Outwardly Cézanne liked to appear as an unrefined peasant in both his dress and manners, often behaving roughly. (In later years this side of his character softened and, according to contemporaries, he became extremely polite.) This behaviour was partly linked to his desire to shock the establishment, through both his art and his personality. However, the image of the social misfit was not merely a form of posturing. Cézanne seems to have had genuine difficulties in coping with the practicalities of everyday reality, as reflected in his frequent comment: 'Life is fearful'. He had neither common sense nor business sense, and in his last years he relied increasingly on his son, Paul, to organize the more down-to-earth aspects of his life.

Though extremely proud, Cézanne had a deep lack of self-confidence and was, as a young man, unsure about pursuing a career in painting. This hesitance was aggravated by the opposition of his father, to the extent that, when he was initially prevented from moving to Paris to study, he considered giving up painting altogether. This prompted Zola to write to him in July 1860 (*Correspondance*, pp. 79–80): 'Is painting for you only a whim, which you happened to grab by the hair one day when you were bored? . . . Sometimes your letters fill me with great hope, sometimes they rob me of that and more; such as your last where you seem to me to be saying goodbye to your dreams'. This self-doubt diminished in his later years as his work progressed and his reputation grew. It was furthermore balanced by an extraordinary determination once his career was decided. Indeed his exhausting work schedule, ruthless self-criticism and obsessive treatment of the same motifs seem archetypal elements of a painter's struggle to perfect his art. Nevertheless, on 21 September 1906, a month before his death, he wrote to Bernard (*Correspondance*, p. 324): 'Will I ever achieve the goal I have sought so fervently and pursued so long? . . . I'm continuing my studies . . . I'm still painting from nature, and it seems to me that I make slow progress'.

IV. CRITICAL RECEPTION AND POSTHUMOUS REPUTATION

Until the very end of his life Cézanne received little acknowledgement or encouragement for his work. His father was unsympathetic about his choice of career and hoped he would enter his bank. He received unfriendly criticism at the time of the First Impressionist Exhibition in 1874 and especially after that of 1877 (after which time he no longer participated in group exhibitions). His works were constantly refused by those responsible for the official Salon in Paris. The only time he managed to get a work exhibited was when he had an unidentified painting entitled *Portrait of a Man* shown in 1882. This was achieved by his describing himself as a pupil of his friend Antoine Guillemet, who was on the Salon jury and could

therefore exhibit the work of one of his students. This prerogative was withdrawn the same year, and Cézanne was consequently refused at the Salon again in the following years. The final blow in his career was his break with Zola, which caused him much pain. As an art critic, Zola had rarely made much use of his access to the press to support Cézanne's work, and he considered his friend's career as a painter as a series of failures. Zola was insistently critical and even as late as 2 May 1896 published a piece (in *Le Figaro*) entitled 'Peinture', in which he described Cézanne as 'an aborted great talent'. Despite this general hostility Cézanne's work did find collectors. The first were Gachet in 1872, Chocquet in 1875, Vollard in 1894 and Durand-Ruel in 1899. In 1883 Gauguin bought two of Cézanne's pictures from the paint-maker and print-seller Julien-François Tanguy, and in 1884 Paul Signac also bought a Cézanne landscape from Tanguy. Tanguy was for a long time the only one to dare to exhibit Cézanne's works.

It was only after the exhibition organized by Vollard in 1895 that Cézanne became esteemed by such young painters as Emile Bernard, Maurice Denis and Charles Camoin and by such writers as Joachim Gasquet and Gustave Geffroy. His reputation increased thereafter. In 1900 the critic Roger Marx succeeded in having three of Cézanne's works exhibited at the Exposition Universelle in Paris, and in 1904 he wrote a glowing review of Cézanne's work at the Salon d'Automne. The latter exhibition was also greatly admired by the young Fauve painters, who were impressed by Cézanne's thickly laid paint, passionate execution and use of the palette knife. The posthumous exhibition at the Salon d'Automne in 1907 (with 56 of the artist's works) deeply influenced many painters of the new generation. His influence extended well into the 20th century, as testified by Henry Moore, who in 1922 saw the *Large Bathers* (London, N.G.) when it was still in the collection of Auguste Pellerin in Paris. He retained an unforgettable memory of the work: 'If you asked me to name the ten most intense moments of visual emotion in my life, that would be one of them' ('Discours de réception à l'Académie des Beaux-Arts, *Chron. A.*, 1259 (1973), p. 11). The late works in particular

summarize a number of artistic aspirations of the 19th century and contain the seeds of both Cubism and Fauvism. Cézanne has therefore come to be seen as the great precursor of modern painting, a perception confirmed by the large exhibitions of his late works held in New York and Houston, TX, in 1977–8 and in Paris in 1978.

□

Writings

J. Rewald, ed.: *Correspondance* (Paris, 1937, rev. 1978; Eng. trans., New York, 1984)

Bibliography

early sources

E. Zola: *Mon Salon* (Paris, 1866)

J.-K. Huysmans: 'Trois peintres: Cézanne, Tissot, Wagner', *La Cravache* (4 Aug 1888); also in *Certains* (Paris, 1889), pp. 41–3

E. Bernard: 'Paul Cézanne', *Hommes Aujourd'hui*, viii/387 (1892)

T. Natanson: 'Paul Cézanne', *Rev. Blanche*, ix (1895), pp. 496–500

F. Zola: 'Peinture', *Le Figaro* (2 May 1896)

E. Bernard: 'Paul Cézanne', *L'Occident*, vi (1904), pp. 17–30

R. Marx: 'Le Salon d'automne', *Gaz. B.-A.*, n. s. 2, xxxii (1904), pp. 458–74

E. Bernard: 'Souvenirs sur Paul Cézanne et lettres inédites', *Mercure France*, lxix (1907), pp. 385–404, 606–27

E. Faure: 'Paul Cézanne', *Portraits Hier*, 28 (May 1910); also in *Les Constructeurs* (Paris, 1914, rev. 1923)

E. Bernard: 'La Méthode de Paul Cézanne', *Mercure France*, cxxxviii (1920), pp. 289–318

——: 'La Technique de Paul Cézanne', *Amour A.* (Dec 1920), pp. 271–8

M. Denis: 'L'Influence de Cézanne', *Amour A.* (Dec 1920), pp. 279–84

E. Faure: 'Toujours Cézanne', *Amour A.* (Dec 1920), pp. 265–70

E. Bernard: 'Une Conversation avec Cézanne', *Mercure France*, cxlviii (1921), pp. 372–97

C. Camoin: 'Souvenirs sur Paul Cézanne', *Amour A.* (Jan 1921), pp. 25–6

E. Bernard: 'Les Aquarelles de Cézanne', *Amour A.* (Feb 1924), pp. 32–6

M. Denis: 'Le Dessin de Paul Cézanne', *Amour A.* (Feb 1924), pp. 37–8

E. Bernard: 'L'Erreur de Paul Cézanne', *Mercure France*, clxxxvii (1926), pp. 513–28

P. Gachet: *Souvenirs de Cézanne et de van Gogh: Auvers, 1873–1890* (Paris, 1928)

F. Novotny: 'Paul Cézanne', *Belvedere*, viii (1929), pp. 440–50

monographs

E. Bernard: *Souvenirs de Paul Cézanne et lettres* (Paris, 1912, rev. 2/1921)

A. Vollard: *Cézanne* (Paris, 1914, rev. 1919)

J. Gasquet: *Paul Cézanne* (Paris, 1921, rev. 2/1926; Eng. trans., London, 1988)

J. Meier-Graefe: *Cézanne und sein Kreis* (Munich, 1922)

G. Rivière: *Le Maître Paul Cézanne* (Paris, 1923)

E. Bernard: *Sur Paul Cézanne* (Paris, 1925)

W. George: *Les Aquarelles de Cézanne* (Paris, 1926)

R. Fry: *Cézanne: A Study of his Development* (London, 1927)

E. Faure: *Cézanne* (Paris, 1936)

R. Huyghe: *Cézanne* (Paris, 1936)

J. Rewald: *Cézanne et Zola* (Paris, 1936, rev. 1939; Eng. trans., New York, 1986)

L. Venturi: *Cézanne: Son art, son oeuvre*, 2 vols (Paris, 1936)

J. Lassaigne: *Cézanne après inventaire* (Paris, 1937)

F. Novotny: *Cézanne* (Vienna, 1937)

A. Vollard: *En écoutant Cézanne, Degas, Renoir* (Paris, 1938)

R. Cogniat: *Cézanne* (Paris, 1939)

L. Venturi: *Paul Cézanne: Aquarelles* (London, 1943; Eng. trans., Oxford, 1944)

B. Dorival: *Cézanne* (Paris, 1948)

A. Lhote: *Cézanne* (Lausanne, 1949)

M. Schapiro: *Paul Cézanne* (New York, 1953, rev. 1973)

T. Reff: *Studies in the Drawings of Paul Cézanne* (Cambridge, MA, 1958)

S. Orienti and A. Gatto: *L'opera completa di Cézanne* (Milan, 1970)

M. Hoog: *L'Univers de Cézanne* (Paris, 1971)

M. Brion: *Cézanne* (Milan, 1972)

A. Chappuis: *The Drawings of Paul Cézanne: A Catalogue Raisonné*, 2 vols (London, 1973)

A. Barskaya and E. Georgierskaya: *Paul Cézanne* (Leningrad, 1975)

M. R. Bourges: *Cézanne et son atelier* (Aix-en-Provence, 1977)

L. Venturi: *Cézanne* (Geneva, 1978)

G. Adriani: *Paul Cézanne: Der Liebeskampf* (Munich, 1980)

N. Ponente: *Paul Cézanne* (Boulogne, 1980)

G. Adriani: *Paul Cézanne: Aquarelles* (Cologne, 1981)

J. Rewald: *Paul Cézanne: The Watercolours* (Boston and London, 1983)

R. Kendall: *Cézanne by himself: Drawings, Paintings and Writings* (London, 1988)

M. Hoog: *Cézanne: 'Puissant et solitaire'* (Paris, 1989)

exhibition catalogues

Homage to Paul Cézanne (exh. cat. by J. Rewald, London, Wildenstein's, 1939)

Cézanne: Paintings, Watercolours and Drawings, a Loan Exhibition (exh. cat. by D. Catton and T. Rousseau jr; Chicago, IL, A. Inst.; New York, Met.; 1952)

Cézanne (exh. cat. by F. Novotny, Vienna, Belvedere, 1961)

Cézanne Watercolors (exh. cat. by M. Schapiro and T. Reff, New York, Knoedler's, 1963)

Watercolour and Pencil Drawings by Cézanne (exh. cat. by L. Gowing and R. Ratcliffe; Newcastle upon Tyne, Laing A.G.; London, Hayward Gal.; 1973)

Cézanne (exh. cat., ed. C. Ikegami; Tokyo, N. Mus. W. A.; Kyoto, Mun. Mus. A.; Fukuoka, Cult. Cent.; 1974)

Cézanne dans les musées nationaux (exh. cat. by M. Hoog, S. Rufenacht and G. Monnier, Paris, Mus. Orangerie, 1974)

Cézanne: The Late Work (exh. cat. by T. Reff and others; New York, MOMA; Houston, TX, Mus. F.A.; 1977–8)

Cézanne: Les Dernières Années (exh. cat. by L. Brion-Guerry, J. Rewald and G. Monnier, Paris, Grand Pal., 1978)

Cézanne (exh. cat.; Liège, Gal. St Georges; Aix-en-Provence, Mus. Granet; 1982)

Paul Cézanne: Peintures, aquarelles, dessins (exh. cat., Basle, Gal. Beyeler, 1983)

Paul Cézanne (exh. cat., Madrid, Mus. A. Contemp., 1984)

Cézanne (exh. cat.; Tokyo, Isetan Mus. A.; Kobe, Hyōgo Prefect. Mus. Mod. A.; Nagoya, Aichi Cult. Cent.; 1986)

Cézanne: The Early Years (exh. cat. by L. Gowing; London, RA; Paris, Mus. d'Orsay; Washington, DC, N.G.A.; 1988–9)

Paul Cézanne: The Bathers (exh. cat. by M. L. Krumrine, Basle, Kstmus., 1989)

Cézanne and Poussin: The Classical Vision of Landscape (exh. cat. by R. Verdi, Edinburgh, N.G., 1990)

specialist studies

J. Rewald and L. Marschutz: 'Cézanne und der Jas de Bouffan', *Forum*, 9 (1935)

—: 'Plastique et réalité: Cézanne au Château Noir', *Amour A.* (Jan 1935), pp. 15–21

C. Sterling: 'Cézanne et les maîtres d'autrefois', *La Renaissance* (May–June 1936), pp. 4–34

M. Denis: 'L'Aventure posthume de Cézanne', *Prométhée*, 20 (1939–40), pp. 193–6

R. M. Rilke: *Lettres sur Cézanne* (Paris, 1944)

J. Cassou: *Les Baigneuses* (Paris, 1947)

M. Merleau-Ponty: *Sens et non-sens* (Paris, 1948)

L. Brion-Guerry: *Cézanne et l'expression de l'espace* (Paris, 1950)

D. Cooper: 'Two Cézanne Exhibitions', *Burl. Mag.*, xcvi (1954), pp. 344–9, 378–83

L. Gowing: 'Notes on the Development of Cézanne', *Burl. Mag.*, xcviii (1956), pp. 185–92

J. Rewald: *Cézanne, Geffroy et Gasquet* (Paris, 1959)

A. Chappuis: *Les Dessins de Paul Cézanne au Musée de Bâle* (Lausanne, 1962)

W. V. Andersen: 'Watercolor in Cézanne's Artistic Process', *A. Int.*, viii (1963), pp. 23–7

M. Schapiro: 'Les Pommes de Cézanne', *Rev. A.* [Paris], 1–2 (1968), pp. 73–87

J. Rewald: 'Chocquet et Cézanne', *Gaz. B.-A.*, n. s. 5, lxxiv (1969), pp. 33–96

D. Sutton: 'The Paradoxes of Cézanne', *Apollo*, c (1974), pp. 98–107

R. Schiff: 'Seeing Cézanne', *Crit. Inq.*, iv (Summer 1978), pp. 769–808

T. Reff: 'The Pictures within Cézanne's Pictures', *A. Mag.*, lii (1979), pp. 90–104

—: 'The Severed Head and the Skull', *Arts* [New York], lviii (1983), pp. 84–100

R. Schiff: *Cézanne and the End of Impressionism* (Chicago, 1984)

J. Rewald: *Cézanne and America: Dealers, Collectors, Artists and Critics, 1891–1921* (Princeton, 1989)

GENEVIEVE MONNIER

Cham [Amédée-Charles-Henry de Noé, Comte]

(*b* Paris, 26 Jan 1818; *d* Paris, 6 Sept 1879). French caricaturist. After failing the examinations at the Ecole Polytechnique in Paris, he entered the Ministry of Finance as a trainee. He soon abandoned this career to train as an artist and entered first the studio of Nicolas-Toussaint Charlet, then that of Paul Delaroche. Under the influence of Charlet he developed his talent for making caricatures and grotesque drawings. He began his career as a caricaturist in 1839, when he published anonymously his first album entitled: *M. Lajaunisse* (Paris). In 1840, being a 'son of Noah' (Fr.: Noé), he adopted the pseudonym Cham (from Ham, Noah's son), which he first used in his third album, entitled *Histoire de M. Jobard* (Paris). In

December 1843 he joined the staff of the magazine *Le Charivari* and, from then until he died, he produced at least 40,000 designs. He also worked (1842–4) for the *Musée Philipon*, a weekly satirical publication to which Paul Gavarni, Honoré Daumier and J.-J. Grandville were also contributors. Cham's work was much appreciated in Britain, where both *Punch* and the *Illustrated London News* carried drawings by him. His designs, made in a style much influenced by Daumier and accompanied by captions, are essentially illustrations of the salons and minor social types of everyday Paris, a city he hardly ever left except for journeys to Boulogne-sur-Mer, Baden-Baden and London. Cham despised the revolutionary tenor of contemporary politics, and during the 1840s and 1850s he produced for *Le Charivari* a few series of comic, reactionary drawings, such as *P.-J. Proudhon on Tour* and *Comic History of the Assemblée Nationale*. Most of his drawings were also collected and published in such albums as *Punch à Paris* (Paris, 1850).

Bibliography

DBF

F. Ribeyre: *Cham: Sa vie et son oeuvre* (Paris, 1884)
D. Kunzle: 'Cham: The "Popular" Caricaturist', *Gaz. B.-A.* (Dec 1980), pp. 213–24

ATHENA S. E. LEOUSSI

Chaplain, Jules-Clément

(*b* Mortagne, Orne, 12 July 1839; *d* Paris, 13 July 1909). French medallist and sculptor. He entered the Ecole des Beaux-Arts in 1857; here he studied sculpture under François Jouffroy and medals under Eugène Oudiné. In 1863 he won the Prix de Rome for medal-engraving and worked in Rome from 1864 to 1868. He exhibited regularly at the Salon from 1863, receiving numerous awards. In 1881 his status as the leading French medallist was recognized by his election to the Académie des Beaux-Arts. His appointment as Art Director of the Sèvres Manufactory in 1896 and as a Commander of the Légion d'honneur in 1900 crowned a career that had been immensely successful in transforming the public perception of medallic art.

Chaplain changed public taste by moving away from the established tradition by which medallic portraits and reverse compositions emerged from a completely flat field bounded by a raised circular rim. Instead, using much lighter patinas than had been fashionable earlier in the 19th century, he incorporated the field into the composition, using it not as a neutral background but as the pictorial space in which event or portrait sitter was situated. By combining a rococo approach to the decorative qualities of clothing and drapery with a rigidly classical approach to composition, he evolved a style that was as suited to the commemoration of great state occasions, such as the *Election of Casimir Perier to the Presidency* (1894; London, BM) or the *Visit of the Tsar and Tsarina to the Paris Mint* (1896; Paris, Hôtel de la Monnaie), as it was to his numerous private portrait commissions, such as those of *Hélène Bibesco* (Paris, Bib. N., Cab. Médailles) and of *Emmanuel Bibesco* (London, V&A). At a time when technical improvements to the reducing machine greatly facilitated the production of the same medal in large and small versions, Chaplain showed an outstanding ability to produce portraits, such as that of *Victor Hugo* (1902; London, BM), and reverses that were equally effective when cast in bronze from the original model or when struck from mechanically reduced dies. He was also active as a sculptor, producing a number of busts and full-length figures, including three for the Hôtel de Ville, Paris, and as a designer of coins and porcelain plaques.

Bibliography

DBF; Forrer; Lami; Thieme–Becker
F. Mazerolle: 'J.-C. Chaplain', *Gaz. Numi. Fr.*, i (1897), pp. 7–41
M. Jones: *The Art of the Medal* (London, 1979), pp. 120–21
The Beaux-arts Medal in America (exh. cat. by B. A. Baxter, New York, Amer. Numi. Soc., 1988)

MARK JONES

Chaplin, Charles

(*b* Les Andelys, Eure, 8 June 1825; *d* Paris, 30 Jan 1891). French painter. His father was English and his mother French, and he only became a

naturalized Frenchman in 1886, although he worked in France all his life. He was a pupil at the Ecole des Beaux-Arts in Paris from 1840, and he regularly visited the studio of Michel-Martin Drolling, whose pupils included Paul Baudry, Jean-Jacques Henner and Jules Breton. In 1845 he entered the Salon as a portrait and landscape painter with his *Portrait of the Artist's Mother* (untraced). His early works, from 1848 to 1851, are characterized by a concern for realism which had been restored to fashion by the Second Republic: he painted the landscape of the Auvergne, showing a regionalism that is found also, for example, in works by Adolphe Leleux and Armand Leleux. Chaplin soon rejected this early manner in favour of a more supple and gracious style that ensured him fame as a portrait painter. His portraits of women, often half-length, with half-clad models posed slightly erotically in misty settings, appealed to society in the Third Republic and ensured his success, although his genre pictures are the most important part of his painted work. As a decorator, Chaplin painted the ceiling and panels over the doors of the Salon des Fleurs in the Tuileries in 1861 (destr.), as well as part of the decoration for the Salon de l'Hemicycle in the Palais de l'Elysée.

One of Chaplin's most famous works, *The Dream* (1857; Marseille, Mus. B.-A.), showing a young girl asleep, is painted in the manner of Jean-Baptiste Greuze; it is evidence of the enormous popularity of 18th-century painting in the 1860s. His painting *Aurora* (untraced) scandalized the Salon jury of 1859; the Comte de Nieuwerkerke, Director General of Paris museums, condemned the work, but when Napoleon III saw an engraving of it he overruled the censor. Chaplin sometimes openly drew his inspiration from 18th-century artists such as Jean-Siméon Chardin, as, for example, in *Soap Bubbles* (1864; destr.) or the *Game of Lotto* (1865; Rouen, Mus. B.-A.), a picture that became famous in its own day and that Chaplin copied several times. Chaplin left an important body of watercolours, mostly original, although he sometimes copied Rembrandt, Peter Paul Rubens and Antoine Watteau. He was made a Chevalier du Légion d'honneur in 1879.

Bibliography

F. Masson: *Charles Chaplin et son oeuvre* (Paris, 1888)

A. DAGUERRE DE HUREAUX

Chapu, Henri(-Michel-Antoine)

(*b* Le Mée-sur-Seine, Seine-et-Marne, 23 Sept 1833; *d* Paris, 21 April 1891). French sculptor. His father, a coachman, sent him to the Petite Ecole (Ecole Gratuite de Dessin), Paris, to have him trained as a tapestry-maker. In 1849 his successes led him to the Ecole des Beaux-Arts, Paris, where he became a pupil of James Pradier, François-Joseph Duret and Léon Cogniet. In 1855 he won the Prix de Rome for sculpture with the relief *Cleobis and Biton* (plaster, untraced; sketch model, Le Mée-sur-Seine, Mus. Chapu); he completed his education at the Académie de France in Rome, remaining there until 1861. During this time he lived as a virtual recluse, his only friend being the painter Léon Bonnat. The bas-relief *Christ with Angels* (plaster, 1857; Le Mée-sur-Seine, Mus. Chapu), which was the first of the works he was required to send for judgement at the Ecole des Beaux-Arts, was strongly criticized by Duret; it now appears to be one of the most sensitive sculptures of a classicizing artist, whose other Roman works included a copy of the antique *Spinario* (marble, 1858; Paris, Ecole N. Sup. B.-A.) and the much-exhibited statue of *Mercury Inventing the Caduceus* (marble, 1862–3; Paris, Mus. d'Orsay).

The Prix de Rome made Chapu eligible, on his return to France, to receive official commissions. His sculptures made to decorate public buildings included statues representing the *City of Beauvais* (stone, 1862; Paris, Gare du Nord), *Mechanical Art* (stone, 1865; Paris, Tribunal de Commerce) and *Cantata* (stone, 1866; Paris, Opéra), as well as a relief representing *Literature* (stone, 1866; Paris, Sorbonne) and many other works of a similar character. He received many private commissions for the sculptural decoration of private residences, including the Hôtel Sauvage (1862–3), the Hôtel Sedille (*c.* 1863) and the château of Chantilly, for which he carved statues of *Pluto* and *Proserpina*

(marble, 1884). He also contributed to the decoration of new commercial buildings, such as the department store Grands Magasins du Printemps, Paris, for which he made statues representing the *Seasons* (stone, 1882; plaster models, Le Mée-sur-Seine, Mus. Chapu).

Among Chapu's religious works is the marble group of *SS Germain and Geneviève* (1874–89; Arras Cathedral), intended for the Panthéon, Paris; while among his numerous fine funerary monuments are the *Effigy of the Duchess of Nemours* (1881–3; Liverpool, Walker A. G.), the elaborate and ambitious tomb of *Mgr Dupanloup* (marble, 1887; Orléans Cathedral) and the moving and lifelike effigy of *Hélène, Duchesse d'Orléans* (1885; Dreux, Orléans Chapel). He was also a superb portrait sculptor, producing large numbers of animated and characterful busts, among them that of *Alexandre Dumas the Elder* (marble, 1876; Paris, Comédie Française), one of the best-known images of the writer, and numerous bronze medallion portraits (58 in the Mus. d'Orsay, Paris), in the tradition of David d'Angers; these include the painters *Léon Bonnat* (1860), *Victor Schnetz* (1861) and *Jean-François Millet* (1884).

Chapu was perhaps most celebrated in his time for the classicizing and slightly sentimental female allegorical statues on his funerary monuments, such as *Youth* on the monument to *Henri Regnault* and the pupils of the Ecole des Beaux-Arts killed in the Franco-Prussian War of 1870–71 (marble, 1876; Paris, Ecole B.-A.), and *Truth* on the monument to *Gustave Flaubert* (marble, 1890; Rouen, Mus. B.-A.); these statues were widely reproduced in a variety of materials. His best-known work is the simple and naturalistic seated statue of *Joan of Arc at Domrémy* (plaster, Salon 1870, e.g. Rome, Villa Medici and Le Mée-sur-Seine, Mus. Chapu; bronze, Copenhagen, Øster Anlæg Park; marble, 1872; Chantilly, Mus. Condé; see fig. 17), which portrays the heroine as a peasant girl at prayer.

In 1867 Chapu was made a chevalier of the Légion d'honneur, in recognition of his works for the Exposition Universelle of that year. In 1880 he was elected to the Académie des Beaux-Arts. The sculptor and later his widow presented the

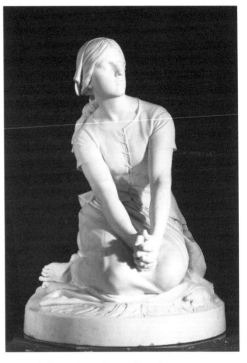

17. Henri Chapu: *Joan of Arc at Domrémy*, 1872 (Chantilly, Musée Condé, Château de Chantilly)

contents of his studio to the municipality of Le Mée-sur-Seine, where they were housed in a building paid for by public subscription. In 1977 they were rehoused in a new building. Large collections of his drawings are in the Musée du Louvre, Paris, and the Musée de Melun in Melun.

Bibliography

Lami

O. Fidière: *Chapu: Sa vie et son oeuvre* (Paris, 1894)

La Sculpture française au XIXième siècle (exh. cat., ed. A. Pingeot; Paris, Grand Pal., 1986)

A. Le Normand Romain: 'Henri Chapu: Crayon, encre et terre cuite', *Rev. Louvre*, 4 (1991), pp. 47–63

Centenaire Henri Chapu, 1833–1891 (exh. cat., ed. A.-C. Lussiez; Melun, Mus. Melun; Le-Mée-sur-Seine, Mus. Chapu; 1991)

ANNE PINGEOT

Charpentier, Alexandre(-Louis-Marie)

(*b* Paris, 10 June 1856; *d* Neuilly, Hauts-de-Seine, 3 March 1909). French sculptor, medallist and designer. After studying with the medal engraver Hubert Ponscarmé, he first exhibited at the Salon of 1879. His first significant work, exhibited in 1883, was a bas-relief, *Young Woman Suckling her Child*; the final version of this, in marble, was later ordered by the State (Aix-en-Provence, Mus. Granet). This work contained most elements of the artist's aesthetic—the choice of a familiar subject from life, treated in a natural and robust style, in the manner of Aimé-Jules Dalou. From the start Charpentier had a clear mastery of bas-relief, and his best work is in modelled reliefs—medals, small portrait medallions of great warmth and integrity (e.g. Paris, Mus. d'Orsay), mural decorations and works on a monumental scale, such as the frieze of *The Bakers*, modelled in 1889 and executed in 1897 in enamelled bricks by the firm of Muller (Paris, Square Scipion).

Charpentier exhibited with the Société Nationale des Beaux-Arts and later the Salon d'Automne, both in Paris, and from 1890 in Brussels with Les Vingt. From the early 1890s he was a key figure in the movement to revive the arts related to interior decoration and design, and one of the founder-members, with Félix Aubert, Jean Dampt, Henry Nocq and Charles Plumet, of L'Art dans tout (1896–1902). His furniture and domestic ornaments, inspired more by naturalism than Symbolism, are typical examples of Art nouveau. In both his collaborative interior design schemes, such as that for the Villa la Sapinière in Evian, Haute-Savoie (*c*. 1897–9), with Félix Bracquemond and Jules Chéret, and his individual work, such as the dining-room for Adrien Bénard (1846–1912) at Champrosay (*c*. 1901; Paris, Mus. d'Orsay), Charpentier acted more as a decorator than a sculptor, carefully creating a perfectly homogenous ensemble, down to the details of the locks and doorhandles. More than these spectacular but rare commissions, it was his innumerable decorative plaquettes in bronze, tin, ceramic, leather and embossed paper (e.g. Paris, Mus. d'Orsay) that brought him lasting success. He also turned his hand to free-standing sculpture, for instance the bust of *Linette Aman-Jean* (terracotta, 1908; Paris, Mus. d'Orsay).

Bibliography

Forrer
M. Bascou: 'Une Boiserie Art Nouveau d'Alexandre Charpentier', *Rev. Louvre*, 3 (1979), pp. 219–28 [with extensive bibliog.]
A. Pingeot, A. Le Normand-Romain and L. de Margerie: *Catalogue sommaire illustré des sculptures*, Paris, Mus. d'Orsay cat. (Paris, 1986)
C. Matthieu: *Guide to the Musée d'Orsay* (Paris, 1987), pp. 232–3

MARC BASCOU

Chatrousse, Emile(-François)

(*b* Paris, 6 March 1829; *d* Paris, 12 Nov 1896). French sculptor and writer. Born in humble circumstances, he was apprenticed to a jeweller at the age of 11. He subsequently trained with the painter Abel de Pujol (1785–1861) but seems to have taught himself the techniques of sculpture, and at the 1848 Salon he exhibited a plaster sketch of *Khair-ed-Din, called Barbarossa* (untraced). In 1851, on the advice of his patron, the Comte de Nieuwekerke, he became François Rude's last pupil. In 1853 he exhibited a plaster group of *Queen Hortense and her Son Louis Napoleon* (untraced; ex-Bagnères-de-Bigorre, Mus. A.), which brought him a commission from Louis Napoleon, by then Napoleon III, for a marble of the same group (Compiègne, Château); this was exhibited in 1855 at the Exposition Universelle, Paris. During the remaining years of the Second Empire, Chatrousse executed a number of sculptures to decorate public buildings in Paris, such as the Louvre, the Tuileries, the Hôtel de Ville and numerous churches. He exhibited works with religious and historical subjects: some of these, such as *Resignation* (marble, 1855–9; Paris, St Eustache), are characterized by a non-academic, morbid expressivity. After the Franco-Prussian War of 1870, Chatrousse used this expressivity in the service of an elegiac patriotism, most notably in the *Crimes of War* (marble, 1871–6; Nancy, Mus.

B.-A.). In the same decade he became, along with his contemporary Jules Dalou, one of the pioneers of sculptural 'modernity', exhibiting at the 1877 Salon a *Young Parisienne* (plaster dated 1876; Paris, Petit Pal.), and in 1883 a *Young Woman of Today* (marble; Condom, Mus. Armagnac).

Bibliography

Lami

The Second Empire, 1852–1870: Art in France under Napoleon III (exh. cat., ed. G. H. Marcus and J. M. Iandola; Philadelphia, PA, Mus. A.; Detroit, MI, Inst. A.; Paris, Grand Pal.; 1978–9), pp. 222–3

<div style="text-align:right">PHILIP WARD-JACKSON</div>

Chauvel, Théophile-Narcisse

(*b* Paris, 2 April 1831; *d* Paris, 28 Dec 1909). French painter and printmaker. He trained under Claude-François-Théodore Caruelle d'Aligny, Jean-Joseph-François Bellel (1816–98) and François-Edouard Picot, and in 1849 he started working at Marlotte in the forest of Fontainebleau, where he produced works such as *Trees and Rocks* (c. 1852; see Aubrun, pl. 4). He entered the Ecole des Beaux-Arts in Paris in 1854 and won the Deuxième Prix de Rome for historical landscape. In 1855 he made his début at the Salon with a landscape, *Recollection of Neuilly Park* (untraced). After 1859 he devoted himself mainly to etching. He produced original etchings in the 1860s, such as *Solitude* (1862; Paris, Bib. N.), some of which were published and some exhibited at the Salon from 1864. In 1870 he exhibited two reproductive etchings—*Storm* (1870; Paris, Bib. N.) after Narcisse Diaz, and the *Empty Path* (1869; Paris, Bib. N.) after Richard Parkes Bonington. From then on his output largely consisted of etchings after paintings by French and British artists, including Corot, Jean-François Millet, Théodore Rousseau, John Everett Millais and Benjamin Williams Leader. These were published by Galeries Goupil, Georges Petit and the London dealer Arthur Tooth; some also appeared in the *Gazette des beaux-arts*, Edouard Lièvre's *Musée universel* and Léon Gauchez's *L'Art*. Chauvel also continued to produce occasional original works such as the

Banks of the Seine (1899; Paris, Bib. N.) and exhibited at the Salon until 1904.

Bibliography

L. Delteil: *Théophile Chauvel: Catalogue raisonné de son oeuvre gravé et lithographié* (Paris, 1900)

Théophile-Narcisse Chauvel (exh. cat. by M.-M. Aubrun, Paris, Gal. Pierre Gaubert, 1976)

Chenavard, Paul(-Marc-Joseph)

(*b* Lyon, 9 Dec 1807; *d* Paris, 12 April 1895). French painter. From 1825 he studied under Louis Hersent, Jean-Auguste-Dominique Ingres and Eugène Delacroix at the Ecoles des Beaux-Arts in Lyon and Paris. At an early age he held Republican and perhaps masonic beliefs. He was a learned scholar of history, philosophy, Orientalism and mythological symbolism, but his erudition impeded clarity of thought. He was rich enough not to have to support himself by painting, and in 1827 he went to Italy, where he was particularly impressed by the art of the Florentine Renaissance. From 1828 he was associated with the German Nazarenes, who reinforced his belief in the pedagogical value of art and encouraged him to adopt a cooler, more linear style. Peter Joseph Cornelius introduced him to Georg Wilhelm Friedrich Hegel, who soon afterwards tried to interest Chenavard in his own ideas about the philosophy of history. He acquired the idea of 'palingenesis', or rebirth, from the philosopher Pierre-Simon Ballanche; this doctrine, taken from Charles Bonnet and Giambattista Vico and fashionable between 1825 and 1850, interpreted history as an ascending circular movement progressing by leaps, in contrast to the linear development from Genesis to Last Judgement in the Judeo-Christian tradition. 'Palingenesis by water' began with the Flood (or *Kataklysmos*) and ended in a holocaust, which destroyed the degenerate human race and from which the phoenix, symbol of 'renaissance' or palingenesis, would arise.

Chenavard's early paintings *Mirabeau Addressing the Marquis de Deux-Brézé* (1831) and the *Convention after the Vote on the Death*

Sentence of Louis XVI (1835; both Lyon, Mus. B.-A.) depict scenes from French revolutionary history in a broad Romantic style. Two religious paintings followed, the *Martyrdom of St Polycarpus* (exh. Salon 1841; Argenton-sur-Creuze) and the *Resurrection of the Dead* (1842–5; Bohal Church), and at the Salon of 1846 he exhibited the *Inferno* (Montpellier, Mus. Fabre), inspired by Dante and painted in the style of Michelangelo. A close friend of Louis Blanc (1811–82) and Charles Blanc and a supporter of the 1848 Revolution, Chenavard was given an unrivalled opportunity to visualize his complex philosophy when, in a decree of 11 April 1848, Alexandre-Auguste Ledru-Rollin (1807–74), already his patron, appointed him to decorate the walls and floors of the Panthéon in Paris. Chenavard's plan was to depict the unfolding progress of history according to Hegel, from chaos to the present. Forty panels around the walls were to depict the history of man from Adam and Eve to Napoleon Bonaparte, and above these scenes he planned a frieze showing great men from all periods. Under the great dome he intended to install a circular mosaic floor covering 500 sq. m and representing 'universal palingenesis'. This would illustrate the past, present and future of mankind; being a pessimist he foresaw the latter as decadence arising from the profit motive and the Americanization of French society. From the evidence of the surviving cartoons (e.g. the *Social Palingenesis*, exh. 1855; Lyon, Mus. B.-A.) and engravings made after them the style was extremely eclectic (with much borrowing from Michelangelo) and coldly severe: grisaille was preferred throughout. The syncretism and the masonic conception of the project appealed to the provisional government. It also fascinated leading critics, notably Théophile Gautier, Théophile Silvestre (1823–76) and Charles Baudelaire, although it is doubtful whether anyone fully understood all its subtleties. Chenavard worked on the scheme for four years until it was cancelled by the decree of 6 December 1851 restoring the Panthéon to the Catholic Church, which considered Chenavard's programme overtly anticlerical.

Chenavard exhibited only one other work, the *Divine Tragedy* (exh. Salon 1869; Paris, Mus. d'Orsay), a huge canvas painted in Rome which depicts the Fall, the ordeals, the victory of the 'Eternal Androgyne' and the return to unity in divine light. Despite a detailed explanation in the Salon catalogue of the subject, which was based on the ideas of the philosopher Louis-Claude de Saint-Martin (1743–1803), the painting was greeted with incomprehension. Chenavard made further plans for the decoration of the great staircase of the Musée des Beaux-Arts in Lyon, but the clearer design by Pierre Puvis de Chavannes was preferred. An artist always more interested in ideas than execution, Chenavard died a forgotten and disappointed man.

Bibliography

C. Sloane: *Paul-Marc-Joseph Chenavard, Artist of 1848* (Chapel Hill, 1962)

Paul Chenavard et la décoration du Panthéon de 1848 (exh. cat. by M.-A. Grunewald, Lyon, Mus. B.-A., 1977)

M.-A. Grunewald: 'La Palingénésie de Paul Chenavard', *Bull. Mus. & Mnmt Lyon.*, vi (1980), pp. 317–43

—: 'La Théologie de P. Chenavard: Palingénésie et régénération', *Romantisme et religion*, ed. M. Baude and M.-M. Münch (Paris, 1980), pp. 141–52

—: [Paul Chenavard] (diss., U. Paris IV, 1985)

—: 'Paul Chenavard et la donation Dufournet', *Rev. Louvre*, xxxvi (1986), pp. 80-86

<div align="right">MARIE-ANTOINETTE GRUNEWALD</div>

Chéret, Jules

(*b* Paris, 31 May 1836; *d* Nice, 23 Sept 1932). French lithographer, poster designer and painter. Chéret's formal training in art was limited to a course at the Ecole Nationale de Dessin, Paris, as a pupil of Horace Lecoq de Boisbaudran. More important for his future as a poster artist were his apprenticeships with lithographers from the age of 13. He created his first poster, *Orpheus in the Underworld*, for the composer Jacques Offenbach in 1858; this, however, did not lead to further commissions, and he went to London where he designed book covers for the publishing firm of Cramer as well as several posters for the circus, theatre and music halls. These efforts led him to work for the perfume manufacturer Eugène Rimmel, who in 1866 supported Chéret's

establishment of a commercial colour lithographic shop in Paris. First working in one or two colours, in 1869 Chéret introduced a new system of printing from three stones: one black, one red and the third a 'fond gradué' (graduated background, achieved by printing two colours from one stone, with cool colours at the top and warm colours at the bottom). This process was the basis of his colour lithographic posters throughout the 1870s and early 1880s; later, when the format of posters had grown to life-size, his colour schemes became much more elaborate and varied. By 1881 his work had become so popular, and he had become so financially successful, that he was able to transfer the responsibility of his shop to Chaix & Company while maintaining artistic control.

Chéret's reputation as the father of the colour lithographic poster was grounded in his innovative use of lithography for posters. Primarily because of his combination of artistry and technique, the medium became respectable in the art world. He created over a thousand poster designs promoting a great variety of products, performances, theatres, nightclubs, journals, exhibitions and books, as well as lithographic book covers, illustrations and, in 1891, four works described as decorative posters, which advertised no products but were framed and hung like paintings. Among his most important early works are the poster produced in 1874 for the dance hall Frascati (his first large-scale work) and *Les Girard* (1877), whose integration of text with image makes it one of the most stylistically advanced posters of the 19th century. His posters of the 1890s include *Saxoléine* and *Palais de glace*, both of which typify Chéret's romantic vision of *fin-de-siècle* women (the 'chérettes', as they came to be called), while *Bal du Moulin Rouge* (1889) and *Loïe Fuller* (1893) precede and relate directly to the same subjects of his younger colleague Toulouse-Lautrec.

While Chéret's greatest contribution is in poster art, he also produced paintings, pastels and murals. From 1898 he worked on murals for the Hôtel de Ville, Paris, for the Exposition Universelle of 1900 (completed in 1903). Soon afterwards he painted murals for the Salon des Fêtes of the Préfecture of Nice. Chéret's murals, like his posters, reveal the strong influence of the Rococo aesthetics of Antoine Watteau and Jean-Honoré Fragonard and of the paintings of Giambattista Tiepolo. It was this 18th-century style that separated Chéret from his younger colleagues; nevertheless his influence on them in subject-matter, in medium and in the use of art within the advertising world was substantial. He inspired a younger generation of artists, including among many others Pierre Bonnard, Toulouse-Lautrec, Théophile-Alexandre Steinlen and Alphonse Mucha, to create posters in the 1890s. During this period posters of great aesthetic importance produced, notably Toulouse-Lautrec's *Moulin Rouge, la Goulue* (1891) and Bonnard's *La Revue blanche* (1894), which can be equated with Post-Impressionist experiments in paint. Chéret was highly regarded by young avant-garde artists and often participated with them in exhibitions and publications. Toulouse-Lautrec paid special homage to him when he was photographed in front of the latter's poster of 1889 for the Moulin Rouge with his hat removed as a sign of respect.

In 1889 Chéret became a founder-member of the Société des Peintres-graveurs. He exhibited in Brussels with Les XX in 1891, and in 1893 created a lithograph for André Marty's important album *L'Estampe originale* (1893–5). He retired to Nice in 1898, and the Musée des Beaux-Arts (Musée Jules Chéret) there holds a large collection of his paintings and pastels.

Jules Chéret's younger brother, Gustave-Joseph Chéret (1838–94), was a sculptor and ceramic artist. He was a pupil of Albert-Ernest Carrier-Belleuse and produced designs for several manufacturers, including the Cologne furniture manufacturer Pallemberg (c. 1870). He also made models for the Sèvres porcelain factory, of which he was artistic director from 1886 to 1887.

Bibliography

E. Maindron: *Les Affiches illustrées* (Paris, 1886)

——: *Les Affiches illustrées, 1886–1895* (Paris, 1896), pp. 193–242

C. Mauclair: *Jules Chéret* (Paris, 1930)

*The Color Revolution: Color Lithography in France,
1890–1900* (exh. cat. by P. D. Cate and S. H. Hitchings,
New Brunswick, NJ, Rutgers U., Zimmerli A. Mus.;
Baltimore, MD, Mus. A.; Boston, MA, Pub. Lib.; 1978–9),
pp. 3–4, 10–15, 110–12

L. Broido: *The Posters of Jules Chéret* (New York,
1980)

*Le Triomphe des mairies: Grands décors républicains à
Paris, 1870–1914* (exh. cat., Paris, Petit Pal., 1986–7),
pp. 445–9

PHILLIP DENNIS CATE

Chifflart, François(-Nicolas)

(*b* Saint-Omer, Pas de Calais, 21 March 1825; *d*
Paris, 19 March 1901). French printmaker and
painter. He was admitted to the Ecole des Beaux-
Arts in Paris in 1844 and two years later he became
a pupil of Léon Cogniet. In 1850 he won third prize
in the Prix de Rome competition with *Zenobia on
the Banks of the River Araxes* (untraced; sketch
Paris, priv. col., see 1972 exh. cat., no. 3). The next
year he won the Prix de Rome with an equally clas-
sical and academic Salon machine, *Pericles at the
Deathbed of his Son* (Paris, Ecole N. Sup. B.-A.). At
the Salon of 1859 his drawings *Faust in Combat*
and *Faust at the Sabbat* (untraced; lithographed
reproductions, London, V&A) were admired by
Charles Baudelaire and Théophile Gautier. In the
same year his brother-in-law, Alfred Cadart, pub-
lished an album, *Oeuvres de M. Chifflart, Grand
Prix de Rome*, a copy of which was presented to
Victor Hugo.

In 1862 Chifflart became a founder-member of
the Société des Aquafortistes and continued to
pursue his interest in printmaking. In 1865 he pro-
duced what is often considered his masterpiece,
the *Improvisations on Copper*, in which may be
found all his strengths and weaknesses as an
artist. His work was always eclectic, abounding in
often ill-digested references to other artists, par-
ticularly Michelangelo, but there is always a dis-
tinctive quality in his inventions, which makes his
images memorable. J. Hetzel and A. Lacroix's
edition of Hugo's *Les Travailleurs de la mer*, con-
taining 70 illustrations by Chifflart, appeared in
1869. In this work the powerful brooding grandeur

of Hugo's imagination finds perfect expression
in Chifflart's claustrophobic and intense illustra-
tions. In 1868 Hugo wrote to Auguste Vacquerie:
'Chifflart has made a supreme success with the
illustrations to *Les Travailleurs de la mer*, above
all in expressing its terrible aspect'. These illus-
trations remain some of the most familiar visual
counterparts to Hugo's work. They may also have
influenced some of the work of Odilon Redon.
Chifflart continued to be influenced by Hugo in
his Salon exhibits (e.g. *Esmeralda and Gaston
Phoebus*; Saint-Omer, Mus. Hôtel Sandelin) but
with no critical success, and his portrait of the
writer (exh. 1868; Paris, Mus. Victor Hugo)
attracted little attention.

At the Salon of 1863 Chifflart once again
attempted to establish his reputation as a history
painter with *David Victorious* (Saint-Omer, Mus.
Hôtel Sandelin), which received a mixed response
from the critics. He was awarded the commission
to decorate the ceiling of the Cercle International
for the Paris Exposition Universelle of 1867
(untraced, ?destr.), which gave him hope of further
ambitious projects, but no such commissions
resulted. His relationship with the world of offi-
cialdom, never easy, became strained. He with-
drew into himself, becoming more bitter and
intransigent as he grew older.

The main characteristics of Chifflart's essen-
tially conservative style are a recherché academi-
cism mingled with a romanticism reminiscent of
Gustave Doré. In his successful work he managed
to create images of startling power drawn in a
free calligraphic manner, giving the impression of
being improvised directly on the plate. Each is
imbued with a fatal melancholy, which also char-
acterized the artist's life.

Bibliography

C. Tardieu: 'Un Improvisateur sur cuivre', *L'Art*, viii–x
(1877), pp. 199–202, 217–22, 249–54

H. Béraldi: *Les Graveurs du XIXe siècle*, v (Paris, 1886), p. 8

L. Viltart: 'F. N. Chifflart', *L'Artiste*, n. s., xiv (Aug 1897),
pp. 91–6; (Sept 1897), pp. 186–201

François-Nicolas Chifflart, 1825–1901 (exh. cat., ed. P. G.
Chabert; Saint-Omer, Mus. Hôtel Sandelin, 1972)

MICHAEL HOWARD

Chintreuil, Antoine

(*b* Pont-de-Vaux, Ain, 15 May 1814; *d* Septeuil, Seine-et-Oise, 8 Aug 1873). French painter. He grew up in Bresse and in 1838 moved to Paris, where in 1842 he joined the studio of Paul Delaroche. Through the landscape painter Léopold Desbrosses (*b* 1821), in about 1843 Chintreuil met Corot, who became his true teacher and encouraged his inclination towards landscape painting. Following Corot's advice Chintreuil began to paint *en plein air*. During the early part of his career the art critic Champfleury and the songwriter Pierre-Jean de Béranger (1780–1857) befriended Chintreuil and gave him great support. Béranger helped him financially by buying some of his paintings and persuading the French government to purchase others, such as *Pool with Apple Trees* (exh. Salon 1850; Montpellier, Mus. Fabre).

Chintreuil's work can be divided into three main periods. The first period (*c.* 1846–1850) mainly consists of views of the immediate environs of Paris, especially Montmartre, as in *Study of Montmartre* (Douai, Mus. Mun.) and the *Hill of Montmartre*. The latter was, in 1847, his first successful submission to the Salon following a series of rejections. The second period began in 1850 when Chintreuil settled at Igny, in the valley of the River Bievre, south-east of Paris, to study nature and render his 'impressions'. In 1850 he also met Charles-François Daubigny and sometimes painted in Barbizon. Chintreuil spent about seven years at Igny in the company of his friend and pupil Jean-Alfred Desbrosses (1835–1906), the brother of Léopold. He made numerous studies of trees and painted such views of the woods, forests and villages of the area as *Landscape with Ash* (Cambridge, Fitzwilliam) and the *Roqations at Igny* (1853; Bourg-en-Bresse, Mus. Ain).

The beginning of the third and final period is marked by Chintreuil's move in 1857 to La Tournelle-Septeuil near Mantes-la-Jolie, in the Seine valley, where he died, and this period is generally recognized as that of the full maturity of his talent. It was also around this time that critics started noticing his work, Frédéric Henriet being the first to devote an article to him, in the magazine *L'Artiste* in 1857. During this third period

Chintreuil produced no less than 250 paintings, the majority of his landscapes. Completely freed from all artifice, and faithful to his 'impressions', his palette became lighter in tone, and he used glazes to enhance the fluidity of the paint. His subjects were the great, wide spaces of the Seine valley and the subtly changing tones and colours of the sky and of the receding planes when the sun dawns and sets. He also painted mists and rain, as in *Rain and Sun* (exh. Salon 1873; Paris, Mus. d'Orsay).

Chintreuil's compositions are open and simple, and his brushwork is broad and summary. Avoiding details he built up iridescent masses and volumes, as is shown in *Space* (exh. Salon 1869; Paris, Mus. d'Orsay). His interest in light effects and in rendering his 'impressions' of nature make him, along with Eugène Boudin, Johan Barthold Jongkind and the Barbizon painters, a precursor of the Impressionists (in 1859 he met Camille Pissarro). Towards the end of his career Chintreuil produced a few marine paintings. In 1861 he went to Fécamp where he made a series of studies of the sea, such as the *Sea at Sunset: Fécamp* (Bourg-en-Bresse, Mus. Ain). In 1869 and 1872 he spent some time in Boulogne-sur-Mer, producing such works as the *Hamlet and Dunes of Equihem: The Environs of Boulogne* (Pont-de-Vaux, Mus. Chintreuil).

Bibliography
Bellier de La Chavignerie–Auvray; *DBF*

Antoine Chintreuil (exh. cat., ed. G. Pillement; Pont-de-Vaux, Salle Fêtes; Bourg-en-Bresse, Mus. Ain; 1973)

P. Miquel: *Le Paysage français au XIXe siècle, 1824–1874: L'Ecole de la nature*, iii (Maurs-La-Jolie, 1975), pp. 646–63

L. Harambourg: *Dictionnaire des peintres paysagistes français au XIXe siècle* (Neuchâtel, 1985)

ATHENA S. E. LEOUSSI

Christophe, Ernest-Louis-Aquilas

(*b* Loches, Indre-et-Loire, 15 Jan 1827; *d* Paris, 14 Jan 1892). French sculptor. He studied under François Rude, whom he assisted in the execution of the tomb of *Godefroy de Cavaignac* (1845–7;

Paris, Montmartre Cemetery). In a relatively small number of works, which often took many years to complete, Christophe rendered in sculpture literary conceits usually derived from contemporary poets. In his turn he provided subjects for *Le Masque* and *Danse macabre* from Charles Baudelaire's *Fleurs du mal*, the former being inspired by Christophe's allegorical statue *The Human Comedy* or *The Mask* (*c*. 1859; marble, exh. Salon 1876; Paris, Mus. d'Orsay). The effect of this statue changes according to viewpoint, a smiling mask concealing from certain angles the figure's own anguished head. It was followed by a more conventional piece, *Fate* (bronze; Bagnères-de-Luchon, Jard. Pub.), first conceived around 1875 and exhibited at the Salon of 1890; this anachronistic-looking allegory, whose iconography was taken from verses by Charles-Marie-René Leconte de Lisle, was intended as a reflection on Darwin's theory of evolution. Christophe's last work, *The Sphinx* or *The Supreme Kiss* (marble; Le Mans, Mus. B.-A.), exhibited posthumously at the Salon of 1892, shows a young man in a terminal embrace with a sphinx or chimera. Christophe's own grave in the Batignolles Cemetery is marked by a reduced version of his massive figure of *Grief*, which had been shown at the Paris Exposition Universelle of 1855.

Bibliography

Lami
E. F. S. Dilke: 'Christophe', *A.J.* [London] (1894), pp. 40–45
C. Baudelaire: 'Salon de 1859', *Oeuvres complètes* (Paris, 1961), pp. 1025–98

PHILIP WARD-JACKSON

Cibot, (François-Barthélemy-Michel-) Edouard

(*b* Paris, 11 Feb 1799; *d* Paris, 10 Jan 1877). French painter. He entered the Ecole des Beaux-Arts in Paris in 1822, studying with Pierre Guérin and François-Edouard Picot. Between 1827 and 1838 he exhibited small-scale literary genre scenes or historical works in the *juste-milieu* style, in which poignant incidents are enacted in authentic costume. *Waverley Falling Down in Ecstasy upon Hearing Flora Mac-Ivor Improvising on her Harp* (*c*. 1827; untraced; preparatory sketch in French priv. col.) was inspired by Walter Scott's novel *Waverley* (1814) and quoted François Gérard's *Corinna at Cape Misenum* (1819; Lyon, Mus. B.-A.). *Anne Boleyn in the Tower of London in the First Moments of her Arrest* (exh. Salon 1835; Autun, Mus. Rolin) owes its composition to Paul Delaroche's *Execution of Lady Jane Grey* (exh. Salon 1834; London, N.G.) and its subject to Gaetano Donizetti's opera *Anna Bolena* (first Paris performance in 1831). He also painted scenes from French history, such as *Fredegonde and Pretextatus* (exh. Salon 1833; Rouen, Mus. B.-A.) and the *Funeral of Godefroy de Bouillon on the Day of Calvary (January 1100)* (exh. Salon 1839; Versailles, Mus. Hist.); and, from the lives of great artists, he painted *Perugino Giving a Lesson to Raphael* (exh. Salon 1839; Moulins, Mus. Moulins).

Cibot's visit to Italy in 1838–9 marked a turning-point in his career. Thereafter he produced religious paintings and landscapes (encouraged by his friend Adrien Dauzats). *View at Bellevue, near Meudon* (1852; Paris, Louvre) and *Pit near Seine-Port (Seine-et-Marne)* (1864; Rochefort-sur-Mer, Mus. Mun.) are naturalistic studies of light and foliage. A group of 11 paintings described manifestations of charity for the choir of the church of St Leu, Paris (1846–66; destr.). In 1863 Cibot was awarded the Légion d'honneur.

Bibliography

DBF
M. Lapalus: *Le Peintre Edouard Cibot, 1799–1877* (diss., U. Dijon, 1978)
The Second Empire, 1852–1870: Art in France under Napoleon III (exh. cat. by A. Jolles, F. Cummings and H. Landais, Philadelphia, Mus. A.; Detroit, Inst. A.; Paris, Grand Pal.; 1978–9), pp. 270–71
M. Lapalus: 'Le Sejour romain du peintre d'histoire, Edouard Cibot', *Actes du colloque international Ingres et son influence: Montauban, 1980*, pp. 189–203
B. Wright: 'Scott's Historical Novels and French Historical Painting, 1815–1855', *A. Bull.*, lxiii (1981), pp. 268–87
M. Pinette: 'Autun, Musée Rolin: *Anne de Boleyn* par Edouard Cibot', *Rev. Louvre*, xxxiii (1983), pp. 429–30

Un Certain Charme britannique (exh. cat. by B. Maurice, M. Geiger and A. Strasberg, Autun, Mus. Rolin, 1991)

Les Salons retrouvés: Eclat de la vie artistique dans la France du Nord, 1815–48 (exh. cat. by A. Haudiquet and others, Calais, Mus. B.-A; Dunkirk, Mus. Mun.; 1993), ii, p. 33

BETH S. WRIGHT

Ciceri, Eugène

(*b* Paris, 27 Jan 1813; *d* Marlotte, Fontainebleau, 22 April 1890). French painter and lithographer. After training with his father Pierre-Luc-Charles Ciceri (1782–1868), the scene designer for the Opéra in Paris, he decorated the theatre at Le Mans in 1842 under his influence. He was, however, mainly known as a landscape painter and first exhibited at the Salon in 1851. He painted *Landscape* (1850; Blois, Mus. Mun.), which was executed in the style of Corot and such Barbizon artists as Charles-François Daubigny, Jules Dupré, Paul Huet and Narcisse Diaz, whose fluffy brushstroke and buttery impasto he adopted. He worked at Barbizon (at the spot known as 'La Belle Marie') and also around Fontainebleau, the Seine and the Marne, where he produced a beautiful view of the *Banks of the Marne* (1869; Chalon-sur-Saône, Mus. Denon). He also painted several landscapes of Paris, among them a *View of the Moulin de la Galette in Montmartre* (undated; Paris, Carnavalet). As a lithographer he sometimes worked in collaboration with Alfred Dedreux and from 1835 helped to illustrate *Voyages pittoresques et romantiques dans l'ancienne France* (24 vols, Paris, 1820–78), written by Isidore-Justin-Séverin Taylor, Charles Nodier and Alphonse de Cailleux, in particular the volume devoted to Brittany in 1845. He also illustrated *Souvenirs d'Egypte* (Paris, 1851), by Alexandre Bida and E. Bardot, and Victor Fournel's *Paris et ses ruines en mai 1871* (Paris, 1871).

Writings

Cours d'aquarelle (Paris, 1878)

Bibliography

Bénézit; *DBF*; Thieme–Becker

L. Delteil: 'Eugène Ciceri: Catalogue de son oeuvre lithographique', *L'Artiste* (1891), pp. 216–21

A. DAGUERRE DE HUREAUX

Clairin, (Jules-)Georges(-Victor)

(*b* Paris, 11 Sept 1843; *d* Belle-Ile-en-Mer, Morbihan, 2 Sept 1919). French painter. In 1861 he entered the Ecole des Beaux-Arts in Paris, where he studied with François Picot and Isidore Pils. He sent the first of many contributions to the Salon in 1866, an *Episode of a Conscript of 1813* (untraced). By 1868 he had joined the painter Henri Regnault in a visit to Spain, where he was evidently impressed by Moorish architecture and influenced by the Spanish Orientalist painter Mariano Fortuny y Marsal; Clairin's *Volunteers of Liberty: Episode from the Spanish Revolution* (untraced) was exhibited at the Salon of 1869. From Spain, Clairin and Regnault travelled to Tangier, where Clairin made a close study of local costume and constructed a house and studio in partnership with Regnault.

Clairin was one of the last successful practitioners of Orientalist painting. At the Salon of 1874 he showed watercolour views of Granada and of Tangier as well as a large painting of a historical subject, the *Massacre of the Abencerages at Granada* (Rouen, Mus. B.-A.). The theme had been treated in Chateaubriand's novel *Les Derniers des Abencérages* (1826). The preoccupation of Clairin and his circle with lurid, vividly detailed Moorish historical themes may have been inspired by such Romantic works as Delacroix's *Entry of the Crusaders into Constantinople* (1840; Paris, Louvre).

During the 1870s Clairin played a significant role in the decoration of the Paris Opéra: ceiling paintings of *String Instruments* and *Wind and Percussion Instruments* for the small salons at either end of the Grand Foyer; part of the series of decorative panels of the *Months* (1878) in the Glacier; and a large ceiling painting of a *Bacchanal* (1889) in the Rotonde du Glacier, a setting for private receptions. Compared with Isidore Pils's rather stiff, formal decorations for the Grand Staircase, Clairin's paintings have a lightness and energy more in keeping with the

mood of the Opéra. The *Bacchanal* in particular is colourful, realistic and abundantly sensual. Clairin executed other large decorative commissions for public buildings in Cherbourg, Tours and Monte Carlo. He also painted landscapes and portraits of women from society and the theatre, in particular Sarah Bernhardt, whom he portrayed in various roles (e.g. 1876; Paris, Petit Pal.).

Clairin's later Orientalist pieces, such as *Entering the Harem* (Baltimore, MD, Walters A.G.), display an excessive interest in costume and décor that is probably related to his experience as a painter of theatrical subjects. Clairin did not return to North Africa or the Near East, and his later paintings of female subjects (e.g. *The Peacocks*, c. 1890; Paris, priv. col.) are essentially costume studies relating more to the conventions of the Parisian stage than to the actuality of Muslim daily life.

Clairin won numerous academic awards and was given a major retrospective exhibition in Paris in 1901. He continued to submit large Orientalist canvases to the Salon of the Société des Artistes Français until World War I. He is now regarded as a talented, though somewhat facile and conservative, adherent of the long-lived Romantic school of Orientalist genre and history painting.

Bibliography

P. Julien: *The Orientalists* (Oxford, 1977)
J. Foucart and L.-A. Prat, eds: *Les Peintures de l'Opéra de Paris: De Baudry à Chagall* (Paris, 1980)
Orientalism: The Near East in French Painting, 1800–1880 (exh. cat., U. Rochester, NY, Mem. A.G., 1982), pp. 85–7

DONALD A. ROSENTHAL

Claudel, Camille

(*b* Fère-en-Tardenois, Aisne, 8 Dec 1864; *d* Villeneuve-lès-Avignon, Gard, 19 Oct 1943). French sculptor, painter and draughtswoman. Her nascent interest in sculpture was fostered at Nogent-sur-Seine by a local sculptor, later highly successful, Alfred Boucher. She came to share with Boucher a taste for symbolic figure groups with philosophical messages. Her earliest extant works were executed after 1881, when Mme Claudel and her children moved to Paris, and Camille started to attend the Académie Colarossi. These were portrait heads and busts of the family and friends, such as *Paul Claudel Aged 13* (bronze, 1881; Châteauroux, Mus. Bertrand).

It was probably in 1882 that Camille Claudel met and became a student of Auguste Rodin. Their relationship, which developed into a passionate affair lasting until 1898, first transformed her work, then undermined her sense of artistic identity, and may finally have contributed to the severe persecution mania from which she suffered; in the meantime, the period of their liaison corresponded with the bulk of Rodin's work on the *Gates of Hell* (1880–1900; e.g. Paris, Mus. Rodin). The precise degree of collaboration is not demonstrable, but comparisons of the two artists' works in these years provide a glimpse of a rare artistic symbiosis. Claudel's bust of *Rodin* himself (versions in plaster and bronze, 1888–92; Paris, Mus. Rodin) shows the extent to which she adopted the master's craggy modelling style. In more imaginative pieces, she veered between the sensuous abandonment of the *Çacountala* (original plaster, 1888; Châteauroux, Mus. Bertrand; bronze version, 1905; Paris, Mus. Rodin) and the excoriating autobiographical symbolism of *Maturity*, an ambitious three-figure group that went through two versions, before and after the break with Rodin (first version, plaster, 1894–5; Paris, Mus. Rodin; second version, bronze, 1899; Paris, Mus. Rodin and Paris, Mus. d'Orsay). The themes of desire, regret and physical decay are those found also in Rodin's *Gates*, and Camille Claudel's own physical features figure frequently in Rodin's works of these years, notably in *Thought* (marble, 1886–9; Paris, Mus. d'Orsay). Starting in the final years of her relationship with Rodin, Claudel experimented with small figures and groups within a setting, either architectural or natural, as in *The Conversationalists* (version in onyx and bronze, 1897; Paris, Mus. Rodin) or *The Wave* (onyx and bronze, 1898; priv. col., see Paris, pls 45–6).

As a draughtswoman, during the 1880s Claudel executed numerous strongly modelled portrait heads in charcoal, revealing a social-realist interest held in common with her friend the painter

Léon Lhermitte. Representative of this type is *Woman from Gérardmer* (charcoal and chalk on paper, 1885; Honfleur, Mus. Boudin). By contrast, among her few surviving paintings, *Dead Girl with Doves* (oil on canvas, 1898; priv. col., see Paris, pls 40–41) is an excursion into poetic symbolism. Claudel's last ambitious sculpture, *Perseus and the Gorgon* (marble, 1898–1905; Paris, Mus. Rodin), in which the Gorgon's head is a self-portrait, indicates a decline in her executive powers. By 1913 her mental state and eccentric lifestyle led her family to have her interned in an asylum. Transferred in 1914 to a 'home' at Montdevergues, she remained there for the rest of her life.

Bibliography

M. Morhardt: 'Mlle. Camille Claudel', *Mercure France* (March 1898), pp. 709–55

R.-M. Paris: *Camille Claudel, 1864–1943* (Paris, 1984); Eng. trans. as *Camille* (London, 1988)

Camille Claudel (exh. cat. by B. Gaudichon, Paris, Mus. Rodin, 1984) [includes cat. rais.]

F. V. Grunfeld: *Rodin, a Biography* (New York, 1987)

L'Age mûr de Camille Claudel: Les Dossiers du Musée d'Orsay (exh. cat., ed. A. Pingeot; Paris, Mus. d'Orsay, 1988)

PHILIP WARD-JACKSON

Clésinger, (Jean-Baptiste) Auguste

(*b* Besançon, 20 Oct 1814; *d* Paris, 5 Jan 1883). French sculptor and painter. In 1832 his father, the sculptor Georges Philippe Clésinger (1788–1852), took him to Rome, where he was the pupil of the sculptor Bertel Thorvaldsen and the architect Gaspare Salvi (1786–1849). His travels around Europe took him to Paris for the first time in 1838, Switzerland (1840) and Florence (1843) and again to Paris in 1845. In 1847 he married Solange Dudevant, daughter of the novelist George Sand, separating from her in 1852; he was later charged with bigamy. In 1849 Clésinger was appointed Chevalier du Légion d'honneur and Officier in 1864. He joined the Photosculpture society in 1864 and organized public sales of its works in 1868 and 1870. Clésinger led a disordered and reckless existence, weighed down with unfulfilled commissions and reproachful letters from successive administrations. He supported his grand lifestyle with bursaries, including one obtained from the state. He was, however, an instinctive, sensual sculptor and an outstanding craftsman in marble, skillfully exploiting his popularity commercially: the manufacturer Ferdinand Barbedienne bought the rights to his sculptures in advance in order to reproduce them in a range of materials and sizes. Marnyhac also ensured, after 1870, diffusion of his work.

Clésinger's best-known work, the *Woman Bitten by a Snake* (1847; Paris, Mus. d'Orsay; see fig. 18), brought him both fame and scandal, being allegedly the 'portrait' of Appolonie-Aglaé Sabatier, the 'muse and madonna' of the poet Charles Baudelaire. Her lover, a banker, had asked Clésinger to cast the piece from life; shown at the Salon of 1847, the work heralded the thirst for pleasure that accompanied the economic expansion of the Second Empire (1852–70). Self-interest caused Clésinger to support all the regimes in France during the 19th century: for the Second Republic (1848–52) he sculpted *Liberty* and *Fraternity* (both 1848; destr.); for Napoleon III, he sculpted, on the occasion of the birth of the Prince Imperial, the *Infant Hercules Strangling the Snakes of Envy* (1857; destr., scale model; Paris, Mus. d'Orsay); and for the Third Republic (1870–1940) a colossal seated figure of the *Republic* (1878; destr.).

Despite the quality of Clésinger's work, few of his sculptures are exhibited outside. The one exception, *Louise of Savoy, Regent of France, Mother of Francis I* (1847), commissioned by King Louis-Philippe, is in the garden of the Palais du Luxembourg, Paris. Clésinger's equestrian statue of *Francis I* (1853–5; destr.), for the Cour Carrée of the Louvre, is now known only from engravings and photographs (Paris, Archvs N.), notably those by Edouard-Denis Baldus. Of four equestrian statues of French generals commissioned under the Third Republic for the façade of the Ecole Militaire in Paris, only the bronze *Marceau* and *Kléber* (both *c.* 1882; Coëtquidan, Ecole Mil. St Cyr) have survived.

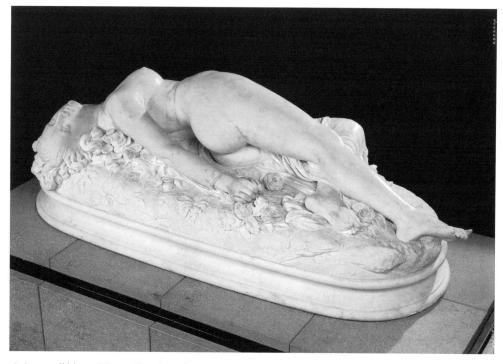

18. Auguste Clésinger: *Woman Bitten by a Snake*, 1847 (Paris, Musée d'Orsay)

Clésinger's religious commissions included the *Pietà* (1850; Paris, church of St Sulpice) and the *Virgin and Child* (1874; Bagnières-de-Bigorre). His bust of *Christ* (1874), reproduced in various materials, was used for numerous tombs, including those of *Henri Joret* (*d* 1883) and *Edmond Leclère* (*d* 1891) in Montparnasse Cemetery, Paris. Among his allegorical or mythological compositions are the *Dream of Love* (1844), *Melancholy* (1846) and the *Gypsy Girl* (all marble, 1859; all St Petersburg, Hermitage), the *Reclining Bacchante* (1848; Paris, Petit Pal.), *Diana at Rest* (1861; Malmaison, Château N.), the *Triumph of Ariadne* (1866; Amiens, Mus. Picardie), inspired by Johann Heinrich Dannecker, *Andromeda* (1869; Perigueux, Mus. Périgord), *Bacchante and Faun* (1869; Minneapolis, MN, Inst. A.) and the *Rape of Deianira* (plaster model, 1878; Nogent-sur-Seine, Mus. Paul Dubois–Alfred Boucher). His paintings often represent the Roman Campagna and depict bulls, a theme he also favoured in sculpture (e.g. *Roman Bulls Fighting*, 1864; Marseille, Mus. B.-A.) between 1864 and 1874.

Bibliography

G. Bresc-Bautier and A. Pingeot: *Sculptures des Jardins du Louvre, du Carrousel et des Tuileries*, 2 vols (Paris, 1986), pp. 84–95

F. Thomas-Maurin: *La Vie et l'oeuvre sculptée d'Auguste Clésinger* (diss., U. Besançon, in preparation)

ANNE PINGEOT

Colin, Gustave

(*b* Arras, 11 July 1828; *d* Paris, 28 Dec 1910). French painter and writer. He served his apprenticeship in 1847 at Arras, in the studio of the landscape painter Constant Dutilleux (1807–65). Later, in Paris, he studied under Ary Scheffer and Thomas Couture. Like many artists from Arras, he was in

close contact with Jean-Baptiste-Camille Corot and absorbed his teaching. In 1857 he made his début at the Paris Salon with a *Portrait of a Grandmother* (untraced). He discovered the Pyrenees in 1858 and settled at Ciboure. Henceforth he painted landscapes, especially coastal views, and bullfighting scenes, in which he captured a colourful atmosphere, highlighting momentary events and changing light. His brushwork became increasingly transparent, his drawing simpler and his palette richer, as in *Charge of the Bullocks in Pasagès Square* (1869; Arras, Mus. B.-A.). The heightened effect of these original compositions invites comparisons with the work of Edgar Degas.

The canvas Colin sent to the Salon of 1863 was rejected. He therefore exhibited at the Salon des Refusés, where he was favourably received. In 1874 he showed five paintings in the first Impressionist exhibition. His touch became still lighter and he produced one of his masterpieces, the *Old Oaks of Belchénia at Urrugne* (1884; Arras, Mus. B.-A.). As a writer he is remembered for his biography of Constant Dutilleux and an interesting article on Corot.

In spite of help from his patron, Count Andrea Doria, Colin had difficulty earning a living. His work deteriorated towards 1900. His prodigious output remains little-known, but he is recognized as an important link between the Barbizon school and the Impressionists and as one of the minor masters of *plein-air* painting.

Writings

Constant Dutilleux: Sa vie, ses oeuvres (Arras, 1866)
'C. Corot', *L'Evénement* (23 March 1875), pp. 1–2

Bibliography

Le Gentil: *M. Gustave Colin, artiste peintre* (Arras, 1891)
Baron de Bermingham: 'Gustave Colin', *Rev. Illus.*, xxiv (1909), pp. 603–8
Gustave Colin, 1828–1910 (exh. cat. by H. Oursel, Arras, Mus. B.-A., 1967)
G.-L. Marchal and P. Wintrebert: *Arras et l'art au XIXe siècle* (Arras, 1987), pp. 59–62

ANNICK DAVY-NOTTER

Compte-Calix, François Claudius

(*b* Lyon, 27 Aug 1813; *d* Chazay d'Azergues, Rhône, 29 July 1880). French painter and lithographer. He took his first drawing lessons under the genre painter Claude Bonnefond (1796–1860) at the Ecole des Beaux-Arts, Lyon, from 1829 to 1833 and again in 1835–6. During his formative period he earned a living as a drawing-master at Thoissey (1829–31) and in the Pensionnat de la Favorite in Lyon (1832–6). After settling in Paris in 1836 he regularly sent work to the Lyon exhibitions. He made his début at the Paris Salon in 1840 with two pictures, *Little Sister* and *The Likeness* (untraced), which launched him on his career as one of the most successful genre painters of the July Monarchy. He was scorned on the whole by critics, but remained popular with publishers, collectors, dealers and the public. His work in Paris retained the poetic and sentimental bias of the Lyon school, epitomizing the international Biedermeier manner of the early 19th century. During the July Monarchy (1830–48) he modified the hard Dutch-inspired manner of Bonnefond, using the freer and lighter touch which was fashionable during this period among a number of genre painters who took their inspiration from 18th-century scenes of *fêtes galantes*. In Paris Compte-Calix also worked as a lithographer and provided illustrations for such magazines as *Musée des dames* and *Bijou*.

Family connections probably explain his decorative work in the interior of Algiers Cathedral (his only recorded work of this type) and the portrait of *Monseigneur Pavy, Bishop of Algiers* (untraced), which was exhibited in 1848. In the Musée Carnavalet, Paris, there is a series of watercolours on the theme of Monseigneur Affre's intervention in the Revolution of 1848. Related compositions are *Mme Lamartine Adopting the Children of Patriots Slain in 1848* (Barnard Castle, Bowes Mus.) and a *Monk Serving in the National Guard* (Leipzig, Mus. Bild. Kst). These examples were unusual excursions into a more serious branch of painting which he treated with characteristic sentimentality. This is even true of his *Monseigneur Affre Speaking to the Insurgents* (Paris, Carnavalet), where he used Delacroix's *Liberty on the Barricades* (1830; Paris, Louvre) as a model.

Compte-Calix spent his later years painting whimsical scenes, often with the epigrammatic titles for which he was well known.

Bibliography
Thieme–Becker

JON WHITELEY

Constant, (Jean-Joseph-)Benjamin
[Benjamin-Constant]

(*b* Paris, 10 June 1845; *d* Paris, 26 May 1902). French painter and printmaker. He spent his youth in Toulouse, where he studied at the Ecole des Beaux-Arts. A municipal scholarship enabled him to enter the Ecole des Beaux-Arts in Paris in 1866. By the following year he was a student in the Ecole de la Rue Bonaparte under the history painter Alexandre Cabanel, and he competed unsuccessfully for the Prix de Rome in 1868 and 1869. His first Salon exhibit, *Hamlet and the King* (1869; Paris, Mus. d'Orsay), established his reputation as a colourist. Constant submitted a number of other traditional history paintings, such as *Samson and Delilah* (1872; untraced). During the Franco-Prussian War (1870–71), however, he travelled to Spain, visiting Madrid, Toledo, Córdoba and Granada, where he came under the influence of the Orientalist painter Mariano Fortuny y Marsal.

In 1872 Constant joined the embassy of Charles Joseph Tissot, French plenipotentiary to Morocco. By his return to Paris the following year he had shifted from historical to Orientalist subjects in his Salon paintings and was increasingly impressed by Delacroix's work. At the Salon of 1873 he showed *Riffian Women of Morocco* (Carcassonne, Mus. B.-A.) and *Moorish Executioners in Tangier* (untraced). Other Orientalist works included *Street-corner in Tangier* (1874; untraced), *Moroccan Prisoners* (1875; Bordeaux, Mus. B.-A.) and *Harem Women in Morocco* (Bordeaux, Mus. B.-A.), for which he received a third-class medal in 1875.

One of Constant's most ambitious paintings, the *Entry of Sultan Muhammad II into Constantinople, 1453* (Toulouse, Mus. Augustins), was unusual in its choice of historical subject. It won the artist a second-class medal in 1876, despite the complaints of some critics that the work was cluttered with a profusion of exotic detail. Constant continued to produce real or imaginary historical scenes: many, for instance *Sherif's Justice* (exh. Salon 1885; Lunéville, Mus. Lunéville), depict the aftermath of violence, demonstrating the artist's predilection for melodrama. He also made several etchings of Moroccan subjects.

Most of Constant's Orientalist works date from the 1870s and early 1880s, after which he became preoccupied mainly with portraits and large decorative projects. He had shown family portraits as early as the Salons of 1876 and 1877 and later enjoyed great popularity as a portrait painter, particularly in England; his eminent sitters included *Queen Victoria* (1899; Brit. Royal Col.), *Edward, Prince of Wales* (untraced) and *Pope Leo XIII* (untraced). After 1896 he also exhibited at the Royal Academy in London. His late portrait style, seen in such works as *André Benjamin-Constant* (1896) and *Alfred Chauchard* (1879; both Paris, Mus. d'Orsay), is sober in colour compared with his earlier works and conventional in composition.

Constant turned to decorative ensembles with his allegories of the *Sciences* and *Belles-lettres* for the Sorbonne (1888). During the 1890s he painted *Paris Welcoming the World* for a ceiling in the Hôtel de Ville (1892), as well as a large ceiling for the Opéra-Comique and a decorative ensemble for the Capitole in Toulouse. Constant's strongly coloured preliminary sketch for *Paris Welcoming the World* (1889; Paris, Petit Pal.) was severely criticized, and he was obliged to submit a more conventional composition. Later, however, he was able to execute the ceiling of the Opéra-Comique in a similarly bold style.

Despite his success in obtaining commissions of this kind, Constant is best remembered for his Orientalist paintings. His work has not won the regard of 20th-century critics, apparently because of his preference for lurid scenes of violence, which were generally avoided by earlier Orientalists such as Delacroix and Théodore Chassériau. Constant's accumulation of ethnographic detail, probably

derived in part from the Moroccan artefacts crammed into his studio, has been compared unfavourably with the more generalized, timeless vision of the earlier Orientalist masters. Many of his figures are clearly Parisian models dressed in North African trappings.

Constant at his best is a fine colourist whose decorative talent is most evident in oil sketches such as the *Odalisque* (Baltimore, U. MD, Mus. A.). His free, painterly brushwork, derived from Delacroix, is more effective in these small works than in his more laboured Salon paintings. Despite his direct experience of North Africa, Constant preferred Oriental fantasy, playing on his audience's preconceptions of the eroticism and violence of exotic lands.

Bibliography

J. Murray Templeton: 'Benjamin-Constant', *Mag. A.* (1891), pp. 181–8

C. D[uflot]: 'Benjamin-Constant', *Les Arts* [Paris], 5 (1902), pp. 26–8

W. R. Johnston: 'Caliphs and Captives', *M: Q. Rev. Montreal Mus. F.A.*, iv/1 (1972), pp. 11–16

Orientalism: The Near East in French Painting, 1800–1880 (exh. cat., U. Rochester, NY, Mem. A.G., 1982), pp. 85–9

The Orientalists: Delacroix to Matisse (exh. cat., ed. M. A. Stevens; London, RA; Washington, DC, N.G.A.; 1984), pp. 116–17

Le Triomphe des mairies: Grands décors républicains à Paris (exh. cat., ed. T. Burollet; Paris, Petit Pal., 1986), nos 230–31

DONALD A. ROSENTHAL

Cordier, Charles(-Henri-Joseph)

(*b* Cambrai, 1 Nov 1827; *d* Algiers, 30 April 1905). French sculptor. He trained at the Petite Ecole (Ecole Spéciale de Dessin et de Mathématiques) in Paris, then with François Rude. He exhibited for the first time at the 1848 Salon, showing a plaster bust of *Saîd Abdallah of the Darfour Tribe*. This work, inspired by the taste for the Orient that Eugène Delacroix had done so much to communicate to a whole generation of artists, achieved a precocious success for Cordier and was ordered by the French government in a bronze version. Cordier held the post of ethnographic sculptor to

the Museum d'Histoire Naturelle in Paris for 15 years from 1851, going on a number of government-sponsored missions—to Algeria in 1856, Greece in 1858–9 and Egypt in 1865. His travels led him to envision a series of modern ethnic types intended to rival those of antiquity. In them Cordier was able to combine his academic training with a passion for exotic subjects and exotic, richly coloured materials and his work made an important contribution to the 19th-century revival of polychrome sculpture. Cordier was able to use onyx from workings in Algeria reopened by the French colonists, and red and ochre-coloured marbles from quarries in Greece on which he reported to the administration of the Beaux-Arts.

The State, and a rich clientele that included Napoleon III, Empress Eugénie and Queen Victoria, bought Cordier's finest works and provided him with encouragement in the creation of an ethnographic gallery, a grandiose project in which he wished to put art into the service of science. Trapadoux's catalogue of 1860 records 50 works. They include the African types *Saîd Abdallah* (1849) and the *African Venus* (1852) (both Osborne House, Isle of Wight, Royal Col.) as well as *Negro of the Sudan* and *Arab of El Aghouat in a Burnous* (both 1857; Paris, Mus. d'Orsay); Asiatic types such as the *Chinese Couple* (1858; priv. col., sold London, Christie's, 25 March 1982, lots 105–6), which was Cordier's first attempt at electroplating and working with enamel on copper; Greek types including *Amphitrite* (1859; Fontainebleau, Château); and also the superb *Egyptian Woman* in bronze and alabaster (1862; Fontainebleau, Château).

Besides these ethnographical busts Cordier was involved in the restoration of monuments and the construction of new public buildings in Paris undertaken by Napoleon III, supplying sculpture for the Tour St Jacques, the Louvre and the Opéra. Examples of his decorative work are the caryatids and atalantes of bronze and onyx ordered from him by Eugène Lami in 1862 for the Château de Ferrières. Cordier also made portrait busts of contemporary worthies and supplied a bronze equestrian statue of *Ibrahim Pasha* for Opéra Place, Cairo (1868–72), and a monument in marble and

bronze to *Christopher Columbus* for the Paseo de la Reforma, Mexico City (1872–5). Until 1880 he ran a large studio, but he was forced for family and financial reasons to exile himself to Nice and then to Algiers, where he died forgotten.

Cordier's son Henri Cordier (1853–1926) was also a sculptor. He developed an interest in the portrayal of movement in animals and men. Among his works are small studies of large animals that he modelled in wax and then cast in bronze, such as *Crouching Lion* (wax model, Paris, Mus. d'Orsay), as well as monumental statues including a bronze of *Général Lasalle* (1887) in the Cour du Château, Lunéville.

Bibliography

Thieme–Becker

M. Trapadoux: *Catalogue descriptif de l'oeuvre de M. Cordier: Galerie anthropologique et ethnographique* (Paris, 1860)

J. Durand-Revillon: *Charles-Henri-Joseph Cordier* (diss., Paris, Ecole Louvre, 1980)

——: 'Un Promoteur de la sculpture polychrome sous le Second Empire: Charles-Henri-Joseph Cordier', *Bull. Soc. Hist. A. Fr.* (1984), pp. 181–98

JANINE DURAND-REVILLON

Cormon, Fernand [Piestre, Fernand-Anne]

(*b* Paris, 24 Dec 1845; *d* Paris, 20 March 1924). French painter. He studied initially in Brussels under Jean-François Portaels. In 1863 he returned to Paris, where for three years he was a pupil of Alexandre Cabanel and Eugène Fromentin. He made his début at the Salon in 1868 and in 1870 received a medal for the *Marriage of the Niebelungen* (1870; ex-Mus. B.-A., Lisieux, 1970). His painting the *Death of King Ravana* (1875; Toulouse, Mus. Augustins), taken from the Indian epic poem the *Ramayana*, was criticized for the choice of an obscure subject but was nevertheless awarded the Prix de Salon in 1875. Soon afterwards Cormon left France for Tunisia. After his return in 1877 he exhibited regularly at the Salon until his death, establishing a reputation as a painter of historical and religious subjects; he also produced some portraits. All of these were

executed in an undistinguished academic style. His later works include *Return from a Bear Hunt in the Stone Age* (1884; Carcassonne, Mus. B.-A.).

Cormon was also responsible for numerous public works. At the Exposition Universelle of 1878 in Paris he showed six decorative panels entitled *War*, *Death*, *Birth*, *Marriage*, *Education* and *Charity*, which were destined for the town hall of the 4th arrondissement. In 1898 he painted decorative panels and the ceiling for the Muséum National d'Histoire Naturelle in Paris. Other works include decorations for the Salle des Mariages of the Hôtel de Ville in Tours in 1902 and ten murals and a ceiling in 1910 for the Petit Palais in Paris.

Bibliography

DBF

E. Montrosier: *Les Artistes modernes*, iii (Paris, 1883), pp. 41–3

Cornu, Sébastien (Melchior)

(*b* Lyon, 6 Jan 1804; *d* Longpont, nr Paris, 23 Oct 1870). French painter. He was taught by Fleury Richard and Claude Bonnefond (1796–1860) at the Ecole des Beaux-Arts, Lyon. He probably left to study in Ingres's atelier in Paris, but he returned to direct Bonnefond's atelier between 1825 and 1828, while the latter was in Rome.

In 1828 Cornu went to Rome where, according to Ingres, he stayed for seven years. On his return to Paris he enjoyed the favour of the July Monarchy (1830–48), being commissioned to produce original paintings and copies of others. In 1841 he worked on the decoration of St Louis d'Antin, Paris (figures of Apostles), and painted the *Surrender of Ascalon to Baudouin III* for the Palace of Versailles. In 1857 he executed murals for St Séverin, Paris. Among his other decorative projects were the completion of a *Transfiguration* (1864) in the north transept of St Germain-des-Prés, Paris, completing work left unfinished by Hippolyte Flandrin at his death, and figures in the chapel of the Palais d'Elysée, Paris (1869). Cornu painted many different subjects, including portraits, mythological, historical and genre scenes, such as *A Bacchante*

(1831; Grenoble, Mus. Grenoble). His cold, unimaginative and impersonal style was derived from Ingres. In 1862 he was made administrator of the Campana collection, whose acquisition by the state the previous year he had helped to negotiate.

Bibliography

B. Foucart: *Le Renouveau de la peinture religieuse en France (1800–60)* (Paris, 1987)

<div align="right">MADELEINE ROCHER-JAUNEAU</div>

Corot, (Jean-Baptiste-)Camille

(*b* Paris, 17 July 1796; *d* Paris, 22 Feb 1875). French painter, draughtsman and printmaker.

1. Life and work

After a classical education at the Collège de Rouen, where he did not distinguish himself, and an unsuccessful apprenticeship with two drapers, Corot was allowed to devote himself to painting at the age of 26. He was given some money that had been intended for his sister, who had died in 1821, and this, together with what we must assume was his family's continued generosity, freed him from financial worries and from having to sell his paintings to earn a living. Corot chose to follow a modified academic course of training. He did not enrol in the Ecole des Beaux-Arts but studied instead with Achille Etna Michallon and, after Michallon's death in 1822, with Jean-Victor Bertin. Both had been pupils of Pierre-Henri Valenciennes, and, although in later years Corot denied that he had learnt anything of value from his teachers, his career as a whole shows his attachment to the principles of historic landscape painting which they professed.

Following the academic tradition Corot then went to Italy, where he remained from November 1825 to the summer of 1828, the longest of his three visits to that country. In Rome he became part of the circle of painters around Théodore Caruelle d'Aligny, who became a lifelong friend. With d'Aligny, Edouard Bertin and Léon Fleury, Corot explored the area around Rome, visiting Terni, Città Castellana and Lake Nemi, and produced some of his most beautiful works. He adhered to Michallon's dictum to paint out of doors directly from the motif and made oil studies of the Colosseum (1826; Paris, Louvre), the Farnese gardens, Caprarola (1826; Washington, DC, Phillips Col.), the bridge at Narni (1826; Paris, Louvre) and the Castel Sant'Angelo (1826; San Francisco, CA Pal. Legion of Honor). From Rome he successfully submitted two canvases to the Salon of 1827: the *Bridge at Narni* (Ottawa, N.G.), which is based on an oil study and modelled after Claude, and *La Cervara* (Zurich, Ksthaus). These pictures were the first of over 100 that Corot showed at the Salon during the course of his career. His submissions ranged from early paintings that emulated Claude and 17th-century Dutch masters, through biblical and literary subjects such as *Hagar in the Wilderness* (1835; New York, Met.), *Macbeth* (1859; London, Wallace) and bacchanals inspired by Poussin, such as *Silenus* (1838; Minneapolis, MN, Inst. A.), to the evocative reveries of his later years such as *The Lake* (1861; New York, Frick) and *Souvenir of Mortefontaine* (1864; Paris, Louvre). In later years he was on the Salon jury and used his influence to help younger artists.

Corot was an inveterate traveller; he toured France in the summer, working on studies and small pictures, which provided the impetus for the larger, more commercial exhibition pieces he produced in the winter. This habit was established early and continued throughout most of his long life. He made two more trips to Italy (1834 and 1843) and visited Switzerland frequently, often in the company of Charles-François Daubigny, whom he met in 1852. With Constant Dutilleux (1807–65) he went to the Low Countries in 1854 and in 1862 travelled to London for a week to see his pictures on show at the International Exhibition. Corot continued to travel until 1874, with a break from 1866 to 1870 due to gout, gradually restricting his journeys to northern France. He visited friends, relations and collectors, seeking both new and familiar sites to paint and producing more and more *souvenirs*, whose popularity ensured brisk sales.

Corot's reputation as a painter of careful and sincere landscapes grew steadily throughout the

1830s and 1840s. He received generally favourable if lukewarm criticism from a wide range of critics until 1846, when Baudelaire and Champfleury began to write warmly about his art. Ferdinand-Philippe, Duc d'Orléans, bought a picture from Corot as early as 1837 and in 1840 the State purchased another in the manner of Claude, his *Shepherd Boy* (1840), for the Musée d'Art et d'Histoire in Metz. Corot also produced a number of religious works during the 1840s, including *St Jerome in the Desert* (1847; Paris, Church of Ville d'Avray) and the *Baptism of Christ* (1847; Paris, St Nicholas-du-Chardonnay). The turning-point of his career, however, came with the accession to power of Louis-Napoléon. Following the unrest of 1848 Corot was elected to the 1849 Salon jury, and in 1851 (the year before he became Emperor Napoleon III) Louis-Napoléon bought from the Salon Corot's *Morning, Dance of the Nymphs* (1850; Paris, Louvre). Collectors and dealers, among them Paul Durand-Ruel, began to be interested in his work, especially in the *plein-air* studies; the first of these to be exhibited was *View of the Colosseum* (1826; Paris, Louvre) at the Salon of 1849.

By the early 1850s Corot's reputation was firmly established, and he moved away from landscapes in the Neo-classical style to concentrate on rendering his impressions of nature. His exhibited pictures and *plein-air* studies grew closer together in motif and execution. High points of this development are *Harbour of La Rochelle* (1851; New Haven, CT, Yale U. A.G.) and *Belfry of Douai* (1871; Paris, Louvre; see fig. 19). Concurrent with his landscape work were figure pieces, ranging from the straightforward *Seated Italian Monk* (1827; Buffalo, NY, Albright–Knox A.G.) to the seductive *Marietta, the Roman Odalisque* (1843; Paris, Petit Pal.). The series of bathers, bacchantes and allegorical figures of his later years are among his most provocative and intellectual works. He also painted several allegories of painting entitled the *Artist's Studio* (1865–8; Paris, Louvre; Washington, DC, N.G.A.; and Lyon, Mus. B.-A.).

Corot painted many portraits of family and friends throughout his life, but he regarded these as private works and did not exhibit them.

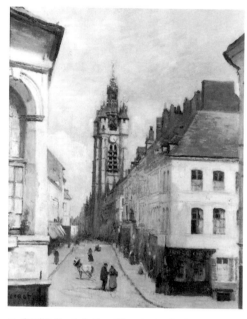

19. Camille Corot: *Belfry of Douai*, 1871 (Paris, Musée du Louvre)

Capitaine Faulte du Puyparlier (1829; Cincinnati, OH, A. Mus.) is one such example. His decorative work was also mainly created for family and friends and included the summer-house at his parents' house at Ville d'Avray (1847), Decamps's studio in Fontainebleau (1858–60) and Daubigny's house in Auvers (1865–8), though the best known is the suite of six Italian landscapes (Paris, Louvre) originally executed for the bathroom of the Roberts' house in Mantes (1840–42). Among the few commissions from those outside his immediate circle were the two panels of *Orpheus* (Madison, U. WI, Elvehjem A. Cent.) and *Diana* (ex-Met., New York; priv. col.), made in 1865 for Prince Demidov's dining-room in Paris. Corot's landscape motifs and style were well suited to this type of work; his feeling for composition through mass and tonal values translated easily into a larger scale.

Corot accepted criticism philosophically and embraced his eventual fame and fortune with equal unconcern. Although he frequently sat on the Salon jury, he was in general too bound up in

his own art to engage in the artistic controversies of his time. He cared little either for the work of his academic contemporaries or for the more avant-garde canvases of Rousseau and Millet. A notable exception was Courbet, with whom he painted in Saintonge in 1862 and whose *Covert of Roe-deer* (Paris, Louvre) he championed at the 1866 Paris Salon. Corot's generosity towards less fortunate artists was also famous. In the 1860s he helped to buy a house at Valmondois for the near-blind Daumier.

2. Working methods and technique

Corot's career can be divided into two parts. The period before *c.* 1850 was a time of experimentation with various styles and models. After this date, his subject-matter was more limited and the difference between *plein-air* and studio work lessened. The harsh light of his earlier paintings became softer and more diffuse. Corot's reputation has always rested on his ability to paint light and to render subtle gradations of tone and value convincingly. While his first trip to Italy sharpened his perception and manual dexterity, he had always been sensitive and responsive to the various effects of light, and his lifelong practice of sketching out of doors forced him to respond and adapt to its vagaries.

Corot developed a shorthand system whereby he could record the relative values he observed in nature: in his pencil sketches circles represent the lightest areas of the scene and squares the darkest. Colour notes were of little use to an artist whose interest was mainly in tonal relationships. He drew constantly, recording scenes and figures in sketchbooks (37 of which are in the Louvre, Paris) as well as on larger sheets. Seldom, however, did a particular sketch serve as a model for a painting. Until *c.* 1850 he used a hard pencil, exploiting the hardness to record the structure of a tree or the geological history of a rock. Sensitive portraits in pencil date from the first part of his career, for instance *Study of a Girl* (1831; Lille, Mus. B.-A.). His paintings from this earlier stage are of two types: *plein-air* and studio work. The *plein-air* pictures are small and generally characterized by a creamy, if thin, paint surface

and by rapid brushstrokes that carry a limited range of colours, chiefly ochres, yellows and greens. Corot's insistence on tonal values eschewed a wide range of hues. His oil studies are notable for the unity achieved through atmosphere and tone. The studio pictures, on the other hand, are large, ambitious works whose subjects were often taken from classical mythology: *Diana and Actaeon* (1836; New York, Met.), the Bible: the *Destruction of Sodom* (first version 1843, second version painted over the first 1857; New York, Met.) or poetry: *Homer and the Shepherds* (1845; Saint-Lô, Mus. B.-A.), which was inspired by André Chénier's *L'Aveugle*. These studio pictures have come to be overlooked in favour of the *plein-air* studies, and while it is true that their execution is less fluid, their atmosphere not as convincing and their figures often stiff in appearance, they are nonetheless strangely moving and reveal an unhackneyed earnestness of purpose.

During the decade 1850–60 Corot sought new subjects and new means of expression and experimented with more overtly allegorical subjects, such as *Melancholy* (Copenhagen, Ny Carlsberg Glyp.) and *Antique Idyll* (Lille, Mus. B.-A.). He was also introduced, through Dutilleux, to Cliché-verre, an experimental medium that combined the techniques of printmaking and photography. Robaut (1905) listed 66 compositions produced by this method, for which Corot chose subjects closely related to those of his oil paintings. The opportunity to experiment with tonal relationships in a new medium and the speed and novelty of the process must have appealed to Corot, who was not particularly interested in the technical aspects of traditional printmaking. Félix Bracquemond helped to bring some of Corot's etching plates to a point where they could be printed. At the same time, Corot also freed himself from some of his self-imposed constraints, such as the hard graphite pencil for drawings and the choice of academic subjects for Salon paintings, and experimented with different means to render observed or, in later years, remembered effects. He began to sketch in charcoal, smudging it in order to soften the contours of objects and to suggest their dissolution by light and atmosphere.

Souvenir of Mortefontaine (1864; Paris, Louvre; see col. pl. IX) epitomizes Corot's later painting style and combines his favourite motifs: a still body of water, hills and trees dimly visible on the distant shore, a gracefully leaning tree with diaphanous foliage and a note of colour provided in the clothing of the figures to the left. The paint is thinner than before and the colour range reduced to greys mixed with greens, yellows and whites. In contrast to such early paintings as *Hagar in the Wilderness*, which were based on the Italian countryside, Corot's later works are only vaguely reminiscent of places; their moist, diffuse atmospheres defy particularity and are rather an invitation to personal reverie.

Corot's style became very popular in the Second Empire. His name came to be associated with a kind of painting that was soft, hazy and subdued, with simple compositions evoking a tranquil mood. His images of private meditation and mysterious women and his reiteration of music and dance subjects have much in common with the spirit of the Rococo revival. Although he had no atelier, other artists were welcome to copy his pictures, either as learning exercises or as a means of producing works for sale. Corot even signed some of the copies made by younger, less fortunate painters in order to increase their value. This practice has complicated the connoisseurship of his oeuvre, as have the numerous forgeries and unauthorized copies of his works.

Antoine Chintreuil and Paul-Désiré Trouillebert were the most faithful followers of Corot, whose fidelity to the effects of light also had a great impact on younger artists such as Camille Pissarro, Berthe Morisot (who took lessons from him in the early 1860s) and Claude Monet. Monet's series of early morning views of the Seine painted in the 1890s are particularly evocative of Corot's *Souvenir of Mortefontaine*.

Unpublished sources

Paris Bib. N. Cab. Est., 3 vols, Yb3 949 [Robaut's invaluable notes for the cat. rais. of 1905]

Bibliography

T. Silvestre: *Histoire des artistes vivants* (Paris, 1856)

A. Robaut: *L'Oeuvre de Corot: Catalogue raisonné et illustré, précédé de l'histoire de Corot et de son oeuvre par E. Moreau-Nélaton*, 4 vols (Paris, 1905); supplements compiled by A. Schoeller and J. Dieterle, 3 vols (Paris, 1948–74)

L. Delteil: *Le Peintre-graveur illustré*, v (Paris, 1910)

P. J. Angoulvent: 'L'Oeuvre gravé de Corot', *Byblis* (summer 1926), pp. 39–55

G. Bazin: *Corot* (Paris, 1942, rev. 3/1973)

P. Courthion, ed.: *Corot raconté par lui-même et par ses amis*, 2 vols (Geneva, 1946)

A. Coquis: *Corot et la critique contemporaine* (Paris, 1959)

Barbizon Revisited (exh. cat., ed. R. L. Herbert; Boston, MA, Mus. F.A., 1962)

Figures de Corot (exh. cat., ed. G. Bazin; Paris, Louvre, 1962)

J. Leymarie: *Corot* (Geneva, 1966, rev. 2/1979)

M. Hours: *Corot* (New York, 1970, rev. 2/1984)

Hommage à Corot (exh. cat., ed. M. Laclotte; Paris, Grand Pal., 1975)

P. Galassi: *Corot in Italy* (New Haven and London, 1991)

FRONIA E. WISSMAN

Courbet, (Jean-Désiré-)Gustave

(*b* Ornans, Franche-Comté, 10 June 1819; *d* La Tour-de-Peilz, nr Vevey, Switzerland, 31 Dec 1877). French painter and writer. Courbet's glory is based essentially on his works of the late 1840s and early 1850s depicting peasants and labourers, which were motivated by strong political views and formed a paradigm of Realism. From the mid-1850s into the 1860s he applied the same style and spirit to less overtly political subjects, concentrating on landscapes and hunting and still-life subjects. Social commitment, including a violent anticlericalism, re-emerged in various works of the 1860s and continued until his brief imprisonment after the Commune of 1871. From 1873 he lived in exile in Switzerland where he employed mediocre artists, but also realized a couple of outstanding pictures with an extremely fresh and free handling. The image Courbet presented of himself in his paintings and writings has persisted, making him an artist who is assessed as much by his personality as by his work. This feature and also his hostility to the academic system, state patronage and the notion of aesthetic ideals have

made him highly influential in the development of modernism.

I. LIFE AND WORK

1. Training and early works, to c. 1849

Courbet came from a well-to-do family of large-scale farmers in Franche-Comté, the area of France that is the most strongly influenced by neighbouring Switzerland. Ornans is a picturesque small country town on the River Loue, surrounded by the high limestone rocks of the Jura; its population in Courbet's day was barely 3000. This social and geographical background was of great importance to Courbet. He remained attached to Franche-Comté and its peasants throughout his life, portraying rural life in many pictures. In 1831 Courbet started attending the Petit Séminaire in Ornans, where his art teacher from 1833 was Père Baud (or Beau), a former pupil of Antoine-Jean Gros. While there he also met his cousin, the Romantic poet Max Buchon (1818–69), who had a determining influence on his later choice of direction. In the autumn of 1837 he went to the Collège Royal at Besançon and also attended courses at the Académie there under Charles-Antoine Flageoulot (1774–1840), a former pupil of Jacques-Louis David. Except for a few early paintings and drawings (Ornans, Mus. Maison Natale Gustave Courbet), Courbet's first public works were the four figural lithographs of 1838 illustrating Buchon's *Essais poétiques* (Besançon, 1839). He went to Paris in the autumn of 1839 to embark on a conventional training as a painter. Like many other young artists of his period he was not impressed by the traditional academic teaching at the Ecole des Beaux-Arts in Paris; instead, after receiving a few months' teaching from Charles de Steuben (1788–1856), he attended the independent private academies run by Père Suisse and Père Lapin and also received advice from Nicolas-Auguste Hesse. At the same time he copied works by the Old Masters at the Louvre.

Like Rembrandt and van Gogh, Courbet painted a large number of self-portraits, especially in the 1840s. These quite often show the artist in a particular role or state of mind. The *Self-Portrait as*

a Sculptor (c. 1844; New York, priv. col., see 1977–8 exh. cat., pl. 9) and *Self-portrait with a Leather Belt* (1845; Paris, Mus. d'Orsay) belong in the first category, and the *Self-portrait as a Desperate Man* (two versions, c. 1843; e.g. Luxeuil, priv. col., see 1977–8 exh. cat., pl. 5), *The Lovers* (1844; Lille, Mus. B.-A.), *Self-portrait as a Wounded Man* (two versions; e.g. c. 1844–54; Paris, Mus. d'Orsay) and *Self-portrait with a Pipe* (c. 1847–8; Montpellier, Mus. Fabre) belong in the second. Courbet seems to have painted himself so often for two main reasons: because of lack of models and because of a protracted crisis of artistic identity. This introspectiveness lasted until the Commune (1871) and shows that he was still influenced by the self-centredness (*égotisme*) typical of the Romantics and that, despite his extrovert image, he felt lonely in Paris for a long time.

In 1846 Courbet visited the Netherlands, where he painted mainly portraits, the most outstanding of which is the portrait of the art dealer *H. J. van Wisselingh* (1846; Fort Worth, TX, Kimbell A. Mus.). He also stayed briefly in Belgium in 1846 and 1847, and travel sketches made in both countries have been preserved (Marseille, priv. col., see 1984 exh. cat.). In the museums in The Hague and Amsterdam he was interested by Rembrandt's chiaroscuro and the expressive, free brushwork of Frans Hals, qualities that subsequently influenced his own painting technique. These experiences had a beneficial effect on *After Dinner at Ornans* (1849; Lille, Mus. B.-A.), a dark, silent group portrait that won him the esteem of Ingres and Delacroix in 1849. It is not clear whether Courbet ever visited England or whether a passage in a letter of 1854 relating to such a visit (see 1977–8 exh. cat., app.) should be interpreted as an imaginary journey. In this he alludes to Hogarth and, though he did paint some satirical pictures, a mention of Constable would have been more illuminating regarding his painting technique.

2. The Realist debate: peasant and modern 'history' pictures, 1849–55

Courbet achieved his real breakthrough with three works that were exhibited in Paris at the Salon of 1851 (postponed from 1850). Two of these,

The Stone-breakers (1849; ex-Gemäldegal. Neue Meister, Dresden, untraced; and A Burial at Ornans (1849–50; Paris, Mus. d'Orsay), had already attracted attention in Besançon and Dijon, while the third, the Peasants of Flagey Returning from the Fair (1850, revised 1855; Besançon, Mus. B.-A. & Archéol., was exhibited in Paris only. (The Stone-breakers was thought to have been destroyed in 1945, but in 1987 the Gemäldegalerie Neue Meister in Dresden catalogued it as missing.) Although all three pictures were influenced by the Dutch Old Masters, they are distinguished by their austerity and directness. Courbet's friends, Champfleury and Buchon, saw them as breaking away from academic idealism and spoke approvingly of Courbet's 'realism'.

Many visitors to the Salon were shocked, however, both because the paintings depicted ordinary people (moreover on a scale normally reserved for portraits of the famous) and because the peasants and workers, based on real people, seemed particularly ugly. In these pictures Courbet was trying to blend large-scale French history painting with Dutch portrait and genre painting, thereby achieving an art peculiar to his own period that would introduce the common man as an equally worthy subject. The pictures also reveal unusual characteristics of social commitment. The labourers in The Stone-breakers, with their averted faces and ragged clothing, symbolize all those workers who toiled on the edge of subsistence. It was this picture that attracted most attacks from the caricaturists and critics in 1851. The group of country mourners in a Burial at Ornans, a scene possibly based on the burial of Courbet's great-uncle Claude-Etienne Teste (1765–1848), stirred the townspeople's fear of being swamped by the rural population. Buchon saw the grave-digger in this picture as representing the avenger of the stone-breakers. Some years later Pierre-Joseph Proudhon noted the proud superiority of the rugged peasants from Franche-Comté in the Peasants of Flagey Returning from the Fair. All three paintings deal with the demographic movements between town and country. At the time this was an acute social issue, which greatly concerned the staunchly regionalist

Courbet. The last of these peasant 'history pictures' was The Grain-sifters (1855; Nantes, Mus. B.-A.), a quiet, simple picture of people at work, which has even been interpreted as having a feminist message (Fried, 1990).

The Bathers (1853; Montpellier, Mus. Fabre) and The Wrestlers (1853; Budapest, Mus. F.A.) are among those provocative pictures that attacked the prevailing aesthetic norms and, as 'modern history pictures', also represented a challenge to society. These pictures show fat, naked women and toil-worn naked men, thus rejecting the academic concept of nude painting and rousing the ire of middle-class Salon critics and caricaturists who considered the pictures un-French. Courbet was able to launch such attacks in the early days of the authoritarian Second Empire only because he had a powerful protector in Charles, Duc de Morny. The Bathers won praise from Delacroix and was regarded by Alfred Bruyas, a banker's son from Montpellier, as marking the beginning of an independent, modern form of art. Courbet confirmed this perception a year later with The Meeting, also known as Bonjour Monsieur Courbet (1854; Montpellier, Mus. Fabre; see col. pl. X), which was painted for Bruyas entirely in light colours, with the landscape executed in a concise, free style. Above all, this picture, which includes a self-portrait, reveals something of the identity crisis referred to above, with Courbet fluctuating between underestimating and overestimating himself. Borrowing from the image of the Wandering Jew, he represented himself as a spurned outsider and at the same time as a superior 'wise man', greeting Bruyas and his servant from a somewhat higher plane. He thus shows, albeit defensively, how an artist without state or church patronage becomes precariously dependent on a private patron.

The culmination of the series featuring Courbet's relation to society is the Painter's Studio (1854–5; Paris, Mus. d'Orsay), which he painted for the Exposition Universelle held in Paris in 1855. Though he had 11 other works accepted, the Painter's Studio was rejected. So Courbet showed it at the independent exhibition he funded and held in the Pavillon du Réalisme on a site close to

that of the official exhibition. This large picture has been called a triptych because it consists of three clearly distinguished parts: at the centre Courbet portrayed himself painting a landscape next to a woman or 'Muse', a cat and a peasant boy. On the left he depicted the 'external' or political world, and on the right the 'internal' or aesthetic world. Courbet himself holds the place of the redeemer. He modelled many of the figures on friends and various political and other personalities, including Napoleon III. With this composition, he brought the dispute about the politically and aesthetically disruptive effects of Realist art to a conclusion. The full title of the work is the *Painter's Studio: A Real Allegory Determining a Phase of Seven Years of my Artistic Life*, which suggests that Courbet saw the work as summing up his development since the Revolution of 1848. But at the same time it contains a vision of the future: Courbet sits at his easel, which shows not his surrounding society but a landscape in Franche-Comté. This indicates that he saw nature, rather than politics or industry, as having the power for the renewal and reconciliation needed by contemporary society—still a Romantic concept.

3. Leisure and private life as subject-matter: landscapes, hunting scenes, still-lifes and portraits, late 1850s and the 1860s

In the *Painter's Studio* Courbet had provocatively placed landscape on a higher level than history painting. He had, of course, painted landscapes before this, but now he gave this genre pride of place. While he combined landscape and figure painting in the *Painter's Studio* and also in the *Young Ladies on the Banks of the Seine (Summer)* (1856–7; Paris, Petit Pal.), in most of his pictures of the late 1850s and 1860s landscape predominates.

'To be in Paris, but not of it: that was what Courbet wanted' (Clark, 1973, p. 31). He did not produce a single townscape of Paris, and his landscapes confronted Parisians with the image of a different world. The meaning of these landscapes is complex: they reflect an increasing need for recreation areas for leisure and holiday activities, a theme that was to become dominant among the Impressionists in the 1870s and 1880s. Courbet

had even wanted to decorate railway stations with pictures of holiday destinations, a project that would have greatly promoted tourism, though it was never realized. However, many of his landscapes are not idyllic but rather enclosed and fortress-like (according to Champfleury). They represent a kind of regional defence force and thus stress the autonomy of the provinces with regard to the centralist power of the State. Regionalism is emphasized in numerous depictions of hidden forest ravines and grottoes, which give the effect of being places of refuge or even of representing the search for concealment in a womb (1978–9 exh. cat.). In particular, the various versions of the *Puits noir* (e.g. 1865; Toulouse, Mus. Augustins) and the *Source of the Loue* (e.g. 1864; Zurich, Ksthaus) can be cited as examples of this.

Hunting scenes by Courbet such as *Stag Taking to the Water* (1865; Marseille, Mus. B.-A.) or *The Kill: Episode during a Deer Hunt in a Snowy Terrain* (1867; Besançon, Mus. B.-A. & Archéol.) are similarly ambivalent. They illustrate the artist's passion for hunting, which was enhanced by trips to German hunting reserves around Baden-Baden and Bad Homburg. He often chose the peace after the hunt, as in *The Quarry* (1857; Boston, MA, Mus. F.A.) and the *Hunt Breakfast* (c. 1858–9; Cologne, Wallraf-Richartz-Mus.), but at the same time used hunting to suggest political persecution. The latent social and political messages in the hunting pictures did not prevent them from generally satisfying a non-political clientele. After the success at the Salon of 1866 of *Covert of Roe-deer by the Stream of Plaisir-Fontaine* (1866; Paris, Mus. d'Orsay; see fig. 20) Courbet had even hoped for an imperial distinction, though this was not forthcoming.

From 1859 Courbet often stayed on the Normandy coast. While there he painted a large number of seascapes (several versions of the *Cliff at Etretat*, e.g. the *Cliff at Etretat after the Storm*, 1869; Paris, Mus. d'Orsay; see fig. 21) and beach and wave pictures, which mark a new peak in his creative achievement. The style of these pictures is very varied: some are block-like and self-contained compositions, which appeared to many critics to have been built by a mason or made from marble (e.g. the two versions of *The Wave*, 1870;

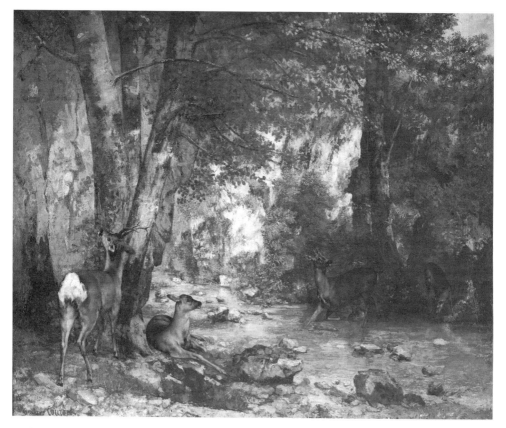

20. Gustave Courbet: *Covert of Roe-deer by the Stream of Plaisir-Fontaine*, 1866 (Paris, Musée d'Orsay)

Paris, Mus. d'Orsay; Berlin, Alte N.G.), and in the same works Courbet completely dissolved the surface of objects, so moving away from naturalistic representation. The tendency towards abstraction and surface colour increased steadily from about 1864; in this respect Courbet was an important forerunner of Cézanne.

In his paintings of nudes Courbet seems to have taken a different path. He attempted to beat the Salon tradition by painting completely naturalistically and choosing garishly brilliant colours. This is particularly true of *The Sleepers* (1866; Paris, Petit Pal.). Here it was far less the form than the subject-matter that was shocking. Lesbian women had hitherto been a theme treated only in small-scale graphic work, whereas Courbet presented it in a format that was larger even than that used for genre painting. The female nude entitled the *Origin of the World* (1866; Japan, priv. col., see 1988–9 exh. cat., p. 178) is also extremely provocative (though like the previous picture it was painted for a private client, the Turkish diplomat Khalil-Bey). *Lady with a Parrot* (1866; New York, Met.) again has slightly ironic links with Salon painting, with the parrot symbolizing a magic bird as in the writings of Gustave Flaubert. *Venus and Psyche* (1864 version, destr.; 1866 version, Basle, Kstmus.) is a fourth important picture in this category.

The still-lifes form another theme in Courbet's art. They reached their first peak as early as the mid-1850s when Courbet painted *Bunch of Flowers*

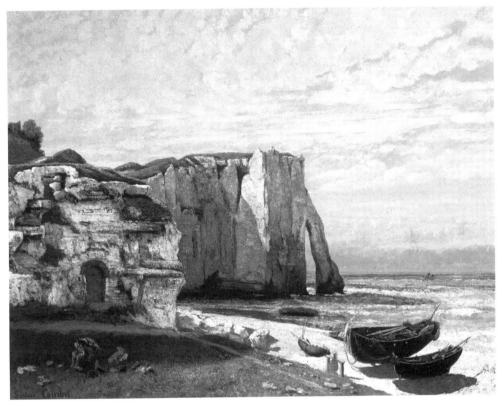

21. Gustave Courbert: *Cliff at Etretat after the Storm*, 1869 (Paris, Musée d'Orsay)

(1855; Hamburg, Ksthalle) in which it is unclear whether the pictoral space is limited by a wall or the sky. This deliberate lack of definition links interior and exterior space in an extremely modern manner. Courbet painted some superb still-lifes during his stay in the Saintonge area in 1862–3 where he worked for a time with Corot. Important examples of his still-lifes are the heavy, assembled blooms in *Magnolias* (1862; Bremen, Ksthalle) and *Flowers in a Basket* (1863; Glasgow, A.G. & Mus.). In *The Trellis* (1862; Toledo, OH, Mus. A.) Courbet combined a still-life of flowers in the open air with a portrait of a woman, producing an asymmetric composition similar to that in works by Degas. Courbet did not produce still-life works of equal stature again until after the Commune.

Turning to themes relating to leisure and private life was a move forced on painters by the political situation in the Second Empire—a withdrawal as happened with Honoré Daumier. The *Painter's Studio* (1854–5; Paris, Mus. d'Orsay; see fig. 22), with its reference to Napoleon III, represents an exception to this tendency; it did not attract unpleasant consequences simply because Courbet composed the picture as a group portrait without any offensive intentions. Individual portraits were another category that flourished in this period. The *Sleeping Spinner* (1853; Montpellier, Mus. Fabre), however, shows that Courbet often depicted types rather than individuals, in this case a peasant girl lost in reverie. Of the portraits he painted in Saintonge, *Dreaming: Portrait of Gabrielle Borreau* (1862; Chicago, IL,

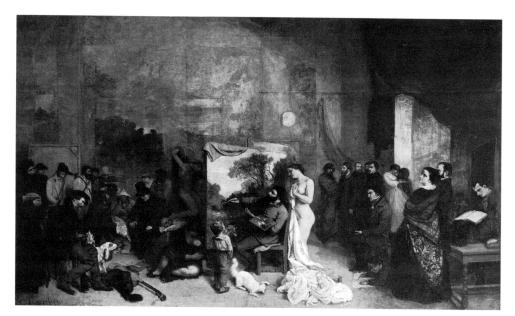

22. Gustave Courbert: *Painter's Studio*, 1854–5 (Paris, Musée d'Orsay)

A. Inst.) combines a dreamy expression with a very free use of colour in the natural background. The four versions of *Jo: The Beautiful Irish Girl* (c. 1865; e.g. Stockholm, Nmus.), depicting Whistler's mistress Joanna Heffernan, stand halfway between Romanticism and Symbolism, showing links with Whistler and the Pre-Raphaelites. The model's sensuous red hair also conjures up the idea of the *femme fatale*. Among the portraits of men, that of *Pierre-Joseph Proudhon and his Children in 1853* (1865–7; Paris, Petit Pal.) deserves a special mention. Courbet had been a close friend of Proudhon's since the philosopher's arrival in Paris in 1847 and painted the work after his death as a memorial. In a second phase of painting he eradicated Proudhon's wife, leaving only his two small daughters. As a result, the solitariness and monumentality of the philosopher are considerably enhanced. As in *Gabrielle Borreau*, the figures in *Pierre-Joseph Proudhon* are painted carefully, while the background is intentionally rendered in a free, slap-dash manner, which excited both criticism and admiration.

4. Renewed political awareness in the 1860s

Two works, *Priests Returning from the Conference* (1862–3; destr.; oil sketch, Basle, Kstmus.) and *Pierre-Joseph Proudhon*, were precursors to a more open use of pictures as a political weapon. Though Courbet's potential for satirical criticism was repressed during the reign of Napoleon III, it was not extinguished, and, like Daumier, Courbet reverted to explicitly political subjects towards the end of the Second Empire. At the beginning of the decade he had painted a portrait of his friend *Jules Vallès* (c. 1861; Paris, Carnavalet), an anarchist writer and later Communard. In 1868 Courbet published in Brussels the anticlerical pamphlets *Les Curés en goguette* and *La Mort de Jeannot* to accompany works on this theme. Champfleury, wary of this development, feared a whole series of anticlerical frescoes. The same year Courbet painted *Charity of a Beggar at Ornans* (1868; Glasgow, A.G. & Mus.), which made a clear reference to the ragged proletariat. Courbet announced that other 'socialist' pictures would follow, a move that was obviously encouraged by the electoral success of the Left in the towns. For the Salon of 1868

he planned a portrait of *Martin Bidouré*, a peasant who was executed after having fought against the coup d'état of 1851. It was clearly intended that Courbet's political urge would be discouraged by the offer in 1870 of the Cross of the Légion d'honneur, an award he, like Daumier, refused.

5. The Commune, exile in Switzerland and collaboration: late works, 1871–7

During the Commune in Paris (18 March–29 May 1871) Courbet did little drawing or painting. He was, however, very active in art politics and, as president of the commission for the protection of the artistic monuments of Paris and delegate for the fine arts, he even saved the Louvre. As he was accused of having been behind the demolition of the Vendôme Column, he was put on trial and gaoled after the Commune's overthrow. He painted a few still-lifes while in prison, but his best pictures—*Still-life with Apples and Pomegranate* (London, N.G.), *Still-life: Fruit* (Shelburne, VT, Mus.), *Still-life: Apples, Pears and Primroses on a Table* (Pasadena, CA, Norton Simon Mus.), *Self-portrait in Prison* (Ornans, Mus. Maison Natale Gustave Courbet) and both versions of *The Trout* (Zurich, Ksthaus; Paris, Mus. d'Orsay)—were not painted until after his release, perhaps not until 1872–3, though some are signed *in vinculis faciebat* or 'Ste-Pélagie' (the name of one of the prisons).

On 23 July 1873 Courbet crossed the frontier into Switzerland as he had been judged responsible for the cost of re-erecting the Vendôme Column and was afraid that he might be arrested. The four and a half years of his exile in Switzerland are often regarded as a period of decline. It is true that in this period Courbet definitely painted with an eye to the market: he was in fact hoping to raise the money to pay for the column so that he could return to France, an aim prompted by the great success of an exhibition at the Galerie Durand-Ruel in Paris in 1872. He therefore engaged a number of journeymen painters whom he instructed in his style: first and foremost Marcel Ordinaire (1848–96), Chérubino Pata (1827–99) and André Slomcynski (1844–1909), but also Auguste Baud-Bovy, François Bocion, Ernest-Paul Brigot (1836–1910), Jean-Jean Cornu (1819–76), Hector Hanoteau (1823–90), Auguste Morel and Alphonse Rapin (1839–89). This collaboration was a disaster, particularly as Courbet apparently signed the works produced by his assistants to augment their value; other works known as 'mixed' pictures must have been only started by him or touched up at the end. Moreover, in his despair Courbet drank a lot as well as suffering from dropsy so that he was only rarely capable of painting well. This makes it all the more remarkable that in these last years he achieved some superb landscapes and portraits. Having experimented with sculpture (1862–4), he turned once more to this medium, creating, for example, a monumental *Bust of Liberty* (1875) for La Tour-de-Peilz, near Vevey.

The first notable painting done by Courbet in Switzerland is a portrait of his father *Régis Courbet* (1873; Paris, Petit Pal.), a picture that once again exercised his full powers. The most noteworthy of his landscapes are the many brilliant versions of Lake Geneva (e.g. *Lake Geneva at Sunset*, 1874; Vevey, Mus. Jenisch) and of the castle of Chillon that stands on its shore (e.g. 1874; Ornans, Mus. Maison Natale Gustave Courbet). Many of these pictures demonstrate marvellous atmospheric effects: *Winter Landscape: The Dents du Midi* (1876; Hamburg, Ksthalle) and *Grand Panorama of the Alps* (1877; Cleveland, OH, Mus. A.) are outstanding among his late works. The former conveys a gloomy mood with heavy, thickly applied colours, while the latter, which used to be wrongly described as unfinished, is in some ways an answer to the Impressionists (even though Courbet was not able to see the First Impressionist Exhibition of 1874). While retaining his use of dark colouring in this work, Courbet broke the objects up into flecks or spots in a technique similar to that of the Impressionists. A basic incoherence between the objects and a consequent independent existence of the painterly means are apparent, anticipating the 20th century.

II. WORKING METHODS AND TECHNIQUE

1. Painting

Courbet's painting technique is not easy to describe because of its variety and disregard for

the academic rules governing composition. He often inserted his figures as if they were removable set pieces (Berger). In spite of this 'collage' technique, many of his pictures look as if they had been painted at a single sitting because of their unity of colour. They were in fact often produced very quickly. Courbet prided himself on being able to paint a picture in two hours as well as produce several versions of equal quality. As every object was in theory of equal importance to him, quite often there is an egalitarian structure in his work. On the other hand Courbet's pictures frequently form a closed world: landscapes can give the impression of being locked away, and, though they are at close quarters, people may turn away from the viewer (*The Stone-breakers*, *The Bathers*, *The Wrestlers* and *The Grain-sifters*). Thus a 'wooden' composition is often found in conjunction with a fluid use of colour.

The special quality of Courbet's work is really achieved by means of colour. Courbet initially imitated 17th-century Dutch and Spanish painters (Rembrandt, Hals, Velázquez, Ribera) from whom he derived the use of black as the starting-point. He employed a dark ground throughout his life, but the treatment of surfaces changed. Courbet resorted more and more to using broad brushes: he rejected detailed academic painting and seems never to have used a mahlstick. By working increasingly with a spatula and palette knife—implements that he used to apply and scrape off colour 'like a mason'—he gave colour a special, substantial quality, which influenced van Gogh and Cézanne.

In figure works Courbet used a variety of procedures and often maintained clear, compact boundaries between objects, though in *A Burial at Ornans*, for example, he merged the figures together in a single dark mass. In the portrait of *Adolphe Marlet* (1851; Dublin, N.G.) the flesh tones were applied on top of parts of the clothing, so disregarding naturalism in favour of an emphasis on the formal qualities of colour. In his final portrait, of his father, the colour does not seem to have been applied spontaneously and freely, but in an even-handed, distanced, almost icy manner—as if Courbet had withdrawn from the outside world.

Colour was applied in a perfunctory, almost careless way in the landscapes, as, for example, in the background of *The Meeting* (1854; Montpellier, Mus. Fabre). In *Rocky Landscape near Ornans* (1855; Paris, Mus. d'Orsay) spots of white were dabbed on to trees to create the effect of blossom. By the 'spontaneous' use of colour, Courbet suggested the effect of instantaneous movement in his landscapes, conveying the impression of light flickering over the rocks, of the surface of the water rippling and of leaves trembling in the wind. By 1864 Courbet's interest in the interaction of colour predominated. In the *Source of the Lison* (1864; Berlin, Alte N.G.) or in the many versions of the *Source of the Loue* Courbet spread colour, dissociated from any object, over the entire surface.

2. Drawing

Unlike Delacroix or Jean-François Millet, Courbet is not one of the foremost French draughtsmen of the mid-19th century. He had taught himself to draw, but his opposition to the classical primacy of drawing led him to work directly with colour. He produced drawings of exceptional expressive power (including two self-portraits; 1847, Cambridge, MA, Fogg; *c*. 1846–8, Hartford, CT, Wadsworth Atheneum) as well as of great penetration (e.g. *Juliette Courbet, Sleeping*, 1840–41; Paris, Louvre). Courbet emerges as a draughtsman essentially in two ways: firstly he produced large single sheets (in chalk or charcoal) with portrait drawings made as pictures, and secondly numerous sketches (mainly drawn with pencil or chalk, occasionally with a wash), which have been preserved either in sketchbooks or singly. The large picture-like drawings, some of them signed like paintings, were sometimes exhibited, even alongside paintings in the Salon, and are now held in a small number of large museums. For a long time many of the sketches remained in the possession of the Courbet family. In 1907 one sketchbook was acquired by the Louvre, followed by two others in 1939, and many loose sketches were still in private hands in the late 20th century (*c*. 30 collections). The drawings in the three sketchbooks (with two exceptions) are regarded as being in the artist's

own hand, but there is controversy over the date and authenticity of many of the loose sketches, which are very uneven in quality.

A painterly treatment of the surface, using broad layers of strokes and smudging, is typical of the picture-like drawings, while the sketches, varied as they are, are characteristically composed of broken, often stiff lines. In both, however, Courbet's aversion to an academically smooth and beautiful use of line is discernible. In the sketches from his Swiss journey (see 1984 exh. cat.) the material structure of objects is clearly apparent; other travel sketches (e.g. *Tree on Rock near Spa*, *c.* 1849; Marseille, priv. col., see 1984 exh. cat., no 48) show, in a very similar way to Courbet's land-scape paintings, how changeable and fragile the substance of objects is in light.

III. Writings

Courbet was not a theorist, but his manifestos, letters and aphorisms, even though influenced by Buchon, Champfleury, Baudelaire and Jules-Antoine Castagnary, are extremely important in considering the debate over Realism, the concept of the independent artist and the ties between art and politics. Courbet also talked in great detail about his pictures in his letters.

1. The Realist debate

In 1849 at the end of a letter about *The Stone-breakers* Courbet enunciated a principle that he later elevated to be the basis of Realism. Writing to the Director of the Ecole des Beaux-Arts, he said: 'Yes, M. Peisse, art must be dragged in the gutter!' (Riat, p. 74). This one sentence and its logical con-version into practice brought personal enmities and negative criticisms to Courbet for nearly 30 years.

Courbet had adopted the concept of 'Realism', which he first used in the *Journal des faits* in 1851, from Champfleury. It can therefore be supposed that the following statement (usually described as the 'Manifesto of Realism') was also influenced by Champfleury. It served as the foreword to the cat-alogue of the special exhibition of Courbet's work that opened on 28 July 1855 in the purpose-built Pavillon du Réalisme in Paris. His insistence on depicting scenes from his own era reflected a demand that had prevailed in France since the Revolution to replace classical imagery with that drawn from contemporary subjects (Courthion, ii, pp. 60–61):

> The name 'Realist' has been imposed on me just as the name 'Romantic' was imposed on the men of 1830 Working outside any system and with no previous prejudice I have studied the art of the Old Masters and the art of the Modern Masters. I no more want to imitate the former than copy the latter; nor have I pursued the futile goal of art for art's sake! No! I simply wanted to draw from a complete knowledge of tradi-tion a reasoned and independent sense of my own individuality. I sought knowl-edge in order to acquire skill, that was my idea. To be capable of conveying the customs, the ideas and the look of my period as I saw them; to be not just a painter, but a man as well; in short, to produce living art, that is my aim.

The idea of 'living art' greatly exercised Courbet's mind thereafter and had a self-liberating effect, for, in contrast to the protago-nists of the French Revolution, Courbet did not believe that man was born free, rather that he became free only through work. Work, including art, could lead to freedom only if it also improved the condition of society. He spoke of this at a con-ference of artists in Antwerp in 1861 (Riat, pp. 191–2):

> The basis of realism is the denial of the ideal . . . *Burial at Ornans* was really the burial of Romanticism We must be rational, even in art, and never allow logic to be overcome by feeling By reaching the conclusion that the ideal and all that it entails should be denied, I can completely bring about the emancipation of the indi-vidual, and finally achieve democracy. Realism is essentially democratic art.

Courbet's missionary mentality led to the rapid dissemination of a 'doctrine' of Realism, which inevitably attracted pupils to Courbet. Yet he did not want to be a teacher as he intended to encourage the artistic expression of each individual. He gave the following explanation of this apparent dichotomy at the opening of his studio (Castagnary, pp. 180–83):

I do not and cannot have pupils . . . I cannot teach my art or the art of any school, since I deny that art can be taught, or to put it another way I claim that art is completely individual and for each artist it is only the talent that results from his own inspiration and his own study of tradition In particular it would be impossible for art in painting to consist of any other things than the representation of objects which the artist can see and touch There can be no schools Unless it becomes abstract, painting cannot allow a partial aspect of art to dominate, be it drawing, colour or composition.

2. Political views

Courbet's political aphorisms cover his whole working period and had a far-reaching influence into the 20th century. However he was politically committed in a strict sense for only short periods (1848–51, 1855, 1863–4, 1868–71), and even then it is only rarely possible to discern a directly political iconography in his pictures. In February 1848 he made a chalk drawing of a man on a barricade waving a gun and flag for the periodical Le Salut public edited by Baudelaire (printed in the second issue of the journal), yet in letters (Courthion, ii, p. 74) he denied any participation in the political events of that year. Nor did he take part in the competition to produce an allegory for the Republic, though he encouraged Daumier to do so. He wrote that, instead, he was 'going to enter the competition open to musicians for a popular song' (Riat, p. 53). It is all the more probable that he took part as he did himself write poetry (Herding, 1988).

Throughout his life Courbet was strongly opposed to state power, an attitude that brought him into conflict with the government of the Second Empire. His ideas on this issue emerge in the discussion he had in 1854 with the Comte de Nieuwerkerke, Intendant des Beaux-Arts de la Maison de l'Empereur. The administration wanted to ensnare the recalcitrant artist by offering him an official commission for a large painting for the Exposition Universelle to be held in Paris in 1855. Courbet rejected the invitation with anti-authoritarian arguments (Courthion, ii, p. 81):

Firstly because he [Nieuwerkerke] maintained to me that there was a government and I did not in any way feel included in that government, I myself was a government, and . . . if he liked my pictures he was free to buy them from me, and I asked only one thing of him, that he should allow the art of his exhibition to be free.

This request met with only partial success; the Painter's Studio was not admitted into the official exhibition. In this, Courbet, driven by his need for independence, anticipated the later Salon des Refusés and secessionist movements.

In declining the honour of becoming a Chevalier of the Légion d'honneur in 1870, Courbet reiterated his liberal and individualistic principles (Courthion, ii, p. 124):

The State has no competence in matters relating to art When it leaves us free, it will have fulfilled its duties towards us. . . . when I am dead people must say of me: he never belonged to any school, any church, any institution, any academy and above all to any régime, except for the rule of freedom.

This stance as an outsider and individualist did not prevent Courbet from perceiving himself as a socialist and being seen as one. On 15 November 1851 Courbet was described in the Journal des faits as a 'socialist painter', and he immediately accepted this designation as his letter of 19

November 1851 to the editor demonstrates; the letter appeared on 21 November, thus just two weeks before Louis-Napoléon Bonaparte's coup d'état (*Bull. Amis Gustave Courbet*, lii (1974), p. 12):

> I am strong enough to act alone … M. Garcin calls me the socialist painter; I gladly accept that description; I am not only a socialist, but also a democrat and republican, in short a supporter of all that the revolution stands for, and first and foremost I am a realist.

Courbet's individualism extended to the wider demand for decentralization. This idea was first expressed in a letter Courbet wrote to Proudhon in 1863 for Proudhon's essay on his art (published in Paris in 1865 under the title 'Du principe de l'art et de sa destination sociale') in which he linked decentralization with his principle that 'independence leads to everything' (*Bull. Amis Gustave Courbet*, xxii (1958), p. 7). In a letter written to Jules Vallès during the Commune in 1871, Courbet stated that he regarded the USA and Switzerland as models for the future form of the French State; he felt France should be decentralized and divided into cantons (Courthion, ii, pp. 47–9). Courbet returned to the theme of decentralization in two further letters (Courthion, ii, pp. 49–59). However, these ideas should not be seen as forming a purely political manifesto. Courbet's painting provided an analogy for decentralization: firstly in its subject-matter, in his preference for the provinces over Paris, and secondly in its form, since for him each object had the same weight.

3. Character and personality

Courbet was regarded as a remarkable figure by his contemporaries: a sturdy man with a look of the people, far removed from Parisian taste, an artist without restraint, someone who saw himself as an anarchist and socialist but who made more of a fuss about it than his knowledge of the subject warranted. Presenting a noisy, obstreperous, extrovert image, he apparently found companionship only in bohemian circles (e.g. at the famous Brasserie Andler where he met Baudelaire, Proudhon, Corot

and, later on, Monet). This idea of an 'uncivilized' and 'independent' Bohemian formed an important feature of Courbet's self-image. He first expressed this Romantic notion in a letter to his friend Francis Wey in 1850: 'In our so very civilized society I have to live like a savage; I have to free myself even of governments. To accomplish this I have therefore just embarked on the great independent, vagabond life of the Bohemian.' (Riat, pp. 80–81). Later too Courbet was repeatedly described by himself and others as 'sauvage' (Courthion, i, pp. 98, 102, 105, 120, 216; ii, p. 93).

In his writings, including his autobiography of 1866 (Courthion, ii, pp. 25–33), Courbet often appears as a lively man who, though fond of laughter and singing, suffered from bouts of depression and a fear of persecution. These qualities are also evident in his extensive correspondence with his patron Bruyas, to whom he wrote at the end of 1854: 'Behind the laughing mask that you see I conceal inside me suffering, bitterness and a sadness that clings to my heart like a vampire.' (Courthion, ii, p. 84). Courbet's last important letter, of 1 March 1873, was again addressed to Bruyas; in it he links his personal suffering with that of society: 'The devotion I have always had for those who suffer has paralyzed the well-being which I could have achieved for myself in life. I have no regrets; I dread only one thing, ending up like Don Quixote, for lying and self-centredness are inseparable.' (Courthion, ii, p. 152).

IV. Critical reception and posthumous reputation

Courbet rapidly achieved a high and controversial profile in his lifetime through his character, life style and political views. Art critics (such as Théophile Gautier, Charles Perrier (*fl* 1850s), Maxime Du Camp, Prosper Mérimée (1803–70) and Alexandre Dumas *fils* (1824–95)) and caricaturists (such as Bertall, Cham, Paul Hadol (1835–75) and Quillenbois (*b* 1821)) reproached him not only for 'democratizing art' (prompted by *The Stone-breakers*) but also for extolling the world of peasants, labourers or wrestlers and for his coarse painting style. Courbet's defenders (such as Buchon,

Champfleury, Castagnary and Théophile Thoré), who pointed to his social commitment, his honest concern with the present and his modernity, were barely able to dent the prevailing academic concepts until the mid-1860s. Only Castagnary eventually succeeded in doing so, but only by a conformist strategy, which sacrificed the content of Courbet's painting. Castagnary was the first to point out the colourful charm, dreamy depths and lively atmosphere of Courbet's pictures; he even maintained that Courbet had never basically been a Realist. Conversely, Champfleury gradually parted company with Courbet for political reasons, and when he learnt in 1882 that Courbet was to be honoured with a large retrospective exhibition in the Ecole des Beaux-Arts, he criticized him as an annoying example of folksiness and spoke of his equivocations and lack of character. Even before that, in 1866, Zola had played Courbet the painter off against Courbet the politician; he particularly hated the sociological interpretation of Courbet's pictures by Proudhon (Picon and Bouillon, pp. 36–56). On the other hand, the socialist writer Thoré thought that Courbet had become depoliticized as he was now 'accepted, bemedalled, decorated, glorified, embalmed' (Thoré, ii, p. 276).

A rehabilitation of Courbet's reputation began in the 1880s when France remembered its republican traditions. Thenceforward Courbet was perceived both as a politically committed artist and as a modernist (see Sanchez), though the polemics against him continued (see Champfleury). In Germany Courbet had been highly regarded by the avant-garde from the time of the exhibitions of his work in Munich (1851, 1869) and Frankfurt am Main (1852, 1854, 1858). Julius Meier-Graefe put this admiration on a scholarly level as early as 1905, emphasizing Courbet's role as a pioneer of modernism, at the same time, moreover, that Cézanne (in conversations recorded by Joachim Gasquet (1873–1921) in *Cézanne* (Paris, 1926)) expressed his reverence for Courbet. The situation in England was similar after pictures by Courbet were exhibited there (in 1856 and 1862).

The position has not altered much since then. Even in France the reproach of 'lowness' levelled

at Courbet and the hatred of the Communards gradually disappeared, and Apollinaire's description of Courbet as the father of modernism has prevailed. In 1946 a small museum devoted to Courbet was opened in Ornans, and in 1971 this was expanded and moved into the house where he was born. The Musée Maison Natale de Gustave Courbet contains works by Courbet and his friends as well as photographs, letters and other material relating to the artist.

Since the 1970s the attitudes of Zola and Thoré have been reiterated and even intensified. A resolution of the sterile dispute over Courbet the artist and Courbet the politician can be achieved only by looking at the multiple meanings in Courbet's work from a different perspective (Hofmann in 1978–9 exh. cat.); by considering new aspects (e.g. the 'gender aspect', see 1988–9 exh. cat.); and by trying to understand Courbet's anti-normative method and rejection of naturalism (which has been so liberating to modernism) as analogies for his anarchic social utopias. Courbet's enduring achievement was unquestionably to free art from the strait-jacket of the academic 'ideal'. Therefore in a special sense he has become 'the artists' artist' (Sedgwick), while some art historians still approach him with reserve.

Writings

P. Courthion, ed.: *Courbet raconté par lui-même et par ses amis*, 2 vols (Geneva, 1948–50)
P. Borel, ed.: *Lettres de Gustave Courbet à Alfred Bruyas* (Geneva, 1951)
P. ten-Doesschate Chu, ed.: *Courbet's Letters* (Chicago, 1992)

Bibliography

early sources
Champfleury: 'Du réalisme: Lettre à Madame Sand', *L'Artiste*, n. s. 5, xvi (1855), pp. 1–5
J.-A. Castagnary: *Les Libres Propos* (Paris, 1864), pp. 174–201
T. Thoré: *Salon de W. Bürger*, 2 vols (Paris, 1870)
P. Mantz: 'Gustave Courbet', *Gaz. B.-A.*, xvii (1878), pp. 514–27; xviii (1878), pp. 17–29, 371–84
J.-A. Castagnary: *Salons (1857–1870)*, 2 vols (Paris, 1892)
——: 'Fragments d'un livre sur Courbet', *Gaz. B.-A.*, n. s. 2, v (1911), pp. 5–20; vi (1912), pp. 488–97; vii (1912), pp. 19–30

general

L. Nochlin, ed.: *Realism and Tradition in Art, 1848–1900* (Englewood Cliffs, 1966)

L. Nochlin: *Realism* (Harmondsworth, 1971)

T. J. Clark: *The Absolute Bourgeois: Artists and Politics in France, 1848–1851* (London, 1973)

G. Lacambre and J. Lacambre, eds: *Champfleury: Le Réalisme* (Paris, 1973)

G. Picon and J.-P. Bouillon: *Emile Zola: Le Bon Combat: De Courbet aux Impressionnistes* (Paris, 1974)

G. Lacambre and J. Lacambre, eds: *Champfleury: Son regard et celui de Baudelaire: Textes choisis et présentés, accompagnés de 'L'Amitié de Baudelaire et de Champfleury' par Claude Pichois* (Paris, 1990)

monographs and symposia

G. Riat: *Gustave Courbet: Peintre* (Paris, 1906)

C. Léger: *Courbet selon les caricatures et les images* (Paris, 1920)

J. Meier-Graefe: *Courbet* (Munich, 1921)

C. Léger: *Courbet et son temps* (Paris, 1949)

G. Mack: *Gustave Courbet* (London, 1951)

L. Aragon: *L'Exemple de Courbet* (Paris, 1952)

R. Fernier: *Gustave Courbet* (Paris, 1969)

A. Fermigier: *Courbet* (Geneva, 1971)

T. J. Clark: *Image of the People: Gustave Courbet and the 1848 Revolution* (London, 1973)

R. Lindsay: *Gustave Courbet: His Life and Art* (New York, 1973)

L. Nochlin: *Gustave Courbet: A Study in Style and Society* (New York, 1976)

B. Foucart: *Courbet* (Paris, 1977)

P. ten-Doesschate Chu, ed.: *Courbet in Perspective* (Englewood Cliffs, 1977)

Malerei und Theorie: Das Courbet Colloquium: Frankfurt am Main, 1979

A. Callen: *Courbet* (London, 1980)

M. Fried: *Courbet's Realism* (Chicago and London, 1990); review by K. Herding in *Burl. Mag.*, cxxxiii (1991), pp. 723–4

K. Herding: *Courbet: To Venture Independence* (New Haven and London, 1991)

J.-H. Rubin: *Gustave Courbet: Realist and Visionary* (in preparation)

catalogues

R. Fernier: *La Vie et l'oeuvre de Gustave Courbet: Catalogue raisonné*, 2 vols (Lausanne and Paris, 1977–8); review by K. Herding in *Pantheon*, xxxix (1981), pp. 282–6

Gustave Courbet, 1819–1877 (exh. cat. by H. Toussaint and M.-T. de Forges, Paris, Petit Pal.; London, RA; 1977–8)

Courbet und Deutschland (exh. cat. by W. Hofmann in collaboration with K. Herding, Hamburg, Ksthalle; Frankfurt am Main, Städel. Kstinst. & Städt. Gal.; 1978–9)

Courbet et la Suisse (exh. cat., ed. P. Chessex; La Tour-de-Peilz, Château, 1982)

Les Voyages secrets de Monsieur Courbet: Unbekannte Reiseskizzen aus Baden, Spa und Biarritz (exh. cat., ed. K. Herding and K. Schmidt; Baden-Baden, Staatl. Ksthalle; Zurich, Ksthaus; 1984)

Courbet à Montpellier (exh. cat., ed. P. Bordes; Montpellier, Mus. Fabre, 1985)

Courbet Reconsidered (exh. cat., ed. S. Faunce and L. Nochlin; New York, Brooklyn Mus.; Minneapolis, Inst. A.; 1988–9)

specialist studies

studies of particular works

R. Huyghe, G. Bazin and others: *Courbet: 'L'Atelier du peintre: Allégorie réelle', 1855* (Paris, 1944)

M. Winner: 'Gemalte Kunsttheorie: Zu Gustave Courbets *Allégorie réelle* und der Tradition', *Jb. Berlin. Mus.*, iv (1962), pp. 150–85

L. Nochlin: 'Gustave Courbet's *Meeting*: A Portrait of the Artist as a Wandering Jew', *A. Bull.*, xlix (1967), pp. 209–22

B. Farwell: 'Courbet's *Baigneuses* and the Rhetorical Feminine Image', *Women as Sex Objects: Studies in Erotic Art, 1730–1970*, ed. T. Hess and L. Nochlin (New York, 1972), pp. 65–79

B. Nicolson: *Courbet: 'The Studio of the Painter'* (New York, 1973)

A. Seltzer: 'Courbet: All the World's a Studio', *Artforum*, xvi (1977), pp. 44–50

J.-L. Fernier: *Courbet: 'Un Enterrement à Ornans', anatomie d'un chef d'oeuvre* (Paris, 1980)

M. Fried: 'The Structure of Beholding in Courbet's *Burial at Ornans*', *Crit. Inq.*, ix (1983), pp. 635–83

——: 'Courbet's Metaphysics: A Reading of *The Quarry*', *Reconstructing Individualism: Autonomy, Individuality and the Self in Western Thought*, ed. T. C. Heller and others (Stanford, 1986), pp. 75–105

L. Nochlin: 'Courbet's *L'Origine du monde*: The Origin without an Original', *October*, xxxvii (1986), pp. 76–86

other

J. Meier-Graefe: *Corot und Courbet* (Leipzig, 1905)

G. Boas: *Courbet and the Naturalistic Movement* (Baltimore, 1938)

M. Schapiro: 'Courbet and Popular Imagery: An Essay of Realism and Naiveté', *J. Warb. & Court. Inst.*, iv (1941), pp. 164–91

K. Berger: 'Courbet in his Century', *Gaz. B.-A.*, n. s. 6, xxiv (1943), pp. 19–40

Bull. Amis Gustave Courbet (1947–)

J. P. Sedgwick: 'The Artist's Artist', *ARTnews*, lviii (1960), pp. 40–44, 65–6

T. J. Clark: 'A Bourgeois Dance of Death: Max Buchon on Courbet', *Burl. Mag.*, cxi (1969), pp. 208–12, 286–90

L. Dittmann: *Courbet und die Theorie des Realismus: Beiträge zur Theorie der Künste im 19. Jahrhundert* (Frankfurt am Main, 1971), pp. 215–39

R. Bonniot: *Courbet en Saintonge* (Paris, 1973)

A. Bowness: 'Courbet and Baudelaire', *Gaz. B.-A.*, n. s. 6, xc (1977), pp. 189–99

K. Herding: 'Gustave Courbet (1819–1877): Zum Forschungsstand', *Kunstchronik*, xxx (1977), pp. 438–56, 486–96

A. Bowness: 'Courbet's Proudhon', *Burl. Mag.*, cxx (1978), pp. 123–8

K. Herding, ed.: *Realismus als Widerspruch: Die Wirklichkeit in Courbets Malerei* (Frankfurt am Main, 1978, rev. 1984)

J.-P. Sanchez: 'La Critique de Courbet et la critique du réalisme entre 1880 et 1890', *Hist. & Crit. A.*, iv–v (1978), pp. 76–83

T. Reff: 'Courbet and Manet', *A. Mag.*, liv (1980), pp. 98–103

J.-H. Rubin: *Realism and Social Vision in Courbet and Proudhon* (Princeton, 1980)

A. M. Wagner: 'Courbet's Landscapes and their Market', *A. Hist.*, iv (1981), pp. 410–31

L. Nochlin: 'The De-politicization of Gustave: Transformation and Rehabilitation under the Third Republic', *October*, xxii (1982), pp. 65–77

N. McWilliams: 'Un Enterrement à Paris: Courbet's Political Contacts in 1845', *Burl. Mag.*, cxxv (1983), pp. 155–6

K. Herding: 'Lautmalereien: Zu einigen unbekannten Gedichten und Briefen Courbets', *Kunst um 1800 und die Folgen: Werner Hofmann zu Ehren*, ed. C. Beutler (Munich, 1988), pp. 233–43

P. ten-Doesschate Chu: *Courbet and the 19th Century Media Culture* (in preparation)

KLAUS HERDING

Court, Joseph-Désiré

(*b* Rouen, 14 Sept 1797; *d* Paris, 23 Jan 1865). French painter and museum director. In 1817 he entered the Académie des Beaux-Arts in Paris, where he studied under Antoine-Jean Gros. In 1821 he won the Prix de Rome with *Samson Handed over to the Philistines by Delilah* (1821; Paris, Ecole N. Sup. B.-A.). He began exhibiting at the Salon in 1824 and in 1827 showed *Scene from the Deluge* (1827; Lyon, Mus. B.-A.), painted while he was in Rome, and the *Death of Caesar* (Paris, Louvre). The latter proved a sensational success: it was initially bought by the Musée du Luxembourg, Paris, and was re-exhibited in 1855 before being sent to the Louvre. The subject derives from Plutarch and shows Antony stirring the Roman citizens to avenge the murder of Caesar. It was praised chiefly for its dramatic composition.

In 1830 and 1831 Court took part in the competitions set up to provide paintings for the Salon de Séances in the Chambre de Députés, Paris. His three works, on the required subjects, were the *Oath of Louis-Philippe* (1830; Saint-Germain-en-Laye, Mus. Mun.), *Mirabeau and Dreux-Brézé* and *Boissy d'Anglas Saluting the Head of Féraud* (both 1831; Rouen, Mus. B.-A.). None of Court's entries was successful, but their reception reflects contemporary debates about the requirements of official art: although it conformed largely to traditional modes of representation, *Mirabeau and Dreux-Brézé* was criticized as being too theatrical and was perceived as lacking the historical literalness required of official art. As a protest against the decision of the competition jury, Court exhibited *Boissy d'Anglas* at the Salon of 1833.

At the Salon of 1836 Court exhibited two further examples of official art: the *Duc d'Orléans Signs the Act Proclaiming a Lieutenance-générale of the Kingdom, 31 July 1830* and the *King Distributing Battalion Standards to the National Guard, 29 August 1830* (both Versailles, Château). The latter was hung in the Salle de 1830 in the south wing of the château of Versailles, a room designed to celebrate the Revolution of 1830 that brought Louis-Philippe to power. In order to create the sense of recording a first-hand experience, Court depicted a close-up view of the event, rather than a panoramic scene. As with other official works, however, the appearance of historical truth disguised the propagandist intent. The picture professed the physical strength of the monarchy and reflected the importance of the National Guard to its security, though in August 1830 the

Marquis de Lafayette was in fact Commander-in-Chief of the National Guard.

Court increasingly devoted himself to painting portraits, such as that of *Marshal Vallée* (1839; Versailles, Château). He also painted a number of religious works, such as the *Embarkation of St Paul for Jerusalem* (1835; Paris, SS Gervais & Protais). After his early successes and critical acclaim, Court's later work was rather mediocre, though his portraits are of historical interest. He continued to exhibit regularly at the Salon, and in 1853 he was appointed director of the Musée des Beaux-Arts in Rouen, a post he held until his death.

Bibliography

Bénézit; *DBF*

H. Marcel: *La Peinture française au XIXe siècle* (Paris, 1905), pp. 128–31

P. Grunchec: *Le Grand Prix de peinture* (Paris, 1983)

M. Marrinan: *Painting Politics for Louis-Philippe: Art and Ideology in Orléanist France, 1830–1848* (New Haven and London, 1988)

☐

Couture, Thomas

(*b* Senlis, 21 Dec 1815; *d* Villiers-le-Bel, 3 March 1879). French painter and teacher. A student of Antoine-Jean Gros in 1830–38 and Paul Delaroche in 1838–9, he demonstrated precocious ability in drawing and was expected to win the Prix de Rome. He tried at least six times between 1834 and 1839, but achieved only second prize in 1837 (entry untraced). Disgusted with the politics of the academic system, Couture withdrew and took an independent path. He later attacked the stultified curriculum of the Ecole des Beaux-Arts and discouraged his own students from entering this institution. He first attained public notoriety at the Paris Salon with *Young Venetians after an Orgy* (1840; Montrouge, priv. col., see Boime, p. 85), the *Prodigal Son* (1841; Le Havre, Mus. B.-A.) and the *Love of Gold* (1844; Toulouse, Mus. Augustins). These early canvases are treated in a moralizing and anecdotal mode; the forms and compositional structures, like the debauched and corrupt protagonists, are sluggish and dull. Yet what made his work seem fresh to the Salon audience was his use of bright colour and surface texture derived from such painters as Alexandre-Gabriel Decamps and Eugène Delacroix, while his literary bent and methodical drawing demonstrated his mastery of academic tradition. The critics Théophile Gautier and Paul Mantz (1821–95) proclaimed him as the leader of a new school that mediated between the old and the new, and looked to him for a revitalization of Salon painting. The air of compromise his works projected made him appear a cultural representative of the *juste milieu* policies of Louis-Philippe.

However Couture was far from happy in this role. Longing to make a statement worthy of the grand tradition of David and Gros, he started to work in the mid-1840s on the monumental *Romans of the Decadence* (completed 1847; Paris, Mus. d'Orsay; see col. pl. XI). It was the triumph of the Salon of 1847 and destined to become his best-known picture. An extension of the moralizing themes of his first Salon exhibits, it represents the waning moments of an all-night orgy in the vestibule of a vast Corinthian hall. The exhausted and drunken revellers are contrasted with the solemn tutelary statues of the great Roman republicans in the niches around the hall; the heroes' descendants have fallen into venality and corruption. The work was interpreted as a satire on the July Monarchy (1840–48) and a wide range of government critics—aristocratic, radical and bourgeois—perceived it as a forecast of the regime's impending doom. The picture also had its admirers in government circles: François Guizot, the king's chief minister, was instrumental in its purchase by the state.

The collapse of the July Monarchy in 1848 seemed to confirm a prophetic interpretation of the picture, and Couture was encouraged to produce a new monumental painting celebrating the Revolution for the Salle des Séances in the Assemblée Nationale. He had already begun his *Enrolment of the Volunteers of 1792* (incomplete; Beauvais, Mus. Dépt. Oise) near the end of 1847, inspired by a series of lectures given by Jules Michelet at the Collège de France, which aimed to regenerate French society through the

invigorating impulses of its youth. Michelet invoked 1789 as an exemplary model, and similarly in the *Enrolment* Couture depicted all classes in society forging a new national unity in the face of external threat. The exhilaration of the picture, its energetic sweep and movement, contrasts sharply with the *Romans* and attests to the sense of revitalization sparked by the 1848 revolution. But the work was never completed: with the counter-revolution in June 1848 and the installation of Louis-Napoléon as emperor the political climate altered so drastically that the *Enrolment* lost its raison d'être. The canvas has some figures almost complete but mainly only underdrawing.

Couture managed to maintain close ties with the various governments of Napoleon III. He received a number of major commissions, but completed only the wall paintings in the chapel of the Virgin, St Eustache, Paris. His *Baptism of the Prince Imperial* (Compiègne, Château), celebrating the dynastic heir of the Second Empire, was commissioned in 1856 with the *Return of the Troops from the Crimea* (Le Havre, Mus. B.-A.) but remained unfinished. A combination of jealous intrigues and his own unstable temperament led to a falling out with the imperial family, and by the end of the 1850s he had nothing to show for his labours except innumerable sketches (e.g. Senlis, Mus. A. & Archéol.).

Couture returned to Senlis in 1859 and devoted the rest of his life to satisfying the tastes of private patrons, many of them Americans. He embarked on a series of pictures based on the characters of the *commedia dell'arte*. His satirical *Realist* (1865; Cork, Crawford Mun. A.G.) shows a bohemian art student seated on the head of the Olympian Jupiter painting the head of a pig. His misanthropic disposition is revealed in his *Courtesan's Chariot or Love Leading the World* (several versions, 1870s; e.g. Philadelphia, PA, Mus. A.), which shows a bare-breasted female pulled in a carriage by four men representing Youth, Riches, Courage and Poetry. The courtesan drives them with a whip, transforming them into beasts of burden. He was a particularly fine portrait painter, as can be seen in the *Young Italian Girl* (1877; Senlis, Mus. A. & Archéol.).

Couture's posthumous reputation rests mainly on his pedagogic skills. In 1847 he announced that he was opening an atelier in Paris independent of both classical and Romantic schools. He soon became a popular teacher. His distrust of academic education and honours, his innovative technical procedures and obsession with the pure colour and fresh brushwork of the sketch, which he encouraged his students to retain into the finished picture, exercised a profound influence. Among his pupils were Edouard Manet, Pierre Puvis de Chavannes, Anselm Feuerbach and many American artists—who preferred his teaching to the more rigid discipline of the Ecole and the Düsseldorf school—notably John La Farge, William Morris Hunt and Eastman Johnson.

Many of Couture's paintings and drawings were destroyed in 1870 during the Franco-Prussian War. The Musée d'Art et Archéologie, Senlis, has a collection of his portraits and oil sketches.

Writings

Méthodes et entretiens d'atelier (Paris, 1867)
Entretiens d'atelier: Paysage (Paris, 1869)

Bibliography

Catalogue des oeuvres de Thomas Couture (exh. cat. by R. Ballu, Paris, Pal. Indust., 1880)
G. Bertauts-Couture: *Thomas Couture (1815–1879): Sa vie, son oeuvre, son caractère, ses idées, sa méthode, par lui-même et par son petit-fils* (Paris, 1932)
American Pupils of Thomas Couture (exh. cat. by M. E. Landgren, College Park, U. MD A.G., 1970)
Thomas Couture, 1815–79 (exh. cat. by M. J. Salmon, Beauvais, Mus. Dépt Oise, 1972)
P. Vaisse: 'Couture et le Second Empire', *Rev. A.* [Paris], xxxvii (1977), pp. 43–68
—: 'Thomas Couture ou le bourgeois malgré lui', *Romanticisme*, xvii–xviii (1977), pp. 103–22
A. Boime: *Thomas Couture and the Eclectic Vision* (New York, 1979)

ALBERT BOIME

Crauk, Charles-Alexandre

(*b* Douchy, 27 Jan 1819; *d* Paris, 30 May 1905). French painter. He was a pupil of Jacques-François Momal (1754–1832) and of Antoine-Julien Potier

(1796–1865) at the Académie in Valenciennes, which gave him a grant, and he then went to the Ecole des Beaux-Arts in Paris in 1840, where he studied under François-Edouard Picot. He exhibited regularly at the Salon from 1845, including such works as *Antoine Watteau, Dying, Gives his last Advice to Jean-Baptiste Pater*. In 1846 he won the Deuxième Prix de Rome for *Alexandre, Ill, with his Doctor, Philip* (sketch Paris, priv. col.), though the Première Prix de Rome was not awarded that year. He is known mainly for his religious paintings, among them the *Ecstasy of St Lambert*, commissioned by the Interior Minister in 1852, and the *Baptism of Christ* (church of Lescas, Basses Pyrenées), commissioned by the Minister of State in 1852. He also painted the *Martyrdom of St Piat* for the cathedral in Angers and four scenes from the life of the eponymous saint for the choir of St Francis Xavier in Paris, as well as numerous cartoons for stained glass in churches at Compiègne, Versailles, Chartres and elsewhere. Crauk executed several civic decorative works for the Galerie des Machines at the Exposition Universelle in Paris in 1889, producing the cartoon for a large stained-glass window on the theme of the *Chariot of the Sun*. He also painted a ceiling for the Musée des Beaux-Arts in Amiens. He was appointed professor of drawing at the Ecole de Saint-Cyr in 1875 and exhibited regularly at the Salon until 1902, with one break in 1893.

Bibliography
Bénézit; *DBF*; Thieme–Becker

A. DAGUERRE DE HUREAUX

Crauk, Gustave-Adolphe-Désiré

(*b* Valenciennes, 16 July 1827; *d* Meudon, 17 Nov 1905). French sculptor. An artist noted more for productivity than originality, he won the Prix de Rome in 1851. He was most successful with commemorative statues in historical, military or ecclesiastical costume, such as the *Intendant d'Etigny* in front of the thermal baths at Bagnères-de-Luchon, Haute-Garonne (1873), *General Chanzy* at Le Mans (1885; Place de la République) and the tomb of *Cardinal Lavigerie* in the basilica of St Louis,

Carthage (1899). Crauk was a compatriot and contemporary of Jean-Baptiste Carpeaux, and both received their first artistic training at the Académie de Peinture et de Sculpture, Valenciennes. Crauk's relationship with his birthplace was commemorated in the town's Musée Crauk, which housed the artist's bequest of his studio contents. Following damage sustained by the museum in World War II, the exhibits were removed to the Musée des Beaux-Arts, Valenciennes.

Bibliography
Lami

De Carpeaux à Matisse: La Sculpture française de 1850 à 1914 dans les musées et les collections publiques du nord de la France (exh. cat., Calais, Mus. B.-A.; Lille, Mus. B.-A.; Arras, Mus. B.-A.; Paris, Mus. Rodin; 1982–3), pp. 172–7

PHILIP WARD-JACKSON

Cros, (César-Isidore-)Henri [Henry]

(*b* Narbonne, 16 Nov 1840; *d* Sèvres, 20 Jan 1907). French sculptor and writer. He was the elder brother of the eccentric poet and inventor, Charles Cros (1842–88), and he received a traditional training under the painter Jules-Emmanuel Valadon (1826–1900) and under the sculptors François Jouffroy and Antoine Etex. He first exhibited at the Salon of 1861 in Paris, showing a plaster bust of his brother (untraced), and in 1863 he participated in the Salon des Refusés. Between 1869 and 1880 he researched techniques of making sculpture in polychromed wax. At the Salon of 1873 he exhibited the *Prize of the Tournament* (Paris, Mus. d'Orsay), a polychromed wax relief studded with pearls, which was purchased for the State. It depicts a stylized group of medieval women in court costumes occupying a box at a tournament. He produced 12 works in this medium, and although few have survived, they served as technical prototypes for the work of other sculptors, notably Degas and Désiré Ringel d'Illzach. His investigations into the way wax had been used in earlier art culminated in a study, undertaken in collaboration with the scientist Charles Henry, of the use of encaustic in the ancient world. From

the mid-1880s Cros became interested in another ancient technique, that of making polychrome sculpture from fired glasspaste imbued with metal oxides. He sought State sponsorship for his research and was rewarded in 1891 by being provided with a studio at the Sèvres Porcelain Factory, for the production of *pâte de verre* sculpture and decorative work. His most substantial surviving pieces in this medium are the *History of Water* (1892–4; Paris, Mus. d'Orsay), a relief for a fountain, and the *History of Fire* (1894–1900; Paris, Mus. A. Déc.), a lunette relief. Unlike the medievalism of his wax pieces, these display a painterly classicism and a free, Symbolist approach to mythological themes. His use of decorative media to break down the boundaries between painting and sculpture is symptomatic of a wider endeavour throughout Europe at the end of the 19th century to unite the fine and the applied arts.

Writings

with C. Henry: *L'Encaustique et les autres procédés de peinture chez les Anciens, histoire et technique* (Paris, 1884)

Bibliography

A. Bourdelle: 'Un Grand Artiste méconnu: Henri Cros', *La Vie*, 8 (1917)

J.-L. Olivié: 'Un Atelier et des recherches subventionnés par l'état: Henry Cros à Sèvres', *La Sculpture du XIXe siècle, une mémoire retrouvée: Les Fonds de sculpture. Rencontres de l'école du louvre: Paris, 1986*, pp. 193–9

PHILIP WARD-JACKSON

Cross, Henri Edmond [Delacroix, Henri-Edmond-Joseph]

(*b* Douai, 20 May 1856; *d* Saint-Clair, 16 May 1910). French painter and printmaker. The only surviving child of Alcide Delacroix, a French adventurer and failed businessman, and the British-born Fanny Woollett, he was encouraged as a youth to develop his artistic talent by his father's cousin, Dr Auguste Soins. He enrolled in 1878 at the Ecoles Académiques de Dessin et d'Architecture in Lille, where he remained for three years under the guidance of Alphonse Colas (1818–87). He then moved

to Paris and studied with Emile Dupont-Zipcy (1822–65), also from Douai, whom he listed as his teacher when exhibiting at Salons of the early 1880s. His few extant works from this period are Realist portraits and still-lifes, painted with a heavy touch and sombre palette (example in Douai, Mus. Mun.).

To avoid working under the shadow of his celebrated namesake, Eugène Delacroix, in 1881 he adopted an abbreviated English version of his surname, signing his works 'Henri Cross' until around 1886, when he adopted 'Henri Edmond Cross' to avoid being confused with the painter Henri Cros.

In 1884 Cross helped to found the Société des Artistes Indépendants and through it became friends with many of the Neo-Impressionists. However, he only gradually assimilated avantgarde stylistic innovations. He lightened his palette and began painting figures *en plein air* in the mid-1880s. *Monaco* (1884; Douai, Mus. Mun.) reveals his study of both Jules Bastien-Lepage and Manet. Towards the end of the decade, when he was increasingly influenced by Monet and Pissarro, he began to paint pure landscapes.

Cross's career took a decisive turn in 1891, when he adopted the Neo-Impressionist technique and showed at the Indépendants exhibition his first large work in this style, the portrait of *Mme H. F.* (now titled portrait of *Mme Cross*; Paris, Mus. d'Orsay; see fig. 23). Also in this year, he moved to the south of France, staying first at Cabasson and then settling in Saint-Clair, a small hamlet near St Tropez where Signac also took up residence in 1892. Cross lived in Saint-Clair for the rest of his life, travelling twice to Italy (1903 and 1908) and annually to Paris for the Indépendants shows.

In the early and mid-1890s, as he developed the Neo-Impressionist method, Cross concentrated on seascapes and scenes of peasants at work. The *Beach of Baigne-Cul* (1891–2; Chicago, IL, A. Inst.) is characteristic of his highly regular technique: over a densely painted ground he placed small and relatively round touches in rows, more or less equally spaced, and mixed colours with white to express the bleaching action of sunlight. *The Farm (Evening)* (1893; priv. col., see Compin, p. 129) exhibits his decorative use of sensuous silhouettes

Cross shared the utopian and anarchist beliefs of many of the Neo-Impressionists. In 1896 he contributed an anonymous lithograph entitled *The Wanderer* (see Compin, p. 337) to Jean Grave's anarchist publication, *Temps nouveaux*. Later he created cover illustrations for several brochures issued by the same journal. Interpretations of Cross's large painting, the *Air of Evening* (1893–4; Paris, Mus. d'Orsay), have stressed the presence of anarchist-inspired sentiments. Like Signac's *In the Time of Harmony* (Montreuil, Mairie) from the same period, Cross's depiction of languorous seaside leisure seems designed to suggest the joy that would be unleashed by anarchy.

The comparatively small size of Cross's oeuvre can be partly attributed to his ill health. Eye problems, which emerged in the early 1880s, worsened in the early 1900s, and bouts of arthritis also kept him from working. Nonetheless, during the last decade of his life he mounted important one-man shows in Paris (Galerie Druet, 1905; Bernheim-Jeune, 1907) and as a result began finally to find a market and enthusiastic critical response.

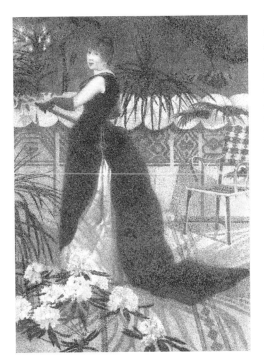

23. Henri Edmond Cross: *Mme Cross*, 1891 (Paris, Musée d'Orsay)

and recalls the Japanese prints and Art Nouveau designs that inspired other Neo-Impressionists at this time.

After the mid-1890s Cross ceased to depict peasants but continued to paint seascapes while exploring such new subjects as the everyday dances shown in *Village Dance* (1896; Toledo, OH, Mus. A.). Working with his neighbour Signac, he gradually abandoned the dot of earlier Neo-Impressionism and employed instead large and blocky strokes; this technique allowed for intense colour contrasts and created decisively decorative, mosaic-like surfaces. Now associated with the so-called 'second' Neo-Impressionist style, these developments inspired Matisse and the other Fauves who visited the south of France in the early 1900s. Also influential on these painters were the nude bathers and mythological figures, particularly the nymphs and fauns, which Cross introduced into his late seascapes.

Bibliography

Exposition H.-E. Cross (exh. cat., preface E. Verhaeren; Paris, Gal. Druet, [1905])

Exposition Henri-Edmond Cross (exh. cat., preface M. Denis; Paris, Bernheim-Jeune, 1907); preface repr. in M. Denis: *Théories* (Paris, 1913, rev. 4/1920), pp. 157–60

C. Angrand: 'Henri-Edmond Cross', *Temps Nouv.*, xvi (23 July 1910), p. 7

E. Verhaeren: 'Henri Edmond Cross', *Nouv. Rev. Fr.* (July 1910), pp. 44–50; repr. in E. Verhaeren: *Sensations* (Paris, 1927), pp. 204–8

Exposition Henri-Edmond Cross (exh. cat., preface M. Denis; Paris, Bernheim-Jeune, 1910); preface repr. in M. Denis: *Théories* (Paris, 1913, rev. 4/1920), pp. 161–5

L. Cousturier: 'H.-E. Cross', *A. Déc.*, xxix (1913), pp. 117–32; as book (Paris, 1932)

F. Fénéon, ed.: 'Le Dernier Carnet d'Henri-Edmond Cross' and 'Inédits d'Henri-Edmond Cross', *Bull. Vie A.*, iii, 10–22 (1922)

M. Saint-Clair [M. van Rysselberghe]: 'Portrait du peintre Henri-Edmond Cross', *Nouv. Rev. Fr.*, liii (1939), pp. 123–7; repr. in M. Saint-Clair: *Galerie privée* (Paris, 1947), pp. 25–38

J. Rewald, ed.: *H.-E. Cross: Carnet de dessins*, 2 vols (Paris, 1959) [sketchbook facs.]

R. Herbert and E. Herbert: 'Artists and Anarchism', *Burl. Mag.*, cii (1960), pp. 473–82

I. Compin: *H.-E. Cross* (Paris, 1964) [cat. rais. and detailed bibliog.]

MARTHA WARD

Curzon, (Paul-)Alfred de

(*b* Le Moulinet, Vienne, 7 Sept 1820; *d* Paris, 4 July 1895). French painter. He belonged to the provincial aristocracy of south-east France. As a schoolboy in Paris, he was impressed by Delacroix's *Medea* (Lille, Mus. B.-A.) in the Salon of 1838. In September of that year he began to experiment with pastel and decided to become a painter. As Ingres no longer ran a teaching studio, he was sent to Michel-Martin Drolling, who presented him at the Ecole des Beaux-Arts on 1 April 1840; but Drolling was never a very successful teacher, and Curzon's fellow student Louis-Georges Brillouin (1817–93) persuaded him to leave in 1845 for the atelier of the landscape painter Louis Cabat. Curzon made his début at the Salon in 1845 with a landscape.

In 1846 Curzon made his first visit to Italy, travelling from Rome, where he met the Bénouville brothers, Alexandre Cabanel and Louis Français, to Venice and Florence. Back in France, he entered the competition in 1848 for a figure of the Republic, without success; he also put his name down for the Prix de Rome competition in historical landscape in 1849. Charles-Joseph Lecointe (1823–86) won the prize, but the critics preferred Curzon's entry (*The Death of Milo of Crotona*; Paris, Ecole N. Sup. B.-A.) and, after a complaint by Paul Delaroche, Curzon was given a vacancy. During his four years at the Académie de Rome (1850–53), Curzon travelled in search of views. In 1852 he visited Athens with Charles Garnier. Works inspired by this period in Italy and Greece, picturesque genre scenes and landscapes, appeared in the Paris exhibitions of the 1850s.

Landscape was Curzon's first love, but he successfully explored other genres. On his return to France in 1853, he collaborated with Eugène Froment in decorating the chapel of the seminary at Autun; his only other religious work of this kind and his only commission for a religious picture, *Christ Showing his Wounds to St Thomas*, was painted in 1860 for the Paris church of St Nicolas-du-Chardonnet. This large, understated picture, dominated by the delicately modelled group of Christ and his apostles, shows Curzon's excellence in figure painting. It is curious that he did no more work like this. His four allegorical panels, executed in mosaic in the *avant-foyer* of the Opéra for his friend Charles Garnier, was also his only effort in secular decorative art.

In the Salon of 1859, *Psyche* (Sermaize-les-Bains, Hôtel de Ville), a pale, luminous sylph drifting towards the spectator, proved Curzon's talent as a painter of classical mythology in rivalry with Paul Baudry and William-Adolphe Bouguereau. The picture was a huge popular success, but this did not divert him from his memories of Greece and Italy, which he continued to illustrate throughout the 1860s and 1870s. *Dream in the Ruins of Pompeii* (1866; Bagnères-de-Bigorre, Mus. A.), inspired by a visit to Pompeii in 1851 with Bouguereau, depicts a company of ghosts wandering in the ruins of the town with the quiet, elegiac poetry which is characteristic of his work. The State recognized his talent: in 1865 he was made an officer of the Légion d'honneur, and his *Dominican Monks Decorating their Chapel* (Poitiers, Pal. Justice) was bought by the State, as was his *View at Ostia* (exh. Salon, 1868; untraced) in 1869. He was a landscape painter with an unusual talent in figure painting and a striking draughtsman with a liking for highly worked effects in watercolour and charcoal. The Musée Sainte-Croix, Poitiers, owns a large number of his drawings.

Bibliography
H. de Curzon: *Alfred de Curzon, peintre (1820–1895): Sa vie et son oeuvre d'après ses souvenirs, ses lettres, ses contemporains*, 2 vols (Paris, [1916])

L'Art en France sous le Second Empire (exh. cat., Paris, Grand Pal., 1979), pp. 337–8, 432–3

JON WHITELEY

Dagnan-Bouveret, P(ascal-)A(dolphe-) J(ean)

(*b* Paris, 7 Jan 1852; *d* Quincey, Haute-Saône, 3 July 1929). French painter. He refused to leave France when his father Bernard Dagnan moved to Brazil in 1868, and he remained with his maternal grandfather in Melun (nr Paris). Later he added the maternal surname Bouveret to his own in gratitude for his grandfather's support, which enabled him to study in Paris.

In 1869 Dagnan-Bouveret entered the Ecole des Beaux-Arts in Paris and studied in the atelier of Alexandre Cabanel. After a few months he joined the atelier of Jean-Léon Gérôme, where he trained as a draughtsman and painter. In 1875 his first works, a painting entitled *Atalante* (purchased by the State; Melun, Mus. Melun) and two drawings, were accepted at the Salon. The next year Dagnan-Bouveret received a second place in the Prix de Rome for *Priam Asking Achilles for the Body of his Son* (untraced) and a first prize for painting the human figure at the Ecole des Beaux-Arts. In 1878 he won a third-class medal at the Salon and left the Ecole des Beaux-Arts, along with his friend the genre painter Gustave Courtois (1853–1923). They went to the Franche-Comté, Courtois's native region, where Dagnan-Bouveret met and eventually married Courtois's cousin Maria Walter. The provincial life of the Franche-Comté provided numerous themes for many of Dagnan-Bouveret's landscape, still-life and genre paintings and sketches (see fig. 24). Some of these reflected an interest in atmosphere, while others explored the effects of light and shade in a manner reminiscent of 17th-century Dutch masters. *An Accident* (exh. Salon 1880; Baltimore, MD, Walters A.G.), depicting a village doctor tending the injured hand of a peasant boy, established Dagnan-Bouveret as a naturalistic painter of great exactitude, interested in psychological character and intent on recording the customs of the region.

Like his friend Jules Bastien-Lepage, Dagnan-Bouveret painted mythological scenes and portraits of his friends and family for the Salons. The anecdotal *Wedding Party at the Photographer's Studio* (1879; Lyon, Mus. B.-A.) displayed an almost photographic realism and was an early example of

24. P.-A.-J. Dagnan-Bouveret: *Blessed Bread*, 1885 (Paris, Musée d'Orsay)

the artist's interest in photography as a theme for painting.

In 1885 Dagnan-Bouveret's large naturalistic canvas *Horses at the Watering Trough* (purchased by the State; Chambéry, Mus. B.-A.) was shown at the Salon and established him as a major figure of the Salon naturalistic school. Critics commented on the painstaking exactitude of the composition and the photographic realism of both horses and handler. For the horses, Dagnan-Bouveret had used a series of photographs (taken in the Franche-Comté). Although he never revealed this device to his public, it aided him in effectively capturing natural poses and detail.

In the same year Dagnan-Bouveret made his first visit to Brittany. *Pardon—Brittany* (1887; New York, Met.) is a naturalistic rendering of a peasant religious celebration based on scenes from Breton folklore. Again he combined preliminary sketches

with photographs of models to achieve his effects. To translate the composition from one medium to another he traced photographs of his posed models, dressed in traditional Breton costume, for his colour studies.

During the 1890s Dagnan-Bouveret turned from naturalistic genre compositions to concentrate on portraiture and themes of religious mysticism. His fashionable, idealized portraits were popular with wealthy patrons and provided him with a high income, enabling him to work on religious paintings, including a *Supper at Emmaus* (1896–7; Pittsburgh, PA, Carnegie Mus. A.). The later canvases confirmed Dagnan-Bouveret's fame and importance at the Salons of the 1890s. During the rest of his life he developed numerous large-scale religious themes, which suggest conversion to intense Catholicism and owe much to Italian Renaissance prototypes, such as Leonardo da Vinci's *Last Supper*. Dagnan-Bouveret selected his models from the people of his local town, Vesoul; by dressing these models in appropriate historical garments and then photographing them, he was able to reconstruct an image of the past while maintaining a naturalist's inclination for exact detail within a mystical setting.

Dagnan-Bouveret received numerous awards, including nomination as Chevalier of the Légion d'honneur (1885) and as a member of the Institut de France (1900).

Bibliography

J. Dampt: 'P. A. J. Dagnan-Bouveret 1852–1929', *Catalogue des oeuvres de M. Dagnan-Bouveret* (Paris, 1930), pp. 3–7

The Realist Tradition (exh. cat., ed. G. P. Weisberg; Cleveland, OH, Mus. A., 1980)

G. P. Weisberg: 'Dagnan-Bouveret, Bastien-Lepage and the Naturalist Instinct', *A. Mag.*, lvi (April 1982), pp. 70–76

——: 'Making it Natural: Dagnan-Bouveret's Constructed Compositions for the Paris Salon of the 1880s', *Scot. A. Rev.*, xv/4 (1982), pp. 7–15

——: 'P. A. J. Dagnan-Bouveret and the Illusion of Photographic Naturalism', *A. Mag.*, lvi (March 1982), pp. 100–05

——: *Beyond Impressionism: The Naturalist Impulse* (New York, 1992)

GABRIEL P. WEISBERG

Dalou, (Aimé-)Jules

(*b* Paris, 31 Dec 1838; *d* Paris, 15 April 1902). French sculptor. Dalou ranks among the greatest sculptors of the 19th century, alongside Antonio Canova, François Rude, Jean-Baptiste Carpeaux and Auguste Rodin. The son of a glovemaker, he was a modern urbanite who believed in the moral efficacy of craftsmanship and manual labour as well as the primacy of democracy and a secular social order. The imagery of his finest works bears witness to these beliefs.

After being encouraged to become a sculptor by Carpeaux, Dalou trained at the Petite Ecole (1852–4), where he learnt the fundamentals of drawing and modelling, and later studied at the Ecole des Beaux-Arts (1854–7), where he was admitted to the studio of Francisque Duret. Dalou's early ambitions were wholly conventional. He competed for the Prix de Rome four times but never won first prize. During the 1860s he exhibited four modest works at the Salon while earning his living as a decorative artist. His most impressive decorative work is in Paris at the Hôtel Menier and the Travellers' Club (formerly the Hôtel Païva). He first won critical and popular success at the Salon of 1870, when his *Embroiderer* (destr.; plaster cast from a preliminary sketch in Paris, Petit Pal.; reduction of final version, in bronze, Karlsruhe Mus.) was warmly received and purchased by the State. He was unable to execute an official commission for a marble version of this life-size genre subject because of the intervention of the Franco-Prussian War and the Commune.

Dalou's lifelong political sympathies were left-wing and republican (but not socialist, as has often been said), and he was confident of the eventual existence of a universal republic and brotherhood among mankind. With the declaration of the Commune in March 1871, he believed that this visionary era was dawning, and he became an enthusiastic participant in Gustave Courbet's Federation of Artists, assuming a curatorship of the Louvre under this branch of the Commune. After the fall of the Commune he was forced into exile, and he lived and worked in London from mid-1871 until the amnesty of 1879. While there he established his reputation with both the public and the

critics with portraits and intimate subjects, for example *Mrs Gwynne* (terracotta, 1877; London, V&A) and *Woman Reading* (terracotta, 1872; Providence, RI Sch. Des., Mus. A.), which elaborated on the stylistic and narrative format first realized in his *Embroiderer*. English collectors were eager to own his works and commission portraits from him. He became a professor of sculpture at the South Kensington School of Art, where his foremost pupil was Edouard Lanteri, and was commissioned by Queen Victoria to design a memorial to her dead grandchildren for the Royal Chapel at Windsor Castle (1878). By the late 1870s, Dalou was tiring of his intimate subjects and portraits; he desired henceforth to make public sculpture of moral and social significance. The only such opportunity for him in England was the commission for a marble figure of *Charity* (1877–9) to surmount a drinking fountain behind the Royal Exchange in London (now replaced by a bronze replica).

When Dalou returned to Paris in 1879, he already held a commission from the City of Paris for the most ambitious undertaking of his career, a colossal ensemble in bronze entitled the *Triumph of the Republic* (1879–99; Paris, Place de la Nation; see col. pl. XII). This was the result of a competition that Dalou entered, but did not win, for a single figure of the Republic to serve as the focal point of the newly developed Place de la République. Dalou's Rubensian ensemble, with a lavishly decorated, lion-drawn chariot carrying the Republic, and allegorical figures of Liberty, Justice, Labour and Peace-Abundance, violated the terms stipulated by the competition but attracted enthusiastic support. Thanks to machinations of favourably disposed members of the left-wing city council of Paris, Dalou was commissioned to erect the group in the Place de la Nation, in the midst of the working-class Saint-Antoine quarter, a location with hallowed associations for the left since 1789. The monument was inaugurated twice with popular festivals meant to emulate those of the revolutionary past, once on the eve of the September elections in 1889, when a full-size patinated plaster version was inaugurated to stir up enthusiasm for candidates opposing General Boulanger's policies, and again in November 1899,

when the ministry of Waldeck-Rousseau organized the inauguration of the definitive bronze as a celebration of the working classes. In both instances Dalou enthusiastically welcomed the propagandistic use made of his monument.

The Salon of 1883 was dubbed 'the Salon of Dalou' by the critic Philippe Burty. Dalou re-entered the world of public exhibitions in Paris with two large and elaborate plaster reliefs, calculated to draw maximum attention to his mastery of the sculptor's art. The bronze version of one of these reliefs, *Mirabeau Responding to Dreux-Brézé*, is in the main entrance hall of the Palais Bourbon. The other, *Fraternity*, is a secularized variant on a Baroque altarpiece type and is in the marriage chamber of the Mairie of the 10th *arrondissement* of Paris. These reliefs earned for Dalou the gold medal of that year's Salon, the Légion d'honneur, an offer of a professorship at the Ecole des Beaux-Arts (which he refused) and recognition as one of the great artists of his era.

Almost all of Dalou's public sculptures are in Paris. The superb bronze recumbent figures of Auguste Blanqui (exh. Salon 1885) and Victor Noir (exh. Salon 1890) in Père-Lachaise Cemetery are two of the most moving tomb sculptures of the 19th century. Both heroes of the left are portrayed as martyrs, and their tombs were intended as pilgrimage sites for what has been called 'the cult of revolutionary remembrance'. Three of Dalou's sculptural ensembles are in the Luxembourg Gardens: the ribald and exuberant *Triumph of Silenus* (exh. Salons 1885 and 1897), the monument to *Delacroix* (unveiled 1890; see fig. 25), which is at once joyous and reverential, and the sober and dignified monument to *Scheurer-Kestner* (unveiled 1908), the Senator who was the first defender of Alfred Dreyfus. During the last years of his life Dalou envisaged a project that did not come to fruition, the *Monument to Workers*. For him this grandiose scheme would have been the crowning achievement of his life. His numerous preparatory clay sketches of individual workers (Paris, Petit Pal.) are among the most spontaneous and brilliant sculptures made during the 19th century. The Petit Palais in Paris houses the largest single collection of Dalou's work;

25. Jules Dalou: *Delacroix*, unveiled 1890 (Paris, Jardin du Luxembourg)

outside Paris his work is known primarily through editions which were cast posthumously according to a decision made by the executors of his estate.

Bibliography

Lami

P. Burty: *Salon de 1883* (Paris, 1883)

G. Geffroy: 'Dalou', *Gaz. B.-A.*, xxxiii (1900), pp. 217–28

M. Dreyfous: *Dalou: Sa vie et son oeuvre* (Paris, 1903)

H. Caillaux: *Dalou: L'Homme, l'oeuvre* (Paris, 1935)

Sculptures by Jules Dalou (exh. cat. by A. Ciechanowiecki, London, Mallett at Bourdon House Ltd, 1964)

Jules Dalou, 1838–1902 (exh. cat., Paris, Gal. Delestre, 1976)

J. Hunisak: *The Sculptor Jules Dalou: Studies in his Style and Imagery* (New York, 1977)

Dalou inédit (exh. cat., Paris, Gal. Delestre, 1978)

The Romantics to Rodin (exh. cat., ed. P. Fusco and H. W. Janson; Los Angeles, CA, Co. Mus. A., 1980), pp. 185–99

J. Hunisak: 'Rodin, Dalou, and the *Monument to Labor*', *Art the Ape of Nature: Studies in Honor of H. W. Janson*, ed. M. Baraschi, L. F. Sandler and P. Egan (New York, 1981), pp. 689–705

JOHN M. HUNISAK

Daniel-Dupuis, Jean-Baptiste

(*b* Blois, 15 Feb 1849; *d* Paris, 14 Nov 1899). French medallist and sculptor. He was the son of a painter and became a student at the Ecole des Beaux-Arts in Paris when only 16 years old. In 1872 he won the Prix de Rome for medals. On his return from Rome he exhibited cast portrait medals of *Charles Bayet*, *Antonin Mercié* and *Luc Olivier Merson*, evincing in these his admiration for Renaissance medals. Daniel-Dupuis was a prolific medallist, who executed numerous commemorative pieces, such as those for the *Election of Jules Grévy as President* (1879); the *Municipality of Paris* (1880); the *Chamber of Deputies* (1884); the *Société des artistes français* (1885); and the *Exposition Universelle* of 1889. In a lighter vein, he also executed one of the first motoring medals (1896) for the Automobile Club of France; while his plaquettes, such as the *Source* (originally modelled in 1873, reduced, engraved and issued in 1898), the *Nest* and *Dîner de la Marmite* (both 1890), and *Madonna* and *Marriage* (both 1892) were very popular with the general public. He also produced a large number of portraits and other studies in the form of medals, plaquettes, busts and bas-reliefs. In 1897 he was appointed an Officer of the Légion d'honneur. Daniel-Dupuis's career ended prematurely in November 1899, when he was murdered by his wife as he lay asleep.

Bibliography

Lami

F. Mazerolle: 'J.-B. Daniel-Dupuis', *Gaz. Numi. Fr.*, ii (1898), pp. 7–40, 167–202

MARK JONES

Daubigny [D'Aubigny]

French family of artists. Edmond-François Daubigny (b Paris, 1789; d Paris, 14 March 1843) was a pupil of Jean-Victor Bertin and painted historic landscapes and city scenes, such as the *Fountain of the Innocents* (1822; Paris, Carnavalet). From 1819 to 1839 he exhibited at the Salon in Paris, showing views principally of Paris and Naples. He visited Italy in 1833. His brother Pierre Daubigny (b Paris, 30 Oct 1793; d Paris, 15 July 1858) studied under Louis-François Aubry (1767–1851) and was a miniature painter, exhibiting from 1822 to 1855 at the Salon in Paris. Pierre's wife, Amélie Daubigny (b Paris, 1793; d Paris, 22 March 1861), also a miniature painter, collaborated with him on many works. She was a pupil of Louis-François Aubry and Jean-Pierre Granger (1779–1840) and showed at the Salon from 1831 to 1844. Edmond-François Daubigny's son (1) Charles-François Daubigny, an admirer of 17th-century Dutch painting, became one of the most important landscape painters in mid-19th century France. He was associated with the Barbizon school and was an influence on the Impressionist painters. His son (2) Karl Daubigny was a landscape painter who studied under his father and exhibited landscapes at the Salon in Paris from 1863.

(1) Charles-François Daubigny

(b Paris, 15 Feb 1817; d Paris, 19 Feb 1878). Painter and printmaker. He studied under his father Edmond-François Daubigny and in 1831–2 also trained with Jacques-Raymond Brascassat. At an early age he copied works by Ruisdael and Poussin in the Louvre, while also pursuing an apprenticeship as an engraver. At this time he drew and painted mainly at Saint-Cloud and Clamart, near Paris, and in the Forest of Fontainebleau (1834–5). In 1835 he visited several Italian cities and towns, including Rome, Frascati, Tivoli, Florence, Pisa and Genoa. He returned to Paris in 1836 and worked for François-Marius Granet in the painting restoration department of the Louvre. In 1840 he spent several months drawing from life in Paul Delaroche's studio, although his early works were much more heavily influenced by 17th-century Dutch painters, whom he copied in the Louvre, than by Delaroche's work.

In 1838 Daubigny first exhibited at the Salon in Paris, with an etching, *View of Notre-Dame-de-Paris and the Ile Saint-Louis*, and he continued to exhibit regularly there until 1868. He travelled a great deal, visiting Etretat and Dieppe on the coast of Normandy in 1842. From 1843 he spent much time in the Forest of Fontainebleau, sending his first painting of a Fontainebleau scene, *The Stream at Valmondois* (1844; priv. col.), to the Salon of 1844. In 1846 he painted with Théodore Rousseau and Jules Dupré at Valmondois and L'Isle-Adam (both Val-d'Oise), two of his preferred areas. The following year he travelled through Burgundy and also visited the Morvan Mountains in central France, where he painted the *Valley of the River Cousin* (1847; Paris, Louvre). In 1849 he was in Dauphiné in south-west France and the area around Lyon, painting at Crémieu and Optevoz and meeting Auguste Ravier and Corot, and in 1850 he worked at Auvers-sur-Oise and visited the Pyrénées. Two years later he and Corot—by now his close friend—spent considerable time painting in the Dauphiné and in Switzerland. Daubigny also painted with Armand Leleux at Dardagny, near Geneva, in 1853, and on the banks of the River Oise in 1856. He spent the next year with Jules Breton at Marlotte and made his first trip on the Oise on Breton's boat *Le Botin*, which had been converted into a studio and permanent home. From this time Daubigny untiringly explored the Seine, the Marne and the Oise by boat, mooring wherever he would find a scenic spot and ascertaining the best viewpoint from which to paint his chosen motif. His method of working *en plein air* was later to be greatly significant to Monet.

From the 1850s Daubigny's financial situation improved, and he began to achieve success, eventually becoming well known. Critics praised two of his paintings submitted to the Salon of 1852—the *Harvest* (Paris, Louvre; see fig. 26) and *View of the Banks of the Seine from Bezon* (Paris, Mus. d'Orsay)—for their luminous colours, fluid atmosphere and simple motifs, although they reproached him for what they saw as carelessness of execution. He sold several works to the French

26. Charles-François Daubigny: *Harvest*, exh. Salon 1852 (Paris, Musée du Louvre)

government, among them the *Pond of Gylieu near Optevoz, Isère* (1853; Cincinnati, OH, A. Mus.), *Lock in the Valley of the Optevoz* (1855; Rouen, Mus. B.-A.) and the *Valley of the Optevoz* (1857; Paris, Louvre). In 1859 he was commissioned to paint decorative scenes (the *Stags*, the *Herons*, the *Palace*, the *Garden of Tuileries*) for the entrance hall and stairway of the Salons du Ministère d'Etat in the Louvre. He also produced engravings after works by such artists as Ruisdael and Claude for the Louvre's Department of Chalcography and from 1853 executed numerous prints in the technique of *cliché-verre*. In 1860 he settled in Auvers-sur-Oise but also travelled extensively in other parts of France and abroad (Brittany in 1867; London in 1865 and 1870; Spain in 1868 and 1869; the Netherlands in 1871).

Daubigny was one of the first landscape painters to take an interest in the changing and fleeting aspects of nature, depicting them with a light and rapid brushstroke; this was a highly novel technique that disconcerted such critics as Théophile Gautier, who in 1861 wrote that 'it is really a pity that this landscape artist, having so true, so apt and so natural a feeling for his subject, should content himself with an "impression" and should neglect detail to such an extent. His pictures are no more than sketches barely begun' (Gauthier, p. 119). Nevertheless, four years later Gautier was to acknowledge that 'the impression obtained by these most perfunctory means is nonetheless great and profound for all that'. In 1865 Daubigny painted *Sunrise on the Banks of the River Oise*, which is typical of his work in both technique and subject-matter and is one of a considerable number of variations on the theme executed between 1860 and 1875 (e.g. *Evening on the Oise*, 1863; Cincinnati, OH, Taft Mus.; *Sunset on the Oise*, 1865; Paris, Louvre). These paintings are good examples of his ability to capture the essence of nature purely in its 'sincerity' without resorting to artifice or metaphysics. His numerous pupils included Eugène Boudin and Johan Barthold Jongkind, both of whom he met in

Honfleur in 1864, his son (2) Karl Daubigny, Antoine Chintreuil, Eugène La Vieille (1820–89) and Jean Charles Cazin. In 1870 he took refuge in London during the Franco-Prussian War and the following year introduced Camille Pissarro and Monet to his art dealer Paul Durand-Ruel, then in England. In 1871 Daubigny met Cézanne at Auvers. He was an important figure in the development of a naturalistic type of landscape painting, bridging the gap between Romantic feeling and the more objective work of the Impressionists.

Writings

E. Moreau-Nélaton: *Daubigny raconté par lui-même* (Paris, 1950)

Bibliography

T. Gauthier: *Abécédaire du Salon de 1861* (Paris, 1861), p. 119
F. Henriet: *C. Daubigny et son oeuvre gravé* (Paris, 1875)
J. Claretie: 'Daubigny', *Première série de peintres et sculpteurs contemporains: Artistes décédés de 1870 à 1880* (Paris, 1881–4), pp. 265–88
L. Delteil: *Daubigny*, xiii of *Le Peintre-graveur illustré* (Paris, 1906–26/R New York, 1969)
J. Laran: *Daubigny* (Paris, 1913)
M. Fidell-Beaufort: *The Graphic Art of Charles-François Daubigny*, 2 vols (diss., New York U., Inst. F.A., 1974)
J. Bailly-Herzberg and M. Fidell-Beaufort: *Daubigny: La Vie et l'oeuvre* (Paris, 1975)
P. Miquel: *L'Ecole de la nature*, iii of *Le Paysage au XIXe siècle, 1814–1874* (Maurs-la-Jolie, 1975), pp. 664–705

LAURENCE PAUCHET-WARLOP

(2) Karl [Charles-Pierre] Daubigny

(*b* Paris, 9 June 1846; *d* Auvers-sur-Oise, 25 May 1886). Painter and printmaker, son of (1) Charles-François Daubigny. He studied with his father and, like him, specialized in landscape painting. He made his début at the Salon in 1863 and continued to exhibit there until the year of his death, winning medals in 1868 and 1874. His earliest works are obviously influenced by his father, but he soon came to develop a more personal and sombre style. The forest of Fontainebleau or the coastline and landscape of Brittany and Normandy provided most of his subjects (e.g. the *Return of the Fishing Fleet to Trouville*, 1872;

Aix-en-Provence, Mus. Granet, and the *Banks of the Seine*, 1880; Brest, Mus. Mun.). He also produced a number of landscape etchings, including several after his father's paintings, two of which appeared in Frédéric Henriet's *C. Daubigny et son oeuvre gravé* (Paris, 1875). Despite his considerable ability, Karl's reputation has been rather eclipsed by that of his father, though he was nonetheless one of the most pleasing French landscape artists of the second half of the 19th century.

Bibliography

DBF
E. Bellier and L. Auvray: *Dictionnaire général des artistes de l'école française*, 3 vols (Paris, 1868–85)

Daumier, Honoré

(*b* Marseille, 26 Feb 1808; *d* Valmondois, 10 Feb 1879). French graphic artist, painter and sculptor.

1. Training and early illustrations, before 1860

Son of a Marseille glazier, frame-maker and occasional picture restorer, Daumier joined his father in Paris in 1816. He became a bailiff's errand boy and was then employed by a bookseller, but his real enthusiasm was reserved for drawing and politics. He studied drawing with Alexandre Lenoir and at the Académie Suisse and then worked as assistant to the lithographer Béliard. Having mastered the techniques of lithography, he published his first plate in the satirical weekly *La Silhouette* in 1829.

Daumier was 22 when the revolution of July 1830 gave the throne to Louis-Philippe as constitutional monarch and power to the French middle-class business community. On 4 November 1830 the print publisher Aubert and his son-in-law Charles Philipon launched the violently anti-monarchist weekly *La Caricature*, followed on 1 December 1832 by *Le Charivari*, the first daily paper to be illustrated with lithographs. In his association with these newspapers and in the company of Republican artists, Daumier found a favourable milieu for developing his vigorous style and progressive ideas.

Less whimsical than Grandville, less elegant than Gavarni and less brutal than Traviès, Daumier distinguished himself by a robust but controlled drawing style, with strong contrasts of volume that were nonetheless accurate in their composition, modelling and chiaroscuro, even when used in caricature. This feature of his style gained him the support of the new petit bourgeois public, who could appreciate a caricature that was neither vapid nor crude and behind the exaggerated outlines of which could be discerned traditional academic values. Balzac even compared Daumier with Michelangelo. Daumier's attacks on Louis-Philippe hit their mark so successfully that the monarch had to reintroduce censorship and condemned Daumier to six months in prison (31 Aug 1832 to 14 Feb 1833) for his lithograph *Gargantua*, published in *La Caricature* (15 Dec 1831). In order to pay the fines imposed on his newspapers, in 1834 Philipon launched a large-format supplement that was even more violent in tone, the *Association mensuelle*. In its pages Daumier published lithographs that have all the power of paintings and are now considered among his masterpieces: *Le Ventre législatif*, *Ne vous y frottez pas!*, *Enfoncé Lafayette* and *Rue Transnonain, le 15 avril 1834*. In the last, Daumier depicted the squalid aftermath of the massacre of working-class opponents of the government. Daumier's undemonstrative title and unheroicized image of corpses sprawled among overturned bedroom furniture lent force to his denunciation of casual State violence.

On 29 August 1835 the government once more prohibited political caricature, and, in order to survive, *Le Charivari* was forced to restrict itself to subjects from everyday life, including street scenes, the theatre and portraits. It published nearly 4000 of these by Daumier. Various series of humorous scenes, all composed with great care, gave a vivid and critical panorama of France's social classes in transition: businessmen (personified by the flattering swindler Robert Macaire), the professional classes (*Les Gens de justice*, 1845–8), traders and the bourgeois in the country, at the theatre and on public transport (*Les Bons Bourgeois*, 1847–9). His work was not only the essential expression of the new taste for an art that had previously been considered trivial but also reflected developments in French society at the time of its greatest economic expansion (between 1830 and 1870) (see col. pl. XIII). He was for this reason considered by several progressive critics—Théodore de Banville (1823–91) as early as 1852, Baudelaire in 1857 and Champfleury—as an artist worthy of comparison with Hogarth and Goya.

Besides his lithographs Daumier also made numerous drawings that were reproduced by wood-engravers as illustrations. In this way he participated in some of the great French publishing enterprises of the Romantic era: the series of *Physiologies* (1841), *Les Français peints par eux-mêmes* from the publisher Curmer (1841), *La Némésis médicale illustrée* (1841) and the most important illustrated magazines then in circulation.

2. Sculpture

Daumier was one of the first French artists to experiment with caricature sculpture. In 1832 he began to produce a series of small grotesque busts of parliamentarians, for instance *François-Pierre-Guillaume Guizot* and *Alexandre-Simon Pataille* (both Paris, Mus. d'Orsay), which were kept in Aubert's printshop. They were originally modelled in terracotta and were cast in bronze only after his death. Daumier succeeded in giving each of these works (generally no more than 200 mm high) individuality and considerable satiric force by gross exaggeration of his victim's most prominent features and characteristic expression. Among other important sculptures (first modelled in clay, then transferred to plaster and subsequently cast in bronze) were the bas-relief *The Emigrants* (c. 1848–50; plaster, Paris, Mus. d'Orsay), in which Daumier depicted a forlorn procession of unindividualized figures with grandeur and compassion, and the statuette *Ratapoil* (c. 1851; plaster, Buffalo, Albright-Knox A.G.), his archetype of the swaggering and corrupt thugs who had brought Louis-Napoléon to power. The dating and priority of the numerous casts of Daumier's sculpture are difficult to establish and remain controversial.

Many of Daumier's prints comment sympathetically on the difficulties of the sculptor in mid-19th-century France (e.g. *Sad Appearance of Sculpture Placed in the Midst of Painting*, 1857).

3. Paintings

Although he never sought to make a career from painting and was probably self-taught, Daumier painted for his own pleasure from 1834. From 1847 these isolated attempts gave way to a solid body of work that began with copies of Millet and Rubens and interpretations in oil of details selected from the subjects he habitually treated in lithography, notably genre scenes, bathers, lawyers and so on (e.g. *Three Lawyers in Conversation*; Washington, DC, Phillips Col.). In 1848, following the creation of the Second Republic, an open competition was held among artists to represent it in allegorical form. Daumier produced an oil sketch showing two children being suckled by a muscular female embodiment of the Republic (Paris, Mus. d'Orsay), which was highly praised by Champfleury and Gautier. His design was shortlisted, and he was commissioned to produce a finished painting, but he was unable to complete it. However, he did execute some State commissions for religious paintings, *Mary Magdalene in the Desert* (priv. col., see Maison, 1968, i, pl. 171) and *We Want Barabbas!* (*c.* 1850; Essen, Mus. Flkwang), thanks to his friend Charles Blanc, who became head of the Bureau des Beaux-Arts in 1848. He exhibited at the Salon of 1849 the *Miller, his Son and the Ass* (Glasgow, A.G. & Mus.), in 1850 *Two Nymphs Pursued by Satyrs* (Montreal, Mus. F.A.) and in 1851 *Don Quixote Going to the Wedding of Gamaches* (Boston, priv. col., see Maison, 1968, i, pl. 147). Apart from one further exhibit in 1861 and the exhibition organized by his friends to help him financially in 1878, shortly before he died, Daumier's paintings were unknown to the public and remained in his studio until his death.

Daumier's paintings, more than 300 oils and numerous watercolours, gained widespread critical recognition after his death, for they reveal qualities similar to those that characterize his lithographs. The brushwork is usually rapid and vigorous, and this, together with the sense of movement and light, ranks them with the finest paintings produced under the Second Empire. He sometimes reverted to observations of daily life (e.g. *Third-class Railway Carriage*, 1864; Ottawa, N.G.; Baltimore, MD, Mus. A.) but frequently drew his subject-matter from mythology (the *Drunkenness of Silenus*, 1863; Calais, Mus. B.-A.) and literature (numerous works featuring Don Quixote and Sancho Panza; see fig. 27).

Daumier did not prime his canvases; they are often unfinished and invariably retain a sketch-like appearance. This lack of both preliminary precautions and finish gives a strong effect of spontaneity but makes the paintings fragile and difficult to conserve. Their dating is often uncertain, and when they began to become popular they were extensively 'finished' by restorers and forgers. His usual signature HD has

27. Honoré Daumier: *Don Quixote* (Munich, Neue Pinakothek)

also frequently been forged, often on unsigned genuine works.

4. Late illustrations, 1860 and after

Abandoned by *Le Charivari* in March 1860, as Philipon claimed (until December 1863) that readers had tired of him, Daumier was free to devote himself to painting, despite his lack of recognition in this field. During the authoritarian phase of the Second Empire in the 1850s satire had lost nearly all its outlets, and *Le Charivari* itself had become feeble. Nevertheless, Daumier recovered his original political and graphic energy in a dozen plates he composed for *Le Boulevard*, a newspaper founded in 1862 in opposition to the regime by his colleague Etienne Carjat. It contained such famous lithographs as *Madeleine-Bastille*, *Le Nouveau Paris* and *Nadar élevant la photographie à la hauteur de l'art*. The *Boulevard* experiment ended in 1863. However, Napoleon III's administration became more liberal, allowing and even encouraging caricature in matters of foreign policy. Daumier tended to treat these subjects with a certain loftiness, in a style that was both more sweeping and more elliptical, making great use of allegory and symbolism. Despite the technical restrictions imposed on the lithographers of *Le Charivari* during the 1870s by the use of *gillotage* (whereby the lithograph was turned into a relief plate to facilitate printing), Daumier's art so gained in luminosity and synthetic power that through the work of his late period he came to be seen as the forerunner of Impressionism, and in particular of Cézanne. Daumier's drawing style in pen and ink also became increasingly free, a mazy line no longer modelling form in any conventional sense, but taking on an expressive form of its own.

The last of Daumier's plates to appear in *Le Charivari* dates from 1875. By 1878 he was nearly blind and living in obscurity at Valmondois, to the north of Paris, in a small house bought for him by his friend Corot. His friends organized an exhibition of his work at Durand-Ruel's gallery, but despite Victor Hugo's acceptance of the honorary presidency and a visit by the eminent Republican Léon Gambetta, it was a complete failure, not even covering its costs.

5. Posthumous reputation

Daumier's funeral, on 14 February 1879, coincided with the consolidation of power by the Republican party, which he had been among the first to support and whose cause he had so enthusiastically portrayed. His Republican artist friends and a number of politicians reawakened interest in his work through a further campaign of demonstrations, articles, speeches and exhibitions, and brought his body back to Père Lachaise Cemetery, Paris. At the same time critics sought to raise the status of the popular art forms of lithography, caricature and newspaper cartoons. As a result, a violent debate began on Daumier's merits as an artist, which, in France at least, has never been completely resolved: the centenary of his death in 1979 was marked by an exhibition in Marseille rather than Paris. The quality of Daumier's work has more readily been recognized and celebrated in Germany and the USA, where the main private collections are located and where several major exhibitions have been held.

Bibliography

The Studio (1904) [issue ded. to Daumier and Gavarni]

L. Delteil: *Le Peintre-graveur illustré*, xx–/xxix (Paris, 1925–30/R New York, 1969)

E. Bouvy: *Daumier: L'Oeuvre gravé du maître* (Paris, 1933) [wood-engrs and chalk pl. prts]

J. Adhémar: *Honoré Daumier* (Paris, 1954)

Honoré Daumier und sein Kreis (exh. cat., Hamburg, Mus. Kst & Gew., 1962)

O. W. Larkin: *Daumier: Man of his Time* (Boston, 1966)

K. E. Maison: *Honoré Daumier: Catalogue Raisonné of the Paintings, Watercolours and Drawings*, 2 vols (London, 1968) [supplemented by 'Some Additions to Daumier's Oeuvre', *Burl. Mag.*, cxii (1970), pp. 623–4]

H. P. Vincent: *Daumier and his World* (Evanston, 1968)

Daumier Sculpture (exh. cat. by J. L. Wasserman, Cambridge, MA, Fogg, 1969)

A. H. Mayor: 'Daumier', *Prt Colr Newslett.* (March–April 1970), pp. 1–4

L. Barzini and G. Mandel: *Opera pittorica completa di Daumier* (Milan, 1971)

Daumier: Verlaggever van zijn tijd (exh. cat. by J. R. Kist, The Hague, Gemeentemus., 1971)

Honoré Daumier: Druckgraphik aus der Kunsthalle Bielefeld und Privatbesitz (exh. cat. by H. G. Gmelin and L. Fabricius-Josic, Bielefeld, Städt. Ksthalle, 1971)

Honoré Daumier: Gemälde, Zeichnungen, Lithographien, Skulpturen (exh. cat., ed. F. Lachenall; Ingelheim, Int. Tage, Villa Schneider, 1971)

D. Burnell: 'Honoré Daumier and the Composition of Humour', *Prt Colr Newslett.* (Nov–Dec 1973), pp. 102–5

Honoré Daumier . . . Bildwitz und Zeitkritik (exh. cat. by G. Langemeyer, Münster, Westfäl. Kstver.; Bonn, Rhein. Landesmus.; Graz, Neue Gal.; 1978–9)

R. Passeron: *Daumier: Témoin de son temps* (Paris, 1979; Eng. trans., New York, 1981)

Daumier aujourd'hui: 300 lithographies et bois gravés de la collection Louis Provost (exh. cat. by J. Rollin and B. Tabah, Saint-Denis, Mus. A. & Hist., 1979)

Daumier et ses amis républicains (exh. cat., ed. M. Latour; Marseille, Mus. Cantini, 1979)

Daumier in Retrospect, 1808–1879 (exh. cat., Los Angeles, CA, Co. Mus. A., 1979)

Honoré Daumier, 1808–1879 (exh. cat. by J. R. Kist, Washington, DC, N.G.A., 1979)

Honoré Daumier et les dessins de presse (exh. cat., Grenoble, Maison Cult., 1979)

Honoré Daumier: Kunst und Karikatur (exh. cat., ed. J. Schultze and A. Winther; Bremen, Ksthalle, 1979)

P. L. Senna: 'Daumier's Lithographic Works', *Prt Colr/Conoscitore Stampe*, 45 (1980), pp. 2–31

'Honoré Daumier: A Centenery Tribute', *Prt Rev.*, 11 (1980), pp. 5–144

Honoré Daumier, 1808–1879 (Los Angeles, 1982)

J. L. Wasserman, J. de Caso and J. Adhémar: 'Hypothèses sur les sculptures de Daumier', *Gaz. B.-A.*, n.s. 6, c (1983), pp. 57–80

Die Rückkehr der Barbaren: Europäer und 'Wilde' in der Karikatur Honoré Daumiers (exh. cat., ed. A. Stoll; Bielefield, Städt. Ksthalle; Hannover, Wilhelm-Busch-Mus.; Freiburg, Augustinmus.; Mülheim an der Ruhr, Städt. Mus.; 1985–6)

M. Melot: 'Daumier and Art History: Aesthetic Judgement/Political Judgement', *Oxford A. J.*, xi/1 (1988), pp. 3–24

The Charged Image: French Lithographic Caricature, 1816–1848 (exh. cat. by B. Farwell, Santa Barbara, CA, Mus. A., 1989)

B. Laughton: *The Drawings of Daumier and Millet* (New Haven and London, 1991)

Daumier Drawings (exh. cat., ed. C. Ives, M. Stuffman and C. Sonnabend; New York, Met., 1992)

MICHEL MELOT

Dauzats, Adrien

(*b* Bordeaux, 16 July 1804; *d* Paris, 18 Feb 1868). French painter, illustrator and writer. His early training was as a theatrical scene painter and a designer of lithographic illustrations. In Bordeaux he studied with Pierre Lacour (1778–1859) and worked with Thomas Olivier (1772–1839), chief scene designer at the Grand-Théâtre. He subsequently studied in Paris in the studio of the landscape and history painter Julien-Michel Gué (1789–1843) and worked for the decorators of the Théâtre Italien.

From 1827 Dauzats provided lithographic designs for Isidore-Justin-Séverin Taylor's series *Voyages pittoresques et romantiques dans l'ancienne France* (1820–78). He travelled in the French provinces, particularly Champagne, Dauphiné and Languedoc, often sketching the medieval monuments that had come into vogue during the Romantic period.

Dauzats also collaborated on lithographs for many other publications, including Taylor's *Voyage en Orient*. For this last project Dauzats travelled to Egypt, Syria, Palestine and Turkey in 1830, a trip that he described in his book *Quinze jours au Sinaî* (written with Alexandre Dumas *père*) and that ultimately inspired his best-known painting, the *Monastery of St Catherine, Mt Sinai* (exh. Salon 1845; Paris, Louvre). Its medieval subject and dramatic setting clearly show his training as a stage designer; despite his reputation as a brilliant colourist it has a sober and restricted tonal range.

A specialist in architectural views, Dauzats travelled widely in Spain, Portugal, Germany and the Netherlands. Perhaps his most memorable journey, however, was in 1839, when he accompanied the military expedition to southern Algeria led by Ferdinand-Philippe, Duc d'Orléans. Dauzats recorded the assault on the Gates of Iron, a formidable natural fortress in the Djurdjura mountains, in his lithographic illustrations for *Journal de l'expédition des Portes de Fer* compiled by the poet Charles Nodier in 1844. His series of watercolour studies of the Gates of Iron (Chantilly, Mus. Condé), on which he based his painting the *Gates of Iron* (1853; Lille, Mus. B.-A.), captures the sombre and forbidding atmosphere of the place.

Dauzats exhibited at the Salon from 1831 to 1867, winning numerous medals. He was awarded the Légion d'honneur as early as 1837. Though

most of the views he depicted were derived from his own observations, he did accept a commission from a Bordeaux collector around 1865 for a series of four paintings from the *Thousand and One Nights*. Even in an imaginary scene such as his *Sindbad the Sailor* (1865; Bordeaux, Mus. B.-A.), however, the architecture, based on his recollections of Granada and Córdoba, completely dominates the human figure. The Orientalist architectural scenes in which Dauzats specialized, though often encountered in the work of English topographical artists such as David Roberts, were relatively rare in France.

Delacroix admired Dauzats's abilities as an architectural painter and consulted him for advice on at least one occasion: Dauzats in turn exercised his influence at court to help Delacroix win state decorative commissions. In his preference for depicting remote and inhospitable places and his taste for picturesque medieval subjects, Dauzats was fully in accord with the aesthetics of Romantic art. He had an unfailing instinct for selecting exotic and memorable views. Unlike his contemporary Prosper Marilhat, however, his need to record precisely all the details of a scene sometimes prevented him from capturing the subject in its most colourful and dramatic aspect.

Writings

with A. Dumas *père*: *Quinze jours au Sinaî* (Paris, 1841)

Bibliography

H. Jouin: *Adrien Dauzats: Peintre et écrivain* (Paris, 1896)

P. Guinard: *Dauzats et Blanchard: Peintres de l'Espagne romantique* (Paris, 1967)

Orientalism: The Near East in French Painting, 1800–1880 (exh. cat., U. Rochester, NY, Mem. A.G., 1982), pp. 48–9

The Orientalists: Delacroix to Matisse (exh. cat., ed. M. A. Stevens; London, RA; Washington, DC, N.G.A.; 1984), p. 123

DONALD A. ROSENTHAL

Debat-Ponsan [Ponsan-Debat], Edouard-Bernard

(*b* Toulouse, 25 April 1847; *d* Paris, 29 Jan 1913). French painter. He trained in Toulouse and later at the Ecole des Beaux-Arts in Paris under Alexandre Cabanel. In 1873 he won second place in the Prix de Rome and in 1874 the Prix Troyon of the Institut. From the Institut he received a bursary that enabled him to visit Italy. In 1870 he made his début at the Salon under the name Ponsan-Debat and afterwards exhibited there such genre and history paintings as *Jephthah's Daughter* (1876; Carcassonne, Mus. B.-A.). He also executed religious works, some of which were for churches and cathedrals: he painted *St Paul before the Areopagus* (1877) for the church at Courbevoie and the *Pity of St Louis for the Dead* (1879) for the cathedral at La Rochelle. From 1880 Debat-Ponsan was the name under which he exhibited. *The Massage* (1883; Toulouse, Mus. Augustins) shows a white female nude massaged by a negress, and the subject attracted comment from contemporary critics. He also painted a number of landscapes, including *Corner of the Vineyard* (1888; Nantes, Mus. B.-A.). These were painted in a style similar to that of Jules Bastien-Lepage and, when they included figures, were often sentimental. His reputation depended, however, on his portraits, which are distinguished by their vigorous colour and precision, as seen in the portrait of *Pouyer-Quertier* (*c.* 1885; Rouen, Mus. B.-A.). Most notable was his portrait of *General Boulanger* (1887; untraced), which was shown at the Salon of 1887 and was accepted in 1889 for the Exposition Universelle in Paris. Amid scandal, Debat-Ponsan withdrew it soon after the opening because he thought that the Exposition was badly organized and his painting was not shown to advantage. He refused the bronze medal awarded it by the jury. In later years, while producing such paintings as *Christ on the Mountain* (1889; Toulouse, Mus. Augustins), he increasingly responded to contemporary events in his work. During the Dreyfus affair he sided with Emile Zola and those calling for Dreyfus's retrial, and his allegorical work *Nec mergitur* (Amboise, Mus. Mun.), depicting Truth stepping out of a well restrained by a soldier and a priest, was exhibited at the Salon of 1898.

Bibliography

Bénézit; *DBF*; Thieme–Becker

G. Vapereau: *Dictionnaire des contemporains*, 2 vols (Paris, 1893)

J. Martin: *Nos peintres et sculpteurs* (Paris, 1897), p. 130

Degas, (Hilaire Germain) Edgar

(*b* Paris, 19 July 1834; *d* Paris, 27 Sept 1917). French painter, draughtsman, printmaker, sculptor, pastellist, photographer and collector. He was a founder-member of the Impressionist group and the leader within it of the Realist tendency. He organized several of the group's exhibitions, but after 1886 he showed his works very rarely and largely withdrew from the Parisian art world. As he was sufficiently wealthy, he was not constricted by the need to sell his work, and even his late pieces retain a vigour and a power to shock that is lacking in the contemporary productions of his Impressionist colleagues.

I. LIFE AND WORK

1. Early years, to 1860

The eldest son of a Parisian banking family, he originally intended to study law, registering briefly at the Sorbonne's Faculté de Droit in 1853. He began copying the 15th- and 16th-century Italian works in the Musée du Louvre and in 1854 he entered the studio of Louis Lamothe (1822–69). The training that Lamothe, who had been a pupil of Ingres, transmitted to Degas was very much in the classical tradition; reinforced by the Ecole des Beaux-Arts, which he attended in 1855–6, Degas developed a rigorous drawing style and a conviction of the importance of line that remained with him for the whole of his career. One of his enduring aims was to be a classical painter of modern life: 'My art has nothing spontaneous about it, it is all reflection'.

In 1856 Degas arrived in Italy where he had an extensive family network. His father's sister, Laura Bellelli, was closest to the young painter, and he spent lengthy periods with her and her family in Naples and Florence over the three-year period that he spent in Italy. He also paid several long visits to Rome, where he worked at the Villa Medici with other young French artists and executed a large number of copies after Old Masters. In July 1858 he left Rome for Florence, stopping at Viterbo, Orvieto, Perugia, Assisi, Spello and Arezzo; during the journey, he made numerous sketches in his notebooks, including drawings of the frescoes by Signorelli at Orvieto. In Florence Degas stayed with the Bellellis until March 1859; during this period he produced dozens of preparatory drawings for a projected family portrait, which he finished in 1867 (the *Bellelli Family*, 1858–67; Paris, Mus. d'Orsay). The sketches range from rough compositional notations to formal portraits, among them some showing the artist's first use of pastel (*Laura Bellelli*, 1858–9; Paris, Mus. d'Orsay). The final painting, which shows Baron Bellelli seated with his back to the viewer, combines classical serenity with psychological tension; the unconventional composition gives the work an unsettling atmosphere, which is one of the most characteristic aspects of Degas's later portraits.

This formative period spent studying and copying the Italian masters laid the foundations of Degas's later career; study after study reveals the influences that were to have a profound effect on most of Degas's oeuvre. A trip to Siena and Pisa with Gustave Moreau in March 1859 was especially important; together they copied the frescoes of Benozzo Gozzoli in the Campo Santo, Pisa. Moreau broadened Degas's interests, encouraging him to experiment with texture and to develop an appreciation of Delacroix. In April 1859 Degas returned to settle in Paris with his father, who encouraged him to study further. In 1860 he visited Naples and Florence again.

2. France and New Orleans, 1861–73

In 1861 Degas stayed in Normandy with his friend Paul Valpinçon; together they visited the Haras du Pin stud-farm, which undoubtedly inspired Degas's first racehorse scenes. *Gentlemen's Race: Before the Start* (1862; Paris, Mus. d'Orsay; see fig. 28) is the earliest of his works to have a resolutely contemporary subject. At the Louvre in 1862, while copying Velázquez's *Infanta Maria Margarita*, Degas met Edouard Manet for the first time and through him made contact with

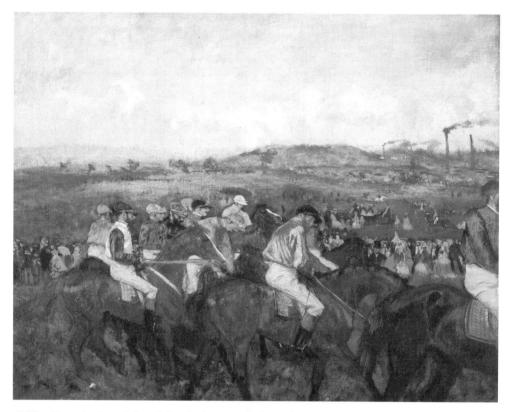

28. Edgar Degas: *Gentleman's Race: Before the Start*, 1862 (Paris, Musée d'Orsay)

the young Impressionists who met at the Café Guérbois.

Until 1865, when Degas exhibited the *Misfortunes of the City of Orléans* (Paris, Mus. d'Orsay) at the Salon, he continued to work on such history paintings as *Semiramis Building Babylon* (1861; Paris, Mus. d'Orsay) and *Young Spartans Exercising* (1860–62; London, N.G.); after that date he concentrated on portraits (*Woman with Chrysanthemums*, 1865; New York, Met.) and racing scenes. In the summer of 1869 Degas returned to the Normandy coast, where he executed a number of pastels before going to meet Manet at Boulogne-sur-Mer. Mostly seashore scenes (e.g. *Cliffs at the Edge of the Sea*, 1869; Paris, Mus. d'Orsay), they are unusual subjects for an artist who normally avoided unpopulated landscapes.

In the 1860s, Degas expanded his subject-matter into the themes of urban leisure typical of Impressionist painting. Towards 1869 he began to make wax sculptures of horses, possibly to help in conceiving and composing such paintings as *The Steeplechase* (1866, reworked 1880–81; Upperville, VA, Paul Mellon priv. col.), and around 1870 he began to take an interest in dance and opera. In 1870, during the Franco-Prussian War, Degas enlisted in the National Guard; in 1871, after the war, he travelled to London. In 1872 he left for New Orleans, where his uncle and two of his brothers were engaged in the cotton trade. While there he painted the *Cotton Market at New Orleans* (1873; Pau, Mus. B.-A.; smaller version (600×730 mm), Cambridge, MA, Fogg). The picture includes several family portraits; carefully chosen as a

modern and 'commercial' subject, the Pau version was the first of his works to be bought by a public collection (1878). Other major canvases from this period include the *Orchestra of the Opéra* (c. 1870; Paris, Mus. d'Orsay), *Orchestra Musicians* (1870–71, reworked c. 1874–6; Frankfurt am Main, Städel. Kstinst. & Städt. Gal.) and *Dance Class* (1871; New York, Met.). In 1873 Paul Durand-Ruel bought several of Degas's paintings, including *Dance Class at the Opéra* (1872; Paris, Mus. d'Orsay).

3. Impressionism and Realism, 1874–81

This was an important period during which Degas considerably broadened his scope and extended his exploration of Realist subject-matter. On 27 December 1873 Degas, Claude Monet, Camille Pissarro, Alfred Sisley, Berthe Morisot, Paul Cézanne and other artists had joined together to form the Société Anonyme Coopérative à Capital Variable des Artistes, Peintres, Sculpteurs, Graveurs etc with the aim of organizing independent exhibitions without juries, selling the works exhibited and publishing a journal. On 15 April 1874 the first exhibition opened at 35 Boulevard des Capucines; Degas exhibited ten works, among them *Carriage at the Races* (c. 1872; Boston, MA, Mus. F.A.). On 15 May, however, the company was dissolved following hostile criticism in the press and lack of buyers. Over the next 22 years, a further seven group exhibitions were held; Degas participated in six, despite a lack of sympathy with some tendencies exhibited by the Impressionists. He shared the group's taste for clear, light painting and for the technique of juxtaposing strokes of paint or pastel, but he rarely painted *en plein air* and seldom directly before the motif, preferring to work up his pictures from memory and from sketches. This emphasis on the role of the imagination distinguished him from Renoir, Monet and Sisley; among the Impressionists he was closest to Pissarro and at one stage to Manet, while in later years he was intermittently intimate with Gauguin.

Degas saw himself as a 'Realist' or 'Naturalist' painter and disliked the term 'Impressionist'; his preference for urban subjects, artificial light and

concentration on drawing became increasingly pronounced after the first group exhibition. As a keen observer of everyday scenes, he attempted to capture natural positions and break down movement, grasping its underlying rhythms; this was an essential part of his work, as was made clear in his repetitions and variations on a few themes (e.g. there are over 600 versions of ballerinas). Fascinated by new inventions, he experimented ceaselessly, making technical discoveries in engravings, photography and monotypes. He had a predilection for developing pioneering mixtures of materials and for using a wide variety of techniques, both in his works on paper and canvas and in his sculptures. He viewed his sculptures as stages in the progress of his research into the nature of movement, similar in their way to the photographs of Eadweard Muybridge, which he admired and was influenced by.

At the Second Impressionist Exhibition in 1876 Degas exhibited 24 works including the *Cotton Market at New Orleans*. In 1877 he showed 25 works at the Third Impressionist Exhibition, including his first monotypes. His difference from the other Impressionists was increasingly apparent, and he wanted the fourth exhibition title to be expanded to 'Groupe d'Artistes Indépendants, Réalistes et Impressionnistes'. In 1878 his *Ballet Rehearsal* (1876–7; Kansas City, MO, Nelson–Atkins Mus. A.) was lent by Louisine Havemeyer to a New York exhibition: this was the first time that his work had been shown there. At the Fourth Impressionist Exhibition in 1879 he exhibited 20 paintings and pastels and 5 fans; at the fifth (1880) he exhibited 12 works. A crisis in the Degas family finances in the mid-1870s made it important to him to sell his work; part of the attraction of the monotypes that he started to produce during this period was the rapidity with which they could be executed. Although his prints and pastels were inexpensive, their subjects—brothel scenes and low-life—were not calculated to please the general public. This became particularly clear in 1881, when he showed the *Little Fourteen-year-old Dancer* (wax original; Upperville, VA, Paul Mellon priv. col.) at the Sixth Impressionist Exhibition. A polychrome wax figure fixed on a wooden base,

wearing a real tulle tutu, a satin ribbon and a wig, the sculpture created an uproar. The most controversial work at the exhibition, it was seen as the apotheosis of scientific Naturalism: 'The terrible realism of this statuette creates a distinct unease; all ideas about sculpture, about cold, lifeless whiteness . . . are demolished . . . at once refined and barbaric . . . [it is] the only truly modern attempt that I know of in sculpture.' (Huysmans, 1883, pp. 226–7). Reviewers suggested that it should be placed in a museum of zoology or anthropology; it was seen as a social 'type', an ethnological specimen, rather than a work of art. Degas had deliberately encouraged this view of the sculpture by including two portraits of teenage males (untraced; see Lemoisne, 1946–9, nos 638–9) in the exhibition under the title *Criminal Physiognomies*; taken from courtroom sketches of prisoners in the dock, they were presented as part of a semi-scientific examination of contemporary society—a theme that can also be seen in such other works of this period as the *Absinthe Drinker* (1875–6; Paris, Mus. d'Orsay), *Dancer Bowing with Bouquet* (c. 1877; Paris, Mus. d'Orsay) and the *Dancing Lesson* (1881; Philadelphia, PA, Mus. A.).

4. Independence and security, 1882–9

By the start of the 1880s Degas was well-established as a major figure in the Parisian art world. His financial troubles were largely over, and by the end of the decade he was able to be highly selective about selling his work. During this period he became increasingly interested in a variety of women workers: dancers, milliners, café-concert singers and laundresses. The human figure acquired even greater importance in a series of pastels of women washing themselves, including *After the Bath* (1885; Pasadena, CA, Norton Simon Mus.) and *Woman in a Tub* (1885–6; London, Tate; see fig. 29). In these works the figures dominate the picture, filling a shallow space, and are shown in intimate surroundings with a naturalism that Degas had sought since the beginning of his career; typically, a low point of view brings the viewer right into the scene. In these works Degas studied the gestures and movements of his

subjects in a process of research that was described by Félix Fénéon (Fénéon, p. 30):

> It is an art of Realism which however does not stem from a direct vision; as soon as a person knows they are being observed, they lose their naive spontaneity of behaviour. Degas therefore does not copy from life but accumulates a large number of sketches on a single subject from which he derives the indisputable veracity with which he endows his work. Never have paintings evoked so little the painful image of the 'model' who 'poses'.

After the last Impressionist exhibition, in 1886, Degas stopped presenting works at group shows and instead sold his works to a small number of dealers including DurandRuel, Boussod & Valadon, Bernheim-Jeune, Hector Brame and Ambroise Vollard. He also made a considerable number of purchases for his own collection of ancient and modern art, including works by Manet (*The Ham*; Glasgow, A.G. & Mus.), El Greco (*St Ildefonso*; Washington, DC, N.G.A.) and Gauguin (the *Moon and the Earth*; New York, MOMA). In 1889 he travelled to Madrid with Giovanni Boldini and then to Tangiers, returning to France by way of Cádiz and Granada. The major works of this period are mainly pastels, variations on the themes of milliners, ironers and women at their toilette, including *At the Milliner's* (1882; New York, Met.), *Ironer* (c. 1884–6; Paris, Mus. d'Orsay) and *Bather Lying on the Ground* (1886–8; Paris, Mus. d'Orsay).

5. The late works, 1890–1912

During the last years of Degas's career, his work moved away from Naturalism; his use of colour grew more strident and brilliant and his line more expressive and independent. At this time the artist was close to Gauguin, and such works as the *Return of the Herd* (c. 1898; Leicester, Mus. & A.G.) are almost Fauvist in their colouring. Paradoxically, as his work became increasingly non-naturalistic, he launched into a series of landscapes in colour monotype inspired by a journey

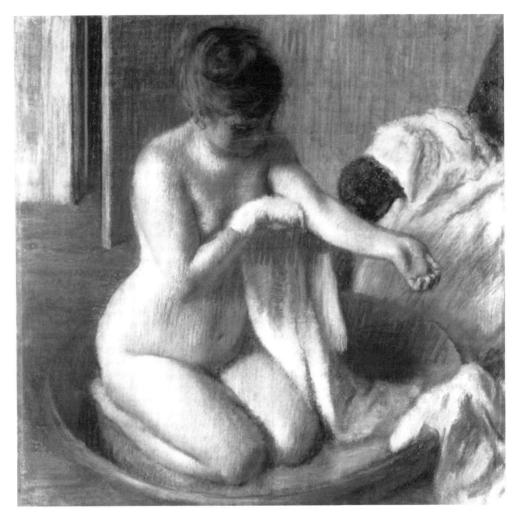

29. Edgar Degas: *Woman in a Tub*, 1885-6 (London, Tate Gallery)

through Burgundy by horse-drawn caravan with the family of his friend the artist Pierre-Georges Jeanniot (1848–1934). Imaginative re-creations done from memory, they were exhibited by Durand-Ruel in 1892 (*Landscape*, 1890–92; New York, Met.). Towards the end of the 1890s new and still more intense colours appeared in his work in such paintings as *Combing the Hair* (c. 1896; London, N.G.), in a range of flaming reds and oranges, and in the pastel series of *Russian Dancers* (e.g. of 1899; Houston, TX, Mus. F.A.), in electric blues, pinks and purples. His modelling became cursory and the figures more angular and distorted (e.g. *Fallen Jockey*, c. 1896–8; Basle, Kstmus.). After 1900 he began to use tracing paper as a support, treating familiar subjects with a strong black outline and searing colours (*After the Bath*, 1896–1907; Paris, Mus. A. Déc.). Other

important works from this period include the *Morning Bath* (*c.* 1895; Chicago, IL, A. Inst.), *After the Bath* (*c.* 1896; Philadelphia, PA, Mus. A.) and *Two Bathers on the Grass* (*c.* 1896; Paris, Mus. d'Orsay). Depressed by failing eyesight and poor health and distressed by an enforced move from his lodgings of 20 years, he produced no more works after 1912.

II. Working methods and technique

1. Drawing

Degas never forgot the emphasis on the importance of line that he had received during his early training. His use of a clear, hard outline distinguished his works from those of the other Impressionists. A consummate draughtsman, he worked with both energy and delicacy. While he sometimes indicated a desire to follow a specific working method (see Guérin, p. 219), in reality he allowed himself to be carried away by a spontaneous ardour, which can be seen in all his drawings. During the earlier part of his career he drew large numbers of preparatory studies for all his historical paintings. Starting with disparate elements of varied origins (Assyrian, Egyptian, Greek and Italian), he integrated them into his composition to achieve a genuine synthesis. While working on a piece, Degas would frequently recall an image he had seen previously and copy it; he would then go on to reinterpret it, often preserving the original movement or position but stylizing the details. This method, based on the progressive assembly of accumulated elements, conformed to the 19th-century academic tradition of Ingres and Moreau. In the drawings executed in his youth Degas showed a need to relate his work to that of his great predecessors and in addition revealed one of his most impressive abilities, the capacity for observation that enabled him to capture an image, a gesture or a movement, so evident in his later work. An attentive observer of the most diverse scenes, he took a passionate interest in everyday gestures. He would often draw a figure from several angles and execute various studies of the same subject on a single page (*Four Studies of a Dancer*, 1878–9; Paris, Mus. d'Orsay).

The juxtaposition of these studies within the space of a single sheet, oriented in different directions, suggests movement. Degas invented many ways of breaking up his forms, isolating a detail in order to intensify perception and multiplying the facets of a figure the better to explore it. He always preferred pencils and pastels to such water-based media as watercolour, as opaque techniques allowed more spontaneity in working and were easier to change. In 1897 a series of 20 of his early drawings, *Degas: Vingt dessins, 1861–1869*, was published in Paris.

2. Printmaking

Degas worked extensively in black and white and in colour, producing etchings (e.g. *Aux Ambassadeurs*, 1875; Paris, Bib. N., lithographs and, most importantly, monotypes (the application of black or coloured paint or ink with a high oil content to a zinc or copper metal-plate. He had been introduced to the monotype method by Ludovic Lepic in 1876; the *Ballet Master* (1876; Washington, DC, N.G.A.) carries the signature of both artists. Degas worked on the plate in a variety of intaglio techniques before applying a damp sheet of paper and placing the ensemble in a press. Normally only the first impression produced by this method is considered adequate; Degas, however, generally did not restrict himself to a single print but used the same plate until every trace of colour had been used up. He then used the last residual impressions as the basis of new compositions, which he picked out in pastel. Between 1876 and 1881 more than two-thirds of his works in colour were pastelized monotypes (e.g. *Women on the Terrace (A Café on the Boulevard Montmartre)*, 1877; Paris, Mus. d'Orsay. In the 1890s he executed a series of landscapes in this way; with a very distinctive, hazy texture, they have uneven patches made by the marks of the brushes, rag, inking pad and the artist's fingers when he applied the ink by hand (e.g. *Landscape*, 1892; Geneva, Gal. Jan Krugier).

Degas was fired by the effects of the contrast between the basic image on the plate—reconstructed in the form of the inverted print—and the variations made possible by the use of pastels,

which he applied directly to pick out the forms, creating a play between the image laid down indirectly on the plate and the line drawn directly on the paper. Sometimes he would wet the pastel embellishments copiously in order to obtain smooth areas and runs. Each colour was applied to the plate in a different manner, using a fine brush, a dry brush or a brushtip to suggest a clump of trees, or vertical lines to represent a mass of trees. These textural effects served to differentiate the elements. Degas's research was essentially into tactical perception, and he viewed these works as scientific experiments. His unremitting fascination with variations on a single theme led to the development of such monotype series as *Leaving the Bath*, which has 22 states (e.g. 14th state, 1879–80; Williamstown, MA, Clark A. Inst.).

3. Sculpture

From the late 1860s Degas produced numerous small sculptures in wax. He concentrated on the subjects that feature in his two-dimensional works—horses, dancers and women washing. The combination of soft wax and frail armatures (often cork) meant that the sculptures were highly perishable: many crumbled during the artist's lifetime, and he often reworked them. His interest in sculpture increased from the mid-1880s and is often attributed to his failing eyesight.

Although these works were largely private and intended almost as sketches, some were quite elaborate: *The Tub* of 1889 (bronze version; Edinburgh, N.G.) originally included a real sponge in the bather's hand and a cloth frill around the bathtub. The only sculpture he decided to exhibit was the *Little Fourteen-year-old Dancer*, which he included in the Impressionist exhibition of 1881. He had thought of having his wax pieces cast in bronze, but in fact casts were only made in 1919, after his death. The caster Adrien Hébrard used the lost-wax method to produce 22 or more copies of each sculpture.

4. Pastel

Pastel opened up several possibilities for Degas: contours could be defined by lines or by hatching,

which could then be covered by layers of paint, concealing the strokes and blurring the forms. He used various techniques on a single sheet of paper, executing some elements sharply and leaving others blurred. His virtuosity in this medium appears in *The Star* (or *Dancer on Stage*, c. 1878; Paris, Louvre; see col. pl. XIV): the dancer's body is lit from below by a spotlight, which marks her neck and chin with a flash of white. The composition is vertiginous and slants diagonally; Degas left a large empty space in the lower left-hand part of the picture, indicating the space occupied by the stage. Dazzling colours—red, ochre, green and turquoise—radiate across the picture in a series of brusque, informal and highly visible lines. In this work, the use of pastels made it possible to represent the swiftness and immediacy of the subject seized in mid-movement. Intense colours co-exist with sharply contrasting brown or black tones standing out against them, for example in the silhouette of the man in evening dress half-hidden behind the stage set, brushed in with a few brief strokes. This kind of framing became increasingly important in Degas's work from the 1870s onwards; he often accentuated the oddity of his compositions by framing them in such a way as to allow the viewer to see only part of a silhouette or a figure, a common Impressionist device that he used especially drastically to give an unsettling feeling to familiar scenes (*At the Café des Ambassadeurs*, 1885; Paris, Mus. d'Orsay). He also regularly used close-ups of faces lit from below, as if by footlights, in scenes connected with the stage—ballet, opera and café-concerts.

As with his oils, prints and sculptures, Degas tended to produce series of pastels on a single subject. In 1869 he began a series of women ironing; often blended with charcoal and white chalk, these works may have influenced Picasso's Blue Period. Around 1876 dancers became his major theme; he used pastels to capture moments of fleeting equilibrium with a rare dynamic intensity. In the 1880s more vigorous lines began to enclose the contours of the figures, and the forms were more clearly marked out against the surrounding space. Towards 1885 Degas obtained some innovative mixtures by superimposing layers

of pastels; a linear structure delimited each different, densely textured area of colour, while stratifications, stripes, streaks and hatching created shades and hues of colour that were difficult to define. Most of the pastels executed during this period have daring layouts and show both skilful organization of line and accentuated schematization (e.g. *Dancers on the Stage*, c. 1882–4; Dallas, TX, Mus. F.A.). By c. 1886 Degas's pastels were more briefly sketched out than previously; they were worked in stripes and zigzags, displaying a more violent style of execution in a more acid range of colours (*Reclining Bather*, 1886–8; Paris, Mus. d'Orsay). Around 1895 Degas used the medium in a new manner. He was growing old, and his sight was deteriorating, but he succeeded in imbuing his works with a new power. His line was less precise; he reworked the outlines time after time, allowing layers of different colours to overlap; he varied his methods, using parallel lines, intersecting hatching, stripes, short and broken lines and white chalk highlights. The combination of different layers of colour, with their unexpected tonal interrelations, created unusual harmonies. Forms and colours melted into one another in these pastels, and Degas's figures were more fully integrated into backgrounds whose purely descriptive elements seemed as if absorbed into his colour and light, although he was still using the same subjects (*After the Bath*, c. 1896; Philadelphia, PA, Mus. A.).

Degas continued to work in pastels during the last period of his life as he pursued the theme of dancers resting. He made this the object of extensive research; every gesture of an arm or a leg was used in the play of curve and counter-curve. Around 1910 he began to work with increasing freedom, emphasizing colour with splashes and patches of luminous pastel powder, as in *Two Dancers Resting* (c. 1910; Paris, Mus. d'Orsay).

III. CRITICAL RECEPTION AND POSTHUMOUS REPUTATION

Largely free from the financial pressures of his Impressionist colleagues, Degas was able to view public criticism of his works with a degree of detachment. Up to the New Orleans period, he produced few works for public exhibition, apart from the history paintings destined for the Salon, and spent most of his time working on portraits of his family and friends. Once he had begun to show in the Impressionist group exhibitions, he never returned to the Salon; unlike Monet and Renoir, who continued to hope for fashionable portrait commissions and positive reviews from establishment journals, he always maintained a certain independence. Within the group, Degas's works were usually singled out as substantially different in feeling from the other pictures on show. Charges of sloppy paintwork, incompetent drawing and lack of finish, which were the staple complaints about Impressionism, were not generally levied at Degas—Emile Zola indeed criticized the *Cotton Market at New Orleans* for excessive clarity and detail. Instead, it was the subject-matter of Degas's work that aroused critical ire; the ugliness of his models was a constant theme, and his fascination with Parisian low-life was either approved of or disliked according to the viewer's position on Realism. From the 1874 show onwards Degas was cited by the more discerning critics as the head of the Realist or Naturalist faction within the Impressionist group; the Realist novelist Edmond de Goncourt described him as 'the one who has been able to capture the soul of modern life'. Louis-Edmond Duranty, a close friend and eloquent advocate of the artist, singled out Degas and Gustave Caillebotte as representing the most vital tendency within the Parisian avant-garde in *La Nouvelle Peinture* (Paris, 1876), the first substantial publication devoted to the Impressionists. By the late 1880s Degas enjoyed a privileged position: he was able to choose his dealers, to exhibit only when he wished to and to lead a rather reclusive existence, secure in the knowledge that discerning buyers and respectful reviews were guaranteed. As he moved away from Realism to a style closer to Symbolism, he won the admiration of a new generation of painters, among them Gauguin and Odilon Redon, who recorded his view of Degas in a journal entry of 1889: 'Respect here, absolute respect' (*A Soi-même: Journal*, Paris, 1922, p. 93).

By 1917 Degas had become almost a public monument; after his death, his reputation mounted steadily. Many of his works entered public collections in Europe, the USA and Japan; most major museums of modern art have acquired at least one Degas. Since the publication (1946–9) of a catalogue raisonné by Lemoisne, there has been a constant stream of research and exhibitions devoted to Degas; a major retrospective (1988–9) in Paris, Ottawa and New York produced an authoritative catalogue and a spate of critical discussion, much of it focused on the issue of Degas's representations of women, which have been variously interpreted as misogynistic and as proto-feminist.

Writings

M. Guérin, ed.: *Lettres de Degas* (Paris, 1931, rev. 1945; Eng. trans., rev., Oxford, 1947)

T. Reff, ed.: *The Notebooks of Edgar Degas*, 2 vols (London, 1976, rev. New York, 1986)

Bibliography

general

L. E. Duranty: *La Nouvelle Peinture* (Paris, 1876)

J.-K. Huysmans: *L'Art moderne* (Paris, 1883)

L. Delteil: 'Degas', *Le Peintre-graveur illustré*, ix (Paris, 1906–26; New York, 1969)

L. W. Havemeyer: *Sixteen to Sixty: Memoirs of a Collector* (New York, 1961)

F. Fénéon: *Oeuvres plus que complètes*, ed. J. U. Halperin (Geneva, 1970) [incl. his reviews of the Impressionist exhibitions]

J. Rewald: 'Theo van Gogh, Goupil and the Impressionists', *Gaz. B.-A.*, 6th ser., lxxxi (1973), pp. 1–108

R. Huyghe: *La Relève du réel: Impressionnisme, symbolisme* (Paris, 1974)

Centenaire de l'impressionnisme (exh. cat. by A. Dayez and others; Paris, Grand Pal.; New York, Met.; 1974–5)

The Painterly Print: Monotype from the Seventeenth to the Twentieth Century (exh. cat. by B. S. Shapiro; New York, Met.; Boston, MA, Mus. F.A.; 1980–81)

The New Painting: Impressionism, 1874–1886 (exh. cat., ed. C. Moffett; Washington, DC, N.G.A.; San Francisco, F.A. Museums; 1986)

La Sculpture française au XIXe siècle (exh. cat., Paris, Grand Pal., 1986)

monographs and collections of essays

P.-A. Lemoisne: *Degas* (Paris, 1912)

J. Meier-Graefe: *Degas* (Munich, 1920/R 1924; Eng. trans., London, 1923)

P. Jamot: *Degas* (Paris, 1924)

A. Vollard: *Degas* (Paris, 1924)

P. Valéry: *Degas, danse, dessin* (Paris, 1934/R 1965)

J. Lassaigne: *Edgar Degas* (Paris, 1945)

J. Fèvre: *Mon oncle Degas* (Geneva, 1949)

D. C. Rich: *Degas* (New York, 1951)

P. Cabanne: *Edgar Degas* (Paris, 1957)

T. Reff: *Degas: The Artist's Mind* (New York, 1976)

I. Dunlop: *Degas* (New York, 1979; Fr. trans., Neuchâtel, 1979)

M. Sérullaz: *L'Univers de Degas* (Paris, 1979)

A. Terrasse: *Edgar Degas* (Frankfurt am Main, Berlin and Vienna, 1981)

R. McMullen: *Degas: His Life, Times and Work* (Boston, 1984)

R. Kendall, ed.: *Degas, 1834–1984* (Manchester, 1985)

D. Sutton: *Edgar Degas: Life and Work* (New York, 1986)

Burl. Mag., cxxx/1020 (1988) [issue ded. to Degas]

catalogues raisonnés and exhibition catalogues

J. Rewald: *Degas: Works in Sculpture: A Complete Catalogue* (New York and London, 1944)

P.-A. Lemoisne: *Degas et son oeuvre*, 4 vols (Paris, 1946–9/R with suppl. by P. Brame and T. Reff, New York and London, 1984)

Edgar Degas: His Family and Friends in New Orleans (exh. cat., New Orleans, LA, Delgado Mus., 1965)

Drawings by Degas (exh. cat. by J. S. Boggs; St Louis, MO, A. Mus.; Philadelphia, PA, Mus. A.; Minneapolis, MN, Soc. F.A.; 1967)

Degas Monotypes (exh. cat. by E. P. Janis, Cambridge, MA, Fogg, 1968)

Degas: Oeuvres du Musée du Louvre (exh. cat., Paris, Mus. Orangerie, 1969)

J. Adhémar and F. Cachin: *Edgar Degas: Gravures et monotypes* (Paris, 1973; Eng. trans., New York, 1974)

The Degas Bronzes (exh. cat. by C. Millard, Dallas, TX, Mus. F.A., 1974)

Edgar Degas: The Reluctant Impressionist (exh. cat. by B. S. Shapiro, Boston, MA, Mus. F.A., 1974)

The Complete Sculptures of Degas (exh. cat., intro. J. Rewald; London, Lefevre Gal., 1976)

Degas (exh. cat. by F. Daulte; Tokyo, Seibu Mus. A.; Kyoto, City A. Mus.; Fukuoka, Cult. Cent.; 1976–7)

Degas in the Metropolitan (exh. cat., New York, Met., 1977) [the Charles S. Moffett col.]

Degas and the Dance (exh. cat. by L. D. Muehlig; Northampton, MA, Smith Coll. Mus. A., 1979)

Degas, 1879 (exh. cat. by R. Pickvance, Edinburgh, N.G., 1979)

Degas: *La Famille Bellelli* (exh. cat., intro. Y. Brayer; Paris, Mus. Marmottan, 1980)

Degas et la famille Bellelli (exh. cat. by H. Finsen, Copenhagen, Ordrupgaardsaml., 1983)

Degas in the Art Institute of Chicago (exh. cat. by R. R. Brettall and S. Folds McCullagh, Chicago, IL, A. Inst., 1984)

Edgar Degas: Pastelle, Ölskizzen, Zeichnungen (exh. cat. by G. Adriani, Tübingen, Ksthalle, 1984)

Degas: The Dancers (exh. cat. by G. Shackelford, Washington, DC, N.G.A., 1984–5)

Degas e l'Italia (exh. cat. by H. Loyrette, Rome, Villa Medici, 1984–5)

Degas: Le Modelé et l'espace (exh. cat., Paris, Cent. Cult. Marais, 1984–5)

Edgar Degas: The Painter as Printmaker (exh. cat. by S. W. Reed and B. S. Shapiro; Boston, MA, Mus. F.A.; Philadelphia, PA, Mus. A.; London, Hayward Gal.; 1984–5)

Degas Monotypes (exh. cat. by A. Griffiths, London, Hayward Gal., 1985)

Degas scultore (exh. cat.; Florence, Pal. Strozzi; Verona, Pal. Forti; 1986)

R. Fernandez and A. R. Murphy: Degas in the Clark Collection (Williamstown, MA, Clark A. Inst. cat., 1987)

The Private Degas (exh. cat. by R. Thomson; U. Manchester, Whitworth A.G.; Cambridge, Fitzwilliam; 1987)

Degas (exh. cat.; Paris, Grand Pal.; Ottawa, N.G.; New York, Met.; 1988–9) [extensive bibliog.]

Degas: Images of Women (exh. cat. by R. Kendall, Liverpool, Tate, 1989)

Degas (exh. cat. by R. Pickvance, Martigny, Fond. Pierre Gianadda, 1993)

specialist studies

G. Moore: 'Degas: The Painter of Modern Life', *Mag. A.*, xiii (1890), pp. 416–25

——: 'Memories of Degas', *Burl. Mag.*, xxxii (1918), pp. 22–9, 63–5

L. Burroughs: 'Degas in the Havemeyer Collection', *Bull. Met.*, xxvii (1932), pp. 141–6

D. Rouart: Degas à la recherche de sa technique (Paris, 1945)

——: Degas monotypes (Paris, 1948)

L. Browse: Degas Dancers (London, [1949])

D. Cooper: Pastels by Edgar Degas (Basle, 1952/R New York, 1953)

J. S. Boggs: 'Degas Notebooks at the Bibliothèque Nationale', *Burl. Mag.*, c (1958), pp. 163–71, 196–205, 240–46

——: *Portraits by Degas* (Berkeley, 1962)

——: 'Edgar Degas and Naples', *Burl. Mag.*, cv (1963), pp. 273–6

R. Pickvance: 'Degas's Dancers, 1872–1876', *Burl. Mag.*, cv (1963), pp. 256–66

T. Reff: 'Degas's Copies of Older Art', *Burl. Mag.*, cv (1963), pp. 241–51

——: 'The Chronology of Degas's Notebooks', *Burl. Mag.*, cvii (1965), pp. 606–16

R. Pickvance: 'Some Aspects of Degas's Nudes', *Apollo*, lxxxiii (1966), pp. 17–23

E. P. Janis: 'The Role of the Monotype in the Working Method of Degas', *Burl. Mag.*, cix (1967), pp. 20–27, 71–81

G. Monnier: 'Les Dessins de Degas du Musée du Louvre: Historique de la collection', *Rev. Louvre*, 6 (1969), pp. 359–68

C. W. Millard: The Sculpture of Edgar Degas (Princeton, 1976)

G. Monnier: 'La Genèse d'une oeuvre de Degas: Sémiramis construisant une ville', *Rev. Louvre*, 5-6 (1978), pp. 407–26

R. Thomson: 'Degas in Edinburgh', *Burl. Mag.*, cxxi (1979), pp. 674–7

M. E. Shapiro: 'Three Late Works by Edgar Degas', *Bull. Mus. F.A., Houston* (Spring 1982), pp. 9–22

A. Terrasse: Degas et la photographie (Paris, 1983)

E. Lipton: Looking into Degas: Uneasy Images of Women and Modern Life (Berkeley and Los Angeles, 1986)

R. Thomson: 'Degas's Nudes at the 1886 Impressionist Exhibition', *Gaz. B.-A.*, 6th ser., cviii (1986), pp. 187–90

R. Kendall: Degas Landscapes (New Haven, 1993)

GENEVIÈVE MONNIER

Dehodencq, (Edmé-Alexis-)Alfred

(*b* Paris, 23 April 1822; *d* Paris, 2 Jan 1882). French painter. He studied at the Collège Bourbon, where he met the poet Théodore de Banville. In 1839 he entered the atelier of Léon Cogniet, and he made his Salon début in 1844 with two figure paintings and a biblical subject, *St Cecilia in Adoration* (untraced). Wounded in the arm during the Revolution in 1848, he left Paris in June 1849 to convalesce at Barèges in the Pyrenees and from there travelled via Pau to Madrid. Apart from a brief visit to Paris in 1855, Dehodencq spent the next 15 years in Spain. In 1850 he entered the atelier of the Madrazo family and with their

encouragement exhibited his *Fight of the Novillos* (1850; Pau, Mus. B.-A.) in Madrid, where it attracted the favourable attention of Manet. His robust style was popular with the Spanish authorities and with the international community in Madrid from whom he received several portrait commissions between 1850 and 1855; for example *Prince Piscinelli* (Bordeaux, Mus. B.-A.).

Dehodencq's image of Spanish and Arab life was coloured by his youthful obsession with the romantic writings of Byron and Chateaubriand. His oeuvre is dominated by dramatic scenes of violence, despotism and fanaticism (*Execution of the Jewess*, 1862; untraced, see Séailles, no. 113), although he also painted more tranquil scenes of Spanish peasantry and gypsies (*Andalusian Peasants*, 1862; Condom, Mus. Armagnac). Works painted after his return to Paris in 1863 show a pronounced debt to Delacroix (*Jewish Festival at Tangiers*, 1870; Poitiers, Mus. B.-A.). A feeble draughtsman, Dehodencq preferred colour as a means of expression. His palette is rich, often gaudy, and his handling robust and sketchlike. He received medals at the Salons of 1846, 1853 and 1865. In 1870 he was made Chevalier of the Légion d'honneur.

Bibliography

G. Séailles: *Alfred Dehodencq: L'Homme et l'artiste* (Paris, 1910)

V. Plat: *Alfred Dehodencq, 1822–1882* (diss., Paris, Ecole Louvre, 1977)

JANE MUNRO

Delaplanche, Eugène

(*b* Paris, 28 Feb 1836; *d* Paris, 10 Jan 1891). French sculptor. Son of a poor wine merchant and a dressmaker, he studied under Louis Auguste Déligand (1815–74) and then at the Ecole des Beaux Arts, Paris, under François-Joseph Duret. He won the Prix de Rome in 1864, by which time he had already exhibited twice at the Salon and executed an elaborate marble fireplace with figures of *Music* and *Harmony* for the mansion of the Marquise de Païva in the Champs-Elysées (1864; *in situ*). The two statues of youths produced during his years in Rome, *Boy Riding on a Tortoise* (1866) and *Shepherd Boy* (1868) (both bronze; Marseille, Mus. B.-A.), belong to the tradition of Italian genre sculpture initiated by François Rude and Duret. However, another work begun in Rome, *Eve after the Fall* (marble, 1869; Paris, Mus. d'Orsay), points the way to Delaplanche's future identification with sensuous renderings of the female body. One of the most acclaimed of these was the rapturous allegorical statue of *Music* for the Paris Opéra (marble, exh. Salon 1878). Even before he won the Prix de Rome, Delaplanche had been connected with the group known as Les Florentins, which included Marius-Jean-Antonin Mercié, Alexandre Falguière and Paul Dubois. His allegiance to this group is especially conspicuous in his *Maternal Education* (plaster, exh. Salon 1873; marble, exh. Salon 1875; now Paris, Place Samuel Rousseau), a modern genre piece interpreted in a Quattrocento manner.

Bibliography

Lami

PHILIP WARD-JACKSON

Delâtre, Auguste

(*b* Paris, 1822; *d* Paris, 26 July 1907). French printmaker. From the age of 12 he worked for the same jobbing printer, but *c*. 1840–41 he was employed by two well-known printmakers, Charles Jacque and Louis Marvy (1815–50), to handle their presses. Jacque and Marvy taught him how to paint and draw, and his experience with them turned him into an artist's printer. He then set up his own studio. In 1848 he completed his first series of etchings, mainly landscape scenes. Although Delâtre was versatile in the various forms of etching, he is best known for the excellence and sensitivity of his work as a printer. He developed the 'mobile etching' technique, a way of painting ink on to the plate so that up to 40 unique impressions could be made from the same plate, rather than a uniformly wiped edition. This skill served the Impressionists and influenced the practice of monotype in such artists as Ludovic Lepic and

Degas. It also inspired fierce debate on the question of printer intrusion. He quickly established a considerable reputation and soon became the only printer to whom the majority of talented etchers would entrust their work. His print shop became a meeting place for such etchers as Charles-François Daubigny and James McNeill Whistler. The cult of Japonisme is said to have begun there through the *Hokusai manga* ('Sketches by Hokusai', 1814–34) he owned.

In 1862 Delâtre helped found the Société des Aquafortistes in Paris, and in 1864, largely at the instigation of Whistler and Seymour Haden, he was invited to England to advise on the setting up of an etching class at the National Art Training Schools, part of the South Kensington Museum (now the Victoria and Albert Museum). He also began painting in oils: *Autumn Evening*, a fine landscape, was shown in the Paris Salon of 1868. In the siege of Paris in 1870 his studio was destroyed, together with all his works and most of his equipment. He took refuge in London, working with other expatriate French artists, such as James Tissot and Jules Dalou. He returned to Paris in 1876 and set up a new studio in Montmartre.

Bibliography

Bénézit

H. Béraldi: *Les Graveurs du XIXe siècle* (Paris, 1884–92), pp. 168–74

J. Bailly-Herzberg: *L'Eau-forte de peintre au dix-neuvième siècle: La Société des Aquafortistes, 1862–1867*, 2 vols (Paris, 1972)

E. P. Jauis: 'Setting the Tone: The Revival of Etching, the Importance of Ink', *The Painterly Print: Monotypes from the 17th–20th Centuries* (exh. cat., New York, Met., 1980), pp. 9–28

ETRENNE LYMBERY

Delaunay, (Jules-)Elie

(*b* Nantes, 13 June 1828; *d* Paris, 5 Sept 1891). French painter. He entered the Ecole des Beaux-Arts in Paris on 7 April 1848, where he was a pupil of Joachim Sotta (1810–77), Hippolyte Flandrin and Louis Lamothe (1822–69). He became a disciple of Flandrin, and, though making his début in the Salon in 1853 with the *Saltworkers of Guérande* (Nantes, Mus. B.-A.), he soon concentrated on history painting. In 1856 he won the Prix de Rome with the *Return of the Young Tobias* (Paris, Ecole N. Sup. B.-A.) and left Paris to study at the Académie de France in Rome. His work is imbued with a deep religious sentiment cast in the restrained, controlled style and formal repertoire of Neo-classicism. From early in his career he produced many easel and wall paintings on religious subjects, such as *Jesus Healing the Lepers* (1850; Le Croisic, Hôp.). In 1854 he received a commission to produce four fresco decorations for the church of the monastery of the Visitation-Ste-Marie in Nantes, which he completed the following year. In 1865 he returned to the monastery to decorate the chapel of St-François de Sales with scenes from that saint's life. He also contributed to the decoration of at least two Parisian churches, the Trinité (*Assumption of the Virgin* and *Isaiah and Ezekiel*) and St-François-Xavier (*Four Prophets*).

In addition to these religious works, Delaunay painted classical subjects, as in the *Oath of Brutus* (Tours, Mus. B.-A.) and the *Death of the Nymph Hesperia* (Copenhagen, Ny Carlsberg Glyp.), both of which were much admired at the Salon of 1863. Perhaps the painting that best encapsulates Delaunay's iconographic and stylistic concerns is the *Plague at Rome* (1869; Paris, Mus. d'Orsay), a subject he had first treated in a sketch made during his stay in Rome. He took up the theme again in Paris, turning it into this finished painting, which celebrates the superior healing powers of the Christian over the pagan faith. The scene combines Delaunay's favourite Christian and classical motifs. It also shows his capacity to construct a dramatic narrative and to render a variety of emotions, as is evident in the figures of the plague sufferers and the exterminating angel.

From around 1870 onwards Delaunay concentrated on painting portraits, which are intensely characterized, vivid and colourful. The sitters stand out as if they were carved in low relief, as shown in the portrait of *Mme Georges Bizet* (1878; Paris, Mus. d'Orsay). Delaunay also produced some watercolour drawings for an illustrated edition of

La Fontaine's *Fables* (Paris, 1860). In this later period he produced his best fresco decorations, for the Panthéon in Paris, for which he was commissioned in 1874. There he executed scenes from the life of the patron saint of Paris, St Geneviève, the most admired of which is *Attila and St Geneviève*. He died before completing this commission, which was then passed on to Henri Courselles-Dumont (*b* 1856). Also in Paris, Delaunay decorated the staircase of the Hôtel de Ville and worked with Paul Baudry on the decorations of Charles Garnier's new Opéra. His *Parnassus* is considered superior to all Baudry's contributions. In 1879 he was elected a member of the Académie des Beaux-Arts and in 1889 was appointed head of an atelier at the Ecole des Beaux-Arts in Paris.

Bibliography

Bellier de La Chavignerie–Auvray; Bénézit; DBF; Thieme–Becker

E. Maillard: *L'Art à Nantes* (Paris, 1889)

P. Leroi: 'Elie Delaunay', *L'Art*, ii (1891), pp. 105, 226, 271

G. Lafenestre: *La Tradition dans la peinture française* (Paris, 1898), pp. 227–92

ATHENA S. E. LEOUSSI

Desbois, Jules

(*b* Parcay-les-Pins, Maine-et-Loire, 20 Dec 1851; *d* Autheuil, Paris, 2 Oct 1935). French sculptor. He studied at the Ecole des Beaux-Arts under Pierre-Jules Cavelier, and made his Salon début with a head of *Orpheus* in 1875. His exhibit of 1877, *Othryades* (untraced), was bought by the state. Around this time he met Rodin in the studio of Eugène Legrain (1837–1915), where both Desbois and Rodin were assisting with the ornamental sculpture for the Palais du Trocadéro. After spending two years in the United States in the studio of John Quincy Adams Ward, Desbois returned to France. He collaborated with Rodin on several major works including the *Burghers of Calais*, and, at certain points, there is close correspondence between their works. *Misery* (wood, 1894; Nancy, Mus. B.-A.), an aged, emaciated female figure, may be compared with Rodin's *La Vieille Heaulmière*. More typical of Desbois's production

is the massive sensualism of his *Leda* (1891; marble version, Luxembourg, Mus. Etat; bronze version, Stockholm, Nmus.). From the mid-1890s he aligned himself with the group of decorative sculptors whose works were sold through Siegfried Bing's shop, La Maison de l'Art Nouveau. His 'art pewters' were exhibited at the Salon of the Champ de Mars in 1896, and at the exhibition of the Société des Six in 1899. His vigorous monumentalism is in evidence in the two allegorical figures that he executed for the façade of the Hôtel de Ville, Calais (1911–18). From 1924 to 1929 Desbois was the Vice-president of the Société Nationale des Beaux-Arts.

Bibliography

J. Mercier: *Jules Desbois: Illustre, statuaire, angevin* (Longué, 1978)

De Carpeaux à Matisse (exh. cat., ed. D. Vieville; Calais, Mus. B.-A.; Boulogne, Mus. Mun.; Paris, Mus. Rodin; 1982–3)

La Sculpture française au XIXe siècle (exh. cat., ed. A. Pingeot; Paris, Grand Pal., 1986)

PHILIP WARD-JACKSON

Desboutin, Marcellin(-Gilbert)

(*b* Cérilly, nr Moulins, 26 Aug 1823; *d* Nice, 18 Feb 1902). French painter, printmaker, collector and writer. Born into a wealthy, aristocratic family, he showed an early talent for drawing but initially trained and registered as a lawyer, though he never practised. In 1845 he entered the Ecole des Beaux-Arts in Paris, studying first under the sculptor Louis-Jules Etex (1810–89) and from 1847–8 under Thomas Couture. From 1849 to 1854 he travelled—to England, Belgium, the Netherlands and finally to Italy, where in 1854 he bought the historic Villa dell'Ombrellino in Bellosguardo outside Florence. He lived there until his return to Paris in 1872, building up an art collection and making engravings. The content of his purportedly large collection has not been established, though he is known to have had a particular love for early Italian Renaissance works and also paintings from the Spanish school. While in Italy he wrote several plays, of which one, *Maurice de Saxe*, was performed at the Comédie Française, Paris, in 1870.

Having exhausted his inherited fortune, he returned to Paris in August 1872, now forced to work as a printmaker for a living. He soon became involved with the group of young Impressionists who met at the Café Guerbois and later at the Café de la Nouvelle Athènes in Paris. Degas included him in his painting the *Absinthe Drinker* (1876; Paris, Mus. d'Orsay) together with the actress Ellen Andrée. Desboutin produced several engraved portraits of his Impressionist friends, particularly in drypoint, as in *Renoir* (1877; see Clément-Janin, p. 216). He also painted such works as *The Musician* (1874; Moulins, Mus. Moulins). From 1880 to 1888 he lived in Nice, returning to Paris in 1890, when he was a founder-member of the Société Nationale des Beaux-Arts. His painted portrait of *Josephin Péladan* (1891; Angers, Mus. B.-A.) was included in the Salon de la Rose + Croix of 1893. He returned to Nice in 1896 and remained there until his death.

Bibliography

N. Clément-Janin: *La Curieuse Vie de Marcellin Desboutin, peintre, graveur, poète* (Paris, 1922)

The Realist Tradition: French Painting and Drawing, 1830–1900 (exh. cat. by G. P. Weisberg, Cleveland, Mus. A.; New York, Brooklyn Mus.; St Louis, A. Mus.; Glasgow A.G. & Mus.; 1980–81), pp. 190, 256–7, 286–7

□

Desgoffe, Blaise(-Alexandre)

(*b* Paris, 17 Jan 1830; *d* Paris, 2 May 1901). French painter. His uncle, the landscape painter Alexandre Desgoffe (1805–82), had studied under Ingres; this perhaps accounts for Blaise's decision to train under Ingres's pupil Hippolyte Flandrin. He entered the Ecole des Beaux-Arts on 7 October 1852, apparently intending to study history painting. At his first Salon in 1854 he exhibited a genre painting, *A Game of Cup and Ball in the Studio*, a portrait and two studies of agate cups (all untraced). He is not otherwise known as a painter of genre subjects or portraits but regularly exhibited still-life compositions of precious objects painted on smooth panels with a heightened

trompe l'oeil realism that was widely compared by critics with 17th-century Dutch still-life painting. He varied the pattern little. Most of his work in the 1860s seems to have been based on 16th-century objects in the Louvre. In the 1870s he added Chinese, Japanese and Greek items, probably on demand. The *Vase of Rock Crystal and Other Objects* (exh. Salon, 1874; New York, Met.) was commissioned from Desgoffe by Catharine Wolfe, who herself selected the items to be depicted from the Louvre. His sense of composition was rudimentary, but his virtuosity was much admired. Two paintings were bought for the Musée du Luxembourg in 1859 and in 1863 (now in Arras, Mus. B.-A., and Angoulême, Mus. Mun.), but by the mid-1870s his meticulous style was going out of fashion. He won a bronze medal at the Exposition Universelle of 1889 and continued to exhibit at the Société des Artistes Français until his death.

Bibliography

C. Sterling and M. M. Salinger: *French Paintings: A Catalogue of the Collection of the Metropolitan Museum of Art*, ii: *XIX Century* (New York, 1966), pp. 184–5

Le Musée du Luxembourg en 1874 (exh. cat. by G. Lacambre and J. de Rohan-Chabot, Paris, Grand Pal., 1974)

JON WHITELEY

Detaille, (Jean-Baptiste-)Edouard

(*b* Paris, 5 Oct 1848; *d* Paris, 23 Dec 1912). French painter. He was born into a prosperous family from Picardy with a military background, his grandfather having served as an arms supplier to Napoleon. Detaille's early interest in art was encouraged by his father, an amateur artist and friend of collectors and painters, including the battle-painter Horace Vernet. At 17 he approached Ernest Meissonier for an introduction to Alexandre Cabanel, but Meissonier preferred to take on Detaille as a pupil himself and was an enormously important influence on his artistic development. From Meissonier he learnt finesse of execution and an appreciation for precise observation. He was soon encouraged to set up on his

own and at the Salon of 1869 won approval for his canvas *A Rest During the Manoeuvre, Camp St Maur* (untraced). In the spring of 1870 he and three other young artists, E. P. Berne-Bellecour (1838–1910), L. Leloir (1843–84) and J. G. Vibert (1840–1902), undertook a sketching trip to Algeria. At the outbreak of the Franco-Prussian War (1870), Detaille obtained a staff position with General Appert, which enabled him to observe the hostilities first hand; this experience provided the mainstay of his subsequent artistic output.

Detaille submitted two Franco-Prussian War subjects, *The Victors* and *A German Convoy* to the Salon of 1872 (both untraced), but he was forced to withdraw them by a French regime still anxious about offending German opinion. Other treatments of the War were nonetheless submitted to later Salons: for example the *Charge of the Ninth Regiment of Cuirassiers into the Village of Morsbronn* (exh. Salon 1874; untraced) and the *Salute to the Wounded!* (exh. Salon 1877; untraced). Visits to Austria, England and Russia acquainted him with the uniforms and customs of the armies of those nations, but the history of the French Army remained his abiding interest. In 1883 his two lavishly illustrated volumes treating the uniforms and classifications of the army from 1789 to 1870 were issued in collaboration with Jules Richard. The 346 figures and 60 coloured plates in *Types et uniformes de l'armée française* comprise an encyclopedia of their subject. Many of these illustrations were studied from the artist's own extensive collection of uniforms and other military artefacts.

Detaille's devotion to accuracy was also to be seen in his two masterpieces, vast panoramas depicting episodes from the Franco-Prussian War, which were subsequently dispersed: the panorama of *Champigny* (exh. Paris, 1882; central section, Versailles, Château) and the panorama of *Rezonville*. The first was based on his 1879 canvas, the *Defence of Champigny* (New York, Met.), and was undertaken in collaboration with Alphonse de Neuville. It shows the desperate French defence against assault by divisions from Saxony and Württemberg on the second day of the battle. The second panorama was done without the aid of de Neuville. For the Salle du Budget of the Hôtel de Ville, Paris, Detaille painted a dramatic allegory *Victory Leading the Armies of the Republic* (Dunkirk, Mus. B.-A.) and two elaborate scenes of leave-taking and return (completed 1905), which emphasize the place of Paris in the military history of the Revolution and the First Empire, and the links between these two eras.

Detaille was the doyen of French military painters of the 'Belle Epoque'. As compared with de Neuville's debonair military personages, Detaille's combatants are rather more credible in their dangerous roles of defending the national honour. He treated the illusion of victory with all the signs of pain and suffering it occasioned.

Bibliography

G. Duplesis: 'Detaille', *Gaz. B.-A.*, n. s. 2, i (1874), pp. 419–33

M. Vachon: *Detaille* (Paris, 1898)

J. Humbert: *Edouard Detaille: L'Héroîsme d'un siècle* (Paris, 1979)

F. Robichon: 'Les Panoramas de Champigny et Rezonville, par Edouard Detaille et Alphonse Deneuville', *Bull. Soc. Hist. A. Fr.* (1979), pp. 259–77

Le Triomphe des mairies (exh. cat., Paris, Petit Pal., 1986), pp. 439–43

FRANK TRAPP

Devéria

French family of artists.

(1) Achille(-Jacques-Jean-Marie) Devéria

(*b* Paris, 6 Feb 1800; *d* Paris, 23 Dec 1857). Painter, lithographer and stained-glass designer. He was a pupil of Louis Lafitte (1770–1828) and, like him, specialized in illustration, which formed the greater part of his output until 1830 (e.g. his illustrations to Goethe's *Faust*, 1828). His experience in the art of the vignette influenced his numerous lithographs (over 3000), most of which were issued by his father-in-law, Charles-Etienne Motte (1785–1836). Devéria was an excellent portrait artist, and his lithographs included portraits of Victor Hugo, Alexandre Dumas (père), Prosper Mérimée, Franz Liszt and numerous other artists and writers whom he entertained in his Paris studio in the Rue de l'Ouest.

Devéria chronicled the taste and manners of the Romantic era in a series of brilliantly coloured lithographs entitled *The Times of the Day* (c. 1829), which depicted the day of an elegant Parisienne in 18 detailed scenes, for example *Five o'Clock in the Morning, Annette Boulanger* (Paris, Carnavalet). Baudelaire believed that the series showed all 'the morals and aesthetics of the age'. In 1831–9 Devéria portrayed his friends wearing elaborate fancy dress in another series of coloured lithographs, *Historical Costumes* (125 plates). Most of his lithographs consisted of pseudo-historical, pious, sentimental or erotic scenes, and these images, disseminated in vast numbers by the new medium of lithography, fed the dreams and fantasies of a generation. Béraldi (1886) felt that such commercial output was devoid of artistic merit, but Farwell (1977) demonstrated how several of Devéria's erotic prints foreshadowed similar paintings by Courbet and Manet by 20 to 30 years, for example a suite of lithographs *Six Female Nudes Studied from Life* (1829).

Devéria was a regular contributor of religious paintings to the Salon. The monumental *Apotheosis of St Clotilda* (1851; Paris, St-Roch) is one of his few surviving works of this type. He also participated in the French 19th-century revival of stained glass. He designed a large number of windows depicting saints for the Sèvres factory and the figures of monarchs for the Henry II staircase in the Louvre, Paris (1840–41). He also designed glass for the church at Sèvres (1839–47) and the chapels of the royal residences at Dreux (1841), Eu (1841–2) and Notre-Dame-d'Auray in Carheil (1847).

Foucart (1987) described Devéria's painting as 'colourful, happy and animated'. The sense of movement is particularly well expressed in the lively gestures of the ascending saint in *Apotheosis of St Clotilda*. A passion for colour is a feature in his work, not only in the lithographs but also in his stained glass for Versailles, the magnificent colour of which accords perfectly with the richness of the architecture. In his choice of subject-matter Devéria was less Romantic than Géricault and Delacroix and rarely depicted grave or tragic themes. Devéria ended his career as curator of the Cabinet des Estampes in the Bibliothèque Nationale, Paris, which has examples of most of his work and an important collection of documents left at his bequest.

(2) Eugène(-François-Marie-Joseph) Devéria

(*b* Paris, 22 April 1805; *d* Pau, 3 Feb 1865). Painter, brother of (1) Achille Devéria. He was a pupil of Anne-Louis Girodet and Guillaume Lethière but was greatly influenced by his brother. Despite differences of taste and temperament—Eugène had an official career and painted on a grand scale—the brothers remained close until Eugène went to Avignon in 1838. He first exhibited at the Salon of 1824 and had his first success with the *Birth of Henry IV* Romantic movement and the successor to Veronese and Rubens.

The success of the *Birth of Henry IV* brought Devéria numerous official commissions. He was asked by the Direction des Musées Royaux to decorate the Salle d'Amasis in the Louvre with the mural *Puget Presenting Louis XIV with his 'Milos of Croton' in the Gardens of Versailles* (1832) and was one of several artists called by Louis-Philippe to decorate the Musée de l'Histoire de France at Versailles. In the *Oath of King Louis-Philippe before the Chamber of Deputies* (1836) he depicted the new alliance between the sovereign and his subjects, and with this history painting joined the tradition of David and Baron François Gérard.

Devéria was one of the few Romantic painters (apart from Delacroix and Théodore Chassériau) to produce religious works, for example his five canvases of the *Life of Christ* (a sixth by Achille) for the church at Fougères, Brittany (1835), and two paintings of the *Life of St Genevieve* for Notre-Dame-de-Lorette, Paris (1835). His most important decorative work was for Notre-Dame-des-Doms, Avignon (1838–40), for which he devised an elaborate programme, though only part was realized. The chapels of the Virgin and St Charlemagne were decorated in encaustic painting and fresco and completed by four large oil paintings depicting scenes from the *Litanies of the Virgin* (1851–6).

Devéria's Romantic style was a synthesis of various elements, combining the influence of

Rubens and Veronese with that of his contemporaries. His work is distinguished by vivid colours, robustly modelled forms (which recall the work of Ingres) and a painstaking attention to detail in the depiction of costume and landscape, characteristic of nascent Orientalism. He was also a skilled portrait painter. His best works are of his family and friends; the intimate charm and engaging character of these works rely on his evident sympathy for his models, for example the portraits of his sister-in-law *Céleste Devéria* (1837; Pau, Mus. B.-A.) and *Eugène and Achille Devéria* (1836; Versailles, Château).

In 1841 Devéria settled in Pau, in the Pyrenees, where he painted village scenes and portraits of local worthies. His conversion to Protestantism in 1843 led to a break with his brother. In his last paintings he remained faithful to the historical vein that had brought him success in 1827. He sent to the Salon the *Death of Jane Seymour* (1847; Valence, Mus. B.-A. & Hist. Nat.), *Cardinal Wolsey and Catherine of Aragon* (1859; Le Havre, Mus. B.-A.) and *Christopher Columbus Being Received by Ferdinand and Isabella*

Bibliography

H. Béraldi: *Les Gravures du XIXe siècle*, v (Paris, 1886)

M. Gauthier: *Achille et Eugène Devéria* (Paris, 1925)

P. Gusman: 'Achille Devéria, illustrateur et lithographe romantique (1800-1857)', *Byblis*, vi (1927), pp. 34–40

J. Lethève and J. Adhémar: *Inventaire du fonds français après 1800*, vi (Paris, 1953)

The Cult of Images: Baudelaire and the Nineteenth-century Media Explosion (exh. cat., ed. B. Farwell; Santa Barbara, U. CA, A. Mus., 1977)

P. Comte: 'La *Naissance d'Henri IV* de Devéria', *Rev. Louvre* (1981), pp. 37–41

R. Rapetti: 'Eugène Devéria et le décor de la chapelle de la Vierge à la cathédrale d'Avignon', *Bull. Soc. Hist. A. Fr.* (1984), pp. 207–27

Achille Devéria: Témoin du romantisme parisien (exh. cat., ed. D. Morel; Paris, Mus. Renan-Scheffer, 1985)

B. Foucart: *Le Renouveau de la peinture religieuse en France (1800–1860)* (Paris, 1987)

The Charged Image: French Lithographic Caricature, 1816–1848 (exh. cat. by B. Farwell, Santa Barbara, CA, Mus. A., 1989)

Autour de Delacroix: La Peinture religieuse en Bretagne au 19ème siècle (exh. cat., essay P. Bonnet, Vannes, Mus. B.-A., 1993)

DOMINIQUE MOREL

Diaz (de la Peña), (Virgilio) Narcisse [Narcisso]

(*b* Bordeaux, 21 Aug 1807; *d* Menton, 18 Nov 1876). French painter. After the death of his Spanish parents he was taken in by a pastor living in Bellevue (nr Paris). In 1825 he started work as an apprentice colourist in Arsène Gillet's porcelain factory, where he became friendly with Gillet's nephew Jules Dupré and made the acquaintance of Auguste Raffet, Louis Cabat and Constant Troyon. At this time he executed his first oil paintings of flowers, still-lifes and landscapes. Around 1827 Diaz is thought to have taken lessons from the Lille artist François Souchon (1787–1857); perhaps more importantly, he copied works by Pierre-Paul Prud'hon and Correggio in the Louvre, Paris, and used their figures and subjects in such later paintings as *Venus and Adonis* and the *Sleeping Nymph* (both Paris, Mus. d'Orsay). He soon became the friend of Honoré Daumier, Théodore Rousseau and Paul Huet. Diaz's pictures exhibited at the Salon from 1831 to 1844 derive from numerous sources, including mythology, as in *Venus Disarming Cupid* (exh. Salon 1837; Paris, Mus. d'Orsay), and literature, as in *Subject Taken from Lewis's 'The Monk'* (exh. Salon 1834; possibly the picture in the Musée Fabre, Montpellier, entitled *Claude Frollo and Esmerelda*). His other themes include a fantastical Orientalism inspired by his admiration for Alexandre-Gabriel Decamps and Eugène Delacroix, as in *Eastern Children* (Cincinnati, OH, Taft Mus.) and such genre scenes as *In a Turkish Garden* (Boston, MA, Mus. F.A.); these are all the more theatrical in that Diaz never travelled in the East. Nevertheless, they display his skill as a colourist and his ability to render light.

From 1835 Diaz regularly stayed in the Forest of Fontainebleau. Although Decamps's influence persisted, Diaz sought greater precision in his composition and executed numerous studies of tree trunks inspired by Théodore Rousseau. In

Ferry Crossing with the Effect of the Setting Sun (exh. Salon 1837; Amiens, Mus. Picardie) he used the sombre tones of Dutch 17th-century landscapes but alleviated them with chiaroscuro and an effect of transparency. According to Silvestre, Diaz presented his first Fontainebleau subject, *View of the Gorges of Apremont* (untraced), at the Salon of 1837. From 1844 the brilliance of Diaz's flecked colours intensified. The lyricism of his unfinished technique can be appreciated in the numerous landscapes that he executed in the Forest of Fontainebleau, such as the *Pack in the Forest of Fontainebleau* (exh. Salon 1848; Copenhagen, Ordrupgaardsaml.) and the *Forest of Fontainebleau* (1859; U. Rochester, NY, Mem. A.G.). His minutely detailed studies, which recall Dutch painting (e.g. *Study of a Silver Birch*; Paris, Mus. d'Orsay), were executed on the spot and then used to compose finished pictures in the studio. Diaz turned increasingly to gypsy subject-matter, as in *The Gypsies* (exh. Salon 1850–51; Paris, Mus. d'Orsay), using the Forest of Fontainebleau and its foliage, bathed in a shimmering light, as a background for picturesque and imaginary scenes.

In an attempt to satisfy the 19th-century vogue for the *fête galante*, Diaz produced numerous genre scenes and pictures featuring fantastical characters and allegorical nudes. Although such works as *The Clown* (Phoenix, AZ, A. Mus.), after Antoine Watteau's *Gilles* (1720–21; Paris, Louvre), represent Diaz's interpretation of 18th-century painting, the quality of his mythological groups (e.g. *Venus with Cupid on her Knee*, 1851; Moscow, Pushkin Mus. F.A.) suffered from his overabundant production. Diaz's poetical style and technique inspired a number of epithets among Salon critics, from Théophile Thoré's 'heaps of precious stones' to Charles Baudelaire's 'nauseating sweeties and sugary stuff' on the subject of the *Lamentations of Jephthah's Daughter* (exh. Salon 1846; St Petersburg, Hermitage). In response to these criticisms, Diaz executed a picture 4 m in height in 1855; the *Last Tears* (priv. col.) is in a drier style, with heavy contours. It symbolizes souls departing from earth and shedding their last tears before attaining eternal bliss. The last pictures that Diaz sent to the Salon, such as *Don't Enter* (exh. Salon

1859; Paris, Mus. d'Orsay), marked a return to the laboured qualities of his earlier work.

Diaz often reused the same compositions, with the centre of the foreground occupied by a clearing, a pond or a path, framed by rows of trees that disappear into the distance and direct the eye from the centre of the picture towards secondary gleams of light, as in the *Pond under the Oaks* (Paris, Mus. d'Orsay). Diaz's late landscapes express a tormented aspect of nature and a realism that, by way of Rousseau, recalls Salomon van Ruysdael. The light came to have a more tragic quality, as in the leaden sky of the *Heights of Le Jean de Paris* (1867; Paris, Mus. d'Orsay), and the composition became more grandiose in the series of landscapes executed towards the end of his life (e.g. the *Threatening Storm*, 1870; Pasadena, CA, Norton Simon Mus.). These works have nothing of the anecdotal about them, with their almost total disregard for the human figure and for civilization, as in *Undergrowth* (1874; Reims, Mus. St-Denis). In 1863 Diaz had met Claude Monet, Auguste Renoir, Alfred Sisley and Frédéric Bazille, who admired his brilliant colours, and his late landscapes may have influenced the Impressionists.

Bibliography

T. Silvestre: *Histoire des artistes vivants français et étrangers* (Paris, 1861), pp. 163–78

J. Claretie: 'Notice biographique', *Exposition des oeuvres de N. Diaz* (exh. cat., Paris, Ecole N. Sup. B.-A., 1877)

——: *Peintres et sculpteurs contemporains*, i (Paris, 1882)

Narcisse Diaz de la Peña, 1807–1876 (exh. cat., Paris, Pav. A., 1968)

P. Miquel: *Le Paysage au XIXe siècle*, ii: *L'Ecole de la nature* (Maurs-la-Jolie, 1975), pp. 282–319

VALÉRIE M. C. BAJOU

Doré, Gustave(-Paul)

(*b* Strasbourg, 6 Jan 1832; *d* Paris, 23 Jan 1883). French illustrator, painter and sculptor. He was born into a cultivated and well-to-do family. By the age of five he was drawing on every piece of paper that came within his reach. He was particularly fond of caricaturing his parents, friends and teachers. In 1838 he was already capable of producing

entire series of illustrations such as *Mr Fox's Meeting* (1839; priv. col.) and *Scenes from the Public and Private Life of Grandville's Animals* (1845; Strasbourg, Mus. B.-A.). By 1843, while studying at the Lycée in Bourg-en-Bresse, he was making brilliant attempts at lithography such as *La Martinoire du Bastion* (1845; Bourg-en-Bresse, Mus. Ain). In 1847 Charles Philippon, founder of *Caricature* and *Charivari*, saw drawings by Doré, who was passing through Paris. He took Doré on, published his *Labours of Hercules* and urged his parents to set him up in the capital. From then on, while still a pupil at the Lycée Charlemagne, Doré found himself contractually bound to produce a drawing a week for Philippon's *Journal pour rire* for the next three years. Largely self-taught and artistically independent by nature, Doré relied primarily on his natural creative flair. His artistic training was slight, although *c.* 1849 he made regular visits to the atelier of Henri Scheffer (1798–1862), the academy of Dupuis and the Louvre and studied engravings in the Bibliothèque Nationale. He also began to take an interest in painting, but the first picture he showed at the 1850 Salon was badly received by the critics.

Freed from his studies and supported by his mother—a very important influence on his life, with whom he shared a house in the Rue St Dominique—Doré embarked on the immense task of illustrating the masterpieces of world literature: e.g. Byron's *Complete Works* (1853), Dumas's *Les Compagnons de Jehu* (1858), Montaigne's *Essais* (1859), Dante's *Divine Comedy* (1861, 1868), Perrault's *Contes* (1862; see col. pl. XV), Cervantes's *Don Quixote* (1863), Chateaubriand's *Atala* (1863), Milton's *Paradise Lost* (1866), *The Holy Bible* (1866), Hugo's *Les Travailleurs de la mer* (1867), La Fontaine's *Fables* (1867), Tennyson's *Idylls of the King* (1867), Coleridge's *The Rime of the Ancient Mariner* (1875), Ariosto's *Orlando furioso* (1879) and Poe's *The Raven* (1883).

Doré depicted the contemporary life of Paris with biting realism in his collections, *La Ménagerie parisienne* (1854) and *Le nouveau Paris* (1860), but probably his greatest achievement was his collaboration from 1868 with the English journalist Blanchard Jerrold on *London: A Pilgrimage* (published 1872). In hundreds of rough sketches he concentrated on recording the details of London social life. The finished drawings worked up from them in the studio emphasized the gulf between rich and poor, and the stark medium of wood-engraving proved particularly suited to capturing the grim life of the latter. Doré's experience of the Paris Commune, while working on the project, only deepened his pessimism, and such images as *Scripture Reader in a Night Refuge* and *Over London by Rail* (see fig. 30), in which huddled figures are dwarfed by surrounding gloom and soulless architecture, have come to symbolize the horrors of 19th-century urban life. Van Gogh was particularly influenced by Doré's vision of London, reworking *Newgate—Exercise Yard* as *In the Prison Courtyard* (Moscow, Pushkin Mus. F.A.).

Thanks to his exceptional capacity for hard work, Doré also led an active career as a painter, with a pronounced taste for very large canvases. He bought the former Amiros gymnasium in the Rue Bayard, Paris, in order to have a studio measuring up to his ambitions. His first series of colossal pictures, *Paris as It Is* (1854; untraced), was in a violently social realist style and was a failure with the public. However, he fared better with the *Battle of Inkerman* (4.8×5 m; exh. Salon, 1857; Versailles, Château), which was purchased by the State. Much greater acclaim came from outside France, with the opening of the Doré Gallery in New Bond Street, London, in 1868; this received about two-and-a-half million visitors before its closure in 1892. The 20 vast religious compositions shown there, such as *Ascension* (6.09×4.11 m; 1879) and the *Vale of Tears* (4.27×6.4 m; 1883; both Paris, Petit Pal.), were often expanded from his black-and-white illustrations: Doré's dramatic exploitation of chiaroscuro effects and generally monochrome palette reflected their graphic origins. In 1892 most of these pictures were sent to the USA to be shown as a travelling exhibition until 1898, when they were dispersed.

Doré was compelled by the human figure but also responsive to nature. He loved to travel, especially in the mountains of the Pyrenees, the Alps and Scotland. He made numerous drawings,

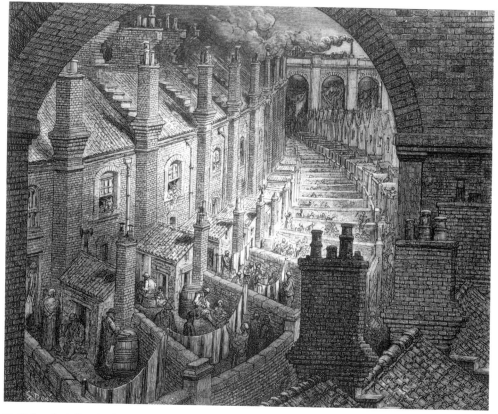

30. Gustave Doré: *Over London by Rail* from *London, A Pilgrimage* (London, 1872)

watercolours and paintings giving his somewhat fantastical vision of the world of peaks and valleys, as for example in *Scottish Lake—After the Storm* (1875; Grenoble, Mus. Grenoble) and *Cirque de Gavarnie* (Lourdes, Mus. Pyrénéen).

At the Salon of 1877 Doré exhibited sculpture for the first time with *Love Triumphing over Death* (terracotta; Providence, RI Sch. Des., Mus. A.). He also showed the equally allegorical *Glory* (plaster, 1878; Maubeuge, Mus. Boez) and *Madonna* (plaster, exh. Salon 1880; bronze version, Albuquerque, U. NM, A. Mus.). His most famous sculpture was the monument to *Alexandre Dumas père* (1883; Paris, Place Malesherbes). But in general his sculpture was hardly better received by the French critics than his paintings. This lack of success affected him deeply, at a time when his

health was also failing from overwork. The death of his mother in 1881 was a severe blow, and two years later he died from a heart attack.

Doré's extraordinary powers of observation were well served by his technical gifts. All his life he seemed to look at everything and note it down with an insatiable appetite. His supreme mastery of drawing and watercolour enabled him to record his impressions of city crowds, characteristic types from different professions, the horrors of war, the strangeness of animals and the splendour of landscape. He was not, however, a Realist and was criticized by Castagnary, Champfleury and others for this. He was, rather, a great visionary, who wanted to live in other worlds (those of fiction, past history, heaven and hell), and someone who agonized over the fate of mankind, visualizing it

through disturbing colour contrasts, claustropho-bic spaces, dense crowds in which the individual is lost, and the sorrow of women and children. Truculence and caricature only represent the superficial aspects of his art, which is essentially a restless meditation on life and death. His work constitutes an incredibly rich and complex world and provides a link between Romanticism and Symbolism.

Bibliography

B. Roosevelt: *Gustave Doré* (London, 1885)

B. Jerrold: *Life of Gustave Doré* (London, 1891)

J. Valmy-Baysse: *Gustave Doré* (Paris, 1930)

H. Leblanc: *Catalogue de l'oeuvre complet de Gustave Doré* (Paris, 1931)

F. Haskell: 'Doré's London', *Archit. Des.*, xxxviii (1968), pp. 600–04; also in *Past and Present in Art and Taste* (New Haven, CT, 1987), pp. 129–40

N. Gosling: *Gustave Doré* (London, 1973)

A. Renonciat: *La Vie et l'oeuvre de Gustave Doré* (Paris, 1983)

GILLES CHAZAL

Dubois[-Pillet], (Louis-Auguste-)Albert

(*b* Paris, 28 Oct 1846; *d* Le Puy, 18 Aug 1890). French painter and army officer. He pursued a military career at the Ecole Impériale Militaire at Saint-Cyr, from which he graduated in 1867. He fought in the Franco-Prussian War (1870–71) and was held prisoner in Westphalia by the Germans; upon release he joined the Versailles army and partici-pated in the suppression of the Commune. Following various assignments in the provinces, in late 1879 he was appointed to the Légion de la Garde Républicaine in Paris.

Dubois was not formally trained in art. However, by the late 1870s he must already have been a fairly accomplished painter, for his still-lifes were accepted at the Salons of 1877 and 1879. After his arrival in Paris in 1880, when he proba-bly began to produce more experimental paint-ings, his works were rejected by the Salons from 1880 to 1883. Among the few extant works of this time is one of his most famous, the *Dead Child* (1881; Le Puy, Mus. Crozatier), shown at the Groupe

des Indépendants in 1884. Its fame derives partly from the fact that it inspired a macabre episode in Zola's novel *L'Oeuvre* (1886), in which the artist Claude Lantier depicts dispassionately the chang-ing hues on the face of his recently deceased infant son.

Dubois played a crucial role in founding and administering the Société des Artistes Indépendants. In 1884 he helped to write the group's statutes, and in subsequent years he seems to have exploited his freemasonic connections to gain favours from the city authorities for group exhibitions. To avoid overt connection between his artistic activities and his military career, he began around 1884 to sign his works with the scarcely disguised pseudonym 'Dubois-Pillet'. (Pillet was his mother's maiden name.) Although in the autumn of 1886 the army forbade him to participate in art exhibitions and belong to the Indépendants, he nonetheless remained a principal organizer of the group until 1888, and until his death continued to participate in their shows annually as well as in other exhibitions occasionally. In 1886 he showed in Nantes; in 1888 and 1889 with Les XX in Brussels. His first one-man show took place in September 1888 at the offices of the Symbolist journal, *Revue indépendante*.

Dubois-Pillet's involvement with the Neo-Impressionist movement stemmed from his acquaintance with Signac and Seurat in 1884. By May 1885 in the *Bread Carrier* (Le Puy, Mus. Crozatier) he was already employing small dashes of colour to create contrasts in a fairly systematic manner. His first fully Neo-Impressionist works, however, date from 1886. Although he continued to paint portraits and still-lifes, he also expanded the range of his subjects to include scenes of urban monuments and river traffic.

Dubois-Pillet experimented restlessly with the theory and practice of Neo-Impressionism. In the autumn of 1886, for example, he and Signac executed pen-and-ink drawings in dots, translat-ing the small-scale colour gradations of Neo-Impressionist painting into a new graphic system of tonal values. Some of these drawings were published in 1887 in the Paris magazine, *Vie*

moderne, including Dubois-Pillet's *Arrivals for a Ball at the Paris Hôtel de Ville* (untraced; see Rewald 1978, p. 453). At the 1888 Indépendants show, where Seurat first displayed his painted frames, Dubois-Pillet exhibited a pointillist frame around his circular painting, *Table Lamp* (New York, priv. col.; see Rewald 1978, p. 110). In this picture he also sought to record the changes in colour perception that occur in artificial light, a problem that occupied Seurat and Charles Angrand as well.

In 1889 and 1890 Dubois-Pillet adapted the Neo-Impressionist technique to accord with what he called *passage*. He wanted to accommodate the early 19th-century ideas of the English scientist Thomas Young (1773–1829) concerning the excitation and fatigue of the retinal nerves by colours. In its simplest form Dubois-Pillet's theory called for a triad of red, green and violet (or derivatives thereof) to appear in proximity and in proportion to one another. His application of *passage* in painting has not been fully analysed; the primary source of information about it remains the 1890 account by Christophe.

Perhaps in response to his repeated defiance of the order prohibiting his artistic activities, the army transferred Dubois-Pillet to Le Puy in November 1889. His last works, including *Saint-Michel d'Aiguilhe in the Snow* (1890; Le Puy, Mus. Crozatier), depict the unusual landscape and churches of the Auvergne. Dubois-Pillet died in a smallpox epidemic in 1890, and the following year the Indépendants brought together 64 paintings for a memorial show. It has sometimes been suggested that a fire subsequently destroyed a number of his works; in any event, his extant oeuvre, as catalogued by Gounot (1969), is relatively small.

Bibliography

F. Fénéon: 'Treize toiles et quatre dessins de M. Albert Dubois-Pillet', *Rev. Indép.*, ix (1888), pp. 134–7; reprinted in J. Halperin, ed.: *Félix Fénéon: Oeuvres plus que complètes* (Geneva, 1970)

J. Antoine: 'Dubois-Pillet', *La Plume*, iii (1890), p. 299

J. Christophe: 'Dubois-Pillet', *Hommes Aujourd'hui*, viii/370 (1890); partly trans. in Rewald (1978), pp. 109–10

J. Rewald: *Post-Impressionism* (New York, 1956, rev. 3/1978)

R. Gounot: 'Le Peintre Dubois-Pillet', *Cah. Haute-Loire* (1969), pp. 99–131 [cat. rais.]

L. Bazalgette: *Albert Dubois-Pillet: Sa Vie et son oeuvre* (Paris, 1976)

MARTHA WARD

Dubois, Paul

(*b* Nogent-sur-Seine, Aube, 18 July 1829; *d* Paris, 23 May 1905). French sculptor, painter and administrator. His wealthy family allowed him to study law, which he abandoned in order to enter the sculpture workshop of Armand Toussaint (1806–62). In becoming a sculptor, he was seeking to follow his great-great uncle Jean-Baptiste Pigalle; when he first exhibited at the Paris Salon (1857), he did so under the name Dubois-Pigalle. In 1858 Paul entered the Ecole des Beaux-Arts in Paris. At his own expense, he undertook a lengthy visit to Italy (1859–62), where he lived like other students, visiting Rome, Naples and, particularly, Florence. His works began to be bought by the French state from the time of his third exhibition at the Paris Salon; among them were *St John the Baptist* (1861) and *Narcissus* (1863–5; plaster models of both, Troyes, Mus. B.-A. & Archéol.) and also the *Florentine Singer* (1865; silvered bronze version, Paris, Mus. d'Orsay), which won the Salon's medal of honour. The Comte de Nieuwerkerke and Princess Mathilde Bonaparte competed for the ownership of the main version of the latter. Dubois's talent is epitomized by these three statues, which portray elegant and refined young men; their feminine equivalents, of a similar neo-Renaissance character, are *Song*, for the façade of the Paris Opéra, designed by Charles Garnier, and the *Birth of Eve* (1873; Paris, Petit. Pal.).

Dubois's delicacy of touch was displayed even in his rare public monuments. The tomb of *General Louis Juchault de Lamoricière* (marble and bronze, unveiled 1879; Nantes Cathedral) recalls the tombs (1499) by Michel Colombe, in the same cathedral, of *Francis II* of Brittany and *Marguerite de Foix*, parents of Anne of Brittany (1477–1514). The bronze *Virtues* stationed on the

tomb also reveal the influence of Michelangelo's tomb sculptures in S Lorenzo, Florence. Two of the *Virtues* were exhibited at the 1876 Salon and earned Dubois his second medal of honour. Several of his equestrian statues remained in rough-hewn versions (wax models, Troyes, Mus. B.-A. & Archéol.), though two were completed: the *Connétable Anne de Montmorency* (bronze, 1886; Chantilly, Château) and *Joan of Arc* (model, exh. Salon 1889; bronze version erected 1896; Reims, Parvis de la Cathédrale). Dubois's funerary statue of *Henri d'Orléans, Duc d'Aumale* continued the series of recumbent figures in the royal chapel at Dreux. Towards the end of his life, Dubois attempted a large composition, the monument to *French Genius*, of which the only completed fragment is *Alsace-Lorraine* or *Memory*.

Dubois was also a painter, and his portraits, whether sculpted or painted, were much in demand. His numerous busts of children are mostly in private collections and known only from their Salon listings and old photographs; however, his busts of the famous, including that of the painter *Paul Baudry* (bronze, 1878; Paris, Ecole N. Sup. B.-A.), the composer *Georges Bizet* (bronze, 1886; Paris, Père Lachaise Cemetery) and the scientist *Louis Pasteur* (bronze, 1890; Paris, Inst. France), are often found in public collections. Dubois derived a substantial income from reduced-scale editions of his works: in bronze by the firm of Barbedienne and in biscuit by the porcelain factory of Sèvres. Among his painted portraits are those of *Mme Casimir Perier* (Vizille, Château) and the *Argenti Family* (Chios, Adamantios Korais Lib.).

From 1873 Dubois was curator of the Musée de Luxembourg, and in the same year he succeeded Eugène Guillaume as director of the Ecole des Beaux-Arts. Because of his administrative duties, he produced little full-scale, finished work. However, his detailed working methods can be studied from the contents of his studio, which were generously bequeathed to French museums by his heirs. From this, it can be seen that he studied each subject minutely, making numerous drawings and wax models, which he dressed in paper or cloth.

Bibliography

F. du Castel: *Paul Dubois: Peintre et sculpteur, 1829–1905* (Paris, 1964)

J.-M. Delahaye: *Paul Dubois, 1829–1905* (diss., Paris, Ecole du Louvre, 1973)

The Romantics to Rodin: French Nineteenth-century Sculpture from North American Collections (exh. cat., ed. P. Fusco and H. W. Janson; Los Angeles, CA, Co. Mus. A.; Minneapolis, MN, Inst. A.; Detroit, MI, Inst. A.; Indianapolis, IN, Mus. A.; 1980–81), pp. 242–6

G. Bresc-Bautier and A. Pingeot: *Sculptures des Jardins du Louvre, du Carrousel et des Tuileries*, ii (Paris, 1986), pp. 172–5

La Sculpture française au XIXème siècle (exh. cat., ed. A. Pingeot; Paris, Grand Pal., 1986), pp. 60–69

Sculptures en cire de l'ancienne Egypte à l'art abstrait, Notes & Doc. Mus. France, xviii (Paris, 1987), pp. 237–51

A. Le Normand-Romain: 'Le Monument du *Général de Lamoricière* à Nantes', *Rev. Pays Loire*, 303 (1988), pp. 76–88

ANNE PINGEOT

Dubufe, (Louis-)Edouard

(*b* Paris, 31 March 1820; *d* Versailles, 11 Aug 1883). French painter, son of Claude-Marie Dubufe. He was trained by his father and then by Paul Delaroche. He first appeared at the Salon in 1839 with the *Annunciation*, a *Huntress* and a portrait, winning a third class medal. He followed this in 1840 with an episode in the life of St Elisabeth of Hungary, which won him a second class medal; in 1844 he won a first class medal with *Bathsheba* and a genre scene set in the 15th century (all untraced).

By the mid-1840s Dubufe seemed firmly established in the sentimental Romanticism associated with Cibot and Ary Scheffer. Baudelaire noted in 1845 that he appeared to have chosen a different path from his father's lucrative profession; in fact, he closely followed the pattern of his father's career, from a relatively unprofitable beginning in history painting into the rich world of fashionable portraits, inheriting the aristocratic sitters relinquished by his father in the early 1850s. Edouard's portraits before 1850 (e.g. *Unknown Woman*;

Autun, Mus. Rolin) have a sharp, bright quality that recalls Delaroche. His later work is softer and more idealized. As with his father, it is difficult to assess Dubufe's range as a portrait painter, but there is an interesting group of works in Versailles (Château), including a memorable portrait of *Rosa Bonheur* with one arm round a bull's head, exhibited in 1857, and a darker, more intense portrait of *Harpignies* sketching *en plein air*, exhibited in 1877; these are striking images of fellow artists but perhaps not as typical as the glittering, featureless portraits of the *Empress Eugénie* in Versailles and Compiègne. As a portrait painter, he shared fashionable Paris in the Second Empire with F. X. Winterhalter.

In 1866 Dubufe attempted to break new ground by exhibiting an immense composition, 12 m long, on the theme of *The Prodigal Son*, which did not please the critics. It was bought by A. T. Stewart, the American delegate at the Exposition Universelle of 1867, who sent it to an exhibition tour of America. It was shown for the last time at the Columbian Exposition in Chicago in 1893 and then disappeared.

In 1842 Dubufe married Juliette Zimmermann, daughter of the pianist, Pierre Zimmermann. She was a sculptor specializing in portrait busts, and she exhibited at the Salon between 1842 and 1853. Their son, (Edouard Marie) Guillaume Dubufe (1853–1909), broke with family tradition by becoming a successful decorative painter, inspired by the contemporary fashion for the art of the Rococo. His work can be seen in Paris at the Hôtel de Ville, the Sorbonne, the Palais de l'Elysée and the Comédie–Française.

Bibliography

Thieme–Becker

JON WHITELEY

Duez, Ernest-Ange

(*b* Paris, 8 March 1843; *d* Forest of Saint-Germain, 5 April 1896). French painter. He studied under Isidore-Alexandre-Augustin Pils and made his début at the Salon in 1868. One of his earliest paintings, *The Honeymoon* (1873), caused a scandal at the Salon owing to its depiction of two lovers in modern dress walking through a sunlit forest. His triptych *St Cuthbert* (1879; Paris, Pompidou) was hailed as a masterpiece of modern art and bought by the State for the Musée du Luxembourg in Paris. The painting depicts the stages of St Cuthbert's life, from child to hermit. Contemporary viewers were struck by the artist's use of a real landscape setting, based on Villerville in Normandy where Duez spent much of his time. In addition to genre, religious and history paintings, in 1876 he began to produce portraits: *Alphonse de Neuville* (1880; Versailles, Château) is a typical example. His brooding, suggestive portrait of *Mme Duez* (1877; see Montrosier, 1896, p. 429) shows the influence of Symbolism. However, he soon returned to painting works that were essentially landscapes, such as the decorative panel *Virgil Seeking Inspiration in the Woods* (1888) for the Sorbonne and a pair of allegorical figures, *Botany* and *Physics* (1892), for the Hôtel de Ville in Paris. He also devoted time to applied art, producing a variety of textile designs. His work was praised for its adept use of colour and for bringing what were seen as modern techniques to traditional subjects.

Bibliography

E. Montrosier: *Les Artistes modernes*, iii (Paris, 1882), pp. 60–64

——: 'Ernest Duez', *Gaz. B.-A.*, 3rd ser., v (1896), pp. 422–31

☐

Dulac, Charles-Marie [Marie-Charles]

(*b* Paris, 1865; *d* Paris, 29 Dec 1898). French painter and lithographer. Born into a poor family, he was trained at the Ecole Nationale des Arts Décoratifs and worked as a designer of wallpapers and theatrical sets. In 1887 he studied painting in the studios of Ferdinand Humbert (1842–1934), Henri Gervex, Adrien Karbowsky (*b* 1855) and Alfred Roll, and he made his Salon début in 1889. In the early 1890s he painted around Paris and in northern France. Around 1892 Dulac experienced a spiritual conversion and joined a religious society, the Third Order of St Francis. He changed his name to

read Marie-Charles Dulac, and from 1892 he con-centrated on colour lithography, choosing pure landscape without figures as the medium for expressing his ardent faith.

From sketches made on his travels through France, Belgium and Italy, Dulac created several lithograph series. In *Series of Landscapes* (1892), simplified forms and dramatic tonal qualities convey mood; transient effects and descriptive details are avoided in the artist's search to convey the essence of divine creation. In 1894 Dulac created a series of nine lithographs, the *Canticle of Creatures*, a visual analogue of the *Canticle of Brother Sun* of St Francis of Assisi. With each plate, Dulac juxtaposed a verse by St Francis and a liturgical text. Dulac's final series, *The Creed*, left incomplete at the artist's death, con-sists of paradisaical visions inspired by the Catholic mass. Mystical gardens and cosmological visions symbolize an ideal universe and eternal peace. Dulac's sacred landscapes were acclaimed by such writers as Joris-Karl Huysmans and Maurice Denis, who recognized that for 'Dulac, Nature is a book which contains the word of God' (1905). A victim of lead poisoning, Dulac died at 33.

Bibliography

A. Marguillier: 'Charles Dulac', *Gaz. B.-A.*, n.s. 3, xxi (1899), pp. 325–32

M. Denis: 'Propos, sur les lettres et paysages de Marie-Charles Dulac', *L'Occident* (Dec 1905), p. 305

T. Greenspan: *'Les Nostalgiques' Re-examined: The Idyllic Landscape in France, 1890–1905* (diss., New York City U., 1981), pp. 359–93

—: 'Charles Marie Dulac: The Idyllic and Mystical Landscape of Symbolism', *Gaz. B.-A.*, n.s. 6, xcix (1982), pp. 163–6

—: 'The Sacred Landscape of Symbolism: Charles Dulac's *La Terre* and the *Cantique des créatures*', *Register* [Lawrence, KS], v/10 (1982), pp. 63–79

TAUBE G. GREENSPAN

Dumont, Augustin-Alexandre

(*b* Paris, 4 Aug 1801; *d* Paris, 27–28 Jan 1884). Son of (3) Jacques-Edme Dumont. He entered the Ecole des Beaux-Arts, Paris, in 1818, won the Prix de Rome for sculpture in 1823 and spent the next seven years in Italy, producing works such as the *Infant Bacchus Nurtured by the Nymph Leucothea* (1830; Semur-en-Auxois, Mus. Mun.). He returned to France shortly after the July Revolution of 1830; a succession of public commissions followed, including one for the statue of *Nicolas Poussin* for the Salle Ordinaire des Séances in the Palais de l'Institut de France, Paris (1835; *in situ*). The gov-ernment of the Second Republic commissioned from him a statue of *Maréchal Thomas Bugeaud de la Piconnerie* (*c*. 1850; version, Versailles, Château). As well as the various large public sculp-tures of historical figures that he produced for provincial centres under the Second Empire, he executed a number of portrait sculptures, such as that of the naturalist *Alexander von Humboldt* (1871; Versailles, Château). Many of the public monuments that Dumont designed were destroyed under the Commune (1871); he was pre-vented by illness from producing any work after 1875.

Bibliography

DBE

G. Vattier: *A. Dumont: Notes sur sa famille, sa vie et ses ouvrages* (Paris, 1885)

La Sculpture française au XIXe siècle (exh. cat. by A. Pingeot, Paris, Grand Pal., 1986)

Dupré, Georges

(*b* Saint-Etienne, Loire, 24 Oct 1869; *d* Paris, June 1909). French medallist. Like his forebear Augustin Dupré, he began life as a chaser before moving to Paris, where he entered the Ecole des Beaux-Arts, winning the Prix de Rome in 1896. In poetic pla-quettes such as *Greetings to the Sun* (1897), *Meditation* (1897) and *Angelus* (1903) he attempted a new fusion between word and image that ensured him wide popular appeal.

Bibliography

F. Mazerolle: 'Georges Dupré', *Gaz. Numi. Fr.* (1902), pp. 225–33

MARK JONES

Dupré, Jules

(b Nantes, 5 April 1811; d L'Isle-Adam, Val-d'Oise, 6 Oct 1889). French painter. He began his career in Creil, Ile de France, as a decorator of porcelain in the factory of his father, François Dupré (b 1781), and later worked at the factory founded by his father in Saint-Yrieix-la-Perche, Limousin. It was in this region of central France that Dupré became enchanted by the beauty of nature. He went to Paris to study under the landscape painter Jean-Michel Diébolt (b 1779), who had been a pupil of Jean-Louis Demarne. Dupré began to see nature with a new awareness of its moods, preferring to paint alone and en plein air. He was fascinated by bad weather, changes of light and sunsets. Many of his paintings depict quiet woodland glades, often with a pond or stream (e.g. *Plateau of Bellecroix*, 1830; Cincinnati, OH, A. Mus.). In 1830–31 he associated with other young landscape painters, including Louis Cabat, Constant Troyon and Théodore Rousseau, and with them sought inspiration for his study of nature in the provinces, exhibiting the finished paintings at the annual Salons. In 1832 he visited the region of Berry with Cabat and Troyon, and in 1834 he was among the first French landscape painters to visit England. He spent time in London, Plymouth and Southampton and painted several views of these cities (e.g. *Environs of Southampton*, exh. Salon 1835; priv. col., see Aubrun, no. 69). While in England he met, and was influenced by, Constable, Turner and Richard Parkes Bonington. He travelled to the Landes and the Pyrenees with Rousseau in 1844, and they also explored the forests of the Ile de France in search of motifs. Dupré also painted in Normandy, Picardy and Sologne. Although he was a member of the Barbizon school, he did not visit the Forest of Fontainebleau as frequently as did others of the group, preferring instead to settle in 1849 in the village of L'Isle-Adam, north of Paris, where he remained for much of his life.

Dupré's approach to nature falls somewhere between realism and Romanticism. For him nature was majestic, and he was fascinated by the alliance of the ephemeral and the eternal. He searched for the mystery of creation by examining the permanence of a natural world dominated by trees, which he saw as a significant element linking heaven and earth. This mystical vision was in part influenced by the paintings of such 17th-century Dutch masters as Meindert Hobbema and Jacob van Ruisdael. One of his most representative works is *The Floodgate* (c. 1855–60; Paris, Mus. d'Orsay), with its tormented conception expressed in shifting chiaroscuro and thick, powerful handling of paint, which shape the natural world of light, trees and plants supporting human beings and animals. Despite his independent temperament, his career was successful, and his work was received with enthusiasm during his lifetime. He was made Chevalier de la Légion d'honneur in 1849 and was awarded several medals at the Salons and at the Exposition Universelle in 1867 in Paris, where he showed 13 paintings. In later years he spent summers at Cayeux-sur-Mer and executed paintings inspired by its coastline (e.g. *The Headland*, c. 1875; Glasgow, A.G. & Mus.). In these works his feeling for the tragic character of nature is heightened as much by his technique as by his lyrical conception. He also painted watercolours (e.g. the *Duck Pond*, c. 1833; Paris, Louvre). He was admired by the Impressionist painters and by their dealer Paul Durand-Ruel for his perception of atmosphere and the rendering of reflections of light, although his popularity declined somewhat in the first half of the 20th century.

Bibliography

Bellier de La Chavignerie–Auvray

L. Delteil: *J. F. Millet, Th. Rousseau, Jules Dupré, J. Barthold Jongkind*, i of *Le Peintre-graveur illustré (XIXe et XXe siècles)* (Paris, 1906–30/R New York, 1969)

M. M. Aubrun: *Jules Dupré, 1811–1889: Catalogue raisonné de l'oeuvre peint, dessiné et gravé*, 2 vols (Paris, 1974–82)

M. Laclotte and J.-P. Cuzin, eds: *Petit Larousse de la peinture*, 2 vols (Paris, 1979)

ANNIE SCOTTEZ-DE WAMBRECHIES

Duret, François-Joseph [Francisque]

(b Paris, 19 Oct 1804; d Paris, 26 May 1865). French sculptor. Son of a sculptor of the same name (1729–1816) and a pupil of F.-J. Bosio, he entered

the Ecole des Beaux-Arts in 1818 and won the Prix de Rome in 1823. Among his works executed at the Académie de France in Rome is *Orestes Mad* (marble, *c.* 1825; Avignon, Mus. Calvet), a colossal head modelled after the Antique that is at the same time a self-portrait, and *Mercury Inventing the Lyre* (marble; destr.), an elegant statue much praised at the 1831 Salon. Journeys from Rome to Naples resulted in *Neapolitan Fisherboy Dancing the Tarantella* (bronze, exh. Salon 1833; Paris, Louvre), which was executed on his return to Paris and was one of the earliest Neapolitan genre subjects in French 19th-century art. In this work Duret reconciled classical form with modern subject-matter and the freedom of modelling allowed by working in bronze. Its popularity led to reduced-scale bronze editions by the founder P.-M. Delafontaine, who also reproduced in this fashion Duret's *Grape-picker Extemporizing* (bronze, 1839; Paris, Louvre).

Duret's interest in genre subjects and the melancholy Romanticism shown in such works as *Chactas Meditating at Atala's Tomb* (bronze, 1836; Lyon, Mus. B.-A.) were abandoned after 1840, as he increasingly devoted himself to working in marble on monumental commissions from the State. He was less at ease working with marble than with his favoured lost-wax method of bronze casting but sought to animate his statues by careful attention to expression and costume, anxiously aspiring after a classical grand manner. He ranged from commemorative statues, such as *Casimir Perier* (1833; Paris, Pal.-Bourbon), *Molière* (1834; Paris, Inst. France) and *Chateaubriand* (1854; Paris, Inst. France), to religious and symbolic works, characterized by ample drapery. This underlines the stances in the low reliefs of the *Stations of the Cross* (1851–2; Paris, Ste Clothilde) and adds to the severity of *Christ Revealing Himself to the World* (marble, 1840; Paris, La Madeleine). Duret's many other commissions include the statues of *Comedy* and *Tragedy* (marble, 1857) at the Théâtre-Français in Paris and the allegorical stone relief *France Protecting her Children* (stone, 1857; Paris, Louvre, Pavillon Richelieu), a rigorously Neo-classical work whose sole concession to modernity is the inclusion of a steam engine. In his Raphaelesque statue

of the *Archangel Michael* (1860) for the Fontaine Saint-Michel, Paris, Duret returned to the use of bronze. He was appointed a professor at the Ecole des Beaux-Arts in 1852. Among his pupils were J.-B. Carpeaux, Henri Chapu and Jules Dalou.

Bibliography

Lami

C. Blanc: 'Francisque Duret', *Gaz. B.-A.*, xx (1866), pp. 97–118

The Romantics to Rodin: French Nineteenth-century Sculpture from North American Collections (exh. cat., ed. P. Fusco and H. W. Janson; Los Angeles, CA, Co. Mus. A., 1980–81), pp. 247–8

A. Le Normand: *La Tradition classique et l'esprit romantique: Les Sculpteurs à l'Académie de France à Rome de 1824 à 1840* (Rome, 1981)

La Sculpture française au XIXème siècle (exh. cat., ed. A. Pingeot; Paris, Grand Pal., 1986)

ANTOINETTE LE NORMAND-ROMAIN

Epinay, Prosper, Comte d'

(*b* Port Louis, Mauritius, 13 July 1836; *d* Paris, 23 Sept 1914). French sculptor. He was born a British subject and was the son of a prominent advocate in Mauritius. From 1857 to 1860 he studied caricature with the sculptor Jean-Pierre Dantan in Paris, and in 1861 he worked in the Rome studio of Luigi Amici (1813–97). He was active in Rome and London between 1864 and 1874 but from the mid-1870s increasingly turned his attention from London to Paris. He maintained a studio in Mauritius, producing statues of his father and of the late governor, *Sir William Stevenson* (bronze, 1865; Port Louis, Jardins de la Compagnie). In England his bust of *Edward, Prince of Wales* (bronze, 1912; Port Louis, Champ de Mars), executed from memory, was purchased by Queen Victoria, and from then until 1881 he exhibited at the Royal Academy, London. With the exhibition of the coquettish nude the *Golden Girdle* (exh. Salon 1874; marble version, St Petersburg, Hermitage), reminiscent of the 18th century and the Fontainebleau school, Epinay won the attention of the Paris public. He shared with his equally well-connected contemporary, the sculptress

Marcello, a tendency to period pastiche, especially in his female portrait busts, which imitate the emphatic verticality and elaborate coiffures of Jean-Antoine Houdon and Augustin Pajou. A concession to Realism is found in the stress on ethnicity in some of his biblical and literary subjects, such as the *Young Hannibal Strangling the Eagle* (exh. RA 1869; bronze version, Duke of Westminster priv. col.).

Bibliography

P. Roux: *Prosper d'Epinay: Sa vie, son oeuvre* (MA thesis, U. Paris IV, 1981)

PHILIP WARD-JACKSON

Etex, Antoine

(*b* Paris, 20 March 1808; *d* Chaville, Seine-et-Oise, 14 July 1888). French sculptor, painter, etcher, architect and writer. The son of a decorative sculptor, he entered the Ecole des Beaux-Arts, Paris, in 1824 as a pupil of Charles Dupaty (1771–1825), moving in 1825 to the studio of James Pradier. Ingres also took an interest in his education, and Etex's gratitude towards him and Pradier was later expressed in projects for monuments to them (that to Pradier not executed, that in bronze to Ingres erected Montauban, Promenade des Carmes, 1868–71).

Etex failed three times to win the Prix de Rome, but in the aftermath of the Revolution of 1830 his Republican sympathies gained him a government scholarship that enabled him to spend two years in Rome. There he sculpted the intensely tragic group *Cain and his Children Cursed by God*, the plaster version of which (Paris, Hôp. Salpêtrière) was one of the great successes of the 1833 Paris Salon. During this period Etex asserted the Republican views that were to earn him the distrust of many of his fellow artists and of the establishment but also gain him the support of the influential critic and politician Adolphe Thiers. He behaved in Romantic fashion as a misunderstood artist, but nevertheless displayed a remarkable tenacity in forwarding his pet projects, including, for instance, schemes for sculptures representing *Napoleon Scaling the World* and the

Genius of the 19th Century (drawings, Paris, Carnavalet), both intended for the Place de l'Europe, Paris, on which he worked from 1839 until 1878.

On his return to Paris in 1832, Etex received regular state commissions for nearly 30 years beginning with a prestigious contract for two stone high-reliefs for the Arc de Triomphe de l'Etoile: the *Resistance of 1814* and the *Peace of 1815* (1833–6), which although composed in a classical pyramidal shape are full of Romantic expressive force. He subsequently executed monumental marble statues for the Galeries Historiques at the château of Versailles (1837) and in Paris at the church of La Madeleine (1838), the Luxembourg Palace (1847) and the church of the Invalides (1852). Among his other state commissions were the bas-reliefs for the statue of *Henry IV* in the Place Royale, Pau (bronze, 1848), the statue of *General Lecourbe* in the Place de la Liberté, Lons-le-Saunier (Jura) (bronze, 1852–7), and the equestrian monument to *Francis I* in the Place François 1er, Cognac (bronze, 1864).

Etex also produced a number of important allegorical works, including the statue originally called *Poland in Chains* but renamed *Olympia* when it was purchased by Louis-Philippe's government (marble, 1848; Versailles, Château), the group of the *City of Paris Praying for the Victims of the Cholera Epidemic of 1832* (marble, 1848–52; Paris, Hôp. Salpêtrière) and the group *Maternal Sorrow* (marble, 1859; Poitiers, Parc de Blossac). All these works display Etex's characteristic combination of Neo-classical form, derived from Pradier, with Romantic intensity of emotion, qualities also apparent in the most striking of his tombs, that of the *Raspail Family* (marble, 1854; Paris, Père-Lachaise Cemetery). Tirelessly active, he also produced a large number of portrait busts and medallions of his contemporaries, including, most notably, a colossal bust of *Pius IX* (marble, 1862; Rome, Vatican Pal.), as well as painting such pictures as the *Death of the Proletarian* (1854; Lyon, Mus. B.-A.), etching a suite of 40 plates called *La Grèce tragique* and producing designs for the reconstruction of the Paris Opéra (exh.

Salon 1861). He also transposed a number of paintings as bronze reliefs. These included a version (untraced) of his own *The Medici* (1831; Montauban, Mus. Ingres), versions of Géricault's major works for his tomb in Père-Lachaise cemetery, Paris (bronze; *in situ*), and of Ingres's *Apotheosis of Homer* (Paris, Louvre) for his monument in Montauban.

Of his numerous writings on art, which included a review of the Exposition Universelle of 1855 and lives of Paul Delaroche, Pierre-Jean David d'Angers, Pradier, Ary Scheffer and others, his most ambitious work was the *Cours élémentaire de dessin*, in which he stressed the harmony that should exist between painting, sculpture and architecture.

Writings

Revue synthétique de l'Exposition Universelle de 1855 (Paris, n.d.)

Cours élémentaire de dessin, appliqué à l'architecture, à la sculpture, à la peinture, ainsi que tous les arts industriels (Paris, 1859)

Souvenirs d'un artiste (Paris, 1877)

Bibliography

Lami

P. E. Mangeant: *Antoine Etex* (Paris, 1894)

The Romantics to Rodin: French Nineteenth-century Sculpture from North American Collections (exh. cat., ed. P. Fusco and H. W. Janson; Los Angeles, CA, Co. Mus. A., 1980–81), pp. 250–54

A. Le Normand-Romain: 'Le Séjour d'Etex à Rome en 1821–1832: Un Carnet de dessins inédits', *Bull. Soc. Hist. A. Fr.* (1981, pub. 1983), pp. 175–88

La Sculpture française au XIXème siècle (exh. cat., ed. A. Pingeot; Paris, Grand Pal., 1986)

B. Chenique: 'Une Oeuvre inspirée par André Chénier: Le Damalis d'Etex au Musée de Lille', *Rev. Louvre*, xl/1 (1990), pp. 26–36

ANTOINETTE LE NORMAND-ROMAIN

Falguière, Alexandre

(*b* Toulouse, 7 Sept 1831; *d* Paris, 19 April 1900). French sculptor and painter. His father, a cabinetmaker, sent him in 1844 to the Ecole des Beaux-Arts in Toulouse, where he won the city's major prize and was awarded a grant to study at the Ecole des Beaux-Arts in Paris. There he was François Jouffroy's pupil but considered himself a follower of François Rude. In order to have enough to live on while studying, he also worked for Albert-Ernst Carrier-Belleuse and Jean-Louis Chenillion (1810–78). In 1859 he was joint winner with Léon Cugnot (1835–94) of the Prix de Rome, for the bas-relief of the *Wounded Mezentius aided by his Son Lausus* (plaster, Paris, Ecole N. Sup. B.-A.). While studying at the Académie de France in Rome, he came under the influence of his fellow student Jean-Baptiste Carpeaux. He remained in Italy until 1865.

The spontaneity of Falguière's approach to composition, and his handling of materials, were in tune with the official taste of the period; in spite of protests from the Académie Impériale about an excess of 'realism' in his works, the sculptures he sent to Paris were readily purchased by the State. They included the *Winner of the Cockfight* (bronze, exh. Salon 1864; Paris, Mus. d'Orsay); *Nuccia the Trasteverine Girl* (bronze, 1864; untraced); and *Omphale* (marble, exh. Salon 1866; Paris, Min. Indust., garden). This last work initiated the magnificent series of female figures with mythological names but modern bodies, such as *Eve* (marble, 1880; Copenhagen, Ny Carlsberg Glyp.), *Diana* (1887) and *Hunting Nymph* (1888; both marble, Toulouse, Mus. Augustins). At the same time he continued the Salon tradition of slender youths in his recumbent figure of the Christian martyr *Tarcisius*; its plaster version was awarded a medal at the 1867 Salon, and the marble version (Paris, Mus. d'Orsay) was awarded the medal of honour at the 1868 Salon.

Falguière worked fast; thus in December 1870 he modelled in snow a statue of *Resistance* on the ramparts of Paris while the city was being besieged by the Prussians (bronze cast of later sketch model, Los Angeles, CA, Co. Mus. A.). He subsequently received the Légion d'honneur and other official honours, being appointed a professor at the Ecole des Beaux-Arts in 1882 and being elected that same year to the Académie des Beaux-Arts. He always completed his commissions punctually and exhibited regularly from 1857 to 1899. He was

immensely popular and prolific (with the help of five workshops), and his work was to be seen everywhere, in public and private sites.

Among Falguière's many sculptures for public buildings, to which his spirited, neo-Baroque style was well suited, were the statue *Drama* (stone, 1869; Paris, Opéra); the group the *Seine and its Tributaries* (plaster, 1878; Paris, Pal. Trocadero, destr.); the great quadriga group the *Triumph of the Revolution* (plaster, 1882; Paris, Arc de Triomphe de l'Etoile, destr. 1886; wax maquette, Paris, Mus. d'Orsay); the statue *Heroic Poetry* (marble, 1893; Toulouse, Capitole); and the huge and ambitious *Monument to the French Revolution* (plaster, 1890–1900; Paris, Panthéon, destr.). He produced other allegorical monuments, not linked with buildings, as well as providing many of the monuments to great Frenchmen past and present set up by the Third Republic as part of its programme of public education. These included the monuments to *Alphonse de Lamartine* (bronze, 1877; Macon, Promenade du Sud); *Pierre Corneille* (marble, 1878; Paris, Comédie-Française); and *Ambroise Thomas* (marble, 1900; Paris, Parc Monceau). What might have been among his most attractive works in this vein, the monument to *Claude Lorrain*, intended for Nancy, never got beyond the stage of a sketch model (plaster, 1886–9; Nancy, Mus. B.-A.). Falguière also executed a certain amount of religious sculpture, but this is on the whole less successful than his secular monuments or even his monuments to churchmen, for example that to *Dom Calmet* at Senones (stone, red granite and black marble, 1873; Senones, St Pierre–St Gaudelbert).

Falguière was a productive and accomplished portraitist. Among his numerous busts was that of the painter *Carolus-Duran* (bronze, 1876; untraced) and of the actress *Marie Heilbron* (bronze, 1851–86; Paris, Montparnasse cemetery, funerary chapel of Marie Heilbron). He also produced a number of paintings, and, though this was a secondary activity, he enjoyed considerable contemporary success with them. Some, such as *Cain and Abel* (1876; Carcassonne, Mus. B.-A.), reflected sculptural themes being explored at the same time. Others, such as *Begging Dwarfs*,

Souvenir of Granada (1888; untraced), were independent productions and underline his predilection for 17th-century Spanish painting.

Falguière was one of the most successful and productive sculptors of the late 19th century in France, his salon exhibits being widely reproduced in bronze by the founders Thiebaut Frères, Fumière & Gavignot; in 1898 he had his one-man exhibition at the Nouveau Cirque, Paris. His robust style combined elements of fleshy realism with neo-Baroque verve of composition, and he found many imitators, particularly among those of his pupils who came from south-western France and were known as 'les Toulousains'; they included Paul Gasq, Laurent Marqueste (1848–1920), Antonin Mercié, Denys Puech and Felix Soulés.

Bibliography

Lami
G. Barbezieux: 'L'Art au Panthéon', *La Paix* (20 Aug 1897)
La Plume (1 June 1898) [issue pubd. at the time of Falguière's exh.]
A. Pingeot: 'Le Fonds d'atelier Falguière au Musée du Louvre', *Bull. Soc. Hist. A. Fr.* (1978), pp. 263–90
The Romantics to Rodin: French Nineteenth-century Sculpture from North American Collections (exh. cat., ed. P. Fusco and H. W. Janson; Los Angeles, CA, Co. Mus. A.; Minneapolis, MN, Inst. A.; Detroit, MI, Inst. A.; Indianapolis, IN, Mus. A.; 1980–81)
M. Scuitti: *L'Oeuvre sculptée de Falguière à Toulouse* (diss., U. Toulouse II, 1985)
Les 'Toulousains': Plâtres originaux et sculptures du XIXe siècle (exh. cat., ed. D. Milhau; Toulouse, Mus. Augustins, 1992), pp. 22–30

ANNE PINGEOT

Fantin-Latour

French artists. (1) Henri Fantin-Latour painted in a wide variety of genres, from portraits and still-lifes to allegorical and mythological works. He also produced lithographs. His wife, (2) Victoria Fantin-Latour, painted some portraits but is best known for her still-lifes.

(1) (Ignace-)Henri(-Théodore) Fantin-Latour

(*b* Grenoble, 14 Jan 1836; *d* Buré, Orne, 25 Aug 1904). Painter and printmaker. He studied with his

father, Jean-Théodore Fantin-Latour (1805–75), from 1846 and then with Horace Lecocq de Boisbaudran at the Petite Ecole de Dessin in Paris from 1850 to 1856. His apprenticeship was based on copying the Old Masters before beginning to study from nature. He had a growing enthusiasm for the Italian painters, particularly Titian and Veronese, whom he copied in the Louvre, Paris, from 1852. *The Dream* (1854; Grenoble, Mus. Grenoble) is one of the first of a series of imaginary scenes in which Fantin-Latour concentrated on the theme of vision, which he later continued in his representations of scenes from various operas. He met François Bonvin and Félix Bracquemond in 1853 and went to the Ecole des Beaux-Arts in 1854, but he left before the end of the year. He began to paint the life around him and did a series of self-portraits from 1854 to 1861, such as *Self-portrait Seated at the Easel* (1858; Berlin, Alte N.G.) and *Self-portrait* (1859; Grenoble, Mus. Grenoble). These two directions—Realism and fantasy—were already clearly defined when he met Gustave Courbet in 1859. For several months in 1861 he was a pupil at Courbet's studio, but from the start he tempered the brutal Realism of his master with a discreet intimacy in such works as the *Two Sisters* (1859; St Louis, MO, A. Mus.), *Woman Reading* (1861; Paris, Mus. d'Orsay) and *Reading* (1863; Tournai, Mus. B.-A.). By rejecting the anecdotal aspect of genre, Fantin-Latour heightened the tension inherent in a contrast between the physical proximity of the models and their psychological distance, creating a sense of solitude.

Through James McNeill Whistler, whom he met in 1858, Fantin-Latour made a succession of trips to England (1859, 1861, 1864, 1881). He met Whistler's brother-in-law, Seymour Haden, who taught him to etch; he exhibited at the Royal Academy, London, in 1862; and he sold his first still-lifes through the collectors Ruth Edwards (c. 1833–1907) and Edwin Edwards (1823–79), whom he portrayed on several occasions (e.g. 1875; Washington, DC, N.G.A.). Fantin-Latour's commissioned portraits, such as *Mlle Marguerite de Biron* (1868; Paris, priv. col., see 1982–3 exh. cat., p. 112), also date from this period.

Fantin-Latour's aesthetic is not easily defined: his friendship with Edouard Manet, whom he met in 1857, and the future Impressionists led him to exhibit in the Salon des Refusés in 1863; but he refused to exhibit with them at Nadar's studio in 1874. Although he was rejected at the Salon of 1859, he appeared there regularly from 1861 to 1899, and his works were generally well received by the critics.

Like his friends, Fantin-Latour had a taste for modern life and contemporary scenes, while rejecting anecdote; he had the same sensitivity to light effects, although he was not attracted to *plein-air* painting. From 1864, in an evident desire to become better known, he began exhibiting group portraits, which brought together avant-garde painters and writers: Edouard Manet and Charles Baudelaire in *Homage to Delacroix* (exh. Paris Salon, 1864; Paris, Mus. d'Orsay); Whistler in *The Toast* (exh. Paris Salon, 1865; destr.); Emile Zola, Claude Monet and Auguste Renoir in *Studio in the Batignolles* (exh. Paris Salon, 1870; Paris, Mus. d'Orsay); the 'accursed' poets Paul Verlaine and Arthur Rimbaud in *Corner of the Table* (exh. Paris Salon, 1872); and finally *Around the Piano*, a homage to Richard Wagner (1885; both Paris, Mus. d'Orsay). Fantin-Latour transformed the traditional apotheosis into a bourgeois homage, a friendly gathering even, but the static composition isolates each immobile figure in a monochrome space. This absence of triteness is also typical of his portraits, such as *Edouard Manet* (1867; Chicago, IL, A. Inst.) or *Reading* (1877; Lyon, Mus. B.-A.). Lack of facial expression enhances the rigour of the composition and the austerity of the mourning worn by the *Dubourg Family* (1878; Paris, Mus. d'Orsay).

Fantin-Latour was similarly far from Impressionism in his still-lifes. He cut flowers and brought them indoors to paint in the studio. He studied the relationship of tones and colours in compositions based on a balanced pyramid, as in *Autumn Bouquet* (1862; Philadelphia, PA, Mus. A.). He achieved complete control of the composition in *Double Chrysanthemums and Fruit* (1865; Boston, MA, Mus. F.A.). He was able to link a precise rendering of plants with the objective

of the overall pictorial effect in *Primulas, Pears and Pomegranates* (1866; Otterlo, Kröller-Müller Sticht.) and in *Tea Roses and a Blue Glass Carafe* (1889; Lyon, Mus. B.-A.). In *White Rambler Roses* (1870; Houston, TX, Mus. F.A.) he depicted only flowers, concentrating on the subtle variations of colour. From the late 1870s he and his wife, (2) Victoria Fantin-Latour, spent the summers in Buré, Orne, and vegetation became accordingly more prominent in his paintings (e.g. *Annual Chrysanthemums*, 1889; Kansas City, MO, Nelson–Atkins Mus. A.).

During the Siege of Paris and the Commune (1871), Fantin-Latour gave up portraiture for more literary pursuits, which he had already tried with the lithographs for *Tannhäuser: Venusberg* (1862; Paris, Bib. N., see 1982–3 exh. cat., p. 153), a theme he also painted (1864; Los Angeles, CA, Co. Mus. A.). This allegory of hedonistic love fitted in with a growing interest in 18th-century painting, particularly *fêtes galantes*, a genre taken up again by Narcisse Diaz and Adolphe Monticelli. From 1870 Fantin-Latour's output was punctuated with such mythological scenes as Danae, Auroras, the *Toilet of Venus* (Geneva, Petit Pal.) and nymphs illustrating an edition of poems by André Chénier (Paris, 1902).

Through such friends as Otto Scholderer, a painter and violinist from Frankfurt, Edmond Maître (*d* 1898), a pianist and dilettante, Adolphe Jullien (1840–1932), his biographer, and the judge Antoine Lascoux, Fantin-Latour discovered the contemporary German music of Robert Schumann, Johannes Brahms and Richard Wagner. He was imbued with the spirit of Romanticism, as underlined by his choices, celebrating in turn Schumann in *Reflections of the Orient* (1864–9; destr.) and Hector Berlioz in *The Birthday* (exh. Paris Salon, 1876; Grenoble, Mus. Grenoble). Music provided a reservoir of ideas in which Fantin-Latour's escapism could find imaginative expression; he discovered the dreaming idealistic side of life that he did not find in contemporary society. Using the flexible technique of tracing with lithographic chalk, later reworked by rubbing or scratching the stone, he created the *Witch of the Alps* (1873; see 1982–3 exh. cat.,

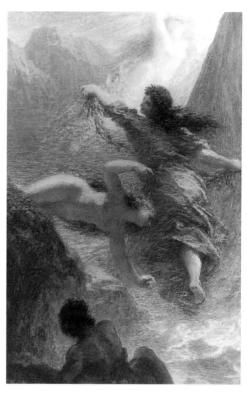

31. Henri Fantin-Latour: *Das Rheingold: Opening Scene*, 1876–7 (Paris, Musée d'Orsay)

p. 223) after Schumann and the *Trojan Duet* and the *Apparition of Hector* (both 1879) after Berlioz. From Wagner he took the legendary romanticism of the eternal temptations and great myths, illustrating *Tannhäuser* with the *Evening Star* (1884; see 1982–3 exh. cat., p. 299), *Lohengrin* with *Lohengrin's Prelude* (1882; see 1982–3 exh. cat., p. 117), *Parsifal* with the *Evocation of Kundry* (1883) and above all *The Ring* (all Paris, Bib. N., Cab. Est.). He depicted the same scenes several times, and the definitive versions appear in Adolphe Jullien's biographies of *Richard Wagner* (Paris, 1886) and *Hector Berlioz* (Paris, 1888). Fantin-Latour's tastes never evolved; only a single journey to Bayreuth in 1876 allowed him to enrich his sources of inspiration by developing such new themes as *Das Rheingold: Opening Scene* (pastel and charcoal on lithography, 1876–7, Paris,

Mus. d'Orsay (see fig. 31); painting, 1888, Hamburg, Ksthalle, in which he showed an Impressionist sensitivity to light and the technique of applying colour in broken strokes.

Unpublished sources

Paris, Bib. N., Cab. Est. |V. Fantin-Latour: *Notes prises par Mme Fantin-Latour du vivant de H. Fantin-Latour, 1836–1860*|

Bibliography

Catalogue des lithographies originales de Henri Fantin-Latour (exh. cat. by L. Bénédite, Paris, Mus. Luxembourg, 1899)

G. Hédiard: *L'Oeuvre de Fantin-Latour: Recueil de cinquante reproductions d'après les principaux chefs-d'oeuvre du maître* (Paris, 1906/R Geneva, 1980)

A. Jullien: *Fantin-Latour: Sa vie et ses amitiés* (Paris, 1909)

V. Fantin-Latour: *Catalogue complet, 1849–1904, de Fantin-Latour* (Paris, 1911, rev. Amsterdam and New York, 1969)

Centenaire de Henri Fantin-Latour (exh. cat., Grenoble, Mus.–Bib., 1936)

D. Druick: *The Lithographs of Henri Fantin-Latour: Their Place within the Context of his Oeuvre and his Critical Reputation* (diss., New Haven, CT, Yale U., 1979)

Fantin-Latour (exh. cat. by D. Druick and M. Hoog, Paris, Grand Pal.; Ottawa, N.G.; San Francisco, CA Pal. Legion of Honor; 1982–3)

V. M. C. Bajou: *Les Sujets musicaux chez Fantin-Latour* (diss., Paris, Ecole Louvre, 1988)

(2) (Marie-Louise-)Victoria Fantin-Latour [née Dubourg]

(*b* Paris, 1 Dec 1840; *d* Buré, 30 Sept 1926). Painter, wife of (1) Henri Fantin-Latour. She studied under the portrait painter Fanny Chéron (*b* 1830) and probably met Fantin-Latour at the Louvre, Paris, where they were both copying in the mid-1860s. Around 1867–8 she was associated with the circle of Edouard Manet, Berthe Morisot, Fantin-Latour and Edgar Degas; it was at this time that Degas painted a very frank and unflattering portrait of her (Toledo, OH, Mus. A.). While it may be impossible to prove that she was actually a pupil of Fantin-Latour, the early works she exhibited at the Salon are in a style close to his, in particular the portrait of her sister *Charlotte Dubourg* (exh. Paris Salon, 1870; Grenoble, Mus. Grenoble). In this intimate indoor portrait the neutral background recalls the austerity of Fantin-Latour's early portraits. The position of the model is a little stiff, and her expression is like that of a spectator. After exhibiting two portraits at the Salons of 1869 and 1870, she showed only still-lifes of fruit and flowers, often signed *V. Dubourg* or monogrammed *V. D.* From Fantin-Latour she derived a simplicity of composition, an absence of detail and neutral but vibrant backgrounds; her flowers, grouped in generous bouquets, stand out from backgrounds of sustained greyish scumbling or red-brown tones. Her brushstrokes, in long flecks of colour or in tight scumbling, emphasize the play of light and shade.

Soon after their marriage on 16 November 1876, the Fantin-Latours began each summer to paint still-lifes (e.g. 1884; Grenoble, Mus. Grenoble) at Buré in Orne. In 1880 they inherited a house there, which Victoria Fantin-Latour depicted in two paintings, the *House at Buré* (Alençon, Mus. B.-A. & Dentelle) and the *Garden at Buré* (Grenoble, Mus. Grenoble). Whereas Henri Fantin-Latour developed a more direct approach to nature in his still-lifes from the 1880s, no such change is apparent in the work of Victoria Fantin-Latour. After her husband's death she continued to paint, with a supple, freer brushstroke. Her colours are very lively in such traditional compositions as *Chrysanthemums* (1908; Grenoble, Mus. Grenoble). She compiled *Notes prises par Mme Fantin-Latour du vivant de H. Fantin-Latour, 1836–1860* (Paris, Bib. N. Cab. Est.) and published a catalogue raisonné (Paris, 1911) of her husband's work. In March 1905, in collaboration with the dealer Gustave Tempelaere, she organized a sale of her husband's drawings and prints, and she subsequently gave numerous works to various museums, especially to the Musée de Peinture et de Sculpture, Grenoble, and the Palais du Luxembourg, Paris.

Bibliography

Fantin-Latour: Une Famille de peintres au XIXe siècle (exh. cat., Grenoble, Mus. Peint. & Sculp., 1977)

E. Hardouin-Fugier and E. Grafe: *French Flower Painters of the Nineteenth Century: A Dictionary* (London, 1989), p. 179

VALÉRIE M. C. BAJOU

Fauveau, Félicie de

(*b* Florence, 1799; *d* Florence, ?1886). French sculptor. Daughter of a Breton banker, she studied drawing with the painters Louis Hersent and Claude Guillot (*fl* 1841–66). In her Salon début in 1827, her dramatic historical relief of *Queen Christina and Monaldeschi* (plaster; Louviers, Mus. Mun.) indicated a debt to her painter friends Paul Delaroche and Ary Scheffer. Passionately loyal to the elder Bourbons, she played a part in the Vendée uprising of 1830 and joined the forces supporting the Duchesse de Berry in 1832. These activities earned her imprisonment first and then proscription. She fled to Brussels but in 1834 settled in Florence, where she and her studio became an attraction for cultured tourists because of the romantic medieval manner she affected. In her magnum opus, a marble monument to *Dante Alighieri* (1830–36; fragments survive, priv. col.), she enshrined the adulterous lovers Paolo and Francesca in a polychrome Gothic tabernacle adorned with symbolic figures and inscriptions. A similar plethora of decorative elements surrounds the ascending soul of the deceased in the marble monument to *Louise Favreau* (1858; Florence, ex-Santa Croce, damaged 1966). In many of the commissions she received from English, German and Russian patrons, assistance in the decorative parts was provided by her brother Hippolyte. In its miniaturism and preciosity, her work represents a translation into sculpture of the so-called Troubadour style of painting.

Bibliography

Lami

P. de Chennevières: 'Souvenirs d'un directeur des Beaux Arts', *L'Artiste* (1883–9); as book (Paris, 1979), section ii, pp. 19–34

Baron de Coubertin: 'Mademoiselle de Fauveau', *Gaz. B.-A.*, n.s. 2, xxxvii (1887), pp. 512–21

La Sculpture française au XIXe siècle (exh. cat., ed. A. Pingeot and others; Paris, Grand Pal., 1986)

G. Schiff: 'Sculpture of the "Style Troubadour"', *A. Mag.*, lviii/10 (1987), pp. 102–10

PHILIP WARD-JACKSON

Feyen-Perrin, (François-Nicolas-)Auguste

(*b* Bey-sur-Seille, 12 April 1829; *d* Paris, 14 Oct 1888). French painter, draughtsman and printmaker. His older brother Eugène (1815–1908) was a painter, who persuaded their father to let Auguste pursue a similar career and served as his first teacher in Nancy. Auguste furthered his studies in Paris with Martin Drolling, Léon Cogniet and Adolphe Yvon. In Drolling's atelier Feyen-Perrin began a lifelong friendship with Jules Breton. He exhibited in the open Salon of 1848, and in 1853 and 1855, as 'Auguste Feyen'. From 1857 he became 'Feyen-Perrin', probably to distinguish himself from his brother, who was also a frequent Salon participant as 'Perrin'.

Influenced by the 1848 Revolution, Feyen-Perrin's first paintings were of peasants, and throughout his career he returned to rural subjects, making a speciality of fisherfolk scenes from Cancale, Roscroft and the isle of Batz in Brittany. In 1857 he sent the *Barque of Charon* (Nancy, Mus. B.-A.) to the Salon and often exhibited mythological and religious subjects thereafter. Quotations from Dante accompanied some early works, but from 1868 Feyen-Perrin almost invariably listed as his inspiration verse by his friend Paul-Arm and Silvestre, a prolific poet, story-writer and art critic. Silvestre was also portrayed as one of the figures in Feyen-Perrin's important realist composition for the 1863 Salon, the *Anatomy Lesson* (Tours, Mus. B.-A.), which depicted with stark Davidian lighting France's most celebrated surgeon, Dr Velpeau (1795–1867), teaching in La Charité hospital. The picture may have influenced Thomas Eakins's the *Gross Clinic* (1875; Philadelphia, PA, Thomas Jefferson U., Medic. Col.). Feyen-Perrin was a successful portraitist, painting, among others, Alphonse Daudet (Salon of 1876; untraced).

Feyen-Perrin was a progressive force in artistic politics: in 1871 the Commune secretly elected

him, with Courbet, to a provisional committee of artists; and in 1873 he joined the group that organized the first Impressionist exhibition the following year, though he did not participate in that show. Instead he exhibited annually at the Salon etchings, lithographs and drawings as well as paintings. He received the Légion d'honneur in 1878. By his own admission Feyen-Perrin aimed at 'une bonne moyenne' (happy compromise): he was a representative French artist of the second half of the 19th century, successful and competent, but lacking in originality or distinctive flair.

Bibliography

P. G. Hamerton: 'Examples of Modern Etching, XVII: A. Feyen-Perrin: "A Sailor's Infancy"', *Portfolio* [London] (1873), pp. 65–6

R. Ménard: 'Feyen-Perrin', *L'Art en Alsace-Lorraine* (1876), pp. 413–14

A. M. de Bélina: *Nos peintres dessinés par eux-mêmes* (Paris, 1883), pp. 217–19

Exposition des oeuvres de Feyen-Perrin (exh. cat., intro. J. Breton; Paris, Ecole N. Sup. B.-A., 1889)

E. C. Parry: '"The Gross Clinic" as Anatomy Lesson and Memorial Portrait', *A. Q.* [Detroit], xxxii (1969), pp. 373–91

The Realist Tradition: French Painting and Drawing, 1830–1900 (exh. cat. by G. P. Weisberg, Cleveland, OH, Mus. A., 1981), pp. 180–81, 288

JAMES P. W. THOMPSON

Filiger [Filliger], Charles

(*b* Thann, Alsace, 28 Nov 1863; *d* Brest, 11 Jan 1928). French painter and engraver. He studied in Paris at the Académie Colarossi. He settled in Brittany in 1889, where he was associated with Gauguin and his circle at Pont-Aven, but he remained a mystic and a recluse. The Breton setting, with its stark landscape and devout peasant inhabitants, provided fertile ground for the development of Filiger's mystical imagery and deliberate archaisms. Filiger's friend, the painter Emile Bernard, characterized Filiger's style as an amalgam of Byzantine and Breton popular art forms. The hieratic, geometric quality and the expressionless faces in his gouaches of sacred subjects such as *Virgin and Child* (1892; New York, A.

G. Altschul priv. col., see 1979–80 exh. cat., p. 71) reveal Filiger's love of early Italian painting and the Byzantine tradition. Evident too in the heavy outlines and flat colours of his work are the cloisonnism of the Pont-Aven school and the influence of Breton and Epinal popular prints. Filiger's landscapes, such as *Breton Shore* (1893; New York, A. G. Altschul priv. col.), share with Gauguin's paintings an abstract, decorative quality and rigorous simplification.

In 1903 Filiger began a series of watercolours, *Chromatic Notations* (projects for stained glass), in which a figure, usually a Madonna (e.g. *Head of the Virgin, on a Yellow Ground*; Paris, Pompidou) or a stylized portrait is placed on a decorative, faceted background within an oval or polygonal frame. These geometric compositions were inspired by the theory of sacred measures developed in the German monastery of Beuron and brought back to the Pont-Aven circle by Paul Sérusier and Jan Verkade. Like most of Filiger's works, they are small in scale. His work was seen often in Paris, for example in the Salon des Indépendants in 1889 and the Salon de la Rose + Croix in 1892, organized in part by Filiger's long-standing patron, Count Antoine de la Rochefoucauld. Filiger collaborated with Rémy de Gourmont on engravings to illustrate the periodical *L'Ymagier* (1894–6). The poets Alfred Jarry and André Breton were particularly impressed with Filiger's mystical images. After 1899 he withdrew completely from Parisian artistic life.

Bibliography

A. Jarry: 'Filiger', *Mercure France*, n. s. 57 (1894)

Neo-Impressionists and Nabis in the Collection of A. G. Altschul (exh. cat., ed. R. L. Herbert; New Haven, CT, Yale U. A.G., 1965), p. 74

M.-A. Anquetil: *Trois peintres mystiques du groupe de Pont-Aven: Charles Filiger, Jan Verkade, Mögens Ballin* (diss., U. Paris IV, 1974)

W. Jaworska: *Gauguin and the Pont-Aven School* (Greenwich, CT, 1974), pp. 159–69

R. Pincus-Witten: *Occult Symbolism in France* (New York, 1976), pp. 124–8

Post-Impressionism: Cross-currents in European Painting (exh. cat., London, RA, 1979–80), p. 71

TAUBE G. GREENSPAN

Flameng, François

(*b* Paris, 6 Dec 1856; *d* Paris, 28 Feb 1923). French painter and draughtsman. He was the son and pupil of the engraver Leopold Flameng (1831–1911) and was taught by Alexandre Cabanel, Edmond Hédouin and Jean-Paul Laurens. He first exhibited at the Salon in 1873, working initially as a history and portrait painter. He produced several large historical compositions such as *Conquerors of the Bastille* (1881; Rouen, Mus. B.-A.), painted in an academic style characteristic of the Third Republic. He also worked as a decorative painter, producing nine panels for the great staircase of the Sorbonne in Paris depicting the foundation of the university and the history of French literature, for example *St Louis Delivering the Founding Charter to Robert de Sorbon* (1887) and *Moralists of the Court of Louis XIV: La Rochefoucauld and Molière* (both *in situ*). He decorated the ceiling over the staircase in the Opéra Comique in Paris with paintings that owe something to Degas, such as *Tragedy* and *Dance* (1897; both *in situ*), but more to Boucher (*Comedy Pursuing the Vices*). He contributed to the design of the Salle des Fêtes at the Exposition Universelle in Paris in 1900 with three enormous compositions, *Silk and Wool*, the *Decorative Arts* and the *Chemical Industries* (all destr.). Flameng also produced ceiling paintings for the buffet at the Gare de Lyon (*in situ*) in Paris as well as wall and ceiling paintings for numerous public and private buildings, including the Hôtel des Invalides in Paris (now in Paris, Mus. Armée), the Grolier Club in New York and the Charitonenko Palace in Moscow (both *in situ*). In 1903 he collaborated with Léon Bonnat, P.-A.-J. Dagnan-Bouveret, Gustave Colin, Léon Glaize, Charles Lapostolet, Joseph Layraud and Tony Robert-Fleury on the decoration of the Salon des Arts in the Hôtel de Ville in Paris, contributing *Music*, a panel painted in a Symbolist style.

Flameng devoted himself almost exclusively to portrait painting in his later years, producing works with an 18th-century flavour such as *Mme Flameng, the Artist's Wife* (1893; Paris, Louvre). In 1894 he travelled to Russia, where his works were well received; Tsar Nicholas II bought four scenes from the life of Napoleon Bonaparte (1894–6; St Petersburg, Hermitage). *Mme Winterfeld* (1910; Nice, Mus. B.-A.) reveals his skill as a portrait painter, with its stylized grace of composition, latent eroticism (the model, covered in jewels, is voluptuously removing her glove) and fluidity of brushwork. Flameng also worked as an illustrator, producing 100 drawings for an edition of the complete works of Victor Hugo (Paris, 1886). He was appointed professor at the Ecole des Beaux-Arts in Paris in 1905 and became President of the Académie des Beaux-Arts in 1910.

Bibliography

Thieme–Becker

Edouard-Joseph: *Dictionnaire biographique des artistes contemporains, 1910–1930*, ii (Paris, 1931), pp. 35–6

A. DAGUERRE DE HUREAUX

Flandrin

French family of artists. Jean-Baptiste-Jacques Flandrin (1773–1838), an amateur painter who specialized in portraits, had seven children, of whom (1) Auguste Flandrin, (2) Hippolyte Flandrin and (3) Paul Flandrin became artists.

(1) (René-)Auguste Flandrin

(*b* Lyon, 6 May 1801; *d* Lyon, 30 Aug 1842). Painter and printmaker. He attended the Ecole des Beaux-Arts in Lyon from 1817 to 1823, studying drawing and painting under Fleury Richard and Alexis Grognard (1752–1840). He produced engraved title-pages for musical romances and lithographic scenes of Lyon, such as the *Ruins of the Roman Aqueduct at Lyon* (1824; Paris, Bib. N.). In 1833 he moved to Paris, where he worked in Ingres's studio for a year. He then moved back to Lyon and in 1838 spent a few weeks in Rome. On his return, he set up a studio in Lyon where such artists as Louis Lamothe (1822–69) and Joseph Pognon studied. As well as landscape lithographs (e.g. *View of the Bridge at Beauregard on the Sâone*, 1834; Paris, Bib. N.), he also painted historical scenes, such as *Savonarola Preaching at S Miniato* (1836; Lyon, Mus. B.-A.), and portraits, such as *Dr S. des Guidi* (1841; Lyon, Mus. B.-A.), which shows the influence of Ingres.

(2) Hippolyte(-Jean) Flandrin

(*b* Lyon, 23 March 1809; *d* Rome, 21 March 1864). Painter and lithographer, brother of (1) Auguste Flandrin. He was initially discouraged from fulfilling his early wish to become an artist by Auguste's lack of success, but in 1821 the sculptor Denys Foyatier, an old family friend, persuaded both Hippolyte and Paul to train as artists. He introduced them to the sculptor Jean-François Legendre-Héral (1796–1851) and the painter André Magnin (1794–1823), with whom they worked copying engravings and plaster casts. After Magnin's death, Legendre-Héral took the brothers to the animal and landscape painter Jean-Antoine Duclaux (1783–1868). Hippolyte and Paul had both learnt the techniques of lithography from Auguste at an early age, and between the ages of 14 and 19 Hippolyte produced a number of lithographs, which he sold to supplement the family income. Many reflected his passion for military subjects (e.g. *Cossacks in a Bivouac, c.* 1825; Paris, Bib. N.). In 1826 the two brothers entered the Ecole des Beaux-Arts in Lyon, where Hippolyte studied under Pierre Révoil. Showing a precocious talent, he was soon advised to move to Paris, and having left the Ecole des Beaux-Arts in Lyon in 1829, he walked to the capital with his brother Paul; together they enrolled in the studio of Ingres. After several unsuccessful attempts, Hippolyte won the Grand Prix de Rome in 1832 with *Theseus Recognized by his Father* (1832; Paris, Ecole N. Sup. B.-A.), despite having suffered from cholera during the competition. His success was all the more spectacular given the general hostility to Ingres; Hippolyte was the first of his pupils to be awarded this prestigious prize. Hippolyte arrived in Rome in 1833; Paul joined him there in 1834. After first working on such subjects as *Virgil and Dante in Hell* (1836; Lyon, Mus. B.-A.), Hippolyte developed a taste for religious works during this stay. From 1836 to 1837 he worked on *St Clare Healing the Blind* for the cathedral in Nantes, winning a first-class medal at the 1837 Salon, and in 1838 he painted *Christ Blessing the Children* (Lisieux, Mus. Vieux-Lisieux), which was exhibited at the 1839 Salon.

In 1838 Hippolyte returned to France; the following year he received a commission to decorate the Chapelle Saint-Jean of St Séverin in Paris with murals depicting the *Life of St John*. Unveiled in 1841, they won him the Croix de Chevalier. The encaustic painting technique resulted in a subdued colour scheme well suited to the Neo-classical austerity of the style. Soon after completing this project, he was one of several artists employed by the Duc de Luynes at the Château Dampierre; with Paul's assistance, he decorated its Great Hall with a series of semi-nude female figures in a graceful 'Etruscan' style. State commissions for murals continued; in 1842 he painted *St Louis Dictating his Laws* for the Chambre des Pairs of the Paris Sénat and began work on a series of biblical scenes for St Germain-des-Prés in Paris. The first, placed in the sanctuary, were executed between 1842 and 1846; the largest depict *Christ on the Road to Calvary* and the *Entry of Christ into Jerusalem*. Set on gold backgrounds, both pictures are highly dramatic despite the use of an emotionally restrained Neo-classical style. From 1846 to 1848 he decorated the Chapelle des Apôtres and the choir, also designing its stained-glass windows. From 1856 onwards he worked on the nave, work eventually finished after his death by Paul. This was the largest part of the commission, consisting of 20 separate panels showing scenes from the Old Testament and New Testament—the *Parting of the Red Sea*, the *Annunciation*, the *Adoration of the Magi*, the *Crucifixion* etc—each surmounted by a prophet or other biblical figure. Though occasionally harking back to Giotto, Flandrin's work was chiefly influenced by Raphael. In 1864 he was also asked to decorate the transepts of the church; these were completed after his death by his pupil Sébastien Cornu.

By this time receiving more commissions than he could execute, Hippolyte was able to specialize in religious scenes; the revived popularity of large-scale church decoration in mid-19th-century Paris meant that there was no shortage of such work. In 1847 he had refused an offer to decorate St Vincent-de-Paul in Paris, in deference to his master Ingres, who had begun and then abandoned the project shortly before. It was then passed to François-Edouard Picot, but when the

1848 Revolution brought about a change in the Paris administration, the new mayor Armand Marast tried once again to persuade Flandrin to take up St Vincent-de-Paul. Finally a compromise was reached; Picot painted the choir and Flandrin the nave. The resulting works, executed from 1849 to 1853, largely consist of two friezes 39 m long and only 2.7 m high. Rather than break them up into smaller panels, Flandrin painted two processions of figures. On the one side are confessors, church doctors, martyred saints and apostles; on the other side are penitents, virgin saints and martyrs. Both friezes have a gold background, reminiscent of mosaics.

In 1853 Flandrin was elected a member of the Académie des Beaux-Arts; the following year he executed two allegorical murals of *Agriculture* and *Industry* for the Conservatoire National des Arts et Métiers in Paris. Returning to Lyon in 1855, he decorated St Martin d'Ainay as part of an overall restoration of the church. In 1857 he was appointed professor at the Ecole des Beaux-Arts in Paris, and in 1863, though in poor health, he moved to Rome. Though primarily known as a religious painter, he also painted numerous portraits; early works, such as *Mme Vinet* (1841; Paris, Louvre), are cold but elegant. His portrait of *Emperor Napoleon III* (1861–2; Versailles, Château) was disliked by the sitter.

(3) (Jean-)Paul Flandrin

(*b* Lyon, 28 May 1811; *d* Paris, 8 March 1902). Painter and lithographer, brother of (1) Auguste Flandrin and (2) Hippolyte Flandrin. Always very close to his brother Hippolyte, Paul followed much the same training, studying under Legendre-Héral, Magnin and Duclaux. Like Hippolyte, he was taught lithography by Auguste. He studied at the Ecole des Beaux-Arts in Lyon (1826–8) and in 1829 moved to Paris, where he enrolled in the studio of Ingres. The two brothers soon became Ingres's favoured pupils, and in 1832, the year that Hippolyte won the Prix de Rome, Paul won a prize for historical landscape, though he failed in the Prix de Rome competition the following year. Finding the separation from his brother painful, in 1834 he moved to join Hippolyte. Once in Rome,

he soon discovered his vocation as a landscape painter. Ingres arrived as Director of the Académie de France in 1835, and Paul, among other artists, received a commission to make copies of the works in the Vatican. Although not a prizewinner, he was closely connected with the Villa Médici and often accompanied the students on their trips to the country. In 1837, fleeing a cholera epidemic in Rome, Paul and Hippolyte visited Padua, Venice, Verona, Mantua and other places. Joined by Auguste in 1838, the three brothers visited Livorno, Milan, Pisa and Florence.

Returning to France in 1839, Paul made his Salon debut that year with two landscapes, the *Sabine Mountains* (1838; Paris, Louvre) and *Nymphée* (1839; Angers, Mus. B.-A.), winning a second-class medal. In 1840 he helped Hippolyte decorate the Chapelle Saint-Jean of St Séverin in Paris, and in 1842 he was commissioned to decorate the Chapelle des Fonts-Baptismaux in the same church; he worked on this until 1845. He often travelled to Brittany, Dauphiné, Normandy and Provence in search of subjects, producing paintings such as the *Dauphiné Valley above Voreppe* (c. 1845; Aix-en-Provence, Mus. Granet). After helping Hippolyte on the decorations for St Paul in Nîmes (1847–9), he remained there to paint the landscape. His pictures are clearly in the classical tradition of Claude and Poussin; some, such as the melancholy *Solitude* (1857; Paris, Louvre), feature figures in antique dress.

State recognition of his work came in 1859 with a commission for the *Flight into Egypt* (1861; Orléans, Mus. B.-A.). In 1862 he painted with Corot and that year and the next worked at Fontainebleau on such landscapes as *At the Waterside* (1868; Bordeaux, Mus. B.-A.). During the Franco-Prussian War he stayed in Angers; in 1876, having lost his hard-won public esteem, he was forced to open a drawing school for girls. He received a commission to produce a cartoon for a tapestry for the Escalier Chagrin in the Sénat in 1878. Through much of the 1880s he worked outside Paris; he continued to paint until the end of the century, although his work was almost completely neglected—a neglect further compounded

by the glittering reputation of his brother Hippolyte. Although Paul was not an innovator in the field of landscape painting, his canvases are invariably very appealing.

Bibliography

DBF

J.-B. Poncet: *Hippolyte Flandrin* (Paris, 1864)

H. Delaborde: *Lettres et pensées d'Hippolyte Flandrin* (Paris, 1865)

M. De Montrond: *Hippolyte Flandrin* (Paris, 1865)

H. L. Sidney Lear: *A Christian Painter of the Nineteenth Century, Being the Life of Hippolyte Flandrin* (London, Oxford and Cambridge, 1875)

E. Montrosier: *Peintres modernes: Ingres, Hippolyte Flandrin, Robert-Fleury* (Paris, 1882), pp. 49–72

F. Bournand: *Trois artistes chrétiens: Michel-Ange, Raphael et Hippolyte Flandrin* (Paris, 1892), pp. 293–382

L. Masson: *Hippolyte Flandrin* (Paris, 1900)

G. Bodinier: *Un Ami angevin d'Hippolyte et Paul Flandrin: Correspondance de Victor Bodinier avec Hippolyte et Paul* (Angers, 1912)

M. Audin and E. Vial: *Dictionnaire des artistes et ouvriers d'art de la France: Lyonnais*, 2 vols (Paris, 1918)

Hippolyte, Auguste et Paul Flandrin: Une Fraternité picturale au XIXe siècle (exh. cat. by J. Foucart, B. Foucart and others, Paris, Mus. Luxembourg, 1984–5; Lyon, Mus. B.-A.; 1985) [full bibliog.]

Flers, Camille

(*b* Paris, 15 Feb 1802; *d* Annet-sur-Marne, 27 June 1868). French painter and pastellist. The son of a porcelain-maker, he first learnt painting in the studio of a porcelain decorator. After a period as a theatre decorator and a dancer, he became a pupil of the animal painter Joseph François Pâris (1784–1871). He devoted himself to landscape painting and became one of the precursors of *plein-air* painting. Referring to himself as a 'romantique-naturaliste', he was a member of the new Naturalist school of landscape painting that emerged in the 1830s in opposition to the official classicism of the Ecole des Beaux-Arts. He was one of the first to paint *sur le motif* (from life) in the forest of Fontainebleau, and he also made frequent visits to Barbizon, joining that group of artists known as 'le groupe de Marlotte'. His works consist largely of views of Normandy and the Paris environs; he concentrated on thatched cottages, farmyards, prairies, ponds and riverbanks. He made his début at the Salon in 1831 with a *View of the Village of Pissevache, Bas-Valais* and continued to exhibit there until 1863. His early style of the 1830s and 1840s is characterized by splashes of thick paint, a roughly textured paint surface, a bright palette and a range of lively tones, as in *Prairie* (1831; Paris, Resche). Between 1850 and 1860 he painted a series of images of rivers and ponds with boats and fishermen. These were executed in a style very close to that of Jules Dupré, with whom he was working at the time. The surface of these paintings is smooth, the touch more discrete with a dominantly light-coloured tonality, as in *Landscape: The Environs of Paris* (1854; Paris, Louvre). Flers was also noted for his pastels, which he exhibited at the Salon from 1843, especially in the 1840s. In 1846 he published his theories of drawing in pastel in the journal *L'Artiste*, and these did much to revive interest in the medium. In common with other artists associated with Barbizon, in the early 1860s Flers experimented with making clichés-verre.

Writings

'Du pastel: De son application au paysage en particulier', *L'Artiste*, 4th ser., vii (1846), pp. 113–16

Bibliography

Bellier de La Chavignerie–Auvray; *DBF*

P. Miquel: *Le Paysage français au XIXe siècle, 1824–1874: L'Ecole de la nature*, ii (Maurs-La-Jolie, 1975), pp. 142–57

L. Harambourg: *Dictionnaire des peintres paysagistes français au XIXe siècle* (Neuchâtel, 1985)

ATHENA S. E. LEOUSSI

Forain, Jean-Louis

(*b* Reims, 23 Oct 1852; *d* Paris, 11 July 1931). French painter, printmaker and illustrator. Around 1860 he moved with his family to Paris, where he was taught by Jacquesson de la Chevreuse (1839–1903),

Jean Baptiste Carpeaux and André Gill. He participated in the Franco-Prussian War (1870–71) and was a friend of the poets Paul Verlaine and Arthur Rimbaud; the latter is the presumed subject of a portrait (1874; priv. col., see 1982 exh. cat., no. 1) that may have influenced Manet's late portrait of *Mallarmé* (1876; Paris, Louvre). Forain first met Manet through his friendship with Degas in the early 1870s at the salon of Nina de Callias. He continued to associate with Manet, meeting the group of young Impressionists at the Café Guerbois and the Café de la Nouvelle Athènes. In 1878 Forain painted a small gouache, *Café Scene* (New York, Brooklyn Mus.), which probably influenced Manet's *Bar at the Folies-Bergère* (1881–2; London, Courtauld Inst. Gals).

In 1879 Forain was invited by Degas to join the fourth Impressionist exhibition, and he exhibited again with the Impressionists in the fifth (1880), sixth (1881) and eighth (1886) exhibitions, receiving favourable reviews from Huysmans, Félix Fénéon and Diego Martelli. He lightened his palette and employed the Impressionist methods of short brushstrokes and complementary colour juxtapositions to create some luminous *plein-air* paintings such as the *Race-track* (1884–5; Springfield, MA, Mus. F.A.) and the *Fisherman* (1884; Southampton, C.A.G.). As Huysmans pointed out, one of Forain's most successful subjects was the Parisian woman, who appeared in many guises in the works of his Impressionist period (c. 1879–1900). Like Degas, who was his best friend and the greatest influence on him, Forain depicted scenes backstage at the Opéra and at the race-track as well as nudes in naturalistic interiors (see fig. 32), often drawing from the same model with Degas. Unlike Degas, Forain exhibited at the Salon des Artistes Français, showing the *Buffet* (Paris, Féd. Mutualiste) in 1884 and the *Widower* (Paris, Louvre) in 1885. Both have more formal compositions, and the figures are solidly delineated, but they also demonstrate Forain's Impressionist principles in the low viewpoint and diagonal composition influenced by Japanese woodcuts, the freely brushed surfaces and the interest in the effects of light.

Forain's career as an illustrator began in 1876

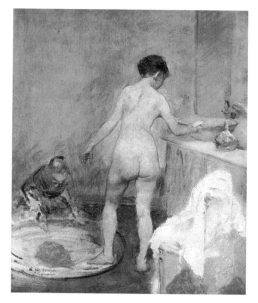

32. Jean-Louis Forain: *The Tub*, 1886–7 (London, Tate Gallery)

when his first published drawing appeared on the cover of *Le Scapin*. He worked regularly for the *Courrier français* from 1887 and drew albums for *Le Figaro* in 1891: he worked on *Le Figaro* intermittently for the next 35 years. His drawings for the *Courrier français* made him famous, his captions so witty and biting that they were described as written in vitriol, and he was known as the 'Juvénal du *Figaro*'.

Forain began printmaking in the mid-1870s. In his first etching period (1875–90) his subjects were backstage views, café-concerts and the Folies-Bergère. He also etched illustrations to Huysmans's *Marthe* (1876) and *Croquis parisiens* (1880). In 1890 he took up lithography with scenes of Parisian life, often several versions of the same subject, such as his six plates of the *Private Room*. He also created some memorable portraits in this medium such as the elegant *Colette Willy*, four brilliant portraits of *Renoir* and two of *Ambroise Vollard*. He resumed etching in 1902 but changed his subject-matter to concentrate on religious and courtroom subjects of great drama and deep feeling, expressed with bravura technique.

After 1900 Forain's painting style also underwent a change, both in technique and subject-matter. The latter change was the result of Forain's experience of the Dreyfus trials, which also prompted him to co-found, with CARAN D'ACHE, the weekly satirical journal *Psst!*, and his renewal of Christian faith in the company of his old friend Huysmans in 1900 at Ligugé: he began to paint biblical and law-court scenes and, in 1915, pictures inspired by World War I. The colours of his work became sombre, reflecting the expressive qualities of this new subject-matter. Among his most moving religious representations are the oil painting the *Prodigal Son* (1909; Boston, MA, Pub. Lib.) and the series of etchings on the same subject. Forain presented this as a contemporary drama of reconciliation, with the figures shown in contemporary dress and attitudes, rather than as a historical biblical scene. Forain's law-court scenes contrast the vulnerability of the defendant with the bored indifference or histrionic gestures of the lawyers, as in *Unwed Mother* ('Fille-mère', 1909; Bristol, Mus. & A.G.). His paintings were championed in 1910 by Octave Maus, resulting in a retrospective of over 400 works at the Musée des Arts Décoratifs, Paris, which revealed the scope of Forain's oeuvre and established him as a major artist.

In February 1915, aged 62, Forain joined the camouflage corps and later became a correspondent for *Le Figaro*, covering all phases of World War I with biting, satirical images of the futility of war. His palette later brightened and his figures became more fluidly rendered and less solid. Although continuing with religious and legal subjects, he returned to the theme of the dance in the oils *Tango* (1925; priv. col., see 1978 exh. cat., no. 58) and *Charleston* (1926; Washington, DC, N.G.A.) and the gouache *Cabaret* (1926; Boston, MA, Pub. Lib.), all virtuoso paintings conveying the jazz rhythms of the speak-easy.

Forain ended his career as President of the Société Nationale des Beaux-Arts, member of the Académie Française and Commandant de la Légion d'honneur. His work was admired by Degas, Manet and Cézanne, and a generation of social realists was influenced by his biting pictorial condemnations of injustice, greed, lust, stupidity and the horrors of war.

Bibliography

J.-K. Huysmans: *L'Art moderne* (Paris, 1883)

M. Lehrs: 'Forain', *Graph. Kst*, xxxiv (1911), pp. 9–28

M. Guerin: J.-L. Forain: *Lithographe* (Paris, 1912) [cat. rais.]

H. Ghéon: 'Jean-Louis Forain', *A. & Déc.*, xxxiii (1913), pp. 1–12

G. Geffroy: 'Forain', *A. & Artistes*, xxi (1921), pp. 49–78

O. Maus: *Trente années de lutte pour l'art, 1884–1914* (Brussels, 1926)

C. Kunstler: *Forain* (Paris, 1931)

L. Vaillat: *En écoutant Forain* (Paris, 1931)

J. Sloane: 'Religious Influences on the Art of Jean-Louis Forain', *A. Bull.*, xxxiii (1941), pp. 199–207

J.-L. Forain: Peintre, dessinateur et graveur (exh. cat., Paris, Bib. N., 1952)

Forain (exh. cat., Williamstown, Clark A. Inst., 1963)

L. Browse: *Forain the Painter* (London, 1978)

Jean-Louis Forain, 1852–1931 (exh. cat., ed. J. Chagnaud-Forain, Y. Brayer and C. Richébé; Paris, Mus. Marmottan, 1978)

J. Bory: *Forain* (Paris, 1979)

Jean-Louis Forain, 1852–1931: Works from New England Collections (exh. cat., ed. A. Faxon; Framingham, Danforth Mus. A., 1979)

A. Faxon: *Jean-Louis Forain: A Catalog Raisonné of the Prints* (New York, 1982)

Jean-Louis Forain: Artist, Realist, Humorist (exh. cat., ed. A. Faxon; Washington, DC, Int. Exh. Found. 1982)

ALICIA CRAIG FAXON

Français, François-Louis

(*b* Plombières-les-Bains, Vosges, 17 Nov 1814; *d* Plombières-les-Bains, 18 May 1897). French painter and printmaker. After attending several courses in drawing in Plombières-les-Bains, he went to Paris at the age of 14 to study. He first worked as a copyist, produced caricatures and drew from models at the Académie Suisse. In 1831 he decided to study painting and completed his first landscapes, painting mainly in the environs of Paris and at Meudon with Paul Huet, who was his adviser for several years. In 1834 he entered the workshop of Jean Gigoux and met Henri Baron, who remained his faithful friend. He also studied

at the Louvre where he developed a lifelong admiration for the work of Claude. From 1834 he lived at Barbizon, and after 1835 he often painted in the Forest of Fontainebleau, where he met Louis Cabat and also Corot, who became his adviser and introduced him to Théodore-Caruelle d'Aligny. Français also made the acquaintance of Narcisse Diaz and of the landscape painter Auguste-Paul-Charles Anastasi (1820–89), who became his friend. In 1837 he exhibited for the first time at the Salon in Paris, showing *Under the Willows* (1837; Tours, Mus. B.-A.), a composition in which the figures were painted by Baron. He exhibited regularly at the Salon until 1896. Between 1836 and 1840 his style was above all a skilful but eclectic mixture of various contemporary trends in landscape painting. He also took up printmaking early in his career, and in 1835 he produced some engravings for Jacques-Henri Bernardin de Saint-Pierre's *La Chaumière indienne* and for Alain-René Lesage's *Gil Blas*. After 1838 his lithographic production was considerable and included such important commissions as that to illustrate Bernardin de Saint-Pierre's novel *Paul et Virginie*. With his friends Baron and Célestin Nanteuil (1813–73), he produced *Les Artistes anciens et modernes* (3 vols; 1848–62), a collection of lithographs after paintings by contemporary artists. Among the prints were those done after Corot's *Landscape, Sunset* (1840; Metz, Mus A. & Hist.), Diaz's *Bathers* (1847) and several of his own paintings.

From 1844 Français regularly visited Marly and Bougival, where, with Baron and Nanteuil, he acquired a boat nicknamed 'La Grenouillère' by the inhabitants of the area. Henceforth he signed his paintings *Français, élève de Bougival*. In 1846 he made his first journey to Italy and remained there for three years, although he had intended to stay for only a few months. He lived in Genoa (1846), Pisa (1846), Florence (1846–7), Rome (1846–9), Frascati (1847), Ariccia (1848) and Tivoli (1848–9). He executed mainly gouache studies in the Borghese Gardens and at Tivoli (e.g. *View of Tivoli*, 1850; Lille, Mus. B.-A.). During these years his style came to fruition, he began to paint in the closely set strokes that would be a feature of his later, better-known works, and his palette became more luminous, due probably to his work in watercolour (e.g. *Fountain at Ariccia*, 1848; Paris, Mus. d'Orsay). After returning to France, he travelled and painted in such regions as Marly, Vaux-de-Cernay, Saint-Cloud and Sèvres, where he painted with Constant Troyon. From 1850 he also frequented Honfleur and, with Corot, Courbet, Eugène Boudin and Johan Barthold Jongkind, painted the town and its environs (e.g. *Sunset near Honfleur*, 1859). In 1852 he travelled to Crémieu with Corot, Charles-François Daubigny and Auguste Ravier. At this time his preferred sites were Saint-Cloud, Plombières-les-Bains and the banks of the Loire, where he painted mainly forest interiors and scenes of riverbanks in a style more realistic than the classicism of his Italian period. Having acquired a passion for the light of the Mediterranean regions, he returned to Italy twice more, staying at Naples in 1858–9 and at Capri and Pompeii in 1864–5. In the 1850s and 1860s he also visited Alsace, Belgium, Switzerland and the Alps.

While Français always remained a much sought-after painter at the beginning of the 1860s, reviews of his work were much less favourable. His painting the *Sacred Wood* (Lille, Mus. B.-A.) was exhibited at the Salon of 1864 in Paris and elicited hostile reactions. Although Corot admired it, Français's patron Alfred Hartmann, an industrialist from Alsace, compared it to 'a chicory dish seasoned with cream' (letter from Hartmann to Rousseau, 17 April 1864; Paris, Louvre, Cab. Dessins). The picture evokes an antique idyll and was painted after sketches done at Vaux-de-Cernay and Tivoli. Français executed other neo-classical landscapes in the same manner, in which mythological characters are introduced into realistic landscape settings painted from sketches made in Italy or France (e.g. *Orpheus*, 1863; Paris, Mus. d'Orsay). After 1873 he spent his winters in Nice, returning each spring to Vaux-de-Cernay and to Plombières-les-Bains in the summer. In 1875 he made a further trip abroad, visiting Algeria. In 1878, six years after he received the commission, he completed *Expulsion from the Garden* and the *Baptism*, painted decorative panels (*in situ*) for the font in La Trinité, Paris. At this time his work developed towards poetic naturalism. He executed

a large number of self-portraits, some of them in pastels, and he also produced numerous pen-and-ink drawings, enhanced by sepia, that convey a certain melancholy. In the paintings of his later years (e.g. *View of Antibes*, 1895; Strasbourg, Mus. B.-A.) there is a return to a colouring similar to that present in his works *c.* 1858.

Throughout Français's career he retained a taste for detail inherited from his master Gigoux, and his works typically display a slightly mannered meticulousness. He rapidly acquired a considerable reputation and, once he had achieved financial success, he was much sought after. Outside France he also exhibited in Geneva (1857, 1858 and 1861) and at the two International Exhibitions of 1862 and 1874 in London. In 1890 he was appointed a member of the Institut de France. In 1901, four years after his death, a monument was erected to his memory at Plombières-les-Bains, and in 1905 his workshop, which he had presented to his native town, became the Musée Louis Français.

Prints

with H. Baron and C. Nanteuil: *Les Artistes anciens et modernes*, 3 vols (Paris, 1848–62)

Bibliography

A. Gros: *François-Louis Français: Causeries et souvenirs par un de ses élèves* (Paris, 1902)
P. Miquel: *Le Paysage français au XIXe siècle, 1824–1874: L'Ecole de la nature*, iii (Maurs-la-Jolie, 1975), pp. 608–45
François-Louis Français, Plombières-les-Bains, 1814–1897: Illustrateur romantique (exh. cat. by R. Conilleau, Plombières-les-Bains, Mus. Louis Français, 1981)
Aquarelles, dessins et gravures de François-Louis Français (exh. cat., Région Lorraine, 1982–3)
Tradition and Revolution in French Art, 1700–1880: Paintings and Drawings from Lille (exh. cat., London, N.G., 1993)

LAURENCE PAUCHET-WARLOP

Fremiet, Emmanuel

(*b* Paris, 6 Dec 1824; *d* Paris, 10 Sept 1910). French sculptor and stage designer. He was born into a poor though well-connected family and from the age of 12 contributed to the domestic funds by doing a variety of unskilled jobs. In 1838 he started evening classes at the Petite Ecole (Ecole Gratuite de Dessin), Paris, and between 1842 and 1844 worked in the studio of the sculptor François Rude, who was his uncle. The impact of Rude's training method, combining the inspirational with an emphasis on the study of natural proportions and structure, was reinforced for Fremiet by the lessons he learnt in his first artistic enterprises: working with the painter and naturalist Jean-Charles Werner (*fl* 1830–60) at the Musée National d'Histoire Naturelle, Paris, on a compendium of comparative anatomy; helping Dr Mateo Orfila (1787–1853) assemble the specimens for his anatomical museum; and adding artistic touches to embalmed corpses at the Paris Morgue.

Fremiet made his Salon début in 1843 with a plaster statuette of a *Gazelle* (version, Paris, priv. col., see 1988–9 exh. cat., p. 74), and animal statuettes in bronze formed the bulk of his early commercial output. Between 1855 and 1872 he personally cast and marketed bronzes from his own models. He began an impressive series of state commissions modestly with a *Marabou Stork and Cayman* (bronze, 1850; Paris, Mus. d'Orsay), designed to support a porphyry table, part of the Egyptian display in the Louvre. Around 1853 he received an extensive if unlucrative commission, made in person by Napoleon III, for 50 statuettes (ultimately there were 72) showing *Figures from the Army of the Second Empire* (destr. 1871; bronze replicas, Dijon, Mus. B.-A.). These scrupulous renderings of character and costume were carried out in a variety of materials for maximum verisimilitude. Fremiet's documentary and educational ambitions in sculpture were shared by such contemporaries as Charles-Henri-Joseph Cordier and Louis Rochet, and on a number of occasions he insisted on the archaeological and anatomical veracity of his natural-historical and historical re-creations. His notorious groups representing confrontations between humans and animals needed such claims to be maintained in the face of controversy. Because it was considered to echo Darwin's views on the origins of man (though this had not been Fremiet's intention), the *Female*

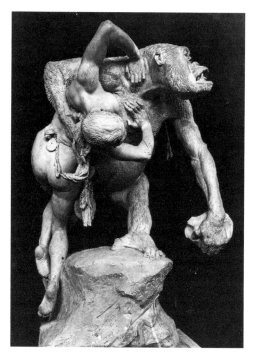

33. Emmanuel Fremiet: *Female Gorilla Carrying off a Woman* (Paris, Jardin des Piantes)

Gorilla Carrying off a Woman (plaster; see fig. 33) was refused by the jury of the Salon of 1859 but exhibited behind a curtain on the authority of the Surintendant des Beaux-Arts; it was destroyed by vandals in 1861 but is known from an old photograph (see 1988–9 exh. cat., p. 99). In his historical reconstructions, documentary study was enlivened by substantial imaginary input, whether the presentation was dramatized, as in the relief of the *Triumph of Merovée* (silver-plated bronze and copper, 1867; Paris, Mus. d'Orsay) and the *Stone Age Man* (bronze, 1872; Paris, Parc Zool.) or static, as in the *Gallic Chief* and *Roman Horseman* (both bronze), which were executed in 1866 for the Musée des Antiquités Nationales at Saint-Germain-en-Laye (*in situ*).

The adaptation of horse to rider in imaginary portraits had already been of concern to Fremiet in his army models, and in the groups for Saint-Germain-en-Laye he treated it on a larger, though

still not monumental, scale. From the mid-1870s onwards the equestrian theme came to predominate over other subjects. His *Joan of Arc* (bronze, 1874; Paris, Place des Pyramides), despite criticisms of the disproportion of horse to rider, almost immediately assumed symbolic status as an emblem of France resurgent after defeat in the Franco-Prussian War (1870). Fremiet's extreme sensitivity on the subject of proportion led him to modify the statue in 1899 to conform with a second version he had done for Nancy (bronze, 1889–90). In its final form, and gilded, the *Joan of Arc* in the Place des Pyramides shares a Symbolist preciosity of style with two other major works by Fremiet from the 1890s, *St George Defeating the Dragon* (bronze, 1891; Barentin, Mus. Mun.) and *St Michael* (bronze, 1896; Mont-Saint-Michel Abbey; replica, Paris, Mus. d'Orsay).

Fremiet continued to maintain his preoccupation with natural history, in 1872 proposing to Charles Blanc the setting up at the Palais du Trocadéro in Paris of an educational sculpture park incorporating models of prehistoric creatures. The project was not realized in the form proposed (an earlier state commission for a statue of a plesiosaurus, in 1852, had equally come to nothing), but a more decorative and allegorical version (some statues, Paris, Mus. d'Orsay) was carried out by a large number of sculptors, including Fremiet, for the Exposition Universelle of 1878 held at the Trocadéro. Fremiet's position as leading national animalier sculptor was confirmed when, in 1875, he succeeded Antoine-Louis Barye as professor of zoological drawing at the Musée National d'Histoire Naturelle in Paris. In 1876 he designed the costumes for Alexandre Mermet's opera *Jeanne d'Arc* at the Paris Opéra (designs, Paris, Bib. N.). In 1887 he exhibited at the Salon a variant of his destroyed *Gorilla* group of 1859, *Gorilla Carrying off a Woman* (plaster; Nantes, Mus. B.-A.), and in 1895 his assistant Henri Greber (1854–1941) carried out in marble his group of an *Orang-utan and Native of Borneo* (Paris, Mus. N. Hist. Nat.). Apart from the many works in public collections in Paris the most extensive representation of Fremiet's work is in the Musée des Beaux-Arts, Dijon, consisting of a

bequest made in 1955 of the master bronzes for Fremiet's statuettes used by the Barbedienne foundry.

Bibliography

Lami

T. H. Bartlett: 'Emmanuel Fremiet', *Amer. Architect & Bldg News*, xxxi (1891), pp. 72–3, 101–3, 134–7, 172–4, 201–4; xxxii (1891) 24–8, 70–72, 113–15, 129–31

J. de Biez: *Un Maître imagier: E. Fremiet* (Paris, 1896)

—: *Emmanuel Fremiet* (Paris, 1910)

P. Fauré-Fremiet: *Emmanuel Fremiet* (Paris, 1934)

The Romantics to Rodin: French Nineteenth-century Sculpture from North American Collections (exh. cat., ed. P. Fusco and H. W. Janson; Los Angeles, Co. Mus. A.; Minneapolis, Inst. A.; Detroit, Inst. A.; Indianapolis, Mus. A.; 1980–81)

La Sculpture française au XIXe siècle (exh. cat., ed. A. Pingeot; Paris, Grand Pal., 1986)

Emmanuel Fremiet: 'La Main et le multiple' (exh. cat. by C. Chevillot, Dijon, Mus. B.-A., 1988–9)

PHILIP WARD-JACKSON

Frère, (Pierre) Edouard

(*b* Paris, 10 Jan 1819; *d* Ecouen, 20 May 1886). French painter. At the age of 17 he entered the atelier of Paul Delaroche at the Ecole des Beaux-Arts in Paris. He exhibited regularly at the Salon in Paris from 1842 to 1886 and at the Royal Academy in London from 1868 to 1885. He was the younger brother of the Orientalist painter Théodore Frère (1814–88) and, unlike many other 19th-century artists, preferred not to live in Paris but in Ecouen.

Edouard Frère is known mainly for his peasant scenes, showing daily life in the country, which gained him popularity with the middle class during the Second Empire. He depicted childhood in such paintings as the *Little Cook* (1858; New York, Brooklyn Mus.), showing an interest in the traditional activities of the poor, a novel idea at that time. He specialized in small-scale genre paintings in warm colours and adhered to a narrative approach to dramatic subject-matter that was softened by a sometimes rather affected sentimentality.

Following Frère's association with the dealer Ernest Gambart in 1854, an exhibition of his work was organized in London, where the mediation of fellow artist and critic John Ruskin, who admired him, was a guarantee of success. From the 1880s his work was popular with American collectors. His pupils included George Boughton (1833–1905).

Bibliography

W. D. Conway: 'Edouard Frère and Sympathetic Art in France', *Harper's Mthly*, xliii (1871), pp. 801–14

The Realist Tradition: French Painting and Drawing, 1830–1900 (exh. cat., ed. G. P. Weisberg and others; Cleveland, OH, Mus. A.; New York, Brooklyn Mus.; Glasgow, A.G. & Mus.; 1980–81)

The Nineteenth-century Paintings in the Walters Art Gallery (exh. cat. by W. R. Johnston, Baltimore, MD, Walters A.G., 1982)

A. DAGUERRE DE HUREAUX

Froment(-Delormel), (Jacques-Victor-) Eugène

(*b* Paris, 17 June 1820; *d* Paris, 1 March 1900). French painter, designer and printmaker. He was a pupil of Jules Jollivet, Pierre Lecomte and Eugène-Ammanuel Amaury-Duval, for whom he also acted as executor. From 1857 to 1885 he worked mainly as a designer for the Sèvres manufactory. He exhibited regularly at the Paris Salon from 1842 to 1880; from 1864 he could exhibit his works at the Salon without having to undergo selection by the jury. Heavily influenced by the style of Ingres's pupils, and especially Amaury-Duval, Froment painted a *Virgin* (1846; Autun, St Jean) that recalls the contemporary work of Ingres for the stained-glass windows in the chapel of St Ferdinand at Dreux. In the same year he painted *St Peter Healing a Lame Man at the Door of the Temple* in the church at Pégomas.

Froment's genre scenes, with their pleasant, decorative symbolism, are often close to the works of Jean-Léon Gérôme and Jean-Louis Hamon, or his friend Henri-Pierre Picou (1824–95). He did many engravings to illustrate such works as Louis Ratisbonne's *La Comédie enfantine* (Paris, 1860) and Victor Hugo's *Livre des mères* (Paris, 1861). He

also did some mural decorations in the chapel of St Joseph in Autun Cathedral, as well as decorating the chapel of St Martin-les-Autun at the seminary at Autun, in collaboration with Alfred de Curzon, in 1855–6.

Bibliography

J. Rerolle: 'Eugène Froment: Artiste peintre, sa vie, son oeuvre', *Mém. Soc. Eduenne*, xxviii (1900), pp. 339–47

La Tradition d'Ingres à Autun (exh. cat. by G. Vuillemot, Autun, Mus. Rolin, 1971)

G. Vuillemot: 'Carnets d'Eugène Froment et album romain d'Amaury-Duval', *Rev. Louvre*, 6 (1972), pp. 497–8

A. DAGUERRE DE HUREAUX

Fromentin, Eugène(-Samuel-Auguste)

(*b* La Rochelle, 24 Oct 1820; *d* Saint-Maurice, 27 Aug 1876). French painter and writer. The wide skies and sweeping plains of his native Charente region left him with a love of natural beauty for which he later found affinities in Algeria and the Netherlands. From his youth he showed academic intelligence, literary talent and artistic aptitude. In 1839 he was sent to Paris to study law, but he became increasingly interested in drawing. Although his father, a skilled amateur artist who had studied with Jean-Victor Bertin, never became reconciled to his son's desire to pursue painting as a career, Fromentin was sent to study with the Neoclassical landscape painter Jean-Charles-Joseph Rémond (1795–1875); however, he preferred the more naturalistic Nicolas-Louis Cabat. Fromentin developed slowly as an artist and began to show real promise as a landscape draughtsman only in the early to mid-1840s. He published his first important piece of criticism on the Salon of 1845.

From 3 March to 18 April 1846, Fromentin made a secret visit to Algeria, to attend the wedding of the sister of the painter Charles Labbé (*fl* 1836–85). The following year he made his debut in the Salon, showing a view of the countryside near La Rochelle (England, priv. col.) and two Algerian scenes, which herald his lifelong devotion to Eastern subjects. He returned to Algeria twice for longer stays (24 September 1847 to 23 May 1848, 5 November 1852 to 5 October 1853).

Between these journeys he began to establish himself as an Orientalist, exhibiting 11 Algerian works in the 1850–51 Salon. He also made a lively but abortive effort to paint Provençal peasants on his honeymoon in 1852. Fromentin used the notes and sketches made on his second and third Algerian visits not only in paintings but also in his two travel books, *Un Eté dans le Sahara* (1857) and *Une Année dans le Sahel* (1859). His twin talents significantly enhanced his critical renown, and he became acknowledged as a leading Orientalist. At the Salon of 1859 he received a first-class medal and the Légion d'honneur, as well as praise from such avant-garde critics as Baudelaire and the young Degas.

During the 1860s Fromentin achieved considerable success. In 1863 he published his only novel, *Dominique*, in which the doomed love of the eponymous hero for a married woman reflects events in the author's own youth. The vigorous rough impasto of his early Algerian paintings, inspired by Decamps, Diaz and Marilhat, and expressing his immediate excitement, was replaced with the softer mature style of his most familar works, in which the filtering process of memory combined with his increasing technical facility. However, Fromentin was not satisfied with his successful pictorial synthesis and, in the late 1860s, made several attempts first to inject greater drama into his work, then to alter his subject-matter. *Oriental Battle Incident* (1867; Dublin, N.G.), *Land of Thirst* (c. 1869, Paris, Mus. d'Orsay; see fig. 34) and *Fantasia* (1869; Poitiers, Mus. B.-A.) all have antecedents in his own travel-books a decade earlier; but in both painting and writing Fromentin's strength lay in the still evocation of place and atmosphere rather than in the representation of action. A series of centaur paintings of 1868, inspired by a decorative commission for Prince Paul Demidov's Hôtel Païva in Paris, was greeted with critical incredulity. Fromentin subsequently shifted to painting scenes in Venice and then in Egypt, where he was invited as part of the French delegation for the opening of the Suez Canal. Lack of critical or popular enthusiasm persuaded him to return to the subjects that had

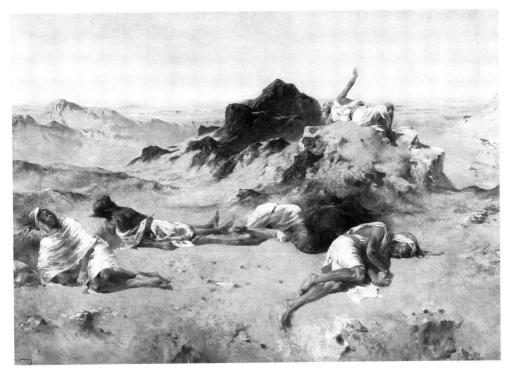

34. Eugène Fromentin: *Land of Thirst*, c. 1869 (Paris, Musée d'Orsay)

made him famous. At the 1874 Salon he exhibited two accomplished works, both entitled *Algeria Remembered* (Dublin, N.G.; Kansas City, MO, Nelson–Atkins Mus. A.).

In 1875 Fromentin made his only trip to the Low Countries, for whose art he had always felt deep empathy. The following year he published *Les Maîtres d'autrefois*, an eloquent and involved visual examination of Flemish and Dutch painting. Fromentin neglected areas then out of fashion, such as early Netherlandish art and Vermeer, concentrating on the 17th century, to which he brought the technical knowledge of a painter and an extremely refined critical intelligence. Influenced by the philosophy of Hippolyte Taine, he sought to relate the achievements of Dutch artists to their way of life and surrounding landscape, although he was equally receptive to the intangible power of Rembrandt's portraits. In 1876 Fromentin exhibited at the Salon two pic-

tures inspired by his trip to Egypt and wrote an anonymous critique of the 1876 Salon, which was published in *Bibliothèque universelle et revue suisse* in Lausanne. He died suddenly the same year from cutaneous anthrax.

The discernment that informed Fromentin's criticism often had a crippling effect on his own art, and his letters poignantly document his self-conscious struggle with a double muse. Fromentin's refined critical sense and his high classical ideals caused him to adjudge his own pictorial efforts a failure; but his romantic persistence in the struggle to produce significant work marks him out as an interesting figure. Like Gustave Moreau and Puvis de Chavannes, Fromentin was an enlightened, established artist, who did not fit the stereotyped repressive academic mould and who was just as opposed as the radical Impressionists to the Salon norms of slick finish and anecdotal content.

Writings

Les Maîtres d'autrefois (Paris, 1876; Eng. trans., Boston, 1882; London, 1913)

P. Blanchon, ed.: *Eugène Fromentin: Lettres de jeunesse* (Paris, 1909)

——: *Eugène Fromentin: Correspondance et fragments inédits* (Paris, 1912)

B. Wright and P. Moisy, eds: *Gustave Moreau et Eugène Fromentin: Documents inédits* (La Rochelle, 1972)

G. Sagnes: *Eugène Fromentin: Oeuvres complètes* (Paris, 1984)

B. Wright, ed.: *Fromentin: Correspondance générale* (in preparation)

Bibliography

L. Gonse: *Eugène Fromentin: Peintre et écrivain* (Paris, 1881; Eng. trans., Boston, 1883)

P. Dorbec: *Eugène Fromentin* (Paris, 1926)

Fromentin: Le Peintre et l'écrivain, 1820–1876 (exh. cat., La Rochelle, Mus. B.-A., 1970)

B. Wright: *Eugène Fromentin: A Bibliography* (London, 1973)

J. Thompson and B. Wright: *La Vie et l'oeuvre d'Eugène Fromentin* (Paris, 1987)

JAMES THOMPSON

Galimard, (Nicolas-)Auguste

(*b* Paris, 25 March 1813; *d* Montigny-lès-Corneilles, nr Paris, 16 Jan 1880). French painter, writer and lithographer. He was given his first art lesson by his uncle, Nicolas-Auguste Hesse, in Paris, then moved to the studio of Jean-Auguste-Dominique Ingres. According to Auvray in the *Dictionnaire général*, he also studied with the sculptor Denys Foyatier. Like a number of Ingres's pupils, Galimard was involved in decorating the newly built or newly restored churches of the July Monarchy and the Second Empire. At his first Salon in 1835 he exhibited *Three Marys at the Tomb*, a *Châtelaine of the 15th Century* and a portrait of his cousin, *Mme Lefèvre* (all untraced). The following year he exhibited one of his first attempts at glass painting, *The Queen of the Angels* (broken by a gust of wind during the exhibition), and a painting, *Liberty Leaning on Christ Flanked by the Apostles James and John* (untraced), a subject indicating sympathy with the social ideology of Charles Fourier or Saint-Simon. In 1848 and 1849 he exhibited a series of cartoons for his first major project, the decoration of the medieval church of St Laurent in Paris, then undergoing restoration by Victor Baltard. When the church was remodelled and extended in 1866–7, Galimard again supplied designs for decorating the choir. None of this remains, but his windows in the south aisle of St Clothilde, Paris, Théodore Ballu's Gothic Revival masterpiece, finished in 1859, provide a good indication of his talent for organizing areas of strong colour in large, simple shapes. According to Auvray's account, Galimard also supplied windows for St Phillipe-du-Roule, Paris, for the church at Celle-Saint-Cloud and elsewhere.

As a painter Galimard is difficult to assess: surviving paintings by him are rare. His *Supper at Emmaus* in St Germain-l'Auxerrois, Paris, is too black to see. His *Ode* of 1846 (Paris, Louvre), however, survives in good condition. This half-length figure of a muse, inspired, it seems, by Nicolas Boileau's *Art poétique* (Paris, 1674), has the soulfulness, the exaggerated purity of form, the strong local colour and enamelled finish common in the work of Ingres's followers. His *Juno* (exh. Salon 1849; Narbonne, Mus. A. & Hist.) is a more eccentric figure, sharply outlined in profile like a character on a Greek vase, with little sense of academic modelling. *Leda and the Swan* (untraced), commissioned by Napoleon III as a present for William I, King of Württemberg, and submitted by the artist to the Exposition Universelle of 1855, was refused by the jury on the grounds of its indecency. Galimard retaliated by holding a private exhibition. It reappeared at the Salon of 1857, and in 1863 Galimard exhibited a drawing of the picture.

Galimard was the author of articles and reviews in *L'Artiste*, *La Patrie* and *La Revue des deux mondes*, published under the names of 'Judex' and 'Dicastes'. He also published lithographs after his own designs for stained glass (1854; Paris, Bib. N., Cab. Est.), a life of the lithographer Hyacinthe Aubry-Lecomte and a review of the Salon of 1849. He based his criticism on the absolute superiority of religious art (pagan and

Christian), and, although not unsympathetic to Théodore Rousseau or Eugène Delacroix, he took Ingres as his ideal. His nickname, 'Pou mystique' ('mystic louse'), reflects the amused contempt felt by some of his contemporaries towards the religious and artistic idealism of Ingres's pupils.

Writings

Chapelle Saint-Paul: Peintures, murales, exécutées à la cire dans l'Eglise Saint-Sulpice, par Martin Drölling (Paris, n.d.)
Les Grands Artistes contemporains: Aubry-Lecomte (Paris, 1860)
Les Peintures murales de Saint Germain-des-Prés (Paris, 1864)

Bibliography

Bellier de La Chavignerie–L. Auvray, p. 601
B. Foucart: *Le Renouveau de la peinture religieuse en France (1800–60)* (Paris, 1987)

JON WHITELEY

Gandara, Antonio de La

(*b* Paris, 16 Dec 1862; *d* Paris, 30 June 1917). French painter, pastellist and draughtsman. He studied with Jean-Léon Gérôme at the Ecole des Beaux-Arts, Paris, from 1876 to 1881 and made his début at the Salon of the Société des Artistes Français in 1882 with a portrait of *Mlle Dufresne*. He soon became successful as a portrait painter of the aristocracy and the French élite (e.g. *Paul Escudier*; Paris, Petit Pal.). He was concerned only with the depiction of physical likeness and the rendering of elegant dress and showed little interest in the sitter's psychology or character (e.g. *Woman in Pink*, Nancy, Mus. B.-A.). He was an acute observer of the fashionable Parisian woman and often included her, along with children, in his many paintings of Paris, especially of the Jardins du Luxembourg (e.g. *Le Luxembourg*). In addition to painting in oil and pastel, he executed drawings in charcoal and pencil.

Bibliography

Bénézit; Edouard-Joseph

ATHENA S. E. LEOUSSI

Gauguin, Paul

(*b* Paris, 7 June 1848; *d* Atuona, Marquesas Islands, 8 May 1903). French painter, printmaker, sculptor and ceramicist. His style developed from Impressionism through a brief cloisonnist phase (in partnership with Emile Bernard) towards a highly personal brand of Symbolism, which sought within the tradition of Pierre Puvis de Chavannes to combine and contrast an idealized vision of primitive Polynesian culture with the sceptical pessimism of an educated European. A selfconsciously outspoken personality and an aggressively asserted position as the leader of the Pont-Aven group made him a dominant figure in Parisian intellectual circles in the late 1880s. His use of non-naturalistic colour and formal distortion for expressive ends was widely influential on early 20th-century avant-garde artists.

1. Life and work

(i) To 1882. His father, Clovis Gauguin, worked on the *National*, a paper with liberal leanings. In 1846 he had married Aline Chazal, whose parents were the engraver André Chazal and Flora Tristan (1803–44), a French socialist writer close to Pierre Joseph Proudhon and George Sand. Flora Tristan's personality, so deeply involved with social struggle that she had acquired mythic status, her egocentricity and her ceaseless travelling prefigure many aspects of her grandson's character. She was the natural daughter of a Peruvian nobleman, Don Mariano Tristan Moscoso, and when Gauguin constructed his image of the 'untamed' artist he often referred to this exotic ancestry. When the revolution of 1848 brought Louis Napoleon to power, Clovis Gauguin, fearing a return to the imperial regime, decided to set off with his family for Lima, where he intended to found a newspaper, but during the crossing he died of a heart attack. Aline Gauguin continued the journey, in order to seek protection for herself and her two children with her uncle, Don Pio Tristan Moscoso.

Until 1855 Gauguin lived the life of a pampered child on his great-uncle's estate in Lima. Then he returned to France where an inheritance allowed

his mother to settle first in Orléans, native city of the Gauguin family, and then in Paris. Gauguin pursued his studies but was an indifferent student and at the age of 17 joined a cargo ship sailing between Le Havre and Rio de Janeiro. In 1867 his mother died, leaving the financier Gustave Arosa as guardian of her children. A collector and photographer, friend of Nadar and Camille Pissarro, Arosa was to have a considerable influence on the young Gauguin. Like many collectors at the end of the 19th century, Arosa was attracted to the French painters of the 1830 generation, and he had put together a remarkable collection, including 16 works by Delacroix and numerous paintings by Corot, Courbet and the Barbizon school. It was in this context that Gauguin first became enthusiastic about painting, which he practised as an amateur with Marguerite Arosa, his guardian's daughter. In 1871 Arosa obtained a position for Gauguin as a stockbroker with a bank. The substantial income he earned in this new post removed any anxiety about money, and in 1873 he married Mette-Sophie Gad, a young Danish woman who bore him five children.

Painting began to occupy an increasingly important place in Gauguin's life, thanks to a series of different people. By 1872 he was regularly visiting Emile Schuffenecker, who like himself worked in a bank and was also a painter. The following year he met the Norwegian painter Frits Thaulow, his wife's brother-in-law. Gauguin visited the First Impressionist Exhibition (April–May 1874) and witnessed the stir it caused in the press and in public opinion. However, it was his meeting with Pissarro that proved the decisive catalyst for his artistic development: probably introduced by Arosa, he was in touch with Pissarro by June 1874 and worked with him at the Académie Colarossi in Paris. Several times during the course of his career Gauguin paid homage to Pissarro who was both a generous teacher and someone who made him appreciate the reality of the struggles faced by avant-garde artists. On his recommendation, Gauguin bought some Impressionist paintings, showing a preference for Cézanne (e.g. *The Castle of Médan*, *c.* 1880; Glasgow, Burrell Col.) and thus becoming one of his earliest admirers. Pissarro also drew him into the Impressionist circle. Gauguin, who had already exhibited a landscape at the official Salon in 1876, participated in their group exhibitions from 1880 onwards.

Gauguin's early works before about 1878 are in a muted Impressionist style, not yet free of a greyish tonality, which was sometimes reminiscent of the Barbizon school (e.g. *Glade*, 1874; Orléans, Mus. B.-A.) and sometimes of the urban landscapes of Stanislas Lépine (*The Seine by the Pont d'Iéna*, 1875; Paris, Mus. d'Orsay). His meeting with Pissarro encouraged him to adopt a more clearly stated luminosity and it liberated his use of colour in landscapes whose compositions were sometimes inspired by Cézanne (e.g. *The Gardeners of Vaugirard*, 1879; Northampton, MA, Smith. Coll. Mus. A.). Gauguin, Pissarro and Cézanne painted together in Pontoise in 1881. Gauguin's interiors and still-lifes on the other hand were more influenced by Degas, as can be seen in *Suzanne Sewing* (1880; Copenhagen, Ny Carlsberg Glyp.). When it was shown in 1881 at the sixth Impressionist exhibition, this work, a resolutely unidealized study of the female nude, aroused the enthusiasm of J.-K. Huysmans who wrote: 'among contemporary painters who have studied the nude, none has yet given such a vehement note to reality'.

(ii) **1883–7.** Following the stock-market crash of 1882, Gauguin lost his bank job. Having no income, he envisaged supporting himself by his painting and took his family from Paris to Rouen and then to Copenhagen, where he worked as a salesman for a canvas manufacturer. He spent a miserable year in Denmark in 1885: neither his parents-in-law, who took the couple in, nor the Danish public appreciated Impressionist painting. Gauguin organized an exhibition of his work, which the Danish Academy forced to close after five days. He returned to Paris a bitter man in June 1885, accompanied by his son Clovis. He was leading a wretched life at that time despite financial support from Schuffenecker. Nonetheless, he continued to paint and in 1886 made the acquaintance of the ceramicist Ernest Chaplet, with whom he then collaborated, for example, on producing

a glazed stoneware vase decorated with Breton girls (1886–7; Brussels, Mus. Hôtel Bellevue, see Bodelsen, fig. 9).

Almost penniless, Gauguin took the advice of the Breton painter Felix Jobbé-Duval to seek a less stressful life in the Breton village of Pont-Aven. He went to live there in mid-July 1886, basing himself at the Pension Gloanec. Gauguin's first stay in Brittany, which lasted five months, did not bring about any radical change in his art: he was still painting in the Impressionist technique of divided tones. However, there was distinct progress in his mastery of form at this time: there was a more conscious stylization of figures and landscape elements, and his compositions became both better ordered and more daring (e.g. *Washerwomen at Pont-Aven*, 1886; Paris, Mus. d'Orsay). According to evidence collected by Charles Chassé, Gauguin frequently talked about synthesis during his first stay in Brittany. He was perhaps developing in conversation the 'synthetic notes' he had written shortly before in Rouen or Copenhagen. At this time the method Gauguin was advocating consisted of making sketches, copies and studies from many different sources and reassembling them in the finished work, a process utterly opposed to the Impressionist *plein-air* painting that had originally inspired him. He was also aiming to produce work in which the colour of Impressionism was allied to the harmony of Puvis de Chavannes. This is what he sought to achieve in a series of pictures produced in Martinique on a visit in 1887 with the painter Charles Laval (1862–94). In *Tropical Vegetation* (1887; Edinburgh, N.G.), the composition, formed by large patches of brilliant colour whose chalky texture is reminiscent of mural paintings, is enlivened by vibrant parallel brush-strokes recalling Cézanne.

(iii) 1888: Pont-Aven and Emile Bernard. During his second stay in Pont-Aven, Gauguin reached full stylistic maturity. He returned to the Pension Gloanec in February 1888, and in August he was again in touch with Emile Bernard; Gauguin was then 40, Bernard 20. The two artists had first met two years earlier but had not worked together then, nor even exchanged ideas. However, on this occasion, Gauguin, influenced by Bernard's aesthetics, made the most decisive stylistic change of his career.

After 1887 Emile Bernard had distanced himself from the Seurat-inspired Neo-Impressionism he had previously been practising, so that with Louis Anquetin he could elaborate a new way of constructing pictorial space, which consisted of covering the picture surface with large patches of flat colour, bounded by a clearly marked line, similar to the leading of stained glass (e.g. Bernard's *The Rag-pickers: Iron Bridges at Asnières*, 1887; New York, MOMA). It is probable that Gauguin was already familiar with these experiments, having returned to Paris from Martinique in November 1887 and having seen the exhibition at a restaurant in the Avenue de Clichy organized by Vincent van Gogh, which included cloisonnist paintings by Bernard and Anquetin. However, the works Gauguin executed in Pont-Aven before Bernard arrived, even if they reflect the growing influence of Japanese prints, were not properly speaking cloisonnist (e.g. *Young Boys Wrestling*, 1888; priv. col., see Rewald, p. 173). It was in August 1888 that, impressed by Bernard's painting *Breton Women in the Meadow* (Paris, Mus. d'Orsay), Gauguin reworked its stylistic features into a picture that marks both his adherence to Cloisonnism and his development beyond it into Symbolism: the *Vision after the Sermon: Jacob Wrestling with the Angel* (1888; Edinburgh, N.G.; see col. pl. XVII). In his *Souvenirs inédits* (1943), Bernard stated:

> Gauguin had simply put into practice not the colour theory I had told him about, but the essential style of my *Breton Women in the Meadow*, having first laid in a completely red ground in place of my yellowish-green one. In the foreground, he put my large figures with the monumental head-dresses worn by châtelaines.

Even if it is true that Gauguin borrowed from Bernard the general arrangement of his composition, as well as the monochrome ground, his motive for using these elements was quite different. While Bernard was mainly concerned with a

formal stylistic experiment—to present a complex decorative arrangement— Gauguin was bent on depicting the image a sermon creates in the minds of those who hear it. The originality of the *Vision after the Sermon* lies in the fact that the imaginary scene of Jacob wrestling with the angel is located on the same plane as the real people, while at the same time it is separated by the trunk of an apple tree, which bisects the composition diagonally. The colour, more muted than in Bernard's work, is marvellously attuned to the spirit of the scene. Gauguin wrote about it to van Gogh: 'I believe I have achieved in these figures a great rustic and superstitious simplicity.' The painting has inspired numerous interpretations. The 'seers' at prayer have been contrasted with the excluded 'non–seers' set aside on the upper left. The physical resemblance between the preacher and Gauguin has led critics to see the work as an image of how the mystery of art may be revealed by an inspired painter. It was on this picture that in 1891 the critic Georges-Albert Aurier based his famous definition of pictorial symbolism: *Le Symbolisme en peinture: Paul Gauguin.* Pissarro saw the *Vision after the Sermon* as marking Gauguin's definitive break with Impressionism. He wrote to his son Lucien: 'I criticize him for not applying his synthesis to our modern philosophy, which is absolutely social, anti-authoritarian and anti-mystical.' (20 April 1891).

In late September 1888 Gauguin met Paul Sérusier in Pont-Aven and the following month instructed him how to paint landscape in the new technique of simplified forms and flat colour patches. The result was *The Talisman* (Paris, Mus. d'Orsay), which Sérusier took back to Paris, where it had a decisive impact on his contemporaries at the Académie Julian, notably Pierre Bonnard, Maurice Denis, Edouard Vuillard and Paul Ranson, who were to form the Nabis. Not only did the Nabis copy Gauguin's way of organizing the picture surface and subjective palette, but his quasi-mythical personality was of exemplary value in their eyes.

(iv) 1888: Arles and van Gogh. While he was at Pont-Aven, Gauguin received insistent requests from Vincent van Gogh and his brother Theo to join Vincent in Arles, where he had recently gone to live. In exchange for coming to the aid of his brother, whose mental health was already failing, Theo undertook to help Gauguin financially by buying his work. For van Gogh, also in search of exoticism, Arles represented an imaginary Japan. He hoped to set up a studio there that would attract numerous other artists. Gauguin, whom he had admired ever since their first meeting in Paris in 1887, would have been its leader.

Giving in to these appeals, Gauguin reached Arles in October 1888. For two months, the two artists lived under the same roof, endlessly discussing artistic theories and working together, out of doors and in the studio. Even in the first letters he wrote to Bernard at the beginning of his stay, Gauguin seemed already to have decided to distance himself from van Gogh, whose fiery but introverted personality hardly seemed destined to accord with his. Their tastes also differed profoundly, Gauguin wrote: 'Vincent can see Daumiers to do here, while I on the other hand, see coloured Puvis to do, mixed with Japan.' This brief partnership of two exceptional artists is one of the most famous episodes in the history of art: van Gogh's mental health rapidly deteriorated, and he was pushed to the limit of his endurance by discussions in which he and Gauguin never stopped contradicting each other, and by the impossibility of realizing his dream of a 'studio in the south'; during the night of 23 December, he cut off his left ear, having first threatened his companion with a razor-blade. This was the grotesque and tragic end of an association on which van Gogh had set all his hopes. Three days later Gauguin returned to Paris.

Did Gauguin's stay in Arles, as he complacently noted in *Avant et après*, only benefit van Gogh? In contrast to Gauguin's relationship with Bernard some months earlier, the reciprocal influence of Gauguin and van Gogh, clearly evident in work by them both, did not produce any definitive stylistic upheaval. If it is true that the surface treatment of a painting such as *Gathering Grapes at Arles: Human Misery* (1888; Zurich, priv. col.;

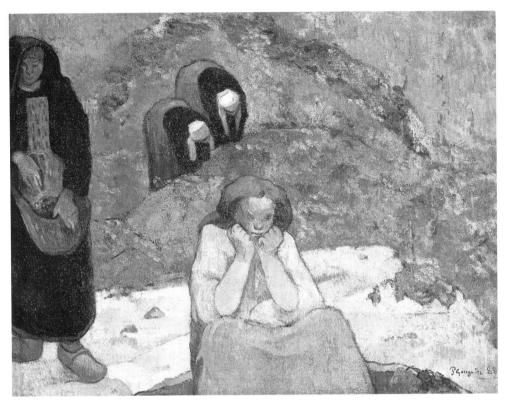

35. Paul Gauguin: *Gathering Grapes at Arles: Human Misery*, 1888 (Zurich, Private Collection)

see fig. 35) shows the heavy impasto of van Gogh, Gauguin's Arles series, with its supple animated forms, is really an epiphenomenon in his work.

(v) 1889–91: Pont-Aven, Le Pouldu, Paris. The two years preceding Gauguin's departure for Tahiti (1891) were marked by frequent trips between Brittany, where he sought to discover new landscapes at the Avens and Le Pouldu, and Paris, where he entered Symbolist literary circles. In January 1889 he stayed with Schuffenecker before returning to Pont-Aven in April. He was invited to exhibit with Les XX in Brussels, but when his 12 submissions were not received as enthusiastically as he had anticipated, he decided not to go to Belgium. At the end of May he was again in Paris, drawn there by the opening of the Exposition Universelle and preparations for the Impressionist and Synthetist painters' exhibition. When the jury of the Exposition Universelle refused to hang the work of Gauguin and his friends, Schuffenecker organized a group exhibition at the Café Volpini on the Champ de Mars, not far from the official art pavilion. Gauguin, Bernard, Laval, Anquetin and Georges-Daniel de Monfreid all took part. Gauguin intervened with Schuffenecker to exclude the Neo-Impressionists (Georges Seurat, Paul Signac, Henri-Edmond Cross and Pissarro), which indicates a new-found awareness of his stylistic identity and his role as the leader of a school, which he insisted on playing from then on. Despite the unquestioned novelty of the works shown, which should at least have ensured a *succès de scandale*, the exhibition was a failure. The national press remained silent and only a few literary friends, such as Félix Fénéon, gave it brief coverage.

Disappointed by this new setback, Gauguin again set off for Brittany at the beginning of the summer, accompanied by Paul Sérusier. Pont-Aven, increasingly invaded by painters, disgusted him, and he took refuge for the winter in Le Pouldu. During this period, the Dutch painter Jacob Meyer de haan worked with him. Gauguin's hatred for anything over-sophisticated, and his search for ever wider horizons, were the signs not just of an inherent instability but also of a frequently expressed desire to safeguard the primitive nature of his art. By December 1889 he was dreaming of leaving for Tonkin and then Madagascar: 'The West is now in a state of decay', he wrote to Bernard.

In 1889–90, even while he was experiencing a succession of failures, Gauguin was gradually gaining considerable notoriety among avant-garde intellectuals who found in his painting an echo of their own preoccupations. During his spells in Paris, he visited Stéphane Mallarmé and his 'Tuesday' group in the Rue de Rome and befriended Aurier, Charles Morice and Jean Moréas. The *Loss of Virginity* (1890–91; Norfolk, VA, Chrysler Mus.), probably painted in Paris just before he left for Tahiti, represents the culmination of an esoteric tendency that characterizes this period. The synthetist stylization is pushed to extremes: for the first time, the landscape is strictly ordered by emphasis on the horizontal to which even a cloud, portrayed as a long pale wisp, must submit. The shape of the cloud is echoed in the foreground by the barely pubescent body of a young girl with her limbs held rigid after a clumsy attempt at defloration. Against her breast she clutches a fox, 'the Indian symbol of perversity' according to Gauguin. As in the *Vision after the Sermon*, the artist artificially juxtaposes two distinct planes in one continuous space. The symbolic foreground appears as the unconscious echo of a real event shown in the distance: a Breton wedding advancing through the countryside. Religious feeling, explicit even in the title of *Jacob Wrestling with the Angel*, is expressed here by a network of more complex symbols, revealing a pagan vision of stages of existence characterized by anxiety and mystery. This search for the primeval emotion of mankind in ritual links Gauguin with Symbolist artists who were rediscovering legend and myth at this time.

(vi) 1891–3: First visit to Tahiti. While in Le Pouldu during the autumn of 1890, Gauguin made the decision to set off for Tahiti and put all his energy into carrying out this plan. On his return to Paris at the beginning of 1891, Gauguin organized an auction of his paintings in order to raise sufficient funds for his departure. A major event in the world of art and literature, this sale, for which Octave Mirbeau wrote the catalogue introduction, was a success. A benefit evening at the Théâtre des Arts was also organized for him, as well as a farewell banquet presided over by Mallarmé. At that point, Gauguin could legitimately have claimed fame and hoped that his return (for his letters show that he did not intend to remain in Tahiti indefinitely) would be the triumph he had so long awaited.

In June 1891 he arrived in Papeete in French Polynesia, after a two-month voyage. On being confronted with the reality, his illusions rapidly dissolved: the revelation he had expected from contact with an imaginary Eden never came, and the numerous expatriates who inhabited Tahiti created a parody of Europe. His constant moving from place to place was evidence of his dissatisfaction. By the summer he was at Mataiea, having spent several months at Pacca. During the first few months of his stay, he amassed what he thought of simply as studies. He wrote to Sérusier in November 1891: 'Not a single painting yet, but masses of research which may prove fruitful; any number of documents which will be useful for a long time, I hope, back in France.' It was not until June 1892 that his letters indicated real confidence in his work. Such paintings as *Vahiné no te tiare* ('Woman with a flower') (1891; Copenhagen, Ny Carlsberg Glyp.) were still reminiscent of Cézanne, but by 1891 Gauguin was already producing several works showing a new boldness, such as *Women of Tahiti* and *Nafea Faaipoipo (When Are You Getting Married?)* (both 1892; Paris, Mus. d'Orsay; see figs 36 and 37) in which the abbreviated forms can be read as a jigsaw of

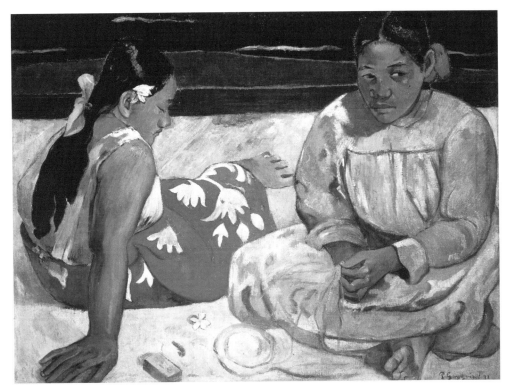

36. Paul Gauguin: *Women of Tahiti*, 1892 (Paris, Musée d'Orsay)

coloured patches, and traditional modelling was reduced to a strict minimum.

In Tahiti Gauguin made considerable progress with his sculpture and woodcuts. He borrowed unashamedly, often copying poses from photographs of other works. In Tahiti this process became quasi-systematic. It is apparent in his small-scale wooden sculptures in which the artist blended Oceanic sculpture and iconography often borrowed from Asiatic art. Thus *Idol with Pearl* (1894; Paris, Mus. d'Orsay), which shelters in a gilded niche a sort of Buddha inspired by the reliefs at Borobudur, shows on its other face two Oceanic *Ti'i* figures (anthropomorphic wooden images), very much like those Gauguin would have seen around him. This assimilation of two cultures shows that Gauguin was in search not of local colour but of a primitive religious spirit, which he believed inseparable from a certain crudity of

workmanship. This roughness is also found in his woodcuts (e.g. *Manao tupapau* ('Watched Over by the Spirit of the Dead'), *c.* 1891–3; Paris, Mus. A. Afr. & Océan., which appeared in large numbers between 1891 and 1893, most of them on themes already treated in his paintings. Gauguin was eager to submit his increasingly 'untamed' style to European judgement. In June 1892, sick and destitute, he asked to be repatriated to France, but he did not leave Tahiti until June of the following year.

(vii) 1893–5: Return to France. As soon as he arrived in Paris, Gauguin became intensely active. He inherited some money, which gave him enough to live on. At Degas's instigation, Paul Durand-Ruel suggested giving a one-man exhibition of his work from Tahiti, for which Gauguin made feverish preparations until November. He saw himself as

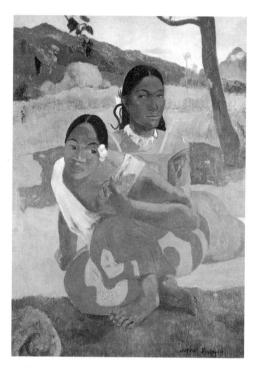

37. Paul Gauguin: *Nafea Faaipoipo (When Are You Getting Married?)*, 1892 (Paris, Musée d'Orsay)

permanently on show and affected an ostentatious exoticism verging on the theatrical. His studio became an Oceanic junk-shop, and he took as his mistress a Parisian mulatto, nicknamed Anna the Javanese.

Because the manner in which he drew attention to his artistic beliefs, however genuine, was crude, Gauguin was often dismissed as a charlatan. Attempts to explain and justify his attitude only met with incomprehension. In Tahiti he had written a text that became *Noa-Noa*, in which he related his discovery of the island and its religious traditions. With the help of Charles Morice, who interspersed the text with his own poems, Gauguin put the work into shape, with the intention of having it published, believing it would help people to understand his painting. (It first appeared in the *Revue blanche* in October 1897.) Despite these justifications of his work, his exhi-

bition at Galerie Durand-Ruel in Paris was received with no more than a certain respect. Preoccupied with promoting his work, Gauguin painted little. He produced a few paintings on Tahitian subjects, such as *Mahana no atua* ('Day of God') (1894; Chicago, IL, A. Inst.). At Pont-Aven, from May 1894, his colour acquired a new acidity (e.g. *David's Mill at Pont-Aven*, 1894; Paris, Mus. d'Orsay) and he painted some snow scenes (e.g. *Breton Village in the Snow*, 1894; Paris, Mus. d'Orsay).

It seems that during this period Gauguin set out to compromise the success he could have achieved if he had only been more patient. In Brittany he brought an unsuccessful lawsuit against the innkeeper Marie Henry in order to recover some pictures he had left with her. He had a brawl with some sailors and was forced to stay in hospital with a broken leg. During this time, Anna the Javanese ransacked his Paris studio. Discouraged by the failure of his exhibition and continued humiliation, he decided in September 1894 to leave France permanently. In February 1895 he organized another auction, which he hoped would raise enough money to finance his departure. The catalogue introduction comprises a text by August Strindberg, frankly unfavourable to Gauguin, and the latter's reply, in which once again he extols his 'untamed' aesthetic. Of forty-seven pictures shown, only nine were sold: the failure was self-evident.

(viii) 1895–1901: Papeete. If his letters are to be believed, Gauguin's second departure for Oceania was undertaken in a different frame of mind from his first. It was not just a farewell to 'the European way of life' in the hope of seeing his family again one day, but also to his artistic career. Above all it was peace of mind that he sought in exile: 'I would be able to end my days free and at peace with no thought for tomorrow and without having to battle endlessly against idiots. Farewell painting, except as a distraction.' On his arrival in Papeete in September 1895 he did not find the restfulness he had counted on: his poor health forced him to stay in hospital and his savings ran out. Nonetheless it was a period of intense creativity, during which he painted and sculpted a great deal

and seemed to go further in his metaphysical questioning, obsessed by the thought of death: he wrote *L'Esprit moderne et le catholicisme*. Periods of great energy alternated with inactivity for the rest of his life. In April 1897 he learnt of the death of his daughter Aline, to whom he was deeply attached. It seems it was this event that made him decide to commit suicide. He embarked on a picture that represents his last will and testament: *Where do we come from? Who are we? Where are we going?* (1897; Boston, MA, Mus. F.A.). Painted on hessian sacking, this vast picture, hastily finished in many places, represents in his work a new surface ruggedness, which with its more spontaneous handling influenced his future output. Gauguin reused a number of individual figures and groups from his earlier pictures, transforming *Where do we come from?* into a kind of résumé of his work. The figures in the foreground, symbolizing the successive ages of an Edenic existence, are counterbalanced by three figures in the background wearing dark clothes, images of the anguish inherent in religion or knowledge. Gauguin juxtaposed the two sides of his personality, one carelessly turned towards sensuality, and the other towards a profound existential anxiety. Thus this work constitutes the concluding synthesis of his Tahitian pictures on religious themes, such as *Te tamari no atua* ('Birth of Christ, Son of God') (1896; Munich, Neue Pin.), a series that culminates in the scepticism embodied in the questions of the title.

Gauguin tried unsuccessfully to kill himself by taking arsenic. Physically and morally shaken, he took an office job in Papeete, which allowed him to earn a living for a while. He seemed to become detached from his own work. When Maurice Denis wrote to him asking if he would participate in an exhibition of the Nabis in Paris, he replied in June 1899 'I no longer paint except on Sundays and holidays'. No painting by him dated 1900 is known. On the other hand, he expended a great deal of energy bickering with the island's administrative authorities, and he worked on a satirical paper in Papeete, *Les Guêpes*, before founding his own publication *Le Sourire: Journal méchant*, which he edited and illustrated with woodcuts.

(ix) **1901–3: The Marquesas.** Gauguin's career can be summarized as the pursuit of an ideal constantly belied by reality. Unsatisfied, he felt the need of new discoveries. He left Tahiti for the island of Hiva Oa in the Marquesas at the end of 1901, seeking a primitive world, unspoilt by any contamination from Europe. The impact of this other world, wilder because, as it seemed, less overrun by colonization, prompted a period of enthusiasm that despite his deteriorating health drove him to produce his last series of works. His financial worries were eased by de Monfreid (his most assiduous correspondent in the final years), the Paris dealer Ambroise Vollard, and the collector Gustave Fayet.

Gauguin was once more attracted to sculpture. Of particular interest are the roughly carved wooden reliefs with which he decorated the doorway of his new hut, the *Maison du jour* (1901; Paris, Mus. d'Orsay). His painting evolved towards a greater sobriety and a linear treatment of form that gives his late work an austere appearance. In *Savage Tales* (1902; Essen, Mus. Flkwang), the thinly applied paint barely conceals the canvas, and in many places the weave shows through. Gauguin superimposed formal ideas already present in earlier works by bringing together two Tahitian nudes and a sinister image of his distant friend Meyer de Haan, half-faun, half-cloven-hoofed-devil, but concentrated the composition, re-linking the separated figures by his use of a decorative ground. He also explored a theme treated during his first visit to Tahiti and central to his art: the contrast between savage innocence and civilized knowledge. Although this group of late works is evidence of a stylistic renewal, Gauguin died no longer expecting his work to be recognized or appreciated, though retaining a keen awareness of the liberating role that his painting would play for the next generation.

2. Working methods and technique

Starting with relatively banal Impressionist techniques, Gauguin evolved towards an increasingly personal treatment of form and colour, and he adapted his technique to new requirements. According to Henri Delavallée (*fl* 1892–6), a painter

who knew Gauguin when he first stayed at Pont-Aven, Gauguin was endeavouring, under the influence of Pissarro, to use Divisionism: 'I only paint with sable brushes . . . ; that way the colour stays thicker: when you use ordinary brushes, two adjacent colours get mixed up; with sables you get juxtaposed colours', he said. In this way he obtained iridescent brushstrokes, which side by side give the stripy effect mentioned by Delavallée. In *Still-life with Ham* (1889; Washington, DC, Phillips Col.), Gauguin organized the whole surface into broad vertical hatching, creating a top paint layer that was homogeneous and fairly thick. From 1892 the vertical stripes became more and more discreet. Then the artist, who was increasingly composing his works with patches of colour bounded by blue outlines, tended to use thinner paint and showed sensitivity to the matt effects obtained by large areas of colour on a canvas whose weave sometimes remained visible (e.g. *Nave nave mahana* ('Days of Delight'), 1896; Lyon, Mus. B.-A.). This tendency increased with time, and in the works from his second visit to Tahiti Gauguin conceived painting in terms of colour alone, to which effects of texture became subordinate; thin impasto, extreme sobriety of unvarnished surface, all bore similarities to the art of mural painting.

Gauguin's attitude to his subject soon set him apart from the Impressionists. Even though he may have completed a canvas out of doors, his starting-point still remained the study produced in his studio from preliminary drawings, a process attested to by his reuse of identical figures in different works. Even in the elaboration of his work, Gauguin remained entirely traditional. An unfinished oil painting on paper, *Tahitian Women Resting* (1894; London, Tate), makes clear how he drew his composition in charcoal very precisely, outlining his figures quite clearly before starting to paint.

In the field of engraving and sculpture, it is important to stress Gauguin's fondness for the most primitive techniques, which correlates with the deliberate 'savagery' of his art. He favoured processes in which the artist's hand was clearly visible in the finished work: thus wood was his favourite material for sculpture, and woodcut his preferred graphic medium. Even in 1880, when his work was still academic, he was already attracted by this material (e.g. the *Birth of Venus*, wood, *c.* 1880; Geneva, Petit Pal.). However, it was most probably modelling in clay that had the greatest effect on his conception of sculpted form. In the pots he made after 1886 with Chaplet, Gauguin worked the clay as a sculptor, and for the usual thrown forms he substituted a strange and personal vocabulary, partly inspired by Pre-Columbian art. Gauguin's early ceramics seem to have led him to adopt a clearer stylization of form in his paintings. The sculptures and woodcuts made in Tahiti owe their primitive roughness to the extreme economy of means employed. In his woodcuts, Gauguin created effects of astonishing novelty from oppositions of black and white and the use of the woodgrain (e.g. *Be in Love and You Will Be Happy*, *c.* 1893–5).

3. Reputation and influence

Although Gauguin is seen as a Symbolist, his place in the art of his own time as assessed by the critics and art historians of the first half of the 20th century is not without a certain ambiguity. He had turned his back on Impressionism by 1888, yet he remained historically linked to the movement and for this reason figured in various works and exhibitions devoted to it. Moreover, Gauguin's artistic descendants at the beginning of the 20th century did not take up the Symbolist aspect of his work. At the same time, modernist critics, and Fénéon in particular, considered Symbolism residual to Gauguin's strictly pictorial preoccupations, and they attempted to isolate him from his period and the circle with which he was involved.

Gauguin's attitude towards his own work was clear: for him, the relationship between a subject and how it was treated pictorially was of crucial importance. He used colour as an emotional and symbolic language, but at the same time a fascination with the supernatural and with metaphysical inquiry were constant features of his thought. Studies have underlined the influence of theosophy on his work: occultism was widespread among the intellectuals with whom he was friendly. Although his independent nature

distanced him from established groups such as the Rosicrucians, Gauguin was familiar with the esoteric writing of Joséphin Peladan, Eliphas Lévi and Edouard Schuré. Because of this, his creative approach cannot be dissociated from the symbolic system on which it relied. For example, he was fascinated by the Buddha figure, which appears in numerous of his paintings and sculpture (e.g. *Savage Tales*). However, his recourse to the model of Asiatic art should be seen not as a simple formal borrowing but as an attempt to give his work a wider spiritual resonance from its earliest conception. In short, if Gauguin belonged to the Symbolist movement by virtue of his focus of interest and even his approach, it should be emphasized that his Symbolism was never the simple transposition of a given idea into paint.

Gauguin held an extraordinary fascination for the Parisian avant-garde and especially for the Nabis, who considered him their spiritual father. Gauguin influenced other leading early 20th-century artists, apart from those who were in direct contact with him. The stylistic changes that determine the maturity of Munch at the time of his stay in Paris in 1889 were probably a result of the discovery of paintings by Gauguin. Likewise the young Picasso owed his change of direction at the end of 1901, which led to his 'blue period', to the influence of the paintings by Gauguin seen at the house of his friend Paco Durio, or at Vollard's. Between 1904 and 1910, Matisse was the artist who came closest, as much in form as in spirit, to Gauguin's aesthetic. A work such as Matisse's *Luxury* (1907; Paris, Pompidou) illustrates the stylistic ties that bound the Fauves (André Derain, Maurice Vlaminck, Albert Marquet and Matisse) to Gauguin, from whose work they, like the German Expressionists (Alexei Jalenski, Ernst Kirchner, Otto Müller, Max Pechstein), retained an expressive use of colour and linear distortion. The Gauguin retrospective at the Salon d'Automne of 1906 in Paris brought home to a wide circle of avant-garde artists the full extent of his genius.

Gauguin was naturally not the only source of inspiration for the revolutionary developments in Western art at the beginning of the 20th century; he shared this role with Cézanne and van Gogh.

Nevertheless, while it is difficult to establish the relative importance of their influence, it must be said that Gauguin's work provided inspiration for the widest variety of artists.

Writings

J. Rewald and R. Cogniat, eds: *Notes synthétiques* (c. 1886) (Paris, 1963) [facs. of sketchbook]
Ancien culte mahorie (c. 1892–3), notes by R. Huyghe (Paris, 1951) [facs. of illus. MS.]
'Noa-Noa, voyage de Tahiti', *Rev. Blanche* (15 Oct 1897); as book (Berlin, 1926/R Stockholm, 1947) [facs. of c. 1893–4 MS., Paris, Louvre]
Le Sourire: Journal méchant (Paris, 1952) [facs. of per. pubd by Gauguin in Papeete, 1899–1900]
Avant et après (Leipzig, 1918 [facs. of 1903 MS.], rev. Paris, 1923/R Copenhagen, [1951]); abridged Eng. trans. as *The Intimate Journals of Paul Gauguin* (New York, 1921)
Lettres de Gauguin à sa femme et à ses amis, ed. M. Malingue (Paris, 1946)
V. Merlhès, ed.: *Correspondance de Paul Gauguin, documents, témoignages*, i (Paris, 1984) [1873–88]

Bibliography
monographs and catalogues

J. de Rotonchamp [Brouillon]: *Paul Gauguin* (Weimar, 1906; Fr. trans., Paris, 1925)
C. Morice: *Paul Gauguin* (Paris, 1920)
M. Guérin: *L'Oeuvre gravé de Gauguin*, 2 vols (Paris, 1927)
H. Perruchot: *La Vie de Gauguin* (Paris, 1948, rev. 1961)
C. Chassé: *Gauguin et son temps* (Paris, 1955)
C. Gray: *Sculpture and Ceramics of Paul Gauguin* (Baltimore, 1963)
M. Bodelsen: *Gauguin's Ceramics* (London, 1964)
G. Wildenstein: *Gauguin: Catalogue*, i (Paris, 1964) [ptgs]
C. Chassé: *Gauguin sans légendes* (Paris, 1965)
Gauguin and the Pont-Aven Group (exh. cat., London, Tate, 1966)
F. Cachin: *Gauguin* (Paris, 1968, rev. 1988)
F. Agustoni and G. Lari: *Catalogo completo dell'opera grafica di Paul Gauguin* (Milan, 1972)
G. M. Sugana and G. Mandel: *L'opera completa di Gauguin* (Milan, 1972) [update of Wildenstein]
B. Thomson: *Gauguin* (London, 1987)
M. Hoog: *Paul Gauguin: Life and Work* (New York, 1987)
E. Kornfeld and E. Morgan: *Paul Gauguin* (Berne, 1988) [cat. rais.]
The Art of Paul Gauguin (exh. cat. by R. Bretell and others, Washington, DC, N.G.A.; Chicago, A. Inst.; Paris, Grand Pal.; 1988–9)

specialist studies

G.-A. Aurier: 'Le Symbolisme en peinture: Paul Gauguin', *Mercure France* (March 1891), p. 155; repr. in *Oeuvres posthumes* (Paris, 1893)

'Gauguin, sa vie, son oeuvre', *Gaz. B.-A.*, n.s. 6, li (1958) [issue devoted to Gauguin]

S. Lövgren: *The Genesis of Modernism: Seurat, Gauguin, van Gogh and French Symbolism in the 1880s* (Stockholm, 1959, rev. 2/1971)

B. Danielsson: *Gauguin Söderhavsar* [Gauguin in the South Seas] (Stockholm, 1964; Eng. trans., London, 1965)

M. Bodelsen: 'Gauguin the Collector', *Burl. Mag.*, cxii (1970), pp. 590–615

M. Roskill: *Van Gogh, Gauguin and the Impressionist Circle* (London, 1970)

H. R. Rookmaaker: *Gauguin and 19th Century Art Theory* (Amsterdam, 1972)

H. Dorra: 'Munch, Gauguin and Norwegian Painters in Paris', *Gaz. B.-A.*, n.s. 6, lxxxviii (1976), pp. 175–80

M. Herban: 'The Origin of Paul Gauguin's *Vision after the Sermon: Jacob Wrestling with the Angel*', *A. Bull.*, lix/3 (Sept 1977), p. 415

V. Jirat Wasiutyński: *Paul Gauguin in the Context of Symbolism* (New York and London, 1978)

——: 'Paul Gauguin's Paintings, 1886–91: Cloisonism, Synthetism and Symbolism', *RACAR*, ix/1–2 (1982), pp. 35–46

J. Teilhet-Fiske: *The Influence of Polynesian Cultures on the Works of Paul Gauguin* (Ann Arbor, 1983)

C. Boyle-Turner: *The Prints of the Pont-Aven School: Gauguin and his Circle in Britanny* (Washington, DC, 1986)

B. Braun: 'Paul Gauguin's Indian Identity: How Ancient Peruvian Pottery Inspired his Art', *A. Hist.*, ix/1 (1986), pp. 36–54

V. Jirat Wasiutyński: 'Paul Gauguin's Self-portrait with Halo and Snake: The Artist as Initiate and Magus', *A.J.* [New York], xlvi/1 (Spring 1987), pp. 22–8

For further bibliography see J. Rewald: *Post-Impressionism: From van Gogh to Gauguin* (London, 1978), pp. 527–36.

RODOLPHE RAPETTI

Gausson, Léo

(*b* Lagny-sur-Marne, nr Paris, 14 Feb 1860; *d* Lagny-sur-Marne, 27 Oct 1944). French painter, sculptor, designer and government official. He trained first as a sculptor and engraver, not taking up painting until 1883. While working at the shop of the wood-engraver Eugène Froment (1844–1900) he met Emile-Gustave Péduzzi (Cavallo-Péduzzi; 1851–1917) and Maximilien Luce. By 1886 all three were experimenting with the stippled brushwork and divided colour they had seen in the works of Seurat, Paul Signac and Camille Pissarro and Lucien Pissarro. That year Gausson made his début at the Salon as a sculptor, with the plaster medallion *Profile of a Young Girl* (untraced). He first showed his paintings at the Salon des Artistes Indépendants in 1887 and exhibited there annually thereafter.

Gausson painted regularly until *c.* 1900, with a brief Neo-Impressionist phase from 1886 to 1890; as the critic Fénéon remarked, 'he soon realized that this technique was ill-suited to his temperament'. In paintings such as *River and Bridge at Lagny* (1886; Paris, priv. col., see 1968 exh. cat., p. 59) and *The House* (*c.* 1887; Lausanne, priv. col., see 1979 sale cat., no. 159) Gausson confined the divisionist procedure to certain areas of the canvas, relying on the comparative freedom of Impressionist brushwork to fill in the rest. As a result, these pictures display a certain technical bravado at the expense of pictorial coherence. Nevertheless, many of Gausson's landscapes have a pleasing decorative effect, and such paintings as *Church at Gouvernes* (1887–8; Amsterdam, Rijksmus. van Gogh), rendered in an Impressionist manner, are remarkable for their fidelity to nature.

Gausson exhibited with the Symbolist painters at Le Barc de Boutteville (1891) and again with the Rose+Croix and the Salon des XX (both 1892). With more dexterity than inspiration, he began to imitate the broad, flat colour areas and smooth brushwork of the Nabis, much at variance with the textured surfaces of his Neo-Impressionist paintings. In subsequent exhibitions at the *Revue blanche* (1896), the Salon de Lagny and the Théâtre Antoine (both 1899), he also showed drawings, bronzes, plaster medallions, poster designs and jewellery. An amateur poet, he published a volume of verse entitled *Histoires vertigineuses* (Paris, 1896) under the pseudonym Laurent Montésiste, and he also illustrated the poems of Adolphe Retté (Paris, 1898). In 1900 he received a commission to engrave a plaque commemorating Charles Colinet

(Fontainebleau Forest) who had been responsible for the restoration of the Forest of Fontainebleau. After this, however, Gausson worked only sporadically as an artist, his time being occupied largely by a series of government posts at Conakry (Guinea) and later in France.

Bibliography

F. Fénéon: 'Léo Gausson', *Rev. Blanche*, x (1896), p. 336
Neo-Impressionism (exh. cat. by R. Herbert, New York, Guggenheim, 1968), pp. 58–60
P. Eberhart: 'The Lagny-sur-Marne Group', 'Léo Gausson', *The Neo-Impressionists*, ed. J. Sutter (Greenwich, 1970), pp. 147–52, 165–70
Léo Gausson (sale cat., Paris, Hôtel Drouot, 3 Dec 1979)
M. Hanotelle: *La Vie et l'oeuvre de Léo Gausson, 1860–1944: Un Peintre méconnu du Post-impressionnisme* (diss., U. Paris IV, 1985)
Peintures néo-impressionnistes (exh. cat., Pontoise, Mus. Pissarro, 1985), nos 7–11

PETER J. FLAGG

Gautier, Amand(-Désiré)

(*b* Lille, 19 June 1825; *d* Paris, 29 Jan 1894). French painter and lithographer. He began as an apprentice lithographer but displayed such a talent for drawing that in 1845 his parents enrolled him at the Académie in Lille, where he studied under the sculptor Augustin-Phidias Cadet de Beaupré (*b* 1800). In 1847–50 he worked in the studio of the Neo-classical painter François Souchon (1787–1857). In 1852 he received a scholarship to study at the Ecole des Beaux-Arts in Paris with Léon Cogniet. He frequented the Brasserie Andler where he met many of the artists who exhibited at the Salon, particularly the Realists. Gautier himself made his début at the Salon in 1853 with *Thursday Promenade*. He shared living-quarters with Paul Gachet, a close friend whom he had known from his days in Lille. Gachet, who was a doctor, introduced Gautier to the environment of such hospitals as La Salpêtrière, and this influenced the direction his art was to take. He was authorized to execute a large number of studies of lunatics in the specialized asylum, continuing the tradition begun some 30 years earlier by Gericault with his scientifically realistic series of monomaniacs. Gautier was fascinated by this experience and, as a result, painted his best-known work, the *Madwomen of La Salpêtrière* (destr. 1870). When the painting was exhibited in 1857 at the Salon in Paris, it was a resounding success, acclaimed not only by Maxime Du Camp but also by Jules-Antoine Castagnary, Théophile Gautier and Charles Baudelaire. The originality of its conception and the virtuosity of its technique made the painting a significant example of Realism, worthy of being placed in the same category as the works of his master and friend Courbet. Their friendship was such that in 1867 Courbet painted Gautier's portrait (Lille, Mus. B.-A.). After his success at the Salon of 1857, Gautier received further praise for the *Sisters' Promenade* (exh. Salon 1859) and a full-length portrait of *Dr Gachet* (exh. Salon 1861; both Lille, Mus. B.-A.). During this time he actively sought a patron, and eventually found one in Louis-Joachim Gaudibert (1838–70), a wealthy shipowner from Le Havre who had already helped Monet and Eugène Boudin. Gautier became friends with these artists who were interested in unconventional ways of painting; he was particularly close to Monet, whom he advised early in the latter's career. He took part in the first Salon des Refusés in 1863, exhibiting *The Adulteress* (1860; untraced). During this time financial needs prompted him to paint portraits for the Salons, where they were favourably reviewed by critics, who compared him to Carolus-Duran. Along with Courbet, he was a member of the revolutionary movement of the Commune and because of his activities was arrested and sentenced in June 1871. He began exhibiting again at the Salon from 1874, showing portraits, still-lifes and religious scenes, and continued to do so until 1888, but these works did not have the conviction of his earlier ones. In his last years he became a recluse in the village of Ecouen and was eventually put in a retirement home by friends.

Gautier was a major figure in French painting from 1850 to 1870, although in later years he was somewhat neglected. He was a major interpreter of the Realist language of Courbet, whose artistic sensibilities he shared, although his contribution as a Realist has been hindered by the fact that

many of his earlier works were destroyed in 1870 during the Franco–Prussian war. The review of the Salon of 1864 in *L'Autographe* described him as 'one of those rare artists who was a born painter'.

Bibliography

Bellier de La Chavignerie–Auvray; Thieme–Becker

F. Verly: *Essai de biographie lilloise contemporaine* (Lille, 1869)

A. M. De Belina: *Nos peintres dessinés par eux-mêmes* (Paris, 1883), pp. 360–61

A. Bloch: *Amand Gautier, 1825–94* (diss., U. Paris IV, 1932)

The Realist Tradition: French Painting and Drawing, 1830–1900 (exh. cat. by G. Weisberg, Cleveland, OH, Mus. A.; New York, Brooklyn Mus.; St Louis, MO, A. Mus.; Glasgow, A.G. & Mus.; 1980–82), pp. 291–2

ANNIE SCOTTEZ-DE WAMBRECHIES

Gavarni, Paul [Hippolyte-Guillaume-Sulpice Chevalier]

(*b* Paris, 13 Jan 1804; *d* Paris, 24 Nov 1866). French lithographer and painter. He was one of the most highly esteemed artists of the 19th century. Like Daumier, with whom he is often compared, he produced around 4000 lithographs for satirical journals and fashion magazines, but while Daumier concentrated on giving a panoramic view of public life, it was said of Gavarni that his work constituted the 'memoirs of the private life of the 19th century'. He specialized in genre scenes, in which the protagonists are usually young women, treating them as little dramatic episodes drawn from the light-hearted life of bohemia, dear to the Romantics (see col. pl. XVIII).

Gavarni was initiated into the art of precision drawing while still very young, being apprenticed to an architect and then to a firm making optical instruments. He was also a pupil at the Conservatoire des Arts et Métiers. His first lithograph appeared when he was 20: a miscellany that accorded well with the taste of the time. His second work, the album *Etrennes de 1825: Récréations diabolico-fantasmagoriques*, also dealt with a subject then in fashion, diabolism. The pattern was set: all his life Gavarni produced works that would have been considered superficial if the delicacy of his line, his beautiful light effects and the wit of the captions he himself composed had not gained him admirers who found his prints both popular in their appeal and elegant. Gavarni also enjoyed writing, producing several plays now forgotten.

From 1824 to 1828 Gavarni stayed in Tarbes in the Pyrénées, where he worked for a geometrician; but he constantly made drawings, especially of local costumes, which he later published in Paris. On this trip he acquired his pseudonym, the 'cirque de Gavarnie'. Back in Paris he had his first taste of success with his contributions to fashion magazines. He was himself extremely elegant and sophisticated, and he adored women. He personified the dandy figure sought out by the Romantics and expressed his personal tastes in his drawings. In March 1831 Balzac introduced him to the paper *La Caricature*, owned by the Republican Charles Philipon, where he joined a team of young graphic artists, most notably Daumier, Jean-Jacques Grandville and Joseph Traviès, who were to raise the status of satirical lithography to new heights. Like them, he produced a few political caricatures directed against Charles X prior to the 1830 Revolution and a few satires against the monarchy in 1832, but he made a speciality of ball and carnival scenes, portraits of actresses and prints of costumes and fancy dress.

In 1833, encouraged by the speed of his success, Gavarni founded his own magazine, *Le Journal des gens du monde*, where, surrounded by artist and writer friends, including Nicolas-Toussaint Charlet, Achille Devéria, Théophile Gautier and Alexandre Dumas, he combined the roles of editor-in-chief, graphic designer and journalist. The magazine was a commercial failure and closed after seven months and eighteen issues. From 1834 he began working on Philipon's principal satirical journal, *Le Charivari*, and after 1837 became a regular contributor both to this and to *L'Artiste*, which since 1831 had been reporting on the art world. It was for *Le Charivari* that he made his main series of lithographs: *The Letter-box*, *Husbands Avenged*, *Students*, *Clichy* (1840–41) (the Parisian debtors' prison to which he had been sent in 1835), *The Duplicity of Women in Matters of*

the *Heart* (1840) and *The Life of a Young Man* (1841). In 1841–3 he made the 'Lorettes' famous: they were young women of easy virtue who haunted the new district around Notre-Dame-de-Lorette in Paris, to which businessmen and numerous intellectuals had been moving.

From the very start of his career in 1829, Gavarni's prints had been published by Tilt in England, where they had been fairly successful. He stayed in England in 1847 and 1851, discovering the wretchedness of the working-class districts of London. There he published his *Gavarni in London* (1849). He began drawing in quite a different way, with greater social commitment and greater bitterness. It was also at this time, no doubt largely under English influence, that he worked in watercolour. On his return to France he published in *Le Paris* the long suite *Masques et visages* over the course of a year and at the rate of a lithograph a day (1852–3). The suite included several series: *The English at Home*, *A Tale of Politicking*, *The Sharers*, *Lorettes Grown Old* and *Thomas Vireloque*. This is perhaps his most important achievement. In it his graphic work is seen at its most lively. His line has become more tense and vigorous, the sense of contrast and movement greater, and the theme (the contrast between appearance and reality) more serious. He became moralistic and critical, often acrimoniously so, and his later work was not a popular success. The image created in the 1830s of a cheerful bohemia in which the lower orders of the bourgeoisie still mingled with the people had disappeared before the confrontation of the working class with the *nouveaux riches*. Gavarni superimposed on his habitual themes a profound disenchantment that owed much to his own aging, in such images as *The Emotionally Sick* (1853). He became increasingly reclusive, abandoning lithography in 1859 to concentrate on his garden, only to see it destroyed by the encroachment of the railways.

Gavarni was praised by the critics of his time: Balzac, Gautier, Sainte-Beuve and Jules Janin. Edmond and Jules de Goncourt, who befriended him after 1851, and of whom he made a lithograph portrait, helped to sustain his reputation after his death. They contrasted the elegance of Gavarni's themes favourably with what they considered the triviality of Daumier. This contrast obscured the more fundamental political division implicit in their work between a bourgeoisie faithful to its popular origins and one proud of its rise. For the latter Gavarni was a less dangerous artist than Daumier, although for later generations he appears less representative of the broad popular current that swept across France in the 19th century.

Bibliography

J. Armelhault and E. Bocher: *L'Oeuvre de Gavarni* (Paris, 1873)

E. de Goncourt and J. de Goncourt: *Gavarni: L'Homme et l'oeuvre* (Paris, 1873)

H. Beraldi: *Les Graveurs du XIXe siècle: Guide de l'amateur d'estampes modernes* (Paris, 1885–92), vii, pp. 5–82

The Studio (1904) [issue dedicated to Daumier and Gavarni]

P.-A. Lemoisne: *Gavarni: Peintre et lithographe*, 2 vols (Paris, 1924)

Inventaire du fonds français après 1800, Paris, Bib. N., Cab. Est., viii (Paris, 1954), pp. 465–581

Paul Gavarni, 1804–1866 (exh. cat. by G. Schack, Hamburg, Ksthalle, 1971)

The Charged Image: French Lithographic Caricature 1816–1848 (exh. cat. by B. Farwell, Santa Barbara, CA, Mus. A., 1989)

MICHEL MELOT

Gendron, (Etienne-)Auguste [Augustin]

(*b* Paris, 17 March 1817; *d* Paris, 15 July 1881). French painter. He entered the Ecole des Beaux-Arts in Paris on 20 October 1827 as a pupil of Paul Delaroche. The title of the picture which he sent to his first Salon in 1840, *Captivity in Babylon* (untraced), recalls the subject of Eduard Bendemann's famous picture of 1832, *Jews in Exile* (Düsseldorf, Kstsamml. Nordrhein–Westfalen). Gendron went to Italy in 1844 at the same time as Delaroche and Jean-Léon Gérôme. From there he sent *A Public Commentary on Dante* (untraced) to the Salon of 1844 and *Willis* (Le Havre, Mus. B.-A.), a vaporous group of spirits, inspired by German literature and also, perhaps, by German art, to the Salon of 1846. The *Willis* made his reputation. Théophile Gautier was predictably impressed, and in his review of the Salon of 1846 he 'discovered'

Gendron as well as most of the painters in Gendron's circle, pupils of Delaroche, who banded together in the late 1840s to form the Néo-grec group. It was, perhaps, in the company of Gautier, Gérôme and the Néo-Grecs, rather than in Italy, that Gendron became interested in the ancient world. His debt to Gérôme is particularly evident in *Tiberius at Capri* (exh. Salon, 1852; Marseille, Mus. B.-A.), where the twisting concubines, as Gendron admitted, were copied from Gérôme's *Greek Interior* (1849; untraced). But the ancient world was never more to him than an excuse to paint variations on the theme of the langorous sylphs who decorate *The Voice of the Torrent* (1857; Le Havre, Mus. B.-A.), *Nymphs at the Tomb of Adonis* (exh. Salon, 1864; Toulouse, Mus. Augustins) and *Foolish Virgins* (exh. Salon. 1873; Angers, Mus. B.-A.).

Gendron's reputation as a Salon painter waned after the success of the *Willis* until 1855, when *Sunday in Florence in the Fifteenth Century* (Fontainebleau, Château), an elegantly idealized vision of life in Renaissance Italy, revived interest in his work. The State bought the picture and gave him the Légion d'honneur. This was the highpoint of his career. Although he continued to exhibit pictures of fairies, Greek nymphs and scenes of everyday life from Italian history, he did not repeat the success of 1846 and 1855. There was, however, a decorative quality in his work that was put to good use outside the Salon by the state officials of the Second Empire. In 1850 he was paid for designing a frieze of *Four Seasons* for a Sèvres jardinière; in 1859 the government commissioned him to paint one of the panels in the Salle des Pas-Perdus in the Conseil d'Etat in Paris; in 1861 he painted a ceiling in an antechamber in the Louvre; he worked in the palace of St Cloud (1856); he painted a frieze in the Galerie Pereire in 1864 and decorated the chapel of St Catherine in the church of St Gervais in Paris in 1866.

Gendron's work represents the official side of the delicate art of Jean-Louis Hamon, Henri-Pierre Picou (1824–95) and their circle, which was popular in the Second Empire, particularly during the ascendancy of the Comte de Nieuwerkerke, who supported these artists. The fall of the Second Empire was a severe setback for Gendron. His eight cartouches representing *The Hours of the Day* in the Cour des Comptes, Paris, and his work at the palace of St Cloud were destroyed in the fires of 1871. He died, forgotten, ten years later.

Bibliography

L'Art en France sous le Second Empire (exh. cat., Paris, Grand Pal., 1979), pp. 360–61

JON WHITELEY

Gérôme, Jean-Léon

(*b* Vésoul, Haute-Saône, 11 May 1824; *d* Paris, 10 Jan 1904). French painter and sculptor.

1. Life and painted work

Gérôme's father, a goldsmith from Vésoul, discouraged his son from studying to become a painter but agreed, reluctantly, to allow him a trial period in the studio of Paul Delaroche in Paris. Gérôme proved his worth, remaining with Delaroche from 1840 to 1843. When Delaroche closed the studio in 1843, Gérôme followed his master to Italy. Pompeii meant more to him than Florence or the Vatican, but the world of nature, which he studied constantly in Italy, meant more to him than all three. An attack of fever brought him back to Paris in 1844. He then studied, briefly, with Charles Gleyre, who had taken over the pupils of Delaroche. Gérôme attended the Ecole des Beaux-Arts and entered the Prix de Rome competition as a way of going back to Italy. In 1846 he failed to qualify for the final stage because of his inadequate ability in figure drawing. To improve his chances in the following year's competition, he painted an academic exercise of two large figures, a nude youth, crouching in the pose of Chaudet's marble *Eros* (1817; Paris, Louvre), and a lightly draped young girl whose graceful mannerism recalls the work of Gérôme's colleagues from the studio of Delaroche. Gérôme added two fighting cocks (he was very fond of animals) and a blue landscape reminiscent of the Bay of Naples. Delaroche encouraged Gérôme to send *The Cockfight* (1846; Paris, Louvre) to the

Salon of 1847, where it was discovered by the critic Théophile Thoré (but too late to buy it) and made famous by Théophile Gautier. The picture pleased because it dealt with a theme from Classical antiquity in a manner that owed nothing to the unfashionable mannerisms of David's pupils. Moreover, it placed Gérôme at the head of the Néo-grec movement, which consisted largely of fellow pupils of Gleyre, such as Henri-Pierre Picou (1824–95) and Jean-Louis Hamon.

Gérôme abandoned his attempt to win the Prix de Rome and, although the ambition to paint a perfect nude never left him, he turned to the art market to exploit his popular success. In 1848 he exhibited a frieze-like composition, *Anacreon, Bacchus and Amor* (1848; Toulouse, Mus. Augustins), which was bought by the State, and he was listed among the finalists in the competition for a figure of the Republic with a monumental allegory (Paris, Mairie Lilas). His *Greek Interior* (1850; untraced), a brothel scene in the Pompeian manner of Ingres's *Antiochus and Stratonica* (1840; Chantilly, Mus. Condé), was bought by Prince Napoléon-Jerôme Bonaparte, whose Paris house Gérôme helped to decorate in the Pompeian style (1858). In 1853, his *Idyll* (Brest, Mus. Mun.), a picture of two Greek adolescents (probably Daphnis and Chloë) with a young deer, returned to the formula of *The Cockfight*. With his *Idyll*, he also exhibited *Nations Bringing their Tribute to the World Fair in London* (Sèvres, Mus. N. Cér.), a frieze of figures inspired by Delaroche's Sorbonne mural and commissioned in 1851 to decorate a vase (now London, St James's Pal., Royal Col.) given by the Emperor to Prince Albert. Gérôme developed this theme in a huge composition, the *Age of Augustus* (1855; Paris, Mus. d'Orsay), commissioned by the Comte de Nieuwerkerke in 1852, that combines the birth of Christ below with a host of conquered nations paying homage to Augustus, an ironic contrast between Bethlehem and Rome, inspired by a passage in Bossuet's *Histoire universelle* (1681) and, like Delaroche's Sorbonne mural, by Ingres's *Apotheosis of Homer* ceiling in the Louvre (1827).

Having received the down payment for the *Age of Augustus* in 1853, Gérôme went to Constantinople with the actor Edmond Got, the first of several journeys to the East that provided themes for many pictures. The sight of regimented Russian conscripts in Romania, making music under the threat of a lash, became *Recreation in the Camp* (sold London, Sotheby's, 25 Nov 1987, lot 19), a modest picture, characteristically ironic, which was more appreciated at the Exposition Universelle of 1855 than his huge masterpieces. He was then hovering on the edge of an official career. A commission to decorate a room in the Conservatoire des Arts et Métiers in Paris (destr. 1965) was followed by a more important commission to decorate the chapel of St Jerome in the church of St Séverin, Paris, completed in 1854. The effect of the pale, flat colours in the *Last Communion of St Jerome*, clearly outlined against a black ground, reflects the influence of Ingres's school on the religious and allegorical works painted by Gérôme and his friends in this period. However, Gérôme did little more like this.

Gérôme's skill as an ethnographer, noticed by the critics in 1855, developed after his first trip to Egypt in 1856. He showed the results at the Salon of 1857. *Plain of Thebes, Upper Egypt* (1857; Nantes, Mus. B.-A.) was the first of many pictures of Arab religion and justice, North African animals and landscape that he composed over the next 40 years. He also exhibited a scene from modern life, *Duel after the Masked Ball* (1857; Chantilly, Mus. Condé; see col. pl. XVI), which Gérôme described as 'a picture in the English taste', inspired, perhaps by a recent duel in Paris, perhaps by the fashionable Pierrot shows at the Théâtre des Funambules.

In 1859 Gérôme returned to painting Classical subjects, exhibiting *King Candaules* (Ponce, Mus. A.), a solitary figure of *Caesar* (untraced) lying below Pompey's statue and a picture of gladiators, *Ave Caesar* (untraced). Delaroche's *Assassination of the Duc de Guise* (1835; Chantilly, Mus. Condé) was the common source of all these. Ingres's *Antiochus and Stratonica*, the immediate source of *King Candaules*, was painted as a pendant to the *Duc de Guise*, and Gérôme's *Caesar* was an enlarged detail, taken from a photograph of a more complex picture inspired by Delaroche's

composition, that had been commissioned by Adolphe Goupil, the print editor, to sell in reproduction as a pendant to the *Duc de Guise*. *Ave Caesar* employs a similar composition and was probably intended as an ironic companion to the picture of the dead Caesar. Gérôme returned to this idea in the *Death of Marshal Ney* (Sheffield, Graves A.G.), which he exhibited in 1867, insisting on his right as a historian to tell the truth, despite official pressure to withdraw a picture that raised painful memories. The limits of Gérôme's repertory were fixed by the end of the Second Empire. History, Greek mythology, Egypt and animals gave him the themes of the many pictures that he exhibited and the many more that he sold through Goupil in the last decades of his life. The Salon became less important to Gérôme as a way of publicizing his work, although he returned very successfully to the Salon in 1874 with *Eminence grise* (Boston, MA, Mus. F.A.).

Gérôme's deity was Truth. In 1896 he painted *Truth Rising from her Well* (Moulins, Mus. Moulins), inspired by La Fontaine. His greatest ambition was to achieve the transparency of an illusion and to describe his subject with the accuracy of contemporary historians. Like a number of painters in this period, Gérôme believed that photography offered an alternative to the old formulae. 'Thanks to it', he said in 1902, 'Truth has at last left her well.' The smooth, highly coloured surface of his pictures and his ingenious effects of light appear photographic. His technique was also admirably suited to the photographic reproductions of his work sold by Goupil.

2. Sculpture

Gérôme surprised the public at the Exposition Universelle of 1878 by exhibiting a large bronze gladiator trampling on his victim (Paris, Mus. d'Orsay), which was taken from his painting *Pollice verso* (Phoenix, AZ, A. Mus.), completed in 1872 with the help of casts from the museum at Naples. The idea of making sculpture from his picture was perhaps inspired by the figurines that Antonin Mercié and Alexandre Falguière made for Goupil after Gérôme's *Dance of the*

'*Älmah* (1863; Dayton, OH, A. Inst.) and *Phryne in Front of the Judges* (1861; Hamburg, Ksthalle), and also by his lifelong ambition to imitate the works of nature. He moved from modelling to carving marble, turning the theme of his early *Anacreon, Bacchus and Amor* (1848; Toulouse, Mus. Augustins) into an accomplished marble statue (exh. Salon, 1878; Copenhagen, Ny Carlsberg Glyp.) that succeeds in creating the illusion of swaying movement and rippling drapery in the hard stone. He then turned to colour, aware of contemporary experiments in tinting marble in imitation of an antique practice. His best surviving tinted statue, *Dancer with Three Masks* (Caen, Mus. B.-A.), combining colour and movement, was exhibited in 1902. He also experimented with mixed media, assembling a charming *Dancer* (Geneva, priv. col.) from tinted marble, ivory and bronze, inlaid with gemstones and paste, which he exhibited in 1891. The following year he exhibited a disagreeable life-size statue of *Bellona* (Toronto, Inn on the Park), made from bronze and ivory, and a tinted group of *Pygmalion and Galatea* (San Simeon, CA, Hearst Found.). (His sculpture also provided inspiration for his pictures. In several late paintings Gérôme depicted himself in the role of Pygmalion, the sculptor who could turn marble into flesh through the intervention of a goddess, as in *Pygmalion and Galatea* (1890; New York, Met.).)

3. Teaching and influence

In 1853 Gérôme moved into the group of studios in the Rue Notre-Dame-des-Champs, the 'Boîte à Thé', which became a meeting place for artists, actors and writers in the 1850s. Gérôme's studio housed a theatre where George Sand gave entertainments and Berlioz, Rossini, Princess Mathilde Bonaparte, Gautier, Brahms and Turgenev were visitors. Gérôme remained at the Boîte à Thé until his marriage in 1863 to Marie Goupil, daughter of the dealer and print editor whose international empire, based in the Rue Chaptal, made several of Delaroche's pupils rich and famous. Although Gérôme was a close friend of the Comte de Nieuwerkerke and welcome at the imperial court, and although he received a handful of state

commissions, of which the *Reception of the Siamese Ambassadors* (1861–4; Versailles, Château) was the most important, his career as an official artist was limited. Nor was he an academic artist, although his attitudes to subject-matter owed much to his early academic training. His appointment as one of three professors at the Ecole des Beaux-Arts in 1863 followed government reforms carried through despite intense opposition from the Academy. He was not then a member of the Institut, although he was elected, at the fifth attempt, in 1864. His influence was extensive at the Ecole, where his sardonic wit, lax discipline and clear-cut teaching methods made him a popular and respected master. In the longer term, his well-known hostility to the work of Manet, Monet, Rodin, Puvis de Chavannes, Jules Dalou and many others, made his influence unfashionable and ineffective. His art could be dry and disagreeable, but it sometimes had a colour and vivacity that was never equalled by his imitators, and his attitude to subject-matter, often misanthropic, tinged with irony, had a refined emotional strength rarely matched by his fellow Orientalists.

Bibliography

E. Galichon: 'M. Gérôme, peintre ethnographe', *Gaz. B.-A.* (1868), pp. 147–51

C. Timbal: 'Les Artistes contemporains: Gérôme', *Gaz. B.-A.*, n.s. 2 (1876), pp. 218–31, 334–46

F. Field Hering: *Gérôme: His Life and Works* (New York, 1892)

C. Moreau-Vautier: *Gérôme: Peintre et sculpteur, l'homme et l'artiste* (Paris, 1906)

Gérôme and his Pupils (exh. cat., Poughkeepsie, NY, Vassar Coll. A.G., 1967); review by G. Ackerman in *Burl. Mag.*, cix (1967), pp. 375–6

Jean-Léon Gérôme (1824–1904) (exh. cat., Dayton, OH, A. Inst., 1972)

Jean-Léon Gérôme, 1824–1904: Sculpteur et peintre de l'art officiel (exh. cat., Paris, Gal. Tanagra, 1974)

The Romantics to Rodin (exh. cat., ed. by P. Fusco and H. W. Janson; Los Angeles, CA, Co. Mus. A., 1980), pp. 285–92

Gérôme (exh. cat., Vesoul, Mus. Mun. Garret, 1981)

G. M. Ackerman: *The Life and Work of Jean-Léon Gérôme* (London, 1986)

JON WHITELEY

Gervex, Henri(-Alexandre)

(*b* Paris, 10 Sept 1852; *d* Paris, 7 June 1929). French painter. His artistic education began with the Prix de Rome winner Pierre Brisset (1810–90). He then studied under Alexandre Cabanel at the Ecole des Beaux-Arts in Paris, where his fellow pupils included Henri Regnault, Bastien-Lepage, Forain, Humbert (1842–1934) and Cormon; and also informally with Fromentin. Gervex's first Salon picture was a *Sleeping Bather* (untraced) in 1873: the nude, both in modern and mythological settings, was to remain one of his central artistic preoccupations. In 1876 he painted *Autopsy in the Hôtel-Dieu* (ex-Limoges; untraced), the sort of medical group portrait he repeated in 1887 with his *Dr Pean Demonstrating at the Saint-Louis Hospital his Discovery of the Hemostatic Clamp* (Paris, Mus. Assist. Pub.), which celebrated the progress of medical science with a sober, quasi-photographic realism. Gervex's most controversial picture was *Rolla* (1878; Bordeaux, Mus. B.-A.), refused by the Salon of 1878 on grounds of indecency, partly because of the cast-off corset Degas had insisted he include. The painting shows the central character in a de Musset poem, Jacques Rolla, who, having dissipated his family inheritance, casts a final glance at the lovely sleeping form of the prostitute Marion before hurling himself out of the window. As his friend, Manet, had done the year before with his rejected *Nana* (1877; Hamburg, Ksthalle), Gervex exhibited his work in a commercial gallery, with great success.

In 1881 Gervex was chosen to decorate the town hall of the 19e arrondissement in Paris. He painted the subjects selected in a sombre palette and realist style: *Civil Marriage* (the wedding of the son of the mayor who had organized the competition; exh. Salon, 1881), *The Docks of La Villette* (bare-chested workers unloading coal on the canal; exh. Salon, 1882) and *The Charity Office* (poor people queuing for state assistance on a winter's day; exh. Salon, 1883). The final ceiling panel, which features two muscular men in the foreground about to slaughter an ox, employed dramatic *di sotto in sù* recession (reduced sketch, exh. Salon, 1905). For the Exposition Universelle of 1889 Gervex collaborated with Alfred Stevens and many

assistants to produce *Paris Pantheon of the Nineteenth Century*, a vast panorama (20×120 m) of a gathering in the Tuileries Gardens, which included the most famous French rulers, writers, artists, hostesses and politicians from Napoleon to those more recently deceased. It was subsequently cut up and sold. Gervex did other major decorative paintings in a more baroque style for the ceiling of the Hôtel de Ville in Paris (*Music across the Ages*; exh. Salon, 1891) and *France Receiving the Nations* over a decade later for the Elysée Palace.

In 1890 Gervex, like many of the most distinguished academic artists of the day, broke with the official Salon to become a founder-member of the Société Nationale des Beaux-Arts, with which he exhibited regularly until 1922. Throughout his long career he was enormously popular and honoured: he was made a member of the Légion d'honneur in 1882, Officer in 1889 and Commander in 1911, and a member of the Institut in 1913. His success in his own lifetime and his subsequent neglect both resulted in part from his exceptional facility. He adopted the appearance of the Impressionist style without quite comprehending its essence. A late series of pictures (1914–21), inspired by World War I, apply his bravura technique to powerful subjects and are worthy of reconsideration.

Gervex had an extremely agreeable personality and numbered among his many friends artists and writers of more avant-garde tendencies than himself, such as Renoir, Manet, Degas and Guy de Maupassant. Zola used him and de Maupassant as his models for the shrewd and ambitious painter Fagerolles in *L'Oeuvre* (1886). Gervex appears in Renoir's *La Moulin de la Galette* (1876; Paris, Mus. d'Orsay) and Degas's *Six Friends at Dieppe* (1886; Providence, RI Sch. Des., Mus. A.). He was also a resolute ally of Manet in his last years and defender of his posthumous reputation. Jacques-Emile Blanche was Gervex's most notable pupil.

Bibliography

J. Reinach: *Peinture de Alfred Stevens et Henri Gervex* (Paris, 1889)

J. Bertaut: *Henri Gervex: Souvenirs, recueillis par Jules Bertaut* (Paris, 1924)

The Realist Tradition: French Painting and Drawing, 1830–1900 (exh. cat. by G. P. Weisberg, Cleveland, OH, Mus. A., 1981), pp. 15–17, 219–20, 292–3 [biog. adapted from J.-F. de Canchy]

Le Triomphe des mairies (exh. cat. by T. Burollet, Paris, Petit Pal., 1987), pp. 116–18, 406–7

<div style="text-align: right">JAMES P. W. THOMPSON</div>

Giacomotti, Félix(-Henri)

(*b* Quingey, Doubs, 19 Nov 1828; *d* Besançon, 10 May 1909). French painter. He entered the Ecole des Beaux-Arts in Paris at 18 as a pupil of François-Edouard Picot. Italian by descent, he took French citizenship in 1849, giving him the right to compete for the Prix de Rome. In 1851 he won second place and took the prize in 1854 with *Abraham Washing the Feet of the Three Angels* (Paris, Ecole N. Sup. B.-A.), a luminous, natural, delicately coloured composition. He studied Raphael in Italy in company with William-Adolphe Bouguereau, his former classmate in Picot's studio, whose influence mingled with that of Raphael in the pictures of Greek mythology that Giacomotti exhibited in Paris in the 1860s and 1870s. His success on his return to Paris was rapid. In 1861 the State purchased his *Martyrdom of St Hippolytus* (Besançon, Mus. B.-A. & Archéol.) for the museum in Besançon, a dramatic composition more like an artist's idea of a scene from Homer than a work of religious significance. His *Agrippina Leaving Camp* (Lille, Mus. B.-A.), an expressive, understated work, was commissioned by the State for the Lille museum in 1862. Shortly after completing this work his brightly coloured *Amymoné* (Lille, Mus. B.-A.), reflecting memories of Raphael's *Galatea* (Rome, Villa Farnesina), was bought in 1865 for the Musée du Luxembourg, Paris. The State, however, could not buy everything he did, and there was little private interest in large pictures of ancient history. He painted at least two religious commissions, the Chapel of St Joseph in Notre-Dame-des-Champs and the Chapel of Catechism in St-Etienne-du-Mont, in Paris. Giacomotti turned to portraits for a livelihood and spent his last years as keeper of the Besançon museum.

Bibliography

A. Estiguard: *Giacomotti: Sa vie, ses oeuvres* (Besançon, 1910)

P. Grunchec: *Le Grand Prix de peinture: Les Concours des Prix de Rome de 1797 à 1863* (Paris, 1983), pp. 182–3

JON WHITELEY

Gigoux, Jean(-François)

(*b* Besançon, 6 Jan 1806; *d* Paris, 11 Dec 1894). French painter, lithographer, illustrator and collector. The son of a blacksmith, he attended the school of drawing in Besançon. He left for Paris and in 1828–9 frequented the Ecole des Beaux-Arts while executing various minor works. He made his début at the Salon in 1831 with a number of drawings. He established himself at the Salons of 1833 and 1834 with such sentimental compositions as *Henry IV Writing Verses to Gabrielle*, *St Lambert at Versailles*, *Count de Comminges*, *Fortune-telling* and such portraits as *Laviron* and *The Blacksmith* (1886; unless otherwise stated, all works are in Besançon, Mus. B.-A. & Archéol.; many drawings in Lille, Mus. B.-A. and Rouen, Mus. B.-A.). His portrait of the *Phalansterist Fourier* (1836) confirmed the success he had achieved as a history painter with the *Last Moments of Leonardo da Vinci* (1835).

In 1836 Gigoux travelled to Italy with his students Henri Baron and François-Louis Français. His friendships with Hygin-Auguste Cavé, the Directeur des Beaux-Arts, and with the influential Charles Blanc advanced his career and made it easier for him to obtain commissions, producing numerous portraits and religious subjects. He executed several works for the Musée d'Histoire at Versailles, including the *Capture of Ghent* and *Charles VII*. The subject-matter of the *Death of Manon Lescaut* (1845; destr.) and *Israelites in the Desert* (1845; Ivry-sur-Seine, Dépôt Oeuvres A.) reflects a period when Gigoux was out of favour: in addition to rejections from the Salon in 1837, 1840 and 1847, he attracted much adverse criticism. In 1848 and 1849 he drew various portraits and sold to Charles Blanc his painting *Antony and Cleopatra Testing Poisons on Slaves*, which had been refused for the Salon in 1837 (Bordeaux, Mus. B.-A.).

Unlike his friend Théophile Thoré, Gigoux supported the Empire and became involved in official art, producing such works as *Galatea and Pygmalion* (1857) and *Napoleon Visiting the Bivouacs on the Eve of Austerlitz* (1857). He executed two vast compositions, later destroyed, for the Conseil d'Etat in Paris, the *Grape Harvest* (1853) and *Harvest* (1855), and the *Flight and Rest in Egypt*, *Entombment* and *Resurrection* for a chapel in SS Gervais and Protais in Paris (*in situ*). Among his later works are *Poetry of the Midi* (1867; Narbonne, Mus. A. & Hist.) and *Father Lecour* (1875), which continued his earlier academic style.

Between 1830 and 1850 Gigoux executed a large number of lithographs of such contemporary figures as *Arsène Houssaye*, *Eugène Delacroix*, *Xavier Sigalon*, *François Gérard* and *Antoine-Louis Barye* and his friends *Pierre-Jean David d'Angers* and *Mme de Balzac* and her daughter. After 1850 these became more fluid, as in *Julia, the Beautiful Englishwoman* and *Memory*. He also illustrated various publications, including Petrus Borel's *Champavert, contes immoraux* (1833) and *Lettres d'Abailard et d'Héloîse* (Paris, 1839), and enjoyed a great success with Alain-René Le Sage's *Gil Blas* (1835). Gigoux was also involved in Jules-Gabriel Janin's *La Normandie* (Paris, 1844) and *Les Français peints par eux-même* (Paris, 1840) among other works. Gigoux was a major collector of paintings, prints and drawings from the Renaissance onwards and owned works by such artists as Dürer, Chardin, Hogarth, Gericault and David. Apart from a few sales and donations to the Louvre and to the Ecole des Beaux-Arts, he left the major part of his collection to the town of Besançon.

Writings

Causeries sur les artistes de mon temps (Paris, 1885)

Bibliography

A. Estignard: *Jean Gigoux: Sa vie, ses oeuvres, ses collections* (Paris and Besançon, 1895)

H. Jouin: *Jean Gigoux et les gens de lettres à l'époque romantique* (Paris, 1895)

P. Brune: *Dictionnaire des artistes et ouvriers d'art de la Franche-Comté* (Paris, 1912)

R. Marin: *Le Peintre Jean Gigoux (1806–1894)* (MA thesis, Paris, U. Paris IV, 1987)

Jean Gigoux, dessins, peintures, estampes: Oeuvres de l'artiste dans les collections des musées de Besançon (exh. cat., Besançon, Mus. B.-A. & Archéol., 1994)

RÉGIS MARIN

Gill, André [Gosset de Guines, Louis-Alexandre]

(*b* Paris, 17 Oct 1840; *d* Charenton, 1 May 1885). French draughtsman. The illegitimate son of the Comte de Guines and orphaned at an early age, he was recommended by the journalist Nadar to Charles Philipon, who hired him to work on the *Journal amusant* in 1859. At that time he signed himself *André Gil*; this changed to *Gill* in 1862. He was very successful during the Second Empire (1852–70) and made a speciality of large caricatures, full of power and movement, that covered the opening pages of satirical magazines — mainly *La Lune*, an opposition journal created by François Polo in 1865, when Napoleon III's regime was becoming more liberal. Gill's attacks reinforced the current of hostility against the regime in the late 1860s. Many of his prints were censored. On 17 November 1867 he drew the Emperor in the guise of Rocambole, a brigand and assassin who was the hero of a popular newspaper serial, and *La Lune* was banned. It was immediately replaced by a new journal, *L'Eclipse*, on which Gill continued to work. Under the Commune (1871) he was appointed Curator at the Musée du Luxembourg. He created two magazines, *Gill Revue* (1868) and *La Parodie* (1869), and in 1876 founded his own republican journal, *La Lune Rousse*. Arrogant and disordered in his life, Gill died in the lunatic asylum at Charenton on the outskirts of Paris.

Bibliography

C. Fontanes: *Un Maître de la caricature, André Gill, 1840–1885*, 2 vols (Paris, 1927)

Inventaire du fonds français après 1800, Bib. N., Dépt Est. catalogue, ix (Paris, 1955), pp. 111–36

MICHEL MELOT

Girardet, Edouard(-Henri)

(*b* Le Locle, Switzerland, 30–31 July 1819; *d* Versailles, 5 March 1880). Swiss painter and engraver. He was the son of the engraver Charles-Samuel Girardet (1780–1863) and the brother of the painters and engravers Karl Girardet (1813–71) and Paul Girardet (1821–93). At an early age he joined his brother Karl in Paris, studying painting with him and attending the Ecole des Beaux-Arts. He had practised the techniques of wood-engraving from the age of nine and concentrated increasingly on the graphic arts after 1835. In 1836 he started work as a draughtsman for Jacques-Dominique-Charles Gavard's *Les Galeries historiques de Versailles* (Paris, 1838–49), a project that continued for the next 12 years. He made his début at the Salon in 1839 with the *Communal Bath* (1839; Neuchâtel, Mus. A. & Hist.), and he continued to submit works until 1876. These included such genre paintings as the *Paternal Blessing* (1842; Neuchâtel, Mus. A. & Hist.) and a number of engravings and aquatints after such artists as Paul Delaroche, Horace Vernet and Jean-Léon Gérôme. Several of these engravings were published by the firm of Adolphe Goupil. In 1844 Girardet and his brother Karl were commissioned by the Musées Nationaux de Versailles to travel to Egypt to paint a historical scene from the Crusades. Girardet responded with the *Capture of Jaffa* (1844; Versailles, Château). He also travelled to England and frequently visited Switzerland, though most of his time was spent in France. In 1857 he finally settled in Paris and devoted himself largely to copperplate-engraving.

Bibliography

DBF

H. Béraldi: *Les Graveurs du XIXe siècle*, vii (Paris, 1888), pp. 154–6

G. Vapereau: *Dictionnaire universel des contemporains* (Paris, 1858, rev. 6/1893)

☐

Giroux

French family of restorers, dealers, cabinetmakers and painters. François-Simon-Alphonse Giroux

(d Paris, 1 May 1848) was a pupil of Jacques-Louis David and became a picture restorer, founding his business in Paris at the end of the 18th century. He specialized in genre paintings of medieval ruins and troubadours and bought particularly from a younger generation of artists such as Louis Daguerre, Charles-Marie Bouton (1781–1863), Charles Arrowsmith (b 1798) and Charles Renoux (1795–1846), all of whom painted church interiors. Giroux also admired Gothic art and became the official restorer for Notre-Dame, Paris. His daughter Olympe Giroux and son Alphonse-Gustave Giroux succeeded him in his business. Another son, André Giroux (b Paris, 30 April 1801; d Paris, 18 Nov 1879), was a painter. François-Simon-Alphonse's firm publicized its stock by holding exhibitions of Old Master paintings and contemporary art and by publishing catalogues of works both for sale and for hire from their premises. After 1828 the firm produced a series of elaborate pieces of furniture in a range of styles from Egyptian to Louis XV, some of which were commissioned by members of the royal family. This was their most lasting achievement, and by 1834 the firm was listed under the heading '*ébéniste*' in the *Annuaire du Commerce*.

In 1838, François-Simon-Alphonse Giroux left the business to his son Alphonse-Gustave Giroux, after which the firm changed in character. Alphonse-Gustave greatly expanded the thriving business and under his direction it became associated entirely with furniture, particularly small decorative pieces. In 1857 he opened new quarters in the Boulevard des Capucines; he sold his business and retired in 1867. Several pieces made by the firm from the 1840s to the 1860s, including a small secrétaire for Empress Eugénie, are now in the Musée Nationale du Château de Compiègne et Musée du Second Empire, Compiègne.

André Giroux exhibited at the Salon in Paris from 1819 and in 1825 won the Prix de Rome for a landscape, *Kalydonian Boar Hunt*. In 1837 he received the Légion d'honneur, and from 1836 to 1844 he also showed at the Akademie der Künste in Berlin. He is best known for his landscapes of Italy, France and the Swiss and Austrian Alps (e.g. *Souvenir of the Ravin de Golling*, exh. Salon 1863).

He also painted views of the coast of Brittany and the environs of Paris, especially Fontainebleau. His style is somewhat crisp and dry, and the staffage of his paintings was often done by Xavier Leprince (1799–1826).

Bibliography

D. Ledoux-Lebard: *Les Ebénistes parisiens, 1795–1830* (Paris, 1951)

From Revolution to Second Empire (exh. cat., London, Hazlitt, Gooden & Fox, 1978) [André Giroux]

Théodore Caruelle d'Aligny (1798–1871) et ses compagnons (exh. cat. by M. M. Aubrun, Orléans, Mus. B.-A.; Dunkirk, Mus. B.-A.; Rennes, Mus. B.-A. & Archéol.; 1979) [André Giroux]

LINDA WHITELEY

Glaize, Auguste-Barthélemy

(b Montpellier, 15 Dec 1807; d Paris, 8 Aug 1893). French painter. He was trained by Eugène Devéria and Achille Devéria and made his first appearance at the Salon, in 1836, with *Luca Signorelli da Cortona* (Avignon, Mus. Calvet) and *Flight into Egypt* (untraced), the first of a number of religious pictures painted in the 1840s in the pleasant, sentimental manner of Eugène Devéria's religious work. The *Humility of St Elizabeth of Hungary* (exh. Salon, 1843; Montpellier, St Louis), *Conversion of the Magdalene* (1845; Nogent-sur-Seine, parish church) and *Adoration of the Shepherds* (1846; Quesnoy-sur-Airaine, parish church) belong to an idea of the Rococo common in the 1840s. Glaize's interest in 18th-century French art is also evident in *Blood of Venus* (exh. 1846) and *Picnic* (both Montpellier, Mus. Fabre). This element was less obvious in the 1850s. In 1852 he exhibited a scene of the savage heroism of the *Women of Gaul: Episode from the Roman Invasion* (Autun, Mus. Rolin), one of the first pictures on a theme that appealed to a new interest in the history of Gaul in the Second Empire. Increasingly, he adopted subject-matter favoured by the Néogrec painters. His *Pillory* (Marseille, Mus. B.-A.), exhibited at the Exposition Universelle of 1855, showing victims of misery, ignorance, violence and hypocrisy from all ages, was probably inspired

by Jean-Louis Hamon's *Human Comedy* (1852; Compiègne, Château). *What One Sees at 20* (exh. 1855; Montpellier, Mus. Fabre), a vaporous allegory in the same vein, was bought by the State. *Love for Sale* (Béziers, Mus. B.-A.), exhibited in 1857, is a neo-Pompeian composition on a theme painted by Henri-Pierre Picou (1824–95) two years earlier.

The State characteristically rewarded Glaize for his success in 1855 by commissioning a picture of the *Distribution of the Eagles in 1852* (Versailles, Château), which was unsuited to his talent. The picture was not a success and brought official disfavour. By 1863 he was in financial difficulty. He retired to the country to paint portraits for a living and missed the Salon for the first time since 1836. He recovered ground in 1864 with *The Reefs* (Amiens, Mus. Picardie), an allegorical picture of idle nudes drifting on a boat below a pink sunset, which was bought by the State for the Musée du Luxembourg, Paris. In this period he was commissioned to paint the walls of chapels in St Sulpice, St Gervais, St Jacques du Haut-Pas and Notre-Dame de Bercy in Paris, of which the two most important, the chapel of St John the Evangelist in St Sulpice and the chapel of St Geneviève in St Gervais, were painted in a dry, flat manner suggesting a debt to the school of Ingres.

Glaize's many allegorical and religious pictures brought a less reliable income than portraits, and he apparently had difficulty selling his work to private collectors. However, he was patronized by Alfred Bruyas, a fellow native of Montpellier, who commissioned a portrait (Montpellier, Mus. Fabre) in 1848 and a picture of his study in which Bruyas, his father and friends admire a picture on an easel (1848; Montpellier, Mus. Fabre), as well as a last portrait, painted in November 1876, a few weeks before Bruyas's death.

Glaize's son, (Pierre-Paul-)Léon Glaize (*b* Paris, 3 Feb 1842; *d* 1932), was also a painter, trained by Jean-Léon Gérôme and his father. He came second in the Prix de Rome competition of 1866. He painted genre scenes, portraits and history paintings, including murals for the Salle des Fêtes of the Mairie of the 20th arrondissement (1883; *Triumph of the Revolution* and *Great Men of the Revolution before the Tribunal of Posterity*), and

for the Salon des Arts in the Hôtel de Ville (1889), both in Paris.

Bibliography

L'Art en France sous le Second Empire (exh. cat., Paris, Grand Pal., 1979), p. 364

Le Triomphe des mairies (exh. cat., Paris, Petit Pal., 1986), pp. 170–71, 296–7 [Léon Glaize]

B. Foucart: *Le Renouveau de la peinture religieuse en France (1800–1860)* (Paris, 1987), p. 268

JON WHITELEY

Gleyre, (Marc-)Charles(-Gabriel)

(*b* Chevilly, nr Lausanne, 2 May 1806; *d* Paris, 5 May 1874). Swiss painter and teacher, active in France. While many of his pictures appear academic in technique and subject, they often treat subjects that are new or imaginatively selected in a manner that betrays varied artistic influences. With his contemporaries Paul Delaroche and Thomas Couture, he helped to create the *juste-milieu* compromise style of painting. Adept in classical and biblical subjects, Gleyre also ventured into historical iconography, employing Swiss rather than French historical events, as well as genre motifs and sometimes obscure original themes. His influence was immense through his art and his teaching, which helped to form the Néo-Grec school of the Second Empire.

Gleyre's earliest artistic training was in the decorative arts in Lyon, where he was sent after the death of his parents. In 1825 he went to Paris, where he enrolled in the studio of Louis Hersent and augmented his education with classes in watercolour under R. P. Bonington. Having perfected his drawing technique, Gleyre set out for Rome in 1828. (He was not eligible to compete for the Prix de Rome because of his Swiss nationality.) Gleyre lived in abject poverty during his six years in Rome, but the stay was extremely valuable as it permitted him to study closely the major Classical and Renaissance monuments, which remained crucial sources for his art and theory throughout his life.

In 1834 Horace Vernet, Director of the Académie de Rome, recommended Gleyre to

accompany an American traveller, John Lowell jr, on an extensive trip to the Near East, serving both as companion and artistic recorder. The two remained together for more than nineteen months, visiting Greece, Turkey, Rhodes, Egypt and Sudan. Gleyre produced a mass of drawings and watercolours at virtually every important site; immediate, sometimes remarkably spontaneous, and always brilliantly coloured, they reveal Gleyre as a draughtsman of exceptional talent and also provide a unique record of significant archaeological sites (some no longer extant), costumes and exotic Near Eastern and North African physiognomies (e.g. *Turkish Woman ('Angelica'), Smyrna*, 1834; Lausanne, Pal. Rumine). The majority of these works are in the Lowell Institute, Boston (on loan to Boston, MA, Mus. F.A.). They were not well known to Gleyre's contemporaries, and Gleyre himself, although having spent more time in the Near East than most other Orientalist painters of the period, rarely made use of them in his later paintings. In November 1835 Gleyre, almost blind from ophthalmia, decided to withdraw from the assignment, finally returning to Paris in 1838.

Gleyre's first efforts on his return to France were in a decidedly academic manner. His most important commission at that time was for the decoration of the stairway of the château de Dampierre, where he worked with the Flandrin brothers and Ingres for the Duc de Luynes. After the murals were completed in 1841, some were intentionally effaced on the orders of Ingres, who was responsible for the overall decorative scheme; the reason for this was never wholly explained. Gleyre's first genuine success was with *Evening*, or *Lost Illusions* (1843; Paris, Louvre; see col. pl. XIX), which became the sensation of the Paris Salon of 1843. This sombre allegory of the human condition, deriving from memories of Egypt but wedded to classical iconography, typifies Gleyre's approach in its dreamy, romantic air, but also with its tightly controlled technique and sense of traditional composition, at once appealing to both academic and romantic tastes. The painting was bought by the government, thrusting on the painter an uncomfortable celebrity. In 1845 Gleyre won a first-class medal in the Salon with his

Parting of the Apostles (Montargis, Mus. Girodet) and also embarked on a curious series of paintings depicting primeval history in accord with contemporary literary and scientific interest in ancient history (e.g. *The Elephants*, c. 1849; Lausanne, Pal. Rumine). However, in 1849, at the height of his career, Gleyre withdrew from exhibiting in the French Salons because of his Republican ideals which clashed with the policies of Louis Napoleon. Gleyre also refused official French commissions and declined the Légion d'honneur, a measure of his staunch independence.

Despite his increasing reclusiveness and misanthropy, in the 1850s Gleyre received various commissions from the city of Lausanne for works depicting aspects of local history. His *Major Davel* (Lausanne, Pal. Rumine, destr.) represented the last moments of the Vaudois hero before his execution in 1723 in a manner that established a universal symbol of political freedom and courage. The *Romans Passing under the Yoke* (1858; Lausanne, Pal. Rumine), commissioned as a pendant, illustrates the Helvetic victory over the Roman legions and demonstrates Gleyre's resourcefulness in dealing with a vast composition of over 50 figures based on a historical event. Both works achieved the status of Swiss national icons and were reproduced in virtually every medium, but neither canvas was shown in France during his lifetime.

Gleyre's later works are marked by a search for new subjects from traditional classical and biblical sources. The most significant is *Pentheus* (Basle, Kstmus.), completed in 1864 on a commission from the city of Basle. The composition is unusually dynamic, with strong, diagonal movement, dramatic lighting and animated figures. Gleyre's last completed canvas, the *Return of the Prodigal Son* (1873; Lausanne, Pal. Rumine), illustrates a well-known theme, but in a manner that is unusually tender and poetic: the son is shown being welcomed home by his mother rather than, as was traditional, his father. Gleyre also added unusually revealing gestures and expressions, as well as exotic details, which enliven the time-worn subject.

A crucial aspect of Gleyre's career was his activity as a teacher. In 1843 he took over from Delaroche

one of the most famous ateliers in Paris, which had belonged to Jacques-Louis David and Antoine-Jean Gros, maintaining it until the outbreak of the Franco-Prussian War in 1870. In many ways Gleyre's atelier was a unique institution. It was run like a republic, in which each student had an equal voice in the daily activities and the general programme. Gleyre refused to accept payment for his efforts but requested instead a contribution for the rent and modelling fees. Gleyre offered practical instruction in drawing and painting, as well as theory, providing the customary correction of student work twice a week. Because of the liberal regime that prevailed in the atelier, as well as Gleyre's well-founded reputation as a solid, conscientious teacher, the atelier was among the most popular in Second Empire Paris. His most important pupils included the Impressionists Claude Monet, Auguste Renoir, Alfred Sisley and Jean-Frédéric Bazille, who all attended briefly in 1863. Gleyre also trained more conservative French painters, such as Jean-Léon Gérôme and Jean-Louis Hamon, and two generations of Swiss artists, including Albert Anker, Auguste Bachelin, Albert de Meuron (1823–97) and Edmond de Pury (1845–1911).

Bibliography

C. Clément: *Gleyre: Etude biographique et critique* (Geneva, 1878) [incl. cat. rais.]

Charles Gleyre ou les illusions perdues (exh. cat., Winterthur, Kstmus., 1974)

W. Hauptmann: 'Allusions and Illusions in Gleyre's *Le Soir*', *A. Bull.*, xl (1978), pp. 321–30

L. F. Robinson: *Marc-Charles-Gabriel Gleyre* (diss., Baltimore, Johns Hopkins U., 1978)

Charles Gleyre, 1806–1874 (exh. cat., New York U., Grey A.G., 1980)

W. Hauptman: 'Delaroche's and Gleyre's Teaching Ateliers and their Group Portraits', *Stud. Hist. A.*, xviii (1985), pp. 79–119

WILLIAM HAUPTMAN

Goeneutte, Norbert

(*b* Paris, 23 July 1854; *d* Auvers-sur-Oise, 9 Oct 1894). French painter and engraver. In 1871, after working briefly as a lawyer's clerk, he entered the studio of Isidore Pils at the Ecole des Beaux-Arts. When Pils died in 1875 Henri Lehmann took over the studio and Goeneutte left, moving to Montmartre. There he met Auguste Renoir, for whom he often modelled, and Marcellin Desboutin, who inspired his interest in engraving, etching and drypoint. Although Goeneutte was associated with Manet, Degas and Renoir, and his work was influenced by them, for instance in the informality of his compositions, he never exhibited with the Impressionist group, preferring instead the official Salons. Every year from 1876 he exhibited several works in the Paris Salon, such as *Boulevard de Clichy under Snow* (1876; London, Tate). He visited London in 1880, Rotterdam in 1887 and Venice in 1890.

In 1891 Goeneutte moved to Auvers-sur-Oise, where Dr Paul Gachet had a studio in his home. He had worked with Gachet on *La Renaissance littéraire et artistique* (1872–3) and on the periodical *Paris à l'eau forte*, and in 1892 he exhibited a portrait of *Dr Gachet* (Paris, Mus. d'Orsay).

Goeneutte portrayed a variety of themes: portraits, scenes depicting the everyday lives of working-class and fashionable Parisians, landscapes of Flanders, Antwerp and Venice. His subjects are depicted simply but with careful attention to detail, and his work emanates a remarkable tranquillity.

Bibliography

H. Beraldi: *Les Graveurs du XIXe siècle: Guide de l'amateur d'estampes modernes* (Paris, 1885–92), vii, pp. 170–72

G. de Knyff: *Norbert Goeneutte: Sa Vie et son oeuvre ou l'art libre au XIXe siècle* (Paris, 1978)

Norbert Goeneutte (exh. cat., ed. E. Maillet; Pontoise, Mus. Pissarro, 1982)

NORBERT GEORGES GOENEUTTE

Gonzalès, Eva

(*b* Paris, 19 April 1849; *d* Paris, 5 May 1883). French painter. Her first introduction to art was through her parents. Her father, Emmanuel Gonzalès (of Spanish origin but naturalized French), was a

well-known writer; her mother, a Belgian, was an accomplished musician. The family salon was a meeting place for critics and writers including Théodore de Banville and Philippe Jourde, the director of the newspaper *Siècle*. At 16 she had art lessons with the society portraitist Charles Chaplin, who ran a studio for women. Gonzalès rented a studio in the Rue Bréda and under Chaplin's guidance executed figure compositions and landscapes, exhibiting at the Salon of 1870 as his pupil.

Gonzalès was introduced to Edouard Manet by the Belgian painter Alfred Stevens in 1869 and became first his model and then his pupil. Manet's *Portrait of Eva Gonzalès* (exh. Salon 1870; London, N.G.) represents the young artist elaborately costumed and seated before an easel, daubing on a still-life. This work invokes the 19th-century stereotype of the 'lady amateur' and belies the seriousness of Gonzalès's attitude to art. She was Manet's only formal pupil, receiving regular instruction and advice from him. Records of their lessons in still-life reveal his method of seeking out the overall tonal relationships of a composition rather than attempting to reproduce in detail what the eye perceives.

Gonzalès exhibited at the Salon, declining invitations to join the independent exhibitions organized by her Impressionist contemporaries. The *Little Soldier* (exh. Salon 1870; Villeneuve-sur-Lot, Hôtel de Ville) was criticized for its suppression of half-tones and the use of harsh contrasts, reminiscent of Manet. Her association with Manet, realist sympathies and direct painterly handling provoked negative comments. *A Loge at the Théâtre des Italiens* (1874; Paris, Mus. d'Orsay) was rejected at the Salon of 1874, and when it was admitted in 1879, Gonzalès's association with Manet was perceived; the bouquet in the bottom left-hand corner was linked with that in Manet's *Olympia* (1863; Paris, Mus. d'Orsay). Many critics preferred her work when it recalled the delicate and more traditional handling associated with Chaplin, but Gonzalès was defended by such realist critics as Edmond Duranty, Philippe Burty, Zacharie Astruc and Emile Zola.

Gonzalès executed both pastels and oil paintings, concentrating on modern-life subjects, portraits and still-lifes. She frequently used members of her family, particularly her sister Jeanne, as models. In 1879 Gonzalès married the engraver Henri Guérard (1846–97), who, after her death following childbirth, married her sister. *Donkey Ride* (unfinished; Bristol, Mus. & A.G.), a work that features her husband and sister, reveals her adherence to Manet's method of proceeding from a sketchy underpainting to the finished work.

Gonzalès's work was exhibited in the offices of the magazine *L'Art* in 1882. In the same year, *The Milliner* (Chicago, IL, A. Inst.) was shown at the women's exhibition at the Cercle de la Rue Volney, and in 1883 she showed at the Galerie Georges Petit. In January and February 1885 a retrospective of 88 works was held at the Salons de *La Vie Moderne*. Although her work was acclaimed by several critics, the exhibition did not draw crowds, and few works were sold at the auction held soon afterwards at the Hôtel Drouot, Paris.

Bibliography

Eva Gonzalès (exh. cat., preface P. Burty; Paris, Salons *Vie Mod.*, 1885)

P. Bayle: 'Eva Gonzalès', *La Renaissance*, xv/6 (1932), pp. 110–15

Rétrospective Eva Gonzalès (exh. cat., Paris, Gal. Marcel Bernheim, 1932)

C. Roger-Marx: *Eva Gonzalès* (Saint-Germain-en-Laye, 1950)

Eva Gonzalès (exh. cat., Paris, Gal. Daber, 1959)

T. Garb: *Women Impressionists* (London, 1986)

TAMAR GARB

Graillon, Pierre-Adrien

(*b* Dieppe, 19 Sept 1807; *d* Dieppe, 14 Dec 1872). French sculptor and painter. Employed in infancy in chalk-quarries and subsequently as a cobbler in Rouen and Paris, he returned to his native town in 1827, where he married and attended drawing-school while earning a living in local ivory and alabaster workshops. In 1836 he went to work in the Paris studio of Pierre-Jean David d'Angers. After his return to Dieppe in 1838, his reputation steadily increased as a sculptor in ivory, unbaked clay, terracotta, wood and alabaster. His small

reliefs, figures and groups representing sailors, fisher-folk, vagrants and scenes from local life were appreciated by his more unassuming compatriots and acquired by tourists. Graillon retained the manner of a man of the people, and in his sculpture and paintings a deliberate roughness of treatment is allied to a strong formal sense and an instinct for natural grouping. He generally avoided the historical and exotic subjects that were the mainstay of the 19th-century statuette industry and was exceptional among contemporary sculptors in his preference for the ordinary local theme. A strain of romantic 'misérabilisme' in his work finds allegorical expression in the group *Misery* (terracotta, 1854; Dieppe, Château–Mus.), and there are echoes of earlier genre painters like David Teniers II, particularly noticeable in the relief of *Card-players* (terracotta, 1849; Rennes, Mus. B.-A. & Archéol.). Remarkably (in that they are little more than seaside souvenirs), Graillon's works anticipate the subjects and treatment of the Realists. He felt occasional dissatisfaction with his modest status. According to David d'Angers, this was exacerbated by a visit paid to him in 1858 by Napoleon III. In the following year, Graillon executed a life-size statue of *Abraham Duquesne* (bronze, Dieppe, Château–Mus.). After his death, his two sons, César (1831–?c. 1900) and Félix (1833–1893), continued to work in their father's idiom.

Bibliography
Lami

A. Bruel, ed.: *Les Carnets de David d'Angers* (Paris, 1958)
P.-A. Graillon (exh. cat., Dieppe, Château–Mus., 1969)
PHILIP WARD-JACKSON

Grasset, Eugène(-Samuel)

(*b* Lausanne, 25 May 1841; *d* Paris, 23 Oct 1917). French illustrator, decorative artist and printmaker of Swiss birth. Before arriving in Paris in the autumn of 1871, Grasset had been apprenticed to an architect, attended the Polytechnic in Zurich and travelled to Egypt. In Paris he found employment as a fabric designer and graphic ornamentalist, which culminated in his first important project, the illustrations for *Histoire des quatre fils Aymon* (1883). Grasset worked in collaboration with Charles Gillot, the inventor of photo-relief printing and an influential collector of Oriental and decorative arts, in the production of this major work of Art Nouveau book design and of colour photomechanical illustration. Grasset used a combination of medieval and Near Eastern decorative motifs to frame and embellish his illustrations, but most importantly he integrated text and imagery in an innovative manner which has had a lasting influence on book illustration.

In 1881 he was commissioned by Rodolphe Salis to design furnishing in a medieval style for the latter's new Chat Noir cabaret in Montmartre. This project brought him in direct contact with Montmartre avant-garde artists such as Adolphe Willette, Théophile-Alexandre Steinlen, Henri Rivière and Henri de Toulouse-Lautrec. Grasset's numerous posters include *Librairie romantique* (1887), *L'Encre Marquet* (1892), *Grafton Gallery, London* (1893) and the series of ten decorative panels produced in 1897 in which he combined his concern for design with the dramatic representation of women, a preoccupation characteristic of the 1890s. Most notable among Grasset's graphic achievements are the lithographs *La Vitrioleuse* (1894) for the album *L'Estampe originale* (1893–5) and *La Morphinomane* (1897), both of which are dramatic and frightening images of women, whose bold, decorative treatment is derived from Japanese prints. By the end of the century Grasset's reputation as a leading figure in the development of Art Nouveau poster design was well established; an article by Frederick Lees (*Mag. A.*, xxiii, 1899, p. 275) brackets him with Alphonse Mucha and Jules Chéret.

During the 1890s Grasset applied the same method of design that he had used in *Histoire des quatre fils Aymon* to his compositions for posters, ceramics, stained glass and tapestries (see fig. 38). He enclosed areas of local colour within strong outlines in the manner of leaded stained glass. Grasset's form of Cloisonnism was reinforced by the theories of the Nabis, and

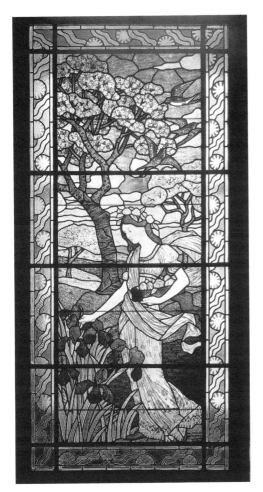

38. Eugène Grasset: *Spring*, 1894 (Paris, Musée des Arts Decoratifs)

two-volume *La Plante et ses applications ornementales* (1897–1900) is a graphic summation of his teaching on the subject during the previous two decades. Around 1900 he created the Grasset roman and italic typeface for Peignot Frères: this was followed in 1905 by *Méthode de composition ornementale*, which graphically explained basic design components valid for all media. His theories and designs were ideologically and stylistically compatible with those of the Vienna Secessionists, founded in 1897, and he was one of the few artists invited by the group to contribute to its magazine *Ver Sacrum*. At the Exposition Universelle, Paris, in 1900 Grasset was represented by tapestry, ceramics, stained glass and enamelled jewellery, while his students exhibited 150 wallpaper designs. Grasset's series of brooches and buckles for the exhibition were designed for the firm of Henri Vever and include such dramatic symbolist images as *Apparitions*, in which the haunting heads of two women are superimposed, as well as highly decorative floral designs based on tenets expressed in *La Plante et ses applications ornementales*.

In 1901 Grasset joined Hector Guimard, Eugène Gaillard and Albert-Louis Dammouse in organizing the Société des Artistes-Décorateurs. While the group never developed substantial projects or programmes of its own, it did inspire the organization of the Exposition Internationale des Arts Décoratifs et Industriels Modernes (Paris, 1925), which promoted the new theories of the Art Deco style. In 1909 Grasset was a founder-member of the Société d'Art Décoratif Français.

Writings

La Plante et ses applications ornementales, 2 vols (Paris, 1897–1900)
Méthode de composition ornementale, 2 vols (Paris, 1905)
Ouvrages de ferronnerie moderne (Paris, 1906)

Bibliography

La Plume, 122 (1894); 261 (1901) [special edn ded. to Grasset]
A. Alexandre: *Eugène Grasset et son oeuvre* (Paris, 1901)
V. Arwas: *Berthon & Grasset* (London, 1978)
Y. Plantin: *Eugène Grasset* (Paris, 1980)

PHILLIP DENNIS CATE

he was one among several artists who created designs for Tiffany stained-glass windows that were included in the opening exhibition of Siegfried Bing's Salon de l'Art Nouveau in December 1895.

Grasset was an important figure in the Arts and Crafts movement in France. He acted as professor of decorative arts at the Ecole Normale d'Enseignement du Dessin, Paris, established by M. A. Guérin in 1881, and was on the editorial board of *Art et décoration*, founded in 1897. His

Grévin, Alfred

(b Epineuil, nr Tonnerre, Yonne, Jan 1827; d Saint-Mandé, Seine, 5 May 1892). French printmaker and costume designer. After leaving school he became an apprentice draughtsman for the Paris-Lyon-Méditerranée railway company. While thus employed he also made his début as a caricaturist in the journal *Gaulois*, to which he contributed from 1858. In 1859 he had the first of many works published in the *Journal amusant*; his *At the Opéra Ball* (1860; Paris, Bib. N.) was for this publication. In 1860 he left the railway company and started to contribute to the *Petit journal pour rire* as well. He began working for *Le Charivari* in 1869, the year in which he co-founded, with Adrien Huart, the *Almanach des Parisiennes*, which published albums of prints for the next 19 years. It was about this time, when he began to concentrate on the manners and language of Parisian society, that Grévin established his mature style. Many of his designs, which were always accom-panied by humorous captions, were inspired by the women of the demi-monde. Unlike many caricaturists of his age he avoided political topics.

Grévin also worked for many years as a costume designer for the popular theatres of Paris, collab-orating on over 65 productions of operettas, comic operas and ballets. Several of his designs were pub-lished in albums, such as those for the comic opera *Fille de Mme Angot* (Paris, 1875). He also illustrated such books as Paul Véron's *Paris vicieux* (Paris, 1880) and *La Chaîne des dames* (Paris, 1881). In 1877 his drama *Le Bonhomme misère*, written in collaboration with Ernest d'Hervilly, was per-formed at the Odéon in Paris. He is perhaps best remembered today for the waxwork museum named after him, which he founded in 1882 in the Boulevard Montmartre, Paris.

Bibliography

DBF

H. Béraldi: *Les Graveurs du XIXe siècle*, 12 vols (Paris, 1885–92), vii, pp. 238–60

Inventaire du fonds français après 1800, Paris, Bib. N., Dépt. Est. cat. (Paris, 1930–), ix, pp. 396–401

Gudin, (Jean-Antoine-)Théodore, Baron

(b Paris, 15 Aug 1802; d Boulogne-sur-Seine, 12 April 1880). French painter and printmaker. He studied under Anne-Louis Girodet and Antoine-Jean Gros at the Ecole des Beaux-Arts in Paris, which he entered on 30 January 1817. With the emergence of the Romantic movement he inter-rupted his Neo-classical training to become a dis-ciple and friend of Delacroix and Gericault. Like Delacroix, he first exhibited at the Salon in 1822, and his submission included the depiction of an eminently Romantic subject, *Episodes from a Shipwreck* (sold, Paris, 7 Dec 1973). However, his greatest success of the 1820s, which established him as a marine painter, was the *Fire on the Kent*, which he exhibited at the Salon of 1827. Following this direction he cultivated his talent for histori-cal naval subjects on a large scale, becoming France's leading painter of sea battles. His style is characterized by the faithful rendering of water, the use of impasto and the careful execution of motifs.

From the beginning of his career Gudin's work was appreciated by both the public and the critics, and he received numerous state, royal and private commissions, becoming a baron under Louis-Philippe. He sold his paintings to the most eminent members of French society, such as the Baron de Rothschild, as well as to such foreign sov-ereigns as King Leopold I of Belgium and the Tsar. Gudin participated in many military expeditions. He was appointed an official artist to the Algerian expedition in 1830 and returned with many paintings that he exhibited at the Salon from 1831 onwards, such as *Hurricane at the Roadstead of Algiers, 7 January 1831* (1835; Paris, Louvre). He also painted other military subjects that glo-rified French valour, particularly French naval vic-tories over the British. During the 1830s Louis-Philippe commissioned Gudin to paint 97 large scenes illustrating the most glorious episodes of French naval history to decorate the galleries at Versailles, 41 of which were shown at the Salon between 1839 and 1848. To this com-mission belong such works as *Capture of the English Corvette 'Le Vimiejo' by a Section of the Imperial Flotilla, 8 May 1804* and *Battle of Chio in*

1681 (both Versailles, Château). This project seems to have drained his inspiration as from then on his work became very repetitive. In 1841 Gudin was commissioned by Tsar Nicholas I (*reg* 1825–55) to paint the ports of Russia and visited Warsaw and St Petersburg.

From the late 1840s into the 1860s Gudin continued to paint historical subjects while also producing some genre scenes, such as a *Scottish Hunting Party* (exh. Salon 1849). He also enjoyed the patronage of Napoleon III whom he joined on his campaigns to Italy and Algeria. Among the commissions from Napoleon III was the *Arrival of the Queen of England at Cherbourg* (exh. Salon 1861). After the Franco-Prussian War of 1870–71 Gudin retired to Scotland, where he raised money to support his wounded compatriots. As well as Paris, Gudin exhibited his work in London, and his paintings appeared intermittently at the Royal Academy between 1837 and 1873 and at the British Institution. In London he understandably showed his coastal scenes (e.g. *Dutch Coastal Scene*, 1846; London, Wallace) rather than his historical paintings. He also produced illustrations for such books as Eugène Sue's *Histoire de la marine française* (1835) and Mme de Staël's *Corinne ou l'Italie* (1841–2).

Writings

E. Beraud, ed.: *Baron Gudin: Souvenirs, 1820–70* (Paris, 1921)

Bibliography

Bellier de La Chavignerie–Auvray; *DBF*
Inventaire du fonds français après 1800, Paris, Bib. N., Dépt. Est. cat., ix (Paris, 1960), pp. 442–4
E. H. H. Archibald: *Dictionary of Sea Painters* (Woodbridge, 1980, 2/1989)

ATHENA S. E. LEOUSSI

Guichard, Joseph(-Benoît)

(*b* Lyon, 14 Nov 1806; *d* Lyon, 31 May 1880). French painter. He was a close friend of Paul Chenavard, both at school and at the Ecole des Beaux-Arts, Lyon, where he trained (from 1819) as a designer. He was taught painting by Pierre Révoil and

drawing by the sculptor Jean-François Legendre-Héral (1796–1851), in whose atelier he met Paul and Hippolyte Flandrin. In 1827 he went to Paris and entered Ingres's studio where he was joined by the Flandrin brothers in 1829. He also attended the Ecole des Beaux-Arts and copied exhibits in the Louvre. In 1833 he exhibited at the Salon with the huge *Dream of Love* (Lyon, Mus. B.-A.). It was praised by the critics, but its debt to Delacroix, whose work Guichard had been studying surreptitiously, infuriated Ingres, and Guichard was obliged to leave his studio. In November 1833 he travelled to Italy, where he copied Daniele da Volterra's *Deposition* (Rome, Trinità dei Monte) and frequented the salon of Horace Vernet. He left Italy for Paris in 1835, the year of Ingres's arrival there.

For the next 30 years Guichard received regular commissions from the state. In 1845 he painted the *Adoration of the Shepherds* and the *Deposition* for the chapel of St Landrin, St Germain l'Auxerrois, Paris; in 1848 *Moses Making Water Spring from the Rock* for the chapel of St Joseph, SS Gervais and Protais, Paris; and the *Dead Christ Surrounded by the Holy Women* for Notre-Dame de Passy (untraced). In 1849 he worked beside Delacroix in the Galerie d'Apollon in the Louvre, where he painted the voussoir with the *Awakening of the Earth* (*in situ*) after a drawing by Charles Le Brun. His studio was frequented by Félix Bracquemond, Henri Fantin-Latour and Berthe Morisot. Guichard's career in Paris was wrecked by financial and domestic problems and in 1862 he returned to Lyon where he succeeded Michel Génod (1796–1862) as a teacher of the painting class at the Ecole des Beaux-Arts, although he resigned after quarrelling with the staff in 1871. In 1879 he was made Director of the Musées de Peinture et Sculpture in Lyon, and he also acted as art critic for the *Courrier de Lyon*. Towards the end of his life he turned to Impressionism, producing a series of small paintings that are marked by a loose painterly style, delicate colour and a control of light and shade (e.g. *Dance at the Préfecture* and *Young Girl at her Mirror*; both Lyon, Mus. B.-A.).

Writings

Les Doctrines de Mr Gustave Courbet, maître peintre (Paris, 1862)

Bibliography

R. Chazelle: Joseph Guichard: Peintre lyonnais (diss., U. Lyon, 1956)

MADELEINE ROCHER-JAUNEAU

Guigou, Paul(-Camille)

(b Villars, nr Apt, Vaucluse, 15 Feb 1834; d Paris, 21 Dec 1871). French painter. Born into a family of landowners, he became a notary's clerk at Apt in 1851 and then in 1854 at Marseille. He learnt to paint with Camp, a teacher at the school in Apt, and then at Marseille with Emile Loubon (1809–63), director of the local Ecole des Beaux-Arts, who urged him (according to Guigou's biographers) to paint directly from nature. Guigou settled in Marseille in 1854, where he participated regularly in the annual Salon of the Société Artistique des Bouches-du-Rhône. Guigou painted almost exclusively Provençal landscapes, which were influenced by the works of the Barbizon painters, who exhibited in Marseille, and by the brownish tones and picturesque figures of Loubon's paintings. The Road to Gineste (1859) and The Washerwoman (1860; both Paris, Mus. d'Orsay) reflect the independent tradition of Provençal painting during the Second Empire, which was characterized by warm colouring and precise lighting used to separate and distinguish forms. His knowledge of the works of Gustave Courbet, acquired during a visit to Paris in 1859, doubtless increased his liking for broad technique and sincere vision, articulated in a strong and ordered construction of space: for example, The Gorges of the Lubéron (c. 1861; Amiens, Mus. Picardie).

In 1862 Guigou gave up his notarial work to concentrate on painting. He moved to Paris and from 1863 exhibited every year in the Salon. In The Hills of Allauch (1862; exh. Salon, 1863; Marseille, Mus. B.-A.), he showed a more independent style, free of picturesque or romantic inspiration. In 1864 he painted at Saint-Paul-lès-Durance with Adolphe Monticelli. In his large landscapes such as The Village of Saint-Paul-lès-Durance (1865; Pasadena, CA, Norton Simon Mus.), the warm colours are heightened in a luminous brilliance that accentuates the rigorous construction of the composition. In 1866 he produced several views in the Ile de France, at Moret and Triel, such as The Village of Triel (Marseille, Mus. Cantini). He visited Algeria, but avoided picturesque orientalism by painting The Gorges at Chiffa (1868; untraced) as though it were a Provençal landscape.

Guigou met Théodore Duret in 1868 and frequented the Café Guerbois in Paris, where he probably met the future Impressionists. Although he shared their interests in realism and liking for broad handling, he was not a precursor of Impressionism. In his work the harsh southern light separated objects without relating them, picking out details and conferring on the arid, bare masses of the Provençal hills a sense of equilibrium and solidity. He often chose the motif of a road vanishing into the distance, as in his View of Saint-Saturnin-d'Apt (1867; Paris, Petit Pal.), or an elevated viewpoint (Provençal Landscape, c. 1869; Montpellier, Mus. Fabre), to create a spreading landscape and an impression of space. In 1871 he became the drawing teacher of Baroness Rothschild, but he died a few weeks later of a stroke. His works went unnoticed at the Salon; his talent was not recognized until Duret wrote an article in the Electeur libre on the Salon of 1870. At the Exposition Universelle of 1900 he was well represented thanks to Claude Roger-Marx.

Bibliography

T. Duret: 'Un Grand Peintre de la Provence: Paul Guigou', A. & Artistes, xv/87 (1912), pp. 97–103
H. Simonnot: 'Centenaire de Paul Guigou', Bull. Officiel Vieux-Marseille (March–April 1934)
Guigou (exh. cat., Paris, Gal. Daber, 1950)
K. Scholtz: Paul Guigou und die provenzalische Landschaft Malerei des 19. Jahrhunderts (diss., U. Hamburg, 1954)
Paul Guigou (exh. cat., Marseille, Mus. Cantini, 1959)
F. Daulte: 'Un Provençal pur: Paul Guigou', Conn. A., 98 (April 1960), pp. 70–77
Paul Guigou, 1834–1871 (exh. cat., Paris, Gal. Daber, 1970)

VALÉRIE M. C. BAJOU

Guillaume, Jean-Baptiste-Claude-Eugène

(*b* Montbard, Côte d'Or, 4 July 1822; *d* Rome, 1 March 1905). French sculptor and writer. Having attended drawing school in Dijon, he entered the Ecole des Beaux Arts, Paris, in 1841. He won the Prix de Rome in 1845 and during his stay in Rome produced several works that were enthusiastically received by the Académie. These included the marble statue of *Anacreon* (exh. Salon 1852; Paris, Mus. d'Orsay), the hedonistic Classical subject and precise execution of which betray Guillaume's debt to his master, James Pradier. Another piece from his years in Rome, *The Reaper* (bronze, 1849; Paris, Mus. d'Orsay), while not going so far as to infringe Classical conventions, frees the representation of labour from traditional poetics.

Guillaume returned to Paris to pursue a successful career as an official sculptor. His iden-tification with the regime of Napoleon III was confirmed by his series of five marble portrait busts and a marble statue of *Napoleon I* (some at Arenenberg, Napoleonmus.), destined for the Pompeian villa of Prince Napoléon-Jérôme Bonaparte. He was involved in virtu-ally every major scheme of sculptural decora-tion for the public buildings of the Second Empire (1851–70), including the Paris Opéra, to which he contributed one of the façade groups, *Instrumental Music* (Echaillon stone, 1865–9). Guillaume was Director of the Ecole des Beaux Arts (1864–78) and played a prominent part in public life, becoming a member of the Commission on Public Instruction in 1866 and Inspector General of Drawing Instruction in 1872.

Writings

Discours et allocutions (Paris, n. d.)
Essai sur la théorie du dessin et de quelques parties des arts (Paris, 1896)

Bibliography

Lami
A. M. Wagner: *Jean-Baptiste Carpeaux, Sculptor of the Second Empire* (New Haven, 1986)

PHILIP WARD-JACKSON

Guillaumet, Gustave(-Achille)

(*b* Paris, 25 March 1840; *d* Paris, 14 March 1887). French painter and writer. He was a student of François-Edouard Picot, Alexandre Abel de Pujol and Félix Barrias. After failing to win the Prix de Rome in historical landscape in 1861, he impul-sively visited Algeria the following year; this journey, which he repeated ten times, determined his development as an Orientalist painter. He was a regular exhibitor at the Salon from 1861 where his combination of picturesque realism and acad-emic composition was positively received by the State as illustrative of its Algerian policies (e.g. *Evening Prayer in the Sahara*, 1863; Paris, Mus. d'Orsay).

The Sahara (1867; Paris, Mus. d'Orsay), which depicts a camel skeleton in a desolate desert landscape, is an important 19th-century example of *vanitas* painting and evinces a philosoph-ical strain in Guillaumet's work. In the *Labours* series (1869–76) he brought out the poetic quality of the remote duars of Algeria and imbued his Orientalism with unusual naturalistic touches. After 1878 his incisive social observations (e.g. the *'Seguia', Biskra*, 1884; Paris, Mus. d'Orsay) and careful study of the Saharan light placed him with Léon Belly among the most authentic Orientalist painters of their generation. Guillaumet's writings, notably *Tableaux algériens* (1888), belong to the travel-writing tradition of Eugène Fromentin. He was also a sensitive pastellist. He exerted a considerable posthumous influence over members of the Société des Peintres Orientalistes Français, which was formed in 1893.

Writings

Tableaux algériens (Paris, 1888)

Bibliography

A. Badin: 'Gustave Guillaumet', *L'Art*, xliv (1888), pp. 3–13, 39–45, 53–60
L. Bénédite: 'La Peinture orientaliste et Gustave Guillaumet', *Nouv. Rev.*, l (1888), pp. 326–42
Gustave Guillaumet (exh. cat., Paris, Ecole N. Sup. B.-A., 1888)
Gustave Guillaumet (exh. cat., Paris, Gal. Durand-Ruel, 1899)

L. Thornton: *Les Orientalistes: Peintres voyageurs, 1828–1908* (Paris, 1983), pp. 146–9

Guillaumin, (Jean-Baptiste-)Armand

(*b* Paris, 16 Feb 1841; *d* Paris, 26 June 1927). French painter and lithographer. He grew up in Moulins, but at 16 he returned to Paris to find work. Despite the opposition of his working-class family, he prepared for an artistic career while he supported himself in municipal jobs. He started drawing classes and then enrolled in the Académie Suisse, where he met Cézanne and Camille Pissarro. Guillaumin began his career as an avant-garde artist by exhibiting with them at the Salon des Refusés in 1863. He was also active in the Manet circle at the Café Guerbois, from which Impressionism developed.

Guillaumin developed his landscape style painting outdoors in the environs of Paris while employed on the Paris–Orléans railway. He frequently painted labourers and barges along the quays of the Seine, for example *Quai de la Rapée* (1879; Paris, priv. col.). Like Pissarro he empathized with the working-classes, and he influenced Seurat, Signac and their Neo-Impressionist followers towards depicting industrial settings. Guillaumin's painting style of the 1860s, like Cézanne's, was inspired by the naturalism and materiality of Courbet's paintings. Dense paint applied in thick strokes, sombre colours and heavy outlines are seen in his *Sunset at Ivry* (1869; Paris, Mus. d'Orsay). The works of the following decade, mostly landscapes, show a lightened palette and small touches of the brush. In the early 1870s Guillaumin worked with Pissarro at Pontoise and also with Cézanne and Dr Gachet at Auvers, where Daubigny also lived and worked. Guillaumin's mature Impressionist style, combining pictorial structure and shimmering light, evolved from his contacts with these artists and their shared aesthetic premises. His extensive work in pastel also contributed to the development of the spontaneous brushstroke which builds form as it captures light. The *Reclining Nude* (1876; Paris, Mus. d'Orsay) and the *Seine at Paris* (1871; Houston, TX, Mus. F.A.) exemplify Guillaumin's use of the constructive brushstroke. The artist's expressive use of colour, which transcends nature in its vibrant harmonies, is also characteristic of his style in the 1870s. He contributed to all but two of the Impressionist exhibitions, showing in 1874, 1877, 1880, 1881, 1882 and 1886.

In the 1880s, like his Impressionist colleagues, Guillaumin experimented with new pictorial techniques to convey a more personal expression of mood and feeling. He used heightened colour, favouring the effects of early morning light or the drama of sunset skies, composing harmonies from complementaries of orange-red and blue-green, purple and green or mauve and yellow. The *Road in the Valley* (1885; Paris, Mus. A. Mod. Ville Paris) and *Twilight at Damiette* (1885; Geneva, Petit Pal.) are typical paintings of this period which inspired critics such as J.-K. Huysmans to call Guillaumin a 'furious colourist', and Félix Fénéon to remark on his 'super-heated skies'.

Guillaumin's passionate response to nature impressed Vincent van Gogh who became his friend in Paris in 1886–7, while Theo van Gogh assisted Guillaumin with sales of his works. Guillaumin's personal fortunes improved with his marriage to a professor in a prestigious school for young women. He expanded his travels from the Ile de France to the central regions and Provence. In 1891 he won a state lottery of 100,000 francs, which allowed him to retire from government service and to devote himself wholly to painting. His extensive travels are reflected in landscapes of France and the Netherlands. Such paintings as *Rocks at Agay* (1893; Paris, priv. col., see Serret and Fabiani, pl. 233) are emblematic of rugged aspects of nature in their bold simplification and strong colour contrasts. They share the primitive spirit of Gauguin and his Pont Aven followers and directly prefigure the intensity of Fauvism. Guillaumin's work continued to show strength and individual character, developing the innovations of Impressionism in a modernist spirit. In 1896 Ambroise Vollard published a suite of his lithographs.

Bibliography

Exposition Armand Guillaumin (exh. cat., pref. A.
 Alexandre; Paris, Gal. Durand-Ruel, 1924)

G. Lecomte: *Guillaumin* (Paris, 1926)

P. Gachet: *Lettres impressionnistes au Dr Gachet et à
 Murer* (Paris, 1957), pp. 63–78

G. Serret and D. Fabiani: *Armand Guillaumin: Catalogue
 raisonné de l'oeuvre peint* (Paris, 1971)

C. Gray: *Armand Guillaumin* (Chester, CT, 1972)

J. Rewald: *The History of Impressionism* (New York, rev.
 4/1973)

*Centenaire de l'impressionnisme et hommage à
 Guillaumin* (exh. cat., Geneva, Petit Pal., 1974)

The New Painting: Impressionism, 1874–1886 (exh. cat.,
 ed. C. Moffatt; Washington, DC, N.G.A.; San Francisco,
 F.A. Museums; 1986), pp. 128, 365, 400, 459

TAUBE G. GREENSPAN

Guillemet, (Jean-Baptiste-)Antoine

(*b* Chantilly, 30 June 1841; *d* Dordogne, 19 May
1918). French painter. He came from a wealthy
family of ship-owners and ship-chandlers based in
Rouen. His boyhood wish to become a sailor was
opposed by his parents in favour of law studies,
which Guillemet soon abandoned to take up paint-
ing full-time in Paris. After meeting Corot through
the Morisot sisters in 1861–2, he remained through-
out his career a devoted friend and admirer of the
artist. During the early 1860s he made sketching
trips with Charles-François Daubigny and
Daubigny's son Karl Pierre, and he began a life-
long friendship with Manet, who immortalized
Guillemet's tall, handsome figure in *The Balcony*
(1869; Paris, Mus. d'Orsay). Guillemet also studied
at the Académie Suisse, where he met Pissarro,
Cézanne and, through the latter, Zola. Although
Guillemet made his début at the Salon in 1865 with
the *Pond at Bât (Isère)* (untraced), the 1860s were,
in general, an unsettled time of experiment and
travel. He lived and worked with Pissarro, Courbet
and Cézanne and became the intimate friend and
correspondent of Zola. Their correspondence
gives fascinating insights into the interaction of
influences between writer and painter.

In 1872, after serving in the Gardes Mobiles
during the Siege of Paris, Guillemet exhibited *Low
Tide at Villerville* (Grenoble, Mus. Peint. & Sculp.),
which depicts a Normandy coastal village near the
mouth of the Seine. It was purchased by Charles
Blanc, director of the *Gazette des beaux-arts*. With
this painting, Guillemet had reached his maturity
and settled successfully to the style and subject-
matter to which he devoted the remainder of his
energetic and productive life. His favourite motifs
were drawn from the beaches and countryside of
Normandy, especially the Cotentin, riverside vil-
lages, usually along the Seine, and, less frequently,
Paris. The capital was, however, the subject of a
remarkable series of large-scale canvases, begin-
ning with *Bercy in December* (exh. Salon 1874;
Paris, Pal.-Bourbon), which was purchased by the
Musée du Luxembourg. In a letter to Zola in 1896,
relating to a now lost panorama of Paris,
Guillemet explained how he had been inspired by
the writer's description of Paris in *Une Page
d'amour* (Paris, 1871). Although Guillemet gave
encouragement to the Impressionists in 1874, the
year of their first group exhibition, he preferred
success in the Salon and fidelity to the teachings
of Corot. The pattern of his life was established
with sociable winters in Paris and summers in
Normandy. His work sold well, although his inde-
pendent means had always freed him from
reliance on sales. Salon exhibits continued to
attract critical acclaim, and he served as a member
of the Salon jury. In 1882 he used the jury
members' privilege of having their pupils admit-
ted to the Salon to enable Cézanne to exhibit
his work there. Cézanne's name subsequently
appeared in the Salon catalogue with the descrip-
tion 'pupil of Guillemet'.

In 1910 Guillemet became a commandant of
the Légion d'honneur, a very rare instance of a
landscape painter reaching this rank. The pur-
chase *c.* 1883 of a property at Moret-sur-Loing, near
the junction of the Loing and the Seine, afforded
the artist many tranquil river landscapes, of which
one of the first exhibited examples was the *Loing,
at Moret* (exh. Salon 1891; untraced). From about
1912 until the end of his life he lived and worked
in the Dordogne, finding refuge there during
World War I. Guillemet was largely forgotten
within a decade of his death, and his work was
not re-examined until the 1970s. He was a minor

master of traditional landscape painting, with an individual style and a sound painterly technique. His work is uneven but, at its best, atmospheric and highly competent.

Unpublished sources

Paris, Bib. N. [corr. between Guillemet and Zola]

Writings

Notes, Paris, Bib. N.

R. Baligand, ed.: 'Lettres inédites d'Antoine Guillemet à Emile Zola (1870–1886)', *Cah. Naturalistes*, 52 (1978), pp. 173–205

Désir de rivage: De Granville à Dieppe (exh. cat., Caen, Mus. B.-A., 1994)

Landscapes of France: Impressionism and its Rivals (exh. cat., London, Hayward Gal., 1994)

Monet to Matisse: Landscape Painting in France, 1874–1914 (exh. cat., Edinburgh, N.G., 1994)

Bibliography

P. Mitchell: *Jean Baptiste Antoine Guillemet* (London, 1981) [with complete bibliog.]

PETER MITCHELL

Guys, (Ernst-Adolphe-Hyacinthe-) Constantin

(*b* Flushing, the Netherlands, 1802; *d* Paris, 13 March 1892). French draughtsman. His father was chief administrator of the merchant navy in the northern Netherlands, but Guys lived for most of his life in France; from 1848 he also spent some time in England. He belonged to the first generation of illustrators to be employed by the earliest of the great illustrated journals. As a correspondent for the *Illustrated London News* (after 1838) and for *Punch* in 1842, he was able to travel widely, visiting Bulgaria, Spain, Italy and Egypt and sending back sketches to be engraved as magazine illustrations. He recorded the *Memorial Service for Greek Independence* in Athens and *The Sultan at the Bairam Festival* in Constantinople. In 1855 he was sent to cover the Crimean War and witnessed the battles of Inkerman and Balaclava.

Guys settled in Paris in the late 1850s, and it was his sketches of society life that made him famous. The compositions, taken from life, of women in crinolines, horse-drawn carriages in the Bois de Boulogne and ball and carnival scenes, were caught with rapid strokes in vigorous wash drawings (very solidly constructed in order to indicate the tonal values to the engravers). They earned him the respect of the most celebrated critics of his time. In 1863 Charles Baudelaire published a long study of him in *Le Figaro*, which achieved lasting fame. He singled out Guys as the quintessential 'painter of modern life' and gave an illuminating description of his working methods (*The Painter of Modern Life*, trans. Mayne, p. 17):

[Guys] starts with a few slight indications in pencil which hardly do more than mark the position which objects are to occupy in space. The principal planes are then sketched in tinted wash, vaguely and lightly coloured masses to start with, but taken up again later and successively charged with a greater intensity of colour. At the last minute the outline of the objects is once and for all outlined in ink.

Théophile Gautier, Philippe Burty, Champfleury, the Goncourts and, among artists, Delacroix, Manet and Nadar, admired the way he depicted his harshly lit subjects in a forthright style. Guys prefigured the flat tints and shadows found in the work of Manet—who owned some of his drawings—as well as that of Toulouse-Lautrec, Forain and Picasso, and was far more closely related to them than to the other Parisian society illustrators such as Marcelin (Emile Planat), or graphic journalists such as Paul Renouard. Without trying to be anything more than a reporter, Guys adopted the techniques of foreshortening and contrast, which were of concern to the Realist painters of the time. He avoided the complacent staginess and anecdotal detail of the Romantic illustrators and sacrificed description of setting to a stark presentation of his characters which had great expressive and dramatic force.

Guys was shy of publicity (he insisted that Baudelaire's *Le Figaro* article should refer to him only by his initials), and his personal life remained private, although he was a member of the Café

Guerbois circle in the 1870s and enjoyed going to parties and receptions. On a carnival night in 1885 he was knocked down by a cab but survived for several years, eking out a living from the sale of the occasional drawing; he died aged 89. His reputation was kept alive by his few admirers, who put on an exhibition of his work at the Galerie Georges Petit in 1895. There is a fine collection of his wash drawings in the Musée Carnavalet, Paris.

Bibliography

C. Baudelaire: 'Un Peintre de la vie moderne', *Le Figaro* (26, 28 Nov, 3 Dec 1863); also in *Oeuvres complètes* (Paris, 1976); also in *The Painter of Modern Life and Other Essays*; Eng. trans. and selection by J. Mayne (London, 1965)

G. Geffroy: *Constantin Guys* (Paris, 1920)

L. Jamar-Rolin: 'La Vie de Guys et la chronologie de son oeuvre: Faits et propositions', *Gaz. B.-A.*, xliii (1956), pp. 69–112

Inventaire du fonds français après 1800, Paris, Bibl. N. Dépt. Est. cat., x (Paris, 1958), pp. 79–83

The Crimean War Drawings of Constantin Guys (exh. cat. by K. W. Smith, Cleveland, OH, Mus. A., 1978)

P. Duflo: *Constantin Guys, fou de dessin, grand reporter, 1802–1892* (Paris, 1988)

MICHEL MELOT

Hamon, Jean-Louis

(*b* Saint-Loup, near Plouay, Côtes-du-Nord, 5 May 1821; *d* Saint-Raphaël, 29 May 1874). French painter and designer. He was encouraged to practise drawing by the Brothers of the Christian Doctrine at Lannion. Through the intervention of Félicité-Robert de Lamennais (1782–1854), he was made drawing-master at a religious seminary at Ploërmel, Brittany, although at this stage he had received no instruction and had never seen an oil painting. In 1840 he asked his *conseil général* for help and left for Paris the following year with a grant of 500 francs. He went to Delaroche's studio, where he made friends with Picou, Jean-Léon Gérôme, Jean Aubert (1824–1906) and Jean Eugène Damery (1823–53). Charles Gleyre, who took over Delaroche's studio in 1843, encouraged and protected him during years of poverty. *Daphnis and Chloe* (untraced), his first Salon picture, exhibited in 1847, was painted in Gleyre's studio.

In 1848, on Gleyre's recommendation, Hamon was given a post as a designer to the Sèvres factory where he developed a thin, pale, transparent style of figure painting especially suited for decorating vases. He worked at this time with the group at 27 Rue de Fleurus where Gérôme and his friends painted their first Salon pictures inspired by the myths and history of Greece and Rome. Hamon's pictures showed the influence of his work at Sèvres. His vase, *Woman with a Butterfly*, was the forerunner of a series of paintings of women and children with insects that he exhibited in Paris. In 1851 he received payment from Sèvres for the *Human Comedy* (1852; Compiègne, Château), which he sent to the Salon of 1852. Théophile Gautier alone remarked that it was arranged like the decoration of a vase, but, like most critics, he was unduly puzzled by the subject of the picture, which shows a group of famous men of all ages, from Diogenes to Dante, gathered round a puppet-show in which the Goddess of Wisdom sends Cupid to the gallows. In 1854 Hamon was dismissed from Sèvres following long absence from the studio. From 1856 until his departure for Italy in 1863 he worked with a team of artists at the studio of Théodore Deck (1823–91), designing pictures for transfer on to porcelain. However, easel painting was now his chief interest. There is no evidence to connect the picture which he exhibited in 1853, *My Sister Isn't There* (destr. 1871), with his ceramic work, but the types of children, the shallow frieze-like composition and pale colours, noticed by all the critics, recall the decoration of a vase. His style was generally liked by the picture-buying public until a revulsion against the Etruscan style in 1859 made his art less fashionable. Hamon was persuaded by dealers to appease criticism by making his pictures less misty, but by 1861 he was in debt.

Hamon went to Rome in 1863 with a letter of introduction to Jean-Jacques Henner, who invited him to share his studio. There he completed *Aurora Drinking Dew* (destr. 1871), inspired by the sight

of an insect sipping from a leaf in the woods at Meudon. The painting revived his reputation and was bought by Empress Eugénie. In 1865 Hamon settled in Capri with Louis Français, Edouard Alexandre Sain (1830–1910) and Jean Benner (1836–1906), convinced that he was going to make a fortune exploiting new subjects. He seems, in fact, to have spent his time there painting replicas of earlier work for American collectors through the intermediary of a Genevan banker, Walter Fol. On one of his frequent visits across the bay to Pompeii he had the idea of *Muses Weeping over Pompeii* (untraced), exhibited at the Salon of 1865, a fantasy like Curzon's *Dreams on the Ruins of Pompeii* (1866; Bagnères-de-Bigorre, Mus. A.) or Gautier's *Arria Marcella*. In 1873 Hamon exhibited his last picture, the *Sad Shores* (untraced), a melancholy, poetic picture that was bought by Fol. His death the following year went almost unnoticed in Paris. His influence, however, survived. Following the reorganization of the Sèvres factory in 1848, he developed a style that lastingly affected the decorative arts in France. His pictures, often disconcerting, sometimes tinged with a darker undercurrent, are always witty and original.

Bibliography

E. Hoffmann: *Jean-Louis Hamon, peintre* (Paris, 1904)

L'Art en France sous le Second Empire (exh. cat., Paris, Grand Pal., 1979), pp. 368–9

JON WHITELEY

Harpignies, Henri-Joseph

(*b* Valenciennes, 24 July 1819; *d* Saint-Privé, 28 Aug 1916). French painter and printmaker. He came from a prosperous, solidly bourgeois background. A precocious draughtsman, he received elementary art training at the municipal school and became a talented cellist who enjoyed playing the chamber music of Haydn and Beethoven in later life. His artistic career was delayed by employment in the family iron forges at Denain and at the Famars sugar refinery, although he drew caricatures under the influence of the great French satirical lithographers. In 1838 he was exposed to a wider variety of French landscape during a two-month tour with

a family friend Dr Lachèze, who also introduced Harpignies to the landscape painter and etcher Jean-Alexis Achard (1807–84), with whom he studied in Paris in 1846. His first significant group of paintings and drawings in a marginally Realist style was made with his master at Crémieu in late 1847, but the Revolution of 1848 obliged him to return home. He then stayed with Achard in Brussels, producing his first sequence of etchings.

In May 1849 Harpignies travelled to southern Germany, visiting Lachèze in Baden and proceeding in November to Rome, where the austere forms of the Campagna under brilliant southern light formed a momentous and persistent influence. The Bay of Naples and, above all, Capri also entranced Harpignies who, by 1851, was producing his first serious watercolours. He was summoned home by March 1852 and settled in Paris. The second dominating influence on Harpignies was the landscapes of Corot, who encouraged him with purchases. Harpignies first exhibited at the Salon in 1853, showing a view of Capri and two landscapes near Valenciennes, and continued to do so regularly until 1912, to generally laudatory reviews and with consistent State acquisitions. He married, unrewardingly, Marguerite Ventillard in 1863, the year in which he commenced a visually stimulating return visit to Italy which lasted until April 1865.

In 1870 during the Franco-Prussian War, Harpignies served in the Garde Nationale at Hérisson, where he passed his summers for the rest of the decade, but otherwise his life appears to have been equable, uneventful and increasingly successful. His connection with the dealers Arnold & Tripp after 1883 ensured his prosperity. He was a Salon medallist in 1866, 1868 and 1869, winning a silver medal at the Exposition Universelle of 1878 with the *Colosseum in Rome* (Paris, Mus. d'Orsay), the Grande Médaille d'honneur for *Banks of the Rhône* in 1897 (although he failed to be elected to the Institut) and the Grand Prix at the Exposition Universelle of 1900. He became a member of the Société des Aquarellistes Français in 1881 and the Société des Artistes Français six years later. He rose through the ranks of the Légion d'honneur from Chevalier in 1875 to Grand Officier in 1911.

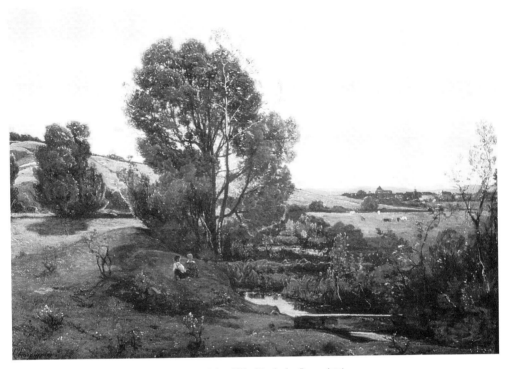

39. Henri-Joseph Harpignies: *View of Moncel-sur-Seine* (Lille, Musée des Beaux-Arts)

Although Harpignies painted occasional still-lifes, interiors and, early in his career, figure subjects, principally of children (e.g. *Sauve qui peut*, exh. Salon 1857; Valenciennes, Mus. B.-A.), he was primarily a painter of landscape and town, especially of Paris (see fig. 39). He travelled widely but is associated above all with central France and the countryside around the River Loire and its tributaries, the Nièvre and the Allier. Fully assimilating the mannerisms of most of the Barbizon painters besides Corot, he carried their subjects, vision and stylistic assumptions into the 20th century, distilling an immediately recognizable personal style of limited range and sophisticated compositional variation. A blue luminosity is often the strongest colour note in a generally greyish-green palette of delicately nuanced tonal values, with a recurring disposition for overlapping planes in a frequently flattened perspective.

Strength and concision also characterize his painting. He advocated linear clarity and distinct outline, but nevertheless fluctuated between a bland evenness of form and a diaphanous, feathery handling of separate touches. Within his overall naturalistic preoccupations, stylization is always apparent. A resolute conservative for over 60 years, adhering to a low-keyed conception of ordered nature, he showed hints of Art Nouveau and Japoniste taste and, for all his recorded antipathy, marginal traces of an Impressionist, even a Post-Impressionist, aesthetic. His range extended in scale from painted lampshades to decorative designs for public buildings in Paris (Opéra, Sénat, Hôtel de Ville).

From 1865 Harpignies increasingly took private pupils and after 1885 taught at his Paris school, becoming widely influential as a watercolourist; many of his drawings were dedicated to his

bourgeois and aristocratic lady students. From 1879 he spent much of his time at his property La Trémellerie at Saint-Privé where motifs abounded, and along the coast, especially at Nice and Menton. In his last 15 years, with failing eyesight, he made many monochrome drawings for sale and presentation under the influence of Léon Lhermitte. Béraldi described 34 small and delicately wrought etchings (and one lithograph), but some fragile drypoints remained unpublished. His output during a long career was immense and his watercolours particularly have remained popular during the partial eclipse of his formidable reputation as a painter in oils.

Bibliography

H. Béraldi: Les Graveurs du XIXe siècle, viii (Paris, 1889), pp. 61–3

L. Bénédite: 'Harpignies (1819–1916)', Gaz. B.-A., n. s. 4, xiii (1917), pp. 207–53

Henri Harpignies (exh. cat., Valenciennes, Mus. B.-A., 1970)

P. Miquel: Le Paysage français au XIXe siècle, 1824–1874, iii (Maurs-la-Jolie, 1975)

P. Gosset: Henri Harpignies (1819–1916) (Valenciennes, 1982)

HARLEY PRESTON

Hébert

French family of sculptors. Pierre Hébert (b Villabé, Seine-et-Oise, 1804; d 1869) studied at the Ecole des Beaux-Arts in Paris, exhibiting at the Paris Salon from 1836 to 1869. He provided monuments for Toulouse, Orange, La Rochelle, Carcassonne and elsewhere. His statues of Louis de Rouvroy, Duc de Saint-Simon and of Jules, Cardinal Mazarin (both stone) are on the Palais du Louvre, Paris. He trained his daughter Héléna Hébert (b Paris, 4 July 1825; d Saint-Michel-de-Chavaignes, Sarthe, 20 April 1909) and son (Pierre-Eugène-)Emile Hébert (b Paris, 12 Oct 1828; d Paris, 20 Oct 1893) as sculptors.

Héléna Hébert was a regular Salon exhibitor and a participant in architectural decorative schemes including the Paris Opéra and the rebuilt Hôtel de Ville, Paris, where she provided a statue of Jean-Siméon Chardin (stone, 1881). She was in the forefront of the campaign for the rights of women artists: in 1881 she founded the Union des Femmes Peintres-Sculpteurs-Graveurs, Décorateurs, becoming its first president; she also sought the admission of women to the Ecole des Beaux-Arts, Paris, and to the Prix de Rome competition. Having exhibited under the pseudonym Allélit in 1849, as the wife of the painter Léon Bertaux (b 1827) she exhibited under the name Mme Léon Bertaux from 1857.

Emile Hébert studied not only with his father but with Jean-Jacques Feuchère. He was competent in the field of official sculpture for public buildings and executed a successful commemorative monument to François Rabelais (bronze, 1880; Chinon, Place de l'Hôtel de Ville). His main achievement, however, was in his treatment of imaginary subjects, most notably Mephistopheles (plaster, exh. Salon 1853; bronze, 1855; Barnard Castle, Bowes Mus.), Bellerophon (bronze, exh. Salon 1874; CA, priv. col.; see Stump, p. 46) and above all And Always! And Never! (plaster, exh. Salon 1859; bronze, c. 1863; Lawrence, U. KS, Spencer Mus. A.). This group of a maiden swooning in the arms of a skeletal lover elicited an enthusiastic response from Charles Baudelaire in his review of the Salon of 1859. Its macabre eroticism, hinting at a folklore source, parallels the treatment of similar subjects in second generation Romantic poetry.

Bibliography

Lami

Catalogue of the 95th Salon of the Union des Femmes Peintres-Sculpteurs-Graveurs, Décorateurs (Paris, Pal. Luxembourg, 1979)

The Romantics to Rodin: French Nineteenth-century Sculpture from North American Collections (exh. cat., ed. P. Fusco and H. W. Jansen; Los Angeles, CA, Co. Mus. A.; Minneapolis, MN, Inst. A.; Detroit, MI, Inst. A.; Indianapolis, IN, Mus. A.; 1980–81)

J. Stump: 'The Sculpture of Emile Hébert: Themes and Variations', Register [Lawrence, U. KS, Spencer Mus. A.], v/10 (1982), pp. 28–61

PHILIP WARD-JACKSON

Hébert, (Antoine-Auguste-)Ernest

(b Grenoble, 3 Nov 1817; d La Tronche, Isère, 4 Nov 1908). French painter. He took drawing lessons

from the painter Benjamin Rolland (1777–1855) in Grenoble from the age of ten, but his father wished him to become a lawyer and in 1834 Hébert moved to Paris to study law. While there he also studied painting and drawing, first under Pierre-Jean David d'Angers and later under Paul Delaroche, and in 1836 he entered the Ecole des Beaux-Arts. His early paintings were portraits and landscapes of his native Dauphiné. In 1839, the year he passed his law exams, he won the Prix de Rome with the *Cup of Joseph Found in the Sack of Benjamin* (1839; Paris, Ecole N. Sup. B.-A.). Following this success his father allowed him to become an artist, and in 1839 he made his début at the Salon with *Le Tasse in Prison Visited by Expilly* (1839; Grenoble, Mus. Peint. & Sculp., on loan to La Tronche, Mus. Hébert). He arrived in Rome in January 1840 to study at the Académie de France. On his way to Italy he met the Comte de Nieuwerkerke. While there Hébert was in regular contact with his cousin, the novelist Stendhal, then consul at Civitavecchia, and became a friend of the composer Charles Gounod. The Director of the Académie on Hébert's arrival was Ingres, who exerted a great influence on him, but Ingres was replaced later in the year by the less distinguished Victor Schnetz.

Hébert remained in Italy until 1847, working in Florence and Ischia, and he made several copies of the works of Michelangelo. Following a period of convalescence in Marseille after a fall, he returned to Paris in 1848. His entries for the Salon of 1848 and 1849 passed largely unnoticed, but his exhibit of 1850, *Malaria* (1850; Paris, Louvre, on loan to Paris, Mus. Hébert), won him a first-class medal and established his reputation. The work depicts an Italian family fleeing in a boat from a malaria epidemic and includes several doleful young females of the type that appear in many of his subsequent works. In 1853 he exhibited the *Kiss of Judas* (1853; Paris, Louvre, on loan to Paris, Mus. Hébert), a dramatic work using strong light effects.

Late in 1853 Hébert travelled to Italy again, living in Cervara, 60 km from Rome, where he painted the everyday life and landscape of the area, as in *Girls of Alvito* (1855; Paris, Mus.

Hébert). He returned to Paris in 1858 and soon acquired great popularity painting portraits of society women, producing such works as *Mme d'Attainville* (1860; Paris, Louvre). Through the influence of Nieuwerkerke he was appointed Director of the Académie de France in Rome in December 1866. While in Rome he painted a number of works that, like *Girl in the Rushes* (1871; Paris, Louvre), depict erotic female figures. During the Franco-Prussian War, to protect his house in La Tronche, he made a vow that in 1872 he fulfilled by painting the *Virgin of the Deliverance* for the church. This is considered one

40. Ernest Hébert: *The Virgin of Paradise* (Paris, Musée Hébert)

of his major works. He was elected a member of the Académie des Beaux-Arts in 1871 and was President from 1878 to 1879. In 1884 he completed a commission for a mosaic for the apse of the Panthéon in Paris, *Christ Revealing to the Angel of France the Destiny of her Country*. During this period he continued to produce such portraits as *Eléanore d'Uckermann* (1884; Paris, Mus. Hébert) and from the 1880s also painted works on the theme of music, among them *Music* (Paris, Petit Pal.).

In 1885 Hébert was appointed Director of the Académie de France in Rome for a second term. In contrast to his successful earlier period there, he had difficulties in his dealings with the younger artists. Nevertheless, he retained the post until 1890 and remained in Rome until 1896. From this later period date such works as *Sleep of the Infant Jesus* (1886; Paris, Louvre), the dark, mysterious spirituality of which has affinities with Symbolism. He continued to paint on his return to Paris, producing such portraits as the *Marchese da Modena* (1897; Paris, Mus. d'Orsay). The Musée Hébert was inaugurated in 1977 at 85 Rue du Cherche-Midi in Paris, and in 1979 his property at La Tronche was given to the State and became the Fondation Hébert–d'Uckermann. For illustration, see fig. 40.

Bibliography

G. Lafenestre: *La Tradition dans la peinture française* (Paris, 1898), pp. 293–348

A. Soubies: *Les Directeurs de l'Académie de France à la Villa Médicis* (Paris, 1903), pp. 89–102

——: *Les Membres de l'Académie des beaux-arts depuis la fondation de l'Institut* (Paris, 1904–17), iii, pp. 237–45

H. Roujon: *Notice sur la vie et les travaux d'Ernest Hébert* (Paris, 1909)

Peladan: *Ernest Hébert: Son oeuvre et son temps d'après sa correspondance intime et des documents inédits* (Paris, 1910)

R. P. d'Uckermann: *Ernest Hébert, 1817–1908* (Paris, 1982)

□

Hédouin, (Pierre-)Edmond(-Alexandre)

(*b* Boulogne-sur-Mer, 16 July 1820; *d* Paris, 12 Jan 1889). French painter, printmaker and illustrator.

He studied engraving and lithography under Célestin Nanteuil (1813–73) from 1835 and in 1838 entered the Ecole des Beaux-Arts in Paris, where he studied under Paul Delaroche. He made his Salon début with a peasant genre scene in 1842 and at the Salon of 1846 was singled out for praise by Baudelaire for his powerful handling of colour.

Hédouin's Orientalist work dates from a visit made to Algeria in the company of Adolphe Leleux in 1847. Sketches executed during this trip provided the themes of finished paintings throughout his subsequent career (*Café at Constantine*, 1868; Narbonne, Mus. A. & Hist.). Hédouin's pleasing, realistic scenes of French, Spanish and Arab peasant life were much to the taste of Second Empire officialdom, and a number of the artist's works were acquired by the State during his own lifetime: for example, *The Gleaners* (1857; Paris, Mus. d'Orsay) and the *Sheep Market at St Jean de Luz* (1863; Valenciennes, Mus. B.-A.). In 1861 he painted decorative panels and medallions on the theme of the Liberal Arts for the Galeries des Fêtes in the Palais Royal in Paris (*in situ*) and later executed schemes in the style of Watteau for the foyer of the Théâtre Français (*in situ*) and for the old Hôtel de Ville (destr. 1871).

Hédouin's interest in printmaking dates from the early 1840s, when he provided lithographs for *L'Artiste*. Around 1845 he abandoned lithography for etching and became one of the founder-members of the Société des Aquafortistes in 1863. His later years were devoted principally to engraving copies of Old Master paintings (Boucher, David Teniers II and Henry Raeburn), and to illustrating the literary works of Sterne (*Le Voyage Sentimental*, 1875), Rousseau (*Confessions*, 1881), Janin and Molière (1888).

Hédouin was awarded medals for painting at the Salons of 1848, 1855 and 1857, and for engraving in 1868 and 1872, when he was also made Officier of the Légion d'honneur.

Bibliography

T. Gautier: *Les Beaux-arts en Europe* (Paris, 1856)

H. Béraldi: *Les Graveurs du XIXe siècle*, viii (Paris, 1889), pp. 68–74

J. Adhémar, J. Lethève and F. Gardey: *Bibliothèque nationale: Inventaire du fonds français*, x (Paris, 1958), pp. 163–76

JANE MUNRO

Helleu, Paul-César(-François)

(*b* Vannes, 17 Dec 1859; *d* Paris, 23 March 1927). French painter and printmaker. In 1870 he entered the Ecole des Beaux-Arts, Paris, where he studied under Jean-Léon Gérôme, a pupil of Ingres. He proudly described himself as 'the grandson of Ingres' and advocated that artists should 'always be classical'. He quickly formed a group of close friends including Sargent, Degas, Whistler, Alfred Stevens and Giovanni Boldini. As a student he was very poor and to earn a living spent 10 years decorating plates for the potter Joseph-Théodore Deck. In 1885 he visited London with Gérôme to paint a panorama (untraced). This was the start of a lifelong affection for England, where he returned almost every year.

Helleu established his reputation with the exhibition of several large pastels at the Salons of 1885 and 1886, including *Woman with a Fan* (exh. Salon 1886; Minneapolis, MN, Inst. A.); Blanche claimed that never before had an unknown artist received such a rapturous reception. Degas invited Helleu to contribute to the Impressionist exhibition of 1886, but he refused because of his dislike of Gauguin's work, a decision that later harmed his reputation. Helleu was a *plein-air* painter; his subjects and style are in the Impressionist mood, though his colours are cooler. In 1886 he married Alice Guérin, then aged 16, who became his favourite model (see fig. 41). Helleu's many sketches and drypoints of his wife and children are among his most charming works.

In 1887 Helleu met Comte Robert de Montesquiou, who bought several of the artist's works and commissioned a series of pastels of hydrangeas for his house at Versailles (untraced). He introduced Helleu into French society and became his greatest admirer and patron. Helleu painted several portraits of Montesquiou's cousin, Mme de Greffulhe (e.g. 1897; France, priv. col.), on whom Marcel Proust based the Duchesse de Guermantes in *A la recherche du temps perdu*, while the painter Elstir is principally based on Helleu himself. Montesquiou's book on Helleu remains the standard work on his oils, pastels and drypoints (a quarrel between them arose, however, over the book's design).

41. Paul-César Helleu: *Mme Helleu, the Artist's Wife, Resting* (Paris, Musée d'Orsay)

In 1886 James Tissot gave Helleu the diamond he used to draw drypoints on copper, for he regarded Helleu as his natural successor. Helleu proved to be a great master of this difficult medium. He exhibited 59 works in 1895 at the Robert Dunthorne Gallery, London, with a catalogue prefaced by Edmond de Goncourt. Princess Alexandra visited the show and commissioned a drypoint portrait of herself. Helleu soon became renowned for these drypoints of fashionable beauties, which he could produce in an hour and a half and for which he charged 1200 francs. Although sometimes unique, they could be produced in editions as large as 150 (examples in Paris, Bib. N.). His sitters were drawn from the aristocracy (e.g. *Duchess of Marlborough*, 1900), the demi-monde (e.g. *Liane de Pougy*, c. 1910) and from literary circles (e.g. *Anna de Noailles*, c. 1905). The precise draughtsmanship of his drypoints contrasts strongly with the flowing brushwork of his paintings; Helleu's work in both media, however, shows the influence of Japanese prints in his choice of compositional perspective.

The last exhibition of Helleu's oils, including seascapes, pictures of cathedrals and views of the park at Versailles, was held at the Salon du Champs de Mars, Paris, in 1897. He had just met Proust, whose admiration for *Autumn at Versailles* (c. 1897; Paris, Mus. d'Orsay) led to a lifelong friendship. Proust visited the artist on his yacht and in his elegant flat, which was entirely decorated in white, his favourite colour.

Helleu visited America in 1902, 1912 and 1920. He admired the beauty and chic of American women and portrayed many of them, including *Helena Rubinstein* (drypoint) and the Director of the Pierpont Morgan Library *Belle de Costa Greene* (drawing in coloured chalks, 1912; New York, Pierpont Morgan Lib.). He also painted the ceiling of Grand Central Station (1912; rest. 1990s) with the signs of the zodiac. Despite the encouragement of his artist friends, Helleu doubted the worth of his oil paintings, which, as Blanche observed, were 'carefully hidden from the public'. The popularity of his drypoint portraits of society beauties has prevented a general recognition of his considerable talents as a painter and pastellist.

Writings

Nos bébés (Paris, c. 1912)

Bibliography

R. de Montesquiou: *Paul Helleu: Peintre et graveur* (Paris, 1913)

J. E. Blanche: *Propos de peintre*, iii: *De Gauguin à la Revue nègre* (Paris, 1928), pp. 115–49

E. de Goncourt and J. de Goncourt: *Journal des Goncourts*, ix (Paris, 1895; Eng. trans., 1937)

P. Howard-Johnston: '"Bonjour M. Elstir"', *Gaz. B.-A.*, n. s. 6, lxix (1967), pp. 247–50

Exposition Paul Helleu (exh. cat., ed. A.-M. Bergeret-Gourbin and M.-L. Imhoff; Honfleur, Mus. Boudin, 1993)

JANE ABDY

Henner, Jean-Jacques

(*b* Bernwiller, Alsace, 5 March 1829; *d* Paris, 23 July 1905). French painter. He was born into a peasant family in the Sundgau and received his first artistic training at Altkirch with Charles Goutzwiller (1810–1900) and later in Strasbourg in the studio of Gabriel-Christophe Guérin (1790–1846). In 1846 he enrolled at the Ecole des Beaux-Arts in Paris as a pupil of Michel-Martin Drolling and, from 1851, of François-Edouard Picot. While a student he was particularly drawn to portraiture, and during his frequent visits to Alsace he made portraits of his family as well as of the notables of the region. He also painted scenes of Alsatian peasant life (e.g. *Marie-Ann Henner Churning Butter*, 1856; Paris, Mus. Henner).

In 1858 Henner won the Prix de Rome with *Adam and Eve Finding the Body of Abel* (Paris, Ecole N. Sup. B.-A.). He then spent five years at the French Academy in Rome, where he discovered Caravaggio, Titian and Correggio, and was inspired by the landscapes of Rome and its surroundings (visited in 1859), of Florence, Venice and Milan (1860), and of Naples and Capri (1862).

Paintings he produced in Italy include the *Repentant Magdalene* (1860; Colmar, Mus. Unterlinden) and the *Chaste Suzanne* (1864; exh. Salon 1865; Paris, Mus. d'Orsay), both of which show the influence of Titian on his treatment of

the nude, and of Corot on his landscape. Henner employed strong chiaroscuro effects, setting his pale figures against a dark background. Their contours were softened by the use of *sfumato*, for which he was indebted to Correggio, and wide, heavy brushstrokes.

In 1864 he returned to France and exhibited with enormous success at the Paris Salon between 1865 and 1903. After working for a time on quasi-mythological subjects, notably nymphs and naiads (e.g. *Byblis*, exh. Salon 1867; Dijon, Mus. B.-A.), he turned towards 'idyllic' painting and, after 1870, to Symbolism, occasionally with explicit political overtones. *Alsace* (1871; Paris, Mus. Henner), which shows a young Alsatian woman in mourning, is a political comment on the German annexation of the province after the Franco-Prussian War. The image achieved a wide circulation in the engraving (1871) by Léopold Flameng (1831–1911).

After 1870 Henner's entire oeuvre became a meditation on the theme of death in various guises, notably in the *Magdalene* series (e.g. *Magdalene in the Desert*, exh. Salon 1874; Toulouse, Mus. Augustins; *Magdalene Weeping*, 1885, untraced), the *Dead Christ* series (e.g. *Jesus in the Tomb*, exh. Salon 1879; Paris, Mus. d'Orsay; *Dead Christ*, exh. Salon 1884; Lille, Mus. B.-A.), *Andromeda* (1879, untraced) and the *Levite of Ephraim* (exh. Salon 1898; Ottawa, Tannenbaum priv. col.). The Italian landscape featured in his early work was gradually replaced by the typically Alsatian Sundgau, expressing the artist's nostalgia for his homeland.

Through the contacts he made in Rome, Henner obtained many portrait commissions, for example *Félix Ravaisson-Mollier* (exh. Salon 1886; Paris, Petit Pal.) and *Laura Leroux* (exh. Salon 1898; Angers, Mus. B.-A.), and these continued to be an important part of his output throughout his life. In 1923 his heirs founded a museum dedicated to him in Paris, in which most of his studio collection was housed.

Bibliography

G. Cheyssial: *Musée National Jean-Jacques Henner*, Petits Guides des Grands Musées, 54 (Paris, n.d.)

L. Loviot: *J. J. Henner et son oeuvre* (Paris, 1912)

E. Durand-Greville: *Entretiens de J. J. Henner* (Paris, 1925)

P.-A. Meunier: *La Vie et l'oeuvre de Jean-Jacques Henner* (Washington, DC, 1927)

Jean-Jacques Henner, Henri Zuber (exh. cat., Strasbourg, Mus. B.-A., 1973)

G. de Lorenzi: *J. J. Henner e lo spiritualismo* (Florence, 1982)

I. de Lannoy: *Jean-Jacques Henner (1829–1905): Essai de catalogue*, 5 vols (diss., Paris, Ecole Louvre, 1986)

ISABELLE DE LANNOY

Henriet, (Charles-)Frédéric

(*b* Château-Thierry, Aisne, 6 Sept 1826; *d* Château-Thierry, 24 April 1918). French painter, writer and engraver. He began his career in Paris as a law student and while completing his degree published short pieces on art and the theatre in satirical journals under a pseudonym. In 1851 the Comte de Nieuwerkerke hired him to assist in the organization of the Salons and then to be his personal secretary (1854–9).

Henriet published Salon reviews in 1852 and 1853. In 1851 he had met the landscape painters Corot and Charles-François Daubigny in the studio of the glass painter and restorer Nicolas Coffetier (1821–84). His friendship with these artists led him to write about their work and finally, having returned to Château-Thierry after his retirement from government service in 1859, to become a painter. Following the acceptance of his landscape *At Corbiers, near Jouarre* (untraced) in the Salon of 1865, he exhibited at the Salon regularly until 1880, albeit without medals. One painting, the *Marne at Tancrou*, was bought by the State in 1868 for the Musée Municipal Hôtel Dieu in Vire.

Henriet's paintings, engravings and watercolours (e.g. the *Farm of Gléret*, exh. Salon 1874; untraced) record his beloved homeland: the Marne River, the Ourcq canal, the village of Jouarre and that of Mézy on the Seine. In pastoral mood, tonal palette and deeply receding horizontal format they echo the plains and valleys, wide, slow waterways and rutted village roads of the Marne Valley, an area painted by his more illustrious

colleagues Daubigny and Léon Lhermitte. Throughout his life, Henriet remained a Barbizon painter of the Marne. In Château-Thierry between 1898 and 1912 he helped administer and publish the *Annales* of the town's Société Historique et Archéologique, as well as being the curator of the town's art museum, the Musée Jean de La Fontaine, where three of his works now hang (the *Village of Montgoins*, the *Banks of the Meuse at Revin* and the *Keep of Vic-en-Aisne*).

Writings

Coup d'oeil sur le Salon de 1853 (Paris, 1853)
Daubigny: Esquisse biographique (Montdidier, 1857)
Chintreuil: Esquisse biographique (Paris, 1858)
Le Paysagiste aux champs (Paris, 1866, 2/1876)
Daubigny et son oeuvre (Paris, 1875)
Les Campagnes d'un paysagiste (Paris, 1891)
Les Eaux-fortes de Léon Lhermitte (Paris, 1905)
Etienne Moreau-Nélaton: Notes intimes (Paris, 1907)

Bibliography

Bénézit
Eaux-fortes par F. Henriet (Paris, n.d.)
H. Beraldi: *Les Graveurs du XIXe siècle*, viii (Paris, 1889), pp. 76–7
E. Moreau-Nélaton: *Mon bon ami Henriet* (Paris, 1914)

NANCY DAVENPORT

(Paris, 1820). His style, formed by his training in the classic works of the past, gradually grew less severe, influenced by such English engravers as William Woollett. His friendship with Ingres, which began in the late 1820s, and his engraving of the *Abdication of Gustav Vasa* (1831; Paris, Bib. N.) were instrumental in winning him critical acclaim. In the 1840s and early 1850s he made engravings after, among other works, Paul Delaroche's *Hémicycle* for the Ecole des Beaux-Arts (1853; Paris, Bib. N.), for which he was awarded the medal of honour at the 1853 Salon. He subsequently devoted himself increasingly to religious work and portraits, producing, for example, the *Deposition* (1855; Paris, Bib. N.) after Delaroche and *Jean-Baptiste Dumas* (1884; Paris, Bib. N.). In 1863 he was appointed Professor of Graphic Arts at the Ecole Nationale des Beaux-Arts and in 1871 was elected President of the Académie des Beaux-Arts, of which he had been a member since 1849.

Bibliography

DBF
G. Vapereau: *Dictionnaire universel des contemporains* (Paris, 1858, rev. 6/1893)
Inventaire du fonds français après 1800 (Paris, Bib. N., Dépt. Est. cat., x (Paris, 1958), pp. 281–92

Henriquel-Dupont [Henriquel, Louis-Pierre]

(*b* Paris, 13 June 1797; *d* Paris, 20 Jan 1892). French draughtsman and engraver. From 1812 to 1815 he studied painting at the Ecole des Beaux-Arts, Paris, and in the studio of Pierre Guérin, after which, with a view to commercial prospects, he devoted himself to the graphic arts and studied under Charles-Clément Bervic, who made him copy the masterpieces of engraving from the 16th and 17th centuries. He competed unsuccessfully for the Prix de Rome for graphic art in 1816 and 1818 and in the latter year established his own studio, where he produced engravings from works by Alexandre Desenne (1785–1827) and Achille Déveria for such books as La Fontaine's *Fables* (Paris, 1819) and Voltaire's *La Pucelle d'Orléans*

Hervier, (Louis-Henri-Victor-Jules-François) Adolphe

(*b* Paris, 1818; *d* Paris, 18 June 1879). French painter, draughtsman and printmaker. He was first taught by his father, Marie-Antoine Hervier (*fl c.* 1810–20), a successful miniature painter and former pupil of David, and he later studied under Léon Cogniet and Eugène Isabey. From the start his work had an individual style. His work first appeared at the Salon in 1849 but, according to Philippe Burty (sale catalogue, Paris, Hôtel Drouot, 26 Feb 1876), was exhibited there only eight more times, with 23 rejections. Gautier, the Goncourt brothers, Champfleury, Corot and Rodolphe Bresdin praised his work, but their admiration brought him little money, and he

was forced to paint backgrounds for other artists, such as the military painter Edouard Armand-Dumaresq (1826–95).

A skilled draughtsman with a lively style, Hervier learnt to etch about 1840 and became a gifted printmaker. His etchings, which are frequently small, resemble sketchbook pages with their innovative use of various printmaking techniques and their fresh ideas. He published several different editions of his prints in his lifetime, and in 1888 the editor and bookseller L. Joly compiled a posthumous *Album Hervier*, containing 43 plates drawn and etched by the artist between 1840 and 1860. His figure style, which, like Daumier's, has elements of caricature, gives expressive life to the peasants and workers he frequently portrayed, for example in *Market at Caen* (c. 1860; Dijon, Mus. B.-A.). His paintings are solidly constructed, with considerable sensitivity to effects of light, perhaps a reflection of the time he spent working around Barbizon with artists such as Charles Jacque. In the last two decades of his life Hervier sacrificed some of his early vigour for a broader, more facile approach, notably in his watercolours. Several sales of Hervier's work were held during his lifetime, though none was very successful.

Bibliography

T. Gautier: *Les Beaux-arts en Europe*, ii (Paris, 1857), pp. 158–9

P. Hamerton: 'Modern Etching in France', *F.A. Q.*, ii (1864), pp. 83–4, 102

H. Beraldi: *Les Graveurs du XIXème siècle*, viii (Paris, 1889), pp. 110–16

E. de Goncourt and J. de Goncourt: 'Le Salon de 1852', *Etud. A.* (1893), pp. 89–90

R. Bouyer: 'Petits maîtres oubliés, I: Adolphe Hervier', *Gaz. B.-A.*, xvi (1896), pp. 61–72

R. Marx: 'Cartons d'artistes, maîtres et petits maîtres du XIXème siècle: Adolphe Hervier, 1819–1879', *Image* (1896–7), pp. 18–23

A. Baudin: *Recherches sur la vie et l'oeuvre du peintre français, Adolphe Hervier (1819–1879), avec le catalogue des oeuvres peintes et dessinées* (MA thesis, U. Lille, 1972)

J. van der Noort: *Catalogue Raisonné* of Hervier's Prints and Watercolours (in preparation)

JAMES P. W. THOMPSON

Hesse, Alexandre-Jean-Baptiste

(*b* Paris, 30 Sept 1806; *d* Paris, 7 Aug 1879). French painter, nephew of Nicolas-Auguste Hesse. He was the son of Henri-Joseph Hesse. He entered the studio of Jean-Victor Bertin in 1820, enrolling at the Ecole des Beaux-Arts the following year. He then travelled in France, visiting the Midi in 1825. In 1830 he visited first Rome, where he met Horace Vernet, Director of the Académie Française, and then Venice. In 1833 he exhibited *Funeral Honours Rendered to Titian after his Death at Venice during the Plague of 1576* (Paris, Louvre) at the Salon, where he won a first-class medal. The same year he returned to Italy, where he made copies of Renaissance masterpieces in Florence and Venice. In 1836 he received a State commission to paint *Henry IV Brought back to the Louvre after his Assassination* (1836; Versailles, Château), which was destined for the Galerie d'Apollon in the Louvre.

In 1842 Hesse exhibited the large work *Adoption of Godefroy de Bouillon in 1097 by the Emperor Alexius Comnenus* (1842; Versailles, Château), which had been commissioned by the State two years previously and for which he was made a Chevalier de la Légion d'honneur that year. Like his uncle, he took part in the 1848 competition to provide an allegorical figure of the Republic. Apart from his Salon paintings he worked on a number of church decorations in Paris, including the chapel at St Séverin (1852) and the church of St Gervais–St Protais (1864–7). He continued to exhibit at the Salon until 1861. His painting was most notable for its intense colours, earning him the name 'the last Venetian'. He travelled regularly and was in Rome again from 1845 to 1857 and in Belgium in 1870. He was elected a member of the Académie des Beaux-Arts in 1867, succeeding Ingres, and in 1869 was made Officier de la Légion d'honneur.

Bibliography

DBF

E. Bellier and L. Auvray: *Dictionnaire général des artistes de l'école française*, 3 vols (Paris, 1868–85)

P. Nicard: *Alexandre Hesse: Sa vie et ses ouvrages* (Paris, 1883)

Hiolle, Ernest-Eugène

(b Paris, 5 May 1834; d Bois-le-Roi, 5 Oct 1886). French sculptor. He studied at the Ecole Académique in Valenciennes before entering the studio of François Jouffroy at the Ecole des Beaux-Arts in Paris. In 1862 he won the Prix de Rome. His first Salon exhibit, the statue *Orion Sitting on a Dolphin* (marble, 1866–70; Paris, Mus. d'Orsay), was executed during his time at the Académie de France in Rome. After several years during which he devoted himself mainly to portrait busts because of a lack of state commissions, he participated in the great public building projects of the Third Republic (after 1870), contributing decorative sculpture to the Paris Opéra and the Hôtel de Ville, among other buildings. Such works as his statues *Narcissus* (marble, 1869; Valenciennes, Mus. B.-A.) and *Eve* (marble, 1883; Troyes, Mus. B.-A. & Archéol.) demonstrate the influence of his years in Italy. He was occasionally assisted by his brother Maximilien-Louis Hiolle (1843–1938).

Bibliography

Lami

LAURE DE MARGERIE

Huet, Paul

(b Paris, 3 Oct 1803; d Paris, 9 Jan 1869). French painter, draughtsman and printmaker. From an early age he painted *en plein air*, especially in Paris and its environs, in the Parc Saint-Cloud and the Ile Séguin. In 1818 he studied briefly in the studio of Pierre Guérin and from 1819 to 1822 he was tutored by Antoine-Jean Gros. In 1820 he also attended the Ecole des Beaux-Arts, and in 1822 he painted the nude figure at the Académie Suisse. Although his first works show the influence of Antoine Watteau and Jean-Honoré Fragonard (e.g. *Elms at Saint-Cloud*, 1823; Paris, Petit Pal.), the major influence was to be that of the English landscape painters, especially after his meeting in 1820 with Richard Parkes Bonington. They became close friends and often painted together in Normandy, and it is sometimes difficult to decide to whom to attribute certain of their works. At the Salon of 1824 in Paris, Huet discovered the work of Constable, and this marked a turning-point in his career: his palette became darker and his paint thicker. He quickly began to show a new sensitivity to the landscape, as is evident in *Sun Setting behind an Abbey* (1831; Valence, Mus. B.-A. & Hist. Nat.), inspired by one of Victor Hugo's poems. Huet was considered to be an innovator in the depiction of landscape in a Romantic vein, and by 1830 he had become one of the leading painters in this manner. Having made his début at the Salon in 1827, he continued to exhibit there until 1869. He also exhibited in 1834 at the Exposition des Beaux-Arts in Lille, where he received a gold medal for his painting *Landscape: Evening* (Lille, Mus. B.-A.), an evocative composition of a woman by the bank of a stream. In 1841 he was made Chevalier de la Légion d'honneur and in 1855 showed at the Exposition Universelle in Paris, where *Flood at Saint-Cloud* (Paris, Louvre) was successfully received.

Huet travelled widely in the French provinces and was particularly fond of Normandy. In 1818, 1821, 1825 and 1828 he visited Trouville and Fécamp and, in 1829, Calais. At various times in the 1830s he was in Honfleur and Rouen, where he advised Théodore Rousseau. From 1822 he painted and sketched in the forest of Compiègne, and in 1833 he was one of the first to become interested in the region of the Auvergne. That year he also made his first trip to Avignon and Aigues-Mortes in the south of France, and he returned there in 1836. From 1838 he spent many winters at Nice, where he painted watercolours bathed in light. He also did several pen-and-ink drawings of coastal rocks (e.g. *Rocks at Nice*; Lille, Mus. B.-A.), a favourite subject of his. In 1841–3 he made an extensive tour of Italy, and in 1849 he began to paint in the forest of Fontainebleau. He returned to Normandy in the 1850s and 1860s, visiting such places as Trépont (1853) and Etretat (1868). He visited London in 1862 and Belgium and the Netherlands in 1864 to see the works of Rembrandt and Rubens. On all of his trips he painted and sketched extensively in watercolour, pastel and pencil. He was especially adept at painting in watercolour, a medium that he had

42. Paul Huet: *Oak Tree Struck by Lightning, Forest of Compiègne* (Sceaux, Château de Sceaux, Musée de l'Ile de France)

mastered at an early age and to which he lent his own innovative quality. Throughout his career he was primarily concerned with interpreting variations in atmosphere, expressing the moods of nature and seeking out the contrasts of light and shade that occur in forests, storms and floods (e.g. *Oak Tree Struck by Lightning, Forest of Compiègne*; Sceaux, Château, Mus. Ile de France, see fig. 42). He applied his paint in a thick impasto to enable him to render the play of light. His style of landscape painting influenced the work of the members of the Barbizon school, as well as that of the Impressionists. He was a close friend of Delacroix, and he also knew the writers Alphonse de Lamartine, Charles-Augustin Sainte-Beuve, Victor Hugo, Jules Michelet and the sculptor David d'Angers. He also produced wood-engravings and lithographs (e.g. *The Heron*, 1833) in which he experimented with contrasts of light and dark and of tones, and in 1831 he contributed illustrations to *Voyages pittoresques et romantiques dans l'ancienne France* (Paris, 1820–78) by Baron Isidore-

Justin-Séverin Taylor and Charles Nodier. His son René-Paul Huet (*b* 1844) was also a painter and was his pupil.

Bibliography
L. Delteil: *Le Peintre-graveur Paul Huet*, vii (Paris, 1911)
R.-P. Huet: *Paul Huet: D'après ses notes, sa correspondance, ses contemporains* (Paris, 1911)
P. Miquel: *Paul Huet: De l'aube romantique à l'aube impressionniste* (Paris, 1962)
Paul Huet (exh. cat., Rouen, Mus. B.-A., 1965)
P. Miquel: *Le Paysage français au XIXe siècle, 1824–1874* (Maurs-la-Jolie, 1975), pp. 194–247

LAURENCE PAUCHET-WARLOP

Hugo, Victor(-Marie)

(*b* Besançon, 26 Feb 1802; *d* Paris, 22 May 1885). Writer and draughtsman. Quite apart from his vast literary output, he produced around 3000 drawings in various sizes and techniques. They constitute a fairly homogeneous body of work,

comprising a mass of comic or grotesque sketches, which are not caricatures properly speaking, views of landscapes and buildings drawn from life or imagination (among them a large number of travel notes) and more delicate works typical of the artistic genres of the time. He was daringly experimental in technique, employing cut-outs, often used as stencils, impressions taken from fabric or natural objects, inkblots more or less reworked and every sort of graphic caprice.

Hugo began to draw seriously from about 1825 with some rather sketchy sheets, but he took 20 years to find a personal repertory and style. Although his taste for the picturesque and search for dramatic effects shows an affinity with Romantic imagery, his drawings go further in their energy, freedom of means and exceptionally intense sense of mystery. From about 1845 these were the dominant characteristics of his work, which persisted without major change for 30 years. Hugo's production continued at an uneven pace, often at its most intense during lulls in his writing (1850), gaining in fluidity during his exile in Jersey and Guernsey (1853–70), when he was confronted by the spectacle of sky and ocean, returning in the 1860s to the picturesque and satirical tendencies of his youth and finally dying away, as his literary output did, after 1875–7.

In Hugo's profoundly Romantic art, all is growth and metamorphosis. The unfinished nature of the forms and the floating or circulating pattern of movement in his drawings speak of an unfettered imagination attempting to come to terms with the infinite universe. The famous inkblot drawings (mostly concentrated in his notebooks of 1856–7) were dictated by chance and daydreaming. Their linear equivalents were improvised fantasies, in which jagged silhouettes were arbitrarily scribbled down and then completed with a few more intelligible details. The 'caricatures' have a less contingent relationship with reality, although they rarely concern precise models, and fantasy and the pleasure of invention probably often preceded satirical intent. A caption, usually at the expense of foolishness and authority, generally supplied the latter.

The superficially flippant turns of phrase used by Hugo to describe his 'scribbles' express his puzzlement when confronted by products that contemporary artistic concepts could only comprehend with difficulty. He spoke of 'hours of almost unconscious dreaming' in which he drew freely, liberated from the framework of rational thought as from social norms and constraints. Hugo's drawings have the emotional charge and revelatory power of 'automatic writing' before its time. Indeed, many remain unsettling and have only become legible since the aesthetic revolutions of the 20th century, especially Surrealism and *Art informel*.

Hugo's prodigious literary output provided ample material for the great French illustrators of the Romantic era. One of Hugo's favourite illustrators and a member of his circle was Célestin Nanteuil (1813–73), who etched frontispieces for *Notre-Dame de Paris* (1832), *Lucrèce Borgia* (1833) and *Marie Tudor* (1833). Outstanding later illustrated editions of *Notre-Dame de Paris* were produced in 1836 (Louis Boulanger and the Johannot Brothers), 1844 (Aimé de Lemud, 1816–87) and 1889 (Luc Olivier Merson). Hugo's own drawings were reproduced in wood- and steel-engravings in *Dessins de Victor Hugo* (1862), and they were also used, together with designs by François Chifflart and Daniel Urrabieta y Vierge (1851–1904), in the 1882 edition of *Les Travailleurs de la mer*.

Writings
Oeuvres complètes (Paris, 1969–76/R 1980), xvii–xviii

Prints
Oeuvres complètes (Paris, 1969–76/R 1980), i–xvi

Bibliography
Drawings by Victor Hugo (exh. cat. by P. Georgel, London, V&A, 1974)
P. Georgel: *Les Dessins de Victor Hugo pour 'Les Travailleurs de la mer'* (Paris, 1985)
G. Picon: *Victor Hugo, dessinateur* (Paris, 1985)
La Gloire de Victor Hugo (exh. cat. by P. Georgel and others, Paris, Grand Pal., 1985)
Maison de Victor Hugo: Dessins de Victor Hugo (Paris, 1985)
Soleil d'encre: Manuscrits et dessins de Victor Hugo (exh. cat. by J. Petit and others, Paris, Petit Pal., 1985)

PIERRE GEORGEL

Ingres, Jean-Auguste-Dominique

(*b* Montauban, 29 Aug 1780; *d* Paris, 14 Jan 1867). French painter. He was the last grand champion of the French classical tradition of history painting. He was traditionally presented as the opposing force to Delacroix in the early 19th-century confrontation of Neo-classicism and Romanticism, but subsequent assessment has shown the degree to which Ingres, like Neo-classicism, is a manifestation of the Romantic spirit permeating the age. The chronology of Ingres's work is complicated by his obsessive perfectionism, which resulted in multiple versions of a subject and revisions of the original. For this reason, all works cited in this article are identified by catalogue raisonné number: Wildenstein (W) for paintings; Naef (N) for portrait drawings; and Delaborde (D) for history drawings.

I. LIFE AND WORK

1. Montauban, Toulouse and Paris, 1780–1806

His father, Jean-Marie-Joseph Ingres (1755–1814), a decorative painter and sculptor as well as an amateur musician, taught him the basics of drawing and also the violin. In accord with contemporary academic practice, Ingres devoted much of his attention to copying from his father's collection of prints after such masters as Raphael, Titian, Correggio, Rubens, Watteau and Boucher; none of these copies survives. The earliest known drawings, some signed *Ingres fils*, are portrait sketches and miniatures of family members and Montauban acquaintances (N 1–8). He studied at the academy in Toulouse with the history painter Guillaume-Joseph Roques and the sculptor Jean-Pierre Vigan (*d* 1829): only a selection of school drawings remains and some records of prizes for excellence in 'composition', 'figures and antique', 'rounded figure' and 'life studies'. He studied landscape painting with Jean Briant (1760–99) and continued his musical training. His entry into the Paris studio of David in 1797 brought him into contact with the most talented artists of his generation—among David's former students still frequenting the studio were Jean-Germain Drouais, François-Xavier Fabre, Anne-Louis Girodet and Antoine-Jean Gros; studying at the same time as Ingres were Lorenzo Bartolini, Etienne-Jean Delécluze, Auguste Forbin, François-Marius Granet, Jean-Pierre Granger (1779–1840), Charles Langlois, Fleury Richard and Pierre Revoil. Signed and/or dated works from this period are scarce. It was in David's studio that the principles of the German theorist Johann Joachim Winckelmann and his apotheosis of Greek art became part of Ingres's artistic credo and that he first became aware of the beauty inherent in the work of such Italian painters as Giotto, Masaccio, Fra Angelico and Perugino. During the next five years Ingres found his own eclectic balance of these stylistic contradictions, to which he added a personal elevation of Raphael as the ultimate classical ideal. He trained his eye to be as acute as David's and sought an even greater degree of historical authenticity.

In 1801 Ingres won the Prix de Rome with the *Envoys of Agamemnon* (W 7, 1801; Paris, Ecole N. Sup. B.-A.), which John Flaxman described as the best painting he had seen from the modern French school. Subsequently Flaxman's illustrations to Homer and Dante became a staple in Ingres's artistic diet, reinforcing his natural proclivity for abstract linearity. *Venus Wounded by Diomedes* (W 28, *c.* 1804–6; Basle, Kstmus.) was painted in direct emulation of Flaxman. Ingres could not immediately claim his prize as the Académie de France in Rome had yet to be funded by the government. He was given a small bursary and studio space and a share of available government portrait and copy commissions. In July 1803 he received the commission for a portrait of *Bonaparte as First Consul* (W 14, 1804; Liège, Mus. B.-A.) for the city of Liège, the first acknowledgement that he was becoming one of the leading portraitists of his time.

At the end of 1805 funds were made available for the Prix de Rome stipends. However, Ingres delayed his departure until the last possible moment, submitting five portraits to the Salon of 1806 just before it opened: a *Self-portrait Aged 24* (W 17, 1804; Chantilly, Mus. Condé); portraits of *Philibert Rivière*, *Mme Philibert Rivière* and *Mlle Caroline Rivière* (W 22–4, 1806; all Paris, Louvre)

and a portrait of *Napoleon I on the Imperial Throne* (W 27, 1806; Paris, Mus. Armée). An additional incentive for him to remain in Paris was his engagement in June 1806 to Julie Forestier (*b* 1789), a painter and musician.

2. Rome, 1806–10

En route to Rome, Ingres stayed briefly with Lorenzo Bartolini's family in Florence, where he received letters with news of the adverse criticism his paintings had received at the Salon. After his arrival in Rome in October 1806, he discovered that even David had found his *Napoleon* 'unintelligible'. Stunned, Ingres realized that he could not leave Rome until he had proved himself to the Parisian art establishment. On 26 December 1806 he moved into the small pavilion of S Gaetano in the grounds of the Villa Medici (home of the Académie de France from 1803). It had a magnificent view of Rome and gave him the privacy he needed to work. A series of landscape drawings and small oil paintings records his response to the city (see 1960 exh. cat.).

In 1807 Ingres began two history paintings. Pen-and-ink sketches (Montauban, Mus. Ingres, 867.2302, 2303) show the evolution of the *Venus Anadyomene* (W 257, completed 1848; Chantilly, Mus. Condé), which was inspired by Botticelli's *Birth of Venus* (Florence, Uffizi). In a letter (Feb 1806) he stated his intention of painting a half life-size *Antiochus and Stratonice*, later (29 May) mentioning that he was going to invite Lucien Bonaparte to his studio to see it as soon as it was finished, although it was not until 1808 that the meeting actually took place (portrait drawing of *Lucien Bonaparte*, N 45; New York, priv. col.). The relationship between the wealthy patron and the ambitious young artist soured, however, when Bonaparte requested Ingres's services not as a history painter but as a copyist. Ingres executed few portraits during these early years in Rome. He continued to work on the *Antiochus and Stratonice* (W 232; Chantilly, Mus. Condé) for the next 30 years, until he finished it for Ferdinand-Philippe, Duc d'Orléans, in 1840; the *Venus* remained unfinished until 1848. These works set a characteristic pattern of procrastination in a search for perfection.

In 1808 Ingres prepared three compositions, all focusing on his expertise with the nude figure, for the annual *envoi* to the Ecole in Paris. The first, now known as the Valpinçon *Bather* (W 53, 1808; Paris, Louvre), is a female bather seen from behind and is derived from the study of a *Half-length Bather* (W 45, 1807; Bayonne, Mus. Bonnat); both of these seem inspired by the nudes of Flaxman and Bronzino and reveal for the first time the cool sensuality that became characteristic of Ingres's vision. The second *envoi* was *Oedipus and the Sphinx* (W 60, 1808; Paris, Louvre). A third painting, *Reclining Woman* (later called the *'Sleeper of Naples'*, W 54, 1808; lost in 1815), was listed in the Villa Medici catalogue of 1808 but was not sent to Paris, being bought by Joachim Murat, King of Naples. The criticism of the paintings for their unorthodox stylizations and departure from academic propriety left Ingres puzzled and angry at the lack of appreciation for his talents.

During his last two years at the Villa Medici, Ingres continued to establish potentially useful connections. Among fellow winners of the Prix de Rome, for instance, was Jacques-Edouard Gatteaux with whom he formed a lifelong friendship and through whom he was introduced to Charles Marcotte d'Argenteuil (1787–1864). The resultant portrait (W 69, 1809; Washington, DC, N.G.A.) clearly reveals what a congenial spirit Ingres found his sitter to be. Commissions from several other French government officials followed, and Ingres's income in Rome was assured.

3. Italy, 1811–15

Encouraged by the steadiness of commissions in Rome, in November 1810 Ingres took an apartment at 40 Via Gregoriana at the end of his tenure at the Villa Medici. Living near by was Granet, of whom there are several portrait drawings (e.g. N 86, 1812; Aix-en-Provence, Mus. Granet), and the two painters had free government studios in the church of S Trinità dei Monti. Ingres was still completing his last *envoi*, the large-scale *Jupiter and Thetis* (W 72, 1811; Aix-en-Provence, Mus. Granet), a subject he had first considered in 1806. He envisioned a 'divine painting' that would convey the full beauty of the god-like forms and expressions.

His Jupiter is a masterly image of male power; the sensuous curves and pliant posture of Thetis express eloquently the sensual intimacy between the two immortals. To Ingres's distress, the painting was severely criticized: in his attempt to reconcile prevailing taste and the classical spirit, he failed to see how unorthodox his painting was in combining an intimate love theme with a massive scale and in introducing wildly manneristic exaggerations of contour and proportion.

For the next two years Ingres devoted himself to three monumental decorative paintings: *Romulus Victorious over Acron* (W 82, 1812; Paris, Ecole N. Sup. B.-A.) and the *Dream of Ossian* (W 87, 1813; Montauban, Mus. Ingres), both for the Palazzo di Monte Cavallo, and *Virgil Reading from the 'Aeneid' before Augustus and Livia* (W 83, 1812; Toulouse, Mus. Augustins) for the residence of General François de Miollis (1759–1828), the French lieutenant-governor who oversaw the renovation of Monte Cavallo (the pontifical palace on the Quirinal was being made into the residence of the King of Rome). The programme was an ambitious mixture of painting and sculpture in the Neo-classical style: its theme was the parallel between Roman and Napoleonic history. Antonio Canova oversaw the selection of artists, which included the Danish sculptor Bertel Thorvaldsen. This commission marked the acceptance of Ingres as a history painter. *Romulus Victorious over Acron* was one of three antique battle scenes for the salon of the Empress. Ingres followed Plutarch's *Life of Romulus* closely, striving for archaeological correctness. The archaisms of the work's stylized composition and the flat colouring were intended to imitate an antique low relief. The *Dream of Ossian*, begun in 1812 in collaboration with Jose Alvarez y Priego, was intended as an oval ceiling decoration for the Emperor's bedroom. (When Ingres bought it back in the 1830s he began to rework it into a rectangular format; it was in his studio with its perimeters unfinished at his death.) *Virgil Reading from the 'Aeneid' before Augustus and Livia*, a night scene painted for General Miollis's bedroom in the Villa Aldobrandini, is perfectly attuned to the traditional Neo-classical approach to subject-matter:

action is frozen, emotion is held in check, gestures tell all. (It too was repurchased, reworked and left unfinished: see below.)

The large commissions were completed by May 1813. Having firmly established his reputation in Rome, Ingres looked to secure a place in Paris. He set to work on an ambitious plan for the Salon of 1814, at which he hoped to outshine the popular historical genre painters. In a letter of July 1813 he mentioned plans to send two *grands tableaux*, two portraits, a painting of the *Interior of the Sistine Chapel* (W 91, 1814; Washington, DC, N.G.A.), which had been commissioned in 1812 by Marcotte, and a small painting of *Raphael and La Fornarina* (W 86, 1813; untraced). Neither of the *grands tableaux* was completed: *Tu Marcellus eris* (W 128; Brussels, Musées Royaux A. & Hist.) is a fragment of the three central figures from a revised *Virgil Reading* cut down (at a later date) from the composition Ingres intended to send to this Salon; it is uncertain what the second *tableau* was to have been. The *Interior of the Sistine Chapel* was finished in summer 1814 and was sent to the Salon accompanied only by another historical genre piece, *Don Pedro of Toledo Kissing the Sword of Henry IV* (W 101, exh. Salon 1814; untraced). It was hardly the *tour de force* that Ingres intended. *Raphael and La Fornarina* reached Paris just days before the Salon closed.

While preparing for the Salon, on 4 December 1813 Ingres married Madeleine Chapelle (1782–1849), beginning 36 years of personal security and happiness. A series of portraits shows his contentment within this new family circle (N 98–111). Another diversion from preparations for the Salon was a summons to Naples, where he spent February to May 1814, painting the *Grande Odalisque* (W 93, 1814; Paris, Louvre) as a pendant to the '*Sleeper of Naples*'. A full-length oil portrait of *Caroline Murat, Queen of Naples* (W 90, 1814) and the *Sleeper* were lost from the palace in May 1815 with the fall of the Murat régime, but a series of portrait drawings of the family remains (N 116–21). He also painted two smaller Troubadour style love scenes for Caroline Murat—the *Betrothal of Raphael* (W 85, 1813; Baltimore, MD, Walters A.G.), which Ingres boasted he completed in just 20 days, and the first

version of *Paolo and Francesca* (W 100, c. 1814; Chantilly, Mus. Condé).

4. Rome, 1815–20

As the withdrawal of the Napoleonic forces from Italy cut off avenues of financial support, Ingres was forced to turn to drawing portraits of tourists and later a host of new officials of the French Restoration government. Eventually these connections led to new historical commissions, but in the meanwhile he was distressed by having to waste time on such portraits. In contrast to these, many of the portrait drawings Ingres did of friends are exquisite in the loving detail he lavished on them. One of the most intimate, and a perfect example of the type, is his portrait of the *Guillon-Lethière Family* (N 140, 1815). In the winter of 1816–17 Ingres received a commission from the Alba family for three small paintings with subjects taken from Spanish history. For *Philip V and the Marshal of Berwick* (W 120, 1818; Madrid, Pal. Liria, Col. Casa de Alba), a scene from 18th-century Alba family history, Ingres raided the Gobelins tapestry series the *Story of the King* for stylistic prototypes. The figures, diminutive in comparison with his other work, are subordinated to the props of the scene, dressed in period costumes, each playing their assigned role. The subject—the Spanish king rewarding a loyal subject—is purely anecdotal, and Ingres had little personal commitment to it. The subject of the second painting moved Ingres from disinterest to disgust. The *Duque de Alba at Ste Gudule, Brussels* (W 102, 1816–17; Montauban, Mus. Ingres) had as its 'hero' the man who led the Catholic campaign in the Low Countries against the Protestant Reformation and who was responsible for the slaughter of hundreds of innocent people. At first Ingres had in mind a horizontal composition with the protagonist receiving honours from the archbishop. Infra-red photographs reveal that the original format of the canvas was identical with that of a drawing (D 216; ex-Paul Rosenberg & Co., New York) done as a model. Then he switched to a vertical format in order to put as much distance as possible between the viewer and the Duque, the latter becoming almost a speck on the horizon in a long view

down the nave of Ste Gudule. Even that did not ease his scruples, and in 1819 Ingres abandoned the canvas. The third painting never reached the drawing phase.

Ingres made concerted efforts to build up connections with the new French Restoration circles in Rome. Commissions were not only smaller but less frequent than in the glorious days of the Empire. It may be fortuitous, or it may reflect a political astuteness for which Ingres does not often receive credit, that the paintings he sent to the first Restoration Salon (1814) were particularly appropriate to a post-Napoleon environment: the *Sistine Chapel* (W 91) and *Don Pedro of Toledo* (W 101). He lost no time in ingratiating himself with the new leadership. He enjoyed the friendship of three diplomatic secretaries, Gabriel de Fontenay (1784–1855), Artaud de Montor and Augustin Jordan (1773–1849), and profited from their acquaintance in many ways. He drew their portraits, made gifts of drawings of his latest genre subjects, and even made a rare venture into printmaking, transforming the portrait of the ambassador *Mgr de Pressigny* (N 170; priv. col.) into an etching, which he hand-tinted. Mgr de Pressigny (1745–1823) was soon replaced by Pierre-Louis-Casimir, Comte (later Duc) de Blacas, a man of independent fortune, powerfully connected to the inner circle of government. Ingres's relationship with this patron yielded two exquisite Bourbon cabinet pictures for Blacas's personal collection, *Henry IV Playing with his Children* (W 113, 1817; Paris, Petit Pal.), a classic of the Restoration Troubadour style that shows Henry IV down on his knees in a cosy domestic scene, and its pendant, the *Death of Leonardo da Vinci* (W 118, 1818; Paris, Petit Pal.), which depicts the artist dying in the arms of Francis I.

In July 1816 Charles Thévenin (1764–1838), the new director of the Académie de France, began successfully to lobby the Direction des Beaux-Arts in Paris on Ingres's behalf. In January 1817 Blacas chose Ingres as one of the artists for the renovation and the decoration of Trinità dei Monti, the focus of the French colony in Rome. *Christ Giving the Keys to St Peter* (W 132; Montauban, Mus. Ingres) was completed in March 1818 for a fee of

3000 francs. Ingres certainly knew the versions of the subject by Raphael (tapestry cartoon, 1515; London, V&A) and Poussin (*Ordination*, 1639–40; Belvoir Castle, Leics), but while they included all twelve Apostles, Ingres reduced the number to six, while retaining the symbolic position of Judas, who stands apart from the others. (Characteristically, he retouched the painting in the 1840s when the Dames du Sacré-Coeur exchanged it with the French government for a copy.) The Comte de Blacas acted as an intermediary in the acquisition by Louis XVIII of *Roger Freeing Angelica* (w 124, 1819; Paris, Louvre), Ingres's first sale to the State and also the first work by him to enter a public collection (by 1824 it had been moved to the Musée du Luxembourg, Paris). With his confidence as a history painter reestablished by these commissions, Ingres sent *Roger Freeing Angelica* to the Salon of 1819 with the *Grande Odalisque*. James-Alexandre, Comte de Pourtalès-Gorgier, acquired the latter from the Salon, as he had *Raphael and La Fornarina* in 1814, but critics and public alike found the arbitrariness of the odalisque's anatomical structure shocking and found so little to interest them in the *Angelica* as to misidentify the scene as representing Perseus and Andromeda. Ingres felt that the three public exhibitions of his work in 1806, 1814 and 1819 had ridiculed him in Paris, and he determined to stay in Italy.

5. Florence, 1820–24

In August 1820 Ingres moved to Florence, where he hoped to renew contact with Bartolini and to explore the artistic and architectural wealth of the city. Bartolini had become a famous sculptor, and the friendship did not survive. Immediately after his installation at Bartolini's home, Ingres finished a variant of the *Sistine Chapel* (w 131, 1820; Paris, Louvre). He made a copy of Titian's *Venus of Urbino* (w 149, 1822; Baltimore, MD, Walters A.G.) for Bartolini to use as a model for his *Recumbent Venus* (1822; Montpellier, Mus. Fabre) and did a portrait of *Bartolini* (w 142, 1820; Paris, Louvre). He also copied a painting in the Uffizi that he believed to be a self-portrait by Raphael (w 163; Montauban, Mus. Ingres), drew the

churches of Florence and the gardens and visited Lucca, Siena and Pisa. In 1821 Ingres did two portrait commissions, *Count Nicolas Dmtrievitch de Gouriev* (w 148; St Petersburg, Hermitage) and *Mlle Jeanne Gonin* (w 147; Cincinnati, OH, Taft Mus.). The Gonin family became lifelong friends, their household being a model of Ingres's ideal world: a patriarchal merchant husband, a devoted wife, clever children and a wide circle of worthy friends and relatives.

One of the commissions Ingres had 'in progress' when he arrived from Rome was from the Comte de Pastoret (1791–1859) for a small history painting of the *Entry into Paris of the Dauphin, the Future Charles V* (w 146, 1821; Hartford, CT, Wadsworth Atheneum) derived from that of 1358 by Jean Froissart. The figure welcoming the Dauphin was one of Pastoret's relatives. The medieval prototypes Ingres sought in developing the painting are to be found in the vignettes from the *Grandes Chroniques de France* (Paris, Bib. N., MS.fr.6465), which Ingres traced from Bernard de Montfaucon's *Les Monumens de la monarchie française* (Paris, 1729–33, iii, pl. XXII and XXXIX). He also borrowed from Jean Fouquet's *Reception of the Emperor Charles IV* (*Grandes Chroniques*, fol. 419) and Franz Pforr's *Entry of Rudolf I of Habsburg into Basle in 1273* (1808–9/10; Frankfurt am Main, Städel. Kstinst). Though finished in 1821 and listed in the Salon catalogue for 1822, the *Entry into Paris* was not shown until two years later, when it received critical acclaim.

Shortly after his arrival in Florence, Ingres received word from Thévenin of a government commission for a religious painting on a grand scale. The official request was for a painting for the choir of Montauban Cathedral; Ingres's response was a plan for a confrontation at the Salon of 1822. The mayor had asked for a work that would show the King placing the royal family of France under the protection of the Virgin at the time of her Assumption. At first Ingres protested that these were two distinct subjects; later he realized the concept was perfect for the Raphaelesque solution he found in the *Vow of Louis XIII* (w 155, 1824). His representation of the Virgin and Child is a reversal of the *Madonna of Foligno* (1511–12;

Rome, Pin. Vaticana) by Raphael. His image of Louis XIII is from a painting of the same name by Philippe de Champaigne (1637–8; Caen, Mus. B.-A.). Ingres had these borrowings firmly in place with an oil sketch by 1822 (w 156; Montauban, Mus. Ingres), but he failed to deliver the painting for two more years because once again his grandiose intentions inhibited his ability to realize the dream. In late 1821 Ingres mentioned that he expected to cover the cost of personally bringing his *Vow* to Paris by finishing a painting begun in 1807, the *Venus Anadyomene*. By January 1822 he had found a buyer for the work, Jacques-Louis Leblanc (1774–1846), a man of patience who advanced funds against the intended purchase and yet never questioned that the *Vow* would take precedence over his commission. By December 1823 the *Vow* had progressed to the point where Ingres expected to bring it to Paris by the spring. However, it was not until November 1824 that he arrived.

6. Paris, 1824–34

The *Vow of Louis XIII* appeared at the Salon on 12 November 1824. Its favourable reception was essentially a tribute to the long-absent artist. Also, the work was sufficiently orthodox in its presentation of traditional values to stand against such Romantic incursions as Delacroix's *Massacre at Chios* (1824; Paris, Louvre). In early 1825 Ingres received the Cross of the Légion d'honneur, was invited to attend the coronation of Charles X and was elected to the Académie des Beaux-Arts. By July Ingres was installed in a two-room studio with his prints, books, earlier canvases and drawings to inspire, and distract, him. In November 1825 he opened a studio for students, foremost among whom were Eugène-Ammanuel Amaury-Duval, Paul Chenavard, Armand Cambon (1819–85), Raymond Balze (1818–1909) and Paul Balze (1815–84), Auguste Flandrin and Hippolyte Flandrin, Henri Lehmann, Franz Adolph von Stürler (1802–81) and Sébastien Cornu. One of the first fruits of his new place as champion of the classical tradition was a commission from the Bishop of Autun for a monumental religious subject, the *Martyrdom of St Symphorian* (w 212, 1827–34;

Autun Cathedral). Shortly afterwards he received the commission for the *Apotheosis of Homer* (w 168, 1827–33; Paris, Louvre) for the ceiling of one of the nine rooms dedicated to Egyptian and Etruscan antiquities in the Musée Charles X (now Musée du Louvre) to be inaugurated in 1827. The transport of the *Vow of Louis XIII* to Montauban was delayed by Ingres's efforts to keep the work in Paris at one of the more prestigious churches. Abandoning that plan, he kept it for several months so that the engraver Luigi Calamatta could make a drawing of it. The painting was unveiled in the city hall in Montauban on 12 November 1826, the only time Ingres ever returned to his birthplace. On his way back to Paris, he stopped in Autun, where he made studies of the old Roman wall for the *St Symphorian*: an oil sketch (w 202, 1827; New York, priv. col.) was completed by February, by which time a watercolour study of *Homer* (D 178, Lille, Mus. B.-A.) was also well advanced.

During this ten-year period in Paris Ingres carefully manipulated his connections with French society: portrait drawings from this time onwards were exclusively for friendship and/or favour (the two were often linked) and never directly for money. His oil portraits of *Mme Marcotte de Sainte Marie* (w 166, 1826; Paris, Louvre) and *Comte Amédée-David de Pastoret* (w 167, 1826; Chicago, IL, A. Inst.) were sent to the Salon of 1827. A portrait of *Charles X* (w 206, 1829; Bayonne, Mus. Bonnat) was followed by paintings that mark the passage from the Restoration to the bourgeois government of the July Monarchy (1830): both the founder and director of the *Journal des Débats* (*Louis-François Bertin*, w 208, 1832; Paris, Louvre) and Louis-Philippe's prime minister (*Comte Louis-Mathieu Molé*, w 225, 1834; priv. col.) symbolized the new age. Painfully aware that the work he had produced during the previous two decades was virtually unknown in France, Ingres was determined to launch prints of his work soon after his arrival in Paris. James Pradier bought engraving rights to *Virgil Reading the 'Aeneid'* and *Raphael and La Fornarina* in February 1825; Pierre Sudre (1783–1866) bought lithographic rights for the *Grande Odalisque* in 1826; Théodore Richomme

(1785–1849) had engraving rights to *Henry IV Playing with his Children* and Charles-François Sellier to the *Death of Leonardo*. These contracts ended financial need, yet Ingres's fussing over the details of how these prints were done, coupled with obsessive reworking of earlier compositions in replicas and revisions from 1828 to 1833, resulted in a marked decline in his artistic output.

The deadline for the Louvre commission, the *Apotheosis of Homer*, was linked to the opening of the 1827 Salon. While Ingres was still laying in preliminary contours on the canvas, the other artists agreed they could be ready in time. Though in place when the Salon opened, the painting was finished only in grisaille; Ingres eventually completed it for the opening of the Salon of 1833. He was now ready to take up again the *Martyrdom of St Symphorian*, depicting the moment at which the young Christian is led out of the city gate to be beheaded. Although the format had been resolved by February 1827, and Ingres listed it in the Salon catalogue of that year, it was not shown until the Salon of 1834; its discordances of space, perspective, emotion and colour were deemed contrary to academic practice, and the painting was damned as an unsuccessful marriage of Raphael and Michelangelo. Profoundly discouraged, Ingres decided to abandon the Paris art scene. He requested, and received on 5 July 1834, the directorship of the Académie de France in Rome. His Paris studio was abruptly closed. He swore that he would neither submit his works to public exhibition nor undertake government commissions ever again; henceforth he would do only small paintings for friends.

7. Rome, 1835–41

Ingres replaced Horace Vernet as director at the Villa Medici. He and his wife soon gathered round them an intimate circle of young artists, including the composer Ambroise Thomas (1811–96), the architect Victor Baltard, the painter Hippolyte Flandrin and the sculptor Pierre-Charles Simart. At first Ingres buried himself in administrative details. In January 1836 his direct superior Adolphe Thiers asked him to return to Paris to work on paintings for the church of La Madeleine.

Ingres politely declined; but he did have a new project in mind, the *Odalisque with Slave* (w 228, Cambridge, MA, Fogg), which he completed in 1839, part token of his friendship with Marcotte, and part repayment for Marcotte's advance in 1825 to Calamatta for engraving the *Vow*. Ingres also had another commitment. In 1834 Ferdinand-Philippe, Duc d'Orléans, eldest son of Louis-Philippe and a prominent Parisian art collector, had commissioned an *Antiochus and Stratonice* as an unlikely pendant to Paul Delaroche's *Death of the Duc de Guise* (1834; Chantilly, Mus. Condé). Ingres had begun work on this subject in 1807 and had reconsidered it several times in the 1820s.

Despite a period of debilitating illness, Ingres continued to work as much as possible. He resumed painting in September 1837, and he was still involved with the *Antiochus* in January 1839; pressure for completion was being applied by Pradier, who had been promised reproduction rights. It was August 1840 before the painting was sent back to Paris. By then the simple cast of three in a narrow rectangular format had developed into a theatrical cast of characters in a room, the architecture of which was based on designs by Victor Baltard and mostly executed by the Balze brothers. The impressive array of auxiliary characters and the splendour of the room reflect Ingres's attempt to match the *juste-milieu* style of Delaroche. The Musée Ingres, Montauban, has more than 100 sheets containing over 300 drawings showing his search for the right balance of detail; there are over 40, for instance, for the position of the arm of Antiochus. Gatteaux delivered the painting to the Duc d'Orléans, who wrote personally to thank Ingres and included payment of 18,000 francs, nearly double the agreed price. The Duc authorized a showing of the completed *Antiochus and Stratonice* each day in the most beautiful Salon of the Tuileries. Never had a work by Ingres excited such admiration.

8. Paris, 1841–55

In May 1841 Ingres returned to Paris, where he was received with acclaim following the favourable reception of the *Antiochus and Stratonice*. In November that year he began a portrait of

Ferdinand-Philippe, Duc d'Orléans (w 239; Louveciennes, priv. col.), which was delivered to the Palais-Royal by May 1842. At the request of Queen Marie-Amélie (1782–1866), Louis-Philippe commissioned a religious painting for the chapel of the château at Bezy (Christ among the Doctors, w 302, completed 1862; Montauban, Mus. Ingres), and in June 1842 he purchased Cherubini with the Muse of Lyric Poetry (w 236, 1842; Paris, Louvre) for the State collection.

Ingres declined to reopen his studio on his return to Paris as he was assured of a secure income not only from such commissions as the Golden Age (see below) but also from society portraits. At the end of June 1842 he was doing an oil sketch (w 238, Paris, priv. col.) for the portrait of the Comtesse d'Haussonville (w 248, completed 1845; New York, Frick) and was about to have his first sitting with the Baronne James de Rothschild (1805–86). Despite his many complaints about the inconvenience such portraits caused, he still gave them the same attention as his history paintings. With the accidental death of the Duc d'Orléans in July 1842, Ingres lost a patron who had shown him much respect and understanding. Shortly afterwards Louis-Philippe asked for a copy of his son's portrait (w 242, 1843; Versailles, Château), and within a year five more copies of the portrait, in varied formats, were requested. The Queen erected a memorial chapel dedicated to St Ferdinand at Dreux and commissioned designs for its stained-glass windows from Ingres. He completed his cartoons (in colour) for the 25 windows with incredible speed in August and September 1842 (Camesasca, 1971, no. 135a–q; Paris, Louvre). In November 1843 he received a request for stained-glass window designs for the royal chapel of St Louis at Dreux, which held the tombs of the Orléans family (Camesasca, 1971, no. 136a–h; Paris, Louvre), and the designs were completed by June 1844.

Meanwhile in 1843 Ingres had begun work on the largest commission of his career. The Duc de Luynes wanted pendant murals of the Golden Age and the Iron Age (unfinished; each mural 4.8×6.6 m) as the principal decorations of the Salon de Minerva, a large room on the second floor of the family château at Dampierre. The theme of the

Golden Age was intended to compare 19th-century Paris with the ideal world at the beginning of time. The literary and artistic sources ranged from Ovid and Hesiod to Mantegna, Raphael, Agostino Carracci, Poussin, Watteau and Anton Raphael Mengs, and Ingres found further inspiration in Milton's Paradise Lost. The project was to occupy him for several years. When Gatteaux asked to see the work in progress in the summer of 1844 Ingres refused, as not even the Duc de Luynes had been admitted to the gallery.

In June 1845 Ingres brought the portrait of the Comtesse d'Haussonville to a remarkable conclusion. It attracted virtually all Parisian high society to his studio, including the sitter's brother, the Prince de Broglie (1785–1870), who immediately commissioned a portrait of his wife the Princesse de Broglie (w 272, 1853; New York, Met.). About this time Ingres did cameo portrait pendants in grisaille of the Queen and her daughter-in-law, the Duchesse d'Orléans (Camesasca, nos 141–2; Paris, Mus. A. Déc.). By the summer of 1845 the Golden Age was progressing steadily, and both Gatteaux and Marcotte were invited to see it in late October. By June 1847 Christ among the Doctors was well advanced, and Ingres had again taken up the Venus Anadyomene (begun 1807), now for Etienne Delessert (1735–1816). In October 1847 Henri-Eugène-Philippe-Louis, Duc d'Aumale (Louis-Philippe's fifth son), offered Ingres a commission for cartoons for the stained-glass windows of a chapel he wanted to restore in his château at Chantilly. The project was cut short by the Revolution of February 1848; Ingres also lost his client for Christ among the Doctors, when Louis-Philippe was deposed and his art collection dispersed.

In the opening months of 1848 social life in Paris halted, and Ingres found the solitude he needed to finish the Venus Anadyomene and the portrait of Baronne James de Rothschild (w 260, priv. col.). Delessert dared to complain of irregularities in the Venus's proportions, and the work was sold in an instant to Frédéric Reiset (1815–91). Ingres excused himself from work on the murals at Dampierre that summer, claiming that the political climate made work impossible. In

I. Antoine-Louis Barye: *Tiger Looking for Prey* (Paris, Musée du Louvre)

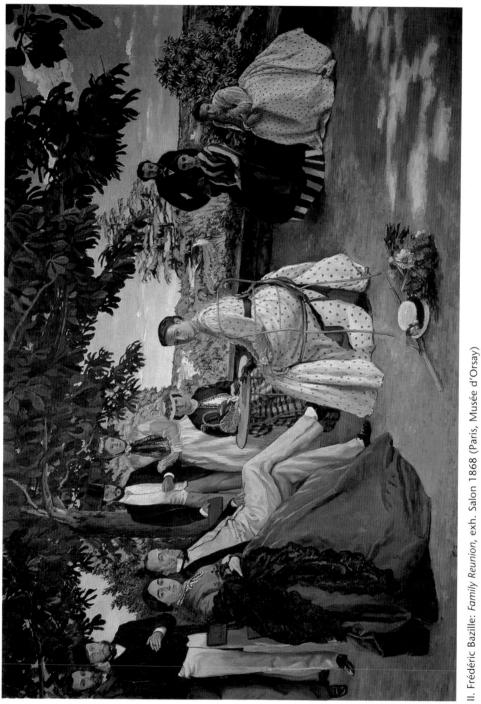

II. Frédéric Bazille: *Family Reunion*, exh. Salon 1868 (Paris, Musée d'Orsay)

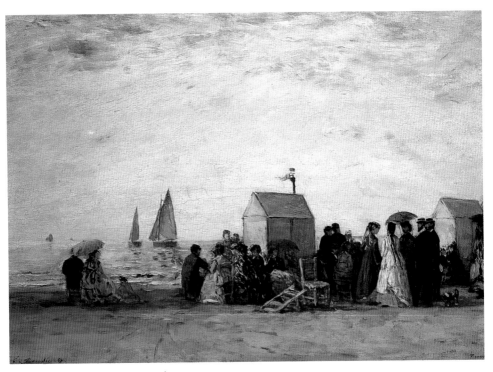

III. Eugène Boudin: *The Beach at Trouville*, 1867 (Paris, Musée d'Orsay)

IV. William Bouguereau: *Napolean III Visiting the Flood Victims of Tarascon in 1856*, 1856 (Tarascon, Hôtel de Ville)

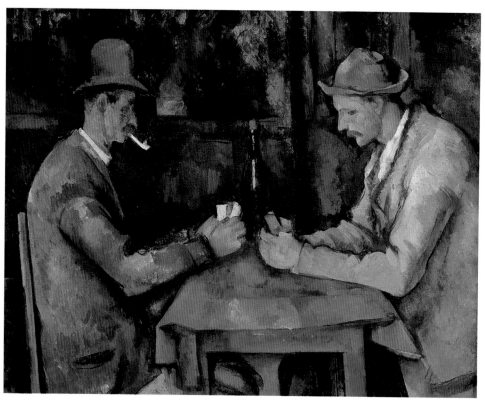

V. Paul Cézanne: *Card Players, c.* 1894–5 (Paris, Musée d'Orsay)

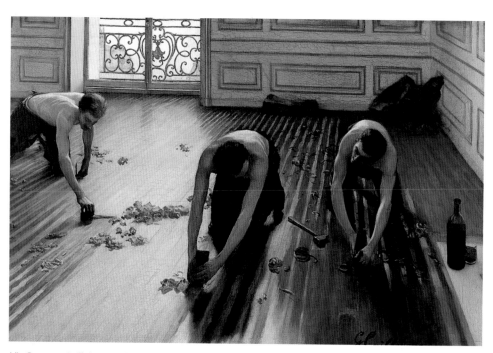

VI. Gustave Caillebotte: *Planing the Floor,* 1875 (Paris, Musée d'Orsay)

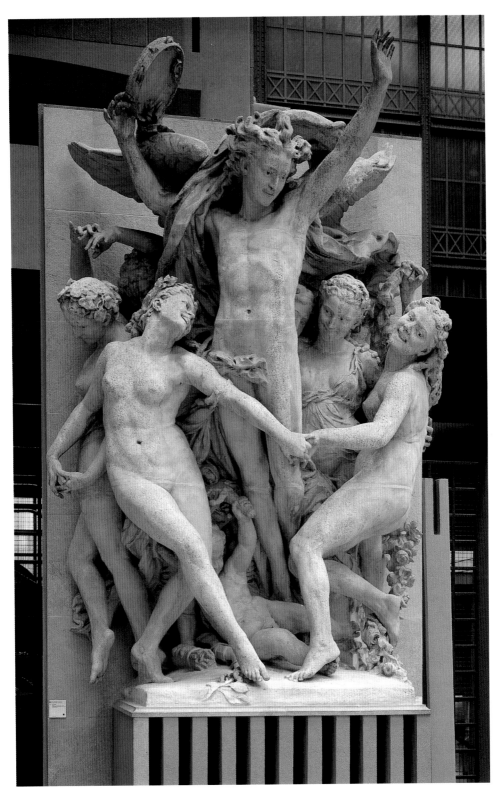

VII. Jean-Baptiste Carpeaux: *The Dance*, 1866 (Paris, Musée d'Orsay)

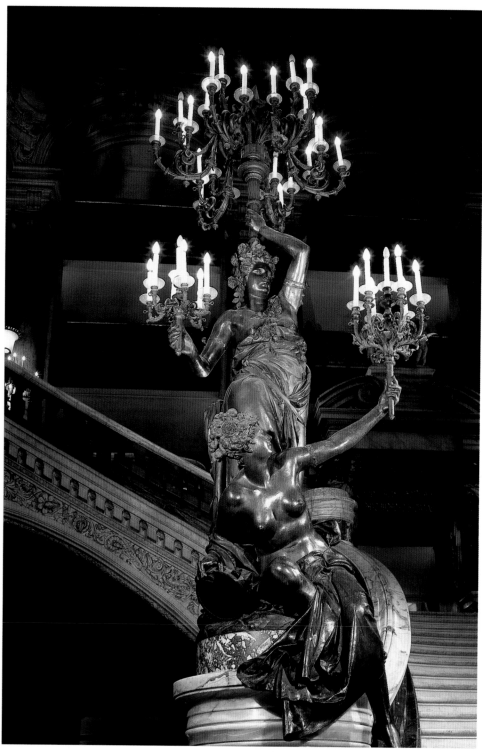

VIII. Albert-Ernest Carrier-Belleuse: *Torchère*, 1873 (Paris, Opéra)

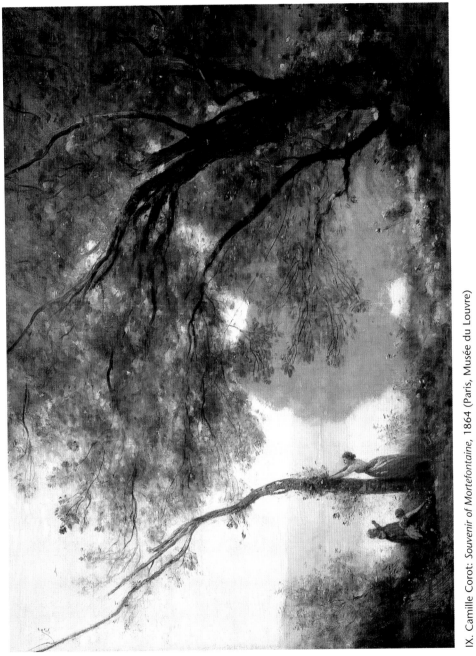

IX. Camille Corot: *Souvenir of Mortefontaine*, 1864 (Paris, Musée du Louvre)

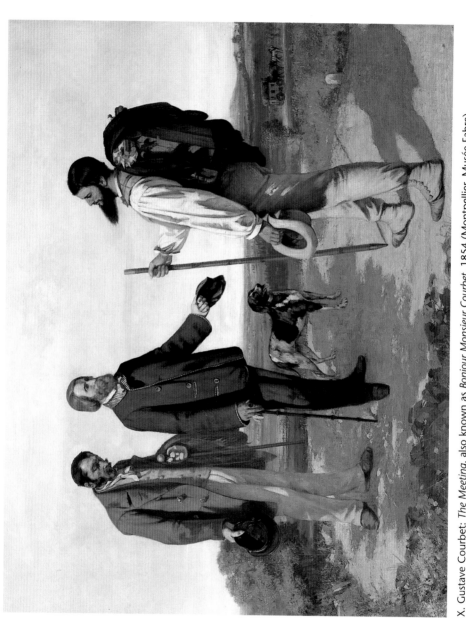

X. Gustave Courbet: *The Meeting*, also known as *Bonjour Monsieur Courbet*, 1854 (Montpellier, Musée Fabre)

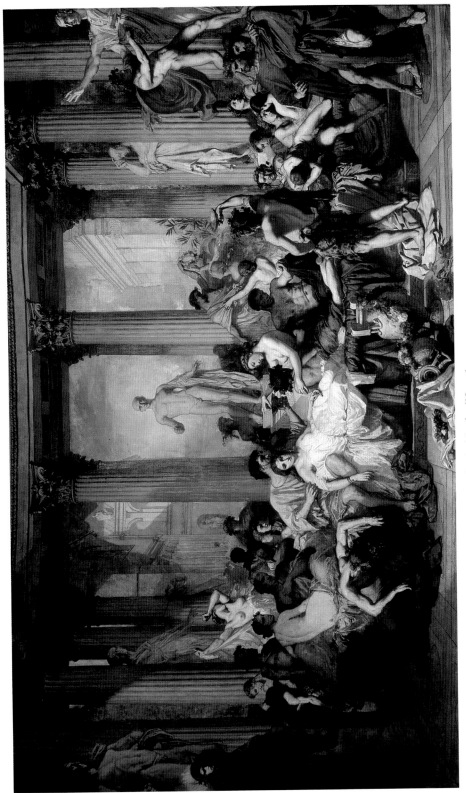

XI. Thomas Couture: *Romans of the Decadence*, completed 1847 (Paris, Musée d'Orsay)

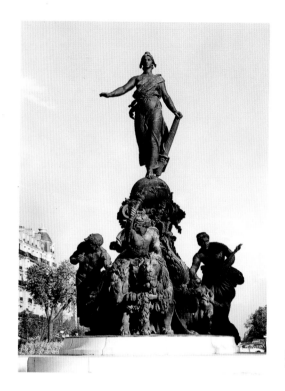

XII. Jules Dalou: *Triumph of the Republic*, 1879–99 (Paris, Place de la Nation)

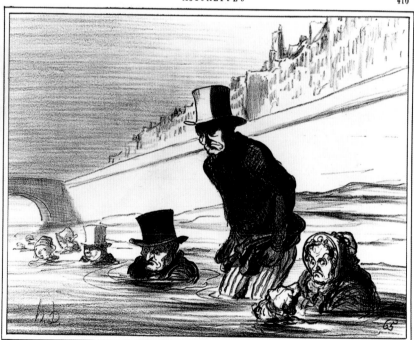

Parisiens prenant déjà leurs précautions pour ne pas être rôtis par la comète.

XIII. Honoré Daumier: *Parisians Taking Precautions so as Not to be Roasted by the Comet*, from *Actualities: The Comet of 1857* (Paris, coll. Marcel Lecomte)

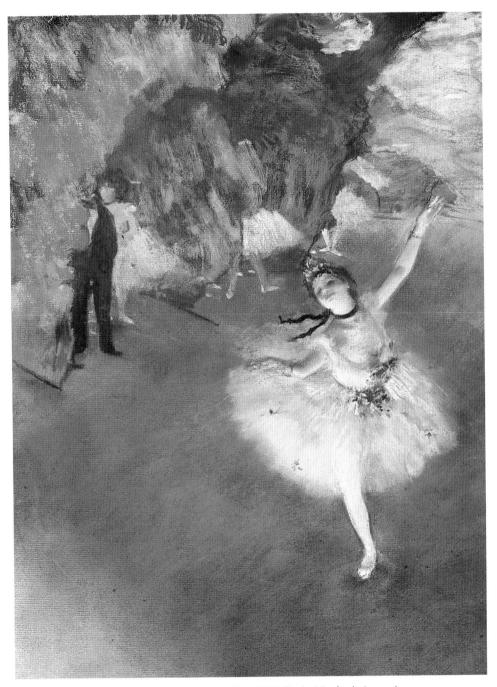

XIV. Edgar Degas: *The Star* (or *Dancer on Stage*), *c.* 1878 (Paris, Musée du Louvre)

XV. Gustave Doré: *Little Red Riding Hood and the Wolf,* from *Les Contes* by Charles Perrault, Paris, 1862 (New York, Pierpont Morgan Library)

XVI. Jean-Léon Gérôme: *Duel after the Masked Ball*, 1857 (Chantilly, Musée Condé)

XVII. Paul Gauguin: *Vision after the Sermon: Jacob Wrestling with the Angel*, 1888 (Edinburgh, National Gallery of Scotland)

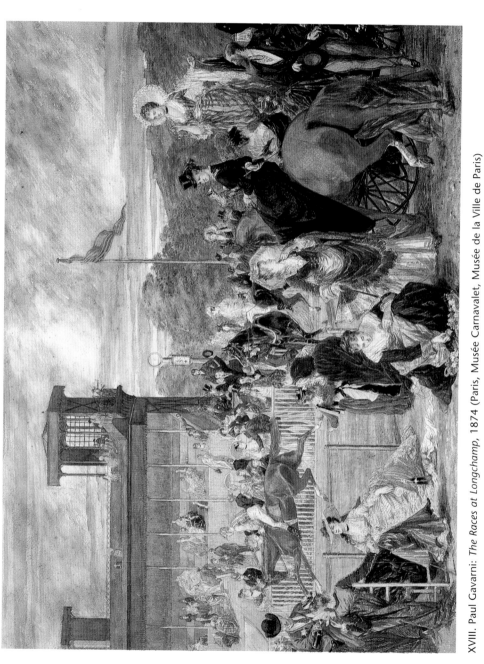

XVIII. Paul Gavarni: *The Races at Longchamp*, 1874 (Paris, Musée Carnavalet, Musée de la Ville de Paris)

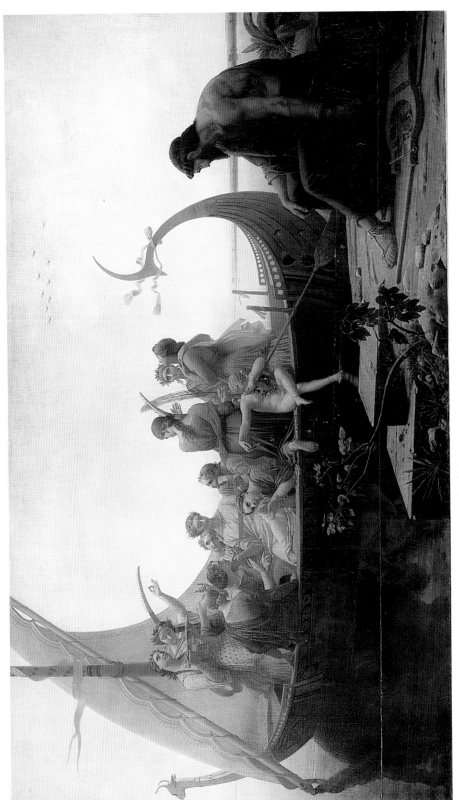

XIX. Charles Gleyre: *Evening*, or *Lost Illusions*, 1843 (Paris, Musée du Louvre)

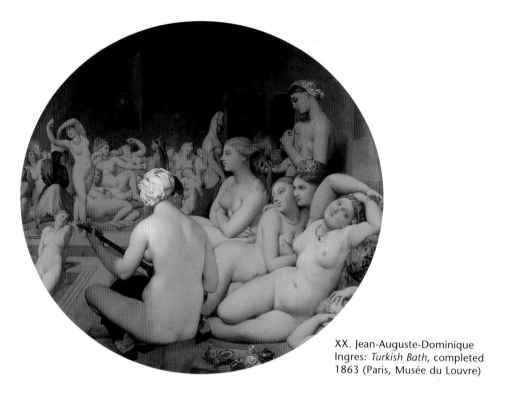

XX. Jean-Auguste-Dominique Ingres: *Turkish Bath*, completed 1863 (Paris, Musée du Louvre)

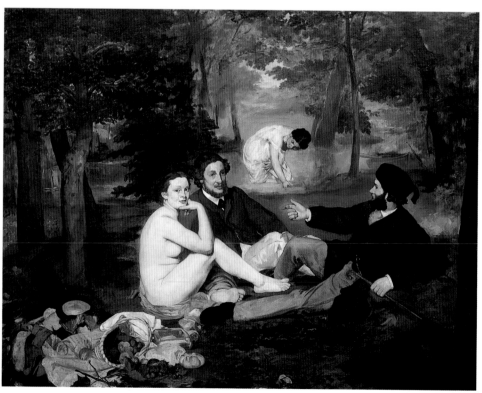

XXI. Edouard Manet: *Déjeuner sur l'herbe*, 1863 (Paris, Musée d'Orsay)

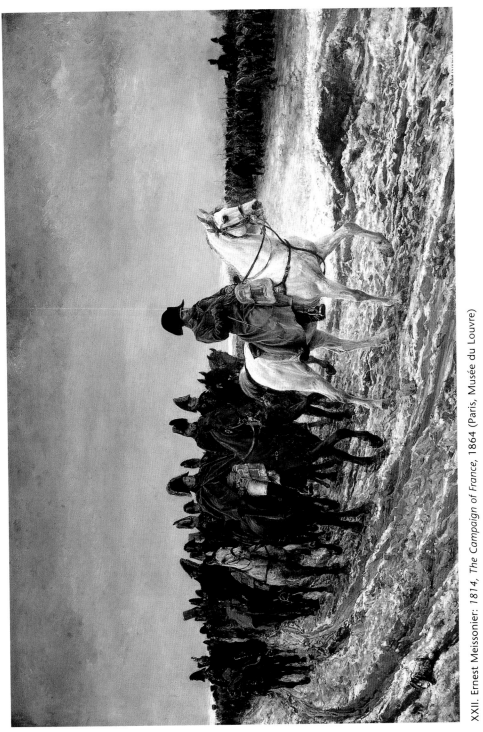

XXII. Ernest Meissonier: *1814, The Campaign of France*, 1864 (Paris, Musée du Louvre)

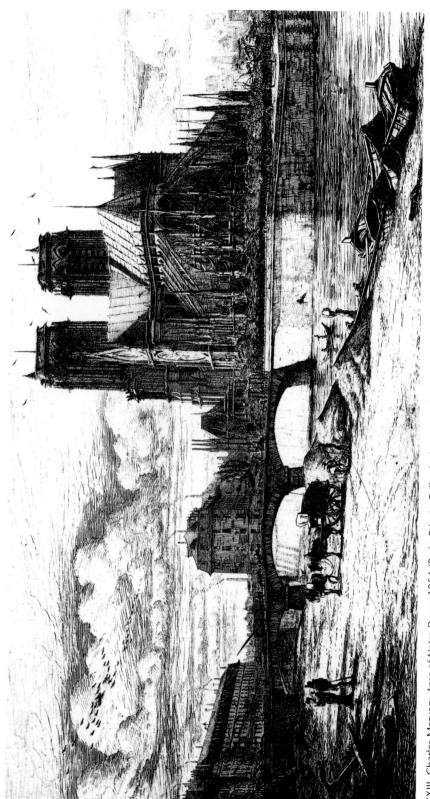

XXIII. Charles Meryon: *Apse of Notre-Dame*, 1854 (Paris, Private Collection)

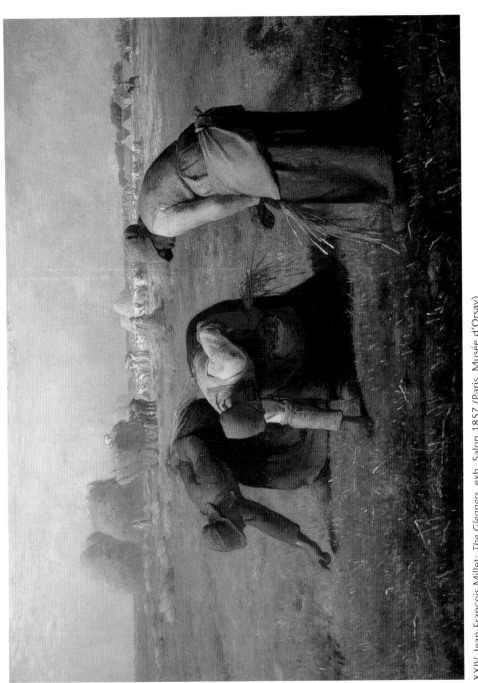

XXIV. Jean-François Millet: *The Gleaners*, exh. Salon 1857 (Paris, Musée d'Orsay)

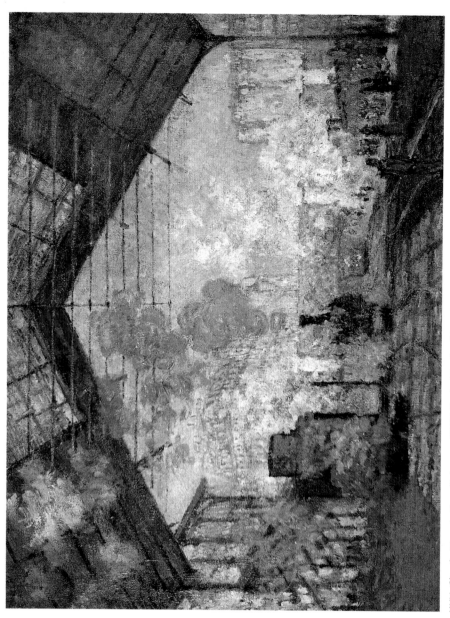

XXV. Claude Monet: *Gare St-Lazare*, 1877 (Paris, Musée d'Orsay)

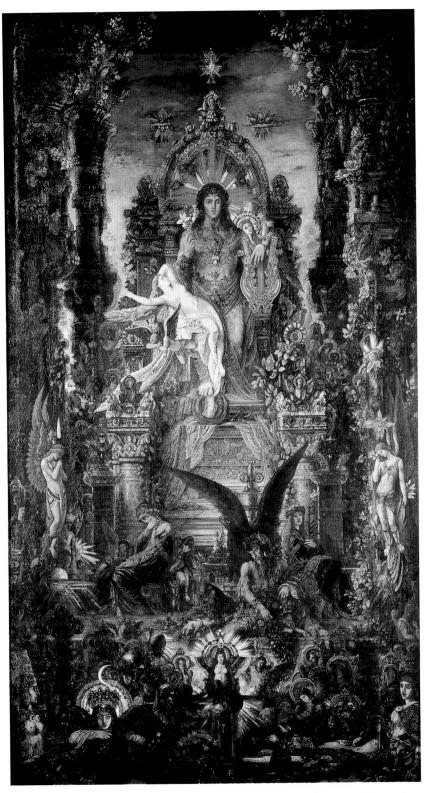

XXVI. Gustave Moreau: *Jupiter and Semele*, 1889-95 (Paris, Musée Gustave Moreau)

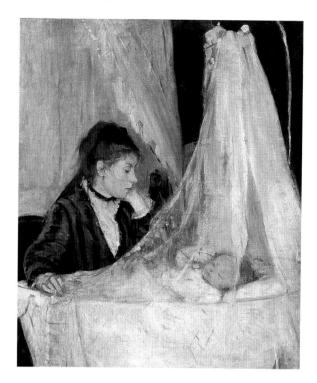

XXVII. Berthe Morisot: *The Cradle*, 1872 (Paris, Musée d'Orsay)

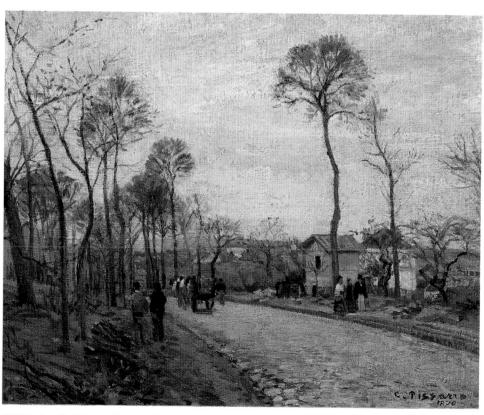

XXVIII. Camille Pissarro: *Road to Louveciennes*, 1870 (Paris, Musée d'Orsay)

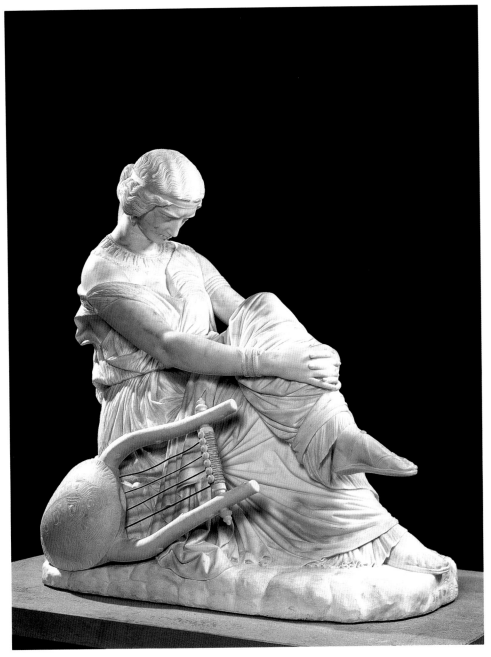

XXIX. James Pradier: *Sappho*, exh. Salon 1852 (Paris, Musée d'Orsay)

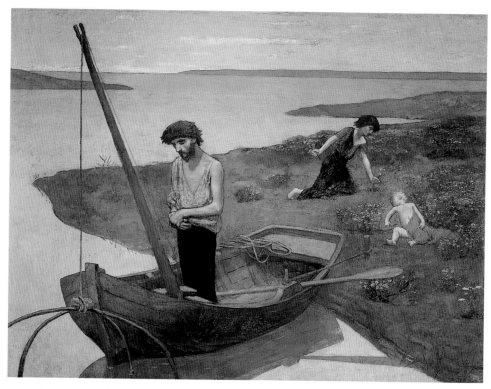

XXX. Pierre Puvis de Chavannes: *The Poor Fisherman*, 1881 (Paris, Musée d'Orsay)

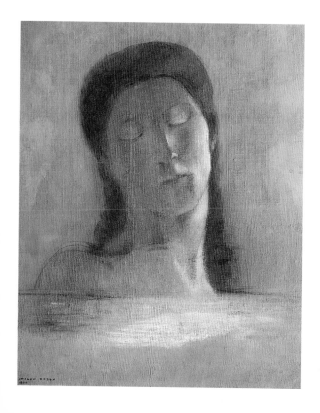

XXXI. Odilon Redon: *Closed Eyes*,
1890 (Paris, Musée d'Orsay)

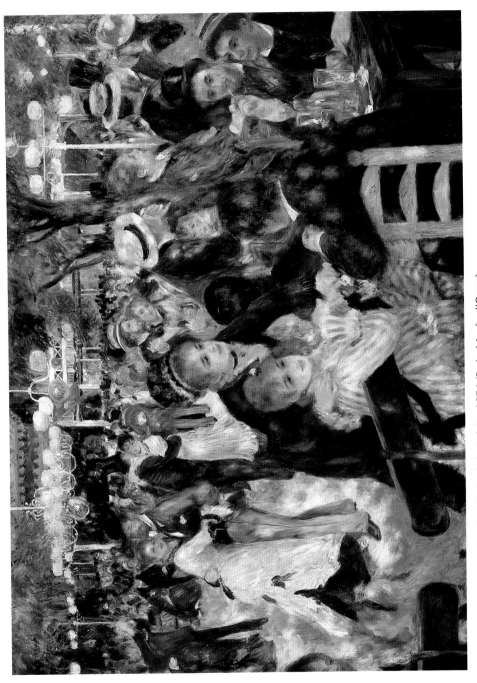

XXXII. Auguste Renoir: *Ball at the Moulin de la Galette*, 1876 (Paris, Musée d'Orsay)

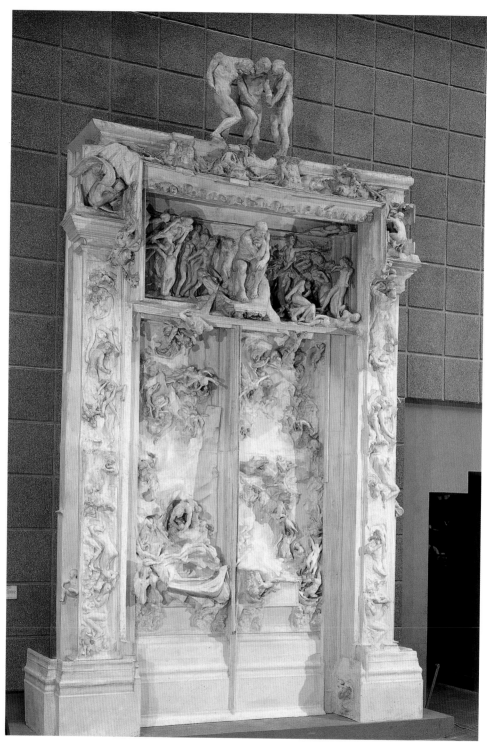

XXXIII. Auguste Rodin: *Gates of Hell*, commissioned 1880 (Paris, Musée d'Orsay)

XXXIV. Henri Rousseau: *Tropical Thunderstorm with a Tiger*, 1891 (London, National Gallery)

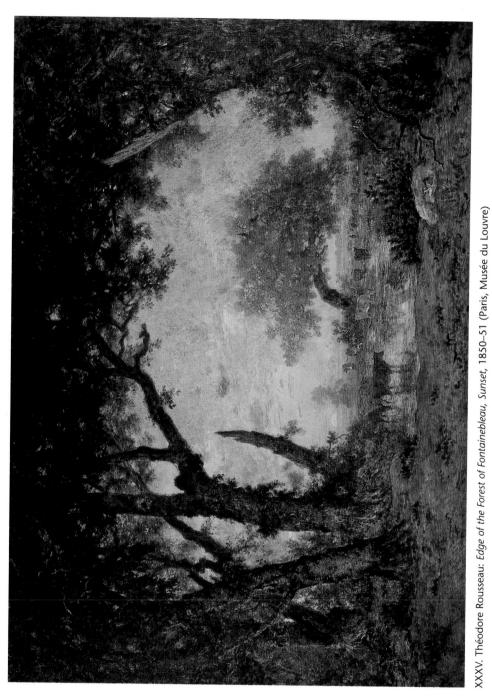

XXXV. Théodore Rousseau: *Edge of the Forest of Fontainebleau, Sunset*, 1850–51 (Paris, Musée du Louvre)

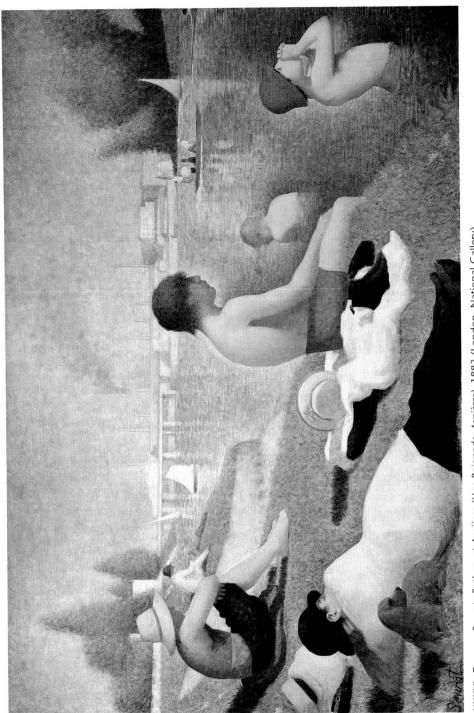

XXXVI. Georges Seurat: *Bathers at Asnières (Une Baignade, Asnières)*, 1883 (London, National Gallery)

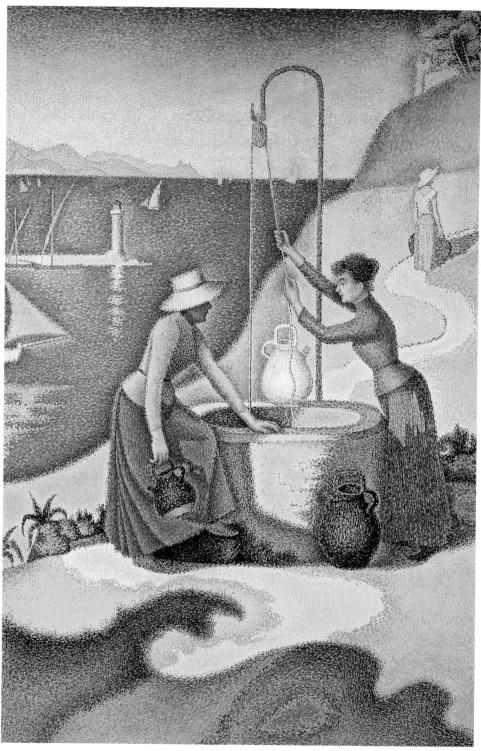

XXXVII. Paul Signac: *Women at the Well*, 1892 (Paris, Musée d'Orsay)

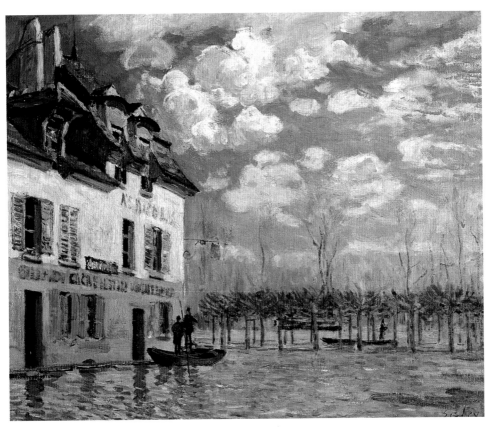

XXXVIII. Alfred Sisley: *Seine in Flood at Port-Marly*, 1876 (Paris, Musée d'Orsay)

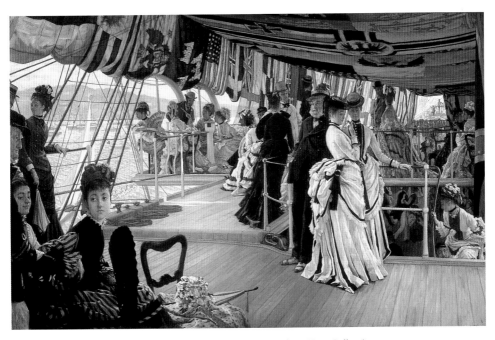

XXXIX. James Tissot: *Ball on Shipboard*, exh. RA 1874 (London, Tate Gallery)

XL. Henri de Toulouse-Lautrec: *Moulin Rouge, La Goulue*, 1891 (Paris, Bibliothèque Nationale)

October he accepted an invitation to be on the Commission des Beaux-Arts, where, remembering his own painful entry into the artistic establishment, he abandoned his conservatism and argued for an open Salon. He was named vice-president of the Ecole des Beaux-Arts for 1849.

When his wife Madeleine died on 27 July 1849, Ingres seems to have felt that his own life had come to an end also. The families of his friends and students placed him under attentive care, and portrait drawings of this supportive circle show the artist being nurtured back into life (N 414–21). One of his disciples, Albert Magimel (1799–1877), suggested that Ingres should prepare his collected works for publication in outline format (Magimel, 1851). Ostensibly a simple exercise in line reproduction based on tracings of his compositions from his portfolios, the project gave Ingres new life. By June 1851 he had returned to portrait painting, blocking in the portrait of the *Princesse de Broglie* and working on the first of two portraits of *Mme Moitessier* (W 266, 1851; Washington, DC, N.G.A.). As soon as Ingres finished the view of Mme Moitessier standing, he resumed work on a portrait of her seated (W 280, completed 1856; London, N.G.; see fig. 43), which he had begun in 1844 as a double portrait of her and her daughter. At this time Ingres believed that his career was nearly at an end. He had abandoned the Dampierre commission in 1850, much to the disappointment of the Duc de Luynes. In July 1851 he donated his art collection to the museum at Montauban, and in October he resigned from the Ecole des Beaux-Arts. However, the beginning of the Second Empire and his marriage on 15 April 1852 to Delphine Ramel (1808–87; portrait drawing, N 427; Bayonne, Mus. Bonnat) rejuvenated him. Close friends realized how painful the loss of his first wife had been and how necessary a second wife was. The only disadvantage of the new marriage was the 'swarm of portraits' required for his extended family (N 428–32, 435–8, 441–2, 448).

In 1851 Guisard, the Directeur des Beaux-Arts, had asked Ingres to paint a subject of his choice for the State. The only stipulation was that Ingres submit a drawing for the approval of the

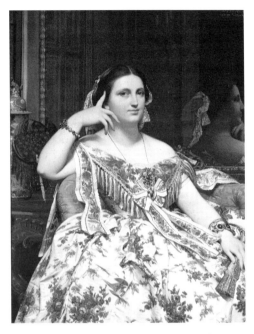

43. Jean-Auguste-Dominique Ingres: *Mme Moitessier*, completed 1856 (London, National Gallery)

government. Ingres rejected the offer, proposing instead to finish two works already under way in his studio. Guisard agreed, and paintings of the *Virgin with the Host* (W 276) and *Joan of Arc* (W 273; both Paris, Louvre) were delivered in 1854. Both works were repetitions of subjects that he had executed in the 1840s: a painting of the former had been commissioned by the future Tsar Alexander II (W 234, 1841; Moscow, Pushkin Mus. F.A.); the latter is based on his drawing (1844; Paris, Louvre) engraved in the second edition of Mannechet's *Le Plutarque français: Vies des hommes et femmes illustrés de la France* (Paris, 1844–7). An infra-red examination of the *Virgin with the Host* reveals that it began as a rectangular composition and was changed into a circular one, with the paired columns becoming two angels and curtains. In Ingres's painting of *Joan of Arc* the heroine is shown surrounded by her pages and followers, among them Ingres, witnessing the coronation of King Charles VII in Reims Cathedral.

The *Apotheosis of Napoleon* (W 270, 1853; destr.) was one of only two exceptions to the pledge Ingres had made in 1834 never again to work on a monumental scale. In March 1853 he accepted a commission from the government of Napoleon III for a ceiling painting for the Salon Napoléon in the Hôtel de Ville in Paris. The work had to be completed by the end of the same year. It was delivered on time, but was destroyed in the fires of the Commune of 1871: an oil study (W 271; Paris, Carnavalet) remains of the composition together with several drawn versions (e.g. Paris, Louvre, RF 3608). It is also known through photographs taken at the Exposition Universelle (Paris, 1855), where all Ingres's important works were hung in a separate gallery. Paranoid as ever, he believed that he had been humiliated by the jury's decision to award gold medals to other artists in addition to himself, including one to Delacroix, 'the apostle of the ugly'. His anger was modified only slightly by being named Grand Officer of the Légion d'honneur, but he vowed again to abandon the public arena.

9. Paris, 1856–67

From 1856 Ingres's work was directed primarily towards a private audience. At his summer residence at Meung-sur-Loire he worked on two drawings: a watercolour of the *Birth of the Muses* (D 28, 1856; Paris, Louvre), painted in imitation of a fresco to ornament the cella of a little Greek temple for Prince Napoléon-Jérôme Bonaparte; and a drawing of *Homer Deified* (D 180; Paris, Louvre, RF 5273), 'reseen and redrawn' and meant to be the model for an engraving after his 1827 ceiling painting by Calamatta. Although he expected to finish it by the end of the summer, it was in progress for nine more years, when Ingres had it photographed by Charles Marville and sent signed copies of it in a limited edition to his friends. He also painted a number of late versions in oil of his early subjects for private clients. For example, the *Turkish Bath* (W 312, completed 1863; Paris, Louvre; see col. pl. XX) is an elaboration of his many earlier bather compositions. The canvas had been in the studio from the early 1850s, when Prince Anatole Demidov was listed as the client;

by the time he considered it to be finished in 1859, however, it was claimed by Prince Napoléon-Jérôme. Much to Ingres's dismay, the painting was returned as Princesse Clotilde found it unsuitable for a family residence. Frédéric Reiset, Director of the Louvre and a friend of both Ingres and the Prince, averted disaster by negotiating an exchange for Ingres's *Self-portrait* of 1806. A photograph (see 1983–4 exh. cat., p. 125) records the *Turkish Bath* as it was then, nearly square in format. Once back in the studio it met the fate common to returned works. In his reworking Ingres increased the number of figures to 23 and gave the composition its circular format. The final painting was sold in 1863 to Khalil-Bey, the Turkish ambassador to France.

Ingres created a private gallery of his work for his wife. The collection (complete list in 1983–4 exh. cat., p. 252) included the *Antiochus and Stratonice* (W 322; Montpellier, Mus. Fabre), which he painted in watercolour and oil over a drawing on tracing paper (affixed to canvas in 1866), a technique that was also used in the *Martyrdom of St Symphorian* (W 319, 1865; Philadelphia, PA, Mus. A.). He gave away some of his works, again all reductions or variants of earlier subjects, as tokens of his friendship: Mme Marcotte (1798–1862) received a *Virgin with the Host with SS Helen and Louis* (W 268; London, priv. col.); Théophile Gautier received a reworked study for the *Apotheosis of Homer, Three Greek Tragedians, Aeschylus, Sophocles and Euripedes* (W 324; Angers, Mus. B.-A.). In 1861 several of Ingres's friends organized an exhibition of about 100 of his historical and portrait drawings in the Salon des Arts Unis, Paris. It was the first time Ingres had consented to let his drawings be shown, as he had previously felt that their popular appeal would distract from his paintings.

Christ among the Doctors was finished in 1862, after Ingres was released from his original contract of the 1840s and given the right to dispose of it as he pleased. A large exhibition of his work, organized by Armand Cambon, opened in Montauban on 4 May 1862; on 25 May Ingres became the first artist since Joseph-Marie Vien to be named Senator. His last will and testament was

signed on 28 August 1866. In it he bequeathed to the city of Montauban his art collection (paintings, prints, drawings, plaster casts, antique fragments, terracottas) and illustrated art books, in addition to the contents of his studio (including the large paintings of *Christ among the Doctors* and the *Dream of Ossian*) and over 4000 of his study drawings. He left the huge canvas of *Virgil Reading the 'Aeneid'*, which had been in his Paris studio for reworking since the 1840s, to the Musée des Augustins, Toulouse. He made provision for his wife's financial security after his death by working closely with his dealer, Etienne-François Haro, to assemble a body of work from his studio for sale. Haro bought 31 oil studies for the history paintings and assorted drawn copies and studies for 50,000 francs. On 6–7 May 1867 the remaining contents of Ingres's studio were sold.

II. Working methods and technique

Marjorie B. Cohn (intro. to 1983–4 exh. cat.) divided Ingres's working method into the generative phase (in which the original idea was conceived) and the extended and obsessive executive phase. The latter included not only the process of realizing the painting, but was extended by Ingres to include a lifetime of reworking favourite compositions in preparation for reproductive prints, in finished drawings and paintings for friends and clients, and in reductions to partial compositions, which were sent into the world, often decades after the original product, as works in their own right. These habits reflected Ingres's profound esteem for repetition as a means of understanding. He was very much governed by traditional Ecole des Beaux-Arts practices. He began with quick pen-and-ink sketches of a general idea and then explored all possible artistic prototypes for the composition. He worked next in a combination of life studies from the model for individual figures and detailed studies of archaeological furnishings from his library of engraved models after antiquity and the Renaissance. He suited his style to the subject, imitating 15th-century primitive oil painting for Troubadour subjects, emulating fresco technique in oil for antique battle scenes,

and used every conceivable drawing material on a wide variety of papers—charcoal for light and shadow studies, pen with ink or a sharp graphite for contour drawings. He was especially partial to working on a translucent tracing paper that aided his endless manipulations of the composition. Some of his drawings are built up of layers of paper types over one another as revision followed revision; other drawings were spontaneously completed in a few perfect contours.

Major history paintings were preceded by relatively finished drawings of the whole composition, by oil sketches of the whole and by detailed studies in oil of the individual figures. When faced with a new commission, Ingres assembled all possible relevant historical documentation, then slowly laboured to dominate the model with his own vision by rebuilding it from the ground up with studies from life. A good example of this approach is the *Golden Age* mural for the Duc de Luynes. In 1843 Ingres started on the commission, alternately working at the château at Dampierre (usually from June to October) and at the studio in Paris (November to June). He worked on the subject for several years (1843–8), especially in the quiet evening hours, making over 500 drawings. During the first year at Dampierre he had a model made of the major figures so that he could study the effects of light and shadow. As he was unable to work from the live model in the gallery, detailed drawings for the major figures were made in Paris. In such later paintings as *Antiochus and Stratonice* and *Odalisque with Slave*, which required elaborate interiors, Ingres began his studies from nature. He prepared the rough sketch on the canvas, and his students then worked on less important parts such as the architecture, mosaics, rugs and furniture, some of which might need repositioning if he decided to change the figures. Since the figures were completed by Ingres, he alone undertook to harmonize the ensemble with innumerable carefully applied layers of colour. His concern for the final touches extended to the last coats of varnish and the exact choice of frame.

A normal day consisted of work in the studio from nine to six, followed, preferably, by dinner

and a quiet evening in preparation for the next day, but more often in Paris by the exigencies of social life. The time devoted to portraits was carefully scheduled and followed a set pattern. Ingres and the sitter met for an hour and a half in the morning, then broke for lunch. While the sitter relaxed, Ingres looked for mannerisms, gestures or opinions that could throw light on the sitter's character. They returned to the studio for a two-and-a-half hour session. At four the sitting was over, the drawing finished. Patience was essential as, regardless of the status of the sitter, the finished portrait might be delivered up to seven years later, or not at all.

Ingres wrote of his working habits, 'I force myself to press ahead by every sort of study, and each step further that I make in the understanding of nature makes me see that I know nothing. The more I reach toward perfection, the more I find myself . . . measuring . . . what I lack. I destroy more than I create' (letter, 24 Dec 1822). Justifying his obsessive reworking, he also noted 'if my works have a value and are deserving, it is because . . . I have taken them up twenty times over again, I have purified them with an extreme of research and sincerity' (Delaborde, 1870, p. 100).

III. Character and personality

Ingres was the staunchest, most conservative defender of the classical tradition, preaching an inflexible, if sometimes contradictory, doctrine of ideal beauty and the absolute supremacy of line and pure form over colour and emotion. He described himself as generally affable but with a 'white hot' temper if he felt himself wronged. His personality, like his art, was marked by a preference for the order of a familiar universe. He adjusted slowly to changes in daily habits and remained the worst sort of provincial traveller, comparing everything that was new to him unfavourably with the home equivalent.

According to Charles Blanc, Ingres's friend and biographer, 'In him genius is will Here was a man for whom invention was painful, but who bent his faults by a prodigious love of the beautiful' (1870, pp. 92–3). In times of stress, Ingres was likely to react with a whole variety of physical symptoms, for example boils and atrocious headaches during the last few months of 1833, while he was working on the *Apotheosis of Homer*. There were times, however, when the pleasures of work were sweeter than ever before: 'Every day I am shut away in my studio from morning to night. I am love struck by painting, I don't possess it, it possesses me' (letter, May 1827). He was not at all the 19th-century bohemian artist; he loved every bourgeois comfort and expected his wife to look after his domestic needs.

In a letter of 7 July 1862 to Hippolyte Fockedey (Naef, 1977–81, iii, p. 371) Victor Mettez described 'le Père Ingres' as 'choleric, impatient, obstinate, good, naive, righteous, lazy . . . by moments eloquent and sublime . . . an incredible mélange'. This 'mélange' was echoed in an intimate sketch of Ingres by the composer Charles Gounod: 'He had an enthusiasm which sometimes approached eloquence. He had the tenderness of a child and the indignations of an apostle. He was naive and sensitive. He was sincerely humble before the great masters, but fiercely proud of his own accomplishments' (*Mémoires d'un artiste*, Paris, 1896).

Ingres's passions for music (Gluck, Haydn, Mozart and Beethoven), for literature (Plutarch, Virgil, Homer, Shakespeare, Dante and Vasari) and the visual arts (Raphael and Michelangelo) were deep and lifelong. His friends were friends for life, unless they crossed him, and nothing pleased him more than his favourite music in the company of a select circle of friends. As a student, he was seen as too serious, intolerant of the usual studio antics; as a teacher, although he often acted as a father figure to his favourite students, he brooked no opposition: 'Discussion was, unfortunately, not possible with M. Ingres' (Amaury-Duval, 1878, 2/1924, p. 61). And M. Ingres he remained, even to his family and closest friends.

IV. Critical reception and posthumous reputation

Ingres alternated between pride and self-doubt, confidence and crisis. This insecurity was fuelled,

and his development thwarted, both in early and mid-career, by constant harsh criticism. At first, he was considered too radical; later he was seen as representative of the moribund old guard. In one year only—1825—did he receive critical acclaim, when he was given the Cross of the Légion d'honneur, following the success of the *Vow of Louis XIII* that welcomed him back to France as champion of the classical style.

There is a marked difference between Ingres's posthumous reputation as a leading figure of his school and the difficulty he had establishing and holding that place during his lifetime. Equally ironic, given Ingres's absolute devotion to his calling as a history painter, is the fact that his portraits are now more widely appreciated than his history paintings. A retrospective exhibition of his work, including 587 paintings, drawings and oil sketches, was held in May 1867 at the Ecole des Beaux-Arts during the Exposition Universelle. It attracted 40,000 visitors.

Writings

R. Cogniet, ed.: *Ingres, écrits sur l'art: Textes recueillis dans les carnets et dans la correspondance d'Ingres* (Paris, 1947)

T. B. Brumbaugh: 'A Group of Ingres Letters', *J. Walters A.G.*, xlii–xliii (1984–5), pp. 90–96 [five letters, 1845–54]

See also Delaborde (1870), Courtheon, i (1947) and Ewals (1984).

Bibliography

general

E. Delécluze: *David, son école & son temps: Souvenirs de soixante années* (Paris, 1862)

E. A. Amaury-Duval: *L'Atelier d'Ingres* (Paris, 1878, 2/1924)

H. Lapauze: *Histoire de l'Académie de France à Rome*, 2 vols (Paris, 1924)

W. Friedlaender: *Von David bis Delacroix* (Bielefeld, 1930); Eng. trans. by R. Goldwater (Cambridge, MA, 1952)

David, Ingres, Géricault et leur temps (exh. cat., Paris, Ecole N. Sup. B.-A., 1934)

F. Lugt: *Ventes* (The Hague, 1938–64), iii, pp. 83–4, 563

J. Alazard: *Ingres et l'Ingrisme* (Paris, 1950)

P. Angrand: *Monsieur Ingres et son époque* (Lausanne, 1967)

The Age of Neo-classicism (exh. cat., foreword J. Pope-Hennessy; ACGB, 1972)

French Painting, 1774–1830: The Age of Revolution (exh. cat., preface P. Rosenberg; Paris, Grand Pal.; Detroit, MI, Inst. A.; New York, Met., 1974–5)

The Second Empire: Art in France under Napoleon III (exh. cat., ed. G. H. Marcus and J. M. Iandola; Philadelphia, PA, Mus. A.; Detroit, MI, Inst. A.; Paris, Grand Pal.; 1978–9)

catalogues raisonnés

H. Delaborde: *Ingres: Sa vie, ses travaux, sa doctrine, d'après les notes manuscrites et les lettres du maître* (Paris, 1870) [D]

D. Wildenstein: *The Paintings of J.-A.-D. Ingres* (London, 1954, rev. 2/1956) [W] [the most useful source for tracing provenance]

E. Camesasca: *L'opera completa di Ingres*, intro. by E. Radius (Milan, 1968); Fr. trans. with add. mat. as *Tout l'oeuvre peint d'Ingres*, intro. by D. Ternois (Paris, 1971)

H. Naef: *Die Bildniszeichnungen von J.-A.-D. Ingres*, 5 vols (Berne, 1977–81) [N]

monographs

A. Magimel, ed.: *Oeuvres de J.-A. Ingres, gravées au trait sur acier par A. Réveil, 1800–1851* (Paris, 1851)

C. Blanc: *Ingres: Sa vie et ses oeuvres* (Paris, 1870)

E. Gatteaux: *Collection des 120 dessins, croquis et peintures de M. Ingres classés et mis en ordre par son ami Edouard Gatteaux*, 2 vols (Paris, 1875)

L. Frölich-Bum: *Ingres: Sein Leben und sein Stil* (Vienna, 1911)

H. Lapauze: *Ingres: Sa vie, et son oeuvre* (Paris, 1911)

W. Pach: *Ingres* (New York, 1939)

P. Courtheon: *Ingres raconté par lui-même et par ses amis*, i: *Pensées et écrits du peintre*; ii: *Ses contemporains, sa postérité* (Geneva, 1947)

H. Naef: *Ingres. Rom* (Zurich, 1962)

R. Rosenblum: *Jean-Auguste-Dominique Ingres* (New York, 1967)

J. Whiteley: *Ingres* (London, 1977)

D. Ternois: *Ingres* (Paris, 1980)

museum and exhibition catalogues

Ingres (exh. cat., Paris, Gal. Martinet, 1861)

A. Cambon: *Catalogue du Musée de Montauban* (Montauban, 1885)

H. Lapauze: *Les Dessins de J.-A.-D. Ingres du Musée de Montauban* (Paris, 1901)

Portraits par Ingres et ses élèves (exh. cat. by C. Sterling, Paris, Gal. Jacques Seligmann, 1934)

A Loan Exhibition of Paintings and Drawings from the Ingres Museum at Montauban (exh. cat., intro. A. Mongan and D. Ternois; New York, Knoedler's, 1952)

Ingres et ses maîtres, de Roques à David (exh. cat. by P. Mesplé and D. Ternois, Toulouse, Mus. Augustins; Montauban, Mus. Ingres; 1955)

Rome vue par Ingres (exh. cat., ed. H. Naef; Lausanne, 1960; Zurich, 1962; Montauban, Mus. Ingres, 1973)

D. Ternois: Montauban, Musée Ingres: Peintures, Ingres et son temps (1965), xi of Inventaire des collections publiques françaises (Paris, 1957–)

Ingres Centennial Exhibition, 1867–1967: Drawings, Watercolors and Oil Sketches from American Collections (exh. cat., ed. A. Mongan and H. Naef; Cambridge, MA, Fogg, 1967)

Ingres et son temps: Exposition organisée pour le centenaire de la mort d'Ingres (exh. cat. by D. Ternois and J. Lacambe, Montauban, Mus. Ingres, 1967)

Ingres (exh. cat., ed. L. Duclaux, J. Foucart, H. Naef and D. Ternois; Paris, Petit Pal., 1967–8) [with excellent bibliog.]

Ingres in Italia: 1806–1824, 1835–1841 (exh. cat. by J. Foucart, Rome, Villa Medici, 1968)

M. Cohn and S. Siegfried: Works by J.-A.-D. Ingres in the Collection of the Fogg Art Museum (Cambridge, MA, Fogg, 1980)

Ingres (exh. cat. by M. Ikuta and others, Tokyo, N. Mus. W. A.; Osaka, N. Mus. A.; 1981)

In Pursuit of Perfection: The Art of J.-A.-D. Ingres (exh. cat., ed. P. Condon; Louisville, KY, Speed A. Mus.; Fort Worth, TX, Kimbell A. Mus.; 1983–4)

subject-matter and iconography

J. Alazard: 'Ce que J.-D. Ingres doit aux primitifs italiens', Gaz. B.-A., ii (1936), pp. 167–75

E. King: 'Ingres as a Classicist', J. Walters A.G., v (1942), pp. 69–113

A. Mongan: 'Ingres and the Antique', J. Warb. & Court. Inst., x (1947), pp. 1–13

D. Ternois: 'Les Sources iconographiques de l'Apothéose d'Homère', Bull. Soc. Archéol. Tarn-et-Garonne (1954–5), 97–108

H. Naef: 'Paolo und Francesca: Zum Problem der schöpferischen Nachahmung bei Ingres', Z. Kstwiss., x (1956), pp. 97–108

N. Schlenoff: Ingres, ses sources littéraires (Paris, 1956)

Ingres and the Comtesse d'Haussonville (exh. cat. by E. Munhall, New York, Frick, 1985)

specialist studies

H. Delaborde: 'Les Dessins de M. Ingres au Salon des Arts-Unis', Gaz. B.-A., ix (1861), pp. 257–69

C. Blanc: 'Du Style et de M. Ingres', Gaz. B.-A., xiv (1863), pp. 5–23

H. Schwarz: 'Die Lithographien J. A. D. Ingres', Mitt. Ges. Vervielfält. Kst (1926), pp. 74–9

Bull. Mus. Ingres (1956–)

E. Bryant: 'Notes on J. A. D. Ingres' Entry into Paris of the Dauphin, Future Charles V', Wadsworth Atheneum Bull., 5th ser., iii (1959), pp. 16–21

M. J. Ternois: 'Les Oeuvres d'Ingres dans la collection Gilibert', Rev. A. [Paris], iii (1959), pp. 120–30

H. Naef: 'Un Tableau d'Ingres inachevé: Le Duc d'Albe à Sainte-Gudule', Bull. Mus. Ingres, 7 (1960), pp. 3–6

—: 'Ingres as Lithographer', Burl. Mag. (1966), pp. 476–9

Actes du colloque Ingres et son temps: Montauban, 1967

D. Ternois: 'Ingres et sa méthode', Rev. Louvre, iv (1967), pp. 195–208

—: 'Napoléon et la décoration du palais impérial de Monte Cavallo en 1811–13', Rev. A. [Paris], vii (1970), pp. 68–89

J. Connolly: Ingres Studies: Antiochus and Stratonice, the Bather and Odalisque Themes (diss., Philadelphia, U. PA, 1974)

Actes du colloque Ingres et le néo-classicisme: Montauban, 1975

C. Duncan: 'Ingres's Vow of Louis XIII and the Politics of the Restoration', Art and Architecture in the Service of Politics, ed. H. Millon and L. Nochlin (Cambridge, MA, 1978), pp. 80–91

M. Lader: 'Gorky, De Kooning and the "Ingres Revival" in America', A. Mag. (March 1978), pp. 94–9

S. Symmons: 'J. A. D. Ingres: The Apotheosis of Flaxman', Burl. Mag., cxxi (1979), pp. 721–5

Actes du colloque Ingres et son influence: Montauban, 1980

M. Méras: 'Théophile Gautier critique officiel d'Ingres au Moniteur', Bull. Mus. Ingres, 47–8 (1980), pp. 205–19

S. Siegfried: Ingres and his Critics, 1806–1824 (diss., Cambridge, MA, Harvard U., 1980)

P. Angrand: 'Le Premier Atelier de Monsieur Ingres', Bull. Mus. Ingres, 49 (1982), pp. 19–58 [with bibliog.]

F. Haskell: 'A Turk and his Pictures in Nineteenth-century Paris', Oxford A. J., v/1 (1982), pp. 40–47

C. Ockman: The Restoration of the Château of Dampierre: Ingres, the Duc de Luynes and an Unrealized Vision of History (diss., New Haven, CT, Yale U., 1982)

A. D. Rifkin: 'Ingres and the Academic Dictionary: An Essay on Ideology and Stupefaction in the Social Formation of the Artist', A. Hist., vi (1983), pp. 153–70

L. Ewals: 'Ingres et la réception de l'art français en Hollande avec des lettres inédites de David, Gérard, Ingres, Vernet, Delaroche, Decamps et Rousseau', *Bull. Mus. Ingres*, 53–4 (1984), pp. 21–42

A. Boime: 'Declassicizing the Academic: A Realist View of Ingres', *A. Hist.*, viii (1985), pp. 50–65

C. de Couossin: 'Portraits d'Ingres: Examen du laboratoire', *Rev. Louvre*, xxxiv (1985), pp. 197–206

P. Condon: *J.-A.-D. Ingres: The Finished History Drawings* (diss., Providence, RI, Brown U., 1986)

D. Ternois: 'La Correspondance d'Ingres: Etat des travaux et problèmes de méthode', *Archvs A. Fr.*, n. s., xxviii (1986), pp. 161–200

B. Ivry: 'Right under his Nose', *Connoisseur*, ccxx (1990), pp. 126–9, 156

PATRICIA CONDON

Injalbert, (Jean-)Antoine [Antonin]

(*b* Béziers, 23 Feb 1845; *d* Béziers, Jan 1933). French sculptor. After serving an apprenticeship with an ornamental sculptor, Injalbert entered the Ecole des Beaux-Arts in Paris in 1866 with a municipal scholarship. His teacher was Augustin-Alexandre Dumont. In 1874 he won the Prix de Rome with a figure of *Orpheus* (1874; Paris, Ecole N. Sup. B.-A.). He exhibited with the Société des Artistes Français only at the beginning and end of his career, otherwise remaining faithful to the Société Nationale des Beaux-Arts. Although he produced many portrait busts and playful allegorical statuettes, Injalbert concentrated on public sculpture. His decorative work, heavy and majestic, adorns many of the most prestigious buildings in Paris, including the Hôtel de Ville (1880) and the Palais de Justice (1913). His statue of the *City of Nantes* for the Gare d'Orsay (1900) is an example of his collaboration with the architect Victor Laloux. The monument to *Octave Mirbeau* in the Panthéon is important, if atypical, since Injalbert produced far more decorative works than commemorative monuments. Most of his sculptures are in the département of Hérault; notable examples include the two stone groups known as *Love Taming Strength* at the main entrance of the Promenade du Peyrou in Montpellier and a fountain with the bronze figure of *Atlas Carrying the World* in Béziers, both in a decorative style reminiscent of 18th-century sculpture.

Bibliography

C. Ponsonnailhe: *Injalbert* (Paris, 1892)

O. Uzanne: *Figures contemporaines tirées de l'album Mariani*, 11 vols (Paris, 1896–1908), ii

D. Cady Eaton: *A Handbook of Modern French Sculpture* (New York, 1913), pp. 259, 291

A. B. [?Alfred Bachelet]: 'Jean-Antonin Injalbert', *Acad. B.-A., Bull. Annu.* [Paris], 17 (Jan–June 1933), pp. 43–8

H. Bouchard: *Notice sur la vie et les oeuvres de Jean-Antonin Injalbert* (Paris, 1935)

PENELOPE CURTIS

Isabey, (Louis)Eugène(-Gabriel)

(*b* Paris, 22 July 1803; *d* Lagny, 25 April 1886). French painter and printmaker, son of Jean-Baptiste Isabey. He spent his earliest years in the Louvre among such artists as François Gérard and the Vernet family, and at 7 rue des Trois Frères at the foot of Montmartre. His first works, mostly landscapes in watercolour, painted on the outskirts of Paris, display an independent character that owes little to the influence of his father or the other artists among whom he had lived. In 1820 he travelled to Normandy with his father, Charles Nodier and Alphonse de Cailleux, the future director of the Louvre. In 1821 he visited Britain with Nodier and discovered British painting; it is uncertain whether Isabey ever met Richard Parkes Bonington (his father certainly knew him), but Bonington's free watercolour technique had a decisive influence on his development. Isabey's admiration for Géricault, the advice of his friends and a passionate temperament also helped to form his style, which was characterized by skilfully worked brushstrokes and a preference for impasto rather than glazing. Between 1821 and 1824 Isabey seems to have returned to Normandy several times, painting on the coast between Le Havre and Dieppe. At the Salon of 1824 he exhibited a series of seascapes and landscapes (untraced), which helped to establish his reputation.

Isabey made a second journey to England in 1825, where he met Delacroix, another important influence on his Romantic vision of landscape. He returned to the Normandy coast in 1826. In 1828

he met Charles Mozin (1806–62) and Paul Huet, who became a close friend, at Trouville, and with them and Théodore Gudin he made famous the genre of Romantic seascape during the 1830s. In 1829 he visited the Auvergne and the Velay, where he made drawings of the region to accompany Charles Nodier's text in the Auvergne volumes of Baron Taylor's *Voyages pittoresques et romantiques dans l'ancienne France*. Isabey's 17 lithographs (1830–32) unify and dramatize the Auvergne sky, landscape and architecture with unusual verve and are among the finest illustrations in this great series (e.g. *Exterior of the Apse of the Church of St Nectaire*).

Isabey was chosen as official artist to accompany the French expedition to Algiers in 1830; he illustrated Denniée's *Précis historique et administratif de la campagne d'Afrique* (Paris, 1830). His enthusiasm quickly changed to disillusion, however, when the drawings and oil studies he brought back failed to sell, and the wide range of subjects he exhibited at the Salon of 1831 reflects the hesitation and confusion he felt at that time. The success there of *The Alchemist* (untraced, see Miquel, no. 1301), then a fashionable subject, the novels of his friend Alexandre Dumas and a certain calculated ambition all encouraged him towards producing anecdotal genre pictures. During the July Monarchy his output alternated between marine subjects, both dramatic (e.g. *Battle of Texel*, 1839; Paris, Mus. Mar.) and placid (*Beach at Low Tide*, 1832, exh. Salon 1833; Paris, Louvre), and historicizing genre subjects—elegant scenes of opening nights in court dress and elaborate re-creations of 16th- and 17th-century ceremonial, often in a maritime setting (e.g. *Arrival of the Duke of Alba at Rotterdam*, 1844; Paris, Louvre). He became one of Louis-Philippe's principal court painters and recorded several important episodes in the life of the July Monarchy (e.g. *Return of the Ashes of Napoleon*; Versailles, Château).

Between 1833 and 1850 Isabey's style fluctuated between the smooth painting loved by the dealers and the thicker impasto found in his large exhibition pieces. At the same time he was producing numerous quickly executed landscape drawings.

After 1844, in vast paintings such as the *Disembarkation of Louis-Philippe at Portsmouth on 8 October 1844* (1844; Paris, Louvre, on dep. Versailles, Château), his palette became brighter and his brushwork gained a glimmering quality that was constant from 1850. A journey to Brittany in 1850 marked the start of a free but more compact style in his seascapes, and at the same time he produced a series of *Scenes in the Park*, in which the study of drapery was enriched by a golden Venetian colouring. In the summer of 1856 he moved to Varengeville, near Dieppe, where he produced watercolours of the local cottages and countryside (e.g. Paris, Louvre, Cab. Dessins), which are among his most uninhibited and original works. The increasingly exuberant colour of his paintings of the 1860s and 1870s was applied to scenes of violence, massacres, duels and looting (e.g. *Duel in the Time of Louis XIII*, 1863; Compiègne, Château). He continued to produce marine views, but his boats were now usually painted from models in his studio rather than from life.

From Varengeville, Isabey travelled to Le Havre in 1859 and then to Honfleur with Eugène-Louis Boudin, on whose coastal views he had an important influence. During 1862 he spent some time in Le Havre, Honfleur and Trouville, where he was joined by his pupil, Johan Barthold Jongkind. In his later years he stayed often in Varengeville, working primarily for dealers and exhibiting little at the Salon.

In his costume pieces Isabey did not merely seek to pursue historical truth for its own sake but became both the creator and the victim of the fantasies of the French upper classes, to whom he offered a pleasantly decorative, if artificial, image of their ancestors. He kept alive the elegant frivolity of the world of his father and his father's friends, the Cicéri, and helped to transmit it to the artists of the Rococo revival, such as Adolphe Monticelli. Similarly, in his freshly painted watercolour seascapes he stood between and helped to bridge the worlds of Bonington and Boudin.

Bibliography

G. Hédiard: *Eugène Isabey: Etude, suivie du catalogue de son oeuvre* (Paris, 1906)

A. Curtis: *Catalogue de l'oeuvre lithographiée d'Eugène Isabey* (Paris, 1939)

Eugène Isabey (exh. cat. by P. H. Schabacker and K. H. Spencer, Cambridge, MA, Fogg, 1967)

P. Miquel: *Eugène Isabey et la marine au XIXe siècle, 1803–1886*, 2 vols (Maurs-la-Jolie, 1980)

PIERRE MIQUEL

Jacquand, Claudius [Claude]

(*b* Lyon, 11 Dec 1803; *d* Paris, 2 April 1878). French painter, designer and printmaker. In 1821 he entered the atelier of Fleury Richard in the Ecole des Beaux-Arts, Lyon. He exhibited for the first time at the Lyon Salon of 1822, in 1824 receiving a first-class medal at the Paris Salon for a *Prison Courtyard* (untraced). He lived in Lyon until his mother's death in 1836, when he settled in Paris. During the 1830s his pictures sold well: Louis-Philippe bought seven paintings for Versailles, and commissioned cartoons of the *Death of the Duc d'Orléans* (1847) for the stained-glass windows of the Chapelle St Ferdinand at Dreux. Although the fall of Louis-Philippe in 1848 deprived Jacquand of official commissions, financial mismanagement of the family polish factory obliged him to earn his living from painting. Between 1852 and 1855 he lived in Boulogne-sur-Mer where he decorated the Salle d'honneur in the Hôtel de Ville. He also obtained the commission for several paintings (1852–4) for Notre-Dame, Roubaix. Government commissions gradually returned: he was asked to decorate the chapel of the Virgin in St Philippe du Roule, Paris (1858–60), and the chapel of St Bernard, St Bernard de la Chapelle, Paris (1867). Jacquand also painted the archivolt of the chapel of the Virgin, St Martin d'Ainay, Lyon (1863).

For his easel paintings Jacquand chose subjects that he knew would appeal to the emotions of his public, for example *Sick Savoyard Child* (1822; untraced) and *Young Girl Being Cared for by Nuns in Hospital* (1824; priv. col.). He was not a history painter, rather a painter of historical anecdote, and he sometimes chose fanciful settings and anachronistic costumes, but he had a gift for selecting the right moment to represent. He was

an eclectic reader and adroitly visualized precise literary descriptions as in his *Death of Adelaide de Comminges* (1831; priv. col.) after Froissard and the *Fifth of March at Perpignan* (1837; priv. col.) after Alfred de Vigny. He also made lithographs for Lyon magazines. Jacquand's concentration on meticulous detail was the fruit of his training in Lyon and his study of 17th-century Dutch painting.

Bibliography

D. Richard: 'Claudius Jacquand "cet habile artiste"', *Bull. Mus. Ingres*, xiv (1980), pp. 23–9

MADELEINE ROCHER-JAUNEAU

Jacque, Charles(-Emile)

(*b* Paris, 23 May 1813; *d* Paris, 7 May 1894). French painter, printmaker and illustrator. In 1830 he worked briefly for an engraver who specialized in cartography, and in that year he produced his first etching, a copy of a head after Rembrandt. From 1831 to 1836 Jacque served in the infantry, seeing action in the siege of Antwerp in 1832. During military service he found time to sketch scenes of army life and is reputed to have submitted two works to the Salon of 1833 in Paris. In 1836 he went to London where he found employment as an illustrator. He was back in France in 1838 and visited his parents in Burgundy, where he became enamoured of the countryside.

Jacque's graphic works in the early 1840s include caricatures published in *Le Charivari* in 1843 and a number of vignettes and illustrations that appeared in the publications of the firm Curmer. More significant, however, are his etchings; this medium was beginning to undergo a revival in popularity at the time, to a large extent through Jacque's efforts. Working in etching and drypoint, he produced numerous small prints of rustic life, beggars, farm animals, cottages and landscapes. An auction of the works of Georges Michel in 1841 profoundly influenced Jacque, who began to emulate the older master, painting landscapes with windmills at Montmartre and later on the Clignancourt plains (e.g. *Herd of Swine*; priv. col., see Miquel, p. 547).

By 1843 Jacque was closely associated with the Realist movement. Although he had previously exhibited only prints at the Salon, in 1846 the State commissioned a painting showing a herd of cattle milling about a pond at twilight, *Herd of Cattle at the Drinking Hole* (Angers, Mus. B.-A.). Meanwhile, he had befriended Jean-François Millet (ii), and in the spring of 1849 the two artists, seeking to avoid an outbreak of cholera in the capital, moved their families to adjoining properties in Barbizon. Thereafter Jacque divided his time between Barbizon, by then an established artists' colony, Montrouge, where he maintained another studio, and Paris. He increasingly concentrated on painting, treating his rustic subjects, barnyard scenes and images of grazing livestock with an unerring though more descriptive realism than that of Millet. The works of this period are often small and painted on panel, such as the barn scene, *The Sheepfold* (1857; New York, Met.), and *Poultry* (Amsterdam, Hist. Mus.), one of many similar compositions in which fowl with brightly coloured plumage are shown against sunlit masonry walls. In the 1850s and 1860s Jacque continued to produce prints, often working in a larger format as in the etchings *The Sheepfold* (1859), *The Storm* (1865–6) and *Edge of the Forest: Evening* (1866).

In addition to his artistic endeavours, Jacque pursued numerous speculative ventures: he raised poultry and in 1858 published *Le Poulailler: Monographie des poules indigènes et exotiques*; he cultivated asparagus; and he invested in real estate. In the course of these activities Jacque alienated his fellow artists in Barbizon and still failed to attain financial security. In the 1870s he became involved with a factory at Le Croisic that produced Renaissance- and Gothic-style furniture, utilizing fragments of original pieces. Although he did not regularly participate in the Salon after 1870, he continued to paint, relying on various dealers for sales. He treated the same subjects, working in thicker impasto and relying increasingly on his palette knife. Many of his later works, including *Forest Pastures near Bas Bréan* (Montreal, Mus. F.A.), are marked by a sombre note bordering on pathos. Jacque's position improved in his last years: he received a gold medal at the Exposition Universelle in 1889 and, outliving his Barbizon colleagues, he benefited from the Anglo-American vogue for landscape in the late 19th century. Working in Jacque's immediate circle were a brother, Léon Jacque (*b* 1828), and two sons, Emile Jacque (1848–1912) and Frédéric Jacque (*b* 1859).

Bibliography

J. M. J. Guiffrey: *L'Oeuvre de Charles Jacque: Catalogue de ses eaux-fortes et pointes sèches* (Paris, 1866)

H. Béraldi: *Les Graveurs du XIXe siècle* (Paris, 1885–92), viii, pp. 162–92

F. C. Emanuel: 'The Etchings of Charles Jacque', *The Studio*, xxxiv (1905), pp. 216–22

P. Miquel: *Le Paysage français au XIXe siècle, 1824–1874*, iii (Maurs-la-Jolie, 1975), pp. 532–63

Millet and his Barbizon Contemporaries (exh. cat. by G. Weisberg, Tokyo, Keio Umeda Gal., 1985), pp. 160–64

☐

Jacquemart, Jules(-Ferdinand)

(*b* Paris, 3 Sept 1837; *d* Paris, 26 Sept 1880). French etcher, illustrator and watercolourist. He received his early training from his father, Albert Jacquemart (1808–75), an amateur artist, botanical illustrator, collector and author. From the outset he distinguished himself with illustrations of various *objets d'art*. His earliest recorded work is an etching of 1859 showing a selection of Japanese and Chinese artefacts, and with Philippe Burty, Henri Fantin-Latour and Félix Bracquemond, among others, he formed a society to study and promote Japanese culture. Also in 1859 he entered into an association with the *Gazette des beaux-arts* that lasted for most of his career. To this periodical he contributed plates illustrating the extraordinary range of objects owned by such notable collectors as Charles, Duc de Morny, Victor, Duc de Luynes, and members of the Rothschild family, as well as those found in the Louvre. In these etchings he proved remarkably adept at rendering reflections and varying textures and colours.

In the process of engraving plates for the *Histoire artistique, industrielle et commerciale*

de la porcelaine (Paris, 1862), written by his father and E. Le Blant, Jacquemart prepared water-colour studies on vellum (e.g. *Sèvres Vase*, 1862; Baltimore, MD, Walters A.G.). In addition, he produced illustrations for other publications treating 16th-century bookbindings (1864), the ceramics of Valenciennes (1868), treasures of the French crown (1868), the history of ceramics (1873) and American medals (1880). He published etchings reproducing paintings by Old Masters and contemporary artists, the most extensive work in this category being *Etchings of Pictures in the Metropolitan Museum, New York* (London, 1874). Although he established his reputation as an etcher of works of art, Jacquemart was also an able watercolourist, specializing in landscapes, and in 1879 was a founder-member of the Société des Aquarellistes Français.

Bibliography

L. Gonse: *L'Oeuvre de Jules Jacquemart* (Paris, 1876)

H. Beraldi: *Les Graveurs du XIXe siècle* (Paris, 1885–92), viii, pp. 192–213

Japonisme: Japanese Influence on French Art, 1854–1910 (exh. cat. by G. P. Weisberg and others, Cleveland, Mus. A., 1975)

WILLIAM R. JOHNSTON

Jalabert, Charles(-François)

(*b* Nîmes, 1 Jan 1819; *d* Paris, 8 March 1901). French painter. Against the wishes of his father, a jeweller, he enrolled in the Ecole de Dessin of Nîmes, directed by Alexandre Colin (1798–1875). A promising pupil, he received the first prize in drawing in 1835 and in painting in 1836 and 1837. A year later he moved to Paris to work briefly for one of his father's associates who urged him to study at the Ecole des Beaux-Arts, where he entered the atelier of Paul Delaroche. He competed three times for the Prix de Rome, faring best with his first attempt in 1841, when he obtained a second prize. However, he submitted his entry of 1843, *Oedipus and Antigone* (Marseille, Mus. B.-A.), to the initial exhibition of the Amis des Arts in Nîmes, winning a gold medal.

Jalabert followed Delaroche to Italy, where he stayed at his own expense until 1846. In Rome in 1844 he began work on *Virgil, Horace and Varius in the House of Maecenas* (Nîmes, Mus. B.-A.), which he intended as the counterpart to the large history paintings sent home by Prix de Rome winners. Embodying all the characteristics of academic history painting, this idealized view of Virgil reading the *Georgics* to his patron launched the artist's career in France: it received a third-class medal at the Salon of 1847 and was purchased by the State.

With Delaroche's sponsorship, Jalabert was introduced to wealthy and influential patrons, including Achille Fould (1800–67) and Emile Pereire. He became associated with the dealer Adolphe Goupil, who popularized his stock through the distribution of prints. Goupil found a ready market for Jalabert's small figure paintings recalling his Italian sojourn, such as the *Peasant Girl* (untraced, see 1981 exh. cat., p. 43), a genre so successfully exploited by Léopold Robert and Ernest Hébert, for his Renaissance subjects, including *Romeo and Juliet* (untraced, see 1981 exh. cat., p. 52) and *Raphael's Studio* (untraced, see 1981 exh. cat., p. 53), and for his religious works. The avoidance of heroic themes from antiquity and the preference for anecdotal, often sentimental subjects from the more recent past were characteristic of Delaroche and his pupils.

Jalabert's official recognition included a commission in 1850 from the Sèvres Manufactory for paintings of the *Four Evangelists* (Sèvres, Mus. N. Cér.), which served as designs for the enamelled plaques presented to Prince Albert at the Great Exhibition of 1851 in London. At the Salon of 1853 Empress Eugénie purchased for her chapel in the Tuileries the *Annunciation* (destr.), originally commissioned by the State for Alès Cathedral. Jalabert won a first-class medal at the Salon of 1853 for *Orpheus* (Baltimore, MD, Walters A.G.); this painting, showing nymphs in a forest glade listening enraptured to the Thracian poet, was praised for the lyrical treatment of the subject and for the delicate nuances and harmonies of its execution. Following his exhibition of several paintings, including *Christ in the Garden of Olives* (Douai,

Mus. Mun.), at the Exposition Universelle of 1855, Jalabert was awarded the Légion d'honneur. After a trip to Italy in 1857 with his pupil Adolphe Jourdan (1825–89) and Albert Goupil, his dealer's son, Jalabert embarked on two projects that proved ideally suited to his temperament: the ceiling decoration, *Night Unfurling her Veils*, for a bedroom in Pereire's hôtel on the Rue du Faubourg St-Honoré (now the British Embassy) and another, *Homage to Aurora*, for the boudoir of Constant Say's hôtel on the Place Vendôme (now the Morgan Bank).

From the mid-1860s Jalabert devoted his time to portraiture. In 1864 a commission from Charles Asseline, the former secretary to Louis-Philippe, for portraits of *Louis-Philippe Albert d'Orléans, Comte de Paris* and *Isabelle, Comtesse de Paris* (1865; untraced, see 1981 exh. cat., p. 64), who were residing in exile in Twickenham, England, linked the artist with the house of Orléans. The following year, while in England, he painted portraits of the Comte's younger brother, *Robert d'Orléans, Duc de Chartres*, and *Françoise, Duchesse de Chartres* (1865; untraced). On a third trip in 1866 he received commissions for a series of portraits from Henri d'Orléans, Duc d'Aumale for various members of his family. These works, together with a posthumous portrait of *Marie-Amélie*, ordered by the Duc d'Aumale in 1880, are in the Musée Condé, Chantilly. Jalabert remained active until his death, dividing his time between Nîmes and Bougival.

Bibliography

T. Gautier: *Les Beaux-arts en Europe*, ii (Paris, 1855), pp. 8–9
C. Blanc: *Les Artistes de mon temps* (Paris, 1876), p. 474
E. Reinaud: *Charles Jalabert: L'Homme, l'artiste d'après sa correspondance* (Paris, 1903)
Charles-François Jalabert, 1819–1901 (exh. cat. by A. Jourdan, Nîmes, Mus. B.-A., 1981)

WILLIAM R. JOHNSTON

Jaley, Jean-Louis-Nicolas

(*b* Paris, 27 Jan 1802; *d* Neuilly, 30 May 1866). French sculptor. He was a pupil of his father, Louis Jaley (1763–1838), a medal engraver, and of Pierre Cartellier. In 1820 he entered the Ecole des Beaux-Arts, Paris, winning the Prix de Rome in 1827 with the relief *Mucius Scaevola before Porsenna* (Paris, Ecole N. Sup. B.-A.). His stay in Rome profoundly affected his style, which was influenced by the sculpture of antiquity and the paintings of Raphael. After his return to Paris, *c*. 1834, he contributed sculpture to all the major state building projects of the July Monarchy (1830–48) and the Second Empire (1851–70), including statues of *Jean-Sylvain Bailly* and *Victor Riqueti, Marquis de Mirabeau* (both marble, 1833) for the Chambre des Députés, Paris, of *St Ferdinand* (stone, 1837–9) for the church of La Madeleine, Paris, and those representing *London* and *Vienna* (both stone, 1862) for the Gare du Nord, Paris (all *in situ*). Jaley also achieved contemporary renown for the elegant, Raphaelesque female nudes that he exhibited regularly at the Salon, with titles such as *Prayer* (marble, exh. Salon 1831; Paris, Louvre) and *Modesty* (marble, exh. Salon 1834; Paris, Min. Finances).

Bibliography

Lami
A. Le Normand: *La Tradition classique et l'esprit romantique* (Rome, 1981), pp. 218, 222

ISABELLE LEMAISTRE

Janet-Lange [Janet, Ange-Louis]

(*b* Paris, 26 Nov 1815; *d* Paris, 25 Nov 1872). French painter, illustrator and lithographer. On 5 October 1833 he entered the Ecole des Beaux-Arts in Paris, where he was a pupil of Horace Vernet, Ingres and Alexandre Marie Colin (1798–1875), but was most influenced by Vernet. He made his début at the Salon of 1836 with two paintings, a *Stud Farm* and *Post Stable* and continued to exhibit there until 1870. His subjects consist mostly of hunting scenes and episodes from contemporary French history. Among the latter are works depicting the Crimean War of 1853–6, (e.g. *Episode from the Battle of Koughil, Crimea*, exh. Salon 1859; Epinal, Mus. Dépt. Vosges & Mus. Int. Imagerie), Napoleon III's campaigns in Italy in 1859 (e.g. *Napoleon III*

at *Solferino, 24 June 1859*, exh. Salon 1861; Versailles, Château, on dep. Rennes, Cercle Mil.) and the Mexican expedition of 1861 (e.g. the *Battle of Altesco in Mexico*, exh. Salon 1864). He also painted religious subjects, for example *Agony in the Garden* (exh. Salon 1839; Castelnaudary, Mus. Archéol. Lavragais).

In 1846 Marshal Nicolas-Jean Soult (1769–1851) commissioned Janet-Lange to make a series of drawings of military uniforms, and these now form part of the archives of the French Ministry of War. He also produced a great number of drawings and lithographs, distinguished by their precision, for the magazine *L'Illustration* and for such other illustrated periodicals as the *Journal amusant* and the *Journal pour rire*. He contributed illustrations of oriental figures to the *Tour du monde* (1862–73), a periodical that was hailed by the critic Léon Lagrange in 1864 as the most lively illustrated publication produced by Hachette. Janet-Lange's illustrations for it were engraved on wood. In addition he illustrated such books as Augustin Thierry's *Histoire de la conquête de l'Angleterre* (1866). He also made a number of Bonapartist lithographs (e.g. *Louis-Napoleon Bonaparte Elected by 7,500,000 Votes*, 1852) chronicling and celebrating the policies and campaigns of Louis-Napoleon Bonaparte (later Napoleon III). Around 1847 he contributed a few cartoons for the publication *Code civil illustré* (1847).

Bibliography

Bellier de La Chavignerie–Auvray; Bénézit; Thieme–Becker

L. Lagrange: 'Les Illustrations du *Tour du monde*', *Gaz. B.-A.*, xvi (1864), pp. 179–83

H. Beraldi: *Les Graveurs du XIXe siècle*, viii (Paris, 1889), pp. 221–2

Inventaire du fonds français après 1800, Paris, Bib. N., Dépt. Est. cat., xi (Paris, 1960), pp. 247–55

ATHENA S. E. LEOUSSI

Janmot, (Anne-François-)Louis

(*b* Lyon, 21 May 1814; *d* Lyon, 1 June 1892). French painter and poet. He belonged to the Lyon school of painting, characterized by idealistic and mystical tendencies similar to those of the Nazarenes and the Pre-Raphaelites. His Christian beliefs, which are very apparent in his art, were strongly influenced by neo-Catholic apologists. From 1831 Janmot studied at the Ecole des Beaux-Arts in Lyon. In 1833 he went to Paris, where he became a student of Victor Orsel at the Ecole des Beaux-Arts. He also attended Ingres's studios in Paris and Rome. His technique was deeply indebted to Ingres, but emotionally and intellectually he was more closely allied with Delacroix, whose enthusiasm for the literature of Dante and Shakespeare he shared. Janmot's style combined the precision of Ingres with the meditative devotion of Orsel. His predilection for heraldic compositions, based on symmetry and repetition, his use of profile and flattened form and his luminous colour were all influenced by a love of such early Italian painters as Giotto and Fra Angelico. Janmot's style has much in common with that of fellow Lyonnais and pupil of Ingres, Hippolyte Flandrin.

The majority of Janmot's paintings were commissions for churches. The *Resurrection of the Son of the Widow of Nain* (1840; Puget-Ville Church, Var) is indebted to Ingres's *Martyrdom of St Symphorien* (1884; Autun Cathedral). His *Agony in the Garden* (1840; Col. Ouillins) demonstrates his doctrinaire pro-Catholic beliefs, with such scenes as Savonarola and the Polish defence of the national religion in the background. Other religious works include *St Francis Xavier* (1843; Lyon, St Paul) and an *Assumption of the Virgin* (1844) for the Mulatière Church, Lyon. Janmot also executed murals, sometimes in fresco, as for example at St Polycarpe (1856; destr.), Lyon; St François de Sales (1859), Lyon; and St Etienne du Mont (1866), Paris. His fresco (1878–9) in the chapel of the Franciscains-de-Terre-Sainte, Lyon, was his last state commission.

Janmot's most ambitious work was a series of 18 allegorical paintings, 16 drawings (Lyon, Mus. B.-A.) and poetic verses called *La Poème de l'âme* on which he worked for over 40 years. The series traces the spiritual and physical history of a soul. Recurrent themes include maternal affection and divine and terrestrial love. *La Poème de l'âme* contains autobiographical references and allusions to such contemporary political events as the

Revolution of 1848. It attracted the attention of Paul Chenavard, Delacroix and Baudelaire at the Paris Exposition Universelle of 1855, but it was not well received by the public. Janmot's personal and poetic approach to his subject-matter as well as his pictorial imagination make him an important link between Romanticism and Symbolism. His work was admired by Pierre Puvis de Chavannes, Maurice Denis and Odilon Redon.

Writings

La Poème de l'âme (Paris, 1881, rev. Lyon, 1978)
Opinion d'un artiste sur l'art (Paris, 1887)

Bibliography

E. Hardouin-Fugier: Louis Janmot, 1814–1892 (Lyon, 1981) [with comprehensive bibliog.]

NADIA TSCHERNY

Jobbé-Duval, Félix(-Armand-Marie)

(b Carhaix, Finistère, 16 July 1821; d Paris, 2 April 1889). French painter, administrator and museum curator. After completing his secondary education at Quimper he moved to Paris where in 1839 he attended classes in the studio of Paul Delaroche. On 1 April 1840 he entered the Ecole des Beaux-Arts in Paris, becoming a pupil of Charles Gleyre. He made his début in the Salon in 1841 with two works, a portrait of M. Kgroen and Study of a Young Girl, and continued to exhibit there until 1882. His contributions included a number of religious paintings, such as the Disappearance of the Virgin (exh. Salon 1849; Le Mans, Mus. Tessé) as well as depictions of classical subjects, such as the Mysteries of Bacchus (exh. Salon 1873; Brest, Mus. Mun.). Jobbé-Duval became a distinguished portraitist and produced likenesses of many contemporary and historical French personages, as in the portrait of J.-R. Bellot, the French polar explorer from Rochefort (exh. Salon 1855, Rochefort, Mus. Mun.), and the portraits of the 16th-century architects Jean Bullant and Androuet Du Cerceau and the sculptor Antoine Jacquet de Grenoble, which were reproduced in tapestry by the Manufacture Nationale des Gobelins for the Galerie d'Apollon in the Louvre. He contributed to the decoration of many chapels and churches as well as civic and municipal buildings, both in Paris and in the provinces, creating not only easel paintings but also fresco decorations on walls and ceilings. In 1864–6 he executed five tympana decorations for the nave of the Trinité in Paris; for the chapel of the veterinary school of Lyon he produced colossal paintings of St Peter and St Paul, which were placed on either side of a Coronation of the Virgin. His decorations of civic buildings included a series of allegorical grisailles illustrating the four seasons for the Hôtel de Ville of Lyon, and two medallions, also in grisaille, representing Agriculture and Commerce and Industry and Art for the Commercial Law Courts of the département of the Seine. In 1864 he also decorated the Théâtre de la Gaîté in Paris.

Jobbé-Duval was deeply involved in the political life of his time, and he has been characterized as a militant republican with socialist tendencies. On his arrival in Paris he joined in the rev-olutionary agitations of 12 May 1839, and he also took an active part in the street fights of the Revolution of 1848. He later supported Giuseppe Garibaldi, and in 1870, during the Franco-Prussian War (1870–71) and the siege of Paris, he organized the Garde Nationale (the civilian militia) of the 15th arrondissement. On 23 June 1871 he became municipal councillor of the quartier Necker (15th arrondissement). He also took an active part in the administration of the arts. He became a member of the administrative commission of the fine arts of Paris and was instrumental in setting up a competition for the reconstruction of the Hôtel de Ville of Paris, which was burnt during the Franco-Prussian War. He ended his career as a curator of the Musée du Luxembourg in Paris.

Bibliography

Bellier de La Chavignerie–Auvray; Bénézit; DBF

G. Vapereau: Dictionnaire universel des contemporains (Paris, 1858, 5/1880), p. 996

G. Lafenestre: 'Salon de 1873', Gaz. B.-A., n. s. 1, vii (1873), pp. 479–82

F. Jaffrenou: Carhaisiens célèbres (1940)

ATHENA S. E. LEOUSSI

Jouffroy, François

(*b* Dijon, 1 Feb 1806; *d* Laval, Mayenne, 25 June 1882). French sculptor. Son of a baker, he attended the Dijon drawing school before enrolling at the Ecole des Beaux-Arts in Paris in 1824. In 1832 he won the Prix de Rome and was charged while in Italy with the task of selecting earlier Italian sculpture for inclusion in the cast collection of the Ecole. Two of his works from the years immediately after his return from Rome stand out from contemporary production: the highly acclaimed *Girl Confiding her Secret to Venus* (marble, exh. Salon 1839; Paris, Louvre), depicting a naked girl standing on tiptoe to whisper into the ear of a herm bust of the goddess, a work recalling Roman genre sculpture as well as the playful gallantry of the 18th century; and the stone pediment for the Institut des Jeunes Aveugles (1840), in the Boulevard des Invalides, Paris, in which Jouffroy rivalled Pierre-Jean David d'Angers in accommodating present-day realities in monumental public sculpture. During the Second Empire (1851–70) Jouffroy participated in the decoration of major public buildings, most conspicuously with the stone groups *Marine Commerce* and *Naval Power* (*c.* 1867–8) for the Guichets du Carrousel of the Louvre and the façade group depicting *Harmony* (Echaillon stone, 1865–9) for the new Paris Opéra. Jouffroy's sculpture classes at the Ecole des Beaux-Arts were attended by some talented students, including Alexandre Falguière, Marius-Jean-Antonin Mercié, Louis-Ernest Barrias, Augustus Saint-Gaudens and António Soares dos Reis, but he is said to have performed his duties there in an increasingly perfunctory manner.

Bibliography

Lami

A. M. Wagner: *Jean-Baptiste Carpeaux, Sculptor of the Second Empire* (New Haven, 1986), pp. 68, 118, 224, 226–7, 229–30, 250

<div style="text-align:right">PHILIP WARD-JACKSON</div>

Lalanne, Maxime(-François-Antoine)

(*b* Bordeaux, 27 Nov 1827; *d* Nogent-sur-Marne, 29 July 1886). French etcher and draughtsman. He went to Paris after 1848 to join the studio of Jean Gigoux, and made his Salon début in 1852. He made an important contribution to the etching revival in France with his illustrated manual *Traité de la gravure à l'eau-forte* (1866) and with his participation in the founding in 1862 of the Société des Aquafortistes, with whom he published seven prints in their *L'Eaux-fortes modernes* series (1862–6). He provided drawings for the Society's journal, *L'Illustration nouvelle* (1868–81), and made prints after paintings by such artists as Corot and Constant Troyon for *L'Artiste* and the *Gazette des beaux-arts*. His etched book illustrations (e.g. *Chez Victor Hugo*, 1864), collections of prints (e.g. *Souvenirs artistiques du siège de Paris*, 1871) and plates for the Société des Aquafortistes (e.g. *Rue des Marmousets*, 1862, see 1982 exh. cat., pl. 69) display his opposition to the Second Empire which extended to dark and sombre views of the industrial and slum areas of Paris, executed with great delicacy and technical assurance. Lalanne's sketches were the subject of his second technical manual *Le Fusain* (1869) and served as illustrations to journals and such books as Henry Havard's topographical *Hollande à vol d'oiseau* (1881).

Writings

Traité de la gravure à l'eau-forte (Paris, 1866, 2/1878; Eng. trans., London, 1880, 2/1926/*R* 1981)
Le Fusain (Paris, 1869, rev. 1874)

Bibliography

P. G. Hamerton: *Etching and Etchers* (London, 1868, rev. 3/1880), iii, pp. 171–202
J. Bailly-Herzberg: *L'Eau-forte de peintre au dix-neuvième siècle: La Société des Aquafortistes, 1862–1867*, 2 vols (Paris, 1972) [vol. i contains entries and reproductions from *L'Eaux-fortes modernes*; vol. ii gives a biography, pp. 124–7]
Visions of City and Country: Prints and Photographs of Nineteenth Century France (exh. cat. by B. L. Grad and T. A. Riggs, Washington, DC, N.G.A.; Worcester, MA, A. Mus.; Chapel Hill, U. NC, Ackland A. Mus.; 1982), pp. 129–32
J. Bailly-Herzberg: *Dictionnaire de l'estampe en France, 1830–1950* (Paris, 1985), pp. 175–6

<div style="text-align:right">LEAH KHARIBIAN</div>

Lami, Eugène(-Louis)

(*b* Paris, 12 Jan 1800; *d* Paris, 19 Dec 1890). French painter and lithographer. As a boy his health was so delicate that he was taught by a tutor at home. In 1815, after seeing some of his sketches, Horace Vernet took him into his studio. Overburdened with work himself, Vernet then sent him in 1817 to Antoine-Jean Gros's studio at the Ecole des Beaux-Arts, where he remained for three years, while also continuing to work with Vernet. While in Gros's studio he met Paul Delaroche, Théodore Gericault and R. P. Bonington. Although Bonington taught him the art of watercolour painting, Lami's early work was largely in the field of lithography. In 1819 he produced a set of 40 lithographs depicting the Spanish cavalry, which reflect his fascination for military subjects. These were published in Paris under the title *Manejo del Sable*. However, his largest project of this period was a set of lithographs called *Collections des uniformes des armées françaises de 1791 à 1814* (Paris, 1821–4), all of which (except for a few by Horace and Carl Vernet) were produced by Lami himself. A series of six lithographs representing characters from Byron designed by Gericault and Lami appeared in Paris in 1823, and in the same year he began a number of caricatures entitled *Contretemps* (Paris, 1824).

In 1824 Lami made his début at the Salon with the painting *Battle at Puerto da Miravete* (1823; Versailles, Château). In 1826 he travelled to London where he stayed until 1827, studying, among other things, the works of Joshua Reynolds and Thomas Lawrence. He returned to Paris where his acquaintance with the Marquis de Murinais led to the series of lithographs *La Vie de château* (Paris, 1828). After the July Revolution in 1830 Lami received a number of commissions from Louis-Philippe for military paintings for the château at Versailles, which the King intended to turn into a history museum. He was also appointed drawing-master to the Duc de Nemours, which further tied him to the Orléans family. The period from 1830 until about 1838 was Lami's most prolific in terms of military paintings, all of which were characterized by a detailed, panoramic view set beneath a vast expanse of sky. These included *Battle at Claye, 27 March 1814* (1831) and *Battle of Wattignies* (1837; both Versailles, Château). In 1837 the museum at Versailles was inaugurated and Louis-Philippe was married. The colourful ceremonies that accompanied these events led to a change in Lami's work. He began to concentrate on the court of Louis-Philippe and bourgeois society; the result was such oil paintings as *Arrival of Queen Victoria at the Château of Eu* (1843; Versailles, Château). Mostly, however, he produced watercolours, such as the *Races at Chantilly* (1835; priv. col.; see Lemoisne, 1912, p. 106), and, except when depicting military scenes, this became his favoured medium.

After Louis-Philippe's fall in 1848 Lami followed him to England where he produced a number of watercolours depicting English society, such as *Costume Ball at Buckingham Palace* (1851; Windsor Castle, Royal Lib.). He returned to France in 1852 but, during the reign of Napoleon III, he never again achieved the official importance he had previously enjoyed. From 1856 he was occupied for some time as artistic adviser to Baron James Mayer de Rothschild (1792–1868) during his construction of a château at Boulogne and his transformation of that at Ferrières. In 1859 he painted a series of watercolours illustrating the works of Alfred de Musset such as *December Night* (1859; Malmaison, Château N.). At this time he became increasingly interested in producing historical watercolours depicting either important events or merely scenes from the past, such as *Festival at the Château of Versailles on the Occasion of the Marriage of the Dauphin in 1745* (1861; London, V&A). During the Franco-Prussian War (1870–71) Lami fled to Pregny in Switzerland with the Rothschilds and only returned to Paris after the Commune. In 1879 he was the driving-force behind the foundation of the Société des Aquarellistes Français. Lami continued to work until his death.

Bibliography

P.-A. Lemoisne: *Eugène Lami* (Paris, 1912)
——: *L'Oeuvre d'Eugène Lami* (Paris, 1914)

Landelle, Charles(-Zacharie)

(*b* Laval, 2 June 1821; *d* Chennevières-sur-Marne, 13 Dec 1908). French painter. His father, a calligrapher and musician from Mayenne, moved to Paris in 1825 to take up a post as musician in the Tuileries. Ary Scheffer, whom Landelle met through his father's contact with the Orléans court, encouraged him to become a painter. He registered at the Ecole des Beaux-Arts on 2 October 1837 as a pupil of Paul Delaroche and made his debut at the Salon in 1841 with a *Self-portrait* (Laval, Mus. Vieux-Château). His first success, *Fra Angelico asking God for Inspiration* (exh. 1842; untraced), indicated a sentimental, religious tendency in his work, which alternated with pretty pictures of young girls. *Charity* (exh. 1843; Compiègne, Mus. Mun. Vivenel), commissioned by Antoine Vivenel (1799–1862), was followed by *Idyll* and *Elegy* (untraced), which were bought by the dealer Adolphe Goupil on the opening day of the 1844 Salon. The contract to buy also included Goupil's right of first refusal on the reproduction of all Landelle's future work. Subsequently, he painted the *Three Marys at the Tomb* (exh. 1845; Perpignan, Mus. Rigaud) in the pious manner of Ary Scheffer and a sweet, angelic *St Cecilia* (exh. 1848; Paris, St Nicolas-des-Champs), commissioned in 1845 by the Prefect of the Seine, in which elements of the early Renaissance art seen by Landelle on a trip to Italy in 1845 combined with the soft, pale style common among some of his colleagues from the studio of Delaroche. He also painted religious works for St Roch (1850), St Germain l'Auxerrois (1856) and St Sulpice (1875) churches in Paris. The competition for a figure of the 1848 Republic suited his talent as a painter of single, idealized figures, and his entry (Paris, Louvre), posed impressively like a Renaissance saint, was liked more than most.

Landelle achieved his greatest popularity during the Second Empire. Through the dealer Theo van Gogh, he was patronized by the Dutch King. Goupil, van Gogh, private collectors and the French government (acting on behalf of the Emperor) competed with each other to buy his *Femme Fellah* (destr. 1871), which was inspired by a visit to North Africa and exhibited in 1866.

Landelle sold the original to Emperor Napoleon III and, according to his nephew, Casimir Stryenski, painted at least twenty copies for his rivals (example in Laval, Mus. Vieux-Château). Like his colleagues, Jean-Léon Gérôme and Charles Jalabert, Landelle abandoned an academic career at an early stage to concentrate on selling pictures with the powerful backing of Goupil, who had promoted his masters, Delaroche and Scheffer.

Bibliography

C. Stryenski: *Charles Landelle* (Paris, 1911)
B. Foucart: *Le Renouveau de la peinture religieuse en France (1800–1860)* (Paris, 1987), pp. 257–8

JON WHITELEY

Langlois, (Jean-)Charles

(*b* Beaumont-en-Auge, Calvados, 22 Aug 1789; *d* Paris, 24 March 1870). French painter and writer. A student at the Ecole Polytechnique in Paris, he enlisted in the army in 1807 and served in the battles at Wagram in 1809 and at Waterloo in 1815. He was briefly out of service after Waterloo and studied painting in the studio of Horace Vernet. The studio, fondly called La Nouvelle Athènes by its young denizens, was a hotbed of Bonapartism during the Restoration. Louis-Philippe, later King of France, was a frequent visitor there, and this may have assisted Langlois in receiving commissions during his reign. There is a drawing (1813–16; Paris, Ecole B.-A.) by Théodore Géricault of Langlois in the uniform of a grenadier with a cartridge box on his back. It was probably drawn in Vernet's lively environment where liberal politics, militarism, nationalism and art were as energetically mixed as they would be later in Langlois's paintings. The Salon catalogue of 1855 notes that Langlois also studied under Antoine-Jean Gros and Anne-Louis Girodet. He re-enlisted in 1819 and went to Spain with the French army sent by Louis XVIII to protect the Bourbon king of Spain, Ferdinand VII, in 1823 and to Algiers in 1830 to defend French colonial interests in Algeria and Morocco. He was a military attaché in St Petersburg in 1832, where he painted a portrait of *Nicholas I and his Family* (untraced). His travels

to Africa, Russia and, in 1855–6, to the Crimea were made to study the terrain of battlefields for his immense and accurate illustrations of France at war.

Langlois's Salon entries were, almost without fail, battle paintings and included depictions of the battles of Montereau in 1814 (Salon of 1831; Versailles, Château), Sidi Feruch in 1830 (Salon of 1834; untraced), Polotsk in 1812 (Salon of 1838), Smolensk in 1812 (Salon of 1839), Champaubert in 1814 (Salon of 1840) and Hoff in 1807 (Salon of 1849; all Versailles, Château). They were usually accompanied by lengthy catalogue descriptions quoting official reports, such memoirs as those of his superior officer Marshall Gouvion St-Cyr or bulletins of the Grande Armée. They were not intended to be traditional allegorical history paintings celebrating national glory but documentary accounts of the execution of predetermined battle plans. Nevertheless the French are depicted as victorious even in such dubious engagements as Eylau, Moscow and the crossing of the Beresine River.

The most innovative of Langlois's works are his battle panoramas, in which, if read from left to right, a series of paintings depicts the sequence of actions that led the French to victory in a particular engagement. Langlois informed his readers in the pamphlet on the Moscow panorama (1835; Versailles, Château) that his works generally have distinct phases: a beginning, a middle and an end, as in all the great battles planned by Napoleon. His other panoramas depicted the battles of Eylau (1846), Borodino (1850; Paris, Mus. Armée (Hôtel N. Invalides)), the Pyramids (1853), Sebastopol (1862) and Solferino (1868), for most of which he published pamphlets including maps of the battlefields, official contemporary accounts of the battles and careful descriptions of his own deployment of the troops. The panoramas, like the works of the popular poet Pierre Jean de Beranger, served to fan the flame of the Napoleonic legend in the 19th century.

Writings

Voyage pittoresque et militaire en Espagne (Paris, 1826–30)

Panorama de la bataille de la Moskowa (Paris, [1835])
Relation du combat et de la bataille d'Eylau (Paris, 1846)
Explication du panorama et relation de la bataille des pyramides, extraite en partie des dictées de l'empereur à Sainte-Hélène, et des pièces officielles (Paris, 1853)
Explication du panorama représentant la bataille et le prise de Sébastopol (Paris, 1862)
Explication du panorama et relation de la bataille de Solférino (Paris, 1868)

Bibliography
Thieme–Becker
E. C. Bouseul: *Biographie du Colonel Langlois, fondateur et auteur des panoramas militaires* (Paris, 1874)
G. Bapst: *Essai sur l'histoire des panoramas et des dioramas* (Paris, 1891); review by J. Guiffrey in *Nouv. Archvs A. Fr.*, 3rd ser., vii (1891), p. 398
G. Pinet: *Le Panthéon polytechnique* (Paris, 1910)
L. Bro: *Mémoires du Général Bro (1796–1844), recueillis, complétés et publiés par son petit-fils* (Paris, 1914)
D. Aimé-Azam: *La Passion de Géricault* (Paris, 1970), p. 166

NANCY DAVENPORT

Larche, Raoul(-François)

(*b* Saint-André-de-Cubzac, Gironde, 22 Oct 1860; *d* Paris, 2 June 1912). French sculptor. The son of an ornamental sculptor, Larche entered the Ecole des Beaux-Arts in Paris in 1878. His teachers there were François Jouffroy, Eugène Delaplanche and Alexandre Falguière. He worked in most branches of sculpture but specialized in that of the 'art-edition'. The founders Siot-Decauville cast many of his statuettes and *objets d'art* such as vases, ashtrays and lamps. His statuette of *Loïe Fuller* is the most famous of these editions, and her swirling drapery epitomizes the Art Nouveau style of Larche's sculpture. The Sèvres factory also reproduced his work in porcelain. Whether mythological, pastoral or religious, Larche's subject-matter was frequently sentimental. He executed large statues of *Joan of Arc* (marble; Paris, La Madeleine) and *St Anthony* (stone; Paris, St Antoine) and undertook a small number of decorative sculptures for Parisian façades, notably for the Grand Palais (1900). His output in all branches of sculpture other than the

'art-edition' was modest, though he entered several competitions for monuments, winning the commissions for those to *Jean-Baptiste-Camille Corot* (1909) and *Jean-Siméon Chardin* (1911) as part of a decorative scheme for the Place du Carrousel in Paris. Larche's design for a decorative basin entitled *The Seine and its Affluents* (plaster version, exh. Salon 1910) was intended for the same site, but this work (perhaps his most famous) was eventually placed near the Grand Palais after being shown there at the retrospective exhibition of his work in 1920.

Bibliography
Lami

H. Berman: *Bronzes, Sculptors and Founders, 1800–1930*, 4 vols (Chicago, 1974–80), i/379, 566; ii/813, 1569; iii/2144, 2292; iv/3340, 4404, 4408

De Carpeaux à Matisse: La Sculpture française de 1850 à 1914 dans les musées et les collections publiques du nord de la France (exh. cat., Calais, Mus. B.-A., 1982), pp. 235–6

G. Bresc and A. Pingeot: *Sculptures des jardins du Louvre, du Carrousel et des Tuileries*, ii (Paris, 1986), pp. 250–56

D. Renoux: *Raoul Larche statuaire* (mémoire de maîtrise, U. Bordeaux III, 1986)

PENELOPE CURTIS

La Touche, Gaston

(*b* Saint-Cloud, 29 Oct 1854; *d* Paris, 12 July 1913). French painter and printmaker. A self-taught artist, he was from childhood determined to be a painter and was supported in this ambition by his well-to-do parents. He admired Zola and provided drypoint illustrations for his novel *L'Assommoir* (1879). His first paintings (1880s) were domestic scenes in the style of the Dutch 17th century. They were vigorous, harsh and sombre and met with no success: he burnt most of them in 1891. The influence of his friend Félix Bracquemond prompted him to discard his early style and to use the colours favoured by the Impressionists; his brushwork is characterized by small, petal-like strokes of colour. In 1890 he showed *Phlox* and *Peonies* (untraced), both colourful scenes of women, children and flowers, at the Société Nationale des Beaux-Arts, which brought him immediate success. His *fêtes galantes* and *singeries* recall French 18th-century art, and he also specialized in Breton subjects, such as *Pardon in Brittany* (1896; Chicago, IL, A. Inst.).

After receiving the Légion d'honneur in 1900, La Touche was given several official commissions for large-scale decorative schemes. These included four views of fêtes at Versailles (never installed) for the Palais d'Elysée (1906; Paris, Pal. Luxembourg), four decorative panels showing landscapes with figures (untraced) for the Ministère de l'Agriculture, four pictures representing the arts (never installed) for the Ministère de la Justice (exh. Salon 1910; Paris, Pompidou) and decorations for the dining-room of the liner *La France* (1912; destr. 1930s). These large canvases, reminiscent of the work of such 18th-century artists as Hubert Robert and Jean-Honoré Fragonard, are characterized by glowing colours and broad brushstrokes. In 1908 La Touche exhibited over 300 of his works at the Galerie Georges Petit in Paris. He painted murals, *c.* 1910, for the house of the dramatist Edmond Rostand at Cambo, Pyrénées-Atlantiques.

Bibliography
G. Mourey: 'The Work of Gaston La Touche', *The Studio*, xvi (1899), pp. 77–90

H. Frantz: 'Gaston La Touche', *The Studio*, xliii (1908), pp. 265–78

A. Segard: *Peintres d'aujourd'hui: Les Décorateurs*, i (Paris, 1914), pp. 139–208, 309–17

A. P. La Fontaine: *Un Grand Peintre bas-Normand: Gaston La Touche* (Calvados, 1935)

JANE ABDY

Laurens, Jean-Paul

(*b* Fourquevaux, Haute-Garonne, 28 March 1838; *d* Paris, 23 March 1921). French painter, illustrator and teacher. At an early age he took lessons from a Piedmont painter, Pédoya, who had come to Fourquevaux to decorate the village church. Pédoya was a harsh teacher, and Laurens moved to the nearby Ecole des Beaux-Arts in Toulouse.

There he studied under Jean-Blaise Villemsens (1806–59), the professor of sculpture, who took a great interest in him. In 1858 he won the Prix de la Ville de Toulouse, which paid for him to complete his studies in Paris. There he was a pupil first of Alexandre Bida (1823–95) and then of Léon Cogniet. After a single unsuccessful attempt to win the Prix de Rome, he made his début at the Salon in 1863 with the *Death of Cato* (1863; Toulouse, Mus. Augustins), which already revealed his fascination for historical subjects.

Laurens's first major success at the Salon came in 1872 with *Pope Formosus and Stephen VII* (1870; Nantes, Mus. B.-A.) and the *Execution of Duc d'Enghien* (1872; Alençon, Mus. B.-A. & Dentelle). The former, which shows the exhumed corpse of Formosus, in sacerdotal robes, being accused by his successor of having usurped the papal throne, exemplifies his inclination for gruesome subject-matter and his interest in obscure events of church history, a feature of his work that earned him the nickname 'The Benedictine'. The painting's char-acteristically detailed and realistic treatment heightens the impact of the distasteful subject. The *Execution of Duc d'Enghien*, another morbid sub-ject, depicts the summary trial and execution of the royalist Duc d'Enghien, an event that caused great indignation during the reign of Napoleon I. In 1875, continuing his treatment of historical sub-jects, he exhibited the *Excommunication of Robert the Pious, 998* (1875; Paris, Mus. d'Orsay; see fig. 44) and *The Interdict* (1875; Le Havre, Mus. B.-A.). In 1877 the *Austrian Military Staff before the Coffin of Marceau* (1877), which depicted the hon-our accorded to the French general François-Séverin Desgraviers Marceau (1769–96) by the Austrians, won the médaille d'honneur.

From 1877 to 1880 Laurens worked on decora-tive paintings for the apse of the Panthéon, Paris: three large panels depicting the dying Ste Geneviève surrounded by devoted admirers. His usual, somewhat harsh, realistic style failed to convey the paintings' intended spirituality. The works were finally put in place in 1882. Numerous

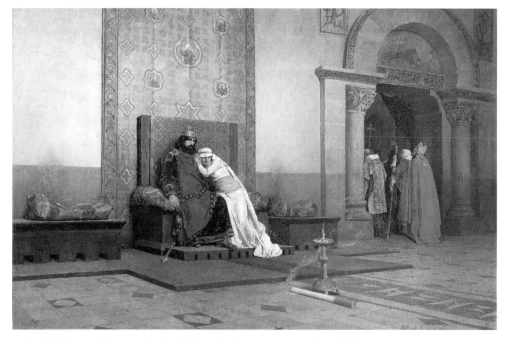

44. Jean-Paul Laurens: *Excommunication of Robert the Pious, 998*, 1875 (Paris, Musée d'Orsay)

public projects followed. In 1888 he decorated the ceiling of the Théâtre de l'Odéon, Paris, and in 1891 started work on decorative panels, featuring scenes from French history, for the Hôtel de Ville in Paris, which were completed in 1898 and displayed in what became known as the Salle de J.-P. Laurens. Overlapping with this was a commission to decorate the Salle de Capitole in Toulouse (1895–9), a project that included such works as *Toulouse against Montfort* (1899), depicting a symbolic struggle between the lion of Montfort and the lamb of Toulouse.

Meanwhile Laurens continued to paint historical canvases, for example *The Alchemist* (1889; Toulouse, Mus. Augustins), including some of more recent historical events, such as the *Last Moments of Maximilien* (1882; St Petersburg, Hermitage). He also designed cartoons for tapestries to be manufactured by the Gobelins, the largest being the grandiose *Triumph of Colbert* (1902; see Thiollier, fig. b0), 13 m long and 9 m high. Later public projects included a triptych on the *Life and Death of Joan of Arc* for the Hôtel de Ville at Tours, executed in 1903. For the Grand Salle of the Préfecture at Saint-Etienne he painted the vast *The Miners* (1904), which, using contemporary subject-matter, showed a column of miners set against a panoramic mining landscape. His later canvases reveal his continued interest in religious subjects, as in such paintings as *Interior* (1908; Beauvais, Mus. Dépt. Oise), which depicts a dying priest in his cell.

Laurens was also a prolific book illustrator, providing plates for Augustin Thierry's *Premier récit des temps mérovingiens* (Paris, 1881), Victor Hugo's *L'Art d'être grand père* (Paris, 1884), Goethe's *Faust* (Paris, 1885) and other works. For some of his paintings he would work with clay models first in order to obtain the required facial expressions and, though not a sculptor, he used this skill to produce a few portrait medallions (see Thiollier, fig. cf). In 1886 he was appointed a professor at the Ecole des Beaux-Arts in Paris and in 1891 was elected a member of the Académie des Beaux-Arts. He also taught at the Académie Julian, Paris, and became director of the Ecole des Beaux-Arts in Toulouse. Through these numerous teaching posts he exercised a considerable influence over contemporary painting. Laurens's work seems unconvincingly grandiose, and although there is real drama in many of his paintings their interest lies mainly in their curious subject-matter.

Bibliography

F. Fabre: *Roman d'un peintre* (Paris, 1878)
—: *Jean-Paul Laurens* (Paris, 1895)
R. Muther: *The History of Modern Painting*, i (London, 1895), pp. 434–5
F. Thiollier: *L'Oeuvre de J.-P. Laurens* (Paris, 1905)
A. Soubies: *Les Membres de l'Académie des beaux-arts depuis la fondation de l'institut*, iv (Paris, 1917), pp. 54–9
French Salon Paintings from Southern Collections (exh. cat. by E. M. Zafran, Atlanta, High Mus. A., 1983), pp. 134–5

☐

Laurent, Ernest (Joseph)

(*b* Gentilly, Val-de-Marne, 8 June 1859; *d* Bièvres, Essonne, 25 June 1929). French painter and printmaker. In 1877 he was accepted at the Ecole des Beaux-Arts in Paris as a pupil of Henri Lehmann. There he befriended Georges Seurat and Edmond Aman-Jean, with whom he regularly visited the Louvre. After military service (1879–80) he returned to the Ecole and in 1882 exhibited *Portrait of my Mother* (priv. col.) at the Salon. Lehmann, having resigned on health grounds, was replaced in 1882 by Ernest Hébert, whom Laurent greatly admired. The Impressionist exhibitions of 1881 and 1882, Puvis de Chavannes and the regular company of Seurat, who was studying value contrasts at this period, were also particularly influential on Laurent. Together Laurent and Seurat produced a number of small oil sketches on wood and a series of chiaroscuro portraits in conté crayon: for example Laurent's portrait of *Georges Seurat* (1883; Paris, Louvre). He also made portrait drawings as preparatory studies for his painting *At the Concert Colonne* (exh. Salon 1884). In his unsuccessful competition designs for Saint-Maur-les-Fossés, Paris IVe and Courbevoie town halls (1882–5), he sought to apply the lessons he had learnt from Impressionism. In 1884 he painted the *Annunciation* (exh. Salon 1885;

Nérac, Mus. Château Henri IV) in a quasi-pointillist manner, but his profound religious faith and increasing attachment to the Symbolism of Hébert and Puvis de Chavannes ran counter to Seurat's rigorous materialism, and the two artists fell out. Puvis de Chavannes, who had particularly admired the *Annunciation*, secured a travel scholarship to Italy for Laurent. He stayed in Venice, Arezzo and Pisa, and also visited North Africa. Fascinated by Italy, he was determined to win the Prix de Rome, which would enable him to return. The subject for the 1889 competition, *Christ and the Palsied Man*, appealed to his religious sensibility, and, although first prize was given to Gaston Thys (1863–93), Laurent won a second prize held over from the previous year. In January 1890 Laurent reached Rome where his former tutor Hébert was still Director of the Académie de France. In Assisi he underwent a mystical experience and during 1891–2 sent back to Paris several religious subjects. His *St Francis of Assisi* (1895; Nantes, Mus. B.-A.) was exhibited at the Salon of 1895.

By the mid-1890s Laurent's technique, which hardly varied over the years, was fixed. It was characterized by juxtaposed brushstrokes, inherited from Impressionism, often in a range of muted colours, and by carefully structured compositions in accord with his academic training. He was soon in the front rank of French artists, while being totally ignored by the public at large. In 1899 the French government commissioned from Laurent a large religious composition, the *First Mass*, for Notre-Dame Cathedral, Montreal. In 1903 he was made a member of the Légion d'honneur. At the same time he was asked to decorate the Salles des Autorités of the Sorbonne, next to the amphitheatre decorated with Puvis de Chavannes's *The Sacred Wood* (1886–9). Adopting themes from this huge frieze, Laurent's four compositions illustrated the arts of *Lyric Poetry*, *History*, *Philosophy* and *Eloquence* (completed 1915). In 1905 Laurent decorated the terminus hotel at Lyon-Perrache with scenes from the regions crossed by the Paris–Lyon–Marseille railway, *Paris*, *Auxerre* and a rural landscape, *Vauhallan*.

Laurent had a small but faithful circle of enthu-

45. Ernest Laurent: *Gabriel Fauré* (Versailles, Musée National du Château de Versailles et du Trianon)

siasts for his easel paintings. His favourite subjects were portraits (see fig. 45), intimate interiors or garden scenes, the female nude and flower pieces. The Countess Lovatelli commissioned one of Laurent's first portraits, *Young Woman in Pink (the Comtesse Lovatelli)* (exh. Salon 1896; Paris, Mus. d'Orsay), which was praised by Roger Marx, thanks to whom Laurent became portrait painter to the Jewish upper-middle-class families of Paris. Laurent was equally accomplished in pastel and in the early 1900s did a large number of monotypes.

In the period before World War I Laurent exhibited frequently, and in 1919 he was elected to the Académie des Beaux-Arts. In the 1920s he was influenced by the Art Deco style through his friend, the architect Auguste Perret, and his art became increasingly purified. With René Lalique and Maurice Denis he helped to decorate St-Nicaise in Reims, painting a *Baptism of Christ* (1926).

Bibliography
P. Jamot: 'Artistes contemporains: Ernest Laurent', *Gaz. B.-A.*, n. s. 4, v (1911), pp. 173–203

L. Rosenthal: 'Ernest Laurent', *A. & Déc.*, xxix (1911),
pp. 65–76
Catalogue des oeuvres de Ernest Laurent (exh.
cat., intro. P. Jamot; Paris, Gal. Durand-Ruel,
1911)
Exposition Ernest Laurent (exh. cat., intro. P. Jamot;
Paris, Mus. Orangerie, 1930)
R. Hurel and A. Klepper: *Le Peintre Ernest
Laurent (1859–1929): Sa vie, son oeuvre,
essai de catalogue raisonné, peintures, dessins,
estampes* (diss., U. Paris IV-Sorbonne,
1976)
Atelier Ernest Laurent (sale cat., Granville, Hôtel des
ventes, 14 Nov 1993) [151 lots]

ROSELYNE HUREL

Léandre, Charles-Lucien

(*b* Champsecret, Orne, 23 July 1862; *d* Paris, 1930). French painter, illustrator and sculptor. He went to Paris in 1878 to study under the painter Emile Bin until 1885, when he entered the atelier of Alexandre Cabanel. From 1883 onwards, he exhibited landscapes, genre scenes and portraits (those of women and children being particularly popular) in oil and pastel at the Salon de la Société des Artistes Français.

Léandre also taught drawing until 1897. His fame was due chiefly to the vast number of Symbolist drawings he produced for newspapers and magazines. His first post was as a caricaturist for *Le Chat noir*, and he later worked for *Le Journal*, *Le Figaro*, *Le Gaulois* and *Le Journal amusant*; his most important work was for *Le Rire*, for which he often illustrated the front page. In 1907 he helped to found the Société des Artistes Humoristes, publishing a magazine, *Les Humoristes*, in 1910.

Léandre produced posters for the nightclubs of Montmartre, artists' balls and chansonniers' tours, and for the first two exhibitions of the Société des Peintres Lithographes. He illustrated many literary works, of which the most famous was Gustave Flaubert's *Madame Bovary*. Léandre also produced sculptures in wood and in terracotta. The Musée Municipal, Vire, and the Musée d'Art, Coutances, have the most important collections of his work.

Bibliography
G. Carpon: 'Musée de Coutances, oeuvres de Charles
Léandre', *Rev. Louvre*, xxii (1972), p. 520

MICHÈLE LAVALLÉE

Lebourg, Albert-Charles

(*b* Montfort-sur-Risle, Eure, 1 Feb 1849; *d* Rouen, 7 Jan 1928). French painter. He had an early interest in architecture and studied under the architect Drouin at the Ecole Municipale de Dessin in Rouen. He became increasingly interested in art and through Drouin met the landscape painter Victor Delamarre (1811–68) who advised and taught him. Giving up architecture altogether, he then attended the Ecole Municipale de Peinture et de Dessin in Rouen under Gustave Morin (1809–86). In 1871 he met the collector Laperlier through whom he obtained the post of professor of drawing at the Société des Beaux-Arts in Algiers. He remained there from 1872 to 1877, producing works such as *Street in Algiers* (1875; Rouen, Mus. B.-A.). He also experimented with depicting a single site in a variety of different lights, in a manner similar to the late works of Monet. After giving up his teaching post in Algeria in 1877 he returned to Paris where he attended Jean-Paul Laurens's studio from 1878 to 1880. It was at this point that he became aware of Impressionism; later he became friendly with Degas, Monet and Sisley. He first exhibited at the Salon de la Société des Artistes Français in 1883 and again in 1886, and after the foundation of the Société Nationale des Beaux-Arts (1889) he exhibited there regularly from 1891 to 1914. Between 1884 and 1886 he spent much time in the Auvergne region, producing such Impressionist works as *Snow in Auvergne* (1886; Rouen, Mus. B.-A.), in which a river re-establishes the habitual presence of water in his work. After living and working in numerous places in northern France, Lebourg travelled in the Netherlands (1895–7), and in 1900 he spent a short period in Britain, which confirmed his love of Turner, Constable and Gainsborough. He continued working in a luminous Impressionist style with landscapes such as *Small Farm by the Water (Ile de Vaux)* (1903;

Rouen, Mus. B.-A.) up until 1921 when he was paralysed by a stroke.

Bibliography

L. Bénédite: *Albert Lebourg* (Paris, 1923)

Lecomte du Nouÿ, (Jules-)Jean(-Antoine)

(*b* Paris, 10 June 1842; *d* Paris, 19 Feb 1929). French painter and sculptor. He was born into a noble family of Piedmontese origin. He studied (1861–3) at the Ecole des Beaux-Arts in Paris under Charles Gleyre and Emile Signol. The major influence on his development, however, was Jean-Léon Gérôme, whose pupil he became in 1864. He was deeply affected by the polished realism of Gérôme's *Néogrec* style. *Death of Jocasta* (1865; Arras, Mus. B.-A.) shows Lecomte du Nouÿ's taste for carefully detailed scenes, the subjects of which were drawn from antique sources. From 1863 he exhibited historical genre, religious paintings and portraits (e.g. *Adolphe Crémieux*, 1878; Paris, Mus. d'Orsay) at the annual Salons, but he did not receive official recognition until 1869, when *Bearers of Bad News* (Tunis, Min. Affaires Cult.) was acquired by the State. In 1872 he first visited Greece, Egypt, and Turkey, and on this and subsequent trips he executed sketches that would serve as the bases for his paintings. He was attracted to themes of eroticism, violence and oriental despotism and throughout his career successfully exhibited paintings of this sort at the Salon, such as the *Guard of the Seraglio: Souvenir of Cairo* (1876; Paris, priv. col., see 1984 exh. cat., no. 86) and the *White Slave* (1888; Nantes, Mus. B.-A.). He was also commissioned to provide paintings for various churches in Paris, including St Nicolas (1879) and the chapel of St Vincent-de-Paul (1879) in La Trinité, and later painted decorative cycles for such churches in Romania as Trei Ierarhi in Iaşi. In 1895 his first sculpture was exhibited at the Salon, and in 1901 he received an honorary mention for the sculpture *Death of Gavroche* (untraced). He also sculpted in Romania, producing such works as the bronze statue of *Prince* *Barbo Stirvey* in Craiova. His brother André Lecomte du Nouÿ (1844–1914) was an architect.

Bibliography

G. de Montgailhard: *Lecomte du Nouÿ* (Paris, 1906)
V. Sisman: *Lecomte du Nouÿ* (diss., U. Paris X, 1981)
The Orientalists: Delacroix to Matisse: European Painters in North Africa and the Near East (exh. cat., ed. M. Stevens; London, RA, 1984)
Tradition and Revolution in French Art, 1700–1880; Paintings and Drawings from Lille (exh. cat., London, N.G., 1993)

JANE MUNRO

Lefebvre, Jules(-Joseph)

(*b* Tournan, Seine-et-Marne, 14 March 1836; *d* Paris, 24 Feb 1911). French painter. He studied in Leon Cogniet's studio from 1852 and competed at the Ecole des Beaux-Arts in Paris from 1853 until he won the Prix de Rome in 1861. In Rome he was influenced by Mannerism and especially by Andrea del Sarto, whose works he copied. In his *Boy Painting a Tragic Mask* (1863; Auxerre, Mus. A. & Hist.) Lefebvre introduced the precise draughtsmanship, delicate colour and a lubricity characteristic of many of his later works. In 1866 he experienced a severe depression caused by the death of his parents and one of his sisters, and by criticism of the last major work he painted in Rome, *Cornelia, Mother of the Gracchi* (untraced). After these experiences he turned from history painting to portraits and nudes; he exhibited 72 portraits in Salons between 1855 and 1898 (e.g. *Julia Foster Ward*; Hartford, CT, Wadsworth Atheneum), but little is known about them since nearly all remain in private collections. Although he occasionally finished large-scale, ambitious paintings (e.g. *Lady Godiva*, Amiens, Mus. Picardie; *Diana Surprised*, Buenos Aires, Mus. N. B.A.), he made his reputation with nudes such as *Reclining Woman* (exh. Salon 1868; untraced). Critics praised this painting and recognized its eroticism, yet there was no scandal as there had been with Manet's *Olympia* (1863; Paris, Mus. d'Orsay). Lefebvre avoided the signs of contemporary social reality,

prostitution or the model's personality that characterized Manet's painting, focusing instead on the woman's beauty and stressing her passivity and availability.

Lefebvre became one of the best-known painters of the female nude, rivalled only by William Bouguereau. He was inspired by Ingres and the Fontainebleau school, notably in his stress on contour, graceful if exaggerated rhythms and smooth surfaces. Such works as *Truth* (1870; Paris, Mus. d'Orsay) earned Lefebvre a special niche among the contemporary painters of nudes, winning success at the Salon and spawning many imitators. He repeated this style and subject for the rest of his career. American collectors were avid fans of Lefebvre's work in the 1870s and 1880s as he satisfied their taste for simple, understandable paintings. Some contemporary critics wrote positively about his work (see Haller, 1899, pp. 213–38) but harsh judgements appeared in *La Presse* by 1875, and in the 1880s the newspaper *L'Intransigeant* expressed hostility towards his painting and to all academic art. Lefebvre sought to balance the rival claims of idealization, modernity, the study of nature and knowledge of the Old Masters in a way that revealed an original point of view, creating a modern ideal by combining art with recording physical reality.

Lefebvre was a professor at the Académie Julian in Paris from the 1870s until almost the end of his life; he was known for his sensitivity to precision in his students' life drawing despite the abstract idealism of the figures in his own paintings. His insistence on absolute accuracy in the rendering of nature was instilled in his students, who included Fernand Khnopff and Kenyon Cox, whether they ultimately decided to pursue some aspect of Realism or to rebel and enter the ranks of the avant-garde. He was a regular member of Salon juries from 1875. He won many awards and honours, becoming Commandeur of the Légion d'honneur in 1898 and a member of the Académie des Beaux-Arts of the Institut de France in 1891.

Bibliography

F. Jahyer: 'Jules Lefebvre', *Gal. Contemp., Litt., A.*, iv b (1879) [unpaginated]

E. Strahan: *The Art Treasures of America* (Philadelphia, 1879)

J. Clarétie: 'Jules Lefebvre', *Grands peintres français et étrangers* (Paris, 1884), pp. 97–112

C. Vento: *Les Peintres de la femme* (Paris, 1888), pp. 299–333

F. Berteaux: *Les Artistes picards* (Paris, 1894)

G. Haller: *Nos grands peintres: Catalogue de leurs oeuvres et opinions de la presse* (Paris, 1899)

——: *Le Salon, dix ans de peinture* (Paris, 1902)

P. Grunchec: *Le Grand Prix de peinture* (Paris, 1983)

C. Fehrer: 'New Light on the Académie Julian and its Founder (Rodolphe Julian)', *Gaz. B.-A.*, 6th ser., ciii (1984), pp. 207–16

JULIUS KAPLAN

Legros, Alphonse

(*b* Dijon, 8 May 1837; *d* Watford, 8 Dec 1911). British etcher, painter, sculptor and teacher of French birth. He is said to have been apprenticed at the age of 11 to a sign-painter, at which time he may also have attended classes at the Ecole des Beaux-Arts in Dijon. He was employed as assistant on a decorative scheme in Lyon Cathedral before moving in 1851 to Paris, where he worked initially for the theatre decorator C. A. Cambon (1802–75). He soon became a pupil of Horace Lecoq de Boisbaudran, whose methodical instruction and liberality in fostering individual talent proved of lasting benefit to Legros. In 1855 he enrolled at the Ecole des Beaux-Arts, Paris, attending irregularly until 1857. During this period Legros had a taste for early Netherlandish art and for French Romanticism, which was later superseded by his admiration for Claude, Poussin and Michelangelo. However, his devotion to Holbein proved constant and was apparent as early as his first Salon painting, *Portrait of the Artist's Father* (1857; Tours, Mus. B.-A.).

Legros began etching in 1855; he preferred this medium and produced over 600 plates. Many of his early works are deliberately rough in execution, yet Legros already valued the medium sufficiently to encourage the publisher Alphonse Cadart to establish the Société des Aquafortistes in 1862. Cadart had published Legros's portfolio *Esquisses à l'eau-forte* (1861), which was dedicated

to Baudelaire, a reflection of the poet's important role as mentor and friend following his enthusiastic review of *Angelus* (ex- Lingard priv. col., Cheltenham) at the Salon of 1859.

In the same year Legros, Whistler and Henri Fantin-Latour, a fellow student at Lecoq's, dubbed themselves the Société des Trois: a union founded more on personal solidarity than on any artistic programme. With *Ex-voto* (Dijon, Mus. B.-A.), awarded an honourable mention at the Salon of 1860, Legros emerged as a leader of the younger generation of realists, notwithstanding his conspicuous dependence on Courbet. However, this critical success brought no financial security, and in 1863, with Whistler's encouragement, Legros visited London where he found admirers and patrons, notably the Ionides family, and was ardently promoted by the brothers Dante Gabriel Rossetti and William Michael Rossetti. Despite winning medals in the Salons of 1867 and 1868 and receiving the support of the critics Louis-Edmond Duranty and Philippe Burty in Paris, Legros resolved to remain in London. He was naturalized in 1880.

In 1876 Edward John Poynter recommended Legros to succeed him as Professor of Fine Art at the Slade School. Legros occupied this position until 1893 and introduced etching and modelling to the syllabus, a reflection of his own interests. He was a founder-member of the Society of Painter-Etchers in 1881 and of the Society of Medallists in 1885; the revival of the cast art medal was due almost entirely to his example. Particularly notable are his softly modelled portrait medallions of great Victorians, for instance *Alfred, Lord Tennyson* (bronze, c. 1882; Manchester, C.A.G.), which reveal his debt to Pisanello.

With its classically inspired economy of form and design, Legros's interpretation of his realist subject-matter exerted a decisive influence in England on the representation of peasant life in the 1880s, comparable with that of Jules Bastien-Lepage. He had a taste for the macabre, which endured from his illustrations of Edgar Allan Poe of 1861 to be absorbed into the Symbolism of the 1890s (as in the series *Triumph of Death*, begun 1894). In the etchings *Death of the Vagabond* and *Death and the Wood-cutter*, these themes coalesce

in a stark blend of realism and fantasy which is simultaneously elevated and humane.

Bibliography

L. Bénédite: 'Alphonse Legros', *The Studio*, xxix (1903), pp. 3–22
G. Soulier: *L'Oeuvre gravé et lithographié de Alphonse Legros* (Paris, 1904)
A catalogue of Paintings, Drawings, Etchings and Lithographs by Professor Alphonse Legros (1837–1911) from the Collection of Frank E. Bliss (exh. cat., London, Grosvenor Gal., 1922)
A Catalogue of the Etchings, Drypoints and Lithographs by Professor Alphonse Legros (1837–1911) in the Collection of Frank E. Bliss (London, 1923)
M. C. Salaman: *Alphonse Legros*, Modern Masters of Etching, ix (London, 1926)
G. P. Weisberg: 'Alphonse Legros and the Theme of Death and the Woodcutter', *Bull. Cleveland Mus. A.*, lxi (1974), pp. 128–35
A. Seltzer: *Alphonse Legros: The Development of an Archaic Visual Vocabulary in Nineteenth Century Art* (diss., Binghamton, SUNY, 1980)
T. J. Wilcox: *Alphonse Legros (1837–1911): Aspects of his Life and Work* (diss., U. London, 1981)
P. Attwood: 'The Medals of Alphonse Legros', *Medal*, ii (1983), pp. 7–23 [with list of sculptures]
Alphonse Legros, 1837–1911 (exh. cat. by T. Wilcox, Dijon, Mus. B.-A., 1987)

TIMOTHY WILCOX

Lehmann, (Charles-Ernest-Rodolphe-) Henri [Karl Ernest Heinrich Salem before naturalization (1846)]

(*b* Kiel, Holstein, 14 April 1814; *d* Paris, 30 March 1882). French painter and teacher of German origin. A pupil of his father, Leo Lehmann (1782–1859), and Ingres, whose studio he entered in 1831, Lehmann enjoyed a long and much honoured career. His work reflects his fervent admiration and emulation of Ingres, his respect for the art of the Nazarenes and his study of 17th-century Italian art. He exhibited regularly at the Salon from 1835, gaining first-class medals in 1840, 1848 and in 1855. He was represented by 20 works at the Exposition Universelle.

Lehmann's most celebrated large easel painting was the *Grief of the Oceanides at the Foot of*

the Rock where Prometheus Lies Enchained (1851; Gap, Mus. Dépt.), which allowed him to exercise fully his talents for dramatic lighting and energetically posed nude figures. It was purchased by the State for 6000 francs. He was awarded many commissions for large-scale figure compositions including decorations for the newly enlarged Hôtel de Ville, Paris, in 1852 (destr. 1871), the church of Ste-Clotilde, Paris (1854), and the throne-room of the Palais du Luxembourg, Paris (1854–6). He produced portraits of many of the leading men and women of the period including Stendhal (1841; Grenoble, Mus. Stendhal), the Princess Belgiojoso (1844; ex-Marquis Franco del Pozzo d'Annone priv. col.) and his friend Franz Liszt (1840; Paris, Carnavalet), which is considered by many to be his most successful portrait. Lehmann concentrated on capturing Liszt's dramatic features and commanding gaze, isolating the composer's spare figure against a neutral background. He was also a prolific draughtsman.

Lehmann was awarded the Légion d'honneur in 1846 and was naturalized as a French citizen later that year. From 1875 until a year before his death, he taught at the Ecole des Beaux-Arts; his students included Camille Pissarro and Georges Seurat, who found his conservative regime unappealing.

Bibliography

Henri Lehmann (exh. cat., ed. M.-M. Aubrun; Paris, Carnavalet, 1983)

M.-M. Aubrun: Henri Lehmann, 1814–1882: Catalogue raisonné de l'oeuvre, 2 vols (Paris, 1984)

MICHAEL HOWARD

Leleux

French family of painters and printmakers. (1) Adolphe Leleux and his brother (2) Armand Leleux were both known mainly as painters of provincial rural life.

(1) Adolphe Leleux

(b Paris, 15 Nov 1812; d Paris, 27 July 1891). Adolphe was 25 before he decided to become a painter. He received no formal schooling in art apart from an apprenticeship in engraving with the printer Alexandre Vincent Sixdeniers (1795–1846). Though brought up in Paris, he often painted rural scenes. In 1835 he exhibited scenes from Picardy at the Salon and in 1838 followed with genre scenes of the rural poor. Beginning in 1838 he turned to Brittany for inspiration. Salon critics such as Théophile Gautier found a sincerity in his work that made his scenes 'almost real'. Gautier praised The Roadmenders (exh. Salon 1844; untraced) as 'one of the major works of the realist school'.

Adolphe exhibited his Breton scenes, and occasionally a Spanish theme (after a trip to Spain in 1843), at the Salons from 1835 until 1881. He received third-class medals in 1842 and 1843, a second-class medal in 1848 and the Légion d'honneur in 1855. Adolphe fought in the revolution of 1848 and later painted pictures such as The Password (1848; Versailles, Château), inspired by his experience on the barricades. Many of these paintings were engraved, the products of which were widely distributed, gaining Leleux a broad following; his images of the 1848 revolution became icons that entered the national consciousness. Adolphe quickly became a favourite of Napoleon III and his canvas of the Fairground of St Fargeau (1855; untraced) was purchased by the state for 3000 francs. He received commissions for a number of works, was invited to official gatherings and enjoyed a profitable career. In later years his style softened, and it was criticized for its lack of definition and focus. Gautier unsuccessfully urged Adolphe to return to scenes in the realist tradition. By the time he died he had fallen into obscurity.

(2) Armand Leleux

(b Paris, 1818 or 1820; d Paris, 1 June 1885). Brother of (1) Adolphe Leleux. He was trained by his brother. His early canvases also had Breton themes, although in his case the inspiration must have come from his brother, for he had never been to Brittany. Adolphe's official ties at court must have greatly assisted the development of Armand's career. In 1846 he was sent to Spain by the French government, probably in order to assess the state of the the arts there, to examine the collections

and to study the people and customs of the country. In the same year he visited Switzerland; he returned there many times after his marriage to the Swiss painter Louise Emilie Giraud (1824–1885), who had studied in Paris at the atelier of Léon Cogniet, and he found many patrons and supporters of his work among her compatriots. In 1863 he also went to Italy. Like his brother, he became a favourite artist of Napoleon III and the court. His composition of *The Knitter* (1854; untraced) was purchased by Napoleon's wife, Empress Eugénie.

The locations of Armand's best-known canvases *The Clogmaker*, *Woman with a Lamp* and *The Forge* (all mid-1850s) were unknown by the 1990s, but they were frequently reproduced as engravings in periodicals of the time. These reproductions make clear that he was influenced by the realist painter François Bonvin and was capable of creating a direct, simple style that was easily understandable. This style, when it was used in the service of common work themes, led critics to regard him as an important contemporary realist. His scenes of rural Spain show a sensitivity to light and an exactitude very different from the frequently dour and dark tonality of his brother Adolphe's painting. Critics encouraged Armand to continue to paint in this mode, recognizing that he had a talent for depicting nature and the effects of sunlight in rich colours; but Armand preferred intimate scenes of family life, perhaps because they appealed to an upper middle-class market and afforded him a degree of financial security.

Armand first exhibited at the Salon in 1839, and his folklore scenes proved popular with the Salon jury. He was awarded a third-class medal in 1844, second-class medals in 1847 and 1848, a first-class medal in 1859 and the Légion d'honneur in 1850. This success generated numerous commissions for genre scenes both from patrons and from the French government. In 1867 Armand was selected for a committee studying popular costume for the Paris Exposition Universelle.

Bibliography

L. Nochlin: *Gustave Courbet: A Study of Style and Society* (New York, 1976), pp. 115–17

The Realist Tradition (exh. cat., ed. G. P. Weisberg; Cleveland, OH, Mus. A., 1980)

G. P. Weisberg: 'The Leleux: Apostles of Proto-realism', *A. Mag.*, lvi (Sept 1981), pp. 128–30

G A B R I E L P. W E I S B E R G

Lemaire, (Philippe-Joseph-)Henri

(*b* Valenciennes, 9 Jan 1798; *d* Paris, 2 Aug 1880). French sculptor. He was a pupil of François-Dominique-Aimé Milhomme, then of Pierre Cartellier, and won the Prix de Rome in 1821. Throughout his career he remained faithful to the Neo-classical style current in his youth and exemplified in the statues he made in Rome for the Paris Salon, such as *Virgil's Ploughman* (marble, 1826; Paris, Tuileries Gardens) and *Girl with a Butterfly* (1827; Valenciennes, Mus. B.-A.).

After his return to Paris in 1826 Lemaire was principally occupied with official and semi-official monumental sculpture for successive regimes. In 1829 he executed a statue of the *Duc de Bordeaux* for the Duchesse de Berry (marble; Valenciennes, Mus. B.-A.), and during the July Monarchy (1830–48) he worked on sculpture for the Galeries Historiques at the château of Versailles, the Arc de Triomphe, and the Colonne de la Grande-Armée in Boulogne, among other projects. He was also involved in the decoration of several Paris churches, his most important work being the monumental stone relief of the *Last Judgement* on the pediment of La Madeleine (1829–34). Its success earned him an invitation to St Petersburg, where he executed models for two pedimental reliefs of the *Resurrection* and *St Isaac* for the church of St Isaac (bronze, 1838–41).

He continued to contribute sculpture to the major Paris building projects of the Second Empire (1851–70), executing work for the Palais de Justice, the Gare du Nord and the Cour Carrée of the Louvre, while for Lille he made a statue of *Napoleon I* (bronze, 1854; Entrepôts municipaux) and for Valenciennes a monument to the chronicler *Froissart* (marble, 1856; Jardin Froissart). Many of his plaster and terracotta models are in the Musée des Beaux-Arts, Valenciennes, and many drawings are kept in the Musée des Beaux-Arts, Rouen.

Bibliography

Lami

A. Le Normand: 'De Lemaire à Rodin: Dessins de sculpteurs du 19ème siècle', *Etudes de la Rev. Louvre*, i (1980), pp. 152–9

De Carpeaux à Matisse: La Sculpture française de 1850 à 1914 dans les musées et les collections publiques du Nord de la France (exh. cat., Calais, Mus. B.-A.; Lille, Mus. B.-A.; Arras, Mus. B.-A.; and elsewhere; 1982–3), pp. 242–5

La Sculpture française au XIXème siècle (exh. cat., ed. P. Durey; Paris, Grand Pal., 1986)

ANTOINETTE LE NORMAND-ROMAIN

Lenepveu, Jules-Eugène

(*b* Angers, 12 Dec 1819; *d* Paris, 16 Oct 1898). French painter. He began his artistic studies in 1834 with J.-M. Mercier (1786–1874), a former pupil of J.-B. Regnault, professor at the Angers drawing school and Director of Angers Museum. He obtained a municipal grant from Mercier to study at the Ecole des Beaux-Arts in Paris, and entered François-Edouard Picot's atelier in 1837. With his friend Léon Bénouville he decorated the Chapelle du Purgatoire of the church of Notre-Dame at Chantilly in 1841 and in 1842 and 1847 exhibited at the Salon with some success. In 1847 he won the Prix de Rome with the grisly *Death of Vitellius* (Paris, Ecole N. Sup. B.-A.). Before leaving for Rome, he finished a fresco for the church in Mareille (1847). He spent five years in Rome from 1848 to 1853, travelled across Italy and Sicily and copied not only the Antique but also Michelangelo, Veronese, Titian, Correggio and Raphael.

When Lenepveu returned to Paris in 1853, he produced a *Christ on the Cross* (1854) for the Palais de Justice and showed *Martyrs in the Catacombs* (Paris, Mus. d'Orsay) at the Exposition Universelle of 1855. Many of his pictures from this period drew on his memories of the Italian masters. In 1857 he showed *Venetian Wedding* (ex-E. Perreire Col.) which, wrote André Joubert, 'revealed the increasingly pronounced individuality of the artist'. His style was full of contrasting elements—an extremely academic classicism, occasionally a Baroque sensitivity and inspiration and a formal rigidity characteristic of the stylistic conventions of the period. He ceased exhibiting at the Salon in 1867.

Lenepveu was a remarkable portrait painter throughout his life: for example *Mercier* (1847; Angers, Mus. B.-A.), the *Five Joubert Ladies* (1872) and his brother *Prospère Lenepveu* (1884; both priv. cols). As a painter of religious scenes, he found his true form of expression in mural decoration. In 1857 he painted *Blessing the Hospice Chapel* for the chapel of the Hospice Général de Ste-Marie in Angers, to which he added ten scenes from the *Life of the Virgin and Christ* between 1858 and 1866. In 1859 Picot chose him to work up his sketches for the Chapelle de la Vierge in the church of Ste-Clothilde, Paris. Ten years later Lenepveu decorated the right transept with two scenes from the *Life of St Valerie*. In 1863 he painted the ceiling of the former Opéra in Rue Lepeltier, with G. Boulanger. In 1870, Lenepveu's friend, Charles Garnier, commissioned the ceiling of the new Opéra from him (obscured by Chagall's ceiling; sketch, Paris, Mus. d'Orsay). This painting, *The Muses and the Hours of Day and Night*, depicted 63 figures on Mount Olympus. Painted in an elevated style and bright colours, it showed a compositional audacity reminiscent of Lanfranco and Giovanni Battista Tiepolo. From 1880 to 1890 Lenepveu did a series of cartoons for mosaics on the Daru staircase in the Louvre, on the theme of painting and antiquity (destr.). Finally, in 1889 he completed scenes from the *Life of Joan of Arc* in the Pantheon, Paris, which were used to illustrate history books for several generations.

Despite numerous honours, including election to the Institut in 1889 and the respect of his fellow artists, Lenepveu never gained a wide public reputation. The largest collection of his work is in the Musée des Beaux-Arts, Angers.

Bibliography

A. Joubert: 'J. Lenepveu', *Rev. Anjou* (1881) [supernumerary issue]

F. Cormon: *Notice sur la vie et l'oeuvre de M. Jules Lenepveu* (Paris, 1899)

Lenepveu, Dauban, Appert (exh. cat., Angers, Soc. Amis A., 1929)

J. Foucart and L. A. Prat: *Les Peintures de l'Opéra de Paris de Baudry à Chagall* (Paris, 1980)

JEAN FOUACE

Lepère, (Louis-)Auguste

(*b* Paris, 30 Nov 1849; *d* Domme, 20 Nov 1918). French printmaker and painter. From an early age he wanted to be a painter, but his father, the sculptor François Lepère (1829–71), stipulated that he also learn a craft that could provide him with a dependable livelihood. At 13 Lepère began an apprenticeship with Burn Smeeton (*fl* 1840–60), an English wood-engraver working in Paris. He began exhibiting paintings at the Paris Salon at the age of 20. In 1875 he showed a painting of the Commune at the Salon des Refusés, *Guardpost on the Rue des Rosiers* (Paris, Carnavalet), which won praise from Camille Pissarro and Armand Guillaumin. (Ten years later Lepère gave Pissarro's son, Lucien, his first lesson in wood-engraving.) From the early 1880s Lepère's wood-engraving business left him little time for painting. He only returned to it seriously after 1900, when success as a printmaker brought him a degree of financial security.

Lepère worked in many other media, including watercolour, ceramic decoration, etching, lithography and leather bookbinding; but it was as a woodcut artist that he made his greatest contribution. He played a major role in the transformation of the woodcut from a reproductive medium of illustration to an independent means of aesthetic expression. In 1875, when Lepère's first signed reproductive wood-engravings began appearing in illustrated periodicals, his name appeared as draughtsman as well as engraver. In 1877 he began publishing wood-engravings based on his own compositions. The first appeared in *Le Monde illustré* (12 May 1877)—five little wood-engravings of the construction of Sacré-Coeur signed 'after nature by M. Lepère'. This was unusual, given the strict division of labour prevalent in wood-engraving ateliers of the period. In the 1880s Lepère became known as an original wood-engraver through his contributions to cultural periodicals, particularly *La Revue illustrée*.

He had, however, the more ambitious aim of establishing the woodcut as a medium that would be disseminated in the form of single-sheet prints, like etching and lithography. In 1888 he organized the Société de l'Estampe Originale, which published an album of ten original prints, including four wood-engravings in May 1888. Further albums appeared in 1889 and 1891. The following year André Marty purchased the rights to the *L'Estampe originale* title and continued to include single-sheet woodcuts—a tribute to Lepère's campaign on behalf of the medium.

In 1889 Lepère broadened the expressive boundaries of the woodcut. He hand-coloured several of his earlier wood-engravings, produced a chiaroscuro woodcut (*Basketsellers*) and experimented with cutting and printing a colour woodcut from sidegrain pearwood with water-based colours in the manner of the Japanese (e.g. *Le Palais de Justice*). In March 1890 he contributed 23 woodcuts to the second Exposition des Peintres-Graveurs at Durand-Ruel's galleries. He continued to produce and exhibit colour woodcuts, his most important work in the medium being *The Convalescent* (1892). His example may have encouraged Henri Rivière to produce woodcuts in the Japanese manner from 1889 and inspired experiments with the medium by Henri Guérard (1846–97) and Charles Maurin in 1890. Félix Vallotton, Maurice Denis, Aristide Maillol and Paul Gauguin took up the woodcut in the 1890s and by 1895 a full-scale revival of the medium was well underway.

In 1907 Auguste Desmoulins began publishing portfolios of three series of wood-engravings that Lepère had created for *La Revue illustrée* in the late 1880s. In 1913 the publisher-dealer Edmond Sagot produced an edition of the popular series *Rouen illustré*, originally made for the journal *L'Illustration* in 1888. Through these editions Lepère's work was disseminated in European and American collections. A complete set of these series is in the British Museum.

Lepère's favourite subject was the city of Paris and its inhabitants. His work in the medium of woodcut is characterized by two distinct styles. His wood-engravings for illustrated periodicals and books are notable for their expressive, etching-like

style, unmatched for the atmospheric qualities achieved through the manipulation of fine black-and-white lines. His woodcuts of the 1890s, on the other hand, often still done on the endgrain, are much broader in approach. Again, one of their most notable attributes is their atmospheric quality, though achieved through different means; for example, in works such as *The Convalescent* subtle effects were achieved by inking the line blocks in brown, blue and grey, and by adding flat colour blocks inked with transparent, water-based pigments in imitation of the Japanese.

Bibliography

R. Marx: 'Peintres-graveurs contemporains: L.-A. Lepère', *Gaz. B.-A.*, n.s. 3, xxxviii (1896), pp. 299–305; xxxix (1908), pp. 78–88, 394–402, 497–512; n.s. 4, iv (1910), pp. 66–70

A. Lotz-Brissonneau: *L'Oeuvre gravé de Auguste Lepère: Catalogue descriptif et analytique* (Paris, [1905])

C. Saunier: *Auguste Lepère, peintre et graveur, décorateur de livres* (Paris, 1931) [incl. G. M. Texier-Bernier's continuation of Lotz-Brissonneau's cat. rais.]

J. Baas: *Auguste Lepère and the Artistic Revival of the Woodcut in France, 1875–1895* (diss., Ann Arbor, U. MI, 1982)

The Artistic Revival of the Woodcut in France, 1850–1900 (exh. cat. by J. Baas and R. S. Field, Ann Arbor, U. MI, Mus. A.; New Haven, CT, Yale U., A.G.; Baltimore, MD, Mus. A.; 1983–4), pp. 40–49

JACQUELYNN BAAS

Lepic, Ludovic(-Napoléon), Vicomte

(*b* Paris, 17 Sept 1839; *d* Paris, 27 Dec 1889). French printmaker, painter and sculptor. A member of a Napoleonic aristocratic family, Lepic was a man of many talents and interests: balletomane, dog breeder, amateur anthropologist and a gentleman jockey, as well as artist. Having abandoned a legal career to study under Charles Gleyre and Alexandre Cabanel, he exhibited at the Paris Salon from 1869.

Lepic became a founder-member of the Société des Aquafortistes in 1862 and by the mid-1870s had developed the idea of 'l'eau-forte mobile' (changeable etching). This technique consisted of using the original etching as a constant and employing various inking and wiping procedures to create different tonal effects. He claimed that he had reworked one of his plates, *View of the Banks of the Escaut*, 85 times, each time changing the light effects or introducing new details (19 impressions in Baltimore, MD, Mus. A.). He summarized his procedures in *Comment je devins graveur à l'eau-forte*, published by Alfred Cadart in 1876.

Lepic's role as a popularizer of a new expressive freedom in printmaking is of great importance, even if he was outstripped in virtuosity and intelligence by Degas, who took Lepic's basic ideas but abandoned the use of an etched line as the basis of the monotype to produce his master-pieces in the latter medium. The first monotype credited to Degas, *The Rehearsal* (*c.* 1874–5; Washington, DC, N.G.A.), bears the signatures of both men in the top left-hand corner. Probably because of his friendship with Degas, Lepic showed watercolours and etchings at the first two Impressionist exhibitions (1874, 1876). In 1872 he founded what is now the Musée Archéologique in Aix-les-Bains.

Writings

Comment je devins graveur à l'eau-forte (Paris, 1876)

Bibliography

H. Béraldi: *Les Graveurs du XIXe siècle*, ix (Paris, 1889), pp. 139–41, 143–5

L. Delteil: *Manuel de l'amateur d'estampes des XIXe et XXe siècles*, ii (Paris, 1925), p. 331

Inventaire du fonds français après 1800, Paris, Bib. N., Dépt. Est. cat., xiv (Paris, 1967)

J. Bailly-Herzberg: *L'Eau-forte de peintre au dix-neuvième siècle: La Société des Aquafortistes (1862–1867)*, ii (Paris, 1972), pp. 139–41

M. Melot: *L'Estampe impressionniste* (Paris, 1974), pp. 106–8

The Painterly Print (exh. cat., ed. J. P. O'Neill; New York, Met., 1980)

MICHAEL HOWARD

Lépine, Stanislas(-Victor-Edouard)

(*b* Caen, 3 Oct 1835; *d* Paris, 28 Sept 1892). French painter. Originally self-taught, he became a

student of Corot and an admirer of Johan Barthold Jongkind, who influenced him in his choice of ships as subject-matter. He also learnt from Jongkind not only how to paint ships accurately but also how to render the depth of the sky and the clarity of waves, as in *Sailing Boats in Caen Harbour* (priv. col., see Serullaz, p. 48). He produced a number of nocturnes of the port of Caen, including *Boats on the River, Moonlight* (Reims, Mus. St Denis) and *Port of Caen, Moonlight Effect* (c. 1859), the latter painting marking his début in 1859 at the Salon in Paris. He specialized in the depiction of the steep banks of the River Seine and the movement of the water, as in the *Seine at Bercy* (c. 1866–72; Edinburgh, N.G.). He also executed views of Paris and was particularly successful in reproducing the atmosphere of the city, especially its overcast days with cloudy skies, as in *Nuns and Schoolgirls Walking in the Tuileries Gardens, Paris* (c. 1871–83; London, N.G.). He also rendered such picturesque scenes in Paris as the old streets of Montmartre where he himself lived (e.g. *Rue Norvins at Montmartre*, 1878; Glasgow, A.G. & Mus.). In 1874 in Paris he exhibited *Banks of the Seine* (1869; Paris, Mus. d'Orsay) with the Société Anonyme des Artistes, Peintres, Sculpteurs, Graveurs etc, the first public showing outside the Salon by the Impressionist painters. Although his work can be said to anticipate the Impressionists' interest in light effects, his brushwork, as well as his depiction of light effects, is much more delicate and subtle than theirs.

Bibliography

J. Couper: *Stanislas Lépine, 1835–1892: Sa vie, son oeuvre* (Paris, 1969)

M. Serullaz, ed.: *Phaidon Encyclopedia of Impressionism* (Oxford, 1978)

S. Monneret: *Impressionnisme et son époque: Dictionnaire international*, 4 vols (Paris, 1978–81)

P. Tucker: 'The First Impressionist Exhibition in Context', *The New Painting: Impressionism 1874–1886* (exh. cat., San Francisco, F. A. Museums; Washington, DC, N.G.A.; San Francisco, CA, de Young Mem. Mus.; 1986), p. 129

K. Adler: *Unknown Impressionists* (Oxford, 1988)

ATHENA S. E. LEOUSSI

Lepoittevin [Poidevin], Eugène (-Modeste-Edmond)

(*b* Paris, 31 July 1806; *d* Paris, 6 Aug 1870). French painter and lithographer. A student of Louis Hersent and Auguste-Xavier Leprince, he was a prolific painter and lithographer and exhibited regularly in the Salons in Paris from 1831. He combined history, genre and landscape in his marine and pastoral narratives. The influence of Dutch painting is not only evident in his scale, topographical accuracy and attention to light and air but also in his choice of Dutch subjects, as in such works as *Van de Velde Painting the Effect of a Broadside Fired from the Ship of Admiral de Ruyter* (1846; see *Art-Union*, viii (1846), p. 100), the *Studio of Paul Potter* (1847; see *Art-Union*, ix (1847), p. 20) and the *Studio of van de Velde* (1854; see *A. J.* [London], vi (1854), p. 184). In these the Dutch painters are ironically depicted working in nature, not in their studios. Lepoittevin's primary figures are often at the apex of a pyramid composed of healthy women and children, faithful domestic animals and other elements in spacious, horizontal formats. While some paintings (e.g. *Shipwrecked*, 1839; *Frankish Women*, c. 1842; both Amiens, Mus. Picardie) suggest the violence of the Romantic Sublime, others, such as the *Fisherman's Return* (1848; see *Art-Union*, x (1848), p. 84), are more sentimental. Beraldi divided Lepoittevin's graphic work into categories entitled marines, patriotic souvenirs and, apparently his most popular, *Albums de diableries*. Lepoittevin travelled and sketched in England, the Netherlands, France and Italy; his work attracted a pan-European bourgeois audience interested in well-composed and carefully costumed romances on a human scale, borrowed from wide-ranging sources in history, art history and literature yet rooted in observed nature.

Bibliography

Bénézit; Thieme–Becker

'The Living Artists of Europe, no. ix: Eugène Le Poittevin', *Art-Union*, viii (1846), pp. 100–01

H. Beraldi: *Les Graveurs du XIXe siècle*, ix (Paris, 1889), pp. 145–6

F. von Boetticher: *Malerwerke des neunzehnten Jahrhunderts*, ii (Dresden, 1895/R Leipzig, 1941), pp. 840–41

H. Mireur: *Dictionnaire des ventes d'art*, iv (Paris, 1911), p. 295

J. Robiquet: 'Pages d'albums de la Restauration', *La Renaissance*, xi (1928), pp. 386–8

NANCY DAVENPORT

Lerolle, Henry

(*b* Paris, 3 Oct 1848; *d* Paris, 22 April 1929). French painter and collector. He was initially a pupil of Louis Lamothe (1822–69) in 1864 but never went to the Ecole des Beaux-Arts. Independent in outlook, he began working in the Louvre, where he met Albert Besnard and Jean-Louis Forain, and made copies after Nicolas Poussin, Veronese and Peter Paul Rubens. He attended the Académie Suisse and exhibited at the Salon from 1868. Having briefly been influenced by Henri Regnault, Lerolle painted works that owed much to the scenes of contemporary life by Jules Bastien-Lepage, Henri Gervex, Alfred Roll and Jean Charles Cazin, who introduced the taste for naturalistic observation, bright colouring and *plein-air* painting to the official Salons. *At the Organ* (exh. Salon 1885; New York, Met.) and *At the Water's Edge* (1888; Boston, MA, Mus. F.A.) disseminated in more accessible terms the still controversial innovations of Edouard Manet and the Impressionists. Lerolle's concern for the structure of his compositions, in which the figures were sometimes off-centre, can be seen in his portraits, such as the *Artist's Mother* (exh. Salon 1895; Paris, Mus. d'Orsay), whose spare, austere realism is reminiscent of Henri Fantin-Latour and James Abbott McNeill Whistler.

Lerolle is known above all for his religious paintings: *Jacob in the House of Laban* (exh. Salon, 1879; Nice, Mus. B.-A.) and the *Adoration of the Shepherds* (1889; Carcassonne, Mus. B.-A.). He also executed many mural decorations in Paris, in which he combined allegory with contemporary dress: *Albert the Great* (1889; Sorbonne), *Christ Appearing to St Martin* (1890; St-Martin-des-Champs), the *Crowning of Science* and the *Teaching of Science* (1889; both Hôtel de Ville). He decorated the salon of the composer Ernest Chausson (1855–99) at 22 Boulevard de Courcelles,

Paris, in 18th-century taste, with airy figures and an animated sense of space. Lerolle was a founder-member of the Société Nationale des Beaux-Arts in 1890.

In 1883 Lerolle bought Puvis de Chavannes's *Prodigal Son* (1879; Zurich, Stift. Samml. Bührle) and two pastels by Edgar Degas. A knowledgeable collector, he owned works by Fantin-Latour, Albert Besnard, Jean-Baptiste-Camille Corot and Auguste Renoir. His wife was painted by Fantin-Latour (1882; Cleveland, OH, Mus. A.) and Renoir painted his daughters at the piano (1892; Paris, Mus. Orangerie). Lerolle's salon was attended by painters, poets and musicians, such as his biographer Maurice Denis, Stéphane Mallarmé, Octave Maus, Paul-Louis-Charles-Marie Claudel, André Gide, Claude Debussy, Degas and Renoir. Lerolle was a violinist and a pupil of Edouard Colonne (1838–1910). Through Ernest Chausson, who married his wife's sister, he discovered modern music, becoming an enthusiastic admirer of César Franck (1822–90).

Bibliography

M. Denis: *Henry Lerolle et ses amis* (Paris, 1932)

Le Triomphe des mairies (exh. cat., Paris, Petit Pal., 1986), pp. 316–17

VALÉRIE M. C. BAJOU

Leroux [Le Roux], (Louis) Hector

(*b* Verdun, 27 Dec 1829; *d* Angers, 11 Nov 1900). French painter. He trained and briefly worked as a wig-maker in Verdun while also following a drawing course at the local art college. His success in winning all the art prizes earned him a small bursary to continue his studies in Paris. He entered the Ecole des Beaux-Arts in 1849, working in the studio of François-Edouard Picot and supplementing his income by producing copies of museum works and illustrations. In 1857 he won the Deuxième Prix de Rome and spent the next 17 years based in Rome, travelling from there to the rest of Italy, to Greece, Asia Minor, Turkey and Egypt, with occasional visits to Paris. Soon after arriving in Rome he received a state commission to paint a copy of Titian's *Sacred and Profane Love*

(*c.* 1515; Rome, Gal. Borghese) and also copied works for the Gobelins. His début at the Salon was made in 1863 with *A New Vestal Virgin* (1863; Verdun, Mus. Princerie). From this time he painted almost entirely classical subjects, for example *Roman Ladies at the Tomb of their Ancestors* (New York, Met.). In *Miracle of the Good Goddess* (1869; Ajaccio, Mus. Fesch), he treated a legend featuring a vestal virgin, one of his favourite themes. He occasionally painted biblical or historical subjects, which, as with all his work, were in an undistinguished academic style. His daughter Laura Leroux was also a painter.

Bibliography

R. Ménard: *L'Art en Alsace-Lorraine* (Paris, 1876), pp. 441–3

E. Montrosier: *Les Artistes modernes*, i (Paris, 1881), pp. 105–8

☐

Lévy, Emile

(*b* Paris, 29 Aug 1826; *d* Passy, 4 Aug 1890). French painter, illustrator and pastellist. He was a pupil of Alexandre Abel de Pujol and François-Edouard Picot at the Ecole des Beaux-Arts in Paris and made his début at the Salon of 1848. In 1854 he won the Prix de Rome with *Abraham Washing the Feet of the Angels* (Paris, Ecole N. Sup. B.-A.). In 1855 he sent *Noah Cursing Canaan* (Aurillac, Mus. Parieu) from Rome for exhibition at the Exposition Universelle in Paris, and the work was bought by the French government. He specialized in classical and biblical subjects executed with the soft colouring, linear precision, prettiness and graceful poses of the Neo-classical style. He became particularly famous for his antique pastoral love scenes, such as *The Bowl: Idyll* (Pau, Mus. B.-A.), which were much appreciated by such contemporary critics as Jules Claretie (1840–1913). However, he also depicted moments of violence and drama such as the *Death of Orpheus* (1866; ex-Mus. Luxembourg, Paris) and the *Judgement of Midas* (1870; Montpellier, Mus. Fabre). His Jewish background led him to choose subjects from the Old Testament in such works as *Ruth and Naomi* (1859; Rouen, Mus. B.-A.) and to describe Jewish rituals in such others as the *Feast of Tabernacles as Celebrated by*

a Jewish Family in the Middle Ages. He made a few attempts to treat modern subjects in the manner of Carolus-Duran, depicting fashionable and worldly ladies in low-cut dresses using brilliant and contrasting colours, as in the interior scene *Letter*.

Lévy received a number of commissions for decorative paintings for both public and private buildings in Paris, such as the chapel of the Virgin in the Trinité, the register office of the Mairie of the seventh *arrondissement* and a café in the Boulevard des Capucines. He also produced illustrations for such books of classical literature as *Poésies de l'Anacréon* (1885). The most successful of his illustrations were those etched by Léopold Flameng (1831–1911) for *Longus: Daphnis et Chloé* (1872). He also illustrated an edition of La Fontaine's *Fables* (1880) and made one etching, *Le Masque*, for *Sonnets et eaux-fortes* (n.d.).

Bibliography

Bénézit

G. Vapereau: *Dictionnaire universel des contemporains* (Paris, 1858, 5/1880), p. 1162

J. Claretie: *Peintres et sculpteurs contemporains* (Paris, 1873, 2/1874)

Encyclopaedia Judaica (Berlin, 1928–34), x

ATHENA S. E. LEOUSSI

Lévy, Henri Léopold

(*b* Nancy, 23 Sept 1840; *d* Paris, 30 Dec 1904). French painter. He trained at the Ecole des Beaux-Arts in Paris from 1856, where he studied first under François-Edouard Picot and Alexandre Cabanel, then with Eugène Fromentin. He made his début at the Salon in 1865 with *Hecuba Finding her Son Polydorus by the Sea* (1865; Roubaix, Mus. B.-A.) and continued to exhibit there until the year of his death. His reputation was established with *Jesus in the Tomb* (Reims, Mus. St Denis), exhibited at the 1873 Salon; contemporary critics admired it as a modern treatment of a traditional subject that stayed faithful to biblical accounts.

Lévy's work mostly consists of historical, allegorical or mythological subjects executed in an undistinguished academic style. In 1878 he painted four large canvases depicting scenes from the *Life*

of *St Denis* for the church of St Merri in Paris. These were exhibited at the Exposition Universelle of 1878 in Paris, and he was awarded a first-class medal. His public commissions included the mural the *Crowning of Charlemagne* for the Panthéon in Paris. Amongst other private commissions, he painted ten decorative panels depicting mythological subjects for Adrien Chevallier's house in Paris. He also decorated the ceiling of the Bon Marché department store in Paris with 15 panels, including scenes depicting *Industry, Commerce* and *Mercury*. Some later works, such as *Oedipus Going into Exile* (1892; Paris, Louvre), show the influence of Symbolism. Lévy won medals at the Salons of 1865, 1867 and 1869, and he was decorated with the Légion d'honneur in 1872.

Bibliography

G. Vapereau: *Dictionnaire universel des contemporains* (Paris, 1858, 5/1880)

R. Ménard: *L'Art en Alsace-Lorraine* (Paris, 1876)

G. Desandrouin: 'Dix compositions décoratives de Henri Lévy', *L'Art*, xviii (1907), pp. 115–26

Lhermitte, Léon(-Augustin)

(*b* Mont Saint-Père, Aisne, 31 July 1844; *d* Paris, 27 July 1925). French draughtsman, printmaker, painter and illustrator. He was the only son of a village schoolmaster and his precocious drawing skill won him an annual grant from the state. In 1863 he went to Paris and became a student at the Petite Ecole, where one of his teachers was Horace Lecoq de Boisbaudran, famed for his method of training the visual memory. Jean-Charles Cazin, a fellow pupil, became a lifelong friend and Lhermitte later got to know Alphonse Legros, Henri Fantin-Latour, Jules Dalou and Rodin, who had all studied at the school. In 1864 his charcoal drawing the *Banks of the Marne near Alfort* (untraced) was exhibited at the Salon. By inclination and by training a meticulous draughtsman, he continued to exhibit his drawings at the Salon until 1889.

In 1866 his first oil painting, *Violets in a Glass, Shells, Screen* (untraced), was exhibited at the Salon, and he produced his first etching, for his friend Frédéric Henriet's book *Paysagiste aux champs* (Paris, 1876). He also did illustrations for a book on insects and for furniture-makers and designed boxes for sweets. In 1869 he made his first visit to London, where he met Legros. On his second visit in 1871 Legros recommended him as an illustrator for *Works of Art in the Collections of England Drawn by E. Lièvre* and introduced him to the dealer Durand-Ruel, who agreed to sell several of his drawings. In 1873 Durand-Ruel sent some of Lhermitte's works to the Dudley Gallery for the first of the annual Black and White exhibitions and Lhermitte subsequently became a regular participant. Prints after Lhermitte's works, which were published in the Galerie Durand-Ruel's *Recueil d'estampes gravées à l'eau-forte* (1873), contributed to his growing reputation.

Lhermitte won a third-class medal in the Salon of 1874 for his painting *The Harvest* (Carcassonne, Mus. B.-A.), which was bought by the state. In 1879 Degas noted in a sketchbook his intention to invite Lhermitte to exhibit with the Impressionists, but Lhermitte never participated in any of their shows. *The Tavern* (priv. col., see Le Pelley Fonteny, 1987), exhibited in the Salon of 1881, initiated the monumental series of paintings on the life of the agricultural worker that came closest to justifying van Gogh's admiring appellation 'Millet the Second'. The next in the series, *Harvesters' Payday* (1882; Paris, Mus. d'Orsay; see fig. 46), was bought for the state and became the artist's best-known work. *The Harvest* (1883; St Louis, MO, Washington U., Gal. A.), third in the series, was included with ten charcoal drawings in the Exposition Nationale in 1883. Lhermitte received the Légion d'honneur in 1884 when he exhibited the fourth monumental composition the *Grape Harvest* (New York, Met.), where the shift in emphasis from physical toil to the emotional rapport between a peasant woman and small boy is indicative of the increased sentimentality of his later work.

Lhermitte was commissioned in 1886 to do two large portrait groups to decorate the Sorbonne. The first, *Claude Bernard in his Laboratory at the Collège de France* (Paris, Acad. N. Médec.), was shown in the Salon of 1889. In 1888 André

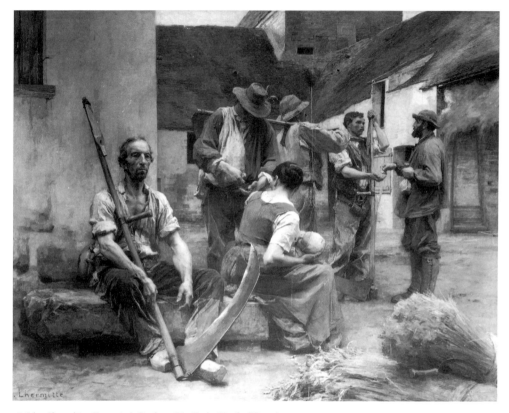

46. Léon Lhermitte: *Harvester's Payday*, 1882 (Paris, Musée d'Orsay)

Theuriet asked him to illustrate *La Vie rustique* (1888), a major commission for which Lhermitte used the many drawings of peasant life he had already executed. Lhermitte was a founder-member of the Société Nationale des Beaux-Arts in 1890. In 1894 he was made an officer of the Légion d'honneur while working on the enormous painting *Les Halles* (4.0×6.3 m; Paris, Petit Pal.), commissioned by the city of Paris to decorate the Hôtel de Ville. This huge, opulent panorama depicting workers at the market dwarfs Ford Madox Brown's *Work* (Manchester, C.A.G.) as an image of labour. Lhermitte was elected to fill Jacques Henner's chair in painting at the Institut in 1905. He continued to exhibit in the first decades of the 20th century, when he was generally seen as a relic of a bygone era, although his style later had an influence on Socialist Realism. Increasingly he worked in pastel, his draughtsman's skill ever in evidence, producing some sensitive portraits and peasant scenes reminiscent of the earlier and more powerful depictions that van Gogh had cited as 'an ideal'.

Bibliography

F. Henriet: *Les Eaux-fortes de Léon Lhermitte* (Paris, 1905)

E. Ménard: *Notice sur la vie et les travaux de L. Lhermitte* (Paris, 1927)

E. Friant: *Discours prononcé à l'occasion de l'inauguration du monument élevé à la mémoire de Léon Lhermitte à Mont Saint Père le 29 juillet 1928* (Paris, 1928)

J. Lhermitte: 'Un Peintre champenois: Léon Lhermitte', *Vie Campagne*, xlvii (1957), p. 26

M. Le Pelley Fonteny: *La Vie domestique dans l'oeuvre de Léon Lhermitte* (Paris, 1971)

——: 'Léon Lhermitte', *A. & Curiosité*, xlv (1973),
 pp. 4–10

M. M. Hamel: *A French Artist: Léon Lhermitte (1844–1925)*
 (diss., St Louis, MO, Washington U., 1974)

Léon Lhermitte (exh. cat. by M. M. Hamel, Oshkosh, WI,
 Paine A. Cent., 1974)

*The Realist Tradition: French Painting and Drawing,
 1830–1900* (exh. cat., ed. G. P. Weisberg; Cleveland, OH,
 Mus. A.; New York, Brooklyn Mus.; St Louis, MO, A.
 Mus.; Glasgow, A.G. & Mus.; 1980), pp. 301–2

M. Le Pelley Fonteny: *Léon-Augustin Lhermitte: Sa vie, son
 oeuvre: Catalogue des peintures, pastels, dessins et
 gravures* (diss., U. Paris IV, 1987)

JAMES P. W. THOMPSON

Luce, Maximilien

(*b* Paris, 13 March 1858; *d* Paris, 7 Feb 1941). French painter and printmaker. He was born and brought up in the working-class surroundings of Montparnasse, and an interest in the daily routines and labours of the *petit peuple* of Paris informs much of his art. After an apprenticeship with the wood-engraver Henri Théophile Hildebrand (*b* 1824), in 1876 he entered the studio of the wood-engraver Eugène Froment where he assisted in the production of engravings for various French and foreign publications such as *L'Illustration* and *The Graphic*. He also sporadically attended classes at the Académie Suisse and in the studio of Carolus-Duran. In Froment's studio he came into contact with the artists Léo Gausson and Emile-Gustave Péduzzi (Cavallo-Péduzzi; 1851–1917) and in their company began painting landscape subjects in and around the town of Lagny-sur-Marne.

At the Salon des Artistes Indépendants in 1887 Luce's *The Toilette* (Geneva, Petit Pal.) caught the attention of Camille Pissarro, the critic Félix Fénéon and Paul Signac, who purchased the painting. *The Toilette*, which depicts a man bent over a wash-basin, is typical of Luce's handling of human subjects with a deliberate but impassive eye and is one of the first paintings in which he attempted to apply separate strokes of pure colour in accordance with the divisionist technique developed by Seurat. Henceforth he exhibited annually with the Neo-Impressionists at the Indépendants, and in 1889 and 1892 by invitation at the Salon des Vingt in Brussels.

Unlike most of the Neo-Impressionists, Luce continued to favour urban subjects throughout his career, depicting the animated bustle of streets in the Quartier Latin, construction workers on the boulevards and sweeping views of the rooftops and chimneys of Montmartre. In his portrayals of the Pont-Neuf at various times of the night and day (e.g. *Pont-Neuf*; Paris, Mus. d'Orsay) the pure colours and flat modelling suggest a familiarity with Japanese prints. Luce travelled widely during the 1890s: to London with Camille Pissarro and Saint-Tropez with Signac in 1892; to Camaret in Brittany in 1893; and repeatedly from 1895 to the Borinage, the coal-mining district of Belgium, where he painted a number of distinguished scenes, for example *Iron Foundry* (1899; Otterlo, Kröller-Müller). He also painted stretches along the Seine west of Paris; his depiction of a bend in the river, the *Seine at Herblay* (1890; Paris, Mus. d'Orsay; see fig. 47), is a prime example of his use of stippled brushwork and high-key colour harmonies. In later years he divided his time between Paris and the riverside village of Rolleboise, painting in an Impressionist manner.

When he was 13 Luce was a witness to the Commune and its harsh suppression in the aftermath of the collapse of the Second Empire, an event that he commemorated years later in *Paris Street in May 1871* (1905; Paris, Mus. d'Orsay). The bland title of this work belies its stark portrayal of corpses beside a barricade. Luce was a staunch advocate of anarchism and occasionally contributed works of art to political fundraising events and to anarchist publications such as Jean Grave's *La Révolte* (later published as *Temps nouveaux*) and *Le Père Peinard*. In a government crackdown following the assassination of President Sadi-Carnot in 1894, Luce was arrested with other suspected agitators including Grave and Fénéon and gaoled at Mazas Prison, from which he was released six weeks later. He documented his experience of prison life in an album of ten lithographs with a text by Jules Vallès entitled *Mazas* (1894).

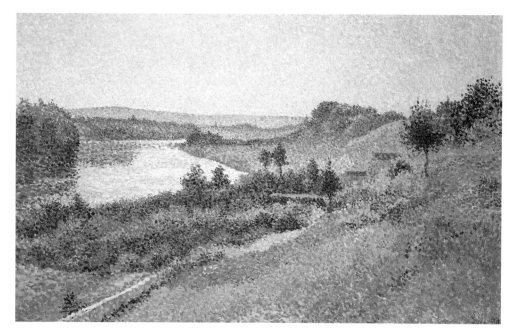

47. Maximilien Luce: *Seine at Herblay*, 1890 (Paris, Musée d'Orsay)

The most extensive collection of Luce's paintings and works on paper belongs to Jean Bouin-Luce, the artist's nephew. There is a large collection of his works at the Musée Maximilien Luce, Mantes-la-Jolie, although it includes few in his divisionist manner.

Bibliography

Exposition Maximilien Luce (exh. cat., intro. F. Fénéon; Paris, Gal. Druet, 1904)

A Tabarant: *Maximilien Luce* (Lyon, 1928)

Centenaire de Maximilien Luce: Peinture du travail et son milieu: Les Néo-Impressionnistes (exh. cat., Saint-Denis, Mus. A. & Hist., 1957)

Maximilien Luce (exh. cat., Charleroi, Pal. B.-A., 1966)

J. Sutter: 'Maximilien Luce', *The Neo-Impressionists* (Greenwich, 1970), pp. 153–64

Maximilien Luce (exh. cat., Albi, Mus. Toulouse-Lautrec, 1977)

P. Cazeau: *Maximilien Luce* (Paris, 1983)

The Aura of Neo-Impressionism: The W. J. Holliday Collection (exh. cat. by E. W. Lee and T. E. Smith, Indianapolis, IN, Mus. A., 1983), pp. 48–54

Maximilien Luce (exh. cat., Paris, Mus. Marmottan, 1983)

J. Bouin-Luce and D. Bazetoux: *Maximilien Luce: Catalogue of the Paintings* (La-Celle-Saint-Cloud, 1986)

Maximilien Luce (exh. cat., Pontoise, Mus. Pissarro, 1987)

PETER J. FLAGG

Maignan, Albert(-Pierre-René)

(*b* Beaumont-sur-Sarthe, 14 Oct 1845; *d* Saint-Prix, 29 Sept 1908). French painter, illustrator and designer. In 1864 he left the Sarthe for Paris to study law. His studies did not prevent him from developing his gift for drawing and painting: he sketched views of Paris, copied works in the Louvre and entered the studio of Jules Noël in 1865. Having gained his law degree in 1866, Maignan was finally able to devote himself to painting. The following year his work was accepted by the Salon des Artistes Français, where he exhibited fairly regularly all his life. In 1869 he entered the studio of Evariste Luminais, keeping company with the group of artists brought together by Eugène Isabey.

Maignan developed ceaselessly, changing the sources of his inspiration and his technique and

varying the range of his palette. His early land-scapes were in the Barbizon style. Like Isabey he was interested in recording historic buildings and in perspective studies of streets. He was also fascinated by archaeological excavations and was an avid collector of classical and medieval antiqui-ties. His early history paintings were influenced by Luminais; he constructed the events of the past with precision and an eye for the picturesque in such works as *Departure of the Norman Fleet* (1874; Nérac, Mus. Château Henri IV) and *Renaud of Burgundy Granting Letters of Enfranchisement to Belfort* (1879; untraced), his first official com-mission for a monumental decorative project. His first visit to Italy in 1875 encouraged him to lighten his palette; in Venice above all he discov-ered the importance of light in the perception of objects and the harmony it bestows on tones. He particularly admired the work of Carpaccio, Giambattista Tiepolo and Michelangelo, which influenced his monumental compositions. Italian settings featured in many of his history paintings. Maignan returned to Italy nine times in order to enrich his style and seek inspiration for his com-positions. His paintings of the 1870s are distin-guished by their generally sorrowful mood, as in such works as *Christ Calling the Suffering to Him* (1877; Paris, Petit Pal.), *Louis IX Consoling a Leper* (1878; Angers, Mus. B.-A.) and *Last Moments of Chlodobert* (1880; Melbourne, N.G. Victoria). For Maignan the lesson of history was essentially a moral one.

In the calm atmosphere of his home at Saint-Prix near Paris, and in the countryside where he walked at the end of each day, Maignan studied the mutability of nature and the vibration of light. As a result his painting became brighter, more luminous and serene, as in *Dante Meets Matilda* (1880; Amiens, Mus. Picardie). There was also a strongly Symbolist strain in much of his later work: the *Voices of the Tocsin* (1881) and the *Birth of the Pearl* (1892; both Amiens, Mus. Picardie). This strain is also evident in *Carpeaux* (1892; Paris, Mus. d'Orsay), which remains his most famous work. In it he accurately depicted the great sculp-tor's work, while also attempting to evoke its essentially dynamic quality. At the same time he meditated on the more general and ancient theme of artistic inspiration, all on a vast scale and with complex lighting effects.

In his many decorative schemes Maignan revealed his gifts for composition, the harmonious rendering of tones and the depiction of move-ment. He painted ceilings and panels: for example in the Salons des Lettres (completed 1893), Hôtel de Ville, Paris, Chambre de Commerce (1896), Saint-Etienne (1896), the Opéra Comique (1898), Paris, the Salle des Fêtes (1900), Exposition Universelle, Paris, and the Buffet in the Gare de Lyon (1900–05), Paris. He produced cartoons for the Gobelins and stained-glass designs. He also illus-trated works by Victor Hugo and Alfred de Musset. Numerous prizes, honours and responsibilities punctuated his career, culminating in a medal of honour at the Salon of 1892 for *Carpeaux*, which was bought by the Musée du Luxembourg.

Bibliography

H. Chantavoine: 'Albert Maignan', *Gaz. B.-A.*, n.s. 4, i (1909), pp. 36–48

D. Mallet: *Maignan et son oeuvre* (Mamers, 1913)

V. Alemany-Dessaint: *Albert Maignan: Artiste, peintre, décorateur* (diss., U. Paris, 1986)

Le Triomphe des mairies (exh. cat., Paris, Petit Pal., 1986), pp. 308–9

VÉRONIQUE ALEMANY-DESSAINT

Maillet, Jacques-Léonard

(*b* Paris, 12 July 1823; *d* Paris, 14 Feb 1895). French sculptor. He studied at a local drawing school in the Faubourg Saint-Antoine, Paris, and then at the Ecole des Beaux-Arts, where he was a pupil of Jean-Jacques Feuchère and James Pradier. In 1847 he won the Prix de Rome. He then spent five years at the Académie de France in Rome, bringing back to Paris the group *Agrippina and Caligula* (marble, 1853; Saint-Germain-en-Laye, Château), his first Salon exhibit. Maillet specialized in decorative sculpture for public buildings and worked on the three great Parisian building projects of the second half of the 19th century, the Louvre, the Opéra and the Hôtel de Ville, as well as on

numerous churches. In these works and such free-standing sculptures as the group *Agrippina Carrying the Ashes of Germanicus* (marble, 1861; Paris, Jard. Tuileries) he demonstrated his adherence to the Neo-classical style. He was also interested in technical developments, occasionally collaborating on mass-produced art objects, and invented a polychroming process.

Bibliography

Lami

LAURE DE MARGERIE

Manet, Edouard

(*b* Paris, 23 Jan 1832; *d* Paris, 30 April 1883). French painter and printmaker. Once classified as an Impressionist, he has subsequently been regarded as a Realist who influenced and was influenced by the Impressionist painters of the 1870s, though he never exhibited with them nor adopted fully their ideas and procedures. His painting is notable for its brilliant *alla prima* painterly technique; in both paintings and prints he introduced a new era of modern, urban subject-matter. In his relatively short career he evolved from an early style marked by dramatic light-dark contrasts and based on Spanish 17th-century painting to high-keyed, freely brushed compositions whose content bordered at times on Symbolism.

1. Life and work

(i) **1832–59.** Manet was the eldest of three sons of Auguste Manet, a distinguished civil servant in the Ministry of Justice, and Eugénie Désirée Fournier, daughter of a diplomatic envoy to the Swedish court. Although he showed talent for drawing and caricature at an early age, his career as an artist began only after his secondary education at the Collège Rollin and two attempts to enter the Naval College, in which he failed even after a training voyage to Rio de Janeiro (1848–9). Encouraged as a schoolboy in his love of art by his maternal uncle Edouard Fournier and by his school-friend Antonin Proust, later to become Minister of Fine Arts, he enrolled, with Proust, in the atelier of Thomas

Couture in September 1850. Among his earliest extant works are copies made in the Louvre after Venetian and Florentine Renaissance Masters and Dutch genre painters. His eclecticism reflected the example of Couture, who also taught the traditional techniques and colour formulae that Manet was later to abandon. During his six years of training with Couture, Manet did not enter the Prix de Rome, preferring to visit museums in Belgium, Holland, Germany, Austria and Italy. In February 1856 he established his own studio, and in 1857 he went again to Florence.

(ii) **1859–65.** By 1860 Manet had moved his studio twice and had set up home with Suzanne Leenhoff, his family's piano teacher, who became his wife in 1863. Manet's earliest independent works such as his portrait of *Mme Brunet* (?1860; New York, priv. col., see Rouart and Wildenstein, no. 31) are dark in tone and are indebted to earlier artists, notably Velázquez, Rubens and Italian Renaissance Masters. His first Salon entry—the *Absinthe Drinker* (1859; Copenhagen, Ny Carlsberg Glyp.)—was refused in 1859, in spite of favourable comment from Delacroix. The *Spanish Singer* (1860; New York, Met.) and his portrait of *M. and Mme Manet* (1860; Paris, Mus. d'Orsay) were accepted in 1861 (the Salon was then biennial), winning an honourable mention and one favourable review. In the same year he also showed work at a private gallery and at the Imperial Academy in St Petersburg. Manet's hopes for early success, inspired by these auspicious beginnings, were soon disappointed.

Manet's art showed marked change and maturation during 1862. The enormous canvas the *Old Musician* (Washington, DC, N.G.A.) still referred to Spanish and other Old Master painting but introduced the subject of marginal city life, while the smaller *Music in the Tuileries Gardens* (1862; London, N.G.) was his first straightforward image of a contemporary urban scene. In such works as *Music in the Tuileries Gardens* and the *Street Singer* (c. 1862; Boston, MA, Mus. F.A.) he identified himself with the dandy in pursuit of the 'heroism of modern life', reflecting his close association with Charles Baudelaire. A number

of pictures were shown in an exhibition at the Galerie Martinet in early 1863, when the first clear signs of unfavourable critical reception emerged.

The three paintings Manet submitted to the Salon of 1863 were refused along with so many other works that the Emperor instituted a 'Salon des refusés', at which the *Déjeuner sur l'herbe* (Paris, Mus. d'Orsay; see col. pl. XXI) was the centre of a critical storm, in part for its challenging subject-matter and in part for its innovative colour and brushwork. Controversy greeted his accepted Salon entries for many years thereafter, reaching its height in the scandal provoked by his *Olympia* (Paris, Mus. d'Orsay; see fig. 48), painted in 1863 but first shown in 1865. In *Déjeuner sur l'herbe* and *Olympia* an element of ironic mockery colours the homage paid to Italian Renaissance art. In poses derived from works by Raphael and Titian, Manet presented on the one hand a foursome of profligate youths picnicking and bathing in compromising circumstances while mimicking idealized river gods of antiquity, and on the other, a heroic but brazen nude figure of a reclining modern courtesan in the pose and setting of Titian's *Venus of Urbino* (1538; Florence, Uffizi). In these, as in several works of 1862 and later, Manet depicted a favoured model, Victorine Meurend. Scholarship has shown these famous compositions to assimilate to Old Master designs the spirit of the popular libertine lithographic and photographic imagery that had become part of the visual culture of mid-19th-century France. By inserting a vulgar modernity into the complex web of references in these paintings, Manet put himself in a theoretical position similar to that of Gustave Courbet, whose work had shocked the French public and critics in the 1850s; but Manet's urban emphasis and a cool, unmodulated paint surface were foreign to Courbet's art.

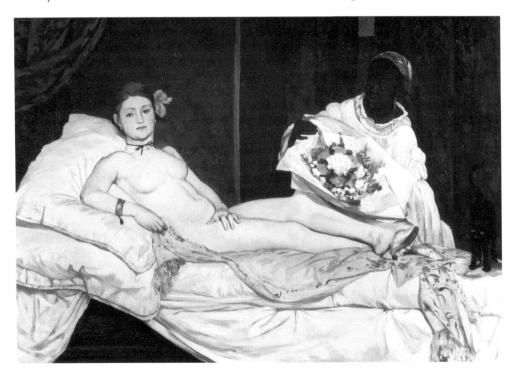

48. Edouard Manet: *Olympia*, 1863 (Paris, Musée d'Orsay)

Acting on his lifelong conviction that the Salon was the place to compete, Manet continued to submit works with varying success: *Episode at a Bull-fight* (?1864–5; fragment, Washington, DC, N.G.A.) and *Dead Christ and Angels* (1864; Washington, DC, N.G.A.) were accepted in 1864, *Jesus Mocked by Soldiers* (1865; Chicago, IL, A. Inst.) in 1865 with *Olympia*. He enjoyed a certain notoriety and was considered the leader of a 'school' that included Edgar Degas and the younger Impressionists whom he saw regularly at the Café Guerbois. In the summer of 1865, following the critical fiasco of *Olympia*, he travelled to Spain where he first saw major works by Goya and Velázquez. Although he had previously painted many pictures with Spanish themes, he was newly inspired by the formal and colouristic features of Spanish painting to produce such paintings as *Matador Saluting* (1866–7; New York, Met.).

Manet played an important part in the revival of original etchings. His career as a printmaker, though it presents problems of chronology, seems to have begun in 1860, with one lithographic caricature and a number of etchings. He showed etchings in 1862 at the print publisher and dealer Cadart's and became a founder-member of the Société des Aquafortistes under whose auspices he issued a portfolio of etchings the same year. This portfolio was reissued with some changes and additions in 1874. Etching was his favoured medium until the late 1860s, after which lithography became more important.

(iii) 1865–70. Emile Zola, writing in *L'Evénement* on the Salon of 1866, launched a spirited defence of Manet, whose *The Fifer* (1866; Paris, Mus. d'Orsay) and the *Tragic Actor* (1865; Washington, DC, N.G.A.) had been rejected by that year's Salon jury. In 1867 he published a fuller biographical and critical study. This support gained Zola the friendship of Manet who painted his portrait in 1868 (Paris, Mus. d'Orsay; see fig. 49). The portrait shows the impact on Manet's art of Japanese woodblock prints, newly available in Paris since the opening of Japan to the West in 1853. A tendency toward flattened space and unmodulated areas of colour,

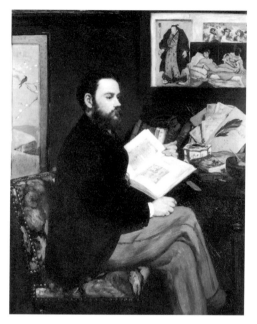

49. Edouard Manet: *Portrait of Emile Zola*, 1868 (Paris, Musée d'Orsay)

already present in such earlier works as *Mlle Victorine in the Costume of an Espada* (1862; New York, Met.), was reinforced, and Japanese artefacts began to appear as accessories. Zola's criticism pointed out these features in Manet's art and argued that he was primarily interested in the act of painting and of representing visual experience rather than in the subject-matter depicted. This approach, intended to defuse hostile reactions to the somewhat shocking subject-matter of *Déjeuner sur l'herbe* and *Olympia*, had the added effect of aligning Manet's art with the prevailing avant-garde theory of Art for Art's Sake.

Not having been invited to participate in the Exposition Universelle of 1867, Manet set up a private exhibition of 50 of his works next to the exposition grounds in a specially constructed pavilion that was ignored by the public and press alike. Manet had, however, published a catalogue with a short, unsigned preface (repr. in Moreau-Nélaton, 1926, i, pp. 86–7), one of the few statements about his art that can be attributed to his

own ideas (it has been presumed that he received help from his literary friends). In it the importance of exhibiting is stressed, and his work is characterized as 'sincere', one of the watchwords of the Realist movement.

In 1867 Manet undertook to paint a vast canvas representing the execution of the Emperor Maximilian, an event that had taken place in Mexico on 19 June of that year. Five versions of this composition exist: a full-scale oil study (Boston, MA, Mus. F.A.), a group of fragments from a dismembered canvas (London, N.G.), a lithograph (see 1977 exh. cat., no. 54), a small definitive sketch (Copenhagen, Ny Carlsberg Glyp.) and the definitive canvas (Mannheim, Ksthalle). Drawing inspiration from Goya's *Third of May 1808* (1814; Madrid, Prado) and contemporary pictorial reportage, Manet created a Realist image devoid of any romantic commentary such as that found in Goya. The charge of lack of interest in his subject is difficult to sustain in this case in view of the time and energy he devoted to it. More persuasive is the proposal that understatement for greater effect (litotes) was his aim (1983 exh. cat., p. 18). Early in 1868 Manet was advised by the administration that his painting of the execution would not be accepted at the next Salon and that authorization to publish the lithograph of it would not be granted. Although Manet defended himself on artistic grounds through notices by journalist friends, it is clear that the subject was calculated to embarrass the imperial regime, an intention that accords with his lifelong Republican sympathies.

In the summer of 1868 Manet met the painter BERTHE MORISOT who was briefly his pupil; she married his brother, Eugène, in 1874, and also modelled for several pictures, including *Resting, Portrait of Berthe Morisot* (1870; Providence, RI, Sch. Des., Mus. A.). The most celebrated of these works, *The Balcony* (1868–9; Paris, Mus. d'Orsay), was accepted at the Salon of 1869, together with *Luncheon in the Studio* (1868; Munich, Neue Pin.). These two pictures were Manet's masterpieces of the late 1860s and display many of his abiding qualities. The most prominent tones were flatly applied and unusual: silky black for Léon Leenhoff's jacket in the *Luncheon* and piercing green for the railings in *The Balcony*. He employed the traditional compositional formulae of earlier art but with minimal spatial recession, creating awkward disjunctions of scale, particularly in the *Luncheon*. Nor do his figures relate in any conventional formal or psychological sense. A mood of enigmatic isolation pervades both the bohemian interior of the *Luncheon* and the more elegant exterior of *The Balcony*.

In 1869 another painter, EVA GONZALÈS, became Manet's student and posed for a portrait (London, N.G.) shown in the Salon of 1870. Although his direct effect on Morisot and Gonzalès was considerable, his influence was far broader, and his position as head of a school was acknowledged by the Café Guerbois group and by contemporary critics.

In 1868 and 1869 Manet and his family had holidays at Boulogne-sur-Mer, where he made a number of marine paintings, ferry departures and beach scenes (e.g. *Folkestone Boat, Boulogne*, 1869; Philadelphia, PA, Mus. A.). His early attraction to the sea is perhaps reflected in his summer sojourns at various maritime resorts between 1868 and 1873, interrupted only by the Franco-Prussian war and civil strife of 1870–71.

(iv) 1870–79. In early 1870 Manet fought a duel with the journalist-critic Louis-Edmond Duranty, whose friend he nevertheless remained, and made common cause with other artists in an attempt to effect changes in the selection of Salon jurors. With the approach of the Prussian Army in September 1870 he sent his family to a resort in the Pyrenees, and joined the National Guard. After the end of the siege of Paris in February 1871, he rejoined his family and remained in the provinces until the days immediately following the 'bloody week' of 21–28 May. A federation of artists under the short-lived Paris Commune had elected him a delegate in his absence, but this organization soon evaporated. Manet's attitude towards the Commune is not documented, but scholarship on the lithographs he made following its bloody events (*Civil War* and *The Barricade*; see 1977 exh. cat., no. 72) suggests that although he did not side actively with the Commune, he did oppose its suppressors (*Art Journal*, 1985, pp. 36–42).

The war of 1870 divided Manet's career into two distinct halves. A number of profound changes in his life and art marked the beginning of the second decade of his professional career. In 1872 he moved his studio to the Rue de Saint-Pétersbourg near the Place de l'Europe, and he and his circle abandoned the Café Guerbois for the Café de la Nouvelle Athènes in the Place Pigalle, then in a newly constructed area of Paris. He travelled in the Netherlands in 1872, renewing his acquaintance with the works of Dutch Masters, especially those of Frans Hals, an experience that is reflected in *Le Bon Bock* (Tyson priv. col., on loan to Philadelphia, PA, Mus. A.); this painting was shown in the Salon of 1873 to unexpected critical acclaim from formerly hostile quarters and equally unexpected adverse criticism from his friends. In 1872 he sold 24 pictures to the dealer Durand-Ruel. He also acquired a new circle of friends who came to his studio, which had become the focus of his social as well as his professional life. At the centre of this circle were Nina de Callias, a somewhat unconventional woman of wealth, generosity and talent, and Stéphane Mallarmé, who replaced Baudelaire, who had died in 1867, in the painter's affections. Among those who frequented their salons were artists, poets, writers, composers and journalists, including Marcellin Desboutin, Verlaine, Leconte de Lisle, Villiers de l'Isle-Adam, Jean Richepin, Henri Rochefort, François Coppée and Anatole France.

In his paintings of the early 1870s, Manet began to adopt a higher-keyed coloration and henceforth dispensed with dark backgrounds, as, for example, in *The Railroad* (Washington, DC, N.G.A.) of 1872–3. Equally new was an extreme freedom and sketchiness of brushwork, as in the portrait of Nina de Callias called *Woman with Fans* (Paris, Mus. d'Orsay) of 1873–4. These new features of Manet's art can be traced to his association with the younger generation of Impressionist painters, who exhibited together for the first time in 1874. (Manet was invited to exhibit but declined.) He spent the summer of 1874 at his family property at Gennevilliers, near Argenteuil, where Claude Monet was at work, and where he also saw Gustave Caillebotte and Auguste Renoir. There he painted

Argenteuil (Tournai, Mus. B.-A.) and *Boating* (New York, Met.), the major works cited as evidence of Impressionist influence on his art, largely because of their subject-matter (boating on the Seine) but also for their high colour values and intensities and their broken brushwork. Manet travelled to Venice in 1875, where he painted in brilliant, quasi-Impressionist style such works as *Grand Canal at Venice* (1875; Shelburne, VT, Mus.).

In the 1870s the Salon juries continued to be ambivalent about accepting Manet's pictures. In 1874 *Argenteuil* was accepted; in 1875 *The Linen* (Merion Station, PA, Barnes Found.) and *The Artist* (1875; São Paulo, Mus. A. Assis Châteaubriand) were refused. The jury of 1877 accepted one picture (*Faure as Hamlet*; Essen, Mus. Folkwang) and refused another (*Nana*; Hamburg, Ksthalle). In 1878 he avoided competing for admission to the Exposition Universelle by exhibiting work publicly in his own studio.

Manet's friendships with writers and poets led him to collaborative ventures in printmaking. In 1869 he had made a lithographic poster, *Cats' Rendezvous*, for Champfleury's book *Les Chats*, and in the early 1870s he made several etchings as illustrations; these collaborations with writers provided the basis for the 20th-century Livre d'artiste. In 1874 a volume of poems by Charles Cros with etched illustrations by Manet appeared. In 1875 he created his masterpiece of this genre, the illustrations for Mallarmé's translation of *The Raven* by Edgar Allan Poe. Many of the prints considered among Manet's most important were not published during his lifetime, and several were never published at all, extant only in a few artist's proofs.

(v) 1879–83. Manet was installed in his last atelier at 77 Rue d'Amsterdam in April 1879. By this time the illness that was to take his life had begun to manifest itself, and he spent annual extended curative sojourns in the country near Paris. During these periods he amused himself by painting small still-lifes and flower-pieces and writing letters decorated with charming watercolours (1983 exh. cat., nos 191–205). In 1881 he received a second-class medal and was thereafter excused from jury

submission. At the end of that year, with his friend Antonin Proust installed as Minister of Fine Arts, Manet was made Chevalier de la Légion d'honneur, a recognition some thought he should have refused.

Contemporary Paris was the subject of his last major painting and his swan-song at the Salon of 1882, a *Bar at the Folies-Bergère* (U. London, Courtauld Inst. Gals.). The figure of the cashier at one of the bars in the largest and most sumptuous place of entertainment in the city presides like a goddess over her domain, depicted in strokes of shattering light and colour. Her centred, frontal figure and her moon-like face with its dreamy expression (seen as sad or weary by some) make of her an urban icon flanked by a still-life of bottles, fruit and flowers. She stands in front of a mirror that reflects the auditorium balcony with its seated spectators, as well as the back of the cashier herself and the patron who faces her on the other side of the counter. The scene is an amalgam of disparate areas in the Folies-Bergère, mediated by the equivocal mirror represented as though parallel to the picture plane and the counter but reflecting the woman and the customer as though at an angle. The liberties Manet took with perspective have been much discussed; it can be concluded that Symbolism won out over Realism; the reflection is necessary to the theme. In popular imagery from 1830 to 1880 *la dame du comptoir* always appears with the still-life of her counter in front of her and her reflection, often displaced, in the mirror behind her. Manet underlined this tradition by exaggerating the reflection's displacement.

By September 1882 Manet's condition had deteriorated enough to prompt him to write his will. On 20 April 1883 his left leg was amputated, and on 30 April he died, probably of tertiary syphilis complicated by gangrene. He was buried on 3 May at the Passy cemetery, his coffin borne by pall-bearers including Proust, Zola and Monet.

Manet's influence on his successors was paradoxically both negligible and enormous. He had few significant imitators, yet he has been universally regarded as the Father of Modernism. With Courbet he was among the first to take serious risks with the public whose favour he sought, the first to make *alla prima* painting the standard technique for oil painting and one of the first to take liberties with Renaissance perspective and to offer 'pure painting' as a source of aesthetic pleasure. He was a pioneer, again with Courbet, in the rejection of humanistic and historical subject-matter, and shared with Degas the establishment of modern urban life as acceptable material for high art. Manet's art, like the contemporary and analogous Realist and Naturalist movements in French literature, occupies a central place within the larger framework of a new modernist culture that was to affect the evolution of these arts in France well into the 20th century.

2. Technique

(i) Painting. Manet was the last great French painter to receive a long and academic training. His technical development, therefore, has particular significance for the evolution of 19th-century art. Once he had graduated from Couture's atelier, he disowned his master's technique as he had disdained while a student the posturing models and the universal insistence on the importance of the nude. He retained for life, however, the use of studio aids and gadgets such as plumb lines and black mirrors and continued throughout his career to outline figures and objects with paint in a kind of brushed drawing derived from Couture's sketching method. His major break with earlier technique was to abandon the practice of covering the canvas with a dark, usually brown, tone upon which the composition was then built up with heavier layers of pigment and translucent glazes. In Manet's mature early style, most passages present a firm, opaque paint layer, and there is little glazing; each colour was selected and applied, from the start, for its final effect (*alla prima* painting). If, after a day's work, he was not satisfied with any completed passage, he scraped it down to the canvas and began again the next day with fresh colours. (Pentiments seen in radiographs represent changes made, sometimes years later, after the original version had dried.)

Manet's adoption of the *alla prima* technique served both practical and expressive purposes and

had far-reaching effects on the art of his younger colleagues. The procedure was useful for completing a passage, or a whole painting, in a day. Manet insisted on having his subject before him while painting, a practice adopted and considerably extended by the Impressionists. Their capturing of moments of light and weather in the permanent medium of oil, often executed out of doors, depended absolutely on *alla prima* technique, as time could not be allotted to the drying of intermediate paint layers. Although there have been revivals of complex Old Master techniques, the methods of Manet and the Impressionists have gradually become the standard practice in oil painting in the 20th century.

Among the idiosyncratic features of Manet's style was his simplification of form by letting one stroke or area of paint of a single colour (a *tache*) stand for a more complex reality. This Tachism, though on a larger scale, stood behind the Impressionists' re-creation of the visible world in small dabs of paint. Another, related feature was his fairly consistent omission of intermediate values between extremes of light and dark, producing dramatic contrasts that are most vivid in his early work. This simplification of the rendering of curved surfaces contributed to the 'flatness' of many three-dimensional forms in his work, for instance the nude in *Déjeuner sur l'herbe* and the figure of *Olympia*. In both, shadow is reduced to a band-like outline. These forms are not, however, composed simply of flat, unified colour. Under raking light one can see that his brush followed the roundness of the form. Broader shadows were brushed in where needed but minimized in the painting's final state, and in the nude of the *Déjeuner* there are slight variations in colour throughout of a sort that Titian or Rubens would have achieved by letting the ground show through. For Manet, each of these passages represented the choice of a colour, mixed and brushed on, making his task more difficult since it was carried out without the traditional formulae of layering. The challenge of rendering a particular optical reality excited Manet and gave to his art a peculiar freshness and novelty disturbing to many in his time. The same method was applied to portraiture, and despite Manet's neutral approach to psychological expression as an indicator of 'character', his portraiture is faithful in a photographic sense to the features of his sitters, whether or not a portrait was intended (and was probably influenced by photography).

Manet was as ready to simplify in composition as in the rendering of surfaces. Several works painted in the 1860s were subsequently reduced by simply cutting up the canvas (e.g. *Surprised Nymph*, 1861; Buenos Aires, Mus. N. B.A.). The *Dead Toreador* (?1864–5; Washington, DC, N.G.A.) as shown in 1864 was part of a much larger composition. Although this work may have been cut down in response to adverse criticism of its perspective, other examples suggest a more positive attempt at simplification. X-radiography has provided insight into Manet's working methods in general and especially in the *Execution of Maximilian*, which was repeatedly revised to achieve a starker, simpler statement (1986 exh. cat., pp. 48–64).

(ii) Drawing. Manet was primarily a painter and did not produce an enormous body of drawings, even though many have surely been lost. The extant drawings are, however, impressive in their own right and are consistent with the paintings in character. A large number of early drawings in pencil or chalk after figures in Old Master paintings reveal a bold, almost aggressive use of outline, drastically simplifying the means of representation in the original, yet maintaining its style and expression. Certain later drawings, heightened with watercolour, that seem to be compositional studies for well-known paintings were probably made after completion of the painting, perhaps with reproductive etching in view. Among a varied sequence of figure studies leading to the great nudes of 1863 is a pencil-and-ink wash drawing of a seated bather (London, priv. col.) that brilliantly displays Manet's early mastery of wash drawing. Many portrait sketches were made in this rapid, summary technique which was later turned to account in illustrative prints. Between 1879 and 1882 he produced a series of pastel portraits of women that fully exploits the fragile delicacy of

the medium, for example *Irma Brunner* (*c.* 1880; Paris, Louvre). Manet's line, whether executed in pencil, pen or wash, is firm, laconic and precise in its representational function, bold and clear in its expression.

(iii) Printmaking. Manet had a thoughtful and sometimes adventurous approach to printmaking. He produced few prints of any kind after 1875. His etchings were chiefly reproductive of his paintings (e.g. *Dead Christ and Angels*, *c.* 1866–7; see 1977 exh. cat., no. 51), whereas many of the lithographs were on topical and independent, often popular, subjects. His earliest etchings were influenced by the conservative style of Alphonse Legros, who taught him the technique. He achieved mastery of the medium between 1860 and 1862, the year in which the portfolio was published by Cadart. Manet incorporated aquatint and other etched tones, and drypoint, into his copperplate repertory, and he relied heavily on the advice and help of colleagues in the biting and printing of his plates. He pursued tonal effects, through both hatched line and aquatint, particularly in the rendering of paintings, a practice at variance with the 'pure etching' ideals of the Société des Aquafortistes. He was much influenced by the etchings of Goya, especially in his use of aquatint (*Au Prado*, *Fleur exotique*). Since many of his later etchings were made for publication in books, they are much smaller than the imposing early portfolio etchings. He used photographs to reduce and reverse paintings for reproduction in prints, for example *Jeanne–Spring* (1882; see 1977 exh. cat., no. 107).

Manet was slower to take up lithography. He seems to have composed *The Balloon* (1862; see 1977 exh. cat., no. 28) directly on to a stone offered him by Cadart. The result was never published, deviating so markedly from the stylistic norms of commercial lithography in its very freely sketched manner that the printer refused to make more than trial proofs. While several crayon lithographs were executed in a more conservative style, *The Races* (1865–72; Cambridge, MA, Fogg) stands out as Manet's most exuberant and striking work in this medium. Exploiting the broad characteristics

of the lithographic crayon throughout, his free, energetic line became in one area a scribble that some have interpreted as a precocious modernism, others an expression of frustration over a failed composition. The stone was probably not printed in his lifetime and impressions are extremely rare. He made sheet music cover illustrations for the music and lyrics of friends in the manner of commercial lithographers and treated the tragic events of 1871 in a broad manner related to that of *The Races* in, for example, *The Barricade* (1871; see 1977 exh. cat., no. 72). The seven-colour lithograph *Polichinelle* (see 1977 exh. cat., no. 90) of 1874 was probably heavily dependent on the help of printers in making the colour separations and therefore comparatively timid in technique.

In 1874–6 Manet turned from the familiar commercial crayon medium to a transfer process for a group of prints culminating in his illustrations for *The Raven* (pubd 1875). In this technique, derived from transfer lithography, he was able to exploit his mastery of wash drawing in rapid, evocative sketches on transfer paper subsequently transferred to zinc plates which were etched and printed probably in the relief process of gillotage (1985 exh. cat., p. 115). It is characteristic of Manet's boldness and his openness to new ideas that he should have approached this project using a technique probably untried for such a purpose.

Spontaneity, directness and simplicity were Manet's aim. He bent every technique to these expressive purposes and in doing so created an art that is unique and consistent in producing an effect of immediacy and freshness.

3. Character and personality

Manet was a well brought up and financially independent member of the old bourgeoisie. Though educated according to the conventions of his class, he retained little interest in reading and wrote almost nothing but letters His mode of life was discreetly bohemian: he lived with Suzanne Leenhoff for years before their marriage but did not disclose the arrangement even to his most intimate friends. He cut the public figure of a dandy. It is reported by Proust that, although he affected

the drawling speech and slouching gait of a Parisian urchin, he never succeeded in looking anything but aristocratic. Blond, blue-eyed and of sunny disposition, he was a witty conversationalist and had charismatic allure for men and women alike. An impressionable youth at the time of the Revolution of 1848, he retained Republican sympathies throughout his life, associating with political liberals and radicals but apparently engaging in no political activities other than occasionally creating works of art that could be seen as offensive to the regime of Napoleon III and the conservative early Third Republic. His association with other men of talent included not only Degas and the Impressionist circle, as well as Henri Fantin-Latour (who had painted his portrait in 1867), but a number of major literary figures, including Baudelaire, Théodore de Banville, Zola and Mallarmé. He was a gregarious man who adored society and maintained a salon in his own studio that included radical friends and demi-mondaines.

Manet's personality had a darker side, reflected in his frequent discouragement over his failure to win success and acclaim at the Salon, in his duel with Duranty and in a serious nervous depression in 1871. Occasional pictures express this side of his psyche, such as *The Suicide* of 1881 (ex-Hatvany Col., Budapest), painted at a time when a friend lay gravely ill and Manet himself was already in the grip of his final illness. However, by far the majority of his pictures and the accounts of his friends reveal a temperament basically happy and at ease with the world, even in his last years when physical disability made standing at his easel difficult. It was during this period that he painted the *Bar at the Folies-Bergère*, a work epitomizing the pleasure he took in the life around him, in the image of woman and in the sheer act of looking.

4. Critical reception and posthumous reputation

Manet was one of many avant-garde 19th-century painters who endured vilification and sarcasm for the novelty of their work. He nevertheless found a few sympathetic critics. The most articulate of these was Zola, who championed Manet's early work and, despite later quarrelling with him, wrote the introduction to Manet's memorial

exhibition catalogue in 1884. Mallarmé wrote a profound appreciation of Manet in 1876 that acknowledged his historic connection with Impressionist painting and his engagement with the contemporary world. In contrast with the rich and poetic art of past ages, he praised Manet for his sincerity and simplicity.

By the time of his death, Manet had gained a grudging reputation as an important and influential innovator but had found few understanding defenders. His reputation has risen steeply, and the body of historical and critical writing on his career is extensive. Several of his close friends produced monographic witness accounts of his life: Edmond Bazire, his first biographer; Antonin Proust, his friend since school days; and Théodore Duret, the critic, who compiled the first oeuvre catalogue. Manet benefited from the rise in the reputation of Impressionism, but it was only in the 20th century that independent studies of his life and work were produced. German scholars were the first to treat Manet's art in its historical context (H. von Tschudi, 1902; J. Meier-Graefe, 1912); Etienne Moreau-Nélaton provided the first detailed documentation of his career (1926).

By the 1920s, with formalist criticism dominant, Manet's art was appreciated primarily as 'pure painting'. This critical view continued well into the post-World War II era but was challenged at the time of the centenary exhibition in Paris of 1932. Left-wing intellectuals saw Manet's apparent lack of interest in subject-matter not as a virtue but as a sign of the bourgeois formalism rejected by Marxist aesthetics. A variation on this view was revived in the 1980s by T. J. Clark.

In 1954 a book by the Swedish artist-critic Nils Gösta Sandblad gave Manet studies a new direction. Concentrating on subject-matter and social context as much as on form, Sandblad anticipated the trend in the 1960s and 1970s, seen especially in American art history and criticism, towards the iconographic study of modern art. Writings by Reff, Fried, Hanson, Farwell and others in America, and Hofmann in Germany, have added to Manet's reputation for formal artistry an equal reputation for social engagement and profound awareness of tradition. Research in the 1980s based on

X-radiography has sought to establish Manet's working procedures with greater precision. The literature on Manet has from the beginning been marked by wide differences of interpretation that may in part be traced to the protean and enigmatic quality of his creative genius.

Writings

Tableaux de M. Edouard Manet (exh. cat., Paris, 1867)

Bibliography

catalogues raisonnés

E. Moreau-Nélaton: *Manet: Graveur et lithographe* (Paris, 1906)

L. Rosenthal: *Manet: Aquafortiste et lithographe* (Paris, 1925)

A. Tabarant: *Manet: Histoire catalographique* (Paris, 1931)

P. Jamot, G. Wildenstein and M. L. Bataille: *Manet*, 2 vols (Paris, 1932)

M. Guérin: *L'Oeuvre gravé de Manet* (Paris, 1944/R Amsterdam and New York, 1969)

S. Orienti: *L'opera pittorica di Edouard Manet* (Milan, 1967; Fr. trans., intro. D. Rouart, Paris, 1967; Eng. trans., intro. P. Pool, New York, 1967)

A. de Leiris: *The Drawings of Edouard Manet* (Berkeley, 1969)

J. C. Harris: *Edouard Manet: Graphic Works, a Definitive Catalogue Raisonné* (New York, 1970)

D. Rouart and D. Wildenstein: *Edouard Manet: Catalogue Raisonné*, 2 vols (Geneva, 1975)

J. Wilson: *Edouard Manet: L'Oeuvre gravé, chef-d'oeuvre du Département des estampes de la Bibliothèque Nationale, Paris* (Ingelheim-am-Rhein, 1977)

monographs

E. Zola: *Ed. Manet: Etude biographique et critique* (Paris, 1867)

E. Bazire: *Manet* (Paris, 1884)

T. Duret: *Histoire d'Edouard Manet et de son oeuvre* (Paris, 1902, 3/1919 with suppl., 4/1926)

H. von Tschudi: *Edouard Manet* (Berlin, 1902)

J. Laran and G. Le Bas: *Manet* (Paris, [1910])

J. Meier-Graefe: *Edouard Manet* (Munich, 1912)

A. Proust: *Edouard Manet: Souvenirs* (Paris, 1913)

E. Waldmann: *Edouard Manet: Sein Leben und sein Kunst* (Berlin, 1923)

J. E. Blanche: *Manet* (Paris, 1924; Eng. trans., London, 1925)

E. Moreau-Nélaton: *Manet raconté par lui-même*, 2 vols (Paris, 1926)

R. Rey: *Manet* (Paris, 1938; Eng. trans., New York, 1938)

G. Jedlicka: *Edouard Manet* (Zurich, 1941)

P. Courthion and P. Cailler: *Manet raconté par lui-même et par ses amis*, 2 vols (Geneva, 1945, 2/Lausanne, 1953; Eng. trans., New York, 1960)

M. Florisoone: *Manet* (Monaco, 1947)

A. Tabarant: *Manet et ses oeuvres* (Paris, 1947)

G. H. Hamilton: *Manet and his Critics* (New Haven, 1954/R New York, 1969)

N. G. Sandblad: *Manet: Three Studies in Artistic Conception* (Lund, 1954)

G. Bataille: *Manet* (Lausanne, 1955; Eng. trans., New York, 1983)

J. Richardson: *Edouard Manet: Paintings and Drawings* (London, 1958/R 1982)

H. Perruchot: *La Vie de Manet* (Paris, 1959; Eng. trans., New York, 1962)

P. Courthion: *Edouard Manet* (Paris, 1961; Eng. trans., New York, 1962)

G. Hopp: *Edouard Manet: Farbe und Bildgestalt* (Berlin, 1968)

W. Hofmann: *Nana: Mythos und Wirklichkeit* (Cologne, 1973)

G. Mauner: *Manet, peintre-philosophe: A Study of the Painter's Themes* (University Park, PA, 1975)

T. Reff: *Manet: Olympia* (New York, 1976)

A. C. Hanson: *Manet and the Modern Tradition* (New Haven, 1977)

J. Wilson: *Dessins, aquarelles, eaux-fortes, lithographies, correspondance* (Paris, 1978)

B. Farwell: *Manet and the Nude* (New York, 1981)

N. Ross: *Manet's 'Bar at the Folies-Bergère' and the Myths of Popular Illustration* (Ann Arbor, 1982)

T. J. Clark: *The Painting of Modern Life: Paris in the Art of Manet and his Followers* (New York, 1985)

W. Hofmann: *Edouard Manet: Das Frühstück im Atelier* (Frankfurt am Main, 1985)

K. Adler: *Manet* (Oxford, 1986)

H. Rand: *Manet's Contemplation at the Gare Saint-Lazare* (Berkeley, 1987)

exhibition catalogues

Exposition des oeuvres de Edouard Manet (exh. cat., preface E. Zola; Paris, Ecole N. Sup. B.-A., 1884)

Manet and the Post-Impressionists (exh. cat., London, Grafton Gals, 1910)

Manet (exh. cat., preface P. Valéry; Paris, Mus. Orangerie, 1932)

Edouard Manet, 1832–1883 (exh. cat. by A. C. Hanson, Philadelphia, PA, Mus. A., 1966)

Manet and Spain: Prints and Drawings (exh. cat. by
 J. Isaacson, Ann Arbor, U. MI, Mus. A., 1969)
Edouard Manet: Das graphische Werk (exh. cat. by J.
 Wilson, Ingelheim, Int. Tage, 1977)
*Manet: Dessins, aquarelles, eaux-fortes, lithographies,
 correspondance* (exh. cat. by J. Wilson, Paris, Gal.
 Huguette Berès, 1978)
Edouard Manet and the Execution of Maximilian (exh.
 cat., Providence, RI, Brown U., Bell Gal., 1981)
Manet and Modern Paris (exh. cat. by T. Reff, Washington,
 DC, N.G.A., 1982)
Edouard Manet, 1832–1883 (exh. cat. by F. Cachin, C.
 Moffett and J. Wilson Bareau, Paris, Grand Pal.; New
 York, Met.; 1983)
The Prints of Edouard Manet (exh. cat. by J. M. Fisher,
 Washington, DC, Int. Exh. Found., 1985)
The Hidden Face of Manet (exh. cat. by J. Wilson Bareau,
 U. London, Courtauld Inst. Gals, 1986) [pubd as suppl.,
 Burl. Mag., cxxviii (1986)]
Manet (exh. cat. by M. Wivel, Copenhagen,
 Ordrupgaardsaml., 1989)
*Manet: The Execution of Maximilian: Painting, Politics
 and Censorship* (exh. cat. by J. Wilson-Bareau, London,
 N.G., 1992)
Manet: The Execution of Maximilian (exh. cat., ed. J.
 Wilson-Bareau; London, N.G., 1992)

specialist studies

S. Mallarmé: 'The Impressionists and Edouard Manet', *A.
 Mthly*, i (1876), pp. 117–21; Fr. trans., *Gaz. B.-A.*, n. s. 6,
 lxxxvi (1975), pp. 147–56
Amour A. (May 1932) [issue ded. Manet; essays by P. Jamot,
 R. Huyghe and G. Bazin]
M. Fried: 'Manet's Sources: Aspects of his Art, 1859–1865',
 Artforum (March 1969) [whole issue]
J. Clay: 'Fards, onguents, pollens', *Bonjour Monsieur
 Manet* (exh. cat., Paris, Pompidou, 1983), pp. 6–24
D. Druick and P. Zegers: 'Manet's "Balloon": French
 Diversions, the Fête de l'Empereur 1862', *Prt Colr
 Newslett.* (May–June 1983), pp. 37–46
A. J. [New York], xlv (Spring 1985) [issue ded. Manet]

BEATRICE FARWELL

Marcello [Adèle d'Affry; Duchessa da Castiglione Colonna]

(*b* Fribourg, 6 July 1836; *d* Castellammare, Italy, 14 July 1879). Swiss sculptor and painter. While studying sculpture in Rome under Heinrich Max Imhof, she married in 1856 Carlo, Duca da Castiglione Colonna, who died of typhoid the same year. Her meeting with Auguste Clesinger and Jean-Baptiste Carpeaux in Rome in 1861 reaffirmed her artistic vocation. She had already fallen under the spell of Michelangelo, feeling the significance of the name she shared with his paragon, Vittoria Colonna. In Paris she figured prominently at the court of Napoleon III in the 1860s and presented at the Exposition Universelle of 1867 a group of eight works, some of which had been shown in the preceding years at the Paris Salon and the Royal Academy in London. The works shown included a full-length statue of *Hecate* (marble, 1866; Montpellier, Esplanade de Celleneuve), an imperial commission. The bulk of her exhibit, however, consisted of historical and poetic busts, some of them pastiches of Renaissance and Rococo styles, such as *Bianca Capello* (marble version, 1872; Fontainebleau, Château), or *Marie-Antoinette at Versailles* (plaster, 1866; marble version, after 1879; Fribourg, Mus. A. & Hist.). A number of portraits of contemporaries, busts and statuettes form part of her bequest to her native town. Her most successful full-length figure, the bronze *Pythian Sibyl* (1867–70), placed in the Paris Opéra in 1875, represents its subject writhing in the throes of inspiration. She also executed drawings, pastels and paintings, including some fancy pieces in an 18th-century style (e.g. *Woman with a Pitcher*, 1873; Fribourg, Mus. A. & Hist.).

Bibliography

H. Bessis: *Marcello sculpteur* (Fribourg, 1980)
La Sculpture française au XIXe siècle (exh. cat., ed. A.
 Pingeot; Paris, Grand Pal., 1986)

PHILIP WARD-JACKSON

Martial Potémont, Adolphe(-Théodore-Jules)

(*b* Paris, 10 Feb 1828; *d* Paris, 14 Oct 1883). French printmaker and painter. He studied under Léon Cogniet and Félix Brissot de Warville (1818–92). His earliest known work is a series of 300 etchings of Paris, *Ancien Paris* (Paris, 1862–6). He then produced several series of prints depicting various

contemporary aspects of the city, such as *Paris sous la Commune, Paris incendié, Les Femmes de Paris pendant le siège* and *Paris pendant le siège* (all Paris, 1871). His best works, however, are the delightful *Notes et lettres manuscrites* (Paris, 1867) and *L'Exposition universelle* (Paris, 1878), which describe the 1867 and 1878 exhibitions and are illustrated with his own lively drawings. In 1873 his book on etching, *Nouveau traité de la gravure à l'eau-forte pour les peintres et les dessinateurs*, was published in Paris. Among his few surviving paintings is the *Vue générale de la Ville de Paris* (Paris, Carnavalet).

Bibliography

J. G. Grand-Carteret: *Les Moeurs et la caricature en France* (Paris, 1888)

F. L. Leipnik: *History of French Etching* (London, 1924)

ETRENNE LYMBERY

Maufra, Maxime(-Camille-Louis)

(*b* Nantes, 17 May 1861; *d* Poncé, Sarthe, 23 May 1918). French painter and printmaker. He began painting under the guidance of local painters in Nantes such as the brothers Charles Leduc (*b* 1831) and Alfred Leduc (*c.* 1850–1913) and the landscape painter Charles Le Roux (1841–95). Having originally intended to go into business, he turned to painting after a visit in 1883 to Britain, where he first saw the work of Turner. He exhibited for the first time in 1886 at Nantes and in the Paris Salon with critical approval. He travelled throughout Brittany and met Gauguin at Pont-Aven in 1890. Maufra settled in Paris in 1892 at the Bateau-Lavoir but returned to Brittany each year, in particular to the Quiberon region. In 1894 Le Barc de Boutteville mounted an exhibition of his work which revealed his individual talents to a wider public. He subsequently exhibited with Durand-Ruel, to whom he remained under contract for the rest of his life. His art was enriched by his travels in the Dauphiné (1904), the Midi (1912), Algeria (1913) and Savoy (1914), and also by his exploration of etching and lithography.

Maufra painted primarily landscapes and marine views. He was influenced initially by Impressionism, although he completely rejected the Impressionists' investigation of instantaneous sensations. For some time he was affected by meeting the artists of the Pont-Aven school, and he retained a pronounced liking for synthesis, strong colour and powerful drawing. These qualities are most strikingly evident in his prints and drawings. Maufra remained an independent and intuitive painter wedded to recording the truths of nature.

Bibliography

V. E. Michelet: *Maufra: Peintre et graveur* (Paris, 1908)

A. Alexandre: *Maxime Maufra: Peintre marin et rustique* (Paris, 1926)

D. Morane: *Maufra: Catalogue de l'oeuvre gravé* (Pont-Aven, 1986)

P. Ramade: *Maufra Maufra* (Douarnenez, 1988)

PATRICK RAMADE

Maurin, Charles

(*b* Le Puy, 1 April 1856; *d* Grasse, 22 July 1913). French painter and printmaker. In 1875 he won the Prix Crozatier, which enabled him to study in Paris, at the Ecole des Beaux-Arts under Jules Lefebvre in 1876–9 and also at the Académie Julian, where he later taught. He exhibited at the Salon des Artistes Français, becoming a member in 1883. Among his paintings are the *Prelude to Lohengrin* and *Maternity* (both Le Puy, Mus. Crozatier). Inspired by the work of Japanese artists and the growing popularity of the 18th-century print, he was one of a small group of artists who experimented with colour plates and in 1891 he patented a new technique of colour printing. His best works are his lightly washed grey and pink etchings of nudes, such as *After the Bath*, *The Model* and *Child with a Pink Ribbon*, which show a high standard of drawing and modelling. He also produced wood-engravings, for instance *Head of a Young Girl in a Landscape* (1890; see 1980 exh. cat., p. 17), and others set in low-life cafés and music-halls.

Bibliography

F. L. Leipnik: *History of French Etching* (London, 1924)

Charles Maurin, 1856–1914 (exh. cat., Le Puy, Mus. Crozatier, 1978)

Post-impressionist Graphics: Original Prints by French Artists, 1880–1903 (exh. cat., ACGB, 1980)

ETRENNE LYMBERY

Meissonier, (Jean-Louis-)Ernest

(*b* Lyon, 21 Feb 1815; *d* Paris, 31 Jan 1891). French painter, sculptor and illustrator. Although he was briefly a student of Jules Potier (1796–1865) and Léon Cogniet, Meissonier was mainly self-taught and gained experience by designing wood-engravings for book illustrations. These included Léon Curmer's celebrated edition of J.-H. Bernardin de Saint-Pierre's *Paul et Virginie* (Paris, 1838), the series *Les Français peints par eux-mêmes* (Paris, 1840–42) and Louis de Chevigné's *Les Contes rémois* (Paris, 1858). Such images, typically measuring 60×90 mm and composed of still-life motifs (books or drapery cascading from a chest, intricately arranged and exhaustively detailed), helped form the style for which Meissonier became famous as a painter.

Meissonier's first painting was the *Flemish Burghers* (190×250 mm, 1834; London, Wallace), exhibited at the Salon of 1834; thereafter he specialized in very small-scale genre scenes featuring costumes and accessories exquisitely rendered with meticulous detail. He was inspired in part by the work of Dutch and Flemish masters such as Gabriel Metsu and Gerard ter Borch and French painters and engravers such as Chardin, Gravelot and Greuze, as well as by contemporary romantic theatre and costume design. His subjects include tranquil 17th- and 18th-century artists and musicians (e.g. *Painter Showing his Drawings*, *c*. 1850; London, Wallace), gentlemen reading, playing chess and smoking (e.g. *Young Man Writing*, 1852; Paris, Louvre; and *Smoker in Black*, 1854; London, N.G.) and rowdy cavaliers (e.g. *A Guardroom*, 1857; London, Wallace; and *Jovial Trooper*, 1865; Baltimore, MD, Walters A.G.). Even the artist's eye-witness view of a demolished barricade and its fallen defenders (*Remembrance of Civil War*, 290×220 mm, 1848; Paris, Louvre) reflects his habit of making a close study of stationary objects and then combining details into more elaborate, but still diminutive compositions. For simpler works

Meissonier often began work directly on a small panel or page, expanding the support if he required more space.

Meissonier also developed a range of military subjects in his paintings. Although he depicted the reigning emperor in *Napoleon III at the Battle of Solférino* (1863; Paris, Louvre), he otherwise devoted himself to re-creating the past, chiefly of the Revolutionary and Empire periods. He executed both small panels of individual guards and cavalrymen and more elaborate canvases, such as *Information: Gen. Desaix and the Peasant* (1867; Dallas, TX, Mus. A.) and *Moreau and Dessoles before Hohenlinden* (1876; Dublin, N.G.). His most ambitious project was a series of moments in Napoleon I's military career, including *1814, the Campaign of France* (1864; Paris, Louvre; see col. pl. XXII), *1807, Friedland* (1875; New York, Met.) and *1805, the Cuirassiers before the Battle* (1876; Chantilly, Mus. Condé). Though some are on a larger scale with more, active figures, these paintings are still distinguished by painstaking research, close work from the model and virtuoso attention to detail.

Extending his ambition to be a history painter and impelled by his own experiences, Meissonier sketched an allegorical response to the Franco-Prussian War (*Siege of Paris, 1870–1871*, begun 1870; Paris, Louvre) and in 1874 obtained a commission (never realized) for a mural in the Pantheon. In 1871 he painted his more monumental *Ruins of the Tuileries* (1.36×0.96 m; Compiègne, Château), fusing personal observation and objective description with larger meaning conveyed in the details. Above a pile of rubble the shell of the great Palace, burnt during the Commune, frames the distant sculpture of *Peace* on top of Napoleon I's Arc de Triomphe at the Carrousel; with her back turned, she seems to depart from a France recently defeated by the Prussians and then ravaged by civil war. Yet a Latin inscription affirms that the glory of the past survives the flames, and still intact are architectural reliefs commemorating Napoleon's victories at Marengo and Austerlitz.

By 1862, perhaps as early as 1848, Meissonier began to construct sculptures of figures and

especially horses. Modelled of wax over an internal skeleton, with cloth, leather and metal for clothing and harnesses, these works served largely as an aid in composing paintings involving more figures or varied movement. Only after Meissonier's death were the sculptures exhibited and two groups of the waxes cast in bronze multiples. These include *Napoleon I in 1814* (wax, 1862; France, priv. col.; Siot-Decauville bronzes, 1894; Shreveport, LA, Norton A.G., and Bordeaux, Mus. B.-A.) done for *1814, the Campaign of France*; *Wounded Horse* (wax, c. 1881–4; Lyon, Mus. B.-A.; bronzes, c. 1893–5; Bayonne, Mus. Bonnat, Dijon, Mus. B.-A. and Grenoble, Mus. Peint. & Sculp.) for the *Siege of Paris*; and *The Voyager* (wax, 1878; Paris, Mus. d'Orsay; Siot-Decauville bronzes, 1894; Lille, Mus. B.-A., and Washington, DC, Hirshhorn) used for several paintings.

From 1840 Meissonier's paintings prompted effusive reviews by critics such as Théophile Gautier, who stressed their affinity with 17th-century Dutch and Flemish masters and exclaimed at the 'microscopic' perfection of the artist's 'Lilliputian' gallery. The disproportionate expense of these diminutive panels became well known, with members of the financial and social élites of the July Monarchy (1830–48) and Second Empire (1852–70) vying for works, both directly from the artist and at resales by auction. Early collectors include members of the Rothschild and Pereire families; Richard Seymour-Conway, 4th Marquis of Hertford, and his son Sir Richard Wallace; Auguste, Duc de Morny; and Napoleon III, who presented *The Brawl* (London, Buckingham Pal., Royal Col.) to Prince Albert at the 1855 Exposition Universelle in Paris. In the 1870s and 1880s Meissonier's work (represented by the fashionable dealer Georges Petit) was sought out by wealthy Americans such as A. T. Stewart, William Vanderbilt and William T. Walters, who were travelling in Europe.

For such authors as Charles Baudelaire, Honoré de Balzac, the de Goncourts and Emile Zola, who wrote both exhibition criticism and fiction, Meissonier's paintings epitomized the taste of the *nouveaux-riches*. His success after the 1850s increasingly made him a target for critics and younger artists in the Realist tradition, among them Degas, Manet and Toulouse-Lautrec; attitudes hardened when Meissonier led the jury to exclude Courbet from the Salon of 1872 because of his political activities during the Commune of 1871. Meissonier gradually withdrew from the public forum of the Salon, preferring to exhibit at less frequent and more selective international exhibitions for which he often served as juror. In the 1880s, he also exhibited in shows organized by dealers and small clubs of amateurs. In 1890 he came back into public life, leading a secession from the established salon of the Société des Artistes Français (then identified with Bouguereau) and, with Puvis de Chavannes, founding the more innovative Société Nationale des Beaux-Arts.

Meissonier was much honoured during his lifetime: he was elected to the Académie des Beaux-Arts (1861), of which he was President twice (1876 and 1891), President of the jury of the Exposition Universelle Internationale in Paris (1889) and the first artist to receive the Grand-croix in the Légion d'honneur (1889). He had only a few pupils, notably his son Charles Meissonier (1844–1917) and the military painter Edouard Detaille, but his success encouraged many derivative artists to specialize in historical genre pieces. Two years after his death his studio was sold, and his reputation declined rapidly, but since the 1970s there has been renewed appreciation of his historical importance.

Bibliography

V. C. O. Gréard: *Meissonier: Ses souvenirs — ses entretiens* (Paris, 1897)

L. Bénédite: *Meissonier* (Paris, 1910)

C. Hungerford: *The Art of Jean-Louis-Ernest Meissonier: A Study of the Critical Years 1834 to 1855* (diss., U. CA, 1976)

——: 'Meissonier's *Souvenir de Guerre Civile*', A. Bull. [New York], lxi (1979), pp. 277–88

P. Guilloux: *Meissonier: Trois siècles d'histoire* (Paris, 1980)

C. Hungerford: 'Meissonier's First Military Paintings: The *Emperor Napoleon III at the Battle of Solférino* and *1814, The Campaign of France*', A. Mag., liv (1980), pp. 89–107

A. Le Normand-Romain: '*Le Voyageur* de Meissonier', Rev. Louvre, xxxv (1985), pp. 129–35

CONSTANCE CAIN HUNGERFORD

Mène, Pierre-Jules

(*b* Paris, 25 March 1810; *d* Paris, 21 May 1879). French sculptor. Having learnt to cast and chase bronze from his father, who was a metal-turner, he began his career by executing models for porcelain manufacturers and making small-scale sculptures for the commercial market. He received his first professional lessons from the sculptor René Compaire and augmented these with anatomical studies and life drawings of animals in the Jardin des Plantes, Paris. From 1838 he regularly exhibited animal sculptures at the Salon. His statuettes and groups, such as *Flemish Cow and her Calf* (wax, 1845; Paris, Mus. d'Orsay), depicted the animal world with great physical precision. He even made sculptures of horses, such as *Ibrahim, an Arab Horse Brought from Egypt* (exh. Salon 1843), *Djinn, Barb Stallion* (exh. Salon 1849) and the *Winner of the Derby* (exh. Salon 1863). Mène was distinguished from other animal sculptors by his well-developed sense of business. He established his own foundry, where he formed a partnership with his son-in-law Auguste-Nicolas Cain, also an animal sculptor; they published a catalogue of their works, which could be ordered directly from the studio. The wide dissemination of reproductions of Mène's works ensured his popularity in France and abroad, especially in England.

Bibliography

Lami

J. Cooper: *Nineteenth-century Romantic Bronzes: French, English and American Bronzes, 1830–1915* (London, 1975)

LAURE DE MARGERIE

Mercié, (Marius-Jean-)Antonin [Antoine]

(*b* Toulouse, 30 Oct 1845; *d* Paris, 13 Dec 1916). French sculptor and painter. Principally a sculptor, he studied at the Ecole des Beaux-Arts in Paris under François Jouffroy and Alexandre Falguière. In 1868 he won the Prix de Rome with the marble statue *Theseus, Vanquisher of the Minotaur* (Paris, Ecole N. Sup. B.-A.) and completed his studies at the Académie de France in Rome. There he was awarded a first-class medal and the cross of the Légion d'honneur for his elegant neo-Florentine bronze statue *David Victorious* (Paris, Mus. d'Orsay). Further success came with the bronze group *Gloria victis* (exh. Salon 1874; Paris, Petit Pal.), composed of a young warrior borne heavenwards by a flying figure, combining the formal elegance of Renaissance sculpture with a powerful Baroque composition. Replicas of it were used on monuments to the dead of the Franco-Prussian War of 1870 in many French towns, including Niort, Deux-Sèvres (1881), Agen, Lot-et-Garonne (1883) and Bordeaux (1884).

Mercié's later output of monumental sculpture tended towards the academic, and, though prolific, he produced little that lived up to the promise of his early works. Among his principal pieces are the statue of *François Arago* (bronze, 1879; Perpignan, Place Arago), the equestrian monument to *William II, King of the Netherlands and Grand Duke of Luxembourg* (bronze, 1884; Luxembourg, Place Guillaume), the patriotic group *Quand même!* (bronze, 1884; Belfort, Place d'Armes) and the funerary effigies of *Louis-Philippe* and *Queen Marie-Amélie* (marble, 1886; Dreux, Eure-et-Loire, Orléans Chapel), as well as numerous funerary monuments in Père Lachaise Cemetery, Paris. Many of his sculptural works were reproduced in reduced-scale bronze editions by Ferdinand Barbedienne (1810–92) and Gustave Leblanc and in biscuit porcelain by the Sèvres manufactory.

One of the most successful French sculptors of his generation, Mercié accrued numerous honours. From 1900 he was a professor at the Ecole des Beaux-Arts and from 1913 he was President of the Société des Artistes Français. From 1880 he exhibited paintings (e.g. *Galathé*, 1909; Paris, Petit Pal.), several of which were acquired by the State.

Bibliography

Lami

The Romantics to Rodin: French Nineteenth-century Sculpture from North American Collections (exh. cat., ed. P. Fusco and H. W. Janson; Los Angeles, Co. Mus. A.; Minneapolis, Inst. A.; Detroit, Inst. A.; Indianapolis, Mus. A.; 1980–81)

Rodin Rediscovered (exh. cat., Washington, DC, N.G.A., 1981–2)

De Carpeaux à Matisse: La Sculpture française de 1850 à 1914 dans les musées et les collections publiques du nord de la France (exh. cat., Paris, Mus. Rodin, 1982–3)

C. Vogt: 'Un Artiste oublié: Antonin Mercié', *La Sculpture du XIXe siècle: Une Mémoire retrouvée. Les Fonds de sculpture* Paris, 1986)

La Sculpture française au XIXe siècle (exh. cat. ed. A. Pingeot; Paris, Grand Pal., 1986)

CHRISTIANE VOGT

Merson, Luc Olivier

(*b* Paris, 21 May 1846; *d* Paris, 14 Nov 1920). French painter and illustrator. He was the son of the painter and art critic Charles-Olivier Merson (1822–1902) and trained initially at the Ecole de Dessin in Paris under Gustave Adolphe Chassevent (1818–1901) and then at the Ecole des Beaux-Arts under Isidore-Alexandre-Augustin Pils. He made his début at the Salon in 1867 and won the Grand Prix de Rome in 1869 with the melodramatic work, the *Soldier of Marathon* (1869; Paris, Ecole N. Sup. B.-A.). As a prizewinner he then spent five years in Italy, where he was impressed and influenced by the works of the Italian Primitives, as is apparent in such works as *St Edmund, King and Martyr* (1871; Troyes, Mus. B.-A. & Archéol.), with its muted colours and rigid composition. In the Salon of 1875 he exhibited *Sacrifice for the Country, St Michael*, which had been commissioned as a design for a Gobelins tapestry for the Salle des Evêques in the Panthéon, Paris. Soon afterwards he was chosen to decorate the Galerie de St Louis in the Palais de Justice, Paris, with scenes from the life of Louis IX. This resulted in two large works, *Louis Opening the Doors of the Gaols on his Accession* and *Louis Condemning Sire Enguerrand de Coucy* (both 1877). He also used historical, often religious, subjects for his smaller-scale works, as in *St Francis of Assisi Preaching to the Fish* (1880; Nantes, Mus. B.-A.). Some, such as *Rest on the Flight into Egypt* (1880; Nice, Mus. B.-A.), resemble Symbolist art in their sense of mystery and use of diffuse light effects.

Merson received numerous further commissions for public buildings, for example he painted the altarpiece *St Louis* (1888) for the church of St Thomas d'Aquin in Paris and *Music in the Middle Ages* (1898) for the Théâtre National de L'Opéra-Comique, Paris, which demonstrated his continuing delight in distant historical subjects. He also produced tapestry cartoons for the Vredespaleis, The Hague, the Musée Municipal, Limoges, and the Ecole des Beaux-Arts, Paris. Commissions for stained-glass window designs came not only from French but also from some American and Russian churches. In 1901 he produced a series of three large works for the Hôtel Watel-Dehaynin in Paris, entitled *Family*, *Truth* and *Fortune* (Paris, Mus. d'Orsay).

Merson also had a successful career as an illustrator. In addition to the work he did for such magazines as *Harper's Magazine* and *Revue illustrée*, he illustrated books, including Victor Hugo's *Notre-Dame de Paris* (Paris, 1895), Gustave Flaubert's *La Légende de Saint-Julien l'Hospitalier* (Paris, 1895) and Léon Gautier's *La Chevalerie* (Paris, 1884). His drawings (Paris, Mus. d'Orsay) for an illustrated edition of Shakespeare's *Macbeth*, executed sometime between 1880 and 1890, were never published. In 1892 Merson was elected a member of the Académie des Beaux-Arts and in 1894 was made professor at the Ecole des Beaux-Arts, of which he became Director in 1906. He resigned the post in 1911 in protest at the lack of emphasis placed on drawing and preparatory studies for paintings, an act that admirably demonstrates his position as one of the last representatives and supporters of 19th-century academic art.

Bibliography
Edouard-Joseph

J. Martin: *Nos peintres et sculpteurs* (Paris, 1898), p. 279

A. Soubies: *Les Membres de l'Académie des beaux-arts depuis la fondation de l'institut*, 4 vols (Paris, 1904–17), iv, pp. 70–75

H. Loyrette: 'Dessins de Luc Olivier Merson pour Macbeth', *Rev. Louvre*, iii (1982), pp. 199–207

□

Meryon, Charles

(*b* Paris, 23 Nov 1821; *d* Charenton, 14 Feb 1868). French printmaker. He was the illegitimate son

of Lady Hester Stanhope's companion and chronicler, Dr Charles Lewis Meryon, and Narcisse Chaspoux, a dancer at the Paris Opéra. He was acknowledged in 1824, but initial separation from his father and the stigma of illegitimacy oppressed him throughout his life. After private schooling at Passy, he entered the French Naval Academy at Brest in 1837 and travelled with his parents in western Europe and on voyages to North Africa and the eastern Mediterranean. A precocious draughtsman, Meryon took some drawing lessons on his return to Toulon in 1840 from Vincent Courdouan (1810–93), from whom he learnt to value the elegant precision of line he was later to develop to a supreme degree. He served as midshipman on the corvette Le Rhin during its mission to the French possessions in Oceania (1842–6). Meryon drew small but lively sketches of shipboard life, minor ethnographic studies and more laboured topographical views. Signs of incipient mental instability occurred as he resigned from the navy in 1848. Having travelled in northern France, Belgium and to London, he settled in Paris to study painting with the minor David pupil, Charles-François Phélippes (d 1867), when he was diagnosed as colour-blind. Despite his unusual visual acuity, Meryon suffered from a common form of Daltonism, or red–green confusion, as is poignantly attested in the pastel the Fishing Boat (Paris, Louvre).

The Revolution of 1848 stimulated only verbal plans for an allegorical painting, but an elaborately finished, if somewhat conventional, monochrome cartoon for the Assassination of Marion Dufrêsne in 1772 (Wellington, NZ, Turnbull Lib.) was exhibited at the Salon of 1848. In the same year Meryon encountered Eugène Bléry, with whom he resided temporarily, and studied etching (1849–50). He began by copying prints by Philippe Jacques de Loutherbourg, Salvator Rosa, Karel Dujardin, Adriaen van de Velde and, most enthusiastically, eight by Reinier Nooms, the Dutch sailor–artist whom he venerated as 'another self' and whose Paris views clearly prompted his own series, Etchings of Paris. The first great original print of this series, the haunting Petit Pont (1850), was shown at the Salon

of that year and was followed by the spectacular sequence of master prints on which his consistent reputation as a major etcher rests: the Clock Tower Turret, Rue de la Tixéranderies, Saint-Etienne-du-Mont and the Notre-Dame Pump (1852), The Chimera, the Arch of the Pont Notre-Dame, the Notre-Dame Gallery and The Pont-Neuf (1853), and, climactically, the Rue des Mauvais-Garçons, The Morgue and the Apse of Notre-Dame (1854; see col. pl. XXIII). A projected suite devoted to the early architecture of Bourges was not realized, but three subjects, most importantly the compelling Rue des Toiles at Bourges (1853), preceded by the extremely rare Gate of an Old Convent (1851), were produced. Prior to the commercially published editions, principally for the Artiste, most subjects were proofed through numerous states by the artist himself, who was unprecedentedly sensitive to the effect of printing variation in wiping, ink tint and paper tone and texture, and inscribed presentation impressions of great brilliance and subtlety exist. From the outset a few enthusiasts realized that for all the precise clarity and ostensible objectivity of his views of the old buildings of Paris, the plates project a mysterious aura and a dream-like, somewhat sinister atmosphere.

From 1855 Meryon's physical and mental health deteriorated and the concentration of his incisive style and geometrically crisp composition weakened, although he began to receive increasing recognition—select, but important—from Baudelaire, Gautier, Hugo, Mantz, Bürger and Burty. His precarious and inadequate liveli-hood became based on reproductive hack-work, book titles and illustrations, many portraits and ephemera, although the privately commissioned panoramic views of San Francisco of 1856 (based on photographs) is more ambitious. The connoisseur Duc d'Arenberg invited him to Enghien to work, but the visit from the summer of 1857 to March 1858 was unproductive. Beset by melancholia and bizarre and complex delusions, Meryon was confined to the asylum at Charenton from 12 May 1858 to 25 August 1859.

When he resumed printmaking, Meryon reworked and modified in hallucinatory manner

the earlier Paris views and elaborated several new subjects, but both conception and execution had deteriorated in intensity and images of arcane and more obvious allegory intrude on the architectural compositions. Always apprehensive of drawing publicly from life, Meryon appended reproductive etchings from Paris drawings by earlier artists to the initial group, and a sequence of his youthful drawings made in Oceania was etched, together with a frontispiece, between 1860 and 1866 in a loose and more casually diffuse manner. Friends and admirers attempted to obtain sales and minor commissions for Meryon. The *Ministère de la Marine* (1865), the sky replete with Polynesian and marine phantasmagoria, was published by the Société des Aquafortistes in 1866. In the same year his sole plate for the Louvre Chalcographie, the *Old Louvre*, after a painting by Reinier Nooms, was finished.

Although Meryon was represented in the Salon from 1863 to 1866, serious paranoid delusions, semi-starvation and religious mania necessitated re-admission to Charenton on 12 October 1866. He died there insane in February 1868 and was buried in Père Lachaise Cemetery in Paris, with a copper tomb plaque by Félix Bracquemond, who had etched the two most important portraits of the artist.

Bibliography

P. Burty: 'L'Oeuvre de Charles Meryon', *Gaz. B.-A.*, xiv (1863), pp. 519–33; xv (1863), pp. 75–88; Eng. trans. as *Charles Méryon, Sailor, Engraver and Etcher: A Memoir* (London, 1879)

A. Bouvenne: *Notes et souvenirs sur Charles Meryon* (Paris, 1883)

L. Delteil and H. J. L. Wright: *A Catalogue Raisonné of the Etchings of Charles Meryon* (New York, 1924, rev. with addenda and errata, London, 1925)

G. Geffroy: *Charles Meryon* (Paris, 1926)

Charles Meryon: Officier de marine, peintre-graveur, 1821–1868 (exh. cat. by J. Ducros, Paris, Mus. Mar., 1968)

R. D. J. Collins: *Charles Meryon: A Bibliography* (Dunedin, 1986)

HARLEY PRESTON

Millet, Jean-François

(*b* Gruchy, nr Gréville, 4 Oct 1814; *d* Barbizon, 20 Jan 1875). French painter, draughtsman and etcher. He is famous primarily as a painter of peasants. Although associated with the Barbizon school, he concentrated on figure painting rather than landscape except during his final years. His scenes of rural society, which nostalgically evoke a lost golden age, are classical in composition but are saturated with Realist detail. Millet's art, rooted in the Normandy of his childhood as well as in Barbizon, is also indebted to the Bible and past masters. His fluctuating critical fortunes reflect the shifting social and aesthetic lenses through which his epic representations of peasants have been viewed.

1. Life and work

Born into a prosperous peasant family from Normandy, Millet received a solid general education and developed what became a lifelong interest in literature. After studying with a local portrait painter, Bon Du Mouchel (1807–46), he continued his professional training in Cherbourg with Lucien-Théophile Langlois (1803–45), a pupil of Antoine-Jean Gros. The talented young artist received a stipend from the city of Cherbourg and went to Paris where he entered the atelier of the history painter Paul Delaroche. Frustrated and unhappy there, Millet competed unsuccessfully for the Prix de Rome in 1839 and left the Ecole des Beaux-Arts. One of the two portraits that he submitted to the Salon of 1840 was accepted. In 1840 Millet moved back to Cherbourg and set himself up as a portrait painter, returning the following year to Paris.

Millet's early years (*c*. 1841–8) were dominated by portraiture, which represented the most lucrative (and often the only) means for a 19th-century artist to earn a living, especially in the provinces. Such early portraits as his *Self-portrait* (*c*. 1840–41) and the touching effigy of his first wife, *Pauline-Virginie Ono* (1841; both Boston, MA, Mus. F.A.), are characterized by strongly contrasted lighting, dense, smooth brushwork, rigorous simplicity and directness of gaze. The beautiful black conté crayon study of his second wife, *Catherine Lemaire*

(c. 1848-9; Boston, MA, Mus. F.A.), with its sensitive crayon strokes and monumentality, heralds a new phase in Millet's artistic evolution, which coincided with his move to Barbizon in 1849. After 1845 Millet painted few portraits, although he continued to make portrait drawings. During the 1840s Millet struggled to survive financially in Paris, lost his first wife in 1844 and failed to achieve critical recognition. In addition to portraits, he produced pastoral subjects and nudes during the 1840s. Around 1848 Millet became acquainted with several of the Barbizon artists, notably Théodore Rousseau who became a close friend. Through an arrangement with Alfred Sensier (1815-77), Millet was able to guarantee his family's livelihood.

Millet's epic naturalist style, which surfaced in the peasant scenes he painted after he settled in Barbizon, coincided with the Revolution of 1848 and his escape from the city. From 1849 Millet specialized in rural genre subjects, which melded together current social preoccupations and artistic traditions. In the aftermath of the Revolution these subjects took on socio-political connotations. Rural depopulation and the move to the cities made the peasant a controversial subject. At the Salon of 1850-51, Millet attracted the attention of both conservative and liberal critics with *The Sower* (1850; Boston, MA, Mus. F.A.). The powerful, striding peasant, exhibited in the same year as Gustave Courbet's controversial *Stonebreakers* (destr.) and *Burial at Ornans* (Paris, Mus. d'Orsay), imbued the common man with a sort of epic grandeur. Millet's *Sower* represents the endless cycle of planting and harvesting and physical toil with dignity and compassion. To conservative critics, there was something distinctly disquieting about this hulking, monumental peasant with his forceful gesture and coarse, unidealized features. To progressive critics, however, the art of Millet and Courbet signalled change and the coming of age of the common man as a subject worthy of artistic representation. Yet, ironically, Millet himself was a pessimist who held little hope for reform. In fact, his paintings of peasants often portray archaic farming methods in nostalgic colours and sometimes allude to biblical passages, as in *Harvesters Resting (Ruth and Boaz)* (1850-53; Boston, MA, Mus. F.A.). Millet made numerous preparatory studies for this painting, which he considered his masterpiece and which won him his first official recognition at the Salon of 1853. In this monumental, classicizing harvest scene, Millet paid homage to his heroes, Michelangelo and Nicolas Poussin. The critic Paul de Saint-Victor (1825-81) perceptively described Millet's *Harvesters* as 'a Homeric idyll translated into the local dialect' (*Le Pays*, 13 Aug 1853).

In 1857 Millet exhibited *The Gleaners* (Paris, Mus. d'Orsay; see col. pl. XXIV) at the Salon. This grandiose canvas represents the summation of Millet's epic naturalism. Three poor peasant women occupy the foreground of the composition, painfully stooping to gather what the harvesters have left behind as they were entitled to by the commune of Chailly. In the background Millet painted with chalky luminosity the flat, fruitful expanse of fields with the harvest taking place. The painting was attacked by conservative critics, such as Saint-Victor, who characterized the gleaners as 'the Three Fates of pauperdom' (*La Presse*, 1857). The three impoverished women, like the figure in *The Sower*, raised the spectre of social insurrection and belied government claims about the eradication of poverty. However, Millet's painting was defended by leftist critics for its truth and honesty. The Realist critic Jules-Antoine Castagnary noted the beauty and simplicity of the composition despite the misery of the women and evoked Homer and Virgil. The monumental, sculptural figures, with their repetitive gestures, are in fact reminiscent of the Parthenon frieze, and the painting itself, despite its apparent naturalism, is composed with mathematical precision. *The Gleaners*, like Millet's other canvases, both reflects and transfigures the realities of rural life by filtering them through the lenses of memory and past art.

The Angelus (1857-9; Paris, Mus. d'Orsay; see fig. 50), which was commissioned by Boston artist Thomas Gold Appleton (1812-84), exemplifies Millet's fluctuating critical reputation. Its widespread vulgarization and unusually specific subject-matter verging on the mawkish have made it Millet's most popular painting. A young farmer and his wife, silhouetted against the evening sky,

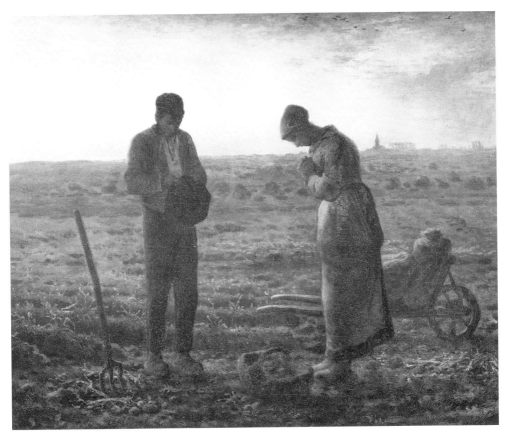

50. Jean-François Millet: *The Angelus*, 1857–9 (Paris, Musée d'Orsay)

pause as the angelus tolls, the woman bowed in prayer, the man awkwardly turning his hat in his hands. In 1889 the painting was the object of a sensational bidding war between the Louvre and an American consortium that bought it for the unprecedented sum of 580,650 francs. Billed as the most famous painting in the world, *The Angelus* was triumphantly toured around the USA. In 1890 Hippolyte-Alfred Chauchard acquired the painting for 800,000 francs, and it entered the Louvre in 1909. However, by that date Millet had fallen out of fashion and the painting became a subject of derision. *The Angelus*, with its rigid gender differentiation, later became a veritable obsession for the Surrealist artist Salvador Dalí.

During the 1860s Millet continued to exhibit peasant subjects, most often single figures. Successful and financially secure, he enjoyed a growing reputation, enhanced by the retrospective of his work held at the Exposition Universelle of 1867 in Paris. In 1868 he was awarded the Légion d'honneur. From 1865 Millet turned frequently to pastels and devoted himself increasingly to landscape painting although he never abandoned the human figure. In particular, he completed the monumental series the *Four Seasons* (1868–74; Paris, Mus. d'Orsay), commissioned by Frédéric Hartmann (*d* 1881) for 25,000 francs. These landscapes, with their loose, painterly brushwork and glowing colour, form the connecting link between

the Barbizon school and Impressionism. In 1870 Millet exhibited at the Salon for the last time. At a public sale held in 1872 his works fetched high prices. In 1874 Millet was commissioned to paint murals illustrating the life of St Geneviève for the Panthéon, Paris, which he was unable to carry out. One of his last completed works is the horrifying but hauntingly beautiful *Bird Hunters* (1874; Philadelphia, PA, Mus. A.), which represents an apocalyptic nocturnal vision recollected from his childhood—an elemental drama of light and dark, of life and death. Severely ill, Millet married his second wife, Catherine, in a religious ceremony on 3 January 1875 and died on 20 January. He was buried at Barbizon next to Rousseau.

2. Working methods and technique

Millet was an exceptional draughtsman whose drawings have perhaps withstood the test of time better than his paintings. His varied graphic oeuvre ranges from rapid preparatory studies (most often in black crayon) to carefully finished pastels, which he sold to collectors for high prices during the last decade of his career. Drawings, which enabled Millet to perfect his compositions, were the building blocks for his paintings. Millet worked in the traditional manner, sometimes producing numerous preparatory studies for a single painting. In particular, he was a master of light and dark, as such nocturnal scenes as *Twilight* (black conté crayon and pastel on paper, c. 1859–63; Boston, MA, Mus. F.A.) attest. Millet's drawings, in their predilection for the expressive effects of black and white, foreshadow those of Georges Seurat and Odilon Redon.

Technically it is Millet's pastels, many of which were commissioned by the collector Emile Gavet (1830–1904), that are the most innovative. Although he had worked in pastel as early as the mid-1840s, Millet turned to the medium with increasing regularity after 1865 and developed an original technique in which he literally drew in pure colour. Beginning with a light chalk sketch, he applied the darks, then rubbed in the pastels to create the substructure and finally built up the surface with mosaic-like strokes of colour. He soon lightened his technique and experimented with different coloured papers, which he allowed to show through in the finished composition. Millet's pastels, in their marriage of line and colour, point forward to Impressionism and Edgar Degas. With typical modesty, Millet referred to his pastels simply as *dessins*.

Although printmaking was never a central activity for Millet, he created in the 1850s and 1860s a series of etchings that often reproduced motifs from his paintings. Millet, like other artists of his generation, was part of the general revival of printmaking in the mid-19th century. He probably began etching about 1855, although Melot (1978) has suggested that he may have begun earlier. Alfred Sensier urged Millet to create a series of etchings from his own designs for commercial publication in the hopes of expanding the market for his art. Millet's etchings, such as *Woman Churning Butter* (1855–6; Delteil, no. 10), illustrate his technical skill with the etching needle although they are generally less forceful than his preparatory drawings. In some instances, however, Millet's etchings anticipate his paintings as in the case of *The Gleaners*. *Woman Carding Wool* (1855–6; D 15) is one of the most monumental images that Millet created in the etching medium.

Millet's work illustrates the complexity of the Realist enterprise at mid-century. His art is a dialogue between past and present—radical in its humanitarian social creed but traditional in technique and classicizing in composition. Millet's rural subjects are drawn from contemporary social reality but interpreted in a highly personal manner. His art influenced Impressionist and Post-Impressionist painters, notably Camille Pissarro and Vincent van Gogh, who idolized Millet and copied a number of his compositions. Even if the peasant no longer strikes the same sympathetic chords for the 20th-century viewer, one cannot help but be moved by the humble majesty of Millet's ageless figures who fill the gap between earth and sky. The retrospective exhibitions held in Paris and London (1975–6) and Boston, MA (1984), provided comprehensive overviews of Millet's varied oeuvre.

Bibliography

E. Wheelwright: 'Personal Recollections of Jean-François Millet', *Atlantic Mthly*, 38 (Sept 1876), pp. 257–76

A. Sensier and P. Mantz: *La Vie et l'oeuvre de Jean-François Millet* (Paris, 1881) [primary source]

J. Cartwright: 'The Pastels and Drawings of Millet', *Portfolio* [London], xxi (1890), pp. 191–7, 208–12

—: *Jean-François Millet: His Life and Letters* (London, 1896)

A. Thompson: *Millet and the Barbizon School* (London, 1903)

L. Bénédite: *Les Dessins de J.-F. Millet* (Paris, 1906; Eng. trans., London and Philadelphia, 1906)

L. Delteil: *J.-F. Millet, Th. Rousseau, Jules Dupré, J. Barthold Jongkind* (1906), i of *Le Peintre-graveur illustré* (Paris, 1906–30/R 1969) [D]

E. Moreau-Nélaton: *Millet raconté par lui-même*, 3 vols (Paris, 1921)

S. Dalí: 'Interprétation paranoïaque-critique de l'image obsédante de Millet', *Minotaure*, i (1933), pp. 65–7

R. Herbert: 'Millet Revisited', *Burl. Mag.*, civ (1962), pp. 294–305, 377–86

Barbizon Revisited (exh. cat. by R. Herbert, Boston, Mus. F. A., 1962)

S. Dalí: *Le Mythe tragique de l'Angélus de Millet* (Paris, 1963)

R. Herbert: 'Millet Reconsidered', *Mus. Stud.* [A. Inst. Chicago], i (1966), pp. 29–65

—: 'City vs. Country: The Rural Image in French Painting from Millet to Gauguin', *Artforum*, viii/6 (1970), pp. 44–55

L. Lepoittevin: *Jean-François Millet*, 2 vols (Paris, 1971–3)

T. J. Clark: *The Absolute Bourgeois: Artists and Politics in France, 1848–1851* (London, 1973)

R. Herbert: 'Les Faux Millet', *Rev. A.*, 21 (1973), pp. 56–65

R. Bacou: *Millet dessins* (Paris, 1975); Eng. trans. as *Millet: One Hundred Drawings* (London and New York, 1975)

J.-J. Lévêque: *L'Univers de Millet* (Paris, 1975) [drawings; good plates]

Millet et le thème du paysan dans la peinture française au 19e siècle (exh. cat., Cherbourg, Mus. Henry, 1975)

Jean-François Millet (exh. cat. by R. Herbert, Paris, Grand Pal.; London, Hayward Gal.; 1975–6) [best gen. disc. of Millet's work; full bibliog.]

A. Fermigier: *Jean-François Millet* (Geneva, 1977) [good plates]

M. Melot: *L'Oeuvre gravé de Boudin, Corot, Daubigny, Dupré, Jongkind, Millet, Théodore Rousseau* (Paris, 1978)

Jean-François Millet (exh. cat. by A. R. Murphy, Boston,

Mus. F.A., 1984) [catalogues extensive Millet holdings of the Museum of Fine Arts, Boston; previously unpubd letters]

K. Powell: 'Jean-François Millet's *Death and the Woodcutter*', *Artsmag*, 61 (1986), pp. 53–9

B. Laughton: 'J.-F. Millet in the Allier and the Auvergne', *Burl. Mag.*, cxxx (1988), pp. 345–51

—: *The Drawings of Daumier and Millet* (New Haven and London, 1991)

B. Laughton and L. Scalisi: 'Millet's *Wood Sawyers* and *La République* Rediscovered', *Burl. Mag.*, cxxxiv (1992), pp. 12–19

HEATHER MCPHERSON

Monet, (Oscar-)Claude

(*b* Paris, 14 Nov 1840; *d* Giverny, 6 Dec 1926). French painter. He was the leader of the Impressionist movement in France; indeed the movement's name, Impressionism, is derived from his *Impression, Sunrise* (1873; Paris, Mus. Marmottan; see fig. 51). Throughout his long career, and especially in his series from the 1890s onwards, he explored the constantly changing quality of light and colour in different atmospheric conditions and at various times of the day.

1. Life and work

(i) The 1850s and 1860s. Although born in Paris, Monet grew up on the Normandy coast in Le Havre, where his father was a wholesale grocer serving the maritime industry. His mother died in 1857, whereupon his aunt, Marie-Jeanne Lecadre, supported his efforts to become an artist and encouraged him during his early career. By *c.* 1856 Monet had attained a local reputation as a caricaturist, attracting the interest of the landscape painter Eugène Boudin, who succeeded in turning Monet's attention to *plein-air* painting. After a year of military service in Algeria in 1861–2 he was released due to illness. In the autumn of 1862 he obtained his father's permission to study art in Paris, where he entered the atelier of the academician Charles Gleyre, studying with him intermittently until *c.* 1864. Of greater consequence for Monet's development was the friendship and informal tutelage of the Dutch landscape painter Johann Barthold

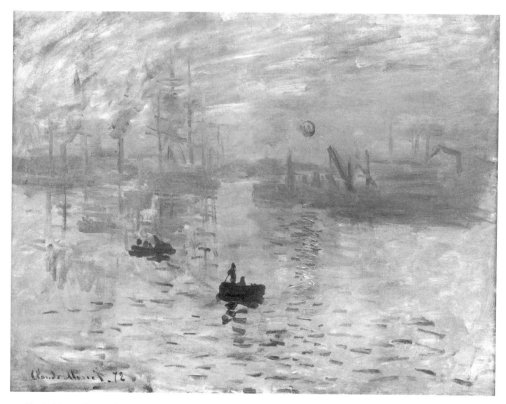

51. Claude Monet: *Impression, Sunrise*, 1873 (Paris, Musée Marmottan)

Jongkind, whom Monet met in 1862. The combined teaching of Boudin and Jongkind proved formative for Monet's future direction as a landscape painter.

Two landscapes, deriving from his first year of active production in 1864 and worked up on a large scale, earned him, on his first attempt, admission to the Salon of 1865: the *Seine Estuary at Honfleur* (1865; Pasadena, CA, Norton Simon Mus., see Wildenstein, no. 51) and *Pointe de la Hève at Low Tide* (1865; Fort Worth, TX, Kimbell A. Mus., w 52). Monet's work appeared again at the Salon in 1866 and 1868, but, having been rejected in the intervening year and with further rejections in 1869 and 1870, he did not submit works thereafter except once, in 1880.

During the second half of the 1860s Monet became the key figure among a group of colleagues whom he had first met at Gleyre's atelier: FRÉDÉRIC BAZILLE, Auguste Renoir and Alfred Sisley. They occasionally made painting trips to Fontainebleau Forest, where in 1865 Monet began a daring project, his *Déjeuner sur l'herbe*, attempting to bring the freshness of outdoor painting to a canvas of life-size figures gathered at a picnic in the forest setting. The painting was intended to make his mark in dramatic fashion at the Salon of 1866, but, working in his Paris studio, he failed to complete the monumental (c. 4.5×6.0 m) canvas in time and was forced to send two other, less challenging, works, both of which were accepted: *Camille* (1866; Bremen, Ksthalle, w 65) and the *Pavé de Chailly* (c. 1865; Switzerland, priv. col., w 19). The canvas was rolled up and put aside and later partly ruined by moisture; two fragments of the final painting

(both Paris, Mus. d'Orsay, w 63a–b) and a large (1.30×1.81 m) final sketch (Moscow, Pushkin Mus. F.A., w 62) are all that remain of this ambitious project.

In his next major painting, *Women in the Garden* (1866–7; Paris, Mus. d'Orsay, w 67), Monet sought to approach a contemporary subject on a large but more manageable scale (2.56×2.08 m), a canvas that would be executed from start to finish out of doors. Despite his efforts he failed to complete the work at the site, not finishing it until the following winter. Consistent with the shift from *plein-air* to studio, the finished painting demonstrates a flattened, decorative treatment of figures and space, aided by the introduction of delicately coloured blue shadows in a system of close-valued hue relationships that deviate from the traditional form-defining technique of chiaroscuro. It was probably such innovations that resulted in his first rejection when he submitted the painting to the Salon of 1867.

In addition to his professional setback at the Salon, Monet suffered grave personal problems during that year. His mistress, Camille Doncieux, whom he had met about 1865, was pregnant; his father, who disapproved of the relationship, refused to help financially, and Monet, all but penniless, was forced to leave Camille in Paris, while he accepted the shelter offered to him alone by his family in Le Havre. In July, as the birth approached, he suffered a partial loss of sight, preventing him temporarily from working out of doors and clearly a sign of his anxious state. But it was also a period of restless probing and experimentation in his art. Following the completion of *Women in the Garden* early in 1867, he pursued his interest in contemporary subject-matter, painting three views of Paris from the east balcony of the Louvre (e.g. *St Germain-l'Auxerrois*; Berlin, Neue N.G.; w 84) in which he further explored the nature of Realism as embodied in *plein-air* painting. In Normandy, despite the temporary problem with his sight, his work ranged from the powerful artifice of his *Terrace at Sainte-Adresse* (New York, Met., w 95), inspired in part by the style of Japanese prints, to the open, atmospheric naturalism of the *Beach at Sainte-Adresse* (Chicago, IL, A. Inst., w 92).

Aided by his first patron, Louis-Joachim Gaudibert of Le Havre, Monet was able to resume his life with Camille and his infant son Jean in 1868; *The Luncheon* (1868; Frankfurt am Main, Städel. Kunstinst. & Städt. Gal., w 132) depicts mother and child at table in their rented house near Etretat in Normandy. Camille also appears in the foreground of *The River* (1868; Chicago, IL, A. Inst., w 110), a work that offers a major statement of Monet's attempt to integrate *plein-air* investigation and stylistic experiment in the last years of the decade.

In 1869 Monet worked alongside Renoir at La Grenouillère, a popular boating and bathing spot on the Seine near Paris. Both artists were aiming once again towards the Salon, at which they hoped (as had Monet in 1865 with *Déjeuner sur l'herbe*) to make an impact with a large-scale depiction of a contemporary subject. Neither artist succeeded in producing such a painting, Monet ruefully referring to the 'bad sketches' with which he had to be content (letter to Bazille, 25 Sept). These sketches, however, became the hallmark of a new style of painting. In such works as Monet's version of *La Grenouillère* (London, N.G., w 135) the traditional academic sketch was in effect reinvented and converted into the Impressionist *tableau*. The fragmented, varied brushwork of this painting suggests the ephemeral character of the subject and reveals the means by which the illusion of the scene was created.

(ii) The 1870s and 1880s. Monet and Camille were married on 28 June 1870. During that summer the Franco-Prussian War broke out, and Monet fled with his young family to London in the autumn, in order to avoid conscription. There he renewed ties with Camille Pissarro, with whom he had painted in the Paris suburbs during 1869, and was introduced to Paul Durand-Ruel, who became his first dealer soon thereafter. During a stay of approximately nine months he painted numerous views of the Thames (e.g. the *Thames below Westminster*, London, N.G., w 166), *Hyde Park* (Providence, RI Sch. Des., Mus. A., w 164) and *Green Park* (Philadelphia, PA, Mus. A., w 165). Having spent the summer of 1871 in Holland, where he

painted several splendid pictures in the style of *La Grenouillère*, he returned to a war-torn France further depleted by the bloody civil war over the Paris Commune. Late that year he settled at Argenteuil, a growing industrial town and boating centre on the Seine to the west of Paris, which was to be his home until 1878.

From 1872 to 1876 Argenteuil became the hub of Impressionist painting. Renoir, Sisley, Pissarro, Edouard Manet and Gustave Caillebotte were each drawn there in turn by the magnetic presence of Monet, whose paintings of the Seine, the interior of the town and the garden settings of his house placed their powerful stamp on the movement's evolution. During the first two years at Argenteuil, Monet profited from the support of Durand-Ruel, who began to purchase the paintings of Monet and his friends. When declining fortunes led Durand-Ruel to suspend his purchases towards the end of 1873, the painters revived the idea of holding an independent exhibition that they had first considered in the mid-1860s. Monet was one of the leading figures in the formation of the Société Anonyme des Artistes Peintres, Sculpteurs, Graveurs etc, which held its first exhibition in April 1874 at the recently vacated galleries of the photographer Nadar on the Boulevard des Capucines in the centre of Paris. Monet's views of Paris painted from the premises late in 1873 include the *Boulevard des Capucines* (Moscow, Pushkin Mus. F.A., w 292), which was shown at the exhibition at Nadar's. One of Monet's exhibited pictures, *Impression, Sunrise* (1873; Paris, Mus. Marmottan, w 263), a sketchy view of the harbour at Le Havre under morning fog, became the occasion for the naming of the group because of its title: they emerged from the exhibition dubbed by the critics the Impressionists. Although *Impression, Sunrise* was not typical of Monet's work at the time, it seems fitting that it played the role it did, for Monet was clearly the most powerful figure among the landscape and *plein-air* painters who dominated the group. His views of the Seine, such as the two versions of the *Bridge at Argenteuil* (1874; Paris, Mus. d'Orsay; Washington, DC, N.G.A.; w 311–12), have come to epitomize the Impressionist effort in the

popular imagination just as they influenced his friends.

By 1876 Monet had begun to look for new subject-matter outside Argenteuil. Seeking new patrons and collectors, he accepted the commission of Ernest Hoschedé in 1876 to produce four decorative paintings for the grand salon of the Château de Rottembourg, Hoschedé's country home at Montgeron: *Turkeys* (Paris, Mus. d'Orsay, w 416), *The Hunt* (France, priv. col., w 433), *Corner of the Garden at Montgeron* and *Pond at Montgeron* (both St Petersburg, Hermitage, w 418, 420). In January 1877, turning his attention to Paris, he took up a subject that had attracted Manet and Caillebotte in the immediately preceding years; he obtained permission to paint at St-Lazare Station (at the Paris end of the line from Argenteuil), where he produced more than a dozen views of the station and its surroundings (see col. pl XXV), several of which appeared at the Third Impressionist Exhibition in the spring, for example *Le Pont de l'Europe, Gare St-Lazare* (Paris, Mus. Marmottan, w 442).

In 1878 the fortunes of Monet and the Impressionists declined sharply. An auction sale of Jean-Baptiste Faure's collection of Impressionist paintings brought low prices, as did the forced sale of Hoschedé's pictures following his declaration of bankruptcy the previous year. In the autumn Monet and Camille, along with Jean and their infant son, Michel, born in March, set up a joint household with the Hoschedés at Vétheuil on the Seine, about 65 km from Paris. Camille died in September 1879, and, as Ernest Hoschedé soon began to spend most of his time in Paris attempting to renew his fortunes, Monet was left as the head of a household including Ernest Hoschedé's wife Alice (his unacknowledged lover) and eight children. Harassed by a combination of personal loss and commitments and acutely beset by financial worries, Monet separated himself from his Impressionist colleagues, his work appearing at the fourth group show in 1879 only through the intercession of Caillebotte. In 1880 Monet followed the course taken by Renoir, Paul Cézanne and Sisley and approached the Salon once more in the hope of reaping financial benefits; one of his two

submissions was accepted, a large view of ice floes on the Seine, *Floating Ice* (Shelburne, VT, Mus., W 568).

Following three years at Vétheuil and a short stay in Poissy, Monet, Alice Hoschedé and the children moved to a rented house in Giverny in 1883, achieving, despite the irregularity of their arrangement, a degree of domestic stability that he had never known before. Giverny was to be his home for the rest of his life; he was able to purchase the house in 1890, and in 1892 Alice became his second wife, following the death of Ernest the preceding year.

Even before settling at Giverny, Monet had begun a pattern of activity that he pursued throughout the 1880s. During the decade he made several painting trips to the Normandy coast, working at Fécamp in 1881, at Pourville and Varengeville in 1882 and at Etretat in 1883 and 1885. In 1886 he spent part of the autumn at Belle-Ile, off the south coast of Brittany, and in 1889 worked during the winter in the Creuse Valley of central France. Between these journeys, in which he engaged with rugged and dramatic scenery in the most changeable of weathers, he visited the Mediterranean, where he was challenged by the clear light and intense colour of the south at Bordighera on the French–Italian border in 1884 and at Antibes and Juan-les-Pins in 1888. These trips were designed to sharpen his sensibilities as a painter and to enlarge the range and appeal of his paintings for prospective buyers. At other times he concentrated on the landscape around Giverny and, during the second half of the 1880s, executed a number of outdoor paintings for which the Monet and Hoschedé children posed, for example *Woman with a Parasol, Turned to the Left* (1886; Paris, Mus. d'Orsay, W 1077).

(iii) The 1890s and after

(a) The series paintings. At the beginning of the 1890s Monet began to elaborate and refine a process that he had begun during his journeys of the 1880s, when he had sought to develop extended groups of canvases devoted to specific sites under differing conditions of light and weather. On a given day, moving with the light and changing position

as the weather shifted, he would work on perhaps as many as eight canvases, devoting an hour or less to each one (as he indicated, in an early instance, in a letter to Alice Hoschedé, 7 April 1882). By the end of the decade, working in the Creuse Valley, the programme of the series was all but fully elaborated.

The development of the series was Monet's great effort of the 1890s: they were a factor in all of his exhibitions during the decade. In 1891 *The Grainstacks* appeared at Durand-Ruel's gallery in Paris; in 1892, also at Durand-Ruel's, he presented his first exhibition devoted exclusively to a single series, the *Poplars on the Epte*. Later that year and again in 1893 he worked in Rouen; 20 of the 50 paintings shown at Durand-Ruel's in 1894 depicted the façade of Rouen Cathedral seen under varying conditions of light, weather and atmosphere (e.g. *Rouen Cathedral, the Façade in Sunlight*; Williamstown, MA, Clark A. Inst., W 1358). There followed in 1895 a limited series done in Norway and, in 1896–7, a reprise of subjects painted earlier in the 1880s at Pourville and Varengeville and a major series of *Mornings on the Seine* (e.g. *Early Morning on the Seine, Morning Mists*; Raleigh, NC Mus. A., W 1474), representing the dawn hours on the river at Giverny. Both groups were shown in a major exhibition at the Galerie Georges Petit, Paris, in 1898. Three trips to London (where his son Michel was studying) from 1899 to 1901 yielded an extended series of *Views of the Thames*, including *Charing Cross Bridge and Westminster* (1902; Baltimore, MD, Mus. A., W 1532), the *Houses of Parliament, Stormy Sky* (1904; Lille, Mus. B.-A., W 1605) and *Waterloo Bridge, London* (1903; Pittsburgh, PA, Carnegie Mus. A., W 1588). After three years of reworking in Giverny they were exhibited at Durand-Ruel's gallery in 1904. A last journey was undertaken with Alice in 1908 to Venice, although the resulting pictures were not exhibited until 1912, a year after Alice's death, at the Galerie Bernheim-Jeune.

At Giverny, during the 1890s, Monet began to develop a large flower-garden in front of his house; in 1893 he acquired another parcel of land, just across the road and single-track railway that

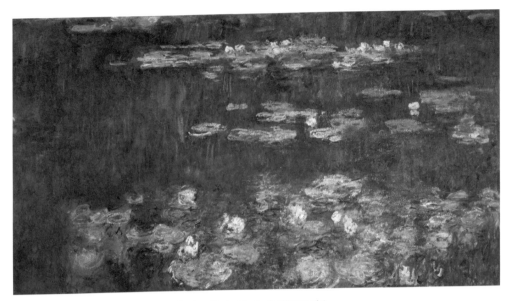

52. Claude Monet: *Waterlillies, Green Reflections* (Paris, Musée de l'Orangerie)

fronted the property, which included a small pond and a stream. He built an arched bridge, based on Japanese designs, across one end of the pond and received permission to control the flow of water entering from the stream, thus creating a receptive environment for the introduction of exotic species of waterlily. He enlarged the pond in 1901 and 1910. The house and water gardens became his dominant subjects for the rest of his life; they were designed mainly to fulfil his dream that painting out of doors should be equivalent to working in a studio. He set up easels around the pond to enable him to work from different vantage-points and devoted himself to a continuous series of waterlily paintings from the late 1890s to 1910.

In 1900 Monet exhibited his first group of pictures of the garden, devoted primarily to the Japanese bridge (e.g. the *Japanese Bridge and the Waterlily Pool–Giverny* (*Le Bassin et nymphéas*), 1899; Philadelphia, PA, Mus. A.). From 1903 to 1908 he concentrated on the enlarged pond with its floating pads and blossoms set in orderly clusters against the reflections of trees and sky within its depths. The results were seen in the largest and most unified series to date, a suite of 48 canvases known as *Waterlilies, a Series of Waterscapes* shown at Durand-Ruel's gallery in May 1909 and subsequently dispersed (see fig. 52).

(b) The waterlilies decoration. During the 1890s Monet had begun to plan a decorative cycle of paintings devoted to the water garden and apparently made some first attempts in that direction. But it was only after a period of 15 years or so, after the final enlargement of the pond in 1910 and the death of Alice, that the plan was renewed. In 1914, encouraged by his close friend the politician Georges Clemenceau to overcome the weariness and depression that had persisted since Alice's death and the shock of his son Jean's death in February, Monet made plans to construct a new, large studio in which he could carry out the project on a grand scale. He persisted despite suffering increasingly from cataracts, which necessitated three operations on his right eye in 1923 and continual, variably successful, experiments with corrective lenses thereafter. Most of the work was done *c.* 1916–21, following completion of the studio, in which he installed his large canvases on moving easels to approximate the oval shape of the scheme

he envisaged, a continuous band of paintings of the pond that would entirely surround the viewer.

In 1918 Monet announced plans to donate the decoration to the State, and in 1920 it was decided that the Government would build a pavilion in the grounds of the Hôtel Biron (now the Musée Rodin) in order to provide a permanent installation. Within a year the site was changed: in April 1921 a new announcement specified the Orangerie, at the far end of the Tuileries Gardens from the Musée du Louvre, as the intended home for the murals. The two oval rooms, situated at ground-level on the south side of the building, were designed by the architect Camille Lefèvre. On 16 May 1927, five months after Monet's death, the decoration was opened to the public for the first time. Here the changeable, fragile natural environment of Giverny, created and nurtured by Monet over a period of almost 50 years, is given its synoptic form in paint. The Musée Claude Monet, his house and gardens at Giverny, was refurbished and opened to the public in 1981.

2. Working methods and technique

During the 1860s Monet was primarily interested in furthering the Realists' concerns with the contemporary in subject and the verifiable in nature by assuming *plein-air* painting as a fundamental principle of his art. He sought to combine his Realist investigation with an inquiry into the possibilities of creating a new style of painting, following the lead that Manet had offered early in the decade. In the paintings produced at La Grenouillère in 1869 he found a way to resolve the often contradictory claims of nature and style, establishing a provocative tension between appearances and painterly invention that proved sufficient basis for the developed Impressionist manner of the 1870s and thereafter.

During the 1870s Monet's touch became softer, his strokes smaller and more varied. His palette tended towards a pastel range, with a play of warm and cool colours; at times he also employed a muted scale of greys—for example in response to dull weather (*Bridge at Argenteuil, Grey Weather*, 1874; Washington, DC, N.G.A., W 316)—or a harsh staccato of reds and greens, as in many sunlit

garden pictures of the mid-decade at Argenteuil (e.g. *Gladioli*, 1876; Detroit, MI, Inst. A., W 414). By the mid-1870s he had all but eliminated black from his palette and reduced the role of earth tones as he sought to restrict value contrasts and effects of modelled form. These experiments with colour were played off against and within a traditional spatial framework, essentially perspectival in nature (e.g. *Gare St-Lazare*, 1877; Paris, Mus. d'Orsay, W 438).

At the beginning of the 1880s there was an identifiable change in Monet's choice of subjects, palette and approach to space. Notably in his paintings of the Normandy and Brittany coasts, for example the *Coastguard's Cottage, Varengeville* (1882; Rotterdam, Boymans–van Beuningen, W 732), he coaxed the large forms of cliffs and sea into cursive formulations—arabesques and broad, arching shapes—that served as decorative fields for an ever more refined, minutely particular application of coloured strokes. He became increasingly interested in harmonious distributions of warm and cool hues—varieties of pink, orange and mauve along with blues and greens (e.g. *Villas at Bordighera*, 1884; Santa Barbara, CA, Mus. A., W 856)—and in an overall organization based on the contrast of complementary colours, for example in *Field of Poppies* (1890; Northampton, MA, Smith Coll. Mus. A., W 1251), with its red meadow set before a row of green trees. His greatest challenge was the Mediterranean, at Bordighera in 1884 and Antibes in 1888, where he translated the brilliance of Mediterranean light into paintings such as the *Gardener's House, Antibes* (1888; Cleveland, OH, Mus. A., W 1165), which he feared would be sure to arouse the ire of 'the enemies of blue and pink' (letter to Durand-Ruel).

In the series of the 1890s and later he sought to convey the unifying effects of atmosphere (the *ambiance* and the *enveloppe*) and tended increasingly to reduce the identity of local colour in favour of decorative, chromatic harmonies, geared in part to natural effects but ultimately determined by the matching of canvas to canvas within the ensemble.

Early in his career, from about the mid-1860s, Monet began to work on canvases primed with a

light-toned ground, most frequently a warm grey or light tan. He used a pure white priming only occasionally in the 1870s and then more frequently during the 1880s; after 1890, for the major series, he turned to white grounds almost exclusively. His method of building up his paintings was fairly consistent throughout his career, despite a gradual move towards a more complex microstructure and heavier texture after 1880 and in many of the series, most notably *The Grainstacks* and *Rouen Cathedral*. He would first lay down a preliminary *ébauche* (underpainting) in polychrome—the colours muted but matched to the basic tonalities of the subject, the strokes ranging from broad and contour-defining to a variety of quickly applied filler strokes for the main masses. From that base he would move (whether in a single day or over a period of days or even months) towards ever greater refinement, differentiation and definition of line, texture and palette, his colours becoming more complex and intense as he proceeded. The final product often provided a record of this process, as areas of the toned ground remained untouched to the end, as broad strokes from the early stages of the *ébauche* stayed visible alongside more elaborated applications, or as the texture of the brushwork from early stages made its presence felt in the final working, perhaps interrupting or affecting the adhesion of the later strokes and resulting in an unpremeditated chromatic and textural complexity of the finished painting.

Beginning in the 1880s, then more persistently and programmatically in the series after 1890, Monet brought more than one canvas to the site, the different canvases geared to differing conditions of light and weather; as the light changed he would put one canvas aside and pick up another, repeating the process when necessary. Perhaps the most deliberate use of this procedure was at Rouen in 1892–3 and in London in the years around 1900, when he painted from protected vantage-points, in the latter case from his window balcony at the Savoy Hotel, where he had perhaps as many as 100 canvases from which to choose. In later years he recalled that he would work on a single canvas 20 to 30 times. He did not, however,

relinquish work in the studio. Although in interviews he insisted upon the primacy and even exclusivity of his activity outdoors, his letters to Durand-Ruel from the beginning of the 1880s clearly reveal his regular practice of reviewing and reworking his paintings once he returned from the site; the series, in particular, were completed and exhibited only after an often prolonged process, during which he continued to revise his canvases, comparing them with one another, seeking a unity of the ensemble of paintings before releasing them for exhibition.

Monet's drawings, notably the pencil drawings contained in eight sketchbooks at the Musée Marmottan, Paris, rarely played any part in the execution of individual paintings but were rather a means of quickly noting down subjects and motifs. He also made a small number of drawings from his paintings between 1880 and 1892 for publication in magazines such as *Vie Moderne* (e.g. *View of Rouen*, 1883, Williamstown, MA, Clark A. Inst.; after the painting of *c.* 1872, priv. col., W 217; see *Gaz. B.-A.*, n.s. 2, xxvii (1883), p. 344).

During his career Monet had no students, although an international colony of painters had gathered at Giverny by the late 1880s, including Lilla Cabot Perry and Theodore Earl Butler (*b* 1876). Closest to him, perhaps, was the American painter Theodore Robinson, who left a diary in which he described his contacts with Monet in the 1890s (MS., New York, Frick).

Monet's chief dealer throughout his career was the firm of Durand-Ruel. Although Paul Durand-Ruel's initial support in the early 1870s was soon halted due to financial difficulties, he resumed regular purchases of Monet's paintings in 1881, permitting Monet to begin his extended painting trips of the 1880s. Other dealers to whom Monet turned, usually against the wishes of Durand-Ruel, were Georges Petit, beginning in 1879, and, from 1887, Boussod Valadon, through their branch manager in Paris, Theo van Gogh. Thanks to their efforts and to Durand-Ruel's successful dealings in the USA from 1886, to which Monet was opposed, his prices rose impressively, permitting him to purchase the house at Giverny in 1890. From that time on his financial position was secured.

Bibliography

early sources

E. Taboureux: 'Claude Monet', *Vie Mod.*, ii (1880), pp. 380–82

Le Peintre Claude Monet (exh. cat. by T. Duret, Paris, Salons *Vie Mod.*, 1880)

W. G. C. Byvanck: 'Une Impression', *Un Hollandais à Paris en 1891* (Paris, 1892; Eng. trans. in Stuckey, 1985)

M. Guillemot: 'Claude Monet', *Rev. Ill.*, xiii (15 March 1898; Eng. trans. in Stuckey, 1985)

F. Thiébault-Sisson: 'Claude Monet, les années d'épreuve', *Le Temps* (26 Nov 1900; Eng. trans. in Stuckey, 1985)

G. Grappe: *Claude Monet* (Paris, [1909])

M. Pays: 'Une Visite à Claude Monet dans son ermitage de Giverny', *Excelsior*, (26 Jan 1921)

G. Geffroy: *Claude Monet: Sa Vie, son temps, son oeuvre* (Paris, 1922, 2/1924)

M. Elder: *A Giverny, chez Claude Monet* (Paris, 1924)

L. Gillet: *Trois variations sur Claude Monet* (Paris, 1927)

L. C. Perry: 'Reminiscences of Claude Monet from 1889 to 1909', *Amer. Mag. A.*, xviii (1927), pp. 119–25

R. Régamey: 'La Formation de Claude Monet', *Gaz. B.-A.*, n.s. 5, xv (1927), pp. 65–84

Duc de Trévise: 'Le Pèlerinage à Giverny', *Rev. A. Anc. & Mod.*, li (1927), pp. 42–50, 121–34 (Eng. trans. in Stuckey, 1985)

monographs, exhibition catalogues and catalogues raisonnés

M. de Fels: *La Vie de Claude Monet* (Paris, 1929)

Claude Monet (exh. cat. by D. Cooper and J. Richardson, ACGB, 1957)

Claude Monet (exh. cat., ed. W. Seitz; St Louis, MO, A. Mus., 1957)

J. P. Hoschedé: *Claude Monet, ce mal connu* (Geneva, 1960)

Claude Monet: Seasons and Moments (exh. cat. by W. C. Seitz, New York, MOMA (1960)

W. C. Seitz: *Claude Monet* (New York, 1960)

D. Wildenstein: *Claude Monet: Biographie et catalogue raisonné*, 5 vols (Lausanne, 1974–91) [complete cat. of ptgs and lett.] [w]

Paintings by Monet (exh. cat., ed. G. Seiberling; Chicago, A. Inst., 1975)

Monet Unveiled: A New Look at Boston's Paintings (exh. cat. by E. H. Jones, A. Murphy and L. H. Giese, Boston, Mus. F.A., 1977, 2/1987)

J. Isaacson: *Claude Monet: Observation and Reflection* (Oxford, 1978)

Monet's Years at Giverny: Beyond Impressionism (exh. cat., New York, Met., 1978)

Hommage à Claude Monet (exh. cat. by H. Adhémar, A. Distel and S. Gache, Paris, Grand Pal., 1980)

Claude Monet au temps de Giverny (exh. cat., Paris, Cent. Cult. Marais, 1983; Eng. trans., 1983)

R. Gordon and A. Forge: *Monet* (New York, 1983) [extensively illus. with good colour pls]

J. Rewald and F. Weitzenhoffer, eds: *Aspects of Monet: A Symposium on the Artist's Life and Times* (New York, 1984)

C. F. Stuckey, ed.: *Monet: A Retrospective* (New York, 1985) [with Eng. trans. of primary source materials and interviews with Monet]

J. House: *Monet: Nature into Art* (New Haven, 1986) [detailed study of working methods; numerous, excellent illus.]

Monet in Holland (exh. cat., preface R. de Leeuw; Amsterdam, Rijksmus. van Gogh, 1986)

Monet in London (exh. cat., ed. G. Seiberling; Atlanta, GA, High. Mus. A., 1988)

Monet in the '90s (exh. cat. by P. Hayes, Boston, Mus. F.A.; Chicago, A. Inst.; London, RA; 1990)

V. Spate: *Claude Monet: Life and Work* (New York, 1992)

—: *The Colour of Time: Claude Monet* (London, 1992)

specialist studies

G. Clemenceau: *Claude Monet: Les Nymphéas* (Paris, 1928)

S. Gwynn: *Claude Monet and his Garden* (London, 1934) [early photographs]

G. H. Hamilton: *Claude Monet's Paintings of Rouen Cathedral* (London, 1960, Williamstown, MA, 2/1969)

I. Sapego: *Claude Monet* (Leningrad, 1969) [ptgs in St Petersburg and Moscow]

J. Isaacson: *Monet: Le Déjeuner sur l'herbe* (London, 1972)

J. Elderfield: 'Monet's Series', *A. Int.*, xviii (1974), pp. 28, 45–6

C. Joyes: *Monet at Giverny* (London, 1975, 2/1985)

S. Z. Levine: 'Monet's Pairs', *A. Mag.*, xlix (1975), pp. 72–5

—: *Monet and his Critics* (New York, 1976)

G. Seiberling: *Monet's Series* (New York, 1981)

P. H. Tucker: *Monet at Argenteuil* (New Haven, 1982)

R. R. Bernier: 'The Subject and Painting: Monet's "Language of the Sketch"', *A Hist.*, xii (Sept 1989), pp. 297–321

J. Pissarro: *Monet's Cathedrals: Rouen, 1892–1894* (New York, 1990)

R. Herbert: *Monet on the Normandy Coast: Tourism and Painting, 1867–1886* (New Haven and London, 1994)

JOEL ISAACSON

Monticelli, Adolphe(-Joseph-Thomas)

(b Marseille, 14 Oct 1824; d Marseille, 29 June 1886). French painter. In 1846, after studying at the Ecole d'Art in Marseille, Monticelli left Provence to study in Paris with Paul Delaroche. Although he had been trained to work in a Neoclassical style by his teachers in Marseille, in Paris he admired the Troubadour pictures of such artists as Pierre Révoil and Fleury Richard and the bold colours and rich surface impasto of Delacroix's oil sketches. He also copied many of the Old Masters in the Louvre. When he returned to Marseille in 1847 Emile Loubon (1809–63), newly appointed director of the Ecole de Dessin in Marseille and a friend of many realist landscape painters in Paris, encouraged him and another local painter, Paul Guigou, to record the landscapes and traditional village scenes of Provence (e.g. Rural Scene, Marseille, Mus. Grobet-Labadié).

In 1855–6 Monticelli returned to Paris, where he met the Barbizon landscape painter Narcisse Diaz. They went on painting excursions to the Forest of Fontainebleau together; Monticelli often followed Diaz's example of including nudes and Watteau-inspired costumed figures in his landscapes, as in the Island of Cythera (1863–5; St Louis, MO, A. Mus.). Diaz, who was himself influenced by Delacroix's bright colours, encouraged Monticelli to use more spontaneous brushstrokes to achieve a sketch-like finish. Monticelli lived in Paris from 1863 to 1870, during the Second Empire, when interest in Rococo art and delight in the ballet, theatre and opera were at their height. He began to specialize in theatrical, brightly coloured fêtes galantes showing elegantly gowned women and gallant gentlemen relaxing in natural settings. Around 1869–70 Guigou introduced Monticelli to the Impressionists at the Café Guerbois, and Monticelli began to use small touches of paint in a landscape style close to that of Camille Pissarro, as in Orchard in Flower (c. 1871; Amsterdam, Rijksmus.).

After the outbreak of the Franco-Prussian War (1870–71) Monticelli returned to Marseille, where he remained for the rest of his life and developed his mature style. He and Cézanne, whom he had known since the 1860s, often painted together in the region around Aix and Marseille, between 1878 and 1884. Although Monticelli earned his living by painting portraits, still-lifes (e.g. Still-life with White Jug, c. 1878-80; Paris, Mus. d'Orsay) and fêtes galantes, his Provençal landscape sketches began to be more experimental (e.g. Under the Trees, c. 1883–5; New York, Lewyt priv. col.), their thicker textures and brighter colours giving them a quality of expressionistic abstraction. Their vigorous brushwork foreshadows later paintings executed by van Gogh in Saint-Rémy. Parts of the wooden support were left bare to act as a foil for the intensely coloured and thickly painted highlights. Monticelli's style was considered so unusual by local collectors and critics that he began to be described as insane. He took these reports with good humour, telling his friends that it would take 50 years for people to understand his experimentation with colour and impasto.

In 1886 van Gogh discovered some of Monticelli's mature works in the Galerie Delarebeyrette, Paris. He began to imitate Monticelli's flower-pieces, for example in Hollyhocks in a One-eared Vase (1886; Zurich, Ksthaus), and later bought six paintings for his personal collection. Van Gogh hoped that his paintings, such as Seascape at Saintes-Maries (1888; Moscow, Pushkin Mus. F. A.), would be understood as a continuation of Monticelli's later experimental pictures. In 1890 van Gogh and his brother Theo funded the publication of the first book about Monticelli; Guigou's text, which praises him as a genius of colour and refutes his insanity, is complemented by lithographs of Monticelli's work by A. M. Lauzet (1865–98), including several from the van Gogh brothers' collection. Most of Monticelli's experimental and stylistic innovations have been ascribed to van Gogh, although van Gogh readily acknowledged his indebtedness to the Marseille painter.

Bibliography

P. Guigou: Monticelli (Paris, 1890) [with lithographs by A. M. Lauzet]

A. Gouirand: Monticelli (Paris, 1900)

L. Guinand: *La Vie et les oeuvres de Monticelli* (Marseille, 1931)

Monticelli et le baroque provençal (exh. cat. by G. Bazin, Paris, Mus. Orangerie, 1953)

A. Sheon: 'Monticelli and van Gogh', *Apollo*, lxxxv (1967), pp. 444–8

A. M. Alauzen: *Monticelli: Sa vie et son oeuvre* (Paris, 1969)

Monticelli: His Contemporaries, his Influence (exh. cat. by A. Sheon, Pittsburgh, Carnegie Mus. A., 1978)

A. Sheon: *Monticelli, 1824–1886* (Marseille, 1986)

AARON SHEON

Moreau, Gustave

(*b* Paris, 6 April 1826; *d* Paris, 18 April 1898). French painter and teacher. He was a strongly individual artist whose highly wrought interpretations of mythical and religious scenes were widely admired during his lifetime.

1. Early life and work, to 1870

A student of François-Edouard Picot at the Ecole des Beaux-Arts in Paris, Moreau competed unsuccessfully for the Prix de Rome in 1848 and 1849 but received several government commissions between 1849 and 1854. His earliest works, apart from some family portraits and landscape drawings, are in a Romantic style indebted to Delacroix and Théodore Chassériau, whose studio was next door to Moreau's, and who became a good friend. The first painting he exhibited at the Salon was a *Pietà* (1851; untraced) strongly influenced by Delacroix. In 1853 he showed the *Song of Songs* (Dijon, Mus. B.-A.) and *Darius, Fleeing after the Battle of Arbela, Stops, Exhausted, to Drink in a Pond* (Paris, Mus. Moreau), which was influenced by Chassériau. Although he received favourable reviews, he was unsatisfied with his work, wishing to reconcile the dramatic language of Romanticism with academic ideals of order, balance and decorum based on Renaissance classicism. This can be seen in the *Young Athenians in the Labyrinth on Crete* (Bourg-en-Bresse, Mus. Ain), exhibited but unnoticed in the Exposition Universelle in Paris in 1855.

Moreau began a two-year stay in Italy in 1857, studying the Old Masters in Rome, Florence and Venice. During this period he was close to Degas as well as to other young artists such as Elie Delaunay, Léon Bonnat, Eugène Fromentin, Henri Léopold Lévy and Emile Lévy, all of whom became established painters in the following decades. His drawings, copies and notebooks reveal a profound immersion in Italian artistic culture. Italian painting formed him as an artist and inspired in him a fervent belief in the spiritual value of art. After creating an unimpressive *Road to Calvary* (1862; Decazeville, Notre-Dame), he synthesized his Italian experience into an original style. He spent several years in the early 1860s on a major work, *Oedipus and the Sphinx* (New York, Met.), for which he made numerous preparatory drawings and studies (Paris, Mus. Moreau). The painting, which won a medal at the Salon of 1864, was purchased by Prince Napoléon-Jérôme Bonaparte and marked the establishment of his reputation. The painting draws on classical art and the work of Mantegna, Giovanni Bellini and Ingres and exemplifies Moreau's desire to demonstrate an understanding of the Old Masters in an original way. Its harsh, linear contours and miniscule strokes create a hatched modelling derived from Renaissance art and his academic training. Over life-sized, the painting depicts a confrontation between Oedipus and the sphinx: the composition, despite its violence, is frozen, and the figures are expressionless and this contradictory stillness is both evocative and mysterious. Moreau's notes reveal that he was concerned with the oppositions between good and evil, male and female, physicality and spirituality, and the painting's power and complexity struck a responsive chord among both critics and the public, even prompting caricatures in the popular press.

Moreau explored the style and subject of *Oedipus* throughout the 1860s, producing large symbolic paintings often focused on contrasting concepts such as life versus death, the clash between love and ambition (e.g. *Jason and Medea*, 1865; Paris, Mus. d'Orsay) or the sacrifice required for art (e.g. *Young Man and Death*, 1865; Cambridge, MA, Fogg). *Diomedes Devoured by his Horses* (1865; Rouen, Mus. B.-A.) is exceptional for Moreau's work of this period in its classical theme

of retribution, smaller figures and violent action.

2. Later career, 1870–96

By the late 1860s critics had become negative about Moreau's work: what had been provocative had become familiar. In response, he withdrew from exhibition and undertook a long and serious re-evaluation of his art during and after the Franco-Prussian War. His new style was indebted to Baroque art, especially that of Rembrandt, and to his use of small wax maquettes as preparatory models. *Salome Dancing before Herod* (1876; Los Angeles, CA, Armand Hammer Mus. A.) heralded this phase of Moreau's art and elicited enthusiastic responses at the Salon of 1876. Moreau emphasized the contrast of light and dark, with small figures in an elaborate, eclectic setting containing a mixture of precise, linear passages and painterly, suggestive ones.

The subject of *Salome* is a variation on the theme of the *femme fatale*, which attracted many 19th-century artists. Moreau used symbolic details to reiterate meaning: Diana of Ephesus placed above Herod is a potent image of female power, and the images of a panther and a sphinx emphasize Salome's role as temptress and destroyer. *Hercules and the Hydra of Lerna* (1876; Chicago, IL, A. Inst.), exhibited at the same Salon as *Salome*, shares its exploration of colour and texture and its theme, a confrontation of good and evil.

Also in the 1870s Moreau began to exhibit watercolours showing a similar technical exploration and excitement as his oils, for example *Phaeton* (1878; Paris, Louvre) and *The Apparition* (1876; Paris, Louvre; see fig. 53). They attracted the attention of Antony Roux (*d* 1913), a collector fascinated by the fables of La Fontaine, who commissioned Moreau, among others, to work on this theme, eventually purchasing 63 of his watercolours. Moreau finished few large paintings after his last Salon exhibition in 1880 with *Galatea* (Paris, Robert Lebel Col.) and *Helen* (untraced). In 1882 he began to revise many of the paintings in his studio, some of which dated from the 1850s. He enlarged them, adding detail and texture, but few were ever completed. This process illustrated Moreau's belief that the artist should always

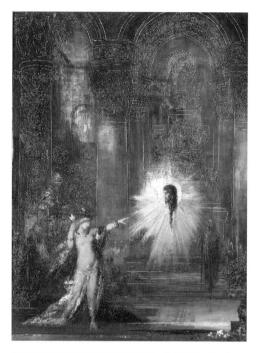

53. Gustave Moreau: *The Apparition*, 1876 (Paris, Musée du Louvre)

try to balance inspiration and intellect. All the large unfinished paintings in the Musée Gustave Moreau indicate his inability to solve this dilemma.

Moreau continued to paint numerous small oils and watercolours, such as *Giotto* (*c.* 1882; Paris, Louvre, Cab. Dessins), and tried to combine a number of these in the ambitious, unfinished *Life of Humanity* (1879–86; Paris, Mus. Moreau), a large, multipartite work with individually titled panels dealing with themes of universal history. The deaths of his mother in 1884 and his mistress, Alexandrine Dureux, in 1890 did not prevent a continual output of small works, which sold well to a steady clientele, and official recognition continued. He was made Officier of the Légion d'honneur in 1883 and was elected to the Académie des Beaux-Arts of the Institut de France in 1888. His fame grew when Joris-Karl Huysmans wrote emotionally of his art in the novel *A Rebours* (1884).

One of the few large paintings finished in the last decade of Moreau's life, *Jupiter and Semele* (1889–95; Paris, Mus. Moreau; see col. pl. XXVI), successfully synthesizes his aesthetic and thematic concerns. Ostensibly relating a Greek myth, the painting contains numerous symbolic figures and decorative details from wide-ranging sources, illustrating man's aspiration to join with the divine. The Arcadian god Pan, accompanied by symbolic figures of Sadness and Death, refers to the work of the Pre-Raphaelite artist Edward Burne-Jones, which he admired, as well as to his own earlier paintings. Jupiter's traditional attributes are enhanced with symbols of sexual potency and eternal power from Indian, Egyptian and occult traditions. He also holds a lyre, classical symbol of creativity. While Jupiter's pose is based on Classical sources, the underlying artistic inspiration is derived from the Flemish Renaissance.

In his exploration of the mythological idea of union with the divine, Moreau joined Gauguin and Edvard Munch in seeking comprehensive answers to the basic dilemmas of life. He wrote two long commentaries explaining *Jupiter and Semele* but also suggested that the viewer approach it with an open mind. This Symbolist aesthetic is based on ideas dating back to the neo-Platonic teachings of the eclectic philosophers Victor Cousin and Theodore Jouffroy (1796–1842), who had influenced him in his youth. However, he did not identify with the younger Symbolist painters and he refused to exhibit at the Salon de la Rose+Croix.

Moreau was appointed professor at the Ecole des Beaux-Arts in Paris in 1892. He was a popular and admired teacher; his students included Albert Marquet and Matisse. He especiallyfavoured Rouault, and he strongly influenced Matisse's views on art, as well as those of many of the Fauves. Moreau was more open than other academic teachers: even when urging his students to copy the Old Masters, he directed them to a much broader range of art than was the norm and encouraged them to find their own direction.

Moreau's last commission was for a cartoon (*The Poet and the Siren*, 1895) for a tapestry woven at the Gobelins (1896–9; Paris, Mobilier N.). In the 1890s he began to work from photographs of his models posing. He began to think of posterity and in 1895 he remodelled his Paris house into a museum, containing the record of his entire working life. Finished in 1896, it became an official state museum in 1902; Rouault was its director. The Musée Gustave Moreau holds over 1000 paintings and oil sketches, 15,000 drawings, numerous sketchbooks, notebooks and letters, his library and his studio props, but only a few large finished paintings.

Writings

B. Wright and P. Moisy, eds: *Moreau et Eugène Fromentin (Documents inédits)* (La Rochelle, 1972)
P.-L. Mathieu, ed.: *L'Assembleur de rêves: Ecrits complets de Gustave Moreau* (Fontfroide, 1984)

Bibliography

L. Thévenin: *L'Esthétique de Gustave Moreau* (Paris, 1897)
P. Flat: *Le Musée Gustave Moreau* (Paris, 1899)
A. Renan: *Gustave Moreau* (Paris, 1900)
G. Desvallières: *L'Oeuvre de Gustave Moreau* (Paris, 1913)
G. Bou: *Moreau à Decazeville* (Rodez, 1964)
R. von Holten: *Gustave Moreau: Symbolist* (Stockholm, 1965)
J. Kaplan: 'Gustave Moreau's *Jupiter and Semele*', *A.Q.* [Detroit], xxxiii (1970), pp. 393–414
H. Dorra: 'The Guesser Guessed: Gustave Moreau's *Oedipus*', *Gaz. B.-A.*, 6th ser., lxxxi (1973), pp. 129–40
Catalogue des peintures, dessins, cartons, aquarelles exposées dans les galeries du Musée Gustave Moreau, Paris, Mus. Moreau cat. (Paris, 1974)
J. Kaplan: *Gustave Moreau* (Los Angeles, 1974)
P.-L. Mathieu: *Gustave Moreau: Sa vie, son oeuvre* (Paris, 1976)
A. Perrig: 'Bemerkungen zu Gustave Moreau (1826–1898) *Salome*', *Krit. Ber.*, v/4–5 (1977), pp. 5–25
O. P. Sebastiani: 'L'influence de Michel-Ange sur Gustave Moreau', *Rev. Louvre*, xxvii (1977), pp. 140–52
H. Hofstätter: *Gustave Moreau* (Cologne, 1978)
J. Kaplan: *The Art of Gustave Moreau: Theory, Style, and Content* (Ann Arbor, 1982)
P. Bittler and P.-L. Mathieu: *Catalogue des dessins de Gustave Moreau* (Paris, 1983)
P.-L. Mathieu: *Gustave Moreau: Aquarelles* (Fribourg, 1984)
Gustave Moreau Symbolist (exh. cat., ed. T. Stooss; Zurich, Ksthaus, 1986)

Maison d'artiste maison-musée: L'exemple de Gustave Moreau (exh. cat. by G. Lacambre, Paris, Mus. d'Orsay, 1987)

JULIUS KAPLAN

Moreau, Mathurin

(*b* Dijon, 18 Nov 1822; *d* Paris, 14 Feb 1912). French sculptor and entrepreneur. His father, Jean-Baptiste Moreau (1797–1855), a sculptor in Dijon, was best known for his restoration of the medieval tombs of the Dukes of Burgundy, which had been damaged during the French Revolution. In 1841 Mathurin entered the Ecole des Beaux-Arts, Paris, where he trained under Etienne-Jules Ramey and Augustin-Alexandre Dumont. He made his Salon début in 1848 with *Elegy* (plaster, Dijon, Mus. B.-A.). In 1852 his *Flower Fairy*, exhibited at the Salon in plaster, was commissioned by the State in bronze (Dijon, Mus. B.-A.). At the 1861 Salon, his marble *Spinner* was also bought by the State, for the Musée du Luxembourg, Paris (version, Dijon. Mus. B.-A.). Poetic and uncontentious works of this kind continued to earn Moreau medals and prizes at subsequent Salons and international exhibitions. Among his public works, he contributed decorative sculpture to the new Opéra and to the rebuilt Hôtel de Ville in Paris, and also produced some commemorative statues, such as that in Dijon to *Sadi Carnot*, President of the French Republic (marble and bronze, 1899; Dijon, Place de la République), which he executed in collaboration with Paul Gasq (*b* 1860; *fl* 1881–1909). However, it was probably the extent of his entrepreneurial activities that won for Moreau an influential position in public life. Having provided many sculpture models for commercial exploitation by the Val d'Osne foundry, he became one of the administrators of the Société du Val d'Osne. Together with his pupil and namesake, Auguste Moreau (1834–1917), he continued, well into the 20th century, to supply models for the manufacture of decorative bronze statuettes that were wholly untouched by more avant-garde endeavours. From 1878 Moreau was mayor of the 19th arrondissement in Paris. The *Civil Marriage*, a painting by Henri Gervex that hangs in the Salle des Mariages of the Mairie of that arrondissement, shows Moreau officiating at his son's civil marriage ceremony, before a distinguished audience.

Bibliography
Lami

J.-C. Ancet: *Une famille de sculpteurs bourguignons: Les Moreau* (diss., U. Dijon, 1974)

PHILIP WARD-JACKSON

Morisot, Berthe(-Marie-Pauline)

(*b* Bourges, Cher, 14 Jan 1841; *d* Paris, 2 March 1895). French painter and printmaker. As the child of upper middle-class parents, Marie-Joséphine-Cornélie and Edme Tiburce Morisot, she was expected to be a skilled amateur artist and was thus given appropriate schooling. In 1857 she attended drawing lessons with Geoffroy-Alphonse Chocarne (*fl* 1838–57), but in 1858 she and her sister Edma left to study under Joseph-Benoît Guichard, a pupil of Ingres and Delacroix. In the

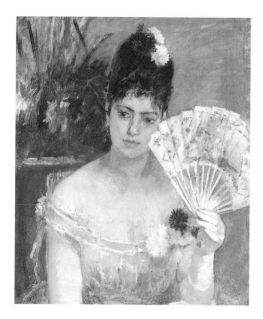

54. Berthe Morisot: *At the Ball*, 1875 (Paris, Musée Marmottan)

same year they registered as copyists in the Louvre, copying Veronese and Rubens. The sisters were introduced to Jean-Baptiste-Camille Corot in 1861 and took advice from him and subsequently from his pupil, Achille-François Oudinot (1820–91). Through these artists they became familiar with current debates on naturalism and began to work *en plein air*, painting at Pontoise, Normandy and Brittany (e.g. *Thatched Cottage in Normandy*, 1865; priv. col., see Angoulvent, no. 11).

Morisot exhibited in the Salon from 1864 to 1868 and received encouraging reviews. In late 1867 or 1868, Henri Fantin-Latour introduced her to Edouard Manet, for whom she modelled, and who became her close friend. In December 1874 she married his brother Eugène. Although Manet advised Morisot on her work, she was never his formal pupil, and their relationship was more reciprocal than is usually supposed. Morisot was not persuaded by Manet to remain within the official exhibiting forum and was instrumental in persuading him to lighten his palette in the 1870s.

Morisot was a central member of the group of artists who initiated the Impressionist exhibitions in the 1870s and 1880s (see col. pl. XXVII). In 1874 she submitted nine works to the first Impressionist Exhibition; thereafter she resolved never to return to the Salon. She showed in seven of the eight exhibitions (1874, 1876, 1877, 1880, 1881, 1882 and 1886), missing only the exhibition of 1879 due to illness following the birth of her daughter Julie at the end of 1878. She was directly involved in the organization of some of these exhibitions and identified strongly with the aesthetic and political principles that led to the establishment of an exhibition forum outside the Salon. In March 1875 Morisot participated with Renoir, Camille Pissarro, Monet and Alfred Sisley in an auction at the Hôtel Drouot, her works fetching marginally higher prices than theirs. Her work was handled by the dealer Paul Durand-Ruel, although she was never financially dependent on sales. Her home was a meeting-place for intellectuals and artists, including Renoir, Degas, Mary Cassatt and Stéphane Mallarmé.

Morisot was regarded by critics such as Paul Mantz (1821–95) and Théodore Duret as a quin-

tessential Impressionist. They believed that she was capable of achieving an 'impression' of nature that was unmediated and 'sincere', and they asserted that such a proclivity was the product of the allegedly feminine characteristics of superficiality and innate sensitivity to surface appearances. However, Morisot's use of luminous tonalities, painterly brushmarks, sketchy surfaces and unprimed canvas, and her adherence to modern-life subject-matter (e.g. *Summer's Day*, 1879; London, N.G., *At the Ball*, 1875; Paris, Musée Marmottan; see fig. 54) are features shared with her Impressionist colleagues, male and female.

Morisot executed pastels and watercolours throughout her life, as well as lithographs and drypoints around 1888 to 1890. In her last years she favoured suggestive and mythic subjects and increased linearity in drawing, as seen in the *Cherry Tree* (1891; Paris, priv. col., see Adler and Garb, 1987, no. 56) and *The Cherry Picker* (1891; Paris, priv. col.; see fig. 55).

Writings

D. Rouart, ed.: *Correspondance de Berthe Morisot* (Paris, 1950; Eng. trans., rev. by K. Adler and T. Garb, London, 1986)

Bibliography

C. Roger-Marx: 'Les Femmes peintres et l'Impressionnisme: Berthe Morisot', *Gaz. B.-A.*, n.s. 2, xxxviii (1907), pp. 491–508

A. Forreau: *Berthe Morisot* (Paris, 1925)

M. Angoulvent: *Berthe Morisot* (Paris, 1933)

Berthe Morisot (exh. cat., intro. P. Valéry; Paris, Mus. Orangerie, 1941)

Berthe Morisot (exh. cat., intro. D. Rouart; ACGB, 1950)

E. Mongan: *Berthe Morisot: Drawings, Pastels, Watercolours* (New York, 1960)

M. L. Bataille and G. Wildenstein: *Berthe Morisot: Catalogue des peintures, pastels et aquarelles* (Paris, 1961; rev., 2 vols, 1988) [cat. rais.]

J. Bailly-Herzberg: 'Les Estampes de Berthe Morisot', *Gaz. B.-A.*, n.s. 5, xciii (1979), pp. 215–27

J. D. Rey: *Berthe Morisot* (Näfels, 1982)

A. Clairet: 'Le Cerisier de Mézy', *L'Oeil*, 358 (1985), pp. 48–51

K. Adler and T. Garb: *Berthe Morisot* (Oxford, 1987)

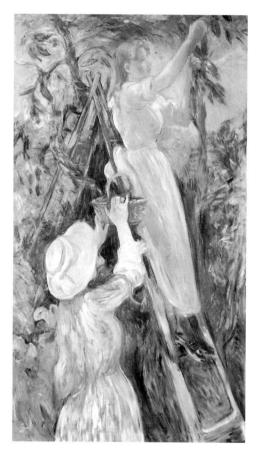

55. Berthe Morisot: *The Cherry Picker*, 1891 (Paris, Private Collection)

Berthe Morisot (exh. cat. by C. Stuckey, Washington, DC, N.G.A.; Fort Worth, TX, Kimbell A. Mus.; South Hadley, MA, Mount Holyoke Coll. A. Mus.; 1987–8)

A. Higonnet: *Berthe Morisot's Images of Women* (Cambridge, MA, 1993)

TAMAR GARB

Mottez, Victor(-Louis)

(*b* Lille, 13 Feb 1809; *d* Bièvres, near Paris, 7 June 1897). French painter. In Lille he studied with his father Louis Mottez and with Edouard Liénard (1779–1840), the director of the art school and a former student of Jacques-Louis David. Mottez went

to Paris at the end of 1828, when, according to Giard, he met the future king Louis-Philippe, then Duc d'Orléans and a student at the Collège Henri IV; their friendship is one reason for the many decorative commissions that Mottez received during the July Monarchy. In March 1829 Mottez entered the Ecole des Beaux-Arts, where he studied with Jean-Auguste-Dominique Ingres and François-Edouard Picot. He exhibited at the Paris Salon from 1833, gaining a first-class medal for history painting in 1838 and a second-class medal in 1845. He was awarded the Légion d'honneur in 1846.

Mottez travelled widely and frequently in order to educate himself in the techniques of fresco and mural painting. In Florence in 1833 he came to appreciate the work of Giotto and the Italian primitives. In 1858 he published a translation of Cennini's *Il libro dell'arte*. He also studied northern European decorative painting, travelling to Belgium in 1833 and to Germany in 1842. It is possible that he met Peter Joseph Cornelius at this time. During the Second Republic, between 1848 and 1852, Mottez lived in England, where he was exposed to Pre-Raphaelite painting.

Mottez's early works are small-scale, literary genre subjects in the Romantic style. He exhibited a scene from Walter Scott's *A Legend of Montrose* and the *Quarrel between Gurth and Cedric* from Scott's *Ivanhoe* at Douai in 1829 (both untraced). His mature style is heavily indebted to Ingres in the strong contours, the distilled essence of physiognomy and idealized approach to form, the media of fresco and mural decoration, and the selection of subjects from Classical history or mythology or from religion. Between 1839 and 1846 Mottez frescoed the porch (destr.) of St Germain-l'Auxerrois and, near the ambulatory, painted *St Martin Dividing his Cloak* (*in situ*). He also decorated the chapels of St François de Sales and the Immaculate Conception in St-Séverin, Paris (commission given 1852), the chapel of St Martin in St-Sulpice (1859–63; *in situ*) and, for Ste Catherine in Lille, the *Four Evangelists*, the *Denial of St Peter* and the *Agony in the Garden* (untraced). The majority of his surviving decorative paintings are in a bad state of preservation; however, photographs of 1854 (see Foucart, 1969) of *Dance* and

Music, a pair of frescoes painted in 1846–7 for the apartment of Armand Bertin (destr. 1854), reveal Mottez's iconography (the Bertin family and their friends in the arts, including both Ingres and Victor Hugo as Olympian gods) and style (similar to Ingres's *Apotheosis of Homer*, Paris, Louvre, and *Golden Age*, Dampierre, Château).

Among Mottez's mature easel paintings are: the *Martyrdom of St Stephen* (exh. Salon 1838; untraced), *Ulysses and the Sirens* (1848; Nantes, Mus. B.-A.), *Melitus Accusing Socrates* (exh. Salon 1857; Lille, Mus. B.-A.), *Zeuxis Taking the Most Beautiful Maidens of Agrigento for his Models* (exh. Salon 1859; Lyon, Mus. B.-A.) and *Phryne Before the Judges of the Areopagus* (exh. Salon 1859; Dijon, Mus. B.-A.). The Musée Wicar, Lille, has a collection of his sketchbooks.

Writings

trans.: *Le Livre de l'art ou traité de peinture* (Paris, 1858) [trans. of C. Cennini: *Il libro dell'arte* (c. 1390)]

Bibliography

R. Giard: *Le Peintre Victor Mottez d'après sa correspondance (1809–1897)* (Lille, 1934)

B. Foucart: 'Victor Mottez et les fresques du salon Bertin', *Bull. Soc. Hist. A. Fr.* (1969), pp. 153–73

J. Lacambre: 'Les Elèves d'Ingres et la critique du temps', *Actes du colloque Ingres: Montauban, 1969*, pp. 104, 109

B. Foucart: *Le Renouveau de la peinture religieuse en France (1800–60)* (Paris, 1987)

A. Haudiquet and others: 'Répertoire des artistes', *Les Salons retrouvés: Eclat de la vie artistique dans la France du Nord, 1815–1848*, ii (1993), p. 130

BETH S. WRIGHT

Nanteuil [Leboeuf], Charles-François

(*b* Paris, 9 Aug 1792; *d* Paris, 1 Nov 1865). French sculptor. He studied with Pierre Cartellier at the Ecole des Beaux-Arts, assimilating a classicizing notion of 'ideal beauty' that lasted throughout his career. He won the Prix de Rome in 1817 and in Rome in 1822 carved the marble *Dying Eurydice* (Paris, Louvre), which made a notable début at the Salon of 1824 and later inspired Auguste Clésinger's erotic marble *Woman Bitten by a Snake* (1847; Paris, Mus. d'Orsay). Nanteuil was an accomplished portrait sculptor, producing many busts, including those of the painter *Prud'hon* (marble, 1828; Paris, Louvre) and of his fellow-fighter against Romanticism, the Neo-classical art critic *Quatremère de Quincy* (marble, Salon of 1850; Paris, Inst. France).

Nanteuil regularly received commissions for large-scale sculpture from the State, such as the group *Commerce and Industry* for the Senate in Paris—inspired by the antique sculpture *Castor and Pollux*—or statues for the historical museum of Louis-Philippe at Versailles, such as the seated *Montesquieu* (marble, 1840; Paris, Pal. Luxembourg; plaster, Versailles, Château). Among his commemorative monuments is an impressive statue of *General Desaix* (bronze, 1844; Clermont-Ferrand, Place de Jaude). Under the Second Empire (1851–70) his increasingly rigorous sculpture helped embellish the Gare du Nord, the Paris Opéra and the rebuilt Louvre.

Nanteuil's most important ecclesiastical commissions were for the pedimental sculpture of Notre-Dame-de-Lorette, Paris (*Homage to the Virgin*, stone, commissioned 1830), and for St Vincent de Paul (*Glorification of St Vincent de Paul*, stone, commissioned 1846). These pediments, decorated with free-standing statues and groups carved from single blocks of stone in the studio, show the influence both of early Renaissance Italian sculpture and of sculptures from Aegina and the Parthenon. Nanteuil was also involved, during the 1840s, in the decoration of the chapel at Dreux built to commemorate Ferdinand-Philippe, Duc d'Orléans, and he carved colossal stone statues of *St Louis* (1843) and *St Philip* (1844) for the principal entrance of the church of the Madeleine, Paris.

Bibliography

Lami

ISABELLE LEMAISTRE

Neuville, Alphonse(-Marie-Adolphe) de

(*b* Saint-Omer, 31 May 1835; *d* Paris, 19 May 1885). French painter. He was first attracted to art while

a cadet at the Ecole Navale. At the insistence of his wealthy family he withdrew after one year to study law. Already keen to become a military artist, de Neuville often sketched the troops training on the Champ de Mars or at the Ecole Militaire. He decided to study art in Paris, although consultations with the established military artists Hippolyte Bellangé and Adolphe Yvon were not encouraging, and it was only with difficulty that he gained a place as a student in the atelier of François-Edouard Picot, where Etienne Prosper Berne-Bellecour (1838–1910) was a contemporary. Soon disaffected with Picot's stultifying regime, de Neuville set out on his own and by 1859 had his first painting accepted at the Salon: the *Fifth Battalion of Chasseurs at the Gervais Battery* (untraced). His entry won a third-class medal and praise from Eugène Delacroix. From then de Neuville's way to independent success was firmly established.

During the Franco-Prussian War (1870–71) de Neuville served on the battle-front north of Paris, first as an officer with the Auxiliary Sappers and later as Gen. Callier's aide-de-camp. Although the war ended in a stunning French defeat, de Neuville thenceforth perpetuated episodes from these campaigns with a verve born of vivid personal experience and a precision of detail earned by careful research. His passion for pictorial authenticity impelled him to exhaustive study of the terrain and its landmarks as well as the uniforms and equipment involved. Typical subjects were the *Bivouac at Le Bourget* (exh. Salon 1872; Dijon, Mus. B.-A.) and the *Last Rounds of Ammunition at Balan* (exh. Salon 1873; untraced). The latter shows the last stand of a French regiment surrounded by the Prussians; they fought and died to the last man amid the ruins of the village of Balan during the Battle of Sedan. It was widely reproduced and inspired theatrical presentation. De Neuville subsequently collaborated with Edouard Detaille in preparing the *Panorama of Champigny* (exh. Paris, 1882; central section, Versailles, Château), based on another famous French defensive action. De Neuville's failing health and untimely death at 49 prevented a second collaboration with Detaille on the *Panorama of Rezonville*.

De Neuville's style owed much to Ernest Meissonier, although his brushwork was usually freer, particularly in his later years, when he adopted in diluted form some of the more superficial features of Impressionist brushwork. His work was widely praised by his contemporaries but has been criticized for unrealistic elegance. With his obvious preference for the officer class, he seemed to lack an adequate sense of the desperation and suffering of the ordinary soldier during the sad season of French military fortunes that provided him with his stock in trade, although he was by no means the only artist of the period devoted to sustaining patriotic illusions of French military glory.

Bibliography

G. P. Chabert: *Alphonse de Neuville (1835–1885): L'Epopée de la défaite* (Paris, 1979)

F. Robichon: 'Les Panoramas de Champigny et Rezonville, par Edouard Detaille et Alphonse Deneuville', *Bull. Soc. Hist. A. Fr.* (1979), pp. 259–77

FRANK TRAPP

Osbert, Alphonse

(*b* Paris, 23 March 1857; *d* Paris, 11 Aug 1939). French painter. He studied at the Ecole des Beaux-Arts and in the studios of Henri Lehmann, Fernand Cormon and Léon Bonnat. His Salon entry in 1880, *Portrait of M. O.* (untraced), reflected his early attraction to the realist tradition of Spanish 17th-century painting. The impact of Impressionism encouraged him to lighten his palette and paint landscapes *en plein air*, such as *In the Fields of Eragny* (1888; Paris, Y. Osbert priv. col.). By the end of the 1880s he had cultivated the friendship of several Symbolist poets and the painter Puvis de Chavannes, which caused him to forsake his naturalistic approach and to adopt the aesthetic idealism of poetic painting. Abandoning subjects drawn from daily life, Osbert aimed to convey inner visions and developed a set of pictorial symbols. Inspired by Puvis, he simplified landscape forms, which served as backgrounds for static, isolated figures dissolved in mysterious light. A pointillist technique, borrowed from Seurat, a friend from Lehmann's studio, dematerialized forms and

added luminosity. However, Osbert eschewed the Divisionists' full range of hues in his choice of blues, violets, yellows and silvery green. Osbert's mysticism is seen in his large painting *Vision* (1892; Paris, Mus. d'Orsay). The Rosicrucian ideal of 'art as the evocation of mystery, like prayer' finds no better expression than the virginal figure of Faith—often interpreted as either St Geneviève or St Joan—set in a meadow with a lamb and enmeshed in an unearthly radiance. Such works were praised by Symbolist writers who considered them visual counterparts of the poetry of Paul Verlaine, Stéphane Mallarmé and Maurice Maeterlinck. Osbert was called a 'painter of evenings', an 'artist of the soul' and a 'poet of silence' for his evocation of a mood of mystery and reverie.

Osbert exhibited frequently in Paris, notably in the Rose + Croix Salons (1892–6). Among his numerous commissions for mural decorations, the most important (entitled *The Spring* and *The Bath*) was for the thermal baths at Vichy (1902), where allegorical and historical figures, posed in idyllic settings, embody the ideas of serenity and harmony. Osbert's later works, such as *Night Song* (1906; Saint-Jean-de-Maurienne, Hôtel de Ville) and the *Hour of Dreams* (1933; untraced), reveal his continued preoccupation with Symbolist subject-matter.

Bibliography

H. Degron: 'Alphonse Osbert', *La Plume*, viii (1896), pp. 136–47

R. Pincus-Witten: *Occult Symbolism in France* (New York, 1976), pp. 110–12

Alphonse Osbert (exh. cat. by Y. Osbert, Honfleur, Mus. Boudin, 1977)

Alphonse Osbert: Gemälde und Handzeichnungen (exh. cat. by G. Roggenbuck and I. Lohmann Siems, Hamburg, Barlach Haus, 1979)

T. Greenspan: *'Les Nostalgiques' Re-examined: The Idyllic Landscape in France, 1890–1905* (diss., NY, City U., 1981), pp. 189–204

TAUBE G. GREENSPAN

Ottin, Auguste-Louis-Marie

(*b* Paris, 11 Dec 1811; *d* Paris, 8 Dec 1890). French sculptor. He was the first of David d'Angers's pupils and worked during his student years as assistant to Antoine-Louis Barye. After success in the Prix de Rome competition of 1836, he spent four years in Rome where Ingres, then the Director of the Académie de France, was impressed by his *envoi* of 1842, *Hercules Presenting the Hesperidean Apples to Eurystheus* (marble; untraced). In Rome, Ottin was converted to Fourierism and later sculpted a polemical fireplace with allegorical figures on the theme of harmony and a portrait of Charles Fourier for the Palazzo Sabatier in Florence (exh. Salon 1850; *in situ*). Ottin's sculpture exemplifies the eclectic spirit of the mid-19th century. *An Indian Hunter Surprised by a Boa Constrictor* (exh. Salon 1846; bronze, 1857, Fontainebleau, Château) is an agitated and colourful piece, owing much to his early collaboration with Barye. In the ensuing years his work on public buildings was either classical or Gothic as the occasion demanded. His most ambitious work, the sculptural tableau of *Acis and Galatea Surprised by Polyphemus* (bronze and marble, 1852–63) for the Medici fountain in the Luxembourg Gardens, Paris, is a highly theatrical and baroque adaptation of a theme already attempted by James Pradier, while in the *Modern Wrestling* (bronze, 1864) in Barentin, Seine-Maritime, he modified a realist subject by giving it a classical treatment. His independent character asserted itself at an advanced age, when he took part in the first Impressionist exhibition of 1874, held in Paris in the former studio of the photographer Nadar. His son, Léon-Auguste Ottin (*fl* late 19th C.), was a painter who worked in oils, watercolour and on glass.

Bibliography

Lami

F. X. Amprimoz: 'Un Décor "fouriériste" à Florence', *Rev. A.* [Paris], xlviii (1980), pp. 57–67

A. Le Normand: *La Tradition classique et l'esprit romantique* (Rome, 1981)

La Sculpture française au XIXe siècle (exh. cat., ed. A. Pingeot; Paris, Grand Pal., 1986)

A. M. Wagner: *J. B. Carpeaux: Sculptor of the Second Empire* (London and New Haven, 1986)

N. McWilliam: *Dreams of Happiness: Social Art and the French Left, 1830–1850* (Princeton, NJ, 1993)

PHILIP WARD-JACKSON

Oudiné, Eugène(-André)

(*b* Paris, 1 Jan 1810; *d* Paris, 12 April 1889). French medallist and sculptor. He was a pupil of André Galle, Louis Petitot and Ingres, and he won the Prix de Rome in 1831. On his return from Rome he was awarded a first-class medal at the Salon of 1839 for his medal commemorating the *Amnesty*, and also in 1843 for his statuary group *Charity* (Le Puy, Mus. Crozatier). After the Revolution of 1848 Oudiné won the competition to design a new five-franc piece: his design symbolically represented the French Republic as *Ceres*. Under the Second Empire Oudiné executed an ambitious series of medals commemorating the *Inauguration of the Tomb of Napoleon I* (1853); the *Apotheosis of Napoleon* (1854) after Ingres; the *Battle of Inkerman* (1854); and the *Plebiscite of May 1870* (*c.* 1875). The latter part of his career saw him moving towards lower, less sculptural relief in his medals for the *Presidency of Adolphe Thiers* (1873) and the Exposition Universelle, Paris, of 1878. Oudiné also continued to be active as a sculptor, executing an entire series of busts, including one of *André Galle* (exh. Salon 1855; Paris, Inst. France), and statues, including a portrait of *Ingres* (Versailles, Château).

Bibliography

Forrer
J. M. Darnis: 'Eugène Oudiné', *Bull. Club Fr. Médaille*, xlix (1975), pp. 200–207

MARK JONES

Perraud, Jean-Joseph

(*b* Monay, Jura, 26 April 1819; *d* Paris, 2 Nov 1876). French sculptor. The son of a vine-grower from the Franche Comté, Perraud was from the same region as Gustave Courbet but represented a diametrically opposed approach to art. He was apprenticed to an ornamental wood-carver in Salins and then attended drawing school in Lyon before arriving in Paris and entering the Ecole des Beaux Arts in 1843. There his masters were Etienne-Jules Ramey and Augustin-Alexandre Dumont. In 1847 he won the Prix de Rome with a plaster relief of *Telemachus Carrying the Ashes of Hippias to Phalantes* (probably destr.), considered by the

Ecole to be a paradigm of student achievement, with its highly considered classical disposition, studied draperies and modern pathos. In his relief *The Farewell* (plaster, 1848–9; Lons-le-Saunier, Mus. B.-A.), executed during his stay in Rome, Perraud simplified and refined a related motif with the perfectionism that was to retain for him the respect of his colleagues. Although on his return to Paris he participated in the architectural decorations of the Second Empire (1851–70), contributing one of the façade groups, *Lyric Drama* (Echaillon stone, 1865–9), to the new Paris Opéra, his most concentrated effort was reserved for free-standing marble figures and groups. Particularly noteworthy examples are the *Childhood of Bacchus* (1861–3; Paris, Mus. Louvre), *Despair* (plaster, exh. Salon 1861, Lons-le-Saunier, Mus. B.-A.; marble, Paris, Mus. d'Orsay) and *Day* (exh. Salon 1875; Paris, Jardins de l'Observatoire).

Bibliography

Lami
M. Claudet: *Perraud: Statuaire et son oeuvre* (Paris, 1877)
——: *La Jeunesse de J.-J. Perraud: Statuaire d'après ses manuscrits* (Salins-les-Bains, 1886)
A. M. Wagner: *Jean-Baptiste Carpeaux, Sculptor of the Second Empire* (New Haven, 1986)

PHILIP WARD-JACKSON

Petitjean, Hippolyte

(*b* Mâcon, 11 Sept 1854; *d* Paris, 18 Sept 1929). French painter. He began his studies in drawing in Mâcon before going to Paris *c.* 1885–6 to join the Neo-Impressionists. He became very close to Seurat, who was generous with his advice and instruction and greatly influenced Petitjean's conté crayon drawings. In 1887 he submitted paintings to the Salon in Stockholm and from 1891 was accepted by the Salon des Artistes Indépendants in Paris. In 1893 he was welcomed in Brussels; in 1898 he gained a new German clientele in Berlin, and in 1903 and 1921 his works were hung in Weimar and Wiesbaden.

Petitjean's output is relatively small, though his paintings are often large in scale. It includes

refined portraits of his wife and daughter (e.g. 1812; Paris, Mus. d'Orsay), epitomizing the era before World War I in France, and views of the Mâcon area and of Paris bridges bustling with figures. But his most notable paintings are symbolical, poetic handlings of the arcadian themes to which Corot was devoted. Though the draughtsmanship derives from Ingres, delicate, immaterialized figures such as *Woman Bathing* or *Venus* (1921; Paris, Louvre) show his great admiration for Puvis de Chavannes. In a recurring image in these idylls, a naked man playing a flute accompanies a soberly dressed young woman.

Bibliography

Thieme–Becker

COLETTE E. BIDON

Piette, Ludovic

(*b* Niort, Deux-Sèvres, 11 May 1826; *d* Montfoucault, Brittany, 14 April 1878). French painter. He studied at the Ecole des Beaux-Arts in Paris during the 1850s under Isidore Pils and Thomas Couture. He attended classes at the Académie Suisse and made his Salon début in 1857 with *The Scorpion Broom* (ex-Mus. B.-A., Rouen). His early works were often based on literary sources and include *The Phantoms* (exh. Salon 1859) and *The Witches Appearing to Macbeth* (exh. Salon 1861). Piette only exhibited at the Salon on two further occasions (1872 and 1876), preferring instead to sell his work at auction in the Hôtel Drouot. In the early 1860s he abandoned literary subjects in favour of working directly from nature, a shift that probably relates to his developing friendship with Camille Pissarro. This association is first documented by Pissarro's portrait of *Piette in his Studio* (1861; Dr and Mrs Jordan H. Trafimow priv. col.) and an important correspondence between the two artists from 1863 to 1877 survives. Piette portrayed Pissarro painting out of doors (*c*. 1870; priv. col., see *Pissarro*, exh. cat., ACGB, 1980, no. 322).

Much of Piette's career was spent on the country estate at Montfoucault, near Mayenne in Brittany, that he had inherited from his parents. Pissarro and his family stayed at Montfoucault on several occasions from 1863 onwards, and in 1870, during the Franco–Prussian war, they took refuge with Piette before moving to England. Piette often stayed with Pissarro at Pontoise, where he painted a number of market scenes, including *A Market-day in front of the Town Hall in Pontoise* and *The Market-place in Petit Matrey* (both 1876; Pontoise, Mus. Pissarro). The brushwork and high-keyed tonality in these works reveal Pissarro's influence, although the panoramic compositions, filled with anecdote and incident, are quite distinct from his work. Piette exhibited 31 works at the third Impressionist exhibition in 1877.

Writings

Mon cher Pissarro: Lettres de Ludovic Piette à Camille Pissarro, ed. J. Bailly-Herzberg (Paris, 1985)

Bibliography

Aquarelles et études par L. Piette (exh. cat., intro. E. Duranty; Paris, Hôtel Drouot, 20–21 Feb 1879)
Peintures et gouaches (exh. cat., intro. A. Tabarant; Paris, Gal. Oru, 1929)
Camille Pissarro, Charles-François Daubigny, Ludovic Piette (exh. cat., Pontoise, Mus. Pissarro, 1978–9)
J. Bailly-Herzberg, ed.: *Correspondance de Camille Pissarro*, i (Paris, 1980)
R. E. Shikes and P. Harper: *Pissarro: His Life and Work* (Paris, 1981), pp. 59–60, 86–9, 120–23, 125–7, 142–3
Le Monde paysan au XIXe siècle (exh. cat., Pontoise, Mus. Pissarro, 1985–6)
Camille Pissaro: Impressionism, Landscape and Rural Labour (exh. cat. by R. Thomson, Birmingham, Mus. & A.G.; Glasgow, Burrell Col.; 1990)

JOHN LEIGHTON

Pils, Isidore-Alexandre-Augustin

(*b* Paris, 19 July 1813 or 7 Nov 1815; *d* Douarnenez, Finistère, 3 Sept 1875). French painter. The son of the painter François Pils (1785–1867), at the age of 15 he entered the studio of Guillaume Lethière, where he remained until the latter's death in 1832. He then moved to that of François-Edouard Picot,

the two men rapidly becoming friends. On Picot's recommendation in 1834 Pils was commissioned to restore the paintings in the Galerie Henri II at Fontainebleau. While working there he produced several pictures of the interior of the palace and the surrounding area. He then returned to Paris and to Picot's studio, intending to compete for the Prix de Rome, but hampered by illness and a stay in hospital he won only the second Grand Prix (1837). However, he fulfilled his ambition in the following year with *St Peter Healing a Lame Man at the Gate of the Temple* (1838; Paris, Ecole N. Sup. B.-A.). He arrived at the Académie de France in Rome, at that time directed by Ingres, in January 1839. The poor health, particularly tuberculosis, that afflicted him throughout his life again frustrated his plans, and from July to September 1839 he convalesced in Ischia. On his way back to Rome he visited Pompeii and made studies from the

antique vases and bronzes there. Despite continued bouts of illness and periods of rest, he managed to study art works in Naples, Florence and Venice but had little success with his own painting, which was poorly received both by his instructors and by Picot.

In September 1844 Pils returned to France and the following year was commissioned to paint a work based on a scene from the life of St Madeleine for the Eglise de la Madeleine in Rouen. This resulted in the *Death of St Madeleine*, which was shown at the Salon of 1847. His first great success at the Salon came with the *Rouget de l'Isle Singing the Marseillaise at the Residence of the Mayor of Strasbourg* (1849; Strasbourg, Mus. Hist.). Its patriotic subject-matter and depiction of ordinary people were to be hallmarks of many of his subsequent pictures. The following year he painted the *Death of a Sister of Charity* (1850; Paris, Mus. d'Orsay; see fig. 56), showing the death

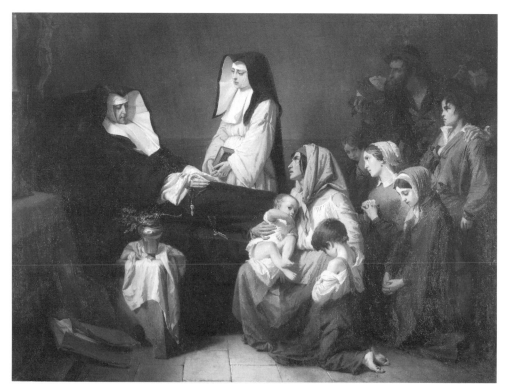

56. Isidore-Alexandre-Augustin Pils: *Death of a Sister of Charity*, 1850 (Paris, Musée d'Orsay)

(1846) of St Prosper in the Hôpital Saint-Louis, where Pils himself had been treated. Continuing his emphasis on ordinary people, here including several children, the work shows him applying the genre of history painting to more contemporary subject-matter, in this case producing a sympathetic treatment of the poor.

In 1852 Pils started painting military subjects and at the outbreak of the Crimean War turned to this for subject-matter, beginning with *Siege Lines at Sebastopol* (1855; Bordeaux, Mus. B.-A.). Aware of the need to maintain public support by showing French victories, the government encouraged such works, and the painting, which despite its realistic treatment displayed much of the Romantic fascination for military subjects, was welcomed by the authorities. Pils received commissions for two further Crimean pictures, one from Prince Napoleon for the *Disembarkation of the French Army in Crimea* (1857; Ajaccio, Mus. Fesch) and one from the state for the *Battle of Alma, 20 September 1854* (1861; Versailles, Château). Unable to travel to the Crimea because of ill health, he established himself at Vincennes where he was able to study the activities and uniforms of soldiers on parade and manoeuvres. On its exhibition in 1857 the *Disembarkation of the French Army in Crimea* was a tremendous success; the *Battle of Alma*, which relied for its specific location on sketches made by soldiers at the battle and the illustrations to official reports, was also a triumph at the Salon of 1861.

Following these successes, Pils was offered a commission to paint a scene depicting the reception of the Arab chiefs by the Emperor Napoleon III during his visit to Algeria in 1860. In preparation, he went to Algeria in 1861 and 1862 to sketch the landscape and people. Staying in the Kabylie region, he was based at Fort Napoleon and travelled from there into the surrounding area. He was particularly struck by the dress and appearance of the Algerians, though often found them unwilling to be drawn. Despite interruptions caused by illness, the *Reception of the Arab Chiefs* (1867; untraced) was completed and exhibited at the Exposition Universelle of 1867 in Paris. Though he

had managed to make preparatory studies for the figures of the Arab chiefs, he had been largely unable to do the same for the Emperor and his entourage and this, coupled with his greater fascination for the Arabs, made his treatment of the French figures less impressive than that of the chiefs. This aroused criticism, though he was nevertheless promoted to Officer of the Légion d'honneur.

In 1863 Pils was appointed a professor at the Ecole des Beaux-Arts in Paris. The success of his earlier decorations for the chapel of St André in the church of St Eustache (1854) and the chapel of St Remy in the church of St Clotilde (1858) won him a commission (1865) to decorate the Paris Opéra. He was required to paint four large areas of the vault over the great staircase with subjects representing the glorification of the arts, which he fulfilled using classical themes. The enormous size of the project proved almost overwhelming and, interrupted by the Franco–Prussian War, the Commune and especially by illness, it was not until 1875 that he completed it, aided by pupils. Exhausted, he was unable to attend the opening. The siege of Paris during the Franco–Prussian War and then the establishment of the Commune provided him with subjects for a number of watercolours, such as *Soldiers in the Ruins of the Château of St-Cloud* (1871; Paris, Carnavalet). In addition to military and historical subjects, he also produced several portraits throughout his life, for example that of *Admiral Rigault de Genouilly* (1867; Versailles, Château). Pils's reputation, high during his own lifetime, declined rapidly after his death, though it has since recovered slightly.

Bibliography

L. Becq de Fouquières: *Isidore-Alexandre-Augustin Pils: Sa vie et ses oeuvres* (Paris, 1876)

J. Claretie: *Peintres et sculpteurs contemporains, I: Artistes décédés de 1870 à 1880* (Paris, 1882), pp. 145–68

The Realist Tradition: French Painting and Drawing, 1830–1900 (exh. cat. by G. P. Weisberg, Cleveland, OH, Mus. A.; New York, Brooklyn Mus.; St Louis, MO, A. Mus.; Glasgow, A.G. & Mus.; 1980–81)

Pissarro

French family of artists.

(1) (Jacob-Abraham-)Camille Pissarro

(*b* Charlotte Amalie, St Thomas, Danish Virgin Islands, 10 July 1830; *d* Paris, 13 Nov 1903). Painter and printmaker. He was the only painter to exhibit in all eight of the Impressionist exhibitions held between 1874 and 1886, and he is often regarded as the 'father' of the movement. He was by no means narrow in outlook, however, and throughout his life remained as radical in artistic matters as he was in politics. Thadée Natanson wrote in 1948: 'Nothing of novelty or of excellence appeared that Pissarro had not been among the first, if not the very first, to discern and to defend.' The significance of Pissarro's work is in the balance maintained between tradition and the avant-garde. Octave Mirbeau commented: 'M. Camille Pissarro has shown himself to be a revolutionary by renewing the art of painting in a purely working sense; at the same time he has remained a purely classical artist in his love for exalted generalizations, his passion for nature and his respect for worthwhile traditions.'

Pissarro's extensive correspondence reveals the sphere of his influence and the steadfastness of his character. Mary Cassatt is reported to have said that Pissarro 'was such a teacher that he could have taught stones to draw correctly'. Cézanne called him 'humble and colossal'. The intrinsic quality of Pissarro's work has never been in doubt, but equally it has never enjoyed the universal acclaim associated with other Impressionist painters. Counter-balancing this is the high regard in which he was held by artists of different generations, his appearance and his manner prompting contemporaries to make comparisons with such biblical figures as Abraham (George Moore), Moses (Matisse) and even God the Father (both Cézanne and Thadée Natanson).

1. Life and painted work

Pissarro was born into a Jewish family of French, originally Portuguese, descent. His parents ran a small business in general merchandise at a time when the commercial prospects of St Thomas (then a Danish dependency) were declining. It was assumed, however, that one of the four sons born to Rachel Petit (née Manzana Pomié) and Frédéric Pissarro would eventually assume responsibility for the family business. The resources for formal instruction in art were obviously limited in St Thomas, and this was a determining factor in Pissarro's outlook. His artistic inclinations first surfaced while he was a schoolboy at Passy, near Paris, from 1842 to 1847, but he was essentially self-taught. Cézanne once remarked: 'Pissarro had the good fortune to be born in the Antilles. There he learnt to draw without masters'.

Pissarro's acquaintance around 1850 with a Danish artist, Fritz Melbye (1826–96), convinced him of his true vocation and also provided him with some academic instruction. Between 1852 and 1854 they travelled together to Venezuela and established a studio in Caracas, which they kept for over a year. Numerous drawings and watercolours survive from this period, although only two dated paintings are recorded. Five other paintings with scenes of St Thomas and Venezuela, including *Coconut Palms by the Sea, St Thomas (Antilles)* (1856; Upperville, VA, Mellon priv. col.), were made retrospectively after Pissarro's move to France. These are all surprisingly sophisticated in composition and technique, presumably, though not necessarily solely, as a result of Melbye's teaching. Two features of these early years are important as regards Pissarro's later development: direct confrontation with nature under tropical conditions (in particular his attention to the effects of natural light) and close observation of peasant life.

Pissarro's arrival in Paris in early October 1855 coincided with the Exposition Universelle of that year. It provided him with an immediate opportunity to broaden his artistic horizons. In Paris he was at first dependent on relatives (his parents had followed him to Paris) and kept up connections and shared a studio with the Danish artists Anton Melbye, brother of Fritz, and David Jacobsen (1821–71). He was also friendly at this time with such painters as Ludovic Piette and the Puerto Rican Francisco Oller. Pissarro attended private classes at the Ecole des Beaux-Arts in 1856, and in

1861 he registered as a copyist in the Musée du Louvre. At the Académie Suisse, which he attended from about 1859, he met Cézanne, Monet and Armand Guillaumin, and his first submissions to the Salon date from this time. His works were accepted for exhibition almost every year until 1870. Although he kept a studio in Paris, Pissarro preferred to live in more rural places, such as Montmorency, La Roche-Guyon, Varenne-Saint-Maur, Louveciennes and Pontoise, where he lived from 1866 to 1868 and again from 1872 to 1882. Around 1860 Pissarro formed a liaison with Julie Vellay, a vine-grower's daughter from Burgundy who worked for the Pissarro family. They had eight children between the years 1863 and 1884 and were married in London in 1871.

By the early 1860s Pissarro's style reflected a knowledge of the works of Corot, Courbet and Daubigny. From Corot he derived his treatment of light and tonal nuance; from Courbet strength of form and bold brushwork; from Daubigny carefully constructed panoramic compositions on varying scales. It was to the work of these artists, particularly Corot, with whom he often painted during these years, that Pissarro harnessed the experiences of his childhood years abroad. Major paintings of this early period are the *Banks of the Marne at Chennevières* (1864–5; Edinburgh, N.G.), the *Banks of the Marne in Winter* (1866; Chicago, IL, A. Inst.), the *'Côté du Jallais', Pontoise* (1867; New York, Met.), *L'Hermitage at Pontoise* (1867; Cologne, Wallraf-Richartz-Mus.) and the *Hillsides of l'Hermitage, Pontoise* (c. 1867–8; New York, Guggenheim). All are on a large scale and were intended for exhibition in the Salon. They were specially praised in the reviews of Emile Zola. Pissarro's success in the Salon was intermittent, however, and he associated himself more closely with the artists he had met at the Académie Suisse who, following the lead given by Manet, were striving to be independent of official art.

Pissarro moved to Louveciennes in 1869 and began to paint in a pure Impressionist style, producing such pictures as the *Road to Louveciennes* (Paris, Mus. d'Orsay; see col. pl. XXVIII). During the Franco-Prussian War (1870–71) the house in Louveciennes was ransacked by Prussian troops,

and many works were lost. Pissarro meanwhile fled to London (1870), where he was in touch with Monet, Daubigny and the dealer Paul Durand-Ruel. On his return to France in 1871 he moved to Pontoise. Stylistically, the first half of the 1870s is often regarded as Pissarro's most successful period. The canvases painted in England and France are notable for their firmly controlled compositions, the lighter brushwork and the use of a brighter palette applied in separate patches of unmixed pigments. These developments were evident in the work exhibited by Pissarro and other artists at the First Impressionist Exhibition of 1874, which Pissarro helped to organize. He showed five paintings, including *Hoar Frost, the Old Road to Ennery, Pontoise* (1873; Paris, Mus. d'Orsay; see fig. 57), a work chosen for discussion by the reviewers. Philippe Burty drew attention to its affinities with Millet's works and called for more precise definition of relief, while Jules-Antoine Castagnary praised Pissarro's sobriety and strength, noting, however, that he had made the mistake of painting shadows cast by trees outside the picture.

Pissarro's aim in such works was to record as accurately as possible on the canvas those feelings (*sensations*) he experienced in front of nature, and his various stylistic changes attest his willingness to experiment with different approaches. In his choice of subject-matter, Pissarro followed the advice of Théodore Duret, who in a letter of 6 December 1873 urged him to 'go your own way, your path of rustic nature', seeing him as a successor of Millet. Indeed, during the 1870s Pissarro seems to have been consciously emulating Millet in the exploration of rural themes around Pontoise and Auvers-sur-Oise, as well as Montfoucault in Brittany, a farm owned by LUDOVIC PIETTE.

Of greatest significance at this time was Pissarro's friendship with Cézanne; they often worked together, sometimes painting the same subjects and frequently re-examining motifs first painted by Pissarro in the late 1860s. In their search for a new sense of space they began to regulate their brushstrokes and restrict the colour range of their palettes. Such works as the *Quarry, Pontoise* (c. 1875; Basle, Staechlin Found.), the *Saint-Antoine Road at l'Hermitage, Pontoise* (1875;

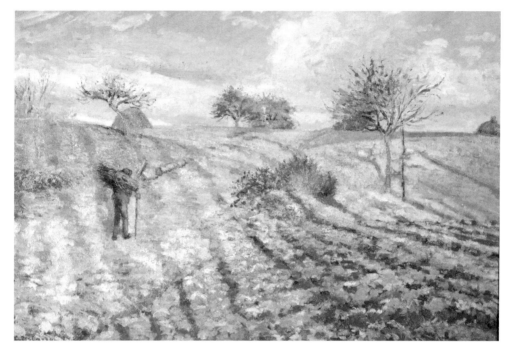

57. Camille Pissarro: *Hoar Frost, the Old Road to Ennery, Pontoise*, 1873 (Paris, Musée d'Orsay)

priv. col., on loan to Basle, Kstmus.) and the *Climbing Path, l'Hermitage, Pontoise* (1875; New York, Brooklyn Mus.) are crucially important for an understanding of the evolution of modern art in that the principles first explored in them were later developed by Cézanne.

Pissarro reached a stylistic crisis at the end of the 1870s as he endeavoured to record the appearance of nature with a myriad of smaller, comma-like brushstrokes built up in layers on the surface of the canvas. Many of these paintings, such as the *Red Roofs, Corner of the Village, Winter* (1877; Paris, Mus. d'Orsay; see fig. 58), the *Côte des Boeufs, Pontoise* (1877; London, N.G.) and the *Pathway at Le Chou, Pontoise* (1878; Douai, Mus. Mun.), are heavily worked. Ultimately Pissarro felt that such compositions lacked clarity, and again he sought to give a new emphasis to his work, this time in collaboration with Degas. For a time they worked together making prints. Degas was the chief advocate of figure painting among the

Impressionists, and the primacy of the human figure at the expense of the landscape background is evident in a series of paintings dating from the early 1880s, among them the *Shepherdess (Young Peasant Girl with a Stick)* (1881; Paris, Mus. d'Orsay), the *Rest, Peasant Girl Lying in the Grass, Pontoise* (1882; Bremen, Ksthalle) and *The Harvest* (1882; Tokyo, N. Mus. W. A.). These works influenced PAUL GAUGUIN, who had begun to paint with Pissarro in 1879 and who remained in close touch with him until 1883–4. Pissarro now began to devise more complex compositions, including crowded market scenes with greater numbers of figures, such as the *Pork Butcher* (1883; London, Tate). He moved away from Pontoise in 1882 to the small neighbouring village of Osny and two years later to the village of Eragny-sur-Epte in Normandy, where he rented, and later bought a large house, converting the barn into a studio.

Pissarro was introduced to Signac and Seurat in 1885, and in the years that followed he began

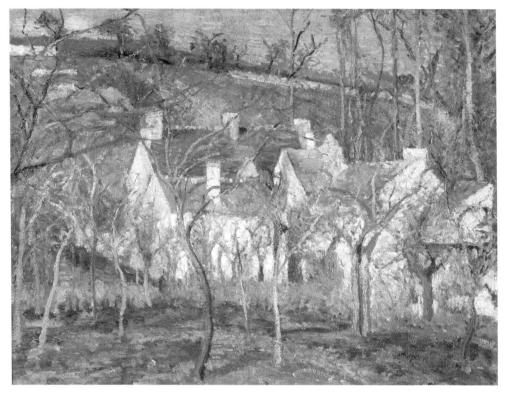

58. Camille Pissarro: *Red Roofs, Corner of the Village, Winter*, 1877 (Paris, Musée d'Orsay)

to work in the pointillist style adopted by the Neo-Impressionists. He thereby aligned himself with the avant-garde, identifying himself with a younger generation of artists, which included van Gogh. Pissarro's interest in Neo-Impressionism was part of a very real concern with the theory and practice of painting, particularly with colour and the application of paint. Pointillism furthermore was a natural outcome of his own stylistic development at this time, being an extension of the smaller, more regular brushstrokes, the grander, more monumental compositions, and the purification of the much wider colour range he used during the late 1870s and early 1880s. Pictures executed in this style are therefore characterized by simplified compositions and an intense luminosity. However, few of his pictures can be strictly defined as pointillist. *View from my Window,*

Eragny-sur-Epte (1888; Oxford, Ashmolean) and *L'Ile Lacroix, Rouen, Mist* (1888; Philadelphia, PA, Mus. A.) adhere more closely than others to the basic principles of Neo-Impressionism. Several canvases in this style were shown in the last Impressionist Exhibition in 1886 and frequently with Les XX in Brussels, where Pissarro continued to exhibit his paintings during the 1890s. Ultimately he found that the technique was too restricting: his output declined, and his response to nature was blunted. Many of the technical advances made during this phase were redeployed in works dating from the beginning of the 1890s, notably in the series of paintings of Kew Gardens, London, undertaken in 1892.

In the last decade of his life, Pissarro returned to a purer Impressionist style, now achieved with greater technical ability, renewed confidence in

his compositions and freer brushwork. The years from 1890 to 1903 represent a resolution of Pissarro's stylistic problems. He struck a balance between urban and rural subject-matter; his exploration of rural themes was limited mainly to areas around Eragny-sur-Epte, and for the first time he included depictions of the female nude. For urban motifs Pissarro concentrated on Rouen, as well as Paris, Dieppe and Le Havre. Several of these paintings were executed in series, the most memorable perhaps being those devoted to the Boulevard Montmartre and the Avenue de l'Opéra. *La Place du Théâtre Français, Paris, Rain* (1898; Minneapolis, MN, Inst. A.) belongs to the latter series and is a good example of Pissarro's ability to create intensely pictorial evocations of city life.

Pissarro's choice of themes in his late work may reflect his political thinking, which became more radical towards the end of his life, and by the 1890s he was a firmly committed supporter of anarchism. He was friendly with the leading representatives of the movement in France, such as Jean Grave and Elisée Reclus, and was well-versed in anarchist literature. His concern for contemporary issues is illustrated in the series of lithographs depicting homeless beggars he made for Grave's anarchist journal the *Temps nouveaux*. He also took a close interest in the Dreyfus affair, which reached its climax in the last years of the century. The extent to which Pissarro can be described as a political painter, however, is debatable. Certainly, his paintings of the 1890s can also be interpreted in the context of contemporary arguments about the relative virtues of rural as opposed to urban life, or indeed in the context of the public world of Rouen and Paris contrasted with the private world of Eragny-sur-Epte. Younger critics, such as George Lecomte, Octave Mirbeau and Gustave Geffroy, saw the artist as someone whose works revealed universal truths.

Despite suffering from the eye condition dacryocystitis, Pissarro maintained a large output of work during his last years. He remained active to the very end of his life, frequently travelling to England to visit his eldest son, Lucien, and spending a short period of self-enforced political exile in Belgium in 1894. The financial hardships of the 1870s and 1880s had eased by the end of his life, and his work was beginning to sell well, not only in France, but also in Germany and the USA. Pissarro is buried in the Père Lachaise Cemetery in Paris. The principal collections of Pissarro's oil paintings are in the Musée d'Orsay, Paris, and the Ashmolean Museum, Oxford.

2. Drawings

Until 1870 Pissarro's working methods were strictly traditional in their progression from preparatory drawings and oil sketch to the finished picture. After this date, with the advent of the more spontaneous style adopted by the Impressionists, Pissarro only rarely used the oil sketch. He continued to rely on drawing, however, as a means of accumulating visual data and evolving his compositions. Like Manet, Degas and Cézanne, he was a prolific draughtsman, and a large number of drawings from each decade of his working life have survived. In compositions such as *The Harvest* (1882; Tokyo, N. Mus. W. A.), in which the human figure is emphasized, preparatory drawings played a particularly important role. Pissaro also made more finished drawings for sale, along with watercolours, pastels and painted fans, especially during his Neo-Impressionist phase when he produced fewer paintings. Such works commanded less exalted prices than oil paintings and could be sold more easily. Essentially Pissarro regarded drawing as a discipline of the eye and hand, but between 1885 and 1890 he often adopted watercolour as an antidote to the more restricted technique of pointillism.

The relationship between the preparatory process and the finished work is central to any discussion of Impressionist painting, and the fact that an artist such as Pissarro made drawings so consistently suggests it was through drawings rather than by painting directly on to the canvas that he was able to transmit the feelings he experienced before nature. Drawings were therefore of prime importance as the agents of spontaneity. There is an extensive collection of his drawings, with sheets dating from all periods of his life, in the Ashmolean Museum, Oxford.

3. Prints

Pissarro was one of the most original and prolific printmakers of the second half of the 19th century. Certainly he was the most prolific printmaker among the Impressionists. His graphic oeuvre falls into three phases: before c. 1879; c. 1879–82; mid-1880s and after. Up to c. 1879 his prints (mostly etchings but also some lithographs) were strictly traditional in the manner of the Barbizon school. Although he became a member of the Société des Aquafortistes in 1863, Pissarro never exhibited with them, and during the later 1870s he became more interested in unorthodox printing methods.

The second phase (c. 1879–82) was the most innovative and was inspired by Degas, with whom he collaborated on a projected journal (*Le Jour et la nuit*) intended to promote the sale of original prints. Such prints as *Landscape under the Woods at l'Hermitage, Pontoise*; *Horizontal Landscape*; *Twilight with Haystacks* and *Rain Effect* (all 1879; see Delteil, 1923) are complex works both in terms of the mixed process used to produce them and in the attempt to create a series of impressions suggesting the fluctuations of nature. *Twilight with Haystacks* was realized in three states, which exist in a number of impressions, some of them printed in colour. Each impression was carefully annotated by Pissarro (one or two were printed by Degas), so that each image in the sequence has a visual integrity of its own, thus eschewing the traditional hierarchical progression leading to a final state. The annotations themselves were often idiosyncratic, including such terms as *épreuve d'artiste*, *épreuve définitive*, *épreuve de choix*. During this second phase etching and drypoint were still used for outline, while a host of different techniques, such as soft-ground, aquatint and granular resins containing salt and sugar, were deployed to create a wide range of tonal effects. Some of these techniques were traditional but applied in unorthodox ways, others totally novel. The emphasis was on experimentation, so that accidents or imperfections were turned to advantage in creating effects of light and texture. The exact process by which some of these prints were made is often difficult to discern. It is now widely acknowledged that printmaking acquired a different status as a result of this concern for the purely creative aspects of the art, whereby each print became a work of art in its own right instead of merely reproducing other works of art. The new-found freedom resulting from the commingling of techniques allowed Pissarro and Degas to obtain atmospheric effects that in general pertained to Impressionist principles and perfectly complemented their paintings of these years.

In the third phase, which began in the mid-1880s, Pissarro moved away from Degas's experimental methods (although he continued to make monotypes) and concentrated instead on producing prints more suitable for sale, often with a topographical emphasis. Having previously relied on professional printers, Pissarro obtained his own press in 1894. This final phase is also notable for the return to lithography, undoubtedly encouraged by print publishers such as André Marty and Ambroise Vollard. Pissarro included his prints in the 1880 and 1886 Impressionist exhibitions, and he also participated in the various exhibitions of the Peintres-graveurs organized by Durand-Ruel during the 1880s and by Vollard during the 1890s. The finest collection of Pissarro's prints is in the Bibliothèque Nationale, Paris, originally presented by the artist to the Musée du Luxembourg. Other important collections are in the Ashmolean Museum, Oxford, the Museum of Fine Arts, Boston, and the New York Public Library.

4. Dealers and collectors

Pissarro experienced considerable financial hardship for most of his life. His uncompromising style and treatment of subject-matter meant that he failed to find buyers for his paintings at the Salon, and there was no ready-made alternative market for his pictures. Although he was dependent on Durand-Ruel, a major dealer, from an early date, such smaller dealers as Père Martin, Henri de Louis Latouche and Portier also bought his works intermittently. It was Durand-Ruel, however, who, sometimes at considerable financial risk, supported Pissarro more whole-heartedly than anyone else by buying his works for stock, arranging one-man exhibitions and promoting the sale of his pictures in England, Germany and the USA. Only

towards the very end of his life did the artist enter into detailed negotiations with a rival dealer, Bernheim-Jeune, although during the 1880s a further outlet for his pictures was provided by Georges Petit, and Goupil-Boussod & Valadon. The first collectors of Pissarro's works were fellow artists, critics and members of other professions related to the arts. Degas, Gauguin and Gustave Caillebotte owned works by Pissarro, as did Duret and the opera singer Jean-Baptiste Faure. Collectors including Eugène Mürer, an ex-pastry cook and hotelier, and the Romanian Georges de Bellio, who was Pissarro's homeopathic doctor, often received works of art as payment. Pissarro's name also occurs among the early Impressionist sales dating from the 1870s. Perhaps the most discerning collectors in France were Antonin Personnaz, Dr Georges Viau and Etienne Moreau-Nélaton. Towards the end of his life Pissarro also attracted the attention of local collectors, such as Edouard Décap and Félix François Depeaux of Rouen, or Pieter Van de Velde of Le Havre.

After Pissarro's death, much of his work was divided among his family, but a studio sale was held in the Hôtel Drouot, Paris, on 25 June 1906. On his wife's death in 1926, there were two further, larger sales of both Pissarro's work and of his collection of work by other artists (Galerie Georges Petit, 3 Dec 1928 and Hôtel Drouot, 12–13 April 1929). The sale of the collection of Alexandre Bonin (Hôtel Drouot, 26 June 1931), the artist's son-in-law, was also significant.

Unpublished sources

Paris, Hôtel Drouot, 21 Nov 1975, Camille Pissarro archives

Writings

A. Tabarant, ed.: *Pissarro* (London, 1925) [lett. to Duret and Mürer]

J. Rewald, ed.: *Camille Pissarro: Letters to his Son Lucien* (New York, 1944, rev. London, 4/1980)

J. Bailly-Herzberg, ed.: *Correspondance de Camille Pissarro: 1865–1894*, 3 vols (Paris, 1980–88)

Bibliography

early sources

J.-K. Huysmans: *L'Art moderne* (Paris, 1883); as *L'Art moderne/Certains* (Paris, 1975) [incl. *Certains*]

T. Duret: *Critique d'avant-garde* (Paris, 1885), pp. 7–8, 75–80

J.-K. Huysmans: *Certains* (Paris, 1889); as *L'Art moderne/Certains* (Paris, 1975) [incl. *L'Art moderne*]

G. Lecomte: 'Camille Pissarro', *Hommes Aujourd'hui*, viii (1890)

G. Moore: *Modern Painting* (London, 1893), pp. 84–90

G. Geffroy: 'Histoire de l'Impressionnisme' and 'Camille Pissarro', *Vie Artistique*, iii (1894), pp. 1–53, 96–110

——: 'L'Art d'aujourd'hui: Camille Pissarro', *Vie Artistique*, vi (1900), pp. 174–85

W. Dewhurst: *Impressionist Painting* (London, 1904), pp. 49–56

G. Moore: *Reminiscences of the Impressionist Painters* (Dublin, 1906), pp. 39–41

T. Duret: *Manet and the French Impressionists* (Philadelphia, 1910), pp. 126–36

O. Mirbeau: *Des Artistes* (Paris, 1922–4), pp. 39–45, 145–53

T. Natanson: *Peints à leur tour* (Paris, 1948), pp. 59–63

E. Zola: *Salons*, ed. F. W. J. Hemmings and R. J. Niess (Paris, 1959)

F. Fénéon: *Oeuvres plus que complètes*, ed. J. U. Halperin, 2 vols (Geneva, 1970)

E. Zola: *Le Bon Combat de Courbet aux Impressionnistes*, ed. J.-P. Bouillon (Paris, 1974)

catalogues raisonnés

L. Delteil: 'Pissarro, Sisley, Renoir', *Le Peintre-graveur illustré*, xvii (Paris, 1923)

J. Cailac: 'The Prints of Camille Pissarro: A Supplement to the Catalogue by Loys Delteil', *Prt Colr Q.* (Jan 1932), pp. 74–86

L.-R. Pissarro and L. Venturi: *Camille Pissarro: Son art et son oeuvre*, 2 vols (Paris, 1939)

B. Shapiro and M. Melot: 'Catalogue sommaire des monotypes de Camille Pissarro', *Nouv. Est.*, xix/1 (1975), pp. 16–23

R. Brettell and C. Lloyd: *A Catalogue of Drawings by Camille Pissarro in the Ashmolean Museum, Oxford* (Oxford, 1980)

J. Leymarie and M. Melot: *The Graphic Works of the Impressionists* (London, 1980)

monographs, exhibition catalogues, symposia and collections of essays

Exposition Camille Pissarro, organisée à l'occasion de la naissance de l'artiste (exh. cat., Paris, Mus. Orangerie, 1930)

J. Rewald: *Camille Pissarro* (New York, 1963)

Loan Exhibition C. Pissarro (exh. cat., New York, Wildenstein's, 1965)

A. Boulton: *Camille Pissarro en Venezuela* (Caracas, 1966)

Pissarro in England (exh. cat., London, Marlborough F.A., 1968)

Camille Pissarro: The Impressionist Printmaker (exh. cat. by B. Stern Shapiro, Boston, MA, Mus. F.A., 1973)

R. Brettell: *Pissarro and Pontoise: The Painter in a Landscape* (New Haven, 1977; 2nd edn New Haven and London, 2/1990)

K. Adler: *Camille Pissarro: A Biography* (London, 1978)

R. Shikes and P. Harper: *Pissarro: His Life and Work* (New York, 1980)

Homage to Camille Pissarro: The Last Years, 1890–1903 (exh. cat., Memphis, TN, Dixon Gal., 1980)

Artists, Writers, Politics: Camille Pissarro and his Friends (exh. cat., Oxford, Ashmolean, 1980–81)

Camille Pissarro, 1830–1903 (exh. cat., London, Hayward Gal.; Paris, Grand Pal.; Boston, MA, Mus. F.A.; 1980–81) [contains one of the fullest and most accurate bibliogs on the artist]

C. Lloyd: *Camille Pissarro* (Geneva, 1981)

Retrospective Camille Pissarro (exh. cat., Tokyo, Isetan Mus. A.; Fukuoka, A. Mus.; Kyoto, Mun. Mus. A.; 1984)

C. Lloyd, ed.: *Studies on Camille Pissarro* (London, 1986)

The Impressionist and the City: Pissarro's Series Paintings (exh. cat. by R. Brettell and J. Pissarro, Philadelphia, PA, Mus. A.; Dallas, TX, Mus. A.; London, RA; 1992–3)

specialist studies

B. Nicolson: 'The Anarchism of Camille Pissarro', *The Arts* [London], i/11 (1946), pp. 43–51

R. Coe: 'Camille Pissarro in Paris: A Study of his Later Development', *Gaz. B.-A.*, n. s. 6, xliii (1954), pp. 93–118

—: 'Camille Pissarro's *Jardin des Mathurins*, an Inquiry into Impressionist Composition', *Nelson Gal. Atkins Mus. Bull.*, iv (1963), pp. 1–22

L. Nochlin: 'Camille Pissarro: The Unassuming Eye', *ARTnews*, lxiv (1965), pp. 24–7, 59–62; rev. in *Studies on Camille Pissarro*, ed. C. Lloyd (London, 1986), pp. 1–14

T. Reff: 'Pissarro's Portrait of Cézanne', *Burl. Mag.*, cix (1967), pp. 626–33

C. Lloyd: 'Camille Pissarro and Hans Holbein the Younger', *Burl. Mag.*, cxvii (1975), pp. 722–6

B. Shapiro and M. Melot: 'Catalogue sommaire des monotypes de Camille Pissarro', *Nouv. Est.*, xix/1 (1975), pp. 16–23

M. Melot: 'La Pratique d'un artiste: Pissarro graveur en 1880', *Hist. & Crit. A.*, 11 (1977), pp. 14–38; Eng. trans. as 'Camille Pissarro in 1880: An Anarchist Artist in Bourgeois Society', *Marxist Persp.*, 11 (1979–80), pp. 22–54

M. Reid: 'Camille Pissarro: Three Paintings of London. What Do they Represent?', *Burl. Mag.*, cxix (1977), pp. 251–61

A. Thorold: 'The Pissarro Collection in the Ashmolean Museum, Oxford', *Burl. Mag.*, cxx (1978), pp. 642–5

C. Lloyd: 'Camille Pissarro and Japonisme', *Japonisme in Art: An International Symposium: Tokyo, 1980*

B. Thomson: 'Camille Pissarro and Symbolism: Some Thoughts Prompted by the Recent Discovery of an Annotated Article', *Burl. Mag.*, cxxiv (1982), pp. 14–23

R. Thomson: 'Camille Pissarro, "Turpitudes Sociales" and the Universal Exhibition of 1889', *A. Mag.*, lvi (1982), pp. 82–8

A. Lant: 'Purpose and Practice in French Avant-garde Print-making of the 1880s', *Oxford A. J.*, vi (1983), pp. 18–29

R. Thomson: 'The Sculpture of Camille Pissarro', ii/4, *Source* (1983), pp. 25–8

C. Lloyd: 'The Market Scenes of Camille Pissarro', *A. Bull. Victoria*, xxv (1985), pp. 17–32

—: 'Reflections on La Roche-Guyon and the Impressionists', *Gaz. B.-A.*, n. s. 6, cv (1985), pp. 37–44

J. House: 'Camille Pissarro's "Seated Peasant Woman": The Rhetoric of Inexpressiveness', *Essays in Honour of Paul Mellon, Collector and Benefactor* (Washington, DC, 1986), pp. 155–71

(2) Lucien Pissarro

(*b* Paris, 20 Feb 1863; *d* Hewood, Dorset, 10 July 1944). Painter, printmaker and typographical designer, son of (1) Camille Pissarro. His father played a prominent role in his formation as an artist. Lucien's chief contribution as a painter was his blending of French and English stylistic tendencies. Several early works are in the Neo-Impressionist style and were included in the exhibition organized by the Société des Artistes Indépendants in Paris until his resignation in 1896, and by Les XX in Brussels.

Lucien moved permanently to England in 1890 and married Esther Bensusan two years later, setting up house in Epping and then Chiswick, near London. His style remained firmly based on accurate drawing and subtle colour and changed little during the course of his life. He frequently painted English subjects but also made regular journeys to France, visiting especially the south from the early 1920s onwards. His inside knowledge of Impressionism and Post-Impressionism ensured him an influential position in the English

art world, and he became involved in turn with the New English Art Club, the Fitzroy Street Group and the Camden Town Group, forming close friendships with Walter Sickert, J. B. Manson and the critic Frank Rutter.

Lucien's career as an illustrator, designer and printer of books ran parallel to his work as a painter and was perhaps of greater significance. In 1884 he studied wood-engraving with Auguste Lepère, and from an early date his illustrations were accepted for publication by French and English journals. He was also profoundly influenced by the work of the Pre-Raphaelites and English illustrators, such as Charles Keene and Walter Crane.

After meeting Charles Ricketts and Charles Shannon shortly after his move to England, Lucien founded the Eragny Press (1894) in the tradition of William Morris, printing his books at first on the Vale Press (1896–1903). After designing his own typeface (Brook type), he set up a press in 1902 at The Brook, Stamford Brook Road, Chiswick, where he lived until 1939. The Eragny Press issued 32 books in Brook type between 1903 and 1914. His wife often collaborated with him, especially in the engraving or cutting of blocks and in the running of the Eragny Press. Some early work is signed L. Vellay (his mother's maiden name). An extensive collection of his work is in the Ashmolean Museum, Oxford, where it was presented together with the artist's papers by his widow in 1950.

Writings

A. Thorold, ed.: *The Letters of Lucien to Camille Pissarro, 1883–1903* (Cambridge, 1993)

Bibliography

J. Rewald, ed.: *Camille Pissarro: Letters to his Son Lucien* (New York, 1944, rev. London, 4/1980)

W. S. Meadmore: *Lucien Pissarro: Un Coeur simple* (London, 1962)

J. Bensusan-Butt: *The Eragny Press, 1894–1914: Short-title List with Notes* (Colchester, 1973)

A. Thorold: 'The Pissarro Collection in the Ashmolean Museum, Oxford', *Burl. Mag.*, cxx (1978), pp. 642–5

——: *A Catalogue of the Oil Paintings of Lucien Pissarro* (London, 1983)

C. Lloyd: 'An Uncut Wood-block by Lucien Pissarro', ii/4, *Prt Q.* (1985), pp. 309–14

——: 'A New Acquisition for the Pissarro Archive in Oxford', v/2, *Prt Q.* (1988), pp. 152–9

CHRISTOPHER LLOYD

Point, Armand

(*b* Algiers, 23 March 1861; *d* Marlotte, Seine-et-Marne, March 1932). French painter and designer. He began his career painting the Algerian scenes of his youth, rendering Orientalist subjects—such as markets and musicians—with a distinctive, unaffected precision. In 1888 he went to Paris to study at the Ecole des Beaux-Arts under Auguste Herst (*b* 1825) and Fernand Cormon. He exhibited at the Société Nationale des Beaux-Arts from 1890.

The discovery of Ruskin and the Pre-Raphaelites, and a visit to Italy in 1894, led Point to model his work on the artists of the Florentine Renaissance. The inspiration of Botticelli and Leonardo can be seen in such works as the *Eternal Chimera* (*c*. 1895; London, Piccadilly Gal.). Under the dominating influence of Gustave Moreau, his work was also aligned with Symbolism. He became a disciple of Rosicrucianism and a friend of Sâr Peladan, fastidiously rejecting the modern industrial world and what he considered the excessive realism of Zola or Courbet. He painted magicians, endowed with a pure and ancient beauty, or figures of Greek mythology (e.g. *The Siren*, 1897; London, Piccadilly Gal.). He exhibited at the Salon de la Rose Croix from 1892 to 1896. Between 1896 and 1901 he lived in Marlotte, where, in the spirit of William Morris, he set up the Atelier de Haute-Claire, producing jewellery, furniture, wallpaper, fabrics and, above all, highly sought-after ceramics. He also painted many Italian landscapes, studies of flowers and animals and, following the nearby Barbizon school, highly stylized rural scenes.

Bibliography

French Symbolist Painters (exh. cat., ACGB, 1972), pp. 97–9

COLETTE E. BIDON

Pompon, François

(*b* Saulieu, Côte d'Or, 9 May 1855; *d* Paris, 6 May 1933). French sculptor and medallist. He was the

son of a carpenter and first studied at the Ecole des Beaux-Arts in Dijon. In 1875 he travelled to Paris, where he worked as a jobbing sculptor, whilst pursuing his studies at the Ecole des Arts Décoratifs under the sculptors Aimé Millet and Joseph-Michel Caillé (1836–81); there he also met the *animalier* sculptor Pierre-Louis Rouillard (1820–81). At the Salon of 1888 Pompon exhibited *Cosette* (plaster; Paris, Mus. Victor Hugo), inspired by Hugo's *Les Misérables*. However, until 1914 his livelihood was gained as a sculptor's assistant. In this capacity he served many of the prominent sculptors of the day, including Rodin. It was his long-term employment with Charles-René Paul de de Saint Marceaux that furnished him with the means to pursue his own career as a sculptor of animals. His studies of animals in the open air began in earnest in 1902, but it was only in 1923 with the exhibition of his *Polar Bear* (marble; Dijon, Mus. B.-A.) at the Salon d'Automne, that Pompon was acclaimed for his refined simplification of nature. His ability to contain the essential character of creatures in smooth and abbreviated form parallels the more audacious abstraction of Brancusi. The *c.* 300 works that Pompon left to the French State were eventually installed in the Musée des Beaux-Arts, Dijon, in 1948. The Musée d'Orsay, Paris, has a large collection of Pompon's plaster models.

Bibliography

François Pompon: Sculpteur animalier bourguignon (exh. cat., Dijon, Mus. B.-A., 1964)

A. Pingeot, A. Le Normand-Romain and L. de Margerie: *Musée d'Orsay: Catalogue sommaire illustré des sculptures* (Paris, 1986), pp. 209–24

La Sculpture française au XIXème siècle (exh. cat. by A. Pingeot, Paris, Grand Pal., 1986), p. 408, fig. 340

François Pompon (1855–1933) (exh. cat. by C. Chevillet, L. Colas, A. Pingeot (in collaboration with L. de Margerie), Dijon, Mus. B.-A., Paris; 1994)

PHILIP WARD-JACKSON

Ponscarme, (François-Joseph-)Hubert

(*b* Belmont-les-Monthureux, Vosges, 20 May 1827; *d* Malakoff, Hauts-de-Seine, 28 Feb 1903). French medallist and sculptor. He came of a peasant family; having at an early age shown a talent for engraving, he gained in 1850 a scholarship to the Ecole des Beaux-Arts, Paris, where he trained under Eugène Oudiné and Augustin-Alexandre Dumont. Ponscarme received his first official commission, for a portrait medal of *Napoleon III*, in 1854, and from 1857 he exhibited regularly at the Salon. The prize medal that he executed for the Exposition Universelle in Paris of 1867 was very well received; the following year, for the Académie des Inscriptions, he modelled an innovative medal of *Joseph Naudet* (London, BM), which, with its matt background and suppression of the customary rim, proved very influential. In 1871 he became professor of medal engraving at the Ecole des Beaux-Arts, where his pupils included Oscar Roty, Jean-Baptiste Daniel-Dupuis, Ovide Yencesse (1869–1947) and Alexandre Charpentier. Ponscarme's work consisted mainly of cast portrait medallions, but he also made a number of struck medals, as well as several busts in marble and bronze.

Bibliography

Bellier de la Chavignerie–Auvray; Forrer; Lami

P. Chevreux: 'Hubert Ponscarme', *Gaz. Numi. Fr.* (1907), pp. 209–65

MARK JONES

Popelin, Claudius(-Marcel)

(*b* Paris, 2 Nov 1825; *d* Paris, 17 May 1892). French enameller, painter and writer. He was a pupil of François-Edouard Picot until 1846 and of Ary Scheffer from 1848 to 1858. He began his career as a history painter, and from 1852 to 1862 he sent paintings based on French and Italian Renaissance subjects to the Salon; from 1860, however, his study of the 16th century inclined him towards the decorative arts. He translated Cipriano di Michele Piccolpasso's *Li tre libri dell'arte del vasaio* (1556–9) and, though initially producing faience, he preferred the delicate technique of painting on enamel, which he learnt from Alfred Meyer (1832–1904). Working in the tradition of the 16th-century Limosin family, from 1863 he devoted the next 30 years to the art of enamelling. His first

works have intense colours enhanced by the sparkle of silver foil beneath and are notable for the backgrounds coloured with a violet of his own invention. He liked to assemble several enamel plaques together within the same frame to develop a single allegorical or historical theme, as in the portrait of *Napoleon III* (1865; Paris, Mus. d'Orsay), which also includes portraits of Charlemagne, Napoleon I and others. His masterpiece, *Triumph of Truth* (1.7×1.5 m, exh. Salon 1867; untraced), consisted of portraits of 12 philosophers arranged around the central figure. His success resulted in orders from manufacturers, and his enamels were used to decorate furniture, bronzes, silver and gold objects and bookbinding plates. Popelin was an erudite artist, a bibliophile and a poet and was one of the circle of artists who met at the salons of Princess Mathilde Bonaparte. He popularized the art of enamelling through several theoretical essays. With the help of photography, after 1870 he adopted the more subtle technique of enamelling in gold grisaille to execute a series of portraits of contemporary celebrities (e.g. *Baron Hippolyte Lazzey*, 1890; Paris, Mus. d'Orsay). A retrospective of Popelin's work was organized at the Musée des Arts Décoratifs in Paris in 1892.

Writings

trans.: C. Piccolpasso: *Li tre libri dell'arte del vasaio* (MS., 1556–9) as *Les Troys Libres de l'art du pottier*, 3 vols (Paris, 1860)
L'Email des peintres (Paris, 1866)
L'Art de l'émail (Paris, 1868)
Les Vieux Arts du feu (Paris, 1869)

Bibliography

L. Falize: 'Claudius Popelin et la renaissance des émaux peints', *Gaz. B.-A.*, n. s. 2, ix (1893), pp. 502–18; x (1893), pp. 60–76
P. de Bouchaud: *Claudius Popelin: Peintre, émailleur et poète* (Paris, 1894)

MARC BASCOU

Pradier, James [Jean-Jacques]

(*b* Geneva, 23 May 1790; *d* Bougival, 4 June 1852). Swiss sculptor, painter and composer. Prompted by his early displays of artistic talent, Pradier's parents placed him in the workshop of a jeweller, where he learnt engraving on metal. He attended drawing classes in Geneva, before leaving for Paris in 1807. By 1811 he was registered at the Ecole des Beaux-Arts and subsequently entered its sculpture competitions as a pupil of François-Frédéric, Baron Lemot. A more significant contribution to his artistic formation around this time was the guidance of the painter François Gérard. Pradier won the Prix de Rome in 1813 and was resident at the French Academy in Rome, from 1814 until 1819. On his return to France, he showed at the Salon of 1819 a group *Centaur and Bacchante* (untraced) and a reclining *Bacchante* (marble; Rouen, Mus. B.-A.). The latter, borrowing an erotically significant torsion from the Antique Callipygean Venus, opens the series of sensuous Classical female subjects that were to become Pradier's forte. In *Psyche* (marble, 1824; Paris, Louvre) new ingredients were added to Pradier's references to the Antique. The critic and theorist Toussaint-Bernard Emeric-David detected in it 'a sort of Florentine grace' and a reminiscence of the 16th-century sculptor Jean Goujon. The sophisticated posture and coiffure, and the contrast between flesh and elaborately involved and pleated drapery, are features that recur in most of Pradier's female subjects.

The government of the restored Bourbons (1815–30) conferred on Pradier a number of prestigious commissions, notably a marble monument to *Jean, Duc de Berry*, for the Cathedral of Versailles (1821–3), and a marble relief for the Arc de Triomphe du Carrousel (1828–31), Paris. As early as 1827 he was made a member of the Institut and Professor at the Ecole des Beaux-Arts. This recognition did not secure him automatic preference in official commissions. His project for the pediment of the Madeleine (1828–9), for example, was turned down in favour of one by Henri Lemaire. At all stages Pradier was strenuous in his pursuit of state commissions. After 1834 his efforts in this direction were to be powerfully abetted by the journalism of Victor Hugo. Notoriously apolitical, Pradier found no difficulty in adapting himself to whatever regime happened to be in power, an adaptability which, by the 1848 Revolution, began to look cynical.

Approval of Pradier's art by the July Monarchy (1830–48) was shown after the Salon of 1831, when Louis-Philippe purchased his *Three Graces* (marble; Paris, Louvre). This group invited comparison with works on the same theme by Canova and Bertel Thorvaldsen and was an unmistakable gesture of loyalty to the tenets of Neo-classicism at the start of the decade that witnessed the emergence of a Romantic style in sculpture. But Pradier, who has been seen as the 'Ingres of sculpture', was no doctrinaire. An area in which he showed particular sympathy with the aspirations of his more overtly Romantic contemporaries was the production of models for statuettes and for figures adaptable for ornamental use. The firms chiefly involved in diffusing his output in this line were the *maison d'éditions* Susse Frères and the founder Salvator Marchi. In his group *Satyr and Bacchante* (marble; Paris, Louvre), shown at the Salon of 1834, Pradier revived in monumental form the explicitly sexual subject-matter of the 18th century. Such erotic motifs frequently occur among Pradier's statuettes. Sometimes their subjects are mythological, as in the undulating *Leda and the Swan* (plaster; Geneva, Mus. A. & Hist.). In other works Pradier introduced a more novel type of voyeuristic genre, as in *Woman with a Cat* (plaster, *c.* 1840; Geneva, Mus. A. & Hist.) or *Woman Putting on a Stocking* (bronze, 1840; Paris, Mus. A. Déc.). The series of Pradier's life-size female statues culminates in the *Nyssia* (marble, 1848; Montpellier, Mus. Fabre) and in the seated *Sappho* (marble; Paris, Mus. d'Orsay; see col. pl. XXIX) exhibited at the Salon of 1852, the first illustrating a modern text, Théophile Gautier's *Roi Candaule*, the second bringing a note of 'modern' melancholy to the treatment of a subject already popularized by Pradier's Neo-classical forebears, the painters Antoine-Jean Gros and Anne-Louis Girodet.

Pradier played a major role in many of the ambitious decorative schemes of the July Monarchy, in particular at the Madeleine and the Palais Bourbon. For the tomb of *Napoleon I* at the Invalides he contributed the 12 severe Victories surrounding the sarcophagus (1843–52). For Louis-Philippe's historical galleries at Versailles he executed a number of statues and busts. However, his initially cordial relations with the Orléans family were soured by accusations of commercialism aimed at him by the painter Ary Scheffer. They may also have been adversely affected by Pradier's reputation as a philanderer, a myth that his correspondence, published in 1984, goes far to dispel. However, in the annals of Romanticism, Pradier the dandy and party-giver has tended to eclipse Pradier the artist.

Despite aspersions cast by critics on the correctness of Pradier's treatment of myth, he remained the leading classical sculptor of his day and exerted a strong influence in the 1840s and 1850s, when a reaction to the turbulent styles of Romanticism prevailed. The combination of the archaeological and the hedonistic characterizing the classical sculpture of the Second Empire (1851–1870) took its main direction from him.

Throughout his life, Pradier remained in close contact with his birthplace. In 1830 he obtained a commission from the town for a bronze statue of *Jean-Jacques Rousseau* (Geneva, Ile Rousseau), a task previously offered to Canova. Pradier's monument was unveiled in 1835. The Musée d'Art et d'Histoire houses an extensive collection of works by Pradier, most of which were acquired after his death. These include oil sketches that indicate an ambition to paint grand mythological subjects, but, of the paintings that Pradier showed at the Salon, only a fragment of a *Descent from the Cross* (exh. 1838; Geneva, Mus. A. & Hist.) survives. A more intimate and colouristic aspect of Pradier's painting may be glimpsed in the *Virgin and Child* (1836; Besançon, Mus. B.-A. & Archéol.), supposed to be a portrait of his wife and baby son.

Writings
D. Siler, ed.: *James Pradier: Correspondance*, 2 vols (Geneva, 1984)

Bibliography
Lami

A. Etex: *James Pradier: Etude sur sa vie et ses ouvrages* (Paris, 1859)

Romantics to Rodin (exh. cat., ed. P. Fusco and H. Janson; Los Angeles, Co. Mus. A., 1980)

Statues de chair: Sculptures de James Pradier (exh. cat., ed. J. de Caso; Geneva, Mus. A. & Hist.; Paris, Luxembourg Pal.; 1985–6)

La Sculpture française au XIXe siècle (exh. cat., ed. A. Pingeot; Paris, Grand Pal., 1986)

PHILIP WARD-JACKSON

Préault, Auguste [Antoine-Augustin]

(*b* Paris, 9 Oct 1809; *d* Paris, 11 Jan 1879). French sculptor. He was born in the working-class Marais district of Paris and was apprenticed to an ornamental carver. He later trained in the studio of Pierre-Jean David d'Angers. His first serious sculptural essays were mostly portrait medallions in the manner of David d'Angers. There is also record of an early relief entitled *Two Slaves Cutting the Throat of a Young Roman Actor*, said to have belonged to Daumier. By the time of his Salon début in 1833, Préault was immersed in the socially conscious subject-matter favoured by the liberal Romantics among whom he moved. His 1833 exhibits were *Two Poor Women, Beggary* and *Gilbert Dying in the Hospital* (all destr.). In 1834 his *Pariahs* (also destr.) was refused, presumably because of its pointed social comment, unacceptable in the bourgeois atmosphere of the July monarchy (1830–48). However, his tumultuous plaster relief *Slaughter* (bronze version, 1854; Chartres, Mus. B.A.) with its emphasis on extreme physical and emotional states was accepted. All these works were broadly and rapidly executed, with bold forms and daring compositions and subjects. Stylistically, they derived less from Préault's teachers and contemporaries than from Michelangelo and his French followers of the 16th and 17th centuries, Germain Pilon, Jean Goujon and Pierre Puget.

The uncompromising nature of Préault's subject-matter and expression caused him to be excluded by the increasingly conservative Salon juries until 1849 (except in 1837, when his *Head of an Old Man*, made several years earlier, was shown). During this time he tried to make his sculpture more widely acceptable by ameliorating his style, as in *Ondine* (1834; Parc de la Bouzaise, Beaune); by choosing more conventional subjects, such as

the *Adoration of the Magi* (1838; destr.); and by giving old works new and less controversial titles: *Despair* (1834; destr.), for example, became *Hecuba*. For a while he was kept from starvation only by minor private commissions, but he began to be patronized by the government in 1838, when he received commissions for a stone statue of St Martha now in the Hôpital Pozzi, Bergerac, and a *Crucifixion* (wood; Paris, St Gervais-St Protais). He turned increasingly to literary and fantastic Romanticism in such works as *Ophelia* (plaster, 1842; bronze, 1876; Paris, Mus. d'Orsay) the stone relief of *Silence* (1842) for the Robles tomb in Père Lachaise cemetery, Paris (bronze, 1848; Auxerre, Mus. A. & Hist.) and *Dante and Virgil in Hell* (wax sketch, c. 1853; Chartres, Mus. B.-A.).

In the more liberal atmosphere after the revolution of 1848 Préault was again able to exhibit at the Salon. In 1849 he was awarded a second-class medal that exempted him from future judgement by the jury. Although he exhibited in 1850–51 and 1853, he abstained from the Salon for the decade up to 1863, perhaps as a form of revenge. During this period he received a series of commissions, both public and private. The most notable of the latter were tomb decorations in the Paris cemeteries. Although Préault continued to create portrait medallions and small-scale works, he was also commissioned to produce a number of public monuments. These included *Marceau* (1850) in the Place des Epars, Chartres, the *Gallic Horseman* (1849) on the Pont d'Iéna, Paris, and *Jacques Coeur* (1873) in the Place Jacques Coeur, Bourges.

Préault's fidelity to the Romantic ideals of 1830 increasingly made him an anachronism, and he became better known for his colourful personality, his vivacious presence at theatres and cafés, and his mordant wit than for his work. Nevertheless, his best pieces never failed to exemplify the vigorous style that made him the epitome of the Romantic sculptor and a remarkable precursor of Rodin. It was David d'Angers's opinion that 'if the jury had not always rejected him, France would assuredly have had a new Puget'.

Bibliography

Lami

T. Silvestre: 'Préault', *Histoire des artistes vivants français et étrangers* (Paris, 1856), pp. 281–303

E. Chesneau: 'Auguste Préault', *L'Art*, xvii/2 (1879), pp. 3–15

J. Locquin: 'Un Grand Statuaire romantique, Auguste Préault, 1809–1879', *Ren. A. Fr. & Indust. Luxe*, iii/11 (1920), pp. 454–63

D. Mower: 'Antoine Augustin Préault (1809–1879)', *A. Bull.*, lxiii/2 (1981), pp. 288–307

H. W. Janson: *Nineteenth Century Sculpture* (New York, 1985)

La Sculpture française au XIXe siècle (exh. cat., Paris, Grand Pal., 1986), nos 191, 196, 197, 202, 205, 208

C. Millard: 'Préault's Commissions for the New Louvre: Patronage and Politics in the Second Empire', *Burl. Mag.*, cxxxi/1038 (1989), pp. 623–30

——: 'Two Monuments by Auguste Préault: General Marceau and Jacques Coeur', *Gaz. B.-A.*, n. s. 5, cxviii (1991), pp. 87–101

CHARLES MILLARD

Prud'homme, Georges(-Henri)

(*b* Cap Breton, Landes, 9 Feb 1873; *d* Paris, 11 Feb 1947). French medallist. He studied under Alexandre Falguière and Alphée Dubois (1831–1905) at the Ecole des Beaux-Arts, Paris. His work included a number of plaquettes, such as *Woman at a Spring*, *Child Fishing*, *Thought* and *Hope*: perhaps the most successful of these was *Sailors' Widows*. He also executed numerous portraits, both of contemporaries, including *Edmond Rostand*, *Pierre Loti* and *Henri Poincaré*, and of historical figures such as *Molière* and *Watteau*. Prud'homme contributed substantially to a series of medals showing the traditional costumes of the various provinces of France, and was commissioned to commemorate such events as the *Battle of Verdun* and the *Signing of the Armistice* (1918). Examples of his work are in the Cabinet des Médailles, Bibliothèque Nationale, Paris.

Bibliography

Forrer

Catalogue général illustré des éditions de la Monnaie de Paris, iii (Paris, 1978)

MARK JONES

Puech, Denys [Denis](-Pierre)

(*b* Gavernac, Dec 1854; *d* Rodez, 9 Dec 1942). French sculptor. In 1873, as a scholarship-holder from the département of Aveyron, he entered the Ecole des Beaux-Arts, Paris, where his teachers were François Jouffroy, Henri Chapu and Alexandre Falguière. He won the Prix de Rome in 1884 and was a faithful exhibitor at the Salon of the Société des Artistes Français from 1875 to 1939. From 1898 to 1907 he was attached to the Manufacture Nationale de la Céramique at Sèvres. He was elected to the Institut in 1905 and was the Director of the Villa Medici in Rome between 1921 and 1933. Puech executed numerous busts (frequently of eminent figures) and participated in several decorative schemes but is principally known for his commemorative monuments. Typically these comprise a bust linked to its base with allegorical figures. Often executed in a combination of stone and bronze, they are lively in composition but lack originality. Among his monuments in Paris are those to the explorer *Francis Garnier* (1898; Carrefour de l'Observatoire), the caricaturist *Paul Gavarni* (1904; Place St Georges), the literary critic *Charles-Augustin Sainte-Beuve* and the poet *Leconte de Lisle* (both 1898; Jardin du Luxembourg). Two of his monuments, in Reims, are dedicated to the dead of World War I, but the majority (*c.* 35) were to individuals, among them a few funerary monuments, including one to the sculptor *Antoine Gardet* (1861–91) in the Montparnasse cemetery in Paris.

Bibliography

H. Jaudon: *Denis Puech* (Rodez, 1908)

D. Cady Eaton: *A Handbook of Modern French Sculpture* (New York, 1913), pp. 271–2

L. Taft: *Modern Tendencies in Sculpture* (Chicago, 1923), pp. 31–2

De Carpeaux à Matisse: La Sculpture française de 1850 à 1914 dans les musées et les collections publiques du nord de la France (exh. cat., Calais, Mus. B.-A., 1982), pp. 278–80

PENELOPE CURTIS

Puvis de Chavannes, Pierre(-Cécile)

(*b* Lyon, 14 Dec 1824; *d* Paris, 24 Oct 1898). French painter and draughtsman. He is known primarily

for his large decorative schemes depicting figures in landscape. Although he is generally regarded as a precursor of Symbolism, he was independent of any contemporary movement, and his works appealed to academic and avant-garde artists alike.

1. Life and work

(i) Training and early work, 1824–60. He belonged to a wealthy bourgeois family, and his father, Chief Engineer of the Mines, wanted him to enter the Ecole Polytechnique in Lyon. However, after obtaining his baccalaureate in Paris in 1842, Puvis was obliged to abandon this plan as a result of serious illness. When he had recovered, he spent several months at the Faculté de Droit, Paris, but left in 1846 to undertake a long trip to Italy, which stimulated his interest in art. Following his return in 1847 he studied for several months with Henri Scheffer (1798–1862), and in 1848 he undertook a second journey to Italy with the painter Louis Bauderon de Vermeron (1809–after 1870). He visited Naples, Arezzo, Venice and Rome, and his first known work, *Allegory* (Norfolk, VA, Chrysler Mus.), dates from this time: it bears the inscription *Rome, 1848*.

At the end of 1848 Puvis entered the studio of Eugène Delacroix, only a fortnight before it closed, and then joined Thomas Couture for a few months. Although Puvis is listed in the records of the Salon as the pupil of Scheffer and of Couture, in fact he accomplished his training largely through independent study with a live model, initially on his own and then from 1852 with Alexandre Bida (1813–95), Gustave Ricard and the engraver Victor Pollet (1809/11–82). Drawings in the Musée des Beaux-Arts in Lyon provide examples from this period of study.

Puvis exhibited for the first time at the Salon of 1850, with *Dead Christ* (Cairo, Gazīra Mus.), but in 1852 the three paintings he submitted were all rejected: *Jean Cavalier Playing Luther's Choral for his Dying Mother* (Lyon, Mus. B.-A.), *Portrait of M. de St O* and *Female Study*. A series of paintings (mostly in the keeping of the families of his heirs) from this period demonstrates Puvis's stylistic experimentation, extending from a realism in the manner of Honoré Daumier, for example in the *Reading Lesson* (1850; priv. col., see R. Jullian: 'L'Oeuvre de jeunesse de Puvis de Chavannes', *Gaz. B.-A.* (Nov 1938), p. 241, fig. 4), to a Romanticism in the style of Delacroix in *Mlle de Sombreuil Drinking a Glass of Blood to Save her Father* (1853; untraced, see Boucher, p. 10). He employed dark, violent colours and effects of light in the service of an expressionism that differs greatly from his future style.

In 1854–5 Puvis executed for his brother, Edouard Puvis de Chavannes (1821–63), the decoration of the dining-room at his country house, Le Brouchy, in Champagnat, Saône-et-Loire; it illustrates the theme of the Four Seasons, with a large central composition of the *Return of the Prodigal Son* (see exh. cat., pp. 37–9). Like all his decorative schemes and contrary to what has often been written, this is composed of painted canvas stuck to the wall; the only frescoes he produced are in the service-quarters at Le Brouchy, and these progressively deteriorated. Following this project, decorative paintings became Puvis's main activity. In 1859 Puvis reappeared at the Salon with the *Return from the Hunt* (Marseille, Mus. B.-A.), which is a replica of one of the Le Brouchy panels.

(ii) Decorative schemes and easel paintings, 1861–98. Pursuing his vocation as a decorator, in 1861 Puvis exhibited two large murals (each measuring 3.40×5.55 m), *Peace* and *War*, for which he received the second-class medal in the history section. *Peace* was purchased by the State, and, in order not to separate the two canvases, Puvis donated *War*. Still without any commissions, he produced the complement to this group, *Work* and *Repose*, which he exhibited at the Salon of 1863. Arthur-Stanislas Diet, architect of the Musée Napoléon (now Musée de Picardie) at Amiens, subsequently approached Puvis to obtain the two series for the museum. The first group was loaned by the State, and the second was donated by Puvis. He also executed eight allegorical figures to complete the group. Puvis's first public commission, in 1864, came from the Musée Napoléon for *Ave Picardia Nutrix* (*in situ*). From then on Puvis exhibited regularly at the Salon. The critics were divided

into two fiercely opposed camps: on the one hand, Jules-Antoine Castagnary, Charles Timbal (1821–80), Edmond About and Charles Blanc all reproached him for a lack of subject-matter and realism, for shortcomings in draughtsmanship and the poverty of his palette; on the other hand, Etienne-Jean Delécluze, Théodore de Banville (1823–91), Théophile Gautier and Paul de Saint-Victor (1825–81) praised his decorative approach and his striving to express an ideal world. Puvis's career continued in a succession of commissions, although he possessed a personal fortune that allowed him to live independently without the need to sell his works.

The decorative art of Puvis is characterized by his desire not to pierce the wall but to respect its surface plane and to integrate the painted work with the architecture. He believed the colour should be neither violent nor hard; the material of the wall itself must be retained or, to be more precise, reconstructed. On the basis of this principle, Puvis never allowed himself to become constrained by a formula. Initially he was influenced by Pompeian art and 15th- and 16th-century Italian frescoes, particularly those by Piero della Francesca at S Francesco, Arezzo (c. 1454–66). He was also deeply and directly influenced by the paintings of Théodore Chassériau for the staircase of the Cour des Comptes in Paris (1844–8). Sensitive as well to contemporary art, he lightened his palette under the influence of the Impressionists. Puvis's originality lies in the importance of the role he accorded landscape, set down in extremely simple, broad planes, in which the naked or draped human figure—defined with an economy of brushstroke and invested with an eternal nature—is at the same time a living being, the expression of an abstract idea and an element in the geometric composition. Through their attitudes, the stiff figures respond to one another and animate the surface; this is seen, for example, in *Pleasant Land* (1882; Bayonne, Mus. Bonnat), painted for the staircase of the Paris home of his friend Léon Bonnat.

The materials and style that Puvis employed are intentionally modest: opaque colours, muted shades, an absence of light and shade and minimum modelling. He prepared his canvases with plaster and glue, using blotting paper to remove excess oil from his paints, in a manner that increasingly imitated the appearance of fresco. Although Puvis obtained assistance for the placing of his large paintings, he was himself responsible for the execution of the works.

The iconographic subject-matter that Puvis tackled is more varied than would appear: historical in *The Year 732: Charles Martel Delivers Christendom by his Victory over the Saracens near Poitiers* and *Having Withdrawn to the Convent of Sainte-Croix: Radegonde Shelters the Poets and Protects Literature from the Barbarism of the Age, Seventh Century* (1870–75) for the staircase of the Hôtel de Ville at Poitiers; religious in a panel and triptych depicting the childhood of St Geneviève, surmounted by a frieze of saints (1874–8), for the Panthéon, Paris; and allegorical in the *Sacred Grove*, *Vision of Antiquity*, *Christian Inspiration* and *The Rhône and the Saône* (1884–6) for the staircase of the Musée des Beaux-Arts at Lyon and in *Muses Welcoming the Genius of Enlightenment* and other works (1895–6) for the staircase of the Boston, MA, Public Library. He also executed themes of a regional nature, as in *Massilia, Greek Colony* and *Marseille, Gateway to the Orient* (1867–9) for the ceremonial staircase of the Palais Longchamp in Marseille and in *Pro Patria Ludus* (1880–82) for the staircase of the Musée de Picardie at Amiens. Among his most renowned and important decorative schemes were, in 1893–8, again for the Panthéon, the decoration of four intercolumnar areas with *St Geneviève Keeping Watch over Sleeping Paris* and the *Provisioning of Paris*, as well as a frieze of saints, for which he executed only cartoons and which were completed in 1922 by his pupil Victor Koos (*b* 1864); in 1889–91, for the great amphitheatre at the Sorbonne in Paris, a vast scheme evoking the various disciplines taught there; and in 1891–2, for the Salon du Zodiac of the Hôtel de Ville in Paris, *Summer, Winter* and four corner pieces, and in 1894, for the Prefect's Staircase, the ceiling painting *Victor Hugo Offering his Poetic Talent to the City of Paris*. The only works in which Puvis evoked contemporary fashion are *Inter Artes et*

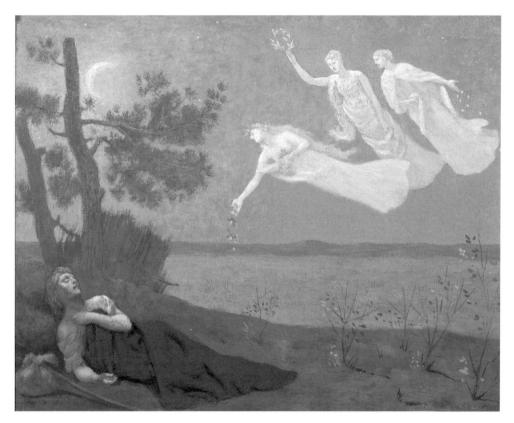

59. Pierre Puvis de Chavannes: *The Dream*, 1883 (Paris, Musée d'Orsay)

Naturum, Ceramics and *Pottery* (1888–91) for the staircase of the Musée des Beaux-Arts in Rouen. Within the limits of a given iconographic programme, Puvis strove to remain master, and he never repeated himself exactly, although certain figures do reappear in several different works. Puvis always made reference to a humanism and system of philosophy of a very traditional nature, which was outmoded for his time. He sought to express simple ideas in an immediately readable form.

Even though Puvis declared the 'true role of painting is to animate walls. Apart from that, one should never create paintings larger than one's hand' (quoted in Vachon, p. 33), his catalogue is not limited to decorative works. Adapting his principles of decoration, he produced a number of easel paintings, most of which were sold through the dealer Paul Durand-Ruel. Among these are works on religious subjects, such as the *Beheading of St John the Baptist* (1869; U. Birmingham, Barber Inst.), the *Magdalene in the Desert* (c. 1869–70; Frankfurt am Main, Städel. Kstinst.) and the *Prodigal Son* (1879; Zurich, Stift. Samml. Bührle). Other works are associated with the Franco-Prussian War of 1870–71: *The Balloon* (1870), the *Carrier Pigeon* (1871; both Paris, Mus. d'Orsay) and the two versions of *Hope* (1872; Paris, Mus. d'Orsay; Baltimore, MD, Walters A.G.). Such works as *Orpheus* (1883; priv. col., see exh. cat., p. 184) and *The Dream* (1883; Paris, Mus. d'Orsay; see fig. 59) are Symbolist in subject. In addition to these commissions, Puvis used the same methods to produce decorative panels, for example *Sleep*

(1867; Lille, Mus. B.-A.), *Summer* (1873) and *Young Girls by the Sea* (1879; both Paris, Mus. d'Orsay; see fig. 60). He also produced some superb portraits: *Eugène Benon* (1882; priv. col., see exh. cat., p. 179), *Princess Marie Cantacuzène* (1883; Lyon, Mus. B.-A.) and a *Self-portrait* (1887; Florence, Uffizi). In *The Poor Fisherman* (1881; Paris, Mus. d'Orsay; see col. pl. XXX) Puvis achieved a great force of expression with minimum means, creating a painting that is neither Realist nor Symbolist but independent of every age and every school.

Puvis produced thousands of drawings, most of them preparatory ones. The majority of these are owned by his heirs, and 1000 were left by his heirs in 1899 to the towns that own his decorative works. His caricatures have a certain force and ferocity; also, from the 1880s he executed numerous pastels.

2. Reputation and influence

Puvis acted frequently as a member of the Salon jury, but disapproving of its intolerance he resigned in 1872 and again in 1881; his painting *Death and the Maidens* (Williamstown, MA, Clark A. Inst.) was submitted in 1872 and rejected. In 1890, together with Ernest Meissonier and Auguste Rodin, he founded the Société Nationale des Beaux-Arts and became its Vice-President, then President in 1896 on the death of Meissonier. Puvis received all the official honours that could be granted to a 19th-century French artist, and the banquet held in his honour in 1895, attended by poets, writers, artists and musicians, was a formal confirmation of the status accorded him by his contemporaries.

The influence of Puvis was enormous. It extended well beyond the studio that he ran, first with Elie Delaunay and then alone, and to which Victor Koos (*b* 1864), Paul Baudouin (1850–1928), Ary Renan, Auguste Flameng (1843–93), Henry Daras (1850–1928), Frédéric Montenard (1849–1926), Georges Clémansin du Maine (1853–after 1896), Emile-Alfred Dezaunay (1854–1938) and Adolf Karol Sandoz (1845–after 1925) all belonged. It extended even beyond such direct imitators as Alphonse Osbert and Alexandre Séon. This influence is supported by the writings and works of a

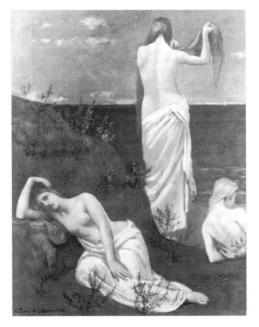

60. Pierre Puvis de Chavannes: *Young Girls by the Sea*, 1879 (Paris, Musée d'Orsay)

wide variety of artists: Edmond Aman-Jean, René Ménard (1862–1930), Henri Martin, as well as Edgar Degas, Paul Gauguin, Georges Seurat, Paul Signac, Odilon Redon, the Nabis with Edouard Vuillard and Maurice Denis and, in the 20th century, Pablo Picasso and Henri Matisse. His influence extended outside France to such artists as Xavier Mellery in Belgium, Vilhelm Hammershøi in Denmark, Ferdinand Hodler in Switzerland, Arthur B. Davies in England and Maurice Prendergast in America. Besides the copying of certain motifs, all these artists were seeking in Puvis a sense of organization of space, a certain type of integration of the human figure and landscape, a sense of gesture and the will to keep the painting on the surface plane.

In 1897 Puvis married Princess Marie Cantacuzène, whom he had met at the home of Chassériau and with whom he had had a relationship since 1856. She died in August 1898, and Puvis, profoundly affected by her death and by two successive accidents of his own, died soon afterwards.

Bibliography

M. Vachon: *Puvis de Chavannes* (Paris, 1895, rev. [1900])

A. Brown Price: *Puvis de Chavannes: A Study of the Easel Paintings and a Catalogue of the Painted Works* (diss., New Haven, CT, Yale U., 1972; microfilm, Ann Arbor and London, 1982)

Puvis de Chavannes (exh. cat., ed. L. d'Argencourt and others; Paris, Grand Pal.; Ottawa, N.G.; 1976–7) [incl. complete bibliog.]

D. W. Druik: 'Puvis and the Printed Image', *Nouv. Est.* (July–Oct 1977), pp. 27–35

M.-C. Boucher: *Palais des Beaux-Arts de la Ville de Paris, Musée du Petit Palais: Catalogue des dessins et peintures de Puvis de Chavannes* (Paris, 1979)

G. Manning Tapley jr: *The Mural Paintings of Puvis de Chavannes* (diss., Minneapolis, U. MN, 1979; microfilm, Ann Arbor and London, 1982)

 MARIE-CHRISTINE BOUCHER

Raffaëlli, Jean-François

(*b* Paris, 20 April 1850; *d* Paris, 11 Feb 1924). French painter, sculptor and printmaker. He turned to painting in 1870, after his early interest in music and theatre, and took the works of Camille Corot, Jean-Léon Gérôme, Ferdinand Roybet and Mariano Fortuny y Marsal as models for his own work. Raffaëlli painted a landscape that was accepted by the Paris Salon jury of 1870. He enrolled in Gérôme's atelier in the Ecole des Beaux-Arts, Paris, in October 1871, but his three months there were his only formal training. Together with a few landscapes the major part of his early production consisted of costume pictures, primarily with subjects in Louis XIII dress, such as *L'Attaque sous bois* (1873; Verdun, Mus. Princerie).

In 1876 Raffaëlli produced a powerful, realistic portrait of a Breton peasant family, the *Family of Jean-le-Boîteux, Peasants of Plougasnou (Finistère)* (Le Quesnoy, Hôtel de Ville), which signalled a new direction in his art. The portrait was praised by the influential critic Louis-Edmond Duranty. By the late 1870s, Raffaëlli's career as a realist artist was launched with the support of Duranty and other critics such as J.-K. Huysmans. At the insistence of Edgar Degas, Raffaëlli was included in the Impressionist group shows of 1880 and 1881, even though his art was stylistically dissimilar. His

works in these two shows aroused the attention of critics, who showered the artist with much attention and praise.

Raffaëlli focused his attention during this period almost exclusively on the newly expanding suburbs of Paris, where he had settled. He scrupulously recorded the inhabitants of these industrial zones along the Seine: vagabonds, absinthe drinkers, *petits industriels*, workers, *petits bourgeois* and, in particular, rag-pickers. Departing from the traditional picturesque image of the rag-picker in 19th-century literature and art, Raffaëlli endowed this marginal member of society with a special meaning; he regarded the rag-picker as a symbol of alienated individualism in modern industrial society, the expression of his own positivistic outlook.

Raffaëlli's philosophical bent led him to articulate a theory of realism that he christened *caractérisme*. He hoped to set himself apart from those unthinking, so-called realist artists whose art provided the viewer with only a literal depiction of nature. His careful observation of man in his milieu paralleled the anti-aesthetic, anti-romantic approach of the literary Naturalists, such as Zola and Huysmans. Greatly influenced by positivism and, in particular, the philosopher Hippolyte-Adolphe Taine, Raffaëlli defined the realist artist as one duty-bound to reveal the essential character of various aspects of reality, including the nature of contemporary society and its individual personalities, together with the artist's state of mind.

In the early 1890s Raffaëlli moved from the suburbs into Paris itself and concentrated on painting more public views of the capital. As his works enjoyed acceptance and brought him increased prosperity, Raffaëlli's positivistic views assumed a buoyant and self-confident optimism, evidenced by his light-hearted scenes of Parisian monuments and boulevards. In later years he made picturesque views of the French countryside and seaports, such as *Port of La Rochelle* (1914–15; Paris, Louvre). At this time, Raffaëlli's major activity was printmaking in colour. He introduced a new technique, whereby up to five plates for one print were executed not in aquatint or wash but

in drypoint hatching. Though not a professional illustrator, Raffaëlli occasionally provided material for newspapers, reviews and books, primarily in the 1880s and 1890s. His subjects, drawn mostly from the industrial suburban milieu, popular city entertainments and street life, accompanied texts by Huysmans, the Goncourt brothers and Victor Hugo among others. One of his most ambitious projects, *Les Types de Paris* (1889), a profusely illustrated album of light-hearted articles written by his literary friends, serves as a retrospective of Raffaëlli's activities as an illustrator of Parisian life.

Like his prints, Rafaëlli's sculpture paralleled and sometimes faithfully reproduced the industrial suburban compositions of his paintings. He exhibited at least 20 different pieces throughout his career. Many used his inventive technique of bronze backgroundless bas-relief. No sculptures are known today and only a handful have been photographed (see Alexandre, pp. 165–70).

Writings

Etude des mouvements de l'art moderne et du beau caractéristique (Paris, 1884)

Bibliography

A. Alexandre: *Jean-François Raffaëlli: Peintre, graveur et sculpteur* (Paris, 1909)

L. Delteil: 'Jean-François Raffaëlli', *Le Peintre graveur illustré*, xvi (Paris, 1923)

B. S. Fields: *Jean-François Raffaëlli (1850–1924): The Naturalist Artist* (diss., New York, Columbia U., 1979)

BARBARA S. FIELDS

Raffet, (Denis-)Auguste(-Marie)

(*b* Paris, 1 March 1804; *d* Genoa, 16 Feb 1860). French lithographer, painter and illustrator. Following the assassination of his father in 1813, the lack of family resources obliged Raffet to work while still a child. He was apprenticed to a wood-turner and attended drawing lessons in the evenings. At the age of 18 he spent a short period as an apprentice porcelain decorator for which he showed remarkable painting skills, and he then began his training as a painter by attending the classes of Charles Alexandre Suisse. There he was befriended by three fellow students who were also pupils of the military artist Nicolas-Toussaint Charlet. Among them was Louis Henri de Rudder (1807–81), who in 1824 introduced Raffet to Charlet. Six months later, on 11 October 1824, Raffet was admitted to the Ecole des Beaux-Arts in Paris, where he spent five years in Charlet's atelier. Following this, in 1829 he became a pupil of Antoine-Jean Gros. While at the Ecole des Beaux-Arts, Raffet prepared himself for the Prix de Rome competition by painting various classical subjects. However, he tried and failed the competition in 1831, and this led him to abandon classical subjects and to devote himself to contemporary history subjects. Though continuing to produce a few paintings, he began to concentrate on drawing, lithography and illustration. Raffet revolutionized the representation of battle scenes. Both his paintings (e.g. *Episode from the Retreat from Russia*, 1856; Paris, Louvre) and his prints form a glorifying and often humorous chronicle of French political history from the Revolution to the culmination of the Second Empire, the battle of Solferino of 1859.

Raffet's oeuvre as a lithographer and illustrator can be divided into three main periods. The first period, while he was still a student, was one of imitation. Having been taught the techniques of lithography by de Rudder, between 1824 and 1830 he produced albums containing lithographs such as *Vive la République!* and *Mon Empereur, c'est la plus cuite*. During this period he primarily copied the style of Horace Vernet but also that of Charlet and of Hippolyte Bellangé. In the second period (1830–37) Raffet improvised and began to develop a personal style. His imaginative powers are evident in the depiction of those events that he had not actually seen, as was the case for the lithograph *The Battle of Oued-Allez*. Drawn from the Algerian expedition, this work, often considered his masterpiece, typifies Raffet's style. It shows his emphasis on the French soldiers, whom he placed in the foreground of the battle scene; his rejection of Neo-classicism in favour of a

concern with depicting real types and manners; and his ability to suggest wide spaces and large numbers on a small scale. He also produced numerous illustrations for such books as Adolphe Thiers's *Histoire de la Révolution Française* (Paris, 1837).

The third period (from 1837) is one of observation. In 1837 Raffet visited Hungary, Moldavia, Wallachia, the Crimea, Smyrna and Constantinople, during which he met Prince Anatole Demidov, who became his principal patron. Raffet produced numerous, highly accurate ethnographic drawings, which he subsequently lithographed and published in Paris. The most important of these are the hundred lithographs that appeared under the title *Voyage dans la Russie méridionale et la Crimée par la Hongrie, la Valachie et la Moldavie* (4 vols), published in Paris in 1857. He continued to travel with Demidov until the end of his life (e.g. to Spain in 1847) and participated in the French campaign in Italy (1859), an experience that resulted in such lithographs as the *Siege of Rome*.

Bibliography

Bénézit

A. Bry: *Raffet: Sa vie et ses oeuvres* (Paris, 1861)

H. Giacomelli: *Raffet: Son oeuvre lithographique et ses eaux-forts* (Paris, 1862)

H. Beraldi: *Raffet: Peintre national* (Paris, c. 1890)

—: *Les Graveurs du XIXe siècle*, xi (Paris, 1891), pp. 61–149

A. Curtis: *Auguste Raffet* (New York, 1903)

R. J. Wickenden: 'Auguste Raffet (1804–1860)', *Prt Colr Q.* (1917), pp. 25–54

P. Ladoué: *Raffet* (Paris, 1946)

The Charged Image: French Lithographic Caricature, 1816–1848 (exh. cat. by B. Farwell, Santa Barbara, U. CA, A. Mus., 1989)

ATHENA S. E. LEOUSSI

Rajon, Paul-Adolphe

(*b* Dijon, July 1842 or 1843; *d* Auvers-sur-Oise, Val d'Oise, 8 June 1888). French painter and printmaker. After a rudimentary education he was employed by his brother-in-law, a photographer, to retouch negatives. He then moved to Paris where he supported himself by working as a photographer while training at the Ecole des Beaux-Arts under Isidore-Alexandre-Augustin Pils. In Paris he became friendly with Emile Boilvin and also came to know Philippe Burty, Félix Bracquemond and Louis-Charles-Auguste Steinheil. Though he studied painting he also learnt to etch under Léon Gaucherel and Léopold Flameng and decided to devote himself to etching. He made his début at the Salon in 1865 with a drawing, but from 1868 he exhibited only etchings. His works, which were mainly reproductions of paintings by contemporary artists or by Old Masters such as Gainsborough, Rembrandt and Rubens, appeared in the journals *L'Art* and *Gazette des beaux-arts* and were also published by Galeries Goupil. He also produced original portrait etchings of contemporary writers including Turgenev, Tennyson and Théophile Gautier. In 1873 Rajon received a commission through Bracquemond to go to England. Thereafter he visited the country for six months a year, making portrait etchings such as *Darwin*, after Walter William Ouless (1848–1933), and *Mrs Rose*, after Frederick Sandys. Both in France and England he enjoyed financial and critical success and, through his acquaintance with the American print dealer Frederick Keppel (1845–1912) in New York, his fame also spread to the USA, which he visited. He was awarded medals for graphic art at the Salons of 1869, 1870, 1873 and at the Exposition Universelle of 1878.

Bibliography

H. Beraldi: *Les Graveurs du XIXe siècle* (Paris, 1885–92), xi, pp. 151–67

□

Ranson, Paul

(*b* Limoges, 1864; *d* Paris, 20 Feb 1909). French painter and designer. The son of a successful local politician, Ranson was encouraged from the outset in his artistic ambitions. He studied at the Ecoles des Arts Décoratifs in Limoges and Paris but transferred in 1886 to the Académie Julian. There he met Paul Sérusier and in 1888 became one of the original members of the group known as the

Nabis. From 1890 onwards, Ranson and his wife France hosted Saturday afternoon meetings of the Nabis in their apartment in the Boulevard du Montparnasse, jokingly referred to as 'Le Temple'. Ranson acted as linchpin for the sometimes dispersed group. Noted for his enthusiasm and wit and for his keen interests in philosophy, theosophy and theatre, he brought an element of esoteric ritual to their activities. For example he introduced the secret Nabi language and the nicknames used familiarly within the group. He also constructed a puppet theatre in his studio for which he wrote plays that were performed by the Nabis before a discerning public of writers and politicians.

Ranson's work showed a consistent commitment to the decorative arts: like Maillol he made designs for tapestry, some of which were executed by his wife. His linear, sinuous style, seen in works such as *Woman Standing beside a Balustrade with a Poodle* (Altschul priv. col., see *Post-Impressionism*, exh. cat., London, RA, 1979, p. 119), had strong affinities with Japanese prints and with contemporary developments in Art Nouveau design; it was a style suited to a variety of media, stained glass, lithography, ceramics or tapestry. Ranson tended to favour exotic, symbolic or quasi-religious motifs rather than subjects observed from nature. In his *Nabi Landscape* of 1890 (Lausanne, Josefowitz priv. col., see P. Jullian, *The Symbolists*, London, 1973, no. 174), for example, he sets a variety of obscure feminine symbols within a fantasy landscape. After his early death in 1909 his wife continued to run the Académie Ranson, which they had opened in 1908 to disseminate Nabi aesthetic ideas and techniques to a younger generation. Teaching was undertaken on a voluntary basis by other Nabis, especially Denis and Sérusier.

Bibliography

A. Humbert: *Les Nabis et leur époque* (Geneva, 1954)
C. Chassé: *Les Nabis et leur époque* (Paris, 1960; Eng. trans., 1969), pp. 171–2
Neo-Impressionists and Nabis in the Collection of Arthur G. Altschul (exh. cat., New Haven, CT, Yale U. A.G., 1965), pp. 84–6

BELINDA THOMSON

Ravier, (François-)Auguste

(*b* Lyon, 4 May 1814; *d* Morestel, nr Lyon, 26 June 1895). French painter. In 1832 he went to Paris to become a notary but, after discovering his love for art, studied with Jules Coignet (1798–1860) and Théodore Caruelle d'Aligny. Between 1840 and 1845–6 he made several trips to Rome, where he painted oil studies reminiscent of Jean-Baptiste-Camille Corot, such as *Villa at Rome* (Paris, Louvre). He finally settled near Lyon (at Crémieu *c.* 1854; Morestel in 1868) and found his landscape subjects locally. Although he seldom exhibited, he did not isolate himself. He respected Turner, whose work he knew and to whom his work has been compared, particularly in the foreground earth tones and atmospheric effects of his watercolours. Corot, Charles-François Daubigny and Louis Français were among his friends. In 1884 he lost the sight of one eye but recovered and authorized Boussod & Valadon (his Paris dealers from 1883 to 1886) to submit his watercolours for the first time to the Salon in Paris, where they were accepted that year. By 1889 Ravier was totally blind.

Ravier's landscape style during the 1850s and 1860s stemmed from the Barbizon tradition. In his later watercolours, for example *Landscape with Sunset* (*c.* 1875–85; Paris, Louvre), he achieved a wide variety of effects by applying gouache like impasto and scratching into the paper with the brush handle. His final oil studies, such as *Pond at Sunset* (*c.* 1880–90; Saint-Etienne, Mus. A. & Indust.), were direct notations done on site, with creamy paint rapidly applied in long, aggressively diagonal or swirling strokes. His scenes from the 1880s, which depict his favourite themes of dawn and dusk, are highly subjective and expressionist and anticipate the Fauves in their use of colour.

Bibliography

P. Jamot: *Auguste Ravier: Etude critique suivie de la correspondance de l'artiste* (Lyon, 1921)
Auguste Ravier, 1814–1895 (exh. cat. by M. Faux and J. Leymarie, Reims, Mus. St-Denis, 1964)
F. A. Ravier, 1814–1895 (exh. cat., Paris, Gal. Jonas, 1975)
Paysagistes lyonnais, 1800–1900 (exh. cat., ed. M. Rocher-Jauneau; Lyon, Mus. B.-A., 1984), pp. 168–76

LYNN BOYER FERRILLO

Redon, Odilon (Bertrand-Jean)

(*b* Bordeaux, 20 April 1840; *d* Paris, 6 July 1916). French printmaker, draughtsman and painter. He spent his childhood at Peyrelebade, his father's estate in the Médoc. Peyrelebade became a basic source of inspiration for all his art, providing him with both subjects from nature and a stimulus for his fantasies, and Redon returned there constantly until its enforced sale in 1897. He received his education in Bordeaux from 1851, rapidly showing talent in many art forms: he studied drawing with Stanislas Gorin (?1824–?1874) from 1855; in 1857 he attempted unsuccessfully to become an architect; and he also became an accomplished violinist. He developed a keen interest in contemporary literature, partly through the influence of Armand Clavaud, a botanist and thinker who became his friend and intellectual mentor.

Redon's vocation was still undecided in 1864 when he studied painting briefly and disastrously at the studio of Jean-Léon Gérôme in Paris. He returned to Bordeaux, and his commitment to the visual arts was strengthened by his friendship with Rodolphe Bresdin, whose drawings and prints he much admired. He learnt from Bresdin's skills as an engraver and made etchings under his guidance. In 1868 and 1869 Redon published his first writings: a review of the 1868 Paris Salon and an article on Bresdin, both in the Bordeaux newspaper *La Gironde*. His criticism looked back to the provincial artistic values of his background but also forward to an art of the future that would advocate imagination rather than pursuing realism. Such views reflected his wider loyalties: to Rembrandt and Corot, and especially to Delacroix. These early developments matured into an active artistic career only after the Franco-Prussian War, in which Redon served as a soldier. He regarded this experience as the catalyst that finally produced in him a firm sense of vocation. He settled in Paris for the first time, spending only his summers at Peyrelebade, and he began to participate in Parisian artistic and intellectual life. He was by then producing large numbers of highly original charcoal drawings, which he called his *Noirs*. They evoke a mysterious world of subjective, often melancholic fantasy. In 1879, partly at the suggestion of Fantin-Latour, he published his first album of lithographs, *Dans le rêve*.

Lithographs formed a major part of Redon's production during the 1880s and 1890s: he used them partly as a way of making his *Noirs* known to a wider audience, bringing to them textures as rich as his charcoal drawings. But he also developed the potential for links with the written word in titles and captions, for example *The Marsh Flower, a Sad and Human Head* (1885), whose caption was particularly praised by Stéphane Mallarmé. Above all he displayed in his lithographs audacious imagery that made the visionary seem plausible. Between 1879 and 1899 he published 12 lithograph albums. Some have strong literary associations; Flaubert's *La Tentation de Saint Antoine* (Paris, 1874) served as the basis for albums in 1888, 1889 and 1896. Such literature-related works are not illustrations but interpretations that are independent works of art. In addition to the albums, he made various single lithographs and also a number of drawings after Baudelaire's *Les Fleurs du mal*, which were reproduced in an album (1890) by the method of engraving known as the Evely process.

Redon held his first Paris exhibitions at the time of the early lithograph albums, showing charcoal drawings at the review *La Vie moderne* (1881) and in the newspaper *Le Gaulois* (1882). In 1884 he helped to organize the first Salon des Indépendants and in 1886 exhibited both at the last Impressionist Exhibition and with Les Vingt in Brussels. Although his *Noirs* made little impact on the general public, they won acclaim in the Parisian literary avant-garde. The aesthetic principles underlying Redon's art were close to those of Baudelaire, as the Decadents, Baudelaire's followers of the early 1880s, recognized. Emile Hennequin and Joris-Karl Huysmans became his champions; the *Noirs* figured in Huysmans's Decadent novel *A rebours* (Paris, 1884). When the term 'Symbolist' became current as a description of the new art and literature in 1886, Redon was considered the major Symbolist artist. His works were widely debated in Symbolist reviews in Belgium as well as France, but Redon himself was alarmed at the excesses of many of these interpretations and maintained a discreet

distance from such groups. His chief literary ally was Mallarmé, whom he met in 1883. Their friendship was close, although their only attempt at collaboration, Redon's lithographs (1898) for Mallarmé's *Un Coup de dés*, was not completed. Redon has been termed 'the Mallarmé of painting'.

Redon's reputation until 1890 rested entirely on work in black and white, but he had been using colour in unexhibited landscape studies. From about 1890 he began to extend his use of colour to works that repeat or develop the subject-matter of the *Noirs*. Many of these were oils, such as *Closed Eyes* (1890; Paris, Mus. d'Orsay; see col. pl. XXXI), but pastels also became frequent (e.g. *Christ in Silence*, c. 1895; Paris, Petit Pal.). During the 1890s he used colour alongside monochrome, colour gradually becoming dominant, and after 1900 he abandoned the *Noirs*. Earlier subject-matter recurred, but new motifs also appeared, flowers, especially, becoming a central preoccupation (see fig. 61). The increasingly decorative tone of these works led to commissions for screens and murals, an outstanding example being the paintings (1910–11) on the walls of the library at Fontfroide Abbey near Narbonne. The serene lyricism of these late colour works contrasts with the prevailing melancholy of the *Noirs*, but Redon's fundamental aesthetic had not altered. The transformation of nature into dream-like images, suggesting indefinite states of mind and expressed in sumptuous textures, remained his central concern, and the exploratory freedom with which he investigated the suggestive potential of colour contributed considerably to Post-Impressionist art. His innovations were admired by the Nabis and by some of the Fauves, including Matisse.

In 1899 Paul Durand-Ruel exhibited Redon's works with those of the Nabis, thereby paying homage to his importance to young painters such as Bonnard and Vuillard. A large selection of his works was shown at the 1904 Salon d'Automne, contributing to the advent of Fauvism. New generations of writers, including Gide and Cocteau, became his companions and interpreters. His reputation spread abroad, notably at the American Armory Show of 1913. Redon's work did not,

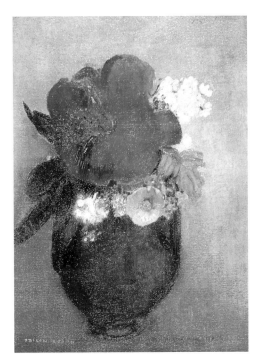

61. Odilon Redon: *Vase of Flowers: The Red Poppy* (Paris, Musée d'Orsay)

however, become popular with the public, and he depended heavily in his later years on individual patrons and collectors, such as André Bonger (1861–1934) in the Netherlands, Gabriel Frizeau (1870–1938) in Bordeaux and Gustave Fayet (1865–1925) at Fontfroide.

Redon had married in 1880, but his first son, Jean, died in infancy in 1886. Only later in his life did domestic happiness accompany his increased prestige. His second son Arî (1889–1972) stimulated the joy and optimism of the late colour works and became a patient advocate of his father's art. His collection of Redon's works, including hundreds of drawings, is now owned by the Musée d'Orsay, Paris, although much of it is currently displayed in the Louvre. After Redon's death, his family and friends completed a project that he had instigated: the publication of selections from his writings under the title *A soi-même* (1922). It contains autobiography, diaries, art

criticism and general reflections, and demonstrates Redon's considerable skills as a writer as well as providing valuable insights into his work.

Writings

A soi-même–journal (1867–1915): Notes sur la vie, l'art et les artistes (Paris, 1922, rev. 1961)

Lettres d'Odilon Redon, 1878–1916, publiées par sa famille (Paris, 1923)

R. Coustet, ed.: Critiques d'art, précédées de confidences d'artiste (Bordeaux, 1987)

Bibliography

A. Mellerio: Odilon Redon (Paris, 1913, R New York, 1968) [complete cat. of lithograph albums and engrs]; review by R. Pickvance in Burl. Mag., cxi (1969), pp. 570–71

C. Roger-Marx: 'Odilon Redon', Burl. Mag., xxxvi (1920), pp. 269–75

A. Mellerio: Odilon Redon, peintre, dessinateur et graveur (Paris, 1923)

S. Sandström: Le Monde imaginaire d'Odilon Redon: Etude iconologique (Lund, 1955)

R. Bacou: Odilon Redon, 2 vols (Geneva, 1956)

R. Bacou, ed.: Lettres de Gauguin, Gide, Huysmans, Jammes, Mallarmé, Verhaeren . . . à Odilon Redon, preface A. Redon (Paris, 1960)

Odilon Redon, Gustave Moreau, Rodolphe Bresdin (exh. cat., New York, MOMA, 1962)

K. Berger: Odilon Redon: Phantasie und Farbe (Cologne, 1964; Eng. trans., 1965)

R. G. Cohn: Mallarmé's Masterwork: New Findings (Paris, 1966) [Redon's lithographs for Un Coup de dés]

A. Werner: The Graphic Works of Odilon Redon (New York, 1969) [lithographs and engrs]

J. Selz: Odilon Redon (Paris, 1971)

J. Cassou: Odilon Redon (Paris, 1974)

R. Hobbs: Odilon Redon (London, 1977)

M. Wilson: Nature and Imagination: The Work of Odilon Redon (London, 1978)

R. Bacou: La Donation Arî et Suzanne Redon (Paris, 1984)

R. Coustet: L'Univers d'Odilon Redon (Paris, 1984)

D. Gamboni: La Plume et le pinceau: Odilon Redon et la littérature (Paris, 1989)

S. Eisenman: The Temptation of St Redon: Biography, Ideology and Style in the 'Noirs' of Odilon Redon (Chicago, 1992)

D. Druick, ed.: Odilon Redon (London, 1994)

RICHARD HOBBS

Regnault, (Alexandre-Georges-)Henri

(b Paris, 30 Oct 1843; d Buzenval, 19 Jan 1871). Painter, son of (1) Victor Regnault. He showed exceptional abilities as a draughtsman from an early age. After a traditional classical education he was sent in 1860 to the Ecole des Beaux-Arts, Paris, where he studied with Louis Lamothe (1822–69) and Alexandre Cabanel. In 1866 he won the Prix de Rome competition with Thetis Giving the Weapons of Vulcan to Achilles (Paris, Ecole N. Sup. B.-A.). In Italy he began several other ambitious history paintings, including Automedon Taming the Horses of Achilles (1868; Boston, MA, Mus. F.A.; sketch, 1868, Paris, Mus. d'Orsay) and Judith and Holofernes (1869; Marseille, Mus. B.-A.).

In 1868 Regnault travelled with his friend Georges Clairin to Madrid, where he was permitted to continue his work on a Prix de Rome bursary. He studied Velázquez and Goya in the Museo del Prado and mingled with the upper and lower classes of the Spanish capital. He was active as a portrait painter, and his most important work of the period is the theatrical equestrian portrait of the liberal revolutionary Gen. Juan Prim y Prats (1869; Paris, Mus. d'Orsay), a very large painting refused by the General but shown successfully at the Paris Salon of 1869. In Granada he admired the virtuoso work of the academic painter Mariano Fortuny y Marsal and painted the large, grisly Execution without Judgement under the Moorish Kings of Granada (1870; Paris, Mus. d'Orsay; see fig. 62), which uses the Alhambra as a background. This work, and a copy (1870; Paris, Ecole N. Sup. B.-A.) of Velázquez's Surrender of Breda (1634–5; Madrid, Prado), served as Regnault's formal student submissions at the Salon of 1870.

From Granada Regnault travelled to Morocco. By 1870 he and Clairin were established in Tangier, where they constructed a house and a studio for the execution of large paintings. Regnault was delighted with the climate, light and culture of Tangier and planned to remain there indefinitely. He enlarged the canvas of a bust-length portrait begun in Italy to paint a naturalistic Oriental genre piece entitled Salome (1869–70; New York, Met.). This painting, with its unusual colour scheme of black and yellow, caused a sensation

the age of 27 shortly before the end of the war. A memorial exhibition was presented at the Ecole des Beaux-Arts in 1872, and a monument by Henri Chapu was placed in the courtyard there. Regnault's posthumous fame was very great, and he was the subject of several commemorative monographs. In addition to his talent, Regnault's attractive personality, his ability as a horseman and his tragic early death were often cited. The few pictures by him still in private collections at his death, such as *Salome*, changed hands at high prices. Regnault's historical position (as distinct from his personal celebrity) is based on his great gifts as a practitioner of the academic style, both in history painting and in Orientalist subjects. Although he shared the Impressionists' taste for strong colour, he also favoured the profusion of background detail and high degree of finish that made his work acceptable to the Académie des Beaux-Arts. The naturalism of such works as *Execution without Judgement* and *Salome*, which seemed daring to Regnault's contemporaries, with hindsight appears well within the boundaries of official 19th-century art.

Bibliography

H. Baillière: *Henri Regnault, 1843–71* (Paris, 1871)

H. Cazalès: *Henri Regnault: Sa vie et son oeuvre* (Paris, 1872)

A. Duparc, ed.: *Correspondance de Henri Regnault . . . , suivie du catalogue complet de l'oeuvre de Regnault* (Paris, 1872)

P. G. Hamerton: *Modern Frenchmen* (London, 1878), pp. 346–422

A. J. Angellier: *Etude sur Henri Regnault* (Paris, 1879)

Orientalism: The Near East in French Painting, 1800–1880 (exh. cat., U. Rochester, NY, Mem. A.G., 1982), pp. 83–5

DONALD A. ROSENTHAL

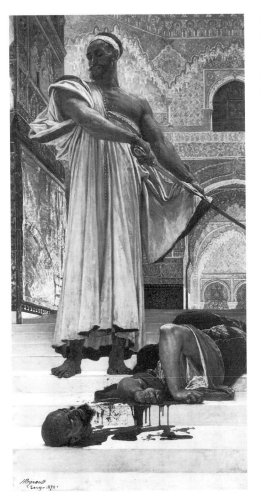

62. Henri Regnault: *Execution without Judgement under the Moorish Kings of Granada*, 1870 (Paris, Musée d'Orsay)

when it was exhibited at the Salon in 1870. Regnault also made colourful oil sketches of traditional Orientalist subjects: *Departure for the Powder-play* (1870; untraced) and *Excursion of the Pasha at Tangier* (1870; untraced).

At the outbreak of the Franco-Prussian War Regnault, who because of his Prix de Rome bursary was exempt from military duty, volunteered for service as a foot-soldier. He was killed in action at

Renoir, (Pierre-)Auguste

(*b* Limoges, 25 Feb 1841; *d* Cagnes-sur-Mer, 3 Dec 1919). French painter, printmaker and sculptor. He was one of the founders and leading exponents of Impressionism from the late 1860s, producing some of the movement's most famous images of

carefree leisure. He broke with his Impressionist colleagues to exhibit at the Salon from 1878, and from *c*. 1884 he adopted a more linear style indebted to the Old Masters. His critical reputation has suffered from the many minor works he produced during his later years.

1. Life and work

(i) **Early career.** Renoir was born in Limoges but lived with his family in Paris from 1844. The sixth of seven children, he came from a humble background; his father, Léonard Renoir, was a tailor and his mother, Marguerite Merlet, a dressmaker. At the age of 13 he was apprenticed to M. Levy, a porcelain painter who perceived and valued his precocious skill. Nevertheless his ambition was to become a painter.

From 1860 he copied Old Master paintings in the Louvre, and by 1861 he was a regular visitor to the studio of the painter Charles Gleyre. He was finally admitted to the Ecole des Beaux-Arts on 1 April 1862. Although there are records of his presence at the Ecole until 1864, it is likely that, following the example of the other young artists he had met at Gleyre's studio, notably Alfred Sisley, Frédéric Bazille and Monet, he was attracted by the practice of painting *en plein air* in the forest of Fontainebleau. According to Meier-Graefe, he had even been encouraged in this by one of the most famous Barbizon painters, Narcisse Diaz (Meier-Graefe, p. 16).

In 1864 Renoir's *La Esmeralda* (untraced, and claimed by the artist to have been destroyed by him), inspired by Victor Hugo's novel *Notre-Dame de Paris* (1831), was accepted by the Salon. The following year a very sober work, a portrait of *William Sisley* (1864; Paris, Mus. d'Orsay), father of his closest friend, Alfred Sisley, was shown in the Salon. Renoir painted many portraits, as much because of his unfailing interest in the face as from financial necessity. *Romaine Lacaux* (1864; Cleveland, OH, Mus. A.) is typical. However, the work that best characterizes the young Renoir is *Cabaret of Mother Antony* (1866; Stockholm, Nmus.), which depicts a group of artists in a room in an inn in Marlotte (the 'annexe' of Barbizon) conversing around a table and attended by a servant. The subject, the energetic brushmarks, generally sombre tonality and ambitious scale (1.95×1.3 m) of the picture are reminiscent of Gustave Courbet, whose influence continued to dominate Renoir's *Diana the Huntress* (1867; Washington, DC, N.G.A.). The Salon jury of 1867 was not deceived by the mythological disguise of this nude, which was obviously a concession by Renoir to the prevailing academic conventions. The work was refused, as were those submitted the same year by Monet and Bazille. They all protested against their exclusion and called unsuccessfully for another Salon des Refusés like that of 1863, in which Manet had shown the *Déjeuner sur l'herbe* (1863; Paris, Mus. d'Orsay). In early 1867 Bazille had rented a studio in the Rue Visconti in Paris, where, during a period of poverty, he put up Monet and Renoir. The influence of Monet, and through him of Manet, is discernible in Renoir's painting from then on: for example in his portrait of Sisley and his fiancée, the *Engaged Couple* (*c*. 1868; Cologne, Wallraf-Richartz-Mus.), and in *Lise with a Parasol* (1867; Essen, Mus. Flkwang), which depicts Lise Tréhot (1848–1922), Renoir's mistress and favourite model until 1872. This picture won Renoir his first critical success at the Salon of 1868. Monet's influence is also seen in several views of Paris (*Pont des Arts*, *c*. 1867; Pasadena, CA, Norton Simon Mus.) and in the revealing series of studies (Moscow, Pushkin Mus. F.A.; Stockholm, Nmus.; Winterthur, Samml. Oskar Reinhart) made in 1869, at the same time as Monet, at La Grenouillère, a bathing place on the island of Croissy in the Seine, near Paris. Lise was again the model for *In Summer* (Berlin, Tiergarten, N.G.), shown in the Salon of 1869, and for two paintings exhibited in the Salon of 1870, *Woman Bathing with Griffon* (1870; São Paolo, Mus. A.)—another obvious homage to Courbet—and *Woman of Algiers* (1870; Washington, DC, N.G.A.), a dazzling display of Renoir's admiration for Delacroix. After the Franco-Prussian war of 1870–71, during which he served in the Tenth Cavalry Regiment, he resumed his links with the artistic world by submitting a work in the same vein to the Salon of 1872, *Parisian Women Dressed as Algerians* (1872; Tokyo, N. Mus. W.A.), a free interpretation of

Delacroix's *Women of Algiers* (1834; Paris, Louvre). This picture was refused, as was the huge *Riding in the Bois de Boulogne* (1873; Hamburg, Ksthalle) in 1873, which he sent to the Salon des Refusés in the same year.

(ii) The Impressionist exhibitions, 1874–8. These repeated rejections encouraged Renoir to join a group of fellow artists, headed by Monet, in the First Impressionist Exhibition, which was held in the spring of 1874 at 35 Boulevard des Capucines in Paris. Renoir showed some recent canvases including *Dancer* (1874; Washington, DC, N.G.A.), *Theatre Box* (1874; London, Courtauld Inst. Gals) and *Parisian Woman* (1874; Cardiff, N. Mus.). These were all smaller than his previous paintings, being easier to sell among the very small circle of collectors such as Victor Chocquet, Gustave Caillebotte, Henri Rouart, Jean Dollfus and dealers (including Paul Durand-Ruel) whom he had attracted. The lighter palette he was adopting is most apparent in the landscapes painted at Argenteuil beside Monet (*Seine at Argenteuil*, 1874; Portland, OR, A. Mus.). At this time he depicted Monet in *Monet Working in the Garden at Argenteuil* (1874; Hartford, CT, Wadsworth Atheneum). The brushstrokes are also more delicate and expressive in these works, displaying all the freedom of a virtuoso. In comparison with his fellow exhibitors, Renoir had been spared by the critics in 1874, but during the Second Impressionist Exhibition in 1876 he was attacked by the critic of the *Figaro*, Albert Wolff, who described *Study (Nude in the Sunlight)* (1875; Paris, Mus. d'Orsay) as a 'heap of decomposing flesh'—an allusion to the bluish shadows cast on the naked figure by the light of the open air filtering through foliage. Similar interests can be seen in the *Ball at the Moulin de la Galette* (1876; Paris, Mus. d'Orsay; see col. pl. XXXII), which he sent to the Third Impressionist Exhibition in 1877. This ambitious composition, depicting a particularly 'modern' subject, namely the animated crowd at an open-air dance hall in Montmartre, where the artist was then living, is brought to life by complex effects of light and is without doubt the most perfect example of Renoir's Impressionism.

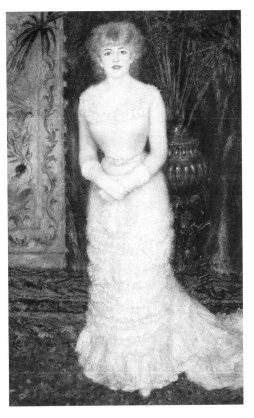

63. Auguste Renoir: *Jeanne Samary*, 1878 (St Petersburg, Hermitage Museum)

(iii) 1879–89. Renoir refused to be involved in the fourth and fifth Impressionist exhibitions in 1879 and 1880 and indeed returned to the official Salon in 1878. He achieved a great success there in 1879 with the portraits of *Mme Charpentier and her Children* (1878; New York, Met.) and of the actress *Jeanne Samary* (1878; St Petersburg, Hermitage; see fig. 63). This success was partly due to the celebrity of his models: Mme Georges Charpentier, wife of the publisher of Flaubert, Zola and the Goncourt brothers, applied herself to launching Renoir in fashionable and wealthy circles where buyers were finally found for his portraits (e.g. *Irène Cahen d'Anvers*, 1880; Zurich, Stift. Samml. Bührle) and other works. This success marked the opening of a new era for Renoir, who was finally freed of

more immediate financial constraints. At the end of the summer of 1880, after having exhibited again at the Salon with *Young Girl Asleep* (1880; Williamstown, MA, Clark A. Inst.) and *Women Fishing for Mussels at Berneval, on the Coast of Normandy* (1879; Merion, PA, Barnes Found.), he began work on a large composition, *Luncheon of the Boating Party* (1880–81; Washington, DC, Phillips Col.) at Chatou, near Paris, beside the Seine, on the terrace of the Restaurant Fournaise. The subject recalls both the views of La Grenouillère painted in 1869 and the *Ball at the Moulin de la Galette*, but comparison with the latter work, painted only four years earlier, reveals a new concern with composition and the distribution of masses, while the drawing is also more meticulous and precise. The faces are clearly individualized; in particular one recognizes on the extreme left Aline Charigot (1859–1915), whom Renoir married in 1890. The picture is painted in a palette of light and vivid tones.

Such works as *Bather* (1881; Williamstown, MA, Clark A. Inst.), *Dance at Bougival* (1882–3; Boston, MA, Mus. F.A.), *Dance in the City* (see fig. 64) and *Dance in the Country* (both 1882–3; Paris, Mus. d'Orsay), *Seated Bather* (c. 1883–4; Cambridge, MA, Fogg) and *Umbrellas* (c. 1881 and c. 1885; London, N.G.) led to Renoir's 'Ingresque' period around 1885 and the incisive and decorative cut-out style of the *Bathers* (1887; Philadelphia, PA, Mus. A.). This evolution was doubtless hastened by Renoir's travels in Italy between 1881 and 1882, from which he returned through the south of France to work beside Paul Cézanne at L'Estaque in January 1882 on such paintings as *Rocky Crags at L'Estaque* (1882; Boston, MA, Mus. F.A.).

The monumental painting of Raphael and the masterpieces of Classical Antiquity confirmed Renoir's desire to challenge the subjective uncertainties of Impressionism. He travelled a great deal at the beginning of the 1880s: in the steps of Delacroix, in 1881 and 1882, to North Africa, which he found dazzling and where he painted some splendid landscapes (e.g. *Mosque* (or *Arab Festival*), 1881; Paris, Mus. d'Orsay); and in 1883 to Jersey and Guernsey and then to the Mediterranean coast between Marseille and Genoa

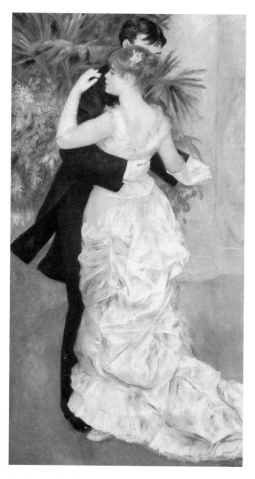

64. Auguste Renoir: *Dance in the City*, 1882–3 (Paris, Musée d'Orsay)

in the company of Monet. He exhibited regularly at the Salon (1881, 1882, 1883 and for the last time in 1890) but refused to submit works to the Impressionist exhibitions after 1877, because he felt his presence might alienate his Salon orientated patrons. However, he was unable to prevent Paul Durand-Ruel, the organizer of the 1882 exhibition, from including his paintings. Despite this, he was happy to cooperate when Durand-Ruel put on Renoir's first individual retrospective exhibition in his gallery in Paris in 1883. Renoir's adoption of a more linear style was badly received by

the critics and by some of the collectors of his work. An exception was Paul Berard, one of his most important supporters, for whom he painted *Children's Afternoon at Wargemont* (1884; Berlin, Tiergarten, N.G.).

(iv) The 1890s. At the end of the 1880s and during the 1890s Renoir often moved around in search of new motifs—Normandy, Brittany, the outskirts of Paris, Essoyes in Champagne (his wife's village) and Provence. He also visited the great museums in Madrid, Dresden, Amsterdam and London, and this pursuit of the art of the past was reflected in his painting by a gradual return to a more fluid technique, which owed a great deal to French 18th-century painting as well as to Titian, Diego Velázquez and Peter Paul Rubens. An important work of 1892, *Young Girls at the Piano* (St Petersburg, Hermitage), is an excellent example of the spirit in which Renoir interpreted a traditional subject. At this time he also did a series of *Bathers* (1892; New York, Met.; Paris, Mus. Orangerie; Winterthur, Samml. Oskar Reinhart). The birth of his second son, Jean, in 1894, inspired a series of intimate scenes in which the dark-haired Gabrielle Renard, one of Renoir's favourite models, also appeared (1895–6; priv. col.); and later with Claude ('Coco') Renoir, the painter's third and last son.

(v) 1900 and after. By the turn of the century Renoir was an established artist. He accepted the Légion d'honneur in 1900. His international standing grew, particularly in the USA, largely due to the unfailing exertions of Durand-Ruel. He was associated with new dealers, notably Ambroise Vollard and the Bernheim brothers and new collectors such as Maurice Gangnat and the Prince de Wagram. After 1902 his health declined progressively and from 1912 he was confined by rheumatism to a wheelchair. His illness led him to prolong his visits to the south of France, and in 1907 he bought the property of Collettes (now a museum) at Cagnes-sur-Mer, where he lived until his death. He worked ceaselessly, trying his hand at sculpture (*Venus Victorious*, 1914; London, Tate) and painting nudes (*Bathers*, 1918–19; Paris, Mus. d'Orsay), portraits (*Ambroise Vollard*, 1908;

London, Courtauld Inst. Gals) and figures in fancy dress (*The Concert*, c. 1919; Toronto, A.G. Ont.). These were accomplished works whose lyrical colour with its crimson accents was tempered by a classical fullness of form. They suffice to compensate for the mass of weak landscape sketches and still-lifes that have greatly prejudiced a fair assessment of Renoir's last period.

2. Working methods and technique

Renoir's nervous personality was matched by a life-long uncertainty when faced with the technical problems of painting and draughtsmanship, which sprang partly from his lack of a full traditional training. He was never interested in theoretical issues.

He adopted the Impressionist broken brushstrokes in the late 1860s under the influence of Monet in such works as *La Grenouillère* (1869; Stockholm, Nmus.). In comparison with Monet's treatment of the same subject (1869; New York, Met.), he concentrated on describing the fashionable costume of the figures in the middle ground with freer and more delicately applied flecks of paint and was more concerned to suggest atmosphere and the effect of sunlight on rippling water than compositional structure or recession.

Renoir's gradual abandonment of this style in the early 1880s is most clearly apparent in *Umbrellas*. The right-hand side of the picture seems to have been painted around 1881 in the soft, blurred brushwork characteristic of his manner from the mid-1870s (e.g. *Theatre Box*). In this area a rich blue predominates with a sparkling surface effect and complex colour mixtures, for instance in the eyes, picked out with liquid highlights, of the little girl. By contrast the right-hand side, painted several years later, is more sombrely handled, with flatter tones and more emphatic and schematized modelling of drapery and faces. The irises of the eyes of the woman in the foreground are represented by flat matt brown discs. It was only in the 1880s that drawing played an important part in his working methods, when he sought through numerous preparatory studies a more considered and linear style and a paler palette for major efforts such as *Bathers* (1887; Philadelphia, PA, Mus. A.).

During the 1890s he adopted an increasingly warm palette and more simplified modelling of flesh through graduated tones and a smooth and unfocused brushwork, which culminated in *Bathers* (c. 1918–19; Paris, Mus. d'Orsay). Renoir emphasized the red tones in this picture, partly in an attempt to compensate for the fading he had observed of the red pigments in his early paintings.

He turned to sculpture only in 1907, and it was not until 1913 that he attempted his first major project, at the suggestion of Vollard, by which time he was too frail to work unaided. For *Venus Victorious*, Renoir sketched his intentions initially in pencil or oil, from which his assistant Richard Guino produced a small-scale statuette in 1913. Renoir seems to have modelled only the head directly. He then guided Guino with a long stick in making the final adjustments to the monumental enlargement of the figure in 1914. The exact extent of Renoir's and Guino's relative contribution to the final result remains uncertain.

In the 1890s Renoir produced about 50 etchings and lithographs. For his lithograph the *Pinned Hat* (1898), he reworked on the stone a design transferred from paper and then gave his printer directions in pastel on how it should be coloured. The subject-matter of his prints did not differ from his easel paintings, and the possibilities of the graphic media do not seem to have really engaged his attention.

His younger brother Edmond (1849–1944) became a writer and journalist. He edited the catalogue for the First Impressionist Exhibition in 1874, assisted Georges Rivière on *L'Impressionniste* and organized exhibitions on the premises of the journal *La Vie Moderne*, for which he also wrote articles. Until the 1880s the brothers were very close: Edmond appears in many of his paintings, including *Theatre Box* (1874; London, Courtauld Inst.). Their relationship cooled prematurely when Edmond's zealous support for Auguste's work led him to criticize the work of the other Impressionists in over-aggressive terms. As a journalist he collaborated on various newspapers, notably *La Presse* and *L'Illustration*.

Bibliography

C. Mauclair: 'L'Oeuvre d'Auguste Renoir', *A. Déc.*, 41 (1902), pp. 172–89; 42 (1902), pp. 217–30
J. Meier-Graefe: *Auguste Renoir* (Paris, 1912)
A. Vollard: *Tableaux, pastels & dessins de Pierre-Auguste Renoir*, 2 vols (Paris, 1918)
A. André: *Renoir* (Paris, 1919, rev. 1928)
A. Vollard: *La Vie et l'oeuvre de Pierre-Auguste Renoir* (Paris, 1919/R 1920)
M. Denis: 'Renoir', *La Vie* (1 Feb 1920); repr. in *Nouvelles théories, sur l'art moderne, sur l'art sacré (1914–1921)* (Paris, 1922)
R. Fry: 'Renoir', *Vision and Design* (London, 1920)
L. Delteil: *Renoir*, xvii of *Le Peintre-graveur illustré* (Paris, 1920–26; New York, 1969)
G. Rivière: *Renoir et ses amis* (Paris, 1921)
P. Jamot: 'Renoir', *Gaz. B.-A.*, n.s. 5, viii (1923), pp. 257–81, 321–44
T. Duret: *Renoir* (Paris, 1924; Eng. trans., 1937)
L'Atelier de Renoir, 2 vols, prefaces A. André and M. Elder (Paris, 1931) [cat. of works in Renoir's studio at his death]
A. C. Barnes and V. de Mazia: *The Art of Renoir* (Merion, PA, 1935)
M. Berard: *Maîtres de XIXe: Renoir à Wargemont* (Paris, 1938)
L. Venturi: *Les Archives de l'Impressionnisme*, 2 vols (Paris, 1939)
J. Rewald: 'Auguste Renoir and his Brother', *Gaz. B.-A.*, n.s. 6, xxvii (1945), pp. 171–88
——: *Renoir Drawings* (New York, 1946)
P. Haesaerts: *Renoir: Sculptor* (New York, 1947)
J. Baudot: *Renoir, ses amis, ses modèles* (Paris, 1949)
C. Roger-Marx: *Les Lithographies de Renoir* (Monte Carlo, 1951)
D. Cooper: 'Renoir, Lise and the Le Coeur Family: A Study of Renoir's Early Development', *Burl. Mag.*, ci (1959), pp. 163–71, 322–30
J. Renoir: *Renoir* (London, 1962)
F. Daulte: *Figures, 1860–1890*, i of *Auguste Renoir: Catalogue raisonné de l'oeuvre peint* (Lausanne, 1971)
J. Leymarie and M. Melot: *Les Gravures des Impressionnistes* (Paris, 1971)
J. G. Stella: *The Graphic Work of Renoir: Catalogue raisonné* (Fort Lauderdale, 1975)
S. Monneret: *L'Impressionnisme et son époque*, ii (Paris, 1979), pp. 179–80
B. E. White: *Renoir: His Life, Art and Letters* (New York, 1984)
Renoir (exh. cat. by A. Distel and J. House; London, Hayward Gal.; Paris, Grand Pal.; Boston, MA, Mus. F.A.; 1985–6) [with detailed chronology and bibliog.]

ANNE DISTEL

Renouard, (Charles-)Paul

(*b* Cour-Cheverny, 5 Nov 1845; *d* Paris, 2 Jan 1924). French printmaker, draughtsman, illustrator and painter. After working as a house decorator, he entered the studio of Isidore-Alexandre-Augustin Pils at the Ecole des Beaux-Arts, Paris, in 1868; they worked together on the decoration of the Paris Opéra, where Renouard was also responsible for the ceilings (1875; *in situ*). He sketched both audience and performers in the Paris Opéra and in London at the Theatre Royal, Drury Lane (1890–91), and published a luxury album, *L'Opéra* (Paris, 1892), containing 30 etchings of his works. Renouard first exhibited at the Salon in Paris in 1877, having submitted pen-and-ink sketches of actors. He became a member of the Société des Artistes Français and of the Société Nationale des Beaux-Arts, receiving an honourable mention in 1883, a third-class medal in 1889 and a gold medal in 1889 at the Exposition Universelle, Paris. Among his work of that period is a series of pencil portraits of British academicians, entitled *The Royal Academy* (1885; Paris, Mus. Luxembourg), which, like much of his early work, was published in *The Graphic*; he also contributed to the periodicals *L'Illustration* and *Paris Illustré*. His role as a chronicler of his time can be seen in, for example, his 150 illustrations for *Les Défenseurs de la justice dans l'affaire Dreyfus* (Paris, 1899). His gentle philosophy and desire to understand human frailty, expressed in so much of his work, can be seen at its best in *The Blind*, his greatest etching of World War I.

Bibliography

H. W. Singer: *Die moderne Graphik* (Leipzig, 1920), pp. 13, 441–2

F. L. Leipnik: *History of French Etching* (London, 1924), p. 157

ETRENNE LYMBERY

Ribot, Théodule(-Augustin)

(*b* Saint-Nicolas-d'Attez, 5 Aug 1823; *d* Colombes, 11 Sept 1891). French painter. After his father died in 1840 Ribot trained himself as an artist while working as a bookkeeper in Elbeuf, a small village near Rouen. In 1845 he married and moved to Paris, where he worked as a decorator of gilded frames for a mirror manufacturer and became a pupil in the studio of Auguste-Barthélémy Glaize. He painted architectural backgrounds for Glaize and made his own studies from the nude model. Around 1848 he went to Algeria, where he worked as a foreman. After his return to Paris in 1851 he practised a variety of trades to support himself, colouring lithographs, decorating window-shades, painting signs and making copies of paintings by Watteau for the American market. It was not until the late 1850s that he began to produce his own paintings, working on realistic subjects at night by lamplight. This circumstance inspired his interest in the chiaroscuro effects that were to characterize his later paintings.

After the Salon rejected his work in 1859, Ribot exhibited canvases in the studio of his friend François Bonvin. In 1861 the Salon finally accepted several paintings depicting cooks, all of which were subsequently bought by Parisian collectors. Ribot won medals at the Salons of 1864 and 1865, and his *St Sebastian* (1865; Paris, Mus. d'Orsay) was purchased by the state for 6000 francs. This and other paintings of comparable subjects, for example *Torture by Wedges* (or *Torture of Alonso Cano*, 1867; Rouen, Mus. B.-A.), showed him to be an artist dedicated to the Spanish masters of the 17th century, in particular Ribera. He painted religious subjects, genre scenes and still-lifes, working in a limited number of muted tones to produce canvases reminiscent of Rembrandt and Frans Hals.

Ribot exhibited at international exhibitions in Amsterdam (1865), Munich (1869) and Vienna (1873), and in local exhibitions throughout France. During the Franco-Prussian War (1870–71) his studio in the Parisian suburb of Argenteuil was sacked by the invading Prussians, and many of his drawings and paintings were destroyed. In later years he tended to concentrate on portraiture. His numerous portraits of his family and friends, such as that of his daughter (exh. Salon 1884; Reims, Mus. St Denis), were also executed in a style inspired by Rembrandt. In the late 1870s he fell ill, moved to Colombes and stopped painting. He was awarded the Légion d'honneur in 1878 and a special award at the Exposition Universelle, Paris (1878).

Bibliography

L. de Fourcaud: *Théodule Ribot: Sa vie et ses oeuvres* (Paris, 1885)

Exposition Th. Ribot au Palais National de l'Ecole des Beaux-Arts (exh. cat. by R. Sertat, Paris, 1892)

G. P. Weisberg: 'Théodule Ribot: Popular Imagery and *The Little Milkmaid*', *Bull. Cleveland Mus. A.*, lxiii (1976), pp. 253–63

The Realist tradition: French Painting and Drawing, 1830–1900 (exh. cat., ed. G. P. Weisberg; Cleveland, OH, Mus. A.; New York, Brooklyn Mus.; St Louis, MO, A. Mus.; Glasgow, A.G. & Mus.; 1980), p. 309

GABRIEL P. WEISBERG

Ricard, (Louis-)Gustave

(*b* Marseille, 1 Sept 1823; *d* Paris, 24 Jan 1873). French painter. In 1840 he won a prize in life modelling at the Ecole des Beaux-Arts in Marseille. His teachers were Augustin Aubert (1781–1857), who had been a student of Jacques-Louis David, and Pierre Bronzet. In Paris by 1843, he entered the studio of Léon Cogniet but spent little time there, for he had already embarked on his lifelong museum study of Old Master techniques, from which numerous remarkable copies still exist—for example *Bathsheba* after Rembrandt (1867; Paris, Louvre). Between 1844 and 1848 he travelled, first to the museums of Italy, where he discovered the colour of the Venetians, then to Belgium to see the paintings of Peter Paul Rubens, to the Netherlands to see Rembrandt's paintings, and finally to England for two years to study the work of Sir Joshua Reynolds, George Romney and Thomas Gainsborough. In the Salon of 1850 in Paris he exhibited a portrait of *Mme Sabatier* (priv. col, see Giraud, p. 88) that brought him recognition. He exhibited two portraits in 1853, seven in 1855 and ten in 1859, without further medals and with mixed reviews, and then did not exhibit in Paris again until 1872, when he exhibited a portrait of one of his biographers, *Paul de Musset* (Paris, Louvre). When at the request of his artist friends the government had offered him the rank of Chevalier of the Légion d'honneur in 1865, Ricard refused; he had already become a reclusive, studious aesthete, leading a monastic existence in a quiet, darkened studio, surviving on an annuity from his family's estate and on fees from his sitters.

Ricard painted nearly 150 portraits. Many were of artists, such as Jean-Louis Hamon, Eugène Fromentin, Félix Ziem, Pierre Puvis de Chavannes, Dominique Papéty, Paul Chenevard and Charles Chaplin (e.g. *Ferdinand Heilbluth*, 1857; Paris, Louvre), from whom he asked no fee. He was known to have turned down important and lucrative commissions from people who did not understand his painting. He worked for long periods of time on his portraits without his sitters being present. When his task seemed almost complete, he would recall them and was quoted as saying that he took pleasure in seeing how they resembled the portraits he had made of them. Ricard also painted still-lifes and in 1865 designed and completed decorative panels (e.g. *Venus and Cupid*, 1866; untraced) for the house in Paris of Prince Paul Demidov (1839–1925), one of his few aristocratic patrons.

In his lifetime Ricard was little appreciated, except by his artist friends and by those few amateurs who admired his art-historical erudition and his knowledge of the working procedures of the Old Masters. It was not until after his death, and with the evolution of Symbolism, that critics began to appreciate his work. Ricard was then considered a prophet of Symbolism. Increasingly, his intense and immobilized sitters look out through veils of Venetian glazing, as if in dreams. Although he made, seemingly, good likenesses, he was determined to separate him-self from 'les peintres exactes'. In his lifetime he was accused of being merely eclectic, but later critics understood that he had reinterpreted the techniques of such artists as Leonardo da Vinci, Correggio, Titian, Rembrandt or Reynolds in order to depict each different sitter as if through the mind of that particular Old Master. Each portrait was at the same time Ricard's own creation. With soft contours, rich Baroque colouring, heavy chiaroscuro, neutral backgrounds, muted and unnatural light and generalized costumes that often echo their Renaissance counterparts, such portraits as *Mme de Calonne* (c. 1852; Paris, Louvre) are both mysterious and spiritual.

Bibliography

L. Brès: *Gustave Ricard et ses oeuvres* (Paris, 1873)

P. de Musset: *Notice sur la vie de Gustave Ricard, suivie du catalogue de ses oeuvres exposées à l'Ecole des Beaux-arts* (Paris, 1873)

C. Mauclair: *Gustave Ricard* (Paris, 1902)

R. Cantinelli: 'Gustave Ricard', *Gaz. B.-A.*, i (1903), pp. 83–101

M. Nicolle: 'Le Portrait de *Mme de Calonne*', *Rev. A. Anc. & Mod.*, xxi (1907), pp. 37–40

P. Flat: 'Un Grand Portraitiste français: Gustave Ricard', *Rev. Bleue* (1912), pp. 680–82

S. Giraud: *Gustave Ricard: Sa vie et son oeuvre* (Paris, 1932)

J. A. Cartier: 'Les Peintres provençaux des XIXe et XXe siècles', *Jard. A.*, xlvii (1958), pp. 716–19

NANCY DAVENPORT

Ringel d'Illzach, (Jean-)Désiré

(*b* Illzach, Alsace, 29 Sept 1849; *d* Strasbourg, 28 July 1916). French medallist and sculptor. He studied with François Jouffroy and Alexandre Falguière at the Ecole des Beaux-Arts in Paris, and with Ernst Julius Hähnel in Dresden. The subjects of his numerous cast portrait medallions included *Sarah Bernhardt*, *Léon Gambetta*, *Jules Massenet* and *Emile Zola*. Ringel d'Illzach was also known for his painted wax sculptures, such as his mask of *Maurice Rollinat* (1892; Strasbourg, Mus. A. Mod.), for his ceramic work (e.g. head of *Berlioz*, enamelled stoneware, *c.* 1900; Paris, Mus. d'Orsay), and for his statues and busts in bronze.

Bibliography

Bellier de La Chavignerie–Auvray; Forrer; Thieme–Becker

La Sculpture française au XIXe siècle (exh. cat., ed. A. Pingeot; Paris, Grand Pal., 1986)

MARK JONES

Robert-Fleury, Tony

(*b* Paris, 1 Sept 1837; *d* Viroflay, Paris, 8 Dec 1911). French painter, son of Joseph-Nicolas Robert-Fleury. He was a pupil of Paul Delaroche and of Léon Cogniet, and the main characteristics of his works were due to this training: correct drawing, a restrained palette, an orderly composition and a general respect for the classical tradition. He specialized in history and genre scenes.

His work can be divided into three main periods. The first is characterized by his interest in the picturesque. Before making his début at the Salon of 1864 he had visited Rome and was attracted by the manners and people he found there. His first submissions to the Salon were of two Italian subjects: *Young Roman Girl* (Bayonne, Mus. Bonnat) and *Child Embracing a Relic*. However, his most accomplished work in this field appeared later (e.g. the *Old Women of the Piazza Navona at Santa-Maria della Pace*, exh. Salon 1867; ex.-Mus. du Luxembourg, Paris). It shows Robert-Fleury's ability to convey his vision while accurately observing both the local types and light. Nevertheless, the generalized treatment of the heads deprives his figures of character and betrays the coldness and formality of his academic, Neoclassical training.

The second period of Robert-Fleury's work is characterized by the production of large historical compositions illustrating events from both ancient and contemporary history. The best works are the three paintings that made him famous. The first is *Warsaw, 8 April 1861* (exh. Salon 1866), which depicts the massacre by Russian troops of 4000 Poles, among them many civilians and clerics, in a square in Warsaw during the Polish insurrection of 1861, an incident Robert-Fleury had read about in the newspaper *Moniteur*. This distinctly Romantic subject allowed him to experiment, very successfully, with the representation of intense emotion and drama. He placed the crowd of Polish insurgents in the middle of the composition in a pyramidal arrangement that culminated in the processional cross held by two Catholic monks. The second great historical painting also depicts a dramatic moment: the *Last Day of Corinth* (1870; Paris, Mus. d'Orsay), a work that won him the medal of honour at the 1870 Salon. The subject was taken from Livy's account of the Roman occupation of Corinth, showing Robert-Fleury's knowledge of Classical literature. In fact,

both the subject and style show his continuing commitment to Davidian Neo-classicism, as revealed by his laborious concern with ideal beauty, evident in the studied attitudes of his female figures who glide around a statue of Minerva in the foreground, and also by the classic inclusion of a chariot yoked to a pair of stationary oxen, all as if Delacroix's massacres and wild horses had never existed. However, there are concessions to the Romantic movement in the richly coloured carpets, the golden vessels and the realism of the deep blue Mediterranean sky and sea. The third major painting of this period was *Pinel Frees the Insane from their Chains* (1876; Paris, Hôp. Salpêtrière). In the third and last period of his work Robert-Fleury changed both his subject-matter and style. He turned to genre painting, taking his subjects from modern life (e.g. *Anxiety*, exh. Salon 1904; ex-Mus. du Luxembourg, Paris) and also from the more private moments of the main characters of the French Revolution (e.g. *Charlotte Corday at Caen*, 1874; Bayonne, Mus. Bonnat). Much influenced by realism and Impressionism, he treated these with lighter, cooler and more harmonious tones than before. He also painted mural decorations for the Palais du Luxembourg and the Hôtel de Ville in Paris.

Bibliography

Bénézit; Thieme–Becker

R. Ménard: 'Salon de 1870', *Gaz. B.-A.*, n. s. 1, iii (1870), pp. 494–6, 498

C. Blanc: *Les Artistes de mon temps* (Paris, 1876), p. 474

C. Saunier: 'Tony Robert-Fleury', *Les Arts*, cxxiii (1912), pp. 25–32

ATHENA S. E. LEOUSSI

Roche, Pierre [Massignon, Pierre-Henry-Ferdinand]

(*b* Paris, 2 Aug 1855; *d* Paris, 18 Jan 1922). French painter, sculptor, medallist and designer. While studying medicine and chemistry he took up drawing and model-making, and then became interested in painting; from 1873 to 1878 and again in 1889 he was registered at the Académie Julian,

Paris, receiving advice on painting from Alfred Roll, and exhibiting at the Paris Salon from 1884 to 1889. A competition in 1888 for a monument to *Danton* inspired him to try his hand at sculpture. The boldness of his entry (drawing, Lyon, Mus. B.-A.; plaster fragment, Troyes, Mus. B.-A. & Archéol.) brought him to the attention of Jules Dalou, who encouraged him. Roche went on to produce a number of fountain figures, including *April* (exh. 1893; executed in bronze and *pâte de verre*, 1906; Paris, Mus. Galliéra, gardens) and *Hercules Diverting the River Alpheus* (executed in lead, by the firm of Thiébaut, and glazed earthenware, 1900; Paris, Luxembourg Gardens).

Roche was fascinated by the possibilities of different new materials and invented a kind of relief colour print that he called 'gypsographie', formed by pressing damp paper into a reverse mould of plaster containing coloured inks (e.g. *Medusa*, 1907; Paris, Bib. N., Dept. Est., Ef 441). He also created sumptuous bindings for Symbolist writers, using spangles of coloured glass embedded in transparent vellum (e.g. Paul Verlaine, *Poésies*, 1897; Joris-Karl Huysmans, *La Cathédrale*, 1898; both Paris, Bib. N.). Roche's interest in relief sculpture led him to work as a medallist, most notably on the *Medallic History of the Great War* (Paris, 1922), and, at the other extreme in size, on architectural ornament, such as the façade (destr.) of the Théâtre de la Loïe Fuller, designed for the 1900 Exposition Universelle in Paris. He also executed relief sculptures of *Drama* and *Comedy* (1901) for the theatre at Tulle and the portal and altar for Antoine de Baudot's reinforced-concrete church of St Jean-de-Montmartre, Paris. It may have been the writings of Huysmans that inspired him to base the seven bas-reliefs for his altarpiece *Deliverance* (lead, wood and plaster, 1905–11; Roubaix, Ecole N. Sup. A. & Indust. Textiles) on the Seven Deadly Sins: it was exhibited in 1910 at the Société Nationale des Beaux-Arts, Paris, and brought him the Légion d'honneur. Roche also built his own house (1902) near Binic in Brittany, and designed for it architectural ornament and fittings in the Art Nouveau style (e.g. Paris, Mus. A. Déc.), employing such materials as pewter and ceramics with metallic lustre glazes.

Writings

'La Gypsographie', *Rev. Enc.*, v (1895), p. 384

'Le Plomb dans la statuaire moderne', *A. & Déc*, xii (1902), pp. 172–6

'L'Art rustique', *A. Déc.*, vi/10 (1904), pp. 157–60

Bibliography

Forrer; Thieme–Becker

L. Vaillat: 'Pierre Roche sculpteur', *A. & Artistes*, 94 (1913), pp. 176–80

—: *Catalogue chronologique des oeuvres de Pierre Roche* (Paris, 1923)

P. Vitry: 'Pierre Roche, 1855–1922', *Gaz. B.-A.*, n. s. 5, vii (1923), pp. 215–28

C. Saulnier: 'Pierre Roche', *Le Larousse mensuel*, 189 (1929), pp. 970–71

La Sculpture française au XIXème siècle (exh. cat., ed. A. Pingeot; Paris, Grand Pal., 1986), pp. 387–8, 390

ANNE PINGEOT

Rochegrosse, Georges(-Antoine-Marie)

(*b* Versailles, 2 Aug 1852; *d* Paris, 1938). French painter, printmaker and illustrator. Stepson of the poet Théodore de Banville, he came from a literary and artistic background. He received his early training from Alfred Dehodencq and later studied at the Académie Julian under Gustave Boulanger and Jules Lefebvre. Rochegrosse was one of the most popular Salon painters at the end of the 19th century. From 1882 he exhibited large-scale historical paintings drawn from the Bible and Classical mythology and reconstructed with meticulous archaeological detail (e.g. *Vitellius Dragged through the Streets of Rome*, 1882; Sens, Mus. Mun.). His preference for dramatic scenes of violent excess and carnage was endorsed by official taste when in 1887 his *Death of Caesar* (1887; Grenoble, Mus. Peint. & Sculp.) was acquired by the State. He also painted murals in the library of the Sorbonne, Paris (1898). Extensive travel in Egypt and North Africa encouraged his use of a rich, often garish palette and vigorous handling (e.g. *Oriental Musician*; Moulins, Mus. Moulins). Rochegrosse gained medals at the Salons of 1882 and 1883 and in 1888 was awarded the Salon prize.

He was made Chevalier of the Légion d'honneur in 1892 and an Officer in 1910.

In 1878 Rochegrosse began his career in printmaking with a series of lithographs for the journal *La Vie moderne* and frontispieces to Banville's works. Later he drew heavily on Wagnerian themes, but his most outstanding achievements as a lithographer were his literary work, in particular his illustrations to Gautier, Banville, Baudelaire, Flaubert, Anatole France, Victor Hugo and Villiers de l'Isle Adam. He settled at El Biar in Algeria towards the end of his life but died in Paris.

Bibliography

R. Marx: *Les Maîtres d'affiche* (Paris, 1896)

J. Valmy Baysse: *Peintres d'aujourd'hui* (Paris, 1910)

JANE MUNRO

Rochet, Louis

(*b* Paris, 24 Aug 1813; *d* Paris, 21 Jan 1878). French sculptor and anthropologist. Rochet studied at the Ecole des Beaux-Arts in Paris under Pierre-Jean David d'Angers, but withdrew from the Prix de Rome competition to pursue Oriental languages (especially Chinese) and natural history, at the same time providing models for commercial sculpture. He returned to monumental sculpture in 1838 and followed the example of David d'Angers in sculpting commemorative statues for the provinces, such as *Marshal Drouet d'Erlon* (bronze, 1844–9; Reims, Place de la Couture). Rochet distinguished himself in the costumed pageantry of figures from earlier French history, such as the equestrian *William the Conqueror* (bronze, 1846–51; Falaise, Hôtel de Ville), the *Marquise de Sevigné* (bronze, 1857; Grignan) or *Charlemagne Accompanied by Roland and Olivier* (bronze, 1853–67; erected 1878, Paris, Place du Parvis Notre Dame). The most popular of these historical recreations was *Napoleon Bonaparte as a Student at Brienne* (plaster, exh. Salon, 1853; marble, exh. Exposition Universelle, 1855; bronze, 1855, erected 1859; Brienne, Hôtel de Ville). The bronze monument to *Don Pedro I of Brazil* (1855–62; Rio de Janeiro) involved Rochet in anthropological

and zoological research, as its granite base was enriched by sculptures of groups of natives and local fauna, symbolizing South American rivers. A historicizing approach to style, first used by Rochet in his colossal bronze *Notre Dame de Myans*, erected near Chambéry in 1855, re-emerged in a later series of Classical subjects, initiated by the '*Archaic*' *Minerva* (plaster, gilded bronze and silver plated, exh. Salon 1864).

Bibliography

Lami

A. Rochet: *Louis Rochet, André Bonne* (Paris, 1978)

La Sculpture française au XIXe siècle (exh. cat., ed. A. Pingeot and others; Paris, Grand Pal., 1986)

PHILIP WARD-JACKSON

Rodin, (François-)Auguste(-René)

(*b* Paris, 12 Nov 1840; *d* Meudon, 18 Nov 1917). French sculptor and draughtsman. He is the only sculptor of the modern age regarded in his lifetime and afterwards to be on a par with Michelangelo. Both made images with widespread popular appeal, and both stressed the materiality of sculpture. Rodin's most famous works—the *Age of Bronze*, *The Thinker*, *The Kiss*, the *Burghers of Calais* and *Honoré de Balzac*—are frequently reproduced outside a fine-art context to represent modern attitudes that require poses and encounters freed from allegory, idealization and propriety. The Rodin mythology embraces the artist's faith in the spiritual dignity of individuals that direct scrutiny can reveal; this is at its most blatant in Rodin's portraits of French heroes such as Balzac and Victor Hugo, presented naked and vulnerable. His numerous biographers dwell on his rise from humble origins and his struggle to be accepted by the juries arbitrating entry to the Salon and to be awarded government commissions. Also part of the myth are the fidelity of Rose Beuret, his companion of 50 years; his brazen sexuality; and the unprecedented international fame Rodin acquired after 1900.

Set outside this familiar story is the artist who has appealed to people with an enthusiasm for the landmarks of avant-garde sculpture and life drawing. A massive legacy of extremely experimental and intimate studies—on paper, in plaster, some merely fragments, some not published until the 1980s—have helped contradict the criticism that Rodin's mature work was compromised by rather dull copies of popular works realized by his large workshop.

Because he encouraged the reproduction and dissemination of his works in bronze and marble editions, Rodin is represented in many public and private collections. The largest collection of his works—drawings as well as sculpture—is in the Musée Rodin, Paris. Many of his original plasters are in the Musée Rodin, Meudon.

1. Life and work

(i) Paris and Brussels, 1840–77. Rodin was born in the working-class Mouffetard district in Paris, the son of a clerk in the police force. At the age of 13 he entered the Petite Ecole (Ecole Spéciale de Dessin et de Mathématiques), where the curriculum stressed the copying of approved styles and learning techniques applicable to the decorative arts. One of his professors was Horace Lecoq de Boisbaudran, who encouraged the development of a personal style and asked pupils to draw from the moving model and from memory. Rodin was a promising student, in 1857 winning first prize for sculpture and second for drawing, but he then suffered the humiliation of failing three times to gain admission to the Ecole des Beaux-Arts. For the next 20 years he was obliged to earn a living as a craftsman or ornamenter, working for a succession of jewellers, masons and craftsmen supplying the large market for decorative objects and embellishments to buildings. Early on the sculptor Constant Simon taught him the technique of modelling in depth from the outermost tip inwards, treating the surface of the work as the skin of the muscles and organs within.

After the death of his sister in 1862 Rodin entered the Order of the Pères du Saint-Sacrement but was encouraged by its head, Pierre-Julien Eymard, to devote himself instead to art. Gradually, as his reputation as a modeller grew, his status changed, and in 1864 he was employed by the successful sculptor Albert-Ernest Carrier-

Belleuse; he continued to work for him intermittently until 1882. Rodin began executing nude figures from his employer's designs, but attribution is difficult, as none bears his signature. The *Vase of the Titans* (version of *c*. 1876–8; London, V&A), for instance, is inscribed *Carrier-Belleuse*, although the figures for it seem to have been modelled by Rodin and to be based only loosely on drawings by the older man. When the decorative trades collapsed in the wake of the Franco-Prussian War of 1870, Rodin followed Carrier-Belleuse to Brussels and, after a quarrel with him, formed an independent partnership with Antoine Van Rasbourgh (1831–1902) to execute public commissions. The last of these was the monument to the burgomaster of Antwerp, *J. F. Loos*, a large fountain with Michelangelesque seated figures of *Industry*, *Commerce* and *Navigation* (marble, 1874–6; *in situ*). He also began exhibiting small-scale works and portrait busts that possess an 18th-century charm (e.g. *Mignon*, 1870; *Paul de Vigne*, 1876; both plaster, Paris, Mus. Rodin).

What is striking about the poorly documented early years is Rodin's tenacious struggle to become a recognized sculptor. This entailed great self-discipline and continuing study. He attended the classes of Antoine-Louis Barye at the Musée d'Histoire Naturelle, which gave him the opportunity to draw and then model animals and also to observe Barye himself, an obsessed and solitary artist whom Rodin praised as 'beyond all and outside of all art influences, save nature and the Antique' (Washington, DC, Lib. Congr., Truman Bartlett papers). He also attended the evening life-drawing sessions at the Gobelins and, in spite of his poverty, rented studios so that he could work on large figures, none of which survives.

The first sculpture to indicate Rodin's bias towards recording directly what he saw before him is the *Man with a Broken Nose* (original terracotta, 1863–4; Antwerp, Kon. Mus. S. Kst.; numerous bronzes). The strongest evidence of imagination and originality, however, comes in the sketchbooks (Paris, Mus. Rodin), which are filled with tiny drawings that begin as cryptic line notations, some using the *écorché* treatment of muscles. One

of the most remarkable of the surviving early sculptures is a seated *Ugolino* (plaster, *c*. 1875; Paris, Mus. Rodin), which was influenced by Jean-Baptiste Carpeaux's anguished *Ugolino and his Sons* (exh. Salon 1863; version, Paris, Mus. d'Orsay). Rodin's limbless, monolithic fragment conveys a rawer and more primitive victim. In the winter of 1875–6 Rodin travelled to Italy, hoping to discover the 'secrets' of Michelangelo; he returned to Brussels equally impressed with Donatello, Raphael and Classical art. He resumed work on a standing nude male figure, using a soldier as his model; this was eventually called the *Age of Bronze* (bronze version, London, V.&A.; see fig. 65), and in 1877 Rodin submitted it to the Cercle Artistique in Brussels and the Salon in Paris. He returned to Paris from Brussels in March of that year.

(ii) **Paris, 1877–95.** Accounts of Rodin's career normally begin with the *Age of Bronze*, his first *succès de scandale*. The statue was unconventional in its lack of a specific subject, reflected in the number of different titles Rodin gave it, and the immediacy of the strained but graceful body of the 'common man' aroused suspicion and disapproval. Official protest was channelled into the accusation that Rodin had relied on life casts, a charge proved wrong not so much by comparing the sculpture with photographs of the model as by the artist's reputation as a superlative modeller. The evidence could be found in other works of the period, especially his portrait busts, his work on commissions for decorative work, such as the mascarons for a fountain (destr.) for the Palais du Trocadéro, Paris, and the robust heroic figure of *St John the Baptist* (bronze version, 1878–80; London, V&A). In February 1880 a group of eight leading artists (Henri Chapu, Paul Dubois, Alexandre Falguière, Jules-Clément Chaplain, Gabriel-Jules Thomas, Mathurin Moreau, Albert-Ernest Carrier-Belleuse and Eugène Delaplanche) sent a letter to the government asking for Rodin, 'whom we expect to occupy a great place among the sculptors of our time', to be officially encouraged. The result was a rapid change of situation: first the state purchased the *Age of Bronze*; then,

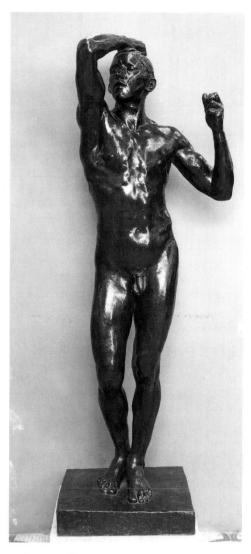

65. Auguste Rodin: *Age of Bronze*, 1876 (London, Victoria and Albert Museum)

that became known as the *Gates of Hell* (original plaster, Paris, Mus. d'Orsay; see col. pl. XXXIII) and to interpret various episodes by means of hundreds of small figures arranged in a tumultuous manner and on a discordant scale, providing a visual analogy for the breakdown of traditional morality associated with the late 19th century. The title is intended to allude to Lorenzo Ghiberti's bronze doors (the *Gates of Paradise*) for the Baptistery of Florence Cathedral. Rodin engaged in two kinds of preparatory drawing for the doors: in his architectural sketches he established a rectangular grid, each panel containing a narrative scene referring to Ghiberti and to Gothic models; in his black gouaches he focused his imagination on intense encounters between two figures—frequently Dante and Virgil, or variations on the themes of Ugolino and Medea, or abducted youths, sometimes in the clutch of centaurs (e.g. Paris, Mus. Rodin; see also 1986 exh. cat.). These were made iconic by reinforced profiles and the repetition of poses and, with the evocative use of gouache and sepia ink, foreshadowed Rodin's search in the medium of clay for a means to articulate human feelings that correspond to 'unknown forces within nature'.

State patronage entitled Rodin to a studio at the Dépôt des Marbres, 182 Rue de l'Université, Paris (where he remained for the rest of his life), and financed a constant supply of models and technicians. He preferred models who were not professional and who were willing to move naturally until he caught an uninhibited action that could inspire a sculpture. Their lean, youthful bodies suited both Romantic interpretations of Dante's story of Paolo and Francesca (e.g. *Eternal Springtime*, which was cast in 3 sizes, 151 appearing by 1919; version, Paris, Mus. Rodin) and figures in postures suggesting feverish excesses of passion. On the tympanum of the *Gates*, the latter represent souls in limbo; in isolation, they were given such generic names as *Sorrow* and *Meditation* (e.g. Paris, Mus. Rodin). At an early stage Rodin began inserting figures into the narrow side pilasters, intertwining their limbs vertically in a manner that recalls the friezes encircling the porcelain vases 'Day' (both 1881–2; Sèvres, Mus. N. Cér.) and

in August 1880, the Under-Secretary in the Ministry of Arts, Edmond Turquet (1836–1914), invited Rodin to provide monumental bronze doors for a planned new museum of decorative arts.

It appears that it was Rodin's decision to choose Dante's *Inferno* as the theme for the doors

'Night' (Paris, Mus. Rodin), which he was designing during the same period at the Sèvres manufactory. There are close correspondences between the designs made in low relief in paste and those made in clay for the *Gates*. Configurations for common themes—'crouching man', 'woman held aloft by a standing man', 'mother and child'—were reworked, and parts or whole figures combined, to form an enduring, sexually ambiguous image. Thus the faun and nymph and the abduction scene on the two vases predict the way he attached the *Crouching Woman* to the *Falling Man*, with head thrown back, to create the astonishingly daring *Carnal Love*, also known as *Le Rut*; when a version of this was shown in 1886 at the Galerie Georges Petit, Paris, it was inscribed with lines from Charles Baudelaire's poem *La Beauté* ('I am beautiful as a dream of stone, but not maternal') and named *Je suis belle* (bronze, *c.* 1887; Helsinki, Athenaeum A. Mus.; numerous posthumous bronze casts).

Visitors to Rodin's studio in the Rue de l'Université compared the rough plaster reliefs attached to scaffolding to Michelangelo's *Last Judgement* in the Sistine Chapel, Rome, and to Eugène Delacroix's *Death of Sardanapalus* (1827; Paris, Louvre). The handling of light and shade, the partial figures caught in the swirling background and the impression of human libido released from religious or social constraints captured the mood of desperation and anarchy fundamental to Romanticism: Théodore Gericault's *Raft of the Medusa* (1819; Paris, Louvre) was a specific source. Rodin's explanation in 1886 of his inability to follow a scheme or to emulate the moral authority of Dante was not disingenuous: 'My sole idea is simply one of colour and effect . . . I followed my imagination, my own sense of arrangement, movement and composition' (see Bartlett, 1889, p. 223).

In 1885 Rodin announced that the *Gates* would be ready to be cast in six months. Plans for building the museum were soon cancelled, however. Freed from a deadline, he let the work stand in his studio, intermittently revising the figure groups and architectural mouldings. In 1900 the plaster sections of the *Gates*, 6.35 m in height,

were transported to a purpose-built pavilion in the Place de l'Alma, Paris, and shown for the first time to the public in an exhibition of 168 sculptures plus drawings and photographs organized by Rodin himself to coincide with the adjacent Exposition Universelle. Rodin's masterpiece remained more or less untouched until after his death, when it was prepared for casting. The first bronze was made in 1925, for Jules Mastbaum (1872–1926) of Philadelphia (Philadelphia, PA, Rodin Mus.), and the last in 1977 for B. Gerald Cantor and placed in the garden of the Stanford University Museum of Art (*in situ*; the other three are in Paris, Mus. Rodin; Zurich, Ksthaus; and Tokyo, N. Mus. W. A.); another was planned for Japan for 1993. The original plaster in the Musée d'Orsay remains the property of the French government.

Rodin was always eager to be awarded public commissions, but he invariably approached them in a manner at odds with approved practice; as his ambition deepened, the process lengthened, and the costs rose. As early as the 1870s he had entered competitions, submitting the *Call to Arms* (1879; plaster and bronze versions, Paris, Mus. Rodin) to the search for an allegorical monument to the defence of Paris in the Franco-Prussian War and in 1879 presenting a bust of his mistress Rose Beuret wearing a Baroque helmet to the committee choosing a symbol of the Republic (*Bellona*, terracotta; Paris, Mus. Rodin; numerous bronze casts). In late 1884 he secured the civic commission for a monument to the *Burghers of Calais* who in 1347 had offered their lives to the English in return for ending their siege. Although commissioned to depict only the leading burgher, Eustache de St Pierre, Rodin decided to show all six, realizing each individually, first nude and then draped, in progressively larger stages, until the final scale of 2 m in height. Grouped one behind another in a ring, these gaunt figures express indecision as much as self-sacrifice. After delays caused by disapproval of the composition and financial problems within the city government, the final work was unveiled in Calais, in front of the Hôtel de Ville, in June 1895. Before 1917 three more casts were made, one of which

was purchased in 1911 by the National Art Collections Fund for the Victoria Tower Gardens, London (Rodin envisaged the monument high on a pedestal, silhouetted against the Houses of Parliament). There are seven additional casts and many bronzes of the individual burghers (e.g. Geneva, Mus. A. & Hist.; Minneapolis, MN, Inst. A.; Paris, Mus. Rodin).

The best of Rodin's memorial statues and portraits are those of creative people. He depicted the painters *Jules Bastien-Lepage* (bronze, 1887; Damvillers Cemetery) and *Claude Lorrain* (bronze, 1892; Nancy, Pepinière Gardens) with their palettes in hand, one stooping, the other as if about to climb a hill. In 1889 he was asked by the committee in charge of sculpture for the Panthéon, Paris, to make a statue of *Victor Hugo*, of whom he had modelled a portrait bust in 1883 (pencil sketches, Paris, Mus. Rodin, D5358; plaster copy presented by Rodin in 1885 to Cambrai, Mus. Mun.). He decided to depict the poet in an even more informal moment: naked, seated on a rock (recalling Hugo's exile in Guernsey), surrounded by female muses. The commissioners objected to seeing a national hero apparently degraded, and the work was never completed, although various extraordinary versions exist in plaster. The most dramatic (c. 1897; Meudon, Mus. Rodin) depicts Hugo accompanied by the grotesque *Tragic Muse* (Geneva, Mus. A. & Hist.) and the *Inner Voice* (c. 1891–7; London, V&A, on loan to London, Tate). A modern cast (bronze; erected 1964) of this version is at the junction of the Avenues Victor Hugo and Henri Martin, Paris.

The invitation issued in 1891 by the Société des Gens de Lettres to portray the writer *Honoré de Balzac* (see fig. 66) initiated a similarly acrimonious saga. Rodin struggled for seven years to find a means of conveying the charisma, intellect and achievement of the writer he most admired. He collected daguerreotypes and caricatures and consulted Balzac's tailor, as well as visiting Touraine to study the local physiognomy. Eventually he modelled what he called 'a Balzac in his study, breathless, hair in disorder, eyes lost in a dream' (*A. & Artistes*, no. 108, 1914, pp. 70–71) and placed the head on top of a plaster-soaked shroud that

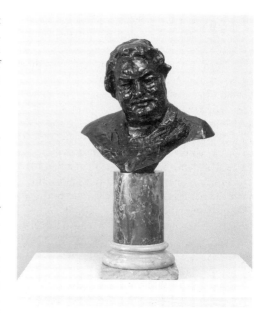

66. Auguste Rodin: *Honoré de Balzac*, 1892 (London, Tate Gallery)

simulated the writer's dressing-gown, an angular projection alluding to his concealed virility. The monument (h. 3 m) was spurned by the Société and ridiculed by the public. Rodin quietly reflected that 'Balzac, rejected or not, is none the less a line of demarcation between commercial sculpture and the sculpture that is art that we no longer have in Europe ... My principle is to imitate not only form but life' (*Le Journal*, 12 May 1898).

Rodin seems to have neglected studio drawing between 1883 and the early 1890s, although he did make several prints (drypoints and etchings), producing his earliest examples in London in 1881 under the guidance of Alphonse Legros (e.g. London, V&A); he also illustrated books, notably the Gallimard edition of Baudelaire's *Les Fleurs du mal* (1888).

Rodin continued to work with figures destined for the *Gates of Hell* throughout the late 1880s and the 1890s. Modelled in the round, they frequently proved viable as independent works, often enlarged. The first group was shown at the Galerie

Georges Petit in 1886, when the eroticism shocked some observers: works with sexual themes of a lyrical nature (bronze, 1886, priv. col.; over life-size marble, 1898, Paris, Mus. Rodin) are an exception. Several embraces parody the lust of older men for young flesh, such as *The Minotaur* (bronze, *c.* 1886; priv. col., see 1986 exh. cat., p. 88) and *Triton and Nereid* (bronze, *c.* 1886; Leipzig, Mus. Bild. Kst.). Many small works have a quiet intensity and intimate observation of female sexuality, the posture of *Despair* (plaster, *c.* 1890; London, V&A), for example, her foot in hand, providing a metaphor for orgasm. By changing the orientation of a reclining pose in *Iris, Messenger of the Gods* (bronze, *c.* 1890–91; priv. col., see 1986 exh. cat., pp. 122–3) Rodin managed to expose the female sexual organs and simultaneously allude to the provocative gestures of the can-can dancers then in vogue. Occasionally his work of the 1890s parallels Symbolist taste, both in the muted treatment of detail and in the concentration of lesbian love and other *fin-de-siècle* themes of decadence.

(iii) Paris and Meudon, 1895–1917. At the end of 1895 Rodin purchased the Villa des Brillants, a modest building in the suburb of Meudon, to which he added a studio and transferred the façade of a ruined château. There, as an international celebrity, he was host to royalty, politicians, society and young writers and artists. Exhibitions of his work were staged throughout Europe as well as in the USA, and Rodin received honorary degrees from foreign universities, beginning with Jena and Glasgow. The poet Rainer Maria Rilke, who published a study of Rodin in 1903, served as his secretary in 1905–6; Henri Matisse and Constantin Brancusi came into contact with him in 1907–8. Naturally shy and preoccupied with his art, Rodin depended on the understanding of a few long-standing male friends and the empathy of intelligent female companions including his biographer Judith Cladel; he also fell prey to manipulative women like Claire Gudert, Marquise de Choiseul. His lifelong habit of making pilgrimages to French cathedrals continued, and in 1914 he published *Les Cathédrales de France*, which contains reproductions of his minimal stud-

ies of architectural detail and his meditations on the Gothic age.

When Rodin resumed drawing in the 1890s, always in the presence of a model, he kept his eye on the body while his hand recorded sensations, often distorting familiar conventions for contour and perspective in order to give an unprecedented feeling of proximity, equipoise and the playful gestures of women. Female sexuality and the relation between the origin of life and artistic creativity are the principal subjects (e.g. *The Abandoned*, *c.* 1910; New York, Met.). The drawings are often annotated or modified by gouache or by smudging the charcoal. Some sheets are tracings or cut-outs of the initial recording of the pose and thus parallel techniques of reproduction and serial changes in the sculpture. The late drawings have frequently been forged; the *Inventaire des dessins* (1984–) of the Musée Rodin, Paris, lists over 7000 works and helps to establish standards and types. The spontaneity, wavering silhouette and curiosity about reorientating the pose of figures in free space transfer to several late three-dimensional studies, including that of *Vaclav Nijinsky* (bronze; priv. col., see 1986 exh. cat., p. 162), who posed in 1912, soon after Rodin saw the first performance of Debussy's ballet *Prélude à l'après-midi d'un faune*.

It was also in the 1890s that Rodin began collecting the art of other cultures; antique fragments and Eastern buddhas were displayed next to his own sculpture, or in some cases little figurines he made were inserted in vases. His interest in Eastern culture, which was substantial, came about partly as a result of his excitement at seeing the Cambodian dancers who visited Paris with King Sisowath in the summer of 1906. He followed them to Marseille in order to make drawings (Paris, Mus. Rodin; exh. Paris, Gal. Bernheim, Oct 1907), and there at the Colonial exhibition met the Japanese actress Hanako, who posed for him intermittently between 1907 and 1910; the 53 or so studies (e.g. bronze, *c.* 1918; Paris, Mus. Rodin) of her face are among his most vivid and experimental late works.

After 1900 Rodin accepted several more public commissions but completed none of them. The

monument to *Puvis de Chavannes* (plaster, 1901; Paris, Mus. Rodin) consists of an assemblage of the painter's bust, which Rodin had made in 1890, placed on a stand beside a naked youth, or 'genie of eternal repose', and an apple branch. Gwen John posed in 1904 for his monument to *James McNeill Whistler* (never cast full-size; plaster, Paris, Mus. d'Orsay), her raised leg adapted from Classical art; the febrile awkwardness of the pose is oddly fitting for the haunted features of the young painter. During this period Rodin also executed a number of portraits of statesmen and wealthy patrons, some friends and admirers, such as *Eve Fairfax* and *Marcelin Berthelot*, and others with whom his relationship was distant, such as *Gustav Mahler* (1909) and *Pope Benedict XV* (1915; versions, Paris, Mus. Rodin). Georges Clemenceau sat for Rodin 18 times in 1911, one version of his features progressing to the next by the alteration of a fresh *estampage*, or clay cast.

In 1916, after lengthy negotiations, the French government designated the Hôtel Biron on the Rue de Varenne, where Rodin had been renting rooms since 1908, as a future Musée Rodin, and received in turn three donations of work owned by the artist, including an enormous quantity of plasters and drawings. In March 1916 Rodin suffered a severe stroke, and in February 1917 he and Rose Beuret were married, two weeks before her death, which was followed by his own in November. Their brain-damaged son, Auguste Beuret, died a rag-and-bone man without heirs.

2. Working methods and technique

In many ways Rodin's mature production reflected the demand during the Second Empire and the Third Republic by both the bourgeoisie and public bodies for monuments and domestic sculpture; after 1900 the demand for his work expanded throughout Europe and to America and even Japan. His early training as a craftsman led him to value the economic privilege of delegating intermediate stages and using specialists. The plaster casts could be reworked, sometimes by simply dipping them in liquid plaster to freshen and mute the surface. Frequently a fresh clay squeeze was made from the mould, a useful record if Rodin wanted to preserve the results of one session, especially with an important portrait sitter, and still continue working with the option of adding clay to the earlier state.

From the early 1880s Rodin rented more than one studio, establishing workshops on the Boulevard de Vaugirard, Paris (from 1886), and elsewhere. He installed his sculpture in the dilapidated mansion of the Folie Neufbourg, Paris (destr.), where he brought the sculptor Camille Claudel, who was then his mistress; he deliberately used the surroundings to create an atmosphere in which the works seemed to 'live', as he was to do at the Hôtel Biron, at Meudon and in the installations of several exhibitions from 1900 onwards. An obsessive interest in lighting and dramatic positionings was extended to the medium of photography, where scenarios could be envisaged that treated the sculptures as dramatic protagonists in a very personal drama (e.g. *Meditation* without arms overshadowed by *The Shade*, photographed by Jacques-Ernest Bulloz (1858–1942); c. 1896; Paris, Mus. Rodin).

The huge quantity of invoices and letters Rodin preserved testifies to how closely he supervised his assistants. The carvers (who used a pointing machine to work up Rodin's plaster models in marble), patinators and founders included such artists as Victor Peter (1840–1918) and Emile-Antoine Bourdelle. His favourite 'collaborator', Henri Lebosse, between 1894 and 1917 carried out numerous enlargements and reductions with the aid of the Collas pointing method, reproducing instinctively Rodin's unconventional lack of finish, especially on the bases. Rodin believed in making his art as widely available as possible and during his lifetime authorized large bronze and marble editions. Over 300 bronze copies of *The Kiss*, for example, had appeared by 1917, in addition to several enormous marble versions made to order (e.g. the one made for Edward Warren Parry, 1904; London, Tate). By the terms of Rodin's will the administrators of the Musée Rodin, Paris, were authorized to initiate and complete editions of bronzes from the vast stock of plasters. Unfortunately strict regulation, with editions limited to 12 copies, began only in 1978.

The firm of Alexis Rudier made both lifetime and posthumous casts; the son Eugène Rudier (1875–1952) executed most until his death, when the nephew, Georges Rudier, took over. Apart from references to provenance, it is extremely difficult to prove whether a work was made in the artist's lifetime, especially as some lifetime works are unsigned, and signatures were traced by founders.

Where no precedent for Rodin's thinking and methods exists is in his reliance on the model to excite his imagination and in his consideration of his own art as legitimate source material: 'Sometimes one believes that there is nothing to be found in a model, and then nature suddenly reveals something of herself, a strip of flesh appears and that scrap of truth reveals the whole truth and allows one to leap with one bound to the absolute principle that lies behind things' (see Dujardin-Beaumetz, 1913, p. 63). Modifying works over a period of years entailed amputating and changing the limbs, combining successful elements and revitalizing previous ideas with a new model. On occasion two distinct figures, sometimes of different scales and genders, were united or juxtaposed. Such revisions led, for example, to the placing c. 1904 of a head of *Gwen John* on one of the *Sons of Ugolino* made c. 1882 (plaster; Paris, Mus. d'Orsay). Increasingly Rodin left evidence of working processes, especially mould seams and the imprint of the wetting cloths, traces of torn clay, broken casts and rough chisel marks. Revisions spanned decades, as when *St John the Baptist* became the armless *Walking Man* installed in the Palazzo Farnese, Rome, in 1912 (bronze; *in situ*).

Among Rodin's finest works are his enlargements. The seductive, complete figure of *Meditation* from the *Gates of Hell* became the mysterious, brutalized fragment *Inner Voice* (numerous posthumous bronze casts, e.g. London, V&A, on loan to London, Tate), while a hovering damned spirit within the roof of the tympanum of the *Gates* changed to the seemingly catatonic horizontal figure of *The Martyr* (1885; bronze versions, Zurich, Ksthaus; Philadelphia, PA, Rodin Mus.; Prague, N.G., Rodin Mus.; Paris, Mus. Rodin; Lausanne, Josefowitz Col.).

3. Critical reception and posthumous reputation

From the moment Rodin's work began to be noticed in 1877, he attracted—and has continued to attract—constant and abundant critical comment. The sources range in seriousness and accuracy, too many accounts stemming from biased personal recollection. In the edited interviews published in his lifetime (particularly Gsell, 1911) Rodin seems suspiciously eloquent, although his letters do reveal an ability to communicate verbally his aesthetic and moral vision. Several of his closest friends and supporters were distinguished writers, notably Roger Marx, Gustave Geffroy, William Henley, Octave Mirbeau and Mathias Morhardt. They, and such poets as Arthur Symons and Rilke, analysed what they saw from a position of vicarious identification with the courageous and candid observation of libidinous thought.

These defenders and political allies could not, however, protect Rodin from persistent invective, which reached new heights during the unveiling of *Balzac* in 1898. Such attacks were often mixed with charges of indecency, as when he rented the Hôtel Biron, formerly occupied by nuns, and began keeping families of gypsy models on the premises. For 40 years after his death there was widespread reaction against his towering presence, partly caused by a 'truth to materials' ethic that criticized his late production. Meanwhile, many bronzes continued to be cast in awkward sizes (like the small *Burghers*), others were given syrupy patinas, and the marbles were copied rather mechanically.

When various critics began to restore Rodin's image (see Steinberg, 1972) they directed attention to the plasters. In the 1960s Elsen initiated a rigorous scholarly approach to Rodin studies, supplemented by the research of his doctoral students at Stanford University and culminating in the *Rodin Rediscovered* exhibition in Washington, DC (see 1981 exh. cat.). In turn the Musée Rodin, Paris, began to produce excellent catalogues (1977–), as well as the illustrated inventory of drawings (1984–) and his collected letters (1985–). The feminist accusation that Rodin exploited the devotion he aroused in female admirers and suppressed the talent of women artists has had to be reversed in

the face of evidence of his encouragement and respect for the work of Gwen John, Camille Claudel, Hanako and many other talented companions. He remains an artist whose production and originality overwhelm those who attempt to explain his entire career.

Writings

Les Cathédrales de France (Paris, 1914; Eng. trans., Boston, 1965)

A. Beausire and H. Pinet, eds: Correspondance de Rodin (Paris, 1985–)

Bibliography

T. H. Bartlett: 'Auguste Rodin, Sculptor', Amer. Architect & Bldg News, xxv (1889), pp. 27–9, 44–5, 55–6, 99–101, 112–14, 198–200, 223–5, 249–51, 260–63, 283–5

A. Symons: 'Rodin', Fortnightly Rev., lxxi (1902), pp. 957–67

R. M. Rilke: Rodin (Berlin, 1903; Eng. trans., Salt Lake City, 1982)

L. Delteil: Rodin, vi of Le Peintre-graveur illustré, 31 vols (Paris 1906–26/R New York, 1969)

R. Marx: Auguste Rodin: Céramiste (Paris, 1907)

P. Gsell: L'Art: Entretiens réunis par Paul Gsell (Paris, 1911; Eng. trans., Berkeley, 1984)

H. Dujardin-Beaumetz: Entretiens avec Rodin (Paris, 1913)

G. Grappe: Catalogue du Musée Rodin (Paris, 1927, rev. 5/1944)

J. Cladel: Sa vie glorieuse, sa vie inconnue (Paris, 1936; Eng. trans., New York, 1937)

A. Elsen: 'The Gates of Hell' by Auguste Rodin (Minneapolis, 1960, rev. Stanford, 1985)

——: Auguste Rodin: Readings on his Life and Work (Englewood Cliffs, 1965)

H. W. Janson: 'Rodin and Carrier-Belleuse: The Vase des Titans', A. Bull., l (1968), pp. 278–80

The Drawings of Rodin (exh. cat. by A. Elsen, J. K. T. Varnedoe, V. Thorson and E. Chase Geissbuhler, Washington, DC, N.G.A.; New York, Guggenheim; 1971–2)

J. de Caso: 'Rodin's Mastbaum Album', Master Drgs, x (1972), pp. 155–61

L. Steinberg: 'Rodin', Other Criteria: Confrontations with Twentieth Century Art (New York, 1972), pp. 322–463

Rodin Graphics (exh. cat. by V. Thorson, San Francisco, CA Pal. Legion of Honor, 1975)

J. Tancock: The Sculpture of Auguste Rodin: The Collection of the Rodin Museum, Philadelphia (Philadelphia, 1976)

Rodin et les écrivains de son temps (exh. cat., ed. C. Judrin; Paris, Mus. Rodin, 1976)

Auguste Rodin: Le Monument des Bourgeois de Calais (exh. cat., ed. M. Laurent and D. Vieville; Paris, Mus. Rodin, 1977)

J. Newton and M. MacDonald: 'Rodin: The Whistler Monument', Gaz. B.-A., xcii, 6th ser. (1978), pp. 221–31

A. Elsen: In Rodin's Studio (London, 1980)

Rodin Rediscovered (exh. cat., ed. A. Elsen; Washington, DC, N.G.A., 1981)

C. Judrin: Les Centaures (Paris, 1981–2); Ugolin (Paris, 1983); Dante et Virgile aux enfers (Paris, 1984) [dossier cats of Mus. Rodin, Paris]

Auguste Rodin: Zeichnungen und Aquarelle (exh. cat. by E.-G. Güse and others, Münster, Westfäl. Landesmus., 1984; Eng. trans., London, 1985)

Inventaire des dessins, Paris, Mus. Rodin cat. (Paris, 1984–)

S. Beatty: The Burghers of Calais in London (London, 1986)

Rodin: Sculpture and Drawings (exh. cat. by C. Lampert, London, Hayward Gal., 1986; 2/New Haven, CT, 1987)

F. V. Grunfeld: Rodin: A Biography (New York, 1987)

A. Beausire: Quand Rodin exposait (Dijon, 1988)

Le Corps en morceaux (exh. cat., ed. A. Pingeot; Paris, Mus. d'Orsay; Frankfurt am Main, Schirn Ksthalle; 1990)

R. Butler: The Shape of Genius (New Haven, 1993)

CATHERINE LAMPERT

Roll, Alfred(-Philippe)

(b Paris, 1 March 1846; d Paris, 27 Oct 1919). French painter. He attended the Ecole des Beaux-Arts, Paris, where he was a pupil of Henri-Joseph Harpignies and of Charles-François Daubigny, and painted his first landscape in 1869. He also painted animals and society portraits in the manner of Léon Bonnat and historical subjects under the supervision of Jean-Léon Gérôme, such as Halt! (1875; Metz, Mus. A. & Hist.), which depicts an episode in the Franco-Prussian War. His interest in documenting the celebrations of the Third Republic can be seen in Centenary of 1789, which he exhibited in 1893, and the Laying of the First Stone of the Pont Alexandre III (1899; both Versailles, Château). In an essentially Realist style and light palette adapted from Impressionism, he recorded typical representatives of contemporary working life such as Manda Lamétrie,

Farmer's Wife (1887; Paris, Mus. d'Orsay) and more contentious political subjects such as the *Miners' Strike* (1884; Valenciennes, Mus. B.-A.).

The range of themes Roll was willing to essay and the acceptable modernity of his technique secured him numerous official commissions to decorate municipal buildings from the late 1860s, for example the ample, languid nudes, painted in the glamorous style fashionable *c.* 1900, which decorate the Salon d'Introduction of the Hôtel de Ville, Paris, entitled *Flowers, Women, Music* (1895) and *Movement, Work* and *Light* (1905). He exhibited at the Salon from 1870. He was made a Chevalier of the Légion d'honneur in 1883 and was a co-founder and later president of the Société Nationale des Beaux-Arts.

Bibliography

L. Roger-Milès: *Alfred Roll* (Paris, 1904)

Le Triomphe des mairies (exh. cat., Paris, Petit Pal., 1986), pp. 379–81

COLETTE E. BIDON

Roty, (Louis-)Oscar

(*b* Paris, 11 June 1846; *d* Paris, 23 March 1911). French medallist. He was the leading French medallist of the late 19th century. He studied painting under Horace Lecoq de Boisbaudran and sculpture under Augustin-Alexandre Dumont. In 1875 he won the Prix de Rome for engraving and, supported by his more conservative mentor, Jules-Clément Chaplain, was elected to the Institut de France in 1888. In 1889 he won the Grand Prix at the Paris Exposition Universelle and was appointed an officer of the Légion d'honneur. In 1907 he was awarded the Salon medal of honour for sculpture, an unprecedented award for a medallist.

Roty's flourishing career reflected his role in what Roger Marx called 'the Renaissance of the medal in France'. This was evident at the Paris Exposition Universelle of 1900, where struck medals by Roty and others sold in tens of thousands. He revived the rectangular Renaissance plaquette in the portrait of his son, *Maurice Roty* (1886). The *Funeral of Sadi Carnot* (1898),

commemorating the assassinated president, evokes on a reduced scale the melancholy grandeur of Antonio Canova's tomb for *Archduchess Maria Christina* in the Augustinerkirche, Vienna. Similarly effective is the message of rehabilitation conveyed in the triptych format of the obverse of the *Prisons of Frèsnes-les-Rungis* medal (1900). Other medals show Roty's versatility and wit; the *Marmite Club* reverse (1881) depicts a cooking pot, while *Vin Mariani* (1895), portraying Venus and the sick Cupid, advertises the restorative powers of medicinal wine. His most famous design, the *Sower*, was for the 1897 coinage; an instant success, it was also used for postage stamps. It combines realism with classical elegance, the flowing hair echoed in the drapery folds. Roty also made bracelets, brooches, mirror backs and architectural sculptures, and was credited with the formation of a new school of medallists, which included Alexandre Charpentier and Georges Dupré.

Bibliography

E. B. S. Forrer: 'Oscar Roty and the Art of the Medallist', *The Studio*, vii (1896), pp. 158–62

R. Marx: *Les Médailleurs français depuis 1789* (Paris, 1897)

L. Bénédite: 'O. Roty', *A. & Déc.*, xxix (1911), pp. 133–6

La Médaille en France de Ponscarme à la fin de la Belle Epoque (exh. cat., ed. Y. Goldberg; Paris, Hôtel de la Monnaie, 1967)

M. Jones: *The Art of the Medal* (London, 1979)

The Beaux-Arts Medal in America (exh. cat. by B. A. Baxter, New York, Amer. Numi. Soc., 1988)

MARK STOCKER

Rousseau, Henri(-Julien-Félix)
[(le) Douanier]

(*b* Laval, 21 May 1844; *d* Paris, 2 Sept 1910). French painter. He is commonly seen as the archetype of the untutored artist and can be considered the first major exponent of Naive art. His brightly coloured, dream-like paintings, many of them depicting exotic subjects, anticipated some of the major artistic movements of the 20th century, including Surrealism.

1. Life and work

He attended the lycée in Laval but had no formal artistic training. His life was one of meagre incident, even though he sought to enhance it with stories of action with the French army in Mexico. In fact, his few years in the infantry were largely spent garrisoned at Angers, and it is likely he never once set foot outside France. By 1871 he had a steady job with the Paris toll-service, which operated at gates in the city wall, a position that in due course earned him the semi-mocking nickname, given by the young poet Alfred Jarry, of 'Le Douanier'.

The circumstances of Rousseau's becoming a self-taught artist remain obscure, although long hours of inactivity at the gates were undoubtedly a contributory factor; it is known that by 1884 he had a copyist's permit for the Louvre, Paris, and was taking his art very seriously. In his earliest works he established a style that scarcely altered thereafter. He exhibited two works in the Salon of 1885, *Italian Dance* and *A Sunset* (both untraced), and was roundly ridiculed by the critics. In the following year, encouraged by Paul Signac, he showed four paintings at the Salon des Indépendants including *Carnival Evening* (1886; Philadelphia, PA, Mus. A.). Rousseau was to exhibit at every Salon des Indépendants (*Liberty Inviting Artists to Participate in the 22nd Exhibition of the Société des Artistes Indépendants*; 1906; Tokyo, N. Mus W. A., except those in 1899 and 1900, until his death in 1910, seeing himself as an 'independent' and a natural associate of such painters as Paul Gauguin, Odilon Redon and Edgar Degas. Most critics thought otherwise and regularly derided his work as being no more than a public joke; appreciative commentaries by Jarry or Félix Vallotton were the exception.

In 1893 Rousseau retired in order to devote more time to his art, implicitly refuting any charge of being a mere 'Sunday painter'. He supplemented his tiny pension by giving drawing and music lessons. In a sense, he went about his business with the obduracy of one who never stepped back to compare his work with that of those artists, largely exponents of academic naturalism, whom he was seeking to emulate. In an autobiographical sketch of 1895, he referred to himself

without irony as being 'in the process of becoming one of our best realist painters' (1984-5 exh. cat., p. 256). In fact, Rousseau had an imperfect grasp of scale, perspective and the academic principles of colouring. Many of his *plein-air* views of the Seine and the Paris parks (e.g. *Paris Bridge*, c. 1898; Paris, priv. col., see Bouret, no. 15) are bland or ungainly, and his portraits from life are rarely lifelike. In common with many naive painters who lack compositional skills, Rousseau had no qualm about turning to ready-made designs such as prints in travel magazines or even an album of animal pictures for children; scholars have subsequently demonstrated that a good many of his more dream-like canvases derive from such nondescript popular sources. In this respect his work might seem derivative and stereotyped, and it would be hard to argue that in every picture he managed to transcend his limitations. Yet in many of his compositions there emerge qualities that are aesthetically intriguing, expressively effective and technically quite startling.

An early work, *Myself, Portrait-landscape* (1890; Prague, N.G., Šternberk Pal.), is typical both stylistically and in what it suggests about Rousseau's attitude towards his art. It is a large, programmatic canvas in which he depicts himself as a massive, bearded figure standing before a favourite scene, the Seine, complete with a flag-strewn ship and a prospect of that emblem of modern life, the Eiffel Tower. The artist sports not only a beard but also a large beret and poses with brush and palette; his dignified expression and stance seem calculated to dispel all doubts as to his professional competence. Despite his limited ability to achieve a plausible likeness he painted several portraits, including *Joseph Brummer* (1909; priv. col., see 1984-5 exh. cat., no. 57) and a portrait of Marie Laurencin and Guillaume Apollinaire entitled the *Muse Inspiring the Poet* (1909; Basle, Kstmus.). The virtue of these works resides in their very stiffness and monumentality; the figures have little personality yet manage to embody an intense and palpable gravity. In a pair of portraits of his second wife, Joséphine, and himself (c. 1900-03; both Paris, Louvre), Rousseau achieved genuine existential impact, rendering

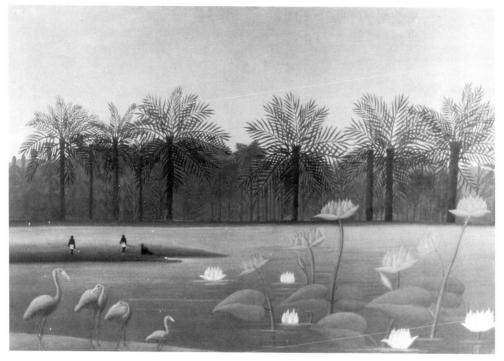

67. Henri Rousseau: *The Flamingos*, *c*. 1907 (New York, Payson Private Collection)

features with sober colour and stark lines that have an almost expressionistic urgency.

One of the most striking aspects of Rousseau's style is the odd stiffening and flattening of his subject-matter, be it landscape, portrait or still-life. It has been suggested that he was simply echoing his contemporaries who, from Camille Pissarro to André Derain, were concerned to shift the viewer's visual response from the sensation of plunging into pictorial space to that of the eye coasting over a textured surface. Rousseau's polychrome jungle paintings have about them a curious lack of solidity, as if they were representations of a theatrical décor, with gigantic leaves and petals so minimally contoured as to create the effect of overlapping cut-outs (see col. pl. XXXIV). In *The Flamingos* (*c*. 1907; New York, Payson priv. col.; see fig. 67), massive pink and yellow flowers dominate the composition, standing taller than the birds of the title and dwarfing the tiny human

figures in the background. In such paintings as the *Hungry Lion* (1905; priv. col., see 1984–5 exh. cat., no. 31) or the *Jungle: Tiger Attacking a Buffalo* (1908; Cleveland, OH, Mus. A.), the wildness of his animals seems to be deliberately evacuated by a deadpan treatment that identifies each creature more as outline than as tactile form.

Rousseau's unorthodox yet clever colour sense can determine the overall efficacy of a composition, as in the *Tropics (Monkeys in the Orange Grove)* (1907; New York, priv. col., see Bouret, no. 35), where discs of orange glow in extraordinary counterpoint against a tangled backdrop of green fronds. Close inspection of his canvases reveals a subtle concern for hues, an aspect he once highlighted when he claimed to be using 22 different shades of green in a given picture. An early woodland painting such as *Rendezvous in the Forest* (1889; Washington, DC, N.G.A.) exemplifies Rousseau's exhaustive attention to

the tiniest detail of leaf and twig; the mass of detail all but stifles the ostensible subject of two lovers on horseback (a motif no doubt borrowed from some popular source), yet engenders an atmosphere of airless impenetrability that, paradoxically, does induce a sensation of forest depths.

Trees are a common feature in Rousseau's landscape paintings, the settings of which range from placid metropolitan parkland to tropical forests. His practical experience of the exotic was restricted to the hothouses at the Exposition Universelle of 1889 in Paris and the Jardin des Plantes, where he regularly drew zoological and botanical specimens from life. One might surmise that what he most relished was the sensation of stepping from a familiar space in one moment into a fantastic one the next. A Surrealist who looks at the *Chair Factory* (*c.* 1897; Paris, Mus. Orangerie) might find in its matter-of-fact treatment of an everyday scene qualities of dream-like expectancy reminiscent of, say, Giorgio de Chirico. An impression of eerie hovering seems to haunt his views of recognizable places, as if he were seeking to make the physical world more buoyant. His overtly exotic (and faintly erotic) scenes, such as the famous *Sleeping Gypsy* (1897; New York, MOMA) or *The Dream* (1910; both New York, MOMA), were prized by André Breton because of their correlation of the strange with the banal; a homely jar, a harmless sofa, seem designed to offset, or rather to tease into focus, the implicit danger in the situation of a defenceless woman recumbent amid savage beasts.

Rousseau increasingly associated with the avant-garde as his career progressed. He exhibited alongside the Fauves at the Salon d'Automne in 1905 and made the acquaintance of Apollinaire, Robert Delaunay, Picasso and others. Gradually his reputation grew, particularly through the efforts of the collector and critic Wilhelm Uhde, whom Rousseau met in 1907 and who was to write the first monograph on him in 1911. Sales of his work had increased considerably by 1910, when he fell victim to an infection and died. His funeral was attended by Signac, and Apollinaire later composed a whimsical epitaph that Constantin Brancusi chiselled into the tombstone (formerly Bagneux cemetery, Paris; now Parc de la Perrine, Laval), thereby situating Rousseau as a kind of unwitting godfather of modernism. At the end of 1910 Max Weber organized an exhibition of Rousseau's works at the 291 gallery in New York, and in 1911 the Salon des Indépendants held a retrospective of forty-five paintings and five drawings.

2. Reputation and influence

Much has been made of Rousseau's technical shortcomings, and tales that reflect his undoubted sense of his own importance—for instance his comment in 1908 to Picasso that 'we are the two great painters of our time, you in the Egyptian style, I in the modern style'—have helped foster an impression of a misguided amateur who, seeking to emulate academic models, succeeds only in producing images of sentimental charm with no real aesthetic impact. Yet towards the end of his life Rousseau was receiving tributes from such considerable admirers as Picasso, who bought several of his paintings and later gave them to the Louvre. In 1908 Picasso held a banquet in Rousseau's honour at the Bateau-Lavoir in Paris, which confirmed his standing among the younger generation of artists who viewed his work with varying degrees of affection and seriousness. Vasily Kandinsky saluted him in 1912 in *Der blaue Reiter* as the pioneer of 'a great new Realism' based on simplification, and the Surrealists saw his work, especially the jungle paintings, as convincing examples of non-rational inspiration.

Yet it has taken several decades for a shift in public taste to allow a fuller appreciation of Rousseau's talents. He may have been naive in many respects, but he certainly held his own among his contemporaries and the traces of his influence are numerous: on certain of Picasso's distorted figures, for example, on Delaunay's footballers, Max Beckmann's stolid portraits, Max Ernst's jungle scenes and Paul Delvaux's dream cities. Rousseau's greatest ambition, to have his pictures hang in the Louvre, was realized after his death, granting him the status of a modern master.

Bibliography

W. Uhde: *Henri Rousseau* (Paris, 1911)

A. Basler: *Henri Rousseau: Sa vie, son oeuvre* (Paris, 1927)

P. Soupault: *Henri Rousseau, le Douanier* (Paris, 1927)

P. Courthion: *Henri Rousseau le Douanier* (Geneva, 1944)

R. Shattuck: *The Banquet Years* (New York, 1955)

J. Bouret: *Henri Rousseau* (Neuchâtel, 1961; Eng. trans., 1961) [cat. rais.]

H. Certigny: *La Vérité sur le Douanier Rousseau* (Paris, 1961)

D. Vallier: *Henri Rousseau* (Paris, 1961; Eng. trans., 1964)

—: *Tout l'oeuvre peint de Henri Rousseau* (Paris, 1970, rev. 1982)

P. Descargues: *Le Douanier Rousseau* (Geneva, 1972)

R. Alley: *Portrait of a Primitive: The Art of Henri Rousseau* (Oxford, 1978)

M. Morariu: *Douanier Rousseau* (Bucharest, 1978; Eng. trans., 1979)

D. Vallier: *Henri Rousseau* (Paris, 1979; Eng. trans., 1979)

F. Elgar: *Rousseau* (Paris, 1980)

C. Stabenow: *Die Urwaldbilder des Henri Rousseau* (Munich, 1980)

Y. Le Pichon: *Le Monde du Douanier Rousseau* (Paris, 1981; Eng. trans., 1982)

Le Douanier Rousseau (exh. cat., Paris, Grand Pal.; New York, MOMA; 1984–5)

G. Plazy: *Le Douanier Rousseau, un naïf dans la jungle* (Paris, 1992)

ROGER CARDINAL

Rousseau, Philippe

(*b* Paris, 22 Feb 1816; *d* Acquigny, Eure, 5 Dec 1887). French painter. He may have received his artistic training in the studios of Gros and Jean-Victor Bertin, since he credited them as his masters when he exhibited at the Salon. He began exhibiting in 1834 with a *View of Normandy* (untraced) and for the next six Salons he exhibited landscapes. In 1844 he began to show still-lifes. In 1845 he was awarded a third-class medal, and in 1847 his still-lifes were admired by Théophile Thoré, who was one of the earliest critics to recognize Rousseau's debt to Chardin. This influence became the subject for his 1867 Salon entry, *Chardin and his Models* (untraced, see McCoubrey, no. 15). The work is far grander and more cluttered in its conception than most still-lifes by Chardin and alludes to the master by faithfully reproducing

some of his favourite objects within a traditional table-top format rather than by an analysis of his compositional devices. A framed reproduction of a self-portrait by Chardin is prominently displayed at the front of the painting.

Rousseau clearly benefited from studying Chardin's still-lifes of humble domestic interiors. The *Still-life with Oysters* (London, N.G.), probably a late work, represents a simple meal with great attention paid to the different textures of the oysters, the glass and knife, all set within an ill-defined space and treated with a very limited palette. However, he was also influenced by contemporary taste for elaborate, highly decorative still-lifes such as those bought by the State for the Luxembourg Museum—the *Storks having a Siesta* and *Kid Grazing on Flowers* (both destr., see 1974 exh. cat., nos 209–10)—which incorporated animals within unlikely architectural settings. Rousseau was one of the most popular and successful still-life painters during the Second Empire. He was commissioned by the State and by individual patrons including Princess Mathilde and was created an officer of the Légion d'honneur in 1870.

Bibliography

P. Lefort: 'Les Artistes contemporaines: Philippe Rousseau et François Bonvin', *Gaz. B.-A.*, n.s. 2, xxxviii (1888), pp. 132–45

J. W. McCoubrey: 'The Revival of Chardin in French Still-life Painting, 1850–1870', *A. Bull.*, xlvi (1964), pp. 39–53

Le Musée du Luxembourg en 1874 (exh. cat., Paris, Grand Pal., 1974)

Chardin and the Still-life Tradition in France (exh. cat. by G. P. Weisberg and W. S. Talbot, Cleveland, OH, Mus. A., 1979)

LESLEY STEVENSON

Rousseau, (Pierre-Etienne-)Théodore

(*b* Paris, 15 April 1812; *d* Barbizon, 22 Dec 1867). French painter. He was considered the leader of the Romantic-Naturalist artists of the Barbizon school, but he also had the unhappy distinction of being known as 'le grand refusé', because of his

systematic exclusion from the Paris Salon between 1836 and 1841 and his abstention between 1842 and 1849.

1. Life and work

His orientation towards *plein-air* painting was apparent when as a schoolboy in Paris he sketched trees in the Bois de Boulogne. According to Philippe Burty, *Telegraph Tower on Montmartre* (c. 1826; Boulogne, Mus. Mun.) was one of Rousseau's first painted studies. Alfred Sensier wrote that it was this work that convinced Rousseau's parents to let him pursue an artistic vocation. A cousin, Alexandre Pau de Saint-Martin (1782–1850), who was a landscape painter, took Rousseau to work in the forest of Compiègne and then advised sending him to the studio of Joseph Rémond (1795–1875), who had won the Prix de Rome for historical landscape in 1821. Rousseau was enrolled in Rémond's studio c. 1826 and shortly thereafter began studying with the history painter Guillaume Lethière (1760–1832). He made an unsuccessful attempt at the historical landscape prize in 1829, but the arid goals and stultifying procedures of Rémond's atelier appear to have been extremely uncongenial to Rousseau. The necessity of 'elevating' a landscape by the addition of a mythological theme was especially galling to him, since he had already developed a passionate attachment to nature as a living entity.

The single significant legacy of Rousseau's academic training was his retention of the distinction between a sketch and a finished painting. Sensier, referring to Rousseau's first exhibited painting, *Auvergne Site* (exh. Paris Salon, 1831), described it as a 'composed landscape . . . because Rousseau did not want to show himself to the public in the rough manner of a study which was for him the preliminary exercise of his work'. However, this painting, which has been identified with the *Fisherman* (Rotterdam, Mus. Boymans–van Beuningen), does not show classical finish or geometrical order.

About 1827–8 Rousseau became acquainted with the area around the Forest of Fontainebleau, but his first extensive travel occurred in 1830, when he spent several months in the Auvergne, a region considered particularly rugged and untamed. Rousseau later made many extensive trips throughout France, but he never went to Italy. Once he abandoned the idea of winning the Prix de Rome he turned aggressively nationalistic in his choice of subject-matter, seeking out the regional character of each area.

The main artistic influences on Rousseau and the majority of Barbizon painters were John Constable and 17th-century Dutch landscape painters. The Barbizon artists began painting during the period of Constable's strongest impact in France, from 1824, when the *Hay Wain* (1821; London, N.G.) was shown at the Salon, well into the 1830s. Nearly 30 Constable paintings were in France during the 1830s, many easily accessible to artists; these works proved that a monumental painting did not require idealizing conventions. English landscape of the 19th century had ties with the Dutch focus on everyday, unstructured aspects of observed nature, and this stimulated the Barbizon painters to study Dutch painting. Rousseau and Jean-François Millet jointly bought a Jan van Goyen painting, and Rousseau eventually owned some 50 prints of Dutch paintings, including copies of works by Jacob van Ruisdael. Rousseau is also said to have made copies, in the Louvre, of the animals in Adriaen van de Velde's paintings and of the paintings of Karel Dujardin, whose typical works are Italianate and often not true landscapes.

Rousseau's début at the Salon of 1831 coincided with those of his friend Jules Dupré, with whom he made many sketching trips, and of Narcisse Diaz. They had little difficulty having works accepted, although Rousseau's eventual nemesis, Jean-Joseph-Xavier Bidauld (1788–1846), was already consistently present on the jury. In 1833 two paintings by Rousseau were accepted, including the large *Coast of Grainville* (St Petersburg, Hermitage). In 1834 one work was rejected; however, *Edge of a Clearing, Forest of Compiègne* (priv. col., see 1967–8 exh. cat.) was accepted, perhaps because it belonged to Ferdinand, Duc d'Orléans, and even received a third-class medal. In 1835 two small sketches were admitted.

Everything Rousseau submitted from 1836 to 1841 was refused; from 1842 until after the

Revolution of 1848 Rousseau abstained. Each time, Bidauld, the single landscape painter on the jury and an intransigent upholder of the classical tradition, rejected Rousseau, although other members of the Barbizon school sometimes were admitted. The rejection of the monumental *Descent of the Cattle* (The Hague, Rijksmus. Mesdag) in 1836 was a particularly severe blow, since this was a major undertaking, inspira-tional in origin. Ary Scheffer so much admired this work that he publicly exhibited it in his own studio. Perhaps the most significant result of this rejection was that it sent Rousseau on his first long sojourn in Barbizon. Henceforth, his time was increasingly spent here and in the Forest of Fontainebleau. The culminating insult occurred when in 1841 the jury refused the *Avenue of Chestnut-trees* (Paris, Louvre), although it had already been purchased by the government.

The Revolution of 1848 marked the end of this era. Rousseau received an official commission, for the *Edge of the Forest of Fontainebleau, Sunset* (exh. Paris Salon, 1850–51; Paris, Louvre; see col. pl. XXXV), which conforms to a favourite type of Rousseau's mature years: a view from within the forest to a clearing outside. In 1849 Rousseau reappeared at the Salon, showing such paintings as *Avenue of Trees, Forest of l'Isle-Adam* (1849; Paris, Mus. d'Orsay), in which he attempted, for the first time in a French exhibition painting, to portray the vertical light of noon, as Constable had in the *Hay Wain*. Rousseau received a first-class medal, which meant he no longer had to submit to the jury; yet he was passed over for the Légion d'honneur, while Dupré was not. This humiliation may have contributed to their breach, but Dupré's place was soon filled by Millet, who moved to Barbizon that year. In 1851 Rousseau was snubbed again, although Diaz was honoured, but in 1852 he finally received the cross of the Légion d'honneur. The zenith of this successful phase came in 1855, when a room at the Exposition Universelle in Paris was devoted to him; this exhibition gave Rousseau an international reputation.

Unfortunately, this period of prosperity did not

last; in the early 1860s Rousseau was forced to sell works at auction, with disappointing results. True financial security did not come until 1866, when Paul Durand-Ruel and Hector-Henri-Clément Brame convinced Rousseau to sell them 70 sketches with which he had always refused to part. Then Rousseau was elected president of the jury for the Exposition Universelle in 1867 and received one of the four grand medals of honour. This occasion was not the unqualified victory Rousseau had anticipated, because he was passed over for promotion to Officer of the Légion d'honneur, doubtless because of the animosity of Comte de Nieuwerkerke, Directeur-général des Musées impériaux. Rousseau's friends maintained this was the cause of the series of strokes he suffered from July onwards. These friends appealed directly to Louis-Napoléon; Rousseau was made an Officer on 13 August, in a ceremony presided over by Nieuwerkerke, who uttered conventional flattering words. Nieuwerkerke had his final revenge after Rousseau died in December, because he did not, as was customary, arrange a memorial exhibition.

2. Working methods and technique

The most noteworthy aspect of Rousseau's working methods was his concern with *plein-air* studies. Although he still worked up finished paintings in his studio in Paris in winter, Rousseau made use of a special easel and lean-to to facilitate working outdoors in summer. Such sketches as *Road in the Forest of Fontainebleau, Stormy Effect* (c. 1860–65; Paris, Louvre) are some of Rousseau's most vital works. The subject, with its casual view of trees and cloudy sky and an interest in changes of weather, suits the technique, which is rough, variable and rich though not brilliant in colour, with flecks of pigment reminiscent of Constable.

Oaks at Apremont (c. 1850–52; Paris, Louvre; see fig. 68), representative of his studio-reworked paintings, shows Rousseau's transitional position between Romanticism and Naturalism. The majestic oaks are rendered so meticulously that one can easily accept Rousseau's assertions that he made portraits of all of them and listened to their

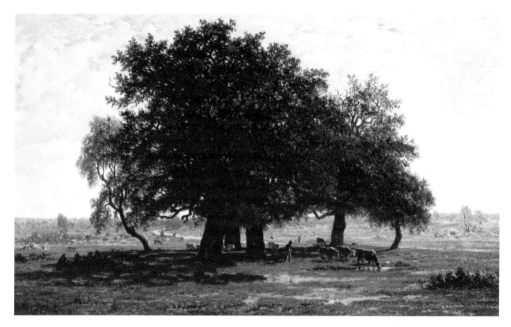

68. Théodore Rousseau: *Oaks at Apremonte c.* 1850–52 (Paris, Musée du Louvre)

voices; equally meticulous is his observation of the noon light. There is still a Romantic attachment to specific truths of nature, but the mood is less obvious than in earlier paintings, such as *Valley of Tiffauge* (1837–44; Cincinnati, OH, A. Mus.), with its marvellously teeming vegetal life in the foreground (dubbed 'weed soup' by mocking critics).

Rousseau's desire for a personal perfection that always seemed elusive often led him to rework his paintings over a period of many years. The monumental *Forest in Winter at Sunset* (New York, Met.) stands as a testament in that regard, since he worked on it from 1846 until his death. The darkening that has affected many of Rousseau's paintings over the years can partly be traced to this laborious procedure, since he often used chemically incompatible pigments and even bitumens (originally suggested by Scheffer), which eventually proved disastrous, accounting for the ruinous state of the *Descent of the Cattle* and *Avenue of Chestnut-trees.* One unprecedented exception to his usual procedure is *Hoar-frost*

Effect (1845; Baltimore, MD, Walters A.G.). Sensier recorded that Rousseau painted it directly from nature on an unprepared canvas in eight days, in his fever to capture a transient effect of nature. The foreground is covered with scintillating dabs of white and the rose reflections of a vivid winter sunset. Here, both in theme and technique Rousseau foreshadowed Impressionism.

3. Critical reception and posthumous reputation

Rousseau's reputation has always been inseparable from his position both as 'le grand refusé' and as a Romantic rebel escaping urbanization. Yet the artist's enforced exclusion was itself the instrument of enhanced recognition and elevated status. Most critics made a point of referring to Rousseau; as a 'refusé', he was often linked with Eugène Delacroix, for example when an article in *L'Artiste* (1834) stated that the jury exclusions had become 'scandalous', even 'monstrous', since they now included such names as Delacroix and Rousseau. From 1836 critics rallied increasingly to Rousseau's support. Bidauld's part in these

systematic exclusions appears to have been well-known and was scathingly noted by Gustave Planche in 1840. After Rousseau had been accepted, such critics as the Goncourts emphasized the artist's truthfulness to nature.

While the Barbizon artists achieved great popularity in England and America around the turn of the century, they have been overshadowed by the movement they herald, Impressionism. This eclipse was partially rectified by the exhibition *Barbizon Revisited* (1962) and the large retrospective exhibition (1967–8) denied Rousseau at his death.

Bibliography

'Salon de 1834', *L'Artiste*, viii (1834), p. 65

G. Planche: 'Salon de 1840', *Rev. Deux Mondes* (1840), p. 100

T. Thoré: *Le Salon de 1844 précédé d'une lettre à Théodore Rousseau* (Paris, 1844), pp. vii–xxxvi; Eng. trans. in J. Taylor, ed.: *Nineteenth-century Theories of Art* (Berkeley, 1987), pp. 319–27

P. Burty: *Les Etudes peintes de Théodore Rousseau* (Paris, 1867); repr. in *Maîtres et petits-maîtres* (Paris, 1877), pp. 71–93

—: 'Théodore Rousseau', *Gaz. B.-A.*, 1st ser., xxiv (1868), pp. 305–25

T. Silvestre: 'Théodore Rousseau', *Figaro* (15 Jan 1868); repr. in *Les Artistes français* i: *Romantiques*, ed. E. Fauve (Paris, 1926), pp. 173–84

A. Sensier: *Souvenirs sur Th. Rousseau* (Paris, 1872) [assiduous transcription of what Rousseau said; numerous errors, nevertheless indispensable]

E. de Goncourt and J. de Goncourt: *Etudes d'art: Le Salon de 1852, la peinture à l'Exposition de 1855* (Paris, 1893); Eng. trans. in E. Holt, ed.: *The Art of All Nations, 1850–1873* (New York, 1981), pp. 82–93 (86)

P. Dorbec: *Théodore Rousseau* (Paris, 1910)

—: 'L'Oeuvre de Théodore Rousseau aux salons de 1849 à 1867', *Gaz. B.-A.*, 4th ser., xix (1913), pp. 107–27

—: *L'Art du paysage en France* (Paris, 1925)

—: 'Le Voyage de Théodore Rousseau en Vendée: Charles le Roux', *Gaz. B.-A.*, 5th ser., xvii (1928), pp. 31–51

M.-T. de Forges: '*La Descente des vaches* de Théodore Rousseau au Musée d'Amiens', *Rev. Louvre*, xii (1962), pp. 85–90

Barbizon Revisited (exh. cat., ed. R. Herbert; San Francisco, CA, Pal. Legion of Honor, 1962)

Théodore Rousseau (exh. cat., ed. H. Toussaint; Paris, Louvre, 1967–8)

J. Bouret: *The Barbizon School and 19th Century French Landscape Painting* (Greenwich, CT, 1973)

P. Miquel: *L'Ecole de la nature* (1975), iii of *Le Paysage français du xixe siècle, 1824–1874* (Maurs-la-Jolie, 1975)

A. Terrasse: *Théodore Rousseau's Universe* (Paris, 1976)

P. Mainardi: *Art and Politics of the Second Empire: The Universal Expositions of 1855 and 1867* (New Haven, 1987)

S. Adams: *The Barbizon School and the Origins of Impressionism* (London, 1994)

DOROTHEA K. BEARD

Roybet, Ferdinand

(*b* Uzès, nr Nîmes, 12 April 1840; *d* Paris, 10 April 1920). French painter. Although he studied engraving at the Ecole des Beaux-Arts in Lyon, he very early devoted himself exclusively to painting. In 1864 he settled in Paris, where his lyrical, zestful canvases, for example a *Jester at the Court of Henry III* (exh. 1866 Salon; Grenoble, Mus. Grenoble), quickly met with success. They chiefly show characters in medieval or Renaissance costume in attitudes of studied ease. Critics noted his strong colours and firm brushwork, regretting only that his shadows seemed too sooty. Roybet was influenced by Théodule Ribot and Antoine Vollon, and in his simple handling of his subjects and the unidealized faces of his models he is close to the Realist painters. Some of his works also testify to his admiration for Delacroix.

In 1871–2 he travelled to the Low Countries and Algeria, the source of some superb harem scenes, such as *Woman with a Parrot* (St Petersburg, Hermitage). After discovering the Dutch and Flemish 17th-century masters he radically altered both his technique and subject-matter. He gradually abandoned canvas supports for mahogany boards prepared with a light-toned ground and acquired a more flowing touch, which gave his paintings a porcelain-like lustre. Despite the occasional allusion to Rembrandt, Hals and David Teniers the younger, he drew his greatest inspiration from the style of northern European genre painting adopted in France in the early 17th

century. Hence gatherings of soldiers in taverns alternate with parties of gentlemen, for example a *Musical Entertainment* (1879; ex-Vanderbilt col., sold London, Christie's, 7 May 1971). Roybet spent many years working on an immense canvas (7.23×6.20 m) depicting *Charles the Bold at Nesles* (1890; untraced). He could also be a fine portrait painter, as is evident in the portrait of *Consuelo Fould* (c. 1895–1900; Courbevoie, Mus. Roybet-Fould). Clients often commissioned portraits of themselves and their families in 17th-century costume, as for example the portrait of *Fernand Dol* (Aix-en-Provence, Mus. Granet).

From as early as 1866 he was working for dealers, who encouraged him to produce slick commercial pictures and to give up exhibiting at the Salon. Much of the vast sums he earned as a successful Belle Epoque society painter were spent on his collection of works of art. Roybet's fame was temporary. He never obtained any state commissions and his later paintings lost the sincere quality which made his early work attractive. The most comprehensive collection of his work is in the Musée Roybet-Fould, Courbevoie.

Bibliography

J. Estève: *Ferdinand Roybet: Sa vie et l'oeuvre* (diss., U. Paris IV, 1979)

J. ESTÈVE

Rude, François

(*b* Dijon, 4 Jan 1784; *d* Paris, 3 Nov 1855). French sculptor. He was of working-class origins and Neo-classical training. After 1830 he identified with the emergent group of Romantic sculptors in France, at the same time retaining his own strong sense of monumentalism. His massive stone relief on the Arc de Triomphe, Paris, popularly known as 'La Marseillaise' (1833–6), and his bronze allegory *Napoleon Awakening to Immortality* (1845–7; Fixin, Parc Noisot) are memorable nostalgic celebrations of the military heroism of the Revolutionary period.

1. Training in France and exile in Belgium, to 1827

Rude was the son of a Dijon stovemaker and locksmith who supported the aims of the French

Revolution to the extent of enrolling his infant son, in 1793, in one of the juvenile battalions known punningly as 'Les Royals Bonbons'. François was early apprenticed to his father, but his interest in art was awakened in 1800, when he attended a prize-giving ceremony at the Ecole des Beaux-Arts in Dijon. François Devosges, founder and director of this regional school, subsequently persuaded Rude's father to allow his son to attend its courses in his spare time. After four years of such study François Rude received his first commission, from a local tax inspector, Louis Frémiet, for a bust (untraced) of a relative, the engraver Louis-Gabriel Monnier (1733–1804). Rude was adopted by the Frémiet family after the death of his father in 1805, and in 1807 he left for Paris, taking with him an introduction to the Director of the Musée Napoléon, Baron Vivant Denon.

With Denon's backing, Rude entered the studio of the decorative sculptor Edme Gaulle (1762–1841), collaborating with him on reliefs for the Colonne de la Grande Armée in the Place Vendôme, Paris. He left Gaulle after less than a year to become a pupil of a more respected sculptor, Pierre Cartellier. In 1809 he was competing at the Ecole des Beaux-Arts, finally winning the Prix de Rome in 1812. Two of his preliminary competition entries survive, a *Marius Meditating on the Ruins of Carthage* (plaster, 1809; Dijon, Mus. B.-A.) and a *tête d'expression*, *Expectation Mingled with Fear* (plaster, 1812; Paris, Ecole N. Sup. B.-A.). The original plaster of his successful Prix de Rome entry, *Aristeus Mourning the Loss of his Bees*, an exercise in bucolic mythology, was later destroyed by the artist but survives in a bronze cast (Dijon, Mus. B.-A.).

The financial plight of the Académie de France in Rome prevented Rude from taking up his scholarship, so he returned to the Frémiet family home in Dijon. After the Hundred Days in 1815, however, Louis Frémiet found himself compromised by his Bonapartist activities, and he took his family into exile in Brussels, followed by Rude, who remained there until 1827.

The 12 years Rude spent in Brussels were on the whole fallow. He did, however, find work with the royal architect Charles van der Straeten

(1771–1834), through the introduction of the exiled Neo-classical painter Jacques-Louis David, the cultural lodestar of the French expatriot community in Brussels. Sophie Frémiet (1797–1861), whom Rude was to wed in 1821, was David's pupil and copyist. The most ambitious of the resulting projects for van der Straeten was the decoration executed in 1823–4 for the hunting lodge of the Prince of Orange at Tervueren. This consisted of eight panels illustrating the *Exploits of Achilles* and a stone frieze of the *Hunt of Meleager* (all destr.; plaster casts, Dijon, Mus. B.-A.). Their composition is austerely classical, enlivened by some passages of distinctive anatomical observation. The sculptural decorations that Rude contributed in 1824–5 to a wooden pulpit for the church of St Etienne, Lille, are equally circumscribed. Although he appears to have made no progress in imaginary sculpture throughout the Belgian period, Rude's portrait busts from these years are impressively forthright naturalistic productions. The marble version of his *William I of the Netherlands* was destroyed in 1819, but a bronze version survives (Ghent, Mus. S. Kst.). His portrait of *Jacques-Louis David* was first executed in 1826. A later marble version (Paris, Louvre) was exhibited at the Salon of 1831.

2. Paris, 1827–c. 1845

Encouraged by Antoine-Jean Gros, Rude returned to Paris in 1827. He was determined to vie with contemporaries who had already established reputations there, notably David d'Angers, Jean-Pierre Cortot and James Pradier. His two 1828 Salon exhibits were a thoroughly official statue of the *Immaculate Virgin* (plaster; Paris, SS Gervais et Protais) and a statue of *Mercury Fastening his Sandal*, also in plaster, which was only completed towards the end of the exhibition. The god is shown at the point of taking to the air after killing Argus, pausing to fasten his winged sandal. The influence on this of Giambologna's famous statue of *Mercury* (c. 1580; Florence, Bargello) indicates a new flexibility in Rude's attitude to sculptural tradition, and the sophisticated movement of his *Mercury* was immediately appreciated by the

critics. A bronze version, exhibited at the Salon of 1834, is now in the Louvre, and a reduction, also in bronze, incorporating some additional features and commissioned by the journalist and government minister Adolphe Thiers, is now in the Musée des Beaux-Arts, Dijon.

Like David d'Angers, Rude compromised his Republican convictions by accepting work on the monumental projects in Paris of the restored Bourbon regime. In 1829 he entered a competition for the pediment of the church of La Madeleine (drawing, Dijon Mus. B.-A.), and in the same year he received a commission for part of the frieze for the Arc de Triomphe de l'Etoile, representing *Charles X and the French Army*. The plaster model for the frieze was completed, but the July Revolution of 1830 brought a halt to the work, and the model was probably destroyed in 1833.

Rude consolidated the popular success that he had won with his *Mercury* when he showed the plaster version of the *Young Neapolitan Fisherboy Playing with a Tortoise* at the 1831 Salon. A vogue for Neapolitan figure subjects in painting had already been created during the 1820s by Victor Schnetz and Léopold Robert. This genre, uniting Classical and Romantic features, was an ideal vehicle for artists seeking stylistic compromise and would continue to be popular with academic sculptors up to the 1860s. Rude's capacity to produce in his *Fisherboy* an entirely plausible evocation of this modern arcadian world of contented physicality, though he had never visited Naples, shows to what extent this genre had already become an artistic convention. At the Salon of 1833, where Rude exhibited his marble version, the public could compare it with the equally well-received *Neapolitan Fisherboy Dancing the Tarantella* (Paris, Louvre) of François-Joseph Duret. Both could be considered an updating of the classical genre piece, but Rude's naturalistic detail and humorous subject made his work the more distinctive new departure. The marble was purchased for the Musée du Luxembourg by Louis-Philippe (now Paris, Louvre).

In 1831, the newly installed regime of Louis-Philippe began a revised project of decoration for

the Arc de Triomphe. The model for the Bourbon frieze having been abandoned, Rude was now commissioned for a section of the new one, showing the *Return of Napoleon's Armies from Egypt*. In 1833, following the completion of this, he was requested by Thiers to produce a total programme for the 'trophies' and capping of the arch. Surviving sketch models (examples in Paris, Louvre and Carnavalet) show that the idea of symbolic trophies had been replaced in Rude's programme by a series of historical allegories, summarizing the different phases of the Revolutionary and Napoleonic wars. However, he finally received the commission for one only of the large stone reliefs. This has since been popularly baptized '*La Marseillaise*', but its proper title is the *Departure of the Volunteers in 1792*. It is dominated by a flying female allegory of the Republic, who brandishes her sword while yelling encouragement to the Revolutionary armies. These are represented by six Gallic warriors, surging forward at her bidding, their racial origin indicated by rugged features and long hair rather than by their accoutrements of Classical armour and chain mail. Rude's group, departing though it does from the formula adopted in the three companion reliefs by Jean-Pierre Cortot and Antoine Etex, which are all anchored by a static central figure, nonetheless combines processional and climactic features. Later in the century it was to provide a powerful source of inspiration to Jean-Baptiste Carpeaux and Rodin in their search for emotive effect in monumental compositions.

The Republican theme is not consistently pursued in Rude's other works from this time. Subjects from pre-Revolutionary history were treated by him, as in the marble statue of *Maurice, Maréchal de Saxe* (1836–8; Versailles, Château) and the silver statuette of the *Adolescent Louis XIII* (1840–42; Dampierre, Château), commissioned by Victor, Duc de Luynes. A *Joan of Arc Listening to her Voices* (marble, 1845–52) was originally part of the series of *Great Women of France* in the Luxembourg Gardens, Paris, but was moved in 1890 to the Louvre. The recently shorn head of the visionary shepherdess, and the inclusion of the sheep shears and clippings, bring a poten-

tially 'troubadour' subject dramatically down to earth. In the field of devotional sculpture, Rude's contribution was also far from negligible: from the Romantic pictorialism of his *Baptism of Christ* (marble, 1838–41; Paris, Madeleine), he progressed to a stark medievalism in his bronze *Crucifixion* group (1848–52) for the high altar of St Vincent de Paul, Paris, reminiscent of the 15th-century sculpture of his native Burgundy. On the other hand, his known Republican sympathies increasingly alienated him from the Orléans regime, just as his identification with the Romantic group of sculptors led him to desist from presenting his work at the Salon after 1838, in protest against the Salon juries' rejection of the others. His candidature for membership of the Institut de France was persistently blocked, and although his teaching style won him a distinct following, with its stress on analytic naturalism, it was known to be of no assistance in gaining the Prix de Rome.

3. Late career, after c. 1845

During the late 1840s, Rude made his most personal profession of political alignment in two works: the tomb of the politician and writer *Godefroi de Cavaignac* (bronze, 1845–7; Paris, Montmartre Cemetery) and *Napoleon Awakening to Immortality* (bronze, 1845–7; Fixin, Parc Noisot). The first took the form of a draped, recumbent effigy of the dead man, holding a pen and a sword. The controversy aroused by this monument resulted in its not being inaugurated until 1856, and then without ceremony. The *Napoleon* was commissioned by a Captain Claude Noisot, a veteran of the Grande Armée, who was devoted to the cult of the Emperor. It was erected with considerable publicity in the patron's picturesque hillside property to the south of Dijon. It is an original and naive popular allegory, representing the Emperor stirring out of his sleep on a rock emblematic of St Helena. The fetters of his captivity are in pieces, but his Imperial eagle is shown lying dead beyond recall. Despite this indication of Rude's anti-Imperial sentiments, his most strident Bonapartist work, the bronze statue of *Maréchal Michel Ney* (Paris,

Avenue de l'Observatoire), was inaugurated in 1853, shortly after the establishment of theSecond Empire, though the commission had initially been confided to him by the Republican government in 1848. Ney is represented brandishing his sabre and shouting 'Forward!' to his troops. Further commemorations by Rude of subjects associated with the Napoleonic era are the bronze statues of *Général Henri-Gatien Bertrand* (1850–54; Châteauroux, Place Ste Hélène) and of *Gaspard Monge* (1846–9; Beaune, Place d'Armes).

As early as 1839 Rude's marble bas-relief of *Kindness* for the tomb of his master *Pierre Cartellier* (Paris, Père Lachaise Cemetery) had shown a nostalgia for the softness and delicacy of pre-Revolutionary sculpture. His artistic legacy to Dijon—two mythological pieces, *Hebe and the Eagle of Jupiter* (marble, 1846–57) and *Cupid, Ruler of the World* (marble, 1848–57; both Dijon, Mus. B.-A.), neither of which was completed at the time of his death—exhibits this nostalgia to a degree that has embarrassed Rude's apologists. It nevertheless accords with a wider accom-modation of 18th-century style among Second Empire sculptors. The *Cupid* was commissioned by Anatole Devosge (1770–1850), son of his first teacher, and so probably represented for Rude a return to his point of departure in art. After his death, and particularly in his native Burgundy, Rude was exalted as a proletarian yet patriar-chal figure, deeply rooted in local tradition. No such stereotype, however, emerges from the informative and scholarly biography by Louis de Fourcaud.

Bibliography

Lami

M. Legrand: *Rude: Sa vie, ses oeuvres, son enseignement* (Paris, 1856)

L. de Fourcaud: *François Rude, sculpteur: Ses oeuvres et son temps* (Paris, 1904)

L. Delteil: *Le Peintre-graveur illustré* (Paris, 1906–26), vi; (*R* New York, 1969); appendix and glossary, xxxii (New York, 1970)

L. Benoist: *La Sculpture romantique* (Paris, 1928)

Romantics to Rodin: French Nineteenth-century Sculpture from North American Collections (exh. cat., ed. P. Fusco and H. W. Janson; Los Angeles, CA, Co. Mus. A., 1980)

Autour du Néoclassicisme en Belgique, 1770–1830 (exh. cat., ed. D. Coekelberghs; Brussels, Mus. Ixelles, 1985–6)

A. M. Wagner: *Jean-Baptiste Carpeaux: Sculptor of the Second Empire* (New Haven, 1986)

La Sculpture française au XIXe siècle (exh. cat., ed. A. Pingeot; Paris, Grand Pal., 1986)

PHILIP WARD-JACKSON

Saint-Marceaux, Charles-René de Paul de

(*b* Reims, 23 Sept 1845; *d* Paris, 23 April 1915). French sculptor. He was the son of a champagne merchant. In 1863 he entered the Ecole des Beaux-Arts, Paris, but in 1868, renouncing competition for the Prix de Rome, he took the then fashionable decision to visit Florence instead. In 1872 he was commissioned to sculpt the tomb of the *Abbé Miroy* (bronze; Reims, Cimetière du Nord), a victim of the Franco-Prussian War. He was awarded a second-class medal for his pathetic effigy of the gunned-down priest, although the work was excluded from the Salon of 1872 out of political expediency. After a further stay in Florence in 1873–4 Saint-Marceaux completed his marble *Genius Guarding the Secret of the Tomb* (Paris, Mus. d'Orsay), a lithe, curiously characterized male figure in a Michelangelesque torsion which was acquired by the State at the Salon of 1879. Hardly less acclaimed was his exhibit of 1880, a clean-limbed *Harlequin* (marble version, Vichy, Casino). In 1891 he joined the newly formed Société Nationale des Beaux-Arts, and the pieces he showed at its exhibitions tended to be either religious, as in *First Communion* (marble, exh. 1893; Lyon, Mus. B.-A.), or symbolist, as in *On the Road of Life* (marble, exh. 1907; plaster, Reims, Mus. St Denis). His efforts to integrate figures and structure in his public monuments can perhaps best be appreciated in his monument to the *Creation of the Universal Postal Union* (inaugurated in 1909) for its headquarters in Berne.

Bibliography

Lami

G. Gardet: *Notice sur la vie et les oeuvres de R. de Saint-Marceaux, lue à l'Académie des Beaux Arts* (Paris, 1919)

L. Olivier: *La Vie et l'oeuvre de Charles-René de Paul de Saint-Marceaux* (diss., Paris, Ecole du Louvre, 1973)

PHILIP WARD-JACKSON

Schoenewerk, Pierre-Alexandre

(*b* Paris, 18 Feb 1820; *d* Paris, 23 July 1885). French sculptor of German descent. He started his career in the studios of Henri-Joseph-François, Baron de Triqueti and David d'Angers. His German parentage disqualified him from competing at the Ecole des Beaux-Arts in Paris, but he exhibited plaster religious and biblical pieces at the Salon between 1841 and 1847. After 1848 he turned to mildly erotic mythological subjects. Frequently employed in modelling figurative ornament for a domestic setting, Schoenewerk, like his contemporary Albert-Ernest Carrier-Belleuse, was inclined in his monumental sculpture to the decorative and precious, as seen in the marble *Bacchus* (1859; Paris, Louvre) commissioned by the State in 1858. In the marble *Young Tarentine* (1871; Paris, Mus. d'Orsay), inspired by the poem of the same name by André Chénier, Schoenewerk's work became more overtly erotic: the drowned maiden's limp and broken body anticipates the uninhibited postures of Rodin's nudes in the *Gates of Hell* (commissioned 1880; Paris, Mus. Rodin). Shown at the Salon of 1873, his *Girl at the Fountain* (Paris, Louvre; marble version, commissioned 1875 for the Musées Nationaux, Paris, Mus. d'Orsay) is constructed on more studied decorative lines. In 1878 he executed a monumental iron statue of *Europe* (Paris, Mus. d'Orsay) for the Palais de Trocadéro and between 1874 and his death a marble, seated figure of the composer *Jean-Baptiste Lully* for the Paris Opéra (*in situ*).

Bibliography

Lami

A. Pingeot, A. Le Normand-Romain and A. Le. Margerie: *Catalogue sommaire illustré des sculptures: Musée d'Orsay* (Paris, 1986), pp. 248–9

PHILIP WARD-JACKSON

Schuffenecker, (Claude-)Emile

(*b* Fresne-St-Mamés, Haute-Saône, 8 Dec 1851; *d* Paris, ?Aug 1934). French painter. In 1871 he entered the stockbroking firm of Bertin, where he met Paul Gauguin who was also employed there. In his spare time he took drawing classes and studied with Paul Baudry and Carolus-Duran, making his début at the Salon in 1874. He also became acquainted with Armand Guillaumin and Camille Pissarro. Following the stock market crash of 1882, he, like Gauguin, was forced to leave Bertin's and gained a job teaching art at the Lycée Michelet in Vanves. In 1884 he was one of the co-founders of the Salon des Indépendants and took part in the 8th and last Impressionist Exhibition in 1886, the year in which he also met Emile Bernard in Concarneau and sent him on to see Gauguin, thus initiating their joint development of Cloisonnism. Though he mixed with the members of the Pont-Aven group his own artistic tastes were very different. While Gauguin and his disciples had little more than contempt for Neo-Impressionism, Schuffenecker was much interested in pointillist techniques.

In 1889 it was Schuffenecker who was primarily responsible for arranging the Café Volpini exhibition to which he, Gauguin, Bernard and others contributed. The same year he began to sell his paintings, using part of this income to continue his support of Gauguin, for whom he also provided lodging and storage space. Gauguin began to take advantage of this generosity and in 1891, on the eve of Gauguin's trip to Tahiti, they fell out, though Schuffenecker continued to send Gauguin money for some time. His own painting had by now settled into an Impressionist style, as shown by *Wash-house at Bas-Meudon* (*c.* 1890; priv. col., see Monneret, p. 231). Some of his drawings (e.g. *Portrait of Gauguin*, *c.* 1890; Providence, RI Sch. Des., Mus. A.) have a swirling Expressionist technique reminiscent of van Gogh's work. At the time of his divorce in 1903 he stopped painting and was forced to sell almost all of his art collection, which consisted of works by Cézanne, van Gogh, Gauguin and others, including Gauguin's *Yellow Christ* (1889; Buffalo, NY, Albright–Knox A.G.). He later returned to painting, continuing to work in an Impressionist style. There is a portrait by Gauguin of Schuffenecker with his wife, son and daughter,

the *Schuffenecker Family* (1889; Paris, Mus. d'Orsay).

Bibliography

Emile Schuffenecker: 60 pastels, 40 dessins (exh. cat. by J. Fouquet, Paris, Gal. Deux Iles, 1963)

S. Monneret: *Impressionnisme et son époque*, 4 vols (Paris, 1978), ii, pp. 231–3

Claude Emile Schuffenecker, 1851–1934 (exh. cat. by J. E. Grossvogel, Binghamton, SUNY, 1980)

J. Le Paul and C.-G. Le Paul: *Gauguin and the Impressionists at Pont-Aven* (New York, 1987), pp. 115–31

□

Schwabe, Carlos

(*b* Altona, Holstein, 21 July 1877; *d* Avon, Seine-et-Marne, 1926). Swiss painter and printmaker of German birth. He became a Swiss citizen and received his artistic training under Joseph Mittey (*b* 1853) at the Ecole des Arts Décoratifs in Geneva. Following brief success there, Schwabe moved to Paris where he supported himself as a designer of wallpaper while he developed considerable graphic skills. He soon became active in Symbolist circles, winning favour as an illustrator of mystical religious themes. His highly refined drawings and watercolours accompany texts such as *Le Rêve* by Emile Zola (published 1892; drawings, Paris, Pompidou; exhibited Société Nationale des Beaux-Arts, also in 1892), Baudelaire's *Les Fleurs du mal* (1900), Maeterlinck's *Pelléas et Mélisande*, Catulle Mendes's *L'Evangile de l'enfance de notre Seigneur Jésus-Christ selon Saint Pierre* (1900) and Albert Samain's *Jardin de l'Infante* (1908). Luxurious editions of his coloured etchings, woodcuts and lithographs, created for bibliophiles, were exhibited at the Salon of the Société Nationale des Beaux-Arts in 1897.

Although Schwabe's characteristic graphic style was considered modern, his idealized feminine figures and carefully rendered floral motifs contain echoes of Botticelli's supple elegance, Mantegna's linear purity and Dürer's firmness and meticulous detail. His dependence on early Renaissance prototypes to express mystical sentiment was also indebted to D. G. Rossetti, Burne-Jones and Walter Crane.

Schwabe's poster (colour lithograph) for the first Salon de la Rose+Croix in 1892 effectively publicized this landmark in the development of Symbolism. A prime example of Rosicrucian art, Schwabe's composition is a pictorial representation of a mystical initiation rite. His finely rendered lithograph in shades of blue represents the ascension of three ethereal women towards spiritual salvation, surrounded by stylized flowers and occult Rosicrucian symbols.

Bibliography

SKL

L'Evangile symboliste: Carlos Schwabe, 1892 (exh. cat. by P. Jullian, Paris, Gal. J. C. Gaubert, 1974)

R. Pincus-Witten: *Occult Symbolism in France* (New York, 1976), pp. 102–3, 246–7

M. Hand: 'Carloz Schwabe's Poster for the Salon de la Rose+Croix: A Herald of the Ideal in Art', *A. J.* [New York], xliv (1984), pp. 40–45

TAUBE G. GREENSPAN

Segoffin, Victor

(*b* Toulouse, 5 March 1867; *d* Toulouse, 17 Oct 1925). French sculptor. Subsidized by the Département de Haute-Garonne, in 1888 he entered the Ecole des Beaux-Arts, Paris, where he studied under Pierre-Jules Cavelier and Louis-Ernest Barrias; in 1897 he won the Prix de Rome. He was influenced by Rodin's expressionism and sought to give extreme tension to his figures, but without losing their quality of realism. He exhibited from 1890 to 1925 at the Salon des Artistes Français and won many official prizes, including a bronze medal at the Exposition Universelle of 1900 in Paris and a first-class medal at the 1905 Salon. In 1906 he was appointed a Chevalier of the Légion d'honneur, becoming Officier in 1921.

Despite much contemporary recognition, few of Segoffin's works are publicly visible: his great bronze *Genius Vanquishing Time* (1908), formerly in the Cour Napoléon at the Louvre, Paris, was melted down during the German Occupation of 1940–44, as was his bronze statue of *Vercingetorix*,

commissioned by the State for the Panthéon, Paris, in 1911. His marble monument of *Voltaire* (1907–21), also intended for the Panthéon, is now in the courtyard of the Lycée Voltaire, Paris. However, his allegorical statue *Sacred Dance* or *War Dance* (marble, 1903–5), formerly in the park of the Elysée Palace, Paris, and then in store, can be seen at the Musée d'Orsay, Paris.

Bibliography

De Carpeaux à Matisse: La Sculpture française de 1850 a 1914 dans les musées et les collections publiques du nord de la France (exh. cat., Calais, Mus. B.-A.; Lille, Mus. B.-A.; Arras, Mus. B.-A.; and elsewhere; 1982), pp. 296–8

Catalogue sommaire illustré des sculptures du Musée d'Orsay (Paris, 1986), pp. 248–50

Le Panthéon: Symbole des révolutions (exh. cat., Paris, Hôtel de Sully; Montreal, Cent. Can. Archit.; 1989), pp. 263, 264, 267, 268

ANNE PINGEOT

Séguin, Armand

(*b* Brittany, 1869; *d* Chateauneuf-du-Faou, Brittany, 30 Dec 1903). French painter and printmaker. He attended the Académie Julian in Paris, and he learnt lithography in a commercial studio. In the 1890s he supported himself as an illustrator for the periodicals *Le Rire* and *Le Chut*. His drawings and engravings were more highly regarded than his paintings, although they show no unifying style: they range from works showing an Impressionist softness of fine contour lines to more striking compositions characterized by decorative simplification and interlocking arabesques. The latter are influenced by Japonisme and demonstrate Séguin's affinities with artists such as Edvard Munch and Jan Toorop, who also revealed Art Nouveau tendencies. Séguin's mature graphic style is seen in his critically acclaimed illustrations for *Gaspard de la Nuit* (1904) by Aloysius Bertrand and Byron's *Manfred* (unfinished) for Ambroise Vollard.

The exhibition at the Café Volpini in 1889 of works by Gauguin, Bernard and other Synthetist artists immensely affected the development of Séguin's painting style. From 1890 he closely followed Gauguin, who acted as mentor to the young artist. Séguin adopted Gauguin's primitivizing and cloisonnist style, with flat colours enclosed in decorative curving patterns. Like his master, Séguin used Breton peasants as subjects to express feelings of naive pietism: for example in *Breton Peasants at Mass* (1894; Cardiff, N. Mus.). For Séguin's one-man exhibition at Galerie Le Barc de Boutteville in 1895, Gauguin wrote a catalogue preface, calling Séguin a 'cerebral artist—he expresses not what he sees but what he thinks by means of an original harmony of lines, limited by arabesques'. Séguin recorded the activities and theories of the Pont-aven group in articles published in *L'Occident* (1903).

Although he shared the artistic goals and pictorial style of the Nabis and was on friendly terms with Sérusier, Denis and Jan Verkade, Séguin never joined their group. Significant paintings by Séguin are portraits of *Mlle Charles Morice* (untraced), *Marie Jade* (1893; Paris, Mus. A. Mod. Ville Paris) and *Nude in Landscape* (Saint-Germain-en-Laye, Dominique Denis priv. col.). He died of tuberculosis at 34.

Bibliography

P. Gauguin: 'Préface, Exp. Cat. Armand Séguin', *Mercure France*, n.s., xiii (Feb 1895), pp. 222–4

C. Chassé: *The Nabis and Their Period* (New York, 1969), pp. 72–7

W. Jaworska: 'Armand Séguin: Peintre ou graveur, 1869–1903', *Gaz. B.-A.*, n.s. 6, lxxvii (1971), pp. 145–58

—: *Gauguin and the Pont-Aven School* (Greenwich, CT, 1974), pp. 139–49

TAUBE G. GREENSPAN

Sellier, Charles-François

(*b* Nancy, 25 Dec 1830; *d* Nancy, 26 Nov 1882). French painter. He studied at the Ecole des Beaux-Arts in Paris under Louis Leborne (1796–1865) and Léon Cogniet and in 1857 won the Prix de Rome with the *Raising of Lazarus* (1857; Paris, Ecole N. Sup. B.-A.). He was then in Rome until 1862 and

exhibited at the Salon from 1857 until the year of his death. His paintings were mainly mythological and historical narratives, such as the *Death of Leander* (1861; Nancy, Mus. B.-A.), *Vitellius Visiting the Battlefield of Bédriac* (1861; Nancy, Mus. B.-A.) and *The Cheat* (1869; Nancy, Mus. B.-A.). He painted with a soft, diffuse light that reflected his admiration for Correggio and Pierre-Paul Prud'hon. Sellier also executed a number of portraits such as *Mme Victor Massé* (c. 1866; Nancy, Mus. B.-A.) and provided paintings for the chapel of St Denis in St Bernard in Paris (the *Flight into Egypt* and the *Workshop of Saint Joseph*). Sellier moved to Nancy where he became Curator of the Musée des Beaux-Arts and Director of the city's drawing school.

Bibliography

R. Ménard: *L'Art en Alsace-Lorraine* (Paris, 1876)

L. Gonse: *Les Chefs d'oeuvre des musées de France: La Peinture* (Paris, 1900), pp. 229–31

Musée de Nancy : Tableaux, dessins, statues et objets d'art, Catalogue descriptif et annoté (Nancy, 1909)

Séon, Alexandre

(*b* Chazelles-sur-Lyon, 1855; *d* Paris, 7 May 1917). French painter and illustrator. On 9 November 1872 he entered the Ecole des Beaux-Arts in Lyon where he worked with the engraver J.-B. Danguin (1823–94) and on 19 March 1877 he was enrolled at the Ecole des Beaux-Arts in Paris, and joined Henri Lehmann's studio, where he befriended Seurat. In 1879 he sent some drawings to the Salon and in the following year two paintings, *Hunting* and *Fishing* (untraced). Shortly afterwards he became the pupil of Puvis de Chavannes, working closely with him for the next ten years. Séon assisted Puvis principally with his murals for the Panthéon in Paris and the great staircase of the Musée des Beaux-Arts, Lyon. In 1884 he won first prize in the competition organized by the municipality of Courbevoie for the decoration of the banqueting halls of the town hall, choosing the theme of *The Seasons* (executed in 1889). During this period he was appointed drawing-master for the schools of the city of Paris. He believed that 'art should be instructive' and interested himself deeply in social problems. In 1891 he painted a portrait of *Joséphin Peladan* (Lyon, Mus. B.-A.) and the following year with Peladan and the Comte de la Rochefoucauld he founded the Salon de la Rose + Croix in order to 'fight against naturalism in painting and to provide a platform for young artists'.

Although strongly influenced by Puvis's painting and Seurat's ideas, Séon developed a personal Symbolist aesthetic, which related colour, line and mood. Melancholy (expressed by blue according to his theory) is the prevailing atmosphere in such easel paintings as *The Chimera's Despair* (1890; Paris, priv. col., see exh. cat., p. 145). His works are also marked by careful draughtsmanship, emphatic outlines and predominantly pale tones. In his illustrations for Edmond Haraucourt's *La Fin du Monde* (1899), he applied a simple linear style to exotic subject-matter with considerable success.

Bibliography

French Symbolist Painters (exh. cat. by A. Bowness, ACGB, 1972), pp. 145–8

H. Dorra: 'Le portrait de Péladan par Séon', *Bull. Mus. & Mnmts Lyon.*, vi/3 (1977), pp. 55–67

MADELEINE ROCHER-JAUNEAU

Seurat, Georges(-Pierre)

(*b* Paris, 2 Dec 1859; *d* Paris, 29 March 1891). French painter and draughtsman. In his short career as a mature artist (c. 1882–91), he produced highly sophisticated drawings and invented the Divisionist technique of painting known as Pointillism, which was taken up by many of his contemporaries associated with Neo-Impressionism. His application of scientific principles to painting and his stress on the surface quality of his work have had lasting effects on 20th-century art.

1. Life and work

Seurat belonged to a Parisian middle-class family. As a child he saw little of his eccentric father,

Antoine-Chrysostome (a customs official at La Villette), or his brother, Emile (a minor playwright). He was more attached to his female relatives and especially his mother, Ernestine (née Faivre), who appears in several drawings of the family apartment at 130 Boulevard de Magenta (e.g. *Embroidery*, *c.* 1883; New York, Met.). Seurat continued to take his evening meal there even when he went to live with his mistress, Madeleine Knobloch, from around 1888, less than a km away.

Although a few juvenile drawings survive, Seurat's serious interest in art probably dates from the informal lessons he received as a teenager from his maternal uncle, Paul Haumonté. Seurat's first formal training began about 1875, when he entered the local municipal art school under the sculptor Justin Lequien (1826–82). According to Edmond Aman-Jean, whom Seurat met there, instruction consisted mostly in drawing from casts and learning to 'stitch on noses and ears from lithographic examples' (Coquiot, 1924, pp. 28–9). Aman-Jean also recalled how Seurat was keenly interested in naturalist literature and the work of Ingres. In February 1878 Seurat entered the Ecole des Beaux-Arts under Henri Lehmann, a disciple of Ingres, and remained there until November 1879. Like many of Lehmann's students, Seurat found his teaching stultifying and sought stimulation elsewhere. He developed an interest in Piero della Francesca from copies recently executed in the school and, together with Aman-Jean and Ernest Laurent, sought instruction from the more 'progressive' Pierre Puvis de Chavannes. Seurat pursued his interests in proportion and expression by making extensive studies in the school's collections of prints, photographs and books. According to a letter he wrote to Félix Fénéon in 1890, Seurat had read Charles Blanc's *Grammaire des arts du dessin* (1867), which introduced him to theories on the expressive value of lines and colours and to the notions of complementary colour and 'optical mixture' that were to remain central to his thinking. Michel-Eugène Chevreul's *De la loi du contraste simultané des couleurs* (1839) was another important early influence. He also studied the work of earlier artists in the Louvre, notably Murillo, Rubens and Delacroix,

whose techniques guided his own experiments with optical phenomena and the expressive value of colour.

In April 1879 Seurat visited the Fourth Impressionist Exhibition, where the paintings of Monet and Pissarro in particular caused him 'an unexpected and profound shock' (Laurent quoted in Rosenthal, 1911, p. 66). From this date Seurat, Aman-Jean and Laurent worked independently in an atelier at 32 Rue de l'Arbalète. In November 1879 Seurat was conscripted into a year's military service at the garrison of Brest where he filled a sketchbook with drawings of soldiers in pencil and coloured crayon (see Russell, 1965, pp. 26–7). Seurat also 'meditated' on the articles 'Les phénomènes de la vision' by David Sutter serialized in the periodical *L'Art* (1880), especially those concerning composition and proportion in Greek art. On his return to Paris in November 1880 Seurat rented an apartment at 19 Rue de Chabrol. In about 1881 he developed his distinctive tenebrous drawing technique (*see* §2(i) below).

In February 1881 Seurat took extensive notes on Delacroix's *Fanatics of Tangier* (1836–8; Minneapolis, MN, Inst. A.). He was particularly interested in Delacroix's use of complementary pairs of colours to represent observed contrast effects, to create 'harmony' and to yield optically mixed neutral tones. In 1881 it is likely that he also read Ogden Rood's *Théorie scientifique des couleurs* (1881), which applied the principles of the Young/Helmholtz three-colour theory to painting. Rood's book suggested a more scientific system of translating natural luminosity and colour phenomena than the subtractive systems he had studied previously.

Seurat began to apply his accumulated research in the panels and canvases he executed between 1881 and 1883 in the Parisian suburbs and in 1882 at Montfermeuil(e.g. *Boy Seated on the Grass, Pontabert*, 1882; Glasgow, A.G. & Mus.). In these paintings he used a *balayé* (or criss-cross) brushstroke, which Boime suggests he may have learnt from Alexandre Boiron (1859–89), a fellow pupil of Lehmann. Towards 1883 Seurat began to develop an Impressionist brushstroke that varied with the texture and movement of the surface represented,

for instance in *Fishermen near a Bridge* (New York, Met.).

Seurat began work on his first important project, the *Bathers at Asnières* (*Une Baignade, Asnières*; London, N.G.; see col. pl. XXXVI) in summer 1883. It depicts on the scale of a monumental Salon painting (2.01×3.01 m) a group of carpenters and other workers relaxing by the Seine near the Parisian industrial suburb of Asnières. Seurat made a large number of small oil sketches *en plein-air* in summer 1883, as well as compositional and figure studies in the painting's final stages. Although Seurat had hitherto exhibited only a finished drawing of *Aman-Jean* (1882; New York, Met.) at the Salon of 1883 and a small panel at the Cercle des Arts Libéraux in 1884, he sent the *Bathers* to the Salon of 1884 where it was rejected by the jury. It was, however, hung at the Salon des Indépendants in May–June 1884. Paul Signac first encountered Seurat's work at this exhibition.

By 1883 Seurat had probably also already conceived the companion to the *Bathers*, *A Sunday Afternoon on the Island of La Grande Jatte* (1884–6; Chicago, IL, A. Inst.)—an equally monumental canvas (2.07×3.08 m) containing about 50 figures enjoying a summer promenade on the island opposite Asnières. Throughout 1884 and early 1885 Seurat worked on preparatory studies for the *Grande Jatte*, which was completed by March 1885. However, in winter 1885–6 he reworked the *Grande Jatte* in the technique that he called 'chromo-luminarism', now known as Divisionism (*see* §2(ii) below). He also repainted sections of the *Bathers* in the same style around 1887. Seurat's ambition in the *Bathers* and the *Grande Jatte* was to 'make the moderns pass by . . . in their essential aspect like figures on a Panathenaic frieze' (Kahn, 1888, p. 143); in effect to record an aspect of contemporary urban life in a style appropriate to it, but also worthy to be compared with the great models of the classical past. Echoes of Courbet's *Young Ladies on the Banks of the Seine* (1856; Paris, Petit Pal.) and Manet's *Déjeuner sur l'herbe* (1863; Paris, Mus. d'Orsay), and the contrast between the relaxed poses of the workers in the *Bathers* and the stiff, immobile middle-class figures in the *Grande Jatte*, hint at the social contradictions and injustices inherent in the differing sorts of leisure enjoyed by the workers and the bourgeoisie.

Seurat exhibited the *Grande Jatte* at the Eighth Impressionist Exhibition in May 1886 and established himself as the leader of a new avant-garde. His engaged subject-matter and his superficially Impressionist technique squared with the naturalist and often socialist demand for *verité* (or sincerity) insisted on by Joris-Karl Huysmans and Paul Alexis among others. His painting was seen to be critical insofar as it subverted dominant conventions that falsified reality, both technically and ideologically, in line with what were seen as 'bourgeois' norms. However, the *Grande Jatte* was also seized upon by the Symbolist writers, who saw in its Neo-Platonic devices and especially its static qualities similarities with their own aestheticizing interests drawn from Schopenhauer and Wagner.

Seurat's association with the Symbolists had begun around October 1885 at the house of Robert Caze where he met Huysmans, Alexis and the Symbolists Jean Moréas, Fénéon, Rudolphe Darzens, Ephraïm Mikhael, Paul Adam, Jean Ajalbert and Gustave Kahn. He met other Symbolist writers at the Brasserie Gambrinus and the Café d'Orient after Caze's death at the end of March 1886, including Charles Vignier, Jules Laforgue, the Wagnerian theorists Téodor de Wyzewa and Edouard Dujardin and the aesthetician Charles Henry. From 1886 Seurat effectively belonged to a small and esoteric avant-garde whose activities were confined almost exclusively within a square kilometre of Montmartre. He only stepped outside this milieu to exhibit biennially from 1887 with Les XX, the Symbolist-led exhibiting society in Brussels, and to show regularly at the Salon des Indépendants.

From 1886, except for a brief period of renewed military service in summer 1887, Seurat divided his time between summer campaigns on the Normandy coast, painting marines of Honfleur in 1886, Port-en-Bessin in 1888, Le Crotoy in 1889 and Gravelines in 1890, and winters spent finishing these and producing large figure paintings. The

first of the latter produced after his contact with the Symbolists was *The Models* (1887–8; Merion Station, PA, Barnes Found.), an interior showing three naked or partly naked models. Apart from *Young Woman Powdering Herself* (1888–9; U. London, Courtauld Inst. Gals), a portrait of his mistress, Madeleine Knobloch, making-up at a small dressing table, Seurat produced only three other major paintings. These were images of popular urban entertainment: *The Parade* (1887–8; New York, Met.), representing a side-show outside the Cirque Corvi, a peripatetic animal circus; *Le Chahut* (1889–90; Otterlo, Kröller-Müller), a painting of the 'quadrille naturaliste' prompted by performances at the cabaret Le Divan Japonais; and *The Circus* (1890–91; Paris, Mus. d'Orsay; see fig. 69), which represents a circus performance and was based on the Cirque Fernando in the Boulevard Rochechouart. In all these works Seurat exploited Charles Henry's ideas of expression and also responded to the Wagnerian emphasis on the consolatory power of music, which he had learnt from his Symbolist colleagues.

The jealousy with which Seurat regarded his position as the instigator of the Neo-Impressionist technique erupted in 1888–9 in disagreements with Pissarro, Signac and some of the minor Neo-Impressionists. Seurat's claim to the leadership of the Parisian avant-garde in painting was also challenged about 1889 with the first important manifestation of Synthetism at Gauguin's Café Volpini exhibition. The Symbolists' support for him in their press declined, Fénéon criticizing the increasingly anti-naturalistic quality of Seurat's recent work in 1889. Few even of his closest friends were aware of his mistress or the son born to them in February 1890. When he died at his mother's home in March 1891 his unfinished *Circus* attracted little attention at the Salon des Indépendants.

2. Working methods and technique

(i) Drawing. Seurat's earliest serious drawings were copies made around 1875 after sculptures and reproductions of them and classicist paintings: for example *Copy after a Fragment of the Parthenon Frieze* (1875; priv. col., see Russell, 1965, p. 11). By

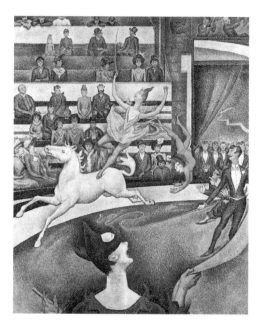

69. Georges Seurat: *The Circus*, 1890–91 (Paris, Musée d'Orsay)

1878 Seurat had acquired considerable technical skill and was able to make highly finished copies after antique statuary such as *Praxitilean Figure* (1877–8; Paris, priv. col., see Herbert, 1962, p. 20), in which tonal gradations are used to define form with great subtlety, and where form is also indicated by an articulated but idealized contour line largely composed of accumulated shadows. In addition to simple line drawings after drawings and paintings by Raphael, Ghiberti, Poussin and Ingres, Seurat also made copies of works by Holbein with great fidelity: for example *Sir Richard Southwell* (1877–8; ex-Paul Eluard priv. col.). Seurat's life drawings sometimes follow the idealizing, chiaroscuro technique he developed for statuary (e.g. *Nude Woman with Baton*, 1878–9; Paris, priv. col., see Herbert, 1962, p. 23), while others adapt the technique to reveal details of musculature and physique in an uncompromisingly realist manner (e.g. *Aged Hindu*, 1878–9; Paris, priv. col., see Russell, 1965, p. 21). Seurat's first fully independent drawings are the pencil sketches of his military colleagues at Brest (1879–80), whom

he described with short, angular strokes. In this sketchbook Seurat also exploited the device of simultaneous contrast in more modelled drawings made in coloured pencil, which have a highly atmospheric and even ethereal quality(e.g. *Ballerina in a White Hat*, 1880–81; New York, Mrs Siegfried Kramarsky priv. col.). Seurat observed the manners and types of Paris in a more fully modelled, parallel hatching technique, for example in *Seated Woman* (1880–81; London, R. J. Sainsbury priv. col.). For the most part, these drawings concentrate on achieving an expressive silhouette at the expense of detail, and they summon up a mood of intimacy and isolation in their frequent presentation of figures from behind or from oblique views (e.g. *Woman Seated Reading*, c. 1881; Paris, priv. col., see Herbert, 1962, p. 45).

Seurat progressed logically from this type of drawing to his fully mature style, in which he applied an interlacing mass of conté crayon strokes to laid Michallet paper (a textured, high quality paper). He created tones ranging from dense and velvety black through subtle greys to white where the paper was left exposed. He also retained a feeling of lustre throughout by allowing the white of the paper to show through where the conté crayon had not reached the troughs in its textured surface. Many of these drawings exploit the phenomenon of irradiation, whereby a dark tone seen against a light background (or vice versa) will become exaggerated, as in *Nude* (?c. 1882; U. London, Courtauld Inst. Gals). Seurat's conté crayon drawings have often been seen as wholly original, but precedents can be found in Daumier's and Fantin-Latour's lithographs, Millet's drawings, Goya's etchings and aquatints, and academic techniques.

Seurat used conté crayon in two distinct types of work: firstly, independent drawings, which were often exhibited, among which are the series of café-concert drawings of the later 1880s, such as *At the 'Concert Européen'* (1887–8; New York, MOMA); and secondly, those used as preparatory studies for paintings. Seurat made eight of these for the *Bathers* (e.g. *Seated Nude*, 1883–4; Edinburgh, N.G.) and twenty-four for the *Grande Jatte* (e.g. *Strolling Couple*, 1884–5; London, BM)

in order to arrive at a simplified, monumental and tonally harmonious treatment of figures and details, which could be transferred to the final works. In some of his preparatory drawings, Seurat also exploited the grid of lines on Michallet paper revealed by conté crayon to balance masses of light and dark and to establish a set of proportional relations into which significant sections of figures' bodies might be fitted, for example in *Trombone Player, Study for 'The Parade'* (1887–8; Philadelphia, PA, Mus. A.).

(ii) **Painting.** Although Seurat devoted considerable energy to his drawings, painted studies and finished marines, he considered his large figure paintings his most 'important' works (letter, 28 Aug 1890, to Beaubourg), because they represented a complex synthesis of modernist procedures (painting large-scale colourist paintings of contemporary life) with academic practices, producing idealized, symbolic and didactic works on a substantial scale. Seurat's working methods on the *Bathers* and *Grande Jatte* reveal much about how he sought to reconcile these ambitions. He began by making numerous small oil studies from the motif in summer, which he often reworked in the studio. After experimenting with several possible compositional and narrative arrangements, he arrived at more definitive formulations in a number of small panels painted in the studio, and, in the case of the *Grande Jatte*, he produced an easel study. In preparation for the large works Seurat also made conté crayon studies. The large oils were painted in a variety of brushstrokes: 'Impressionist' for the water and sky, *balayé* for the grass and (in the *Bathers*) a smoother, fused stroke recalling that of Puvis de Chavannes for the figures. Seurat loosely (rather than systematically) reworked the *Grande Jatte* over the winter of 1885–6 in a 'skin' of divisionist strokes enhancing its optical properties. He harmonized and balanced warm and cool hues in a manner consistent with academic theory as propounded by, for instance, Charles Blanc. He shifted away from strictly recording natural phenomena and became increasingly interested in calculating the emotional effects of his colour harmonies in line with

the synaesthesia theories of Blanc, Sutter, Paillot de Montabert and Baudelaire. Thus the cooler and more subdued colouration of the *Bathers* contrasts with the slightly more acid and warmer tones of the *Grande Jatte* to emphasize the differing 'moral' qualities of the two sites' populations.

The *Models* was unusual technically, since Seurat abortively experimented with painting it on a plaster ground during summer 1887. Its evolution was also less complex than that of earlier works: he made only five drawings, five panels and an *esquisse* for the final painting. As in his other late works Seurat employed Charles Henry's theories concerning the expressive values of line and colours, principally that warm colours and upward moving lines had a 'dynamogenic' or uplifting effect while cool colours and descending lines were 'inhibitory'. Seurat aligned the directions of the models' discarded umbrellas with the directions plotted for their respective colours in Henry's colour circle. Similarly, in *Parade* Seurat used repeated horizontals and descending verticals to express a mood of calm and melancholy. He expressed the contrasting emotion of joy through emblematic upward-moving shapes representing gas jets, and in the warm light these are seen to cast on the painting's performers. He also abandoned Rood's naturalistic paradigm in favour of Henry's theories, when he adopted as complementary pairs of colours: orange-yellow representing gaslight and violet-blue in the shadows. Moreover, the distribution of individual dots corresponds less closely than before with the logic of naturalistic observation, which is subordinated to the demands of expressive harmony and achieves the effect of an ethereal nocturnal luminosity. In both *Le Chahut* and *The Circus* Seurat followed Henry in repeatedly using upward moving lines set at 30, 45 and 60 degrees to the horizontal to express joy. Henry's theories also help to explain the predominantly bright colouration of *The Circus*, which was intended to capture the intensity and warmth of the artificial light that illuminates most of his later figure paintings.

Seurat's entertainment paintings follow the moral and technical demands of Wagnerian theory as laid down by his Symbolist friends. In particular, Seurat's use of line and colour in these works is consistent with how de Wyzewa recommended their deployment in musically affecting combinations independent of their representational role. In the near-completed sections of *The Circus* the surface is treated as a gradated flux of two pairs of complementaries, red-green and orange-blue; a third complementary pair, yellow-purple, is visible in areas on the right of the painting. Colour touches are also organized in streams, which exaggerate contrast around the edge of objects giving the whole canvas a rhythmic quality consistent with current notions of how line and colour could blend their 'melody' and 'harmony' into an overall flux shifting with the emotion to be expressed (as Wagner was popularly considered to have done).

Seurat's landscapes such as *Port-en-Bessin, the Jetties* (1888; New York, MOMA) are also organized in clear rhythmic areas. Their colour, like that of the entertainment paintings, is at once ostensibly naturalistic from a viewing distance that allows optical fusion, while close up it may be seen to be organized in arbitrary harmonic combinations of complementary pairs. Seurat's landscapes from Le Crotoy and Gravelines illustrate his growing concern for the surface value of his pictures and play especially with empirically determined rhythms of spaces and linear masses.

In 1887 Seurat seems to have begun giving to his pictures frames painted in the pointillist technique. From 1889 he painted borders directly on to the canvas to modulate more smoothly between picture and frame (and he also repainted a number of his early paintings with similar borders). The predominantly dark colours chosen for both borders and frames from *c.* 1890 were complementary to the adjacent section of the painting: for example *Le Crotoy, Looking Downstream* (1889; Detroit, MI, Inst. A.). Seurat also seems to have intended that they should imitate Wagnerian productions where the stage was the unique source of attention in a dark auditorium.

3. Character and influence

Seurat was described by his closest acquaintances as 'not very forthcoming, affected by a marked

silence' (Alexandre, 1891, p. 5) and possessed of 'a slightly cold appearance' (Kahn, 1891, p. 108). His reserve dissolved somewhat among friends when 'he spoke with animation about his art, both its aims and its technical objectives' (Kahn, 1891, p. 108). Witness accounts concur that Seurat was very firm in his opinions and cogent in defending them: 'He believed in the power of theories, in the absolute values of methods' (de Wyzewa, 1891, p. 263).

Both de Wyzewa and Verhaeren recall that Seurat had methodically planned his theoretical and technical researches and his career. The notes Seurat made from Delacroix in 1881 also suggest his ambitions for success were determined early, since he copied from the earlier painter the passage: 'One cannot create a school without providing many great works as models' (Fénéon, ed., 1922, p. 155). Joze wrote of Seurat: 'The public considered him to be a young man doing bizarre painting, he considered himself the great artist on whom Paris would pride itself within ten years' (1890, pp. 18–19). Seurat's sustained hostility towards Gauguin and his insistence on his 'prior paternity' in inventing the Divisionist technique (letter to Fénéon, 20 June 1890) confirm this impression.

In the 1880s Seurat's technique was adopted with varying conviction in France by PAUL SIGNAC, Camille and Lucien Pissarro, Albert Dubois-Pillet, Charles Angrand, Maximilien Luce, Henri-Edmond Cross and Hippolyte Petitjean, and in Belgium by Theo Van Rysselberghe, Henry Van de Velde, Georges Lemmen, Alfred William Finch and others. Seurat was sometimes worried about his technique being corrupted.

Seurat's influence, and especially that of his colour, may be traced in van Gogh's work and, indirectly, through Signac's adaptation of Neo-Impressionism and his book *D'Eugène Delacroix au Néo-Impressionnisme* of 1899, in the work of Matisse, Robert Delaunay and Picasso. André Breton claimed Seurat as an important predecessor of Surrealism: indeed his work was sometimes viewed as bizarre or caricatural in the 1920s. He is an important figure in modern art for shifting painting away from the goal of realism and

for stressing the surface properties of painting as the prime 'quality' of the medium.

Writings

F. Fénéon, ed.: 'Notes inédites de Seurat sur Delacroix', *Bull. Vie A.* (1922), pp. 154–8
R. L. Herbert, ed.: 'Seurat and Emile Verhaeren: Unpublished Letters', *Gaz. B.-A.*, liv (1959), pp. 315–28

Bibliography
early sources

P. Alexis: 'A minuit', *Cri du Peuple* (15 May 1884, 1 April 1886, 25 April 1886, 2 May 1886, 5 May 1886, 15 May 1886, 25 July 1886, 19 Feb 1887, 29 March 1888) [a record of Seurat's participation in the avant-garde]
P. Adam: 'Peintres Impressionnistes', *Rev. Contemp.* (April–May 1886), pp. 541–51
J. Christophe: 'Chronique, Rue Laffitte no. 1', *J. Artistes* (13 June 1886), p. 193
F. Fénéon: *Les Impressionnistes en 1886* (Paris, 1886); also in *Oeuvres plus que complètes*, ed. J. Halperin (Geneva, 1970), pp. 28–52 [indispensable col. of all Fénéon's writings on Seurat]
G. Kahn: 'Chronique de la littérature et de l'art: Exposition Puvis de Chavannes', *Rev. Indép.*, vi (1888), pp. 142–3
J. Christophe: 'Georges Seurat', *Hommes Aujourd'hui*, viii/368 (1890) [whole issue; first biog. of Seurat]
V. Joze: *L'Homme à femmes* (Paris, 1890) [Seurat features throughout as Georges Legrand]
A. Alexandre: 'Un Vaillant', *Paris* (1 April 1891), pp. 5–8
G. Kahn: 'Seurat', *A. Mod.*, 11 (1891), pp. 107–10
H. Van de Velde: 'Georges Seurat', *Wallonie*, v (1891), pp. 167–71
E. Verhaeren: 'Georges Seurat', *Soc. Nouv.*, 7 (1891), pp. 429–38
T. de Wyzewa: 'Georges Seurat', *A. Deux Mondes*, 22 (1891), pp. 263–4
A. Alexandre and others: *Georges Seurat (1859–1891)* (Brussels, [1895]) [an exceedingly rare text collecting accounts of Seurat by his closest associates]
P. Signac: *D'Eugène Delacroix au Néo-Impressionnisme* (Paris, 1899, rev. 5/1978) [important account of the optical theories Signac learnt and developed from his friendship with Seurat]
L. Rosenthal: 'Ernest Laurent', *A. & Déc.*, iii (1911), pp. 65–76
G. Kahn: *Les Dessins de Seurat*, 2 vols (Paris, 1924)
J. Rewald, ed.: 'Extraits du journal inédit de Paul Signac',

Gaz. B.-A., xxxvi (1949), pp. 97–128; xxxix (1952), pp. 265–84; xlii (1953), pp. 27–57

—: *Camille Pissarro: Lettres à son fils Lucien* (Paris, 1950)

monographs, catalogues

L. Cousturier: *Georges Seurat* (Paris, 1921, rev. 2/1926)

G. Coquiot: *Seurat* (Paris, 1924) [contains valuable reminiscences of Seurat by Aman-Jean, Angrand, Signac, etc.]

J. Rewald: *Georges Seurat* (Paris, 1948)

Seurat: Paintings and Drawings (exh. cat., Chicago, IL, A. Inst.; New York, MOMA; 1958)

H. Dorra and J. Rewald: *Seurat: L'oeuvre peint: Biographie et catalogue critique* (Paris, 1959) [contains extensive quotations from contemporary criticisms]

C. M. de Hauke: *Seurat et son oeuvre*, 2 vols (Paris, 1961) [contains Seurat's notes from Chevreul]

R. L. Herbert: *Seurat's Drawings* (New York, 1962) [publishes a number of drawings not catalogued elsewhere and is thoroughly documented with an important bibliog.]

W. I. Homer: *Seurat and the Science of Painting* (Cambridge, MA, 1964, rev. 2/1970/R 1978) [important but somewhat schematic account of Seurat's interest in and exploitation of theories of optics and expression]

J. Russell: *Seurat* (London, 1965)

H. Perruchot: *La Vie de Seurat* (Paris, 1966)

Neo-Impressionism (exh. cat. by R. L. Herbert, New York, Guggenheim, 1968), pp. 98–127

N. Broude, ed.: *Seurat in Perspective* (Englewood Cliffs, 1978)

S. Faunce: 'Seurat and the Soul of Things', *Belgian Art, 1880–1914* (exh. cat., New York, Brooklyn Mus., 1980), pp. 41–56

Georges Seurat Zeichnungen (exh. cat. by E. Franz and B. Growe, Bielefeld, Städt. Ksthalle, 1983)

R. Thomson: *Seurat* (Oxford, 1985)

M. Ward: 'The Rhetoric of Independence and Innovation', *The New Painting: Impressionism 1874–1886* (San Francisco, 1986), pp. 420–42

Chicago technical report on *Grande Jatte* (in preparation)

specialist studies

R. Goldwater: 'Some Aspects of the Development of Seurat's Style', *A. Bull.*, xxiii (1941), pp. 117–30

R. L. Herbert: 'Seurat in Chicago and New York', *Burl. Mag.*, c (1958), pp. 146–55

—: 'Seurat and Jules Chéret', *A. Bull.*, xl (1958), pp. 156–8

W. I. Homer: 'Seurat's Formative Period, 1880–84', *Connoisseur*, cxlii (1958), pp. 58–62

A. Chastel: 'Une Source oubliée de Seurat', *Etudes et documents sur l'art français*, xxii (Paris, 1959), pp. 400–07

R. L. Herbert: 'Seurat and Puvis de Chavannes', *Yale U. A.G. Bull.*, xxv/2 (1959), pp. 22–9

A. Boime: 'Seurat and Piero della Francesca', *A. Bull.*, xlvii (1965), pp. 265–71

H. Dorra and S. C. Askin: 'Seurat's Japonisme', *Gaz. B.-A.*, lxxiii (1969), pp. 81–94, 108, 111–12

N. Broude: 'New Light on Seurat's "Dot": Its Relation to Photo-mechanical Printing in France in the 1880's', *A. Bull.*, liv (1974), pp. 581–9

E. Pearson: 'Seurat's *Le Cirque*', *Marsyas*, xix (1977–8), pp. 45–51

R. L. Herbert: '*Parade de cirque* de Seurat et l'esthétique scientifique de Charles Henry', *Rev. A.* [Paris], l (1980), pp. 9–23

J. House: 'Meaning in Seurat's Figure Paintings', *A. Hist.*, iii (1980), pp. 354–6

P. Smith: 'Seurat and the Port of Honfleur', *Burl. Mag.*, cxxvi (1984), pp. 562, 564–7, 569

J. Stumpel: '*The Grande Jatte*, that Patient Tapestry', *Simiolus*, xiv (1984), pp. 209–24

J. Gage: 'Seurat's Technique: A Reappraisal', *A. Bull.*, lxix/3 (1987), pp. 448–54

A. Lee: 'Seurat and Science', *A. Hist.*, x/2 (1987), pp. 203–26

P. Smith: 'Paul Adam, *Soi* et les "peintres impressionistes"', *Rev. A.* [Paris], 82 (Dec 1988), pp. 39–50

general works

R. Rey: *La Renaissance du sentiment classique dans la peinture française à la fin du XIXe siècle* (Paris, 1931), pp. 95–137 [reproduces Seurat's clippings from Sutter's articles and Seurat's 'esthétique']

J. Rewald: *Post-Impressionism: From van Gogh to Gauguin* (New York, 1956, rev. 2/1978)

S. Lövgren: *The Genesis of Modernism: Seurat, Gauguin, van Gogh and French Symbolism in the 1880s* (Stockholm, 1959, rev. 2/1971), pp. 50–88

P. Angrand: *Naissance des artistes indépendants* (Paris, 1965), pp. 37, 108–11, 113–17

J. Sutter, ed.: *Les Néoimpressionnistes* (Neuchâtel, 1970), pp. 11–46 [contains an important essay by Herbert on Seurat's style]

PAUL SMITH

Signac, Paul

(*b* Paris, 11 Nov 1863; *d* Paris, 15 Aug 1935). French painter, printmaker and writer. He came from a well-to-do family of shopkeepers. A visit to the exhibition of Claude Monet's works organized by

Georges Charpentier at the offices of *La Vie moderne* in 1880 decided him on an artistic career and encouraged him to try painting out of doors. His early works, landscapes or still-lifes of 1882–3 (*Still-life*, 1883; Berlin, Neue N.G.), show an Impressionist influence, particularly that of Monet and Alfred Sisley. In 1883 Signac took courses given by the Prix de Rome winner Jean-Baptiste Bin (1825–c. 1890), but they had little effect on his style. Such suburban Paris landscapes as *The Gennevilliers Road* (1883; Paris, Mus. d'Orsay) place his works in a world of modern images comparable to those of Jean François Rafaëlli in which factory chimneys, hoardings and etiolated trees abound (e.g. *Gas Tanks at Clichy*, 1886; Melbourne, N.G. Victoria). Already a friend of Henri Rivière, Signac soon met Armand Guillaumin, who provided important encouragement. In 1884 he was a founder-member of the Salon des Indépendants, where he met Georges Seurat who that year was exhibiting *Bathers at Asnières* (1884; London, N.G.). In this painting Seurat had already begun to apply principles of Divisionism (although not yet the dot-like brushstroke), while Signac was still practising an orthodox form of Impressionism.

Seurat's theory of colour division seduced Signac by its rigour, which was in opposition to the instinctive approach of the Impressionists. The two men pooled their research. Signac persuaded Seurat to remove earth pigments from his palette, and by 1885 Seurat had encouraged Signac to adopt a Divisionist handling of paint (e.g. *The Seine at Asnières*, 1885; artist's col., see Cachin, p. 16). By 1886 they were both using the pointillist brushstroke. In emulation of Seurat's *A Sunday Afternoon on the Island of La Grande Jatte* (1884–6; Chicago, IL, A. Inst.), Signac painted a series of three major views of contemporary interiors with figures posed in stiff profile (e.g. *The Dining-room*, 1886–7; Otterlo, Kröller-Müller Sticht.). Associated with anarchist circles and the *Revue indépendante*, Signac was close to Félix Fénéon, who devoted several articles to him. Camille Pissarro was another friend, who adopted the Neo-Impressionist technique from 1886 in response to seeing Seurat's and Signac's work. In 1886–7 Signac met van Gogh, whom he saw again when he visited Arles in 1889. While remaining faithful to his own style of brushstroke and a subjective conception of colour, van Gogh was influenced by Signac's version of the Divisionist technique as can be seen in such paintings as *The Bridge at Asnières* (1887; Houston, TX, Menil Col.).

From the mid-1880s Signac exhibited regularly. Apart from the Salon des Indépendants, in which he figured every year, he showed at the last Impressionist Exhibition (1886) at the invitation of Pissarro, from 1888 at Les XX in Brussels, and later at Libre Esthétique. From 1892 he exhibited watercolours, e.g. *Trois notations à l'aquarelle* (exh. Paris, Salons Hôtel Brébant, *Exposition des peintres néo-impressionnistes*, 1892–3). However, it was only in 1902 that he had his first one-man exhibition, in Siegfried Bing's gallery in Paris. Like other members of the Neo-Impressionist group, Signac received little public acclaim for the first 20 years of his career. Fénéon, Arsène Alexandre and Antoine de la Rochefoucauld were the only critics who supported his work consistently. Signac patiently developed a style whose essential principles had been laid down at the outset of his career. Within the dictates of the Neo-Impressionist method his art evolved from the outdoor painting of his early work towards an increasingly subjective approach. In 1891 he began introducing indications of musical tempos to the titles of his works (e.g. *Presto (finale)*, 1891; London, priv. col., see 1979–80 exh. cat., p. 139), thereby underlining his investigations into abstract visual rhythms at a time when Baudelaire's theory of correspondences was very much in fashion. By 1892, when he moved from Paris to St Tropez, direct observation of nature was occupying a less important place in his work: he was painting almost entirely in his studio from sketches and watercolours made in front of the motif, mostly in the course of his travels. A keen sailor, he went on a number of cruises, which took him to various ports in France and also to Italy, Holland and Constantinople.

The formal evolution of Signac's painting followed two directions. Never an abstract painter, he nonetheless elaborated an aesthetic in which the

beauty of pure colour was an end in itself: '[colour] division is more a philosophy than a system', he wrote. The bold juxtaposition of bright colours (e.g. *Women at the Well*, 1892; Paris, Mus. d'Orsay; see col. pl. XXXVII) gave way in 1905 to more muted harmonies where he applied the principles of interaction between coloured masses with greater freedom (e.g. *Paris, Ile de la Cité*, 1912; Essen, Mus. Flkwang). On the other hand, his brushstroke, which until 1890 was no more than a little dot designed to produce 'optical mixture' at a distance, grew larger and then became a square or a rectangle whose size was adapted to suit that of the picture, which was conceived as a form of mosaic (*Venice*, 1905; Toledo, OH, Mus. A.). In 1927 he used the opportunity of writing a work on Johann Barthold Jongkind to produce a remarkable treatise on watercolour.

If Seurat was the founder of Divisionism (*see* SEURAT, GEORGES), Signac deserves credit for making its principles known. A friend of the chemist and colour theorist Charles Henry, he designed the illustrations for Henry's *Cercle chromatique et rapporteur esthétique* (1888). In the background of his *Portrait of Fénéon* (1890; priv. col., see 1979–80 exh. cat., p. 211), with its spiralling forms of vividly contrasting colour inspired by a Japanese print, he applied Henry's theories concerning the emotional effect of colour and linear direction. Signac proved his ability as a theorist in his important work, *D'Eugène Delacroix au néo-impressionnisme* (1899), in which he defended the Neo-Impressionist aesthetic just as Fénéon was abandoning his activity as a critic. Like Fénéon, Signac sought to place Neo-Impressionism in a historical context, although his dogmatism and his desire for clarity gave his work the force of a manifesto. The book was one of the key sources of the renewed interest in Divisionism between 1900 and 1910; it was widely read by artists, not only in France, but also in Germany (where it was translated in 1903), and in Italy where the Futurists took up the Divisionist technique. The Fauves, and especially Matisse, who in 1904 was working with Signac at St Tropez, found in it the sanction for a freedom of colour that they would accentuate even more, as would Robert Delaunay and František Kupka.

Writings

D'Eugène Delacroix au néo-impressionnisme (Paris, 1899/R 1964; Ger. trans. 1903; rev. 1978 with notes by F. Cachin)

Jongkind (Paris, 1927)

J. Rewald, ed.: 'Extraits du journal inédit de Signac', *Gaz. B.-A.*, n.s. 6, xxv (1949), pp. 97–128; xl (1952), pp. 265–84; xli (1953), pp. 27–57

Bibliography

R. L. Herbert: 'Artist and Anarchism: Unpublished Letters of Pissarro, Signac and Others', *Burl. Mag.*, cii (1960), pp. 473–82, 517–22

Signac (exh. cat. by M.-T. Lemoyne de Forges and Mme P. Bascoul-Gauthier, Paris, Louvre, 1963) [important bibliog.]

F. Cachin: *Paul Signac* (Paris, 1971)

E. W. Kornfeld: *Catalogue raisonné de l'oeuvre gravé et lithographié de Paul Signac* (Berne, 1974)

Post-Impressionism: Cross-currents in European Painting (exh. cat., London, RA, 1979–80)

Van Gogh à Paris (exh. cat. by B. Welsh-Ovcharov, Paris, Mus. d'Orsay, 1988)

Signac & Saint-Tropez, 1892–1913 (exh. cat. by J.-P. Monery, M. Ferretti-Bocquillon and F. Cachin, St Tropez, Mus. Annonciade; Reims, Mus. St-Denis; 1992)

RODOLPHE RAPETTI

Signol, Emile

(*b* Paris, 6 April 1804; *d* Montmorency, nr Paris, 4 Oct 1892). French painter. He was admitted to the Ecole des Beaux-Arts in Paris in 1820 on the recommendation of Merry-Joseph Blondel and entered the studio of Antoine-Jean Gros in 1821. In 1830 he won the Prix de Rome for his *Meleager Taking up Arms Once More at the Insistence of his Wife* (Paris, Ecole N. Sup. B.-A.). As a *pensionnaire* at the Villa Medici in Rome from 1831 to 1835 he demonstrated a capacity for absorbing new sources into his art. He gained particularly (as did Friedrich Overbeck) from his discovery of the Italian 'Primitives', including Giotto, Fra Angelico and Perugino among others, during a period spent in Florence and Assisi in 1833 and soon became one of the most interesting religious painters of his generation.

A number of Signol's works are equal to the best works of the Nazarene school, including

Christ in the Tomb (1834; untraced), which depicts Christ watched over by the figure of Religion while awaiting his resurrection, *Awakening of the Just, Awakening of the Wicked* (1835; Angers, Mus. B.-A.), in which his depiction of the Last Judgement emphasizes the joys of the blessed, and the *Christian Religion Comes to the Aid of the Afflicted and Gives them Resignation* (exh. 1837) in the church of Lubersac. Their distinctive Nazarene features included a Pre-Raphaelite air, an understanding of Christian symbolism, and references to the theology of *Espérance* then propounded in France by Henri Lacordaire, Charles-Forbes-René, Comte de Montalembert, Antoine-Frédéric Ozanam and others.

These works were successful, though, arguably, Signol's mature oeuvre surpassed them. His numerous later paintings include: the two panels of *The Adultress* (exh. 1840 and 1842; Paris, Louvre; Detroit, MI, Inst. A.), the *Taking of Jerusalem (1099)* (exh. 1848; Versailles, Château), the *Crusaders Crossing the Bosphorus* (exh. 1855; Versailles, Château)—Christian versions of historical dramas were extremely popular during the 1850s—the *Holy Family* (exh. 1859) in the church at Bény-sur-Mer and the *Four Evangelists* (1867) in the church of St Augustin, Paris. Signol's mature works are best represented by his mural paintings executed in wax and/or in oils for various churches in Paris. These murals are: the *Death of St Mary Magdalene* (1841) in La Madeleine, *Christ between SS Louis and Francis* (1841) in St Louis-d'Antin, the *Marriage of the Virgin* and the *Flight into Egypt* (both 1847) in St Séverin, *Christ among the Doctors* and *Christ Blessing the Little Children* (both 1853) in the chapel of the Catechism in St Eustache, the *Road to Calvary*, the *Crucifixion*, the *Entombment* and the *Resurrection* (all 1860) in the transept of St Eustache, the *Kiss of Judas*, the *Crucifixion* (both 1872), the *Resurrection* and the *Ascension* (both 1876), all in St Sulpice.

Signol's compositions were in effect an increasingly vehement form of protest against the developments of his century. This protest was expressed through the radical classicism of his pictures (with their monumental layout, the sculptural and geometrical strength of their forms, the concentrated action and balance of warm and cold tones) as well as in his clearly articulated choice of scenes emphasizing the 'greatness of Jesus'.

Bibliography

Bénézit; Thieme–Becker

C.-F.-R. Montalambert: *Du vandalisme et du catholicisme dans l'art (fragmens)* [sic] (Paris, 1839), p. 179

C. Lavergne: *Restauration de l'église S.-Eustache* (Paris, 1856), pp. 20–21

Ernestine Signol: *Souvenirs* (Paris, 1893)

L.-O. Merson: *Notice sur la vie et les oeuvres de M. Emile Signol* (Paris, 1899) [given at the Académie des Beaux-Arts, 25 Feb 1899]

M. Denis: *Théories* (Paris, 1912, 4/1920), pp. 101, 111–12

——: *Histoire de l'art religieux* (Paris, 1939), p. 269

M. Caffort: 'Un Français nazaréen: Emile Signol', *Rev. A.* [Paris], lxxiv (1986), pp. 47–53

——: L'Evolution de la peinture religieuse en France et les modèles du seicento', *Seicento: La Peinture italienne du XVIIe siècle et la France* (Paris, 1990), pp. 358–72

——: 'Rigorisme, liguorisme et iconographie chrétienne dans la France de la première moitié du XIXe siècle (l'exemple de la peinture)', *Peinture et vitrail au XIXe siècle: Lyon, 1990*

——: 'Renouveau pictural et message spirituel: L'Exemple des Nazaréens francais', *Cristianesimo nella storia*, 14 (1993), pp. 595–623

MICHEL CAFFORT

Simart, Pierre-Charles

(*b* Troyes, 27 June 1806; *d* Paris, 27 May 1857). French sculptor. Despite the opposition of his family, who were joiners in Troyes, he was enabled to go to Paris to study sculpture by a municipal grant in 1823. This aid and that of the prominent Marcotte family from Argenteuil-sur-Armançon supported him while studying with Antoine Desboeufs (1793–1852), Charles Dupaty (1771–1825) and then Jean-Pierre Cortot. In 1831 Simart first exhibited at the Salon, showing *Coronis Dying* (marble; Troyes, Mus. B.-A.), a work in which a sentimental, melancholic sensibility shows through despite his strictly Neo-classical training. The following year he accompanied James Pradier to Italy, and in 1833 he won the Prix de Rome. During the ensuing stay at the Académie de France in Rome the supervision of Ingres, whom he had already met in Paris, curbed Simart's Romantic

tendencies. Under Ingres's influence he produced his harmonious, restrained masterpiece *Orestes Taking Refuge at the Altar of Athena* (marble, 1838; Rouen, Mus. B.-A.), which was acclaimed at the Salon of 1840; Ingres called it 'the most beautiful sculpture of modern times'.

After his return to France in 1839 Simart's career developed rapidly, with important public and private commissions. From 1841 he worked alongside Ingres on the decoration of the château of Dampierre, Yvelines, for Albert, Duc de Luynes; first on a series of marble bas-relief friezes depicting *The Golden Age* and *The Iron Age* (1841–3; *in situ*), then on a chryselephantine reconstruction of the *Athena Parthenos* (1846; *in situ*) to stand before Ingres's mural of *The Golden Age*. In this reconstruction he was guided by the archaeological ideas of his patron and assisted by the architect Félix Duban and the goldsmith Edmond Duponche: it was ill-received when shown at the Exposition Universelle in Paris in 1855, but is notable for the graceful bas-relief of *Pandora Receiving the Gifts of the Gods* which decorates the pedestal.

Simart's most successful works were bas-reliefs, such as the series showing the *Story of Orpheus* (1844) for the Paris home of Gabriel de Vandeuvre (*in situ*; plaster models, Troyes, Mus. B.-A.). His reliefs for the tomb of *Napoleon* in the crypt of the church of the Invalides, Paris (marble, *c.* 1850–53; *in situ*) suffer from cramped positioning: the polychromed plaster models (1846–7; Troyes, Mus. B.-A.) better demonstrate the sculptor's assimilation of the Parthenon friezes. The problem of transcribing the sobriety and elegance of his models on to a monumental scale also besets his ceiling for the Salon Carré in the Louvre (stucco, 1849–51; *in situ*) and his pedimental sculpture (stone, 1855; *in situ*) for the Pavillon Denon, there. Simart succeeded Pradier at the Institut de France in 1852. His early death was due to an accident.

Bibliography

Lami

G. Eyries: *Simart, statuaire, membre de l'Institut: Etude sur sa vie et sur son oeuvre* (Paris, [before 1860])

A. Le Normand: *La Tradition classique et l'esprit romantique* (Rome, 1981), pp. 251–8

J. P. Boureux: Les Sculptures du XIXe siècle dans le département de l'Aube', *Vie Champagne*, 324 (1982), pp. 19–21

P. Durey: 'La Tombeau de Napoléon Ier aux Invalides', *La Sculpture française au XIXe siècle* (exh. cat., ed. A. Pingeot; Paris, Grand Pal., 1986), pp. 126–82

PHILIPPE DUREY

Sisley, Alfred

(*b* Paris, 30 Oct 1839; *d* Moret-sur-Loing, nr Paris, 29 Jan 1899). British painter, active in France. Although overshadowed in his lifetime by Monet and Renoir, Sisley remains a quintessential representative of the Impressionist movement. He was almost exclusively a painter of landscape.

1. Life

Alfred Sisley was born into a family of Anglo-French descent, the second of four children following the marriage of William and Felicia Sisley who were cousins. His father was director of a business concerned with the manufacture of artificial flowers, which collapsed as a result of the Franco-Prussian War (1870); his mother is said to have been musical. Sisley inherited British nationality from his father, but he made two unsuccessful attempts (1888 and 1898) to become a naturalized French citizen. He lived in France all his life, apart from the years 1857–61 when he was sent to London by his parents to train for a business career. Shorter painting expeditions to Britain were undertaken in 1874, 1881 and 1897. He married Marie Lesouezec in 1866 by whom he had two children, Pierre (1867–1929) and Jeanne (1870–1919).

Although based for a time in Paris, Sisley moved to Louveciennes in 1871 during the period of the Commune and tended from that time to remain aloof from life in the capital. He continued to live to the west of Paris near the banks of the Seine until 1880, moving the short distance from Louveciennes to Marly-le-Roi in 1875 and then again to Sèvres in 1877. In 1880 he moved further away from Paris, settling to the south-east not far from the forest of Fontainebleau, where he had first painted in 1863 and 1865. Here he established himself successively in villages near the

confluence of the Loing and the Seine: Veneux-Nadon (1880), Moret-sur-Loing (1882), Les Sablons (1883) and finally back to Moret-sur-Loing (1889).

The financial security of Sisley's early life was in marked contrast to the hardships that set in during the 1870s. It is probable that Sisley was forced to make his living as a painter because of the failure of his father's business, and this situation brought with it the pressure of the constant need to sell his paintings. Unlike some of the other Impressionist painters, Sisley suffered financial difficulties to the end of his life. Although promoted by such dealers as Paul Durand-Ruel, Georges Petit and Goupil (Boussod & Valadon), and although he participated in the Impressionist exhibitions (except those of 1879, 1880, 1886) and was a member of the Société Nationale des Beaux-Arts founded in 1890, his work did not dramatically increase in value during his lifetime. Sisley therefore remained dependent on the generosity of his friends and a small group of patrons, such as Jean-Baptiste Faure, who financed his visit to England in 1874, and Félix François Depeaux. Similarly, Sisley's work was appreciated and discussed by only a small number of critics, notably Théodore Duret and Adolphe Tavernier. Added to the financial anxieties of his later years was the constant pain of a fatal illness diagnosed in 1895. He died of cancer of the throat in January 1899, a few months after his wife's death.

2. Work

Sisley's firm commitment to painting began only in 1862, when he joined the studio of Charles Gleyre, which Monet, Renoir and Frédéric Bazille also attended. It is not known what, if any, formal training Sisley had had before this date. The four years (1857–61) spent in England may not all have been devoted to business studies, and it is feasible that a burgeoning landscape painter may have looked at the work of Turner and Constable, whose *Cornfield* (exh. RA 1826; London, N.G.), for example, is distantly echoed in one of Sisley's early pictures, *Road near a Small Town* (c. 1865; Bremen, Ksthalle). Virtually no research has been done on Sisley's links with earlier French, Dutch or English painting.

After Gleyre's studio closed in 1863, Sisley often worked with Monet, Renoir and Bazille, depicting motifs in the forest of Fontainebleau. His first paintings are surprisingly strong, revealing a debt to the Barbizon school, but also an independence that corresponds, to a certain extent in the brushwork and directness of observation, with Monet's early development, for example *Chestnut Trees at La Celle-Saint-Cloud* (c. 1865; Paris, Petit Pal.). Sisley's paintings were accepted for the Salons of 1866 (*Village Street at Marlotte: Women Going to the Wood*, 1866, Tokyo, Bridgestone A. Mus.; and *Village Street at Marlotte*, 1866, Buffalo, NY, Albright–Knox A.G.), 1868 (*Avenue of Chestnut Trees at La Celle-Saint-Cloud*, 1867; Southampton, C.A.G.) and 1870 (*Barges on the Canal Saint-Martin*, 1870, Winterthur, Samml. Oskar Reinhart; and *View of the Canal Saint-Martin*, 1870, Paris, Mus. d'Orsay; see fig. 70) but were refused in 1867 and 1869.

While he was living in Louveciennes and Marly-le-Roi, Sisley's output increased dramatically, and his style of painting became quintessentially Impressionist in the application of pure colour with broken brushstrokes and in the treatment of light. This style is seen at its finest in paintings of Louveciennes (*Snow at Louveciennes*, 1878 (Paris, Musée du Louvre; see fig. 71), Marly-le-Roi (the *Waterworks of Louis XIV at Marly*, 1873; Copenhagen, Ny Carlsberg Glyp.), Argenteuil (*Bridge at Argenteuil*, 1872; Memphis, TN, Brooks Mus. A.) and Bougival (the *Hillsides at Bougival*, 1875; Ottawa, N.G.). There are numerous similar examples. During his visit to England in 1874, Sisley explored related motifs along the banks of the River Thames, for example the *Bridge at Hampton Court* (Cologne, Wallraf-Richartz-Mus.) and *The Thames with Hampton Church* (Radier Manor, Jersey). All these paintings of the first half of the 1870s are characterized by carefully balanced compositions, supple handling of paint and eloquent tonal nuances. Their luminosity is enhanced by the extremely delicate range of colours, often pastel shades of blue, green and red. This period of Sisley's work, with its harmony and subtlety, can be considered one of the outstanding moments in Impressionism. Camille Mauclair

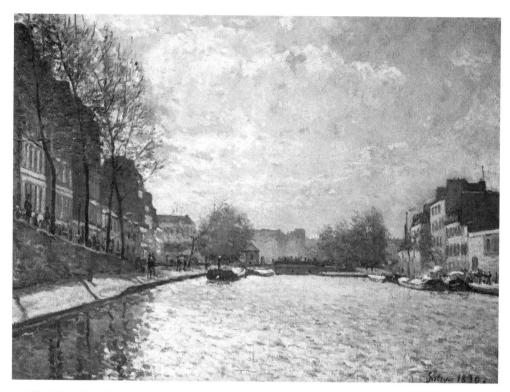

70. Alfred Sisley: *View of Canal Saint-Martin*, 1870 (Paris, Musée d'Orsay)

(1904) declared that Sisley was 'the painter of great blue rivers curving towards the horizon, of blossoming orchards, of bright hills and red-roofed hamlets scattered about; he is, beyond all, the painter of French skies, which he presents with admirable vivacity and facility'. Yet, paradoxically, as Mauclair concluded, it is perhaps these fine paintings of the early 1870s more than any others in the painter's oeuvre that have caused Sisley to be dismissed as merely 'a pretty colourist'.

Sisley, like Monet, continued to explore the Impressionist style during the 1880s and 1890s. By the end of the 1870s his brushwork had become more vigorous and his palette more varied. Duret (1902) referred to Sisley's 'power of expressing the smiling mood of nature', asserting that his 'originality was principally shown in a novel and unexpected coloration', which the critic described as 'a rose-tinted lilac blue'. The combination of loose rhythmical brushstrokes and vibrant colours (blue, green, orange, yellow, red) gives the paintings of the late 1870s and early 1880s their originality. Among these are *Watering-place at Port-Marly* (1875; Chicago, IL, A. Inst.), *Street in Louveciennes* (c. 1876; Cambridge, Fitzwilliam), *View of Saint-Mammès* (c. 1880; Baltimore, MD, Walters A.G.) and the *Path to the Forest of Roches-Courtant at By—Summer* (c. 1880–81; Montreal, Mus. F.A.). Such pictures were undertaken at a time when Sisley hoped to exhibit once more at the Salon where he was rejected in 1879.

At the beginning of the 1880s, while fellow Impressionists, such as Pissarro and Renoir, were concerning themselves more with the human figure, Sisley continued to concentrate on the fugitive effects of light and atmosphere. Compositionally, he placed great emphasis on the sky, regarding this as the most active part of a

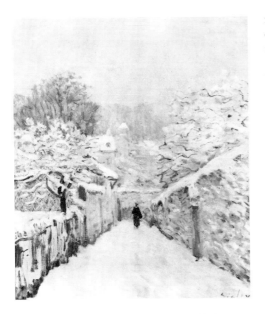

71. Alfred Sisley: *Snow at Louveciennes*, 1878 (Paris, Musée du Louvre)

landscape, which served to fuse together the other elements. For the close examination of the landscape under changing conditions, Sisley began to restrict himself to a limited number of motifs, mainly at Saint-Mammès and Moret-sur-Loing. Examples include his series of paintings of the *Church at Moret-sur-Loing* (six date from 1893 and eight from 1894), inspired by Monet's series of *Rouen Cathedral*. Earlier, in 1876, Sisley had painted six canvases of the *Seine in Flood at Port-Marly* (see col. pl. XXXVIII), and in 1885 he depicted the *Loing Canal at Saint-Mammès* in a number of closely related pictures notable for their smaller, more regular brushstrokes and brighter palette, so the principle of painting in series was not new in his work. Yet there is a clear distinction between Monet's paintings of *Rouen Cathedral* and Sisley's of the *Church at Moret-sur-Loing*. Where Monet allowed the architecture to be enveloped by light and atmosphere, Sisley exercised strict control over the architectural forms and was content to record the play of light or the changing temporal effects on them. For Sisley,

fugitive effects never resulted in the dissolution of forms; instead they helped him to define form more precisely.

In general, Sisley's later work is characterized by a variety of brushstrokes and intensity of colour that originates in Impressionism but at the same time transcends it. Outstanding examples of his late style are *Haystack at Moret, October* (1891; Douai, Mus. Mun.) and *Haystacks at Moret: Morning Light* (1891; Melbourne, N.G. Victoria), where the powerful forms of the haystacks stand out against trees and sky. Such pictures confirm Bibb's opinion (1899) that in his early work Sisley 'had carried forward and filled with new life the exquisite tradition of Corot; in his later manner he was preparing the way for future discoveries'. Though Sisley did not belong to any of the movements that evolved out of Impressionism, he was aware of them. His detachment led to the development of a highly individual style that does not suffer on comparison with Monet's. In modern criticism Sisley has been unjustifiably overshadowed by his contemporaries, regardless of the fact that earlier writers and friends recognized the significance and originality of his contribution to painting. When Pissarro, for instance, was asked by Matisse in 1902 'What is an impressionist?', Pissarro replied 'An impressionist is a painter who never paints the same picture, who always paints a new picture'. This prompted Matisse to ask 'Who is a typical impressionist?' He was given the answer 'Sisley' (A. H. Barr: *Matisse: His Art and his Public*, New York, 1966, p. 38).

Sisley did not concern himself unduly with theory, yet the only recorded opinions about his painting, made in an extended letter to Adolphe Tavernier in 1893, are surprisingly relevant for the development of modern art. A single quotation may serve as an example of its interest:

The animation of the canvas is one of the hardest problems of painting. To give life to the work of art is certainly one of the most necessary tasks of the true artist. Everything must serve this end: form, colour, surface. The artist's impression is the life-giving factor, and only this impression can

free that of the spectator. And though the artist must remain master of his craft, the surface, at times raised to the highest pitch of liveliness, should transmit to the beholder the sensation which possessed the artist.

Sisley was principally a landscape painter. He produced few still-lifes and scenes portraying specific activities or events. There are no formal portraits, and in only two of his paintings are members of his own family closely depicted, *The Lesson* (*c.* 1872) and *Woman with a Parasol: Summer Scene* (1883; both priv. col., see Daulte, 1959, nos 19 and 485). Drawings and prints are limited in number. Only a few preparatory studies for pictures seem to have survived, in addition to a group of informal studies of his family. Some sheets, mostly drawn in pen and ink, were made for reproduction, while others, principally the important sketchbook (Paris, Louvre), record painted compositions. Pastel appears to have been used on several occasions during the 1880s and 1890s, for example *Landscape: Riverbank* (1897; Paris, Mus. d'Orsay), which is related to a lithograph of the same subject published by Ambroise Vollard (1897). The contents of Sisley's studio were sold at the Galerie Georges Petit, Paris, in 1899.

Bibliography

correspondence

A. Tavernier: 'Sisley', *A. Fr.* (18 March 1893) [letter to Tavernier]; abridged in *Artists on Art from the XIVth to the XXth Century*, ed. R. Goldwater and M. Treves (London, 1947), pp. 308–10

T. Duret: 'Quelques lettres de Manet et Sisley', *Rev. Blanche* (15 March 1899), pp. 435–7 [letters to Duret]

R. Huyghe: 'Lettres inédites de Sisley', *Formes: Rev. Int. A. Plast.*, xix (1931), pp. 151–4 [letters to Georges Charpentier, Tavernier and Octave Mirbeau]

Bulletin des expositions, 11, Paris, Gal. A. Braun & Cie (Paris, 30 Jan–18 Feb 1933) [letters to Duret, Monet and Dr George Vian]

L. Venturi: *Les Archives de l'Impressionnisme*, ii (Paris, 1939), pp. 55–63, 241–2 [letters to Durand-Ruel and Octave Maus]

P. Gachet: *Lettres impressionnistes au Dr Gachet et à Murer* (Paris, 1957)

P. Niculescu: 'Georges de Bellio, l'ami des Impressionnistes', *Paragone*, ccxlix (1970), pp. 50–51 [letter to de Bellio]

P. Angrand: 'Sur deux lettres inédites de Sisley', *Chron. A.*, lxxvii (July–Sept 1971), p. 33

catalogues

Tableaux, études, pastels par Alfred Sisley, foreword G. Geffroy and A. Alexandre (sale cat., Paris, Gal. Petit, 1899) [artist's estate]

L'Atelier de Sisley (exh. cat., intro. A. Tavernier; Paris, Gals Bernheim-Jeune, 1907)

L. Delteil: *Le Peintre-graveur illustré: Pissarro, Sisley, Renoir* (Paris, 1923)

Sisley (exh. cat., preface C. Roger-Marx; Paris, Gal. Durand-Ruel, 1957)

Alfred Sisley (exh. cat., chronology F. Daulte; Berne, Kstmus., 1958)

F. Daulte: *Alfred Sisley: Catalogue raisonné de l'oeuvre peint* (Lausanne, 1959)

Sisley (exh. cat. by F. Daulte, New York, Wildenstein's, 1966)

Alfred Sisley (exh. cat., Paris, Gal. Durand-Ruel, 1971)

Alfred Sisley (1839–1899) (exh. cat. by R. Pickvance, U. Nottingham, A.G., 1971)

J. Leymarie and M. Melot: *The Graphic Works of the Impressionists* (London and New York, 1980)

Alfred Sisley 1839–1899 (exh. cat. by R. Nathanson, London, David Carritt, 1981)

Retrospective Alfred Sisley (exh. cat. by C. Lloyd, Tokyo, Isetan Mus. A.; Fukuoka, A. Mus.; Nara, Prefect. Mus. A.; 1985)

Alfred Sisley (exh. cat., ed. M. A. Stevens; London, RA; Paris, Mus. d'Orsay; Baltimore, MD, Walters A.G.; 1992–3)

specialist studies

B. Bibb: 'The Work of Alfred Sisley', *The Studio*, xviii (1899), pp. 149–56

J. Leclerq: 'Alfred Sisley', *Gaz. B.-A.*, n. s. 2, xxi (1899), pp. 227–38

G. Geffroy: *Sisley* (Paris, 1923, rev. 2/1927)

R. H. Wilenski: 'The Sisley Compromise', *Apollo*, vii (1928), pp. 69–74

G. Jedlicka: *Sisley* (Berne, 1949)

C. Sisley: 'The Ancestry of Alfred Sisley', *Burl. Mag.*, xci (1949), pp. 248–352

O. Reuterswärd: 'Sisley's "Cathedrals": A Study of the "Church at Moret" Series', *Gaz. B.-A.*, n. s. 5, xxxix (1952), pp. 193–202

G. Wildenstein: 'Un Carnet de dessins de Sisley au Musée du Louvre', *Gaz. B.-A.*, n. s. 5, liii (1959), pp. 57–60

A. Scharf: *Alfred Sisley* (Bristol, 1966)

F. Daulte: *Alfred Sisley* (Milan, 1972)

K. Champa: *Studies in Early Impressionism* (New Haven, 1973), pp. 80–83, 90–95

R. Shone: *Sisley* (Oxford, 1979)

R. Thomson: 'A Sisley Problem', *Burl. Mag.*, cxxiii (1981), p. 676

R. Shone: *Sisley* (London, 1992)

general

W. Dewhurst: *Impressionist Painting: Its Genesis and Development* (London, 1904), pp. 53–4

C. Mauclair: *L'Impressionnisme: Son histoire, son esthétique, ses maîtres* (Paris, 1904); abridged Eng. trans. as *The French Impressionists (1860–1900)* (London, 1912), pp. 136–40

T. Duret: *Histoire des peintres impressionnistes* (Paris, 1906), pp. 105–26; Eng. trans. as *The French Impressionists* (Philadelphia and London, 1910), pp. 151–8

J. Rewald: *The History of Impressionism* (New York, 1946, rev. London, 4/1973)

O. Reuterswärd: *Auf den Spuren der Maler der Ile de France* (Berlin, 1963)

CHRISTOPHER LLOYD

Somm, Henry [Sommier, François-Clément]

(*b* Rouen, 1844; *d* Paris, 15 March 1907). French painter, illustrator, designer and printmaker. He was trained at the Ecole Municipale de Dessin in Rouen under Gustave Morin (1809–86). He was obliged to sell illustrations to periodicals to make a living, contributing, among others, to *Charge*, *Cravache*, *L'Inutile*, *Chronique parisienne* and *Courier français*. His drawings were spirited, but because their humour often relied on topicality his fame was short-lived.

Somm's ability to design works with a direct and simple appeal is best seen in such ephemera as menus, invitations, visiting cards and almanacs. Félix Bracquemond commissioned him to produce series of designs for plates during his period as artistic director of the Haviland porcelain factory. Somm also illustrated Gaston Bergeret's *Journal d'un nègre à l'Exposition de 1890* (Paris, 1890) and drew vignettes for Achille Melandri's numerous works of light literature; typical were slight but lively illustrations of elegant women in large hats. Somm left a number of sketchbooks containing fleeting sketches of great skill that provide a fine record of late 19th-century customs. He also produced a portrait of *Sarah Bernhardt* (Kansas City, MO, Nelson-Atkins Mus. A.).

Bibliography
H. Beraldi: *Les Graveurs du XIXe siècle* (Paris, 1884–92), pp. 41–5

J. Grand-Carteret: *Les Moeurs et la caricature en France* (Paris, 1888)

E. K. Menon: 'Henry Somm's Japonisme (1881) in Context', *Gaz. B.-A.*, cxix (Feb 1992), pp. 89–98

—: 'Potty Talk in Parisian Plays: Henry Somm's *La Berline de l'émigré* and Alfred Jarry's *Ubu Roi*', *Art Journal*, lii/3 (Autumn 1993), pp. 59–64

ETRENNE LYMBERY

Steinheil, Louis-Charles-Auguste

(*b* Strasbourg, 26 July 1814; *d* Paris, 16 March 1885). French painter, designer, illustrator and glazier. A pupil of the history painter Henri Decaisne (1759–1852) and of the sculptor David d'Angers, and brother-in-law of the painter Ernest Meissonier, he made his début at the Salon of 1836 in Paris with a genre painting, *Consolation* (untraced); he exhibited there annually until 1855. During the same period he illustrated a number of novels, including Bernardin de Saint Pierre's *Paul et Virginie* (Paris, 1838) and Victor Hugo's *Notre-Dame de Paris* (Paris, 1844), and religious books.

In 1839 Steinheil provided the architect Jean-Baptiste-Antoine Lassus with a cartoon, depicting the *Passion*, for one of the first antiquarian stained-glass windows in France, installed in the Chapelle de la Vierge in St Germain-l'Auxerrois, Paris. It established his reputation among architects and scholars who were eager to rediscover and reintroduce the religious art and artistic techniques of the Middle Ages. Steinheil devoted most of his energies to producing drawings and

cartoons, based on original medieval and Renaissance examples but modernized to make them more accessible to contemporary taste. As a result he became one of the most sought after painters of cartoons on all subjects, and he was appointed a member of the Commission des Monuments Historiques. He used his skills to restore the stained-glass windows in Sainte-Chapelle, Paris (1849–55), for which he also produced plans for mural paintings (1855). His major mural designs are in the Chapelle St-Georges (1862) in Notre-Dame, Paris; in the Sacré-Coeur chapel (1866) in Amiens Cathedral, jointly with Théodore Maillot (1826–88); and in the St-Joseph chapel (1872) in Limoges Cathedral. He made designs for sculpture, especially for Adolphe-Victor Geoffroy-Dechaume, also a pupil of David d'Angers, for St Germain-l'Auxerrois (1838) and later for the bronze doors (1872–9) of the main portal of Strasbourg Cathedral, which were inspired by the original doors of 1343. One of his cartoons, *St Agnes*, was produced as a tapestry by the Manufacture des Gobelins (1875–6; Paris, Mobilier N.).

In the restoration of medieval stained glass Steinheil's main task was to provide cartoons to replace missing sections, although because of his training as a master glazier he was able to participate very directly in the practical restoration work. He worked in nearly all the major workshops involved in restoration, together with the most famous craftsmen, including Nicolas Coffetier (1821–84) at Bourges Cathedral (from 1853), Le Mans Cathedral (1858–75) and Chartres Cathedral (1868–83) and Baptiste Petit-Gérard (1811–71) at Strasbourg Cathedral (1847–70). Steinheil also supervised the local master glaziers at Angers Cathedral (1855) and Auxerre Cathedral (from 1866). Working with Coffetier, Steinheil at times overcame the constraints of designing archaeologically accurate stained glass: for example, in the four stained-glass windows representing the *Life of the Virgin* in St-Bonaventure, Lyon (1854–5), he chose the form of a stained-glass tableau extending over the whole bay; and in the series at Notre-Dame, Paris, that depicts the *Life of St Geneviève* (1860–65), his design and colours recall Pre-Raphaelite painting.

His son, Adolphe-Charles-Edouard Steinheil (1850–1908), was a painter and stained-glass artist.

Bibliography

Bénézit; Thieme–Becker

J. Taralon: 'De la Révolution à 1920', *Le Vitrail français* (Paris, 1958), pp. 277–8

CATHERINE BRISAC

Steinlen, Théophile-Alexandre

(*b* Lausanne, 10 Nov 1859; *d* Paris, 13 Dec 1923). French illustrator, printmaker, painter and sculptor, of Swiss birth. After studying at the University at Lausanne and working as an apprentice designer in a textile factory in Mulhouse, Steinlen arrived in Paris in 1881 and quickly established himself in Montmartre, where he lived and worked for the rest of his life. In 1883 the illustrator Adolphe Willette introduced him to the avant-garde literary and artistic environment of the Chat Noir cabaret which had been founded in 1881 by another Swiss expatriot, Rodolphe Salis. Steinlen soon became an illustrator of its satirical and humorous journal, *Chat noir*, and an artistic collaborator with writers such as Emile Zola, poets such as Jean Richepin, composers such as Paul Delmet, artists such as Toulouse-Lautrec and, most important, the singer and songwriter Aristide Bruant, all of whom he encountered at the Chat Noir. Bruant's lyrics incorporate the argot of the poor, the worker, the rogue, the pimp and the prostitute, for whom Steinlen's empathy had been awakened on reading Zola's novel *L'Assommoir* (1877). Steinlen became the principal illustrator for Bruant's journal *Le Mirliton* (1885–96) and for the various books containing his songs and monologues, including the two volumes of *Dans la rue* (1888–95).

Steinlen created over 2000 illustrations for journals and books using the newly developed photo-relief printing processes and about 500 lithographic images for individual prints, music sheets, book covers and book illustrations as well as over 100 etchings. Throughout his long career Steinlen's art was dominated by his humanitarian concerns, exemplified during the 1890s by hundreds of covers for *Gil Blas illustré* accompa-

nying the short stories of contemporary realist authors such as Guy de Maupassant. His work for the covers of the journals *Chambard socialiste* (1893–4) and *Feuille* (1897–8) reveal his anti-bourgeois, anti-military, socialist/anarchist sympathies, which at the time of the Dreyfus affair (1894–1906) placed him actively on the side of the Dreyfusards. These were followed in the early 20th century by his illustrations for *Assiette au beurre* and *Canard sauvage*, both journals of social and political satire.

While Steinlen is best known for his bold, highly stylized black and red poster for the Chat Noir (1896; Paris, Bib. A. Déc.; see fig. 72), his greatest contribution to the poster art of the 1890s was his production of realistic colour lithographic images such as *Mothu et Doria* (1893), *Lait pur sterilisé de la vingeanne* (1894), the massive, life-size *La Rue* (1896) and the politically poignant *Petit sou* (1900), which indirectly advertised products by conveying human sympathies and ideals. Between 1898 and 1902 he also executed over 30 colour etchings which are more personal and intimate. In these delicate etchings of nudes and landscapes, produced in very small editions, Steinlen experimented with the media of softground and aquatint. During World War I he designed patriotic prints, for example his lithograph *The Republic Calls Us* and his etching of *The Mobilization* (both 1915).

As a prolific and realistic illustrator Steinlen was better known to the general public than Toulouse-Lautrec, whose work was considered stylistically more avant-garde, yet the two artists had in common such subjects as the cabaret performers Bruant and Yvette Guilbert and the theme of prostitution. Steinlen's empathetic depictions of the poor influenced the early work of many artists who emerged at the beginning of the 20th century such as Picasso and Edward Hopper.

In general Steinlen's paintings are less successful than his graphic works and bronzes. Many derive from Honoré Daumier's style and subject-matter but have a muddier palette and reveal less finesse in the handling of figures. The best of Steinlen's paintings, for example *14 July* (1895; Geneva, Petit Pal.), are usually similar in

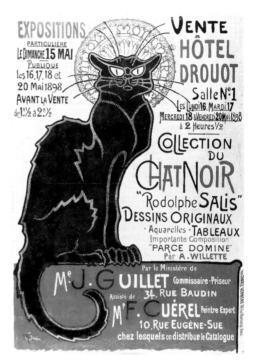

72. Théophile-Alexandre Steinlen: *Chat Noir*, 1896 (Paris, Bibliothèque des Arts Décoratifs)

subject and technique to his journal illustrations, while *Young Woman of the Street* (1895; Geneva, Petit Pal.) suggests the expressive chiaroscuro effects of Eugène Carrière's symbolist paintings. During the first decade of the 20th century Steinlen created numerous small and medium-sized bronzes of cats in repose, for example *Two Cats Crouching* (c. 1904; Mrs Susan Schimmel Goldstein priv. col.; e.g. Geneva, Petit Pal.). These works retain the hand-moulded quality of Daumier's clay busts of legislators and the abstraction of Rodin's *Balzac* (e.g. Paris, Mus. Rodin): indeed, the bronzes are some of Steinlen's most expressive works.

Bibliography

E. de Crauzat: *L'Oeuvre gravé et lithographié de Steinlen* (Paris, 1913)

Dessins de Steinlen, 1859–1923 (exh. cat. by F. Viatte, Paris, Louvre, 1968)

M. Pianzola: *Théophile-Alexandre Steinlen* (Lausanne, 1971)

Théophile-Alexandre Steinlen, 1859–1923 (exh. cat., W. Berlin, Staatl. Ksthalle, 1978)

S. Gill: 'Steinlen's Prints: Social Imagery in Late 19th-century Graphic Art', *Print Colr Newslett.*, x/1 (1979), pp. 8–12

P. D. Cate and S. Gill: *Théophile-Alexandre Steinlen* (Salt Lake City, 1982)

PHILLIP DENNIS CATE

Tassaert, (Nicolas-François-)Octave

(*b* Paris, 26 July 1800; *d* Paris, 24 April 1874). Painter and printmaker, son of (2) Jean-Joseph-François Tassaert. As a child he worked with his brother Paul Tassaert (*d* 1855), producing engravings, but he later turned to painting and from 1817 to 1825 studied at the Ecole des Beaux-Arts in Paris, first under Alexis-François Girard (1787–1870) and then Guillaume Lethière. In 1823 and 1824 he tried unsuccessfully to win the Prix de Rome, an early failure that greatly disheartened him. For much of his career, until 1849, he continued to work in the graphic arts, as well as painting, producing lithographs and drawings on various subjects: historical scenes from the First Empire, portraits, and mythological and genre scenes. He also produced illustrations for the Romantic novels of Victor Hugo, Alexandre Dumas *père* and François-René Chateaubriand. Though he achieved moderate success at the Salon, it was the graphic work that provided his small income during this period. His impoverished lifestyle is reflected in the gloomy painting *Corner of the Artist's Studio* (1845; Paris, Louvre), which depicts a shabbily dressed young artist peeling potatoes to make a modest meal.

Tassaert's first success at the Salon came in 1834 with the painting of the *Death of Correggio* (1834; St Petersburg, Hermitage), which was bought by Ferdinand-Philippe, Duc d'Orléans. It was inspired by the fictitious story that Correggio had died after contracting a fever caused by his carrying a large weight of copper received in payment for one of his paintings. Tassaert also painted other historical works, such as *Funeral of Dagobert at Saint-Denis, January 638* (exh. 1838; Versailles, Château), and such religious works as the *Communion of the First Christians in the Catacombs* (exh. 1852; Bordeaux, Mus. B.-A.).

It was, however, as a genre painter that Tassaert achieved real success, with a series of works depicting the widespread poverty and misery of Paris. The most famous of these, and all of his works, was the *Unhappy Family* (1849–50; Paris, Louvre), which he was commissioned to paint by the State after his plea of poverty had been sympathetically heard by the Director of the Musées Nationaux, Philippe-Auguste Jeanron. It was inspired by Lammenais's romantic novel *Paroles d'un crovant* and depicted a destitute mother and daughter committing suicide, an increasingly common real-life occurrence at this time. The work was praised at the 1850–51 Salon, where it was described as being in the style of Jean-Baptiste Greuze and Pierre-Paul Prud'hon, and Tassaert was asked to paint four replicas. In the same vein were his pictures of poor children, garret scenes and views of Parisian backstreet life, subjects that earned him his nickname of 'the Correggio of the attic' and 'the Prud'hon of the suburbs'.

At the Exposition Universelle in Paris of 1855 Tassaert's work was well received and in particular prompted a lengthy and favourable review from Théophile Gautier. Other admirers of his work included Eugène Delacroix and Alexandre Dumas *fils*. Despite this encouragement Tassaert became increasingly misanthropic and disgusted with the art world, exhibiting nothing after the Salon of 1857. He became an alcoholic and in 1863 sold 44 of his works to the art dealer Père Martin for a mere 2400 francs and a crate of wine. Close to blindness and in poor health, he moved to Montpellier in 1865 but soon returned to Paris, where he remained until his suicide by asphyxiation. Alexandre Dumas *fils* paid for his body to be conveyed to the cemetery of Montparnasse. His reputation waned swiftly, and his work now seems sentimental and melodramatic.

Bibliography
J. Claretie: *Artistes décedés de 1870 à 1880*, i of *Peintres et sculpteurs* (Paris, 1882), pp. 24–8

B. Prost: *Octave Tassaert: Notice sur sa vie et catalogue de son oeuvre* (Paris, 1886)

The Realist Tradition: French Painting and Drawing, 1830–1900 (exh. cat. by G. P. Weisberg, Cleveland, OH, Mus. A.; New York, Brooklyn Mus.; St Louis, MO, A. Mus.; Glasgow, A.G. & Mus.; 1980–81), pp. 44–7, 94–5, 157–8, 164–5

☐

Thomas, Gabriel-Jules

(*b* Paris, 10 Sept 1824; *d* Paris, 8 March 1905). French sculptor. Son of the sculptor Alexis-François Thomas (1795–1875), he was renowned for his precocity in the art. At the Ecole des Beaux-Arts, Paris, which he entered in 1841, he was known to fellow students as 'Coustou' Thomas, indicating an early preference for an animated Baroque style. One of his masters, Augustin-Alexandre Dumont, successfully harnessed these powers to the classical tradition, and Thomas won the Prix de Rome in 1848. On his return from Rome his unemphatic classicism was demonstrated in the marble statue of *Virgil* (Paris, Mus. d'Orsay), commissioned in 1859 for the Cour Carrée of the Louvre, Paris, but later acquired for the Musée du Luxembourg. In Thomas's pair of caryatids representing *Drama* and *Music* (bronze and marble, 1866–73) flanking the door to the orchestra stalls of the Paris Opéra, materialistic extravagance is allied to imaginative restraint in a combination typical of much Second Empire decorative sculpture. On occasion, however, Thomas lived up to his student nickname: his statue of *Mlle Mars as Celimène* (marble; exh. Salon 1865) for the theatre of the Comédie Française, commissioned in 1862 as a pendant to François-Joseph Duret's *Rachel as Phèdre*, is a spirited costume piece, while his kneeling portrait for the tomb of *Monseigneur Landriot* in La Rochelle Cathedral (marble; exh. Salon 1880) recalls the vivid worldliness and stylish drapery of 18th-century portraiture.

Bibliography

Lami

J.-J.-B. Salmson: *Entre deux coups de ciseaux: Souvenirs d'un sculpteur* (Paris, 1892)

PHILIP WARD-JACKSON

Tissot, James [Jacques-Joseph]

(*b* Nantes, 15 Oct 1836; *d* Château de Buillon, Doubs, 8 Aug 1902). French painter, printmaker and enamellist. He grew up in a port, an experience reflected in his later paintings set on board ship. He moved to Paris *c.* 1856 and became a pupil of Louis Lamothe and Hippolyte Flandrin. He made his Salon début in 1859 and continued to exhibit there successfully until he went to London in 1871. His early paintings exemplify Romantic obsessions with the Middle Ages, while works such as the *Meeting of Faust and Marguerite* (exh. Salon 1861; Paris. Mus. d'Orsay) and *Marguerite at the Ramparts* (1861; untraced, see Wentworth, 1984, pl. 8) show the influence of the Belgian painter Baron Henri Leys. In the mid-1860s Tissot abandoned these tendencies in favour of contemporary subjects, sometimes with a humorous intent, as in *Two Sisters* (exh. Salon 1864; Paris, Louvre) and *Beating the Retreat in the Tuileries Gardens* (exh. Salon 1868; priv. col., see Wentworth, 1984, pl. 45). The painting *Young Ladies Looking at Japanese Objects* (exh. Salon 1869; priv. col., see Wentworth, 1984, pl. 59) testifies to his interest in things Oriental, and *Picnic* (exh. Salon 1869; priv. col., see 1984 exh. cat., fig. 27), in which he delved into the period of the Directoire, is perhaps influenced by the Goncourt brothers. Tissot re-created the atmosphere of the 1790s by dressing his characters in historical costume.

During the Franco-Prussian War Tissot participated valiantly in the defence of Paris, but his abrupt move to London in 1871 has been interpreted as an attempt to escape reprisals for associating himself with the Paris Commune. A more plausible explanation for the move might be his desire for better professional opportunities than existed in a war-ravaged city. His acquaintance with Thomas Gibson Bowles (who owned the magazine *Vanity Fair*, for which Tissot had been drawing caricatures for some time) gave him an important entrée into social and artistic circles in London.

In 1872 Tissot began exhibiting regularly at the Royal Academy, where he had first shown in 1864, and continued to do so until 1881 (except

for 1877–9). His early London paintings are in the Directoire manner, as exemplified by an *Interesting Story* (exh. RA 1872; Melbourne, N.G. Victoria), but he soon shifted to scenes of fashionable West End life (*Too Early*, exh. RA 1873; London, Guildhall A.G.), of lovers parting (the *Last Evening*, exh. RA 1873; London, Guildhall A.G.), of festive social occasions (*Ball on Shipboard*, exh. RA 1874; London, Tate; see col. pl. XXXIX) and of elegant young people at their leisure (*The Thames*, exh. RA 1876; Wakefield, A.G.). These paintings appear to fall within the English narrative tradition but are often infused with a languorous atmosphere whereby his subjects seem emotionally detached and pensive. This confluence of narrative and non-narrative, or emotive, aspects makes his subject-matter open to different interpretations. His technique remained impeccably craftsmanlike and traditional, particularly in depicting the details of women's fashions.

Around 1875 Tissot met Kathleen Newton, a beautiful divorcee, and their relationship represented Tissot's only period of real family life as an adult. Mrs Newton and her family dominated the subject-matter of his paintings, particularly those concerned with domestic life and travel, as in *By Water (Waiting at Dockside)* (watercolour study, c. 1881–2; London, Owen Edgar).

In his London works Tissot avoided his previous superficial japonaiserie in favour of more pronounced Oriental qualities, for example *The Gardener* (c. 1879; untraced, see 1984 exh. cat., fig. 68). At the same time his skill as a painter reached its peak, and his interest in printmaking, particularly etching, was renewed (e.g. *Summer*, etching, 1878; London, BM).

In the late 1870s Tissot also began producing cloisonné enamels, partly inspired by his interest in Japanese metalwork and partly by artists such as Lucien Falize and Ferdinand Barbedienne. The majority of his enamel work took the form of small objects and plaques, a fine example of which is the oval jardinière *Lake and Sea* (bronze mount, 240×620×310 mm, c. 1884; Brighton, Royal Pav.). A popular and successful artist in London, Tissot considered himself to be fully modern, as shown by the title of his last important exhibition at the Dudley Gallery in 1882, *An Exhibition of Modern Art*.

Kathleen Newton's death from tuberculosis in 1882 affected Tissot deeply and marked an important transition in his artistic development. He returned to Paris and held a large one-man exhibition at the Palais de l'Industrie in 1882. In 1885 his exhibition entitled *Femme à Paris*, held at the Galerie Sedelmeyer, included a series of 15 large paintings presenting modern woman in her various occupations. This was part of an ambitious venture, which, had it been finished, would have combined painting, printmaking and literature in a truly novel scheme. During the 1880s he became popular as a portrait painter and began to experiment with pastel (e.g. *Berthe*, 1882–3; Paris, Petit Pal.).

While working on one of the *Femme à Paris* paintings Tissot claimed to have had a religious revelation; this resulted in *Christ the Comforter* (c. 1884; St Petersburg, Hermitage), a large painting showing Christ comforting two downtrodden pilgrims in the ruins of the Cour des Comptes in Paris. Tissot also became interested in spiritualism and in 1885 was convinced that Kathleen Newton had materialized at a séance in London, an event he recorded in a mezzotint after a lost painting: *The Apparition* (1885; priv. col., see 1984 exh. cat., no. 151).

His religious experience led him to devote his remaining years primarily to illustrating the Life of Christ and the Old Testament (see fig. 73). Tissot felt impelled to depict the Palestine of Christ's day and he made several trips to the Holy Land to do research. His series of 365 gouache illustrations for the *Life of Christ* (New York, Brooklyn Mus.) were executed at the Château de Buillon, which he had inherited from his father in 1888 and shown to enthusiastic crowds in Paris (1894 and 1895), London (1896) and New York (1898) and then toured North America until 1900. They were published in 1896–7 and in several later editions. Tissot left his Old Testament paintings (New York, Jew. Mus.) unfinished, but they were subsequently completed by other artists and the engravings published in 1904. These two religious series were the most notable visual summation of the Catholic revival in late 19th-century France.

73. James Tissot: *Hagar and the Angel in the Desert* (New York, Jewish Museum)

Tissot was initially remembered as an illustrator of the Bible but his depictions of fashionable 19th-century life and his charming genre scenes are now regarded as his most significant work. In a distinctly personal way his work reflects nearly every important artistic development of his time and reveals the interaction between academic and avant-garde developments in art.

Bibliography

James Jacques Joseph Tissot (exh. cat., ed. D. Brooke; Providence, RI Sch. Des., Mus. A., 1968)
W. Misfeldt: *James Jacques Joseph Tissot* (diss., U. Washington, 1971)
James Tissot: Catalogue Raisonné of his Prints (exh. cat. by M. Wentworth, Minneapolis, MN, Inst. A., 1978)
W. Misfeldt: *The Albums of James Tissot* (Bowling Green, OH, 1982) [many previously unpubd works]
J. James Tissot: Biblical Paintings (exh. cat. by G. Schiff, New York, Jew. Mus., 1982)
M. Wentworth: *James Tissot* (Oxford, 1984) [generously illus.]
James Tissot (exh. cat., ed. K. Matyjaskiewicz; London, Barbican A.G., 1984)
C. Wood: *Tissot* (London, 1986)

WILLARD E. MISFELDT

Toulouse-Lautrec (Montfa), Henri(-Marie-Raymond) de

(*b* Albi, Tarn, 24 Nov 1864; *d* Château de Malromé, nr Langon, Gironde, 9 Sept 1901). French painter and printmaker. He is best known for his portrayals of late 19th-century Parisian life, particularly working-class, cabaret, circus, nightclub and brothel scenes. He was admired then as he is today for his unsentimental evocations of personalities and social mores. While he belonged to no theoretical school, he is sometimes classified as Post-Impressionist. His greatest contemporary impact was his series of 30 posters (1891–1901), which transformed the aesthetics of poster art.

1. Life and work

(i) Family life and early training, to 1882. Many of the defining elements of Toulouse-Lautrec's life and work came to him at birth. His parents, Comte Alphonse-Charles de Toulouse-Lautrec (1838–1912) and Comtesse Adèle Zoë Tapié de Céleyran de Toulouse-Lautrec (1841–1930), were first cousins. From them he inherited wealth, an aristocratic lineage, artistic talent and a genetic disorder that would leave him dwarfed and crippled from early adolescence.

Except for one year, Toulouse-Lautrec was educated at home, by occasional tutors and by his mother, with whom he developed a love–hate relationship that was a continual source of conflict for him. His brother Richard had died in infancy and she served and protected her surviving child with well-meaning but iron-willed vigilance; they slept in the same bed until he was eight or nine years old, and even after Toulouse-Lautrec was an adult, his mother lived much of the year close by his studios. When they were in

the same city he dined with her almost daily. His father was nearly always absent. A profoundly eccentric man, subject to unpredictable mood-swings resembling symptoms of manic-depressive disorder, the Count spent his time either living in quasi-isolation, deeply involved in all forms of the hunt, or displaying comically attention-seeking behaviour such as bathing naked in his brother's courtyard or driving his carriage through the streets of Paris with cages of hunting birds—owls and falcons—swinging from the rear axle, so they 'could get some air'. A superb athlete, the Count also was reputed to be an incorrigible womanizer, favouring housemaids and peasant girls. As a child, Lautrec quickly learnt that he could not compete with such a colourful figure. 'If Papa is there,' he commented to a grandmother, 'one is sure not to be the most remarkable.' He was right. No matter how exhibitionistic or scandalous the adult Lautrec chose to be, he could never outdo his father in gratuitous eccentricity. Many of Lautrec's passions—drawing and sketching, non-conformist behaviours such as dressing in costumes, collecting eccentric curios and a fascination with animals and women—reflected his father's habits.

Beginning around age ten Toulouse-Lautrec suffered from severe bone pain and was hospitalized for more than a year. In 1878 he fell from a low chair and broke his left thigh bone and in 1879 the right one. His growth stopped at 1.52 m. By age 16 he was permanently dwarfed, and the bone breaks had crippled him so that as an adult he walked as infrequently as possible, in a kind of duck-like stagger using a cane.

Throughout his childhood Toulouse-Lautrec drew and painted alongside his father or one of his uncles, all talented amateur artists. Art became his strongest weapon: with it he was able to fight the depression of long convalescences and the well-meant but stifling protectiveness of a concerned family. He drew constantly, covering schoolbooks and sketchbooks with drawings of animals and caricatures of people. He lived surrounded by horses and dogs, his father's hunting birds and his grandmother's pet parrots and monkeys. He had a striking talent for accurate observation of animal and human movement, which has been described as the ability to capture progressive stages of motion in one image. Recognizing his talent, his parents arranged for him to have early training from his uncle Charles de Toulouse-Lautrec (1840–1915) and from a deaf-mute sports-artist friend, René Princeteau (1844–1914), who taught him to draw horses. When it was apparent that he was irretrievably handicapped, his parents allowed him to go to Paris to study art.

(ii) Success and decline, 1882–1901. In 1882 Toulouse-Lautrec moved to Paris with his mother to study first with Léon Bonnat (1833–1922) and then with Fernand Cormon (1845–1924). He was close to the Cloisonists Louis Anquetin and Emile Bernard and to Vincent van Gogh, all of whom worked with him at Cormon's. At age 19 he received his first commission, to illustrate Victor Hugo's *La Légende des siècles*, although his work was finally not used. After some five years of formal academic training, he had become expert in rendering perspective and volume, but in his own work he freely abandoned the conventions to explore other possibilities. Unlike many of his friends, Toulouse-Lautrec never joined any formal theoretical school, although his work shows the clear influence of Edgar Degas, Honoré Daumier and Jean-Louis Forain among others. He later befriended the Nabi painters Pierre Bonnard and Edouard Vuillard, whom he met through *La Revue blanche*, a magazine that published their work as well as his own. Toulouse-Lautrec's work also shows the influence of Japonisme.

In January 1884 Toulouse-Lautrec set up his own studio in the Rue Lepic, Montmartre, a *quartier* of Paris his mother considered both scandalous and dangerous. It was a haven for the poorest, most marginal members of society and since the 1850s, due to its low rents, had been a neighbourhood of predilection for artists. By 1880, a series of dubious nightclubs at the foot of Montmartre had earned a reputation for wildness and bohemianism. Toulouse-Lautrec and a group of artist-friends quickly developed a highly visible lifestyle, visiting galleries and museums in

groups, meeting in cafés to argue loudly, dressing in costumes to attend the popular *bals masqués*, sharing studios and models and generally enjoying all the excitement Paris had to offer. For the rest of his life Toulouse-Lautrec lived in Montmartre (although he took long trips to the south of France), painting friends and models or working from sketches done in the evenings in the Moulin Rouge and other nightspots.

An early tendency to abuse alcohol quickly led Toulouse-Lautrec into hopeless alcoholism. Often drunk, he behaved outrageously, disrupting the bars and dance-halls. Because of his conspicuous appearance, unpredictable behaviour and ever-present sketchbook, he became a well-known figure at such places as the Moulin de la Galette, the Elysée Montmartre and the Chat Noir. His raucous lifestyle offended his family, causing constant conflict not only over money, but also over his right to use the family name, his artistic style and even his subjects—more particularly perhaps because they were also his friends. He had intensely loyal friendships with people of widely varying milieux: aristocrats; artists; left-wing intellectuals and writers; side-show, circus and nightclub performers; actors; professional athletes; milliners; prostitutes; and coachmen. His father repeatedly tried to convince him to use a pseudonym. Over the years the painter used a series of names, particularly the anagram 'Tréclau'. In the long run he signed himself *H. T. Lautrec* or just with his initials, H. T. L.

Despite his physical handicaps, Toulouse-Lautrec always refused to hide from public view. He had developed a hatred for the hypocrisy and sentimentality that masked people's treatment of him and, as he was coming to realize, all their human relations. Always an aristocrat, he now became an iconoclast, resolutely destroying false pretensions with a sharp word or a sabre slash of pencil on paper. He was increasingly sensitive to anyone's attempts at putting on appearances. His greatest artistic skill perhaps was the psychological acuity with which he portrayed facial expressions and body language: the ability to get behind his models' surface defences and petty vanities to show their vulnerabilities and vices. His portraits capture hidden emotions: hostility, indifference, desire, self-indulgence. His artistic honesty created some tense moments with his models, who sometimes refused to continue posing for him, afraid of his unflattering ability to reveal their true feelings. His subject-matter was almost entirely autobiographical; he primarily depicted the people he knew, often shown in his own studio. After 1886 he tended also to pose them in settings with a social context: in Montmartre's streets, bars and dance-halls or in the circuses, racetracks, sports arenas and brothels of Paris. Today, his images of cancan dancers and nightclub singers, prostitutes lining up for their medical examinations or waiting, bored, for clients, mark our impressions of turn-of-the-century Paris.

In spite of his irregular and distracting lifestyle, and perhaps in part because he was so visible, success as an artist came quickly to Toulouse-Lautrec. As his work began to sell well, he took pride in keeping separate bank accounts for his sales and for his monthly allowance from his parents. Although his allowance (c. 15,000 francs per annum) was perfectly adequate, he was always short of money, a by-product of extravagant tastes and lavish generosity. He received critical acclaim from such major art critics as Roger Marx, Gustave Geffroy and Arsène Alexandre. In addition, he was remarkably productive. By age 21 he was selling drawings to magazines and newspapers; he also illustrated books, song sheets, menus and theatre programmes. After being in his first group show (Pau) in 1883, he exhibited in group shows in Paris at the Salon des Arts Incohérents (1886, 1889) and at the Exposition du Petit Boulevard organized by Vincent van Gogh in 1887. He participated a number of times in the annual exhibitions of Les XX in Brussels and at the exhibitions in Paris of the Société des Peintres-Graveurs Français at the Galerie Durand-Ruel, Louis Le Barc de Boutteville's exhibitions of the *Estampe originale* and Impressionists and Symbolists, the Cercle Artistique et Littéraire Volney, the Société des Indépendants and the exhibitions of the *Journal des cent*. Although he exhibited in various places and sold works

through a number of dealers, beginning in 1888 he became affiliated to Boussod, Valadon & Cie through Theo van Gogh (1857–91) and he remained with them thereafter. He shared their gallery with Charles Maurin (1856–1914) for his first two-man exhibition in 1893 and had his first one-man show in 1895 at the same gallery, later called Manzi-joyant after it was acquired by Michel Manzi and his childhood friend Maurice Joyant (1864–1930). He also exhibited at their London branch in 1898.

Toulouse-Lautrec's success with the artistic avant-garde was equalled by his popular audience. From 1886 his work was placed on permanent exhibition in one of his habitual hangouts, a Montmartre cabaret known as Le Mirliton, and in 1889, for its grand opening, the Moulin Rouge nightclub hung his painting *At the Fernando Circus: The Equestrienne* (1888; Chicago, IL, A. Inst.) in the entrance hall. In 1891 the nightclub itself was the subject of Toulouse-Lautrec's first poster, *Moulin Rouge, La Goulue* (see col. pl. XL), a work that made him famous all over Paris. Over the next ten years he did a great deal of commissioned work: posters, portraits, book illustrations, advertisements, stage décors and the covers of sheet music. He also made brief forays into the Art Nouveau crafts movement, experimenting with ceramics, book-binding and stained-glass windows. The Moulin Rouge continued to feature in a number of works, including *Jane Avril Leaving the Moulin Rouge* (1892; Hartford, CT, Wadsworth Atheneum) and *At the Moulin Rouge* (1896; Chicago, IL, A. Inst.).

By 1893 those who knew Toulouse-Lautrec were aware of his alcoholism and several friends reported that he was also suffering from syphilis. His behaviour became increasingly erratic and eccentric. He lived briefly in several brothels, narrowly escaped violent physical confrontations while drinking and was arrested at least once. He was institutionalized briefly in 1899, an event that caused substantial outcry in the newspapers. In 1901 he suffered a stroke while on holiday at Arcachon and was taken to his mother's house, where he died shortly before his 37th birthday.

In his short life Toulouse-Lautrec produced a

phenomenal quantity of work. The 1971 catalogue raisonné of his oeuvre, which even before its publication was recognized as incomplete, lists 737 canvases, 275 watercolours, 369 prints and posters and 4784 drawings, including about 300 erotic and pornographic works. Although important original works are held by museums and individuals throughout the world, the largest body of Toulouse-Lautrec's work was donated to form the Musée Toulouse-Lautrec in Albi by his mother after his death. A complete set of his prints and posters (including all states of each work) is in the Cabinet des Estampes, Bibliothèque Nationale, Paris.

2. Working methods and technique

Toulouse-Lautrec freely adopted any technique or style that helped him to attain a desired effect, from classical composition to Impressionist colour theory. His artistic goals remained highly eclectic and personal. He was interested in doing art, not talking about it, and he believed rules were to be broken as he desired.

In his painting and drawing, Toulouse-Lautrec worked in oils, watercolour, charcoal, pastel, ink and, very occasionally, coloured pencils. He favoured artificial rather than natural light and seemed to enjoy ironically posing subjects in contexts where they felt ill at ease (e.g. *Golden Helmet*, c. 1890–91; Philadelphia, PA, Walter Annenberg priv. col.; *Redhead in a White Blouse*, c. 1884; Boston, MA, Mus. F.A.). Working in oils, he often sketched the original outlines with a brush in intense blue or green, allowing those lines to show through subsequent layers of translucent paint to give the finished work a rapid, sketchy quality, which is sometimes enhanced by the presence of bare canvas and undeveloped areas of composition. Imitating a technique developed by Jean-François Raffaëlli, he often painted on raw cardboard *à l'essence* ('with solvent'), using oil greatly thinned with turpentine. The absorbent surface gave the paint a powdery, almost chalky texture as it dried.

Toulouse-Lautrec made a few monotypes and drypoint engravings, but his important contributions to printmaking are in the field of lithography

and most importantly in the colour poster. His experiments in lithography included spattering and the use of gold dust, as in *Miss Loïe Fuller* (1893), both based on Japanese techniques. His use of large, flat areas of colour and stylized shapes (e.g. the cape in *Aristide Bruant*, 1893; or the high-kicking legs in *Mlle Eglantine's Company*, 1896) makes posters that are not only immediately comprehensible to the passer-by but also function as works of social and artistic complexity, full of visual commentary on society and references to other works of art. In some prints his coloured shapes dominate the work as abstractions, moving it beyond the purely representational.

Possibly as a result of his disdain for the kind of art that won prizes at the official Salon, Toulouse-Lautrec developed an absolute hatred for varnished painting, for any surface that was falsely sealed and glossy. To him the varnish and affectation of such works symbolized the hypocrisy and sentimentality that surrounded bourgeois social conventions.

Repetition is characteristic of Toulouse-Lautrec's work. He repeated stories, acts, images. Occasionally he literally traced the same lines over and over. He is said to have gone 20 nights in a row to see Marcelle Lender (1869–1927) dance the bolero in the comic opera *Chilpéric*, because, as he explained, she had a beautiful back. Often his work represents a series of studies of the same model; there are, for example, numerous paintings of 'La Rousse', a model named Carmen Gaudin (?1866–1920). He had a series of 'furias' as he called them—passionate attractions to a person, place or activity, which would dominate his life and art for a time and just as suddenly disappear. There are drawings, paintings, posters and lithographs of music-hall performers La Goulue (Louise Weber, 1870–1929), Jane Avril (1868–c. 1932; see fig. 74) and Yvette Guilbert (1867–1944; e.g. 1894; Albi, Mus. Toulouse-Lautrec), each in her turn.

After Toulouse-Lautrec was released from the asylum in 1899, his palette moved from the clear, bright colours characteristic of most of his previous work to looming contrasts of dark and light, increasingly marked by blood tones, dense brushstrokes and impasto.

74. Henri de Toulouse-Lautrec: *Jane Avril Dancing*, 1892 (Paris, Musée d'Orsay)

Unpublished sources

Austin, U. TX, Ransom Human. Res. Cent. [several hundred MS. letters by members of the Toulouse-Lautrec family]

Bibliography

M. G. Dortu and P. Huisman: *Lautrec by Lautrec* (Seacaucus, NJ, 1964)

L. Goldschmidt and H. D. Schimmel: *Unpublished Correspondence of Toulouse-Lautrec* (London, 1969)

M. G. Dortu: *Toulouse Lautrec et son oeuvre*, ed. P. Brame and C. M. de Hauke, 6 vols (New York, 1971)

M. Melot: *Les Femmes de Toulouse-Lautrec* (Paris, 1985)

C. de Rodat: *Toulouse-Lautrec: Album de famille* (Fribourg, 1985)

W. Wittrock: *Toulouse-Lautrec: Complete Prints* (London, 1985)

The Circle of Toulouse-Lautrec (exh. cat. by P. D. Cate and P. E. Boyer, New Brunswick, NJ, Rutgers U., Zimmerli A. Mus., 1985)

Henri de Toulouse-Lautrec: Images of the 1890s (exh. cat., ed. R. Castleman and W. Wittrock; New York, MOMA, 1985)

G. Adriani: *Toulouse-Lautrec: The Complete Graphic Works, a Catalogue Raisonné, the Gerstenberg Coll.* (London, 1986)

B. Foucart: *La Post-modernité de Toulouse-Lautrec: Tout l'oeuvre peint de Toulouse-Lautrec* (Paris, 1986)

G. Adriani: *Toulouse-Lautrec* (London, 1987)

G. Beaute, ed.: *Toulouse-Lautrec vu par les photographes suivi de témoignages inédits* (Lausanne, 1988)

J. Sagne: *Toulouse-Lautrec* (Paris, 1988)

B. Denvir: *Toulouse-Lautrec* (London, 1991)

G. B. Murray: *Toulouse-Lautrec: The Formative Years, 1878-1891* (Oxford, 1991)

H. Schimmel, ed.: *The Letters of Henri de Toulouse-Lautrec* (Oxford, 1991)

Toulouse-Lautrec (exh. cat. by R. Thomson, C. Frèches-Thory, A. Roquebert and D. Devynck, London, Hayward Gal., 1991; Paris, Grand Pal., 1992)

J. Frey: *Toulouse-Lautrec: A Life* (London and New York, 1994)

JULIA BLOCH FREY

Triqueti [Triquetti], Henri-Joseph-François, Baron de

(*b* Conflans, 24 Oct 1804; *d* Paris, 11 May 1874). French sculptor and designer of Italian descent. He studied painting with Louis Hersent in Paris before embarking on a career as a sculptor. He made his début at the Salon of 1831 with a bronze relief of the *Death of Charles the Bold* (untraced); closely based on 15th-century models, it identified him as one of a new generation of Romantic sculptors who rejected the Neo-classical teaching of the Ecole des Beaux-Arts in favour of learning from medieval and early Renaissance examples.

Triqueti occasionally put his knowledge of medieval art into practice as a restorer, working on the famous bone and marquetry reredos from the abbey of Poissy (Paris, Louvre) in 1831, and in 1840-48 on the restoration of the Sainte-Chapelle, Paris, under the supervision of the architect Félix-Jacques Duban. Numerous drawings provide further evidence of his interest in medieval and Renaissance monuments (e.g. *Romanesque Portal of Basle Cathedral*, 1831, Montargis, Mus. B.-A.; *Chevet of St Pierre in Caen*, 1855, Paris, Ecole N. Sup. B.-A.). During his many travels, especially in Italy, he kept notebooks and made drawings (e.g. Montargis, Mus. B.-A.; Paris, Ecole N. Sup. B.-A.) of paintings and sculptures in Milan, Venice, Padua and most often in Florence. His bronze doors for La Madeleine, Paris (1834-41; *in situ*), decorated with reliefs of the *Ten Commandments*, are clearly inspired by the Baptistery doors of Florence Cathedral. (He received this commission despite being a Protestant convert.) His admiration for such 15th-century Florentine sculptors as Benedetto da Maiano (whom he considered superior to Lorenzo Ghiberti) is also reflected in such works as his marble medallion portraits, bordered by foliage and grotesques (e.g. *Blanche Triqueti*, 1852, untraced; plaster version Montargis, Mus. B.-A.).

In 1842 Triqueti was commissioned to decorate the cenotaph of *Ferdinand Philippe, Duc d'Orléans*, at the Chapelle St Ferdinand, Neuilly-sur-Seine (1842-3; *in situ*), to a design by Ary Scheffer. The recumbent marble figure is surrounded by two angels sculpted by Marie, Princesse d'Orléans, and the base has an *Angel of Death* in shallow low relief. The following year he was commissioned by the architect Louis-Tullius-Joachim Visconti to decorate the crypt of Napoleon's tomb at Les Invalides, Paris; although unexecuted, this led him to experiment with marble intarsia, a technique he used in a panel representing *Peace and Plenty* (1845; Montargis, Mus. B.-A.) and, on a grander scale, in scenes from the *Iliad* and the *Odyssey* for University College, London (1865; *in situ*). It was probably the figure of *Ferdinand Philippe* and Triqueti's later statue of *Edward VI Studying the Holy Scriptures*, sold to Queen Victoria, that led to his being given the most important commission of his career and an opportunity to exploit his experimental intarsia to the full: the cenotaph of *Prince Albert* (after

1865) in the Albert Memorial Chapel, Windsor Castle. The Gothic Revival tomb consists of a recumbent figure of the Prince in medieval armour on a base adorned by a delicate colonnette structure; between the columns there are six statuettes of *Virtues* with eight small angels on the corners. There are also marble portraits of all the royal couple's children. The decorations for the walls of the chapel, combining low relief sculpture with variously incised and painted marbles, include scenes from the *Passion*.

Triqueti also produced swords, daggers, hunting-knives, chandeliers, mirrors and vases, both in a Gothic Revival style and, as exemplified by a bronze vase decorated with a Bacchic procession (Paris, Mus. A. Déc.), in a classicizing style derived from antique sculpture and from Roman silverware (drawings in Paris, Ecole N. Sup. B.-A.).

Bibliography

Lami

M. Beaulieu: 'Un Sculpteur français d'origine italienne: Henri de Triqueti', *A travers l'art italien du XVe au XXe siècles* (n.d.)

B. Read: *Victorian Sculpture* (New Haven, 1982), pp. 97, 139, 194

H. W. Janson: *Nineteenth-century Sculpture* (London, 1985), pp. 121, 124–5, 134, 162, 205

ISABELLE LEMAISTRE

Troyon, Constant

(*b* Sèvres, 28 Aug 1810; *d* Paris, 20 March 1865). French painter. He was brought up among the Sèvres ceramics workers and received his first lessons in drawing and painting from Denis-Désiré Riocreux (1791–1872), a porcelain painter who was one of the founders of the Musée National de Céramique. Troyon began his career as a painter at the Sèvres factory while also studying landscape painting in his spare time. He became a friend of Camille Roqueplan, who introduced him to a number of young landscape painters—especially Théodore Rousseau, Paul Huet and Jules Dupré—

75. Constant Troyon: *View from the Hilltops of Suresnes*, exh. Salon 1859 (Limoges, Musée Municipal)

who were later to become members and associates of the Barbizon school. After an unremarkable début at the Salon of 1833, where he exhibited three landscapes depicting the area around Sèvres (e.g. *View of the Park at Saint-Cloud*; Paris U., Notre-Dame), he took up his career in earnest and made several study trips to the French provinces. Following the example of contemporary collectors, he began to take a great interest in 17th-century Dutch painting, particularly the work of Jacob van Ruisdael, whose influence is seen in such early paintings as *The Woodcutters* (1839; La Rochelle, Mus. B.-A.). At the Salon of 1841 he exhibited *Tobias and the Angel* (Cologne, Wallraf-Richartz Mus.), a biblical landscape that attracted the attention of Théophile Gautier. The subject was intended to satisfy the critics, but the painting served as a pretext for portraying a realistic and sincere representation of nature, even though its ordered and classically inspired composition perfectly fitted the requirements of a genre, the origins of which were the 17th-century paintings of Claude and Poussin and their followers.

At the Salon of 1846 Troyon was awarded a First Class medal by Louis Napoleon (later Napoleon III) for the four paintings he exhibited there, all land-scapes inspired by the countryside around Paris, confirming a reputation that continued to grow year by year. In 1847 he travelled to the Netherlands and Belgium, where he discovered the work of the painters Paulus Potter and Aelbert Cuyp; this trip was to have a profound influence on the direction of his career. He was made Chevalier de la Légion d'honneur in 1849, and it was from this time that he devoted himself almost exclusively to the painting of animals, a genre that ensured him substantial financial success due to its popularity with his admirers. He was extremely prolific, and his canvases are often large in format, usually depicting farm animals and labourers in the extreme foreground against a low horizon with dramatic, cloud-filled skies or splendid sunrises or sunsets; examples are *Oxen Going to Plough: Morning Effect*, shown at the Exposition Universelle in Paris of 1855 and View from the *Hilltops of Suresnes* (Limoges, Mus. Mun.; see fig. 75), painted in 1856 and exhibited at the

Salon of 1859. Troyon was no innovator, but his painting technique was excellent, and he had a sensitive, yet broad-based and solid mastery of his craft. His more exploratory paintings were executed on the coast of Normandy during his last years. These paintings reveal that he was looking closely at variations of light and was expressing a sensitivity not too far removed from that of the precursors of Impressionism.

Bibliography

C. Blanc: *Les Artistes de mon temps* (Paris, 1876)

A. Hustin: 'Troyon', *L'Art*, xlvi (1889), pp. 77–90; xlvii (1889), pp. 85–96

L. Souillié: *Peintures, pastels, aquarelles, dessins de Constant Troyon relevés dans les catalogues de ventes de 1833 à 1900* (Paris, 1900) [biog. entry by P. Burty]

W. Gemel: *Corot und Troyon*, Künstler Monographien, lxxxiii (Bielefeld and Leipzig, 1906)

The Realist Tradition: French Painting and Drawing, 1830–1900 (exh. cat. by G. P. Weisberg and others, Cleveland, OH, Mus. A.; New York, Brooklyn Mus.; Glasgow, A.G. & Mus.; 1980–82)

A. DAGUERRE DE HUREAUX

Vallotton, Félix(-Emile-Jean)

(*b* Lausanne, 28 Dec 1865; *d* Paris, 28 Dec 1925). Swiss printmaker, painter and critic, active in France. He attended school in Lausanne, then moved to Paris in 1882 and enrolled as an art student at the Académie Julian. Paris remained his main base for the rest of his life, although he returned regularly to Switzerland to see his family. He became a close friend of Charles Cottet and Charles Maurin, who was his teacher and mentor. As a student, copying in the Louvre, Vallotton was drawn to the minute realism of the earlier masters, in particular Holbein, whose work he sought to emulate. He succeeded in having portraits accepted by the Salon jury in 1885 and 1886.

Vallotton was primarily a printmaker. He first made a drypoint etching in 1881. Between 1888 and 1892, to make ends meet, he produced repro-ductive etchings after such artists as Rembrandt and Millet, and from 1891 to 1895 he worked as

Paris art correspondent for the *Gazette de Lausanne*: he showed sympathy for independent artists such as Puvis de Chavannes, Whistler and Toulouse-Lautrec and praised the innovations of his contemporaries in the avant-garde. In 1892 he produced his first woodcut, and it was in this medium, largely neglected until its revival in the 1890s, that Vallotton was to excel. His work appeared regularly in the *Revue Blanche*. In 1892 he joined the Nabis group. That year he exhibited woodcuts at the first Salon de la Rose+Croix, in the company of Maurin, and participated in the second Nabis group exhibition at Saint-Germain-en-Laye. From this date he exhibited regularly with the Nabis in Paris and elsewhere. In the favourable climate of Art Nouveau, Vallotton's woodcuts awakened international interest; examples appeared in *The Studio* (1893), the American *Chap Book* (1894) and the German periodicals *Pan* and *Jugend* (1895–6) and he had a substantial influence on the German woodcut revival at the beginning of the 20th century.

Vallotton's woodcut style is extremely simple; it makes play with contrasts between pure blocks of black and white and stark contours, exaggerated almost to the point of caricature. Unlike the other key exponents of the woodcut in the 1890s, Gauguin and Munch, Vallotton did not exploit the irregularities of the wood grain for artistic effect but relied on icy precision, a quality he also cultivated in his painting.

Vallotton found the subjects of his woodcuts in the tense and humorous spectacles of modern city life, both public and private. In *The Demonstration*, for instance, which was included in *L'Estampe originale* (1893–5), an album dedicated to promoting the original print, Vallotton bore witness, as an anarchist sympathizer, to the street violence that frequently resulted from social unrest in the early 1890s in Paris. In the celebrated series *Intimacies* (1898), ten woodcuts depicting the traumatic disintegration of a love affair, Vallotton found inspiration in a contemporary novel by his friend Jules Renard; his stark use of the woodcut medium added a mood of Symbolist intensity to these private interior scenes.

Following his marriage in 1899 to Gabrielle Rodrique-Henriques, a member of the Bernheim-Jeune family, Vallotton's financial security was assured. He continued to produce illustrations for journals such as *L'Assiette au beurre* (1901) and demonstrated his social views in the album *C'est la guerre*, a series of anti-German propagandist woodcuts published in 1917. After 1902 Vallotton concentrated mainly on painting highly finished studies of interiors and nudes, such as *Models Resting* (1905; Winterthur, Kstmus.). He continued to exhibit regularly, though with less success after 1914. His brother Paul, an art dealer in Lausanne, assisted in promoting Vallotton's work in Switzerland.

Bibliography

M. Vallotton and C. Georg: *Félix Vallotton: Catalogue Raisonné of the Printed Graphic Work* (Geneva, 1972)
G. Guisan and D. Jakubec: *Félix Vallotton: Documents pour une biographie et pour l'histoire d'une oeuvre*, 3 vols (Lausanne, 1973–5)
The Graphic Work of Félix Vallotton, 1865–1925 (exh. cat., ACGB and Pro Helvetia, 1976)
Félix Vallotton (exh. cat. by R. Koella, Winterthur, Kstmus., 1978)
G. Busch, B. Dorival and D. Jakubec: *Félix Vallotton: Leben und Werk* (Freuenfeld, 1982; Fr. trans., Lausanne, 1985)
S. M. Newman: *Félix Vallotton* (New Haven and New York, 1991)

BELINDA THOMSON

Vernon, (Charles-)Frédéric(-Victor) de

(*b* Paris, 17 Nov 1858; *d* Paris, 28 Oct 1912). French medallist and sculptor. He first trained with Paulin Tasset (*b* 1839) and from 1879 with Jules-Clément Chaplain at the Ecole des Beaux-Arts in Paris. In 1887 he won the Prix de Rome for medals. In Rome he produced portrait medals of *Edgar Henri Boutry*, *Henri-Camille Danger* and *Georges Charpentier*; after his return to Paris he won a first-class medal at the Salon of 1895. He was equally successful with official commissions, such as the *Welcome to Nicholas II* (1896) and the *Mayors' Banquet* (1902), and more personal plaquettes, such as *Solidarity* (1901), *The Kiss* (1902), *Eve* (1905) and the *Communicants* (1905). In 1907

he won the medal of honour in the sculpture section of the Salon and in 1909, after Chaplain's death, he succeeded him both as a member of the Académie des Beaux-Arts and as Professor of Medal Engraving at the Ecole des Beaux-Arts. In 1908 Vernon executed a series of bas-reliefs for the French Embassy in Vienna. His later medallic portraits include *Gaston Darboux*, *Armand Gautier* and *Georges Picot* (all 1911).

Bibliography

Forrer

F. Mazerolle: 'F. de Vernon', *Gaz. Numi. Fr.*, iii (1899), pp. 109–209; viii (1904), pp. 409–26

International Exhibition of Contemporary Medals (exh. cat., New York, Amer. Numi. Soc., 1911), pp. 346–55

J. Belaubre: 'Charles-Frédéric-Victor de Vernon', *Bull. Club Fr. Médaille*, xxix (1970), pp. 82–5

Vollon, Antoine

(*b* Lyon, 20 April 1833; *d* Paris, 27 Aug 1900). French painter. Having worked for a maker of enamelled metalwork and an engraver, Vollon attended the Ecole des Beaux-Arts in Lyon (1850–52), where he won awards in printmaking. He subsequently copied 18th-century paintings for industrial design. He had begun to concentrate on his own work by 1858 and joined a group of Romantic artists based in Lyon, including Francis Verney (1833–96), Fleury Chenu (1833–75), Joseph Ravier (1832–78) and Joseph and Jean Antoine Bail. In 1859 Vollon moved to Paris, where he met the realist painters François Bonvin and Théodule Ribot, who encouraged him to paint genre and still-life scenes. Until 1863 he earned government stipends for copying pictures in the Louvre (e.g. Ribera's *Adoration of the Shepherds*); that year he exhibited at the Salon des Refusés. He achieved public recognition in 1864 after his genre piece *Kitchen Interior* (untraced), one of two paintings accepted at the official Salon, was purchased by the state. In 1865 he earned a Salon medal for *Interior of a Kitchen* (Nantes, Mus. B.-A.), a genre scene inspired by Chardin and 17th-century Dutch art. Vollon was best known for his still-lifes, in

which he frequently depicted objects stored in his studio. Painted in a vigorous style, these range in palette from pastels to vibrant reds. In the rich colouring and sumptuous effects of *Curiosities* (Lunéville, Mus. Lunéville) Vollon demonstrated his love of metallic surfaces, armour and elegant porcelains. He exhibited at the Salon until 1880 and was admitted to the Académie des Beaux-Arts in 1897. His son Antoine (1865–1945), who worked under the name Alexis Vollon, painted genre scenes and still-lifes and exhibited at the Salon from 1885. He won a few awards but did not achieve the success of his father.

Bibliography

E. Martin: *Antoine Vollon: Peintre, 1833–1900* (Marseille, 1923)

G. P. Weisberg: 'A Still Life by Antoine Vollon, Painter of Two Traditions', *Bull. Detroit Inst. A.*, lvi/4 (1978), pp. 222–9

The Realist Tradition: French Painting and Drawing, 1830–1900 (exh. cat., ed. G. P. Weisberg; Cleveland, OH, Mus. A.; New York, Brooklyn Mus.; St Louis, MO, A. Mus.; Glasgow, A.G. & Mus.; 1980), pp. 311–12

GABRIEL P. WEISBERG

Willette, (Léon-)Adolphe

(*b* Châlons-sur-Marne, 31 July 1857; *d* Paris, 4 Feb 1926). French illustrator, printmaker and painter. After studying at the Ecole des Beaux-Arts, Paris, Willette entered the studio of Alexandre Cabanel where he encountered Rodolphe Salis, the future founder in Montmartre of the Chat Noir cabaret (1881) and journal (1882). As a member of the Club des Hydropathes (1874–81), a group of writers, actors and artists who met regularly at a café in the Quartier Latin and from 1881 at the Chat Noir, Adolphe Willette became associated with the anti-establishment, humorous and satirical spirit of the avant-garde artistic community in Montmartre.

Willette was an early and regular illustrator of the *Chat Noir* and *Courrier français* (founded in 1885), the two principal (albeit tongue-in-cheek) chronicles of Montmartre. For two years from 1888 Willette and the poet Emile Goudeau

published the satirical journal *Le Pierrot*: in 1896 and 1897 they collaborated on the sporadically issued journal *Vache enragée* which served as a forum for the artists of Montmartre. Willette is best known for his numerous sympathetic depictions of a pierrot (e.g. *Pierrot pendu*, lithograph, in A. Marty: *L'Estampe originale*, vi, 1894), who resembles the artist himself and serves as a metaphor for the alienation of artists from society.

Willette's philosophical and political views were a strange combination of anarchism, socialism, nationalism, militarism, anti-Catholicism and anti-Semitism, all of which he promoted in his prints and illustrations. In 1889 he created a lithographic poster announcing his candidacy on an anti-Semitic platform for the local legislative election. His illustrations during the 1890s for Edouard Drumont's journal *Libre parole* graphically put forth the fanatical anti-Semitic rhetoric of the writer-politician. Together Willette's images and Drumont's essays helped to establish the virulently anti-Semitic environment in France at the end of the century. Other prominent satirical journals for which Willette worked were *Le Rire*, *Assiette au beurre* and *Canard sauvage*. Although less prolific as a printmaker, he created three lithographs for André Marty's *L'Estampe originale* (1893–5).

Willette executed numerous decorative schemes for cabarets, dance halls and cafés. He also decorated the waiting-room of the Hôtel de Ville, Paris (1904).

Writings

Feu Pierrot: 1857–19? (Paris, 1919) [autobiography]

Bibliography

The Circle of Toulouse-Lautrec (exh. cat. by P. D. Cate and P. Boyer, New Brunswick, Rutgers U., Zimmerli A. Mus., 1985), pp. 186–91

PHILLIP DENNIS CATE

Yvon, Adolphe

(*b* Escheviller, 30 Jan 1817; *d* Paris, 11 Sept 1893). French painter. Having studied at the Collège

Bourbon, he was employed by the Domaine Royal des Forêts et des Eaux at Dreux. He resigned in 1838 and went to Paris to become an artist. He studied under Paul Delaroche at the Ecole des Beaux-Arts and had three religious compositions accepted for the Salon of 1841: *St Paul in Prison*, *Christ's Expulsion of the Money-changers* (both untraced) and the *Remorse of Judas* (Le Havre, Mus. B.-A.). Yvon's début attracted some critical attention, and his canvases were purchased for the State; but he was more interested in depicting the exotic worlds popularized by artists like Alexandre Decamps and Prosper Marilhat. In May 1846 he departed for Russia on a voyage of six months that was to have a profound influence on his subsequent career. Drawings made on the trip led to a painting of the *Battle of Kulikova* (1850; Moscow, Kremlin), depicting the Tatar defeat. It was eventually sold to Tsar Alexander II in 1857. Yvon's familiarity with Russia contributed to his appointment as the only official artist accompanying French forces during the Crimean War in 1856. His *Taking of Malakoff*, painted for Versailles (*in situ*), was shown at the Salon of 1857 and again at the Exposition Universelle of 1867.

Following the Revolution of 1848 and the proclamation of the Second Empire, Yvon gained the favour of Emperor Napoleon III and henceforth served as an official artist of his regime. The glorification of the Napoleonic past became State policy, and Yvon's portrayals of patriotic exploits from that period were much in demand. He won praise for his painting, *Marshal Ney Supporting the Retreat of the Grand Army, 1812* (exh. Exposition Universelle 1855; Versailles, Château). He accompanied the imperial forces on the Italian campaigns against Austria, representing in heroic pictorial language the second attack on Magenta and the Battle of Solferino in 1859 (exh. Salon 1863; both Versailles, Château). In 1861 he was commissioned to paint *Eugene Louis, Prince Imperial* and in 1868 painted an official portrait of *Napoleon III* (both untraced).

Yvon received many honours for sustaining the desired imperial image: he was awarded the Légion d'honneur (1855) and promoted within

the order (1867) and he was made professor at the Ecole des Beaux-Arts. In 1867 he published a manual of design for use in art schools and lycées. In 1870 Yvon was commissioned by a wealthy American collector, Alexander Turney Stewart, to create a colossal allegory of the *Reconciliation of the North and the South* (untraced). Yvon's reputation hardly outlasted the fall of the Second Empire in 1870. Facile and adaptable though he may have been, he was also prone to a literalism that has dated badly.

Writings

Méthode de dessin à l'usage des écoles et des lycées (Paris, 1867)

Bibliography

A. Thierry: 'Adolphe Yvon: Souvenirs d'un peintre militaire', *Rev. Deux Mondes*, n. s. 2, pér. 8, lxxi (1933), pp. 844–73

E. Heiser: *Adolphe Yvon, 1817–1893, et les siens: Notices biographiques* (Sarreguemines, 1974)

FRANK TRAPP

Ziem, Félix(-François-Georges-Philibert)

(*b* Beaune, 21 Feb 1821; *d* Paris, 11 Feb 1911). French painter. He studied architecture at the Ecole des Beaux-Arts in Dijon until he was expelled in 1838 for unruly behaviour. In 1839 he left for Marseille, where he was Clerk of Works on the construction of the Marseille canal. In November 1839 he was noticed by Ferdinand Philippe, Duc d'Orléans, who accepted two watercolours that Ziem presented to him and commissioned a further six. This first success decided Ziem's vocation, and he started a drawing class that was attended by Louis Auguste Laurent Aiguier (1819–65) and Adolphe Monticelli. During this period he also encountered the Provençal artists Emile Loubon (1809–63), Prosper Grésy (1804–74) and Gustave Ricard.

In 1842 Ziem left for Nice, where he came into contact with members of the European aristocracy, with whom, thanks to his talent and his charm, he was soon on familiar terms. During the following years he travelled widely. Sophie, the Grand Duchess of Baden, invited him to Baden in 1842. In 1843 he travelled with the Gagarin princes to Russia, where he stayed over a year. Between 1846 and 1848 he was in Italy, visiting Florence, Venice, Genoa, Naples and Rome. By 1849, when Ziem exhibited at the Salon for the first time, he was already making a comfortable living from his art; he exhibited there regularly until 1868. In 1854 he set off for North Africa and returned the following year to Tunisia. He divided his time between his Paris studio in the Rue Lepic, his travels and, after 1853, frequent visits to Barbizon, where he was an active member of the Barbizon school. His works enjoyed growing success and were much sought after by upper-class collectors. After 1876 he regularly spent the winters at Sainte-Hélène, his property in Nice, and went less frequently to Martigues, where he had built a studio in the Oriental style in 1861. Towards the end of his life he received many official honours, and his paintings were the first by a living artist to enter the Louvre in 1910. The contents of his studio are now housed in the Musée d'Art et d'Archéologie in Martigues.

Ziem was above all the painter of Venice: he visited the city more than 20 times. The commercial success of his views of Venice has often obscured their originality and the diversity of their compositions. Such works as *Venice: The Bacino di S Marco with Fishing Boats* (c. 1865; London, Wallace) are among his most beautiful achievements. He was also a prolific painter of Orientalist subjects, for example *Fantasia at Constantinople* (Paris, Petit Pal.). He painted some rare but magnificent canvases of Fontainebleau Forest in the style of the Barbizon school (e.g. *Stag in the Forest of Fontainebleau*; Paris, Petit Pal.). He was primarily a landscape painter, but he also worked on still-lifes and animal paintings. The vivacity and freshness of his palette, his nervous, vibrant touch, with passages of great virtuosity, his determination to seize fleeting effects of light and his ability to transcribe the iridescence of sunlight on water have often invoked comparisons with Impressionism. In fact the spirit of his work was fundamentally different. Ziem wanted to express the poetic quality of his subject, to

transform it into an essentially dream-like vision, rather than to transcribe an immediate reality. He was also a fine draughtsman and left nearly 10,000 sheets, which attest to the variety of his interpretative gifts and the diversity of his technique.

Bibliography

T. Gautier: *Ziem* (Paris, 1896)

L. Fournier: *Un Grand Peintre: Félix Ziem* (Beaune, 1897)

C. Mauclair: *L'Art de Ziem* (Paris, 1897)

R. Miles: 'Ziem', *Figaro Ill.*, 178 (Jan 1905), pp. 1–24

H. Roujon, ed.: *F. Ziem* (n.d.), Collection des peintres illustres, 50 (Paris, *c.* 1900–14)

J. Sauvageot: *Les Peintres de paysages bourguignons au XIXe siècle* (Dijon, 1966)

E. Hild: *Etudes sur l'oeuvre dessinée de Félix Ziem (1821–1911)* (MA thesis, Aix-en-Provence, U. Aix-Marseille, 1976)

P. Miquel: *Félix Ziem (1821–1911)*, 2 vols (Maurs-la-Jolie, 1978)

Ziem en marge (exh. cat. by E. Hild, Saint-Tropez, Mus. Annonciade, 1980)

ERIC HILD-ZIEM

Black and White Illustration Acknowledgements

We are grateful to those listed below for permission to reproduce copyright illustrative material. Every effort has been made to contact copyright holders and to credit them appropriately; we apologize to anyone who may have been omitted from the acknowledgements or cited incorrectly. Any error brought to our attention will be corrected in subsequent editions.

Art Resource, NY Figs 31, 67

Erich Lessing/Art Resource, NY Figs 2, 4, 5, 6, 9, 10, 13, 16, 17, 20, 23, 24, 26, 35, 36, 37, 41, 43, 44, 47, 58, 64, 74

Erich Lessing/Art Resource, NY/© Fig. 52

ADAGP, Paris and DACS, London 1999

Giraudon/Art Resource, NY Figs 1, 3, 7, 8, 11, 12, 14, 15, 18, 19, 21, 25, 27, 28, 33, 34, 38, 39, 40, 42, 45, 46, 48, 49, 50, 53, 54, 55, 56, 57, 59, 60, 61, 62, 69, 70, 71, 72, 75

Giraudon/Art Resource, NY/(c) ADAGP, Fig. 51
Paris and DACS, London 1999

Image Select/Art Resource, NY Fig. 30

The Jewish Museum, NY/Art Fig. 73
Resource, NY

Scala/Art Resource, NY Fig. 22, 63, 68

Tate Gallery, London/Art Resource, NY Fig. 29, 32, 66

Victoria & Albert Museum, London/Art Fig. 65
Resource, NY

Colour Illustration Acknowledgements

Erich Lessing/Art Resource, NY Plates II, III, V, VII, IX, XI, XIX, XX, XXIV, XXVIII, XXX, XXXV, XXXVI, XXXVII

Giraudon/Art Resource, NY Plates I, IV, VI, VIII, X, XII, XIII, XIV, XVI, XVIII, XXI, XXII, XXIII, XXVI, XXVII, XXIX, XXXI, XXXII, XXXIII, XXXIV, XXXVIII

Giraudon/Art Resource, NY/© ADAGP, Plate XXV
Paris and DACS, London 1999

Musée Toulouse Lautrec/Art Resource, NY Plate XL

National Galleries of Scotland, Edinburgh Plate XVII

The Pierpont Morgan Library/Art Resource, NY Plate XV

Tate Gallery, London/Art Resource, NY Plate XXXIX

Appendix A
LIST OF LOCATIONS

Every attempt has been made to supply the correct current location of each work of art mentioned, and in general this information appears in abbreviated form in parentheses after the first mention of the work. The following list contains the abbreviations and full forms of the museums, galleries and other institutions that own or display art works or archival material cited in this book; the same abbreviations have been used in bibliographies to refer to the venues of exhibitions.

Institutions are listed under their town or city names, which are given in alphabetical order. Under each place name, the abbreviated names of institutions are also listed alphabetically, ignoring spaces, punctuation and accents. Square brackets following an entry contain additional information about that institution, for example its previous name or the fact that it was subsequently closed.

ACGB: see London
Aix-en-Provence, Mus. Granet
 Aix-en-Provence, Musée Granet
Ajaccio, Mus. Fesch
 Ajaccio, Musée Fesch
Albi, Mus. Toulouse-Lautrec
 Albi, Musée Toulouse-Lautrec
Albuquerque, U. NM, A. Mus.
 Albuquerque, NM, University of
 New Mexico, Art Museum
Alençon, Mus. B.-A. & Dentelle
 Alençon, Musée des Beaux-Arts et
 de la Dentelle
Amboise, Mus. Mun.
 Amboise, Musée Municipal [Musée
 de l'Hôtel de Ville]
Amiens, Mus. Picardie
 Amiens, Musée de Picardie
Amsterdam, Hist. Mus.
 Amsterdam, Historisch
 Museum
Amsterdam, Rijksmus.
 Amsterdam, Rijksmuseum
 [includes Afdeeling Aziatische
 Kunst; Afdeeling Beeldhouwkunst;
 Afdeeling Nederlandse
 Geschiedenis; Afdeeling
 Schilderijen; Museum von
 Asiatische Kunst; Rijksmuseum
 Bibliothek; Rijksprentenkabinet]
Amsterdam, Rijksmus. van Gogh
 Amsterdam, Rijksmuseum Vincent
 van Gogh

Angers, Mus. B.-A.
 Angers, Musée des Beaux-Arts
Angers, Soc. Amis A.
 Angers, Société des Amis des Arts
Angoulême, Mus. Mun.
 Angoulême, Musée Municipal
Ann Arbor, U. MI
 Ann Arbor, MI, University of
 Michigan
Ann Arbor, U. MI, Mus. A.
 Ann Arbor, MI, University of
 Michigan, Museum of Art
Antwerp, Kon. Mus. S. Kst.
 Antwerp, Koninklijk Museum voor
 Schone Kunsten
Arenenberg, Napoleonmus.
 Arenenberg, Napoleonmuseum
Arras, Mus. B.-A.
 Arras, Musée des Beaux-Arts
 [Ancienne Abbaye Saint-Vaast]
Atlanta, GA, High Mus. A.
 Atlanta, GA, High Museum of
 Art
Aurillac, Mus. Parieu
 Aurillac, Musée Hippolyte de
 Parieu [Musée des Beaux-Arts]
Autun, Mus. Rolin
 Autun, Musée Rolin
Auxerre, Mus. A. & Hist.
 Auxerre, Musée d'Art et
 d'Histoire
Avignon, Mus. Calvet
 Avignon, Musée Calvet

Baden-Baden, Staatl. Ksthalle
 Baden-Baden, Staatliche
 Kunsthalle Baden-Baden
Bagnères-de-Bigorre, Mus. A.
 Bagnères-de-Bigorre, Musée d'Art
Bagnères-de-Luchon, Jard. Pub.
 Bagnères-de-Luchon, Jardins
 Publics
Baltimore, MD Inst., Decker Gal.
 Baltimore, MD, Maryland
 Institute, Decker Gallery of the
 College of Art
Baltimore, MD, Johns Hopkins U.,
Garrett Lib.
 Baltimore, MD, Johns Hopkins
 University, John Work Garrett
 Rare Book Library
Baltimore, MD, Mus. A.
 Baltimore, MD, Baltimore Museum
 of Art
Baltimore, MD, Walters A.G.
 Baltimore, MD, Walters Art
 Gallery
Baltimore, U. MD, Mus. A.
 Baltimore, MD, University of
 Maryland, Museum of Art [in
 grounds of Johns Hopkins U.]
Barbizon, Salle Fêtes
 Barbizon, Salle des Fêtes
Barentin, Mus. Mun.
 Barentin, Musée Municipal
Barnard Castle, Bowes Mus.
 Barnard Castle, Bowes Museum

Basle, Gal. Beyeler
 Basle, Galerie Beyeler
Basle, Kstmus.
 Basle, Kunstmuseum [incl.
 Kupferstichkabinett]
Basle, Staechlin Found.
 Basle, Rodolphe Staechlin
 Foundation
Bayonne, Mus. Bonnat
 Bayonne, Musée Bonnat
Beauvais, Mus. Dépt. Oise
 Beauvais, Musée Départemental de
 l'Oise
Belleville-sur-Bar, Sanatorium
Berlin, Alte N.G.
 Berlin, Alte Nationalgalerie
Berlin, Bodemus.
 Berlin, Bodemuseum [houses
 Ägyptisches Museum und
 Papyrussammlung; Frühchristlich-
 Byzantinische Sammlung;
 Gemäldegalerie; Münzkabinett;
 Museum für Ur- und
 Frühgeschichte;
 Skulpturensammlung]
Berlin, Neue N.G.
 Berlin, Neue Nationalgalerie
Berlin, Staatl. Ksthalle
 Berlin, Staatliche Kunsthalle
Berlin, Tiergarten [Kulturforum]
Berne, Kstmus.
 Berne, Kunstmuseum
Besançon, Mus. B.-A. & Archéol.
 Besançon, Musée des Beaux-Arts et
 d'Archéologie
Béziers, Mus. B.-A.
 Béziers, Musée des Beaux-Arts
 Hôtel Fabregat
Bielefeld, Städt. Ksthalle
 Bielefeld, Städtische
 Kunsthalle
Binghamton, SUNY
 Binghamton, NY, State University
 of New York
Birmingham, Mus. & A.G.
 Birmingham, City of
 Birmingham Museum and Art
 Gallery
Blois, Mus. Mun.
 Blois, Musée Municipal de
 Blois

Bordeaux, Mus. B.-A.
 Bordeaux, Musée des Beaux-Arts
Boston, MA, Mus. F.A.
 Boston, MA, Museum of Fine Arts
Boston, MA, Pub. Lib.
 Boston, MA, Public Library
Boulogne, Mus. Mun.
 Boulogne, Musée Municipal
Bourg-en-Bresse, Mus. Ain
 Bourg-en-Bresse, Musée de l'Ain
Bremen, Ksthalle
 Bremen, Kunsthalle
Brest, Mus. Mun.
 Brest, Musée Municipal [Musée des
 Beaux-Arts]
Brighton, Royal Pav.
 Brighton, Royal Pavilion
Bristol, Mus. & A.G.
 Bristol, City of Bristol Museum
 and Art Gallery
Brussels, Mus. A. Mod.
 Brussels, Musée d'Art Moderne
Brussels, Musées Royaux A. & Hist.
 Brussels, Musées Royaux d'Art et
 d'Histoire [Koninklijke Musea voor
 Kunst en Geschiedenis]
Brussels, Mus. Hôtel Bellevue
 Brussels, Musée de l'Hôtel
 Bellevue
Brussels, Mus. Ixelles
 Brussels, Musée Communal des
 Beaux-Arts d'Ixelles
Budapest, Mus. F.A.
 Budapest, Museum of Fine Arts
 (Szépm@vészeti Múzeum)
Buenos Aires, Mus. N. B.A.
 Buenos Aires, Museo Nacional de
 Bellas Artes
Buffalo, NY, Albright-Knox A.G.
 Buffalo, NY, Albright-Knox Art
 Gallery [formerly Albright
 A.G.]
Caen, Mus. B.-A.
 Caen, Musée des Beaux-Arts
Cairo, Gazira Mus.
 Cairo, Gazira Museum
Calais, Mus. B.-A.
 Calais, Musée des Beaux-Arts et de
 la Dentelle
Cambrai, Mus. Mun.
 Cambrai, Musée Municipal

Cambridge, Fitzwilliam
 Cambridge, Fitzwilliam Museum
Cambridge, MA, Fogg
 Cambridge, MA, Fogg Art Museum
Carcassonne, Mus. B.-A.
 Carcassonne, Musée des Beaux-
 Arts
Cardiff, N. Mus.
 Cardiff, National Museum of
 Wales
Castelnaudary, Mus. Archéol.
Lauragais
 Castelnaudary, Musée
 Archéologique du Lauragais
Chalon-sur-Saône, Mus. Denon
 Chalon-sur-Saône, Musée Denon
Chambéry, Mus. B.-A.
 Chambéry, Musée des Beaux-Arts
Chantilly, Mus. Condé
 Chantilly, Musée Condé, Château
 de Chantilly
Charleroi, Pal. B.-A.
 Charleroi, Palais des Beaux-Arts
Chartres, Mus. B.-A.
 Chartres, Musée des Beaux-Arts
Châteauroux, Mus. Bertrand
 Châteauroux, Musée Bertrand
Cherbourg, Mus. Thomas-Henry
 Cherbourg, Musée Thomas-Henry
Chicago, IL, A. Inst.
 Chicago, IL, Art Institute of
 Chicago
Chios, Adamantios Korais Lib.
 Chios, Adamantios Korais Library
Cincinnati, OH, A. Mus.
 Cincinnati, OH, Cincinnati Art
 Museum
Cincinnati, OH, Taft Mus.
 Cincinnati, OH, Taft Museum
Cleveland, OH, Mus. A.
 Cleveland, OH, Cleveland Museum
 of Art
Cody, WY, Buffalo Bill Hist. Cent.
 Cody, WY, Buffalo Bill Historical
 Center
Coëtquidan, Ecole Mil. St Cyr
 Coëtquidan, Ecole Militaire de St
 Cyr
Cognac, Mus. Cognac
 Cognac, Musée de Cognac [Musées
 des Beaux-Arts]

Hamburg, Mus. Kst & Gew.
 Hamburg, Museum für Kunst und Gewerbe
Hannover, Wilhelm-Busch-Mus.
 Hannover, Wilhelm-Busch-Museum
Hartford, CT, Wadsworth Atheneum
Havana, Mus. N. B.A.
 Havana, Museo Nacional de Bellas Artes [in Palacio de Bellas Artes]
Honfleur, Mus. Boudin
 Honfleur, Musée Eugène Boudin
Houston, TX, Menil Col.
 Houston, TX, Menil Collection
Houston, TX, Mus. F.A.
 Houston, TX, Museum of Fine Arts
Indianapolis, IN, Mus. A.
 Indianapolis, IN, Museum of Art [incl. Clowes Fund Collection of Old Master Paintings]
Ingelheim, Int. Tage
 Ingelheim, Internationale Tage [C. H. Boehringer Sohn annu. exh.]
Ivry-sur-Seine, Dépôt Oeuvres A.
 Ivry-sur-Seine, Dépôt des Oeuvres d'Art de la Ville de Paris
Jacksonville, FL, Cummer Gal. A.
 Jacksonville, FL, Cummer Gallery of Art
Jarville, Mus. Hist. Fer
 Jarville, Musée de l'Histoire du Fer
Kansas City, MO, Nelson-Atkins Mus. A.
 Kansas City, MO, Nelson-Atkins Museum of Art [name changed from W. Rockhill Nelson Gal. c. 1980]
Kobe, Hyogo Prefect. MOMA
 Kobe, Hy!go Prefectural Museum of Modern Art (Hy!go Kenritsu kindai Bijutsukan)
Langres, Mus. St-Didier
 Langres, Musée St-Didier
La Rochelle, Mus. B.-A.
 La Rochelle, Musée des Beaux-Arts
La Roche-sur-Yon, Mus. A. & Archéol.
 La Roche-sur-Yon, Musée d'Art et d'Archéologie
La Tour-de-Peilz, Château
Lausanne, Pal. Rumine
 Lausanne, Palais Rumine [houses Musée Botanique Cantonal; Musée Cantonal d'Archéologie et d'Histoire; Musée Cantonal des Beaux-Arts; Musée Géologique Cantonal; Lausanne, Musée Historique, Cabinet des Médailles du Canton de Vaud; Musée Zoologique Cantonal]
Laval, Mus. Vieux-Château
 Laval, Musée du Vieux-Château
Lawrence, U. KS, Spencer Mus. A.
 Lawrence, KS, University of Kansas, Spencer Museum of Art
Le Croisic, Hôp.
 Le Croisic, Hôpital
Le Havre, Mus. B.-A.
 Le Havre, Musée des Beaux-Arts
Leicester, Mus. & A.G.
 Leicester, Leicestershire Museum and Art Gallery
Leipzig, Mus. Bild. Kst.
 Leipzig, Museum der Bildenden Künste
Le Mans, Mus. Tessé
 Le Mans, Musée de Tessé [Musée des Beaux-Arts]
Le Mée-sur-Seine, Mus. Chapu
 Le Mée-sur-Seine, Musée Henri Chapu
Le Puy, Mus. Crozatier
 Le Puy, Musée Crozatier [Jardin Henri-Vinay]
Le Quesnoy, Hôtel de Ville
Liège, Gal. St Georges
 Liège, Galerie Saint Georges
Liège, Mus. B.-A.
 Liège, Musée des Beaux-Arts
Lille, Mus. B.-A.
 Lille, Musée des Beaux-Arts [in Palais des Beaux-Arts]
Limoges, Mus. Mun.
 Limoges, Musée Municipal
Lisbon, Mus. Gulbenkian
 Lisbon, Museu Calouste Gulbenkian [Fundação Calouste Gulbenkian]
Lisieux, Mus. Vieux-Lisieux
 Lisieux, Musée du Vieux-Lisieux
Liverpool, Tate
 Liverpool, Tate Gallery Liverpool
Liverpool, Walker A.G.
 Liverpool, Walker Art Gallery
London, ACGB
 London, Arts Council of Great Britain
London, Barbican A.G.
 London, Barbican Art Gallery
London, BM
 London, British Museum
London, David Carritt
 London, David Carritt Ltd
London, Grafton Gals
 London, Grafton Galleries [closed]
London, Grosvenor Gal.
 London, Grosvenor Gallery [Sevenarts Ltd]
London, Guildhall A.G.
 London, Guildhall Art Gallery
London, Hayward Gal.
 London, Hayward Gallery
London, Hazlitt, Gooden & Fox
 London, Hazlitt, Gooden and Fox
London, Lefevre Gal.
 London, Lefevre Gallery [Alex Reid & Lefevre Ltd]
London, Marlborough F.A.
 London, Marlborough Fine Art Ltd [incl. Marlborough New London Gallery]
London, N.G.
 London, National Gallery
London, N.P.G.
 London, National Portrait Gallery
London, Piccadilly Gal.
 London, Piccadilly Gallery
London, RA
 London, Royal Academy of Arts [Burlington House; houses RA Archives & Library]
London, Tate
 London, Tate Gallery
London, V&A
 London, Victoria and Albert Museum [houses National Art Library]
London, Wallace
 London, Wallace Collection
London, Wildenstein's
 London, Wildenstein and Co. Ltd

Lons-le-Saunier, Mus. B.-A.
 Lons-le-Saunier, Musée des Beaux-
 Arts
Los Angeles, CA, Armand Hammer
Mus. A.
 Los Angeles, CA, Armand Hammer
 Museum of Art and Cultural
 Center
Los Angeles, CA, Co. Mus. A.
 Los Angeles, CA, County Museum
 of Art [incl. Robert Gore Rifkind
 Center for German Expressionist
 Studies]
Louisville, KY, Speed A. Mus.
 Louisville, KY, J.B. Speed Art
 Museum
Lourdes, Mus. Pyrénéen
 Lourdes, Musée Pyrénéen
Louviers, Mus. Mun.
 Louviers, Musée Municipal de
 Louviers
Lunéville, Mus. Lunéville
 Lunéville, Musée de Lunéville
 [Château de Lunéville]
Lyon, Mus. B.-A.
 Lyon, Musée des Beaux-Arts
Mâcon, Mus. Mun. Ursulines
 Mâcon, Musée Municipal des
 Ursulines
Madison, U. WI, Elvehjem A. Cent.
 Madison, WI, University of
 Wisconsin, Elvehjem Art Center
Madrid, Mus. A. Contemp.
 Madrid, Museo Español de Arte
 Contemporáneo
Madrid, Pal. Liria, Col. Casa Alba
 Madrid, Palacio Liria, Colección
 Casa de Alba
Madrid, Prado
 Madrid, Museo del Prado [Museo
 Nacional de Pintura y Escultura]
Malmaison, Château N.
 Malmaison, Château National de
 Malmaison [houses Musée de
 Malmaison]
Manchester, C.A.G.
 Manchester, City Art Gallery
Mannheim, Städt. Ksthalle
 Mannheim, Städtische Kunsthalle
 Mannheim [Städtisches
 Museum]

Marseille, Mus. B.-A.
 Marseille, Musée des Beaux-Arts
 [Palais de Longchamp]
Marseille, Mus. Cantini
 Marseille, Musée Cantini
Marseille, Mus. Grobet-Labadié
 Marseille, Musée Grobet-Labadié
Martigny, Fond. Pierre Gianadda
 Martigny, Fondation Pierre
 Gianadda
Maubeuge, Mus. Boez
 Maubeuge, Musée Henri Boez
Melbourne, N.G. Victoria
 Melbourne, National Gallery of
 Victoria [Victorian A. Cent.]
Melun, Mus. Melun
 Melun, Musée de Melun
Memphis, TN, Brooks Mus. A.
 Memphis, TN, Memphis Brooks
 Museum of Art [Brooks Memorial
 Art Gallery]
Memphis, TN, Dixon Gal.
 Memphis, TN, Dixon Gallery and
 Gardens
Merion Station, PA, Barnes Found.
 Merion Station, PA, Barnes
 Foundation
Metz, Mus. A. & Hist.
 Metz, Musée d'Art et d'Histoire
Meudon, Mus. Rodin
 Meudon, Musée Rodin
Milwaukee, WI, A. Mus.
 Milwaukee, WI, Milwaukee Art
 Museum [formerly A. Cent.]
Minneapolis, MN, Inst. A.
 Minneapolis, MN, Minneapolis
 Institute of Arts
Montargis, Mus. B.-A.
 Montargis, Musée des Beaux-
 Arts
Montargis, Mus. Girodet
 Montargis, Musée Girodet, Hôtel
 de Ville
Montauban, Mus. Ingres
 Montauban, Musée Ingres
Montpellier, Mus. Fabre
 Montpellier, Musée Fabre [Musée
 des Beaux-Arts]
Montreal, Cent. Can. Archit.
 Montreal, Centre Canadien
 d'Architecture

Montreal, Mus. F.A.
 Montreal, Museum of Fine Arts
 [Musée des Beaux-Arts]
Mortagne-au-Perche, Maison Comtes
du Perche
 Mortagne-au-Perche, Maison des
 Comtes du Perche [Mus. Alain
 since 1977]
Moscow, Kremlin (Kreml')
Moscow, Pushkin Mus. F.A.
 Moscow, Pushkin Museum of Fine
 Arts (Muzey Izobrazitelnykh
 Iskusstv Imeni A.S. Pushkina)
Moulins, Mus. Moulins
 Moulins, Musée des Moulins
Mülheim an der Ruhr, Städt. Mus.
 Mülheim an der Ruhr, Städtisches
 Museum [incl. Kunstmuseum;
 Heimatmuseum; Ausstellungen
 Museum Alte Post]
Mulhouse, Mus. B.-A.
 Mulhouse, Musée des Beaux-
 Arts
Munich, Maximilianum
Munich, Neue Pin.
 Munich, Neue Pinakothek
Münster, Westfäl. Landesmus.
 Münster, Westfälisches
 Landesmuseum für Kunst und
 Kulturgeschichte
Nagoya, Aichi Cult. Cent.
 Nagoya, Aichi Cultural Center
 (Aichikenritsu Bunka Kaikan
 Bijutsukan) [Aichi Prefecture
 Cultural Centre and Art
 Museum/Aichi Prefecture Art
 Gallery]
Nancy, Mus. B.-A.
 Nancy, Musée des Beaux-
 Arts
Nancy, Mus. Fer
 Nancy, Musée du Fer
Nantes, Mus. B.-A.
 Nantes, Musée des Beaux-Arts de
 Nantes
Nara, Prefect. Mus. A.
 Nara, Prefectural Museum of Art
 (Nara-kenritsu Bijutsukan)
Narbonne, Mus. A. & Hist.
 Narbonne, Musée d'Art et
 d'Histoire

Stanford, CA, U. A.G. & Mus.
 Stanford, CA, Stanford University
 Art Gallery and Museum
Stockholm, Nmus.
 Stockholm, Nationalmuseum
Strasbourg, Mus. A. Mod.
 Strasbourg, Musée d'Art Moderne
Strasbourg, Mus. B.-A.
 Strasbourg, Musée des Beaux-Arts
Strasbourg, Mus. Hist.
 Strasbourg, Musée Historique
Tokyo, Bridgestone A. Mus.
 Tokyo, Bridgestone Art Museum
Tokyo, Isetan Mus. A.
 Tokyo, Isetan Museum of Art
Tokyo, Keio Umeda Gal.
 Tokyo, Keio Umeda Gallery
Tokyo, N. Mus. W. A.
 Tokyo, National Museum of
 Western Art
Tokyo, Seibu Mus. A.
 Tokyo, Seibu Museum of Art
Toledo, OH, Mus. A.
 Toledo, OH, Museum of Art
Toronto, A.G. Ont.
 Toronto, Art Gallery of Ontario
Toulouse, Capitole [Hôtel de Ville]
Toulouse, Mus. Augustins
 Toulouse, Musée des Augustins
Tourcoing, Mus. Mun. B.-A.
 Tourcoing, Musée Municipal des
 Beaux-Arts
Tournai, Mus. B.-A.
 Tournai, Musée des Beaux-Arts de
 Tournai

Tours, Mus. B.-A.
 Tours, Musée des Beaux-Arts
Troyes, Mus. B.-A. & Archéol.
 Troyes, Musée des Beaux-Arts et
 d'Archéologie
Tübingen, Ksthalle
 Tübingen, Kunsthalle Tübingen
Tunis, Min. Affaires Cult.
 Tunis, Ministère des Affaires
 Culturelles
Valence, Mus. B.-A. & Hist. Nat.
 Valence, Musée des Beaux-Arts et
 d'Histoire Naturelle
Valenciennes, Mus. B.-A.
 Valenciennes, Musée des Beaux-
 Arts
Verdun, Mus. Princerie
 Verdun, Musée de la Princerie
Verona, Pal. Forti
 Verona, Palazzo Forti [formerly
 Palazzo Emilei; houses Galleria
 Comunale d'Arte Moderna; Mus.
 Ris.]
Versailles, Mus. Hist.
 Versailles, Musée d'Histoire [in
 Château]
Vesoul, Mus. Mun. Garret
 Vesoul, Musée Municipal Georges
 Garret
Vevey, Mus. Jenisch
 Vevey, Musée Jenisch, Musée des
 Beaux-Arts et Cabinet Cantonal
 des Estampes
Vichy, Casino
Villeneuve-sur-Lot, Hôtel de Ville

Wakefield, A.G.
 Wakefield, Wakefield Art
 Gallery
Washington, DC, Corcoran Gal. A.
 Washington, DC, Corcoran Gallery
 of Art
Washington, DC, Lib. Congr.
 Washington, DC, Library of
 Congress
Washington, DC, N.G.A.
 Washington, DC, National Gallery
 of Art
Wellington, NZ, Turnbull Lib.
 Wellington, NZ, Alexander
 Turnbull Library
Williamstown, MA, Clark A. Inst.
 Williamstown, MA, Sterling and
 Francine Clark Art Institute
Windsor Castle, Royal Lib.
 Windsor, Windsor Castle, Royal
 Library
Winterthur, Kstmus.
 Winterthur, Kunstmuseum
 Winterthur
Winterthur, Samml. Oskar
Reinhart
 Winterthur, Sammlung Oskar
 Reinhart [am Römerholz]
Zurich, Ksthaus
 Zurich, Kunsthaus Zürich
Zurich, Rau Found.
 Zurich, Rau Foundation
Zurich, Stift. Samml. Bührle
 Zurich, Stiftung Sammlung E.G.
 Bührle

Appendix B
LIST OF PERIODICAL TITLES

This list contains all of the periodical titles that have been cited in an abbreviated form in italics in the bibliographies of this book. For the sake of comprehensiveness, it also includes entries of periodicals that have not been abbreviated, for example where the title consists of only one word or where the title has been transliterated. Abbreviated titles are alphabetized letter by letter, including definite and indefinite articles but ignoring punctuation, bracketed information and the use of ampersands. Roman and arabic numerals are alphabetized as if spelt out (in the appropriate language), as are symbols. Additional information is given in square brackets to distinguish two or more identical titles or to cite a periodical's previous name.

A. Bull.
 Art Bulletin

A. & Curiosité
 Art et curiosité

A. Déc.

A. & Déc.
 Art et décoration [prev. pubd as *A. Déc.*]

A. J. [London]
 Art Journal [London]

A. J. [New York]
 Art Journal [New York; prev. pubd as *Coll. A. J.; Parnassus*]

A. Mag.

Amour A.
 L'Amour de l'art [cont. as *Prométhée; reverts to *Amour A.*]

Artforum
 Arts [New York; prev. pubd as *A. Dig.*; cont. as *A. Mag.*]

Arts [Paris]
 Arts: Beaux arts, littérature, spectacle [Paris] [prev. pubd as *Beaux-A.: Chron. A. & Curiosité; Chron. A. & Curiosité*]

Art-Union

Bull. Amis Gustave Courbet
 Bulletin des amis de Gustave Courbet

Bull. Cleveland Mus. A.
 Bulletin of the Cleveland Museum of Art

Bull. Detroit Inst. A.
 Bulletin of the Detroit Institute of Arts

Bull. Mus. Ingres
 Bulletin du Musée Ingres

Bull. Soc. Hist. A. Fr.
 Bulletin de la Société de l'histoire de l'art français

Bull. Soc. Sci., Lett. & A. Bayonne
 Bulletin de la Société des sciences, lettres et arts de Bayonne

Burl. Mag.
 Burlington Magazine

Byblis

Cah. Naturalistes
 Cahiers naturalistes

Chron. A.
 Chronique des arts [suppl. of Gaz. B.-A.]

Gaz. B.-A.
 Gazette des beaux-arts [suppl. is Chron. A.]

Krit. Ber.
 Kritische Berichte

Kunstchronik

L'Art
 L'Art: Revue hebdomadaire illustrée

L'Artiste

Le Journal

Le Pays

L'Illustration
 Illustration: Journal universel [cont. as *Nouv.-Fém.-France-Illus.*]

Mag. A.
 Magazine of Art [incorp. suppl. RA Illus. until 1904]

Marxist Persp.
 Marxist Perspectives

Nelson Gal. & Atkins Mus. Bull.
 Nelson Gallery and Atkins Museum Bulletin

Nouv. Archvs A. Fr.
 Nouvelles archives de l'art français [prev. pubd & cont. as *Archvs A. Fr.*]

Nouv. Est.
 Nouvelles de l'estampe

Pantheon
 Pantheon: Internationale Zeitschrift für Kunst [cont. as *Bruckmanns Pantheon*]

Prt Colr Q.
 Print Collector's Quarterly

Prt Q.
 Print Quarterly

Prt Rev.
 Print Review

Racar
 Racar: Revue d'art canadienne

Rev. A.
 Revue de l'art

Rev. Blanche
 Revue blanche

Rev. Enc.
 Revue encyclopédique

Rev. Louvre
 Revue du Louvre et des musées de France

Romanticisme
 Romanticisme: Revue du XIXe siècle

Scot. A. Rev.
 Scottish Art Review

Appendix C
LISTS OF STANDARD REFERENCE BOOKS AND SERIES

This Appendix contains, in alphabetical order, the abbreviations used in bibliographies for alphabetically arranged dictionaries and encyclopedias. Some dictionaries and general works, especially dictionaries of national biography, are reduced to the initial letters of the italicized title (e.g. *DNB*) and others to the author/editor's name (e.g. Colvin) or an abbreviated form of the title (e.g. *Contemp. Artists*). Abbreviations from Appendix C are cited at the beginning of bibliographies or bibliographical subsections, in alphabetical order, separated by semi-colons; the title of the article in such reference books is cited only if the spelling or form of the name differs from that used in this dictionary or if the reader is being referred to a different subject.

Bellier de La Chavignerie-Auvray
 E. Bellier de La Chavignerie and
 L. Auvray: *Dictionnaire général
 des artistes de l'Ecole française
 depuis l'origine des arts du
 dessin jusqu'à nos jours*, 2 vols
 (Paris, 1882-5), suppl. (Paris,
 1887)
Bénézit
 E. Bénézit, ed.: *Dictionnaire
 critique et documentaire des
 peintres, sculpteurs, dessinateurs
 et graveurs*, 10 vols (Paris, 1913-22,
 rev. 3/1976)

DBF
 *Dictionnaire de biographie
 française* (Paris, 1933-)
Edouard-Joseph
 R. Edouard-Joseph: *Dictionnaire
 biographique des artistes
 contemporains*, 3 vols (Paris, 1930-
 34)
Forrer
 L. Forrer: *Biographical Dictionary
 of Medallists*, 8 vols (London, 1902-
 30)
Lami
 S. Lami: *Dictionnaire des*

 sculpteurs de l'Ecole française, 8
 vols (Paris, 1898-1921/R Nendeln,
 1970)
SKL
 C. Brun: *Schweizerisches Künstler-
 Lexikon/Dictionnaire des artistes
 suisses*, 4 vols (Frauenfeld, 1905-
 17/R Nendeln, 1967)
Thieme-Becker
 U. Thieme and F. Becker, eds:
 *Allgemeines Lexikon der
 bildenden Künstler von der Antike
 bis zur Gegenwart*, 37 vols
 (Leipzig, 1907-50)

The Grove Dictionary of Art

From Monet to Cézanne

The Grove Dictionary of Art

Other titles in this series:

From Renaissance to Impressionism
Styles and Movements in Western Art, 1400–1900
ISBN 0–333–92045–7

From Expressionism to Post-Modernism
Styles and Movements in 20th-century Western Art
ISBN 0–333–92046–5

From Rembrandt to Vermeer
17th-century Dutch Artists
ISBN 0–333–92044–9

From David to Ingres
Early 19th-century French Artists
ISBN 0–333–92042–2

Praise for *The Dictionary of Art*

'It is hard to resist superlatives about the new *Dictionary of Art*... If this isn't the most important art-publishing event of the 20th century, coming right at its end, one would like to know what its plausible competitors are. In fact there aren't any....'
Robert Hughes, *Time Magazine*

'The *Dictionary of Art* succeeds in performing that most difficult of balancing acts, satisfying specialists while at the same time remaining accessible to the general reader.'
Richard Cork, *The Times*

'As a reference work, there is nothing to compare with *The Dictionary of Art*. People who work in the arts - lecturers, curators, dealers, researchers and journalists - will find it impossible to do their jobs without the magnificent resource now available to them.'
Richard Dorment, *The Daily Telegraph*

'These are whole books within books... An extraordinary work of reference.'
E. V. Thaw, *The Wall Street Journal*

'It's not at all hyperbolic to say the dictionary is the rarest kind of undertaking, one that makes you glad it happened during your life.'
Alan G. Artner, *Chicago Tribune*